S

Hans Ulrich Obrist
Interviews

Volume I

Edited by
Thomas Boutoux

FONDAZIONE PITTI IMMAGINE DISCOVERY / CHARTA

Editorial coordination
Emanuela Belloni, Elena Carotti

Design coordination
Gabriele Nason

Proofreading
Charles Gute

Copywriter and Press Office
Silvia Palombi Arte&Mostre, Milan

Web Design and Online Promotion
Barbara Bonacina
—

Fondazione Pitti Immagine Discovery

Chairman
Alfredo Canessa

Board of Directors
Gaetano Marzotto, Raffaello Napoleone

Secretary General
Lapo Cianchi

Art Director
Francesco Bonami

Communication and Editorial Project Director
Maria Luisa Frisa
—

Fondazione Pitti Immagine Discovery
via Faenza 111
50123 Florence
T +39-0553693211/407
F +39-0553693200
discovery@pittimmagine.com
www.pittimmagine.com

Edizioni Charta
via della Moscova 27
20121 Milan
T +39-026598098/026598200
F +39-026598577
edcharta@tin.it
www.chartaartbooks.it

A project produced by
Fondazione Pitti Immagine Discovery
for La Biennale di Venezia
(50th International Art Exhibition), 2003

Artistic and Project Coordination
Maria Luisa Frisa

English Text Editor
Ali Subotnick

Editing and Editorial Coordination
Simone Metta, Giulio Saetta, Gráphein s.r.l., Milan

Design
Alessandro Gori

Cover Image
Hans-Peter Feldmann

Secretary of Production
Valeria Santoni

Press Office
Francesca Tacconi

Translators
Stephen Berg (L. Pape), Sarah Crowner (P. Parreno), Christopher Evans (S. Boeri),
Christian Rattemeyer (M. Diers, T. Hirschhorn, F. Otto, F. West), Richard Sadleir (G. De Carlo,
M. Merz, E. Sottsass), Studio Asci Srl Multimedia Multilingual Communications (M. Pistoletto),
Catherine Temerson (C. and L. Boltanski, C. Meireles, A. Varda), Stephen Wright (D. Buren, Constant,
E. Glissant, D. Gonzalez-Foerster, Huang Yong Ping, C. Parent, J. Rouch)

Transcribers
Gilles Amalvi (C. and L. Boltanski, D. Buren, Y. Friedman), Boris Belay (Constant, O. Eliasson, B. Eno,
Z. Hadid, S. Hall, A. Isozaki, R. Koolhaas), Thomas Boutoux (C. and L. Boltanski, D. Buren, E. Glissant,
D. Gonzalez-Foerster, Huang Yong Ping, P. Huyghe, R. Matta, C. Parent, P. Parreno, J. Rouch, A. Varda),
Ana Paula Cohen (L. Pape), Cécile Dazord (C. Meireles), Elena Filipovic (J.G. Ballard, G. Orozco),
James Lee (Lee Bul), Doris Lösch (J. Cladders, H.-G. Gadamer, C. T. Hirschhorn, C. Höller, F. Otto),
Patrizia Losito (W. Hopps, P. Hulten, G. Richter), Wonga Mancoba (E. Mancoba), museum in
progress (V. Acconci, D. Birnbaum, D. Gordon), Michelle Nicol (A. Zeilinger), Federico Nicolao
(S. Boeri, G. De Carlo, M. Merz, M. Pistoletto, E. Sottsass), Kayoko Ota (K. Sejima), Carrie Pilto
(F. Gonzalez-Torres, J. Grigely, B. Klüver, S. Maharaj and F. Varela, A. Sala), Alexandre Pollazzon
(I. Prigogine), Matt Price (M. Abramović and G.J. Chaitin, M. Barney, S. Boeri, M. Cattelan, Esquivel!,
Y. Friedman, Gilbert & George, D. Graham, C. Höller, R. Horn, A. Isozaki, R. Koolhaas, J. Mekas, S. Mofokeng,
Y. Ono, G. Orozco, I. Rosenfield, A. Sala, L. Steels, R. Tiravanija, L. Weiner, C. Wyn Evans), Vivian Rehberg
(D. Graham), Dörte Zbikowski (F. West)

Acknowledgements

Hans Ulrich Obrist would like to thank very specially all the interviewees who have agreed to the publication of their text in this book, and Francesco Bonami, Laurence Bossé, Thomas Boutoux, Lapo Cianchi, Hans-Peter Feldmann, Elena Filipovic, Maria Luisa Frisa, Alessandro Gori, Kasper König, Koo Jeong-a, Giuseppe Liverani, Doris Lösch, Kathrin Messner & Josef Ortner, Suzanne Pagé, Matt Price, and Ali Subotnick. Without them this book could not have happened.

Deepest gratitude to all the architects, artists, composers, curators, designers, filmmakers, philosophers, scientists, social theorists, and writers with whom Hans Ulrich Obrist has recorded interviews to date.

Thanks to Martine Aboucaya, agnès b., Gilles Amalvi, Sandra Antelo-Suárez, Sara Arrhenius, Jack Bankowsky, Eric Banks, Nick Barley, Carlos Basualdo, Ute Meta Bauer, Olivier Baumgartner, Marie-Claude Beaud, Boris Belay, Emanuela Belloni, Olivier Belot, Jonathan Bepler, Stephen Berg, Roman Berka, Marie-Laure Bernadac, Aaron Betsky, Klaus Biesenbach, Tatiana Bilbao, Rob Birman, Daniel Birnbaum, Beatrice von Bismarck, Petra Blaisse, Caroline Bourgeois, Lionel Bovier, Fiona Bradley, Jacqueline Burckhardt, Hubert Burda, Elena Carotti, Christophe Cherix, Vincenzo Chiarandà from undo.net, Signe Christensen, Carolyn Christov-Bakargiev, Élisabeth Claverie, Jean-Max Colard, Brigitte Cornand, Chantal Crousel, Sarah Crowner, Bice Curiger, Alberto Curotto, Daniel Buren Studio, Catherine David, Cécile Dazord, Marco De Michelis, Catherine Dempsey, Chris Dercon, Michael Diers, Philip Dodd, Sabine Dreher, Pamela Echevarría, Okwui Enwezor, Jan Fabre, Arlette Farge, Anthony Fawcett, Susan Ferleger Brades, Christine Ferry, Agnès Fiérobe, Peter Fischli/David Weiss, Robert Fleck, Mark Francis, Bettina Funcke, Julia Garimorth, Isa Genzken, Christiane Germain, Guilaine Germain, Matteo Ghidoni, Ida Gianelli, Liam Gillick, Massimiliano Gioni, Christophe Girard, Sylvie Glissant, Marian Goodman, Catherine Grant, Elsa Guigo, Annika Hansson, Yuko Hasegawa, Salah Hassan, Alanna Heiss, Jens Hoffmann, Hou Hanru, Brigitte Huck, Yoshiko Isshiki, Rumiko Ito, Gregor Jansen, Maaretta Jaukkuri, Steven Johnson, Évelyne Jouanno, Morgan Jouvenet, Martina Kandeler-Fritsch, Georg Kargl, Chitti Kasemkitvatana, Paul Katzberger, On Kawara, Samuel Keller, Walther König, Peter Kogler, Helena Kontova, Wolfgang Kos, Jannis Kounellis, Rudi Laermans, Yvon Lambert, Bruno Latour, Élisabeth Lebovici, Maria Lind, Jean de Loisy, Geert Lovink, Christa Maar, Michèle Manceaux, Wonga Mancoba, Karen Marta, Rosa Martínez, Ramuntcho Matta, Bruce Mau, Karla Merrifield, Annette Messager, Simone Metta, Olivier Michelon, Jeremy Millar, Viktor Misiano, Akiko Miyake, Stephanie Moisdon-Trembley, Isabela Mora, Sylvie Moreau, Daniel Mouchard, Nobuo Nakamura, Gabriele Nason, Molly Nesbit, Michelle Nicol, Federico Nicolao, John-Peter Nilsson, F&E. Obrist, Olu Oguibe, Kayoko Ota, Paula Pape, Beatrice Parent, Adriano Pedrosa, Virginia Pérez-Ratton, Alessandro Petti, Julia Peyton-Jones, Mario Pieroni, Carrie Pilto, Olivier Poivre D'Arvor, Giancarlo Politi, Alexandre Pollazzon, Eve Presenhuber, Cay-Sophie Rabinowitz, Bruno Racine, Christian Rattemeyer, Vivian Rehberg, Pedro Reyes, Kathrin Rhomberg, Michele Robecchi, Fernando Romero, Véronique Rousseau, Beatrix Ruf, Claire Sabatié-Garat, Giulio Saetta, Valeria Santoni, Angéline Scherf, Nicholas Serota, Giuliana Setari, Jennifer Sigler, Matthew Slotover, Misook Song, Nancy Spector, Jean-Cyril Spinetta, Lilijana Stepancic, Dora Stiefelmeier, Diethelm Stoller, Meg Stuart, Anna Stuart Tovini, Studio One, Harald Szeemann, Gilaine Tawadros, Catherine Temerson, Clara Tran Qui, Hendrik Tratsaert, Nicolas Trembley, Trouble/Paris (Boris Achour, Claire Jacquet, François Piron and Émilie Renard), Ines Turian, Barbara Vanderlinden, Manuela Vaney, Roemer van Toorn, Simona Vendrame, Angela Vettese, Anton Vidokle, Robert Violette, Aurélie Voltz, Peter Weibel, Élisabeth Wetterwald, Ingeborg Wiensowski, Iwan, Manuela and Ursula Wirth, Stephen Wright, Ulf Wuggenig, Marleen Wynants, and Antonio Zaya.

Boots UK Limited
LIME STREET STATION - 1233

05/2023 10:33
ved by: Sam £

t Jnt Pr 30g 8.20
Ibu 200 Tab 16 1.70
(CONTAINS IBUPROFEN)

TOTAL TO PAY 9.90
CARD SALES £9.90

--- ADVANTAGE CARD STATEMENT ---
PICK UP YOUR INSTANT ADVANTAGE CARD
YOU COULD HAVE EARNED 27p IN POINTS

sa AUTH:004609
**********4305
0: ***42712 REF: 1 /02
0:A0000000031010

CARDHOLDER VERIFICATION
U WILL BE DEBITED BY: £9.90
EASE RETAIN THIS FOR YOUR RECORDS

0 0154 1233 501

Foreword

Lapo Cianchi

The Fondazione Pitti Immagine Discovery has hitherto largely concerned itself with the hybridization of visual models (art, architecture, design, photography, cinema) and, in part by this approach, with constructing a state-of-the-art fashion culture capable of measuring itself against contemporary total living, equipped with adequate instruments of analysis and representation. So the publication of some of the interviews conducted by Hans Ulrich Obrist marks a debut in the literary-essay field.

In the introduction, Michael Diers perceptively illustrates the reasons behind the current success of the genre of the interview—an almost essential part of today's conversation society—and brings out the qualities that assimilate it to a work of art as well as its role in fashion. This would be sufficient in itself to explain why a cultural body focused on what is seen and what becomes fashion should concern itself with the production of a book made up of texts alone, of interviews with artists, curators and directors of museums, architects, photographers, philosophers, scientists, filmmakers, and writers. But there are also other motives.

Among them is the growing and widely felt need for content, which cannot be conditioned by the form in which it is offered. Content and ideas, therefore, more than information (of which there could well be an excess, beginning with visual information), which betrays at points the signs of a certain tiredness of seeing. And above all there is the figure of the author, Hans Ulrich Obrist, an intellectually omnivorous weaver of connections between distant disciplines and cultures, whose workings he investigates while also exploring their remotest confines and revealing an intense intellectual passion for the personalities of the interviewees: spaces for interdisciplinary laboratories, as Diers describes the interviews contained in this book.

Bodies like the Fondazione Pitti Immagine Discovery, that draw

their very credibility from their vital, constant rapport with the economic realities of which they are originally the embodiment, and that at the same time aspire to the status of an institution in the ambit of contemporary culture, need to adopt complex strategies. For this reason our objective is, certainly, to be brilliant and rapid, to produce entertainment, spectacle, but at the same time to combine these qualities with high-level educational projects as well as experiments in radical research. Achieving these objectives is no easy matter, and we confess that we often have to be content with a fair percentage of achievement.

Our thanks are due to Hans Ulrich Obrist, our publishing partner Charta, and to all those who have worked on the book, with particular gratitude to the Venice Biennale for presenting the decisive occasion and a framework in which to undertake and realize this project.

"Infinite Conversation"
Or the Interview as an Art Form*

Michael Diers

Monday, August 21, 1978—It was such a pretty day.
Hot and dry and breezy. Started walking downtown
handing out *Interviews* over on the East Side.
The Andy Warhol Diaries, 1989

"In one's own words"

Over the last three decades, the literary genre of the interview has had a rather unusual career in the visual arts, and judging by the contemporary practice, one might consider it the preferred textual format of art criticism. For quite some time now, interviews have been an integral part of art magazines, and the format has assumed an authoritative voice in the contemporary art world, while it has also become fashionable. This trend seems to be perfectly in synch with a society of conversation that practically worships any form of public utterance. Under the media's pressure for publicity and publication, any given opportunity to draw a microphone and to turn on the cameras is seized. The desire for audio-visual recording transmits well into the private sphere and is continuously stimulated by the ever smaller and more conven-

*The first part of the title refers to the English title of the book *L'Entretien infini* (1969) by Maurice Blanchot (1907-2003), which Hans Ulrich Obrist quotes often to characterize his interview project. Cf. Maurice Blanchot, *The Infinite Conversation*, translated by Susan Hanson, (Minneapolis and London: University of Minnesota Press, 1992). — I would like to thank Hans Ulrich Obrist for the numerous private and public conversations we had about his interview project, most recently on the occasion of the conference "Kunstgeschichte der Gegenwart schreiben" (Writing Art History of the Present) in Winterthur, Switzerland (Vereinigung der Kunsthistorikerinnen und der Kunsthistoriker in der Schweiz VKKS und Sektion Schweiz der Association Internationale des Critiques d'Art, AICA, October 11-12, 2002), on the occasion of the lecture series "Kunst der Gegenwart" (Contemporary Art) at the Staatlichen Hochschule für Gestaltung, Karlsruhe (January 15, 2003), and during the XXVII. Deutschen Kunsthistorikertag in Leipzig in the section "KunstGeschichte und GegenwartsKunst" (Art History and Contemporary Art) (March 12-16, 2003).

ient equipment provided by the home electronics industry. Recorders and empty tapes ask to be put to use, an increasing number of channels require transmission. The technologies of visual media, above all television, have unexpectedly empowered the act of speech and the spoken word and have elevated it above the written word and text, while the excess of supply has simultaneously devalued it. Talk shows, statements, and interviews on the most arcane of topics occur in epidemic proliferation and, as a form of public rhetoric, are of central significance to the society of the (media-)spectacle that Guy Debord described.

Andy Warhol has programmatically made the interview acceptable for contemporary art. Founded by Warhol and the members of his Factory, his magazine *inter/View*[1] first appeared in fall 1969, and was meant to be "a monthly film journal": "Our journal *Interview* came out of an interest for the history of fashion and society and for entertainment. We did not just want to go to dinner parties, by no means. And Andy also constantly records everything on tape and film. He basically only does what many artists before him have done, like Marcel Proust, for instance."[2] Warhol's magazine project aimed both in the direction of prominence and the audience. While it supplied readers with informative entertainment, it provided a platform for the (film) stars to "*just talk*—[in]

1. This is the original spelling of the magazine's title for the first issues.

2. Robert Colacello, quoted by Bice Curiger, "Alles ist viel zu ernst—Interview with Andy Warhol," in: Bice Curiger, *Kunst expansiv—Zwischen Gegenkultur und Museum*, (Regensburg: Lindingen & Schmidt, 2002), p. 135.

3. Pat Hackett, "Introduction," in Pat Hackett (ed.), *The Andy Warhol Diaries*, (New York: Warner Books, 1989), p. xii. [Emphasis is the author's].

4. Cf. the hideously failed interview between Warhol and an unnamed German journalist that Warhol published as a caricature in his *Index (Book)*: German Reporter: You are a difficult subject to interview, because... Andy [Warhol]: I told you, I don't say much. German Reporter: Yah, I know, talk is very little, doing is everything. Andy: Yes. German Reporter: You don't want to talk at all... Andy: Eh. No.... German Reporter: You said that you're willing to talk to me. And obviously, since you were nice enough to say, well, okay, we'll talk, that I would ask you questions, and that the questions would be more or less that I would like a definition of Andy Warhol, because I wouldn't want to define you, I would rather have a definition of you about yourself and the role you think you are playing among young people, because they are flocking to you. They are adoring you. They love you. I know that because I have talked to many. This is what interests me and it interests me what it does to you. Andy: [Nothing]."

"An Interview with Andy Warhol at the Balloon Farm," in: *Andy Warhol's Index (Book)*, (New York: Black Star Books, 1967), unpaginated.

their own words, unedited—and, wherever possible, to be inter-
viewed by other stars. This was something new in magazine pub-
lishing."[3] The famous artist replaced the traditional reporter:
Warhol himself, accompanied by an editorial staff member, ini-
tially conducted interviews. The idea was to enable a conversation
among equals—no journalist would torture the interviewee with
stupid questions;[4] instead, one could talk in a relaxed atmosphere,
often over a good meal.[5]
But Warhol's magazine stands only for the presentation and pro-
duction sides of an interview practice that during the 1960s was
developed mainly by artists themselves. Necessitated by the dis-
tance and lack of understanding that art criticism exposed in rela-
tion to the most recent art of their times, artists like Carl Andre,
Donald Judd, or Robert Morris took the explanation of their
work into their own hands. The restrictions associated with the
critics' and curators' roles as "gatekeepers" (Lawrence Alloway)[6]
ultimately forced the artists to "fill the discursive gap with self-
presentations in interviews as well as conceptualizations of con-
temporary tendencies."[7] However, this self-empowerment of the
artists associated with Pop, Minimal, and Conceptual art was not
always well received by the critics, as it raised their concern that
artists from now on would rather speak than create.[8]
But the sheer quantity and ubiquity of published "conversations
with artists" also raised a more serious critical response. Already
in 1972, Lawrence Alloway voiced his skepticism with the grow-
ing popularity of the artist's interview, especially as it concerns
the disparity of the conversation's context and the threatened
independence of the interviewer. For only too often, the artists
use the interview as a means to steer the conversation and to bias
the critic: "The failure to interpret has left us with a backlog of

 5. Cf. Curiger, *op. cit.*, p. 129.
 6. Lawrence Alloway, "Artists as writers, Part Two: The Realm of Language," *Artforum*,
April 1974, pp. 33; 35.
 7. Thomas Dreher, "Interview Yourself!" Amy Alexander, IASLonline Lektionen in
NetArt (http://iasl.uni-muenchen.de/links/lektion9.htmlm), p. 5; this very informative arti-
cle provides a good overview of the topic.
 8. Cf. the title of the introductory essay to the German edition of Andy Warhol's
diaries, in *Andy Warhol, Das Tagebuch*, Pat Hackett (Ed.), (Munich: Droemer Knaus, 1989),
p. 7. Nemeczek improvises on Goethe's famous saying, "Bilde Künstler, rede nicht!" ("Cre-
ate artist, do not talk") when he writes, "As the artist no longer had anything to say, he
began to talk."

unevaluated interviews... Contact with the artist can produce information of an accuracy impossible to achieve in another way, but it can also inhibit writers from taking the discussion in directions that the artists resist or have not thought of. If the critic's interpretations are bound by the intentions of the artist, there is a corresponding neglect of comparative and historical information."[9]

But the interview's proponents are equally ready to stress the particular advantages of the format. Saul Ostrow, art editor of *BOMB* magazine (which is celebrated for its interviews), champions the format for allowing emerging and established artists alike "to publicly voice their views," to critically reflect on their own body of work and its reception, and to supply "readers of *BOMB* magazine with raw material from which to draw their own conclusions."[10] And his colleague Betsy Sussler, a founder of *BOMB* magazine, adds in regard to the qualities of the genre: "The interview is a form unto itself. While questions can be prepared, and the artist's work researched, what takes place in conversation happens spontaneously, and cannot be scripted; queries arise from responses, ideas are circled and searched for. While conversations often can seem elliptical or tangential, there is always, embedded in the transcript, a thread, a rhythm, a subtext, and an interior logic."[11]

While Alloway, Ostrow, and Sussler ponder the advantages and disadvantages of the format, Russian curator and critic Olia Lialina strictly rejects the interview as a kind of uncritical homage. In an entry on the news group mailing list "nettime," she writes: "The interview approach cultivates stars, not ideas."[12] But her general skepticism also disavows those standards and possibilities achieved by Warhol and the Minimal and Conceptual artists. The California artist Amy Alexander has given a rather different, self-referential spin to one of her works: For her "Interview" project,

9. Lawrence Alloway, "Network: The Art World described as a System," *Artforum*, December 1972, p. 31.

10. Saul Ostrow, "Introduction," in: Betsy Sussler (Ed.), *Speak art! The Best of BOMB magazine's interviews with artists*, (New York: Bomb Magazine, 1997), p. XIII.

11. Sussler, "Preface," in: Sussler, *op. cit.*, p. IX.

12. Dreher, *op. cit.*, p. 1.

13. Cf. Tracey Emin's self-interview in her video *The Interview* (1999); it is no coincidence that her work has been described as "confessional art."

she invited peers and colleagues to "self-interview" themselves.[13] Alexander's most recent project "Interview Yourself!" reacts to the critical engagement of art critics to Net art, which has been limited or entirely missing. She creates a public sphere in which the artists can present their own projects, approaches, and theories, and invites artists to interview themselves. The artists can select the questions they consider most appropriate for the understanding of their work and the presentation of their concepts."[14] This might be seen as making a virtue of necessity, but it also reduces the potential dialogue to a soliloquy and thus either points to its final and inherent limits or renders it entirely absurd.

> "... there is in fact no better way to learn about
> this art (painting) than to speak often with those
> people that are knowledgeable about it."
> ANDRÉ FÉLIBIEN, *Entretiens sur les vies et les ouvrages*
> *des plus excellents peintres anciens et modernes, Paris 1666*[15]

"Inter-View"[16]

The term interview originally designated the journalistic and published format of interrogating a contemporary.[17] It paradoxically constitutes what could be called a one-sided conversation, as it usually excludes alternating speech, or dialogue, and remains reduced to the structure of question and answer. The German etymological dictionary offers a rather helpful definition by concluding that the "interview is a conversation between a (newspaper) journalist and a figure from public life about a current event or another topic that is of particular interest because of the person interviewed." It further specifies that [interview] is an English-American word, which was appropriated into the general

14. Dreher, *op. cit.*, p. 1.; cf. the interview-platform by Amy Alexander at http//:plagiarist.org/iy.

15. Cf. Louis Marin, *De l'Entretien*, (Paris: Éditions de Minuit, 1997).

16. Hans Ulrich Obrist in, *Hans Peter Feldmann—272 pages*, Helena Tatay (Ed.), (Barcelona: Fundació Tàpies, 2001), p. 238.

17. "The interview is a journalistic questioning with the purpose of rendering a current news topic as a personal report in the form of a conversation. Its attraction lies in the personal connection, its art in the animated account..." (Emil Dovifat, "Interview," in *Emil Dovifat, Zeitungslehre*, Vol. I, Berlin: De Gruyter, 1968, p.28).

vocabulary from journalistic nomenclature in the late 1800s and which itself derives from the French term *entrevue*, meaning "arranged encounter." The French verb *entrevoir*, which is at the root of the term, means "to see each other at close distance," "to meet each other," and "to encounter," and is itself a neologism of the French word *voir* "to see" (cf. the Latin *videre*).[18] The terminology's focus on the visual rather than the vocal aspects emphasizes the moment of encounter rather than the act of talking, which has to be imagined as an exchange of conventional courtesies and at best as *conversation*, a term that well into the sixteenth century was defined merely as "keeping company" and not as a form of dialogue.[19]

The technique of the interview, elevated from the realm of journalism, has become a scholarly method used in the social sciences, in history, and in cultural studies, and even psychoanalysis is based on a more elaborate form of interrogation.[20] Usually it is used to collect information given in oral testimony and make it available in transcribed or recorded form, either as a statement, report, or narrative. Authenticity, authority, and subjectivity are central qualities of this form of documentation. The relevant information collected in this way can be considered a source, which can be quoted and referred to as supporting evidence.

The interview is part of the category of statements, and its history, as well as the history of the artist's interview, remains to be written, even though its importance for the history of art and art theory would grant a more thorough study by now.[21] Such a study

18. *Der Große Duden: Etymologie. Herkunftswörterbuch der deutschen Sprache*, Mannheim 1963, p. 290 passim.

19. Cf. in length: Claudia Schmölders, *Die Kunst des Gesprächs. Texte zur Geschichte der europäischen Konversationstheorie*, (Munich: Dtv, 1979), p. 25.

20. While the conversation may be considered as one side of the *dispositif* of the interview, the (criminal) interrogation may be seen as the other side.

21. I am grateful to Peter J. Schneemann, Bern, who has informed me of the unpublished thesis text by Christoph Lichtin on the "conversation with the artist" (Christoph Lichtin, "Das Künstlerinterview. Analyse eines Kunstproduktes," University Bern, 2002), which I unfortunately was unable to read. Louis Marin's small book (*op. cit.*) follows a different concept.

22. Cf. the well known study by Ernst Kris and Otto Kurz, *Legend, Myth, and Magic in the Image of the Artist: A Historical Experiment*, Alastair Laing (Trans.), (New Haven: Yale University Press, 1979). This book is based on the German text from 1934, and was expanded by Otto Kurz. Cf. Martin Warnke, *The Court Artist: On the Ancestry of the Modern Artist*, David McLintock (Trans.) (Cambridge & New York: Cambridge University Press, 1993).

would have to consider the prehistory of the genre, which dates back to the earliest recorded artists' statements, often disguised in the form of anecdotes, legends, and biographic reports.[22] And as art history develops a historical self-consciousness and begins to form itself as a discipline, they are collected in voluminous tomes and anthologies, which, like Giorgio Vasari's *Lives of the most Eminent Painters, Sculptors, and Architects*, (1511–1574) are used as a reference until today.[23] These collections of biographies and work reports do present an almost inexhaustible source, even though their historical veracity should not be overestimated. Vasari, an artist himself, began his extensive enterprise to recount the history of art "until the present day" and his elaborations, spanning almost three centuries, finally end with contemporaries, covering artists like Michelangelo, Titian, Jacopo Sansovino, Giulio Clovio, as well as his colleagues from the Florentine Academy like Bronzino, and—last but not least—himself.[24] It is reported that for his book, Vasari—like an art historian—"had to travel long distances, study remote sources and inscriptions, consult archives, and maintain a vivid correspondence with many humanists and local historians ... in order to give a historical perspective to the right of art to resist its cooptation through its independence."[25] It is safe to assume that as he was moving into his own period, Vasari also conducted conversations with his peers—although probably not structured as interviews—and included the outcome into his *Lives* wherever he felt compelled to do so.

Two examples of such studio conversations come to mind. In both instances, Titian is at the center, one time in Venice, the other in Rome. Vasari reports from Venice: "When Vasari, the writer of this history, was at Venice in the year 1566, he went to visit Tiziano, as one who was much his friend, and found him at his painting with brushes in his hand, although he was very old; and he had much pleasure in seeing him and discoursing with him."[26] And from Rome comes the following report: "Michelan-

23. Giorgio Vasari, *Lives of the most Eminent Painters, Sculptors, and Architects*, Gaston Duc du Vere (Trans.), (London: Macmillan and Co. & The Medici Society, 1912–13, X Volumes).

24. *Ibid.*, Vol. X.

25. Martin Warnke, "Der Vater der Kunstgeschichte: Giorgio Vasari," in: *Ders., Künstler, Kunsthistoriker, Museen.* (Luzern and Frankfurt: Beiträge zu einer kritischen Kunstgeschichte, 1979), p. 21.

26. Vasari, *op. cit.*, Vol. X, p. 178.

gelo and Vasari, going one day to visit Tiziano in the Belvedere, saw in a picture that he had executed at that time a nude woman representing Danae... and they praised it much as one does in the painter's presence. After they had left him, discoursing of Tiziano's method, Buonarrotti commented it... saying that his colouring [*sic*] and his manner much pleased him, but that it was a pity that in Venice men did not learn to draw well from the beginning..."[27] Such remarks occur during a conversation among artists and can be seen as theorems and statements on equal footing with the kinds of statements made in a modern day interview. And it is not difficult to imagine Vasari equipped with a microphone and a tape recorder (or even a video camera).

It is the merit of Annibale Caro, whom Vasari had asked to give some friendly advice and editorial help, to render the conversational character of such remarks visible. In a letter written to Vasari, he particularly focuses on this quality: "For a work like this, the author should attempt to write *as if he is speaking*, and he should always use a simple expression and keep a distance to metaphors, affectation, and everything foreign."[28] The particular oral status that also characterizes the interview, is thus again emphasized.[29]

The studio visit is not only an iconographic trope of art history, but also a trope in the history of the "conversation with the artist."[30] Already in 1940, the Swiss art historian Heinrich Wölfflin (1864–1945) stressed the importance of the conversation with the artist in understanding art and the concept of one's own disci-

27. Vasari, *op. cit.*, Vol. X, p. 170–171.

28. Annibale Caro in a letter to Giorgio Vasari, Rome, December 11, 1547. [This letter is excerpted in a footnote in both the Italian and the German versions of Vasari's *Lives*. Unfortunately, no English version contains this footnote, and it is thus translated from the German quote, under close comparison with the original Italian. The corresponding page in the English edition would be Vasari, *op. cit.*, Vol. X, p. 196–197. [Emphasis is the author's]

29. It is the rule that orally conducted interviews (with artists) are edited for publication. Julia Gelshorn, Department of Art History, University of Bern, has recently confirmed this for the artist Gerhard Richter by documenting his minutely detailed editing process of an interview. (Julia Gelshorn, "Der Künstler spricht. Vom Umgang mit den Texten Gerhard Richters," lecture at the conference "Kunstgeschichte der Gegenwart schreiben," organized by the VKKS in collaboration with the Swiss AICA, Winterthur, October 11–12, 2002; a publication documenting the conference is in preparation). The Swiss artist Thomas Hirschhorn has also remarked on the burden of reworking his interviews; he would always have "to rewrite everything, because I am so dissatisfied with the interviews (my answers, of course)." Quoted from Ursula Arx, "Was soll der Professor sagen, Herr Hirschhorn?" in: *Neue Zürcher Zeitung (NZZ) Folio*, October 2002, p. 9.

pline: "For whoever visited the artists' studios has experienced the deep trench that exists between the historians of art and the 'experts' of art working here; this is understandable, given that both groups talk about the same thing in very different languages. I believe that we have to begin here and attempt to illuminate the specificities of artistic achievement."[31] Wölfflin himself made these studio visits only very hesitantly and dedicated himself firstly to the history of art (and thus the general principles) and engaged the more current art only much later. The reason for his failure to follow his original plan was that "one first had to understand the general before one could engage with the particular." For a long time, art history mainly maintained the "conversation about art"[32] while the "conversation with the artist" was avoided, even though Vasari, the "father of art history," had provided such a great example when he founded the principles of the discipline. The conversations about art were mainly conducted among philosophers, historians, and connoisseurs, while artists generally remained excluded. One important exception is the "Entretiens sur les vies et les ouvrages des plus excellents peintres anciens et modernes" by the French court architect and historiographer André Félibien (1619–1695), which is a collection based on conversations with his friend, the painter Nicolas Poussin. But more recent art history has preferred to interpret simply the art works and the statements embedded within them.[33]

30. A brochure of the "Akademie der Staatlichen Museen zu Berlin" (Academy of the State Museums of Berlin) announcing the classes for the winter semester 2002/02 listed a class with the title "Kunst jetzt: Aktuelle Positionen der zeitgenössischen Kunst..." [Art Today: Current trends in contemporary art]. It listed conversations with artists and studio visits as part of the class program, and further explained: "The question What is art? has to be answered anew every week, as there are no defined criteria for the approach of contemporary art, and sometimes the artists themselves have to answer this question as well." Akademie der Staatlichen Museen zu Berlin, program brochure, winter semester 2002/03, p.19.

31. Heinrich Wölfflin, *Gedanken zur Kunstgeschichte*, (Basel: Schwabe & Co., 1941), p.1. [—Trans]

32. Compare for instance the title of the magnificent work by André Félibien, *Entretiens sur les vies et les ouvrages des plus excellents peintres anciens et modernes* (Paris, 1666), or the small book by L. Marin, *op. cit.*, translated into German as "Das Kunstgespräch," 2001. [The French term, "entretien" of course means conversation, talk, or interview. The German title bears a clear distinction, meaning "a talk about art" in opposition to the term "Künstlergespräch," the "talk with the artist."—Trans]

33. Cf. Matthias Winner (Ed.), "Der Künstler über sich in seinem Werk." Internationales Symposium der Bibliotheca Hertziana Rom 1989, Weinheim, 1992.

This approach is not only valid for the more ancient art, it also works for contemporary art as well, as Robert Rauschenberg has demonstrated with one of his early combine paintings, entitled *Interview,*[34] giving concrete artistic form to the theme. The rectilinear, vertical combine painting is split into two by a movable white door. Resembling a baroque "Wunderkammer," heterogeneous objects, like boxes and bins, a rock, a baseball, several fabrics, and images in every conceivable facet are combined. The title *Interview* might allude to the opened artist's studio, into which we are granted a view, mediated by the autobiographical shrine. The conversation is not conducted directly, but rather is mediated through objects and images that besides their more general meaning uphold a very personal one, which is given access to by means of a "silent conversation" with the viewer during an imaginary visit to the studio.[35] In a conversation between Hans Ulrich Obrist and Douglas Gordon, Gordon says that "art is an excuse to have a dialogue."[36]

> "Dear Hans Peter [Feldmann;]
> The interview book is increasing our skepticism
> about the viability of interviews.
> Gadamer said to me that one big problem
> with interviews was that you can't transcribe the silences.
> Best wishes,
> Hans Ulrich [Obrist]"[37]

Art Form

Hans Ulrich Obrist's interview project, as it is documented in this book and soon to be continued in a second and third volume, is cast from a very unusual, individual mold. It is neither a journalistic nor a scholarly enterprise, but it rather follows an encyclopedic-philosophical model, based on a very emphatically understood concept of the conversation as a fruitful/successful exchange of ideas and exemplified in the form of the interview.

34. *Interview,* (1955), 182 x 123 cm, Museum of Contemporary Art, Los Angeles.
35. About the painting, see Roni Feinstein, *Robert Rauschenberg: The Silkscreen Paintings 1962-64,* (New York: Whitney Museum of American Art) 1990), S.23f.
36. Interview with Douglas Gordon in this volume, p. 323.
37. H.U. Obrist, *op. cit.,* p. 238.
38. To this day, there are about 400 interviews in the archive.

This encyclopedic character is less a product of the sheer number of existing interviews,[38] but rather an outcome of the manner in which the interviews were conducted and of the range of professions, both from science and art, represented by the interlocutors. Starting from a series of interviews with artists that Obrist conducted in the early 1990s for the museum in progress in Vienna,[39] the circle of those interviewed has increasingly widened internationally and now includes curators and museum professionals, art historians and critics, writers, filmmakers and photographers, philosophers and scientists, architects and urbanists. Most conversations originated from concrete work relations and commonly have friendly relations at their basis. In his function as curator and organizer, Obrist has traveled around the world and has come into contact with countless individuals. He has used every possible and impossible occasion—in airplanes, taxis, boats, and elevators, on the phone, by E-mail, or by fax, in one or in several installments—to conduct his interviews. Douglas Gordon has emphasized the conditions of modern everyday life as they influence the conversations: "I really think that the difference between our generation and other generations is that it's not even a flow of images that we have to deal with, or a flow of information—it's a deluge, and I think probably the way this interview is going is absolutely indicative—there are so many other things happening. ... Since we came into this flat where we are having a conversation with each other, and while we are talking in real time, we are remembering what happened five minutes ago, we are anticipating the next question, we can hear the roadwork outside, there is a TV here, there is the telephone ringing, there is music playing—but we can handle this as human beings. But this is very late twentieth century. I think this is absolutely not the way that someone like Broodthaers could live, or someone like Duchamp could live."[40]
These conversations are rarely scheduled or planned, and are most

39. Cf. the video-editions in the series, "Künstlerporträt" (Artists' Portrait), (museum in progress, Vienna; since 1995 Kunsthaus Bregenz), after a concept by Peter Kogler, 1992–1997. "Self presentations and authentic statements by the artists. They select their interview partner and edit the video themselves." From the 2003 brochure of Barbara Wien, gallery and bookstore for art publications, Berlin). Also cf. the book about the video series: *KünstlerInnen. 50 Positionen zeitgenössischer internationaler Kunst*, (Cologne: Kunsthaus Bregenz, 1997).
40. In this volume, p. 323

commonly conducted as a byproduct of another event. Sometimes they even expand from a dialogue to a triad. Obrist is a passionate conversationalist, mainly because of his personal desire to find out more about a given subject or a certain position, often inspired by an essay, a book, or an artwork. He is full of questions and his search for answers brings him into contact with those recognized as experts in the different fields. Questions initiate a collaborative reflection, and soon the interview has given way to a normal conversation.

It was Hans-Georg Gadamer who said that the secret to a good conversation lies in the questions.[41] And Hans Ulrich Obrist's reason to interview this philosopher—in an act of self-reflection about his own practice of communication and interrogation— may be seen in his desire to consult a conversation expert on the historical and general dimensions of this art of verbal (ex)change. According to Gadamer, the conversation is the main form of communication and the oral word assumes priority over the written word precisely because the modulating qualities of the voice are especially successful in joining the rational element together with the emotional. Naturally, transcription loses many of these advantages, but a small solace might be derived from the fact that the original recordings remain stored.

The present volume is a source book that brings together different authors and positions, from Abramović to Zeilinger. However, it is also a reader that enables a trip around the world in 66 conversations, as much as art, architecture, literature, film, photography, and systems of thought are able to portray it adequately. And it is further a portrait album that among those interviewed also renders visible the interviewer. Its litmus test is a definition by Sigmar Polke: "An interview is good when it has its own internal logic, when it becomes an art form."[42]

Each individual interview in this anthology remains legible in its own right, but also enters a larger context, which could be described by J.G. Ballard as a laboratory for interdisciplinary dialogues[43] and with Hans Ulrich Obrist as part of an infinite con-

41. Interview with H.-G. Gadamer. See this volume, p. 244.

42. Bice Curiger, "Ein Bild ist an sich schon eine Gemeinheit: Interview mit Sigmar Polke" *op. cit.* Curiger, 1984, p. 151.

43. Interview with J.G. Ballard. See this volume, p. 61.

versation. The idea of the laboratory stressed the space for tests, concepts, and thought experiments, and the infinite conversation refers to Maurice Blanchot's book of the same title. Historically, it goes back to the concept of German romanticism that a conversation will never reach an end, for it always only approximate its subject and therefore always requires continuation.

Michael Diers is lecturer at the Department of Art History at the Humboldt Universität, Berlin. He has written and spoken extensively over the years on Renaissance art, nineteenth- and twentieth-century art, contemporary art, photography and new media, political iconography, art and media theory, and the history of science. He is the joint editor of the series of studies on the complete writings of Aby Warburg, published by Akademie Verlag, Berlin, since 1998; and since 1991 he has been the editor of the series of pocket books, "kunststück" (monographs on works of art), published by Fischer Taschenbuch Verlag, Frankfurt (1991–2001, ca. 50 volumes). Other publications include: *Porträt aus Büchern* (Ed.). Hamburg and London: Bibliothek Warburg and Warburg Institute, 1993; *Mo(nu)mente. Formen und Funktionen ephemerer Denkmäler* (Ed.) Berlin: Akademie Verlag, 1995; *"Der Bevölkerung". Aufsätze und Dokumente zur Debatte um das Reichstagsprojekt von Hans Haacke* (Ed., with K. König). Cologne: Verlag der Buchlandlung König, 2000; and *Kunst und neue Medien* (Ed.). Forthcoming, 2003.

Interviews

ABRAMOVIĆ, Marina
and CHAITIN, Gregory J.

*Marina Abramović was born in Belgrade, Yugoslavia, in 1946. She currently lives and works in Amsterdam and New York. Between 1965 and 1970 she attended the Academy of Fine Arts in Belgrade, and in 1972 she completed her graduate studies at the Zagreb Academy of Fine Arts. While still a student, Abramović produced numerous sound-based installations and gave her first provocative public performances. Her performances involved testing and challenging the body's limits in front of an audience—either by screaming until she lost her voice (*Freeing the Voice, 1975) or by running into a wall repeatedly until she collapsed (Interruption in Space, 1977). From 1975 until 1988, Abramović and the German artist Ulay performed together, dealing with relations of duality (woman/man; sound/silence; inertia/energy) as in the "Relational Work" series (1976–1980). The year 1989 marked Abramović's return to solo performances. Abramović has presented her work with performances, sound, photography, video, sculpture, and "transitory objects for human and non human use" in solo exhibitions at major institutions in the U.S. and Europe, including the Stedelijk Van Abbemuseum, Eindhoven, The Netherlands (1985); Musée National d'Art Moderne, Centre National d'Art et de Culture Georges Pompidou, Paris (1990); Neue Nationalgalerie, Berlin (1993); and the Museum of Modern Art, Oxford (1995). Her work has also been included in many large-scale international exhibitions including the Biennale di Venezia (1976 and 1997) and documenta 6 and documenta 7 (Kassel, Germany, 1977 and 1982).*

Gregory J. Chaitin was born in Chicago in 1947. He currently lives and works in New York. Chaitin studied mathematics at the City College of the City University of New York where he was awarded the Belden Mathematical Prize in 1965 and the Nehemiah Gitelson Medal for the "Pursuit of Truth," in 1966. In the mid-'60s, Chaitin created algorithmic information theory (AIT), which combines, among other elements, Claude Shannon's information theory and Alan Turing's theory of computability. In the four decades since then, he has been the principal architect of the theory. Among his contributions are the definition of a random sequence via algorithmic incompressibility, and his information-theoretic approach to Kurt Gödel's incompleteness theorem. Chaitin is currently a mathematician and computer scientist at IBM's Thomas J. Watson Research Center in Yorktown Heights, New York.

........................

This conversation took place in Kitakyushu, Japan, in July 2001.

Hans Ulrich Obrist:

Marina, I know that you've been reading this interview with Gregory done by Guillermo Martínez that will be published in Conversations with a Mathematician: Math, Art, Science and the Limits of Reason *(2002), and that you found some interesting biographical similarities. Maybe we should open this conversation on these similarities.*

Marina Abramović:

Yes, I thought there were some amazingly interesting points in our biographies which kind of cross. The one thing he couldn't tell me was where your grandparents come from.

Gregory J. Chaitin:

They came from Borispol, the airport of Kiev, on my father's side. My mother's side was Romanian—Moldavian actually—and Odessa. Those are my grandparents.

MA:

Mine come from Montenegro, Yugoslavia, and are very strongly oriented towards Russia, so I think geographically there is a connection between us. The second thing I found out about you is that you said that you have been working on one idea since you were 15. I've also been working on one idea since I was 15.

GC:

Really?

MA:

The main idea of my whole work is the body. What is yours?

GC:

Randomness.

MA:

So randomness and the body it is!

GC:

So we were both obsessed by one idea—our lives have been consumed by one idea?

MA:

Another interesting similarity here is that you are interested in putting complexity into simplicity.

GC:

Okay.

MA:

You have said that you want to put very complex things into the smallest possible data.

GC:

I like unifying ideas, yes.

MA:

I also try for a synthesis of information into a really simple message, and to create a strong image. And this is an interesting process.

GC:

It does sound related, yes.

MA:

Another similarity is this enlightened effect, you know? You were talking about this in the city [Kitakyushu] yesterday, that in this lifetime there are very few moments that we can describe as enlightened states.

GC:

Yes, it does seem like enlightened states are what some people would describe as a spiritual experience, I think. All of a sudden, it feels like your mind is working more clearly and somehow you understand and you're more connected with everything. It's actually quite an amazing experience. Do you have a similar kind of experience?

MA:

Yes, that's one of the most important experiences I'm waiting for, and it is unpredictable. You never know when it will come. It sometimes comes as a total surprise and it's very short, but unholdable. I was always interested in how I could learn some kind of method so that I can really live in this moment, so that this moment is extended.

GC:

These moments are just magic, and that's why when I get in this emotional state I don't let anything distract me. For example, if I've been trying to write a book and it starts to work, I don't stop, because I know I can't stay in that state forever. So I'm pushing. I'm trying to sustain the emotion, to keep the mood going long enough to get to the end of the book, you see.

MA:

Yes, yes.

GC:

So when a moment like that comes I just push everything out of the way. I don't pay my bills; I don't do anything else in my life. I just concentrate on following the inspiration and on working— working like mad because, as you say, these moments are magic and you never know when they're going to come and how long they're going to last.

MA:

These moments don't always come when you're in the studio, when you're in a situation where you're really working on something, but instead when you're hiking, walking or swimming—it can be totally unpredictable. This is a strong link with the state of the artist. Sometimes we work very hard on one idea and it doesn't

work; it doesn't actually bring any results, so you start on something completely different, and suddenly the solution or the result comes as a shock, in a completely unpredictable way.

GC:

I think your subconscious is working on it like mad, even when you don't realize it—if you've been really obsessed by what you're trying to do—even when you think you're not working on it.

MA:

There's one very strange example, and perhaps we should ask our colleagues about this; it's in *The Idiot* (1868) by Dostoyevsky, when one of the main characters has an epileptic attack. He described the situation before the epileptic attack as being a feeling of absolute clearness—a kind of stillness with nature, total harmony with the outside world. And this sensation is so strong that his body and mind cannot bear it.

GC:

As if one can't bear the presence of God—it's too much for him.

MA:

And then it turns into an epileptic fit, a kind of drastic solution from the brain. Why is it that at the moment of total harmony, we can't bear it?

GC:

For me it's a moment of elation. I wouldn't say you can't bear it. What I can't bear is when I come out of that and I have to go back to real life.

HUO:

So it always fades away at a certain point?

GC:

Yes, but it can last for a month while I'm working on a book—the inspiration and the feeling of elation. I often think of it in terms of mountain climbing. You go up to the top of a mountain and the view is wonderful, the air seems so clear, it's an absolutely exhilarating feeling, and then there's that horrible problem of having to get back down. Getting up, you want to go up, so it doesn't matter how tired you are, you have this wonderful goal. But getting back down, you're tired, you're exhausted because you made it to the summit, but then, unfortunately, you have to go all the way back down, and that's not a goal really worth striving for, and it's very unpleasant.

HUO:

Perhaps you could both speak about the beginning. How did you, Marina, come to working almost only on the body, and you, Greg, on randomness?

GC:

You've always been an artist, would be my guess. And I've always been doing research. I didn't have my first idea when I was 15; I was doing research before, all the time. Isn't it the same with you?

MA:

Actually, I've never doubted what I was going to be. There wasn't one second of doubt. I've never even considered other professions. I had my first exhibition when I was 12 years old. It was like nothing else.

HUO:

Was it in Belgrade?

MA:

It was in Belgrade. And in a funny way, at the time when my mother was pregnant with me, she was studying art history, just after the war. And then they took me to museums when I was born, so one of my first words that came out, when you say mama and papa for the first time, I said "El Gleco"—it was El Greco!

GC / HUO:

[*Laugh*]

MA:

You put all your energy in one direction. It was almost like a distorted energy.

GC:

Same in my case. But my parents also took me to museums. I practically lived in the Museum of Modern Art in New York City. I always loved art but I somehow always knew that I wanted to be a scientist. Exactly what kind of thing I would do, that was another matter. I think at first I was interested in physics, astronomy and cosmology.

HUO:

Do you remember the first science book that you read?

GC:

It's hard to remember, but one that I remember from a long time ago was by the Russian-American, George Gamow: *One Two Three... Infinity: Facts and Speculations of Science* (1947). There were also math books I read very early in my life. I just lived in the library.

MA:

Did you ever try any poetry?

GC:

Did you?

MA:

Yes I did, very much. I was so romantic. I am so amazed, I always

had a totally different opinion of mathematicians being very dry, very exact, very realistic, but then I find that firstly you're very poetic and second that you have this enormous erotic energy.

GC:

Uh-huh?

MA:

It's amazing.

GC:

For me, mathematics is a passion really. [*Laughs*]

MA:

Sexual energy is the basic energy that people have.

GC:

It's the life force; it's the life force, that's right.

MA:

You have to be as passionate about life as you are about your work.

GC:

You have to be incredibly passionate. I'd like to hear, Marina, about how it is with the kind of art you do. With the kind of mathematics I do, you may spend many years trying to solve a problem, and you have to be really passionate about the importance of what you're doing and about your desire to understand. It takes enormous energy and, I would say, optimism, to do that.

HUO:

And is it also about taking risks?

GC:

It's very risky because you can spend years working on something and not get a good idea and not understand what's happening. That never bothered me somehow. I was just so passionate about these ideas. I loved them so much. Maybe it was all a form of misplaced sexuality, since we're talking about sex, you know!

MA:

No, no.

GC:

Having one hundred women—many men have done that, but maybe it is more interesting to put all that energy into mathematics!

HUO:

Many artists say that doing art puts oneself in a risky situation somehow.

MA:

Exactly. The risks are so important because if you don't take risks, you don't move on, there's no progress.

GC:

That's right. Exactly.

MA:

I was interested by Hans Ulrich's statement in your previous interview with him when he quoted Man Ray to you. In science, there is progress, and Man Ray said that there is no progress in art, there are just different ways of doing it. And somehow I don't agree with that. I think there is progress, but it is in the development of the artists themselves, and the phases of development they are going through. There can be inner progress. There has to be emotional progress when you're going from one state to another and so on. In mathematics or in science in general there is this kind of result, going from one theory to another, progressing. It is exactly the same in art. I definitely don't think that there is no progress.

HUO:

I wanted to ask about this notion of "big steps" in both of your work, because you both stated that an artist or a scientist doesn't have that many main ideas, and rather that there are only a certain number of ideas that they will have. Greg, you said before that a mathematician had only three main ideas in his or her life.

GC:

It all depends on the size of the ideas. Some ideas are major, and others seem like a breakthrough for you at the time, but you realize that they're not at the level of your best ideas.

First of all, I'd like to speak about taking risks. It really depends on the person. I think we have another thing in common, Marina. What you're doing, a lot of people say isn't art, and what I'm doing, a lot of people say isn't mathematics. The mathematics community is upset, many logicians are furious at me. I'm an unmentionable name. And it's also a question of risk-taking. For me, there is no point in doing anything the way anybody else does it, because if somebody else is doing it, it's been settled, it's being taken care of. So I think that the only activity that's worth it for me as an intellectual—and perhaps it's the same for you as an artist— is to go off in a direction that nobody else would dare to, except perhaps for you and me. And I don't view it as a question of risk— I just think it's a complete waste of time not to do this. There was never any doubt in my mind about picking an unusual path, because, otherwise, what's the point of doing it at all?

I've always had the feeling that one should not be a cork, one should not be passive. The waves are going by and you're just a cork going up and down! There's no point to that kind of life, real-

ly, because soon it's going to be gone, and what did you do, what did you accomplish? You did nothing. You did what other people wanted you to do. G. H. Hardy, a mathematician, put it this way: he said that it's never worthwhile for someone who's first rate to follow a majority view, that is, if there are already plenty of people who feel a certain way about something and who believe in it and are going to argue in that direction. So if someone is first rate, it's a waste of their time to agree with the majority; you always have to go in a different direction. That's the role we can play for human society.

Marina breaks the concept of what is the artist and what is the observer, and in my case, I'm challenging mathematicians' conceptions of what mathematics is. I'm claiming that mathematics is more like physics than mathematicians think. I'm not saying it's identical, but that it's much more similar as an intellectual enterprise than people thought. And mathematicians either say that they don't understand what the hell I'm talking about, or else they just get furiously angry at me. I consider that a good sign, because no one would get furiously angry if I weren't touching on something important for them—they would just laugh and say "poor fellow." A reaction of outrage is often a good reaction.

HUO:

Does it also have anything to do with changing the rules of the game?

GC:

Aren't you doing that Marina? Looking at your work I really felt that you were changing the rules of the game.

MA:

There's a wonderful quarter page of text—I can't quote it here, but perhaps we can insert it later. Basically it was talking about how the father of John Cage was an inventor.

GC:

... John Cage the musician and composer?

MA:

... And he said that what he learnt from his father the inventor was that whenever he made something that was accepted by society, he immediately moved to an area where it wasn't, and that's very important.

["Well, I keep telling everybody this, and it's actually kept me in good stead because I was the son of an inventor. The fact that people weren't accepting what I was doing indicated that I was inventing something. In fact, I developed the opinion, which may be right

or wrong but I still have it somewhat, that if my work is accepted, I must move on to the point where it isn't." (John Cage, 1982)]

GC:

And he knew he was doing something wrong if it was accepted.

MA:

It's this immediate consumption, making things so simple. I think that art has so many layers, and that every society can benefit from one layer at a time, as even simple things can be very complicated. There is complex complexity and complexity of simplicity, you know, and what is so important is this pioneering of new territories—that's the main thing. How can you actually find a way to break through the unknown and find different ways and different rules? That's very interesting.

GC:

Pioneering is so much fun!

MA:

To shift the way society thinks into different directions, that is incredible. The intensity of that moment when you realize that you're on the right track. It doesn't matter that you're not accepted at that moment, because deep down you know that you're right. Throughout history people have had to die and the ideas wait hundreds of years to be consumed by society.

GC:

I worry if people like what I'm doing too much.

MA:

It's like reading the daily newspapers—tomorrow it's an old paper. You have to go beyond that, beyond the daily news.

HUO:

Marina, could you speak a little about some of the key moments which have changed you and moved your thinking forward?

MA:

I was working as a painter, and I had different periods in painting. At one point I had this obsession with sky, so I was painting sky. And I remember so clearly when this happened. I was painting the sky and I was always looking at clouds. And at one point there was a totally clear sky and there were 16 military airplanes passing through the sky of Belgrade, and that was such a revelation. I saw this wonderful drawing that the planes had made. I saw the making of the drawing, I saw the existence of the drawing and I saw it disappear—I saw the whole process in just a few minutes. There

was such a realization that my paintings were complete nonsense—
there was something two-dimensional about them that didn't have
anything to do with anything. So I decided to go to the military
base, to ask them for 15 planes to make drawings for me. And so I
did it. I went to the military base and they called my father, who
is a military man, and said, "Take your daughter out of here. Do
you know how much it costs to make 15 planes fly to make draw-
ings for her?"

GC:

[Laughs]

MA:

But it was an incredibly important step because it meant that I left
this two-dimensionality of painting and I started using real mate-
rials. And I started working with sound and projects, and then this
led to performance and so on. Another important moment was
when I walked the Great Wall of China and understood the rela-
tionship between landscape and different states of mind, and the
importance of the magnetic energy lines. And I wanted to transport
the feeling of the experience to the public. Then I found this form
of transitory objects, and I knew I had to work with transitory
objects.

HUO:

It occurred to you when walking the Great Wall of China?

MA:

Yes. I never wanted to make sculptures because I'm not a sculptor.
I wanted to make something of a cross—using just experience—
you have the experience and then it can be moved. I found there to
be a very voyeuristic relationship between the performer and the
public. The public doesn't really get into it, they just always take
the same role as the viewer. And I wanted a public that can only be
transformed if they have their own experiences.

GC:

The public has to take a risk, you might say.

MA:

I was arguing with a scientist that they're always observing but
they don't make observations of themselves. I wanted the observa-
tion to be central in you first, so you are the first one to be observed
and to be changed and transformed. So that was the next step that
I made—the public body, the public as performer. So this was real-
ly important to shifting the rules of the game. The problems of

serving art are in there somewhere. So the public became the art, together with the object. There was another moment, in the early '70s, when we had a very small number of public, say 10 or 15 people. It was very underground; performance was not accepted and so on, and we just made our performances. At one point I ended up in a very large exhibition—documenta 6—for which, together with Ulay, I performed a piece called *Expansion in Space*, and it ended with 1500 people present, for the first time in my life. That was the first time that I understood the power and the energy of the public and how, as a performer, you can take this energy, transform it, and give it back to them. This was the first time that I understood what it means, what an energy dialogue is, and how the energy in the performance works.

GC:

You know that mathematical research is all energy. You have to throw yourself at the problem. It's like you're running up a mountain. You're not just going up, you're *running* up. And you've *got* to make it to the top of the mountain, and it's a tremendous burst of energy and concentration. So when you say the word "energy," you know, that's a key word for me.

HUO:

Can you give me one or two examples of such situations, where you are "running up mountains?"

GC:

In my research? It's so completely emotional to solve a mathematical problem. You have to really want to solve it. It's like adrenaline, it's like energizing yourself. I want to smash against the problem. I'm going to run and throw myself against the wall. I'm going to smash through the wall. I think of it as a wall, you know, my lack of understanding. And you want to just smash right through it. It's just a question of energy, it's energy. That's the key word; otherwise you can't do research.

MA:

There is a text in my last book called "Towards the Pure Energy" (*Marina Abramović: Public Body*, 2001) and that's really what it's all about. And that's the kind of special state where you really want to be. You have to question everything to transform it to the same state.

GC:

And human society doesn't want us to do this because it's too dangerous, you know. You're supposed to stay in your place and do

what you're told. And to crash through the barrier is to break through. But this is the kind of energy that can make a social change, not just an intellectual change. It can transform society. It's the life force. It's the only basis for anything of value. Every time one does anything of value—like the Center for Contemporary Art here in Kitakyushu for example, someone was telling me what they were going through politically to be able to have this institution. Every time you want to do anything good, you have to fight the whole world to do it, because this planet is arranged so that everything is okay as long as you do what everybody else does. But that doesn't create anything new. For our personalities, Marina, that's impossible, but everyone is fighting us. That reminds me of a story I heard about Fermilab, in Illinois, which is the biggest accelerator in the United States.

HUO:

The Fermi National Accelerator Laboratory. It's a particle accelerator?

GC:

It's a particle accelerator, right. The man who built that accelerator, Robert Wilson, built it under budget; he built it ahead of schedule, and he managed to make it more powerful than it was supposed to be. He's even an artist—he put sculptures there, and used the material they had excavated from the tunnel to arrange in interesting ways. So what was the result? Of course, everybody hates him. So what you do is, after he creates this, you immediately fire him and you put another man there—another man who has not made enemies accomplishing this wonderful thing. It's a typical thing to do. You use someone to accomplish something, but to accomplish anything of value you make enemies everywhere, you rock the boat. So the moment it's done you get rid of this person and you put in a nonentity who hasn't made any enemies because he hasn't accomplished anything, and then everyone's happy. The world goes back to its normal state!

MA:

Can you tell us the precise moment when you really found your randomness?

GC:

It's hard for me to remember. I was 15. I just had this tremendous, essential joy in reading and understanding mountains of books. I was wildly enthusiastic about it. And I wasn't just reading in one narrow specialty; I was reading all kinds of things. I was following my intuition, reading everything that excited my imagination.

Computers excited my imagination, cosmology excited my imagination, all kinds of things, I don't know. There were areas of mathematics I somehow found beautiful, other areas of mathematics I thought were infinitely ugly—I couldn't force myself to look at them. It was all done completely emotionally, like when you see one woman and you find her exciting and beautiful, and another woman you don't. And you can't explain why, there's no way to explain it. It's just a total reaction that one person feels and another person doesn't feel. It's not rational; I just followed my feelings. And then I had lots of ideas that I was excited about, but they were all from different areas—people who don't normally talk to each other. And all of a sudden I saw a connection. It looked pretty obvious to me. It was a way of defining randomness, but it required combining ideas from four or five different fields.

HUO:

What were those five fields?

GC:

I was combining ideas from probability theory, from game theory and information theory (which is communications engineering), ideas from the philosophy of physics and the foundations of quantum mechanics, and ideas from mathematical logic and the foundations of mathematics. A whole lot of areas, and I saw the connection, it was obvious to me, it was my definition of randomness. But this was because I was looking at a whole bunch of fields, and because I didn't see a wall between those fields. But certain people in these fields, especially logicians, hate me. They used to mention my name occasionally, but not anymore. I consider this a compliment by the way, and I'm not just saying this for psychological reasons, as a defense mechanism. The fact is that before, logicians in the United States used to occasionally mention me, nicely even. Now there is a conspiracy of silence. My name has become unmentionable!

To give you an example, the man who wrote the "official" biography of Gödel, John Dawson (who is accepted as the official biographer of the great mathematician, at least in United States), he has a chapter in his book talking about the work that followed Gödel's work, and I'm not mentioned anywhere in that book, not even in that chapter, where I certainly should be mentioned. But this man knows me so well that he sent me a copy of a previous book of his with a dedication. He certainly knows about my work, if he sent

me a book of his with a dedication on it; he signed it and sent it as a present. I think that it's great that these people are so threatened by my ideas that they react in this childish, emotional way. I think it's fantastic. Of course, if it costs me my job at IBM, or something like that, then it stops being a joke.

I should mention that there is a lovely biography of Gödel written by two men who live in Vienna, John Casti and Werner DePauli, and their book has a chapter on my ideas.

I don't know how I got onto this. What were we talking about?

HUO:

I was asking about when you found out that randomness was your idea, and about key moments in your work and how they occurred.

GC:

There's another key moment in my research that I want to mention. It was when I had an idea in Rio, the week before carnival. Being in Brazil was very exciting for me. The sensuality, the women, the tropics, the colors, the heat. I was living in Buenos Aires, which is very European. It's not the United States, but it's inhibited, it's middle class. And you go to Rio and it has this African sensuality. The women love being women, you know, they want to drive the men crazy. The sex in Brazil is not like in France. In France the women are very sexual, but it has to be done with elegance, right? But in Rio they throw it in your face!

HUO / MA:

{Laugh}

GC:

So what did I do in Rio? You might think I spent all my time making love to these beautiful women. Maybe that's what I should have done, but instead it just energized my mind. I had all these mathematical ideas!

HUO:

And what came out of this stay in Rio?

GC:

I realized that even though most things are random, according to my definition of randomness, you can never prove it in individual cases.

MA:

Are there any sexual undertones?

GC:

It's theorems, it's mathematics! The normal output of sex is children, beautiful children, so math is a more interesting, or certain-

ly a more unusual output, let's put it that way! I had come up with a definition of randomness and then suddenly I realized that it would give me a completely new attack on Gödel's incompleteness work. This had subconsciously been my goal all along. One of the reasons I went into mathematics, besides the beauty of the ideas, was Gödel's Incompleteness Theorem, which was a main source of motivation for me. But when I got the idea of randomness, I had years of work to develop it. And you temporarily put aside a more important goal to concentrate on that kind of subsidiary goal. It was a stepping stone; but while you're working on that thing, all your concentration is on that and maybe you forget the original reason that you went in that particular direction.

So after I finished developing my idea of randomness, I was able to relax, to calm down and step back and ask myself "What now?" And then I was in Rio and all of a sudden I realized that this definition of randomness was perfect, it was exactly what I needed to be able to get back to incompleteness, which had obsessed me and brought me into mathematics. I realized that randomness completely changed the way you think about incompleteness. This was not by chance. I'm sure that for subconscious psychological reasons I had been going exactly in the direction for penetrating the fundamental mystery of incompleteness—because that's where mathematics turns back, where mathematics stops, you know, where there's a wall. I felt this was so fascinating—how can mathematics show that mathematics has limitations? And so this is what happened in Rio, and then I spent years working on that.

Another idea I had was more technical. In my theory, the proofs, the reasoning, they were ugly. I was annoyed. I had developed a theory but it seemed a little clumsy. Even though I had achieved my goals—I had a theory of randomness, I was applying it to incompleteness—the proofs bothered me, they annoyed me. It's like a painting when you feel it's not finished, that there's something wrong with it but you can't say what, that there's something that isn't right. And I was looking at this painting, and it was a good painting, but it wasn't finished.

This led me to redo my theory. I changed the definition of randomness, in a way that would be hard to explain to you. It was a technical change that all of a sudden made the theory more beautiful. I don't know how to describe it. It's as if I had been looking at everything out of focus, and suddenly I adjusted my binoculars a little and could see sharp, you know? The theory was suddenly *right*. I had the feeling that this had to be the correct theory. After-

wards, it seemed inevitable that the new theory was the right theory, but it had taken me a lot of work and a lot of experimentation to get the right formulation. But afterwards I said to myself, "How could anyone ever have conceived of doing it any other way?" And it's good sign when you feel like that.

MA:
There was another moment in my life, which happened some time ago and I really think I'm right, but it's still not there. It's like the whole idea of how art's going to look in the next century. How are things going to develop? And I honestly strongly believe that art is going to the point where the objects will be removed—there will be no objects: no paintings, no sculptures, no installations, whatever. There will just be this artist directly translating energy through the public, with no object in between, and that's it. Objects won't be necessary any more; but to get to that point, the public has to be prepared as well as the artist. And one of the reasons for these transitory objects is to prepare the public to be able to receive it, so it can really be developed in the same way as artists, because artists go through the process of change, but most of the time the public doesn't. It is a two-way process: the public body performing and the artist's body performing to find an end point for this transformation—without objects—to take place. This is really my vision of the future.

GC:
Let me react strongly to that, Marina. The crazy thing is that I feel like I'm a performance artist too, really. For me also, apart from creating new mathematics, one of the most intense moments is transmitting it to the public—I feel I'm a performer. I love sharing my enthusiasm for ideas with the public.

ACCONCI, Vito

Vito Acconci was born in 1940, in the Bronx, New York, and currently lives and works in Brooklyn, New York. Acconci graduated from Holy Cross College in Worcester, Massachusetts, in 1962, with a major in English Literature. He then attended the Writers Workshop at the University of Iowa, where he received his Master of Fine Arts in creative writing. After graduating in 1964, he moved back to New York City where he lived as a writer until he made a gradual transition to visual art in the late '60s. His first works in the art context used performance, film, and video as instruments of self-analysis and person-to-person relationships. Acconci's audio and video installations of the mid-'70s turned exhibition spaces into community meeting places. Acconci pushed this interest forward in the '80s by making more and more architecture-related works; in 1988 he started an architecture firm, Acconci Studio. While Acconci continues to exhibit in galleries and museums, he has devoted most of his recent career to re-envisioning public spaces. These proposals include Garbage City (1999), a theoretical project for the Hiriya Garbage Dump in Tel Aviv; Screens for a Walkway (2000), Shibuya Station, Tokyo; and a Design Shop for MAK, the Museum of Applied Art in Vienna (2001).

..................

The first part of this interview took place in Vienna, in May 1993; the second part is the record of a public dialogue between Vito Acconci and Hans Ulrich Obrist, entitled, "Museums: The Mausoleum, the Laboratorium, the Meditation Chamber and the Rave," that took place at the MAK—Austrian Museum of Applied Arts in Vienna, in April 2001.

[1]

Hans Ulrich Obrist:
Let's begin with this period in the mid to late '60s, when you went from being a writer in New York to being a performance, video, and installation artist.

Vito Acconci:
Well, my background wasn't a visual arts background; my background was a writing background. Until 1968, 1969, my work was in a context of writing, context of poetry. Towards the end of the time I was writing, the things that interested me about writing were notions of the page as a space to move over. In other words, towards the end of the time I was writing I became concerned, maybe overly concerned, with questions like, "What makes me move from the left margin of the page to the right margin? What makes me turn from one page to the next page?" In other words, I was thinking of the page, the book, almost as a field for me, as writer, to travel over.

Then, in turn, this page would be a field for you, as a reader, to move over, to travel over. Towards the end of the time I was writing, because I was so interested in the literalness of the page, eventually the choice of words became a problem. It started to become... it started to seem impossible to use on the page a word like "tree," or a word like "chair," because this referred to another space, a space off the page. Whereas I could use on the page words like "there," "then," "at that time," "in that place"—words that referred to my activity on the page, my act of writing on the page. In fact, I was driving myself into a kind of corner, into a kind of dead end, where in order to preserve the literalness of the page the only thing I could use on the page were commas, periods and punctuation points. So I've gotten into this kind of dead-end block. Once you got into that block, all you could do was in some way try to make a leap out of the corner. So, for me, the leap out of the corner was off the page and into actual space, into real space.

HUO:
What were you aiming at when you entered the visual art context?

VA:
Well, for me the biggest point of reference was that up until that time I had assumed I was a writer. Because I had assumed I was a writer, I assumed that I knew what my ground was: my ground was this piece of paper in front of me. Now I had gotten to that point where there wasn't that piece of paper anymore. So, for me, the starting point was "Now that I'm in real space, now that I'm in actual space, what makes me move there, what gives me a reason to move?" The work began with trying to find reasons for action. For example, I would decide on a scheme of... following a person. Once I had decided on that scheme, decisions of time and space were out of my hands. I gave myself a reason to move—I could move as long as I could follow the person. So, my work began, I think, very, very literally. Of course, there were things in the background. Things that interested me at that time were basically psychological texts, sociological texts. Psychology, sociology, writers like [Erving] Goffman who had books like *The Presentation of Self in Everyday Life* (1959). At that time, I was interested in things like system theory. Therefore, the way I thought of my work was, "I would find some kind of system that already existed in the real world, I'd find some way to tie myself into that system, I'd become part of that system." There's a system of "people walking in the street" and I'd find some way to tie myself into that system.

HUO:

What were the first pieces that you did in a museum context?

VA:

Maybe the first pieces of mine that were done in a museum, were shown in 1970 at the Museum of Modern Art in New York, in the "Information" show and in another show called "Software," also in New York, in 1970 ("Software, Information Technology: Its New Meaning for Art," Jewish Museum, New York).

HUO:

These pieces and performances were titled Service Area*-Information (1970) and* Proximity Piece *(1970), respectively; that's not uninteresting to mention.* Service Area *was a three-month activity in which you picked up your mail at the museum. Could you tell me more about these first projects?*

VA:

Yes. For me, you know, the idea of doing something in a museum... I thought at that time that my work was about a kind of everyday life, street space. The idea of doing something in a museum seemed very problematic to me. The only way I could deal with it was try to make museum space part of my everyday life space. So my space in the museum became used as my mailbox, so that mail would be forwarded by the post office to the museum, and anytime I wanted mail, or needed mail, I would have to go up to the museum to get it. In other words, it seems like early work for me was sort of about how to cause more trouble than necessary for me. I mean, it would have been easy to pick up mail here, but in order to find that theory I had to find a more complicated way to get mail.

HUO:

Was there at that time any contact with Robert Morris who during those years was looking for ways to charge the Minimalist vocabulary with a psychosexual dimension?

VA:

For some reason... I mean, I became very interested in Morris's work, but I wonder if it wasn't a little bit later... And I'm not exactly sure why. But, at that time... certainly, I saw my stuff as related to Minimalism. For me, Minimal art was almost a kind of "father art." This was the art that probably meant the most to me in the mid-'60s, towards the end of the '60s. Because probably, until Minimal art, I had been taught or I had taught myself, when I looked at art, to look at what was within the frame and to ignore what was outside. In the presence of Minimal art that was no longer possible.

Suddenly, in the presence of Minimal art, I had to recognize the room, and I had to recognize people in the room. So, for me, Minimal art was a kind of breakthrough; that was the art that was most important for me. At the same time—probably in order to do something myself—I had to try almost desperately to find something wrong with Minimal art. Because if there was nothing wrong with it there would be no reason for me to do anything. In other words, if Minimal art was the "father art" for me, I had to find some way to kill the father. It seemed like the one possible flaw I could find with Minimal art was that Minimal art appeared as if no one had put it there, as if it was there from all time. It was a little bit like the black monolith in [Stanley] Kubrick's *2001: A Space Odyssey* (1968): suddenly this object appears. The problem with that is once that object appears all you can do is bow down in front of it. All you can do is treat it as a kind of religion. Because if this object appears and you don't know where it came from, the possibility is that it has more power than you do, and so you'd better try to respect it, just in case. Seeing that as maybe a possible flaw in Minimal art probably made me decide: O.K., whatever I did, then I wanted to make its source clear. So, probably for me, Minimal art made me start to develop a way of thinking that whatever I did, the doer, the agent was going to be apparent.

HUO:

So, the conditions of production and the importance of the context and of "the agent": that was a very sociology-based line of thought.

VA:

Yes, the conditions of production but also the agent of production. So that if I appeared as part of a work... O.K., you might have objections to it, you could hate it, but at least I made it clear who's responsible. I mean, I've always had problems... maybe because I began as a writer, I sort of developed this way of thinking that I could find the context, that I could find the way to put myself into different contexts. The interesting thing for me, when I started doing stuff in an art context, is that it was clear that there was really nothing that I knew how to do. And I didn't know the rules of the art context, and I didn't have any particular skills. And in some ways that gave me a kind of advantage because if I didn't know the rules then I would really have to find some way to fit myself into that context. Somehow, that way of thinking has persisted; I mean, for everything I've done I never really knew how to do it.

HUO:

Even now with the architectural projects?

VA:

Well, I have no idea how to build for example, but I probably know how to find the people who can build. I've always been in a position where I don't know how to do anything, so I can use the Yellow Pages of the telephone book and I can find the people who can build. It has always put me into the position of almost a kind of movie director. I can be behind the scenes, I can bring in the person who can do such and such a thing, bring in the person who can do another kind of thing, etc. Whereas I have the luxury of having sort of vague ideas, I can then bring in other people who may help me to start to clarify those ideas. I think it's important now to see that it was 1968: it was the time when universities were starting not so much to have particular departments but rather they would have interdisciplinary departments. It was the time of blending of disciplines. I mean, at another time, probably, it would have been much harder for me to say, "Now I'm in a writing context, now I'm doing something that allows me to be in an art context," because the boundaries would have possibly been more rigid. But at that particular time, there was such a melting of boundaries that I never had to think this was a kind of traumatic decision. And it wasn't, I mean, it wasn't so much that I thought: "Now I'm a writer, now I'm... whatever." It was more that the work started to drift, to drift into another field. Anyway, it was the time of interdisciplinary studies. Or maybe, a more precise way of saying that is that it was, possibly, a time of interdisciplinary studies because it was the time of the Vietnam War. It was the time, in the United States, of demonstrations against the Vietnam War. It was the time when... you know, when I grew up, in the '40s, it was assumed that America meant something. It was assumed that the United States was the "power." In 1968 that power started to break. I mean, all of us started to question that. It was the time when the notion of "nation" was breaking, the notion of "father" was breaking, and the notion of "male" was breaking. All those power categories were dissolving; they didn't seem as rigid anymore. I think maybe that's what interested me and, I think, a lot of people in my generation in an art context.

HUO:

How much was the art context a privileged place for that line of thinking?

VA:

What a lot of us thought at the beginning was that we were going to completely change the art context—we were going to make the

art context impossible to exist. A lot of us, at that time, thought that the work we were doing—because it didn't involve something that was saleable, and since an art gallery and an art system is dependent on sales—that our work was going to change the art system. But we didn't do that, we did exactly the opposite! I think that we made the art system more powerful than it ever was before.

HUO:

Why? And how?

VA:

Because, I think that the problem was that a lot of our work certainly didn't sell, but it caused a lot of attention. So, whether we were aware of it or not, we really fulfilled a business function: we provided publicity for a gallery, we provided window dressing for a gallery. A lot of us, I think, at that time—I know I was, so maybe I should just say "I" rather than "a lot of us"—at least I, at that time, was so naive about what a business context was. One impetus for my generation was a reaction against, for example, the Abstract Expressionist attitude. That when an Abstract Expressionist painter was asked about work of theirs, the kind of typical response was, "I don't know where it came from." But the implication was, "It came to this person, it didn't come to others." So, that person was set aside as this specialized receiver of a gift. And I think, for my generation there was such resentment against that!

HUO:

Your idea was that there was nothing really special about art?

VA:

I mean, we wanted to see art as a... yes, there is nothing special about art, there's just the decision to do it. It's not about a particular gift, a particular skill, certainly not about a particular vision. It's about a decision of a way of doing, a way of producing. So, I think, for a lot of us the urge was always to come down to earth.

HUO:

So Duchamp was very important at the time?

VA:

I always had a mixed relation do Duchamp. I mean, obviously, my stuff and the work of people in my generation were influenced by Duchamp. But, on the other hand, I saw Duchamp as this kind of mystifying dandy, and I hated that part of Duchamp: the artist who, you know, keeps secrets. I didn't want to keep any secrets. I mean, at least, I might not know everything about my stuff, but when I know, I want other people to know. Because that notion of that kind of secret

seems so... that seems to be this kind of "let's retain power by secre-cy," and that's a kind of religion trick in a lot of ways. You know, Duchamp... I mean, I see most art as detestable. No, I just hate the idea of art. And I think a lot of it has to do with that notion of observ-er. Because an art context is a context of observers. In every other field of life, when you come upon something for the first time, you know, just out of normal circumstance, you pick it up, you touch it, you pos-sibly smell it, you taste it. But in art, the tradition is that you stand aside and look. And there's probably an economic reason for that. If you stand aside and look, then you're always in the position of desire. And you can never *have*. So you're always in the position of being low-er than the art. Museums usually have no windows so that when you go into the museum you become suffocated by art. I think that for my generation, we started to ask, "Is art so fragile that a museum has to keep it so separate from other things in life?" And I think the answer is "Yes, art is so fragile, it only exists because an art world agrees that it exists, because that art world agrees that certain things have a cer-tain value." But show these things to normal people and most of these things don't have any value. I mean, the art world is the kind of world that's sort of complete in itself. It has its agents, the artists, it has its receivers, the collectors, it has its distribution system, the magazines, etc. So it has everything, everything it needs to keep itself going, but it keeps itself going as a closed world. Once that stuff is taken out of the art world and brought into some other world it probably sort of totally dissipates. In other words, probably, the things that have val-ue in an art world, when taken out of that and brought into an every-day world made up of people who never have any reason to go into museums, once it's brought into that world, it probably makes no sense at all. For me, those people outside of the art world maybe can judge this more precisely and more correctly than people who are in the art world because they have to judge these things. In other words, if art doesn't exist, what else can they do? If art doesn't exist, they no longer have any kind of reason to exist. I mean, this obviously applies to me too. Because at the same time that I say all this, I wouldn't have any existence if it wasn't for an art world. Sure, I claim now that I'm much more interested in, you know, public space, public context, but nobody would ask me to do any public projects if I didn't have an art world existence. You know, I don't exist without that gallery/museum world.

HUO:
It's the big ambiguity behind the notion of "space-specificity"...

VA:

Yes, because all the places that my pieces are specific to are always institutionalized places. I'm doing something particular for a gallery, I'm doing something for a museum, I'm adapting to the space of a gallery, to the space of a museum. After a while, I have to ask myself, "Am I only adapting myself to the space or am I adapting myself to an institutionalized frame of mind?" In other words: O.K., I started showing in galleries in, whatever, 1970–71, and after a few years I started to think that it's not so precise to say: "I'm doing art." Rather, I'm doing gallery and museum art—this is really the context for my work. So therefore, I'm obviously developing the frame of mind of a gallery or a museum. I mean, usually a gallery or a museum doesn't have to censor you because you have already censored yourself. Because once you are working in that context, you have now been learning the rules. So, you learned to know what gallery art is and what museum art is. I think in the mid-'70s I was starting to wonder: "Is my position doing art in a gallery? Is my position something like being a kind of interior decorator for a gallery?" Because when a gallery gives you a show, it's as if, for that three-week period, your job—or, at least, my job at that time—was to camouflage the gallery's existence as a store. If I provide an installation in a gallery, this is a kind of subterfuge. This is hiding the fact that the gallery really is a kind of selling place. I mean, again, I could raise these questions: I didn't quite know how to answer them, necessarily.

HUO:

What about public spaces?

VA:

In the United States, most things that are public, that are so-called public spaces, are plazas that are owned by corporations. The only reason that public space exists is because the corporation is allowed to build a building ten stories higher if they provide public space. But the problem with that public space is, yeah, it's public as long as you obey the rules of the corporation. If you decide to use this public space to sleep on a bench or, you know, piss on the street, now it's no longer public because you haven't obeyed the corporation rules. Something about the very words "public space"... If certain places in the city are called public spaces, the implication is the rest of the city doesn't belong to you. The implication is that the rest of the city is obviously not your territory. So it is as if public places are

places, which you are allowed—almost like children—to use: you have a kind of kindergarten place to play.

HUO:

But the transitions between public and private spaces are sometimes, or can be, developed as more fluid or more opaque ones, don't you think?

VA:

I think it started to blend. Like in New York, for example, it is very difficult to say if a space is public or private when there are people sleeping on the subways... It is causing me a lot of difficulties, because of my proposals for public places. I'm not even sure what public place means now. I mean, at the end of the twentieth century, public place is probably television and telephone, it's not a plaza. It makes me wonder about the work I'm doing, or that I've done lately. Now, maybe, if I had been doing public stuff in the late '60s, I would have had my answers to why you would do public stuff, that is: it's supposed to cause a revolution. I'd still love to say that now, but I don't know if it's quite as simple as that, or maybe it has to be done a little bit differently, or a little sneakier. Or maybe, in the late '60s, there was a solution because of things like demonstrations against the Vietnam War: there was a solution in that there was a kind of community that could group. I'm not quite sure what that community would be now, so that I'm not quite sure if a public space should be a grouping space. Or that in a world in which politics occur more by means of telephone, television, and computer, maybe there has to be a redefinition of privacy. It's maybe more in those private moments now that a person becomes political. Which, for me, is very jarring, because I've always thought of politics as the gathering of people in a plaza. But it probably isn't that anymore.

HUO:

These perceptions and analyses of the state of things seem to influence your most recent work a lot, like the **Virtual Pleasure Mask** *(1993) that was shown here in Vienna {Museum für Angewandte Kunst (MAK), Vienna, 1993}.*

VA:

Yes. I mean... it seems like space in the late twentieth century—if it's true that an electronic age de-emphasizes space—is space on the run, space on the move. So that there've been some recent pieces that seem to deal with kinds of toys, devices, things you could take with you as you go. There have been a number of pieces that involve sex dolls that also function as radios, so you could sort of pick it up and take it with you. You can have entertainment and sex on the run. So,

there have been a number of pieces... I know, I keep focusing lately on words like "devices," "instruments," "toys," maybe as an alternative to place. If place is something you go to, then device and instrument is something that you take with you. You know, probably, I've always had this nostalgia for wanting to believe that the artist works as a kind of guerrilla fighter. You go to a certain terrain, you examine that terrain, you learn where to plant the bomb in that terrain, and then you go to another terrain. But you always need a terrain. A bomb doesn't make sense without a terrain to put the bomb in. But, lately, I know there has been some wondering on my part if there is some other way of working.

[2]

HUO:

In your lecture today, you mentioned the proposal you made for the Museum of Contemporary Art, Los Angeles (MOCA LA) in 1988. Your idea was to turn a passage into a place to inhabit. But still it would have happened outside the museum?

VA:

It was outside, but in a way, the site was part of the inside. There's a canopy—a mesh-covered roof—outside the front of the museum. What [Frank] Gehry did was take the columns from inside the museum and extend the columns outside; the only reason the columns are there outside is to support the roof. We wanted to make the canopy usable, inhabitable. The roof became the support for a cluster of upside-down houses: the mesh roof was the bottom of the houses; the upside-down roof extended down to the ground as a stairway. You could step up inside the houses. The houses functioned as the support for plantings, for landscape; it was as if the canopy were a hill—an Italian hill town. By that time, my frame of mind had changed, my career had changed; I had convinced myself that the work wasn't art anymore; it was architecture and landscape architecture.

HUO:

How did your office change over the last few years from a studio into an architecture office? Did it happen gradually?

VA:

In 1988 I did a show at the Museum of Modern art in New York; I called it "Public Places." Once the title was a banner outside the Museum of Modern Art, I couldn't take it back. It was like [Jean] Genet being called a thief—then he had to become a thief. Once I

had announced that these were *Public Places*, I had to take it serious-
ly. If I really thought my work was designed for public spaces, then
I had to work the way an architect works. I had to work with peo-
ple, and they had to be from an architecture background. There were
two basic reasons. Number one: I didn't know how to do anything—
I have no particular skills. I can only look in the yellow pages and
find people who have those skills. So, in 1988, I needed people
around me who knew materials, who knew engineering, who knew
how to think in plans and sections. Reason number two, and this is
the most important reason: I paid attention to phrases like, "A per-
son who lives by the sword dies by the sword." In other words, if a
project starts out as private, it ends private; if something is meant to
be public, it better start at least as a semi-public project. Now, one
is private, and two is a couple, a mirror image, but three is a crowd;
three spoils the couple, so it must be the beginning of public. I need-
ed people working with me because the work had to start from a dis-
cussion, it had to start from a composite of privates.

HUO:

In a way, you have been using the Whole Earth Catalog, *the unofficial
handbook of the counterculture that was first published in 1968 by Stewart
Brand, in the same way that you used the Yellow Pages...*

VA:

The *Whole Earth Catalog's* subtitle was *Access to Tools*. It was a maga-
zine of books, with excerpts from those books. It was divided into
categories: organization, technology, survival. It was compiled by
people who seriously believed that a revolution could occur; and, if
that revolution was going to occur, we had better be prepared. We
needed to know how to survive, we needed to understand whole sys-
tems because in a time of revolution, particular abilities don't count
so much, but the organization and deployment of abilities counts. It
was the magazine for the generalists; it was a user's guide to the
world. For many of us then, the world was an encyclopedia. We
could open it where we wanted, in any order we wanted, and the
Whole Earth Catalog was its tourist guide.

HUO:

*What about the role of the museum in this perspective? Should the museum
be a user's guide to the world too? Aren't museums too often mausoleums?*

VA:

Things exist best when they have multi-functions. What revivified
my work in the last 12 years is that I work as part of a group rather
than as a single person. The studio has worked best when there's

been a mix of ages, a mix of genders, a mix of cultures. We might be using the same word but, because of our different backgrounds and biases, we mean very different things. I don't know now how to define "public," but it's at least a composite of privates. I want to start work with an awareness of the multiplicity of all those privates. Working with a studio has expanded a frame of mind that probably became very self-enclosed when it was only me. Yes, maybe a museum is a place for the dead, but the dead can be surrounded and infiltrated. Maybe a museum can be surrounded with a passage where you never have time to stop, and all the art there is moving. Maybe both the art and the design of the container always change, and the dead can be surrounded by the living or the living can go through the dead.

HUO:

Does your studio work like a laboratory?

VA:

Of the six people, four are architects, one is an artist, and one is an art historian. Two have an art background, one of them has an art history background and she acts as the office manager and administrator. It's the artists who handle the making of physical models, and that's probably purposeful: our models don't look like architectural models. Our models look as if they belong in a model railroad (I'm not sure that I like this anymore)—our models are the kind that children would understand. I love abstract models, but they're ideas and essays; I need to see the idea embodied and the theory put into practice. I want to know what a project is going to be materially, how it will fit into or collide with the rest of the city, and what the space is like around the corner. The studio is full of computers now, but we can't stop making physical models. The computer helps us to easily design the fluidities that we're drawn to—but maybe too easily. We need the resistance of physicality; we need a mix of virtual and actual.

HUO:

What's the role of your library in the working process?

VA:

The two most important physical surroundings in the studio are books and music. One part of the studio is divided from the other by a wall of books. We work in the middle of reminders, in the middle of predecessors, in the middle of information; we're working on something and it reminds somebody of such and such, so you pull out a book like a brick. Or we're stuck, and each of us gropes around

that wall of books, as if blindfolded. And music is always on in the studio. The music changes with the times. For me, the mid-'90s brought with it the first music that had excited me since mid-'70s Punk: Tricky, Moby—a blending of person and machine, an insinuation rather than an attack; things. The music we listen to now acts as a surrounding, a background. I'm thinking of music as architecture, as wallpaper; the music we listen to in the studio is mostly electronic-based.

HUO:

You suggested that we add "rave" to the title of this discussion. What interests you in the rave phenomena?

VA:

I've never actually been to a rave, but I've read about them. That applies to most things in my life: I do things in my closet—I can read about it, write about it, design it, but I don't actually do it. I have a kind of classic way of knowing things. "Rave" was a last minute addition to the title of this discussion. I was thinking of a large group of people in a vast field—the sun is coming up—the atmosphere is replaced by music. They're not dancing with each other; they're not touching each other—they're all together, but each is very alone. I wonder about the museum as hypnotism, as a kind of drug: each person stands in front of an object, walks around an object. They all look the same, they all believe. The problem with art is that it's only a field whose name not only categorizes it but also gives it value: when we say something is "art," we're praising it. So art praises itself as it names itself; it comes pre-approved.

BALLARD, J.G.

James Graham Ballard was born in Shanghai, China, in 1930. He currently lives and works in Shepperton, England. Ballard spent the first 15 years of his life in China. Interned in a Japanese camp during World War II, he was repatriated to England at the age of 16. After studying medicine at Cambridge, in 1956 he sold his first story to New Worlds, *which had been England's leading magazine of "imaginative fiction" under the editorship of Ted Carnell and Mike Moorcock in the '50s and '60s. Ballard is the author of numerous novels, short stories and non-fiction collections that have earned him the reputation of being one of the world's most imaginative and thought-provoking writers. Sometimes seen as an author of science fiction only, Ballard has in fact produced work that crosses many boundaries, borrowing from and blending several genres: fusing action and adventure with hard science, psychiatry with surrealism, and postmodernism with narratives. Books by Ballard include* The Drowned World *(1962),* The Atrocity Exhibition *(1969 and 1990),* The Vermillion Sands *(1971),* Crash *(1973),* Empire of the Sun *(1984), and* A User's Guide to the Millennium *(1996).*

........................
This interview was conducted by fax in January 2003.

Hans Ulrich Obrist:

I would like to begin with the early years: your childhood years in the Far East and your arrival in England just after World War II. You've often said that those years in China greatly influenced your writing—all the abandoned cities and towns and beach resorts that you keep returning to in your fiction are related to these spaces in China that the Japanese had abandoned during the war; as well as the semi-tropical nature of the place, the lush vegetation... When you came to England, it was totally exhausted. In an interview with James Goddard and David Pringle from 1975, you said, "The War had drained everything. It seemed very small and rather narrow mentally, and the physical landscape of England was so old." I'm wondering how this experience of postwar England as a very dull place compared to China has influenced later your work as a (science) fiction writer. You said also, "Why I became a science-fiction writer was because the future was clearly better and the past was clearly worse." And, "I came from a background where there was no past. Everything was new—Shanghai was a new city." So I'd like to open the conversation on this period with a reflection on these few quotes.

J.G. Ballard:

Yes, I don't think it's possible to escape from one's past. The brain and the imagination are imprinted forever with the images of one's first years. I think puberty is an important turning point, as it is in the case of language acquisition. I lived in Shanghai until I was 15, went through the war and acquired a special "language"—a set of images and rhythms, dreams and expectations that are probably the basic operating formulas that govern my life to this day. Shanghai was almost a twenty-first-century city—huge disparities of wealth and poverty, a multi-lingual media city with dozens of radio stations, dominated by advertising, befouled by disease and pollution, driven by money, populated by twenty different nations, the largest and most dynamic city of the Pacific Rim, an important political battleground. In short, a portent of the world we inhabit today. The significant thing for me was that all this was turned upside down by war. Friends suddenly vanished, leaving empty houses like the Marie Celeste, and everywhere I saw the strange surrealist spectacles that war produces. It taught me many lessons, above all that the unrestricted imagination was the best guide to reality.

HUO:

You studied medical science at Cambridge, then spent time in the RAF in Canada, and then came back to England to become an editorial assistant of a science magazine. At the time, you had already started writing fiction. Were your interests in science and technology—the predicament of the individual in a highly mechanized society, and the way in which certain symbols and images can precipitate complex chain-reactions in the imagination—present from the very beginning? Could you tell me about the way you honed your work and your style?

JGB:

Yes, I think that my imagination was fully formed from the beginning, though that is probably true for most painters, novelists, poets, and so on. I've always believed in the radical imagination that sets out to change reality—probably a doomed ambition. I wasn't interested in accepting the social consensus. I wanted to unsettle and unnerve, to provoke the reader. I never consciously shaped my ideas or my style. I simply followed my obsessions and was confident that they would take me to strange destinations beyond the edge of the map.

HUO:

The same year that you published your first texts, in London, the Independent Group organized the exhibition "This is Tomorrow" (Whitechapel Art Gallery, 1956), which startled everybody with its flood of popular imagery, undiluted in scale and treatment: films, advertising billboards, car styling,

consumer goods, and comics. You said about your experience of this exhibition, "To go to the Whitechapel in 1956 and to see my experience of the real world being commented upon, played back to me with all kinds of ironic gestures, that was tremendously exciting. I could really recreate the future that was the future, not the past. And Abstract Expressionism struck me as being about yesterday, it was profoundly retrospective, profoundly passive, and it wasn't serious." Could you tell me more about your memories of this show?

JGB:

At the time, I didn't see "This is Tomorrow" as an aesthetic event. For me it wasn't primarily an art show, just as I didn't see exhibitions of Francis Bacon, Max Ernst, Magritte, and Dalí as displays of paintings. I saw them as among the most radical statements of the human imagination ever made, on a par with radical discoveries in neuroscience or nuclear physics. "This is Tomorrow" showed how the world could be re-perceived and re-made. Very few people today are old enough to remember how traumatized Britain was by the Second World War (which in many ways we had lost). The British were locked into an exhausted present, and were trying to find their way back into the past, where they hoped they might be happier and discover their former certainties. A hopeless quest. A new future has to be built from scratch, and "This is Tomorrow" was a start. What impressed me was that it was a confident art.

HUO:

Did you befriend Richard Hamilton and Eduardo Paolozzi there, or did you know them before? You've always said that you had been influenced as a writer by certain artists, painters, and even that novels, like Crash *(1973) for instance, were composed as visual experiences, marrying elements in the book that make sense primarily as visual constructs. Did the artists of the Independent Group have a direct influence on you?*

JGB:

I didn't meet Paolozzi until 1966 and Hamilton somewhat later. I admired their work greatly, but I think the Surrealist painters had the biggest influence on me: de Chirico, Ernst, Dalí, and [Paul] Delvaux. These are all painters of mysterious and disconnected landscapes, through which the few human beings drift in a state of dream-like trance, which had a direct and powerful appeal for me. I admired many of Hamilton's paintings, such as *Homage to the Chrysler Corporation* (1957) and his masterpiece, the collage *Just What Is It That Makes Today's Homes So Different, So Appealing?* (1956), and I also admired Paolozzi's great early sculptures, the totemic figures constructed from machine-parts, and his brilliantly original screen-prints.

HUO:

Were they interested in science fiction writing, in the magazine **New Worlds** *and in your stories you published there in particular? I suppose it's difficult for you to say, but do think that they considered you as a visionary writer?*

JGB:

I don't think I was any kind of influence on them. They were much more interested in American science fiction with its high-technology images.

HUO:

The ICA {Institute of Contemporary Arts, London} was a powerhouse of experimental exhibition practice at the time, a laboratory for interdisciplinary dialogues. Did you see it like that at the time, and why did it work? What can we learn from this experience for the present?

JGB:

The ICA has always been enormously important as an ideas laboratory, not only in the days of the Independent Group in the '50s, but also in the late '60s after it moved to its present home in The Mall. There were many important exhibitions devoted to Surrealist and installation art, and the ICA was a hothouse where people met to exchange original ideas. In the last few years it's regained its old flavor. Part of the problem it faces is that the avant-garde is now the new establishment. The new is in danger of becoming the new old. But today's ICA seems to be successfully reporting itself as a post-2000 ideas lab.

HUO:

There is this exhibition that you designed in the late '60s at the New Arts Lab, where crashed cars were displayed (Institute for Research into Art & Technology Gallery, London, 1970). You called it "New Sculpture." I know that this show encountered massive hostility, that the cars were attacked. In a conversation with Eduardo Paolozzi published in Studio International *in 1971, you said about this exhibition: "The whole thing was a speculative illustration of a scene in* The Atrocity Exhibition *(1969). I had speculated in my book about how the people might behave. And in the real show, the guests at the party and the visitors later behaved in pretty much the way I had anticipated. It was not so much an exhibition of sculpture as almost of experimental psychology, using the medium of the fine art show. People were unnerved, you see. There was enormous hostility." So, did you consider the exhibition medium to be a unique tool in this respect?*

JGB:

My show of crashed cars was held at the New Arts Lab in April 1970. It was an art show designed to carry out a psychological test, so that I could decide whether to write my novel *Crash*—begun in 1970 and finished in 1972. I wanted to test my own hypothesis

about our unconscious fascination with car crashes and their latent sexuality. One could argue that today's Turner Prize, and the exhibitions of work by [Damien] Hirst, [Tracey] Emin, and the Chapman brothers, perform exactly the same role, that they are elaborate attempts to test the psychology of today's public. Going further, I'm tempted to say that the psychological test is the only function of today's art shows, and that the aesthetic elements have been reduced almost to zero. It no longer seems possible to shock people by aesthetic means, as did the Impressionists, Picasso, and Matisse, among many others. In fact, it no longer seems possible to touch people's imaginations by aesthetic means. People in London flocked to the Barnet Newman show out of a deep nostalgia for a time when the aesthetic response still mattered.

HUO:

In 1971 you also said, "Violence is probably going to play the same role in the '70s and '80s that sex played in the '50s and '60s. There's what I call in my book The Atrocity Exhibition *the 'death of feeling,' that one is more and more alienated from any kind of direct response to experience. And the car crash is probably the only act of violence most of us in Western Europe are ever going to be involved with, is probably the most dramatic event in our lives apart from our own deaths, and in many cases the two are going to coincide." What do you think of that statement retrospectively? What about now?*

JGB:

Violence does seem to play a dominant role in our imaginations, perhaps for good reasons: a symptom of our need to break down the suffocating conventions that rule our lives. Human beings today display a deep and restless violence, which no longer channels itself into wars but has to emerge in road rage, Internet porn, contact sports like hyper-violent professional rugby and U.S. football, reality TV, and so on.

HUO:

In this same interview of 1971, there is an almost unbelievable statement that you make. You said, "I think that the biggest need of the painter or writer today is information. I'd love to have a tickertape machine in my study constantly churning out material: abstracts from scientific journals, the latest Hollywood gossip, the passenger list of a 707 that crashed in the Andes, the color mixes of a new automobile varnish. In fact, Eduardo {Paolozzi} and I in our different ways are already gathering this kind of information, but we are using the clumsiest possible tool to do it: our own hands and eyes. The technology of the information-retrieval system that we enjoy is incredibly primitive." It's really a premonition of the Internet! So now, do you think it changed the way artists and writers look at and interact with the world?

JGB:

Yes, it was a premonition of the Internet, which I relish for the unlimited information it provides, and the unlimited possibilities. Large sections of it strike me as remarkably poetic. It may turn out to be more important and more innovative than television. It's a kind of collective lucid dreaming.

HUO:

What do you find of specific interest in works made by young visual artists today? And what is your opinion on contemporary literature?

JGB:

I take a keen interest in what today's painters and sculptors are doing. On the whole, my views coincide with those of the great Brian Sewell, but I see the young British artists of the past ten years or so from a different perspective. They find themselves in a world totally dominated by advertising, by a corrupt politics carried out as a branch of advertising, and by a reality that is a total fiction controlled by manufacturers, PR firms, and vast entertainment and media corporations. Nothing is real, everything is fake. Bizarrely, most people like it that way. So in their installations and conceptual works, the young artists are rebelling against this all-dominant adman's media-landscape. They are trying to establish a new truth about what an unmade bed is, what a dead animal is, and so on. Our mistake is to judge them by aesthetic criteria. By contrast, the novel resists innovation, and is much closer to the TV domestic serial.

HUO:

Your novels and stories fascinate a lot of young artists, and I know of at least one dialogue—the one with Tacita Dean. You wrote a short piece on her work that was included in a book published by the Tate in 2001, where you concentrated on her pieces entitled Trying to Find the Spiral Jetty *(1997) and* Teignmouth Electron *(1999), a series of photographs of a derelict trimaran that belonged to yachtsman Donald Crowhurst, who sent false radio signals giving the impression he was undertaking a round-the-world race, while in fact he was preparing for death in the Atlantic Ocean. Could you tell me more about this dialogue between the two of you?*

JGB:

I met Tacita at the opening party for Tate Modern, and was immediately charmed by her, as everyone is. I saw her films and was very impressed by them, especially the film made in the rotating restaurant above the Berlin TV tower (*Fernsehturm*, 2001). It's her masterpiece so far, and a deeply moving effort of the imagination that I haven't yet come to terms with. Above all, it displays the foundation structure of reality—the movement of time through an imperceptibly moving

space, the passage of light and dark, and it shows that human beings are the briefest visitors to the universe that is all around them, but of which they are barely aware. Tacita follows her obsessions and, fortunately, it is impossible to guess where they will lead her.

HUO:

You wrote several texts on William Burroughs: "Hitman for the Apocalypse" (1991), "Sticking to His Guns" (1993), "Mythmaker of the Twentieth Century" (1964), and an obituary in the Guardian. *Like you, Burroughs was very interested in painting and you both studied medicine before becoming writers. Could you tell me more about your connections to Burroughs and the importance his example had for you as a writer and thinker?*

JGB:

I am a huge admirer of Burroughs, whom I consider the greatest writer in English to appear since the Second World War. I admire him above all for his radical imagination, which he used like a weapon against his readers. Everything he wrote is a challenge, just as his life was a challenge against bourgeois America, which offered suburban values, the family, and a passive acceptance of the capitalist ethos with all its corruption and power-hunger. Burroughs was the ultimate non-conformist, the model for all writers who believe in their own obsessions.

HUO:

I just read Mike Davis's latest collection of essays Dead Cities *(Dead Cities. A Natural History, 2002). It's interesting how social commentators in recent times have been asked to (or themselves willingly) play the role of prophets. Do you share any of Davis's analyses of all the wreckages caused by the city's growth, his comments on white flight, deindustrialization, housing and job segregation, and discrimination, and what he calls "national sacrifice zones?" What about his prophesies on the future of life and cities in the face of catastrophic terrorism, global warming, runaway capitalism, and fears of all kinds?*

JGB:

I have just read *Dead Cities* too, and am a great admirer of Mike Davis, especially for *City of Quartz (City of Quartz: Excavating the Future in Los Angeles, 1990)*. Perhaps he is a little too nostalgic for an idealized America dominated by clean rivers and civic responsibility. I feel that he hasn't come to terms with the form that late twentieth- and early twenty-first-century cities have taken: unrestricted urban sprawl, the de-centered metropolis, a transient airport culture, gated communities, and an absence of traditional civic pride. The problem facing planners and architects is how to accept and make the most of this.

HUO:

In your books you have long questioned the state, and especially the "normality" that state institutions indoctrinate and protect. What do you think

of the current prevalence of surveillance, "dataveillance," the loss of civil liberties, and increased state control?

JGB:

Deplorable. I've long said that the totalitarian systems of the future will be subservient and ingratiating, the false smile of the bored waiter rather than the jackboot. We see this subservient Stalinism in London Mayor Ken Livingstone's plans for controlling central London traffic. Hundreds of spy cameras, an army of wardens, a computerized surveillance system out of Alphaville—in short, an Orwellian nightmare come true, but disguised as a public service. Of course, there should be no parking or traffic restrictions of any kind. What we need are more roads, a huge system of overhead freeways on the Los Angeles pattern. But we are too brainwashed to demand this.

HUO:

Do you see the recent shift of "acceptable" societal behavior into increasingly conservative norms as one more potentially dangerous form of such control?

JGB:

There are swings and roundabouts. The loss of freedom in the surveillance society is balanced by the huge gain in freedom and possibility found in the Internet. On the whole, there is a loss in freedom, and the danger is that people may move into the area of psychopathology in order to enlarge the scope of their lives and imaginations.

HUO:

Of course it is somewhat implicit in my last questions, but I'm tempted to question you specifically about September 11 and this new history into which we've found ourselves projected since. And now there are so many geopolitical reshufflings. How does it feel to be a (science-fiction) writer—or more generally an artist—in light of these developments? Do you think the artist has a duty to be in some way critical of global or political events?

JGB:

September 11 changed America, one of the few countries in the past century that has never been bombed from the air. I feel that the U.S. is still trapped in the twentieth century, and is still trying to solve its problems by twentieth century means—carriers, field armies, and bomber groups. Of course writers should speak out.

HUO:

The urban metropolis is often much more than a mere backdrop and becomes a character in itself in your novels. What is it about the metropolis that prompts this? And regarding your research and experience of writing The Empire of the Sun *(1984), can you tell me how much memory you have of the city of Shanghai?*

JGB:

The "urbanization," which has replaced the city of old, is where most people live, and its contours shape their minds. Patterns of urban life are constantly shifting, and constitute a script that we all have to perform. We're allowed a certain freedom to improvise, but our roles are written by the city. I went back to Shanghai in 1991 for the first time in 45 years, and found that my memories were remarkably intact, though the city is a forest of high-rises and TV towers and has expanded far out into the countryside. In due course, it will become the most important city of the Pacific Rim, eclipsing Los Angeles and Tokyo.

HUO:

The other day you mentioned that you saw "Cities on the Move", the exhibition that Hou Hanru and I curated at the Hayward Gallery in London (1999). What were your impressions?

JGB:

It was a remarkable exhibition, one of the most impressive I have seen for many years, and I am still digesting it.

HUO:

You wrote in the Observer *in 1997 a piece on airports and London where you said that, "By comparison with London Airport, London itself seems hopelessly antiquated. London may well be the only world capital—with the possible exception of Moscow—that has gone from the nineteenth century to the twenty-first without experiencing all the possibilities and excitements of the twentieth in any meaningful way." And you carry on mentioning your admiration for the Hilton Hotel in Heathrow. Can you tell me why that building, and what relationship or dialogue you have in general with architecture or architects?*

JGB:

The Heathrow Hilton designed by Michael Manser is my favorite building in London. It's part space-age hangar and part high-tech medical center. It's clearly a machine, and the spirit of Le Corbusier lives on in its minimal functionalism. It's a white cathedral, almost a place of worship, the closest to a religious building that you can find in an airport. Inside it's a highly theatrical space, dominated by its immense atrium. The building, in effect, is an atrium with a few rooms attached. Most hotels are residential structures, but rightly, the Heathrow Hilton plays down this role, accepting the total transience that is its essence, and instead turns itself into a huge departure lounge, as befits an airport annex. Sitting in its atrium one becomes, briefly, a more advanced kind of human being. Within this remarkable building, one feels no emotions and could never fall in love, or need to. The National Gallery or the Louvre are the complete opposite, and people there are always falling in love.

HUO:

And what is your favorite museum and why? What do you think of the evolutions undertaken by museums in the last few decades? In your view, what role do museums play today? And ideally what do you think their role should be?

JGB:

I like traditional museums, the less frequented the better. All the changes in the past fifty years have been for the worse. I remember the Louvre in 1949 when it was completely deserted, whereas today it is a theme park where you can enjoy "the Mona Lisa experience." This isn't only a matter of funding. Museum directors enjoy being impresarios, guru-figures manipulating the imaginations of the public. Museums shouldn't be too popular. The experience within the Louvre or the National Gallery should be challenging and unsettling and take years to absorb. The Italians had the right idea. Most of their paintings were in dimly lit churches, unclean and difficult to see. As a result, the renaissance endured for centuries.

HUO:

I'm currently working on an exhibition project investigating the significance of the notion of Utopia today; we are gathering all kinds of comments, ideas, "Utopistic"—like Immanuel Wallerstein says—works, projects, and concrete Utopias coming from various disciplines. I cannot help asking you what Utopia means for you and if you think the term has resonance today?

JGB:

Sadly, I think that the notion of a Utopia died at some point in the twentieth century. Two vast utopian projects—Soviet Russia and Nazi Germany—turned into the greatest nightmares the human race has ever experienced, and people now are understandably skeptical about any future Utopia. We're still living in the aftermath of an extremely dangerous century. People today are rightly skeptical about any proclaimed intentions to build heaven on earth. We now live in the present, unconsciously uneasy at the future, and this short-term viewpoint does have dangers. We know that, as human beings, we are all deeply flawed and dangerous, but this self-knowledge can act as a brake on hope and idealism. I look forward to seeing your exhibition.

HUO:

I also want to ask you who or what in your mind—in the present or the past—has come closest to realizing a utopian project.

JGB:

There were times in its history when the United States came close to suggesting what a utopian project might be, but the less appealing

sides to American life now seem to be in the ascendant—there's a self-infantilizing strain that gives America the look of Peter Pan's Never-Never Land. However, the future may well be a marriage between Microsoft and the Disney Company—an infantilized entertainment culture imposed on us by the most advanced communications technology. What I fear for my grandchildren is a benign dystopia of ever-present surveillance cameras watching us for our own good, a situation in which we will acquiesce, all too well aware of our attraction to danger.

HUO:

In many of your novels, ambiguity seems a prevalent feature. I've read an interview in which you spoke about the importance of being ambiguous in your work (For instance, in relation to your book **Crash**: *should or can people find car crashes sexually exciting? You leave multiple readings open-ended.) Could you tell me more about ambiguity in your work? Do you think ambiguity could be characterized as a central theme, a "red thread" or strategy that connects your diverse works?*

JGB:

I hope everything I have written is ambiguous, reflecting the paradoxical faces that make up human nature.

HUO:

Regarding this notion of ambiguity, was Pop Art and its critical fascination with mass culture, television and the media, and its own theorization of the media important for you?

JGB:

Yes, because the mass media have turned the world into a world of Pop Art. From JFK's assassination to the coming war in Iraq, everything is perceived as Pop Art. Nothing is true. Nothing is untrue.

HUO:

Is the archive an important site for you, either physically or symbolically?

JGB:

There are no Ballard archives. I never keep letters, reviews, or research materials. Every page is a fresh page.

HUO:

In many of your stories, and **The Drowned World** *(1962) is just one example that comes immediately to mind, the protagonist is a scientist. What, for you, is the link between literature and science?*

JGB:

Science is a new religion waiting to be born. Infinitely more important than literature, which is an old religion—poetry—waiting to die.

BARNEY, Matthew

Matthew Barney was born in 1967 in San Francisco. He currently lives and works in New York. Matthew Barney was raised in Idaho, where he lived with his father, and in New York with his mother (where he first encountered art). He was a wrestler and football quarterback in high school, and he studied medecine at Yale University before transferring to the studio art department and eventually graduating in 1989 with a B.F.A. With the combination of physically challenging/endurance test-like performances, sculptures made with unusual materials, and video, his debut exhibitions in 1991 attracted immediate attention and acclaim. In 1992, Barney introduced fantastical creatures into his work, a gesture that presaged the vocabulary of his subsequent narrative films. The multi-channel video installation OTTOshaft *(1992), which premiered at documenta IX in Kassel (1992), featured bands of dueling bagpiper players.* Drawing Restraint 7 *(1993), which was shown in the 1993 Biennial Exhibition at the Whitney Museum of American Art in New York and at "Aperto '93" (La Biennale di Venezia, 45th International Exhibition, 1993), included mythological satyrs battling for supremacy while riding in and out of Manhattan's bridges and tunnels in a limousine. In 1994, Barney began working on his epic* Cremaster *cycle (1994–2002), a five-part film project accompanied by related sculptures, photographs, and drawings. Eschewing chronological order, Barney first produced* Cremaster 4 *in 1994. Featuring Barney himself in a variety of roles as well as such iconic figures as writer Norman Mailer, artist Richard Serra, and actress Ursula Andress, the* Cremaster *cycle has been described as a Wagnerian meditation on what Barney has called, "desire in the guise of a digestive system." Barney uses imagery, narrative, and character, but very little dialogue, to weave together his unique mythology. With the exhibition "Matthew Barney: The Cremaster Cycle" (1994–2002), the project reached its finale in an installation taking over the exhibitions spaces of the Ludwig Museum in Cologne (2002), ARC/Musée d'Art Moderne de la Ville de Paris (2002), and the Solomon R. Guggenheim Museum, New York (2003).*

........................

This interview was recorded over the phone in July 2000 {1} and continued in Paris in July 2002 {2}.

[2]

Hans Ulrich Obrist:

Before the **Cremaster** *cycle (1994–2002), your work quickly became visible in 1991, with three shows in the United States ("Matthew Barney: New Work," San Francisco Museum of Modern Art; "00," Barbara Gladstone Gallery, New York; "{facility of INCLINE}," Stuart Regen Gallery, Los Angeles). In your earliest work, you explored the transcendence of physical limitations, using different media such as performances, video installations, sculpture, photography, and drawing. Could you tell me about the transition that led to* **Cremaster***?*

Matthew Barney:

Before *Cremaster*, my work had more to do with live performance. Those exhibitions, which were probably understood as video installations, had much to do with documenting real-time action. It was around that time that I became more interested in telling stories. That was a turning point, rather than a beginning. The *Cremaster* cycle is in itself a narrative, but not necessarily a linear one.

HUO:

For the first time in your work, one saw links to mythology.

MB:

It started with *OTTOshaft* (1992), shown at documenta IX. *OTTOshaft* took place in the parking garage and various elevator shafts at the museums in Kassel. Using different locations, a bagpipe was drawn. The parking garage became the bag and the elevator shafts became the drones. The piece aligned itself with the myths of Pan and the panpipe. Several known myths came forward in an unexpected way, and that excited me. Maybe I wanted to see if the *OTTOshaft* project could live inside a known story, and still remain an abstract piece.

HUO:

So Cremaster *grew out of this work?*

MB:

It probably started as a literal extension of *OTTOshaft*, and how five locations could be assigned to the mouthpiece, the chanter, and to the bass and tenor drones. Something that was fractured, but local, could be projected onto a landscape at a much larger scale. It began as five locations, but the narratives would not fall together in a linear fashion. So I decided at that point to start with *Cremaster 4* (1994) and establish a kind of boundary, and then go back to *Cremaster 1* (1995). I felt pretty certain that ending in the middle would be the way to finish. There was a kind of system that I laid out before *Cremaster*, which started in a place called "Situation," a sexual place trying to define drive or desire. That impulse would then pass through a kind of visceral funnel, called "Condition," that would shape that raw drive. And then "Production" was an anal or oral output that would be bypassed by connecting those two orifices and making a circular system. "Situation," the sexual station, was always drawn as a reproductive system, before its embryonic point of differentiation between male and female.

HUO:

And when did you give it the name?

MB:

Well, I was at my sister's wedding, sitting next to a doctor, Dr. Lung, a man I grew up with in Idaho. I was talking to him about this system, about an unfixed, general point of sexuality, and he said I should look at the cremaster muscle, which is associated with but not actually related to the height of the gonads during sexual differentiation in the womb. A story could be developed about a sexual system that could move at will, and within this fantasy, the cremaster muscle would control that, although in fact it does not.

HUO:

In the Cremaster *cycle, there are many strong narratives, a polyphony of beginnings and ends.*

MB:

The *Cremaster* cycle tries to take on a cinematic language that I had not dealt with before. I wanted to see how this sculptural project, which is what it is, could align itself with the cinematic form, and still come out as sculptural. And this was also the first time that I had made single-channel pieces, knowing that they would be seen from the beginning to the end in a way that my other work had not. I enjoyed the way the other installations could be seen for a number of minutes, even in the middle of one of the channels, and you could move on to the next channel and gain a perfectly adequate experience from it without seeing all channels in any particular way. *Cremaster* is different. Another shift was in somehow putting a musical narrative on top of the visual narrative and, in the case of *Cremaster 5* (1997), developing the two simultaneously. This really solidified the experiment. Up to that point, I was still straddling two different types of structure. Something changed with *Cremaster 5*, and it probably has to do with the music. It ended up being an opera. We went to Budapest with the finished work of music, where Ursula Andress could lip-sync over the recording. In developing the work in general, it was so helpful for me to have a sense of how it might sound.

HUO:

It has been said that you infiltrate or infect closed systems, like the opera, by bringing in some disturbance or shift or virus. Yet Cremaster 2 *(1999) is more like a landscape.*

MB:

Yes. At least for my understanding of *Cremaster 2*, it is important for that landscape to be draw-able as a discrete object. That it should be

possible to make a sculptural form from the Canadian Rockies or the Utah Salt Flats, for example. It's the only way that I could make the piece as a contained form, in the same way that the stadium in *Cremaster 1* is a contained form, or the Isle of Man in *Cremaster 4*, the opera in *Cremaster 5*, and the Chrysler Building in *Cremaster 3* (2002). The initial concept was to put together five locations as singular sculptural entities, on a line from west to east, so that a line could be drawn between them—not just by me but by anybody.

HUO:

Every time I visit your studio I am impressed by the storyboards you produce, which include drawings, postcards, photography, cut-outs of many things—a lot of research material. What is your working method?

MB:

The storyboards start as a drawing practice. In fact, the storyboards that precede the *Cremaster* cycle have little other than drawing in them. *Cremaster* combines source material from the five locations, and those elements were organized into vertical lines around the studio, which became individual scenes in the narrative. As the filming for one of the films approached, aspects of a scene would be drawn more specifically for camera composition. These drawings would function more practically for the production, but the preliminary conceptual storyboards were a critical step for me in building the pieces.

HUO:

In the Cremaster *cycle you have brought in several non-professional actors such as Norman Mailer in* Cremaster 2, *whose Executioner's Song (1979) is an important point of departure in the film. Why did you bring in Norman Mailer himself, especially to portray Harry Houdini?*

MB:

In *Cremaster 2,* there is a paternal constellation of Mailer, Gary Gilmore, and Harry Houdini that made the choice seem obvious. Mailer becomes paternal to Gilmore as the author of *The Executioner's Song.* Although it is brief in Mailer's book, the relationship here to Houdini is that Gilmore's grandmother may or may not have had an affair with Houdini at the 1893 World's Fair; whether or not it is true is unknown. This would make Gilmore Harry Houdini's illegitimate grandson. The *Cremaster 2* story has to do in part with this leap from Gilmore's generation to Houdini's. When he was younger, Mailer looked an awful lot like Houdini. But the issue of likeness was not really the point. It had to do with that constellation, and with Mailer's physicality. I think of these characters as physical states rather than as developed narrative charac-

ters. Somebody like Mailer brings to that role everything that he stands for. The types of characters that I gravitate towards, the types of icons, tend to have a heavy physicality in that way.

HUO:

You cast Richard Serra in Cremaster 3.

MB:

Yes, Richard is very good that way too. And so is Ursula Andress in *Cremaster 5*. There is a slight brutality to her, in the way that she is a proto-athletic sex symbol, whose shoulders are bigger than her hips. For Serra, I suppose there was an expectation that I would take a logical step in this last *Cremaster* piece, *Cremaster 3*, towards conventional cinematic form and dialogue, something that the previous *Cremaster* pieces took baby steps towards. I felt pretty strongly against casting somebody who would advance the project in that way.

HUO:

Why in Cremaster 3 *did you choose the Chrysler Building in New York as your principal location?*

MB:

A number of reasons. One, that it is the corporate headquarters of a maker of vehicles. And two, that it lends itself to other aspects in the project, where a vehicle is necessary to move the narrative across the landscape or to connect one story to another, almost as if the entire project was about UPS, the United Parcel Service! It would give the project a color, brown, and an air fleet and a ground fleet that would carry the story from one location to the next. Each location could still have its own logic and story, but there would be a company in place to move it. The Chrysler Building satisfies those interests and it is also a reflector, in that it sits between the two halves of the story. The piece is set in 1929–30, when the Chrysler Building was constructed, and relates somewhat to the conflict between the stonemasons' union and the metalworkers' union. The story moves through the different floors of the building as it is being constructed, towards the top, which is effectively a transmitter. From there it moves into a space that is not really set in time. This scene was shot in the rotunda of the Guggenheim museum on the different levels and feels almost like a video game. Many of the actors and characters in earlier parts of *Cremaster 3* appear in this game. There are five levels, which take on five different allegories of the five *Cremaster* chapters. Once that transmission is finished, the story is transported back to the Irish Sea, where *Cremaster 3*

begins, and gets involved in old creation myths of the Isle of Man, between a giant in Scotland and a giant in Ireland. We tried to shoot those scenes like a fairytale.

HUO:

The Cremaster *cycle has been shown in cinemas, and it might appear on TV in the U.S. Your work has gone far beyond the usual boundaries of the art world. What then is the function of the art world for your work today?*

MB:

For me it is critical that all of these forms come together as one piece: the films, the sculpture, the photographs, the books. And the museum is the place for that to happen. Probably the moving image aspects can travel most easily beyond the walls of the museum: the further, the better. But the museum is the place to make the overall form very clear, as we have done with the exhibitions at the Guggenheim and in Paris.

HUO:

Books have played an important role in your work from the beginning.

MB:

They certainly are pieces. I tend to think non-hierarchically in the way that the different aspects of the *Cremaster* project are symbiotic. It's the books that end up having the widest distribution, and that interested me in the way that the moving image is slowed down and crystallized in a particular way in the books, and how that informs some of the questions raised in the films and installations. Aspects of the films that are elusive become clearer in the books. For instance, the photography in the books, which is photographed rather than videotaped, tends to have a resolution and a stillness that makes it possible to study the detail in a way that cannot happen in the moving image. The books function as manuals, and bring clues to the narrative questions. In the designing of the books—and I like the way that every spread in a book has a gutter—it started to align with sculptural notions deriving from the natal cleft of the body, that line, the residue of initial cell division. From that symmetry, asymmetry can be introduced. The form of the book, and the gatefold in particular, lends itself to that idea.

[1]

HUO:

Cremaster *is a finite cycle. At the same time, by starting with "4" and not "1," you defined from the very beginning a nonlinear sequence. Was*

there an a priori, clearly defined situation of what would happen, or has it evolved as a complex dynamic system?

MB:

The five-part story is a geographical story and layers were built on top of these geographical stations. A story was developed for each location, one by one. The first location—for *Cremaster 4*—was the Isle of Man, and it was there that the narrative started to develop. What did exist initially was a simple structure, the biological structure I mentioned, and the five sites, which stretch from west to east on, more or less, the same line of latitude. As the project has evolved and more of these locations have been executed, the biological structure has been less emphasized and other structures have come forward as each narrative is developed in tandem with its site. The individual stories still have remained secondary to the geographical/architectural character. *Cremaster 2* takes on the Gary Gilmore story, but it could have taken up a handful of other stories and function just as well, in that its primary character is the Rocky Mountain Range.

HUO:

Your work exceeds the art context. It seems to be about multiplying contexts, about making transitions fluid.

MB:

I am interested in its potential as a form, to see how far this form can move out into an unprotected space and still operate as an artwork. Sculptural form, I think in most cases, needs the protection of the fine art institution. On the one hand, I am interested in pushing it out of that and see if it can still defend itself. On the other, I am not working with the purpose of breaking boundaries. I am quite happy working within the art context and appreciate what it values.

HUO:

One aspect of your work I'm especially interested in talking about now is the way you've been using music. You have often worked with the composer Jonathan Bepler...

MB:

Our significant collaboration started with *Cremaster 5*, when I was visiting Budapest, trying to understand the city a bit more. I was originally drawn to locations of the old empire—the old Turkish baths, but then I started to take more interest in the Budapest of the late 1800s. Jonathan Bepler had been steering me towards Mahler at the time, and we decided to make a more romantic piece, based on the structure of opera, invoking the period when all that

construction went on—when the opera house itself was built, when they connected Buda and Pest with the Chain Bridge, and when the art nouveau baths were built. We began a parallel development between his music and the libretto that I was writing, which had to do with the visual story I was constructing. It was a very enlightening procedure that has changed the way I've worked since then. With *Cremaster 5*, we had no choice but to finish the music before filming due to the onscreen singing and orchestra. This meant that the piece had a predetermined time base, and was virtually edited before it was shot. With the projects that followed, this process wasn't necessary, yet we were enthusiastic about continuing to work this way—to let the music and the picture develop in a sympathetic way.

HUO:

How would you describe your interest in the medium of opera and the possibilities of reanimating it?

MB:

Opera is a model that, in a lot of ways, I feel closer to than film. It is related to the way the architecture of the opera house is anatomical. It is built in such a way that amplification is not necessary. It is not unlike being inside a chest cavity, the way that the curves operate in terms of the acoustics. I think there is a similar relationship in the works that I make, where the frame or housing for the narrative is a kind of a body. The element in the opera house that interests me most is the proscenium arch itself. This was explored in *Cremaster 5* with the idea of describing a sort of pressure between the space of the stage and that of the audience in the house... something to do with an axis of performance. The proscenium arch in *Cremaster 5* draws an axis that lies between three models: the first being the Caspar David Friedrich painting where a wanderer is looking over the foggy valley, and is looking out over this expanse in a posture that implies a feeling of dominance over this dictated backdrop. In contrast to that model, is a press photo of Henry Rollins, lead singer of the band Black Flag, who is facing the audience, aggressively hunching forward, the cables tightly wrapped around his hand, screaming into the microphone, and dominating the crowd. I was thinking of these two types of authority over the constructed landscape of the stage set, and the constructed reality of the passive audience. What is between these two spaces is the proscenium arch, which was the third alternative

within the *Cremaster 5* story. The character was not comfortable turning away from the audience in some belief in the constructed backdrop, nor could he turn outward. The third option was to turn to the side... The character decides to take the third option and tries to exist in the space between.

HUO:

Last but not least, let's talk about your project for the Vienna Opera House; you were asked to produce a large-format picture for the safety curtain of the Opera for the 2000–2001 season, and your curtain juxtaposes elements from the **Cremaster** *cycle but also from your previous work to form an amalgam that is rich in allusive associations (*Safety Curtain, *Vienna State Opera, 2000).*

MB:

The curtain design is a similar meditation on the proscenium arch. One satyr faces the house, the other turns away to the stage. They are both simply chasing their tails. The constructed landscape in question is seen through the looking glass. The yellow, blue, and green ribbon signify the three options... yellow representing the golden house, pale blue representing the painted landscape in the backdrop, and cool green representing the highlight in the reflection of the gilded arch itself.

BIRNBAUM, Dara

Dara Birnbaum was born in New York in 1946. She currently lives and works in New York. Dara Birnbaum holds degrees from Carnegie Mellon University, Pittsburgh, Pennsylvania (Bachelor of Architecture, 1969), and painting at the San Francisco Art Institute (Bachelor of Fine Arts, Painting, 1973). Recognized as one of the first video artists to employ the appropriation of television images as a subversive strategy, Birnbaum's early video-based works analyze TV's idiomatic grammar (reverse-angle shot, cross-cut, insert) and genres (game shows, sitcoms, crime dramas), along with their inherent stereotypes. These works function as new readymades for the late twentieth century and set an early precedent for "scratch" video. Birnbaum describes her early videotapes as "works that manipulate a medium which in itself is highly manipulative." In the '80s she started producing multi-media installations, applying both low-end and high-end video technology to subvert, critique, or deconstruct the power of mass-media images. Birnbaum's work is further known for her ability to challenge the dominant media by finding a place to relocate the voice of the individual within the structures of dominant technology and mass media's formidable transmissions. Her isolation of gestures and encapsulations of precise moments in time have assisted in defining mythologies of culture, history, and memory. Exploring how technology and media function in culture through a collusion of art and television, Birnbaum has produced works for various contexts ranging from public sites to MTV. Her work has been exhibited internationally, including the Museum of Modern Art and the Marian Goodman Gallery, New York, and the Kunsthalle Wien. She has also been included in major international exhibitions such as documenta 7 (Kassel, 1982), documenta 8 (Kassel, 1987), documenta IX (Kassel, 1992), "60'80 Attitudes/Concepts/Images," Stedelijk Museum Amsterdam (1982), "L'Époque, La Mode, La Morale, La Passion. 1977–1987" (Centre National d'Art et de Culture Georges Pompidou, Musée National d'Art Moderne, Paris, 1987), "The American Century Art & Culture 1900–2000," (The Whitney Museum of American Art, New York, 2000), and the "Bienal de Valencia," (2001). She was the first woman in video to be awarded the prestigious Maya Deren, the American Film Institute's Award for Independent Film and Video (1987). She has been awarded a Certificate in Recognition of Service and Contribution to the Arts, by Harvard University.

......................

This interview took place in Vienna in August 1995.

Hans Ulrich Obrist:

Your early works aimed at recontextualizing pop culture icons and TV genres to reveal their subtexts. Here I'm thinking in particular of Wonder Woman (Technology/Transformation: Wonder Woman, 1978–1979) and Kojak (Pop-Pop Video: B. Kojak/Wang, 1980): you took fragments and you changed the speed, you accelerated it, you slowed it down. You said

that you slowed down the "technological speed" in order to arrest movements of
TV-time for the viewer. Was it also about creating other narratives?

Dara Birnbaum:

Never. Not at the beginning. I took exactly what was there. The
only thing is that when you see it, because it's taken out of the nar-
rative flow, you look and you think the speed is wrong. Another
one is *Laverne and Shirley* [*(A)Drift of Politics (Laverne & Shirley)*,
1978]—my first installation. That piece was all about two shots.
There are two women and they confront the world together; they
face the world together. This was the end of the so-called nuclear
family in America, meaning: Where is the father? Where is the
mother? We are, as adolescent Americans, alone now. They're
women, but they're girlish women. When you see the original pro-
gram, "Laverne and Shirley" (1976–1983), they are working on a
[brewery] assembly line [as bottle capers]. They finally take off
their rubber gloves—this is around 1977—and put the rubber
gloves over the beer bottles. (Now with AIDS, unfortunately, there
is a need for everything to have this rubber membrane.) But here
they cover the Coke bottles with these rubber gloves and they leave
the plant. They go out into the world. And they are their own
nuclear family. I presented this work with another woman, Suzanne
Kuffler. We were both doing our own work. But for me it was
almost like we were "Laverne and Shirley": we had to go out and
face the world together—and at least I had another bright woman
to talk with. We wouldn't do collaborative work, but we would
collaborate in getting the work out there. But I thought it was real-
ly important not to change the speed and not to change the medi-
um. And with *Laverne and Shirley*, for example, I took only the two
shots and butt-edited them. Then I made subtitles, because I took
the audio and I put it in a separate room. And I thought: "Let the
audio be like a radio play when you go in there. And in this first
room let there only be imagery: the two shots." You could read in
the subtitles what they were saying, but the subtitles went by so
fast that you couldn't believe what they were saying.

HUO:

So your approach is a deconstructivist one; you deconstruct television's visu-
al economy of sexuality and consumerism, and you operate primarily
through shifts of context?

DB:

Absolutely, and through not shifting the medium. I did relate
myself to people dealing early on with media-related images like

Jack Goldstein, Robert Longo, Cindy Sherman, and Sherrie Levine. If Robert Longo, as an example, would take an image from a [Rainer Werner] Fassbinder film, he would freeze a moment and isolate it. For example, he would take someone who had been shot in the back. They—meaning Longo and Goldstein—talked about media space as a kind of new empty space. Nam June Paik talked about it as a non-gravitational space. So the image was also extracted. Robert sometimes made it into relief painting, very early on. Jack Goldstein sometimes made it into painted form. Or on film, Jack took an image and rotoscoped it—isolating a main object from the original image. He did some very brilliant films that are not watched enough. For me, though, these artists were always translating the medium, and I wanted to use the medium by itself. I remember in Amsterdam that they had an exhibition, a kind of multi-part exhibition/talk/symposium. The organizers gave me a compliment and said they named it in part after what I was doing. They called it "Talking Back to the Media." And I think this was it: I wanted to arrest the image without translating it. And I thought, "How do you put video onto video? Television on television? Especially at a time when you don't have Betamax and VHS." So people said that I became a "pirateer": It's interesting, because in the '70s I had this ferocious image. I was the pirate woman. I got my photo around a lot; they called me the "pirateer of images." Then, in the early '80s they said, "Oh, she appropriated images." And then in the mid-'80s they said I stole images, and in the '90s they said that I sampled images... It kind of goes like that as the generations change.

HUO:

*Then you made a book with an explosion of sources with regard to Situationism. In terms of stealing, in the Deleuzian sense—creative theft (*Every TV needs a Revolution, *1992).*

DB:

But the creative theft process was absolved by the Situationists. And at the very beginning, the book is dedicated to these people who made these anonymous street posters. It's something I really respect—their approach to the "original"—the original was seen as a multiple, and it was owned by everyone. When it was produced it was basically silk-screened. The images became plastered on the walls, as in Paris. And it was said, "You can take these images. You can take these words. There is no copyright." I'm actually in a dilemma. I took images that I felt belonged to me, but that technically

didn't. Like with *Wonder Woman*—a woman who transforms herself by a burst of light and spinning around in space three times. This was a special effect in 1977. In a burst of light she changes, and I said, "No, it's not acceptable, and it's my landscape." TV, at that time, was being watched by the average American family seven hours and twenty minutes a day. So I said, "It's landscape. I can paint my own landscape. I can take from it. There's no difference." And I took the imagery and made it my own. Now, the strange thing is that the images were put back out again like a kind of regurgitation of their double. Taking it in—throwing it back out, in a Baudrillard sense. I put it on cable TV opposite the "real" "Wonder Woman" series. I put it into an avant-garde film festival and made it like a barroom B-film. It penetrated a storefront; it was the image that was sold in the storefront of H-Hair. But what happened after that, years later, is the nightmare in a way: I felt like I owned these images. And that's the strangeness of the art-making practice for me.

HUO:

Like a boomerang.

DB:

It's a boomerang. It comes back again. But what I'm saying is that the Situationists created images, as with the posters, that were sent out to affect mass numbers of people, and they didn't attempt to own those images. The images were made to affect a relationship with the viewer. But no one signed them. And you were told, "These are anonymous and you can take them." Whereas I've become an owner in some ways of "Wonder Woman." And I think I have to constantly ask questions of myself: What images am I making? What am I making that is consumed? What marketplace am I playing into? You know, there's an image highway, not only an information highway, and the image highway is, in part, the galleries and the system of selling images. And for us, meaning a peer group, let's say, of Bill Viola or Gary Hill and Mary Lucier, it's different now again. But I would say that at the very beginning we got into video because we thought of it as a multiple, as it doesn't carry the "aura" of a painting in the sense of Benjamin.

HUO:

And was it also against the system? Lucy Lippard once said that the goal of feminism is to change the character of art and directly attack the infrastructures of the art world. Was it also, at the beginning, your idea to attack the infrastructures of the art world? Or at least to undermine them?

DB:

I think we thought that there would be something else. I don't

think I made my work so much to directly undermine. I had such a non-belief in that structure that it didn't matter to me. My belief—and I want this still to be true—was in the message. So I don't know how "McLuhan" I am, but I just knew [that] something had to be said regarding mass-media imagery. And I did perhaps see art—for me very idealistically—as an activist position. It was one of the few positions that could be held in a society that was activist. Then, the more I learned, the more I saw what was controlled. How do you become the one who penetrates—who hacks through this system? Do you want to be the hacker? I don't know.

HUO:

With regard to your early works, you often cited Raymond Williams as a reference. What was the importance of Raymond Williams' texts for you?

DB:

In 1974 I lived in Florence, Italy. At that time in Florence there was a small gallery that was producing videotapes of various international and Italian artists. I remember seeing something which I found interesting in their storefront window. There were two lithographs—one by Vito Acconci and the other by Dennis Oppenheim. In the back of the gallery they were watching a television, but they weren't "watching television"—they were watching video art. I didn't know. So they said, "Come in, come in." And the first video artwork I ever saw was in that gallery. And it was very potent for me. I saw it as a tool, a really good tool. So this became my first meeting of video artworks. Later, I got to meet some of the artists using video. I was also exposed to the work of Dan Graham, whom I later met in New York City and I think he was the one who said, "Well, you can read this [the book by William], I'll lend it to you as a friend." That loaned book was my first encounter with Raymond Williams' texts—and a structural look at British television. In England there existed the remnants of the nuclear family. TV was structurally programmed keeping this in mind; it was formatted for people at home, especially housewives. So that was a beginning.

HUO:

You were talking about the screening of Wonder Woman *in the H-Hair salon. Then in 1989 you completed the* Rio Videowall, *a permanent large-scale outdoor video installation, a 25-monitor interactive wall at Rio Shopping/Entertainment Complex in Atlanta, Georgia. Besides museums, art galleries, and other various contexts where you have shown your work, you also made interventions directly on television. For instance, there are your recent projects for MTV networks. Could you tell me more about such projects that are, this time, not readable in terms of contextual shifts?*

DB:

There were two different projects that I did for MTV. One was an "ArtBreak" ("ArtBreak," MTV Networks, Inc., 1987). In 1987, they invited six artists in the United States—but I was the only video artist—and they said, "Do whatever you want to do." Everyone was so hot to look at the new kind of graphics that could be made: digital processing or at that time especially Claymation to animate the image. And they had really the most grotesque representations of women, as they still do, in my opinion. And maybe of men also. So they said, "You've got thirty seconds, and you have no budget." And I said, "Artists working with video never have a budget." They said, "No, what we mean is that you can go wherever you want. We're paying your bills." So for an artist that's a very privileged position. The art world in America, I thought, was already beginning to reveal forms of censorship (it's getting very strong now, unfortunately). So thirty seconds. I remember a very stern warning coming from Benjamin Buchloh, the Marxist-based historian and critic. "[He said,] What are you going to do for MTV, entering into that supermarket of imagery?" And I said that I would rather enter, risk, and perhaps fail. I would rather learn from it than not enter it. So I went for a very early cartoon animation by Max Fleischer, "Koko the Clown" ["Koko the Clown (Out of the Inkwell)," 1916–1962]. Koko came out of the inkwell, and then he used to get into fights with the guy who animated him—Fleischer—and he would take the pen away from him and say, "You're not going to animate me anymore—I'm animating myself." So I guess I was very sympathetic to Koko, growing up. And now, as a woman in America, I thought, "Fuck your images of women on MTV. This is really getting ugly. So I'll animate myself." I took the original Fleischer cartoon, cut it up a lot, very quick, thirty seconds. And in this kind of quick mini-narrative you see Fleischer drawing Koko. Then Koko looks up and there's a machine drawing a woman for Koko. He has to have a woman. I don't blame him! And then he looks up, and he gets really excited looking at the image of the woman. The machine has an erase-arm, and it erases the woman. And he gets very upset. But in this case we changed the animation. I found someone who did illustrations for Fleischer Studios in the '40s, and he did "cell animation." One point was to go back to the original animation in America that was really strong, cell animation, especially because everyone was looking for the newest digital effect or a digital version of a film scratch. People would be sitting

there wasting a fortune trying to make MTV videos that looked like scratched film, so instead of making scratched film, they would make beautiful images on camera, and then they'd get someone in post-production to put in the scratches. And you're sitting there for $1,000 an hour, putting scratches on film. So I thought, "I'm going to the original form of animation; I'm getting the cell animation. We're redrawing the original Fleischer, using his own devices." In this case the woman's kiss, which she blows to Koko, becomes an MTV logo. It's shaped like a rock of MTV. It lands on his crotch; he falls out of the frame. And at the end you see a woman animator now trying to make a new image. And already in her palette is Fleischer. So history has become a piece of digital information. We're all becoming part of the palette.

HUO:

So one could say that you reversed the traditional gender roles of the producer and product of commercial imagery. And what about the second project?

DB:

Years later they came back. The Whitney Museum, the American Center in Paris, and the Public Art Fund in New York came and said, "You are one of seven people we picked to work with video imagery. We will be able to give you some money to create a piece that will be shown on MTV." This project was called "TRANS-VOICES" and my piece was called *Transgressions* (1992). Now, in a practical history of video art making or art making with video, if the year was 1992, then you have a five year difference between these two commissioned works. Now the further difference was: I got twice as much time—so sixty seconds instead of thirty seconds—to express myself in, and less than half as much money. It was very funny. In 1987 there was no limit to the budget at that time—MTV went anywhere, everywhere they wanted to go. And by 1992 you were offered really—as an artist using this kind of visual medium—almost no money, unfortunately. Someone in a commercial area, doing commercials for MTV, would use the money that was given to us to make the entire sixty seconds, in less than a few hours of working-time. The artists' spots that were created for screening on MTV were also shown on Canal Plus, in France. It was to be a dialogue, because it was to be about: "Where are you now in 1992?" For America it was a celebration of the five-hundredth anniversary of Christopher Columbus' discovery America, and in France you had the beginnings of the formation of the EEC [European Economic Community]. These wonderful things that don't exist for me at all. The EEC didn't get together in 1992. And if

you're a little wise, you know that it's perverse to say that Christopher Columbus found America. Of course he did make a history that did find America in one way. So we had a cross-dialogue, a "Trans-voices." My piece shows a lot of mappings, mappings of the growth of the United States and France, everything in transition; boundaries and transitions. And you know from [Paul] Virilio, as I did—because I know we both read his books—that now we deal with invisible boundaries, boundaries much less visible to us.

HUO:
Since the end of the '80s, you have designed your large-scale installations more and more like "passages" in the sense given by Benjamin to this notion. Could you tell me about this new shift and about projects such as Rio Videowall, *that we mentioned earlier, or your examination of the role of the media in the Chinese student uprisings in your five channel installation* Tiananmen Square: Break-in Transmission *(1990), or* Transmission Tower: Sentinel *(1992) that was exhibited in documenta IX?*

DB:
I think they're each a little different, but they're each an investigation for me. *Tiananmen Square: Break-In Transmission* came after the *Rio Videowall*. Here we have, for *Rio*, this television box as one of 25 units—thus you could begin to symbolically relate the box to a "pixel," as well as a TV: microcosm and macrocosm. The television image now breaks through its "frame" for the first time in history. Well, because the image was previously contained within an individual box, an individuated frame, and then the image pushed out into a multi-frame matrix, making it larger than it previously could be, stretching out past its previous boundaries. For me *Tiananmen Square* was a very large image in a much different way. It was CNN, round the clock, bringing you images that I had no way of—and probably still have no way of—really absorbing. Certainly if there was Tiananmen Square, the Gulf War did it better and worse at the same time on television. In seeing that, I then made very small boxes, a landscape of imagery formed by LCD monitors—an image that you can see only frontally, and if you go to the side it ghosts out. That's the mechanics of it, the technology of it. You see them only as lights hanging from the ceiling, as if information is coming down at you—not video on pedestals. Here there was always the attempt to hang, I think, because the feeling was already, as with the *Transmission Tower*, that it's coming from out there. I think there was a tradition in video that developed this bedrock foundation for video sculpture. And at the

time a lot of people were working with that notion. The way muse-
ums and institutions chose to contextualize it was to build a plat-
form for it, as a base for a sculptural event. You put the monitor
on, you see the image. So here it was coming, like lights—I
thought they have to be something similar to utilitarian lights,
small. At a distance you only see light. When you come closer, you
see image. So given this necessary proximity of the viewer, the
viewer has to travel through that space to see many small images.
There is, from my point of view, no "eyewitness news." We have
that slogan from Channel 7 in New York, ABC, one of the biggest
networks in the United States: "We bring you Eyewitness News."
No, you bring to me, obviously, a mediated portion of news. And,
in America, since about the year 1965, the networks own their
news. Before that, news was in the public domain. So here, you
would say ABC's version of the news of Tiananmen Square—they
own that news; you have to buy it from them. And so, if you go and
say, "I really want to do this work and re-represent the news," and
they say, "Oh, and who will you make it for? Will you make it for
the State of New York? Then we will charge you one rate per
minute for the news. Will you make it for the country of America?
Oh, you also want to go to Europe? Which countries?" And then
you get all different amounts you have to pay out, and you even
have a rate now for the cosmos, for the universe. And you pay for
that. The networks already know where this is all going.

HUO:

Television transforms itself into a bank...

DB:

Not only a bank, but they want to own territory. I think the most
important thing for me in my work has first been to find out what
the mechanism of television was, to question it, and then to find
this larger mechanism developing, this communication, the net-
working that happens. And even television has projected itself out
into space already. It had that idea of going out there. Then, in the
United States there was some good science-fiction writing devel-
oped about [what happens] when it goes out there. "Wonder
Woman," you know, will eventually reach someone on a distant
planet. It will be picked up and they will see "Wonder Woman" in
a different time and space than we ever have. So I think with the
works *Tiananmen Square*, etc., I was trying to say, "You've made an
awfully large image for me on TV." I have to deal with that size,
and I have to know that there's really no unity in that image.

HUO:

So you de-unify the image, displaying different views or takes on the event?

DB:

Different views, from a "garage" song composed by students, "The Wound of History," to the exact moment—which for me was a very important moment in the history of television—when CNN and CBS were taken off the air. When they were told, "You will cease to exist in this way. There will be no more satellite transmission of images." This shutdown of transmitted imagery was by the Chinese government, knowing that they would eventually break down and crack down on the students. It's an interesting thing for me—one that I try to use significantly in all my art work, the pulse I want to reach—to take and to give back. The major networks knew that any minute, any moment, these demonstrations would turn violent. That's what everyone looked for—the break, the rupture where this would happen. [Dan] Rather is there, they have the image of him, headphones on, a big satellite dish in the background. What he's hearing in his headphones is, "They just broke off transmission of CNN." And he's hearing from their field reporters, "We're getting the first images of violence, of the police cracking down on people." At CNN's headquarters there, when I show you that imagery, I re-show you, re-represent it: you see that in the CNN newsroom, when the government comes in to issue, "Stop," the news team tries to push the government representatives back out; they're trying physically to say, "No, what are you doing? You can't stop us!" Dan Rather makes it a diplomatic moment. He stalls, he says to the government as they come in, "I'm sorry, I don't understand. Oh, you need to shut us down." What he's doing is buying time. He bought one-sixteenth of a second or so, and by buying just enough time, he got out the first images that there was violence happening, out to the audiences worldwide. That's my interest—to see these historic moments in time and how they affect us. I think I want to leave a kind of totem. I want to leave behind pieces of the history in this crazy industrialized telecommunication that affects all of us. Maybe it's the telecommunications that are making an envelope like a membrane.

HUO:

Through the installation, there is no given path; every viewer has to find her or his own path and decipher and articulate the different pieces of information displayed.

DB:

That is true. And this too; you can be a director, yet with no given path. Each viewer can find what images he or she wishes to look at. But overriding the small images—repeat loops—there is a large monitor in the background, and there is a surveillance switcher. And the surveillance switcher is going around the room and taking grabs from these small images and putting them up on the large monitor, randomly. So if you're viewing an image, that image may be taken by the surveillance switcher. It can be taken away from you and all of a sudden put onto the large monitor, as TV. So there's all of this too. I think the work is about control. When are you in control or out of control? When are you in control of your own representation or out of control of it? Do you have the ability to control it? Even going back to 1979 in *Kiss the Girls: Make Them Cry*, that shows women presenting themselves—they're all in a kind of grid structure, a tic-tac-toe board of boxes. And I very purposely used these images of women and stereotyped them even further, so as to look at the cliché—a blond, a brunette, a young girl, a redhead. And each one makes a different gesture, and you see it very clearly because I've dislocated it, I've repeated it. And you see how they're fighting to find an identity to ride over the stereotype. How do you introduce yourself to an audience of millions? What becomes your identity? Is it in the smallest nuance of gesture or form? And now we are entering into the World Wide Web. We have a big television audience, in a certain way. You're introducing yourself; you're going on a bulletin board. Which bulletin board? And if Nam June Paik would say, "Ah, video—very good—no gravity"; now you have no identity. You make your identity, right? "Well, I think I'll be Laura today!" I mean only because it's already happening. I think really one says, "This is great—I can live out my fantasies in a good way..." I guess maybe there's been an evolved crisis of identity and the ability to act as an individual in a highly technocratic society. And I knew from the very beginning, from *Wonder Woman*, I knew that was a very technocratic view of a woman. You either heroicize her, or you underrate her as a secretary. And what place did you ever create for me (this meaning my representation)? Where am I? In-between? There is no space in-between. The burst of light said that I'm a secretary—I'm a Wonder Woman—I'm a secretary—I'm a Wonder Woman. And nothing in-between. And the "in-between" is really the reality we need to live in.

BOERI, Stefano

Stefano Boeri was born in 1956 in Milan, where he currently lives and works. Boeri studied architecture at the University of Venice (Istituto Universitario di Architettura, IUAV) where he was awarded his PhD in 1989. Boeri's research, which focuses on the problems of representation of contemporary territory and the analysis of so-called "nebular" urban landscapes surrounding all big European cities, fuels his practice as an architect, a writer, a teacher of urban design, and an organizer of interdisciplinary exhibitions. In 2000, together with Maddalena Bregani, John Palmesino, Giovanni La Varra, Francesco Jodice, and Francisca Insulza, Boeri co-founded Multiplicity, "an agency for territorial investigations on the recent and hidden processes of transformation of urban conditions," based in Milan. Multiplicity "realizes projects in diverse areas of the world using multiple systems of analysis, surveying, and representation," and brings together a whole network formed by architects, geographers, artists, urban planners, photographers, sociologists, economists, filmmakers, etc. Projects carried by Multiplicity include Uncertain States of Europe (USE), which was developed in the framework of the traveling exhibition "Mutations," inaugurated at Arc en rêve, Centre d'Architecture, Bordeaux, in 2000. USE is an ongoing collective research project that explores the relation between territorial mutation and self-organization in various urban locations, presented through different case studies in Bordeaux, Brussels, Milan, Tokyo, and Perth, and through many publications. For Documenta 11 (Kassel, 2002), Multiplicity presented Solid Sea, *a research-based installation which aims to detect the new, unpredictable nature of the Mediterranean Sea. Multiplicity has also been recently included in "New Trends of Architecture in Europe and Japan" in various sites in and around Tokyo, Porto, and Rotterdam (2001) and "Geography and the Politics of Mobility" at the Generali Foundation (Vienna, 2003). Boeri teaches urban design at the universities of Venice and Mendrisio and has been visiting professor at the Berlage Institute in Amsterdam. He writes regularly for the cultural supplement of the daily* Il Sole 24 Ore, *the major Italian financial newspaper.*

........................

This interview was recorded on board a Tokyo–Rotterdam flight in March 2001 and a Paris–São Paulo flight in April 2002.

[1]

Hans Ulrich Obrist:
When was your first visit to Tokyo?

Stefano Boeri:
I came here with my mother in 1979; she was working as an industrial designer for a Japanese firm. We visited Osaka, Kyoto, and Tokyo (where we met Kenzo Tange, he looked incredibly old...) and then we escaped to Beijing. We were probably the first Western tourists who visited China without the constant presence of an official guide.

HUO:

What are your impressions of Tokyo? You seem fascinated by this city: I saw you looking intensely out of the window of the plane.

SB:

Last time I came here, two years ago, I spent three weeks in Tokyo with people from the Berlage Institute in Amsterdam (I was teaching there). We worked on the notion of "void" in Tokyo. We developed a vocabulary of voids in observing only the empty spaces, the blanks in Tokyo. It was very interesting because it was quite bizarre to observe unbuilt spaces in the El Dorado of built architecture. We met a lot of thinkers, architects, artists, filmmakers, photographers, philosophers... also Stefano Mirti and a cosmopolitan group of researchers from the Tokyo University (Todai) who helped us with the research.

HUO:

And you documented it with photographs?

SB:

Yes, made by Francesco Jodice. We did a sort of collection of voids in Tokyo. Part of the material was published in the first issue of the magazine published by the Berlage Institute, *Hunch*.

HUO:

A collection of voids? How would you describe it?

SB:

A first class of voids is formed by the channels: Tokyo was a water city, but nowadays the channels are completely forgotten and hidden. Buildings are turning their backs to the channels. But if you take a small boat and you move within this narrow forgotten water network, you may really recognize and discover a dimension of the city that you don't see otherwise because it is covered. Another dimension of voids was the spaces in-between the buildings. Indeed, in Tokyo, even in the most compressed part of the city, buildings never touch: there is always an empty vertical space. We spent something like five days trying to explain these narrow intervals, these vertical gaps. But nobody was able to accurately explain this phenomenon. We received several explanations. One is that in these vertical voids you can put all of the domestic infrastructures (gas, electricity, water tubes, etc.). Another is that these voids become important when you have to subdivide the lot: when parents die, you can subdivide the inherited lot into two parts. With the money received from the selling of one part, you can pay the heritage taxes, which in Japan are very high. Another reason is totally metaphysical: the concept of *Ma*, which determines the

presence of vertical voids between the buildings. Because you always need to be surrounded by a void. Also, it is a metaphor, a symbol of a real unbuilt space. And then another type of void is the open space inhabited by the homeless. The homeless in Tokyo, as you know, are an incredible population: mobile, clean and disparate; completely invisible, but present. People don't see them, but they are there. They are dressed in these incredible blue covers and they walk and choose voids for temporary halts.

HUO:

So the voids that structure the city.

SB:

Isozaki worked on this concept of *Ma*.

HUO:

It has nothing to do with the earthquakes?

SB:

Yes, that is another reason. Very important, very material. *Ma* and Earthquakes... amazing opposition! Then there is a third type of void, that we called "vacant voids." You know that in Tokyo the life span of a building is about 25 years?

HUO:

That is what Cedric Price always said: a building shouldn't last more than ten or twenty years.

SB:

It is 25 in Tokyo; so it is incredible. And so it means that you very often meet voids in the blocks. What is interesting is how the owners try to make temporary uses of the voids, waiting for the new building. So voids are really used as voids. They are "empty" spaces open to different temporary uses: a leisure space for children, a park... In Tokyo these vacant voids compose a sort of puzzle of collective micro-spaces. Another type of void is the huge void created by the collapse of the Japanese economy in the '90s. For instance, there is one huge incredible void in Odaiba, near the Tokyo Bay; it's a huge project that was interrupted by the economic collapse in the early '90s.

HUO:

That is a bit like in Korea where Rem Koolhaas has one of his projects. It is now like a big cave, an empty space, unfinished.

SB:

Exactly. But here it is not a cave, it is a desert. Another type is the voids in the suburban part of Tokyo: a multitude of small voids related to the domestic environment—the courtyards of single-family

houses. In sum, it was amazing to understand how much the voids really structure Tokyo in terms of ancient principles of order. It gives new perspectives and makes you understand a city that is completely chaotic—and what's amusing is the fact that Tokyo has founded the architectural myth of compression and density.

HUO:

Voids make me think of unrealized projects. You never really speak about your unrealized projects.

SB:

My unrealized projects? Well, I don't have many unrealized projects. I mean, I really think we have several different ways to realize a project. One, the basic one, is simply to explicate it. But in terms of interrupted projects, probably what I did for the Port of Naples is the biggest one. I spent a part of my life in Naples. At the end we realized only one percent of what we could have done there.

HUO:

It was a whole urban development plan?

SB:

An urban development plan for the port, a sort of master plan for the touristy part of the port, the passenger places on the port. I experimented there... We presented three different proposals simultaneously: a master plan, several architectural suggestions and a built anticipation of what this part of the port should be in the future. In other words, while we were working on the master plan and on general architectural solutions, we built—in two months—a large temporary pedestrian platform; a new, strong, small, public space in-between the port and the city. This new public space was in a crucial position because it was next to Maschio Angioino Castle. So it was highly visible. It produced incredible reactions. And of course many polemics...

HUO:

What were the reasons?

SB:

There were several reasons. One was that we had the courage—or you could say we had the arrogance—to produce something so close to a monument, to a historical building. I was accused of contaminating the history of the city. [*Sigh!*] In Italy, every attempt to add contemporary architecture to a historical environment is considered an outrage. Nostalgia always wins.

HUO:

And so the test square blew up the whole project?

SB:

Yes, but in a certain sense I am very sure that even without this anticipation, the entire project was doomed. Now the process is going on without us, but following our design, our project. They have completely opened the port; they are working in the touristy district of the harbor.

HUO:

So, your project in Naples was almost an urban litmus test? Litmus, like when you have a chemical substance and the paper shows if it is acid or not.

SB:

Yes, that is a perfect metaphor. It is exactly what we tried to do. The temporary platform is still there. It is still working in a certain sense: anticipating and attracting the critics, the reactions... Probably our project was destined to collapse. It was probably too strong for the southern Italian nostalgia.

HUO:

Do you continue to frequent Naples?

SB:

Yes, as a researcher. The city, the local urban society is an amazing laboratory for self-organized phenomena.

HUO:

Could you link gaps to self-organization? Is your gap research in Tokyo closer to "bridge the gap" or to "mind the gap?" Should we just leave gaps as gaps, like what Carsten Höller says—we shouldn't eliminate gaps? Gaps are important.

SB:

Gaps are absolutely important. I am influenced by what I am reading now, a book written by Per Bak, a Norwegian author who wrote *How Nature Works: The Science of Self-Organized Criticality* (1996). It refers to fractal geometry and the repetition of some structures at the different scales. Gaps in Tokyo can be understood in a very schematic way in this light. When I think about gaps I think about the fact that Tokyo is a city composed by an incredible amount of individual buildings. It is the most variable city I have ever seen, with a multitude of different, compressed, isolated buildings, without any kind of logic, or logical contiguity. In the same street you can see a sequence with a building that is two stories high and then a skyscraper and then an empty space and then another single-family house and then a huge shopping mall. Gaps are the unique structure, the unique element of *longue durée* (long term) in such a hyper-eclectic and always-mutant city. The structure of Tokyo is in the voids, in the system of voids. I continue to

repeat this because I am fascinated, not particularly by voids but by their role in the evolution of Tokyo.

HUO:

Evolution? You often make references to Stephen Jay Gould. I am curious to hear about the link you're making between architecture and urban planning and Stephen Jay Gould.

SB:

What I consider incredibly interesting is the theory of "Punctuated Equilibria," because it can be used—metaphorically—also to explain the evolution of other complex systems. For instance, when we observe the evolution of the urban settlement, it is incredibly clear that this evolution is not determined by homogeneous upheavals, or by a gradual concentration of energies, but instead it is determined by an unpredictable series of individualities and by specific and local accelerations of the urban materiality. Our urban societies are composed by a multitude of subjects able to directly change the physical environment. The change, in terms of material mutations, is caused by this multitude of individual "tremors" that sometime, suddenly, find a point of attraction.

HUO:

How can you represent these evolutions, these mutations?

SB:

I think we should go back to the experience developed in the early '80s by Jean-François Lyotard. He did an incredible exposition at the Centre Pompidou called "Les Immatériaux" (Centre National d'Art et de Culture Georges Pompidou, Paris, 1985). In that exhibition he found a way to collect several scientific points of view about evolution and the function of cities. In an essay he wrote for the Canadian magazine *Parachute*, he presented this exhibition starting from an observation of the perception of a generic suburban environment: a perception felt from inside of a car during a road trip in California. A sensorial perception of an urban nebula, where you don't recognize where you are, and you have the feeling that this anonymous continuous low-density city will never finish... Like an unfinished hyper-fragmented soundtrack...

It was great. And he invented a way to recreate this feeling within the exhibition simply by using sounds, as you did perfectly in the Bordeaux exhibition (*Sonic City* project for "Mutations," Arc en rêve, Centre d'Architecture, Bordeaux, 2000), because sound is immediately connected with your sensorial position; and nowadays you cannot separate any theoretical thought about contemporary city evolu-

tion from the explicitness of your personal perspective, the individual point of view you are using when you elaborate on this thought.

HUO:

You mentioned when we were boarding the plane that you recently re-read {Michel} Foucault's Archeology of Knowledge *(L'Archéologie du savoir, 1969). What is essential for you in Foucault's thought?*

SB:

There are two concepts in Foucault which I still think are incredibly relevant today. One is the notion of "discursive formations." What Foucault said was that there are some disciplines that have a very strong knowledge structure, for example mathematics or physics or biology, and that there are other disciplines that don't have such a codified structure of knowledge. These different disciplines have an uncertain status and are used to import words and categories usually vacant from other more structured disciplines. I think that the disciplines that observe the complex phenomena connected with the physical environments and urban behaviors should be considered as "discursive formations": these are open, inclusive, mobile networks of concepts. They are disciplines that often suffer from their original weaknesses. Personally, I have spent part of my life trying to radicalize these characters because I really think that this weakness could be transformed into potential. The process of research on urban conditions is coming to a certain specificity. We are trying to work in a hybrid zone in terms of knowledge. In recent years there were a lot of links between sociology, geography, and the field of arts, as well as with the world of media. Communication is employed as a capacity to represent daily life, political events, to use art as a tool of knowledge, for instance. We gradually constitute a new knowledge, a knowledge that is more a discourse, not so much a discipline with a clear status or with a clear starting point. It is an area of knowledge which is still quite mixed and which starts to develop a distinctive character. Architecture and urbanism have to be inclusive in the observation of what surrounds them and exclusive in the capacity to "close the future," designing one—only one—concrete volumetric configuration. In the past, I have used the word "Eclectic Atlases" trying to underline this necessity to use heterogeneous gazes to observe the contemporary city, the contemporary urban condition. In our research we have to be rigorous and experimental, always. What is interesting nowadays is that we are all observing the same phenomena—I mean, urban condition—from different points of view using different key entries, using different categories and tools.

HUO:

What about the second concept that you picked up in Foucault?

SB:

I think what Foucault explained in an incredibly interesting way is the evolution of knowledge in these non-systematic disciplines: they proceed with sudden accelerations and jumps, and I think that concerning the different knowledges that serve the urban condition, we're within one of these accelerations...

HUO:

Is it a revolution of knowledge?

SB:

We are close to really establishing a new "discursive formation" and we are all within this process: segments of knowledge coming from architecture, urbanism, visual arts, geography, social sciences: all involved in the birth of a new thought on urban condition. What is interesting is that we are observing the same things, but maintaining our specificity, our identity, our technical tools.

This phase is signed by some main event, like the last documenta in Kassel (documenta X, 1997) or your and Hou Hanru's traveling exhibition "Cities on the Move" (1997–2000). I also consider the exhibition "Mutations," and the book itself, to be excellent indexes of this transitional phase.

HUO:

What specifically did you find important in Catherine David's documenta X?

SB:

What for me was really astonishing in Kassel was the coherence of the whole exhibition. It was incredibly rich and heterogeneous, and "urban condition" was the unique issue that connected the contributions produced by all the various artists, as well as thinkers, invited. It was, for me, the first time I realized that contemporary and visual art was so close to my research themes. Really, I was astonished, shocked by this. I understood that most of the artists selected by Catherine David and Jean François Chevrier were able to work with rigor and experimentation while observing urban phenomena. I don't think that it is possible to understand the new urban condition by simply going to see what is happening. Documentation is not enough. It is not enough to say "Well, we take a car, or an airplane, or a map, and then we'll see where the 'new' is in our territory..." I'm sure that the "new urban condition" is everywhere, also in the center, still here, nearby us, and in order to observe it, it is crucial to use a lateral gaze, to shift our point of view a little bit. We

begin to understand that we really inhabit a new urban dimension in terms of daily life. But this dimension is emerging, visible only when we activate a lateral movement in our gaze, which allows us to observe how much the relation between our body and the urban environment is changing. So documenta X was interesting because many artists were there not saying, "Well, see, this is new." What was incredibly interesting in the exhibition was the work about the "ordinary": ordinary city and ordinary life. Many artists were observing the ordinary, thanks to a slight switch in their point of view, lateral switches, enabling the production of small vibrations and gaps on the surface of urban phenomena, and making visible its new identity under the ordinary appearance. There is nothing more boring, further from the nature of our condition than an exhibition which represents just results, trying to describe what the city is. Because what we need to do is to reproduce the polyphony, which is specific to the condition of our contemporary city.

HUO:

Are there other exhibitions that you think are important in this relation?

SB:

Yes, I think we can propose a short list of exhibitions that have really caused some catastrophes—in terms of innovation—in urban studies. The Venice [Architecture] Biennale curated by Paolo Portoghesi in 1980 (Prima Mostra Internazionale di Architettura, 1980) was one; he proposed an artificial street, 1:1, which represented the claim for the return of historical models in contemporary architecture. Then there is Lyotard's "Les Immatériaux" where, as I said earlier, the urban condition was also represented in a sensorial way. Then documenta X, and its choice to use ordinary urban spaces to cause turbulences in the citizen's/visitor's ordinary experience. Then your "Cities on the Move" mobile experiment, a sort of cumulative itinerant device... So I do believe that exhibitions— more than written texts or works built by architects—have become the "inaugural" places where new ideas are introduced and begin to circulate. This is in part because this type of spreading of knowledge rewards events that are for quick consumption and more powerful from a communicative point of view. It is also because today every new idea on urban space—which is something ultra-ordinary and at the same time hyper-specialized and which we all know about but few presume to explain—achieves consensus only if it effectively represents the urban condition we all live in daily. Not understanding this, then it loses force and it is simply an abstract

theory. More than books and built architecture, exhibitions are successful, at times, in reconstructing the perceptive experience of the contemporary city: that clash of information, messages, codes, but also sounds, sights and perceptive rhythms that we live with each day.

HUO:

What about the Triennale curated by Giancarlo De Carlo in Milan in '68 ("Large Numbers," XIV Triennale di Milano, 1968)?

SB:

Of course, you know I've always considered it crucial. It was probably one of the most important events in the history of visual arts concerning the urban condition. De Carlo chose a theme that was, for the period, radical: "Large Numbers." It was a theme critical of both the proliferation of individual consumerism and of the homogenization of behavior, which had already begun to bolster and institutionalize the fledgling revolutionary movements. "Large Numbers"—opposed to the mass, movement, class—as the sum of irreducible individuality. "Large Numbers"—opposed to party politics, avant-garde, organizations—as a "multitude" of autonomous subjects who share a common choice. "Large Numbers"—opposed to planning, territorial government, urban law— as an attempt to introduce an anarchical seed of thought into reflection on the city. "Large Numbers"—opposed to a city of component parts, monuments, residential areas, public districts, center/periphery—as a critical vision of the individualistic fragmentation that had, by that time, already begun to characterize the suburban areas of European cities.

To illustrate the theme of "Il Grande Numero," Giancarlo De Carlo called upon some recognized architects involved in the international debate, albeit little known in Italy: Saul Bass (who had constructed an immense framework on which to place creativity), Gyorgy Kepes (with a project on the shape of the city at night), Archigram, Peter Smithson, Aldo van Eyck, Arata Isozaki... along with intellectual and artistic Italians such as Marco Zanuso, Albe Steiner, and Alberto Rosselli. Surprisingly, however, on the day the exhibition was due to open, architectural students and a group of Milanese artists (who were among those not invited to the exhibition by De Carlo) proceeded to invade and occupy the Triennale, which was seen as an institution of power. The occupation took place after a lengthy discussion with De Carlo outside the Palazzo dell'Arte of Milan, and De Carlo tried to convince them of the

importance of the proposed themes for the exhibition and of the urgency to discuss them. He had little success. This big misunderstanding (or possibly a violent, unconscious intolerance towards such a "cutting" theme, difficult even for the leaders of the new European Left to accept) lasted for ten days of occupation, destroying almost all of the preparations. At the end of the tenth day, the police, called in by the Board of Directors of the Triennale, stormed into the Palazzo dell'Arte and removed the protestors.

HUO:

Nobody saw the exhibition. It was a sort of ghost event...

SB:

The XIV Triennale never opened. Yet, paradoxically, that sophisticated and forward-thinking reflection on mass individualism, never even inaugurated, came to have extraordinary success in the years following. Indeed, it was to be a far greater and enduring success than many celebrated exhibitions on an urban theme. Furthermore, today "Il Grande Numero" appears to be the only code through which it is possible to decipher the new diffused town we see scattered around, and often connecting European cities. The XIV Triennale was, therefore, a kind of "ghost event" that—as it is for the books that we never read, but hear spoken of so frequently—we have made sense of through notoriety rather than experience. A "void" so surrounded by rumor that it became full. The exhibition on "Il Grande Numero" survived to witness its implosion, largely because the only people to have witnessed it were a group of artists, critics, and intellectuals who, with time, became an elite in the world of European culture. On the international circuit, it is ever more frequent to hear it spoken of when people discuss or are looking for new models to represent the contemporary urban condition. Today, without this reflection on "Il Grande Numero," the town that we live in would appear so much more difficult to interpret. In any case, it could be really exciting to work on this list of crucial exhibitions, to make a catalogue of these innovative experimentations in the fields of architectures and visual arts.

HUO:

An archeology of exhibitions...

SB:

An archeology of exhibitions, right, returning to Foucault's thought. We should really elaborate—in Venice, or at Castello di Rivoli, or in Vienna, or in Paris, or in Kitakyushu—a genealogy of this new knowledge about the urban condition, simply using exhibitions as nodes, as reference points.

HUO:

In a recent lecture you spoke about the city's syntax and the grammar. Can you tell me more about this?

SB:

What I tried to explain yesterday was how the contemporary city uses these principles in a completely new way. For example, the "grammar" of the new city is built of elementary phrases, rather than (as it was in the past) articulated statements of clearly distinguishable categories. This is the effect of the invasion of a multitude of solitary and agglutinated built objects, produced by a society that has democratically constructed territories that reflect itself.

HUO:

What do you mean?

SB:

The contemporary Western city has radically altered the relation between the principles of variation and difference. Today the principle of difference no longer acts between contiguous and diachronic urban components (i.e., between the nineteenth-century city and the Renaissance city, between the modern suburb and the nineteenth-century grid, etc.), but rather between the single molecules of the urban organism's vast territorial sprawl: between the family house and the contiguous shopping mall, between the shopping mall and the adjacent low rise building, between the car wash and the industrial shed with the built-in house, etc. In the same way, the principle of variation does not have an effect within the boundaries of vast or compact urban parts, but rather operates with the declaration of a few families of urban forces that regulate the composition of the emerging city.

HUO:

What about the syntax of cities?

SB:

The "syntax" of the new cities consists of a limited number of organizational rules and a multitude of phrases; it is an impoverished language repeatedly making use of only small parts of its rich vocabulary.

[2]

HUO:

We've never really spoken of the very beginnings, the early stages. One of the only things that I know—which is something your mother told me—was the importance in your formative years of the Aldrovandi bookstore in Milan.

SB:

It was to some extent the point of reference for all the Italian left-wing intellectuals. After the war, Giulio Einaudi, whose name is linked to the great days of Italian publishing, and who was also a close friend of my mother, had entrusted a bookstore located right in the heart of Milan, on Via Manzoni, to his brother-in-law Vando Aldrovandi—also know as "Al"—who had fought as a quite well known communist commander in the Italian anti-Fascist Resistance.

My father had had been in the Resistance too, but he was the commander of the Justice and Freedom Partisan Brigade; he had a secular background, but not communist. Let's say that he was a left-wing liberal, but the term liberal is important in Italy, as it designates what has always been a marginal and defeated part of political society. Going back to Aldrovandi, Einaudi put him in charge of this bookstore. And it was there that all the meetings took place, with people like Elio Vittorini, Enzo Paci, Luigi Nono, Renato Guttuso, Gianfranco Contini, Piero Sraffa, Italo Calvino, Giorgio Strehler—not only with the Einaudi authors. He was the interface between the Italian intellectual milieu (well represented by Einaudi) and the Italian Communist Party (that Al softly represented). A lot of things in the Italian cultural context were turning around or happening in this place. I remember, for example that the nominations of the *Corriere della Sera* directors like [Alberto] Cavallari or [Ugo] Stille were decided at meetings taking place at the Al library, around a coffee and in between Al's phone calls with [Enrico] Berlinguer or [Giancarlo] Pajetta.

HUO:

Berlinguer was the Communist Party leader in the '70s...

SB:

Yes. So the library was one of the most important places in Milan, but it had a European dimension too. Because it was almost natural for the authors who met there to be in touch with the whole of French literature, with the English literature that arrived in places like these, and whose principal books were passed from hand to hand. I remember meeting Samuel Beckett, and running into people like Pierre Klossowski or Peter Brook. I recall encountering some extraordinary figures that often came to dinner with my parents as well. I remember, for example, the evenings in '68 with the Living Theater, which were something quite extraordinary in Italy (I still remember the marijuana smell, which remained in our home for days and days after that party...). Bear in mind for instance, to

give you an idea, the fact that my father, a neurologist and neuro-psychologist, was also a great lover of drama and had formed an association: the friends of the Piccolo Teatro of Milan. The Piccolo, directed by Paolo Grassi and Strehler, was a quite different thing then compared to what it is now—nothing to do with what the theater represents socially today. For young people today the Piccolo is awful, something that is too boring even to mention, but at that time it was interesting and, along with the Casa della Cultura and the Triennale, it was one of the points of cultural reference in Milan, in a very lively Milan where lots of things were going on. Perhaps the Piccolo Teatro is a good example of how this link between the performing arts, culture, and politics came about.

HUO:

How were you involved in this cultural environment?

SB:

When I started to get involved in politics this also meant distancing myself somewhat from this world, and reacting against it. I joined a movement on the far Left that was very critical of the Communist Party. Highly critical, however surprising this may seem today, of a world of intellectuals who in the end did not seem sufficiently committed, never engaged enough. And a certain radicalization of ideology that was typical of the time left a deep mark on our generation's attitude to culture. Al has been for many years the partner of my mother, and this explains also the intolerance I have for this kind of smooth hidden negotiation which took place in Al's library and in my home.

HUO:

But the interaction between such distant spheres as politics, art, science, and literature was undoubtedly an interesting aspect of the environment in which you grew up. Giancarlo De Carlo always stresses the fact that the link with literature in that period was very strong and influential for him. He believes that he learned more about the city from people like Calvino or Vittorini than from anyone else. The same holds true for Claude Parent with Julien Gracq. In this sense, what was going on in Italian cities was no different from what happened in cities like Paris, New York, or London. This fertile historical situation, in which there was a genuine circulation of the different branches of knowledge, gradually came to an end, and this kind of mingling, it seems to me, has to some extent been lost. How have you seen the situation change in Milan?

SB:

Well, it's true that the ideological radicalization of which I spoke

intervened at just this point in the situation. The '70s were years in which, in the end, taking part, taking a stand prevailed over any intellectual speculation. So what we are talking about has gradually been lost. Certainly, as you were saying, the '60s were important years in Europe, above all for this profound mingling of ideas. There were a few great figures capable of influencing the context in which they lived. I think that in those years the great currents of thought were very deep. And thanks to these currents that ran through the situation, you had all the disciplines represented, because someone who was interested in literature was interested in photography, and someone who was interested in photography was interested in drama. These great encounters took place across the disciplinary borders. There were some great ways of seeing and interpreting the world, like phenomenology and structuralism and their influence on the fields of psychoanalysis, sociology, literature, theatre, etc. You don't have to think just in terms of politics. Think of phenomenology, for example. The importance that Husserl had. The presence in Milan of a philosopher like Enzo Paci, who taught Husserl at the State University. He was a friend of Ernesto [Nathan] Rogers and Paolo Grassi, the director of the Piccolo Teatro, and his weekly lectures were followed by a large number of eclectic thinkers.

HUO:

Ernesto Rogers, the architect of Torre Velasca in Milan, was also the director of Casabella...

SB:

There was a sharing of ideas that meant, for example, that Rogers worked with Paci and went to teach at the faculty of philosophy, while Paci came to teach at the faculty of architecture. And this was not because he had a particular interest in our profession, but because a certain way of seeing the world made this totally natural. It wasn't yet political: it was pre-political, and politics at the beginning of the '70s killed all this. Because in Italy, politics has plugged into this structure and, rather than devouring it, has fragmented it, has made it less fluid. I think that it was the same in France. I think that the same thing happened with Sartre. I remember in May '68, going with my mother, who had just separated from my father, to see the May uprisings in France and I remember—we were children—this large poster at the entrance of the École des Beaux-Arts on which was written: "Jean-Paul Sartre: L'imbécile."

HUO:

How would you describe the alchemy of these encounters between branches of knowledge if you were to take a historical perspective?

SB:

If I have to be schematic, I would say that the '60s were perhaps the years in which the ideas that were going to mingle were born; the '70s the ones in which a series of extraordinary, interesting intellectuals did most of the work in isolation, the years in which certain writers in Italy, like Calvino, worked in a certain sense in solitude, vertically in the world. Beside the big noise made by politics

HUO:

What about the '80s?

SB:

Shirking the obligation to come up with definitions, I will confine myself to saying that the '80s were the years of the discovery of a different world from the one in which we thought we lived. You see, in the '70s there was not the idea of being a minority. Everyone believed that they were at the top of a social movement, or heading it. It was a very rude awakening. As far as politics were concerned, France and Italy had shifted decidedly to the left in the '70s. The tide of '68 had fairly soon, if not right away, made its repercussions felt. Thus the '80s were the years in which we finally realized that we were finished, that the world was going in another direction. The Western society was clearly no longer a classist one. New middle-class subjects were emerging. The young, the very young were attracted by new lifestyles, went dancing, politics meant nothing in their lives, they had no sense of community. Something was under way, a very, very great change. Television was booming. Individualism, radical individualism was showing its unbelievable power in the collective imagination. The contact with a very different reality was sudden, for everyone, and also very interesting. Very interesting for art, I believe... The '80s in Italy, in Milan, were a breathtaking time.

HUO:

The '90s?

SB:

You always have to bear in mind the perspective you are looking at things from, but I'm straightaway inclined to speak of the '90s as perhaps more a time of reconstruction or of balancing. I think so at any rate.

HUO:

And...

SB:

And... Now!... Well, it's hard to say. It's not at all clear. It's not clear in the sense, for example, in which it could be said that today there is no philosophy of feeling the present time. Today the present is an unknown. It is all fairly fragmented and perhaps the end of the millennium has created a sort of collective imagery, which gives us the sensation of having crossed a threshold. Looking around, it seems to be quite a good moment. Even this feared return of the Rights—in Austria, Holland, Italy—should not necessarily be seen as a negative thing. I say this almost reluctantly, obviously, but it also has a positive side, because it breaks a little, if I can put it like this, with this sense of power—power without a project, a strategy, developed by the Italian left in the last decade.

HUO:

You mean positive in the sense that it possibly triggers the birth of a new community of resistance?

SB:

No, I think that it is like a question of enzymes that have begun to circulate in the blood again. A blood system that had become kind of atrophied. We wrongly felt ourselves to be in a situation of atrophy, in the sense that we had begun to feel sure of being able to do things that were delegated to others. No one wanted to even think about protesting, because who were we going to protest against? The expression that I heard most often was "What's the use?" Today all this has gone with the Right in power; compromises are avoided. All the compromises have been lost, everything is faster. I'm not saying that it's better (look at what's happening in Italy with Silvio Berlusconi) but, let's admit it: there are more tensions, there is a greater circulation of ideas. What we should do now is to stress our capacity of understanding the present; our capacity of deconstructing the new rhetoric... to liberate energies...

Let me give you an example: some recent social commentaries, such as the ones made by Zygmunt Baumann or Manuel Castells, have identified an apparent and pervasive "fluidity" in social and cultural relations found in modern society—especially in Europe—and give the view of a "smooth" geopolitical map. In this map the social substrata and the hierarchical super-structure is reduced and the individual takes its place over and above the whole social organization. Individuals flowing freely in a liquid society... This is probably the last Utopia we've inherited from the last century.

HUO:
It's a way to emphasize globalization processes.

SB:

Although these different, but at the end convergent, interpretations are symbolically persuasive in their message of the "flow" in the contemporary world, they tend to observe the movements that have been deemed media-worthy and are in the public eye. But—and this is what I mean with "discovering the present"—any careful study of our surroundings however shows us a contrasting phenomenon. Wherever one glances: living spaces today in fact offer a proliferation of borders, walls, fences, thresholds, signposted areas, security systems and checkpoints, virtual frontiers, specialized zones, protected areas and areas under control. The multiplication of fences and sub-system controls (which in the contemporary world take on many different, and often, changing appearances) is an inevitable—if not surprising—outcome of any study and mapping of territory. As much as this proliferation of walls and borders can and should be seen as the result of the pervasive population flow, their heterogeneous and especially micro nature, show us that the two processes are not simply opposing or complimentary. Population flows and confinements are not two extremes of the same process of a territory's economic and social adaptation; they are not the opposites of an evolutionary phase in our society.

HUO:
And what are the results of these proliferations?

SB:

From a study of the infinite restrictions that space places on an uncontrolled flow of population into a particular territory, and the social relations that follow it, a kaleidoscope of boundary devices can be called up that has nothing to do with the mirroring of geographical fluctuations in population or even with the traditional subdividing of the modern map in large political, social, and cultural areas. A careful study of geographical boundaries that gives a different representation of the world and our societies could read the proliferation of fences and sign-posted areas (both the controversial as well as the ordinary ones) as a reflection of the many highly-charged instances of identity and protection that explode everyday between groups in our multifaceted societies. It could reveal the densely differentiated and kaleidoscopic nature of our contemporary societies. This is an example of what we should do now, in the "third millennium"... We should, above all, rediscover the present.

HUO:

What kind of projects would enable this to happen? And in this light could you speak about the projects carried out by Multiplicity—the multidisciplinary collective you co-founded several years ago?

SB:

Beyond the rhetoric of an interdisciplinary perspective, we should continually seek to circulate information in different formats and to collect a diversity of evidence on one specific condition. For instance, we should observe a phenomenon concerning space—relating to immigration, or transformation of production structures, or innovation in ways of inhabiting the home—and then stratify the information: the facts and the appearance of things, the findings available on the ground and the images of the places, the written documents and the available zenith views, the interviews with the leading players and witnesses and an analysis of available literature. What is put into practice is not so much the rule of work across different disciplines—although Multiplicity is a group where experts of diverse cultural and disciplinary origins converge—but rather the many-sided forms of reality that are observed firstly in their complexity and conspicuousness.

HUO:

It's the methodology of Multiplicity.

SB:

We should substitute an interdisciplinary perspective as an a priori choice, as a methodological objective, with an inquiry into what resonates when observation is carried out from different viewpoints—from those of the sociologist, the artist, the architect, the filmmaker, the photographer, and the geographer, and together these viewpoints are projected onto the same phenomenological field: the urban space. It is thanks to this totality of perspectives on a single object and the "eclectic" nature of the observations arising from this that, for example, we could be able to offer samples that are indicative of the urban condition. If, for example, we wish to inquire into the often fleeting and faint evidence of some new lifestyle, we need to know how to bring together knowledge of cartography, anthropology, and the visual arts. At the same time, it is necessary to learn to understand what important photographic and video-film techniques can best be used to carry out a kind of tailing of the actors in these shifting and unpredictable events. This needs to be done without losing sight of the possibility of mapping

them synoptically, and also undertaking a survey of the territories where the phenomena occur. I can tell you that I was happy when there was "Mutations": it was a period during which we used to meet every so often around a project, a single articulate project. It was a great and elegant pretext to meet. Pretexts that make us study more: that's what we need; and when I get involved in a project, that's what I'm looking for now. And exhibition projects, well, an exhibition also means making a journey, meeting seven or eight people. Then things like "Mutations" or USE (Uncertain States of Europe) are forms in which the outcome of a production that is still under way is produced while it is also exhibited. My dream is to exhibit this introspective phase.

HUO:
Can you tell me about the development of USE?

SB:
When I was asked to do something on Europe, there wasn't much money and time was very short. So, from one point of view, the only thing I could do was to present something... that was already there. I had established links with a net of young researchers who were working on space, on the city, on urban condition. I particularly like finding the conditions directly on the ground, stimulating the invention of something different. This was also the origin of Multiplicity. For USE we were a research team of 74 people coming from 15 different countries. How did we select them? Simply because we knew they were working on themes that are close to our intention even if of course the methodologies were very different. The question is: How to keep this richness? At the same time you should translate this richness in a code. But you have to produce an exhibition. We developed a method to select a certain number of presentational tools: collect data, produce interviews, follow some witnesses in that environment, produce diagrams of change in real time, and some other things. And at a certain point we decided to use these representational results everywhere—the same ones that we planned to use in the exhibitions. Because the exhibition was trying, above all, to display these tools, this methodology. At the outset the organization was crucial; what counted was the way in which we managed to pass the information around. We were able to make inquiries locally and compare the results in different situations. This was the underlying meaning of the USE exhibition—and in general of the Multiplicity exhibitions.

HUO:

How was USE developed during the sequence of the "Mutations" exhibitions?

SB:

I see the life of USE as a complementary and autonomous project from "Mutations." "Mutations" was staged in Tokyo, in Brussels, and USE was adapted each time, more or less successfully. Sometimes there were problems, but they were stimulating. We always had the impression that we had gotten hold of the center of the exhibition; so it was like: we had the island, but we didn't have the sea. To reconstruct the sea required a very interesting work, as each time the sea was no longer the usual one, but was different. And so we had to build around the heart of the exhibition.

HUO:

Were the seminars important in this process?

SB:

Very important, almost more so than all the rest. Seminars, during the introspective phase, were useful to share in the research network some sampling criteria. Some were more successful than others, to be sure, but all were fairly interesting in the way that they gave another emphasis to the meaning of the exhibition. And then out of an exhibition like that so many other projects have been born: the project on the Mediterranean is an idea that came out of USE. Finally, USE has created a sort of very limited network of authors which is now the Multiplicity core. And now I don't know whether this network of people should become a kind of editorial team and remain just that and carry out other projects, or whether instead it should be destroyed, dissolved. I'm interested in your opinion. Maybe you could advise me on this! What do you think?

HUO:

I think that it's much more interesting when you choose not to become an institution: everything stays, and should stay, fluid.

SB:

I think you are right.

HUO:

It is for just this reason, among others, that I'm interested in your way of teaching. You teach in Lausanne, you teach in Rotterdam, Genoa, Venice, you teach in Vienna. You teach in seven or eight cities at the same time. It is a new experiment, isn't it?

SB:

I don't do that much teaching! In reality I always teach the same thing, that's the truth. Inexorably the same thing. It is a sort of

continual circulation: teaching serves also to structure your think-
ing. When you teach in Venice and you meet in front of the stu-
dents, for example, you certainly do it in a different way than in
Rotterdam, Paris or, I don't know, Saint-Malo. The production is
limited and encouraged by all the possible routes that are created
around: those who write in the magazines, who teach, who travel...

HUO:

*Can you tell me more about the exhibition that you are preparing with
Multiplicity on the Mediterranean?*

SB:

To be specific, the first stage of this project is the one that goes to
Kassel, but I would be more interested in investigating it together
with other people. I like the idea of working on the Mediterranean
as if it were a "solid sea." The Mediterranean, in reality, is a great
barrier. The people who cross it are often unregimented in their
identity. The Mediterranean is pervaded by cuts. There is a
Mediterranean of emigrants, a Mediterranean of nets, of fishermen,
of the military, of tourists, and these never come into contact with
each other. So today it is interesting to reveal this new dimension
of the Mediterranean, which is a political dimension that is truly
worrying. This is a work that I would really like to do. But you
could do an exhibition on the Mediterranean by again proposing,
for example, eleven journeys, eleven experiences in, I don't know,
the space of two weeks...

HUO:

*Since it's my habit to end interviews with a question on a project that has
not been realized, can you tell me about an unrealized project that's partic-
ularly important to you?*

SB:

The Ponte Parodi project in Genoa, an architectural project I did
with Rem Koolhaas. It was a beautiful project, one of the finest, I
would say, that I've ever done.

BOLTANSKI, Christian and Luc

Christian Boltanski was born in Paris in 1944. He currently lives and works in Malakoff in the out-skirts of Paris. Boltanski's artistic career began when he left formal education at the age of 12; he start-ed painting and drawing and soon came to public attention with short avant-garde films and with the publication of notebooks in which he came to terms with his childhood. Since the '60s, Boltanski has developed an oeuvre which could be seen as a disturbing archive of our social, cultural, ethnic, and per-sonal histories, working with the most ephemeral of materials—newspaper clippings, photographs, found snapshots, clothing, candles, light bulbs, and old biscuit tins—to examine and to mark our transitory passing here on earth. The many subjects that Boltanski treats in this light vary from the trivia and detritus of everyday living to the supreme seriousness of the Holocaust. Described by Harald Szeemann as "the master of the exhibition as medium," Boltanski conceives of his installations as exhibitions and exhibitions as installations, creating evocative atmospheres that allow the viewer's reaction to the com-plexities of the past, present and future. His work has been widely exhibited internationally, in group exhibitions and events including documenta 5 (Kassel, 1972); documenta 6 (Kassel, 1977); "Cham-bre d'Amis" (Museum van Hedendaagse Kunst, Ghent, 1986); "Magiciens de la Terre" (Centre National d'Art et de Culture Georges Pompidou / Musée National d'Art Moderne, Paris, 1989); and "The Museum as Muse: Artists Reflect," (Museum of Modern Art, New York, 1999). Recent one-per-son exhibitions include "Dernières années" (ARC/Musée d'Art Moderne de la Ville de Paris, 1998); "Night in August" (Museum of Contemporary Art, Helsinki, 1998); "Facets of Memory" (The Jew-ish Museum San Francisco, San Francisco, 2001); and "Sombras" (Museo de Santa Rosa, Puebla, Mexico, 2002).

Luc Boltanski was born in 1940 in Paris, where he currently lives and works. Luc Boltanski studied sociology at the Sorbonne University in Paris and in the early '60s he began working as a collaborator of Pierre Bourdieu at the newly founded Centre de Sociologie Européenne. Boltanski published his first articles at the age of 25 in Un art moyen. Essais sur les usages sociaux de le photographie *(Pho-*tography: A Middle-brow Art, *1965) supervised by Bourdieu. In 1969 he became a research assis-tant at the École des Hautes Etudes en Sciences Sociales in Paris, where he has remained a professor-researcher. From 1974 to 1976, Boltanski participated in Bourdieu's innovative and experimental soci-ological review* Actes de la Recherche en Sciences Sociales *before devoting most of his time to writing his first major theoretical book,* Les Cadres *(1982). In the '80s, Boltanski distanced himself from Bour-dieu's influence, co-founding in 1985 the Groupe de Sociologie Politique et Morale that aimed at ques-tioning the assumptions on which reasonings in social theory and political philosophy are based and how these reasonings relate to social actors' own engagement with the world. With Laurent Thévenot, Boltan-ski published* De la Justification *(On Justification, 1991), a study of the different intuitive notions of justice that people bring to their encounters with the world of social relations and objects. Crucial to Boltanski's work of the late '80s and '90s is the identification of six "regimes of justification," systemat-ic and coherent principles of evaluation. These multiple orders (civic, market, transcendence, fame, industrial, and domestic) are not bound to particular social domains but coexist in the same social space.*

In Le Nouvel Esprit du Capitalisme *(with Eve Chiapello, 1999), Boltanski explored a seventh "connectionist" regime (organized around the concept of flexible networks now prominent in the conception of "the Project") based on a systematic analysis of managerial science literature in the '60s and '90s.*

........................

This interview was recorded in Luc Boltanski's kitchen in Paris in October 2002 and in March 2003.

[1]

Hans Ulrich Obrist:

Is there a common point of departure for discussing the way in which you see your respective practices and approaches?

Luc Boltanski:

For me, in the realm of art there's one thing that troubles me very much and that is, to put it bluntly, the weakness of the works. Why are works in such need of authors? Why is it so rare to be attracted by a poem when you don't know its author? This is a problem I'm very aware of when I'm looking through an anthology of poems. Why is this so? Why must we cart along all that human flesh along with the work?

Christian Boltanski:

I think there's an interesting subject, which we know well, Hans Ulrich and I, and that's [Niele] Toroni. For forty years, Toroni has been painting brush marks, thirty centimeters apart. A Toroni painting can only be understood and admired if you know that Toroni has been making the same painting for over forty years. When you see the Toroni painting, what you see entails a knowledge of everything that happened before. Or André Cadere...

HUO:

In Cadere's case you might have thought that it was because he always traveled with his work. But even now, when he's no longer here to make his presence known, young artists are still very interested in Cadere. And it travels very well.

CB:

For it's not his work that's interesting, it's the history, the life as a work.

LB:

But why? My dream is of a work that would live on its own. Why isn't that possible?

CB:

I think we like the idea of a form of beauty existing divorced from everything, but I have the distinct impression that very often, involuntarily, we always place a work in a context, a context that is more or less genuine, or more or less imagined. Everything we

know of the transformation, the unfolding of things, of history, reemerges inexorably. Art is within history.

LB:

I have an idea that at present the scientific and technical model dominates much more than in the past. It's become the prevailing model. And, of course, the scientific model is an impersonal model. People in physics work in groups of 500 around machines. And so, in contrast, this gives rise to the artist whose very uniqueness becomes the work, whose person becomes the work, and it breaks down that intermediary step of the person who has completely transported himself in his work. Do you see what I mean? You have three positions: work that is entirely impersonal (physicists, the collective with no author, Science with a capital S); Cadere who goes around with his stick and forms one body with his work; and finally that third possibility, which is disappearing more and more, where the work is completely unique and the person is no longer needed. The uniqueness in the work is sufficient. That's what seems to me to be the richest, most interesting position for art.

CB:

But is it even possible? I'll give you another example: Heinrich Schütz. I don't know anything about Schütz's life. What I know of his work, I like very much. But I have no image of him. Yet in spite of that, when I think of Schütz, I think of the German religious wars, the massacres, the cold... so, without wanting to, I put Schütz into a context. It may not be a personal context, but that's what it evokes for me, that's what it summons up.

LB:

Still there's a difference. What you're saying here is perfectly normal and I think we all do it. I'm talking to you about a moral problem. I'm not speaking as a sociologist. The moral requirement would be a work that bears the entire weight of uniqueness just on its own.

CB:

What you say is true, for it is indeed the work that counts; but at the same time, I think the artist's life as such... If you take the most simple-minded example—Van Gogh's paintings are very beautiful, beautiful in themselves without knowing anything about them, but a Van Gogh painting is also so deeply tied to a specific period in the history of art, to a very specific artistic quest... There are good reasons why people are so interested in Van Gogh's letters. If Van Gogh had painted only one picture, it would be less interesting than if he had painted, I don't know, 300 let's say.

LB:

You're right. The same thing applies to Gérard de Nerval, whom I adore.

CB:

And in the case of Van Gogh, it's that somewhat Christ-like image, those rejected works, his solitude... Knowing these things adds to the appeal of his work. When it's throughout a whole lifetime—and that's why I like Toroni—there's that aspect of "I devoted my life to that gesture." The same applies to you when you discuss your scientific work; you say you've been working on quarrel and denunciation for twenty years. The different works are enriched by one another. If you had written only a single article on that question, it would surely be less interesting than it is through this development in your work.

LB:

Yes, but my justification—which is wrong, of course, because I don't believe in the sciences, or at any rate in Science with a capital S as Bruno [Latour] would say—is that I am taking part nevertheless in a collective work. That's not me that I've been displaying for twenty years in quarrels. I don't walk around with my factor analyses; they're not tied to me. It's an interesting problem, at least I'm very interested in it. And in front of a painting, it's that relation between quantity and quality. To be a great artist, do you have to have produced one or two good works, or many good works? In the case of Nerval it's very interesting, for he wrote a great deal, and some things that are not exceptional but he wrote three or four magnificent poems and 300 pages of fiction. Or take the example of T.S. Eliot, to my mind the greatest twentieth-century poet; his complete poetry works must come to 200 or 300 pages. In the case of poetry, it's such complicated work. Sociology, on the other hand, is very easy to do if you've had a good training or if you have a bit of imagination. Poetry is very difficult, so when people have succeeded in writing one or two impressive poems in their lifetime, it's extraordinary...

HUO:

But in architecture or art it's often the same: it's often two or three pieces that make the difference...

LB:

You think so? It's the same for artists?

CB:

Yes, I agree with Hans Ulrich. It's just that artists produce a lot because of the way things function economically which makes them

produce more, and also because we're partly artisans and we produce objects. An artist usually has two or three creative periods in his or her life, and among the works produced there are often only five or six that are determining. Afterwards, the artist embroiders on these works, arranges them, and remakes them, sometimes very well, but the number of determining works remains extremely limited. This is what I call a time of creativity, at the very most an artist has two or three such periods in his or her life. Those moments are extremely rare. I must have made about a thousand works in my life, but I think they could be reduced to a very little number. The others are forced, so to speak: because of exhibits...

HUO:

There are some that were remade...

CB:

But to get back to what you were saying, the problem that always surprises me enormously is the problem of the individual and history: the fact that we can distinguish a late-eighteenth-century painter from an early-nineteenth-century painter. When you're an artist, you're under the impression that you are you, but in fact you are you within a time period, and each work is completely datable. This is an unnerving thing. I've often said, "If I had been born earlier, I would probably have been an Abstract Expressionist painter." Whereas I don't like Abstract Expressionist painting! We speak using a language (and formal language is a very important factor in painting) that is so closely linked to a period of time.

LB:

According to me, everything has been said for three thousand years, roughly between four thousand and two thousand years ago. Therefore, there's no need to exert oneself trying to say new things; it's completely pointless. What's required is to make things go through varieties of uniqueness and bring them out in formal ways, each time thanks to small displacements. That's why I'm completely opposed to avant-gardes: because I believe it's a simple-minded project. It's a scientific project, if you wish. The idea of the avant-garde is a mixture of political conceptions and scientific conceptions, linked to the idea of progress, which is meaningless.

CB:

Meaningless in art! That there's no progress in art, I agree. But at the same time, art marks milestones in history.

LB:

No! Well, it all depends what you call history. If by "in history" you

mean to say, "which is steeped in a formal universe," then I agree.

CB:

Yes, quite right. Art, or at any rate, painting, being after all very closely tied to the idea of form, there's a very big difference between a painting by Fragonard or Watteau and a painting by David. I don't know how many years there are between the two, perhaps fifty years, yet there's no connection.

HUO:

Do you notice certain parallels that surface between the two of you?

CB:

I think there's at least a kind of unfolding of thought that we have in common. I also think, precisely, that we're caught in a history and that therefore there's an unfolding of age (there isn't a big age difference between the two of us). Though there might not really be any connection, (sometimes I don't understand what he's say-ing), there are, inevitably, thought patterns that lead to certain things at certain times, things that don't necessarily come togeth-er, but are parallel, or, to put it differently, are on the same level. And this for a rather simple reason, which I think stems from the fact that the end of communism changed art, changed sociology, etc. The end of the last great Utopia was such a shock that it changed art, sociology, and perhaps mathematics.

LB:

Yes, that's undeniable. To return to forms, there's a quarrel that often crops up between the two of us, which is when Christian says to me, and he often does, "that can't be done anymore." That state-ment drives me crazy. The more I'm told that something can't be done anymore, the more I want to do it. I think this has no mean-ing and that no form can be obsolete. Obsolete in relation to what? Since there's no progress. On the contrary, I think that tragedy and the Alexandrine can be revived... not in the same way, but in dis-placing these forms.

CB:

I think you're absolutely right. But I think it's a bit like the Borges story of the man who rewrites Don Quixote. Which is what I dis-covered with you when we were in the country together, in the Massif Central, and you showed me a Romanesque church, and I said to you then, "my work is that." I believe artists are constantly relying on history; I agree with the statement that there is no progress; but I believe that we are constantly relying on history, on the history of things seen. After that I went to Venice, and I saw

very beautiful things, but they were not part of my history. One always relies on history but never on the same segments of history. One can be interested in pavement—and we know that Mondrian was very interested in seventeenth-century Dutch painting because there were tiles in the churches—but one can be interested in other forms, such as a small lamp in a Romanesque church. I think that when you're an artist you accumulate an incredible amount of information. You know everything. And then, occasionally, some of the things that are inside you come to the surface. When I was twelve, I saw a small lamp in a church. This is a bit of information that was mine for a very long time but it had never come to the surface until very recently. And when you're an artist, it's all those bits of information that you stockpile; the black plastic on the table; those two chairs placed on top of each other, etc. You accumulate all those images and at a given moment you dig into the dustbin, or into that big bag, and you use it all.

LB:

That's what inspiration is! I happen to be a great defender of the idea of inspiration, an idea that was foolishly invalidated by the people in the *Tel Quel* group in the '70s, and more generally by all those people who wanted to reduce literature to a linguistic exercise. But it's exactly what Christian says: it's so difficult to make something, for you have to have mastered those forms, but since you can't control that stockpile completely, the important thing is to know how to use everything that might come to the surface.

CB:

I always say, the viewer must not discover, he must recognize. But in fact, it's not just the viewer but also the creator; he doesn't discover, he recognizes. We do nothing more than recognize; when we write, when we paint, we recognize. Everything is known, everything is there, and sometimes we recognize something...

LB:

Earlier, you spoke about the connection or parallels between art and sociology. The great difference, it seems to me, is that we're under very strong constraints. We're under obligations, we're subject to intense social supervision, disciplinary oversight, with journals and peer review. As a result, the stability of the forms is infinitely greater than in the artistic area. The requirement of substantiation is overriding: you can't utter three words without adding four pages of notes, of justifications. This is because the model is supposed to be an impersonal model. According to this model, the sociologist never expresses himself in his own name. In reality, he is only sup-

posed to be the Pythia who examines the entrails of the horses or television screens and hands the floor over to the impersonal. The impersonal is all the people who are around the sociologist and who control him. In art, on the other hand, the fact that the possibility of uniqueness in the work is recognized, confers greater freedom.

HUO:

All these conversations, like the one I'm recording today, and which you have very regularly, have never led you to carry out a joint project?

LB:

We tried. And we're still thinking about it. For instance, we tried to do a book with images done by Christian and poems written by me.

CB:

That's a project that we haven't completely abandoned, but which poses another problem: the difference in artistic forms. The power of poems lies in the fact that a single word can evoke a whole range of images and emotions... The latitude in reading a poem is very, very wide, an enormous amount of space is left to reconstruction. All the attempted images I made seemed to me too illustrative and so they oriented things too much and narrowed the latitude. Having the image on the left and the text on the right is not possible unless it is decided that my images would be unrelated to the text. But in that case, why make a book together? Unfortunately I'm not a painter; I think a painter could extricate himself more easily from this pitfall. But since I work from photographs and hence elements of the real, "the thing is much more the thing." A coffee pot on a wood-burning fire remains a coffee pot on a wood-burning fire. If you make a drawing of a coffee pot, you might just possibly work things out so that the coffee pot resembles an elephant. With photography, it's very difficult to escape the illustration effect.

[2] Six months later...

HUO:

You called me because you thought we should pursue the discussion we had had several months ago, on the one hand because the book which was then a work in process, À l'instant (2003), has now been published by Alain Veinstein's new publishing company, Melville, and especially because you, Luc, had found deep connections between your work and Christian's.

LB:

As I said to you, I'm presently working, as a social scientist, on procreation and abortion. I'm trying to create a grammar of procre-

ation. I realized something extremely banal in itself, but which seems to me important when it's integrated into the framework of sociology. There's a problem that has been very widely overlooked in the realm of sociology and that's the question of the uniqueness of human beings. This was overlooked because sociology modeled itself on the nineteenth-century positivist sciences; it was based on Aristotle's idea that science could only be general. It wanted [it] to disassociate itself from psychology, which was seen as too individual. The main criticisms against the social sciences consist in saying, "You're forgetting that individuals are unique, that they're not just statistics." That's the basic, simple-minded critique. At the same time, what most of the social sciences didn't see is that the uniqueness of individuals is not a given. This is one of the things that people must bring about in society, for instance through kinship.

HUO:

You also said that this revelation of the homology between your work and Christian's had occurred incidentally, so to speak.

LB:

We had a house in Normandy, which we liked a lot, and we sold it; I went back there and all the objects from the house were in a shed, damaged. We had taken very bad care of this; it was during the time when our mother was dying. Everything was piled up, it was dreadful. The objects of abandoned orphans, and you could still recognize the trace of their uniqueness. But they had lost all their worldly attachment. And I really understood Christian's obsession and what gives his work its grand metaphysical scope; it's a very impressive visual reflection on this. The large exhibit in the Musée d'Art Moderne three or four years ago had shocked me—it was somewhat unbearable for me, I had found it too hard to take—but it was entirely about that ("Christian Boltanski: Dernières années," Musée d'Art Moderne de la Ville de Paris, 1998). First, human faces were present en masse, but whose humanity was oozing, and it finished with abandoned objects.

CB:

I've made works that I called *Dispersions*. These are heaps of clothes; for a very small sum of money, you could fill your bag with clothes. I did this, for instance, in a Protestant church in Harlem, in New York. For example, take a jacket; someone had chosen it; someone liked it; then that person died. The object finds itself on the sidewalk, at the flea market. It's a completely dead object. If I reclaim it, there's a kind of resurrection, since I will look at it again, and that object will begin to exist for me. For the exhibit at the Musée

d'Art Moderne, these objects were waiting to be reclaimed by someone. The former owner is gone, but these objects will be put up for sale again, someone will reclaim them.

LB:

Gothic literature is full of writings in which someone acquires an object; and not only does it live again, but it takes possession of the person, because it's inadequately detached from its former owner, and the uniqueness of the former owner inhabits the new owner through the object.

CB:

I bought a jacket in the flea market, and in the pocket there were still some unused theater tickets to a New York show.

LB:

This is an experience I had the first time I went to Harvard. I had exchanged my Paris apartment for the apartment of a young Harvard professor. One evening I was feeling very anxious: I opened his closet, and I put on his clothes. Everything fit me perfectly. It was a very unpleasant experience. I think all these questions aren't at all those of Conceptual art. It's ritual art. In anthropology, a distinction is made between myth and ritual. Myth is the locus of metaphysics, and ritual is the implementation of the metaphysics that is lodged in the myth. Therefore it's an art that is completely metaphysical, but implemented not through speech, but through the ritual. An installation in which you can move about is a ritualistic configuration.

HUO:

That first point Luc brought up could be a link between the two of you. When I saw Christian's first exhibits, I was reading Un art moyen. Essai sur les usages sociaux de la photographie, *which Luc wrote with {Pierre} Bourdieu* (Photography: A Middle-brow Art, *with Robert Castel, Jean-Claude Chamboredon, and Dominique Schnapper, 1965)...*

LB:

It's a superficial link, a link rooted in the period. We adopt the language of our period; I came into sociology in the '60s, the '70s, and since I was close to Bourdieu, I adopted Bourdieu's language. I think that in art, Christian borrowed...

CB:

I've never read anything, but I think there are things that transcend knowledge. At the beginning of my artistic activity, anthropologists were very influential, the Musée de l'Homme, and certainly [Claude] Lévi-Strauss, though I've never read a line of his. It was the period when the human sciences, particularly anthropology, were floating around art.

LB:

Yes, but I think that in your art the connection with the social sciences was a mimetic and superficial connection, whereas what you've been doing over the last ten or fifteen years is metaphysical; it no longer has any connection with the social sciences.

CB:

Yes, I agree, it has no connection with the social sciences; in fact I strongly deny that it has.

LB:

If you want, your work is to metaphysics what ritual is to myth. I'm not versed well enough in art history, and there are certainly other works that this is true of as well, but when I tried to study these subjects seriously, I was surprised to realize the subtlety of what you succeeded in achieving with methods that do not involve words. I only know words; I don't know how to do anything outside the realm of words. I know how to cook, I know how to assemble a bookcase, but I don't know how to create anything outside the realm of words. And I realized that a metaphysical demonstration could be made on a large scale with photos, metal wire, pieces of cardboard, old clothes, etc.

CB:

I think all places of worship—for example Zen temples—are metaphysical in relation to space and architecture. Therefore, the fact of talking about metaphysics without words but with... space—I don't have the proper word to say it—is something that is constant in the history of mankind. For a very long time art revolved around this problem of metaphysical sites, and tried to explain metaphysics through forms—the metaphysics of its time at any rate.

LB:

I thought about the fact of belonging to a religious community; I belong to a community where people are working on renewing the liturgical symbolism. They are trying to shatter the routine of this symbolism. For example, for Whit Sunday, a friend and I had devised the following format: we brought Bibles and asked about ten people to each take a Bible, go to different corners of the church, open it at random and read the passage they had opened to in a very loud voice. It was very beautiful. It was like a theatrical format; in the distance you heard segments of the Old Testament, proverbs yelled out, and at the other end, you heard segments of the Gospel. That and my interest in theater have helped me to understand.

CB:

These are the kinds of things that interest me. There is no doubt that churches are theaters, since they involve lights, gestures, music.

LB:

Yes, and the words themselves are gestures, the words of consecration transform the matter that is consecrated.

CB:

Yes, all the more so since these words are repeated: we are involved in something that is close to theater. What I'm trying to do—what interests me at present—is halfway between theater and installation and very close to that situation. Even if I have no real knowledge of the subject, I would say that Poussin's paintings, for example, are completely metaphysical. I think that Duchamp too is a metaphysical artist.

HUO:

This is what you were saying to me the other day, when we were discussing Picabia.

CB:

We were saying that Duchamp and Beuys were in the realm of metaphysics. As for Picabia, he is linked to a period that is ours, and which is against metaphysics. It's a kind of derision, or nihilism.

LB:

A fashionable nihilism.

CB:

Even if Picabia is a great artist and I adore him, his realm is indeed one of constant mockery and relativism. For Duchamp, each object had a metaphysical value.

LB:

Yes, in fact that's why there has been so much written about Duchamp. It's a different vision: there would be a metaphysical line in art and a nihilist line, which would consist in work on the functioning of art. This brings us back to the question of Conceptual art. Perhaps it's because I can't really understand Duchamp, but as you know I'm not a great fan of Conceptual art; I think that sometimes you have taken up some conceptual ideas in your work, but in the end it has nothing conceptual about it. Ritual doesn't express anything with words, it doesn't require interpretation; it's through the emotion it brings you, through the changing states that it causes within you, that it makes metaphysics enter into your innermost fibers .The work you do, since it involves a real ritual, something

expressionistic, and genuine emotions, it transmits the metaphysical message, like all ritual, without requiring a detour through interpretation. The detour can be made, but it is not necessary for the effect to be produced.

CB:

I've always said that in my work, the viewer must not discover, but recognize. Naturally, he relies on past rituals. I'm talking about things that are inside everyone. The fact, for example, of plunging the viewer in a locale without light, of placing recognizable objects as though they were sacred objects; a used garment is necessarily a sacred object. I use it to speak of something that is basically akin to the metaphysical rituals of the societies I know. I work on common sense, and therefore someone who comes into one of my exhibits, if he accepts it, is in the same state as someone who comes into a sacred site.

LB:

Except with the difference, nevertheless, that usually, when he comes into a sacred site, he is aware ahead of time that he will feel agitated. At any rate, he thinks he recognizes his own agitation. Whereas when he comes into one of your exhibits, he doesn't recognize his agitation; this would be the difference between art and ritual. The role of ritual is still, after all, to create a communion among the participants. It is therefore necessary for all of them to recognize their state so they can all find one another. If what you were doing were merely a ritual, it would be pompous traditional art.

CB:

What interests me in art is that it's something that each person can see through the prism of his own history, his own past. Art objects, those I make in any case, have something imprecise about them. One person might say, "Oh, yes, it's the Holocaust," and someone else, "It reminds of the office where they used to put up the photos of the best workers." Of course, there's a general line; for example, clothes spread out on the floor necessarily summon the Holocaust in the West. But in Japan I've been told, "You're very familiar with the Zen tradition, you've taken inspiration from the lake of the dead." It seems to me that the beauty of art lies in the fact that there is an ambiguity in what one creates. In a ritual, everything is so well known that there is far less ambiguity. The thing must be deliberately ambiguous—for example, speaking of "found objects," there are a lot of people who find it merely amusing. It can be seen that way. I don't reject that way of seeing it.

LB:

The thing that's impressive in your work is that it points to the problem of identity, the problem of uniqueness, and the tension between the replaceable and the unique.

CB:

The question I'm concerned with is both each person's uniqueness and at the same time, their extreme fragility. In other words, each person is unique and at the same time each person is so fragile that he or she can very quickly be forgotten. I always bring up our grandmother, who was a remarkable person, but of which nothing is left; there remains vaguely a few very dim memories in our heads. And when we die, there really will be nothing left of her. The exhibit plays on what I call the loss of identity. There were all these images that were images of unique individuals—that's why I called it *Menschlich* (1994)—and at the same time forgotten individuals. There were also names; I establish an equivalence among the names, the photographs of faces, and the objects, which are each time objects that recall the absence of a subject. If you see a name, you know there was someone who was called Lionel Smith, but that's all you know. You know someone unique existed with that name, but today it's merely a name on a list. Ever since my first little book, which I did in 1969 [*Recherche et présentation de tout ce qui reste de mon enfance (All I Remember About My Childhood)*], the problem I've been concerned with is rescuing what I've called the "small memory." The great memory, that of kings, stays around a bit longer, but what makes the uniqueness of an individual, for example knowing where to find the best quiche in Paris, or knowing amusing stories, all of that has disappeared; it disappears very quickly with the person's death.

HUO:

In the book that just came out, À l'instant, *where Luc's poems are illustrated with Christian's images, you talk about these questions of uniqueness and work on them, don't you?*

CB:

That's all we talk about. There is something in common in our work, which revolves around the idea of mourning, the idea of celebrating the dead. Luc was telling me that a large part of his artistic work consisted in celebrating the dead. Celebrating the dead would mean summoning their return, in other words, recalling the uniqueness of deceased human beings.

LB:

This is why I believe we're in a period that isn't very fond of poet-

ry. In France, for the last thirty years, we're in a period of pure criticism. The only thing that is recognized is the value of criticism. The value of criticism is very great—a world without criticism is a fascist world—but I think that a good society is a society that balances criticism and celebration. Poetry is primarily a celebratory activity.

HUO:

In this book, therefore, there are poems by Luc and images by Christian.

CB:

Mainly poems by Luc. There's a section of the book that is autobiographical, that deals with our common childhood. I started with a personal family photo to try to do something parallel to poetic work which never completely describes a situation but gives flashes of insight into a situation, and thereby gives a truth. Instead of describing a situation like ours today completely, to say "orange curtain, sun coming in, coffee, friends discussing."

HUO:

That's precisely the work of poetry.

LB:

Particularly in contemporary poetry, which no longer resorts to vast systems of comparison, of imagery, and which therefore loses the metaphorical work that could be made based on the elements of the same situation: it's work that will be done by erasing the context. Hence one is completely in the realm of uniqueness, but without giving the reference of what is being described. This makes the poem obscure, but at the same time that's what allows it to cause other distinctions to come and contaminate the uniqueness introduced by the poet. The book is crammed with names, first names. But it is not known to whom these names belong to, and the poem doesn't say. On the formal level, the general theme is the lost reference, which can only be lost. All efforts at restoring the reference only take us further away from the reference.

CB:

The more information one gives, the more one gets lost. The more proof one accumulates, the more the thing becomes confused.

LB:

I've always been very troubled by snapshots, family photos, by what has been fixed. One of the poems is a commentary on a photo where you see Richard Strauss during the war, coming out of a concert surrounded by two singers. They are happy; they are ridiculous. All these moments of happiness are more troubling than photos of corpses.

CB:

Roland Barthes said that photography is inevitably death, since it's the instant—three seconds later, it's already the past. Inevitably, every photo carries within it the fact that it is already the past. A photo is inevitably linked to something that no longer exists and will never exist again. You could say that as soon as we preserve, we inflict death.

HUO:

In an interview I did with Israel Rosenfield, he said that according to him, there is a great misunderstanding concerning memory, which is that we treat or talk about memory as a static set of elements. For him, who has given close attention to these questions, there is, on the contrary, nothing more dynamic than memory, for memory is uniquely dependent on contexts in which these operations of memory take place, and these contexts are inevitably constantly changing.

LB:

What you're saying is very true, and I think it is related to something that is important at the present time, which is the denigration of institutions. The problem with memory is that it can't dispense with institutions. In fact, institutions—and that's why they are said to be conservative—are primarily memorizing machines. For example, in the case of churches, people say, "I'm willing to have a personal relationship with God, but beliefs, churches, they're rotten, they're institutions, they're strategies of power." That's true but at the same time it's foolish, because without institutions there is no extension in time. The institution that used to convey the uniqueness of past human beings was kinship first and foremost. Therefore I think that the present obsession with the theme of memory stems from the fact that no one wants the instruments that are absolutely indispensable to the construction of memory. In fact, everyone would like a kind of memory that would be immanent in each person. That's absurd; memory is inevitably transcendent.

CB:

I think that the questioning that is common to everyone is the idea of death. We all have a memory, we are all unique, and we tap our heads saying, "You're a pile of shit, all of this has disappeared." This is something that has always existed. One of the ways of fighting against it was the fact of passing on—transmitting something. In traditional societies, when the grandfather died on the farm, the

father would start to manage the farm, the son would take the place of the father, and what mattered was the transmission of the land. You taught your child to be an artisan, there was a transmission, hence death was less painful since something continued that was outside the self. This idea of transmission has completely vanished. Death has become more and more of a void. There is nothing anymore. We are us, and nothing will remain of us. The world will have evolved.

Death is all the more present in that it is all the more denied. It is rejected—just as old age is rejected. In my youth, people used to wear a black armband when they had lost someone. Today, if you did this at the death of your mother, you would be considered ridiculous, it would embarrass everyone. To even speak about the death of someone close is embarrassing; we no longer dare show signs of sadness. I remember something concerning Warhol who loved his mother very much. His mother died, and people asked him, "How is your mother?" He answered, "Fine, she's in a rest home." How could he explain that his mother had died?

HUO:

I think it's very interesting to end this discussion on this question of memory, insofar as this book of interviews can in a sense be considered an archive of memories.

CB:

Any interview is inevitably concerned with that, whether it is in the framework of the small memory or the great memory.

BUREN, Daniel

Daniel Buren was born in 1938 in Boulogne-Billancourt, France. Buren started working as a painter in the beginning of the '60s, and created with Michel Parmentier an association with two other painters, Olivier Mosset and Niele Toroni, which was called the BMPT group after its collapse and against the will of its four participants. The association was very active in Paris officially from December 1966 to September 1967. At first, Buren developed canvas paintings with regularly striped patterns. The vertical stripes—always having the same breadth, and in white and one other color—served as a means to reduce the pictures to object-like, material qualities, thus questioning the fundaments of painting. According to Buren, stripes as a "visual tool" are "no longer a work to be seen, to be looked at, but the element that allows something else to be seen." These stripes are the only non-variable elements between of thousand always changing, in the work of Daniel Buren. Since the '70s, Buren has been working with mirrors, glass, wood, concrete, and electricity, as well as transparent materials such as foils or Plexiglas. The aspect of reflection and transparency serves to not only enhance the color range and alter the appearance, but it also renders significant the immaterial factor of light. The stringency and radicality of his working method also become clear in Buren's numerous art-theoretical texts. Up to now, Buren has realized more than one thousand site-specific installations in galleries and museum settings as well as in the public realm, in cities and gardens, responding each time to the surrounding space or the context of an exhibition with great acuity. Recent one-person exhibitions of his work include: "Colour-Transparency: Cabanes Eclatées No. 26 A and 26 B" (Portikus, Frankfurt, 1998); "Mises en demeures, Cabanes Eclatées, 1999–2000" (Institut d'Art Contemporain, Villeurbanne, 2000); "Une traversée, Peintures 1964–1999" (Musée d'art moderne Lille Métropole, Villeneuve d'Ascq, 2000); "Les couleurs traversées" (Kunsthaus, Bregenz, 2001); "Sélection 1 1965–2000" (Centro de Arte Hélio Oiticica, Rio de Janeiro, 2001); "Selección 2 Cabañas estalladas 2000" (Laboratorio Arte Alameda, México, 2002); and "Le Musée qui n'existait pas" (Musée National d'Art Moderne/Centre National d'Art et de Culture Georges Pompidou, Paris, 2002).

........................
This interview was recorded in Rome in June 2000.

Hans Ulrich Obrist:
I've just finished reading the book by the American landscape architect {Lawrence} Halprin...

Daniel Buren:
I only know him by name.

HUO:
He was extremely active in the '60s and '70s. Today his firm has scaled down its activity a great deal, and he must be going on 85. He profoundly influenced the whole phenomenon of what today are known as participa-

tory processes in architecture, as well as the whole relationship between architecture and gardens, the city and gardens, and more generally the relationship to "landscape architecture." And that is precisely what I'd like to talk about with you right now: that part of your own work devoted to gardens. What was your first incursion into this field?

DB:

The first time that I was able to do something in that area was with Alexandre Chemetoff. The first garden was done in La Villette Park in Paris—a garden known as the "Bamboo Garden." It was dug into the earth, producing a sort of microclimate in La Villette Park. It was the first time that I had worked specifically with vegetable matter on that scale, in a relationship with the area itself, and not with respect to built-up architecture. During that same period, I planted 11,000 tulips in the Keukenhof Park in Holland, outlining a very long white and red striped carpet that crossed one of the park's points in a diagonal (*11000 Tulipes*, 1988).

HUO:

What year was that?

DB:

It must have been in 1987–88.

HUO:

Prior to that, had there been any aborted attempts or projects?

DB:

One finds traces, for instance, in those works which, without actually being garden constructions, play on landscaped spaces. I am thinking primarily of the Ushimado work in Japan [*L'Arc en ciel* (*Rainbow*) and *Sha-Kkei* (*Borrow the Landscape*), 1985], done more or less at the same period. Before that, of course, I had done things that impacted directly on the landscape, but they tended to be more urban landscapes, because in a way, wild spaces don't interest me—at any rate, not for my work. In 1982 I did a piece in Canada, *The Gallery as a Periscope,* in the Walter Phillips Gallery, dealing with the little forest that surrounds the Banff campus. The whole piece plays on the layout of the trees. Though I didn't actually touch the trees, I transformed them by using a series of masks at various levels, which played on the vision of the landscape that one had looking out from the big window of the gallery where I was showing—the campus gallery.

HUO:

There too, it had to do, let's say, with an exhibition-oriented project.

DB:

Yes, it was definitely an exhibition, but the whole visual part was set outside of the gallery, directly in the landscape. But many of my works are on this sort of fringe, while still being more like landscapes than gardens. With the exception of one, which was genuinely conceived as a garden—that is, the Villette project—and the project done in Keukenhof Park.

HUO:

What you've just said is interesting with respect to Halprin, because as he explains in his book, in the eighteenth century the landscape was brought into the garden. But what he proposes for the twentieth and, consequently, for the twenty-first century is, on the contrary, to bring the garden into the landscape. He mentions a social conception of the "campagne," or countryside.

DB:

I think that some countries that are highly cultivated from an agricultural point of view—such as France, indeed all of Western Europe, except for the furthest flung spots in the Alps—are nothing but big gardens. It is striking that when you fly over them by plane, or when you cross the French or the Italian countryside by car—for instance, when you travel around in Tuscany—you have the impression of never getting outside of a garden—in other words, of a composition. And I think that this composition, on the same scale as the surrounding nature, is designed in the same way as one might design a garden: it is sublime like a garden. And that represents centuries and centuries of human labor. That's why I am not someone who works in "wild" nature, but only in nature that has undergone human transformation. As I see it, there is not a lot of difference, in terms of spirit, between the nature in which I work and the architecture or the urban space in which things happen. Which is why when my work leaves the city for the countryside, it is with the idea that this countryside that I use is entirely built up. I don't think I would be interested by the prospect of heading off into the desert to do a piece, as so many artists did back in the '60s. As a matter of principle, I wouldn't go. It is not an aesthetic point of view. I might go to look around, but not to work. Because at that point, one finds oneself in places where human beings are merely visitors and no longer social beings. It is a place without human encounters and without human history, whereas in the countryside—as Halprin describes it—people meet one another; it is a "natural" social space.

HUO:

When you talk about the desert, are you thinking in particular of {Paolo}
Soleri or of land art? Though their approach is different, do you neverthe-
less find their work interesting?

DB:

I think that an idea as highly utopian as Soleri's, if ever it was to
be implemented—and it was to some marginal extent implement-
ed—will create a situation in which a certain urbanity can appear.
Thus, in a certain way, it transforms something uninhabited into
something where people are able to dwell—just as man has always
done. But at the level of the artwork, this exoticism, in other
words, this idea of showing something that is virtually invisible—
because it is nothing short of a veritable safari to get there—
requires great effort, and the problem is that nobody meets any-
body else there, except those people who have come especially to
see the work. And that, for me—from a philosophical point of
view, let's say—is really devoid of any interest; it's even more ide-
alistic than the idea of the museum itself... and that's putting it
mildly! Of course, I am interested to I see what they've done. But
those are two different things. In a museum, too, there are plenty
of works that fascinate me, but I neither forget where they are, nor
overlook the influence of this particular context on the type of read-
ing one can do of them. With regard to the landscape, it was when
I worked on Mies Van der Rohe's houses, in Krefeld, that I discov-
ered something I had not been aware of. I took up the plan of the
Haus Lange and entirely transported it, walls and all, into the Haus
Esters (*Plan contre-plan*, 1984). It was a translation of one house into
the other. In so doing, I learned something highly interesting
regarding the juxtaposition of large bay windows: I learned that in
his day, Mies had used window frames prior to construction; he
would use wooden frames which enabled him to determine just
exactly where he should put the openings toward the outside. That
gives you some idea to what extent he built his houses on the basis
of holes, and thus in keeping with the layout of the surrounding
park—a very simple park, as a matter of fact, with its plantations
along the sides and directly in front. The house was thus organized
on the basis of the main bay window. And it was only when I trans-
ported the houses that I made this extraordinary discovery. I knew
his work, but I hadn't interpreted that fairly essential detail, that
in working around an empty space, around an opening, it was the
outside landscape, which organized the inside of the building.

HUO:

What you have just said unmistakably brings Japan and Japanese archi-tecture to mind. You and Japan go way back, it seems to me.

DB:

For Japanese garden artists, nature is in the garden. In many places where there are gardens, for instance in Kyoto, either the gardens are entirely enclosed, where everything around is hidden, except the little piece that is to be shown (generally something Zen and highly concentrated), or the gardens' walls are positioned in such a way and are small enough to reveal what is behind them—the nature outside of the garden itself: a mountain, or a forest. This openness is incorporated into the garden itself; suddenly, given the precision of the design of the little garden, all the nature that is beyond the garden—insofar as it hasn't also been retouched—also becomes something well ordered, because the foreground is so rig-orous, so meticulously designed.... The other notion, which I like tremendously, and that I use in conjunction with landscapes and architecture, and which affects all my work, has to do with their famous windows—which show either a bit of wall or a bit of land-scape. The Japanese use a special word, which, contrary to our Western language, doesn't mean "frame the landscape" or "enclose the landscape," but rather, "borrow the landscape."

HUO:

That's magnificent!

DB:

Isn't it. And so I use that idea a great deal, wherever I work and whenever the occasion arises. In the case of *Deux Plateaux* (1986) for instance, one might say that I borrowed the Palais Royal. One can no longer separate the Palais Royal from what I did without destroying either what I did, or the Palais Royal, or both. Even if it is to last fifty or a hundred years, this osmosis between the addi-tion and the existent has to be considered as a loan. It didn't become my own and yet at the same time it is no longer quite the way it was, no longer quite the previous Palais Royal. And although in the case of the Palais Royal we are dealing with stones, I think that the notion remains the same. It is a garden of stones facing the tree-planted garden, which is its prolongation.

HUO:

How paradoxical—a sort of impermanent permanence.

DB:

Yes, in Japanese terminology that is the notion they use to talk

about certain temples, which have sometimes been reconstructed ten times over. But they are permanent. Even when they are destroyed, they are reconstructed identically. There are temples where one finds this form of window that has existed for 500 years, which is called "Sha-kkei." It's a very rich paradox. You borrow the landscape as if it were for three seconds—the way one might say, "I'm borrowing your pencil." The very fact that the term has stuck is meaningful. Even if the loan lasts for centuries, it still doesn't—and never will—belong to you. It is the opposite of appropriation. Borrowing is not appropriating. With regard to everything that has developed in the course of the twentieth century around the question of appropriation, Duchamp and so on, this strikes me as something completely different.

HUO:

Yet the readymade is a form of loan as much as a form of appropriation, in that it plays precisely on the borderline between the two notions.

DB:

Except that it has become far closer to appropriation. Though that has nothing to do with Duchamp; it is what people have done with it.

HUO:

When one looks at Duchamp's texts there are also open partitions, readymades that he never produced. For instance, "Buy a dictionary and take out all the words that you like." Readymades are not necessarily frozen. We could buy a dictionary today and do what Duchamp suggested. But as you say, it is not that conception or that particular aspect that is focused on today.

DB:

And that's why when one talks about readymades—actually, when one talks about any work whatsoever, even more classical painting, like Matisse's—if one does not define the work one is talking about, I think one's just spouting empty words. If, instead of saying, "I am talking about such and such type of readymade and about such and such readymade in such and such an exhibition," one merely says—and this is invariably the case—"Duchamp," or even "Duchamp and the readymade," in those three words one already admits that there are not merely Duchamp's readymades, but also those of this person and that person. And it is to forget that Duchamp himself referred to retouched readymades and non-retouched readymades, and so on.

HUO:

Happy readymades, and unhappy readymades...

DB:

Yes, and so he had already developed a series of categories. And even if one only talks about the "readymade" to the exclusion of the rest—which is already slightly more precise than merely saying "Marcel Duchamp"—one must truly specify the type of readymade one is referring to, in order to highlight such and such decision, or appreciation or reading. But I think that is true for every artist. If one talks about Matisse and one only uses his name, one doesn't even know what one is talking about. That being said, to come back to the discussion, I nevertheless maintain that Duchamp opened the door to the idea of appropriation rather than to borrowing, which implies that one could either leave the thing along the way or return it to its place. Duchamp's notion led, above all, to appropriation pure and simple. Right up to the appropriation of the works of others. But to come back to the notion of borrowing, when one does a work that is not autonomous—which is the case for my work—I find that it is absolutely necessary to understand why this work is not autonomous, to understand that there is a lot of hybridization and a lot of parameters making it what it is. If one thinks that all of that ends up creating a unity, which can then be signed, one is mistaken. Even if it is signed, in every case this new form, which comes together as a whole, does not become something autonomous. It is always a loan, which means that when it is there, it has a meaning. Which is to say that it can fall apart, revert back to its place, and does not become the property of the work in question.

HUO:

What is interesting in what you just said about Japan, regarding the notion of borrowing, is that when the research was being done for the Villa Medicis, for the garden, we also asked several Japanese people to talk to us about their gardens. During a conference I had asked the audience if they knew about the gardens, about what the idea behind them was; I subsequently received a lot of information. Most of the information was linked to the partition and music. Just think of Duchamp's filiations, which include John Cage, who is himself far more recognized in Japan than elsewhere. There was one of Cage's students who actually talked about the composition of gardens. In what you describe with regard to the windows, it is as if the partition was given. Which brings us back to Duchamp's partitions in the infinitive.

DB:

It is something that is at play not merely at the margins but also in parentheses. These parentheses are like a framework; the framework of the window is either a parenthesis in the city or a paren-

thesis in the house. The city is fragmented by these frames. But suddenly this piece of architecture falls into a hole. The walls are to some extent bracketed off in two ways, like parts of a city. And one understands why architecture, in part, acquires its grandeur from the fact that these sorts of parentheses and holes are placed where they are needed. One also understands why certain architects, including Mies, worked at some point on the basis of the hole—in other words, starting with something which, by definition, is not built. To attempt to build something around a hole.

HUO:

That comes back to what Cage said about silence.

DB:

Absolutely. I would link that question to this example, or to certain pieces, such as the experiments on the train. When it's recorded, one can almost say that it is at once a loan and an appropriation. The two things are, in my opinion, very linked to that particular moment, inasmuch as one removes the sound from its context and can hear it only thanks to the phenomenon of capturing sounds. But I think—at least in my own personal interpretation—that what Cage is telling us is obviously to listen to what he performed, but also to pay attention just for its own sake. And in that case, the issue is not one of appropriation, but is something that one does in a certain way, like personal mental gymnastics, which is never returned, and thus is borrowed.

HUO:

There is another thing that interests me with respect to the city. When you mentioned the importance of the garden in your work, you said that it wasn't a question of nature, or of the countryside, but rather an urban question. That brings us back to your piece for the exhibition at the Villa Medicis (Cabane éclatée à l'obélisque, 2000, "La Ville, le Jardin, la Mémoire," Villa Medicis, Rome, 2000). Rome is visible, omnipresent; it is all around the garden. There is a form of silence which finds its way into the garden, and which accounts for something of the site's exceptional aspect; but at the same time it has a utopian dimension because one nevertheless hears the noises and vicissitudes of the surrounding city. What do you think of the relationship between Rome and that particular garden?

DB:

I think that in this case we have a series of constructions of highly exceptional objects. The site is exceptional in relation to the city. The building is exceptional with regard to the other buildings. The use of the nature in the park, which is kept natural, is also exceptional. It is almost a textbook case, a dreamed object. I'm not, how-

ever, saying that it is an Utopia, merely that is rare to see all these elements joined together—and what is more, in a city like Rome. In other words, one generally only finds such magnificent situations in the middle of the countryside.

HUO:

Those are the advantages of the city. One can find the countryside in the city, but never the city in the countryside.

DB:

Exactly. Here we are in a place that brings together all of these elements, and which has virtually all the advantages of these environments. With the exception of the noise of the city, which obviously didn't exist a hundred years ago here, we really were in the countryside: we overlooked the city, we had our feet in the city and at the same time, over on the other side, it was the countryside. Today, the other side is just as noisy as this side—and perhaps even more so, given the freeway. On top of which, we are on the inside of the Villa, in an extremely articulated, extremely urbanized setting. The garden is designed in an almost methodic way, even if it is not immediately comprehensible. It is highly designed, and conceived the way one might conceive of a house, or a series of houses in a village or in a city. This garden, like so many gardens (but this one in particular), makes me think of a prolongation of a house out of doors. I say that because everyone knows the squares surrounded by walls of vegetation, which are on the left side: those are the bedrooms, there's no doubt about that. In the same way, for the purposes of the exhibition, it is as if everyone had a room. It is exactly like in a museum, except that the walls are vegetation, and the sky is the roof. So, in the final analysis, I find that we're in a pretty funny place, which moves simultaneously from one form of architecture to another. The idea of nature—if one speaks about the garden while thinking about the nature which comes into the city, or about paradise, in other words, about something highly sophisticated, a sort of idea of peace and happiness—has quite simply been transformed. And my feeling is that when you leave the Villa, you are still in the Villa. One might say that there is a protected place and another slightly less protected one. But only slightly less. What one sees of the city becomes an enormous decor. Whereas the garden, which, generally speaking, is made to be the decor of a house, in this case practically becomes like a house. It doesn't appear as a decor, but rather as the enlargement of the house. And on the other side, on the city side, the city is idealized *de facto*. First

of all because, obviously, it is rather harmonious and beautiful. There's not much that recalls ugliness (of course, there is the monument of Mussolini), and, when you look a little further afield, there are elements that don't fit in. But overall, the harmony and the color, which emanate from the city, are utterly extraordinary. And the position of the Villa—I think that it must have been the will of whoever built it or commissioned it—allows it to keep this distance with regard to the city.

HUO:

So far away, yet so close by.

DB:

Yes, and one might perhaps even say that, ironically, this distance is even greater than if there were a piece of countryside in between the city and the Villa. It hasn't by any means disappeared—far from it. Take, for instance, the location of my hut: one clearly sees in that instance that when, by chance and always by surprise, the city enters into the hut by means of the reflection—and this can be clearly seen with the dome of Saint Peter's—it enters in almost like an idea, in that it is seen from above. It is, in my opinion, still more striking to see the city in its reflection than to see it directly. Here, one might imagine—and I think that was for a very long time the case for the Villa, closed in on itself—that the city ceased to exist except as a postcard. Suddenly, there can be no further exchange, neither in one direction, nor in the other. That is perhaps the source of the idea behind this site—which talks about creation, art, music—in other words, the idea behind doing something which can be built up alongside the people who live in it and which can also open up toward the outside. The point is to attempt to reverse what is inscribed in the construction itself.

HUO:

The idea being to return the Villa to the city.

DB:

The question comes up at any rate. Because as soon as that question arises, there has to be a means to reconnect the Villa to the city, other than by means of its aesthetic aspect. Because what is happening today is that the Villa is in the city, but in an almost purely ideal relationship. It is the Villa that has the most beautiful position. When you see it, it is magnificent, and when you look out from the Villa, everything you see is magnificent. But you can't touch it. It is possible to avoid a direct relationship.

HUO:

Yesterday we were on the roof, and what one sees from the roof echoes what you were saying about your experience in the airplane. When you look out from an airplane, you have the impression that everything is a garden. Even Rome is a garden, and when you look down from the roof of the Villa, you see on the one side the Villa's garden, and on the other side you see the city— the city-garden with its hundreds of roofs and terraces. That also attenuates considerably the idea that the Villa is somehow particular, with its very high garden, because ultimately, when one is on the roof, it is just a garden amongst hundreds of others. In fact, you said that one garden always conceals another garden, that one city always conceals another.

DB:

Yes, one does feel that. I believe that it is linked to the question of the height you look down from. That is also the case in Paris. For someone above the Pavillon du Louvre, Paris is a boat; it's as if one were on the parapet of a ship, and Paris were the sea. You sail through the city. As soon as you go up a bit higher, on top of the Arc de Triomph or Sacré-Cœur Cathedral, it ceases to be a ship and becomes a flood tide, at once chaotic and balanced, made up of very special colors, somewhat white, even grayish, beneath the blue sky. Here the Villa is so high, both the building itself and its site, that the view and the impression you get are completely different in this dining room or in the Turkish bedroom. And if you go up to the top floor, to the terraces, you truly have the impression of flying above everything. The city becomes entirely different, and it loses its ideal aspect to some extent. Actually, one particularly finds the postcard side on this floor where we are right now—framed as it is by the windows.

HUO:

For this piece you are going to use mirrors—as you often do—and you are also going to be using water as an element. Could you tell me in general terms something about the use that you will be making of mirrors and water?

DB:

What really interests me in the mirror is obviously not the fact of seeing oneself, but of trying to use it as a third eye. In other words, by means of the mirror, being able to see at once what is in front of us and behind us. It is in that sense that the mirror interests me a great deal. But of course it is far more complex than what I can express with words. Because as soon as you look into a mirror, there

are a multitude of very surprising things which fasten onto the retina, surprises that teach us something. With respect to water, I am not going to provide any detailed description, but if you take, for instance, the Place des Terreaux, there are no mirrors; however, the 69 fountains on the ground were made to have different aspects (*Déplacement-jaillissement: d'une fontaine les autres*, Lyon, 1994). The most radical aspect is when there is no water, when it is dry, and one walks along on top of it like on paving stones.

HUO:

That's the most basic level.

DB:

Exactly. The water that first appears comes from the highest side and covers over the granite stones, which make up the fountain's receptacle. The water completely covers over the paving stones and becomes a mirror that reflects all the architecture bit by bit. Unfortunately, through lack of maintenance, this effect, which was carefully developed, has gotten all out of whack. For it to function properly, more qualified people would have to be put in charge of maintaining the work. It was a very fragile mechanism, requiring a level of exactitude of a couple of millimeters, but it worked. When that film of water begins to flow, the slope is so gentle that there are no ripples, and that creates a mirror. And it is all the more legible in that there are a lot of them. Thus, these squares are like slabs of mirrors. The important point is the idea of introducing into the Place des Terreaux—a very noisy place because of all the buses and the traffic—a device that works like an acoustic buffer. The terrace, where people sip coffee when the weather is good, is fairly far removed from the traffic, and so when all the fountains are working, the noise is somewhat deadened by the murmur of the water. The murmur of the water is such that the traffic noise takes second place. At the Palais Royal, on the other hand, the water is far more discrete. My idea started with the fact that the city is crisscrossed by rivers, by little arms of water, by springs. At the Palais Royal, we are led to reflect on the fact that, in a city such as Paris—as in all cities—there is water beneath our feet, there are streams and sewers. And thus, that everything is fluid.

HUO:

There again is the idea that the city's invisible side has to be made visible, in places, by fragments...

DB:

Yes, an invisible city, partially aquatic: regulating sewers for the

flow of waste, the regulating of rainwater, and so on. At the Palais Royal, which is a very mineral place, and protected from noise, the addition of this sound brought some freshness. In that case, the water didn't play on the visual level, but rather on the sound level; actually, I would say, even though I don't much like the term, that it played on the conceptual level. One immediately notices that in a large city there is water circulating virtually everywhere. At the Villa, one finds yet another situation. There is, in effect, the fountain, and I think that the fact of surrounding it and making it reverberate to infinity brings in a whole new dimension. It is precisely something that already existed in both Italian-style and French-style gardens. In the gardens of Boboli, for instance, there are a series of water jets, spreading out in cascades, in rivers, and so on. So you see what I mean: ultimately I think that inside the hut, the play of mirrors ends up recreating—or better still, reusing— something fairly classical. In effect, just as in those large parks, where water is used in such exuberant fashion, here the fountain, which is actually very small, suddenly takes on far greater importance, thanks to the play of the mirrors set at 90° toward one another. That is why I wanted to see it function so quickly; the effect has to be very surprising, as if one was suddenly immersed into the magic of this sort of park with its water jets multiplied to infinity.

CATTELAN, Maurizio

Maurizio Cattelan was born in 1960 in Padua, Italy. He currently lives and works in New York. Cattelan did not study art in school, but taught himself through a whole series of odd jobs including furniture design. He had his first gallery shows in Italy in the beginning of the '90s, and quickly gained international acclaim, participating in numerous international exhibitions. Cattelan often uses the characteristic parameters he sees in the specific context of each of his exhibitions as a starting point for his subversive works and happenings. In 1998, for his exhibition at the Museum of Modern Art in New York, he arranged for an actor in an oversized cartoon Pablo Picasso mask to welcome the public at the entrance, pointing at the relationship between American museums and consumer-oriented theme parks. In 1999 Cattelan organized the 6th Caribbean Biennial which, despite having the appearances of an international art exhibition, featured no artwork, and served as an all-expense paid vacation for the participating artists. For the Venice Biennale in 2001 (XLIX Biennale di Venezia, 49th International Art Exhibition, 2001), Cattelan created a larger-than-life replica of California's landmark Hollywood sign, and installed it on top of a city dump overlooking the Institute of Visual Art, in the city of Palermo (Holly-wood, 2001). Cattelan's work has been the focus of many solo exhibitions in the United States and Europe, at various institutions including Le Consortium, Dijon, France (1997); The Museum of Modern Art, New York (1998); INOVA, University of Milwaukee-Wisconsin (1998); Kunsthalle Basel (1999); and the Museum of Contemporary Art, Chicago (2001).

...........................

This interview took place in Yokohama in September 2001.

Hans Ulrich Obrist:

To start with, it would be interesting if you could tell me about some of your unrealized projects—projects that were too big to be built, too small, or simply unrealizable, unfeasible, or abandoned.

Maurizio Cattelan:

Most of them weren't too big, they just weren't accepted. They were rejected. Every project involves an exchange: you win something, and you lose something else. I never come up with a finalized project: I start with an open scheme and I try to scale it to the situation in which I'm working. One of the projects that was refused was the *Nazi Rally* [proposal] for Sonsbeek 93 (Arnhem, 1993).

HUO:

What happened?

MC:

Nothing, really. The curator started screaming on the phone, saying, "Do you know what you are talking about with the *Nazi?*" At the time, I couldn't really say a word. So, I had my knuckles severely beaten. I'm sorry, but that's life! I was beaten up by my mother for twenty years, so I was used to it in a way.

HUO:

What was the project exactly?

MC:

She said the issues were too delicate. Basically, I wanted to advertise a Nazi skinhead rally, a fake one. The project was going to be posters, flyers and handouts disseminated all through the city, announcing this imaginary Nazi skinhead meeting. It was a way to use information to spread fear: it was a psychological lab in real life.

HUO:

Are there other unrealized projects?

MC:

There is the project for Stefano Basilico, the [former New York gallerist].

HUO:

This one was published in Unbuilt Roads *(1997), the book that I edited with Guy Tortosa. Your idea was to make Basilico into a living sculpture.*

MC:

Yes, more or less. Stefano Basilico had worked for Ileana Sonnabend and her gallery for ten years. Everyone in New York knew it. So, the idea was to have Basilico wear a costume for the duration of the show, and the costume would have been a puppet of Ileana Sonnabend. It was a very complicated dress, a sort of carnival costume: it would have seemed as if Ileana Sonnabend was carrying a little Stefano on her shoulders.

HUO:

And why did it remain just a project?

MC:

Basilico said that the piece was too much about him. To me it was more about the idea of moving the office into the exhibition: it was a way to expose the dealer instead of the art. He would have had to work all day in that costume, doing his normal business at the office.

HUO:

These projects all seem to deal with violence...

MC:

There was another one that was refused. And it was for a group show about violence at Andrea Rosen Gallery. I didn't want to show an old piece, so I said: "Okay, I can give you something else, something new." I always like exhibitions to be a public rehearsal, like a trial and error process. So I made a new project, but they refused it. The idea was to have a dog on a leash: the leash was to be as long as a portion of the gallery, so when you entered the space, you got the impression that the dog was running towards you. I wanted a very mean, aggressive dog.

HUO:

Was it to keep the visitors out?

MC:

No, they could walk around the gallery, but they would be afraid of the dog: it was again a form of psychological threat.

HUO:

So far you have spoken about projects which haven't been realized because of resistance or rejections. Have other projects been too big or simply unrealizable? Dreams projects?

MC:

It's not about scale. The point is how you can get other people involved. And most of the times these projects are more interesting as unrealized ideas. I'm sure most of them would be a total disaster if we actually made them. Once in a while we put a lot of effort into not making anything. It's an exercise in loss.

HUO:

Tell me about these ideas then.

MC:

Well, there is *The barking birds*: I want to teach Indian birds how to bark. And then there is a project with a small goldfish. We're having a two-dimensional aquarium built: the idea is to have a goldfish in there since the day it's born. So it'll have to adapt itself to the environment: it'll have to grow as a flat fish, a two-dimensional creature, like a spontaneous genetic mutation. It's about finding out how far you can go to adapt yourself in a hostile system. Another idea that somehow had to do with hostility was the project for St. Martin's College, which of course was refused: I wanted all the teachers in the school to wear underwear in public for one day. And the students weren't allowed to laugh. There was

a system of punishment for the students who laughed at the teachers. It was about the idea of respect and power, like an upside-down day, in which roles are subverted and exchanged.

HUO:
Would you say that these are utopian projects?

MC:
No, it's more about portable Utopias. It's like admitting you can't actually create Utopia: you can't really imagine a brave new world. We are bound to work on smaller systems. The idea of the animal learning to speak another language is simply about survival. It's a test to see how flexible we are: maybe that's Utopia today. The margins of freedom are smaller and smaller, and we simply have to adapt.

HUO:
Why do you say "we"? Who's "we"?

MC:
Maybe my Utopia is schizophrenia, enjoying the symptoms of schizophrenia; that's my own or our own personal project.

HUO:
How is it a project?

MC:
Well, that's the rumor.

HUO:
Let's talk about rumors then. The conceptual couple rumor/information is crucial to the understanding of your work.

MC:
Some artworks come with a story, and you never know if the story is true or false. I always tell this story that my pope wasn't supposed to be lying down. He was meant to be standing, and then we spread the rumor that it was a last minute decision to change the position of the sculpture and throw in the meteorite. I don't even know if this is exactly a rumor. It has to do more with misinformation. I like to package artworks with an enormous amount of fake information, so that at the end there is no truth.

HUO:
Can you give other examples illustrating this attitude?

MC:
Well, my interviews for example. They are often made by cutting and pasting other sources. Actually, I never do my interviews myself. I have someone else doing them, so there is no truth, just confusion, or different degrees of interpretation. But the packaging

must be perfect: misinformation has to be built very effectively, with the same system that information itself traditionally uses. We replicate what's already there: you learn a lot from copying. You copy the format, but you slightly bend it to insinuate confusion, and to multiply perspectives.

HUO:

So we go back to schizophrenia.

MC:

I don't know if it's schizophrenia. Maybe schizophrenia isn't that funny or interesting: maybe it's just tragic. I think of this idea of the interviews as a personality made up from other people. It's an exploded personality. It's weaker, and fragmented, but more adaptable.

HUO:

Let's be concrete and discuss works. We can start with the two working mini-elevators for the Yokohama Triennale 2001 (Untitled, 2001). Can you tell me a little bit about them?

MC:

I always start with an image, never with a meaning. First you have the image, and the image must be strong enough to stand by itself. Then you sit down and try to discuss it. Many of my pieces go through a test before being shown. I talk to a lot to friends and other people: we discuss the idea, I show them the image, I think about their ideas, and I edit and throw away lots of projects. And that's when meaning comes in, when people start projecting new ideas on the image. Sometimes when you are preparing the press release for a show, you use the same words a friend used to describe a piece. Some other times you steal ideas from others, you copy press releases or statements. To me, content and meaning are constructions; they are built through a process; they are never a given.

HUO:

But what about the elevators?

MC:

People keep asking about the elevators and I really don't know what to say. Someone said it's a house for the "Mini-Mes." Or maybe it's about replicating your own personality in a smaller space. Someone else said it's about the fear that elevators stop, or claustrophobia. Or maybe it's about an endless replication of what is already there. Maybe it's about working without really doing anything.

HUO:

"Working without working" is a very Alighiero Boetti idea. You met Boetti, didn't you? At least, I heard rumors (precisely) about a meeting between you, Boetti, and Jenny Holzer in Venice.

MC:

Yes, that was 1990. I was visiting the Biennial and Jenny Holzer was representing the United States in the American Pavilion. She made all these posters with her truisms. I went in and Boetti was there. I loved his work, so I started talking to him, and at the time I had this idea for a form of collaboration: I wanted artists to add new things to someone else's artwork. So I told him about it and he picked up a Holzer poster, and he just scribbled "NEVER SAY BULLSHIT" at the end of her truisms. And he signed the poster, as if it were his own work. And that image always stayed with me: the idea of simply appropriating someone else's work. He was a great conspirator in a way, but very generous too. To me, instead, the idea of not working always had to do with the fear of failure.

HUO:

For the World Question Center, a project that he started in 1971, {James Lee} Byars asked lots of different people to send a question. I believe even the Dalai Lama wrote one. Cedric Price's question was: "How can we learn to make failures?" What exactly is your "fear of failure"?

MC:

I have been a failure for most of my life. I couldn't keep a job for more than two months. I couldn't study; school was a torture. And as long as I had to respect rules, I was a disaster. Initially art was just a way to try a new set of rules. But I was very afraid of failure in art as well. I even wanted to start a university of failure, a way to teach failure. Maybe it was just a way to insinuate weakness in a system that is obsessed with success.

HUO:

How was this university supposed to work? Did you go that far in terms of conceptualizing it?

MC:

I don't know. It never really started. It was a failure in that sense, from the very beginning. But there was the *Oblomov Foundation* (1992), which in a way was an institution to teach failure.

HUO:

In what sense? It was a project through which you raised funds to subsidize market-saturated artists as long as they agreed to curb their production.

MC:

It was a scholarship. The point was to get money from different donors and trustees and give it to an artist who would accept not to exhibit for a whole year. So you would get the money, but you had to disappear from the art world.

HUO:

How many times was it awarded?

MC:

Actually, it was never awarded, because we couldn't find an artist who wanted to accept the grant. It was a dangerous deal: we were giving money to an artist so that he or she could fail. In the end, the story says I kept the money. Well, I didn't keep it: I used it.

HUO:

What did you make with it?

MC:

I don't remember. Maybe I bought lollypops, or opened an orphanage... Money is not the issue. It's really about what you make with it. Many times these projects generate money that can be transferred and used somewhere else. Like *Permanent Food* for example...

HUO:

... the magazine that you founded with Dominique Gonzalez-Foerster.

MC:

Yes. Sometimes museums want a show and they want to do a catalogue, and I try to convince them to put the money elsewhere. That can pay for *Permanent Food*. Sometimes it's Franck [Gautherot] at the Consortium (Dijon), sometimes I find other people to sponsor it. It's all about the distribution: you gather the money in one place and you put it somewhere else. It's a family business in this sense.

HUO:

How did Permanent Food *start?*

MC:

I think Dominique found the name. We were doing it together at the beginning. So she had the name *Permanent Food*. Sometimes you only need a name: you can do incredible things with just one name. It's like creating an authority or a brand. So we had the name, and then came the magazine.

HUO:

Why did you want a magazine?

MC:

I wanted something that I had never had before. That was it. I wanted a magazine.

HUO:

Did you decide right from the beginning that the magazine would involve other people?

MC:

It wasn't really a decision. We wanted to have lots of sources and contributors, as any other magazine. And the idea of asking different people to send us the pages directly was the easiest way to create something that would resemble the structure of a magazine, and still cut down on all the expenses. So from the very beginning we knew we wanted *Permanent Food* to be a second-generation magazine, something that grows by taking what's already there. And I also wanted to have a magazine without personality. So the more personalities were involved, the less the magazine would have looked like the product of a single person. Then the evolution of *Permanent*, the permanent evolution has been dictated more and more by my addiction to images. Now *Permanent Food* is more a collection of images chosen by Paola Manfrin and by myself.

HUO:

Dominique is no longer involved?

MC:

She left the magazine after the second issue, because she's more like a start-up person in a way. She has a fantastic energy and she really likes adventure. For her it was more like establishing a trend or launching a firm. To me, instead, it's about setting some rules and then following them forever. When you find something really good, you have to continue to the end. If you do a magazine and you only do three issues, it's no longer a magazine. A magazine is something with fifty issues or more. I never thought of using *Permanent Food* as a sort of dream: it's a magazine, and it must work as a magazine.

HUO:

It's interesting the way that **Permanent Food** *was your own, but it never really was, because it was made by others. There is always this struggle between what you are and what you refuse to be: you make art works but you don't actually make them—someone else makes them; you do interviews but you always get someone else to do them...*

MC:

I don't think it really matters who does what or who signs it. The content and the image are the most important thing. It is more about spreading content, whether it is a rumor, an idea, or an image. In the end, everything belongs to everyone.

HUO:

Isn't there another link to Boetti here? I see Boetti as the European Andy Warhol; both were obsessed by the idea of distribution.

MC:

I would say that Boetti was the physical materialization of generosity.

HUO:

And what about you: is your work about generosity or exploitation?

MC:

It's more about indicating. You have a library and sometimes you prefer one title instead of another. So everything is already there, and you move things around, trying to come up with new connections. It's about a re-ordination of reality according to your tastes and experience—it's a virtual library in a way. Also, I always thought that in the end, Warhol was producing and instead Boetti was celebrating the end of production. One is a factory, and the other is not doing anything: he is trying to demonstrate that there is no production. Those were probably the Utopias of the '60s: either stop working, or just work more and more till you fill up the world with new objects and new wealth. Even Warhol goes back to that same idea.

HUO:

You have also worked quite a lot in a collaborative mode.

MC:

That's because I am like an empty box. I don't know if it's about humility or generosity. I can't do anything without others: I'm empty, useless. But I don't know if it's collaboration. It's an exchange, a form of editing. I don't think that in my work the accent is on collaboration; it's more on the process of exchange. Then the piece is there, and it belongs to everyone. It's something I do in an intuitive way, simply because I couldn't work otherwise. Intuition is a kind of nose. Without your nose, you can't do anything. My nose is a great part of my job, and I guess it shows.

HUO:

I recently spoke with Philippe Parreno and we agreed on the statement: "The '90s have been a decade with a prevalence of collaboration." Ten years after there's a tendency almost towards the opposite: nowadays there are a lot of individual things happening and less and less collaborations. What do you think?

MC:

I think that Philippe has always been on the track of collaborations, even in the years leading up to the '90s. I have always been seduced

by this idea that together we can be stronger, but every time I tried it, in the end I realized that it didn't really work for me. I never understood the stories about movements or waves. Sometimes I find myself inside a wave, and yet I just know I'm in the wrong place. It's hard to explain because I do collaborate a lot, and re-adjust my ideas when I talk to people, but in the end there must be some control. You need to be able to say yes to this or no to that. I need to do the editing myself. In that sense, I feel more and more like an employer, and less and less like an artist.

HUO:

But you did collaborate with other artists?

MC:

I did something with Philippe (*CPC or La Dolce Utopia*, 1996), for "Traffic" (Capc – Musée d'Art Contemporain, Bordeaux, 1996). But the project didn't really work out. We wanted to do a TV only for one person, a sort of big contradiction in terms of what a TV means, and the production was supposed to take place directly in the exhibition space. Maybe I simply find it difficult to work with another artist. But I like exchanging ideas and information: there is always someone who can do the job better than you. It depends what you are working on: you have a project and you go out and look for a consultant, a specialist, an architect, a manufacturer... I don't know if it's collaboration, or just a form of specialization.

HUO:

It's a pooling of knowledge.

MC:

Yes, but you try not to come up with just an average of knowledge, but with something more interesting, something that maybe can even be new to all the people involved.

HUO:

Is it important that you expose yourself in the end?

MC:

If it has to be the case, it depends on the project. At times, it makes sense to leave it anonymous. Now that I'm more easily recognizable, I keep using myself as the face or the signature, but it could really be someone else's.

HUO:

So you're like the packaging?

MC:

I go for the easiest solution. There must be confusion and different perceptions, but in the end I always need something quite simple

and direct. So I expose myself, because it's the most efficient way to do it for the moment, the most direct, and the simplest.

HUO:

When do you say to yourself that a piece works?

MC:

I don't know. I can feel it when something works.

HUO:

In the nineteenth century, Théodore Géricault's Radeau de la Méduse *(Raft of the Medusa, 1819) almost triggered a state crisis. In some ways your crushed Pope {La Nona Ora (The Ninth Hour), 1999} reiterated this with the protest of the Catholic League in Poland.*

MC:

I did a piece in 1994 which was made of rubble from a terrorist bombing in Italy. It didn't generate a state crisis but it was attacked by different fronts. And something similar happened with the Pope in Poland: the sculpture became an issue to be discussed in the Parliament. But I think art can no longer generate those crises you are referring to. I mean, I see it in my work as well; there's been a period when my work carried only a single issue at a time. Now the work is more strictly controlled and yet looser. It's coordinated, but more carefree. So what I do now is more difficult to pin down. It doesn't come with a single message or a caption.

HUO:

It's more ambiguous?

MC:

Definitely. Not giving a precise direction to the work means you are giving it a longer life. So the more issues it incorporates, the better. Maybe it's no longer time to create crisis, but rather to reflect crisis in the piece itself. The piece has to reflect a certain complexity.

HUO:

Do you think your work was also more political at the beginning?

MC:

I'm not a political person. I'm as political as anyone else. Since the very beginning, my work has been about the politics of the everyday, the struggle of getting by.

HUO:

Do you think that the movement from very specific issues to more ambiguous works participates in a larger change or is it just a personal thing?

MC:

Probably both. I always try to find some excitement in what I do, and I'm always afraid of repeating myself. People sometimes say that I have no style, but it's simply because I'm trying to keep up

the enthusiasm, and you can't be enthusiastic if you work on a formula. Initially I believed you had to work in a more straightforward manner, like do this, and then get to that, and then move a little further... I thought that's the way you are supposed to grow. But then I've discovered that there is an incredible new power in different forms of communication, like in advertising for example. It was something I was attracted to from the very beginning, but I learnt about it very slowly. So now, I see that art has a great potential to refer to a broader debate, to go out there and reach an incredible audience. And if my work can't do that, well, it's useless.

HUO:

We were talking about politics and then you start talking about communication: are they related? What's your understanding of the public? Do you feel like you need to talk to anyone?

MC:

No, you don't have to talk to everybody. In fact, you don't talk to anyone. But even if they don't understand what you're saying, it's important to be out there and be present. When you watch a movie, you see it's very easy to talk to people, so why shouldn't we want to do the same with art? For some reason there is always this fear or this need to keep this position of being an intellectual, removed from what people are thinking of or talking about.

HUO:

What kind of audience would you like to reach?

MC:

I haven't yet really realized which audience we can reach. But if we have the word audience, it means we can use it. It's okay to try and go out there and talk to everyone. In a sense, the real meaning of your work is simply what people are going to make of it. Art is often a matter of misunderstanding, because people can do whatever they want with it. I've been thinking a lot about religion: it's the perfect communication tool—it can be understood by almost everyone, it's often visually striking, and it has no meaning by itself, while it carries an infinity of sense.

HUO:

Can you tell me a little bit more about this misunderstanding dimension?

MC:

There is a misunderstanding when you really want to say something, and people don't get it. For me the misunderstanding is much stronger than the idea I started off with.

HUO:

It's again a way to spread confusion?

MC:

I just want to offer different points of views and angles to look at my work. It's a trick maybe, to find a personality. My great problem is that I don't have a personality. And I have to find ways to get by. We all read magazines, and if you happen to read an article about someone twice, the first time you read it because you are curious, but the second time you just say, "Come on, give me a break." I have to change ideas and points of views all the time.

HUO:

So you create confusion so as not to get bored?

MC:

Yeah, probably. It's a daily struggle against boredom.

HUO:

It seemed it started early, and that art was at first another station in that struggle. What were the beginnings before the beginnings?

MC:

You begin when you are born and then you die. There is no great beginning. Every time you try to understand where you are and where you are going. You try to make your trip more pleasant and that's it. The train I was on was going in a terrifying direction. I couldn't control my trip, so I had to step down. Get off the train.

HUO:

But before you were working as a designer?

MC:

I was doing all kind of jobs, terrible jobs. And then, yes, I found myself working as a designer.

HUO:

Were you working in a studio?

MC:

No, I started making furniture for myself, in my apartment. I was unemployed for a while.

HUO:

What was this apartment like? You mentioned it very mysteriously many other times. What exactly happened in there? Were those your first exhibitions?

MC:

No, my apartment was completely empty and I needed a table, a chair—the basic stuff that you need for an apartment. This was in the mid-'80s.

HUO:

In Milan?

MC:

No, this was in Forlì. It was such a big apartment that I decided to close one room with bricks: I didn't have enough furniture. It was human necessity. If you are living in a cave, you probably start making utensils. It was a basic need.

HUO:

When did you first start working with non-functioning objects or non-objects, something that more resembled art?

MC:

When I went to Milan I realized that I was somehow interested in it. I started to produce different things, and I realized I wasn't that interested in working with objects—it was almost painful. It was like going back to school or just like having another job. And I needed to change that. I couldn't take it anymore: I needed to change.

HUO:

The theme of necessity is recurrent and always present.

MC:

The fear of going back to poverty is a great theme for me. I mean, it's not a theme; it's pure fear, terror. It's my waking nightmare. I also fear going back to a regular job, back to a world where no part of yourself is allowed to be alive and you are trapped in a process in which you give energy away to produce something that doesn't mean anything to you. Again, with my nose, it took me ten years to realize that the problem wasn't me. The problem was the job.

CLADDERS, Johannes

Johannes Cladders was born in Krefeld, Germany, in 1924. He currently lives in Mönchengladbach. Cladders worked as a freelance journalist and art critic before serving as a scientific assistant at the Kaiser Wilhelm Museum and Museum Haus Lange in Krefeld (1957–1967). From 1967 to 1985, he was the director of the Städtisches Museum Mönchengladbach where he organized the first museum retrospective of Joseph Beuys ("Parallelprozeß I" {Parallel Process 1}, 1967) and a series of pioneering exhibitions of artists such as Robert Filliou, Marcel Broodthaers, and Daniel Buren. He collaborated with Harald Szeemann on documenta 5 (Kassel, 1972) and he was the curator of the German Pavilion at the Venice Biennale (1982–1984). "He was one of the most inspired museum directors of the '60s–'70s art world," Daniel Buren once said of Cladders.

........................

This interview was recorded in Krefeld in 1999.

Hans Ulrich Obrist:

How did everything start? How did you get into making exhibitions and what was the first exhibition you organized?

Johannes Cladders:

I actually had a very conventional museum career as an assistant at the Kaiser-Wilhelm-Museum, as well as at the Museum Haus Lange, in Krefeld. Under the leadership of Paul Wember in the '50s and early '60s, it was the only institution in Germany that actually had the courage to show contemporary art. It was a marvelous education for me, and it gave me the opportunity to make a lot of contacts with artists, especially with the Nouveaux Réalistes and all the Pop artists, who were very popular at the time. In 1967, the directorship of the Städtisches Museum Mönchengladbach became available and so I applied for it, and from that point on, I was able to realize my own ideas independently. The first exhibition I organized there was of Joseph Beuys. At that point, Beuys was around 46 years old and he had never had a major museum retrospective. And it hit like a bomb. Suddenly, the institution was known well beyond Mönchengladbach.

HUO:

From the beginning, your main interest was for the very contemporary?

JC:

From the start, my focus was always on the present—the immediate present—that I considered crucial to the development of art. This means that I never made any concessions to the taste of the public, or gave room to derivative art, with any of the exhibitions that I organized. After all, with all due respect to the work of artists, art must move forward! I always tried to discover where the innovative ideas were—where the new ideas were coming from—in the sense that "art defines art." It was from this that I developed my program. The next exhibition—because finances were tight—meant finding opportunities closer to home. I showed the cardboard works of Erwin Heerich.

HUO:

Today the Städtisches Museum Mönchengladbach is also legendary for its cardboard box catalogues; for instance, for the Robert Filliou and George Brecht show ("La Cedille qui sourit," 1969) the box took the form of a large matchbox containing leaflets, loose paper pages and objects such as metallic screws. I know it started with the very first show that you organized there— the Joseph Beuys show. How did it come about? What was your idea?

JC:

I made a virtue of necessity. The financial situation was not very good, and I only had a small budget, but I did not want to produce flimsy pamphlets. I wanted something for the bookshelf, something with volume. A box has volume. You can put all sorts of things into it that you have money to buy. With this in mind, I went to Beuys and told him that, for his catalogue, I had a printer that would print a text and reproductions for free, though only of a limited size and not more. This size was not enough and was way too thin. "What can you contribute?" I asked him. He promised me an object made out of felt, which he would make. With that, we almost had the box filled.

HUO:

The decision was made with Beuys?

JC:

He agreed with my idea to make a box. I talked to him about the form of the box—I mean the measurements. We did not want the standard size, but something unusual. It was then that Beuys defined the dimensions of the box, which we kept for all future exhibitions. I also remember telling Beuys that I wanted to print an edition of three hundred. Beuys said, "I don't like that at all. That's a strange number. It's too smooth. Let's make it 330. 333 would be too perfect." So, I always maintained an irregular number, even for larger editions.

HUO:

It's interesting how similar to the catalogues this interim solution was, in that you also had to make a "virtue of necessity"—something that was used to such effect by so many artists. Over and over again, artists have told me how important the circumstance of this space was to them.

JC:

It really was important. In the first place, very young artists did not have great *œuvres* in those days, that is, bodies of work sufficient enough for a big retrospective. Secondly, in most cases, they had never had a solo exhibit in a museum. Usually, they had had experiences with commercial galleries only, where space was typically restricted. Thirdly, there was a tendency among artists to avoid the sanctified halls of museums altogether. The inclination to go into a museum, into those "sanctified halls," was not widely developed. There was more of a tendency to avoid them. Though our institution was technically and legally a museum, it was in many ways more comparable to a private enterprise in someone's house—a fact that has something to do with the atmosphere the place had and the way I ran it. I made decisions that I was not theoretically entitled to make, but nobody seemed to mind. There were no committees to decide what artists to show or when.

HUO:

Bureaucracy had not contaminated the museum world yet...

JC:

No bureaucracy. Because of that, I had no difficulty making contact with artists who were skeptical of the museum as an institution. In other places, there were aggravations or things that did not even get off the ground, but I did not have any problems.

HUO:

It's under your directorship that the museum moved into the new building. The first exhibitions happened in a provisional space.

JC:

When I came to Mönchengladbach, the museum existed only as this provisional space. I went there, though, because the city had stated its intention to build a new museum. The site for it had been under discussion for a long time. I went to Mönchengladbach in 1967, and the location was finally decided on around 1970. In 1972 I was able to approach the architect Hans Hollein, and the city commissioned him to design the museum. The planning lasted until 1975, and the building was finally finished in 1982. So, I was in this "residential" space for fifteen years.

HUO:

Would it be right to say that Mönchengladbach had the advantage of being more of a laboratory situation than a representational situation?

JC:

Exactly!

HUO:

When I talk to Harald Szeemann or to other curators working in the '60s, they often say that there were only a few interesting places in Europe at the time. In your eyes, which ones were they?

JC:

Amsterdam, Bern, Krefeld. But I have to add that the Kaiser-Wilhelm-Museum in Krefeld closed for renovation soon after I left. The Museum Haus Lange shut down because it did not belong to the city, but actually to the Lange heirs, who decided not to extend its lease. Therefore, exhibitions were no longer held there. So, the only place in Germany that was internationally interesting was thus out of commission for a time. This was my chance to relieve Krefeld of its solitary responsibilities, as it were, which I promptly did.

HUO:

Were there other museum directors involved with contemporary art?

JC:

Not really. There were a few: Werner Schmalenbach in Hannover, for example. But they all showed what was already to society's taste. Taking care of art and making a contribution as a museum to the definition of the term "art"—that nobody did. Their exhibitions served other aims than the ones in Krefeld and Mönchengladbach. I did not want my work to degenerate into a business. You know: I have such-and-such budget, I can therefore only organize a fixed number of predetermined exhibits set to run one after another. No, some of my exhibits occurred very spontaneously. Things happened from one day to the next. You met with particular artists you had known for some time, and asked them at a certain point, "Do you have time next month?" The question of money did not really play a role. Of course, one needed money, but it was improvised.

HUO:

Alexander Dorner's writings on museums and exhibitions deal with this kind of improvisation.

JC:

I was already interested in Dorner in the '50s because he was one of the few people seriously thinking about the function of museums. He was somebody who did not just pass through an institution with-

out asking any questions, but who developed a comprehensive idea, which I could follow. I have always believed that it is the artist who creates a work, but a society that turns it into a work of art—an idea that is already in Duchamp and a lot of other places. In most cases, museums have failed to see the consequences of this notion. I have always considered myself a "co-producer" of art. Now, do not misunderstand me. I do not mean this in the sense of dictating to an artist: "Listen, now paint the upper left-hand corner red!" but rather in the sense of participating as a museum—as a mediating institution—in the process that transforms a work into a work of art. So, it was always clear to me that I did not need to do anything for works that had already been declared as art by common consent. Instead, I was interested in those that had not found that consent and so they were still *works*, not *works of art*.

HUO:

Besides Alexander Dorner, were there any other figures what influenced you?

JC:

Not off the top of my head. Willem Sandberg, though, was a great influence on me. I think this is true for many others, as well.

HUO:

Why was Sandberg so important?

JC:

Sandberg excited me because he totally turned the definition of a museum—that was so tightly allied to the one of art—upside down, even more than Dorner. His ideas, which he disseminated in the publication *NU* (*Now, In the Middle of the 20th Century*, 1959; *Now 2*, 1967), and which caused such a stir at the beginning of the '60s, abandoned the old notion of the museum as a permanent exhibition. Artworks should be warehoused, he said, and brought out for specific exhibitions and shown in a leisurely fashion. All institutional conventions governing art's veneration should be given up, and it should feel as if you could play ping-pong in the museum right next to the walls with the paintings on them.

HUO:

Art and life?

JC:

To bring art and life completely together and, therefore, to give up the institution of the museum—at least as it is traditionally understood. Sandberg's ideas suited me very much, although I adjusted them to a degree when I started in Mönchengladbach.

HUO:

How did this transition come about?

JC:

It was initiated by the controversy over the term "museum." I had problems with a notion, common in those days, which held that problems with the museum could be solved by simply replacing the word with something else. Analogous to the term "anti-art," the notion of the "anti-museum" was developed to reinvigorate the concept of the museum. But, despite the prefix, I did not want to completely abandon "museum" as a term. This was probably my main difference with Sandberg. Unlike him, I tried to explain my position within the context of the history of the museum and of its development. However, in a publication, I said I was not against playing ping-pong in a museum, but thought that the paintings should be removed from the walls first, since they would be a distraction.

HUO:

In an interview I did with Pontus Hulten, he also talked about art and life in relation to the museum—in particular the Kulturhuset, which was very important in Stockholm at the end of the '60s as a pan-disciplinary utopian idea. It was also about the blurring of art and life through the integration of things such restaurants, interactive rooms, workshops, and laboratories. However, he said that, for him, separation was always a very important aspect of the Kulturhuset concept, though one that was never actually realized. He later played with this notion at the Centre Georges Pompidou, but still, the collection was always the priority. This is similar to what you just said, "One can play ping-pong in a museum, but while the exhibition is somewhere else."

JC:

Exactly. This was basically my position on separation. I still wanted the museum, but I said that just because you put another label on a bottle doesn't mean that the wine inside changes; it is the wine that needs to be altered. It is the inner attitude that we have to alter. We finally have to stop defining art as only those objects that have been accepted as art by society. We have to concentrate on allowing art to evolve through how it is received. It did not help me bring art closer to life simply by setting up a cafeteria or a playground or a workshop. This will not resolve the question of the museum. The museum question can only be resolved through mediation. Our responsibility, on the one hand, is to make works into works of art, and on the other hand, to preserve works that are already works of art, and to keep them from becoming antiquated. This was my view. As a result, I wanted a conservative museum and I chose the term "anti-museum," not because I understood "anti-art" to mean something that could never be art, but something rather that invites the per-

manent renewal of art. Not negative, but a very positive phrase. A process of constant creation, so to speak. Although the institution itself does not make works, it takes on the role of the viewer, eventually making social consent possible and thus making works of art.

HUO:

Were there artists who were important to developing your notion of a museum?

JC:

Yes, there were quite a few. The question of the museum was a major topic of discussion in the art world. I especially remember Daniel Buren and Marcel Broodthaers in this regard. I generally would do only one exhibition per artist, because I did not want to work like a gallery and show the same artist over and over again. I did exhibit Daniel Buren twice though ("Position/Proposition," 1971, "Von da an...," 1975).

HUO:

Looking at your catalogue boxes, it becomes obvious that there were hardly any group shows. Could you say something about this? In this regard, I also found your statement for documenta 5 (Kassel, 1972) very interesting. Harald Szeemann invited you to do a section in 1972, and your statement was "Deepening and not extending." You deepened individual positions and showed Broodthaers, Beuys, Filliou, and Buren among others.

JC:

Harald had the idea of a section called "Individual Mythologies," and asked me if I would do it. I told him, "These are terms I can no longer work with as you have conceived them. I consider every artistic work an individual mythology." I was not interested in baptizing certain styles or movements, a common practice among curators. Take a term like "Nouveau Réalisme." It did not come from Jean Tinguely or Yves Klein or someone else associated with the group. They were lumped together in a group that never was a group at all. I wanted art to stand for itself. I always looked at art as the solitary effort of individuals who make works. I found it important to present these works as purely as possible, which was only possible in a solo presentation. I never thought much of exhibitions in which twenty artists are shown with three works apiece. This does not provide a clear picture of an artist. The primary focus must be on works that represent an individual. This is the reason why I rarely organized group shows or thematic exhibitions.

HUO:

Could you talk about your first Broodthaers exhibition ("Film als Objekt— Objekt als Film," 1971)?

JC:

The Broodthaers show took place around 1970 or 1971. It dealt with the subject of "film as object—object as film" and how both terms turn into each other. We screened all the films he had made up to that point and exhibited the films' props—a chair, map of the world, pipe, calendar pages—as art objects on the walls.

HUO:

Was there a dialogue with Broodthaers before the exhibition?

JC:

A very long one.

HUO:

Does this mean your exhibitions originated out of intense dialogues with artists?

JC:

Yes, every exhibition. Even when they came about spontaneously, the dialogue had already begun some time earlier. I had known many of the artists for a long time.

HUO:

What do you think of the increasing acceleration of the art world? The number of exhibitions is exploding!

JC:

This is basically the curse of an evil deed. People, whom we have already mentioned several times, such as Szeemann and Hulten, were very successful. Whatever they did was news. Nowadays, museums go to enormous lengths to get publicity, something that just was not necessary back then. Scandal went with every new exhibition, which is inconceivable today. Today, many people are trying to profit from these earlier successes by saying, "We have to do this, too." So now—and here I am exaggerating—we have a museum of contemporary art in every town and village. The available material gets quickly used up unless you want to exhibit every local artist. Whoever is of interest at the moment will be approached by twenty-five institutions. Before, the same artist would have been asked by three, at best.

HUO:

The problem is that the accelerated pace of art institutions is often totally detached from the pace of the artists.

JC:

So it is. Institutions have become disconnected from artists. They celebrate themselves and their patrons. Their primary function, transforming a work into a work of art, has become obsolete. The institution confirms its own identity as an institution, and thus the question of the number of visitors plays an increasingly important

role. What is this all about? The quality of a work cannot be measured by the quantity of people that visit an institution. One example is Holland. There, anybody who claims to be an artist gets financial support. But not one single artist has emerged from this. This is not the way to establish an artistic existence.

HUO:

At some point, you decided not to continue with this kind of museum. What were the reasons for your decision?

JC:

No, I think I could have mastered the matter of management. Originally, I had intended to use the opening of the museum in 1982, as an occasion to say goodbye. Then I decided not to because I thought everybody would criticize me for bringing something about that I still had not proven could work. I stayed another three years to do just that. That was one reason. The other reason really came out of the art itself. I tried desperately to find artistic innovation, in the sense of art that defines art. I did not simply want to open a "stable" of artists like some art dealers do. The "business" of art overwhelmed me from all sides, and I was not willing to participate in it. I did not see sufficient artistic potential there.

HUO:

What do you think of the way that artists in the '90 picked up on things from the '60 and '70?

JC:

By 1989, I had been out of the museum for a long time. It is probably a function of my age that I recognize only too well appropriated or recycled elements in art. I am not saying that this does not lead to anything of value. An artist does not just copy things, but uses them as starting points to develop into something else. I recognized this as early as 1960. There were a lot of attempts in Nouveau Réalisme to refer to Duchamp and the Dadaists. I do not fault them. Nobody "falls from the moon," as they say. Everybody comes out of a tradition.

HUO:

Were there exhibitions that you were interested in the '90s?

JC:

I was interested in Franz West, for example, who drew from a number of sources, from Fluxus to Nouveau Réalisme. But he also adds a strange Austrian Surrealism, which was not found in either of these movements. This brings with it a certain mentality, a world of experience, which played a strong role in Surrealism and which goes by Freud's name. I found this very intriguing. While Nouveau Réal-

isme and everybody who worked with trash—if I may put it so casu-
ally—was materialistically oriented, Franz West has come up with
an entirely different dimension that is non-materialistic in nature.
Nightmares are created that did not exist in Arman's work, for
example. These were new tendencies that I believe will last. No
longer the youngest, though still playing a dominant role in recent
developments, is somebody like [Christian] Boltanski. Younger
artists for me are people like Wolfgang Laib, Giuseppe Penone, and
Lothar Baumgarten, all of whom I exhibited in the '80.

HUO:

*Finally, a question about Hollein's building for the museum. You had
already done a Hollein exhibition in the '70s, and it was from this dialogue
that the building resulted. What kind of dialogue was it?*

JC:

The dialogue began with the preparations for an exhibit on the sub-
ject of death. At the time, we had the opportunity to discuss, in a
hypothetical way, the idea of a museum. When I was later given the
task of realizing the new building, I suggested that, instead of hold-
ing a design competition, we should commission an architect who
would develop the concept, from the first sketch on, in close collab-
oration with the museum staff. I suggested Hans Hollein. This was
the beginning. The whole thing is very complex and difficult to
explain. The service features of the museum were not a top priority.
From the cafeteria to the painting class, the lecture hall to the "ping-
pong room," I took the view that these were just service features, and
the construction of the building shows it. Nevertheless, we did not
want them on the margins of the museum, but embedded in it.
Everybody should feel that these are just services within the muse-
um. For that very reason, the cafeteria is only accessible from inside
the building. In most cases, cafés in museums nowadays are also
accessible from the street. I have always maintained that if you want
a cheap cup of coffee here, you have to run the gauntlet of the art
first. I also want to make clear that the architecture was not my cre-
ation. Hollein was the architect, not me. Every idea was his.

HUO:

*Your intention was to avoid what seems to be happening in many museums
today; namely, that their peripheral functions are becoming their main ones.*

JC:

I wanted to have it the other way around. While not neglecting
these peripheral functions, I wanted to reemphasize that there are
main functions, that a museum is a museum. Furthermore, I want-

ed a democratic museum. Everything authoritarian or absolutist is symmetrical. I wanted a museum that has no predetermined route. Moreover, I wanted confrontation, which does not mean having everything confront each other in the same room. I wanted more of a transparent view. For example, I see a work in a room devoted to a particular artist, and always have other views possible of works in other rooms, even if it is just out of the corner of my eye.

HUO:

No isolated white cubes?

JC:

Exactly. Furthermore, I did not want most things to be communicated verbally, but rather through architecture. The labyrinth served this. Whoever gets lost in a jungle remembers every single orchid that leads him back home because he says to himself, "I've already seen this before." I wanted a building with a little bit of the character of a jungle, where I could lose myself, and so be forced to find landmarks. I think that Hollein solved this problem remarkably well. Hollein also wanted to use certain prototypes from the history of architecture, like the dome of the Pantheon. Thus there is, for example, a small room with a cupola. This corresponds to the original one in the Pantheon, which is known to us, thanks to our education, as a legitimate cultural space. Everything shown in such a room gets consumed as culture, meaning it becomes part of the cultural discourse. I want works that most visitors would not consider works of art in an architectural context that makes people discuss them culturally—even if one possible result is that such works do not satisfy every individual need.

HUO:

This would be the primary function of a museum?

JC:

Yes, the primary idea of a museum, but supported by its construction elements. The museum is a non-verbal mediating system. The question of views, or the democratization (meaning: I have to decide for myself), all belong to this mediation system. I did not want to cling to any ideology that says that people have to get drunk on art. They can still enjoy their alcohol in the cafeteria, but they should be in the context of the museum and they should feel it!

CONSTANT

Constant was born Constant Anton Nieuwenhuys in 1920 in Amsterdam. He currently lives and works in Amsterdam. From 1939 to 1941, Constant studied painting at the Rijksakademie van Beeldende Kunsten and began his career as a painter. Together with other experimental artists including Corneille and Karel Appel, he founded the Experimentele Groep (Dutch Experimental Group) in July 1948. During a stay in Paris in 1946, Constant befriended the Danish artist Asger Jorn, with whom he founded the CoBrA group (Copenhagen, Brussels, Amsterdam) in November 1948. Constant moved to Paris in 1950, where he stayed until 1952. Following the demise of the CoBrA group after a last exhibition at the Palais des Beaux Arts in Liège in 1951, Constant's interest progressively shifted to architecture. Back in Amsterdam he worked together with architect Aldo van Eyck, together the exhibition "Mens en Huis" {Man and Habitation} at the Stedelijk Museum in Amsterdam in 1953, and he worked with Gerrit Rietveld on an apartment project. In 1958 Constant joined the Internationale Situationniste (I.S.) and developed, with Guy Debord, a theory of unitary urbanism in the group's review I.S. This resulted in a project called New Babylon, *a city of the future, for which Constant elaborated numerous models and drawings (1956–1974) that were widely exhibited in Europe between 1960 and 1974 in venues including the Museum Haus Lange, Krefeld (1964); the Kunsthalle Bern (1966); La Biennale di Venezia (33rd International Art Exhibition, 1966), and more recently Documenta 11, Kassel, Germany (2002). In 1969 he resumed painting.*

........................

This interview was recorded in Amsterdam in April 1999.

Hans Ulrich Obrist:

What is behind your shift away from painting and CoBrA toward your ideas regarding housing and the various projects related to New Babylon? *What were the key elements in determining that transition?*

Constant:

Right from the outset, the notions of unitary urbanism and an opposition to functionalism were very important for the Internationale Situationniste, and those concepts were very present at the time of its founding, in 1957, in Cosio d'Arroscia. I already knew Debord and a number of the other Situationists, including Gil Wolman, whom I had met at the congress in Alba, Italy, of the "International Movement for an Imaginist Bauhaus" (MIBI), which the Lettrists had joined and which was directed by Asger Jorn (First World Congress of Free Artists, Alba, 1956). It was Jorn who

invited me, and I entitled my contribution "Tomorrow Poetry Will Dwell in Life." All of us, including Jorn, were very interested in new forms of architecture and urbanism. At the time I was already very interested in architecture and urbanism; I was a friend of long standing with a number of architects, including van Eyck and Gerrit Rietveld. My ideas were already in place.

HUO:

So Asger Jorn was the linchpin between the Situationists and yourself?

C:

Yes. Prior to that, Jorn had suggested that Debord send me *Potlach*, the journal of the Internationale Lettriste, which came out on the occasion of the Festival of the Marseilles Housing Unit, where the Lettrists proclaimed: "To the housing unit, we oppose the vacant lot."

HUO:

What exactly was your position with regard to Le Corbusier? You refuted his dual approach to housing and the movement of people, based upon two separate systems?

C:

We were utterly opposed to Le Corbusier. He was the enemy. What I found especially funny was that *Potlach* turned against the festival in Marseilles, the housing unit, with all the artists on the roof. The artists were happy to take part in the festivities, and I was happy to see a group of young people turn against the festival and against functionalism. It was a true movement. It was like CoBrA, which, after the war and everything we had experienced, appeared like a new beginning for artistic creation. Before that, there was nothing—really nothing at all. It was a new artistic élan—a miracle, an enigma; I still don't know how it was possible that all of us—all us young artists—were able to come to any agreement. It was a spontaneous movement. Later I rediscovered something of that when I saw the reaction against Le Corbusier's functionalism beginning to emerge.

HUO:

Between 1958 and 1960 you were a member of the Internationale Situationniste, and it was in one of the very first issues of the journal I.S. (Internationale Situationniste) *that you launched the* **New Babylon** *project through a series of texts and drawings. Was the idea of actually building it ever present at all, even at the beginning?*

C:

I've never done things in order to carry them out. My interest in

urban planning—initially architecture, followed by urban planning—was as an artist. Debord and I undertook the writing of a text, which subsequently came to be known as the "Amsterdam Declaration" (*I.S.*, No. 2, 1958), in which we sought to provide an eleven-point definition of unitary urbanism. There was still no mention of *New Babylon* in our Amsterdam Declaration. The eleven points in Amsterdam were then discussed in Munich at the Situationist conference (1958) and were unanimously accepted. I then began to think that, as an artist, painter, and sculptor, I could start doing illustrations, drawing up plans, making models and descriptions like an urban architect. And it was then that I started doing my first scale models and constructions, presented through a series of photographs and texts in issues 2, 3, and 4 (I believe) of the *I.S.* I opened an office—called Unitary Urbanism—in Amsterdam with a few architects, who unfortunately accepted—unbeknownst to me, and for lack of money—a commission to build a church, and published several photographs of models in the magazine *Forum*, a Dutch architecture journal. Debord found out about it and immediately threw them out—as was his habit. Personally, I had no problem with what they had done. It was an architectural firm; they were utterly unfamiliar with Situationist issues, and hadn't the slightest idea that building a church was in contradiction with being part of the Internationale Situationniste [*laughs*].

HUO:

And how did the rupture between Debord and yourself come about? I read that the disagreement had to do with the fact that you argued that your research around New Babylon *prefigured a world that would be achieved neither by you nor by the* I.S.*, and that your work had to do with perfecting society rather than overthrowing it—which was of course Debord's very blurry objective.*

C:

It was above all for other reasons that I left the I.S. I had been painting for a long time—for 25 years by then. But at that time I was very anti-painting. I no longer wanted to be surrounded by these neo-CoBrA painters. And I thought at the time that it just wouldn't work between us. Now I think differently, because I have become a painter once again. But I still think that the Situationist movement and painting don't go together. However, Debord and I completely agreed that unitary urbanism could not be brought about without a social revolution—a revolution that would take place simultaneously or beforehand, but at any rate a revolution. Nobody thought about bringing it about.

HUO:

At the time of New Babylon, *did you consider yourself to be merely an architect?*

C:

I don't consider *New Babylon* to be an architectural project—not in the slightest. In my eyes, it is an illustration done by an artist—a painter or a sculptor—the illustration of an idea. We had planned an exhibition at the Stedelijk in Amsterdam ["Die Welt als Labyrinth" (The World as a Labyrinth), 1959], and we had planned a three-day *dérive* through the city of Amsterdam. However, the museum's director cancelled the project. But I thought even that was already too much. Later Debord admitted that he was happy that the museum director had ditched the project. So was I. The fact that things were cancelled at the last minute was very Situationist. And it was also very Situationist when the Centre Pompidou put on an exhibition—some ten years ago now—of the Internationale Situationniste, and the day after the opening, the museum staff all went on strike, shutting down the Centre Pompidou for the entire duration of the exhibition ["Sur le passage de quelques personnes à travers une assez courte unité de temps: à propos de L'Internationale Situationniste 1957–1972" (On several people's passage through a relatively short period of time: on the Internationale Situationniste 1957–72), Centre National d'Art et de Culture Georges Pompidou, Musée National d'Art Moderne, Paris, 1989]. People I knew had come all the way from Italy to see the exhibition. Highly Situationist, I find.

HUO:

Do you still think that New Babylon *is destined to remain an inapplicable model?*

C:

Yes. I always said that *New Babylon* would be created by "New Babylonians." I wrote that text before I even started on "New Babylon" ["Une autre ville pour une autre vie" (Another city for another life), *I.S.*, No. 3, 1959]. How is one supposed to imagine an architectural project adapted to a way of life that is yet to be invented?

HUO:

But through your drawings, your models, and your paintings, wasn't that precisely what you were sketching out?

C:

Painting is something highly personal. I am not an abstract painter. I show my conception of the world. In my case, I offer a critique of society.

HUO:

Mondrian referred to painting as an inapplicable model. What is your thinking on that?

C:

New Babylon was idealistic. I was a Marxist—a Marxian, as Henri Lefebvre would say. Mondrian was a theosopher, which is altogether different. I don't agree with Mondrian's ideas at all. I am against them, though he commands respect. But he ruined my entire life. To start with, my first wife's father was a close friend of Mondrian. When I got a studio in Amsterdam during the war, it turned out that it was Mondrian's studio. Now the Gemeentemuseum in The Hague, which owns several of my works, including the models of *New Babylon*, has the largest Mondrian collection in the world. So, although Mondrian died in 1944, he has never stopped interfering in my life. I know Mondrian's work well. I even restored one of Mondrian's canvases when I was young—a canvas belonging to my father-in-law, who owned several. At the time, he wasn't taken seriously; he was considered to be offbeat, unlike today.

HUO:

Many contemporary architects are interested in New Babylon *precisely because it is not an applicable model, but rather a city of constant flux and permanent transformation. You made a great deal of the notion of* Homo Ludens *and the social function of play…*

C:

It was the Dutch historian, Johan Huizinga, who first talked about *Homo Ludens*, and who wrote an historical study on the subject [*Homo ludens: Versuch einer Bestimmung des Spielelementes der Kultur (Homo Ludens: A Study of the PlayElement in Culture)*, 1939]. *Homo Ludens*: all artists can identify with man as a playful being. But I was the first to have talked about the idea with the Internationale Situationniste, about the need to make *Homo Ludens* the prototype of man as a playful being, to create a playful society. It is obviously an idea that appeals a great deal to artists. But what you are referring to are the models which we made for unitary urbanism— models which are not merely architectural forms, but which are related to an ambiance of life. An ambiance, and above all a way of life. Urban planning for life. Like Debord, I gave a great deal of thought to that idea in drafting the Amsterdam Declaration. Following our rupture, I still continued to think about it, to work on the idea of a playful city.

HUO:

Is the idea of liberated time also something you have written about?

C:

Especially liberated energy. In every man, a creature lies dormant. Liberated because I don't think of my trade as work, but rather as play. It takes energy, but it's not work. If I want to do a painting, I have to draw, which takes time.

HUO:

And in New Babylon *there are also zones which you refer to as liberated zones, temporarily unused zones…*

C:

Those are zones which have yet to be built. *New Babylon* is not a construction because it is at the same time a deconstruction: one builds and destroys at the same time; there are simple elements that appear and disappear on a line that remains, naturally, unchanging.

HUO:

On the plans that I've seen, there is also the idea that the ground remains empty.

C:

Yes, unobstructed.

HUO:

Does that have to do with the idea of circulation?

C:

With putting an end to the separation between the city and the landscape. The landscape continues and the city is placed on a different level. It is a network, rather than a core. A city is not an area, a section of packed-down earth surrounded by a landscape, but a network that spreads on another level above the landscape. An urbanistic network. That corresponds to the design for a new nomadic way of life: because just as one crosses the city, one can continuously cross the network. But, in the course of this crossing, the network changes. One never recognizes the same place when one comes back to it. It is a permanent journey, which is obviously very much linked to the Situationist notion of a "*dérive.*" The first title proposal for the urban-planning project was, in fact, "dériville," but Debord found that to be too direct and too bound up with the notion of the city (*ville*). It was not supposed to be a city. The *dérive* demolished the city. Debord and I had talked at length and decided upon *New Babylon*. I forgot to mention that prior to the *New Babylon* idea, I had lived, in 1956, in Alba, Italy, at

the invitation of Pinot Gallizio, where he was the landlord of a
piece of land that he had handed over to Gypsies, who had set up a
trailer camp. So in fact, I had already come up with a gypsy camp,
with a scale model, before *New Babylon*, in 1956. The Gypsies had
managed to remain nomadic. Prior to the invention of agriculture,
men were nomadic, living from the hunt, and the Gypsies simply
continued in that vein and never became sedentary.

HUO:

*And where did the name come from? You said earlier that it was like New
York or New Mexico?*

C:

Yes, I came upon Babylon, the Evil City. New Jerusalem is the
holy city. Babylon is the city of sin, of evil. People thought that it
was in opposition to the holy city. In fact, it came up in the course
of a brainstorming session. We had decided that Babylon had to be
included in the name, and then "New" came up, and we decided
that it had to be written in English. Debord was very interested in
American culture. He was always reading comic books.

DE CARLO, Giancarlo

Giancarlo De Carlo was born in Genoa in 1919. He currently lives and works in Venice and Milan. De Carlo graduated with a degree in engineering from the Milano Polytechnico in 1942, took an active part in the wartime resistance movement, and subsequently studied at the Istituto Universitario di Architettura (IUAV) in Venice, where he became a professor of urban design in 1955. He set up his practice in Milan in 1950. Through his activity as a publisher and as organizer of the architecture triennial La Triennale di Milano (1954 and 1968), De Carlo contributed to establish fruitful relationships between innovative architects from various parts of the world. In the late '50s, De Carlo became affiliated with the architectural group Team X, led by Peter and Alison Smithson and Aldo van Eyck. Eschewing the scientific methods of the Modern movement, Team X posited a broader anthropological approach to design. De Carlo particularly condemned the impositions made by authoritarian-type planning and instead advocated the idea of participatory processes with those who would use the building—dedicating himself to encouraging the dialogue of analysis, planning, and evaluation on all levels. In this spirit, De Carlo coherently put into practice the ideas that he maintained, and his work at the Free University in Urbino, over the span of fifty years provides a concrete example of an architect that supplied new aims and therefore new life to an ancient city that was on the verge of becoming a flagging tourist monument. De Carlo has applied the same process working in diverse circumstances: in the industrial community of Terni (1970–1975) and on the island of Mazzorbo in the Venetian lagoon (1979–1986). In 1976, De Carlo founded the International Laboratory of Architecture and Urban Design (ILAUD), an association whose members include the architectural schools from Barcelona, Berkeley, Brussels, Grenoble, Lund, MIT (Massachusetts Institute of Technology), Oslo, UCLA, Zagreb, and Zurich. The association has met in various cities over the years. ILAUD is neither a school nor a summer course: it is a place where continuous research is carried on by architects and non-architects from a variety of nations, who meet, compare their ideas and their work, explore theoretical themes, and conceive of projects based on a line of common interests.

........................

This interview was conducted together with architects Stefano Boeri and Rem Koolhaas in Milan in March 2000.

Hans Ulrich Obrist:

I'd like to begin by evoking the XIV Milan Triennale ("Large Numbers," La Triennale di Milano, 1968). Some years back I was in Japan and I did an interview with Arata Isozaki. Like a number of other architects before, he confirmed the importance of that Triennale and began to talk enthusiastically about the experience, stressing how much it meant to him. We also talked about it this morning at the current Triennale.

Stefano Boeri:

Yes, because Archigram are here at the Triennale, too. They were opening an exhibition of theirs today ("Archigram: Experimental Architecture 1961–1974," La Triennale di Milano, 2000).

Giancarlo De Carlo:

Oh yes? Then they're here, they've survived!

SB:

Yes, they're touring with an exhibition that's here in Milan right now, a survey of their work; very interesting, very upfront and simple.

HUO:

The 1968 Triennale—though it didn't have much of a public because the different projects were pulled down on the day of the opening—managed to open up all the potential for dialogue. For instance, Isozaki told me it was there that he came across Archigram for the first time.

GDC:

Certainly, I remember it clearly.

HUO:

Can you tell us about the concept, the theme behind the '68 Triennale? It was inspired by the theme of the greater number and the unifying topic of the show was "multitude." Stefano told me that it was dedicated to seeking an alternative to the "massification" of society, the concept of participation in culture with a capacity to safeguard individuality, and that for this reason it was a visionary concept in terms of globalization theory.

GDC:

We can start from Isozaki. Isozaki was a complete unknown at that time. Nobody knew he existed. I'd been lucky enough to see a work of his in Japan and it struck me as really interesting. That's why, having to choose among the various architects that represented contemporary thought, I chose Isozaki. What's more, this was the way we met up with others like Archigram. They weren't known at all in Italy, but I'd met them in England. And in the same way a lot of others came, actually visiting Italy for the first time, such as [Hugh] Hardy from New York, for instance. The Triennale had a theme. It was "multitudes" and, I'd say, yes, you could do a Triennale today on the same theme, because the issue underlying it was of the greatest importance and it was formulated very simply. We said more or less that we were moving towards a mass society. So the question was whether to accept the idea of a mass society or whether we want a different kind of society, a society of individuals. So our problem wasn't and isn't the mass, but multitudes. There was a lot of discussion and debate around the theme. I wrote

some texts on the subject and we called on various people to say what they thought. The opinions put forward, as always happens when there are creative people around, led in a lot of different directions. Isozaki had made some very interesting panels, using a fascinating technique. He drew red signs on aluminum panels, really dramatic. They immediately conjured up Hiroshima and Nagasaki, events definitely bound up with the dilemma of mass culture and the culture of big numbers. Then there was Saul Bass, the great American graphic designer, who died not long ago. He produced a wonderful story, a stunning film. The story of a ping-pong ball that didn't want to be like the other ping-pong balls, so it kept jumping out of the boxes full of them, making extraordinary sounds, going about on its own and asserting its individuality as a ping-pong ball. It was really incredible! I don't know what became of the film. Let's hope it's in the archives of the Triennale because Saul Bass was really outstanding, like many others at the exhibition.

HUO:

György Kepes was there also, right?

GDC:

Kepes, whom I know well, I knew well. I hope he's still alive. He must be getting on now.

HUO:

That's the big question. But how can we find him?

GDC:

At MIT! They'll have news of him, for sure!

HUO:

Who could I ask?

GDC:

Stanley Anderson.

SB:

You were important in that way too. Kepes, in fact, wasn't well known at the time in Italy.

GDC:

True enough. No one knew who he was.

SB:

And it was Giancarlo De Carlo who published his texts for the first time. At this point I'd better mention that Giancarlo was editing a series of texts about issues concerning the development of the city. A series that was vital to my generation, and also the one before.

HUO:
This series had a name?
GDC:
Well yes. It was called "Struttura e Forma Urbana."
SB:
Published by Il Saggiatore.
GDC:
Let's see if I can find a volume by chance, because I haven't even got the whole collection. Just imagine how disorganized my organization is. No, not a single copy. But I'll find a couple and let you see them.
SB:
It was the series that published authors like {Christopher} Alexander and a lot of others that later became well known and highly respected.
GDC:
Alexander was another unknown in Italy at the time. We met right after his return from India, at Team X's Convention at Ronchamps, where he spoke about that work of his, really interesting, on the Indian village. Well, a lot of those people met at the Triennale in 1968. If you think about it, it was a remarkable coincidence. Because they were all outstanding people who, once they understood the theme of "the big numbers," tackled it intelligently, each naturally taking it in his own direction. It was extraordinary how those directions tallied and in the end they formed a fascinating fresco. Van Eyck had prepared a beautiful exhibition! The installation of a forest—really a kind of forest!—that evoked Vietnam. The war in Vietnam, the destruction of Vietnam and its forests: in Vietnam they were flattening everything so it would all be the same, forever. You see, the arguments of the XIV Triennale were of this kind, all impassioned. But then a mass of idiots turned up who understood nothing. And at a time when it was urgent to discuss those topics, when we just had to thrash them out, they faked a rebellion so nothing got discussed. The Triennale was set up to open discussion on these subjects and instead they destroyed it. You know how? By refusing to discuss them. It was really stupid, atrocious.
SB:
It should be said that a lot of the people that more or less deliberately led the sit-in were excluded from the Triennale itself.
GDC:
That's true; they weren't among the people who worked on the Triennale.

HUO:

We're in a different situation, yet it's equally urgent. Some days ago I was talking with some friends in Paris about how we could mount a subversive exhibition today, against the omnipresence of mere spectacle. We decided that perhaps our only chance would be to do an exhibition that nobody sees. In fact, if it was done well, it would be a fabulous exhibition, precisely because it wouldn't be seen. I think your Triennale became so well known for this reason.

GDC:

That's right; it was for that very reason.

SB:

Yes, it could be the right strategy for relaunching the Triennale, because there's this empty space that needs to be filled with different values. This morning, with Archigram, we talked at length about this, and they agreed with the idea.

GDC:

Certainly, certainly, it strikes me as interesting.

HUO:

Let's continue on the topic of exhibitions. How could an exhibition be representative of the city—represent its complex and problematic nature? Did you have a sort of master plan, or did you adopt some other approach?

GDC:

On that occasion there was the idea of a master plan, or at any rate a coherent approach. I knew all the people invited and though I didn't know exactly what would come out, I'd followed all the projects. Those people were in touch with us all the time while we were working on the sections of the exhibition that involved them. Then, to get back to your question, their varied contributions were definitely organized according to a master plan that could easily be figured out right from the time they were invited. On the one hand, it would have been interesting if the different voices came together. On the other, it was fine if they didn't all chime in harmoniously. At any rate, what generally happened was there was no uniformity. There was a rich variety of voices around a single theme. Not just a single voice, which I feel happens now: a hundred people talking and it sounds like a single voice. To give an example from a different field, right here in Italy: we're heading for new elections, and the various platforms are photocopies of each other. This is something new in Italy and still seems incredible. Left and right have identical platforms; they say the same things. Now a vigorous society, if it's not a mass society, is one that doesn't say all

the same things. It says a lot of different things, even contradictory or conflicting, and there's a debate. That's what the society of the multitude ought to be—an infinity... of voices interweaving and taking up different positions, and in their interweaving they become creative. My background is one of an anarchist. I try to take it seriously, not fatuously. I believe in anarchism as a goal that I pursue and never reach, and I feel it's a relevant way to be. There have to be a lot of voices; we shouldn't be afraid of conflict. In fact, conflict is healthy. I believe society needs to be variegated, because if society is like a slab of marble it doesn't work, it gets dangerous. Instead it seems that contemporary ideas and events are going the opposite way; it seems they're pursuing a society made of marble, nice and smooth—it looks nice and smooth though actually it's all riddled and cracked inside. I wonder how I managed to plan the exhibition we presented. I must say at that time architects talked to each other more. They knew more about each other's ideas. Some of those taking part in the XIV Triennale came from Team X: the Smithsons, [George] Candilis, van Eyck, [Shad] Woods. The others were quite close to Team X, they came to our gatherings. So we knew each other, we knew what ideas they all had, and there was no need to work out a master plan to know how their ideas would shape up with ours.

HUO:

It's curious: just last week Smithson was telling me about this side of Team X, and I felt that he found it really important to have an arena for this kind of dialogue. This really seemed to be the big priority for him. I'd like to know more about your contribution to the dialogue within Team X.

SB:

It would also be interesting if you told us about Urbino. Because Team X actually held one of its encounters in Urbino, right at the time when you were right in the middle of work there.

GDC:

Yes, we had two encounters: one in Urbino, another in Terni.

SB:

It's interesting to see that this group was an elite—that's undeniable, I guess. Every time they met they took advantage of the meetings to express their ideas, certainly, but also to talk about concrete experiences and quite specific events. So you were circulating not just ideas, but also this concrete knowledge, and the two things went together. Those encounters weren't just engaged in abstract, erudite thinking.

GDC:

True enough! The interesting thing about Team X was this fertile tension. To give you an example: I didn't care at all for the exhibition the Smithsons did at the Triennale about "multitude." I found it a bit fuzzy. But though I didn't like it, that wasn't the point.

SB:

It should be said that the Smithsons presented a project about Florence, the historic city, and everyone was a bit surprised.

GDC:

And bored, I'd say, because the issues of the day were much starker. Those were times when young people were in open rebellion. And they turned up with this rather odd display.

SB:

It was a big lawn dotted with monuments. And suspended in the sky there were the buildings.

GDC:

That's right. It was a very intelligent concept, because the things the Smithsons did were always intelligent. They were very intelligent, but, to confirm what I was saying—you see, I remember at the time I didn't think much of that work of theirs, but I sensed its importance. The crucial point, come to think of it, was that it didn't matter whether I liked it. What mattered to me was that it was intelligent. Then their exhibit didn't appeal to me, but I was pleased they'd done it. Team X was like that. None of us did the same kind of architecture as the others and if you compared our architecture there was no family resemblance. My architecture has nothing in common with Peter Smithson's or Candilis's. There's a common spirit, not a common vocabulary.

HUO:

Can you tell us how the group got started?—because it's unusual for a group to emerge from these differences.

GDC:

When they asked Shad Woods what Team X was, he used to say, "It's a club for people with flat feet." Because he and Peter Smithson had fallen arches—they walked like ducks. Then [Ralph] Erskine used to say, "It's a group of people who practice what they preach," meaning we were consistent in the way we thought about architecture and did it. I find both definitions interesting. The first is humorous and means, "Don't take it all too seriously." Architects are always taking themselves seriously, at least in public. We nev-

er called in the press, we never issued a manifesto. We main-
tained—on principle—that what we said was never definitive.
HUO:
So Team X wasn't opposed to something that...
GDC:
... It wasn't against anything! We'd disbanded the CIAM [Congrès
Internationaux d'Architecture Moderne], we'd broken it up. We
broke it up quite peacefully. We weren't against Le Corbusier—we
thought he was a great architect. That wasn't the issue. Le Cor-
busier is a great architect, but not necessarily one you have to fol-
low, to be his faithful disciples, like some members of the CIAM,
the "Ciamisti" we used to call them. We thought, "I still think Le
Corbusier's a great architect, but nothing more, and anyway that's
already plenty."
HUO:
*And here, there's a big difference from the Situationists or other groups who
engaged in forms of blunt contestation.*
GDC:
We weren't against, no, no. Or if we were against something, it
was the bureaucratic spirit. CIAM had become a bureaucratic orga-
nization and we were against that kind of bureaucracy. But we
weren't against particular architects at the CIAM. Le Corbusier was
a great figure in our eyes, we respected him. But we felt much less
respect for Le Corbusier's disciples, the fans of Le Corbusier—but
it didn't go any further. The important point was that we were
engaged with architecture—that was the big thing. We weren't
critics, we were architects. We built architecture and all our dis-
cussions were about this: the fact that we went and built it. And,
as always, when you concentrate on a thing you believe in, it is
interesting to swap ideas with people outside, and not to arrive at
a single approach. Quite the opposite—we were after the opposite.
SB:
You didn't want to found a school, in short.
GDC:
Nor to create a style. We had no intention of defining a style and
urging it on others. That wasn't what mattered, it wasn't our con-
cern. That's why there were always cross currents in Team X. I felt
a lot of intellectual sympathy, a conjunction of ideas, with people
like Peter Smithson, for example. The discussion between us had
gone on for thirty years. Whenever we meet it's as if we'd broken off
the evening before. We pick up our discussions where we left them.

HUO:

He told me the same.

GDC:

On the other hand, with van Eyck it was quite different. Our architectural languages did flow into each other. His architecture really interested me and still does. And van Eyck showed a keen interest in my architecture. A good architectural critic can spot these things easily, because he looks at the projects and hears echoes of one in the other. I was very interested in Erskine, because he's a very fine architect, a person of extraordinary moral integrity, moral and social integrity. He left England for Sweden, where he thought he would find real socialism. Then perhaps he failed to find the socialism he was looking for, but that's not the point. The point is the coherence of his urge. In Team X there were cross currents in our sympathies. Our meetings were clashes of a kind I've hardly ever had, because we were quite truthful, which is rare. Someone might say, "I don't like this design for such-and-such a reason, you've got to clarify it." The analysis was stringent, but we stayed friends because there was a profound reciprocal respect. For instance, I really didn't care for some things Candilis was doing, but I thought he was a person of outstanding human qualities, great honesty, who devoted all his life passionately to architecture, and that was enough for me.

SB:

It was extraordinary. The absence of this transparency is a catastrophe for the construction of an intellectual elite. Today an elite is usually constructed only through mutual recognition based on the purely formal affinities between architectural works. Much the same thing happened at the CIAM, while I think that Team X was unique in that respect.

HUO:

But it seems a perfectly valid and encouraging model.

GDC:

Luckily we left few traces behind us.

SB:

Not by accident, I'd say.

GDC:

Not by accident, certainly, and perhaps we can add "luckily," because whatever comes next will be new, not a reproduction.

HUO:

When we first talked about the Triennale you mentioned Kepes. I'm inter-

ested in that, because Kepes often talked about a certain interdisciplinary approach and its importance. He said in an interview in 1965, "What I'm interested in is how we re-establish the communication of ideas." When I talked to Smithson, he stressed that in his research; in addition to meetings and talks at Team X, he felt the importance, almost the need, for this dialogue with artists from different fields. I'd like to ask how you see this interdisciplinary approach in your work.

GDC:

That's a difficult question for me. I've often thought about it. To tell the truth, I tend to distrust artists who work "to produce art." I have to say the only artist I've ever worked with properly—it might sound ridiculous to say this—was Fernand Léger. For a ship, one of the first jobs I did, he made a big canvas and glued it to a wall measuring 6 meters by 2.10 meters. You see, this contact was really important for me.

HUO:

What year was that?

GDC:

It was 1951, 1952. To me it was important because Léger was a great artist, a man of really extraordinary human generosity, and he really knew what architecture was about. He attended the CIAM conference in Athens [in 1933] and there he made a brilliant speech about Paris II, while they were drafting the *Charter of Athens* (1943). He was very critical of architects and it was really interesting. I repeat: this happened because Léger knew what architecture was about. I often meet artists who have no idea about architecture or think it's less important than their art, and this rankles. Not because I think architecture is the center of the world, but if someone isn't interested in space, in the qualities of space, he's simply lost. Because if the quality of space was annihilated, there'd be nothing left worth experiencing in the world. So if I meet someone who shows no interest in the quality of space, then I smell a rat. I often have a difficult rapport with artists, because in the end a lot of them aren't interested in collaborating but in getting their foot in the door, which is different. But there are a lot of artists I respect. I found it easy to work with people rather on the sidelines of art production, such as Kepes, for instance. But Kepes was above all a critic, though he painted a lot. Because he *did* paint. Did you know that?

HUO:

He produced some catalogues with multimedia illustrations, interactive

illustrations. Some were about participation in the creation of art.

GDC:

We discussed his research a lot. When I met him at MIT, he was interested in how to use new multimedia techniques to create innovative representations of the city. They were unusual and highly significant. He brought three works to the Triennale (actually he said only one was his, he was clear about this). They were very unusual views of the city by night, in Boston. Using these multimedia techniques he managed to confer a different significance on the city. His work was really interesting. He did these things with T. McNulty, who was an architect, because Kepes was a painter and art critic but not an architect. If he had to make a model he always went to an architect. It was '68, the years from '67 to '70. I was in the States a lot. That was a period when I taught courses at the MIT, and I often saw Kepes. There was a lot more debate in the universities then, that's my impression. There were a lot of assemblies where everyone discussed what should be taught and why. It doesn't seem to happen now. One of the basic issues was participation; it was just emerging then in the States as a need being enforced in the universities, both at the grass-roots level and from the top. They were trying to understand how to establish a new rapport between people so the dialogue didn't all go in one direction, but in multiple and complex directions. This was a basic issue. It was a question of understanding how people represented themselves in architectural settings: represented their needs, but also their expectations, their desires, the way they saw the world. Those were the big questions we were discussing. And Kepes was a big help in these discussions because, taken all in all, he had worked through the whole range of modern architecture. I can't say how old Kepes is. He's definitely getting on, but I can't say just how old.

SB:

You know, his books don't mention his date of birth.

HUO:

I think I've got it. He must be 95. He was born early in the century, 1905 or 1906, I think.

GDC:

He was a very curious character, because his hair was all black—not dyed, naturally black, and so it was hard to tell his age. Then he had a very fresh complexion and a wife—I hope they're still together—who was delightful, very intelligent and gentle.

HUO:

It was really interesting to hear about your collaboration with Léger and Kepes. I was wondering if you had had other similar encounters, but with the sciences.

SB:

You could talk about those in music.

GDC:

Yes, there were some, but I can't get them into focus.

SB:

There was the dialogue with Karlheinz Stockhausen.

GDC:

Stockhausen... that's right. He came to ILAUD twice and stayed three or four days each time. Once, in Siena, he also did a performance that was wonderful. I had very interesting talks with him. [Luciano] Berio came too, but the discussions with Stockhausen were really interesting because he's so deeply involved, endowed with a really awesome energy. Stockhausen discussed participation with us. He found analogies—which actually exist—between music and architecture. Stockhausen sees music as a field for participation, though you don't see this immediately, because his music is highly personal. But his way of assembling it isn't, because his performances are very anarchic. His thinking is truly like the wind; it moves in all directions. It's highly interesting. Then if I think of connections with science, it occurs to me that at ILAUD we had a lot of scientists who came to discuss things with us, from astronomers to physicists.

HUO:

Can you tell us about ILAUD?

GDC:

ILAUD is an international laboratory or workshop. It is supported by thirteen universities at the present time, mostly European and North American. During the year they're supposed to work on a topic we've established with a group, though not all of them manage to do it. After which, for five weeks, mainly in August, they send five or six students from each university and one or two faculty members. Then we invite some others. Smithson is one of those always invited to stay a couple of weeks, but others come and stay for two or three weeks. They work with the students in international groups on a topic selected by the city. For instance, in Venice recently we've been working on the Arsenale.

SB:

The location changes each summer. We move about. We've been three years
in Venice. Before that we were in San Marino and Urbino.

HUO:

It's a nomadic laboratory?

GDC:

Exactly—a nomadic laboratory.

HUO:

And you founded it?

GDC:

I founded it together with some friends from other universities.
Donlyn Lyndon of MIT, Henry Millon, Sverre Fehn, and Bengt
Edman.

HUO:

When did you start ILAUD?

GDC:

In 1976. It's getting on; it's already 25 years old. It's only vaguely
known about, as often happens with cultural initiatives. They don't
explode like chestnuts in the fire.

HUO:

I've read that many of your projects are evolving, are evolutionary projects
so to speak. In particular, I'm thinking of Urbino. I'd like to know what
Stefano thinks of it.

SB:

I think the achievement at Urbino is unique in Italy. It is the work of an
architect who not only succeeded in creating some important signs, land-
marks, at different points in the fabric of the city, but who has actually
succeeded, after a lapse of decades, in somehow reinterpreting the same signs
in a new wave of architecture. In this respect I think Giancarlo evokes cer-
tain Renaissance architects in his ability to shape, in part, the evolution of
a city. So, in the case of Urbino, the inauguration of the School of Econom-
ics is the last in an unbroken chain of events.

HUO:

And how did this experience begin?

GDC:

It was all due to an outstanding Italian intellectual called Carlo Bo,
who for fifty years was rector of the University of Urbino and still
is. I met him during the Resistance, through Elio Vittorini, a great
Italian writer, and Italo Calvino, whom you certainly know. Like
Bo, I was a friend of Calvino and Vittorini, and Carlo Bo decided—
it sounds normal, put like this, but it's not in the least normal real-

ly—that the way to run a university was not just by changing the teachers and courses but by changing the physical space as well. No one thinks of space as a way to stimulate renewal, as well as being a sign of it. But Carlo Bo had that insight. He called me in and we started from scratch.

[*Rem Koolhaas arrives*]

SB:

Ahh, there he is. He's arrived.

GDC:

Show him in.

HUO:

That's a rarity, what you were saying.

GDC:

It's not at all normal what happened in Urbino. But thanks to Carlo Bo it did. We started without anything; there was hardly any money. We began with a small project in the old premises, then, gradually, the project spread.

RK:

Hello! I'm really happy to meet you.

GDC:

Oh, thanks a lot. Please, take a seat.

SB:

Would you like a quiet place to rehearse your lecture for tonight at the Triennale?

RK:

Well, I'd rather stay here and listen.

SB:

Giancarlo was telling Hans Ulrich about his projects in Urbino.

HUO:

You were saying that you began with very few resources.

GDC:

Yes, we began with small projects and then went on. The interesting point is that it has been a truly evolutionary process, as Stefano said, in the sense that I really began with small steps and then took others and eventually went back to the first ones. The design of Urbino's university campus has become a permanent project. It has been going on since 1951. My experience at Urbino has lasted half a century, and if you can say it's an evolving process it's because every time the experience has been new. I've just finished the School of Economics. I tried to transfuse into it the experience

acquired in all my projects. This way of working completely absorbs me. I've been lucky; I've been able to play this game right through. In Catania, too, we started with very little and now it's become a complex process, one involving the whole city.

HUO:

How many years have you been working on the University of Catania?

GDC:

I must have arrived in Catania in the '80s. So this experience is a bit shorter, but similar to that in Urbino. In Catania I'm working on projects that flow into each other and they're really engrossing.

HUO:

We could call it a cumulative process?

GDC:

Evolving, rather, evolving, as Stefano said. He also mentioned the "Renaissance." I feel Renaissance architects worked in ideal conditions, because they were itinerant designers and at the same time they were tied closely to a single place. I've always felt I wasn't a citizen of the cities where I designed, and I was happy not to be, because that's the only way to see the context clearly. I wouldn't view it with the essential detachment if I was a citizen. I like being partly a citizen and partly a traveler. I'm interested in being a fixture and at the same time an outsider in a place, otherwise I'd lose the keenness and pleasure of discovery, as well as the pleasure of detachment. For instance, I was really interested when I taught abroad, not only because it enabled me to see Italy from a distance, but because it helped me to see it more clearly. I love Italy deeply, but I'm extremely critical of it.

HUO:

I'd like to go back to the principle of your laboratory. You stay a few years in a city and then the show hits the road again.

GDC:

We've been to various cities. We were in Urbino for six years, then in Siena for nine, again in Urbino for three years, and then we went to San Marino—a little republic in the belly of Italy—and now we're in Venice. In Venice we've worked three years on the key problem of the city, the Arsenale. This last stage is interesting, too! Things happen, then, by chance, though in reality it's never wholly chance. It strikes me as significant that this road show, after traveling around for twenty years, has reached Venice, because Venice is the real crux of the urban issue. In Venice you find the rest of the world, and not just because the rest of the world is Venice. But in

Venice you grasp the complexity of the urban problem, the infinity of forms in which it's embodied. You see the close ties between the physical organization of the city, its environment, and the representation of that environment, which in Venice is incredibly clear and eloquent. Venice is a city that's riveting for an architect.

SB:

In recent years, Venice has been the Italian city that's had the biggest number of start-ups of contemporary projects. It's an incredible paradox, in a way.

GDC:

I believe that's true. Yes, there've been a lot of new projects. For instance I'm doing a building on the Lido.

RK:

How can you explain this happening in Venice?

GDC:

I think the main reason is because they have an excellent mayor, an intellectual, a philosopher, Massimo Cacciari. He's very sensitive to architecture, he understands architecture. I think that was a good opportunity for Venice to get a period of modernization, with new ideas and openings.

RK:

And is it working?

GDC:

I think it did work, but now Cacciari is leaving Venice to run for president of the Regional Assembly. I think it's a pity for the city, but anyway the process is under way and I hope it will continue. Currently I'm building a project at the Lido, and that's another very interesting topic because the relationship between Venice and the sea is a crucial issue. So I've found myself in trouble, as they gave me a commission for something that's becoming uncommon in Italy: a public building which should contain a restaurant, a cafe, and a piazza, a place where people can enjoy the sight and look at the sea. It's not common nowadays to consider the lack of these spaces as a social problem. Normally housing and schools are considered social necessities, not leisure facilities. Oops, sorry! I've drifted off the point.

HUO:

I'd like to ask one more question, which I ask all the architects I meet. I always ask about their favorite unrealized project. Which of your unrealized projects would you like to build first?

GDC:

You've asked me two questions. One is: "Which are my favorite unrealized projects?" The other one: "Which projects would I like to see built?" They're two questions! I couldn't really answer the second because I don't know if I'd like to see them realized. I'm not sure. Because I did them in another time and perhaps, if I did them now, I'd do them differently. In fact I'm pretty sure I'd do them differently. We did a project, each of us, Rem Koolhaas and I, working separately, at Thessalonica, and I liked mine. But if I were to do it again, I'm not sure I'd do it like that. Because I've changed.

HUO:

Thessalonica must have changed too.

GDC:

Thessalonica has certainly changed. A wonderful virtue of architecture is that its time changes continuously. If someone's really an architect and in harmony with the time, he can't do the same thing again five years later.

RK:

Absolutely true. Not even four.

GDC:

He can't even do the same thing again if he's in harmony with the time. But instead, if he's just practicing a style, he can. Architects who practice a given style can keep on doing the same thing. Architects who are responsive to the changes of time can't. Your other question was, "Which are my favorites among my unrealized projects?" Well, I deeply regretted not being able to build the tower in Siena, which I feel made some interesting innovations. It is a project I really regret not realizing.

HUO:

This project was originally for a competition?

GDC:

Yes, a competition. I'm also sorry I lost the competition for the IUAV in Venice, because I'm sure the project contained some points of interest.

SB:

Probably tomorrow you'd give a different answer.

GDC:

Yes, I'd certainly give a different answer. I'm sorry because I'd have liked to work on a project of that kind in Venice, which is difficult. My life is dotted with unrealized projects. I've built very few projects compared with the ones I've done.

RK:
What sort of percentage?

GDC:
I guess 15 percent. I'd say I built 15 percent.

RK:
So you've built up to 15 percent?

GDC:
I think so. Is it the same in your case?

RK:
Oh no, less.

GDC:
Oh well, maybe I'm exaggerating. It's almost an existential condition for an architect: to design a lot and build little.

RK:
Do you think it matters? Because now I have the feeling it doesn't really matter. The need to realize it is almost arbitrary. But that may be because there are so many different media and many people just don't know whether something actually gets built or not, which is not necessarily a happy situation.

GDC:
But you get to a certain point in your life... anytime I lost a competition it meant suffering, a drama. And I was angry every time, you know. But now, looking back in perspective, you know, I think: "Hey! That's the life of an architect." And I am sure I didn't lose what I lost. It was recovered somehow, in another project.

RK:
In terms of intensity?

GDC:
Yes, intensity, and then, you know, you need some rage. If you won all your competitions you wouldn't get mad any more. And you have to be enraged constantly, because otherwise the intensity goes slack.

RK:
How do you work up a rage now?

GDC:
Oh, I have lots of good reasons.

RK:
But no more losing?

GDC:
Oh yes, I'm going to lose all right. Well, I just lost a competition recently for five piazzas in Milano.

RK:

Was it a single competition or different ones?

GDC:

No, it was just one, in five different places around the city.

RK:

I'd really get mad then!

HUO:

There was one last question I'd like you to discuss, about the issue of participation. I was interested in those very complex participatory strategies.

RK:

Yes, that would be really interesting because, if I think about it, your attitude in that is quite essential. You were working on it right at the start, when it was still totally authentic, and then it became political and very degraded. So I would like to know if you saw these changes.

GDC:

I quite agree. If you consider the end of the '60s, at the same time there were two things that were important. One was the rebellion of the students and the other was a new consciousness in the trade unions that was also very relevant. The workers at that time were crucial. In that period I worked on two projects. One was for a housing complex in Terni and the other was an urban plan for the new center of Rimini, both based on the idea of participation. Then, after that phase, a more bureaucratic period started, when participation became something very formalistic and stupid. I felt the problem had changed, and we tested these changes at ILAUD. The question was how to devise an architecture that is intrinsically participatory. This becomes a question of the architectural language. How can the language be such that it favors and fosters participation? I think this question still has to be explored, in many different fields. Just think, for instance, of the technology we use. It's important to use technologies that are understood. I believe the crucial issue still is to use language people can understand, figure out, and eventually use. So, in my opinion, the process has now become longer.

RK:

You're still working on language, now?

GDC:

Yes, I'm still working on language. Participation is a process you should start, but then—and this is something you need to remember—it goes on forever.

RK:

Yes. In fact, somehow, I feel I miss it.

HUO:

But what do you mean when you say you miss it?

RK:

Well, I miss a certain kind of resistance.

GDC:

In terms of nostalgia?

RK:

No, in terms, really, of resistance, and of course that's not contemporary any more.

GDC:

Yes, that's quite true.

ELIASSON, Olafur

Olafur Eliasson was born in 1967 in Copenhagen, Denmark. He currently lives and works in Berlin, Germany. Eliasson attended the Royal Academy of Arts in Copenhagen from 1989 to 1995. Following his graduation, Eliasson quickly took his place on the international art circuit with a series of solo exhibitions at major institutions including: Kunsthalle, Basel (1997); De Appel Foundation, Amsterdam (1999); Kunstverein, Wolfsburg (1999); the Art Institute of Chicago (2000); Neue Galerie, Graz (2000); Zentrum für Kunst und Medientechnologie (ZKM), Karlsruhe (2001); ICA, Boston (2001); the Museum of Modern Art, New York (Projectseries 2002); ARC/Musée d'Art Moderne de la Ville de Paris (2002) and Reina Sofía, Madrid (2003). Commenting on his own work—which includes sculpture, environmental installations, photographs, artist's books, and engravings—Eliasson has claimed that he is first and foremost interested in looking at the way we see and experience things. Using simple devices like mirrors, holes, and optical matters to affect the spectator's vision, Eliasson attempts to reproduce such ephemeral phenomena as fog, ice, and rainbows inside galleries and museums settings. In order to challenge viewers in a situation in which they reflect on their modes of thought and behavior towards these natural phenomenas, Eliasson has recreated the sparkling quality of rain by illuminating a water-fall with stroboscopic lights (Your strange certainty still kept, 1996); *caused a cool breeze to blow* (Your windless arrangement, 1999); *created a solar eclipse (*No nights in summer; no days in winter, 2001); *and traced luminous rings in water (*Neon Ripple, 2001).*

........................

This interview was recorded in Berlin in March 2001.

Hans Ulrich Obrist:

Why don't we start from the recent events that took place in Stockholm (2000), which belong to your Green River *project (1998–ongoing)? Through these interventions, different rivers in different cities were colored with fluorescent green, challenging the knowledge of the city's inhabitants of their daily environment. How did it take place in Stockholm?*

Olafur Eliasson:

I had thought about doing the *Green River* in Stockholm for a while. I was already working on another project with Mats {Stjern-stedt], Karen [Diamond], and Daniel [Birnbaum] at IASPIS [International Artists Studio Program in Stockholm] and I couldn't link it directly with the institution there, so basically I bought the color in Germany and brought it with me, in my suitcase, through the

customs—which was quite a funny feeling; not that it's illegal to do so, I guess, but there was a lot of suspense in carrying enough dye to color central Stockholm through customs in a normal suitcase. So I did my exhibition project at IASPIS ("Your intuitive surroundings versus your surrounded intuition," 2000)—a smaller project about seeing, and after realizing the *Green River* in Strømmen, I realized that the *Green River* project in Stockholm in large part was about seeing as well. I hadn't told anybody about the *Green River*, it wasn't official, and there weren't any invitations. I did some measurements on the water and turbulence for a few days: we'd throw small pieces of paper and walk along the river to measure the time, and the amount of water going through... We prepared quite carefully; we looked at where all the city surveillance cameras are—which may seem somewhat pathetic, but if you think about it, it's really hard not to get filmed in downtown Stockholm. It just happens that the dead center of the ruling organ of the country is where the best current is: the streams run very nicely there. So we put some effort into the planning, since it's a hit-and-run, so to speak. And at one o'clock on Friday, Emil [Tomasson] and I walked out onto the bridge a bit up the stream, and we stood there, a bit tense, with a shopping bag full of the dye powder. The traffic was jammed somehow, so there were cars standing right next to us while we were on the sidewalk pretending to stare at the water. This was the moment I wanted to do it—there were no other people walking around on the bridge, just all these cars that were not moving, so I was getting more and more nervous because the people in the cars seemed to stare at me and Emil, thinking, "If those two guys with that large, strange-looking bag do something weird I'll call the police." After some moments of eternity, I thought, "What the heck, I'll just do it." The powder was quite red, so when I emptied the shopping bag over the bridge railing a large red cloud of powder appeared in the wind. Now, this may be my feeling, but I had the sense that everybody took their foot off the stressed gas pedal, and all the cars suddenly became very silent. Obviously, I was very nervous as this big red cloud was flying over the water, like a sort of gas cloud. And as it landed in the water, carried by the wind, things turned totally green, like a shock wave. I had made sure to have the wind in my back. There was a full bus right there ten meters from me, and all the people in it were looking at the water, then at me, and then back at the water. So I said

to Emil, "Let's walk away really slowly, as if all of this was very normal." That's what we did, and I threw away the color bag in a garbage can, properly, as if this was the daily routine of coloring central Stockholm green. Eventually we just walked into IASPIS where I washed my hands. When I came back out, my heart really jumped, because the whole stream was totally green, totally, and a lot of people were stopping to look at it. It was really amazing. Then I got nervous about the other people, like Mats and Daniel: are they O.K.? Have they seen it? Did they know that it's happening? Eventually I learned that Daniel and the other people were standing further down the river. They had quite a nice description: they could see the green appearing from far away, and they were thinking, "Look at that funny green color coming over there!" And then, because of the way the turbulence mixed the color, the whole area turned instantly really very green, and for the others it also seemed to be a shock effect. Anyway, it was a success, and the story ended the next day, when the front page of the newspaper showed the river saying, "The stream has been colored green." There was also a small article saying that the green color had upset some people who had called the police, who calmed these people saying that the color came from some heating plant, not being dangerous at all. So it was interesting how the press reacted to this. It's something about Sweden always being able to come up with the right answers to reassure people. Finally, I should say that, of course, the color is not polluting or dangerous at all.

HUO:

Basically, your idea was to make visible the invisible city, to make visible the act of seeing?

OE:

Yes. When I said the show was about seeing, I meant that the *Green River* was about—and maybe this is also what the other *Green Rivers* are dealing with as well—we have this picture of our city, we have a picture of the water in the city, just like the Spree water in front of my window in the studio in Berlin, and my idea is: do we see the water as a dynamic element in the city, or do we see it as a static image or element? Is it somewhat present or is it a representation? Among other things, I want to see what happens for the hours it takes before the green color is gone again, when the river becomes so present, the movement and turbulence in the water becomes visual. The invisible becomes visible—for a moment the river becomes, let's say, three-dimensional, a space, instead of the usual

two-dimensional, static, representational experience we tend to have of a city center. So when the water is artificially colored it becomes more "real" than in its normal state. Even though it's a bit generalizing, I am thinking of the way that many cities through history have decided to present themselves and their ideologies: the focus has been on monumental and class power structures. And it has made the experience of public spaces more about representational iconographic form, and it has influenced our sense of orientation. So for many people I think that the city space is perceived like an image, like something that you don't relate to as a process, or even with your body.

HUO:

There is this book by Alighiero Boetti and Anne-Marie Sauzeau Boetti from the '70s, The Thousand Longest Rivers in the World *(I mille fiumi più lunghi del mondo, 1977), which is about the impossibility of measuring rivers—the order being always a disorder. I was wondering to what extent it was planned and to what degree you could not predict what was going to happen? Which part of the* Green River *project is unpredictable?*

OE:

That's a good question. There is a certain amount of unpredictability because, for instance, if it had rained, the water level in the stream would have been much higher, and there is a dam controlling the amount of water flowing through this and the amount of turbulence. I was more afraid that the day I would do it the water would run the other way, or would not run at all, it would be still, and so on. And then, of course, I could not predict people's reaction, if a riot would start in downtown Stockholm, or if the government would instantly close off the waterfront. But by experience, I have learned that normally very little happens from the people side. As I said, the city as such is more an image and not a space where interaction or engagement is practiced. The tendency seems to be that people do stop and look, but fundamentally they don't really care so much.

HUO:

Looking at the image printed in the newspaper the day after, what strikes me is the fact that this image is without authorship. Is the fact that the event happens anonymously important to you?

OE:

Yes, in this case it is, since it's more central that it corresponds with the expectations and memories of people in the street. In Canada, I did a project where I put chalk on the street with a small machine [*The very large curve* (1997), "3rd Symposium on Visual

Arts, LANDART," Amos]. It was the kind of chalk and machine used for football fields, and I shifted the map of the city by painting a new map directly onto the ground and, of course, eventually the chalk would just disappear with the wind, or the first rain... But the organizers of this event wanted to put large signs on the sidewalk advertising that this was a piece of art, so the piece never really worked. Through limiting the engagement with the experience of the people by culturally coding it as "art," it was formalized and thus a certain representational way of seeing was promoted, making my chalk lines into paintings rather than possible road adjustments or so. But with the *Green River* on the cover of the newspaper, it worked differently; this was not conceived as art and the themes that the *Green River* would deal with if perceived as an art project are here not submitted to the secure representational distance of the art-institutional practice. Of course, the institution is always there, it is just tilted slightly, so now I can say that the article is a part of the piece, and so on. The fact that a number of people actually called the police shows that what they saw was not a representation. In Paris, when we did the ice action in Nanterre ("Nuit Blanche. La jeune scène nordique," Musée d'Art Moderne de la Ville de Paris, 1998), the question was also: is this some leftover of an ice machine? Is it a sculpture? I'm not sure people would actually read it as a sculpture, since it didn't correspond to our expectations of what a sculpture should look like.

HUO:

Or it could have been taken as something extraterrestrial, in the same way Orson Welles, with his 1938 radio program The War Of The Worlds, *managed to have people believe some UFOs had landed in the U.S., creating a mass hysteria as the rumor spread around—it was true for a certain time, it was their reality!*

OE:

Yes, that's great—that's what I have to do next! I have to find another rumor like that. But it's funny to see how this is disappearing in a way, the ability of rumors in the city as such is disappearing, since we don't have, let's say, the social correspondence between the social levels, groups, or places in the cities where different social purposes interact. It's just a feeling I have, but how could you spread a rumor here, in Berlin, on Potsdamer Platz? It's impossible, because all the people present are there for the same purpose, and they don't link up or overlap with any other purposes so to speak. How should I say it? At six o'clock, in another city,

you would have another group of people there, and the rumor might travel to them, but here at Potsdamer Platz, at six o'clock, everybody goes home and it's empty, a social dead end.

HUO:

It would have to spread through E-mail...

OE:

Exactly. I believe this is right, and I guess it will grow much more. But also, the Internet has a form that is inseparable from its contents. But I think the megalomaniac companies who are going to sell for millions in the future are the rumor-spreading companies, with their rumor machines and strategies. What I find particularly interesting is that in the Internet, we have a space without time, as we know it; it has lost its relation to relativity, or at least made a new one. The limits of time have dissolved into a spatial relationship: the ability to relate to somebody elsewhere, or to rumors, or to whatever, no longer has a time-proportional dimension. How should I say it? Duration is no longer outside of us connected to three dimensionality; duration is now internal inside ourselves, and the time passes differently for you than its does for me. I think that this is something new—we relate to an idea of time, which is more individual. Time is less and less a measurable or objective truth, (not that it ever was, but anyway...). So the Internet is not a direct translation of our known everyday into a parallel setup—it's a whole new condition of space. It's like nomadic living—only we do not change our spatial location. The nomadism is in the other dimension; it is in time.

HUO:

Does this mean that we have a permanent present?

OE:

I guess we always had a permanent present—anything else would be a paradox. Anything else is impossible, at least when we look at the world from a non-commodified point of view. Commodification, I believe, is essentially about dislocating our sense of presence. It interests me, and it's something that I am working with. The sense of past, future, and time as such, has by definition been taken for granted as the fourth dimension to space, and like I mentioned before, I think that is a mistake which we are slowly realizing partly due to the Internet. I think there is a stronger sense of time being not past and future but rather memory and expectations, my time and your time. This is what I meant by saying that the objective timeline has disappeared: we are even able to relate to spatial issues without a constructed objectified time. Before, it was

always about the "here" and "now," about space and time as a convention. Now it is, to a higher degree, about how you and I construct a "here" and "now" for ourselves. Time is not measurable; it's now. When I talk about my memory and my expectations, meaning my past and future, I do this "now," and when you think of it, the thinking itself then becomes a part of your now—or your memory and expectations are now in the world, your world. I made a title for a book that I am doing; it's about nine process-related works, and the title is *My now is your surroundings* (*My now is your surroundings—process as object*, 2001).

HUO:

You have made interventions in a whole series of cities. How do the specificities of each location influence your projects?

OE:

Often when I work on site, I don't at the outset have a very clear idea of where the project will eventually lead. The idea is mostly developed as I am working, and I guess the one thing guiding it, so to speak, is how the spectators or recipients see themselves in a given space. It is basically a very open formula for almost all of my work. So with the *Green River* I tried to pick very different notions of the river in the city: In Moss, in Norway, it was a very small, intimate setting. There you could say was a quite Romantic notion of what the water was doing in that space. In LA, where water is something almost sacred, it is completely different than, for instance, in Stockholm. So obviously it's very ambiguous. In America, everything is very valuable but nobody takes care of it—not only the river, but the whole country in a way. In LA I did it as an action with a few people watching, and I felt sure that I was either going to have lots of police and problems, or nobody would care at all, and the latter happened: nobody paid attention. I did it in Iceland as well, out in the countryside: I wanted to see it both in an artificial and a so-called natural environment, researching what a river does to a city or a landscape. It was interesting when the water in the Icelandic countryside turned all green; it looked like a picture, a representation. I thought I could make the landscape even more real or hyperreal by changing it with the impact of the color.

HUO:

Some people sometimes view your work as having something to do with nature, but the river is more of a hybrid between nature and artifice, isn't it?

OE:

Surely. What is nature, anyway? And who cares about this constant

search of the boundary between culture and nature, really? If there is a nature, I come to it through the people who are there and their idea about where they are; if there are no people, the so-called nature doesn't interest me.

HUO:

When did your practice of doing things out of the institutional frame-work—of doing public, often clandestine interventions, without having a commission to do so, without telling anybody—start?

OE:

I think I needed it to avoid formalization. The work I do is very dependent on people being involved with it, engaged in one way or the other. The shows inside an institutional frame at some point run into a barrier of objectification—or actually, rather, commod-ification: commodification of seeing and even thinking. Since my work is very much about the process of seeing and experiencing yourself rather than the actual work, it becomes a problem when formalization through the institutional structures objectifies your way of seeing, rather than questioning it. So working "outside" with improvised interventions is both a desire to dissolve my work formally, and to show the formalizing powers of the institutions, and finally, of course, to engage another audience. One of the first times was at the Johannesburg Biennale ("Trade Routes: History and Geography," 2nd Johannesburg Biennale, 1997). I was invited to participate with a photo series. The fact that I was showing these photos there gave me a feeling of—how shall I say it? —deploy-ment, or so. So immediately when I got there I knew I wanted to do something else as well, which, without being opportunistic, also questioned the situation of the local institutional frame and the whole set-up there. I saw this smaller rainwater reservoir and I found a person who could help me, so eventually I did the *Erosion, Water-Project* (1997) there. I did the project before the opening of the exhibition, so it would be even less within the official frame of the exhibition—and the curators and people of the biennial didn't know that I had done it until halfway through the project when the water was running all over the place.

HUO:

Johannesburg is a city without a river, isn't it; so you actually created a river?

OE:

I emptied out this rainwater reservoir. The water ran for one and a half kilometers through the city like a small river. It looked won-derful—very simple and poetic at the same time.

HUO:

For your piece The very large ice floor *(1998) at the São Paulo Biennale (XXIV Bienal Internacional de São Paulo, 1998), in the inside there were many art visitors skating on your piece, whereas outside, skateboarders were using the margins of your piece, performing all kind of tricks on its outside structure. What was fascinating was that the two audiences kind of met without really meeting. Did you want to bring the two audiences closer to each other?*

OE:

Well, maybe it actually took them even further away from each other, or at least exposed the distance between the people in the exhibition and the ones not inside. The distance between the two was bigger due to the glass in the window separating them. The glass might work as an interface, or maybe rather as a... who talks about loosing the tactile relation to our surroundings, keeping just a picture of it? I think Richard Sennett somewhere? He talks about the glass house of Phillip Johnson, or is it the Mies [van der Rohe] Farnsworth house north of Chicago? Anyway, Sennett suggests that by putting up the glass and isolating the tactile relations to the outside, our relations to the outside change and the sensation gets more representational. The Modernists, I guess, believed that the glass sort of opened up the border between inside and outside, but in fact the border, I believe, on the contrary got even more exposed, not to mention the social differences of who was inside and who was outside. But by isolating only some of our senses—such as sound and smell—from the "other side," the glass creates an image or picture not unlike a very realistic movie. We know the outside is there, but our engagement with it is slightly more representational. I would argue that there is a somewhat proportional relationship between how many senses are engaged and the level of representation. And this is something that I was trying to work with in São Paulo: that people outside became an image or representation when looked at from the inside and vice versa—for the people who did not pay the entry and stayed outside looking into the exhibition, saying, "The people in there—they think it's an artwork, but it's in fact just ice, and them walking on it is the art seen from here (outside)." So among other things, the idea of the glass was a soft borderline between reality and representation. This also goes back to the piece in Paris: is this ice-sculpture in Nanterre real? —I picked this particular area in the suburbs of Paris because it's so utopian—or should I say desperately trying to be "real." So

the question was—and I don't even think that "real" exists, just to make that clear—what is more real: Nanterre or the museum? I actually think the museum is more real in a funny way, and the sculpture in the grass is more artificial.

HUO:

So maybe it's like a litmus test for reality?

OE:

Yes, that's a good one. I should keep it for a title: "A litmus test for reality"! [*Laughs*] But to finish on the glass and my clumsy terms—real and representation—if we put on a Walkman when walking down a street, replacing the sound of our surroundings with music, the experience of the street changes due to its new "soundtrack"—it gets some sort of narration to it. And if we even recognize the particular street from films, such as Fifth Avenue in New York, the narration can be even more extreme and therefore the level of representation higher. At the Carnegie International, in Pittsburgh, most people looked at my steam column and water pool through a window; only very few people actually walked out into the museum courtyard to look at it from the outside [*Your natural denudation inverted* (1999), Carnegie International 1999/2000, Carnegie Museum of Art, Pittsburgh]. I ask you—how can you look at the outside steam project from the inside? Well, it's very easy, you just look through the glass, surely; you don't hear the sound and you don't have the sensation of pressure and suspense in the steam pipes, the wind and temperature in the museum court and so on. This is what I meant: the window, in a museum in this case, is always like a frame of a picture, and you look through the frame to see a picture of the picture of the picture of the picture... And most importantly; I believe that we *are* indeed able to orient ourselves within these levels of representation. It is very important to understand that I am not moralizing about this as a kind of loss—we are not losing it! It's not about romanticism. The only crucial thing is that when looking through the glass we have to be aware of this, or at least be informed in this case by the museum— that "you are in fact looking through a glass" and the experience of the rain "outside" is obvious, but you don't get wet. It's extremely important for me to notice, that we have to be aware of the "sliding" between the levels so to speak. And that we are aware when putting on a Walkman that it's not the sound of the street but the music of the Walkman. Or when looking through the window at the steam at the Carnegie Museum in Pittsburgh we don't feel or

hear the pressure at the steam nozzles but rather the sound of the museum shop behind us, and the steam is accordingly more abstract and movie-like. If we are aware of what our senses are telling us about our surroundings, we can indeed orient ourselves. Or I think it's a matter of responsibility of the institutions that they inform the visitors that the used display and presentation is a mediation of our senses. If we are mistaken about what we sense and believe that looking at the steam from the inside through a window is a truthful experience of the steam, we have a problem. It gets worse when believing that the music in the Walkman is the actual sound of the street or when driving a large jeep is mistaken for hiking in the mountains. This is why it's so important to see yourself sensing or sense yourself seeing. To survey our experiences from a sort of "third person" point of view—a double perspective— to support a sensation of presence on even extreme representational levels. Even in a film we are able to orient ourselves, as long as we know that it's a film. Or think about *The Truman Show* (1998). Now I don't know how we got to this! [*Laughs*]

HUO:

This leads me to another question, one about the relationship of your work and thinking to architecture. You went to art school, but you didn't study architecture, did you?

OE:

No, it sort of happened naturally... I was working with the notion of the spectator from quite early on. I tried to argue that I was just creating a non-mystical machine and the piece would really be the field between the spectator and this machine. The gaze of the spectator in a complex way constitutes or creates the piece. This meant that I thought a lot about what is a space, and more importantly, how do we orient and understand ourselves in a space? And this is how I came to architecture: the fact that the architecture is not the shell, but the shell would adjust itself or be a result of what's going on inside—or outside for that matter.

HUO:

For me, the first time that your link to architecture really became visible was in your Manifesta piece (Manifesta 1, Rotterdam, 1996), where suddenly there was a link to Buckminster Fuller through a very special experimental tent structure on which you collaborated with Einar Thorsteinn.

OE:

At this point, it was still a contained object, even though I tried to

integrate the Manifesta piece into the garden behind the museum. I never thought of this project as the beginning of my architectural interests, but maybe you're right.

HUO:

Well, it's the beginning of my noticing it in your work—not knowing it so well, so maybe I'm wrong. Could you tell me more about the dialogue with Einar?—as it seems to be a very important and long-term dialogue for both of you.

OE:

Yes, he is very inspirational, and he supports me with his great knowledge on so many things. It's hard to say, because we disagree on many things as well, and so we often have big discussions. But I should say as an introduction that he studied and started working with Frei Otto in the '60s. Then he worked a bit on very diverse things, getting to know a wide range of great people such as Buckminster Fuller. I met Einar the first time some years ago when I needed someone who could calculate a complex geodesic structure that I was working on. And since then we have become friends and worked together on many things.

HUO:

You mentioned earlier that the generation of artists who emerged in the '90s often has shared this doubt about the object, or a negation of the object. There seems to be a very interesting parallel with the architectural references which crop up in your work—you've talked about Buckminster Fuller before, and also Frei Otto, etc. These are all architects whose work doesn't care much about the object itself but, as Buckminster Fuller said, "It's a service, it is a relation, it can appear or disappear." What do you think about this link, then, between artists of this generation and these architects and urbanists—Yona Friedman or Cedric Price are other examples—who actually questioned the notion of the building as a permanent thing?

OE:

Just like the dematerialization of the art object became relevant again in the last ten years, the decentralization of the objective modern space into a non-central perspective understanding has arrived. And it's important that the new "understanding" is not a new model replacing an old one. We have now understood, I believe, that we cannot criticize the modern idea by simply making a new one replacing it—that would somehow just bring us back to the start. We cannot step out of history or modernity for that matter; what we can do now is to a higher degree evaluate where we ourselves stand in history—our own position has become

a part of our surroundings. For me, this is partly why I enjoy some of the more utopian architects and thinkers with their ability to reflect upon their own position from the outside.

HUO:

But this again seems to have to do with our generation—and that leads me to a question I wanted to ask before, about the difference you could see with the '60s or '70s—not only in terms of technical differences, but also in terms of this seemingly seamless oscillation between inner and outer institutional practice?

OE:

Do you think the institutions today are opening up like that? Maybe a few, but in general I only think it happens much too rarely that the inner and outer practices are joined. I think that artistic practice as such is mixing inner and outer structures, but the institution only follows this and only very seldom takes an active role in questioning these relationships.

HUO:

Do you see yourself as an infiltrator, as somebody who infiltrates the institution?

OE:

If you talk about the infiltration into the subject—the spectator or interpreter and how they see themselves in the institution—then yes. The institution, or lets say the museum, only really exists as a constitution or construction, and it is always changed or infiltrated with every show in one way or the other. I believe the viewers have much more power than they are actually offered, so to speak. Museums too often pacify the audience rather than activating them, often through what I mentioned earlier: not disclosing their own construction. The institutions, still after so many years of criticism, continue to commodify thinking or objectify "seeing" by their repressive way of communicating. I do see a general neglect of a great potential.

HUO:

"The spectator does (at least) fifty percent of the work?"

OE:

Yes, always—whether they are aware of it or not—and this interests me. The visitor or spectator is engaged in a certain situation; if the situation is activating, she or he will see the situation "engaging" back so to speak. Obviously, the situation doesn't actually react back at her, but she, through a constructed third person, sees

herself seeing. I don't think this is new at all; I think it's the same in the illusionism of Baroque painting: everybody knew that it was a painting, not a ceiling going all the way up to God with plenty of fabulous angels on the way. Everybody was suppose to know that it was an illusion—otherwise it wouldn't have been fantastic, it would just have been a very high building. However there are surely many differences too: today it would be an illusion to believe that we could actually make the conditions of our experiences completely transparent, because the third person perspective is just as well a creative, progressive, and productive act—there is nothing "behind," no truth to be revealed.

You relate to space: you see it, you walk in it, or you do something in it, and the space, due to its disclosed ideology, has the ability to show you that you are in it. It's like a reversal of subject and object: the spectator becomes the object and the surroundings the subject. Therefore [it's] endlessly seamless if you want. This is why I try to make the spectator the exhibited part, being in motion, dynamic and engaging. Pretending that the architecture and the situation is the subject. It becomes more and more complex, but an example is the show I did in Tokyo. You have a strong light shape projected on the wall. You look at it and it goes away, causing an afterimage on your retina where the projected light used to be. The afterimage is the complementary color. You now see the afterimage for a minute or so, no matter what direction you look. So now, suddenly, you are the second projector; you're projecting the image onto the wall. The person has become the machine.

HUO:

So the inside becomes the outside, the object becomes the subject.

OE:

If you like, but of course it doesn't stay like this, it flips back and forth: subject, object, subject, object... And I think this can be used as a quality. It's not a loss of abilities; it can be something positive and productive.

HUO:

Is this a new situation?

OE:

Well, I am not sure. Let me give an example: we look at a map if we can't find our way in a city. Just think of the many times we walk in the city and find our way due to our memory of the map we have at home. The map is a representation of the city as we know it. And the map is not better or worse than the city, it's just

something different, a different representational level of the city if you like. We use it to orient ourselves. The problem arises if you believe that the map is in fact the city, or the city is the map. Like at Potsdammer Platz in Berlin, where they suggest that the real situation is your experience of some sort of Italian piazza situation without disclosing the mediated elements. This phenomena, I would argue, is a manipulative displacement. So I don't think it's new that we are being displaced, but I think it's new that we, to a higher degree, can reflect upon this and understand the mechanisms. But let me add: this might make sense right now but maybe it doesn't in a few years' time...

HUO:

{Jonathan} Crary, in his text "Visionary Events" for your Kunsthalle Basel catalogue (Olafur Eliasson: The Curious Garden, 1997) *talks about the admission of Deleuzian virtuality in relation to your work: "virtual" not in the sense of virtual reality, but as potential, as something which can happen. So I was wondering if you could tell me more about that notion, because this is also something that I ask architects a lot.*

OE:

Virtuality is to me like a field of not yet used potentials—but it also and maybe more importantly stands for the focus on the process rather than the end result. My work very often deals with the processes in one way or the other—and like I said before, I think that it is important not to look at "other" potentials as alternatives to the current situation. Just like my work and its engulfed processes, virtuality is for me about the ability to desire and imagine in our life.

HUO:

In this regard, can you tell me about your dearest unrealized project. It's a question I like to ask artists in relation to the architectural setting, since in architecture, unrealized projects are an important tool—often architects have more things unbuilt than built—Zaha Hadid is an example—and little by little the work is getting ready to be built. But in the art world, people are almost ashamed of talking about their unrealized projects because they take them as failures—and I think that should change, because unrealized projects show how we should change, how museums would have to change, in order to make them happen.

OE:

Yes, I think my life in general is a yet-unrealized project. This is, let's say, the bottom line. I have tried to work with anti-gravity,

and I found a few people who are quite interesting. But this for now turned out to be a big unrealized area both mentally and physically. Still, it's very hard for me to say that this project is not realized, because all of the things which are unrealized are still in the big mixture-process-soup. Eventually, maybe one part from one project and another part of a different project float together and I have something which gets realized. Anti-gravity started with Euclidean geometry, then the relativity of Einstein, and later I was looking at Niels Bohr and the fact that when you measure something you've already had an impact on the measured, and so on. But as for specific plans, I would like to do a botanical garden in a large climetrondom—and ideas like this come and go every day.

HUO:

Crary wrote about your work in which he says that you escape any form.

OE:

Yes, I guess so. Like the strobe light, because gravity is maybe only something we imagine—if we didn't know, we might not even sit here on the chair, but fly around while talking.

HUO:

But you also have another unrealized project, the Berlin Green River, *which, through its publication in the media, almost became realized—it's a paradox, no?*

OE:

Yes, the city only exists inside you and me and inside everybody in the city, and since the sketches of the *Green River* were exposed so heavily in the press, many people talked about it and thought it had already happened. Even some said they had seen it so we did, in a way, have a *Green River* on our hands.

HUO:

What about the notion of collaboration? You're good example of how artists have, since the early '90s, returned to a more collaborative kind of practice. To what extent are collaborations fueling your practice?

OE:

In a certain way I think I always do it. The collaborative idea can be on various levels. In the case of an exhibition, I am lost if I don't have some sort of a collaboration with the curator or other people who are involved. I'm more responsive to the people in a given situation than the specific environment. I never do a project that I haven't spoken about to somebody. It's just not possible. So I'm totally dependent on the people who help me in my studio all the

time. And so this means for me that any sort of work that I do always, in one way or the other, has levels of collaborations in it—and it has always been like that.

HUO:

Can you tell me about the specifics of the collaboration with architects?

OE:

Especially now, as I've started to work much more with architects—both being more involved with commissioned work integrated into architectural projects, but also just by involving various architects into my own practice. The thing is that the whole field of what constitutes architecture and the ways architects work is changing super-rapidly, and I found a great amount of inspiration in this. In the same way that artistic practice has rediscovered its ability to constantly reevaluate its own platform, the architectural discourses have opened up a bit to engage in matters other than their own formal setup. This is why integrating architects—and engineers or scientists—is crucial to bring me to places I couldn't get to alone.

ENO, Brian

Brian Eno was born in 1948 in Woodbridge, England, and currently lives and works in London. While studying at the Ipswich School of Art, Eno fell under the influence of avant-garde composers Cornelius Cardew, John Cage, and Steve Reich. Although he could not play an instrument, Eno enjoyed tinkering with multi-track tape recorders, and in 1968 he wrote the theoretical handbook **Music For Non Musicians**. *In 1971 he rose to prominence as a member of the seminal glam band Roxy Music, playing the synthesizer and electronically treating the band's sound. Eno soon turned to his first solo projects, writing pop tunes with bizarre lyrics and quirky vocals, and in 1975 released his third solo album,* **Another Green World**, *consisting of nine long, repetitive, and ethereal electronic instrumentals. While developing these experimentations, he coined the term "ambient music," and gained popular success and critical acclaim both as a composer and a producer for David Bowie, Devo, and the Talking Heads. In 1979 Eno began making a series of vertical-format video installation pieces accompanied by his ambient soundtracks.*

........................

This interview was recorded in London in 2000.

Hans Ulrich Obrist:
In your book **A Year With Swollen Appendices** *(1996), there is this wonderful list, simply titled "I am," of thirty nouns, thirty roles that you must fulfill:*
I am a mammal
a father
a European
a heterosexual
an artist
a son
an inventor
an Anglo-Saxon
an uncle
a celebrity
a masturbator
a cook
a gardener
an improviser
a husband

a musician
a company director
an employer
a teacher
a wine-lover
a cyclist
a non-driver
a pragmatist
a producer
a writer
a computer user
a Caucasian
an interviewee
a grumbler
a "drifting clarifier."
What was the idea behind this list?

Brian Eno:

Well, I sat down and I thought, "I shall think of everything that I am." Have you ever made a list like that for yourself? It is terribly interesting, because there are quite a few things here that I didn't really think about before I started to make the list. I suppose that what happens when people get a job is that they put that at the top of the list and then everything else falls below it. I wasn't doing that.

HUO:

This self-description exercise dates back to 1995. Let's go back to the beginnings: who was Brian Eno at the beginning? Not yet a musician, a producer, a writer, a company director, a celebrity...

BE:

Well, I started life as a fine art student.

HUO:

Where did you study?

BE:

I studied at a very, very interesting, very experimental college called Ipswich School of Art that was run by Roy Ascott. I think of him as a great educationalist that had a way of setting up very interesting places where lots of things happened. He was very doctrinaire. Doctrinaire is not bad in education. In general, I would say that liberals don't make such good educators. I think what makes for a good educator is someone who has a very strong position that you can define your own position in relation to. Because of the clarity of their posi-

tion, you can see where you agree and where you disagree. I went to that school, which was very interesting, and then I was already experimenting with music a little bit. In fact, my first access to a tape recorder was there.

HUO:

So you produced your very first music piece there?

BE:

My very first piece was not very different from some of the pieces I am doing now. Inside the art college they had a very big lampshade, a big metal lampshade, and I used it as a bell, basically. I did a piece with these very long bell tones, and then I used the different speeds on the tape recorder to create layers of very deep sounds. And then I played it back in a room, and that was an important part of it, that it occupied a room. I put speakers around the room and the sound filled that room: so that was, actually, my first sound installation. After I left college, I joined a band that was also very visual and very aware of its visual character. This was sort of original at the time because there had been a period through the late '60s and early '70s where the idea of being a musician was that you, sort of, turned your back on the audience and got into the music and we just hated that kind...

HUO:

... of artistic existential approach?

BE:

Yes, that's right, this very romantic sort of approach, totally lost in the music without even realizing that there is an audience out there. By the early '70s, we were all completely sick of it. We wanted to do things that were theatrical and had a big show element. Another thing was that rock music was old enough—mind you, it was only 15 years old then—to start looking at its own history. Part of the job of being a musician, in this kind of band that we were in was not only playing music, but also taking a position in relation to the history of that music. We quite consciously imported things from previous musical forms and stuck them together.

HUO:

It was a sort of proto-sampling?

BE:

Yes, it was. We were very clear about what we were doing there. It was the very beginning of the idea that rock music could have itself as its own subject, its own content. I suppose that really was the beginning of sampling. Later, at the end of the '70s I made a record with David Byrne called *My Life in the Bush of Ghosts* (1981)...

HUO:

... on which you used sampling and found sounds extensively.

BE:

Yes. And I had two reasons for the way I worked on that record. One was because I was fed up with songwriting. I was fed up with the idea that the voice that is used in a piece of music should always be the center of the piece, and that one should always see the music as the support structure for somebody's message. I didn't like it any longer. I never liked it very much, actually. So I started thinking about using voice, making songs, and making it clear that these voices are just on the same level of meaning as any other instruments there. There are no longer special focal points, and they don't carry the message of the song.

HUO:

But somehow this was already present on your first solo albums of the '70s. It's quite a linear process that you followed from these first albums to the moment you invented "ambient music."

BE:

I think what happened as I started making records in the early '70s is I started to become more and more interested in what was called the background of the music, and less and less interested in the foreground. The way songs are traditionally structured is that you have the rhythm section down at the bottom, and then you have a bundle of instruments in the middle, and then you have the voice sitting on the top. Most of the music I really liked didn't do that. It was flattening the whole thing out, like soul music for example; the rhythm instruments were so loud that often the voice became a rhythmic... just part of the rhythm. I started to think that what I really like is an undifferentiated field of some kind, and so I started to make music of that kind. That is what I subsequently called "ambient music."

HUO:

Your work has always created bridges from art to technology and science. How did this approach take shape? Was it with Roy Ascott at Ipswich?

BE:

I think it did. I think it started because in the mid-'60s, in England, there was a fantastic crossover that happened between contemporary music, avant-garde music, pop music, and what visual artists were thinking about. There was a feeling around at the time that art was not a question of techniques, but a question of concepts. If you had a bundle of concepts, you could just as easily move over into anoth-

er area and use the same concepts. You've probably heard about the Scratch Orchestra, Cornelius Cardew's group. That was a prime example of that way of thinking; that there was no difference, really, in theory, between literary output, behavioral output, performance, music, or painting; things could come out in all different ways. You might make a painting today and a piece of music tomorrow. The particular set of ideas that interested me, that seemed to stand below all of that, were: what kinds of processes do things come into being from, how do we describe them? I had already got pretty interested in Cybernetics, and that was very much a part of Roy Ascott's legacy—he was big on Cybernetics.

HUO:

Yes, interestingly, Roy Ascott's thesis, Behaviourist Art and the Cybernetic Vision *(1966), begins with the premise that interactive art must free itself from the ideal of the "perfect object." What particular musical experiments did you find influential at the time?*

BE:

There was a particular piece of music that completely intrigued me and I spent a long, long time thinking about it and writing about it and trying to understand how it worked, because I felt it was the beginning of a new way of understanding art—actually, art and culture in general. The piece is by Cornelius Cardew and it is called *The Great Learning* (1969/1971). In fact, there is an essay about it in *A Year with Swollen Appendices*: it is an essay I wrote in 1975, so the writing style isn't that good, but I still really stick by the content of it. What I think I noticed there was that it was a way of composing that was really quite different from the way classical music is composed or from the way pop records were made. That way of composing is to suggest a set of rules and conditions, which are actually the piece of music, and then an individual performance is one possible outcome of those rules and conditions.

HUO:

So it is a complex dynamic system that grows?

BE:

That's right. Instead of building a house—which is the way classical symphonic composition saw itself: building a cathedral—instead of doing that it is like designing a seed. You plant it and it grows into something.

HUO:

This time-based idea also makes me think of Gordon Pask and the architect Cedric Price.

BE:

You know, they both came to talk to us at Ipswich; those ideas really took root in me; the idea that an artist didn't finish a work but started it. You design the beginning of something, and the process of releasing the work is the process of planting it in the culture and seeing what happens to it.

HUO:

Were there other main influences?

BE:

There was one prior to *The Great Learning:* the Steve Reich tape pieces, which I thought were sensational because they were so economical. I loved the fact that you could get so much music out of such a tiny input. That piece called *It's Gonna Rain* (1965) is from a loop, which is less than two seconds long. I also liked the way that those things worked in that they were very simple forms, of which I have been doing a lot since, which is just setting in motion two processes and letting them overlap, letting them interact with each other in different ways without trying to control how they do it. So that happened. The other thing that happened towards the end of the '70s was that I saw John Conway's *The Game of Life* (1970). John Conway is an English mathematician. He became interested in instruction theory and he invented this tiny little game. It starts with a grid. Each of these squares has only two conditions: it can either be dead or it can be alive. O.K., we will say that is a live square. There are only three rules for this game. They tell you about what is going to happen in the next generation, about whether a square is going to come to life or whether it will continue being alive or whether it will die. Those rules have to do with proximity to neighbors, so a square with three living neighbors stays alive. A square with more than three living neighbors dies from overpopulation, and a square with less than three also dies from isolation. So there are only those three rules and you don't think much is going to happen. So, you tell a computer to do this and you press "go" and it goes [*computer noise*]. This thing is the most beautiful thing you have ever seen. You go "wow" and you change, you start it again and now you change the position of one square, just one, and it goes [*gesturing*], finished. It is the most unintuitive thing you have ever seen. The initial conditions are completely important in a way that you simply can't intuit. The rules are very simple: they are totally deterministic. Nothing exot-

ic about them, you can easily understand them, but the interaction of those three simple rules produces a level of complexity that absolutely changes your life. Once you have seen that you believe everything about Darwinian evolution.

HUO:

Is it also about unpredictability of outcome?

BE:

Yes, and what is so fascinating is your complete inability to intuit what will happen. I always like to show this to people who think they have good intuitions. It just shows you that, even with three simple rules working, you simply can't predict the future. I think there is something about *Life* in there actually, John Conway's *Life*. I am giving a talk about that at the ICA [Institute of Contemporary Arts, London] next month, because I think it is the easiest way for artists to understand what is really exciting about science.

HUO:

So it influenced your work in the sense that it was a model for doing rule-based music pieces?

BE:

Exactly. Conway's game started me thinking about building rule-based systems. This led me into, on the one hand, things like *Music for Airports* (*Ambient Music 1: Music for Airports*, 1978) which is, yes, essentially, a rule-based piece of music, and on the other hand into working with computers. The interesting thing about working with computers is that they can handle a lot of rules at once. I had been working for a long time with a piece of software called Koan, which allows me to write a number of musical rules having to do with scale, harmonization, and pace, and I can write lots of probabilistic rules. I can say, "Use this scale but only use this note an average of forty percent of the time and this one eighty percent of the time," and so on. Each piece of music is a little machine, in a way, for producing. It is like each set of rules is a single kind of genome, and then each individual performance is one of that species. They are related, but they are not identical. Similarly, I have been working with a similar system where I make things that keep reconfiguring in different ways. The initial material can be quite small, but the number of reconfigurations is huge.

HUO:

The unpredictability of the outcome, in the art context, is what makes the conceptual couple instructions/performances fascinating: this uncertainty gap

between the imagination of how the piece should be or should look and the interpretation, the various interpretations that can be given following the instructions. For Fluxus artists, everything was about intention and misunderstanding. In {Robert} Filliou's words: "It is either well done or badly done or it is not done at all, but there can't be hierarchy between these three."

BE:
One's position on these things depends on how much you think the work consists of the process of making it and how important it is for you to make something that sits separate from you and your explanations of it. For instance, I worked with Filliou and George Brecht thirty years ago. I worked with them on several things. Their process of working was totally intriguing. Very often, the result was almost irrelevant. But result is not the issue. The issue is the whole process, with the result included as a relic of it—really as a pointer back to it. I didn't want to make things only like that. I wanted to make things that had a separate existence in the world. When I talk about making seeds, I am very aware of the idea that you become aware of in pop. Pop music—the idea of planting something that is actually quite innocent, which flowers into something far beyond what any of its makers would have imagined, and which stimulates the active interpretation and participation of millions of people. That slightly changes how you fall on that spectrum of what kinds of instructions you are using.

HUO:
Filliou's works were mostly made for twenty people, twenty testimonies...

BE:
That's the other thing. These twenty people were there with him, so that is a different feeling altogether. I like the idea of making things that exist quite happily without me being around them. In music, you talk about releasing records, and I always liked that expression because that is exactly what you do: you release it from yourself. You release it from you standing around and defending it and saying this or that about it. You set if free and it is just floating with everything else out there and then it takes whatever value is conferred upon it. I am very keen on this idea of conferral of value. The old idea with artists is that they take dead material and fill it with value, and I never liked that. From the age of 15 I didn't like that. What I liked was the idea of making things that attract value to them. They can be quite small. You put something out into the world and either it disappears completely, which often happens, or it starts to accumulate resonance... A record like *Music for Airports* was a very strange record to release in 1978, because it was completely minimal, but it

was being put out into a pop context. It wasn't being put out as: here is a piece of arcane minimalist music. I put it out as a pop record.

HUO:

Can you tell me more about the importance of titles in your work?

BE:

Well, I stopped writing songs quite a long time ago, but I still love words, so the only lyrics I still have are titles. I have to use very few words to create a big picture. *Music for Airports* was very successful at that because as soon as it came out everyone thought that it was such a funny idea to call a record *Music for Airports*. It got tons of attention because of that title. I really like *Before and After Science* (1977) also. Titles are something I have put a lot of attention into. You only ever have to suggest to people that those ideas might be in there and they will find them.

HUO:

Could you mention some of your unrealized projects?

BE:

You mean deliberately unrealized projects?

HUO:

Well, there are all kinds of unrealized projects, but I'm interested specifically in the projects that were too big to be realized, or too small, or to expensive, or censored, even self-censored, or just not realized yet—unbuilt roads.

BE:

O.K. One project which hasn't been realized, and I have thought about it for a long, long time, is to try to build music almost from the atomic level. I use generative and rule-based systems to organize sound, to organize already existing pieces of sound. But what I would like to do, really, is to use those same systems to actually make the sounds, to create the sound on the atomic level, as it were, in exactly the same way that I then configure the sound afterwards; to use the same set of principles all the way through. I haven't done it because it is technically quite difficult, but I want to do that. That is a very technical project that I've been thinking about for, well, 25 years or so, and I have made lots of notes and sketches for it and one day I think I will do it. Another unrealized, unbuilt road is my idea of "quiet clubs," clubs you go to where nothing much happens.

HUO:

What would that look like?

BE:

I have had the idea to build a quiet club for a long time—not as a kind of art installation, but as a working club that people would go

to and enjoy. It would support itself. I have done them as installations in museums. I have done demos of what they might be like, but that is not the same for me. I want to do it for real and see if it can survive. If I start thinking about unbuilt roads, I get depressed, really. There are so many of them. I've got a whole bloody road network of unbuilt roads. The other one that I am still working on is the idea of a text-generating machine. I've worked a lot with music software and it is very obvious that making music has become more and more easy. I work with a lot of people and I see the music appearing very, very quickly, but the lyrics are appearing incredibly slowly. The text does not happen. I start to think, "Well, it should be very easy to start to build a software into which you can enter lots of bits of text that you are interested in, that you like, ideas you want to play with, and you should be able to enter rhyming schemes and stress meters, schemes for basically organizing the words." Then it should be possible for the thing to start giving you arrangements of the things you put in. You might, very rarely, get finished lyrics from that, but what you would get would be very interesting beginnings. If you could take a line like "desolation at epicenter" and put it in with phrases and words that kind of fit together in your mind...

HUO:

It's a bit like a computerized version of the generative constraints set by Georges Perec to write poems?

BE:

But writing for songs is quite different from writing for poems. You have to consider rhythm, melody, and stress very much more than you do in poetry...

HUO:

Another unrealized project is this garden project in Barcelona, the "Real World Experience Park." What are gardens to you?

BE:

I love gardens; I think it is the most extraordinarily sophisticated form of sculpture. Sculptors really have a very easy life by comparison to gardeners. A gardener not only has to think of changes within a year, but each year as it grows up. This is an amazingly complex four-dimensional problem, working in space and time. The city of Barcelona invited Peter Gabriel, Laurie Anderson, and myself to design a park for them.

HUO:

Was it their idea that you collaborate or did it come from you?

BE:

No, no, it came from us. Peter's idea was to design a new kind of theme park. The more I got involved with it the more I thought that just building a park was actually a better idea. We had been given a site in Barcelona, in the city itself. The problem with a theme park is that it is terribly expensive to maintain, so you have to charge a lot of money for people to get in, which ends up excluding the general population and then it becomes like a bubble that they rarely penetrate. So we then started developing the idea of a park that would attract very interesting things to happen in it, you know, all the sorts of things that go on in a city, like skateboarding, snowboarding, and roller-skating, and dancing in the streets—to make a park that is able to accommodate all of that. So, this is a project that may be revived.

HUO:

The collaborative Barcelona project leads me to question you about the notion of collaboration itself. Would you agree that your work as a producer for David Bowie, David Byrne's Talking Heads, and U2 are long-term collaborations? Could you tell me about your relationship towards such collaborative practices?

BE:

I love collaborating with people. First of all, if you are working with someone else there is a pressure to finish the work. I lack that pressure often when working on my own. I take the thing to a certain point and then I go on to something else. If you are working with someone else, because you don't want to disappoint each other or because you told people that you are doing it, or for whatever reason, you want to get the thing finished. Also, when you are working with somebody else you keep being put into positions that you would never have found yourself otherwise. It is a much more alive situation. The landscape keeps changing underneath you and you have to rebalance yourself constantly. I like collaborating with certain people very much, and my role becomes more and more clear as time goes on. I am called a producer, but actually that is a funny name for what I do. What I often end up doing is trying to help them make good music; it's as simple as that. If that means helping them write the music, that's what I'll do. If it means organizing the studio in such a way that I know people are going to feel comfortable in there, I'll do that. One of my longer-term collaborations is, obviously, with David Bowie, and that's been a very fruitful collaboration. I like working with him a lot.

HUO:
And it's ongoing?
BE:
Yes. We are just talking now about working together again. We really work in a different way. I put in a lot of time and I like building something up, a kind of context, and then I like it when he walks into the studio and he hears for the first time a quite full piece of music, quite a completed thing, and he gets excited about it and responds immediately to it. He's totally gifted in the studio. I have never seen anybody who can just spit things out as quickly as he does. He works very fast. I work quite methodically. I think I work quite fast as well but sometimes I am building up something that has six or eight instruments in it, or even more. I know how David works now. If you build up something that is six-and-a-half minutes long, it will end up six-and-a-half minutes long. He doesn't edit. So I try to pre-edit as well. I try to think, "O.K. he's going to sing something there, then he's going to want something else to happen there, so I am going to make something else happen; he's probably going to run out of ideas about here, so let's end it." I like that kind of anticipation. I don't always get it right, though, but he is a pleasure to work with from my point of view. He's very fast and I like that. Some people work very slowly and I can't really retain my concentration for that long. I go in and out of the projects. If they're very long projects, I simply leave them and then come back in. And when I come back in, I can really pull things together; I can create focus by not being there all the time. Lately I have been collaborating with a German musician who I get on very well with—a guy called Peter Schwalm. Together we made a kind of music that is not like anything he's ever done before and it is not like any thing I've done. It really came out of this partnership. It is very beautiful, I think—very strange new music. He's a young guy who grew up listening to Miles Davis records in the '70s. He had never heard of me. He had no idea who I was, which, of course, is great. He grew up listening to those records, then he went to music school and he studied drumming. Then he made a record of his own (Slop Shop, *Makrodelia*, 1998) which is a sort of weird new kind of jazz, I would say.

HUO:
Since the beginning of this interview, you've mentioned these multiple roles or activities of composer, producer, and (long-term) collaborator, not to mention the thirty elements composing the "I am" list again. But there's another

activity that we have only lightly touched upon here, which is the one of a
visual artist. It really started in 1979, with exhibitions in galleries in New
York. Could you tell me a little bit about this work?

BE:

I think that stands in a rather strange place. I never thought of it as
being part of the art world. One of the reasons for that is because it
has absolutely no text, and in the British art world, if it doesn't have
text it has no position really. I have always wanted to do something
that would be the visual art equivalent of pop music. I remember in
a show I had in Holland, one of the nicest things anyone has ever said
to me was, "Oh, is this your work?" And I said, "Yes." And he said,
"It's really fantastic, but who did the music?" I was so pleased.

HUO:

One last question: How would you define the notion of ambient music today?

BE:

Well, it has become such a broad category now. I don't know how
to answer it because I don't know what is not included. I just recent-
ly heard something that somebody played for me called "ambient
trash metal." I can see the point, because I often used to say in the
early days of ambient music that the closest music to it was heavy
metal music. That is another completely immersive music. If you go
to a heavy metal show you are not going to listen to the lyrics, you're
not going to hear guitar solos. You are going to absolutely bathe in
this sound, and it is an incredible experience. If you have ever been
to a loud heavy metal show, it is really something. It is like experi-
encing the physicality of sound. I can see the linkage there. I sup-
pose what I would say now if I were going to come up with a defi-
nition, I would say it is immersive rather than narrative music. That
is about the only thing that I think is retained in all the things that
are now called ambient.

ESQUIVEL!

Juan Garcia Esquivel was born in 1918 in Tampico, Mexico. He died in January 2002 in Jiutepec, Mexico. A keyboard and electronics prodigy, Esquivel was featured soloist on the radio by the age of 14, and at 18 he was conducting his own band with 22 musicians and five vocalists, performing on the radio and appearing in theaters and on the concert stage. Esquivel honed his writing and conducting abilities providing the background music for a daily radio show starring the comedian "Panseco" (Arturo Elizondo). "He'd ask things like 'Can you play something that sounds like a Russian guy walking through China?' and somehow, I would do it," Esquivel later recalled. By the early '50s, Esquivel had expanded his orchestra to 54 pieces and had become one of the most popular artists in his homeland. Las Tandas de Juan Garcia Esquivel, his first album, was released in Mexico in 1956. In 1957 he released a mono album in the U.S., and was brought to Hollywood in 1958 by RCA Victor producer Herman Diaz. Esquivel took advantage of the latest development in stereo to use his albums as laboratories of sorts to explore the spectrum of recorded sound, as reflected in albums such as Other Worlds, Other Sounds *(1958);* 4 Corners of the World *(1958);* Infinity in Sound *(1960) and* Latin-esque *(1962). Esquivel employed then-exotic instruments such as the Theremin, the ondioline, early Fender-Rhodes keyboards, Chinese bells, the bass accordion, and boo-bams (a 24-bongo kit tuned to F) to get the sounds that he desired. In 1963, Esquivel switched from studio work to live performance, creating a stage show featuring four svelte female singers, flashing lights, and choreographed routines; he played Las Vegas and Lake Tahoe circuits until 1975. During that period, Esquivel also composed extensively for Universal Studios, writing theme songs and soundtracks for TV shows including "The Six Million Dollar Man," "Charlie's Angels," "Magnum, P.I.," and "Kojak." In 1979 he returned to Mexico. Beginning with an interview in* Incredibly Strange Music, Vol. 1 *in 1993, Esquivel enjoyed a tremendous revival in the last decade of his life, and many of his albums were reissued. With the space-age pop/exotica revival of the mid-'90s, Esquivel was not just being rediscovered, he was being championed as a cutting-edge innovator, and dubbed the "King of Space Age Bachelor Pad Music."*

........................

This interview was conducted together with Mexican artist and architect Pedro Reyes in Cuernavaca in July 2001.

Hans Ulrich Obrist:

My first question is about the exclamation mark that always follows your name. What is its significance?

Esquivel!:

It is true that they don't generally use my full name, they just use "Esquivel!" Juan Garcia Esquivel: they shortened the name and added the exclamation mark. I don't really care, so I took it as a

trademark. The first time it had been used was in a place in the States called Lake Tahoe, and *voilà*. It's a kind of frontier between California and Nevada. It's a place of gambling and casinos, about a four-hour drive from Las Vegas. This was a long time ago. It was in a very nice hotel resort called Harvey's, quite a beautiful place, both in winter and in the summer. Now, I have been out of circulation because of an accident I had where I broke my hip. They had to operate on my leg and so for almost seven years I have been in bed. It's a shame, but I'm doing therapy. They're giving me some exercises, so soon I hope I'll be up and around again.

HUO:

You have been a pianist, a composer, an arranger, and a conductor. How did you handle these different roles?

E!:

In my day, one thing led to another. I started being a piano player, then I had a radio program that became really popular.

HUO:

When was it?

E!:

In the '40s. I then decided to form an orchestra because people wanted to see me. Now, to form an orchestra I had to learn how to write music, so I started studying different instruments. That was at my school; I gathered around twenty or thirty musicians and I asked them what they played. "I play trombone," "I play trumpet," and so on and so forth. And, "What can you do with your instrument?" "What's your range?" I was learning to make notes, and then the orchestra boy (I had a boy who used to help putting up music stands for the orchestra), would give each of the musicians a sheet of music paper and a pencil, so every one of them had to write. I was at the piano in the middle of the orchestra, conducting from the piano. I had 24 musicians. It was quite an experience for me. And that's how I arranged; that's how I learned to conduct an orchestra, and how to arrange music all whilst playing the piano. One thing led to another: first piano playing, then arranging, then I decided to conduct. I had to start studying the instruments.

HUO:

Studying and also inventing instruments, right?

E!:

Yes, I made them myself. I gave the ideas for what I wanted. I tuned bongos chromatically. I used 24 bongos to play melodies. It was very unusual, as the bongos are used mainly as accompanying

instruments, just in the background. I also made a steel guitar, a lot like the one that very famous musician in the States uses. I don't know if you have heard of Alvino Rey? He plays the console guitar.

HUO:

He used your invention?

E!:

Actually, we did it together. Because when I arrived in the States, I asked the musical contractor if I could have someone that played like Alvino Rey, and she said, "You can have Alvino Rey—he will play for you." In the States, I found it very easy to hire whomever you wanted. It's not like in the Latin countries. In the Latin countries, when a musician gets famous, he refuses to play as a sideman. But in the States, whatever you want, you just ask. Any name, you make an appointment with a musical contractor and he asks you what you want. So I told him I wanted five voices: two girls and three men and what kind of ranges. He would willingly give me whatever I wanted.

HUO:

Who else did you hire?

E!:

In the States I used the best trumpets they had. I had a large orchestra there. I used five trumpets and four trombones, five saxophones, four French horns, two alto flutes and all the rhythms— organ, bass, guitar, drums—until I started thinking about not having such a large orchestra. For the contractor, it's much easier to pay for six or ten musicians instead of thirty plane tickets and thirty rooms. I started thinking very seriously of writing music for six guys and four girls, and that was a very nice group.

HUO:

That was your Las Vegas band "The Sights and Sounds of Esquivel"?

E!:

Yes, and I performed in Las Vegas at the Stardust Hotel. I was there for about 12 years. I was quite busy. My contract with the Stardust Hotel was for 26 weeks a year. You had a lot of big bands, and I was one of the last ones to perform with a big band because of the rock. Rock'n'roll came, and I knew it was the trend to follow, but I wasn't ready to change my style so I just chose to make it a small show.

HUO:

Before that turn, you invented these groundbreaking multi-media shows with incredible light effects; these shows influenced the whole of the pop industry so much. One can say that you invented a new medium.

E!:

Yeah. I had to leave Hollywood. I had to leave town and go to live in Las Vegas. I would perform every night and when I made my recordings, I often had to fly from Las Vegas to Hollywood. Every night, every week, I had to fly and I would record in Hollywood. Then I would fly back to Las Vegas. Wow. It seems such a long time again ago: forty years. That's a long, long time. And almost all the recordings I made in the early '60s were only released in 1998. And then suddenly all the recordings I had made almost forty years ago came alive again.

HUO:

See It In Sound! *was one of them. It came out in 1999, although it was recorded 39 years ago. RCA thought it would be too jarring for their customers' ears...*

E!:

When I made that recording, they didn't like it. It's not that I don't like RCA, because I like RCA very much. They never said no to any of my ideas. As a matter of fact, once I had two, no actually three studios at the same time. One studio had a piano and the rhythm section; and then in another studio I had the trumpets and the trombones. And in another studio, I had the saxophones. The musicians could see me through a closed circuit TV. I was lucky because RCA gave me all the facilities. They never said no.

Pedro Reyes:

I have a friend who has all of your records, not on CD but LPs. He's a big fan of yours and he has all of your records. He's very funny because when he gets these records in flea markets for ten or twenty pesos, he then goes to the United States and sells them for a hundred dollars.

E!:

[*Laughs*] I know. Once a friend of mine told me that he had gotten $150 for one of those. It's amazing.

HUO:

What's the title of the album that you recorded in different studios?

E!:

This was *Latin-esque* (1962), it was the time when they were selling stereo equipment, so they would give away albums with the machines. They gave away about 60,000 copies of *Latin-esque*.

HUO:

It's interesting to mention that you had a degree in engineering and it maybe explains why you've always been fascinated with the latest achievements in stereophonic sound. In your albums, Other Worlds, Other

Sounds *(1958) or* Exploring New Sounds in Hi-Fi *(1959), you sought to push stereo music to its limits, weaving unusual sounds into your music, ping-ponging them from one side of the headphones to the other.*

E!:

Before I started with music, my intention was to be an engineer, and it was then that I developed my knowledge of microphones. That helped very much in the recordings because I had all these ideas that I then had the opportunity to develop. Also because of my desire to invent new things; I don't think I could have done it without this knowledge in my head. And as I said, I had a big chance with RCA and I'm very grateful to them. And by the way, do you know that they are going to make a film about my life?

HUO:

No, that's wonderful. Fantastic!

E!:

It will be a movie with a young actor—John Leguizamo. He's from New York—very talented. I had a visit here from the director, Alexander Payne, and from the scriptwriter who comes from Spain. He came all the way from Spain to visit me here, to get information.

HUO:

Did you expect this to happen?

E!:

I was very surprised because I didn't think my life was worth making a film about. But on the other hand, I'm very flattered of course, and very anxious to see what they're going to do. My life has been very interesting and I have had the pleasure of being listened to by very important people like you, from London, Switzerland, from Budapest, Hungary, from Spain, from the States. It is nice to know that in spite of all the time that has gone by... They sent me a video of this actor and he was in New York performing to a full audience, by himself, just one man filling the stage. He talks and kind of dances. He's very talented. Of course, people will want to know what I looked like sixty years ago. But this guy will wear glasses like I used to.

HUO:

You said that in terms of color, it's as if you were a painter: there is a canvas and the music is the color. You also referred to Van Gogh being a great influence for your music. I was wondering if you could tell us a little about your relationship with the visual arts, and the importance of the visual arts for your music.

E!:

Well, I consider that my music is like a painting because I use different colors and different moods. I could say that, yes, my music is like a painting. I like very much Van Gogh. The only thing that I don't like about him is that he cut his ear off. I wonder why. He must have been very depressed or something like that. But his music, his painting is very fine. I like him very much. I have two paintings by Van Gogh in my home in Mexico.

PR:

You studied at Mexico University at the time it was a very experimentalist place. In the '50s—I was telling Hans—the color television was developed here and some interesting research on cardiology, and that it was a good period for technological and scientific research in Mexico. Maybe this was at the same time you were active in Mexico.

E!:

It was my desire when I was very young to be an engineer.

PR:

Is there any footage in existence of you performing? Any videos of your shows?

E!:

Some. I used to have a big collection of cameras and all kinds of films. My life has been full of experiences—photography, engineering. I was in the home of a son of mine who lives near here in Taxco. I decided to go over and spend some time there and I was with him for almost a year after I had finished my contract in Las Vegas. In his bedroom he had a very slippery floor, and I fell down four times and hurt my leg. But I never imagined that I was going to come over here. I was trying to make some financial transactions. I hired a taxi; it was an experience because the chauffeur didn't have a license to drive. He didn't own the car he was driving. So we lost three hours running through all this, then finally a policeman stopped him and we found out that this guy didn't have a license. So anyway, the car wasn't his and he didn't know the area. So I tried to call my brother who lives here. I found a phone booth and was in an almost desperate hurry because we'd been lost in the city. When I got out of the car, I fell down and broke my hip and that's why I've been in bed all this time. But I kind of like it. My brother's home is a few blocks away. I found this place by chance because it's secluded. And now I live here with no problems I'm happy. Two girls take care of me. I have my studio across the room with a synthesizer, my piano.

HUO:

So you continue to write music?

E!:

I'm a little behind with my writing because I've got this little infection in my eye. I have to put some eye drops in my eye. Have you ever been to Japan?

HUO:

Yes, many times. Why?

E!:

That's the one place I always wanted to go to, but couldn't because of my contracts here, I mean, in the States. I was close by though— I went to Korea. I went also to Tahiti, Morocco...

HUO:

Can you tell us about your experiences conducting a large orchestra? You once said in an interview that to a certain extent the conductor has to be a dictator.

E!:

Yes, as a matter of fact, I once conducted the Boston Symphony Orchestra. Victor Young asked me for an arrangement for the film *Around the World in 80 Days* (1956), and he said, "This is your turn, Maestro," and I had the pleasure of conducting. It was a very important moment in my life. I'm trying to make some new music because my manager in New York is asking me for new material. I'm writing a novella entitled "Guacamole." It's a nonsense thing, done on a synthesizer. And it's nothing but rhythm and the orchestra. But once in a while in the arrangement, the words "guacamole, molé, molé, molé, molé."

HUO:

"Guacamole, molé, molé, molé" reminds me of "Zu-zu-zu" and "Pow! Pow! Pow!"

E!:

Yes, well, that I have in mind to finish, that and more ideas which I shall try to complete.

HUO:

Can you tell us a little more about your 12 years in Las Vegas?

E!:

It's wonderful because in Las Vegas, one of my roles was as a communicator, because I would talk to the people. I presented my show, my arrangements, and sometimes I would try to make jokes, subtle jokes. I learned how to live by night and sleep in the daytime. I had to go to bed at 4:00 in the afternoon and get up at 12:00 at night, take a shower and go to work. I would perform two

shows a night; one of them was at 1:30, the other was at 4:00 a.m. And sometimes, after the show I would call for a rehearsal and work with the orchestra after having done two shows. We would go to the cafeteria and have something to eat, then we would rehearse from 8:00 to 11:00 in the morning. At 11:00, I would go home. I had a nice large swimming pool. I would sunbathe a little. At 12:00 I would go inside the house to write music and to make phone calls because of the time difference between Las Vegas and New York. So life was very busy. Working at night and rehearsing in the morning, and bed at 4:00 p.m. Tremendous.

HUO:

Was the city an inspiration? Did you "Learn from Las Vegas"?

E!:

Oh, a lot. A lot of things. Do you remember Frank Sinatra? Frank used to come and see me when he was in town. He used to come to my show, and I would always know he was there because he would send notes in the napkins saying "Play *Bye-Bye Blues*!" He liked that song and arrangement. That's how I would know he was there. And he used to go with many artists. He took Shirley MacLaine, Ann-Margret. It was very nice.

HUO:

And it's also at this time that you started to make music for television, during the Las Vegas years?

E!:

I wrote a lot for television. I wrote music for series like "Kojak" and for the "The Six Million Dollar Man."

HUO:

Amazing!

E!:

And for "Columbo." He was a detective. I made close to 200 songs for Universal Studios. I have an infection in this eye, I guess from watching so much TV. I wanted to put music to what is happening. I have a knack for descriptive music, you know, like when a girl is walking at night, alone, and suddenly a hand grabs her; I have a disposition for putting music to all kinds of scenes. Music for love, music for storms, electric music, horse music. I even wrote music for Indians and cowboys.

HUO:

What's really fascinating in your case is how you've been at the forefront of pop avant-gardism, working very experimentally, and yet you've never had a problem with commercialism and mainstream.

E!:

I have never said no to any job. They asked me, "Will you write music for this?" And I would say yes even if I didn't know how to do it. I had to invent, I had to make inventions. But I don't remember having turned down an invitation to write music for anything. That has taken me to very particular circumstances, because not knowing anything about the media I had to learn. So I had to learn about writing. If you asked me to write Chinese music, I'd say yes, even though I don't know anything about it. I would find a way to learn. It was a funny thing. I said I wrote music for Indians and cowboys. I had never written anything for Indians, and I remember a very famous actor—Randolf Scott, he was as famous as John Wayne—when he heard my music for Indians, he said, "This guy must have some Indian blood, because this is the best music for Indians I have ever heard." That was a compliment, and also because it was the first time I had ever written for Indians and cowboys, but like you said, always using different aspects of music. I would use different instruments. It was a very nice experience. I love that way.

It's very interesting because I always… well it's a little immodest on my part to say, but I think that most of the time I succeeded. To me, making music is like giving me a doll, and I take the clothes off and I can put anything I want on her. I can put Greek or Swiss dresses or hair, or I can draw a moustache, or I can put a cigar in her mouth. Experimenting; and that's very gratifying, thanks to the good will of the people that let me do my experiments. Because I don't know, if I were in other people's shoes I don't know if I would hire myself.

HUO/PR:

[*Laugh*]

E!:

Because I'm experimenting all the time; I can never guarantee that, yes, this is going to be alright. They let me do it, so I tried.

HUO:

And do you have unrealized projects, projects that weren't possible under the given circumstances?

E!:

One thing I considered was working with Ima Sumac. Do you know her? She's a singer. She has a wide range from the very low notes to the highest note. She was very popular. I don't know if she's still living, or what she's doing, but all my life I tried to find a way to use her. She's fabulous. And now … I don't know. I will

quote General McArthur. He used to say to his troops during the war in the Philippines or wherever: "I shall return." But the last time—I don't know if he was commanding the troops in Germany—he said, "The forecasts for the war I have ahead of me are not as clear as they used to be, so this time I can't say I shall return." So, right now, I can't say I have any ambitions or any desire, cause I don't know. I am 82 years old, so who knows what destiny has to serve to me, or how long I'm going to live. So, for the moment, I'm very happy here. It's beautiful weather, very nice. At times it rains; especially now, it is time for the rain. Otherwise, all the time it's a beautiful temperature, very quiet, very peaceful, so if time allows me, I'll be ready for any new venture. If not, all I can say is that I have had a beautiful life. I'm very happy to have lived my life and I'm ready to go away whenever God wills, because I know that for me I have had six different lives as you mentioned before: as an engineer, composer, a pianist, an arranger, a conductor and a communicator. So right now, what I'm learning to do is to take care of my eye because it's weeping. It's an infection I have. I'm planning to go to the ophthalmologist to see what I'm going to do with my eye.

FRIEDMAN, Yona

Yona Friedman was born in 1923 in Budapest. He currently lives and works in Paris. Friedman studied at the Technical University in Budapest before continuing his training from 1945 to 1948 at the Technion in Haifa, Israel, where he worked as an architect until 1957. In 1953–54, he met Konrad Wachsmann, whose studies on prefabrication techniques and three-dimensional structures had a considerable influence on him. In 1956, at the 10th CIAM {Congrès Internationaux d'Architecture Moderne} in Dubrovnik, Modernism was called into question by his universalist approach and his belief in progress. At the congress, people were taking "mobile architecture" to mean "the mobility of the dwelling." With the "ville spatiale" example, Friedman exhibited—for the first time—the principles of an architecture encompassing the ongoing changes required to provide "social mobility" based on an "infrastructure" admitting dwellings and town-planning provisions that could be composed and re-composed, depending on the intentions of the occupants and residents. In 1958, Friedman founded the Groupe d'Étude d'Architecture Mobile (GEAM), which, up until 1962, would focus on the adaptation of architecture to the changes occurring in modern life. At the same time, Friedman formulated his "African Propositions," which consisted of combining techniques for local constructions with a modern infrastructure. In 1963 he developed a line of thought about bridge-cities, and planned a bridge over the English Channel. In the '70s, Friedman was commissioned to design the Dubonnet factory in Ivry, France (which was never executed) and in 1978, the Lycée Bergson in Angers, France, which he completed in 1981. For these two projects, Friedman initiated a process according to which the distribution and arrangement of all the components were conceived and designed by their future users. In order to achieve this, Friedman rewrote his book Pour l'architecture scientifique *(1967) into "comic strips," so that non-professional people could understand and apply this method. In 1987 he completed the* Museum of Simple Technology *in Madras, India, which implements principles of self-construction based on local materials such as bamboo. Besides his work on architecture he published books on themes relating to sociology,* Utopies réalisables *(1974; 2000) or epistemology (*L'Univers erratique, *1994).*

........................

This interview is the result of several conversations that took place in Paris from 1998 to 2002.

Hans Ulrich Obrist:

Let's begin with the beginnings. You said that you grew up in a very positivist environment, and forged yourself a positivist attitude towards science and faith in science. I quote you: "As a child I discovered that not all predictions in that positivist environment stood up. And at that point, I realized that there was absolutely no way I could predict the action of others." This, one could say, is the statement that you have always addressed through your architectural work. I was wondering if there were some deci-

sive encounters with scientists that lead you to formulate this statement. Did you meet Ilya Prigogine for instance?

Yona Friedman:

I met Ilya Prigogine back in 1977. But, long before that I had met [Werner] Heisenberg. I went to his seminars in 1941.

HUO:

Heisenberg was a teacher of yours?

YF:

Heisenberg was in Budapest in 1941 as a guest lecturer at a seminar. I was still at secondary school, but the seminar was open to the general public. I was obviously very impressed.

HUO:

And afterwards, what role did science play in your career? You studied architecture and other multi-disciplinary studies.

YF:

Like you said, my career in architecture, which was informed by my approach of science, is based on the primordial importance of individual behaviors and acts and the unpredictability of such acts. The acts of one individual are totally unpredictable even for himself. But it doesn't mean—on the contrary—that these unpredictable acts are not decisive, because they define complicated processes. As far as the field of architecture is concerned, plans are no more than statistical fictions. No individual, whether in physics of particles or in sociology, behaves according to abstract laws, unless you call it the "principle of individuality." It means and postulates that one individual cannot be substituted for another one, and that two facts, considered to be identical, are not. This is a law of course, so you could say that I'm living a contradiction, but the difference is that "the principle of individuality," contrary to other laws, can't explain what will arise as a result.

HUO:

Because of complexity?

YF:

That observation goes well beyond the concept of complexity. I prefer to call it "complicated," because the maximum complexity of a set is limited by a number of possible relationships between the terms of that set. As far as "maximum complication" is concerned, that may be infinite. What is "complicated" can be achieved by applying an indeterminate number of arbitrary rules. To visualize this, just take a line. Its complexity is minimal. However I can

twist it as much as I want, and by so doing I will increase its complication, but I would not increase its complexity.

HUO:

After you had left Budapest for Israel, you started working as a construction worker, but at the same time, on your own, you were developing your theories in a very interdisciplinary way, digging elements in all kinds of fields—in engineering, sociology and science in particular—and that lead to your ideas of mobile and participatory architecture. You presented these ideas at the CIAM in Dubrovnik in 1956. Could you tell me how you honed this interdisciplinary theory of architecture?

YF:

Perhaps I am not very disciplined, but essentially I do not believe that discipline provokes anything else but an unjustified monopoly. I am simply a normal human being who projects an image of the world for himself, without creating barriers between the elements of this image. But I have the value of "externalizing," of expressing my image of the world. I dare to talk about science without having a diploma in science; I talk about architecture as sociology and of sociology as communication. I have tried to build theories basing myself on the same logic in science and sociology: the "principle of individuality," "mobile architecture," "urban mechanism," and the "groupe critique" can be observed as expressions of the same logic.

HUO:

Can you tell me about what you call the "critical group size" ("groupe critique")? Is it a premise that there is a maximum group size for effective communication?

YF:

I first spoke about the "critical group size" in 1973 at a conference about research on the future: the "critical group size" is a limit in order that communication can be made without it becoming deformed. This theory that communication impedes itself is now commonly accepted in mainstream sociology. Now to come back to your question about interdisciplinarity, some twenty years back I wrote an article, "The right to understand." That means that all human experience can be expressed in comprehensible language. Then I showed that different academic subjects attempted to interfere with language. They do it for different reasons, in some cases to maintain a monopoly or to maintain a class system. We live in a class system of formulated concepts. We have a tacit idea of the world which is... I don't want to use the term "interdisciplinary,"

I prefer to say "global" because the first of the two means that I accept disciplines, and the word "global" is like any person in an African tribe or the natives in the Brazilian forests, who are architects, scientists, hunters or cooks at the same time.

HUO:

They have generalist knowledge.

YF:

Yes, and I am a cook too, and I like it. I decorate my apartment because I like it. I don't sing because I don't like my voice, but I wouldn't have minded had I been able to do so.

HUO:

So instead of using notions such as "interdisciplinary," "multi-disciplinary" and "trans-disciplinary," you'd rather use the term "global"?

YF:

I accept "global" and the globe because I cannot get round it for the moment. It is the closed system but the broadest closed system possible. By the way, you know I learn a lot from my dog—I am saying that very seriously. You see, my dog's behavior shows me a global panorama with no discipline. He knows how to behave when faced with isolated and often irrational phenomena. There is no way to express this rationality that I call "surrationalism." Like realism and surrealism, there is rationalism and surrationalism. It is a global rationalism, which is totally closed and is not to be communicated in words. We are talking about human intelligence. My dog understands me but I do not understand it. Who is more stupid?

HUO:

In his book called Seven Experiments That Could Change the World: A Do-It-Yourself Guide to Revolutionary Science *(1995), Rupert Sheldrake speaks about experiments with dogs too, and he mentions the fact that a dog knows when his owner is going to arrive at least ten minutes prior to the event.*

YF:

It's true. I have tried to work upon the basis of this and to say that my dog lives in a time framework, which is different from mine.

HUO:

In rather odd ways, it leads us to the problem of the city and of town planning. Frequently the way cities are organized rules out the possibility of dialogue, of communication. In 1957 when you settled in Paris, you established the Mobile Architecture Study Group and got in contact with Frei Otto. The group's manifesto, your L'Architecture Mobile, *was published in 1958. At the time, you all stated that urban planning had failed com-*

pletely—the traffic congestion, the poor quality accommodation, the exodus from the city on the weekends—and you developed new models of cities with new ideas concerning the pattern of moments in the cities. How have your views on city planning evolved over the years?

YF:

Some ten days ago I gave a conference at Columbia University where I touched upon these subjects. For me it's very important to distinguish the "hardware" of a city and the "software" of a city, which is an unknown quantity. We talk about urban mechanisms that explain things to some extent, but a city is not used in the same way. It only needs for people to get together, to change their routes, to walk some other way for the city to change. If, for any reason, people decide not to walk down a given street, then it's not the same city. I consider that a city is different by day and by night; there are night cities and daytime cities, summer cities and winter cities, etc. It is the same "hardware," but the city is completely unpredictable. We get to the idea that all predications with respect to the city are statistics and are false. And that is something that has never really been taken into serious consideration. Like I said at the beginning, people's behavior is as unpredictable as the behavior of a group of individuals. Up until now, we had not attached importance to the fact. For example, I cannot predict how people are going to sit when they go into a cinema or to a conference. You have commercial centers where people don't go, piazzas that people avoid, and small cafes that people just love and would wait on line to get inside. The occupation of time and space is unpredictable. For that reason, we are in a society where the center is shifting all the time. I have formulated a hypothesis called "weak communication." One network connects everybody but each is a small center of another group like his neighbor. Here, when I refer to the city, I call this the "private city." The people that I communicate with in the city belong to my private city. The people I connect with on the Internet belong to my private city. And there are no two private cities that coincide. That means that each of us is a mini-center in an immense system of behaviors.

HUO:

What about your mobile structures within the cities that echo the visions of contemporaries such as Constant, Cedric Price, Peter Cook, and Archigram? What about the notions of the ephemeral and nonlinear applied to city models?

YF:

Since the early twentieth century, writers, or rather narrators, have debated about linear narratives. All of Marcel Proust's effort was to escape from linear narration, but it is impossible: narration is necessarily linear. One can make a narrative structure complicated. Now, if you observe the behavior of a person in the city, we can only observe their itineraries. That is a necessarily linear perspective. We can imagine no itinerary that is not linear. These itineraries are highly complicated if you observe them and know them all, but nobody knows the reasons for their complexity. Sometimes I look at the news on television and in the background of the image there is a man crossing the street without looking at anybody. I see what he does but I don't know why he does it. No theory can give me the answer. If we go further, we can somehow postulate that the man himself doesn't know why he does it. What I mean is that there are individual acts that cannot be explained theoretically, contrary to what was believed in the nineteenth or even in the twentieth centuries. For me, there is no intelligence that can understand everything. That means that there is no rule that can predict what a city will be like or how the citizens will use that city. There are only general guidelines that can change at any given time. And it takes us to the idea that we should make the "hardware" as soft as possible. That was my theory of mobile architecture. Hardware should be adaptable. In all the models and drawings I made in the last fifty years, I tried to concentrate on the idea that they serve or visualize the irregularity that comes from each inhabitant shaping his "niche" in his/her particular individual way, unpredictable and which I cannot know about. Twice in my lifetime I had the opportunity to test this case in real life; to let real people conceive of their ideas about their working place, and fit more ideally into a collective plan, in their own way, without me counseling or persuading them. The object they conceived was materialized twenty years ago, and it has been continuously changing with every new generation working there.

HUO:

You and Constant are contemporaries. What was your relationship?

YF:

I was on friendly terms with Constant. I did not know about his work and he didn't know about mine. We met in 1960 or 1961. He had read my pamphlet on "Architecture Mobile," and so we got

into an exchange of letters. In this correspondence you could see the differences between our attitudes. Constant's way of thinking is what I call in my book "a paternalist Utopia": a Utopia based on the initiative of "someone who knows." My point of view was exactly the opposite: "I do not know." The initiatives are those of small, unknown people deciding themselves, of people who cannot express it by words: a real variety of small individual acts. In a way, Constant acts like a "*maître de ballet*," creating a very beautiful ballet invented exclusively by him. As for me, I do not intervene into what the real performers do. I don't even know what they do; for me it is sufficient if they are satisfied. The difference between the ballet and people in the street expresses our conceptual difference. A ballet can remind a street crowd, and a crowd can remind a ballet, but they are structurally completely different.

HUO:

We have hardly touched upon your realized works such as your Museum of Simple Technology *(Madras, India, 1982–1986), which was designed as a cluster of hut-like units demonstrating building techniques that could be appropriated by the poor to improve their own dwellings. You've said that we could all learn a lot about town planning from India.*

YF:

What is interesting about marginal areas or the Third World, in towns, is that the systems of property as well as the whole social organization are much more elastic. In the Turkish Empire, you planted a tree and the land in its shade was yours. Which means that land could be acquired without payment. This is what happens in the marginal areas of Istanbul. People plant trees. You can define how long the neighborhood has existed only by looking at how high the trees are. The rules of property are different in these places. They're not pre-planned or abstract. Property in our system is abstract. There is a paper with a drawing on it. This paper with the property explains everything. In the Third World, property is much more tangible and material.

HUO:

You mentioned the term "illegal city." That calls to mind Kowloon or the walled city in Hong Kong.

YF:

Hong Kong was highly planned. The illegal skyscrapers have "savage" facades. However, we would have to consider just how many rules actually exist in the city of reeds on the sea and whether they are respected. The rules of property are different but they are not

abstract. In reality, I have tried to put abstraction in its place: the importance of the individual as opposed to statistics is the importance of reality as opposed to abstraction. Abstraction is necessary but not to the point of saturation. Abandon abstraction. We need a new balance.

HUO:

Can you tell me more about your Museum of Simple Technology?

YF:

I called it a museum because it was more a vehicle of communication, a kind of soft museum... I used a very simple system of communication by comic books. Even the most complicated and abstract things can be explained by comic books. These were for people with no formal schooling, on specific subjects such as health and food. And most importantly they were "incitation to invent." I was not telling people "You should do this and that," but rather, "You are able to invent how to improve this and that." I did use for this communication posters with very simple drawings and very simple texts, sort of comic books. It was a vehicle of communication leading to consensus. People could discuss on this basis. In India, these posters were largely distributed, maybe to ten million people. Even today I receive letters from these people. This is a technique of communication, easy-to-read and easy-to-make. Certain communities in India have appropriated this technique on their behalf, distributing their own ideas the same way. I called them "manuals": they are not schoolbooks or recipes. I did not restrict my action to topics of urbanism and architecture, but rather to a general science for survival: water management, micro-farming, etc. Water-capting with simple means is very important in India: small "water traps" are more efficient than reservoirs. Growing some food near the house is often vital in shantytowns. ... The solutions were, in most cases, not my inventions. My purpose was to make people invent them. With the *Museum of Simple Technology*, the idea was that the things that are explained in the manuals are to be seen in the objects on display. The museum presents the manuals as if they were mural newspapers. And they were also distributed via local press set up. It is a didactic museum, not a museum for preservation. The building was made to exhibit these simple and economical techniques.

HUO:

For almost a decade you have developed these do-it-yourself manuals. How many are there?

YF:

Some hundreds (*Popular Encyclopedia for Survival* and *Immediate Educate for Survival*, 1980). The United Nations wanted to develop this project to an even greater extent, and so we worked on the Communication Center of Scientific Knowledge for Self-Reliance in Paris, which I directed. But at one point they cut the budgets. But I showed it was possible.

HUO:

John Cage defined the notion of the open partition which is very close to your idea of incitation to invent.

YF:

I met John Cage once at a symposium. But, for me, the decisive factor was my effective contact with shantytowns. It was during the Second World War that I learned the importance of survival through self-help. During the war, survival depended on invention. Invention might sometimes be erroneous, but it assures a better chance to survive. One proof is that I did survive. If you think of survival as a profit, then profit means for a large part of humanity to assert existence (not in terms of economy). But surely it depends largely on personal capacities.

HUO:

In 1970, for your competition entry for the Centre Pompidou in Paris, you proposed to transform the site into one large, covered public square. In line with the principles of the mobile architecture, nothing was predetermined in terms of uses; it was just about volumes, movable and transformable volumes.

YF:

Yes, because for me the museum is defined above all by its audience. I tried, for example with the manuals, to show the global spirit of the problems for an audience without formal schooling, insisting upon the need for the survival of even the poorest people (health, water, social organization); how to create a one-man business, how to behave like children. That is what is important for the audience. The Pompidou Center is a mix: you have the conservation of artworks with the Musée National d'Art Moderne, you have the library, etc. What I proposed for the Centre Pompidou in 1970 (I made the same proposal to the Museum of Modern Art in New York) was a skeleton, an outline, a physical and, why not, spiritual framework within which to work. How the volumes are organized can be changed. With each new generation a museum should change.

HUO:

Can we talk about mutating buildings?

YF:

I would prefer to talk about "constantly changing buildings" because the city is constantly changing. There are no rules in nature. A museum is also an image of the world.

HUO:

My last question is about your unbuilt roads. I was wondering whether you could tell me about one of your unrealized projects, one that was too big or to small to happen, or a forgotten project that you would like to mention.

YF:

I designed few projects; I research. But there is a project that I published in 1960 or 1961, which was a map of Europe showing the main railway lines. I made the statement that the 120 odd cities on this net was Europe. Thirty-five or forty years later, in a conference related to the reunification of Germany, I was talking about Europe as [a] "continent-city," with the railway network becoming a commute net linking the existing cities. All French cities today are linked by the TGV [High Speed Train] network that makes distances smaller. Marseille is today barely three hours from Paris (in 1960 it was eight hours). It is this continental fabric that became the "new city." All my ideas of self-planning: "continent-city," urban agriculture, and mobile architecture are interrelated. They are not separable projects. I really do not consider myself entirely an architect as, the extra-architectural aspects interest me more. The purely professional side seems banal to me.

GADAMER, Hans-Georg

Hans-Georg Gadamer was born in Marburg, Germany, in 1900. He studied in Breslau under Richard Hoenigswald and in Marburg with Nicolai Hartmann and Paul Natorp. Gadamer graduated from the University of Breslau {now Wroclaw} in 1922 with a thesis on "The essence of pleasure and dialogue in Plato," and he wrote his second doctoral dissertation under Martin Heidegger at the University of Marburg (1929). In 1937 he became a professor in Marburg, and two years later in Leipzig. After the Second World War ended he was made rector of Leipzig University, but in 1947 he moved back to Frankfurt and then finally to Heidelberg in 1949, where he remained until his death in 2002. In 1960 Gadamer finished the book that was to become the key accomplishment of his career, Wahrheit und Methode (Truth and Method), *in which he developed a new approach to thinking and understanding that he termed "philosophical hermeneutics," through an extensive analysis of the nature and role of language in human perception and understanding. Gadamer developed the concept of understanding as opposed to the approach of the natural sciences that discover through rigid empirical method. He led the way to questioning the extent of real objectivity in the sciences. In the years after the publication of* Wahrheit und Methode, *Gadamer developed an international reputation as one of the world's leading philosophers; his theories have been widely influential and have had an impact not only in philosophy, but also in literature and literary criticism, theology, history, and sociology. His "hermeneutics" pre-dates the "deconstructionist" direction of Postmodernism. Some of his other significant works include,* Kleine Schriften (Philosophical Hermeneutics, 1967), Vernunft im Zeitalter der Wissenschaft (Reason in the Age of Science, 1976), *and* Dialogue und Dialectic (Dialogue and Dialectics, 1980).

..........................

This interview was recorded in Heidelberg in May 2000.

Hans Ulrich Obrist:

I would like to talk about the opening of conversations.

Hans-Georg Gadamer:

The opening of a conversation is the first question that has been asked. I start from the assumption that if we want to understand what it means to speak, we should realize that it means answering or asking questions. Preserving this in its meaning is extremely important because for a long time teaching foreign languages has been aligned with reading texts. One learned a language in order to read the bible or another text. In grammar school we have underestimated face-to-face communication too long. I remember my own school days. I attended grammar school in Breslau, when in

the spring of 1914 a French teacher came, unfortunately only for three months. Then the First World War broke out, and henceforth such things would belong to the past. However, this teacher was a big surprise to all of us, because we found out how hard it was for us to understand him. Actually we were only used to applying our knowledge of grammar and vocabulary to dead texts. For a long time I have been arguing in favor of three living languages, if we want to live democratically in Europe. In addition, conversation should be given priority over texts in language education.

HUO:

In Gedicht und Gespräch *(Poem and Conversation, 1990), you explain precisely that language only lives in conversation.*

HGG:

Of course, because in conversation one is indeed always in motion. By giving an answer, the other completes one's own speaking.

HUO:

Again and again you refer to the importance of conversation to philosophy in your work, and to how rarely conversation appears in philosophy after Plato. How would you explain the absence of conversation in the history of philosophy?

HGG:

People still don't believe that Plato did not have the answers to the questions asked. But actually, this is essential to the question. We are cheating if we ask questions we know the answer to. The natural way is that one wants to understand the other and his answer too.

HUO:

You also mention the difficulty or even the impossibility of transcribing conversation into text. The conversation we are having will be transcribed too. Are there any possibilities to cope with this difficulty?

HGG:

There are no simple rules for this. Plato has been able to do so. What is so attractive about these dialogues is that they are clear at once. It is as though you were present on the scene. How can this be achieved? In general, one finds the right words whenever it is urgent to know the answer. The intelligent question is the key to a good conversation. Naturally, the essence of exchange bears on our association with objects. Of course the same reciprocal equality holds true as far as question and answer are concerned. Here those things we do not immediately express in words are important

too. An impatient question will have a different answer. Not, however, because one says, "Now I am impatient." Language contains so many statements which are not directly verbal. This is the main reason why talking and asking can hardly be represented in writing. Plato has been able to do so. In most other cases, we have the disconcerting feeling that they do it in line with a particular regulation. Plato keeps us so enthralled because in his case we believe in the conversational situation. Therefore I am confident enough to say that it is significant when someone wants to put his philosophy in writing only in this form.

HUO:

In interviews, you often mention the downright catalyzing effect which your conversations with Heidegger had on you. Could you say something about your first meetings? You describe the first conversation in particular as a crucial event.

HGG:

I must admit that I cannot really remember this exactly anymore. I think that one should realize above all that Heidegger has recognized the importance of silence. This constitutes a significant part of his effect. Silence is a way of talking. It invites completion.

HUO:

This reminds me of John Cage and his iconoclastic gesture of remaining silent.

HGG:

This is a game with the dying down of sound. I couldn't imagine a stronger feeling of serenity than when a piece of music comes to an end and fades away.

HUO:

Should we stop now?

HGG:

Being silent is an extremely strenuous accomplishment, maybe more difficult than talking. For in fact, we always believe to know the answer. Renouncing this attitude and listening to how things proceed, in order then to maybe understand better, certainly belongs to every good conversation. People who at once start talking 19 to the dozen are exasperating. Just consider those documentary films about animals, in which those young, good-looking commentators say something which doesn't have anything to do with an answer. This is actually meaningless, because things are just being read off and because the spokeswoman has never seen the animal. This is one of my chief torments. Whereas our ability to

interfere with the private life of animals is indeed a great and positive moment in technology. But it is also connected with this theater of falsehood. At the first beginnings in the field, researchers would personally report what they had seen. This was entrancing. It is really beautiful to hear somebody expressing his passions.

HUO:

How would you assess the prospects for conversation in the future?

HGG:

It goes without saying that we are gradually drawing apart from each other as we communicate through machines. Unfortunately this is unavoidable. Computer science, which is inflated nowadays, is an enrichment only in a very particular sense. It rarely happens that one can actually use information. As a matter of fact, "I am informed now" actually means: "I do not need this information anymore." Information is made available, and does not ask what should be done with it. To a certain extent, information is a conclusion. And this conclusion also means: "Now I shall put it to the test." Whenever a piece of information seems to be interesting to me, I demonstrate my interest, and this means my readiness to put it to the test. Information overload is the utmost reverse of the extension of our knowledge. I cannot help but think of the Egyptian king for whom the system of writing has been invented.

HUO:

What are the different and shrewd ways in which a conversation can be conducted?

HGG:

I have not really been collecting. I would rather point to the fact that in philosophy, Plato's example has often been imitated, but in most cases it just didn't work. Plato still took questions seriously. He realizes that he does not know. That is why he has Socrates and the oracle at Delphi. Therefore, I am surprised at the fact that the Platonic system of thought is still misconceived in the history of philosophy until today. Plato has not worked things out, and that is why he has never stopped approaching things from different angles. One has to come to a mutual understanding. Each statement is indeed nothing but a choice from an infinite amount of possible answers. To make sure that an actual concentration on the matter is behind it is already a remarkable accomplishment. I think that people are just being unfair to Socrates, for Plato has not created this Socrates figure for nothing. To that extent, it is rather silly to expect that we should know which answer is ultimate and correct.

HUO:

You have spoken about the infinite aspect of conversations...

HGG:

One of the first certitudes is that whenever one confronts a question, one is dealing with the possibility of different answers. A conversation which is fully unequivocal is a rarity, in the case that questions have turned into new certainties. In that sense, I believe it pertains to the infinity of conversation, that it is never the last one. This becomes clear when we consider the fact that for Plato, not even definitions have the last word, but rather the appropriate relationship with the other. We cannot express ourselves in writing either, since true communication implies the person who assimilates and answers as well as the one who affirms or asks. In this sense the era of writing has immensely changed, of course. Therefore, this should deserve a thorough and far-reaching perspective of treatment. We could use this as a preliminary report for the Internet as a medium. We don't know how long this medium will be in use. There will be a new world of experience in which the deficiency of communication through the Internet will be revealed. The fuss that is being made about it is an understandable exaggeration. The enthusiasm for these new possibilities is indeed understandable, but I don't believe that great discoveries will result from it.

HUO:

Do you yourself use E-mail?

HGG:

E-mail is a modest auxiliary means of communication, and in some ways very useful.

HUO:

What is there to learn primarily from conversations?

HGG:

The acknowledgement that a conversation always reveals new perspectives and that it can therefore never be the last word. That is why I consider it to be an immense folly that in Plato studies people still hope to find a definitive meaning.

HUO:

Speaking of "last words," can you tell me about projects you have not yet realized?

HGG:

There are so many of them in every productive life. Everybody has unfinished things waiting on his writing desk which still have meaning in a different place.

HUO:

One that is very important to you?

HGG:

There are so many. Doesn't one have a scintillating bandwidth in one's imagination? Indeed, the exception is that permanent affirmation is found.

HUO:

May I ask you, in conclusion, what you are currently working on?

HGG:

The task I wanted to set for myself was to reveal the concept of hermeneutics in all its dimensions, so we wouldn't have to cope with such simple questions anymore. Under what conditions can we find yet another access to the question? As long as we hang on to particular questions only because they seem to be obviously right, we will fail to find better ones. The general boundlessness of possible answers is so immense for each particular conversation that we cannot say what could be the most fruitful answer that directly triggers off the next question for one or both conversation partners. But this is precisely what is so great about such a philosophical investigation, that we expose ourselves to these many multiple possibilities. Settling things once and for all is indeed what we call dogmatic.

GILBERT & GEORGE

Gilbert was born in 1943 in the Italian Dolomites. He studied at the Wolkenstein School of Art and the Hallein School of Art, Austria, and the Akademie der Kunst, Munich. George was born in 1942 in Devon, England. He studied at the Dartington Adult Education Centre, Devon, Dartington Hall College of Art, and the Oxford School of Art. Gilbert & George met while students at the St Martin's School of Art, London, in 1967, and have lived and worked together in London since 1968. Moving to the working-class neighborhood of Spitalfields in London, Gilbert & George revolted against art's elitism, naming their house "Art for All" and declaring themselves to be "living sculptures." Although their early work centered on living sculpture, the artists soon turned to video, photo-based pictures, and drawing. As early as 1969, the artists participated in an exhibition at the Stedelijk Museum, Amsterdam, and by 1972–73 they began showing with prestigious galleries such as Konrad Fischer, Sonnabend, d'Offay, and White Cube. Their use of black-and-white photographic assemblages first surfaced in 1971, developing into large pictures by the late '70s. The duo participated in documenta 5, documenta 6, and documenta 7 in Kassel (1972, 1977, and 1982, respectively). In 1980, the Stedelijk Van Abbemuseum in Eindhoven, The Netherlands, organized a mid-career retrospective of the artists' work, which traveled different venues throughout Europe. In the early '80s, Gilbert & George added a range of bright colors to their pictures. In 1986, Gilbert & George were awarded the Turner Prize. Their work has been exhibited worldwide in cities including Moscow (1990), Shanghai and Beijing (1993), and Athens (2001).

........................

This interview was recorded in Mexico City in June 2002.

Hans Ulrich Obrist:

This is only your second visit to Mexico, so I was wondering if you could tell me about your first impressions.

Gilbert:

Our first impressions were ten years ago, and the thing that struck us most was flying into Mexico City. You just see a big valley full of buildings and nothing else. It was unbelievable. And the faces of the people.

George:

That's one type of physiognomy that we don't have in London, and have never had in Europe. It's remarkable to see so many thousands and thousands and thousands of people that are just completely glamorous and different. Extraordinary!

HUO:

And have you visited the {Luis} Barragán House, from 1947, which is now a museum celebrating his work?

GIL:

We were quite impressed by Barragán, but after that, I think that we were more impressed by Chucho Reyes. What do you think George?

GEO:

It's true.

GIL:

We realized that he was a self-taught eccentric that was able to encapsulate the feeling of Mexico into his being and his work, the paintings and the furniture. Chucho Reyes had to leave the town. He was even imprisoned for his homosexuality. And I think it's quite amazing that they end up being sexual outsiders. And they were probably lovers. The colored walls are probably the most interesting thing about the whole architecture.

GEO:

We always mystify journalists in Europe by saying no work of art can have anything to do with anything else apart from sex, race, money, and religion. Here you see that completely to the fore. From the minute you step into or out of the hotel, those issues are completely wide-awake and right in front of your face. And those issues are very alive in the Barragán house and the Chucho Reyes house as well.

GIL:

Barragán had to hide his sexuality because if he didn't, he wouldn't have been able to make another building. I think the State and the Church would have forbidden him. He would have been the black sheep of architecture probably. That's why he always walked around with beautiful girls.

GEO:

We're always suspicious of single gentlemen who have lots of pictures of ladies in their houses. It's always a rather promising sign. *[Laughs]*

HUO:

You said that your house in London is more like Chucho Reyes' house than Barragán's house in terms of it being a collection.

GEO:

If one had to say which one it was like it would be that one, absolutely.

GIL:

Chucho Reyes' house is more human. You feel you could live in that one. He had a lot of little interests, so on every shelf there was a little collection of the things he was interested by in life. So you feel much more at home in a house like that. The other is more like an artistic sculpture, an architectural sculpture.

GEO:

We were inspired by the lady who showed us around Chucho Reyes' house. We thought we should take her back to London to be our house guide; she'd be very good at it.

GIL:

She was very good at influencing us. She really managed to convince us that he was the more important person of the two. She wanted to convince us that he started it all twenty years before Barragán.

HUO:

So you're thinking of hiring her for your house on Fournier Street?

GEO:

She'd be ideal. We'd just have to teach her a little of the subject matter we have. She'd be very good I'm sure.

HUO:

So you could hide in the annex house and work...

GEO:

... while she shows people the vases! [*Laughs*]

HUO:

In terms of your house, the new big change is the arrival of this mega-computer that you're planning to work with.

GEO:

It's not even all arrived yet. It's all in one small room at the moment, but once we know how it works, we shall have a proper room for it.

GIL:

We are training every day now. And it's quite exciting. Everybody seems to know how to work a computer but they don't have a vision of what to do with it. We know exactly how we will use it. We'll use it as a tool to create our pictures, so we'll know exactly what we're doing.

GEO:

We're using it to continue our art. There will be changes, as there have always been changes in our art. When we first started to make pictures, in maybe 1969, we had a totally different studio and equipment to use. Then we changed that, and two years on we

changed it again, then we introduced color and changed the equipment again. So it's another stage like that.

GIL:

We feel it is another technology for speaking with, for expressing oneself in a faster way. Normally when we do pieces they are so laborious and so handmade, and maybe we'll be able to cut down some of the hours and make more pictures. That would be amazing.

HUO:

You'll become a picture machine.

GEO:

Yes, we're always disappointed that we're unable to do all the pictures that we've had inside ourselves. We've always had to stop.

GIL:

And we've always had the idea of projecting our ideas directly from our brains onto the wall. And we're nearly able to do that! This will be the perfect machine for us.

HUO:

It's an extremely high-resolution digital printing machine?

GEO:

It's a digital scanning system—the most advanced scanner that you can have, for our purposes. Then we will have inkjet printers to print the pictures out. The young people around us are amazed that we're able to go into this technology, which is extremely naïve. We say to them, if we were to put them into our studio as it is now, would they be able to make works like ours using the old system? Not for one second, they would be completely baffled by it all— they wouldn't know which liquids to put in which tray. They'd be totally foxed.

HUO:

In the last interview, we spoke about this extremely complex procedure, a process that is very layered.

GEO:

Very elaborate.

GIL:

Thirty years ago we used the enlarger to project images onto the wall from which to make pictures. That was very progressive in those days. We're always trying to use technology to give us more time to concentrate just on the art.

HUO:

Will the grid of the framing system remain, or will the digital technology trigger a change?

GEO:

We always think of our pictures as digital anyway, because of the form. If you see a picture of ours a hundred yards away in a museum, you'll recognize as it as one of ours. That's very important. From the very first photo pieces we did, they've always been digital, all those little panels coming together to make forms.

GIL:

The machines can only print out at a certain size, so we keep to that. We love the structure of the grid because we can make compositions. And also the framing and glazing would become impossible on a larger scale.

GEO:

It limits you. We're not sitting like the traditional artist in front of a blank canvas wondering what to do. We don't have that total freedom. It's so important for transport and for maintaining the picture. Can you imagine the things people would write on our pictures if they weren't glazed?

HUO:

You mean it's an anti-graffiti system!

GEO:

That's true! Although we are pro-graffiti, remember! That's what we said when we went into the church yesterday and saw all these poor people being completely oppressed by this fascism of faith, and I wanted to say, "They need some boys with their spray cans in here, that's what they need!" Everyone has been so terrified of this for centuries.

GIL:

It's like a totalitarian system—if you don't believe, you go to hell forever.

GEO:

And the superiority of the people in charge we find very oppressive.

HUO:

I've just seen your amazing "Dirty Words" show at the Serpentine and there is a really strong presence there of graffiti ("The Dirty Words Pictures, 1977," Serpentine Gallery, London, 2002).

GEO:

It was extraordinary to get them together again after so long.

GIL:

We'd tried to realize it in many different ways. It was quite difficult; even the Serpentine refused it at first, or rather, they didn't reply to our letters. The reaction in England was still in some

ways quite negative. It was unbelievable. After 25 years! What can you say about that? They're part of history; they are classic pieces.

HUO:

Where does this resistance towards your work come from?

GEO:

One review ended with a horrible sentence in which the reviewer said that they were so pleased that the world has moved on, and that art has moved on from 1977. And that's just not true. The issues that are alive in the *Dirty Words* pictures are as current today as ever. Problems with drugs are even greater today. Issues with the police and so on.

HUO:

And are there other similar shows that are still unrealized?

GEO:

I think our Brooklyn [Art Museum, New York] retrospective is about to become an unrealized project! [*Laughs*]

GIL:

[*Laughs*]

GEO:

It was all going well under Arnold Lehman and his lady curator. They were very proud to invite us to do it. We constructed a huge model of the museum and installed the whole show in it. And from that moment onward it started to fall to pieces and to crumble. They saw our definitive model as a starting point, and they didn't understand that that was it. Then they came to London and spent two days going through every single picture we'd ever created, making a pile of "yes" pictures and a pile of "no" pictures. And we had to select our exhibition from the "yes" pile. That's more oppressive than anywhere else in the world!

GIL:

Then he went home trying to arrange other venues for the exhibition. Very negative. We believe that because of Christian fundamentalism, curators in America are terrified to touch anything that is a little controversial, to do with nakedness or sex. They're absolutely horrified. Arnold Lehman is probably one of the most liberal museum directors around. But he couldn't find people to take the show.

GEO:

He said to us that someone was so offensive to him that for the first

time in his life he put the phone down on someone—he couldn't bear their manner.

GIL:

They would ask questions such as, "Are women in their art now?" That was important for them!

HUO:

So once you've designed the exhibition layout, that's it. Basically you conceive your exhibitions as whole pieces, is that fair to say?

GEO:

Absolutely. It's different from the museum professionals, because they always want to install it with a view to taste, what they would like, whether fewer or more pictures. We install it as though we are the viewers, as if they're arriving in the museum and have never seen an exhibition before. They come and see the first picture on the wall, they turn to the left, they turn to the right. We try to create the same adventure for visiting the exhibition as we had when creating it, to make it a human experience. And the professionals tend not to have that idea. They tend to make an installation that pleases them personally.

GIL:

They always try to put in their favorite pieces, and we never have favorite pieces. We always arrange the rooms with different kinds of emotions. We arrange different configurations, trying out, say, '80s images in one room, all black or whatever. We do this so that for every room that you walk into, your emotions are affected in a different way. If you can't affect the ordinary public, they will leave the museum empty-handed. They will not remember anything about it; they'll just forget it. And that's why we want to concentrate on the viewer.

HUO:

As in your Guggenheim show ("Gilbert & George," Solomon R. Guggenheim Museum, New York, 1985), you have often layered your pictures, developing really experimental displays. Could you tell me about such experiments?

GEO:

We always like to take on the space, because museum directors sometimes invite you and say rather apologetically that it's not such a good space, that they don't even like their own museum so much. And we say, whatever the space is, come to terms with that. It's like people that don't like the appearance of different people— they don't fancy this person or that: see what is in that person that

is interesting. See what is in that person that somebody will one day fall in love with, whether it's the eyes, the hair or skin, and go for that. And it's the same with the museum: find the nature of that museum. Somebody built it that way, and once you take on that space then you can use it in a friendly way.

GIL:

It's very simple for us. We can use any space, especially difficult spaces. They're much more challenging. And even because exhibitions immediately look different from others, and how to double hang or whatever, all these things are acceptable to us: anything goes. It's the propaganda of inner feelings.

GEO:

And to seize that moment. There's still an ongoing debate in London about the Hayward Gallery. Half of the educated public would like to tear it down, others want to paint it white or put a glass roof over it or cover it with plants or whatever, but we say we love the Hayward, it's fantastic, we'd use it as it is. If you want something different, have another one as well. London has such a great collection of buildings, we think; it doesn't have a general scheme. Within a five-minute walk in London you can see buildings from every single period of architecture, and we like that. It's chaos.

HUO:

Have you been thinking this way since the very beginning?

GEO:

You can put it in a nutshell: the directors and curators of the world can be divided into roughly two groups: those who wonder which artist to give an exhibition to—that's what they're always thinking, should I give this one an exhibition or that one; the other curators are wondering which artist's work they want to bring to the public of that city or country and its visitors. We only realized that when we had the Guggenheim exhibition, and many journalists said to us "So how does it feel to be given an exhibition at the Guggenheim?" And we thought, "Oh my goodness, that's wrong!" They didn't give us an exhibition: we were giving the visitors an exhibition. It's the other way around, and it's a very important difference.

HUO:

Everything you have done has been part of the work, nothing has been secondary and there is no hierarchy. For instance, your posters and books are as important as your pictures.

GEO:

We want the whole world in that way—"cosmology" as we used to call it.

HUO:

The graphic design of your posters is extremely direct, often using quite brutal lettering. You have invented something that is not often seen in graphic design.

GEO:

I don't know when our use of that started.

HUO:

The South London Art Gallery show of the Naked Shit *pictures was one of the earliest I can think of (1995).*

GEO:

And we had the *Time Out* [London] campaign with the full-page ads; that was extraordinary. Then we paid for billboards to be put up in the borough of the exhibition. And again it's an example of how some things are very important and some things are just not important. The local council, (for which we were sponsoring an exhibition in a way; we were helping that borough to have an exhibition), wanted to take us to court for having our billboards on their railings around the borough. Now, if a famous pop group with all their tongues out and their trousers down sticks their posters up, the council doesn't bother with them. Artists are different. Even the national newspapers can put their billboards up over the weekend advertising their papers, but the local council would never dream of taking them to court. Art is something different, it just is.

GIL:

One of the most amazing posters was for the Hayward show in 1987. All the old ladies thought that the fingers that were over the cross were penises ("Pictures 1982 to 1985," Hayward Gallery, London, 1987). It was all over London. We did an illegal one of 8000 posters and we paid for that.

GEO:

So the Hayward had the formal one on the underground and in other public places, and we did the other one.

GIL:

Time and time again we have been accused of self-promotion, but recently they have stopped accusing us of this.

GEO:

It's absurd because if you put up more posters you generate more awareness among more people. It's not sending us to the exhibition—we know about it anyway!

GIL:

Everybody has to promote their work, but when it comes to art,

they think you shouldn't do it. If people like it and come to see the show it's as if you're lucky or something. And we don't believe in that. It is part of an exhibition. You have to get the people there to have a look at it.

GEO:
Exhibitions of contemporary artists, on a grand scale, are so rare anyway. You can only do a show like the one that we did in Athens once in a lifetime—never again on that scale ("The Art of Gilbert & George," The Factory, Athens School of Fine Art, 2001)

GIL:
The graphic design of invitations was already something we were doing in 1969, because we realized that every single card that we send out has to be beautiful so that people will remember it and so that they won't throw it away. *All my life I give you nothing and still you ask for more* (postal sculpture, 1969) was probably one of the first ones.

GEO:
I still don't understand the sentence, but it is a very good one. "All my life I give you nothing and still you ask for more." Very good. It sums up everything, but I still don't know what it means.

HUO:
Books have always been a medium for you; they are never secondary in your work.

GEO:
We are so keen to have control. Like with the layout of an exhibition, the museums always have an aesthetic agenda for the catalogue. Their agenda is to do something that is prestigious for the museum, that is a compliment to their designer, and they don't think so much about the vast general public who may or may not buy one, or two copies, or send a copy to a friend.

GIL:
Graphic designers all use computers. The first thing they do is take things to pieces.

GEO:
Cut them in half...

GIL:
They cut them in half and play with our pictures. And we say no. But that's what they'll do first if you let them loose.

HUO:
You moved away from the small-run artist books and into catalogues, which you design yourselves. The first publication that I could afford to buy was from

your Basel exhibition ("Pictures 1982 to 1985," Kunsthalle Basel, 1986).

GEO:

If we show a catalogue of most exhibitions to our younger friends in Brick Lane, they won't have a single word to describe it. They won't know whether it's a book or a magazine, they don't know what it is. But if you hand them the Basel catalogue and ask them what it is, they'll tell you it's a catalogue. It's a more democratic object. If you make a catalogue so weird that only some people in four Western cities understand the art object, that's no good.

HUO:

So it's part of the "art for all" idea?

GEO:

Absolutely, democratic art.

GIL:

We don't analyze ourselves so much. We're not artists who are totally conscious and knowing of what we are doing. We are just driven to the next thing. We always feel that they are beating us down and we have to fight like dogs.

HUO:

So it's not about mirroring your own production, it's about the next step?

GEO:

Absolutely. It's an enormously complicated thing to be an artist, have a studio and exist in the world, so complicated.

GIL:

And doing artworks that aren't easy. We are making art to disturb the middle classes, that's what we're trying to do.

HUO:

Since the very beginning you have had a very global impact. How do you feel about that?

GEO:

Well, the first thing is that it's very important that contemporary art reach people during the artist's lifetime. It's like medicine or anything else: if an invention is made it should be available everywhere. Some countries had to wait sixty years before they got penicillin. I don't think they should have to wait sixty years before they see an abstract painting or whatever the latest form is.

GIL:

It's very funny because on the one hand we'd like to be in Fournier St. all the time—we don't want to travel the world really. We'd like to make an art that is global but so that we can stay in Fournier St.

GEO:

We've always said that Fournier St. is the final cosmological place for us because you meet people from all over the world everyday on Brick Lane. Until we came to Mexico, and we realized that we rarely see Mexicans anywhere in London. It's a gap, and we'll have to see what we can do about this! *[Laughs]*

HUO:

Very early on, in the beginning of the '90s, you had shows in Russia and China ("Pictures 1983–1988," Central House of the Artists, New Tretyakov Gallery, Moscow, 1990; "Gilbert & George: China Exhibition," National Art Gallery, Beijing; The Art Museum, Shanghai, 1993). Perhaps you could tell me about these?

GIL:

We like the idea of confronting different cultures with our work. If you can make it a powerful exhibition it doesn't matter where it is. They are able to read it and see it without words. They have to be able to feel what we think about being alive. And that's how we did it in Russia and in China. Even in Athens it was the same; confronting ordinary people with what we do.

HUO:

Athens doesn't have a contemporary art museum.

GEO:

Even Lisbon has never had a major Modern Art exhibition like Picasso or Braque. Portugal and Greece have come out from difficult governments in recent years. But I think the availability of living artists' work is so important in places like Russia. We realized that when we arrived there and we were taken to some studios where many artists worked. They asked us to sign a copy of our Van Abbemuseum catalogue (*Gilbert & George 1968 to 1980*, 1980) and we said "Of course!" So they went and brought it to us, and it looked 300 years old. All of the edges were rounded like an antique book and the sides were yellow. We realized that thousands and thousands of people had been through that one copy. That shows an extraordinary need for people to be involved in whatever's happening in the world today.

It was interesting in China because we had to visit the two artists groups for a formal reception. First we went to the official artists, who all had oil paintings on canvas of Venice or places in China that looked like Venice, and they were like early slightly Impressionistic pictures. They were very official artists approved by the government. They arranged a little reception for us and drank a

toast to us: "To Gilbert & George, very good artists." And then we had to go to the dissident artists' settlement, which was out of the town. They were making art like you'll see in any magazine from 1965 on. It was indistinguishable from art outside of China in a way. They also arranged a nice little reception for us and they drank a toast to us: "To Gilbert & George, bad men," because bad men were good for the dissident artists! So good for one lot, bad for the others, but it meant "good" in both cases.

HUO:

And what about your experience of Russia?

GIL:

Russia was extraordinary. It was just at the end of Perestroika, when everything was falling apart and the time when they were trying to whistle at Gorbachev. Really it was the beginning of the collapse of Communism. Everyone thought it was going to be a new opening but it wasn't because they are so entrenched in corruption and old ideas of communism and socialism. They don't want to do anything. They don't want to work.

GEO:

Everyone believed, both in the West and in Russia, that it was the beginning of a great new chapter. One or two memories stick out very clearly. I remember before the private view, all the people were in the foyer of the building and outside the building waiting for the moment when the exhibition would open. We were inside and suddenly two very tall people in full military costume arrived, went all the way through the exhibition, and left. Five minutes after that, the doors opened. That must have been a very meaningful moment—military representatives had to see the show and maybe check it out. The other memory, which is extraordinary, is from a press view. We had to do many, many interviews, and the organizers decided to get all the newspapers together at breakfast the next day. So the next morning we met with all these journalists, but of course there was nothing in the papers. The Union of Artists was completely shocked that nothing had appeared, and the following morning there was still nothing. The Secretary General said, "I'll have to do something about this—I'll get a copy of the catalogue to Gorbachev's desk," which he did that day. The following day all of those interviews appeared in the newspapers. A copy actually had to go through the President's office—extraordinary!

We believe that cities and countries are just a tiny bit different because of exhibitions. Like we know, in London, after the *Naked Shit* Pictures, it was a different city—slightly, slightly different.

They started to change the advertising; they started to change texts in newspapers. Tiny, tiny details started to enter the fabric of life. They changed the advertisement for ketchup, for the first time, saying, "You can give it a good smack on the bottom." They'd never advertised ketchup with that before. And we had made pictures of bum holes. Lots of details like that.

HUO:

Ever since the '60s you have developed different "circuits." The usual situation is that contemporary art travels through the same somehow limited circuits: to put it simply, there is a gallery show, which is followed ten years after by a museum show. You have had your own circuits from the very beginning.

GEO:

We feel the need for that. We were saying earlier that not to be shown is not necessarily a disadvantage, and to be shown all the time is not necessarily an advantage. In London, when the Tate Modern opened, lots of so-called "ordinary" people talked to us about it, like taxi drivers, saying that they've been to Tate Modern—people who may have never been to the Tate before. And we would always ask them the same question: "Which was your favorite work of art?" And they all answered in the same way: "Er, well, I don't think I had a real favorite." So they go to this extravagant new museum built at vast expense, and they cannot name one work of art that spoke to them, which is a disastrous reality in a way.

GIL:

Yes, the museum is more important than all the art—the art is not so memorable. I think the view from the top floor from the café is more memorable than the whole lot. I think how art is displayed and concentrated shows how the Tate never wants to make an artist move. They want to democratize them, to make them all equal, so that one is not shining more than the next. Everyone has to be the same because of equality or whatever it is. Art has never been based on that. Art has always been based on artists doing their own personal thing and making it shine.

HUO:

And when you disturbed this system in an interesting way, by introducing an object, limited-edition adhesive tape featuring details from your picture Death, Hope, Life, Fear *(1984), into the Tate shops, it created a scandal.*

GEO:

Ah yes, with our tape. It's very good.

HUO:

Even the police became involved, didn't they?

GEO:

We were amazed! We came home from a journey and were checking our faxes. We were amazed to discover a fax from the North Yorkshire Police saying that they would like us to contact them immediately, which we did. We were alarmed to find out that somebody had been either strangled or bound up in the Tate tape. We were amazed that they came to interview us, because if the same lady had been strangled with a Sainsbury's bag, they wouldn't go and ask Mr. Sainsbury for an interview. It's discrimination against the artist.

GIL:

And not only that. They did a leading article in the *Evening Standard*, trying to make us responsible.

GEO:

As near as possible without getting into trouble with the law. The suggestion in the *Evening Standard* was "well what do you expect with art like theirs?"

HUO:

And did the Tate remove the tape?

GIL:

They removed the tape. I don't know if they've put it back on sale.

HUO:

It's a disruption of this shop mania that has taken over most major museums recently.

GEO:

It's true. And a killing from time to time spices things up!

HUO:

Going back to the global issue: a lot of support for your work has come from abroad, ever since the early '70s.

GEO:

The first exhibition we had was in Holland, the second was in Germany, the third was in America.

HUO:

And what was your first exhibition?

GEO:

Well the first exhibition was actually in England; when we were students we exhibited in the West End. But the first proper commercial gallery show was abroad.

GIL:

I wouldn't regard our student exhibition in that category.

GEO:

At the end of term at St Martin's you do a "final show," and people from the college and visitors go round and talk about each object. And we didn't like the idea of this traditional traipsing around the college, arguing in front of the works. So we blocked off the entrance to the studio where we had our works with a big sheet of Plexiglas, so that you could look into the room and see our works, but you couldn't go up to them and poke them. We tried to keep the visitors at a distance in a way.

HUO:

And what was in the studio?

GEO:

We had sculptures by Gilbert and sculptures by me, but they were around in the room so that there was no way of distinguishing them. They weren't labeled clearly as to which works were by which artist.

GIL:

And we put artificial snow on the floor so that it was like a snowscape. All the objects were on the floor and then you could see the whole landscape of Soho outside, which became part of the art. You could only see through the door, so it was like a picture—an installation in which you could see the city of London and these objects.

HUO:

What came after that?

GIL:

Then we started to do little exhibitions all over town. Every week we had a new project.

GEO:

We even offered projects and living artworks to hotels at that time. We got a "no" from every gallery in London, so we moved onto hotels. We even went to the central government. We asked the Minister of Works whether we could erect a tent in Trafalgar Square and present a living sculpture to the general public, so we went straight into Westminster and up this amazing neo-gothic staircase, up to the office of this very important minister. He's since died. He was called Bob Mellish. He was obviously a hardworking, isolated person, and a household name, so it was impossible for him to have any fun in life. So he started to masturbate under his office

desk in the middle of Westminster. And I'm sure it's because in the evenings he wasn't allowed to go clubs or whatever. That was extraordinary for us. We were rather shy going into Westminster, this great government building with enormous security, and we were very nervous as we went up the stairs and were led into this room. And then to be confronted by a man masturbating under the desk, to us, was very shocking.

HUO:

{Laughs}

GIL:

One of the first realized projects was *George the Cunt and Gilbert the Shit* (1969) in Robert Fraser's gallery (London, 1969). He was the only one who said yes, though only for three hours.

HUO:

Kasper König was working at that gallery at the time.

GEO:

That was another shock for us, because Kasper König telephoned— and I don't know whether we knew who he was at that time—and said that he would like to do a book with us.

HUO:

And that was the first book, your Side by Side *(1971)?*

GEO:

We'd published little booklets ourselves I think, but not proper published books.

GIL:

To be with art is all we ask (1970), or *A Day in the Life of George and Gilbert* (1971). I don't know if you know of them. They were fantastic little booklets. And the one of drawings. And the cards of 1969 were very successful. Again it was a matter of impact. Everybody sent cards out all the time and they just got thrown in the bin. But we had the idea of making cards that people don't throw in the bin.

HUO:

So the card was a medium, not a secondary piece of work.

GEO:

Yes, we called them "postal sculptures." We felt that if we couldn't have a work in public, we could at least go through the letterboxes.

GIL:

We had to make them so personal and so beautiful that they wouldn't chuck them away.

GEO:

We did one called *Lost Day* and we got lots of replies back from all over the world, people telling us very personal things that happened to them on that same day. They were almost confessional in a way.

HUO:

And that was a postcard?

GEO:

It was more of a greeting card. We did postcards and folded cards.

GIL:

One of the most important ones was called...

GEO:

A Message (A Message from the Sculptors, 1970). It was very international; it went out all over the world. Within days people were seeing them in London, New York, Paris and Berlin.

HUO:

At the beginning you used to sign some things as George and sometimes as Gilbert?

GEO:

We used to swap over. We wouldn't even think about it.

GIL:

It wasn't until around '78 that we always kept it the same.

GEO:

Even the *Dirty Words* Pictures are some of one and some of the other.

GIL:

The best thing is the Royal Coat of Arms, even in the *Dirty Words*.

GEO:

We signed underneath the Royal Coat of Arms in every picture until 1977.

GIL:

It's totally forbidden.

HUO:

Really?

GIL:

Oh yes, you have to have permission.

GEO:

Technically, yes.

HUO:

And you did it without permission?

GIL:

Yes, because we wanted to be established artists.

GEO:

We still want to be established artists!

GIL:

We never get it! We never get it! [*Laughs*]

GEO:

[*Laughs*]

HUO:

So the first big book, which is one of the rarest books on the planet, was Side by Side *published by the König brothers in an edition of 600. I was wondering if you could tell me more about this.*

GEO:

Side by Side and *Dark Shadow* (1976) were both based on a single spread, so they weren't like books you can read from page 1 to 500. You can go into the book at any point and one spread of the book is self-supporting, so that text relates to that plate and doesn't continue in any way.

GIL:

First we did the plates and then we did the writing on top of the plates. We would go to the Wimpy near Liverpool St. Station because we had no heating in our place, and we would put one photograph or drawing against the glass and then we would write about it. That's how we did it.

HUO:

So the book was made in a Wimpy?

GEO:

Yes, absolutely. It was the cheapest food.

HUO:

It has a lot to do with a storyboard. And you said that that the covers were all handmade, so there must have been mountains of linen in your house.

GIL:

They were all individually marbled by us, by hand. And they took ages to dry. The whole house was filled with these sheets.

GEO:

We realized a long time ago how important books are for people in different ways. Some people keep the books they acquire as young people until their dying days because they want to have those books on their shelves. When people go to visit someone's house, they always glance at the bookshelf because they think that they can get a character reading of their host by seeing the books that he

or she has or doesn't have. We had a beautiful letter from a lady recently, saying that she was 84 and she was moving from her house into a retirement home, so she was only going to have a small room and she was very sad that she would not be able to take her furniture with her. She could only take a few things with her. But she's taking all of our catalogues with her and she said that she's going to go through them every day!

GIL:

The most important book—it was a revolution for us—was the catalogue that we did for the Eindhoven show ["Photo-Pieces 1971–1980," Van Abbemuseum, Eindhoven, 1980; *Gilbert & George 1968 to 1980*, 1980)].

HUO:

Which was edited by Rudi Fuchs?

GEO:

Yes.

GIL:

We designed that from the beginning to the end. And the museum was absolutely shocked. Nobody had ever printed such a big catalogue before. But we confronted them and they couldn't say no! Even Mark Francis told us that when he went back to London to have a meeting about printing this catalogue, they were also shocked because nobody had any money at that time.

GEO:

If you look back, all the catalogues from museums at that time were not only very slim, they were often very poorly printed, and sometimes even had stuck-in prints. They weren't even properly published books.

HUO:

Sometimes with advertising in the back.

GEO:

Yes, for some local company or whatever. And very interestingly, we had the final meeting with Rudi Fuchs, who was terrified by the cost of this project, and he said that the only way they could do it was by asking for some sponsorship help. He suggested to us that Ileana Sonnabend might help. And we said, "Of course, feel free to ask her." But he wanted us to ask her, which was rather embarrassing I felt. But he dialed the number in the office and passed the phone to me. I felt very embarrassed to ask her to pay for a big part of this catalogue, and very quickly she said, "No, but I'll call you back," and she called back and said yes. But in the archive of the Eindhoven museum, Rudi does have in a folder two letters: one is

from the Minister of Finance saying, "What on earth is this proposed budget for a catalogue? This is impossible! This is more than it costs to make seventy books. We can't possibly have you spending this amount of money on one publication." And there was another letter from the same government department two years later saying, "We feel we must congratulate Eindhoven on having a prize-winning catalogue, you should do more publications of this sort." [*Laughs*] Every artist wanted a catalogue like that afterwards.

GIL:

When the show went from Eindhoven to Düsseldorf and so forth, it was amazing. It was a revolutionary show on all levels. Behind the scenes, they didn't all want to work—because of the unions.

GEO:

The museum staffs at that time were quite different from the museum staffs of today. They were all very nationalized and very unionized, and were very reluctant to work hard. Wherever you went the museum staff was always playing cards and drinking beer.

GIL:

We had to buy them beer in Düsseldorf!

GEO:

And also in Paris at the Pompidou, I remember. They would go away and have three-hour lunch breaks.

HUO:

What about The Complete Pictures *book, which was quite extraordinary also* (Gilbert & George: The Complete Pictures 1971–85, *1986).*

GIL:

We designed *The Complete Pictures*. We did drawings of every piece we had done. An American publisher wanted to do it, and he was totally terrified when we said that we wanted to do 25,000 copies. He would have done 3000 or 4000. So Anthony d'Offay said, "So let's do it together." And we thought that was a good idea, so we went to Stuttgart, to Cantz Publishing, and they did some proofs for us. We were very pleased, had an estimate and said yes. Every museum was going to take 2000 copies during the show. We started in Bordeaux, then we went to Basel, then to Munich, then to the Hayward Gallery and Brussels. Each venue had to take 2000 copies.

HUO:

Again this is a system that you introduced, because after that, many publishers did the same with artists all over the world.

GEO:

The important thing was that we explained to each of the museums that part of the deal would be that they take 2000 copies of the publication and that they sold them at cost price. All of the museums, when they saw the book, said, "Oh this is far too cheap. People won't buy it when it is so cheap. We must charge double, and then they will buy it." But we said no, that they should sell them at cost. That way, they would sell them all. We always want to break that circle whereby the fewer you print, the more expensive they are and therefore the fewer you sell. You have to break that.

HUO:

You mentioned your first exhibitions in London, but you have also spoken of other early projects abroad. What was your first exhibition outside of the U.K.?

GIL:

That was Düsseldorf ("The Pencil on Paper: Descriptive Works," Konrad Fisher Gallery, Düsseldorf, 1970).

GEO:

That was extraordinary because again it came out of rejection—not the show but the introduction. We always think that everything is fine; if people are happy then it's fine, if they're unhappy it's better that you find out. That way there's no disaster. So when an exhibition called *When Attitudes Become Form...*

HUO:

... curated by Harald Szeemann...

GEO:

... came to London to the ICA [Institute of Contemporary Arts, London, 1969], we were very excited because we heard that wherever it descended in the world, it would be added to by a local curator. And we were very thrilled because we knew that the local curator would be Charles Harrison, who knew our work well. While we were baby artists, we knew that he might well choose us to add to the exhibition. And much to our amazement and horror, he didn't add us to the show. We were so shocked; we'd taken it for granted. There were only four artists in London and we weren't included. We thought we had to do something about it. If we couldn't be in that show, what could we do? So we decided to do a *Living Sculpture* at the opening, which we did. We arrived in the evening with our heads and hands in bronze paints, and we stood there, and it stole the show. In some ways it wiped out the rest of the show. At the end of the evening this young man came up to us and said "My name's Konrad Fischer, you'll do something with me in Düssel-

dorf, no?" And he was the most famous art dealer in the world at that time. Artists would have cut their legs off to be invited by him to do a show at that time.

GIL:

So he arranged for us to be part of an exhibition in Düsseldorf. Between shows I think it must have been. Marcel Broodthaers was there. Some girl was there pouring sand. So we went over to Düsseldorf for the first time. And before that we hadn't done a sculpture for more than two minutes, and we thought that we had to do it differently here; we have to show something! So we decided we would have a table, go up to it and stay there for 8 hours non-stop (*Underneath the Arches*, 1970).

GEO:

For as long as the museum was open.

GIL:

And that was a revolution. Even [Joseph] Beuys came to have a look. Everybody came to look. It was a sensation!

HUO:

And that was your first project in Germany?

GEO:

Yes. We're never sure whether the first show that we did abroad was in Amsterdam at Art and Project ("Art Notes and Thoughts," 1970) or that one in Düsseldorf.

HUO:

What about your Posing on the Stairs *at the Stedelijk Museum, Amsterdam (1969)?*

GEO:

Yes, that was important.

GIL:

We used to be friends of an artist called Ger van Elk, and he was quite close to some curators at the Stedelijk Museum, so they managed to persuade Wim Beeren to let us do a "living piece" on the stairs of the museum. So we did that one Saturday. They were all there. There are pictures of them all standing there and looking up at us standing there.

HUO:

One of the world's leading scientists today, Luc Steels, was a student and he had a part-time job at Galerie Art and Project / MTL in Antwerp at the time. He said that you had an impact on him. In a way it was a factor in him becoming a scientist. Your work is always such a trigger. It never leaves people indifferent. Each exhibition ruptures indifference.

GEO:

We've always said that we think people should go home from an exhibition being different. If there's not something different inside of them then there's no reason to visit an exhibition. We say it's like when you read a book that means a lot to you: if you can't remember or say to a friend exactly what happens in the book, it's too long a story, but you know that bit of you that's inside, which is different because you read that book, some tiny detail of humanistic thought.

HUO:

There are often museums where artists feel at home. The Van Abbemuseum in Eindhoven in the '60s was such a museum for you perhaps. Artists are also very often interested in different types of museums. We have in the past discussed Sir John Soane's Museum in London, museums which are not necessarily monumental, but which are maybe trying out different models. So I was wondering, what are your favorite museums in the world?

GEO:

We want museums that have the most democratic public. If you speak to ordinary people in London and ask them where to go to see Modern Art, if you pretend to be a tourist, they would tell you to go to Tate Modern—99%. We should tell another amusing story about the Tate. When the Tate bought the picture *Balls or The Evening Before the Morning After* (1972)—it's the first and larger drinking piece that we did—one of the curators wrote to us and asked whether we would have lunch at the Tate to meet two or three curators to talk about how we created that picture. We were very embarrassed by that idea. We'd never done that before. We'd never been for a posh lunch. We'd certainly not talked about how we made our pictures to professional people employed by the nation, and we tried to get out of this lunch. But they insisted we do it, so we agreed. And we went down and talked about how we'd come to the idea of making "drinking sculptures." And of course we drank quite a lot because it was a lunch with alcohol and we were discussing that. Years later, the person who had invited us to the Tate said that when he had submitted his monthly expenses, the receipt from the lunch had been returned from the director with the wine and the port crossed out, accompanied by the words "only a modicum of wine is permitted." So even when we reluctantly went to the Tate, they censored our drinking whilst talking about a drinking sculpture that we didn't want to talk about. Amazing.

GIL:

We feel that we were among the first people to create art through the negative image that was not documentarian, making a real artwork out of photography. Everybody was doing documentation, but never a big artwork.

HUO:

It's only recently that photography has really been accepted in museums. At that time it was still a struggle. It's opened doors, because now photography can be in a museum like a painting. It wasn't obvious at that time.

GEO:

It's very complicated because some museums have a photography department where photographers are collected, like the Victoria and Albert Museum has a photographic department. And a lot of museums wanted to accept our works in that way. And we said no, no, we don't want to be part of the photographic collection, we're artists. So it was a difficult thing.

GIL:

We called them sculptures at the beginning, then pictures, to get away from the idea. Photographs meant little photographs done by a photographer, not a big artwork. I think that was a revolution that took us many years to establish. A recent example was when we were at the Tate and they said that they only started to buy photo artworks in the '90s, but that's not true. They bought the enormous *Balls Piece* in 1972. Nobody realized how important that was for the art world in general. Now, 80% of young artists use big photographs.

HUO:

And then there is the transition to color, which is very important in your work, and I realized that even more after I saw the "Dirty Words Pictures" exhibition at the Serpentine.

GEO:

We didn't come from a picture-making background. We didn't study making paintings in that way. So when we started to be artists, we didn't have a box of crayons or colors like most artists have. Even children and amateurs have the full choice of colors. We had no colors because we were sculptors. So we started off using the negative image. We made them into charcoal, then we discovered black as a color, then red, two or three years before we discovered yellow. Then we found four colors and later all the colors.

GIL:

We always made our art like manic people, always thinking of the next one, never looking back. That's how we did it, without analyzing exactly what we were doing.

HUO:

You were always pushing forward.

GIL:

Yes, pushing forward, don't you think George? Making it and showing it. Showing is the most important part for us. We prefer not to make it, but we have to do it because that's the only way to show it. But in the future maybe it will be simpler.

GEO:

Normally our pictures are finished just in time for them to go onto the airplane to the gallery or the museum. So we don't tend to have works of art hanging around in the studio for months so you can touch it up or change it a little.

HUO:

Walt Disney used to say that deadlines make the world go round.

GEO:

Certainly in the early days, especially. We were always working at breakneck speed for deadlines.

GIL:

We have a system for making each work of art, and once we decide on the system we cannot change it. That's it; you have to accept it. It's an amazingly good discipline to have to accept what you do. Other artists might paint over the top and start all over again. We don't do that. We've never done that, and we've never rejected an artwork that we've made, never. What we've done is done.

GEO:

We always say that it's taking embarrassment and awkwardness into the normal fabric of the world. So when we have an idea such as doing the *New Horny Pictures* (2001) or to do *Drinking Sculptures* (1974), if you think for four or five minutes you will reject the work—they are awkward, silly or embarrassing—but if you do it, if you drag yourself out there and the pictures are done and they've been colored and then they're being exhibited, suddenly in some way it takes on a normality in the world. They are there, we did them and people can discuss them.

GIL:

Embarrassment is very important. When we are embarrassed about what we are doing, then it works. We know that, and we are terrified.

HUO:

That raises the issue of the masterpiece. By not eliminating work, deciding quickly and so on, this is a way of working that bypasses the hierarchy. There might be twenty works in an artist's studio, and then all of a sud-

den the artist thinks that one is a masterpiece and the others are not. So is every work a masterpiece?

GEO:

We know one thing very simply, which is that it's rude to choose!

GIL:

It's rude to choose!

HUO:

And this way, it is always about beginnings, new beginnings, the first picture everyday.

GEO:

Losing our virginity every day!

GIL:

And we like the idea of being childish, of being silly. When we go out and enjoy ourselves, we can be totally silly, and this is our freedom.

HUO:

Robert Louis Stevenson once said that art should be serious, but it should be serious in the way that children are serious when they play.

GEO:

That's a very good quote.

GIL:

"Love thy neighbor" is our motto.

GEO:

The only rule in life that we always keep is, "Do whatever you like but don't beat up your neighbor," to which I say: "Yes, unless of course he enjoys it!" [*Laughs*]

GIL:

[*Laughs*]

GLISSANT, Édouard

Édouard Glissant was born in 1928 in Sainte-Marie, Martinique. He currently lives and works in Paris and New York. Educated at the Lycée Schoelcher in Fort-de-France, Glissant immigrated to Paris to study philosophy at the University of La Sorbonne and ethnology at the Musée de l'Homme. Glissant became a prominent intellectual figure in the '50s in Paris, publishing his first collections of poems—Un Champ d'îles (An Expanse of Islands, 1953); La Terre inquiète *(with lithography by Wilfredo Lam, 1955), and* Les Indes (The Indies, 1956)—*collaborating on Maurice Nadeau's periodical* Les Lettres Nouvelles, *and working at the organization of the first Congresses of Black Artists and Writers in Paris (1956) and Rome (1959). For his first novel,* La Lézarde (The Ripening, 1958), *he was awarded the Renaudot Prize. Accused of sedition in Guadeloupe, Glissant was forced to reside in France until 1965, when he returned to Fort-de-France and founded* Acoma, *a review of social sciences, in 1971. Concurrent with writing novels—including* La Case du commandeur (1981), Le Tout-monde (1993), Sartorius, le roman des Batoutos (1999), *and* Ormerod (2003)—*Glissant has been developing his theory of creolization, fueled by the understanding that Caribbean culture and identity are the positive products of a complex and multiple set of encounters of African, European, and East Indian cultural patterns. His theoretical books—that include,* Le discours antillais (1981), Poétique de la relation (Poetics of Relation, 1990), *and* Traité du Tout-Monde (1997)—*have proved a lasting influence on postcolonial studies and theories of globalization. Since 1988, Glissant has taught literature at the City University of New York, and since the end of the '90s he has been working on "M2A2," the future Musée Martiniquais des Arts des Amériques in Lamentin, Martinique.*

..........................

This interview took place in Paris in September 2001.

Hans Ulrich Obrist:

My first question has to do with the idea of setting up a museum in Martinique. What first gave rise to the idea?

Édouard Glissant:

The idea of a museum in Martinique sprang from a conjunction of different factors. First of all, from the fact that when I was growing up in Martinique, particularly in 1941, while I was in high school, I kept company with a group of friends who were five or six years older than I and were students of Césaire. In 1941, many artists and intellectuals who had fled Nazism stopped off in Martinique on their way to the United States: [André] Breton, [Claude] Lévi-Strauss, [André] Masson, Wifredo Lam. And from that moment on, there was

something of an openness with regard to the American—and in particular the Latin American—world. Secondly, when I was in France, I ended up working with basically all the artists—with [Roberto] Matta, with Lam, with [Agustín] Cárdenas—of those particular generations. At the time, in the '50s and '60s, most Latin American artists came to Europe, whereas today, they tend to go to Miami, Los Angeles, or New York... But at that time, [Jesús Rafael] Soto, [Carlos] Cruz-Diez—everybody was in Europe. Because I worked so extensively with all those artists—who are of great importance in Latin American—they agreed to donate the works to set up the museum. The third factor is that it has all taken place in Martinique, in other words, in a small country which is at the very hub of the Caribbean chain. There is certainly a sort of geographical magic about the situation, which allows all the attention of South and North America to focus in on this point. So we came up with the idea of this Martinique Museum for the Arts of the Americas. The starting point, however, was above all Latin America—the arts of Latin America. To be quite honest , the basic idea for the museum was that I had always wanted to put together a historical and comparative encyclopedia of the arts of the Americas. And I think that is what is really behind the museum idea... In other words, that is the project that will be served by and will push forward the collections we will be assembling—in other words, something that just doesn't exist. There are extraordinary studies on everything imaginable in the realm of art: there are studies on the art of the Maya, the Aztecs, the Incas, and so on, which are just sensational; there are studies on the Mexican muralists, the Constructivists from the southern cone, kinetic artists from Venezuela, graffiti art... everything you can imagine. But there has been no work done not so much in terms of a synthesis, but in terms of coordinating what has gone on in the Americas, artistically speaking. For instance, in a city like New Orleans, in a city like Saint-Pierre de la Martinique, or in a city like Montevideo, what was going on artistically in, say, 1850? Was there anything going on, or nothing whatsoever? And if there wasn't anything, why wasn't there? If there was something, was it directly linked with the native arts, with the aboriginal arts in these areas? Was it an imitation of Western art, or influenced by Western or European art? In this imitation, was art production passive, did it react, or were there new creations? It seems to me that reflecting on all of that in historical and comparative fashion may enable us to see what is newest and most up-to-date in terms of art across the continent. The

point is not to put together a sort of well-greased machine designed to explain everything. The point, rather, is to gain perspectives—the perspective of the Grand Canyon as much as the perspective of the tiny rice paddy; the perspective of the great rivers and the perspective of the little spring... and to see all of that through a multitude of perspectives. I think that sort of work drives our vision of how the museum should operate.

HUO:

I have the impression that the big question that arose in the course of the museum project had to do with time, and you have just—at least partially—answered that question. We might nevertheless pursue the issue a little further, because, with regard to time, there is a new fashion or tendency in museums to abandon the chronological and temporal aspect and to move toward a purely—I would say—intuitive organization. However, although your museum remains attached to the idea of temporality, of possible temporalities, it strikes me that there is not just a temporal perspective, but an opening up onto multiple temporalities.

EG:

It is very interesting to look at the Americas as a whole—and not merely the United States and Canada—and in particular at those American countries with an African population, such as Brazil or the Caribbean: one notices that the act of colonization (above all with regard to the native populations of the United States) has tended to erase historical time from peoples' memories. Take just one very simple and very small example: for a long time, the history of Martinique was reduced to the list of the governors of Martinique. As if that were all there was! And in some way, we suffered a loss of historical memory. In order to struggle against it we were obliged—in my own case that is, in my literary work—to use an expression I often apply to this case: to "jump from rock to rock in an uncertain time." Consequently, we do not have a linear vision of time: we have no vision of time passing. Which is why I often say that we could never have come up with something like Proust's *A la recherche du temps perdu* (*In Search of Lost Time*, 1913–1927)—that enormous and well-constructed, perfectly pyramidal architectonic project, which culminates in the present. As I see it, we haven't actually lost our time... in the sense that it was never actually ours. The people of Brazil, the Caribbean, the islands, and even the peoples of Latin America all had their time stolen from them. And consequently, we are obliged to reconstitute it in chaotic fashion, going from here to there, "jumping" as we go along. It is a time frame that is no longer

linear. And our conception of time is at odds with the Christian conception based on the BC/AD dividing line. For instance, it is very difficult when, with respect to the memory of Mayan, Aztec, and Incan civilizations, someone informs us that such and such an event took place in "600 BC" or in "1000 AD" That just doesn't have any meaning in the perspective of American time and space. Consequently, we have started off with a circular or spiral—and above all chaotic—conception of the re-conquest of a possible time. No artwork, and consequently no work of any kind that deals with artistic questions, can submit to a linear notion of time of that kind. If we want to put together an historical and comparative encyclopedia of art in the Americas, it is really because time is just not the same on a small Caribbean island or in Terra del Fuego, in the Canadian north or east of Santiago de Chile. We didn't so much want to establish equivalences as create relationships between all these different times in an attempt to see what is pulsing and bubbling in the American environment.

HUO:

I had a very interesting E-mail exchange with James Clifford last week. He sent me an E-mail saying that for him, the sort of museum truly worth thinking about is one that would enable the coexistence of different timeframes.

EG:

[Laughs] That's what I just finished saying... That is the very underpinning of the museum that we want to set up.

HUO:

So you imagine the museum as a series of connected islands...

EG:

I imagine the museum as an archipelago. It is not a continent, but an archipelago.

HUO:

A very elegant definition. And so, in that sense, the challenge for the architect—because last time we met, you mentioned that you were launching an architecture competition—would be to invent a way of spatializing this "archipelago-making" process. It will be the opposite of anything monumental.

EG:

Just the opposite, not a diffuse but rather a diffused space.

HUO:

With regard to these definitions, how would you describe the museum as a tool of memory, as a tool for resisting amnesia?

EG:

On the one hand, this museum is going to be installed in the largest sugar and rum refinery in Martinique, built in 1850 and shut down

in 1975. It is actually a marvelous building. Why is that important? First of all because in Martinique, which was based on an entirely colonial economy, this refinery was at the very center of the country's life. As a child I was raised only two or three miles from the factory, which was the focus of working-class struggles, agricultural labor struggles, and strikes which, throughout the whole period, were put down by shootings and killings.

HUO:

Is it part of your childhood memory?

EG:

Yes, and it is also part of the collective memory in Martinique. It is interesting that this collective memory—which, at the same time, is not really a collective memory at all, but rather an effort to wriggle toward collective memory, inasmuch as every attempt was made to erase it from collective memory—the memory of the plantation, be it the memory of Louisiana or Mississippi, the memory from the depths of the plantations in Cuba or in the Sudeste of Brazil, are all the same... And consequently it is not so much a particular memory unique to the little island of Martinique, but rather a memory common to the whole region, to the Caribbean, Brazil, the American Deep South, the coasts of Venezuela and Colombia... It is the memory of a very particular economic system, the memory of common alienation and common suffering. And that is why it was so important that a museum of this kind be set up there.

HUO:

I recently spoke to a number of scientists regarding the whole notion of dynamic memory, the museum in general and the question of memory, and they told me that, from a scientific perspective, memory was something dynamic, always situated in the present. And with regard to the notion of a museum, they said that memory has always been apprehended in static fashion.

EG:

And why is that? Because in European cultures, the museum recapitulates what already existed as an evident manifestation, for instance, of art, life, the economy, and what have you. The museum recapitulates. Whereas in our culture, in the Americas, the museum hasn't got to the extent of recapitulating... We see the museum as on a quest, seeking out... Which is not the same thing at all. That fact has two consequences. If we actually manage to do the encyclopedia, we still don't know what we are going to find. It is not a recapitulation of something which existed in an obvious way. It is the quest for something we don't know yet. And consequently, this research into

memory is not a table of contents; it truly is pure research. That is the first point. The second point is that because it has to do with memory, a museum of this kind is inclined to hook itself into all the remaining traces of the past which are still alive and exploitable. Not only traces in the ethnographic sense, but living traces. For instance, the museum to be set up in the factory will start off with video interviews of all the former factory workers who are still alive—even if they are very old because the factory, in fact, was hellish. The workers worked in unbearable heat, with unbearable noise. It was anything but idyllic. It is extraordinarily beautiful, but it is not a frozen beauty, not a conventional beauty. And the first thing that we sought to do was to spot all the traces which lived in the site, the traces that lived throughout the whole region of the Americas. And consequently, they are not conventional traces... And to have an art collection around all of that requires two things: firstly, gathering the living trace of the different facets of the historical past; but secondly, to ensure that this living trace is not transformed into folklore... to make sure that it is not once again frozen into folklore.

HUO:

Is it presented as a model, or rather as a toolbox?

EG:

Not as a model—in any case, inasmuch as models are always somewhat constipated, somewhat frozen. As a toolbox, yes, sure. But we know very well that the best quality of a young artist today is his or her sensitivity in understanding what is going on all over the world. And not merely what is happening in his or her particular region. Thus, with regard to memory, the interest in a museum of this kind is that it can be the point of convergence for many different memories. And that is the important thing: not only many individual memories in a single place but also many different places which come together... and almost compare their densities and objects between themselves.

HUO:

In short, it is the contraction of a multitude of memories?

EG:

Exactly, and that is the most interesting thing of all.

HUO:

Earlier you told me that "the museum hasn't yet discovered; the museum is still looking." In what way could one make use of the notion of the laboratory in the museum? Will the museum be a laboratory?

EG:

It will indeed be a laboratory—a laboratory for setting up parallel relationships and evidencing different experiences. But perhaps we will find commonplaces with regard to these different exigencies. I think that one of the characteristics, one of the commonplaces, of all the art forms in the Americas is that these various art forms in the Americas never benefited from the spiritual and technical experience of perspective—the invention of perspective. Perspective is an invention of Western art, and more particularly of the Italian Quattrocento. In the Americas, however, one has to notice that artistic expression, of whatever kind—from the art of the Incas to Jackson Pollock—bears no relation to the invention of perspective. What does that mean from the point of view of time and the space of time? Because that is one of the great inventions of Western art. And even when an American artist uses the techniques of perspective, its use is not what accounts for the creative drive in the Americas. It has nothing to do with that. And that is something worth looking into. We are looking and haven't discovered yet. But the fact is that the arts in the Americas often do not conceive of emptiness as a natural setting. The canvases are always full, there are no vanishing points in an infinite space. What does that mean? Is it in someway related to a community of perception? In other words, one may make a mistake in formulating theories in *a priori* fashion—and we will endeavor to avoid that problem—but one can also endeavor to discover things which are not yet obvious for everyone.

HUO:

And make an unforeseeable museum... That leads me very naturally to ask you about the relationship with the public. You have talked about islands and the multitude of temporalities, which I found very beautiful. However, in a very practical sense, I wonder how, in the museum space, you are going to deal with these different forms of spatial, temporal and cultural translations.

EG:

We intend to proceed in a very humble and modest way. First of all, we are going to think of the museum as a focal point. If you look attentively at the map, you can't help but notice Martinique; you notice that all of the Americas are there, and you start drawing broad strokes. That is what exhilarates people in Latin America: Martinique is a focal point upon which painters and artists from Argentina, Brazil, North America, and Venezuela can set their sights. And consequently, one of the museum's principal activities will be to have a perpetual exchange (we have a dozen-odd studios

for residencies) with artists from all over the continent. And this perpetual, ongoing exchange won't be for naught, because we will be very vigilant, right from the outset, that from all of these experiences emerge not merely traces but also possible conclusions. That is something very important because what is most lacking in the Americas is the relationship between all these islands, between all these memories. That is one of the things that is most sorely lacking. There are very few North American artists who have traveled to—or even toward—the South. It has, of course, happened to a large extent in music—there have been a lot of connections made between the different types of music in Latin America, the Caribbean, Brazil and the United States... One need only think of "salsa jazz" for instance. But there hasn't been anything comparable in the fine arts. Of course an artist from Montevideo knows all about Pollock's work, he has seen all the catalogues, read the books, watched the videos, but there is no genuine connection. And we are going to try, in our modest way and at our own level, to establish those connections. At the same time, we are going to try and see whether, within these multi-memories, there are any corresponding memories: whether, for instance, memory in Cuba is the same as that in Jamaica or in Martinique. Or whether, to take another example, the system of plantations in the Caribbean world, in the Brazilian world, or in the Deep South of the United States, has any influence on the sensibility, the mentality, or the artistic expression—in the same way as the system of *latifundia* in Argentina. Or if, on the contrary, there are differences. In other words, it is an immense field, which it is fascinating to explore. I don't know if we'll succeed, but I believe that it is worth looking into.

HUO:

That's how experimentation works...

EG:

It is both an experiment and an invention. A connection in the true sense of the word: *colligere*, bringing closer, putting together.

HUO:

In Celia M. Britton's book on your work (Édouard Glissant and Post-colonial Theory, 1999), there is a whole chapter devoted to the analysis of language as a resistance strategy. To what extent do you consider that the museum can also be understood as a resistance strategy? An idea, moreover, which would seem to corroborate the discourse of many contemporary artists who frequently make use of the idea.

EG:

It is first and foremost an act of resistance against the erasure of individual and collective memory. Had we conceived of the museum in Western fashion, in my opinion, it would have served no purpose whatsoever. Secondly, it will be a resistance in the sense that we are going to try and show that for certain artistic currents, for certain artists, it is political in the sense that it confers a sort of permanence on new forms of artistic expression. Take Wifredo Lam for instance: what is interesting in his painting is that it is very political, but not in the sense that it is politicized. These new forms, because they are linked in particular to African forms, are acts of resistance—and in particular, of resistance to the model of the Greek statue, which has been imposed as a universal model. As soon as that work is done, there is resistance. If, for instance, you take Incan or Mayan art forms, once they have been removed from the traditional museum, from convention, once they have been taken into consideration by artists who make use of them as a starting point for their own reflection, who position themselves against them or adapt them, they become forms of resistance—resistance against an imposed Western model. Therefore I think that a museum conceived in this way is a political museum. But it is not a partisan-political museum. It is a museum that glorifies the processes of artistic creation and new forms.

HUO:

Since you just mentioned Lam, now is perhaps the moment to talk about a few other artists to whom you were close. Last time we met, you told me about Matta and {Victor} Brauner and the movement which, in the '50s, was connected with the Galerie du Dragon in Paris

EG:

That was immediately after the war, in the '50s. One of the particularities of the Galerie du Dragon was that the people who founded it were poets— above all Max Clarac-Sérou, who recently passed away. They refused the art business, which was completely utopian. It was bizarre, because they were dealers whose first principle was not to make money. So it was no wonder that, after ten or twelve years, the gallery went under. But for those ten or twelve years, the gallery was a place of intense influence for the art of the time. It was a gallery which began with the collective exhibitions of Max Ernst, Lam, Masson, Picabia, Dalí, and so on, but which also discovered and launched new artists including [Antonio] Segui from Argentina, [Vladimir] Velikovic, Cárdenas from Cuba. It was a place of intense

innovation, while at the same time being careful to maintain a sort of spirit of quality in terms of artistic expression. Things weren't like they are today. Today, a young artist can be a resounding success... indeed, today it may even be necessary that a young artist have resounding success, because today art is done in the whole world, and the whole world is chaotic. But at the time there was concern to develop legacies. There was Arp and Brancusi's legacy in Cárdenas's work. There was Matta's legacy in the work of such young Latin American masters as [Joaquín] Ferrer or [Gerardo] Chávez in Peru. All these people either transited through or emerged from the Galerie du Dragon.

HUO:

It was an exhibition place, but it was also much more than that...

EG:

Yes, of course, it was a place where most of the poets, the young poets of the day, could be found.

HUO:

This dialogue between art and literature has vanished today. Yet that dialogue is essential for any project based on the interdisciplinarity of forms. One can only hope that it will find its place in your museum—that the museum will foster this sort of dialogue.

EG:

Absolutely. For the museum's inauguration there will be as many poets and writers as artists, sculptors, and painters. Because it is important to rebuild this sort of dialogue and solidarity that previously existed in the Galerie du Dragon. What is discouraging today in art galleries is that there are no more poets at all...

HUO:

It is a real problem. The dialogue has broken off and has to be reconstituted.

EG:

It has to be recreated.

HUO:

You mentioned Matta a moment ago. The notion of resistance is perfectly applicable to his work.

EG:

I consider Matta to be a fabulous character... Not only was he a great painter, but he was also a great poet. The very object of Matta's painting was bizarre right from the outset. He would say, "In the painting I want to show the upheavals, the conflicts, which are there in the minds and bodies of modern men and women." It was absolutely fantastic. He didn't want to do it in an intimate way, as if it were some sort of psychological study—that would have been

stupid. I said in a text—because I wrote a great deal on Matta—that he wanted to establish an equivalency between the conflicts of the human psyche and the upheavals of matter. It was, in other words, something that already prefigured the current world. As a matter of fact, he had a word for it: he talked about "chaosmos," and I talked about the "whole world" ["tout-monde"] as if it were a "chaos world" ["chaos-monde"]. And so we came into contact in a deep-seated way on that level, and we then worked together a great deal.

HUO:

How did you come up with the conception of the "chaos world?" Did it stem from your interest in science?

EG:

Yes, well, in fact [*laughs*] it actually came from my innate inability to understand what science is all about! In fact, the available texts by theorists of the science of chaos were all supremely beneficial to me. For instance, the idea that knowledge is not produced on a continuous line—that it is not a progression along a line but rather that scientific knowledge is produced in chaotic fashion, in very different and often even contradictory conditions or the idea that the very object of the world is not knowable in a uniform and progressive way or again, the idea that science could entail a poetic approach to, or description of, the world. That is something that struck me a great deal. For a long time I had thought that human identity was not uniform, that it did not follow a line. It may be contradictory but without necessarily leading to conflicts. Very early on I had the idea of a "rhizomic identity" or an "identity-relation"—an idea that for years I had a lot of trouble getting people to understand. And in all those respects, I was close to—and continue to be close to—the thought and work of Matta.

HUO:

And of Gilles Deleuze...

EG:

And of Deleuze, on the philosophical level—that's obvious. The distinction that Deleuze and [Félix] Guattari establish between the single root and the rhizome was extraordinarily profitable for me: the single root which kills everything around it, and the rhizome which, on the contrary, spreads out toward other roots without killing them. If this idea had been given any real publicity in the world, it would have fought off any number of enclosures, and forms of sectarianism... and I continue to believe that holocausts and massacres

will not be vanquished by military might or political imposition. They will only be vanquished once the mentality and spirituality of human beings and the human race of today comes to accept an idea of this kind. And in particular this idea—that I have repeated tirelessly for many years now—according to which "I can change through exchange with the other, without either losing or distorting myself." One of the stumbling blocks of today is that everyone is afraid of changing, the fear that in taking something from the other, one is in danger of disappearing, of vanishing, of becoming diluted. And that's just not the case! We have to carry out this basic revolution in the history of the humanities, in order to be able to say, "I can change... I am not obliged to remain the same, I can take from the other." And that doesn't mean that I am liable to lose myself in the process.

HUO:

It's a form of Utopia.

EG:

Yes, a form of Utopia. But we're faced with an urgent situation; we have to fight for that Utopia. It is a Utopia not in the sense that it isn't true, because it is true: it is a Utopia because it isn't yet possible to get the majority of humanities to agree to it. If I say to a Catholic or a Protestant, who are at each others throats in Ireland, or to a Jew or a Palestinian, who are in the throws of killing each other in the Middle East, or to a Hutu and a Tutsi "I can very well be a Tutsi and take something from the Hutu without it killing me, without it leading to my demise, but, on the contrary, being enriched by it..." If we start to think along those lines, we will have truly started to fight against the holocausts and massacres of today. I just don't believe there can be any political or military solution to these kinds of problems. It is inside people's heads that things have to change; it is in their imaginations that we have to challenge the idea that we exist only through a sole and unique identity. It's strange to say such a thing at a time when there are ever more massacres being committed.

HUO:

But all the more urgent.

EG:

True, all the more urgent.

HUO:

What are your unrealized projects—those which you were never able to carry out, but which remain particularly close to your heart?

EG:

We have a lot of unrealized projects. But I don't know whether it is really necessary to focus on all those. I think that unrealized projects leave a trace in one's consciousness and in one's subconscious; and that trace defines what we do subsequently. But it is not necessary to draw up a statistical inventory of them all, because if one does that, they lose their form as traces. And I believe very strongly in the notion of the trace, which in my opinion is fundamental. It is no longer in the state of the trace that the unrealized project functions within me, but rather in the state of the obstacle, the wall, and the trace disappears in favor of a wall—the wall of the unfeasible. I don't think that's a good thing. That said, it's true that there have been a lot of projects we haven't been able to carry out—all of us, that is, including myself. But I believe that it is these unrealized projects that motivate us with regard to those project we are able to realize. But there is no point drawing up a precise inventory. A small component of an unrealized project, in the form of a trace, lives on inside me and makes its way into yet another project, different again, but in which there is still a little trace...

HUO:

What is your favorite museum? Have you ever been really impressed by a museum?

EG:

I don't have a favorite museum. Like [André] Malraux, I could say that I have an "imaginary museum." But it is true that there are museums which are genuinely exciting. For instance, when I go to the Metropolitan in New York, as soon as I go in, I go straight for a particular canvas that I want to see—and it's always the same one.

HUO:

Which one?

EG:

It's the *View of Toledo*, signed by El Greco. It's a rather somber painting, with white highlights that define the contours. Every time I go to the Metropolitan, I follow the same circuit and become extraordinarily elated as I approach the painting. If you asked me why, I could try but would be virtually unable to account for my feelings. But that is the effect it has on me. There are museums that, on the contrary, impress you through their very mass. It is not some particular piece that you see, but rather the totality of the museum.

HUO:

There is also the Hermitage Museum in Saint Petersburg.

EG:

Exactly. In the case of the Hermitage Museum, it was the museum as a whole that completely bowled me over. As a museum, it is a sort of miracle. One wonders how, for instance, looking at the Rubens rooms, or the Rembrandt rooms, the Impressionist rooms—particularly the Impressionist rooms—so many works can have been collected with so little waste. One feels that it is just not possible—and in this case, it is the very mass of the museum which is impressive. Another example is the Museum of Archeology in Mexico City. There too, it is the mass, the overall collection, the relationships between the works themselves which is impressive, which grabs you. Aside from that, I don't like many specialized museums, such as museums devoted to seventeenth-century painting or some other such thing... because in those cases the museum is really a recapitulative museum. And that kind of museum bores me.

GONZALEZ-FOERSTER, Dominique

Dominique Gonzalez-Foerster was born in 1965 in Strasbourg, France. She currently lives and works in Paris. Gonzalez-Foerster studied at the École des Beaux-Arts in Grenoble (1982–1987) and at the École du Magasin, Grenoble (1987–1988), before moving to Paris where she followed the activities of the Institut des Hautes Etudes en Arts Plastiques headed by Pontus Hulten. Gonzalez-Foerster gained attention in the '90s for her series of spatial installations entitled **Chambres** (rooms), in which she displayed different elements of daily life that became simple signs of an absent figure, allowing the viewers to relate stories. Since 1996, when she made her first 35-mm film Île de Beauté with Ange Leccia, she has been using film to depict particular urban atmospheres and moments such as a telephone conversation between a young couple in Kyoto (**Riyo**, 1999), or a young woman waiting for the arrival of her brother and walking along the Hong Kong Bay (**Central**, 2001). Gonzalez-Foerster places her work at the crossroads of disciplines, fostering an exchange of ideas that has led her to work with artists Pierre Huyghe, Philippe Parreno, and Ange Leccia; publications such as **Purple** and **Permanent Food**; musicians such as Jay Jay Johanson, Christophe, and Christophe van Huffel; and architects including Philippe Rahm, Camille Excoffon and Ole Scheeren. Recently, she has had solo exhibitions in institutions including the Fundació Mies Van der Rohe, Barcelona (1999), Portikus, Frankfurt (2001), and Le Consortium, Dijon (2001). Recent group shows include "Elysian Fields" (Musée National d'Art Moderne / Centre National d'Art et de Culture Georges Pompidou, Paris, 2000); "Egofugal Figure from Ego for the Next Emergence," 7th International Istanbul Biennial (2001); "Mega-Wave: Towards a New Synthesis," Yokohama 2001: International Triennale of Contemporary Art, and Documenta 11 (Kassel, 2002). As recipient of the Marcel Duchamp Prize 2002, Gonzalez-Foerster presented the installation **Exotourisme** (2002) at the Centre Pompidou in Paris.

........................

This interview was recorded in Paris in August 2001.

Hans Ulrich Obrist:

There are so many questions I'd like to ask you that I don't know where to start.

Dominique Gonzalez-Foerster:

[Laughs] I still can't get over the fact that we've gotten to the point where instead of postponing we're actually starting...

HUO:

What if we started with this rumor about Paris being on the verge of turning tropical?

DGF:

Yes, Paris is in the process of becoming tropical. Let me begin with

the hard facts, and perhaps even before turning to the facts, there is this desire—this desire for tropicalization. It goes back a few years now to when I set off around the world in search of tropical zones, tropical cities—places where plants and organic matter have a certain power. That was what I explained to Jens Hoffmann in the interview for the catalogue of "Tropicale Modernité" (Pabelló Mies van der Rohe, Barcelona, 1999), where I said that, in my opinion, modernity in architecture comes fully into its own when confronted with an organic environment which is in itself robust or powerful. It struck me that in certain places, where a certain type of architecture was brought into relation with a certain type of vegetation, it suddenly took on a whole different look. And so that's what I wanted for Paris too... Seriously, though, what Paris really lacks is plant life, tropical life. Paris is too dry, too mineral, completely gray, and then last September I noticed a bunch of spiders—it was like in the Tintin comics: little ones, big ones—an amazing number of spiders. I don't know where they could have come from. I didn't mention it—well, I vaguely brought it up with Carsten Höller; I told him that I'd seen all these spiders, and the explanation we came up with was the increase in humidity, or even an insect missing from the food chain... In any event, there was an increase in the number of spiders. The second important fact, similarly coming from very basic observations from my balcony was that I noticed moss coming up from the cracks in the cement, like in a Kyoto Zen garden. Never, in the seven years that I'd lived there, had I ever seen moss on my balcony.

HUO:

{Laughs} That's a sure sign of tropicalization...

DGF:

You bet it is.

HUO:

You speak of tropicalization and not tropicality, rather in the way that Edouard Glissant speaks of creolization and not creolity.

DGF:

Exactly, because it is a process—an unfolding process. So, you have these two very important facts: on the one hand, the mass of spiders; and on the other hand, the moss. And then, in the spring we had rains that everyone described as tropical rain. It wasn't made up, we had rain every day... a true rainy season. As for the vegetation—if you are in any way observant, and lucky enough to live, as I do, in a building where the entrance is full of plants—the vegetation

tripled in volume this summer. I don't even know if people meas-
ured it, but it was striking. And I read an article last week in *Libéra-
tion*, saying that the planet was, on the whole, greener... This was
noted recently because, contrary to what we often suppose, all the
measurements indicate that the planet is getting greener and green-
er. And in Paris, it's incredible. For the first time I actually find
Paris pleasant, because I now feel this mass of greenery.

HUO:

So it's no longer necessary to travel.

DGF:

Exactly! The tropicalization of Paris has finally made it possible to
stay at home, well balanced amid the vegetal, organic, and miner-
al ecosystems.

HUO:

*Whereas before you had to go away to find that. We should perhaps go back
a bit to those trips now—some linked to urbanism and architecture, to dif-
ferent modernities... I'm thinking of the trips you made to Brazil, or to
Asia, to those adventures in search of different modernities, not "the"
modernity. Why this need to travel?*

DGF:

Maybe because I grew up in Grenoble, a laboratory city, and more
precisely, in the neighborhood of the Villeneuve...

HUO:

Why do you say it was a laboratory city?

DGF:

Because in the '60s the city hall was run by socialists, and because
during the same period there was a group of people, particularly an
important group of urban planners at the university, as well as sci-
entists, the Laue-Langevin Institute and so on, and because in
Grenoble there is a scientific and urban-planning tradition of long
standing. In the '60s it was a group of people who, along with the
mayor, Hubert Dubedout, transformed Grenoble and decided to
make it a laboratory city. And so the Villeneuve, the neighborhood
where I grew up, was created by these people... It's a neighborhood
inspired by Le Corbusier. Of course, Grenoble also began develop-
ing as a new city in the '50s. You might say it's the anti-Bordeaux
or the anti-Lyon—of course, there's the old downtown, but it's
above all a modern city. And I also think that has a lot to do with
why all the people who came out of the Grenoble School of Fine
Arts (which was a more "digital," more scientific school than the

others, rather than a painting school), Philippe Parreno, me, and others, were influenced by certain things rather than by others. I also think it can be explained in the Grenoble context: a scientific, intellectual, experimental and laboratory-like city. However, when I was little, I had no idea I was growing up in a laboratory city. But I nevertheless went to the experimental school, I lived in the experimental neighborhood... in the whole academic, scientific environment, which understandably influences one deeply. In a more bourgeois city I would have been influenced in a different way, and would have had a different relationship to culture. Here I should also add that [today] I live in a modern building and I can't imagine living in an old building. I think that I will always seek out this modernity. And so when I went to Chandigarh for the first time, it wasn't like I was returning to my village, but, well, like I was going to rediscover—I was going to look for something that had influenced me.

HUO:

Were you interested by the sometimes utopian dimension of these projects?

DGF:

Not necessarily by the utopian aspect actually, but by the experimental aspect. When I was little, I had the good fortune of going to an experimental school: school started much later than the other schools; the first day of school we worked exclusively on mushrooms; we called the teachers by their first names. And then my parents had a, so to speak, experimental life as well: they were active in May '68, they had lived in Strasbourg, where the Situationists were, and later in Grenoble in the Olympic village... They had an experimental lifestyle. So, it was more to do with the experimental than with the utopian, at once on the political level, the emotional level, and on many other levels as well.

HUO:

How did this environment influence your work, your spaces? Because it's not entirely innocuous that you talk about the experimental environments in which you grew up, and that today you describe your works as more like environments than like pieces.

DGF:

Of course not. Having grown up in this context, my spaces are experimental. The empty spaces, the parts that they leave free, the fact that they are structured neither by symmetry nor in their construction, nor with the aim of filling them up, but on the contrary they are freeing. And that was the idea behind the Villeneuve: free

up the ground space, build upwards in order to free up the park as an area of adventure. The same went for Brasilia, with all its esplanades, its spaces that have potential. It's sort of the enlargement of Donald W. Winnicott's concept in *Playing and Reality* (1971), who argued that after the separation from the mother, there is the discovery of the play space, a space that later becomes a potential space. I believe that my research in the space of the city has always been directed toward potential spaces. The banks of the river in Kyoto, with the telephone conversations in *Riyo* (1999)—that is a potential space. The huge esplanade, the enormous empty center and its vast lawns in the middle of Brasilia—a central emptiness is much more powerful than a full center—that's what I call a potential space. That was what I tried to show in Stockholm as well: the idea that architecture's greatest strength lies perhaps not in its full spaces, but in its empty spaces (*Brasilia Hall*, 1998–2000, in "What If: Art on the Verge of Architecture and Design," Moderna Museet, Stockholm, 2000). And then there is, of course, the wonderful idea of the Beaubourg Piazza, the idea of opening up that area—it's perhaps more beautiful than Beaubourg itself.

HUO:

So you think that it would be best to leave that space open where the twin towers stood in New York?

DGF:

... and create a potential space. Let's hope! Let's hope that we won't see the Berlin syndrome of identical reconstruction come back again, and that we'll see something other than the triumph of some phallic thing or symbol. That instead, there will be a huge esplanade, which could be used for future projects.

HUO:

That brings us right back to Japan and Tokyo. With regard to your research, your great love affair, your obsession, so to speak, with Japan and Japan with you... in a form of possessive reciprocity, which cropped up again just recently in Yokohama. Where did this double obsession come from?

DGF:

What was very surprising in the course of my first trip to Japan was that I felt immediately at home. Of course, other people have had this feeling, but for me it was striking. What does it mean to feel at home? It doesn't necessarily mean finding the same things you have at home; it means you feel surrounded by affection, taken care of—you feel good. Feeling at home, not in the sense of being part of a family, but of feeling secure. There was the humidity that I was

fond of, all the signs that spoke to me... and in spite of the fact that I didn't speak a word of Japanese, I had the impression that everything spoke to me: that each and every detail, each and every doorway was my size, that every gesture told me something. And so there was already, right from the beginning, a form of reciprocity: the attention I conferred to things was, in a way, given back. And then, I think I was fascinated right away by the playfulness of the architecture, by the gaming, by the number of possibilities explored which are, when compared to Paris or other cities, infinitely greater. I was fascinated by this type of investigation into what architecture could be—in a manner that was completely prolific and organic. But that was only a part of it; there was also the temperature, the food, the pleasure of seeing this concentration of people. There were so many things I could immediately relate to... it was a bit like [Roland] Barthes' description of the feelings of being in love: everything was a sign to me, super significant. And in that state, when everything is super significant, you're very happy—it's above and beyond language. I had the impression of being in an environment where the verbal was not a determining factor, there were so many dimensions that spoke to me directly that I could skip language. And for years, in fact, I refused to speak Japanese in order to remain in that state of nonverbal hyper-receptivity.

HUO:
That was back in the '80s.

DGF:
Yes, in 1987, and things just went from there because, subsequently, I went back again and again, until today I find myself unable to imagine a year going by without a trip to Japan. I feel that aspect of Japan that's often spoken about: its maternal dimension, along with its very disturbing, controlling dimension. Yet I feel surrounded by its affectionate and gentle dimension as well. To me, it felt like an immersion. Research is a permanent feature for me—and it's particularly the case for my series of *Chambres* (1989–ongoing)—because I've always looked for a relationship to the environment, an immersion, rather than a relationship to the object. I've never been interested in a relationship with something you can hold, but rather in a relationship with things that surround us. And that, I think, is precisely what I found in Japan.

HUO:
Wasn't that the premise of the work you showed in Yokohama (Petite, *2001)?*

DGF:

In fact, for the Yokohama piece you have to go further back, back to the Villeneuve neighborhood I spoke about. When I was ten or eleven years old—and here I'm going to tell you about something that is as anti-maternal as it gets—my mother wanted to us to go to Germany with my two brothers. But I really didn't want to go; I fought against this trip and asked to stay at home. Finally, my mother said it was all right for me stay at home, and so I lived at home all alone for a couple of days—and for a child of ten or eleven, that was a pretty strange experience. I think it was then that I experienced... my most terrifying and visionary moments. I remember perfectly the moments of terror and at the same time the moments that were completely new to me... being in touch with your imagination. And, perhaps, the fact of not speaking for a few days... It was in fact something very similar to what I later discovered in Japan: the thrill of not speaking, of simply being in an environment. I remember that moment perfectly. And the little girl in Yokohama behind the glass was exactly that: someone—and it's what we see come from her—who has taken up with the act of watching... and all that it entails. It's the connection between watching and seeing: seeing not what is in front of you, but rather inside of you. It was an attempt at reproducing this childhood experience.

HUO:

The viewer remaining outside...

DGF:

Yes, and the viewers can see themselves in the little girl, like a reflection in a mirror.

HUO:

Did you do that bit of animation in Japan?

DGF:

It was done using animation and takes the place of any viewer... But no, it was done here in Paris. It's the continuation, in a certain way, of the first little girl, who was at the entrance to the exhibition, "Elysian Fields" (*Rosebud*, 2000). It's an adaptation of this little girl... but, it's really a return to that early experience. A few years ago I asked my mother: "How... why did you leave me all alone like that?" I had begun psychoanalysis and the memory had come back to me, so I asked her the question. And she replied, "You really wanted to and you seemed so sure of yourself." So, I believe it was at once experiencing my autonomy and... Paradoxically, it's in Japan—the country where I found this maternal "holding"—that I manage to show this experience—one that remains for me truly

fundamental to my relationship to the city. That's what we feel with the little girl: behind her the images of the city file past... It's linked to the way we move through things... and to how a form of autonomy can be a constituent element in relation to images.

HUO:

I remember the discussion we had while preparing "Cities on the Move," (various locations, 1997–2000). Concerning your participation in the exhibition, you told me at the time that your relationship to Asia went way back to your childhood, and I think that was what became clear in your exhibition in Cologne at the Schipper und Krome Gallery as well ("Séance de Shadow III," 1999).

DGF:

Yes, it's funny because the photos of me as a child show very clearly that I was Japanese at birth [*Laughs*]. I was born Japanese with very long, black hair. Right away I was given a little Japanese hair cut—like so. I was born "yellow"—that's what my mother always said to me. And until I was three, I think I looked totally like a little Japanese girl. And then later, as I got older, when I was given children's books that were set in Japan, or had something to do with Asia somewhere, I completely identified with those books. I don't know how to explain it. I believe that one of my grandparents was of Asian descent—but still, that's going very, very far back. I honestly can't explain it, but it's been the case ever since childhood in fact. We could even illustrate this text with one of these photos... I was born Japanese.

HUO:

And in the piece at Esther Schipper's...

DGF:

There I was investigating her history... along with my relationship to that history. I discovered that she was born and grew up in Taipei; and that her father, Christopher Schipper, who was a Taoïst and an important scholar, went there to be adopted by a family and become a Taoist priest. And then we discovered all these photos... and the exhibition is a sort of mixture of these images. At that time, I also went to the Chinese neighborhood everyday to look for traces, clues to it all—combinations between all these elements.

HUO:

It's a pivotal work, also in the sense that it leads me to ask another question: actually for me, your piece was also a form of echoing your dialogue with Felix Gonzalez-Torres and the way he worked on biography. Today there's a whole academic thing going on around Felix: everyone says or writes that Felix Gon-

zalez-Torres was in some way the father of your generation, that he brought about the transition between the '80s and the '90s—and, in fact, we don't listen to the people who knew him anymore. You were very close to him and I'd like you talk about this relationship, not only in connection to your work, but also with regard to your friendship, your dialogue...

DGF:

The first time we met was at Castello di Rivoli during an exhibition organized in the castle by Benjamin Weil ("Itinerari," 1991), Gregorio Magnani, who took care of the programming, was also there. Of course I had heard of him; this was back in 1991, and it was [...] how should I put it [...] we immediately felt like cousins. The meeting then continued on with a picnic, the beginnings of a discussion, and then during "No Man's Time" at the Villa Arson, where I did *Son esprit vert* (1991)—an autobiographical work in three parts which was inspired by Wallace Stevens' poem "Description Without Place" (in *Transport to Summer*, 1947) Wallace Stevens is a very important American poet, who Felix liked as well. In fact, I knew very little about Felix's work, and our friendship was initially a physical meeting. When I saw this guy, incredibly [...] I don't know how to say it [...] there was something of a teddy bear about him. He was incredibly affectionate, with such an amazing gentleness... He was an incredible mix of something so affectionate and at the same time scathingly ironic.

HUO:

I might add that his dog was also incredibly representative of this mix; amazingly gentle at times, and then utterly ferocious.

DGF:

[*Laughs*] That's true, and there was something of that in Felix. And I think we saw right away that we had that in common, being at once very gentle, and... For example, he accused me of leading him to acquire a taste for Roquefort Papillon. I received a letter from him saying [*laughs*] that he was very angry with me because it was my fault he was going broke buying Roquefort Papillon in New York. That the cheese had become his favorite thing and this was so terrible.

HUO:

When you went to New York you stayed at his place?

DGF:

Yes, I stayed at his place many times, and afterwards I received all these photos of his cats: his cats talking to me, his cats insulting me because I didn't come to visit often enough. There's all this [...] the mixture of a relationship that was [...] how can I put it [...] one of the deepest I've ever known, one of the most affectionate. One time

when I went to his place, I got there and he had set up a little mattress beside his bed in his room, with children's bed sheets [*laughs*]. And we both had two cats on our beds, and... Felix sometimes worked very late—until four or five in the morning. I went to bed earlier.

HUO:

He worked...

DGF:

Yes, he would sit at his desk, reading. He always worked in his apartment, and this was also a point we agreed on: I had never been a studio artist either—we were both artists who worked in apartments. In the sense, as well, that we both based our work on our books, on what we read, what we ate, our photos. We both loved the 10x15 format, snapshots, and everything that had a domestic format. And when I went to his place, it was very clear that everything came out of the domestic environment, the home, and not at all from a professional environment. It came from cakes, things like that. And, when I saw that little mattress—of course there too, with the sheets and the cats, is something maternal—they were things... no one else had ever done that for me. It was the same thing with the letters he sent me: I remember once I was in love and I wrote to him, and the response he sent me... it was in a way... a love letter. No one... I've never known anyone who was so attentive, but attentive to a form of beauty as well, an ever-changing beauty. And that's why I can't stand to see the extent to which he has been made into a museum piece today, because I think his sense of beauty went in the opposite direction, towards ephemeral things and not towards things that were... finished.

HUO:

Had you never thought of co-signing exhibitions or doing works together?

DGF:

No, because I think somehow, as odd as it may seem—it was rather something like the closeness I shared with Japan—there were moments when certain things that he did [...] felt like I had done them. And vice versa, because he told me he completely saw himself in certain things that I had done. So that's even deeper than collaborating. Somehow I was him, and he [...] yes, we had all those things so much in common, we didn't need to be grafted onto each other. I've never felt that with other people.

HUO:

Then it was completely different from your collaborations with Pierre Huyghe or Philippe Parreno.

DGF:

Completely different, yes. Because in those cases, the collaboration was based on our differences; whereas with Felix, I don't think it was founded on our differences... It was more like...

HUO:

An osmosis perhaps.

DGF:

Yes, it's like discovering someone who has had a different history from your own, but is lead to the same... the same... I don't know. There were, of course, also differences, but I was always surprised by our closeness. And yet, there were differences: he was a man from Cuba with a totally different history, and I was a girl born in Strasbourg. And then there was the similarity of our names...

HUO:

And, it's true, there still is confusion between your surnames.

DGF:

Well yes, I'm still sometimes called Mrs. Gonzalez-Torres—that happens a lot. But I never feel sad about it. Which comes back to what I said about Felix and I feeling like cousins. I know that a part of my family, on the Gonzalez side, was a very long time ago in Cuba, and thus I have always had in the back of my mind the picture of us as cousins. It proved itself true, in a manner of speaking. There was an incredible proximity—and there was no need to bring out that proximity through collaboration.

HUO:

There was also the meeting in the hotel room ("Hôtel Carlton Palace, Chambre 763," Paris, 1993) where you did something for the bathroom and Felix did something for the bathroom—for the mirror.

DGF:

With the image... yes... and we coincided in that way, very close to each other.

HUO:

Astounding coincidence...

DGF:

But it always happened like that... and I'm sure that if Felix had been able to go on, if he'd got the medicine a little sooner, we would still be close in that way. And, actually, I really should mention that there are many things, especially in the metro station (*Bonne Nouvelle*, Paris, 2001) with its string of lights... There are parts of him inside me... the things that I continue to do. There are so many things that I've done in the last few years that are connected to him. I could be more specific about it, but it's very clear.

It has nothing to do with a form of homage to him; it happens naturally... It's as if it just spreads.

HUO:

It's a sort of mystical light.

DGF:

[*Laughs*] That's right, I have the impression I'm continuing something...

HUO:

You've participated on many projects with different artists, and this activity relates somewhat back to what Douglas Gordon called a "promiscuity of collaboration" in reference to certain artists in the '90s. Even if it was not a real collaboration with Felix—it was more than that—you've nevertheless collaborated with other artists, let's say in more classic fashion, and you've also been part of curating various exhibitions. And as I see it, what has begun to change in the last few years is that today it's less a question of collaboration between artists, than of collaboration extending to other practices. In this sense, you seem to me the perfect example of this development, in that you have worked with musicians, composers, architects, and have made use of literature. I'd like to know if you too feel there's been a shift, a change in this sense. And I'd like you to go back a bit and talk about your collaboration with Jay Jay Johanson in Dijon ("Cosmodrome," Le Consortium, Dijon, 2000).

DGF:

Yes, it's very clear... In any case, whether it be Philippe [Parreno] or myself... we work in dialogue. But, I've come to realize that dialogues where differences are greater often end up being more productive than dialogues with artists. In dialogues between artists, you always wind up with a similar language. As for myself, I am very curious about how other things function—whether it be in architecture or music... or literature. That's only the beginning: I just recently worked on a project with a future architect, Martial Galfione—a housing, building project—a proposition for mobile units for residencies for artists. There is an obvious continuity with "Quelle architecture pour Mars?" (Le Consortium, Dijon, 2001) even if it was also about a film at the same time. I'm not kidding around when I ask the question, "What architecture for Mars?"—it really obsesses me. I'd say we're really going to have to think about this question... [*Laughs*] It's no mere joke. And so that gives way to a really nice discussion because I bring images and ideas into the equation, whereas he proposes things. It's the same with the house we're building for this collector in Japan—a project I'm

working on with an architect, Camille Excoffon. And then there is also the film for Seoul that we did together with Ole Scheeren—an architect as well (*102*, 2000). So, there's that whole dimension at the moment, what with all these collaborations.

HUO:

With Philippe Rham as well?

DGF:

Yes. With Philippe Rham, things are going to start with a discussion, which will no doubt lead to other things. For now, this discussion—which takes place not only with any particular architect, but with architecture as a whole—is the discussion I had with the buildings when I went to see all those cities... and which has now shifted towards people. I looked at all those places, and now I have to convert that to people—so it can take on new dimensions. With Jay Jay... How should I put it? You know, it's not easy to talk about all that...

HUO:

I was wondering if all this wasn't connected to the remark you made—a remark that I found quite problematic—where you said that perhaps you no longer wanted to do exhibitions?

DGF:

Yes, that's also part of it. It's the possibility of a complete renewal of this idea of the exhibition through tackling other temporalities, other formats, other ways of working. And when you are, in that way, confronted with other ways of working—because architecture or music truly are different ways of working—you realize to what extent an exhibition can be fascinating in its laboratory dimension. That was also what your exhibition "Laboratorium" (co-curated with B. Vanderlinden, various venues throughout Antwerp, 1999) was all about, and the hypothesis that for people coming from other disciplines—for a biologist, an architect, a writer—the exhibition is, at a given moment, a very satisfying form because it's much quicker and far more stimulating. There are many architects who get excited right away at the idea of doing exhibitions, because they are caught up in the deadlines, in constraints that are utterly different. So, I think that the exhibition is perhaps the experimental form *par excellence*...

HUO:

{Laughs} So "exhibition" is synonymous with "Grenoble."

DGF:

[*Laughs*] But afterwards there's Mars... First comes Grenoble and

then comes Mars. Mars is an entirely different story though. At some point you have to be able to get out of the laboratory. Even if you worked on full-scale projects in the laboratory; even if, in itself, each innovative building remains a prototype, at a given moment you still have to go to Chandigarh, to Brasilia and see how it all functions—and that was when I went off to see all those cities. It was at a time when I couldn't imagine not moving on to the habitable dimension, the fordable dimension, to this potential space where I couldn't even imagine myself not being able to enlarge the experiences which had been done in the framework of the exhibition, and carry them into another space.

HUO:

Which brings us to your work in the Paris metro station Bonne Nouvelle.

DGF:

Yes, ultimately it was possible to apply the whole program, all these ideas which are not ideas about art as an object, or ideas of being object-based. Instead, ideas which are linked to ways of exploring the latent potential in each thing, a way of saying, "Here are some seats, yet if we put two of them together it will trigger something. Over there, there are some posters, yet it's possible to use them in a different way." It's not about some gesture of *tabula rasa* and renewal, but rather of reconsidering existing vocabulary and allowing things to voice different meaning. Then, suddenly, a light becomes a string of lights, a publicity billboard becomes a projection screen, letters start to dance. This has nothing to do with the idea of relocating art there... like some supplementary object, but rather it's far more about a method of transformation. This same method of exploration was used once again during the construction of the house in Japan—we actually started off from a well-known system of building in Japan. We didn't invent a new system, but we started off building the way all these small houses are built... What I quite liked about the metro station was what I also liked in this project, starting with a container, a silo... And yet it's not a readymade, it's a conjunction—because at the same time it's not a thing either; it's not the revelation of a thing that is made apparent, it's the conjunction of a vocabulary—a complex language in fact. And I think that this is what the '90s, compared with the '80s, has achieved. We've gotten beyond the stage—that I rather like in fact—of putting the fridges on top of television; we've gone beyond the object, and we've moved into a zone of articulation. And in my opinion, this is the way that film has served as a metaphor. If we have made such abundant use of the analogy with film, it's because here we

could take the example of a language that articulated the sound, the image… which was based on a conjunction of elements.

HUO:

Can we come back to the question of the exhibition, inasmuch as the exhibition has to do with this interior complexity? I spoke about it recently with Philippe Parreno, and he told me that for him—and, in his opinion, for you too—{Jean-François} Lyotard's exhibition, "Les Immatériaux" (Centre Pompidou, Paris, 1985) was decisive. In what way was this exhibition a key moment? And what were the other exhibitions that influenced you or particularly struck you in the '80s, and then in the '90s? Truly striking exhibitions are, after all, quite rare.

DGF:

Yes, exhibitions that make a mark are rare. "Les Immatériaux" was truly a memorable exhibition. Strangely enough, my most memorable experiences have been in environments, complete environments—for example, when I actually went to see Pierre Loti's house—rather than in exhibitions per se. I've rarely found in exhibitions the excitement I felt when I went into the Musée Gustave Moreau or into a full-fledged environment. And that's what I then tried to reproduce in exhibitions—in other words, not just reproducing the object detached from its context. This is also something you can explore in London, in the house of Sir John Soane ("Retrace Your Steps: Remember Tomorrow," Sir John Soane's Museum, London, 2000). I had seen the house before; it was on the list of environments that I find very stimulating because art doesn't appear detached from a context, but is, on the contrary, part of the whole. And I must admit that I do have trouble finding exhibitions where I can feel the notion of environment. Later, of course, there was the fascination with panoramas… but what I think was still really beautiful in "Les Immatériaux" was the exploration of all the dimensions of light and sound by means of infrared and text. The viewer's movement was taken fully into consideration. For all those reasons, it was actually a very important exhibition.

HUO:

In relation to this notion of environment, but also in your desire to explore new ways of exhibiting film or sound, could you go back a bit to the Dijon projects? You told me a few months ago that they might be your last exhibitions. And I think, at least from a rhetorical point of view, that all exhibitions might be the last exhibition…

DGF:

No, when I said that it wasn't just rhetoric. I no longer consider the two Dijon proposals to be exhibitions.

HUO:

Rather as trans-exhibitions... We'll have to come up with a neologism.

DGF:

[*Laughs*] I haven't found a name. On the one hand, there's a "cosmodrome," and on the other hand, there's a question: "What Architecture for Mars?" A title that is at once serious and nutty, deliberately both exploratory and informative. I thought this title could be exciting for all sorts of different people, for architects or for scientists. In this sense, it's not an exhibition... but I have yet to find the word that suits the project. But that took place after the exhibition. It functions in a global way, not through focusing attention—which is one of the specific qualities of the exhibition, in other words, of pointing out a certain number of elements. Because in that sense, many exhibitions are based on islands—they are the outcome—each work is a type of island. "Cities on the Move" goes beyond this cartography of works that assigns each work a sort of place. In Dijon, both with "Cosmodrome" and "Quelle architecture pour Mars?" I sought out an overall way of working—that didn't allow for the isolation of the parts. And I did so in spite of the fact that, in "Quelle architecture pour Mars?" it remains possible to enter into the film at a particular moment. But we remain in the framework of a language, of a complete space... with its slanting walls. It's impossible to dislocate or isolate one thing or another.

HUO:

In asking you that question, I also had in mind another exhibition—not "Les Immatériaux," because I couldn't see it—that I saw and that really made an impression on me: "Der Hang zum Gesamtkunstwerk" in Zurich ("In Search of Total Artwork," Kunsthaus Zurich, 1983). It was an idea that was at once extremely important and dangerous... And in Yokohama, they developed in the title itself an idea that was also a bit dangerous: the notion of a "new synthesis." And yet, I don't think it had to do with a new synthesis, but at the same time there is the desire to bring together a whole array of things.

DGF:

Yes, I think that's why I've always preferred the word "environment" over the word "installation." I find that as a metaphor for nature it's right on. And for me, there is a hardware-store side to installation, whereas with the notion of environment... there's a dimension that is romantic, natural. And in the idea of the total work of art, there's something that scares me... I find it's linked to

the idea of domination—something that's a bit disturbing. And on the other hand, I believe a lot in the fact that we are at once—and this was also present in Yokohama—inside as a viewer, and at the same time we are on the outside. This is a fundamental issue, because it's a position that must always be explored, whether it be when we are faced with ideas, or in a city, or facing somebody. It must be possible to see and to have autonomy towards this thing. In this sense, I am very resistant with regard to the art object, because as I see it, the relationship to an object or to a thing is all too obvious a relationship. I prefer to be in a relationship with something that is around me, but which I am, at the same time, myself around... around this thing... and I'd rather explore that kind of complex situation. There are many examples of enveloping works that allow for—at the same time and at certain moments— being outside of them. There is an entire history of works like that. And, in any case, architecture is just that: you go out, you go in, and so on. That is the particular quality I am after. And for me, the exhibition becomes fossilized when a series of objects are lit up like so many dots. Whereas it is freed when the idea of moving through the exhibition becomes a decisive factor: when different sensorial levels are called upon; when we don't remain stuck on the optic, scopic impulse; and where our actions are conditioned by what we hear. This synaesthesic dimension is fundamental. If we remain purely scopic—though it can remain very powerful, because, all the same, the eye is closest to the brain—we lose so many dimensions.

HUO:

And in the area of sound there is your work with Jay Jay... And there is also, of course, the question of smell...

DGF:

Smell... Actually, I haven't yet had many occasions to tackle that one, but it's very important because every place has its own smell and that is bound to intensify. What is very important in "Cosmodrome" is that no point of view is favored, you find yourself in that whole mass of sand. We worked on all the dimensions: on top, underneath, on the sides. Though it begins on a painting, a computer, afterwards all the different directions are possible. The question of viewpoint disappears. And for the sound—just think of that wonderful book by David Toop—who also did the exhibition at the Hayward Gallery in London ("Sonic Boom," 2000), but that had less to do with immersion—*Ocean of Sound* (1995), about immersion and ambient music... and his whole dialogue with Bri-

an Eno. It's the awareness of an unlimited environment that is not objectified and immediate—it's the highway for the art of the future. As for myself, I've been working for some time on a book on descriptions of art and architecture of the future in science fiction. And in fact, you realize that it really coincides: the art of the future is often described as an art of ambiance, a dematerialized art. One of the most recurrent things in science fiction is the sound and light organ: a type of machine that lets you produce environments. And I trust science fiction to have a feeling for that. The "Cosmodrome" was, in a way, a dematerialization. I've always had the idea that before the year 2000... I sincerely thought that we were going to get to the year 2000, and that a whole series of works— that perhaps I myself wouldn't understand – was going to emerge, works that would function at a completely different level. Perhaps they are on the verge of emerging. And I've always had this fantasy with regard to the art of the future. I hardly even want to talk about the notion of contemporary art anymore—the question of the art of the future interests me more.

HUO:

The transition is plain to see: what are your future projects, your unrealized projects... not necessarily from the point of view of Utopia—because, as Dan Graham put it, there is the danger of the unproducible—but rather from the point of view of a concrete Utopia?

DGF:

In the long term [*laughs*]... In the long term, I really want to work on [...] *Brasilia Hall*, the films: those things are merely the identification of zones of potential spaces that I really want to produce... In the very long term—and I have the impression that I'm preparing for this through the films that, more than the exhibitions, allow the spaces to be recorded, to make them visible. But in the very long term, the project is to go beyond the exhibition, or to have the exhibition set up permanently.

HUO:

Urban planning?

DGF:

Yes, urban planning, existence, and no longer just a laboratory. I want to go beyond the model stage. And on that note, I think it makes a pretty good conclusion.

GONZALEZ-TORRES, Felix

Felix Gonzalez-Torres was born in Guáimaro, Cuba, in 1957 and he died in Miami, Florida in 1996. After fleeing Cuba in 1971 for Spain and later Puerto Rico, Gonzalez-Torres moved to New York City in 1979, where lived until his death. From 1981 to 1983, he attended the Whitney Museum of American Art Independent Study Program and received his M.F.A. from the International Center for Photography and New York University (1987). Gonzalez-Torres joined the artist collective Group Material in 1987 and had his first solo gallery show at Andrea Rosen Gallery in 1990. Works by Gonzalez-Torres often employ everyday objects and materials: a string of light bulbs, an enormously enlarged photograph of an empty double bed, a mountain of foil-wrapped candies piled in a large corner, a full-length curtain blown by a breeze, or two identical black-rimmed Seth Thomas wall clocks placed adjacent to each other. His works also suggest a new relationship between art and the public as they require active participation from the viewer such as taking home pieces of candy or sheets of paper, for example. The extreme sensitivity and openness of his works has turned him into one of the key figures of the art of the '90s. His work has been presented in numerous group exhibitions and he has had one-person exhibitions at the New Museum of Contemporary Art, New York (1988); Brooklyn Museum, New York (1989); Andrea Rosen Gallery, New York (annually 1990–93, and 1995, 1997); Museum of Modern Art, New York (1992); Milwaukee Art Museum, Wisconsin, and Museum in Progress, Vienna (1993); Museum of Contemporary Art, Los Angeles (1994); Solomon R. Guggenheim Museum, New York (1995); Musée d'Art Moderne de la Ville de Paris (1996).

.......................

This interview took place in Vienna in March 1994.

Hans Ulrich Obrist:

Can you tell me about your Untitled (Passport #1) *of 1991, consisting of a stack of blank sheets which viewers are free to take away with them. How is this piece somehow emblematic of your work?*

Felix Gonzalez-Torres:

That "Passport piece No. 1," which is a white stack, 24-by-24-by-6-inches high with just white paper you can take—that the public can take—functions like most of my work. I need a viewer; I need a public for that work to exist. Without a viewer, without a public, this work has no meaning; it's just another fucking boring sculpture sitting on the floor, and that is not what this work is all about. This work is about an interaction with the public, or a large collaboration. That "Passport piece" is really about the way we are defined in our

culture, the way our self is constructed through many different chan-
nels. One of these channels is that little thing called a "passport,"
which identifies us as coming from some type of gender, coming
from some kind of country, and also being born somewhere at a cer-
tain date. To top it all, it has numbers. That's what we are. That
number is unique; no one else in America has that number except
me. And that again is another definition of who we are, in a very
abstract way. One of the things that bucks the hell in the last few
years is this whole talk about "body art," which is almost like the
criminal system. These people, in order to think about a body, to talk
about a body, need to see a body, right? As if you are going to a
gallery, you see five bodies hanging everywhere, people say, "Oh, it's
about the body." I say, "Well, no shit. But it's not really about the
body, it's about wax, or it's about plaster," because the body at this
time in our history, at this time in culture, is defined not just by the
flesh but also by the law, by legislations, and by language first of all.
Therefore, when we feel pain in the body, when we feel decay in the
body, when we feel pleasure in the body, all those issues are very
much related to the law or to the symbolic order—in that case to the
phallocentric order. Of course, there is our rejection or our acceptance
of that order; sometimes we accept certain parts and sometimes we
reject certain parts of that. But that functions only vis-à-vis the def-
inition that is based on language. So I think that when you see a pass-
port, what you are really seeing there is a body, because it is about a
definition of a body: a body that can travel from one place to anoth-
er. And it's only based on the fact that there is a passport that defines
us, that sometimes can be helpful or could be detrimental.

HUO:

*The articulation between private matters and public issues really constitute
the thread of your work. I'm thinking here also, for instance, of your project
for MoMA ("Projects 34: Felix Gonzalez-Torres," 1992) which consisted
first of photographic billboards of an unmade bed displayed in 24 sites
around New York City (Untitled, 1991), but also of the installation of
an unmade bed inside the museum.*

FGT:

Well, I mean, the billboards for MoMA came from a very specific per-
sonal impulse. I needed to see my bed; I needed distance first of all.
Let me put it this way for you: I needed distance from my bed, and
that bed became a site that was not only the place I sleep in, it was
also the place of pain at night. That is the personal impulse. And then

there are also the formal issues as well as other issues that just influence the way we work, right? I was asked by MoMA to do this show, and I am someone who tries to be honest with... I mean with the way I feel; at least I try. So, when I went to MoMA, when I went to see the room—it is such a beautiful room—I said, "Why fuck it up with art? This place does not need any art, it is a very beautiful space, let's do something outside." And besides that, they have so much art in there already! So I said, "Why don't we do something that includes all the possibilities and that is not just this very prescribed notion of having a project in which you just show your wares like in a showroom?" So, the initial idea was not to even show anything inside the museum, not to have any billboards inside, just to have the booklets that told people where to go to see the things in the streets. But of course, they had some problems with that at the museum; it is almost like, you know, they need to see the monetary worth. So, I put one piece there, which I am happy I did now, and then I showed, like you said, 24 billboards of the same image at 24 places in the city.

HUO:

What was particular about this unmade bed that one could find inside the museum?

FGT:

It was an unmade bed in which two people slept, or had left their impression on the bed, on the pillows. At this point, we have to question if there is anything, if there really exists any division between public and private. Recent developments in America—and I can only talk about America, because that's where I live, that's where I am—have proven that there is not such a thing like a private space or a public space, especially for certain segments of the population who love people from the same gender, from the same sex. I am referring, you know, to the year 1986, the case of Bowers v. Hardwick, in which the Supreme Court voted that gay men and lesbians have no right for privacy. They voted that the state could actually go into their bedrooms and legislate and penalize the way they express love to each other. You know the words, "Some people are more equal than others..."—but that's another story. I think at this point in history, what we are really talking about is private property (and perhaps not even that) and not about private space, because our most intimate desires, fantasies, and stories are intersected by sectors legislated and controlled by the law. And again, when we are talking about public spaces, I always wonder how public it is when Philip Morris and Marlboro can actually pay for these public spaces. When I started making these stacks in 1981 it was

because—it may sound funny—at that time in New York everybody was fighting for wall space. I mean, the walls were all already taken. When you were going to be in a group show, you had to get into a fistfight to get two inches on the wall, right? So I said, "Fuck the walls. I'll just do something on the floor." No one was doing sculptures. Now everyone is doing "give-away-stuff." But I mean, that is just one point; the other thing is that I have always been very interested in the writings of Walter Benjamin, especially at the time I was just coming out of the Whitney Museum Independent Study Program. That's where I read Benjamin for the first time. So at some point between 1981 and 1983, I was very influenced by his writing and the relevance of that writing in our time and culture, so I wanted to make a work that took some of those ideas into consideration. What's important is that the work does not really exist; works are destroyed because there is never an original.

HUO:

Another way of putting this is to say that it's unlimited.

FGT:

It's an unlimited issue, you know.

HUO:

The idea that the real problem is not the beginning or the end of a thing, but has to do more with its "in-between" qualities of existence, is reinforced by this issue of the unlimited-ness, I think. It's unsettling because the work itself, in its production and "de-production" modes, is completely unstable.

FGT:

The work is always extremely unstable. But that is one thing that I enjoy very much. I enjoy that danger, that instability, that in-between-ness. If you want to relate it to a personal level, I think in that case that the work is pretty close to that real life situation that I am confronted with daily as a gay man: a way of being in which I am forced by culture and by language to always live a life of "in-between." So the work was an attempt—especially at that time, in 1987–89, when we were still at the height of the '80s boom... you might want to call it "art market," right?—to deal with the fact that having this stack on the floor that was not an original—you could never have an original—that you could show this piece in three places at the same time and that it would still be the same piece. And it was almost like a threat—not only a threat but a reinterpretation of that art market and the marketing of an original piece, which it really never is, as I said before. And at the same time, the work is almost like a metaphor because you cannot destroy some-

thing that does not exist. The same applies to the billboard; it just disappeared but will come out again in a different cover, in a different cultural, historical context.

HUO:

It was a similar process in Venice ("Aperto," 45th Venice Biennale, 1993): the stack was very small, so very quickly it was not visible anymore, but it could reappear in any other place. You said that it was also a metaphor for human relationships.

FGT:

Yes, well, I mean it was not just dealing with the ideas of Walter Benjamin and *The Work of Art in the Age of Mechanical Reproduction* (1935) and trying to destroy the aura of the artwork, but also, on a more personal level, it was about learning to let go. When I first made a show with Andrea Rosen—which was only stacks—I mean, the show could have disappeared if you'd have had a lot of people coming to the show, because everything was free for the people to take. Just to quote Sigmund Freud: "We rehearse our worst fears in order to lessen them," right? So, at that time, I was losing Ross, and I wanted to lose everything in order to rehearse that fear and just confront that fear and perhaps learn something from it. So I even wanted to lose the work, this stuff that is very important in my life. I also wanted to learn to let go. The first piece I made, those slides, have to do with America. They have to do with freedom in America, with the desire for freedom in America... and again, it is very important to mention that those pieces are very democratic too, because whoever has them, whoever installs them, decides the installation of the piece: how the piece is going to look, how it's going to be installed. They are all exactly the same, but at the same time they are different in the sense that they are always installed differently. Therefore, they all have different titles. And it's not so important how I install them for the first time. Sometimes I don't even install them for the first time. After that, whoever gets them—a collector, or a museum, or an art handler, or an art installer at a gallery—will decide how this piece is installed. I have no say; once I lose my domains the piece is on its own and it gets installed, you know, any way the person wants it. It can be on, up, whatever...

HUO:

So it is very different from most Conceptual or Minimal art where there are these certificates that are used as control tools.

FGT:

Yes, I don't have that phobia of the two inches... You know: "If a

work is two inches to the left, you have to destroy the work!" No, that's just that big thing from the '60s, that they were, like, constipated. I always say, "Honey, take a bow and relax, no big deal, two inches, three inches..." But it is funny because, you know, when I send this stuff to museums, art handlers and historians have a hard time deciding what to do with these things. They keep faxing us back saying, "What do we do with this thing?" and we keep faxing them back saying, "Whatever you want!" and they just don't believe it. They say, "This cannot be true!"

HUO:

They would rather refuse the liberty that you offer to them?

FGT:

Right, they want the traditional conceptual instruction saying, "Five inches to the left, six inches to the right and then 22 feet down," and I say, "No, you do whatever you want. You are responsible for the piece. You are responsible for the construction of the piece." In the same way, I tell the viewer, "You are responsible for the final meaning of this piece of paper that is part of this stack." And that's problematic on many levels, because what is the piece? Is the piece the simple sheet of paper or is the piece the stack? Well, it could be both, and I never define which one is which. I like that "in-betweenness" that makes the work difficult to define, hopefully.

HUO:

What about the Untitled (A Portrait) *of 1991, your video piece without images, but only subtitles giving information on images, which viewers can only invent? Why did you call those "portraits"?*

FGT:

I asked people if they wanted to do a portrait of someone. I asked them to give me a list of personal events and public events that have affected their lives, and then I just read them, and I added new ones or went back and asked them for more information. The whole thing is based on the idea of a photograph. In our culture, we read photographs in two ways: what is denoted and what is connoted. What is denoted is that kind of thing that we have very little to argue about, for example: if it is a black-and-white photograph, if it is a photo of a man or a woman, if this man or woman has long hair, short hair, blond hair, brown hair, black hair, curly hair, big eyes, small eyes, whatever; that is the stuff that is denoted, right? The person is wearing a shirt or is wearing a coat or is wearing nothing; that's denoted, right? But what is connoted is the other way of reading the pho-

tographs, which for me is the most interesting, because it has to do with the text that we have in our heads: "This person with the long hair—is that a '60s hair cut or is that a Vidal Sassoon '70s hair cut? Or is the coat just a simple T-shirt or is it a Dolce & Gabbana T-shirt or is it a Pierre Cardin T-shirt? Is that building in the background an Adolf Loos or is it a Corbusier?" That is what is connoted! In order for us to read a photograph, we have to have a language transaction. The only way we can read a photograph is through language. So, I decided to go the other way, to get rid of the image and just use the language. In order to read a photograph, this person who was getting the portrait made gives me a date, let's say for example, "Silverhouse 1964." And none of us had a fucking idea what "Silverhouse" is, but the person does have a very specific idea, you know, as a subject, of what "Silverhouse" meant in his or her life. It is the same when we look at a photograph. The photograph, really, as Barthes said, does not have an index. It just isn't telling us much: "It is just a photograph of a woman." But where was this woman? Was she in Vienna, Berlin, Cuba, Havana? I mean, where was this woman? Where was this photograph taken? There is very little that these photographs can tell us. In a way, the *Portrait of Austrian Airlines* (Museum in Progress production, Vienna, 1993) was related to the same work I have been doing for the last five years on portraits. These portraits are painted directly on the wall in a room, way up high, like a frieze, like a Greek frieze, all around the room.

HUO:

Again, it triggers travels, at least imaginary ones.

FGT:

With the portrait of Austrian Airlines, I wanted to give the people something very beautiful, and something enabling them to travel in their minds to all these places, and what it's like when they see "Amman," when they see "Minsk," when they see "Moscow," when they see "London," when they see the word "New York." Some of them either had been there or had seen pictures of these places, or maybe want to go to these places, or maybe they don't want to go there at all. But at least these places are there and hopefully when they read these texts something will be triggered in their minds about these places. For me the ideal thing is when something takes place, when there is some action, when there is some movement, when there is some travel in the minds, when the work becomes some kind of catalytic element for something to happen, for something to become possible. Think of the light string at Jennifer Flay that allowed the viewer to go to the dancing, and the public started

to dance, which was a completely new perspective for me because, as you know, I had two couples who were supposed to come and do it, and then suddenly the viewer, the public started doing it.

HUO:

And what's really beautiful is that it kept on going, it exceeded the time-lapse of any performance.

FGT:

Yes, it kept on going! That was a very nice surprise for me. But again, the viewer is something that I love, is something that I need for the work to exist, to happen, for the final meaning of the work. Because otherwise, like I said before, this is another boring Minimal piece of shit sitting on the floor, and that is not what my work is all about. That is a problem when I apply for grants, because they get these slides of these things sitting on the floor, and especially when there are sculptors as part of the panel, they look at this stuff and say, "Oh," you know, "Sculptures!" But this is not what it is really about. This is almost like an excuse to really find my role as an artist, because I see myself almost like a theater director directing a very spontaneous performance. Even with a stack, when the viewer takes the paper from the stack or takes the booklet from the stack, or when the viewer takes the candy and eats it and shits, you know, the candy piece at the end, because that is the final piece when the candy or the sweet gets eaten and then is spilt as shit from the body, that is also, you know, again an ultimate collaboration, because I am actually giving energy to this body to function.

HUO:

And this also echoes what you told me the other day—that you saw yourself as a kind of infiltrator, as a kind of spy.

FGT:

I want to be a spy means I want to be the one that looks like something else in order to infiltrate, in order to function as a virus. I mean, the virus is our worst enemy, but should also be our model in terms of not being the opposition anymore, not being very easily defined, so that then we can attach ourselves to institutions which are always going to be there. And, as [Louis] Althusser said, these institutions or these ideological institutions are always replicating themselves. If we are attached to them as a virus, we will replicate together with these institutions. As we know, these ideological apparatuses are never going away. They are always going to be there, and when we think we have pinned them down, they replicate themselves somewhere else. I think that's a fascinating aspect of being an infil-

trator or working as a virus—being attached to these institutions.

HUO:

So, going back to the beginning of this interview, to the MoMA project with the billboards in the city and the unmade bed displayed in the museum: that's why it is important to operate a constant transgression of the borders between the "inside" and the "outside," the "public" and the "private."

FGT:

Right, absolutely. And there is also the content of that work. I mean, it's not just about two empty beds. It's about the way some people read it in the streets. It was about emptiness, it was about homelessness, it was about, you know, love, man and woman, man and man, woman and woman, whatever; it was about an announcement for a movie that was about to come; it was about an advertisement for a White Sale at Bloomingdale's. It could be about anything. And that is exactly the way I want it to function, because some other readings could always be right. But the reading that I wanted to give to the work is very subtle. It is not about confrontation, it is about being accepted. And then, once you accept these things in your life, then I say to you: "But I just want you to know that this is about this," and then it is already too late, it is already inside the room.

GORDON, Douglas

Douglas Gordon was born in 1966 in Glasgow, where he continues to live and work. After studying at the Glasgow School of Art from 1984 to 1988, Gordon attended the graduate program at the Slade School of Art in London from 1988 to 1990. In 1991, Gordon started sending unsolicited, but not anonymous, one or two-line texts in the form of letters or phone calls to members of the art world, such as: "I am aware of who you are and what you do"; "Nothing can be hidden forever"; and "I have discovered the truth," which functioned by insinuation and incrimination, their ultimate meaning depending upon how they were received. In his video-work, Gordon treats film as a readymade; he abstracts the cinematic apparatus, often slowing down, dissecting, and projecting both archival and commercial films onto free-standing screens. In one of his best known works, 24 Hour Psycho *(1993), Gordon slowed down the projection of Alfred Hitchcock's classic film,* Psycho, *so that the film takes a full day and night to run its course. As Gordon once explained, "It is as if the slow motion revealed the unconscious of the film." Gordon was awarded the Turner Prize in 1996, the Premio 2000 at the Venice Biennale in 1997, and the Hugo Boss Prize in 1998. He has exhibited his installations, text pieces, and video projections widely in both solo exhibitions and group shows around the world. Gordon brought together his work from the past ten years in the exhibition "What have I done?" (Hayward Gallery, London, 2002).*

........................

This interview took place in Vienna in August 1996.

Hans Ulrich Obrist:

Douglas, from the very beginning, in your work there is this back and forth between things that you make within the studio and within confined spaces, and the other things like your letters that you make or send "out there."

Douglas Gordon:

Around 1990-91, I was living in a very small flat in Glasgow and—I don't think it was so much an ethical position like artists from the '60s—it was a much more pragmatic decision for an artist living in Glasgow, with no money and no space, no studio. There wasn't an idea of a rejection of institutions. It was just an idea that institutions and the gallery system don't exist in Scotland in the way that they do elsewhere in Europe. So I just wanted to get ideas out. And one of the ways to get ideas out was to use the postal system and the telephone. In a way, if you made letters and made telephone calls you almost weren't as far away from people as it might seem geographically.

HUO:

In some way isn't the large-scale 10 by 54 meter painting on the façade of the Kunsthalle Vienna, which is almost like a gigantic street-painting graffiti with just three words, "Raise the Dead" (Raise the Dead, 1996) *another example of your "public art"?*

DG:

Some ideas are specifically good in a more public situation. And, you know, you are a human being and you have lots of ideas, so let's have some of the ideas in museums that should be in museums, because they would be stupid on the street, and let's have some ideas on the street that would be stupid in the museum. It was really as simple as that.

HUO:

I tend to think that the most interesting art in the '90s is art that has this mobile fluid strategy like your "Migrateur Project" (ARC/Musée d'Art Moderne de la Ville de Paris, 1993) where you had the same sentence appearing in different forms: as graffiti on the toilets, as a virus in the telephone system, and then as a museum presentation.

DG:

You can take a red balloon and let it float around the street where it may mean one thing; you have a red balloon in a house, it means another thing. You know, for instance, this text that we used at the "Migrateur," which was really based around, I suppose, the principle of transience between a possible meeting between one or two or more people. If you sit on a toilet and you read, "From the moment you read these words until you meet someone with blue eyes," it's very different from reading it when it's hanging next to Sonia and Robert Delaunay. And it is also very different from if you hear it on the telephone. You could take something which was apparently absolutely finite because it's words, it's language appeared to be concrete—but by just letting it go into a different field, each time it could mean more things to more people.

HUO:

Returning to your large-scale Viennese painting, it is also an exhibition for the traffic jam: every day you have hundreds of thousands of car drivers passing by and maybe catching a glimpse of this work. The pars pro toto *{part for the whole} seems something that is constantly at the core of your work. For instance, your* List of Names *(1990–ongoing) is a kind of encyclopedic drive, which of course always remains incomplete. And it's the same thing for your cinematic work, for viewers seeing* 24 Hours Psycho *(1993) or* 5 Year Drive-By *(1995); it's always a* pars pro toto. *The*

viewer can never grasp the whole, and has to think about what it means to have a 24-hour or five year film and only see a fragment of it.

DG:

You know, to me I think it has never been important that people see everything all of the time. I think the idea that there is a missing part means that the meaning can't be absolutely clinically defined, and I suppose, you know, maybe this is something that I enjoy. If you can make a statement that has got a missing part, it makes people come back and look at the statement again and again.

HUO:

It's exactly what happened with your sentence in Vienna: you decided it would be more interesting to erase half of it. It should have been, "Cinema is dead. Raise the dead."

DG:

For the large-scale painting project, when we spoke originally, we were talking about this idea of two separate sentences existing on the one large-scale painting that would say, "Cinema is dead"—which is almost a common phrase nowadays, like "Painting is dead." And I liked this idea that if painting is dead or if cinema is dead then, well, let's "raise the dead"; let's bring it back to life, because the idea of raising the dead is absolutely taboo in every culture on every level. When they're dead you're supposed to acknowledge the dead and let them be, and by raising the dead you bring in lots of other ideas of zombiism and ghosts and specters and doppelgangers—and that to me was very interesting when I started to think about it more. It was fundamentally the idea of raising the dead; not just to link the cinema, but just... where that phrase could sit in culture, and not even in culture but on the street in Vienna. I was interested in what other people had done with the large-scale painting—Gerhard Richter, Ed Ruscha, and Walter Obholzer; they had almost taken art into the street. But I didn't want to do that again. I liked the idea of taking the street onto the street but in a kind of super-realist way. And also it's a street from one city taken to a street in another city. The photograph is made in Glasgow, but it's on show in Vienna; the language is English in a German-speaking city; you are seeing the super-realist image in black-and-white but it is in color. The phrase itself, "Raise the dead," is a perfectly simple phrase, but is a completely anti-social, pagan, anti-twentieth-century idea. It goes against the rationale which modern cities have been built on.

HUO:

Your work is frequently associated with a kind of neo-gothic movement; is there a link with "Raise the dead"?

DG:

This whole idea of the gothic has been talked about a lot recently with the exhibition in Rome ("British Waves, Tendenze nelle arti visive e nello spettacolo in Gran Bretagna," Galleria Bonomo, Rome 1996). I made images of myself as a monster, only using Sellotape, and it's a completely hideous image (*Monster*, 1996). There is this association with Alighiero Boetti and his belief in systems of knowledge other than the one that a human rationale would tend towards. Lord Byron's real name is George Gordon, so probably there is a family connection somewhere along the line and of course all those weird things that Byron and Shelley were up to, trying to raise the dead and raise spirits and things. Yeah, I'm interested in all this.

HUO:

And what about the erased part of the sentence: "Cinema is dead"?

DG:

It is not a big deal to say that cinema is dead. But if it is dead, then what are we going to do with it? Let it stay dead or try and see that it's not nostalgic? If you have a ghost, the ghost is a problem because the ghost can't relate to what's happening in daily life. I like that idea—that just by raising the dead you cause a rupture, and in this case maybe it's a rupture in the city. And also, I think that in a city like Vienna that could be a strange thing to walk home to at night with this idea in your head about ghosts and spirits. Are these things dead in the first place? You know it is a finite statement, but I think that there are infinite ways of reading it. A lot of questions arise because of the simplicity of the text: Why raise the dead? What will happen when you raise the dead? And who is dead? I always liked the idea that words, that are supposed to be concrete, when spoken by a different person at a different time can have a completely different meaning. This always reminds me of an amazing thing: when you are reading something on a page, you have a voice in your head that is reading and telling you the words. Where does this voice come from? Whose voice is it? I think this is still one of the critical things that you can do with text that you can't do with another medium—to have this invisible voice. Maybe you have a person driving home seeing this text: "Raise the dead". It means nothing, but it means possibly everything. What do they do? Do they go home and forget about it or do they go home and say to their girlfriend or boyfriend or son or daughter, "Did you see this thing? What can it mean?" Because for me, art in any circumstances, whether it's in a museum, or outside the museum is for people to go home or to a bar and talk about it. And if they

end up talking about something else altogether that's O.K., because then the art has acted as a trigger to a social dynamic.

HUO:

Yes, triggering talk or gossip or rumor or discussion or discourse or whatever it can be —small or big stories. This was also common to many performances from the '60s: lots of different events that only five persons witnessed have been made famous through the testimonies of these persons. Art history in this sense functions like oral history; it functions almost like a chain letter.

DG:

I think the idea or the mechanism of mythology is one of the most important social mechanisms. To understand that mechanism, I think, is absolutely critical. It's like you say, all these things that happened in the '60s, like some Joseph Beuys performances. As an artist from a different generation, one has a relation to it only through second, third, fourth-hand oral history. I think that this is just an incredible social mechanism, where people who have no experience of the object, of the action, can have a dialogue about something that maybe did not even exist in the first place. And I think this is a beautiful, fundamental aspect of human relationships. And that human beings sitting in a room or in a bar somewhere are willing to make a kind of leap of faith towards an object which may never have existed, towards an action which may never have happened, and have a discussion about it, and I mean really about it and around it. I think that my whole family background was always about storytelling. People will sit and tell stories all the time, and actually I think probably the first few times that you came to Glasgow there was very little discussion about the art object or the art action, but there was a lot of talks around these issues of storytelling, less with fairy tales, much more with urban mythologies. If somebody tells you a story, take an image away.

HUO:

Another important aspect is the translation from color to black-and-white. Felix Gonzalez-Torres always told me that he thought the most abrasive thing is to put black-and-white in a place where you usually have a color advertisement.

DG:

What we are seeing is really only a photograph of a piece of graffiti which has been made in Glasgow and which has been taken to Vienna and re-scaled. The decision to make it in black-and-white and on such a scale—it's like the scale of a super-large drive-in movie. And the black-and-white reference is obvious, I mean, people can relate that to film. There is this idea that black and white, in a way, can

have more impact than these super-real color strategies. If the real world is living in real time and in real color, all of a sudden by slicing through, by taking a different time to look at something, but in the real world—that dislocation is interesting to me. You have a whole city basically revolving around the Kunsthalle. I liked the fact that right at the center of the city you could have something that was, like, slicing through reality; it was a representation of reality, but at once remove from it simply by making it in black-and-white. It's a translation. I think it's not a formal translation between color and black-and-white, but a translation of time.

HUO:

Somebody once described your work as "assisted readymade." I would rather talk about "time readymades." Duchamp had foreseen this but it was little explored, and it needed a generation of artists to come to this kind of time readymade. Duchamp had this second type of readymade, that was only instructions. For instance, he wrote, "Buy a dictionary and cross out all the words you dislike." I think that the way you use film material, filmic archive materials, distorting or re-slicing and re-contextualizing them—like in the case of John Ford's The Searchers *(1956) that you extend to five years—push forward this notion of the time readymade.*

DG:

When I was about 15 or 16 years old, making drawings of stuffed animals and rotting vegetables, like every schoolchild does, I remember one of my teachers, coming up with two books and saying, "I don't really like these guys very much, but I think they are probably quite important for you to look at." For me, one of the most important things when I was reading Duchamp was this chess game with the naked woman [Eve Babitz] in the Pasadena Art Museum ("By or of Marcel Duchamp or Rose Sélavy," Pasadena Art Museum, 1963). To take social activity as a readymade, bring it into the museum, and almost kill people with time because of how long this was going to take. I don't play chess, but I love the idea of it, the strategy over a long period of time and the fact that if you are a spectator at a chess match, you have this incredible feeling that real life has somehow stopped, because everyone in the arena is completely absorbed in this battle, which is so slow.

HUO:

I recently spoke with Walter Hopps who organized this exhibition in Pasadena, which was the first retrospective of Duchamp in a museum ever, and Walter Hopps told me what he learned from Duchamp was that an art object should never stand in the way.

DG:

This is really my principle that art is really an excuse to have a dialogue. As I don't collect art, I make art. And as a maker of it, it's the ideas that are important. I know I don't really care about the objects. So, for me, I make art so that I can go to the bar and talk about it.

HUO:

This principle is not only leading your work but the exhibitions and the displays of your work also—the way you arrange the different screens spatially?

DG:

In a way I'm trying to set things up where people may remember doing something as a child with the experience of television or pop music or film for the first time. And you know when you are in a cinema for the first time, immediately as a child you put your hand up and you try to interrupt the projection just to see what happens, and then you can decide whether to continue to annoy everyone or stop. And I think we still carry these things around with us, and I think we can re-animate the museum in a way, but not by setting it up for people really to play with. I mean to try and use the readymade really just as a small piece in a large game—and the game has absolutely no rules for people. They can come back and play it again in a different way.

HUO:

This time readymade notion brings us to John Latham's time-based work. What are the main differences?

DG:

I really think that the difference between our generation and other generations is that it's not even a flow of images that we have to deal with, or a flow of information—it's a deluge. And I think probably the way this interview is going is absolutely indicative—there are so many other things happening.

HUO:

Marcel Broodthaers used to say, "Every truth is always surrounded by many other truths which are worth being explored."

DG:

Since we came into this flat where we are having a conversation with each other, and while we are talking in real time we are remembering what happened five minutes ago, we are anticipating the next question, we can hear the roadwork outside, there is a TV here, there is the telephone ringing, there is music playing—but we can handle this as human beings. But this is very late twentieth century. I think this is absolutely not the way that someone like Broodthaers could live, or someone like Duchamp could live.

HUO:

In the Art of Memory *(1966), Frances Yates explains that our mind always works in a cinematographic way somehow.*

DG:

I think you mentioned the idea of oral history. Oral history is translated and remembered as it can be remembered as a series of images like in Yates' "theater of memory" where you open one door and one person walks out and they tell you something, which is a memory. For our generation the flood of images and flood of information is just incredible. Most people use the Internet while watching TV, listening to music, speaking and drinking, all at the same time. And they're maybe also on the telephone. It's almost like taking the idea that was in Manifesta 1 (Rotterdam, 1996) from Uri Tzaig, where he has this game of football happening, where you play one game of football with two balls (*The Universal Square*, 1996), but it's almost like you have to take it even further. It really is like an insanity, that you have a stadium with football with two balls and tennis balls and some horses running around, etc.... I think it is a kind of schizophrenic cohabitation of one body. That schizophrenia isn't always necessarily to be seen as one body battling to reach between all the different personalities, but it's the battle between the personalities to inhabit one body. And I think that the way that life is heading, in 1996 towards 2000, is an absolutely schizophrenic experience. We see it everywhere. Vienna is a particularly schizophrenic city.

HUO:

The process you're describing is also an undoing of hierarchy—which opens multiple passages and translations.

DG:

I really like the idea of taking flaneurism into the twenty-first century, where we are not only walking around the city, we are really not scanning things but we are trawling. If you have a trawler and you throw a net wide enough, what you bring in is not just what you want to get. Sometimes you get these dangerous fish, ugly things. But you bring it all in and look at it. And see, yeah, you get trash. Which takes us to Andy Warhol: the whole idea of trawling for trash in the way that he was trawling for images. I think that we are even in a better position to trawl because we don't have to make a distinction in terms of a hierarchy. To me the John Ford movie is equal to this pornographic film that I found in San Francisco, which is equal to the scientific documentation of madness, which is equal to the films of the flies. This is the one thing that we can do with the readymade—to reduce everything or to elevate everything to the

same status. I still think this is one of the great things that art can do, because we don't have to work with the established system. It is the job of the first artist to collapse the system, and then out of that collapse allow people to pick up and identify whatever it is they find interesting. They don't know it is art, it just looks interesting.

HUO:

You frequently make casual collaborations with friends.

DG:

I've made collaborations with Craig Richardson, Roddy Buchanan; I've been working on things with Jackie Donachie, Graham Gussin, Simon Patterson, Rirkrit Tiravanija, Liam Gillick, probably more to come. It's a social thing again. Two people can come together at one point in their lives and do something together which is appropriate. We don't have to get married and live together forever, but we can have a nice affair and, you know, move on and do it again with someone else. And I think probably for our generation, the "AIDS generation," maybe this is one of the few places left that you can be promiscuous.

HUO:

Scientists see the '90s as the "decade of the brain."

DG:

I mean, if the respected scientists say that the '90s is the decade of the brain, this is fantastic, because no one knows how the brain works. So then the '90s becomes the decade of no one knowing how anything is working anymore. We are both saying that neither of us can remember the '80s. I actually doubt if we will remember the '90s either. And maybe this is one of the long-term effects of this flood of information. And maybe our generation's easy access to information and lack of interest in making a hierarchy out of all the information—maybe that's something the next generation will have to do. I think at the moment we're trawlers, and the next generation may be going fishing for something specific.

HUO:

What about the "object" amidst all of this information deluge?

DG:

As someone who appropriates other images, I know that a lot of this material I made temporarily concrete is then on to somewhere like the Internet, or is in magazines and other people are using it already.

HUO:

"Art for all," as Gilbert & George always say.

DG:

At the moment I don't see a lot of people that we work with mak-

ing huge impossible paintings or impossibly heavy sculptures. People are more trading in ideas.

HUO:

This also lead us more and more away from this confining and limiting notion of ownership. Buckminster Fuller is the big pioneer of this move; Fuller always said, "Housing is a service. Why do we have to own a car? Why do we have to own all these things?" Maybe it is the same thing about art.

DG:

You know, I never thought of anyone owning art, even if I went to visit a collector and they had some beautiful work. I remember waking up in someone's house with a terrible hangover, and the first thing I saw was this fantastic Marcel Broodthaers—the cows with the names of the cars. And that was my experience. It doesn't matter who owned it; it was my experience and I took it away, not physically but psychologically. And for me, you know, the idea of an owner of an idea is an impossibility.

HUO:

Five years ago you said, "We are '90s people, not '60s people. I do really believe that the best artists working at present all over the world are trying to find new territories." How would you see these new territories now?

DG:

I think whatever the new territories were five years ago are completely different already. It's constantly shifting, physically and politically. From 1991 to 1996, in terms of Eastern Europe, there is complete border-shifting all over the place. Sometimes change is being made obviously not for the better, but the fact is they are new territories. I think maybe the identification of the territory is something personal for the artist, but something maybe professional for a curator to identify so I don't want to be the one who identifies the territory. I'm still in the woods. I can't get out of the woods to see where I am. I'm still moving so I don't know which territory I'm in yet. I didn't know where I was five years ago: I don't know where I am now.

HUO:

"In the middle of everything, but in the center of nothing."

DG:

Yeah, those old wall drawings of, "I've forgotten everything, I remember nothing, I cannot remember anything." You know, the more you say this, the more definite the state of amnesia becomes. And that, I think, is a beautiful paradox in itself—a concrete state of amnesia. It's a contradiction, but it's a nice one.

GRAHAM, Dan

Dan Graham was born in 1942 in Urbana, Illinois. He currently lives and works in New York City. Graham did not receive any formal art training; he was a founder of the John Daniels Gallery in New York (1964–1965) before embarking on an artistic career in 1965. Since then, he has produced an important body of art and theory that engages in a highly analytical discourse on the historical, social and ideological functions of contemporary cultural systems. Public architecture, music, suburbia, video, and television are among the focuses of his investigations, which are articulated in essays, performances, installations, videotapes, and architectural/sculptural projects. Graham began using film and video in the '70s, creating installation and performance works that actively engage the viewer in a perceptual and psychological inquiry into public and private, audience and performer, objectivity and subjectivity. Restructuring space, time, and spectatorship in an examination of the phenomenology of viewing, his early installations often incorporate closed-circuit video systems within architectural spaces, manipulating and displacing the viewer's perception through such devices as time delay, surveillance, and mirrors. Seminal early magazine essays like Homes for America *(1966–1967) use the magazine as a disposable medium rather than placing art in a gallery. The later pavilion works, with their use of glass and two-way mirrors, use the audience as part of the spectacle, as viewers experience different situations constantly, depending on the light situation and on who else is viewing the work. Graham has had many retrospective exhibitions in institutions including the Stedelijk Van Abbemuseum, Eindhoven; Museum of Modern Art, Oxford, England; The Renaissance Society, University of Chicago; Kunsthalle Berne; Le Consortium, Dijon; Museu de Arte Contemporanea de Serralves, Porto; Musée d'Art Moderne de la Ville de Paris, Paris; The Kröller Müller Museum, Otterlo; Kiasma Museum of Contemporary Art, Helsinki; Kunsthalle Düsseldorf, Düsseldorf; and Kunst-Werke, Berlin.*

........................

This interview was recorded in New York in 2001.

Hans Ulrich Obrist:

Maybe we could start by talking about gardens and your first works and pavilions in relation to gardens. When did this interest in gardens start?

Dan Graham:

I think I got interested in gardens because of the regionalization of art in France in the '80s. There were many chateaux, in different regional areas, and the chateau was set on an overlay of gardens. Or maybe it actually began in Münster ("Skulptur Projekte Münster," 1997), when I did the piece with Klaus Bussmann, *Octagon (or Fun House) for Munster* (1997). This piece was based on an area around

an octagonal Baroque palace. The site that Bussmann showed me had eight *"allées"* [paths]; he said there had been pavilions in the center of each *"allée."* One was still in existence—a nineteenth century music gazebo. He showed me a spot for another pavilion, adjacent to the *"allées"* with the music gazebo. My first garden pavilion at documenta 7, 1982, [*Two Adjacent Pavilions* (1978–1982)], had two small pavilions in relation to the larger palace. Gardens were always important to me; after I first researched them, I realized that the first museums were not the enlightenment museums but, as Buren talks about, Renaissance period gardens. They were for the aristocrats—educational. They also contained Disney-like elements like water tricks and archeological remains. They were allegorical in terms of poetry, narrative, and philosophy. I became very interested in the eighteenth-century, allegorical English garden, which also contained allegories of politics.

HUO:

And so it gave a new direction to your work?

DG:

I wanted a narrative structure to defeat the Minimal art object. I also wanted something you could walk through. In other words, things that were for a large public to walk through—to walk through things narratively. I realized that Mies Van der Rohe's *Barcelona Pavilion* (1928) was actually allegorical in relation to its original landscape situation. As people walked through, it was an allegory for the Weimar Republic. You see, first you have World Fairs, which begin with the nineteenth century's huge exhibitions in London's Crystal Palace. You have to move people through an allegorical space. When I showed *Public Spaces/Two Audiences* in 1976, for the show that Germano Celant did in the Italian section, called "Ambiente/Arte" at the Venice Biennale in 1976—that show was about over-all environment works from Kandinsky to El Lissitzky to "Tableaux Vivants" and Arte Povera, like [Jannis] Kounellis's horses in a stable. I realized that every World's Fair and every Venice Bienniale was a showcase for the most important artist or artists from a particular country. So, with my pavilion I made a showcase situation for the public: I put the audience inside the showcase window, so they observed themselves in terms of their perceptual processes, looking at each other.

HUO:

When you speak of the Crystal Palace as an allegorical space, do you also refer to the inside/outside theme, whereby the garden is both inside and outside?

DG:

Well, what I talk about only took place in northern climates, in large northern European countries where you have glass botanical gardens displaying flora from southern colonized areas of the world. The public could go inside during the winter and see southern climates. But this had changed when I wrote about the corporate atriums. Corporate atriums had gardens from different seasons. In other words, in the Chem Corp. building [Chemical Bank Headquarters, Park Avenue, New York], at every different season you would have a different suburban garden inside. What they are trying to do in the Chem is get people into the city by making the center of the city into a peaceful suburbia. I got very interested in landscape architecture inside corporate atriums. But, basically, what I saw was that the idea of the museum as a self-contained museum was giving way in Europe to the museum as a garden.

HUO:

When did you observe this?

DG:

In the '80s in France. There was a return to the museum with gardens as a site for outdoor work in France. And also, you know, there had been an interest by Modernism to forget the past. Everything was the present: "forget about the past." My interest was always the "just past." The Dia Art Foundation piece (*Two-Way Mirror Cylinder Inside Cube*, 1981–1991) is about the corporate atria of the '80s and the alternative spaces of the '70s. Because normally we eradicate the recent past in favor of new trends. Like the new trend now is the neo-'60s, or, as the young artists call it, the neo-'70s. But for fashion, now it's all about the '80s. But what Walter Benjamin says and what I say is that the most important thing is for the art spectator to have a consciousness of what just past. I love Paul McCarthy's work *Michael Jackson and Bubbles (1999)*, because he is doing neo-'80s or '90s, here re-doing Jeff Koons. But of course, in the '80s or '90s you have people like Sherrie Levine, who were doing copies, or almost copies.

HUO:

This notion of the "just past" was of course crucial to your early video works, based on delays.

DG:

I think that when I was doing video time delays, with six-second delay, I was also interested in the just past. In other words, there was an extended present time where you had a feedback to the brain of what you just did, into what you are doing now in the

present, an expanded drug time present. This was a critique of the
'60s, when there was an interest in the instantaneous present
time—everything was instantaneous, thrown away, disposable. But
my interest after this was in an extended present time, extended
into the just past and projected into the future. I did a piece called
Past/Future/Split Attention (1972), which is about that. I agree with
Walter Benjamin, that we always have the ever new, which is
always the replication of something, so we have collective amnesia
about the just past or real history. My work can be very complex
about this.

HUO:

What about The Yin/Yang Pavilion *(1997–98)?*

DG:

The *Yin/Yang Pavilion* is a parody of Bill Viola's interest in New
Age. I think Bill Viola is doing a kind of corporate Zen Buddhism,
sponsored by Sony. I think a lot of these artists, like [Tobias]
Rehberger, are doing neo-'70s, or Andrea Zittel (who is actually
taking literally from Joe Colombo).

HUO:

What are the other aspects of gardens that you find interesting?

DG:

I think my other interest in gardens is because my work is very
much about the suburbs of the '50s and '60s. I go back to the sub-
urban barbecue pit and the swimming pool. When *Two-Way Mir-
ror Hedge Labyrinth* (1989) was finally realized, it was actually part
of the collector's garden. It was originally for International Garden
Year in Stuttgart. In Germany, every three years, the city puts
together its parks and has a radical redesign of its central parks and
has a big garden show. Artists were invited to do works which were
meeting places. *Two-Way Mirror Hedge Labyrinth* was originally
proposed for this show. In its use of two-way mirror glass, it was
emblematic of the city; the banks and corporate office buildings
were in the city center. My use of the labyrinth goes back to the
Baroque garden hedge labyrinth. But simultaneously, it evokes the
suburban yard and garden where the hedge is the dividing line
between the public and private spaces. My garden/two-way mirror
pavilion pieces are always emblematic of the park in the center of
the city. Historically, they relate to [Marc Antoine] Laugier's the-
ory of the "primitive hut," where you have a rustic hut, emblemat-
ic of utopian possibility in the city against the dystopic despolia-
tions of the industrial city. The primitive hut uses wood, twigs,

and branches in the structure of a classical Greek temple. In my use of the garden pavilion, I'm also evoking the pleasure pavilion (the German word for this is "lustpavilion"). Actually, I think my work also relates to Impressionist painters like Seurat, by creating a place for working- and middle-class people to rest on the grass with their children or lovers on the weekend.

HUO:

I recently had a discussion with Cedric Price about the garden folie, *which is a sophisticated dwelling built in gardens for entertainment; for him it produces a kind of distortion of space and time. Cedric Price also related it to the museum, explaining that when he goes to the British Museum for instance, it always feels like a distortion of space and time. What do you think?*

DG:

Well, I see the garden *folie* as in [Michel] Foucault's words, a "heterotopia." In other words, it's a kind of Utopia of all of the senses, which of course is repressed in the modern city where we've become very specialized. Of course, it's a bit of fantasy. I think the experience of my work is a little bit filmic. But, I also think the facades in the city are filmic. You get that from Aldo Rossi writing about [Michelangelo] Antonioni as his biggest influence. I was very influenced by artists more like Sol LeWitt, who was also very influenced by Antonioni. In fact, most of the artists I know were also influenced by films of the '60s. For me, the greatest films were [Elio] Petri's *The Tenth Victim* (*La Decima Vittima*, 1965) and Rossellini's history films. And, I was finally influenced by my friend Rüdiger Schoettle, the dealer, who taught me about the Rococo gardens.

HUO:

I knew about the influence of cinema on your work, but not about LeWitt. The artists that you showed with in the '60s were mostly influenced by cinema?

DG:

Well, I think we were all influenced by [Jean-Luc] Godard. I was influenced by science fiction films as well, films like [Franklin Schaffner's] *The Planet of the Apes* (1968). I love science fiction. My favorite sci-fi writers are Phillip K. Dick, Michael Moorecock, or Brian Aldis of the '60s. When I saw sci-fi films like *The Tenth Victim*, I was astonished. But I think the idea I always had for my work in the beginning was in relationship to the city plan. I read an article Don Judd wrote about the Kansas City city plan at the turn of the century, in *Arts Magazine*, and then I noticed that Judd's first

work was seen to be facades of the suburbs... So, I thought, in *Homes for America* (1966–1967/1997), to write about the city as a suburban city. And instead of the white cube of the gallery, I was interested in the city plan and the suburbs and the city. My Dia Art Foundation piece is also about the city. It's an uptown penthouse roof on a downtown slum roof. And that's the reason I put boardwalk material on the inside because I was linking it to Battery Park City. I thought in the late '80s, when I conceived the piece, that Battery Park City would be moving up the Hudson River. I had seen [Robert] Venturi's plan for a westway, a causeway along the Hudson.

HUO:

Speaking of Venturi, we spoke a lot in previous discussions about architecture and architects. How would you define your relationship to architecture?

DG:

Well, my favorite writer in the '60s was Michel Butor, who wrote a book called *Passing Time* (*La Modification*, 1957). Sol LeWitt and I loved the book; it was about the city as labyrinth and the city plan. It's about being lost in an industrial English city, probably Manchester. And, of course, my favorite rock group was The Kinks, who wrote about London. And Antonioni did *Blow Up* (1966), and Godard, *Two or Three Things I Know About Her* (*Deux ou trois choses que je sais d'elle*, 1966).

HUO:

So, it wasn't really urbanists, it was more cinema and literature that triggered your interest in the city.

DG:

I think when the city was being destroyed by Nixon in the '70s, it was a great period because the city was crumbling and there were alternative spaces, born from the ruins. P.S.1 was an old school, and since I didn't go to college or art school, because I hated schools, I loved the idea of making holes inside a school. And, of course, punk rock was urbanist against the old hippies who were going to the countryside.

HUO:

And how do you see the city now?

DG:

I see New York, at least, as a city of immigration and tourism. Every country has a different situation. Germany has many medium-sized cities like Greek city-states in competition with each oth-

er. Each city has money for football teams and for large art exhibitions. I think it's a big mistake to make Berlin into the capital, because it's become very bureaucratic, very corporate. When Berlin was in ruins after the war, after the Wall went down, it was a wonderful place.

HUO:

What is your favorite city?

DG:

Probably your least favorite, Brussels.

HUO:

Why?

DG:

Because on the outskirts it is sort of like a suburban Versailles with lots of hedges. It's not naturalistic. I also used to love London, but London has become very expensive and very touristy. London is also a garden city. I guess because I grew up in the suburbs, I love garden cities. I also love Los Angeles. I would never live there because I don't drive, but it has the best bookshops, the best architecture, and it's an absolutely wonderful city. But, I guess that I like the idea of artists having more than one city. For me, it was Canadian cities, when I was teaching in Canada and living there. Then it was London as an alternative city.

HUO:

So, less the idea of belonging to a city than being between cities.

DG:

No, I don't like to be always in the air between cities at all. Even Zurich has its points. I also love Tokyo. But not to live there. The most important thing to me about cities, because I travel so much, is that they are places to meet people when traveling. What I love about New York is that it is not only a place to see international friends; it is a city to walk in.

HUO:

Tokyo is too somewhat.

DG:

In Tokyo you have to have a watch and know exactly where you are at every moment because everything is timed. What I also love about Japan is the prefectures, the small periphery cities. America had a huge influence on Japan after the War. America was socialist during the FDR [Franklin Delano Roosevelt] period. I think what we created, or helped to create, were decentralized cities, prefec-

tures, with community centers, gymnasiums, all of the areas where architects can do work which is not corporate.

HUO:

And what about Japanese gardens?

DG:

I guess a lot of my interest in gardens probably comes from what was very oppressive. When I grew up, I hated the suburbs. What I hated most was the drive from one suburban town to another, on Sunday in the family car. When I did the "Westkunst" video [*Westkunst (Modern Period)*, 1980], I asked Glenn Branca to do a soundtrack which was pastoral but a little bit nauseous; in other words, the feeling that you had when you were driving on Sunday in the suburbs in the family car. But I think Godard's *Contempt* (*Le Mépris*, 1963) also had that feeling.

HUO:

I visited Robert Venturi and Denise Scott Brown in Philadelphia a few days ago, and they were showing me drawings they had done since the '60s, where they had this idea of the city becoming a more and more electronic space. You did this very important piece in which you referred to the open possibilities of video as a present-time, architecturally deconstructive medium. You reinserted into the public sphere something as public as television programming, but with the particularity that, in this case, was a family's choice of television programs.

DG:

You refer to my project *Video Projection Outside Home* from 1978. Well, I think Venturi was interested in the domestic space, which is based not only around the fireplace, but the TV screen. When I did the video projector outside the suburban house, it came directly from two of Venturi's ideas. One was his Quaker housing, the *Guild House* (Philadelphia, 1966). He had a gold, anodized aluminum antenna on the roof to symbolize the fact that old people mostly watch TV. It's also a play on Renaissance and Mannerist architecture facades in Italy. He was also very interested in the ornamentation that people have outside their houses, which is symbolic of what the house was like inside. I took a house that had a picture window where you could see the TV set, and whatever was shown on the TV set, I wanted to have on a huge Advent projector—which was new when I had this idea during the late '70s—on the outside. If people were looking at cartoons, kids with cartoons, there would be cartoons outside. I thought people might be watch-

ing public television, Channel 13, PBS, and I didn't realize that people late at night might be watching pornography. So, whatever the family was like inside, according to what they were watching on TV, you would see as an ornament outside. But, in a lot of my early work, I was trying to combine two people who don't combine together: Mies van der Rohe and Venturi. Venturi did an amazing critique of Mies van der Rohe's corporate period in America. He was also criticizing Louis Kahn. He said he wanted to get rid of monumentality and corporatism to do something that was very domestic and small scale.

HUO:

Kahn spoke of ornament as opposed to decoration, not that decoration would be added, but that with ornament two things that don't belong together come together, like a junction.

DG:

But I think, like Venturi, a very important part of my work begins with Pop Art. The first important Conceptual artist in America was Ed Ruscha, who comes out of Pop Art and graphic design.

HUO:

He also influenced Venturi and Denise Scott Brown's book Learning from Las Vegas *(Learning from Las Vegas. The Forgotten Symbolism of Architectural Form, 1972).*

DG:

I think he and [Claes] Oldenburg are the big influences. But of course, the music that I was interested in, rock 'n' roll, began in Cleveland, a decayed city. So decayed cities are very important.

HUO:

A bit like Detroit now.

DG:

Well, Detroit had Iggy Pop, Detroit Techno.

HUO:

They are ruined cities, almost.

DG:

Yes, and Patti Smith lived there until recently. Of course, you have medieval ruins in garden architecture. You know, Jean-Jacques Rousseau died in a philosopher's hut in Ermonville. I saw Ermonville; it was pretty amazing. I think that for the French Socialist government in the '80s, regionalism was extremely important. And for me, I had almost given up on art. Art was becoming very Europeanized, there were no more artist-writers. I liked architecture and rock music. Because of the possibilities of

working in a landscape context, I was able to work in France and Germany. So, I related immediately to the overlay of different gardens in the FRACs [Fonds Régionaux d'Art Contemporain]. For me, Le Consortium in Dijon was very important. And Münster is important because it's a university city. Klaus Bussmann, who worked with Kasper König, was an expert on eighteenth-century architecture. On "Skulptur" ["Skulptur Projekte Münster"], he found the site and he told me what the work should be. I loved collaborating with Klaus.

HUO:

Could we talk more about collaboration? You've collaborated with a lot of different practitioners.

DG:

Collaboration is about fun. I often think of my art as a kind of hobby, not totally professional. So what I love doing with younger artists or musicians is to collaborate on a project. Kim Gordon lived downstairs from me for about 12-15 years, and when I was doing *Rock My Religion* (1982–1984), the one-hour, sort of documentary fiction, I needed songs. So, I told Kim to write a song about the Shaker circle dance. [Sonic Youth] also did "Brother James" (1983) which is about a fundamentalist preacher, and I incorporated them into *Rock My Religion*. With Glenn Branca I've done about three collaborations. Every time I need a soundtrack, I go to him. When I had a large show at the Kunsthalle Bern, we also collaborated. It's fun to collaborate.

HUO:

So music, always music...

DG:

In the '70s, artists were friends with musicians. My best friend was Steve Reich, and his other best friend was Michael Snow. Richard Serra was friends with Phil Glass. The ideas were so similar and it was so non-competitive. It was great to talk to people in slightly aligned areas. But also, I got into art in the '60s because art wasn't only about painting and sculpture. Artists could write, they could make films. Dance and performance were very close to art. Many of the projects I did involved people in other fields. James Coleman asked me to do a stage set for *GuaiRE* (1983). I learned an enormous amount from Marie-Paule MacDonald, for my project for *Museum for Matta-Clark* (1983). She loves rock 'n' roll. As a student, she did this great project, *Nightclub for the Rolling Stones*.

HUO:

Can you tell me more about the Gordon Matta-Clark Museum?

DG:

It had an interesting beginning. In Paris they were destroying an old church for the Curie Institute. And France had suddenly discovered the New York alternative spaces, maybe twelve years later. But France was very anti-American. So I wanted to bring in a situation, with Gordon Matta-Clark, where nobody knew anything about him. I wrote a text about him and put the text inside the church.

HUO:

What year was this?

DG:

It was in 1983. The show was "À Pierre et Marie" (Paris, 1983–1984). It was an old desecrated space, and artists would work there just as they had in New York at P.S.1 and other spaces. What I wanted to show was that although Matta-Clark was American, he had done something like his project at Les Halles. He was working with both France and America. *Museum for Matta-Clark* was definitely about the area where Matta-Clark did *Splitting* (1974), which was a suburban area defined by being near the railroad. There were two parts to the exhibition. In the first part, I wrote this article, and in the second part, I asked Marie-Paule MacDonald, who was studying urban design in Paris, to design *Museum for Matta-Clark*, which would not only be about Matta-Clark, but also about city planning. I thought the key to art and architecture was city planning. She took the area of *Splitting*: one house was splitting and others were simple houses, which might be in the area of *Splitting*. She used the form of the block to show the relation of *Museum for Matta-Clark* for the suburban plan in New Jersey. See, my work is based on highway culture after World War II. I think *Splitting* is based on houses built along the railroad after World War I. So, what she did was to take notches out of the sides of two of the buildings, and the building was a little Venturi-like. The "museum" simulates *Splitting*. Marie did most of the work on it, though it was my idea. Unfortunately, every time the work is sold, they take her name off.

HUO:

The art market seems to have a strong resistance against the whole idea of collaboration.

DG:

Totally, or they have something called "Collaboration" in *Parkett*, where the artists don't even know each other. Lawrence Weiner

asked me, "What's Rachel Whiteread's work like? We're supposed to collaborate and I don't know what her work looks like."

HUO:

What are your current collaborations?

DG:

I'd also like to collaborate with Rodney Graham and also to work with Marie-Paule MacDonald again. For my survey retrospective catalogue, I want to have a cartoonist and young writer to do a cartoon biography of my life.

HUO:

Who is writing it?

DG:

You don't know them. The guy's name is Fumihiro Nonomura, he is a writer in Japan and his friend is doing the cartoons. There is also a section on collaboration, with Markus Muller interviews with some of my collaborators.

HUO:

Since you mentioned the **Matta-Clark Museum**, *I wanted to ask you a little bit more about museums. What is your favorite museum—it can also be an old museum—and how would you expect a museum to work?*

DG:

Well, my favorite museum used to be the ICA [Institute for Contemporary Arts] in London. And what I tried to do for the Dia Art Foundation was to make an outdoor terrace like the ICA. What I like about the ICA is that there is a very important bookshop and also a coffee bar; it's a dating pick-up place. And for the old museums, I have to say this, although it sounds horrible, I love seeing 12 year-old girls with their fathers looking at Botticelli paintings. In other words, I think museums are basically kind-of eroticized social spaces. They are also very good for coffee and meeting people. What I tried to do with "Skateboard Pavilion," which was never realized for the "International Garden Exhibition" in Stuttgart (1993), was to do something for teenagers. I noticed that skateboarders were using the Hayward Gallery [in London] for skateboarding, so I love the idea of combining museums and skateboarding.

HUO:

What about children's museums?

DG:

What I saw in the late '90s, especially in Holland, but everywhere, all of the money was going for children's education programs in museums. I think what we want, for the '90s and the early twenty-

first century, is to be gentler and kinder, to quote President Bush.
We want an America that would be gentler and kinder.

HUO:

You mean the old Bush or the son?

DG:

The old Bush. He said he wanted a "gentler and kinder America."
So, I think we now have extreme capitalism, but we do things for
children. We buy for children, we buy for ourselves as if we were
children. In America especially, people don't want to grow up. So,
we are just buying for children and doing things for children. Hol-
land will soon have a Kunsthalle for children in Rotterdam. It's the
big hype. But I think it's capitalist narcissism. In other words, we
are narcissistically identifying with our children. On the other
hand, my pieces are always enjoyed most by children. I think it's
also about the mirror stage, since it's about inter-subjectivity. My
work is often like a fun house situation. It's also like a photo-oppor-
tunity situation for kids and parents on weekends. When I did
Wild in the Streets (1987), the mini-rock opera, it was about "don't
trust anyone over thirty." America has always had this obsession
with being a child, with youth. I think Jeff Koons is right in doing
things only for children.

HUO:

Humor?

DG:

The main thing about my work is that it is about anarchistic
humor. So, in that sense, you could say that it's a little bit teenage.
But if I were young, I would destroy a Dan Graham piece [*Laughs*].
In other words, I would smash the goddamn Dan Graham piece
[*Laughs*]. But I was never a real teenager, that was my problem.

HUO:

Do you think that today the art schools are in a state of crisis?

DG:

Well, the problem with artists now is that they all went to art
school. I tried to drop out of high school, and my friend Flavin was
one day away from being a priest. And my other friend Robert
wanted to get his high school degree from correspondence school.
I think the real crisis is in schooling. People stay in art school and
in schools because they don't want to go into the real world. The
problem is that artists then, to make a living, become teachers in
art schools. So you have all this art school academicism. I am actu-
ally not against education. I think some of the best artists went off

and did other things besides being artists. Jonathan Borofsky and Dara Birnbaum went off to architecture school. Sol LeWitt was going to be an architect; he did graphic design for *Seventeen Magazine* and he also worked for I.M. Pei. Jo Baer was a biologist before doing art. And I think Judd wanted to be a philosopher.

HUO:

I recently looked into the work of Lee Bontecou. She kind of stopped.

DG:

She stopped making art?

HUO:

She didn't stop making art, but she stopped exhibiting.

DG:

In protest.

HUO:

Did you know her?

DG:

No, but I read Judd's article on her. I think she had a huge influence on Judd. His first articles were about the Kansas City plan, Lee Bontecou, and [Yayoi] Kusama. I think Judd was a very strange character, a very fragile person. A lot of his work was influenced by women artists, and in the end he was super-macho and paranoid. Typical American. Very fragile.

HUO:

We have already been talking about some of your unrealized projects. Could you tell me more about unrealized, or unrealizable projects?

DG:

The most important one was the one I was going to do for documenta X (Kassel, 1997): *Double Exposure*. We raised money from the Süddeutsche Bank. The project is a landscape pavilion that has time-delay, even though it has still photographs. It was to be at the end of Documenta near the river. Two sides of the triangle are two-way mirror, which you can enter, and the other side is a very light Cibachrome, almost transparent, a photograph of a spring day, at around sunset. It's about fifty-meters long, in front of the inside of the pavilion.

HUO:

The same spot?

DG:

The same spot, but looking fifty meters in front. So, you could look through it, since it is a Cibachrome, and see present time, which is a moving present time against the still photograph. A year later, it

almost coincides. And of course, on the sides of the two-way mirror you are getting the sun changes, both reflective and transparent images. And you see the landscape in the two sides of the pavilion. So, you see through the old photograph, the current situation on the sides, and people looking on the inside and outside. It's a way to have time-delay with a still photograph. Normally it would fade, but there is a new process whereby it could stay up for about ten years without fading.

HUO:

This takes us back to the beginning of our discussion. Is this piece also about the "just past" and the extended present?

DG:

Well, it's about time delay. It's about Caspar David Friedrich. I'd like to combine two people from Hamburg: Caspar David Friedrich and [Philip Otto] Runge. For children, small children, for landscape. I got the idea from Flavin. Flavin tried to combine [Vladimir] Tatlin, [Albert] Speer, Caspar David Friedrich, Barnett Newman and Bowery bar lighting. I'd like to combine two irreconcilable people or ideas. It's a little like Venturi's idea of the either/or, or rather, the both/and. I'd also like to make a triptych between two areas: architecture, criticizing art, or art criticizing architecture. I think my work has never been very popular because it's always hybrid. People like Serra because he does sculpture. And I think architects like Serra because he is suspicious of architecture. There is something very wrong about that.

GRIGELY, Joseph

Joseph Grigely was born in 1956 in East Longmeadow, Massachusetts. He currently lives and works in Chicago. Grigely became deaf as a result of a childhood accident at the age of 10. He received his formal education at the National Technical Institute for the Deaf, Rochester, from 1974 to 1975, and studied mechanical engineering before turning to Nineteenth-Century British literature and critical theory. He received a D.Phil. from Oxford University in 1984. Used to situations in which he speaks and his hearing interlocutor has to write everything down, Grigely has often introduced these writings of others made in the process of dialogue with him, into tableaux and spatial arrangements, sometimes alongside texts of his own. Grigely first started to exhibit these pieces in the early '90s and since he has had solo shows in institutions including the Whitney Museum of American Art, New York ("White Noise," 2001); Index, Stockholm (2000); the Barbican Centre in London ("Barbican Conversations," 1998); the Center for Contemporary Art, Kitakyushu, Japan ("Pretty Paper," 1998) and ARC/Musée d'Art Moderne de la Ville de Paris ("Migrateurs," 1996). Grigely is the author of Textualterity: Art, Theory, and Textual Criticism *published by the University of Michigan Press in 1995.*

........................

This interview was recorded in New York in March 1999, and revised by the artist in 2002.

Hans Ulrich Obrist:

I want to begin with a set of questions concerning the parallels, the differences, and the bridges that exist between art and science. How can we bring art and science together in a comprehensive context?

Joseph Grigely:

This is a huge question. One of the more manageable approaches concerns ideas related to reproduction and replication. The dissemination of art, like the dissemination of humanity, depends upon how both textual bodies and biological bodies distribute themselves through reproduction. This brings together two seemingly disparate fields: textual criticism and biology. Walter Benjamin's idea of "mechanical reproduction" is important too. But Benjamin seems to have missed how the production of "types" and "copies" also involves the production of unpredictable variations, so a copy is never wholly identical to its original model or form. The same poem printed in a different context ultimately inflects how the poem is read—just as the display of one painting in different sites affects how it too is read. Thus the

sequence of exhibition spaces allows for infinite variation, repetition, and difference. That's why contemporary culture is so obsessed with cloning—so obsessed with control. Not that this is new: Diderot, in the *Encyclopédie* (1751–1772), remarked how the graft is a triumph of art over nature. Only now, with recent advances in biological engineering, the graft as a paradigm is much more complex in how it addresses the very idea of "reproduction technology."

HUO:

In a previous conversation, you mentioned your idea of a new kind of "Interdisciplinary Institute." I recall you once referred to it in terms of "posthumanities." Can you tell me about it?

JG:

The term "posthumanities" comes out of the book, *Posthuman Bodies*, that Ira Livingston and Judith Halberstam edited in 1995—though the term had been talked about for years prior to this. Historically, the typical institute for the humanities explores the various arts—including literature and music—as being part of the continuum of the "natural" human body. But what is a "natural" human body? There is an immense space between Darwin's "natural" world and the "natural" world of creatures that appear in the tabloid *Weekly World News*: Batboy, frog boy, and the horse born with a human face. Jackalopes, wolpertingers, professors of interdisciplinary studies. Mutation is most interesting not as a biological fact, but as an etymological construct that emphasizes changed and changing states. Absurd as it may seem, it is the world of the constructed body that is most natural now. Grafting, splicing, eclecticism, conflation—these things happen not arbitrarily, but because of a certain human will and desire.

HUO:

What about Donna Haraway? Is her work an example of "posthuman" criticism?

JG:

Haraway is an excellent example. Starting with *Primate Visions* (1989) and later in *Modest Witness* (1997), Haraway's work has focused on how the posthuman body is fundamentally a constructed body. One of the characteristics of postmodern bodies is that their filiation is non-linear. Their genealogies do not have straight lines. Our natural world is a world we had once called "artificial." It is the word "natural" that now wears the scare quotes: "natural," with its Eden-like mystique and untainted purity, represents a perpetual nostalgia for something that is and is not present. Haraway's universe is a terribly complex universe of transgenic foods, mice with patented cancer-

bearing genes, and related fabrications. Frankenstein was relatively simple in comparison: the monster was the product of edited pheno-types. "OncoMouse," as it is known, is the product of edited geno-types. There's a world of difference between the two. What we need is more critical discourse like Haraway's to address the comparative importance of this difference. The traditional American institute for the humanities rarely addresses these issues—which is why we need, in some form, an institute for the posthumanities.

HUO:

Can such an institute of interdisciplinarity happen within the existing struc-tures of the academy, where one can sense some kind of omnipresent anxiety of interdisciplinarity?

JG:

Well, this is complex—being as it is an administrative sort of ques-tion. Many institutional think tanks are already doing engaging inter-disciplinary work, both in the U.S. and Europe, as well as in Asia and Latin America. But only to a certain extent. What you describe as "the omnipresent anxiety of interdisciplinarity" is a very real anxiety, since it goes against the grain of institutional history: the Western univer-sity is traditionally devoted to the process of taxonomizing knowl-edge, of breaking it down into discrete categories of disciplinary thought and discourse. The anxiety comes from being in a realm that lacks the precepts of historical continuity. People are for the most part reticent to embrace any school of thought whose fundamental super-structure lacks a positivist impulse. Look at deconstruction as an example. In a very broad sense, deconstruction is "interdisciplinary" in the ways that it explores the practice of reading: reading poems, read-ing novels, reading paintings, reading virtually any act of human com-munication. Like the philosopher Nelson Goodman, Derrida created a vocabulary to suit his own disciplinary needs: his is a vocabulary of lin-guistics without being linguistic, a vocabulary of anthropology with-out being anthropological. Which is precisely why his work is trou-bling for some people: his notion of difference takes pleasure in the very idea of difference, and the peregrinations of the mind.

HUO:

What are the advantages and the dangers of interdisciplinarity?

JG:

The ostensible danger is that because people like to label other peo-ple—and their work—they tend to ignore or disparage those they can't easily compartmentalize. On the other hand, the most compelling attraction of interdisciplinary work is how it invokes the constant flux of humanist and posthumanist inquiry. It's not inherently better than

mono-theological forms of inquiry—there's some pretty bad "interdisciplinary" stuff out there—but when good, as it is in Donna Haraway's work, it's engaging, enlightening, intelligent, and accessible.

HUO:

In interdisciplinary projects there is sometimes a disappearance of differences between the disciplines and an adjustment of vocabularies. How is it possible to have an interdisciplinary situation that at the same time allows very complex discourses to develop?

JG:

This is difficult, and I have a relevant anecdote that illustrates the dilemma. A little while ago, I asked several colleagues of mine who were participating in a yearlong seminar at the University of Michigan Institute for the Humanities to read a chapter of Richard Leppert's book, *The Sight of Sound* (1993). The book is a historical study of visual representations of domestically produced music in the eighteenth century. It covers various fields: history, musicology, art history, and social anthropology. What intrigued me was the way the book explored how ubiquitous sonoric experiences—music and conversation for example—are represented in painting and drawing. Deep down, it's really an amazing topic: how do we take an auditory experience and translate it into a visual experience? How do we take the discourse of speech and translate it into a discourse of visual representation? How do conversations draw themselves in two-dimensional space? My colleagues seemed unimpressed, if not also unchallenged; one historian was concerned about Leppert's definition of "medieval." A composer was troubled by Leppert's description of a composition. The key thing is that they ultimately read Leppert through a template of their own disciplinary discourse. Cultural criticism is very much a territorial sort of business. The sense of resistance, though somewhat disconcerting, is also a necessary resistance: without the tensions of disagreement and conflict, the practice of criticism would simply implode.

HUO:

You often speak about the Library of Alexandria as a model...

JG:

It was at the Library of Alexandria that some of the first efforts were made to explore issues related to textual dissemination and reproduction. The efforts centered around Homer's lost texts, and attempts were made to reconstruct them by examining fragments and secondary texts. Ultimately, the Homer we read today is a Homer that has been unmade, remade, and made over—a Homer

whose texts live not because they depend upon maintaining a specific form, but because of their malleability, and their ability to sustain themselves through these inevitable re-makings.

HUO:

*Is this exploration of the transmission of cultural texts what you defined as "Textualterity" in your book (*Textualterity: Art, Theory, and Textual Criticism, *1995)?*

JG:

In a way, yes. Literally, textualterity is textual alterity: an understanding that a specific text will have many different forms, all of which express a degree or variation. The variation is rarely merely arbitrary, but rather reflects the possibilities of human intention. One of my favorite examples is Thomas Bowdler's 1807 "Family Edition" of Shakespeare's plays (*Family Shakespeare*). History regards Bowdler as a miscreant: he edited Shakespeare's plays in such a way as to omit, as he said, words and expressions which cannot with propriety be read aloud in a family. A man of considerable moral probity, Bowdler saw himself performing a public service. Most editors do. Even censors do. This issue for me isn't whether he was "right" or "wrong" to do what he did, but how it reflected his own moral interests, and how he was perfectly honest about it all. His text is not Shakespeare's text, but Shakespeare's as inflected by Bowdler: it is a text of culturally motivated difference. The key idea behind textualterity is that it looks at variation and change not as being "good" or "bad" but as something that is inevitably part of the expression of the vicissitudes of our human nature.

HUO:

Can one use notions such as "complex dynamic system," "non-linearity," and "in-betweenness" to describe this ever-growing text?

JG:

Yes, so much so that it's hard to think of an existence that is otherwise. I'm momentarily reminded of Marc Augé's book on supermodernity: *Non Places. Introduction to an Anthropology of Supermodernity* (*Non lieux. Introduction à une anthropologie de la surmodernité,* 1992)—and how our everyday lives now consist of constant spatial displacement. So-called "transit lounges" or "waiting rooms," which once had the appearance of being points of stasis, are now points of motion. People used to take vacations; they now take "working vacations." We are constantly developing a technological architecture to support this dynamic: wireless communications, in particular, have freed us from the anchorage of a physical place. In another sense, it seems to me that the entire notion of interactive dynamics

is fundamental to our human existence. At almost every level of human evolution, a certain kind of dynamic friction had the effect of challenging the mind, forcing it to push itself a little further and a little harder. And what's especially wonderful is not knowing where the twists and turns of these peregrinations will take us.

HUO:

What's your opinion on the current debate on the origins of language, where a structuralist approach is more and more contradicted by a more contextual and evolutional approach of dynamic parameters in which language develops? What do you think of this argument between Noam Chomsky and Luc Steels or Brian MacWhinney who attempt to propose an alternative theory?

JG:

Well, Chomsky's been around for a long time now, and for good reasons. But this also means that evolutionary and syntactic theorists have the inevitable obligation of ramifying his arguments. How can one decide between a primarily innate theory of language—Chomsky's position—and one in which a minimal innate capacity is developed through a highly interactive environment—which is Steels' position? In a way, Steels is putting to test some very interesting Enlightenment philosophy. Rousseau and Condillac had both argued that deaf people were incapable of acquiring language. They reasoned that deaf people, lacking auditory input, could not participate in the crucial sort of "language game" that Steels—and others—have found to be fundamental to linguistic development. But the problem is that Rousseau and Condillac equated speech with language, and neglected to explore the significance of visual languages such as sign language. It took another Enlightenment thinker—the Abbé de L'Epée—to discover how two deaf siblings were using, and developing, a sign language with each other—and then go on to establish the first school for the deaf to use sign. This was in Paris in the middle of the eighteenth century. L'Epée's experience with the siblings parallels Steels' recent experiments: a human brain, when provided with meaningful linguistic input, will play with it, develop it, and make something out of it. The modality is not important: speech, signing, or colored squares. The amazing thing about the brain is its adaptability. It will make a communication system, if not a language, when provided with appropriate stimuli. In this respect, Chomsky and Steels aren't necessarily counterpoints: their research is in fact complementary in fundamental ways.

HUO:

Let's discuss your artistic work: precisely when did you install the text fragments in an exhibition for the first time?

JG:

I started working with the "Conversations with the Hearing" in the early '90s, and the first exhibition of them was at White Columns in New York in 1994. The paradox, however, is that it took so long. When I became deaf at the age of eleven, there was this social expectation that I learn to lip-read. I was really terrible at it though. I still am. But when I could, I'd ask people to write things down for me. Most people were happy to do this. It was efficient and simple, and even if it went against the grain of social expectations, it worked for both of us. Then there was a day in the early '90s when I had dinner with a friend, and afterwards there were scraps of paper all over the table with fragments of our conversation. They were all disconnected, quite lacking continuity, and somehow more engaging that way—as if they told a story without telling too much. After that dinner, I started saving the papers on which people had written, until I had a good-sized archive, and one day I spread them on the floor of my studio. I had expected to see a lot of writing, but what I saw instead was a lot of talking—and the difference is a big one. The words simply went all over the pages. Sometimes there was only one word. Sometimes there were words on top of words. The most interesting stuff was ironically the most banal and ordinary stuff—stuff that hardly ever gets written down. What was so crucial as part of this discovery was to find a way to share the experience of communicating, rather than simply narrate that experience. This is part of an ongoing process for me. The most recent installation of the "Conversations" was a project at the Whitney Museum in New York called "White Noise": an oval room filled floor to ceiling with over 2,500 sheets of white paper on which people have conversed ("Joseph Grigely: White Noise," Whitney Museum of American Art, 2001).

HUO:

Could you tell me about how your work refers to the tradition of the "conversation piece" and then about the collection of the Sir John Soane's Museum in London?

JG:

The conversation piece is an eighteenth- and nineteenth-century genre of painting and drawing typically practiced in England and the lowlands. The genre is distinguished by the fact that people are present and seem to be talking, but their words are absent. Their bodies and gestures are positioned in a way as to suggest para-linguistic traces of the conversation. [Antoine] Watteau, [Thomas] Gainsborough, and [Thomas] Rowlandson all painted conversation pieces. Soane's collection of works by [William] Hogarth and Canaletto

could be included in this genre. Take for example Soane's copy of *The Riva degli Schiavoni: A View of Venice Looking West* from 1736—a very conventional Canaletto of the sort he painted for the English tourist crowd. Whether he was painting a palazzo or a lido, Canaletto typically filled his canvases with small groups of people who seem to be chatting, people who seem to yell, and people whose gestures bespeak directions. In *The Riva degli Schiavoni*, a dog's head is cocked to the conversation of a cluster of people a few steps away; nearby, a bargeman gestures and yells loudly enough to capture the attention of a woman walking by; beyond them heads are turned and bodies are positioned in a way that says only one thing: words are moving. This is the secret of the conversation piece as a genre: it is not just a visual scene being represented—a visual experience—but the human occupation of that expanse, and the fact that this occupation is characterized not by things seen, but by things heard. In this respect, I consider Canaletto a noisy painter. Strictly speaking, most art historians would not consider Canaletto or even Watteau as being painters of conversation pieces, but their work is nonetheless about the auditory field. This is very similar to the dilemma posed by my "Conversations with the Hearing:" we all know what a conversation sounds like—but what does a conversation look like?

HUO:

About conversations, one of the interesting things is silence, also. Hans Georg Gadamer pointed out to me that the problem with conversations that are transcribed—particularly in the case of interviews—is that language contains many non-verbal utterances and silences that cannot be transcribed or written down. The only thing possible is to indicate "silence" or "gesture," which is of course unsatisfactory. What do you think about this issue?

JG:

I agree wholeheartedly with Gadamer's point that speech is so nuanced that writing cannot convey its emotional complexity. This is one reason why computer-based speech-to-text recognition programs are so fallible: as humans, we inflect our speech in an incessant variety of changing ways. Silence to a speech recognition program is represented as a gap in the speech stream. But silence is never really "empty" or "redundant," even for a deaf person. It's always filled with visual information of some kind—the gestures we make when the voice pauses, for example. Or the weight of one's eyes, or the turn of the brows. Only we don't have a critical or scientific discourse that explores the richness of silence in a way that goes beyond kinesics and the over-worn notion of "body language"—so silence has some of its greatest moments in spoken arts. Shakespeare in particular is a master of the pause.

HADID, Zaha

Zaha Hadid was born in 1950 in Baghdad, Iraq. She currently lives and works in London. Hadid studied architecture at the Architectural Association (AA) in London beginning in 1972, and was awarded the Diploma Prize in 1977. She then became a partner of the Office for Metropolitan Architecture (OMA), co-founded by Rem Koolhaas and Elia Zenghelis in 1975, but soon opened her own studio at the AA until 1987. Hadid's major breakthrough came in 1983 when her competition entry in The Peak *project took first place. The project was to design a multi-level sports club in Hong Kong. Her design consisted of a "horizontal skyscraper which swept diagonally down the hillside site." But the project was never constructed because of logistical reasons following the retrocession of Hong Kong to China. In 1988–1989, she received the commission for the* Vitra Fire Station *in Weil am Rhein, Germany, which was immediately recognized as one of the key buildings of late-twentieth-century architecture. Other major projects have included an exhibition pavilion for video art in Groningen (1990) and the installation for the exhibition "The Great Utopia" at the Solomon R. Guggenheim Museum in New York (1992). Recently Zaha Hadid's office has worked on a variety of projects that are currently under construction, including Contemporary Art Museums in Cincinnati and Rome.*
......................
This interview took place in London in August 2001.

Hans Ulrich Obrist:

My first question is about exhibition design. There seems to be almost a forgotten history of exhibition design: in order to fight this amnesia, I wanted to know how you started to work on exhibition design, and what this medium means for you?

Zaha Hadid:

Actually, it started with us doing our own exhibitions and always wanting to do something like hallucination in that space. The first show I had (the idea of the show goes back to 1976 or 1977) was at the AA in the student shows where you try to do everything. We did these very large boxes, like architectonic fragments, which landed in the AA's Members' Room. And we were accused of being imperialist by a well known architect who was speaking there at the time: the idea was that we had destroyed a perfectly nice English space. It was very curious, let's say. And then I did another show, in 1982, in the same room, the Members' Room, where I was

showing the renovations for a house in London, which I was going
to do in Eaton Place (59 *Eaton Place*, 1981–82), and I also wanted
to make an installation in the space. I wanted to put in a black
floor, but it had a wooden floor and they wouldn't let me use any-
thing else, so I put plastic sheets and sand on the floor. And every-
body was freaking out about these plastic rubbish bags, so I said,
"O.K., so I want linoleum," so they just gave me black boards. In
all of the shows, we always wanted to do something with the floor,
whether in the student works or with my own shows. And when we
did a show in 1983, for *The Peak* (Hong Kong, 1982–83) we also
did these environments. So we started like that, not trying to do
other installations, but installations of our own stuff. Then we did
the Russian avant-garde show at the Guggenheim ("The Great
Utopia," New York, 1992).

HUO:

Before speaking about the Guggenheim show, could you tell me a little bit
more about these early AA shows?

ZH:

We only did one room at the AA; it was more of a grab bag. For
example, we did a whole field on the ground, where we put down
black boards and painted the floor, so instead of a painting on the
wall it was a painting on the floor. The idea was that the floor also
becomes interesting; you can walk on a painting, and walk on lines.
In a way it's similar to our recent installation in one of the gardens of
the Villa Medici in Rome (*Meshwork,* 2000), although that was more
volumetric whereas the AA room was more flat. And then, for the
show at the Guggenheim, we couldn't do all the pieces we designed,
but it was very important to explore how you can occupy the ramps
and the void and also how you interpret that entire exhibition in a
way that exposes the works differently. What is interesting is that
you test ideas about how you can install art or objects, how you can
connect them through a theme, but also, you can take some of the
ideas which you're interested in as a project and try to test them on
something like a scaled model. They're not literally trial projects, but
obviously they connect to what you are working on at the time. For
instance, at the Hayward Gallery, for the "fashion show" ("Address-
ing the Century—100 Years of Art and Fashion," London, 1998), we
also tried to combine a few things: the idea of the field, seeing things
from different terraces, which works well at the Hayward because it
is similar in the sense that you see things in strange adjacencies. It is

also comparable to doing a book; the project itself becomes a product on its own. It's the same with installations, where, at that moment, you connect these pieces in this particular way.

HUO:

In terms of the history of exhibition design, there was a very strong momentum at the beginning of the century: for instance, Erich Buchholz, the German Constructivist, in 1921, even had his apartment transformed in an installation where the architecture, the walls, furniture, art, etc., of the room are integrated to create the total arrangement and structure of the space.

ZH:

Oh, that's interesting, because in Mondrian's studio in New York everything is by Mondrian, but it was not designed as an installation, but rather as a complete environment. But also, the whole issue was that people used every possible moment to actually expose another idea. There was a lot of interest in using every facility to test and make immediate some of the discourse that was taking place. Exhibitions are actually the most immediate way to test some of these ideas as an environment. Of course, at the time there was also the importance of many exhibitions between art, architecture, and lifestyle, on how we would live in the future, how we would work. There was a tremendous preoccupation with future existence, which was eradicated after a period of time because the future was always seen as rather grim. But I suppose it also relates to all the world expos, where there were many environments designed to expose ideas of transportation, related to industry, so there were different forms of installations, let's say, or exposing life in a contained space. And I guess later people became much more blasé, because they thought that they knew everything; they travel and they see things, so there is no need to be confronted with this stuff anymore.

HUO:

In other words, the "laboratory years" were over. In The Power of Display *(1998), a book about the history of MoMA {Museum of Modern Art, New York}, Mary Anne Staniszewski writes that in the early years of the museum, Alfred Barr, the director then, saw MoMA as a laboratory for exhibition design. Philip Johnson did some incredible exhibition designs there, which were in turn influenced by Duchamp, the Bauhaus, Mies van der Rohe, Lily Reich, etc. Somehow, these laboratory years came to an end in the '70s. MoMA declared "the laboratory years to be over" and things became more rigid and conventional.*

ZH:

Yes, I hate to say this, but in many museums, the curators have very

particular views on how art should be displayed. For instance, the only reason we did what we did at the Guggenheim in 1992 was because the time was very tight; we got away with it because there was no time to change things so much. But the [ruling] idea is that you can only see art in an absolute moment of silence; that you have one painting here, one painting there, one object there… And that clustering or compactness was really unheard of in the art scene in terms of painting. But these Suprematists paintings were never intended to be isolated in the white cube; they were part of a field or "cosmos." This is another thing that I think is a test of a particular environment, because most of those are interior conditions, and through that, you can challenge how people see things, but also make an environment that gives you another perception. I think the curatorial wariness stems from the fact that they think that perception is fixed: that there is only one way of perceiving things, not a multiplicity. And they don't see that it doesn't necessarily do harm to the works. I was really shocked by how rigid it is in the museum context to exhibit work.

HUO:

The white cube carries the ideology of the museum as a "neutral space."

ZH:

Variety gives you much more curatorial flexibility. I think that in some installations it could work well to have a minimalist space, but I don't think it works well in every aspect of art installation. The Tate is a good example because there's a real Tate thesis on not only what to have on view, but also how to install art. It works well inside their spaces, but I don't think it does justice to many of the works because you see everything in exactly the same way, and I don't think it works particularly well for painting.

HUO:

But if you take the example of Gilbert & George, they conceive of their own exhibitions more like a chapel; the installation is skying. There can be differences; it has to do with longing for difference, don't you think?

ZH:

Yes, difference, exactly. And it's also affect. I mean, you want to see an exhibition; otherwise, you could just look at a book. First of all, you have the impact of an environment on you, but also how it makes you look at a particular work in a particular way. An example would be the 1992 exhibition at the Guggenheim, where we did the five-by-five meter room which displayed all the works by [Liubov] Popova and [Alexander] Rodchenko on Plexiglas walls, so you see them also as a space of differences. We tried to install all of the Russ-

ian Constructivists almost as they were done at the time, but in different ways since they were done in different galleries, and we tried to show the journey from the paintings, through the reliefs exploring the "culture of materials," to the sculptures and spatial installations. With respect to the "five-by-five" show of paintings, I thought that we had to paint a wall black at the end of the space, because I didn't think Rodchenko's black-on-black paintings could be seen well on a white background, which would diminish them. But that idea took hours of negotiations, and yet it worked extremely well for two reasons: first, it pulls you to the end of the space, but also when you come to the end of the space, you finally start to differentiate the subtle nuances. And also, I think it's like film, not identical with real life: it is a strange moment of life. Because people always think that normative existence is an absolute, and hence this embedding of works in a kind of minimalist space, since that is seen as the most normative, puritanical space. But what is extracted from it is the severity and authority it has, which I don't think is normative, which should not be part of normal existence. So what I think is interesting about exhibitions is that they give a momentary take on something. And also that you can have the same show installed in many different ways with as many different takes: there isn't this idea of a singular vision about how these things could be shown.

HUO:

It's also interesting to bring in the viewer. What is first visible in your drawings for exhibition spaces is this real freedom of the viewer. And that relates back to the laboratory years also, because at the beginning of modern museums, the idea was that the viewer could move freely, in a non-linear way across the space. So it was exactly the opposite from the way it is today, where it reaches its highest point in linearity with the "audio-guide model."

ZH:

Well, I suppose that part of the reason is that in the early years, the work that was shown was still in the making. And then there was a moment when it was felt that Modern Art was done, when Modernist painting, as a period, was conclusive and finished. Thereby, they became very precious, and this preciousness allowed for an incredible constipation in the way that they are perceived: they are very important pieces, they should not be adjacent to someone else, you should see them in one way. And thus, museums really became institutions, very dogmatic institutions. It was the end of the idea of the laboratory, of experimentation.

HUO:

But in your exhibition and museum projects, there is obviously a connection to this modern laboratory: How do you view and conceive of this relationship, in terms of repetition but also difference from what has been done in the past?

ZH:

Well, when we did the early, very strange projections, people took them to be pictorial or visual representations, but what it did was to challenge people's perception of how to present architecture, in what mode, but also how your eye travels on the wall, because there wasn't necessarily one point or corner view. This led to the idea that there isn't a singular view, there isn't a singular corner, there is a multiplicity of views. And it implied a kind of organic organization that is not a closed system. The most important thing for me is that these systems are no longer about completeness; they are incomplete compositions, and also not closed systems of organization. All of this has to do with porosity in organization: the idea of absolute space shifted to the idea of different adjacencies where you can see things more than once. I've always found this very interesting and intriguing because you can never see the same thing in the same way. You know that when you see an exhibition a few times: every time you go, you see something differently. And what is interesting about installations is that they channel that view; each one has a take on the way you perceive that object or that piece.

HUO:

Is intensity—or as you mentioned it, compactness—a condition for that?

ZH:

Well, I think that for instance, you can move from a room with one piece to a room that has a hundred pieces, and there isn't a singular layout. For example, when we did the Hayward show, the Hayward detested the idea of field on the ground, but also there was a problem because all the objects had to be sealed off from light and air, so that essentially you don't see them at first, you only see them when you're very close to them, so there is an element of surprise. And also, you have to move through the objects themselves, so you move inside it and therefore it's no longer just about an object which you see that way, but about trying to occupy it as you move through it. The show becomes a new spatial experience, but of course, we were interested at the time in the pixilated field: through repetition, you organize a space, which has fluidity. One interesting thing about museum spaces, or display, is that you might use standard items, but whether you organize them together in clusters, or fragments, or one field, you connect them differently. And this kind of organization

could also apply to a larger territory, like a big terrain or museum. So the interesting thing about installation is that you can take an idea and test it in different ways, and it could then have a ricochet effect on its neighboring conditions, the next side, the next room...

HUO:

Cross-fertilization, cross-contamination...

ZH:

Exactly. And the Hayward is relatively neutral, but not totally. They try very hard to make it neutral, with white walls, rooms made into cellular spaces, where you move from one cell to the next cell. It's very strange. I think all of this relates to the galleries that were occupying warehouse buildings that were converted into these neutral spaces. They work O.K. when there are two or three rooms, but when you translate them into a space that has fifty rooms, it becomes totally monotonous. And that would be O.K. if it were ultra-monotony, but as it is slightly monotonous, I find it utterly irritating. But I'm sure you could do something with it, it could be challenged. For instance, when we occupied the ramp at the Guggenheim, we put zigzag panels and what was interesting is that it pushed people to the edge as they moved through the space and it made this particular part of the ramp very narrow. And apparently—I only discovered this later—in some early studies, Frank Lloyd Wright had done provisionary studies on how to occupy the ramp, which have never been used. The ramp was never seen as a space that only occupies the niches. So it is actually interesting how the idea of the temporary occupation of these spaces could also lead to other ideas. For example, the idea that you can actually exist on the ramp condition: the incline becomes an interesting terrain to occupy permanently, because you can deal with it, and also because, as a level, you can always see something from below, from above.

HUO:

You and I first met over the phone when I was with Rem Koolhaas, thinking about his exhibition design for "Cities on the Move" at the Hayward Gallery (London, 1999), and we decided to recycle your previous exhibition design, which is something that happens rarely because usually exhibition designs come and go, there is a tabula rasa *thing, no traces...*

ZH:

Yes, I agree. In all museums, if they do an elaborate installation, it's not precious enough for them to keep, so they chop it up and throw it away. They could be recycled, or reused. Even if a person doesn't like it, it doesn't really matter; what is more interesting is how other people combine it, and how a show could be different with these

combinations. For example, the Guggenheim always has these shows in the central space, where they have the artist do a piece, and Thomas Krens has kept them all, or many of them, and these have resurfaced as big objects in Bilbao. But it was obvious that they had been done for the New York Guggenheim rotunda because they were obviously cruder, rougher than the normal things that these guys do. So it would have been nice if they had been combined in a kind of territory of all these objects, since they are all related to this idea of the rotunda: some of them were hung above, some are big pieces, like the Dan Flavin piece. This piece was stunning in the Guggenheim, because it was supposed to come up to this level, suspended from the ceiling. Because of the psychological impact it has on you, that it might fall on you, they dropped it to here, and everybody thought that it would touch the ground, but it never did. And when you know it doesn't touch the ground, as an installation piece that is the most interesting thing about it, not because of the element of danger, but because it's precarious. It's the same with Richard Serra's pieces: what is great about them is not only their size, but also their material. And when they were shown at the Dia Center in New York, the place was so small that they were close to each other, and it was spectacular because they were so tight, and you know they're made of steel. It transformed that space completely, and also the space had an effect on it and that is what is interesting about the installation: that dual effect. But fundamentally, I think you can test some ideas, which you can also want to expose—not that you are competing with the art. But I always think there should be more than one take, because, again, there isn't one single view on anything. And the reason, it seems to me, that installation art is so popular and, at any rate, interesting, is because people see it in different ways.

HUO:

How do you explain that the excitement for transdisciplinary approaches in museums has faded in such a way?

ZH:

Well, I think the misunderstanding is that they think that when architectural designers do a space, it conflicts with the art. I find that incredibly ridiculous, because how could something distract? O.K., if it's something done very badly... But on the other hand, if you think about major art pieces which are installed outside buildings—public art or land art—this is not a place where you can define space: you have no take on the pavement, or the landscape you install it in, but there, the beauty is in inhabiting strange conditions. I once had

a great experience with Christo, when I went to the Reichstag wrapping; it was a signal that this idea that the populace does not enjoy strangeness had been eradicated. There were millions of people singing and dancing there, who had all flocked to see this building wrapped, because that was a strange idea.

HUO:

And he actually anticipated the {Frank} Gehry-Bilbao effect.

ZH:

Exactly, a few years before. And so it was an extraordinary event, and historically very critical, because people are not just fascinated by the idea of wrapping an object, but how you wrap it, how you make something. And it's a similar intention when you do an installation, because you're looking at two things: the art piece, and the way the space forces you to move in certain ways, which is what I find interesting about it. Many years ago, somebody who was writing about me said something like "Zaha used to do many exhibitions, like in the AA," as if it was meaningless. But what they don't understand is that that was the only venue, the only place in which you can actually explore and discuss these ideas through these means. So again, installations are interesting because you can test some of these ideas, and also discuss them with others.

HUO:

I interviewed other architects, like Peter Smithson and Cedric Price, who both insisted on the fact that exhibitions in the '60s were thought of as places to test ideas.

ZH:

Yes, exactly. But now people think that if you're an architect, you only do particular things, if you're an artist, you do particular things... People are always asking me: "Why are you interested in doing installations?" And I answer, "You know, I'm interested in very different things!" I liked doing the dance piece with Frédéric Flamand (*Metapolis Project 972*, 2000) because I was interested in ideas of movement, and in the seamlessness between objects and costumes.

HUO:

And this is another link to the avant-garde, for whom theater was very critical.

ZH:

Yes, and for us it was incredible, because, as usual, there is always a small budget, and you have to deal with a stage...

HUO:

Where was this presented? Was this your first work in the performance medium?

ZH:

It was first done in Charleroi and then in Paris. Actually, we were approached ten or twelve years ago, by a choreographer named Rose-marie Butcher who also asked us to do a piece for dance. It was going to be done at first as a rehearsal, and then we did one piece for her at the Royal Festival Hall which was only based on lines, and that was very interesting because I find choreography very challenging. The whole thing was done with tape, and the lines connected with the lines of the dancers. But we did another piece in which we tried to make these topographies like bridges; it was about the metropolis and landscapes, where the dancers could actually wear or move these pieces as if they were skirts. On the one hand, they seemed heavy, but on another, they could seem very light. The question was that of the relationship between the set, the body, and also what they wear and how these things could be totally seamless. For example, in one piece, the whole object was like a net, and all the dancers move through it, and it's really like watching an animation of a wire-frame model. These things are spatially very intriguing, because they can move with you and become distorted. And all of these tests eventual-ly lead to other things in terms of one's thinking. And what intrigues me is that other media actually have an impact on the work, because it's not something that we are always used to, or familiar with; it advances your general thinking. For instance, many years ago I was doing a project for a Verner Panton chair: we were supposed to paint them or add things to them, and I was wondering about what would happen if you would take a Verner Panton chair and melt it. This idea of melting was intriguing: if you stretched it, it could become a chaise; if you pulled it up, it could become a bar stool... We decid-ed to paint it, but what was interesting about that was that when you stretched it, it eventually implied a space which is very stretched, and also fluid, and when you compressed it, it became a very compressed space. That really led to other spatial things that we are doing: this idea of very fluid or compressed spaces, of elastic spaces. So, it went beyond the idea of making a Verner Panton chair: it led to other things. And to go back to installation, what is interesting to me is that you can do them quite quickly, and also, you can test them in so many different ways, materially, and so on.

HUO:

The Vitra Estate in Weil am Rhein, where you did the **Vitra Fire Station** *(1991–93), was such a place where ideas could be tested.*

ZH:

Yes, Vitra, ten years ago, was really the one terrain where they tested so many projects. They haven't done that for a while now, I think the purchasing of the Barragán archives stopped everything for a while.

HUO:

Because it took so much time?

ZH:

And investment. I had an argument once with Max Protech who sold them the Barragán pieces, and I don't want to be misunderstood about this, but I really think that it's a pity that they bought it. Only because I thought that Rolf [Fehlbaum]'s great draw was to commission artists to do projects. I am glad that the Barragán has a home, and I don't want to diminish its importance as an archive in any way, but his role as a client was very important. Because he was also interested in furniture, it started out with commissioning people to do a series of chairs that were not about normal ways of sitting. And that role was very critical because the Vitra production campus could become a place for many full-scale installations, and we're hoping it goes back to that.

HUO:

Is the Fire Station *a laboratory?*

ZH:

Yes, when we did the *Fire Station*, I always thought that the garage could also be used for events—as a performance and event space, and also for exhibitions. It has been used for exhibitions. The difficulty is that they want to touch it, but they don't want to touch it, to change the building. And if you don't touch it, you can't really use it as a gallery; you can use it as a raw space, and if you transform it, it might do something... But I always thought that you should really think about something interesting, like making another room inside the room, or a series of ways of installing the objects there, so it gives them a kind of life, a life beyond its life as a fire station. For example, it's very difficult to exhibit furniture, unless you think in advance about how this furniture could be used in different layers. And for furniture, I like it when they put them all on those archival shelves, but I always think they should make a kind of field, because putting a chair on display doesn't work. We have it at the ICA (*zaha hadid z-scape*, Institute of Contemporary Arts, London, 2000), but that was seen as a kind of a way where you can have objects above and on the ground, occupying different layers. About this idea of the podium, and going back to the example of the Guggenheim, many

of the responses to the Guggenheim show were because when they have mobiles on display, they always put a kind of low podium underneath them. I've always thought that that was ridiculous: the mobile is there and the podium is here, and so if you don't keep an eye on it, you fall on the podium. So that's why, when we did the room with the works of CoBrA, we thought of making it into something like a hill, so that it's no longer an object, but a sort of landscape. This way, the landscape almost pops up through the floor, and it becomes like a globe with these objects suspended above it. In turn, that led to the idea that the floor doesn't have to always be flat and devoid of obstacles; the obstacles are also seamless with the floor, like a landscape.

HUO:

Again we come back to this attitude that consists of using the exhibition context as a place to test ideas.

ZH:

Yes, testing ideas about how you can occupy spaces; but there is another element that I think is very interesting, which is about an interior urban condition. Many people don't really know how to occupy very large interior spaces. They think: "My God, it's too big!" That's always the comment. But the idea is to invent an interior complexity, like an interior urban condition: you won't have the experience of walking in a city, but it could be as enriching as the urban context of a city—that could really be sucked into an interior—and an installation would be a way to test that these very vast spaces could be occupied in different ways.

HUO:

Would this mean that these become more of a performative rather than a representational space?

ZH:

Yes, in the same way that artworks are tests for certain ideas, these installations too could be a test for certain ideas.

HUO:

Doesn't this analogy of the exhibition and the city take us even further away from the tabula rasa idea, since cities have so much to do with feedback loops; cities don't grow from a tabula rasa, *they are complex dynamic systems that happen in time.*

ZH:

I don't think we should try that in exactly the same way, but if one could translate some of these ideas, for example, how you can deal with very large interiors not only as an installation, but also as a different way of occupying the space... When we did the competition

for the new orientation center for the Victoria & Albert Museum in London (1996), for example, one space was about many terraces moving gently, so it was not one smooth ground, but many grounds. And the terracing goes with different kinds of modules, which cluster and separate, so the idea is that when you're higher up, you see things looking down, and when you are below, you can see things above. But it's done as part of a system that is a kind of repetition of the same thing, it is about how you can use one module to make a field that is flexible, or permeable, or fluid. And the idea for the Hayward floor was not taken from there, but based on a similar idea about how you can deal with museum spaces in terms of fields. So you can combine things together in a new working way: it can be seen as a kind of pixilated wall, or a shifted geometry of an exterior wall. But perceptually, I think the most interesting thing is how you would perceive these things.

HUO:

And how do you see the Mind Zone *(Millennium Dome, London, 1998–2001), another exhibition design of yours, in this context?*

ZH:

For the Dome, the whole idea of the *Mind Zone* was based on how to occupy this very large space as an interior urban landscape, and also the idea of the walls becoming the ceiling, becoming the floor, and vice-versa. The idea was actually to form a seamless installation on all these surfaces and to allow us to use material that could be used for all layers. Originally, we wanted to have a much bigger curatorial role on this show, and that's why we insisted on using many of the artists, because we thought that that should not only be a way of looking at the mind in a scientific way, that ideas of perception, ideas of language, of identity, for example, are very critical aspects of what we call mind, as well as interpretations on development. So it should not only be seen through textbook experiments, and a lot of artists now are really dealing with this idea of perceptual quality. You have two conditions, for example: the false perspective that diminishes, so it makes the figure bigger or smaller, depending on how you see it. There are moments when it's sitting like this and you see it from the back, in a photograph, and you really don't realize that it's so big. So there is this idea of scale, and the intention was that you combine the installations with time. For example, we had this ant colony, and they were hiding for five months, and now the ants have finally come out of their hibernation. They were imbedded in the structure; they wouldn't come out. After five months I thought they wouldn't come

out any more, but a friend of mine went to see it and said that he had taken his kids, and he said they were totally fascinated by these ants.

HUO:

Another thing that struck me when I went back to see it was the sound space made by Ryochi Ikeda. It is interesting in terms of exhibition that there is a strong visual primacy, and the sound and smell of exhibitions are neglected issues.

ZH:

These are very interesting phenomena, and not much is focused on them. Another thing that is weird, because you don't expect it, is the issue of scale in all aspects of architecture. And I think the idea that you can show video only on a straight wall is ridiculous. But there's never a seamless kind of environment. Actually, when I saw the 2000 Whitney Biennial in New York (Whitney Museum of American Art), there were some interesting pieces there in the video installations, quite intriguing.

HUO:

Could you tell me about your collaboration with the Pet Shop Boys for the stage designs of their world tour (1999–2000)?

ZH:

Yes, that was actually very interesting because you had to think about the fact that that show had to move to very different theaters: small ones and large ones. And you had to think about them in a system in which they could easily be taken apart in one night, packed in a truck and moved.

HUO:

So that's even faster than a traveling exhibition. It reminds me of Duchamp's "suitcase museum."

ZH:

Yes: every night, they have to uninstall, pack up, and go somewhere else. It has an optimum time: they have to do it within a few hours; they can't take any longer. And most of the time there was someone else performing the night before. For instance, when we went to the Wembley performance, we had a drink with them backstage, and when we came out the stage was packed in less than an hour. So you have to conceive of it in this way. And also, what these guys would use to walk up and down into a space had to be simplified because of this whole packing business. And since some of the theatres were very small and some very large, it had to work in both of these kinds of spaces. So we started from the idea of a landscape that can fold in on itself, then we thought of it as a kind of big suitcase that comes

into pieces, and then the two combined into a kind of landscape that goes into a suitcase to be shipped out. So again, it was about more than one level: there were two or three levels... And it was also that they could sit if they wanted... It didn't have to be the same routine at each performance: you could go up or down, you could go inside the enclosure... And like in the dance piece, they had these three special performances in which they moved a part of the set away, so they had to be big enough to whisk a lot away. So it was like an interactivity between the performance and the object. And it was almost like when, in a drawing, you see something as flat, and little by little it begins to lift up, like an animation, the question was how to do something like that in real life.

HUO:

The Villa Medici piece that you did for the show that I co-curated with Laurence Bossé and Carolyn Christov-Bakargiev, "(La ville), Le Jardin, (La mémoire)" (Villa Medici, Rome, 2000) is also a performative platform, as dance events took place there during the exhibition.

ZH:

Well, the Villa Medici piece was very interesting because it was an outdoor space, a landscape, and because you cannot really touch the ground in Rome, because of the archaeology. So we thought about how we could occupy this whole terrain given that I never saw it as a flat terrain, but always as a whole volume, and obviously not with a ceiling. The idea was how to begin to define the grid: not begin to shoot out from inside, but to kind of connect these buildings down through these elastic strings that also pull your view across. And what was really great about it when it was done—because it was an open terrain—was how the light changed these lines from invisible to visible: the lines flowing through the space.

HUO:

So did this Roman historical specificity also influence your plans for the Center for Contemporary Arts in Rome (Centro nazionale per le arti contemporanee, *1998–ongoing)?*

ZH:

In a garden, it flows and it returns, but in the Rome museum, the idea is that they flow and return, but they also disarray each other, almost like a new geological condition, but there is never the same repeated moment. And these lines can also make you move through a space as if you're going through a stream, almost as if you canoe into a space, a stream, or many streams, like a delta with many confluents of liquid spaces moving into each other, separating and con-

verging, becoming something else, connecting again... For instance, what is interesting when you're walking without a particular trajectory is that you meander into spaces and you discover things unexpectedly. When you go into the wilderness, you don't have a path, or something that tells you that you can only go through this path. And through that, you discover spaces and things that you didn't necessarily intend to. You can get lost sometimes, but these moments focus your view in different ways. For the Rome piece, you had to have an idea that once you remove the boundary of a particular site, there's no longer a fortified site, but you have to come back to the city and really reinvent these event spaces. The intention was to really make these event spaces into a field. So there is an equal importance of the space that is the occupied gallery space, which is enclosed into the open field: it is not made of just one space, it is made of many pockets that create an event-field. The idea in the Villa Medici piece is that these lines push you to meander through this field, and because you are moving around them, you have a different journey than if you had crossed it like that. And it also forces you to view the space in different ways: normatively, you just walk in and you see that and you walk out, but this makes you perceive things differently because of the way you're standing. People talk about the importance or non-importance of geometry, but geometry forces you to face things in particular ways: you are not always aware of the way your body actually rests against a wall, and such things. People always talk about how nice it is to go to the park: that is because you're not forced in this particular way. But people don't analyze it that way.

HUO:

The last question, which I ask in all interviews, is about unrealized projects: What is your favorite unrealized project or unbuilt work?

ZH:

It changes from time to time. We have a lot of unrealized projects, a plethora of them... What is difficult is that when something is not realized and you look back at it, you would change certain things. I suppose there are aspects of certain works which have never reoccurred, *The Peak*, for example: this idea that a public space no longer exists as a confined space here, but is suspended above: to shift the idea of a normative civic space, and the importance of the void for us really started with that project, and eventually it became very important, as important as the occupied mass. Düsseldorf, for instance, is very interesting in terms of adjacency: you have an office

building that is like that, and you see your neighbors but you can't touch them because you are separated by air. And what was intriguing in some of our recent work, like with the extension of the Reina Sofía Museum (Madrid, 1999), was that we were able to give the building a space that they never could have had because of the linear organization of the hospital. And also how it operates when all the levels are different, so you are slightly... not confused, but lost in this space. But also you can actually place yourself because of all the circulation that is always going through it. The whole organization of the museum is so linear, but they don't like it, so they make walls throughout the space. But here, because it's so narrow, you can't have a corridor; it's nonsense space. So the question is how to occupy this kind of left-over land in this incredible place in Madrid. About another project, in Cardiff (*Cardiff Bay Opera House*, 1994–1996), the idea of the artificial terrain was also very interesting: what it would really be like to be standing not only inside the opera house, but also under these enormous rehearsal rooms that are clustered above you as if they were in another world. And also to test ideas about acoustics in an opera house, to see how and if symmetry really works acoustically. But there should be a show of all of this, of all the great projects which we've done for all these cities, and which were never realized...

HUO:

Such an exhibition could be very interesting also in the sense that it would perform a distortion of space and time.

ZH:

Yes, because you can connect things that you've never placed in your mind at the same time... For the Cardiff project, we faced resistance against our asymmetric design of both the stage and the auditorium. It was claimed that the singers do not want to sing and perform on a stage that has no symmetry. It's an extraordinary thing. I was myself on a stage giving a talk on architecture, which was bizarre enough, and I could see nothing, nobody, it was totally blank, the reverse of giving a speech, where you have to see the audience. But you obviously sense the space, the parameters of the space. So it's very curious to think that someone who is supposed to have incredible creative talent is supposedly scared of asymmetry or any spatial feature that might influence their performance.

HUO:

Many cultural institutions have these defensive moments. Obviously, there's a fear of pooling knowledge.

ZH:

It's definitely a fear. One fundamental problem is that it's very dif-
ficult for them to be challenged on their positions. That's the fun-
damental problem: if you're challenged, you have to readjust your
views. I find that the most challenging thing, and that's the reason
why people do different things: travel, see different worlds, do exper-
iments... You need to understand that there are other situations
which are equally valid, and that teaches you something. The sense
of displacement can be very liberating because there isn't one par-
ticular way that your behavior should be. People don't like that.
They always try to make of you what they think normal people are,
and those people don't like to be challenged. It's very strange. Some-
body will come to you and say, "This is a sharp corner. I'm going to
fall over it." And you can say, "Feel it!" In my house, for instance,
there is all this very sharp-cornered furniture, and once some friends
of mine came with their children, and I was petrified because they
were this big and the table came up to here. But these kids were run-
ning around like in a park and it was amazing, because they were
very smart: three years old, running around, and when they came to
a corner, they just went around it. Because they had no fear, of
course, there could have been an accident, but none of them fell. And
I was really intrigued by that, and I thought, "Goodness, adults have
been so imbedded into one way of existence." And that has to be
continuously challenged and changed!

HALL, Stuart

Stewart Hall was born in Kingston, Jamaica, in 1932. He currently lives and works in London. Hall was educated at Jamaica College and he attended Merton College, Oxford, as a Rhodes scholar (1951–1957), where he received his Master's degree in Literature. He was the founding editor of the New Left Review *(1959–1961) and was then appointed as a lecturer in Film and Media Studies at Chelsea College, University of London, before going to the University of Birmingham in 1964 to help Professor Richard Hoggart establish the Centre for Contemporary Cultural Studies. There he was a Research Fellow, and then director of the Centre from 1970 to 1979, when he took a position as Professor of Sociology at the Open University in London (1979–1997). Hall is currently Emeritus Professor at The Open University and Visiting Professor at Goldsmiths College, University of London and chairs the board of two publicly funded "cultural diversity" arts agencies: the Institute of International Visual Arts (inIVA) and Autograph, the Association of Black Photographers, both in London. Hall has written and spoken extensively over the years on critical, social, and cultural theory, on media and visual representation, on race, ethnicity, cultural identity, and contemporary politics. Key works and articles include:* Encoding and Decoding in the Television Discourse *(1973);* Culture, Media, Language *(with Dorothy Hobson, Andrew Lowe, Paul Willis, 1980);* The Hard Road to Renewal: Thatcherism and the Crisis of the Left *(1988);* New Times: The Changing Face of Politics in the 1990s *(with Martin Jacques, 1989); and* Modernity and Its Futures: Understanding Modern Societies *(1993). His most recent publications are* The Question of Cultural Identity *(with Paul du Gay, 1996) and* Different: Contemporary Photographers and Black Identity *(with Mark Sealy, 2001).* Without Guarantees, *a volume of essays in his honor was published in 2000 under the editorship of Paul Gilroy, Lawrence Grossberg, and Angela McRobbie.*

........................

This interview was recorded over the phone in March 2003.

Hans Ulrich Obrist:

I'd like to open the conversation on the interdisciplinary or transdisciplinary aspect of Cultural Studies.

Stuart Hall:

From a very early stage, I've been involved with what has come to be called Cultural Studies; and although somebody or other has always been interested in questions of culture, and in that sense it's not a new field, Cultural Studies has emerged as a new field, partly because it has been preoccupied with the questions that conventional disciplines ignored or suppressed—the relation between cul-

ture and power, the material and the symbolic—but largely because of its transdisciplinary character. It was always drawing on the existing disciplines, whether those were in the visual arts, in media studies, history, literature, literary theory, sociology, anthropology—it drew differentially on all those fields, but it constituted the study of culture as essentially a transdisciplinary approach. Thus it always had to consider the nature of "the break" between inherited concepts and paradigms, and an emergent field (paradigm change is never a simple question of leaving one thing behind and "moving on to something new"). It had to be transdisciplinary because, I suppose, one understood culture then as a product of the interaction of a variety of different processes, which required a form of understanding that didn't exist within the heavily policed boundaries of the way in which knowledge had been carved up—largely in the academic, intellectual world. So one had to take a risk and transgress those boundaries in order to get anywhere. I don't want to present this as an easy thing to do, because I think you can get a sort of undisciplined raiding, a sort of free-floating across disciplinary boundaries, which isn't anchored in any serious understanding of how traditions of thought operate—and what we know about thinking is that you can't think outside of a frame, and very often those frames have been given, not necessarily by the academic disciplines in an institutional sense, but by the key figures who have occupied and refined the tools of analysis and the concepts and theories from within a broad disciplinary field. Take the field of sociology: in its weakly bound field, everybody is now a sociologist. Nevertheless, there is a real tradition of thought there, from Marx to [Max] Weber to [Émile] Durkheim to [Michel] Foucault and [Pierre] Bourdieu, from the German Idealists through to the French empirical sociologists, which constitutes a long line of thought. And I think that you can't just erase all of the lines of thought without understanding that we are losing something in doing so. On the other hand, the pressure of what is new, of the new configurations and their requirements, the fact that they, in their very intrinsic character, outrun and outreach the sort of knowledge that has been produced from within the disciplines, is a bigger challenge and one has to take the risk of going into the unknown. In Cultural Studies, we very much had the feeling that with our graduate students, we were making the field up as we went along. There was no such field; and we had to make them read all these other disciplines, but not so they would submit them-

selves to discipline, but to reach for good ideas and draw them out of their integument within particular traditions and lines of thought, and reorganize them around a kind of "field." The new idea of an interdisciplinary or transdisciplinary field of study is what has replaced—in really important new creative work—the old idea of the academic and intellectual disciplines.

HUO:

In a lot of the interviews I have conducted with Italian artists or thinkers, Italy in the '50s and '60s was presented as a real laboratory of transdisciplinarity—Milan in particular. Stefano Boeri, the architect and urbanist, pointed out how much politics played a role in bringing together disciplines—through political activism, poetry met literature, met cultural studies, and all other kinds of fields. Similarly, your work toward setting up the groundbreaking Centre for Contemporary Cultural Studies in Birmingham was anticipated by your work in the early '50s with the New Left in London. So would you agree with this argument of Stefano Boeri's that it is essentially through politics that disciplines meet?

SH:

Well, I know what he is saying, and it is true that the political upheavals of the '60s radically transformed the disciplinary fields— radically. But I am wary of the argument that politics alone allows the disciplines to reach across their boundaries and intersect. I think there is also something about the object of study itself, about contemporary society, about modern culture, and even modern politics itself, which is no longer intelligible within the old framework. This is really an "epochal" shift. So, if I might put it in such a crude way, reality itself escaped the paradigms. The paradigms became inadequate to the nature or the complexity of late-modern reality itself. Now, of course, to simply take a contemplative attitude toward that shift—and thinking that means we must take a lot of time to generate new paradigms—that in itself is not enough. It's not until one goes into a particular field, whichever it is: if one is in a cultural field, the politics of culture, or the politics of communication, or the politics of creativity, are just as relevant to this break-up of the older landscape as the politics of state power or the attempts to bring the new social movements into positions of efficacy in society. In short, my hesitancy is because I think politics itself has been transformed, proliferated: it has been widened in its meaning. It no longer means simply the system of representative government, nor just the state, or even the welfare state. It's much wider—to include what Foucault called "the micro-physics of power." It's the politics of food, the politics of

family, the politics of love, the politics of the body... So politics itself has been "transdisciplinized." And one has to take that into account before one accepts the rather old opposition, the traditional opposition between theory and practice, and the simple privileging of "practice" over theory. I don't want to go down that divided route. I'm a Gramscian—or the true Gramscian scholars would say "a sort of Gramscian!" I think you can't advance knowledge without being responsible for its efficacy in the social world (politics), but you can't understand your efficacy in the social world without making sure that you understand the world better than your opponents, and that requires serious theoretical work, it requires organizational work, it requires creative cultural work, it requires fighting in the streets—it requires a hegemonic strategy, which is essentially a strategy to become the leading force on many different fronts.

HUO:

In an interview I read recently, you talk about the years between 1956 and 1962 as the height of the New Left period and you mention the influence of Raymond Williams. Could you tell me more about your dialogue with Raymond Williams, and to what extent it was a trigger?

SH:

When I talk about a highpoint, I mean it in perhaps a more restricted way than you understand it: I mean it's the high point of that form of the New Left which came into existence in 1956 in opposition to both the Suez War and to the invasion of Hungary—so it was an independent left position which was opposed to the imperialism of both sides. That New Left then developed into the *New Left Review* and that particular formation sort of began to fall apart as an organized political tendency by the early '60s. The *New Left Review* continued to exist, but it didn't have activist politics of any kind, it was principally an intellectual and theoretical position. So that early New Left has its high point right around those years. And if we're talking about that, people like the historian Edward P. Thompson, who charted a much broader conception of class and class conflict than we had been working with before, and Raymond Williams, who gave a much deeper weight to the notion of culture itself—these are key figures in the formation of that "first" New Left. However, there is a sense in which there are many New Lefts: the New Left of 1968 is another kind of New Left, and we have seen a kind of continuity in the attempts to put together what I would call "Left positions" that are neither Leninist nor Social-

Democratic, that are somewhere between the organized bureaucra-
cy of the Social-Democratic Labour parties of that type and the Sta-
tist recipes of Leninism and the Stalinist experiment. That is a
broader way of thinking about the New Left, and I am astonished
how, despite the fact that the historical conditions radically
change, somebody is still bringing to bear on the new situation
what I would call a kind of "New Left attitude." I don't want to
claim that everybody is an inheritor of what we did in the '50s and
'60s, far from it, but I am charting the existence of a continuing
form of political and social consciousness, which is sometimes well
organized and at other times seems to be ebbing and doesn't come
to the forefront, but keeps returning to the stage as the only real
long-term strategic alternative we have to those of Neo-Liberalism
on the one hand—into which liberal democracy and social democ-
racy is increasingly absorbed—and on the other side, the kind of
reverie and nostalgia for the Winter Palace and the Proletarian
State.

HUO:

*How do you see this at the very moment? It seems that in a big part of
Europe, we have a sort of disappearance of the Left and at the same time a
sort of reemergence of different forms of the "Leftism."*

SH:

Well, I was careful to say that I don't think that what I call the pos-
sibility of the New Left has been a continuous political presence
throughout the period. It has waned and risen within different sit-
uations. I think the Left in general received an absolutely massive
blow as a result of 1989, and this is an astonishing thing, because
there were many of us who had never believed in the Soviet exper-
iment, we'd never been Leninists in that dramatic sense, and not
even in the Slavoj Zizek upside-down sense. Since 1956, we had
been looking forward to a breaking up of the ice flows of the dif-
ferent cultures and movements that had been congealed in the
Soviet model. So it was astonishing to us that, instead of a sense of
liberation and a sense that a New Left had incipiently reappeared
in the Velvet Revolution, in the consumer revolutions in Eastern
Europe, in the cry for some alternative between America and the
Soviet Union, etc.—we were astonished that that hope was swiftly
swept away and that in its place came a kind of recoil or general
defeat of the Left including the Social-Democratic Left. It was
hammered by the collapse of the Soviet Union, which is an aston-
ishing thing, if you think about it, because it had fought the Stal-

inist model its entire life! It was also derailed by the way the gospel of the free market and neo-liberalism captured the former Soviet Union and Eastern Europe, leading to the disastrous "mafia-capitalism" we see in that part of the world today. So we're not beginning now from a very positive base, but all that I can say is that "New Left" sensibility will resurface, since it is the only place we can find a principled objection to the world of neo-liberal capitalism which is not based on a desire for a return to bureaucratic and authoritarian Statist socialism. It won't look exactly like the New Left did in the '50s and '60s (it will be radically more global), it won't look like '68 (it will be less anarchically libertarian), but it will have about it something that will remind you of the attempt to hold to Left values and positions and at the same time steer some independent pathway between what have been the two monolithic alternatives that have dominated the second half of the twentieth century and will try to dominate the twenty-first century.

HUO:

In this framework, how do you see the question of Utopia? Molly Nesbit and Rirkrit Tiravanija and I are currently engaged in a large project called "Utopia Station," which is an exhibition project, but also a workshop involving philosophers, artists, scientists, poets and so forth, to figure out the role and the definition of Utopia now, and also to challenge the sense of obsolescence of Utopia after the fall of the Berlin Wall. What is your relationship to the question of Utopia?

SH:

I suppose it depends on how one defines it. If you think of utopias as imaginative explorations of the horizon of the possible—what could be, beyond the brute fact of what already exists—then it seems to me that anybody who is interested in change of any depth must be a kind of utopian. Only those that Gramsci calls the traditional intellectuals, those who align themselves with the existing dispositions of power, only they can hope to stifle the utopian impulse, because they don't want to get beyond what we already have, which is their horizon. [Francis] Fukuyama in that sense is an anti-utopian, since he thinks that liberal democracy is the last expression of the hope for freedom and liberation that mankind will ever have, and what we have now is the end of ideology, the end of history. The concept of history cannot exist without a utopian dimension—an opening to the future, a sense of history's undeclared possibilities, its necessary contingency. People of that persuasion have to be committed to the notion of what we might become as well as what we are. In that sense, Utopia is absolutely

critical. But there is one side of me that is cautious about Utopias, because I am also aware of the fact that, though, in the past, utopias have been capable of furthering the imagination—especially the utopias of artists, which have been massively important in opening horizons and breaking up existing landscapes and continents of epistemological knowledge, and crossing the difficult frontiers to re-map the world—although that is essential to the project of change of any kind, nevertheless, another side of the project of change has to be scrupulously realistic about the existing disposition of power. In that sense too, I'm a Gramscian: "pessimism of the intellect, optimism of the will." You have to know how bad things are. And believe me, in the beginning of the era of Neo-Liberal globalization, dominated by the American imperial ambitions and the military's "overwhelming force," we are in grim times. The prospects are exceedingly grim. And we are going to need all the resources of understanding to really grasp—as Marx tried to ground his outlook not by writing utopian essays about socialism but by unmasking the operations of Capitalism in the present. We haven't yet been able to define the present at all, and you have to define the present before you can know what has not been hegemonized in the existing system, that is to say, what Raymond Williams called the emergent elements—the elements that have escaped the configuration of Neo-Liberal military dominance by the West, the free-floating radical elements, if I can use a biological metaphor. That is exactly what will trouble and undermine the existing structure of power and authority—that is the constitutive outside of the present, as [Ernesto] Laclau and Judith Butler would put it. Those are the utopian elements which one has to correctly identify (not be falsely optimistic about) in order to build them back into our understanding of "the system," so that our knowledge of the present now becomes an understanding of "the system *and its contradictions*." So I am in favor of Utopia, always opening out the horizon to the possibility of what can be, what remains possible but not yet accounted for in the existing system of power and hegemony: what *we* can become, how we can produce ourselves as new subjects in the world. But I think there is a harder tension to the analysis of exactly how the contemporary system is working; and remember that we are talking about a contemporary system which has itself been radically transformed. The new global capitalism is a different beast from the old industrial one. The new imperialism that we are seeing today is a global one; it's not the old

imperialism of conquest or mandates and occupation. So these new dynamics really require as much of the mental capacities as we have, and they're not unfortunately utopian, they're only too pragmatic, needed to address the world as we find it. But we have to understand this before we can be "realistically utopian"—before we understand what are the real contradictions that allow other elements to be free to be reworked into a system which is more progressive, more humane, more socially just, more equal than the one we have in existence now.

HUO:

This brings us to an urgent question about the now, since we are doing this interview a few days after the war in Iraq has begun. Throughout the '80s, you were one of the key opponents to the Thatcher administration and the Reagan administration, so I was wondering about your current involvement and forms of resistance with regard to the Bush-Blair alliance.

SH:

I don't have a lot of involvement, because unfortunately I'm not terribly well, I'm not very mobile, I'm on dialysis three times a week, I can't even stand in long demonstrations. So I'm not very involved like that. Mentally and intellectually, I'm passionately involved. I'm working as hard as I can to unpick and undo the terrible compromise which the Blair New Labour has imposed on the situation. It is a species of transformation which, paradoxically, under the aegis of "modernization," a sort of welfare-state Social Democracy is transforming the country into a Neo-Liberal globally-oriented society. The Thatcher-Reagan moment was the moment of radical rupture, and the emergence of neo-liberal globalization. But what we see now in Blair and elsewhere in Europe is the combination of a (weak) social democracy and a (strong) globally oriented neo-liberalism. And this combination—what Gramsci would have called "transformation," or a "passive revolution" and the Clintonites called "triangulations" (borrowing equally and indifferently from left and right) is horrendous since it is better than Reagan-Thatcher in dealing with residual social problems, and is much more effective at disorganizing the Left. This therefore represents a further expansion, a deepening on a global scale, of that break which was constituted in the mid-'70s and '80s by Reagan and Thatcher.

I was opposed to Reagan and Thatcher at that time because of the whole introduction of a Neo-Liberal approach, but I wrote as much

at that time on what Labour would have to do to effectively count-
er "Thatcherism." What I tried to say was that, unless the Left had
a project which was equally hegemonic, equally wide-ranging,
involving the drawing together of philosophical, intellectual, the-
oretical, active, institutional, trade union and labor movements,
new social movements, current elements—unless Labour could
confront the Thatcher-Reagan era with as broad a counter-hege-
mony as they had created—it would be captured by its enemy. It
would take power, when it did finally take power, on terrain
already re-circumscribed and redefined by the Neo-Liberal break.
The Left would have no other place to go but to repeat, mimic or
ventriloquize global Neo-Liberalism within its own framework—
which is exactly what Blair has done, and other Neo-Liberal Social-
Democratic governments have done too. So I've seen this coming
for a very long time. On the day of the election of the first New
Labour government, Martin Jacques and I wrote an article in the
Observer entitled "Thatcherism with a Human Face." And I'm cur-
rently doing work trying to understand exactly what the triangu-
lation between a minority social-democratic redistributive element
and a dominant Neo-Liberal agenda, which constitutes the distinc-
tiveness of the Blair agenda. That's what I meant earlier on by say-
ing that there is a lot of work to do to understand how the
"Blairite" form of Neo-Liberalism differs from the Reagan-
Thatcherite form of Neo-Liberalism. That is also compounded by
the fact that, in the '80s, when I was writing about Thatcherism, I
didn't sufficiently appreciate that the reason why Neo-Liberalism
had been able to make such grounds in the '70s, was because of the
transformed geo-political that is to say, because of globalization
itself, which had transformed the politics and economics of the pre-
vious 200 years. This is something which Immanuel Wallerstein
has made very clear: for a long period, there was room for strong
labor movements, strong movements of the Left, strong Social-
Democratic parties, etc., to wrest something out of the system
(welfare reforms, some redistributive measures). That could only be
done in a period of strong Nation-States, when politics were being
decided by social forces within the framework of the Nation-State.
You couldn't battle within that to do something about Africa, but
you could do so to win some welfare-state National Health Service
kind of compromises for poor people within the society. Globaliza-
tion has transformed that: you can't fight those battles within the
Nation-State framework any longer, and that is the reason why

Neo-Liberalism is now, by definition, a global operation. And why the field of American hegemonic power is no longer an old kind of imperialism, but much more, as [Michael] Hardt and [Antonio] Negri name it, a global empire, an imperializing of the global framework. I don't agree with a lot of other things that they say in *Empire* (2000) but that stress on globalization as a new form of sovereignty, new form of hegemonic power, and radically de-territorialized, is absolutely key to what is going on now. So, this is what, if you're relatively immobile as I am, you can do: you can urge people to think more profoundly about these questions—and about how these new realities change the nature of the struggle to reform and transform them.

There is beginning to be disillusionment among the younger echelons in the UK—the political technicians and managerialist of New Labour—that went with Blair in 1990. Some of them now say, "We hated what you said in 1997, when the Blair government came in, we hated the issue of *Marxism Today,* which you published, that simply had a picture of Blair on the front with the word "Wrong!" We had resurrected *Marxism Today* for one issue, we held a conference and published a critique of the Blair government, in its first term. Nowadays, some people from the Blair Left are beginning to withdraw from it, now they see what the full implications of it are, both in terms of the Iraq war, the new civilizational struggle, the paramountcy of American global interests and the doctrine of the preemptive strike, and in terms of the privatization of public goods. There's a new dialogue to be had, and this is beginning to reenergize a wide range of people, including many who were traditionally non-political, towards left positions. So what I can do is to help put together a kind of intellectual resistance movement to this global neo-liberal shift, and to try to analyze it better, and to prepare for the time when, politically, people might be willing to say: "We've tried the Thatcherite option, that didn't work; we don't like the Reagan or Bush option; we've seen what New Labour does, and what it does it to give us a sort of Social-Democratic version of Neo-Liberalism—what is a Left position that is not that?" At that point, we ought to have some answers.

HUO:

I would like now to ask you about the Centre for Contemporary Cultural Studies in Birmingham, particularly about the Centre as a model of collaborative research, which is something that is particularly missing now.

How do you envision this retrospectively, with the distance of time, what made it work in a way most universities don't work?

SH:

Well, retrospectively, I would say it was a utopian moment! It was before the heavy organization of graduate students' work in England: you couldn't do the Centre for Cultural Studies now. In those days, there was very little organized graduate work, people did their PhDs more or less individually. So we set up the CCS mainly for M.A. s and PhDs to do graduate work. We wanted students who already had a discipline and were dissatisfied with its limits; so in breaking from the discipline to these new questions, then they could come to the CCS. So it was decidedly transdisciplinary in that sense. We took graduate students from literature, sociology, anthropology, foreign languages, and media studies, etc. We didn't have a lot of students who were from the creative arts.

HUO:

So there were not many artists there?

SH:

No, there were not. And what that reflects is the particular structure of art education in England, where the universities are not deeply involved in artistic training. Until recently, the big art and architecture schools functioned slightly separately from the universities. So it wasn't at all a surprise not to find creative artists operating within the Centre, because we couldn't validate them because our students were required to write very standard PhDs. What I think accounts for the impact, then, are two things: one is how we organized the intellectual work of the Centre, which has become a kind of model for people who want to do this kind of thing in other fields. The other is the fact that what we address is culture, and that subject had an immediate bearing for a lot of people who were in the creative arts. Our subject matter and our organizational practice opened the door to a dialogue with artists who were themselves becoming more interested in theoretical questions. Cultural Studies became part of and in turn influenced a wider intellectual movement—that associated with what has been called "the cultural turn" (including post-structuralism, feminist theory, psychoanalysis, deconstruction, identity politics, post-colonial theory) which has transformed many of the disciplines in the last two decades. It was through that wider mediation that Cultural Studies spoke to the theoretical interest of practicing artists. They really forged the

connection. Retrospectively, I'm still really surprised to find how early on, practicing artists who had no direct connection with the Centre drew inspiration from the way of working at the Centre and from its publications. I, myself, have moved—I left the Centre for Cultural Studies, worked at the Open University (trying to take the Cultural Studies ideas to a much wider, less academic pedagogic constituency), and since I retired, my main work is with the Institute of International Visual Arts and with Autograph, the Association of Black Photographers. So I have moved toward those creative artists who are, as I see it, addressing the same questions that we were addressing theoretically and conceptually; the same issues. They have the same capacity to produce knowledge, although you have to understand how this knowledge relates to the theoretical knowledge that is being produced elsewhere. Everything doesn't have to happen in the same space or within the same languages, because increasingly, there is dialogue across those frontiers.

To go back to what I think was inspirational about the Centre's way of working. Because it was a new field, we couldn't set ourselves up as teachers in the conventional sense, as the exclusive owners of knowledge—we had simply read a few more books than our students! So we had to work collaboratively with them. They knew that we were often reading the next three texts a week before they did. So that exploded the myth of the professor and "his" [sic] apprentices. Obviously, we were at different stages of our lives, at different stages of experience, and so on, than our students, and there is no point in disguising that in a falsely utopian way. But essentially, we were in this together. It involved a very collaborative style. And that was compounded by the fact that we worked very much in groups, which were not formally required by the protocols of the PhD and not formally assessed by our way of preparing our students for research in a newly emergent, transdisciplinary field. So the groups were as often led by a student reading a paper as they were by one of us. There wasn't a lot of direct, formal, professorial teaching. We designed and ran the Master's program more as an introduction for people who hadn't had any sociology, coming from literature, or who hadn't read any literature, coming from anthropology, etc.: the transition point between intellectual paradigms. The M.A. was where the disciplines and their frontiers broke down and people started to speak one another's language. But when they got into the research groups, then in a sense they were helping informally to constitute a distinctive language or "field"—Cultural Studies.... The

thing that happens with most PhDs is that the first chapters are always extremely boring resumes of "the literature in the field": so and so said this, so and so said that... We decided to collectivize that activity, so in effect everybody read and "wrote" the first chapters defining the general field of research collectively! We were all reading these books, so what was the point of each person carving their own personal path through Freud, Foucault, Marx, or Weber, for God's sake! So we sort of collectivized that practice: each person, of course, had their personal theme or topic of research, but that was related to a kind of collective base in the study groups, and behind that, to a collective curriculum in the Master's program. Then, in the spirit of 1968, which we were very much informed by, we decided to collectivize the practice of publishing, so we started to write together and publish with our students.

HUO:

So you had your own magazine?

SH:

Yes, we decided to publish our own magazine. We decided to encourage students to publish before they submitted their theses— an unheard of thing in Britain! The wonderful book on subcultures and style by Dick Hebdige is his M.A. thesis! We told him: what are you waiting for? Publish it! And he did.

HUO:

It's another kind of Do-it-yourself project!

SH:

Yes. Well, first of all, we got a duplicating machine—actually two duplicating machines: one was for the requirements of the Centre's administration and all that, and the other was at the disposal of the students. They had the right to publish and circulate internally anything they liked. They could slag us off, they could publish counter-papers opposed to what we were proposing, they could publish counter-curricula to what we were proposing... That was a free space, and we had no control over it. We'd simply see these sheets of papers appear in our pigeon-holes... And at the collective meetings, which were always nearly a whole day's business, with endless collective debate... Organizational matters would have to be discussed, and some collective decision would have to be taken. So we collectivized the Centre's practice. Then we started the journal, *Cultural Studies,* which was edited by a PhD student—and again, a group of staff and students decided what would go in it. And after that, we started to publish books which were jointly

written. Me and four of my graduate students produced the study on street crime, racism, and the emergence of Thatcherite politics, *Policing The Crisis*, which has been immensely influential in the teaching of crime, criminology, race, and politics. Of course, there is some cost to all that—I don't want to present it romantically. Really changing one's practice is much more difficult than talking about it! Collective production takes much longer—we were producing *Policing The Crisis* for eight years. You don't get out of a collective book like that the kind of conciseness and coherence of thought and expression that you get out of a single-author monograph. But what you get is a more wide ranging, open text—more of a cascade of thoughts and ideas. And this "freedom" permitted a text which started out as a book about race and street crime to become an analysis of the political conjuncture which led to the rise of Thatcherism. And of course, collective writing was also an incredible discipline for the teaching staff, who had to see their precious words blue-penciled by their students!

HUO:

In a discussion with Philippe Parreno, we were talking about similar moments at the Black Mountain College, where a small teaching unit or a small school is so immersed in the present that one almost has to wear sunglasses. My impression of the Centre for Cultural Studies at that time was that it was so close to what was happening in music at the time, or in culture generally at the time, that it was precisely one of those moments.

SH:

Yes, it was a "sunglass moment" because what was happening in culture at that moment was also shifting in the brains and hearts of many of our students. So the opportunity to bring to bear the complex theoretical and conceptual questions on, as it were, their life-experience—their experience of the new music, of the visual explosion, of the new image economies, of consumption for the first time—to make those life experiences the object of rigorous analytical work, gives a different identification from the students with the project: they owned the project, the project was theirs as much as it was ours. I think there are only some moments like that. You can't sustain that forever. Cultural studies have become more institutionalized, there are more jobs in it—masses of them in the United States, but in many of them, the life and certainly the politics has gone out of it. So I think that one has to think of new analogues for the new situation, not repeat the old. But those creative moments are very important, and I'm greatly privileged to have had a place in one while it lasted.

HUO:

I spoke with Rudolf Arnheim recently, who was telling me that he believes such moments are always related, that they are not "XL" or "XXL," they are not large, but very often they are quite small entities. So I was wondering about the scale of the CCS, because it seemed to me it wasn't a huge group.

SH:

When I was there, the CCS had two on the teaching staff and one research fellow. It then expanded to a teaching staff of three. There were no professors, because they wouldn't make me a professor. In fact, they very much hoped to get rid of the CCS, as they have, as you know: it's been closed down recently. So, there were no professors, three on the teaching staff, and one research fellow, who was one of the graduate students: Paul Willis, who eventually produced many important pieces of writing about changing working-class culture and experience (e.g., *Learning To Labour*, 1977), and of course, there were the graduate students. I suppose there were about 15 graduate students at any one time that had their fees paid. And then, we allowed people who had not completed their theses or people who were teaching in the city to continue to come to our seminars—this was probably not formally proper, but there it was! In fact, there were often quite vigorous contributors to it, so they swelled the numbers to about 25, I suppose; never any larger than that.

HUO:

So you would agree with Arnheim on that point?

SH:

Yes, I do think scale has something to do with it. I don't want to be romantic about this; I didn't oppose the institutionalization of Cultural Studies because many more people have had access to it than could join a little creative group like that in '70s. But I think that is a different kind of work: it is educational and pedagogical work. The moment when the flame catches, which is a very creative moment, has a beginning and an end. It's very much related to a kind of condensation of all the elements—artistic, aesthetic, cultural, political, etc.—in play at that moment, and a certain opening of the institution allows it to happen before the institutional gates close again. So these are temporary flames, I would say; the fire flames up in these places. And if you were thinking about doing it now, I suppose you wouldn't go to the university to do it, you certainly wouldn't go to the British universities—which have become managerialist nightmares—to do it! You would look for

another place which might become a kind of center of radical theory and productive work.

HUO:

This leads me to a question about your dialogue with artists. I remember a conversation between Isaac Julien and Mark Nash where they speak about your decisive influence on artists. I'm also in contact with a younger artist, Zeigam Azizov, on whom you are also a great influence. How would you describe the importance of these very concrete dialogues with artists?

SH:

This is absolutely essential. It started earlier on: I was interested in film, in photography, in the visual arts, but I didn't know professionally about any of them. But I taught film and television at a very early stage, long before there was anybody teaching film and television in British universities. So I've always been interested in that side of the arts, and of course, as the electronic and the digital media become more central to the visual arts, the question of the image has precipitated this shift from art history—in which I had no formal training —to visual culture, which I know a lot about. That's made it a lot easier to talk to practitioners in the arts. Of course, I'm the learner and they are the teachers. It's been wonderful for me to have the privilege of going alongside their work, of talking with them about it; of helping the two institutions whose board I chair to nurture and nourish the creative work of younger artists, especially those from the diasporas and the South. I'm very involved in building a new art center in London which will house these two institutions and which will showcase both the works of that diaspora generation and of comparable international artists who don't get seen in the current global international art market, as it's represented in British mainstream galleries and institutions. So this is very, very important. And I've been writing more in this area. I wrote the text to a book on contemporary photography and black identity with Mark Sealy of Autograph, called *Different*, published by Phaidon last year (*Different: Contemporary Photographers and Black Identity*, 2001). I've just written the introduction to Sunil Gupta's collection of photographs. I'm writing in Gilane Tawadros's catalogue for the African pavilion at the Venice Biennale (50th International Art Exhibition, 2003) and I wrote with Sarat Maharaj those conversations about "difference and translation" which inIVA published as *Annotations 6: Modernity and Difference* (2001).

HUO:

We've also found a marvelous idea for our poster for the "Utopia Station" in Venice with Zeigam...

SH:

I've had excellent conversations with Zeigam for more than three years now. I've been extremely interested in his migration project, *Migrasophia* (2001), and we've talked about migration and hybridism and all of those concepts extensively. Zeigam Azizov is really on to something very profound about contemporary art and culture—a concern with how the relationship of "otherness" between the conditions of displacement in the modern world and the contemporary artwork, which is no longer marginal—a problem for the minorities only—but is absolutely central to mainstream aesthetic and political consciousness. Interestingly, for me, his experience arises from the *new* generations of migrants—that of the asylum seekers, the refugees and economic migrants and the *sans papiers*, often from Eastern Europe and the former Soviet Union, as he is, or from the Middle East and North Africa, who constitute the emerging objects of vilification and racism in the West today, and who are the site of a new kind of "differential" cultural racism, which expands the older skin-color and biological-based racism.

Really, I feel extremely lucky, at the end of my life, in my seventies, to have found such creative dialogic relationships with younger artists, at the height of their creative powers: and to discover some unexpected points of convergence between their work and mine. So this is a very important and novel aspect of my life today. It is partly because I have moved on a little bit from what I would call the analytical and conceptual moment towards the knowledge-producing capacities of the creative arts. That is only a slight transition, because I carry all the conceptual baggage from the first moment into the second, but the second adds something. It adds a new dimension of the transcription into the visual, it operates in languages, in registers which are different from that of the cognitively conceptual. And I regard that as equally productive of new kinds of knowledge about the world as theory was in a previous moment of "the cultural turn" in the '70s and '80s.

HUO:

One of the artists you have been in dialogue with the most is Isaac Julien. He's told me you've been involved in almost all of his projects.

SH:

I suppose it comes from the fact that a lot of my work is about migration and the diasporas. I've been very interested in the non-

European diasporas into Britain—not only sociologically and polit-
ically, but also aesthetically and culturally—since my arrival in
Europe in the '50s as a diasporic subject myself. I want to under-
stand the new forms of engagement with what I call "vernacular
cosmopolitanism," which one finds in the works of these diaspora
artists—the refusal of the absolute difference of cultural national-
ism and at the same time of the false promises of Enlightenment
universalism. I was always interested in those who used the arts and
the visual media to express and interrogate something about this
complex, double experience. And what I realized after a while is
that, since a great deal of the problems had to do with racial and
ethnic difference, the question of *difference*—which has been one of
my key conceptual concerns, is fabulously engaged and explored by
them within the visual media, within the visual register. The visu-
al is, after all, about the marking of difference, and racism is also
about differences: above all, about *visual* difference as it is inscribed
on the body, in "the epidermal scheme," as [Franz] Fanon put it, as
well as in other, less obvious categories of differentiation. There was
a coming together of those issues and a putting into question of how
to conceptualize difference—via [Jacques] Derrida's concept of *dif-
férance*—provoked by the construction of the new diasporas in the
Western metropolis and the first attempts of the art world in
Britain, obliged to be more attentive to the huge wave of creativity
among the second generation African, Caribbean, and Asian young
people which exploded in the UK in the '80s. I wrote an essay on
that subject for a conference at Duke University called "Assembling
the '80s," which will be published later this year. I was trying to
account for this enormously creative explosion which occurred in
the '80s and '90s, and for what I have called its deep engagement
with, and at the same time its movement beyond, "cultural identi-
ty." That is also the work I wrote about with Mark Sealy in *Differ-
ence*. Obviously, young filmmakers like Isaac Julien, John Akom-
frah, etc., who emerged alongside the visual artists like Sonia Boyce
and Keith Piper, Eddie Chambers, Sunil Gupta, Rotimi Fani-Kay-
ode, Zarina Bhimji, stand in the forefront of this movement, and...
were critical to my understanding of that moment. Do you know,
there were probably seventy or eighty exhibitions by diaspora sec-
ond-generation artists and visual practitioners in one year in the ear-
ly '80s—one year! A fantastically creative moment.

HUO:

*In the case of Isaac Julien, you not only wrote on his work and worked on
his narrations, but you also acted in some of his films.*

SH:

Yes, but you have to understand that this is not primarily "a col-
laboration." It is the result of meeting Isaac, seeing his early works,
like *Territories* (1984)—which, as you can imagine, for anybody
interested in anti-racist politics, is a wonderful film, a fabulous
film, because it gets at the heart of what is going on, but it doesn't
use simple documentary techniques of expression, it transforms
them. I was driven by that early introduction to his work. And he
has been my friend and conversationalist since then, and many dif-
ferent things have come out of that. But it's because I'm around
with him—we meet often—and I constantly want to know what
he's doing next, so we are always talking, a sort of continuous con-
versation. Also, he's an extremely generous person with a rich and
complex imagination, which he's willing to share with other peo-
ple. We talked at length about the *Looking for Langston* project
(1989), I looked at the script, and I still think it's one of the most
wonderful, sensuously erotic, films produced by any filmmaker in
that period—visually, a ravishingly beautiful film. And he knew I
thought that, so he asked me to do some of the narration. And then
we talked about his next project (*The Attendant*), and I said, "Isaac,
I'm not going to allow you to make another film without having
me in it! You had my voice last time, now I have to be in it prop-
erly." Well, he put me in it; I was in a nice blue suit walking
around the gallery, and I said to him, "Isaac, next time, I need to
wear angel's wings because it's much more interesting than the
things you get me to do. You get me to represent rational man, but
I want to express some of the angelic properties that you give to the
beautiful young men that you have in your films!" It was just a
joke, of course, but what I'm trying to tell you is that this is not a
formal collaboration, I don't collaborate with him in that sense.
His real collaborator is his partner, Mark Nash. But our conversa-
tions have "tracked" his projects, and I am grateful for the oppor-
tunity to "think" *alongside* him, and to learn from him and his rav-
ishingly developed "eye." We talked a lot about the Fanon film
[*Frantz Fanon: Black Skin White Mask*, 1995; 1996]—Mark Nash
was critically important in the conception of that film too—and I
was excited to be part of that, because I think he was trying to do
a new "poetic/intellectual" style of documentary, which engages
serious intellectual and political issues, using a range of archival

and other material, but not assembled in a naturalistic mode. His new film, *Paradise Omeros* (2002), is also something which he talked to me about: it's about the experience of coming to England and his relationship to his mother and to that older migrant generation to which I belong. That theme appears in a lot of the works that I don't take part in. As it happens we were both together in St. Lucia with Derek Walcott at the Documenta 11 conference on "creolization" when he started to film it. So this has been a rich series of exchanges over 15 years, and to be honest, I am still slightly taken aback to find how much he attributes to those conversations in what he and Mark Nash have kindly written, because I would never have said that myself.

HUO:

There has been a lot of discussion recently in the art field around geography and its changing relationship to mobility—of things, of people, of goods, and about the new landscapes that result, new cultural, social and virtual landscapes that cannot be described by traditional geo-scientific categories. What is your take on all of that?

SH:

Well, my period in Europe coincides with the period of mass migrations that followed the Second World War: I arrived in 1951, by 1953 substantial numbers of people from the Caribbean and the Asian subcontinent were coming as migrants to live in Britain, and the same thing was happening elsewhere in the old empires. So my whole project has been to write about not so much the Caribbean—although I have written about it too—but really about the diaspora in the metropolis. That is the kind of work I've done in terms of identity, in terms of race and ethnicity, in terms of cultural identity, and anti-racist politics—which is very much about how people who are not established, traditional citizens of a homogeneous European culture, can claim rights and responsibilities and find ways to survive in the new borderless world of globalization. I also wanted to understand how the old imperial world would and could deal with the strong traces of imperial consciousness which continue to be a legacy of the old imperial order. So the migration theme has figured in a lot of the work I've been writing right from the early stages. Now it figures even more because I think migration is a kind of paradigm experience, good and bad, of the latest forms of globalization. It's part of globalization from what I would call "above," that is to say, the additional planetary circulation of capital, money, messages, media, and

technologies—and interestingly, of course, one of the things that is not supposed to move is labor: people are not supposed to move; capital and commodities can move. Images, media, and technologies can move, but labor should stand still so that the developed world can take advantage of the low-wage conditions of the Third World. So migration is also, in part, a resistance to the logic of globalization, where some people say, "I don't see why I should stay here and starve or watch my children die of malnutrition and poverty, I want a better life too!" So migration is also coming into a certain kind of modernity, what I would call "vernacular modernity," modernity from below: the possibility of many modernities, that are not going to simply mimic the modernity of Europe or the United States, but that nevertheless is part of the ambition of ordinary people across the globe to live "a modern life," to live a life in the conditions which are accessible to people with the knowledge, the technology of a modern world. This, I see as the contest that confronts us, a contest between a globalization from above that will try to control and limit and bring under the sovereignty of global capital, and those forms from below, which are trying to either legally or illegally escape from, subvert, or challenge that. That's one of the tensions that makes migration a very contemporary fact. Migration is thus one of the most contradictory facts of contemporary globalization. But there is another aspect to it: another consequence of economic globalization is migration, due to the squeeze which the global system now puts on poor communities: on dispossessed people, on backward rural economies which can't survive the dumping of agri-business surpluses on the poor farmers in the South, or that are on the receiving end of American corporate agricultural firms that patent nature and sell them genetically-modified seeds that can't reproduce; who are exposed to the IMF [International Monetary Fund] and World Bank, which structurally adjusts them, obliges them to sell off and privatize public goods, and the WTO [World Trade Organization], which rigs the terms of trade against them, and pushes them into a free-trade, open market, trickle-down trap. Globalization is squeezing this other world in an extraordinary number of ways—and one of its results is to precipitate the spontaneous movement of people. They get on the trucks, the backs of buses, they try one time, they're sent back, they try another time, they climb under the wheels of aircrafts, they don't know what they're coming to, they can't speak the language, but they're on the move. These are

"the new multitudes." Then, a third kind of migration is that which is the result of violence—of the breakup of the colonialism and the failure of the nationalist project in Africa and elsewhere in the Third World, opening up the gap between ordinary people and the elites, and the impossibility of weak post-colonial states without social and economic change to establish an effective kind of life for ordinary people, and the way in which these elites are now bowled over or seduced by globalization, becoming local agents of the global corporate system. So we have quite a new kind of relationship between the poor and dispossessed of the world and corporate global interests, represented very much by the United States, but also by Blair, by European powers, etc. I think these are the lineaments of new configurations of power and exclusion. They're not exactly like the Cold War, or old-style Imperialism, but at the center of each of them is migration. And that includes the people driven across borders by vicious civil wars—and civil wars are a kind of privatization of violence in the absence of a strong and effective state. They're very much the result of the global trade in arms, in resources like diamonds and gold, which are used to finance the wars, and the international trade in drugs, both of which are the "dark side" of globalization. Migration is not, as the new racist Right would have it, the cause of all this, but it figures in each of these huge trouble spots, these huge maelstroms, these areas of contention and disturbance around the world. And I want to put that alongside what is obviously the positive aspect of migration, which is that, of course, as some landscapes break up, new landscapes emerge, new relationships are forged. People move from one place to another and they establish relationships with people and cultures who are quite different from themselves, whom they would never have met if they weren't in Paris, Amsterdam, Madrid, Rome, or London. This is the emergent hybrid vernacular metropolitan culture that is arising in the wake of global migration The new and the old—this is very much the contradictoriness of the new global system.

HUO:

As you know, the museum is not outside of this sort of worldwide evolution. I recently had a long discussion with Edouard Glissant about the museum he is setting up in Martinique under the model of the archipelago, rather than a homogeneous continent. I wanted to have your vision of this, which you've already hinted at in your marvelous lecture on "Museums of Mod-

ern Art and the End of History" at the Tate Gallery in 1999. What is
your vision of the museum of the future, what should a museum be like?
And what kind of museum do you like?

SH:

Well, what I see in the museum and gallery world is very much a
reflection of what I just said about globalization in general. When
we first started against the backdrop of that creative upsurge
among second-generation migrant young people, we were very
attentive to breaking the dominance of the national galleries, the
big commercial galleries, and the national art institutions in giv-
ing a highly Eurocentric account of Modernism. And there seemed
to be no space in the dominant art world story for the extraordi-
nary impact of the non-European world on European Modernism,
for the way in which Modernism had been taken up and indige-
nized in many places, including the Caribbean, Latin America,
India, and so on. This monolithic story was sustained in part by
national institutions. So inIVA and Autograph—the two agencies
that I work with—were funded by the Arts Council to try to
diversify the mainstream institutions. Their purpose is to knock
on the door of these institutions to try to introduce into the main-
stream the work of diverse artists, both from Britain and from
elsewhere, who are not working according to the canon of Mod-
ernism and the contemporary art movements in the immediate
wake of Modernism. But of course, the situation has changed,
because many of these big institutions have now, as a result of
globalization, bought "diversity," "gone global," they've become
"international." This is a new circuit: it's the circuit of biennales,
exhibitions, etc., which is in reality still a very closed circuit. It's
international in the sense that it's no longer constrained by the
Nation-state and national culture, but it's international only in a
very limited way, because there are first-division and second-divi-
sion biennales, (like Havana, Seoul, Johannesburg), which *the glit-
terati'* may or may not bother to go to. But you must be seen at the
big biennales and exhibitions which come out of New York, Lon-
don, Paris, Venice, etc. So there is a new kind of internationalism
in which the museums and galleries continue to play what I think
of as a very conservative, conserving role and function in a very
exclusionary way. They can't proceed without allowing some
openings to the outside, but these are very well controlled and
patrolled. What is really interesting is that outside of that, there
are also many smaller, more temporary collectives of artists, young

curators, artists working as curators, small galleries, small agencies who have made lateral connections, mainly of a global kind. They are speaking to one another around, underneath, and behind the big institutional, international conversations. This is my contrast between globalization from above and globalization from below.

Globalization from above has a distinctive cultural character. Because it is dominated by the U.S. and by Western Europe, by West-centric conceptions, and because it is tied to the cultural industries and the technological infrastructure of the developed world, and even the cultural works, artistic production, and cultural and popular art of these dominate that world, its effect is homogenizing. It is responsible for the tendency toward the Nike-ization of the world: making everywhere look the same, giving exactly the same look to every international airport, making every Big Mac, whether in Las Palmas or Moscow, exactly the same size, the same consistency, the same taste, etc., as every other. Standard-ization, homogenization—this is a very powerful geo-political, cultural thrust. It's part of the same thrust that thinks that the Middle East must look like Texas—everywhere must look like everywhere else: it must have a liberal democracy, a market society, a popular culture serviced by Western technology, etc. Imposing this universal model is what the hawks in the Bush administration think the New World Order is really about! And the homogeniza-tion that is going on in the art world is similar, but it's a tiny piece of a much larger puzzle. Now if that was all that was going on, it would be a pretty serious outlook, but I think that, just in the same way as illegal and illicit movements of people take place right underneath the nose of the control of labor and labor movements by dominant globalization, so in the arts and culture, there is a massive globalization from below. It is not institutionalized, it is not the same, but it will continue to rattle the doors of the insti-tutions. And since I'm not an alternative person, I believe in "the long march" through the institutions. I don't mind if some of the struggles are fought over the Tate Modern. We have to fight for the big institutions as well as the small ones. But the real agents of this kind of globalization from below, which is attached to difference, to heterogeneity, to pluralism—it doesn't intend to subscribe to one artistic form, it's not captured by one artistic language any more than by one political paradigm, one form of state or one style

of economy—represents the coming of a multi-polar world, genuinely global, as opposed to a neo-global world. In that context, the connections between artists who know more about what is going on, across the divide between North and South, the West and the East, etc.—these are the real growth points at the base of a different kind of global consciousness, what I call the seedbed of vernacular modernities.

HUO:

As a last question, I wanted to ask you a question I ask at the end of every interview, a question about unbuilt roads. What could you tell me about unrealized projects of yours? Unwritten books, but also other kinds of projects you haven't had time to complete, or were too big or too small?

SH:

Well, I suppose if I had another thirty years to live, one of these days, I would actually make something! I would become a creative artist, instead of an intellectual! [*Laughs*] But I don't think I'm going to have the time to do that...

HIRSCHHORN, Thomas

Thomas Hirschhorn was born in 1957 in Bern, Switzerland. He currently lives and works in Aubervilliers, France. Hirschhorn studied graphic design at the Schule für Gestaltung in Zürich. After completing his studies in 1984, he moved to France and joined Grapus, a Parisian collective of communist graphic designers. By 1986, the year of his first solo exhibition at Bar Floréal in Paris, he had abandoned graphic design in favor of the visual arts. Since then, Hirschhorn has been producing ephemeral and unstable constructions—he'd rather call them "displays" than "installations"—that overflow onto street corners or museum and gallery settings. In his work that often combines materials of waste and impoverishment, such as aluminum foil, plastic, cardboard, plywood, or pages torn from magazines with a wide array of cultural references through theoretical text fragments, Hirschhorn tests and longs for new forms of knowledge production. For a number of years, Hirschhorn has also been constructing outdoor precarious monuments, and altars that adopt the format of spontaneous public memorials dedicated to cultural and intellectual figures like Spinoza (Spinoza-Monument, Midnight Walker and City Sleepers, Amsterdam, 1999), Raymond Carver (Raymond Carver-Altar, 1998 in Fribourg, in 2000 in The Galleries at Moore, Philadelphia, and "Vivre sa vie," Glasgow, and in 2002 near the South Public Library at Miami), Gilles Deleuze (Deleuze-Monument, "La Beauté," Avignon, 2000), and Georges Bataille (Bataille-Monument, Documenta 11, Kassel, 2002).
........................
This interview took place in Paris in August 2001, and was revised in January 2002.

Hans Ulrich Obrist:

Maybe we should start by talking about your new project for the MACBA (Museu d'Art Contemporani de Barcelona) that has do with excavation sites and the kind of information one can retrieve when carrying out excavations ("Archeology of Engagement," 2001). What triggered this project?

Thomas Hirschhorn:

A soccer fan in the south of France was charged a fine because he had sprayed the graffiti "Allez l'O.M." ("Come on O.M." which abbreviates Olympic de Marseille, a French soccer team) onto a prehistoric excavation site. Since the sprayed rock also contained carved prehistoric signs, the sprayer was charged with damaging cultural patrimony. The judge basically excluded the possibility that "Allez l'O.M." could be valued equally to the old, carved signs. He overlooked the fact that in 20,000 years the phrase, "Allez l'O.M." could

be a subject of archeological research. I don't exclude that. This was the starting point for the work "Archeology of Engagement."

HUO:

Are you asking for a completely different approach to archeology?

TH:

In an excavation, the most diverse things come to the surface. It is not immediately apparent what is historically significant and what is not. It includes rubble and trash. An excavation is never finished, because there are always deeper strata which are not unearthed. An excavation site is like a never-ending construction site. And it allows for misinterpretations and incorrect judgments. You discuss the age, the value, and the significance of the individual found objects, and you have forgeries.

HUO:

Like with {Heinrich} Schliemann who in 1870 identified Troy's location through clues he found in Homer's Iliad, *but because he wanted to cause a sensation, he also falsely christened gold jewelry from the Troy II layers "King Priam's Treasure." And until today, nobody really knows the content or the possible extent of the entire excavation site.*

TH:

An excavation site is a place without hierarchy. No answers are given, only questions are asked. Time is frozen and the excavated objects are judged without establishing a hierarchy of value. That's why I chose the topic of "archeology."

HUO:

And so, for you, the graffiti artist hasn't really destroyed anything, but just added another layer.

TH:

Yes, that's the point. Why are the wall drawings that were made thousands of years ago considered art and the recently sprayed slogan considered vandalism? Does the passing of time only determine the significance? I am interested in these layers. I am interested in what exists outside the hierarchy of values, not in the hierarchy. That is why I wanted to combine the topic of "archeology" with the concept of "engagement." The engagement of a mercenary, the religious or artistic engagement, the political engagement, the engagement of an employee of a fast-food chain, and many other forms of engagement are questioned. I presented the most diverse types of engagement in an exhibition modeled after an excavation site. In "Archeology of Engagement" I wanted to raise the question of engagement in a value-free, nonhierarchical manner. I considered an excavation site to be well suited.

HUO:

Does it mean that visitors are meant to stroll through these various engagements like flâneurs.*?*

TH:

I wanted the viewer to keep a distance from the "excavated," the engagements. I wanted the visitor to view the different displays without comparing. I wanted the viewer to understand the site as a whole, and nothing in isolation. The viewer should not judge which engagement would be worthwhile, and which engagement will be forgotten.

HUO:

For this exhibition you worked very closely with the French art critic Jean-Charles Massera. What is particular about this collaboration is that he didn't write a text for the catalogue, but his intervention was part of your display.

TH:

Jean-Charles Massera wrote 36 texts for "Archeology of Engagement." These are not texts about my work. Rather, these are 36 texts that pose the question of engagement. Jean-Charles wrote the texts for the exhibition as an integral part of the exhibition. The texts were issued in French and Catalan, photocopied, and integrated into the exhibition in an edition of 3000. Visitors could take the copied sheets with them; they could either take one, several, or the complete set of 36 texts. I wanted to activate, extend, and mobilize the exhibition. Jean-Charles Massera's texts are part of the exhibition. They are integrated texts.

HUO:

And you've used those "extensions" or "integrations" before, no?

TH:

Yes, I have often worked together with authors, for instance with Alison Gingeras, Stephanie Moisdon Trembley, Manuel Joseph, Christophe Fiat, Marcus Steinweg, and Jean-Charles Massera. As one part of my last exhibition, "Wirtschaftslandschaft Davos" ("Davos as a Business Landscape," Kunsthaus Zurich, 2001), I included the screening of Rolf Lyssy's film *Konfrontation* (*Confrontation*, 1974). This might enable an extension of the exhibition if viewers come to my exhibition and then watch Rolf Lyssy's film, or if they only come to see the film. And if viewers visit my exhibition only to read or take away the texts, then a first step towards a broader audience is made. A catalogue text often reduces and remains inactive; instead of broadening, it limits.

HUO:

You are not only against catalogue texts, you are basically against catalogues.

TH:

The problem with catalogues is that they often want to assume authority. A catalogue is often intended to legitimize or revalorize the artwork. I reject that. A catalogue should inform, create knowledge, and discuss connections and contexts. It should provide space to raise questions, not try to convince me of the work's validity, and above all it should not attempt to intimidate through its size and style.

HUO:

From the very beginning, you've always designed the layout of your catalogues yourself.

TH:

Indeed, I designed several catalogues. This also has practical reasons: it is cheaper, it's often faster, and I can decide for myself which photos to use, because I do not share the criteria of quality established by the specialists: photographers, designers. A technically bad photograph is usually discarded systematically, even though it might explain the work better than other photos. For the layout of a catalogue, I also use the principle: "Quality No! Energy Yes!"

HUO:

What was your first catalogue?

TH:

My first self-made catalogue was a 46-page photocopied edition that I produced for a show at the Künstlerhaus Bethanien in Berlin in 1995 (*Thomas Hirschhorn, 1° Auflage katalog*, 1995). It was designed like a high school magazine, and included my own texts and illustrations that were often third and fourth generation photocopies. A photocopied catalogue has the advantage of being easily expandable and it can be produced and sold at a very low price.

HUO:

These strategies are found more commonly in anarchist and autonomous scenes and less in the art world.

TH:

Exactly. What is important is the distribution of ideas, positions, and manifestos, not the form and design. The photocopier is used as a tool to quickly and inexpensively duplicate existing texts and books. This urgency is reflected in the form of such autonomous and anarchist publications. It is not about owning your personal individual copy, but about the circulation and discussion of the contents. Luxurious catalogues exclude readers, while I want to expand the readership.

HUO:

So you consider the catalogue as a complementary tool to fulfill your objectives?

TH:

I try. For me, art is a tool to learn about the world, a tool to engage with reality, and a tool to experience the time I live in. A catalogue is part of this tool. My project *Les plaintifs, les bêtes, les politiques*, which I published in 1995 at the Centre Genevois de Gravure Contemporaine (Genf), was a work that only existed in printed form. The layout was composed of torn cardboard sheets, onto which I scribbled texts and glued various printed matters. The layout in and of itself was not interesting and became significant only when it was printed. I wanted the printed product not to be a result of a process, but its tool.

HUO:

But this project is also related to your "kiosk" work: printing books and constructing kiosks are two sides of an approach that is very concerned with the question of display and the modalities of displaying knowledge or information. Can you tell me how you developed the concept of the "kiosk"?

TH:

The work "kiosk" is the result of a commission to produce an artwork for the Institut für Hirnforschung [Brain Research Institute] of the University of Zurich. The project is a "work in progress." Over the period of four years, eight kiosks will be erected for a period of six months each. Each kiosk is dedicated to an artist or writer and has two primary functions: on the one hand, it should inform about the artist's or writer's work, and on the other hand, it should radiate energy through its presence. This energy, which is unconnected to the Institute's research areas, is the energy of artists and writers who created extraordinary achievements in their respective fields. I wanted to confront the researchers and scientists at the Institute with artistic and literary concerns. I wanted to use this neutral, functional, and aseptic site to raise irreconcilable questions and problems. The kiosk's form and construction method is precarious to highlight the project's temporary nature and its refusal of eternal validity. The researchers themselves rarely stay longer than three or four years at the Institute. Why should art be eternal?

HUO:

Whereas "public art" is commonly thought of as permanent, stable, architecturally concerned objects, your kiosks present impermanent, fleeting information. What's your opinion about public art, and do the kiosks fall into the category of public art nevertheless?

TH:

Public art has to be rethought. Public art is often boring, nondescript, and it is required to be easily maintainable. Usually this has nothing to do with art anymore. When developers and architects require the art to enhance the value of their building, or even to disguise constructive flaws, then artists can't work. There was resistance against my kiosk project as well, but the committee responsible for art remained steadfast and made the work possible. The work will remain only as an experience, through the memories and encounters. The only remnant will be a documentary video that assembles statements by users and staff members of the Institute, collected over the entire period of the project. These statements will engage the overall kiosk project as well as the individual artists and writers presented.

HUO:

Who are the eight protagonists?

TH:

They are artists and writers that I admire and whose work I love: Robert Walser, Ingeborg Bachmann, Emmanuel Bove, Meret Oppenheim, Fernand Léger, Emil Nolde, Ljubov Popova, and Otto Freundlich.

HUO:

The kiosk demonstrates to what extent information is homogenized. At the regular kiosks and newsstands, one usually only finds standardized publications distributed globally. Your kiosks create a counterbalance to this homogenization.

TH:

Actually, I rather wanted to create a counterbalance to the research activities at the Institute. I wanted to offer an alternative to the competitive research activities that are conducted at the Brain Research Institute, the Institut für Molekularbiologie [Institute for Molecular Biology], and the Institut für Neuroinformatik [Institute for Neuroinformatics] in Zurich. I wanted to convey knowledge about individuals that have achieved outstanding accomplishments in other areas and disciplines. But there is no requirement to take up this offer. The kiosk simply conveys the possibility of attaining information through its sculptural presence.

HUO:

Wouldn't it be nice to have a Robert Walser kiosk in Appenzell or a Samuel Beckett kiosk in Paris, etc.? To what extent is location important?

TH:

All kiosks in the world have something in common: their respective

placement. A kiosk is always placed either within or near an important building or next to a heavy traffic area. The kiosk itself isn't the event; it retains its autonomy in regard to the event. You have a train station kiosk, a prison kiosk, a glacier kiosk, an Eiffel tower kiosk, etc.

HUO:

You often use newspapers for your works. You tear pages from magazines and integrate them into your displays, catalogues, and books. What is your relationship to this material?

TH:

I don't collect material about individual topics over longer periods of time. And I don't have an archive or a system. I want to connect what cannot be connected; I want to bring together what must remain separate. I am not a scientist, researcher, or historian; I use what is already there and I work out of necessity. Every decision I have to make in my works is based on the guiding principle of my desire to "give form."

HUO:

So with the kiosk, the viewer can navigate among the information displayed as freely and as randomly and independently as you do?

TH:

Yes, when I achieve to "give form" and not create form. When I achieve to remain truly free with what is mine, then the viewer can also remain free: not out of randomness, but because I made my part of the work for which I assume responsibility. To be free with that which is your own is difficult, and even though I know that, I don't achieve it very often. I also know that what is truly mine also concerns the other. I incorporate texts, photocopied newspaper clippings, books, and magazines into my work for their information value, but also because of their energy. You don't have to read everything. Sometimes one sentence that you select may be enough. It suffices if you experience the unread text as a source of energy.

HUO:

You maintain a rather iconoclastic relation to your source materials. You puncture books and you pin them to the wall. You overwork and alter the magazine pages before they are entered into your work. Are you an iconoclast?

TH:

A punctured book still remains readable. It is not destroyed; I only irritate the readability. I have no respect for culture. I respect the human being, all over the world. Culture is not art. I reject it if culture and cultural artifacts are used to erect walls between people. Art is able to break down walls; it has a potential for exchange and dialogue. It can liberate activity.

HUO:

Could one describe your position as one suspended between iconoclasm and iconophilia? Is it a suspended position?

TH:

Nothing is suspended. It is a fight/battle/struggle between agreement and rejection, between love and hate. It goes back and forth, from one extreme to the other. And there are brief moments when energies collide and meet.

HUO:

Can you describe your method of collecting visual material for your works?

TH:

I regularly buy *Der Spiegel, Time, The Economist, Bizarre, Vogue, Newsweek, Al-Majalla, African Business, New African, Elle, Focus, Al-Mussawar, Al-Arabi, Business Week, Arrajol, L'Espresso, Cosmopolitan* or *Paris Match.* I also find fashion magazines in the recycling bin. Occasionally I collect magazines and journals about specific topics, such as hunting magazines, watch magazines, and sport magazines of all sorts. A well-assorted kiosk covers an incredible range of topics that people are interested in. I clip the visual material I find interesting and remove the images without any corresponding text or captions. Everything can be seen, comprehended, or not comprehended. John Heartfield once said, "Use photography like a weapon."

HUO:

Can you talk about an unrealized project that was very dear to you?

TH:

That's a project called *Conduit.* I proposed it for the exhibition "Voilà" at the Musée d'Art Moderne de la Ville de Paris in 2000. I wanted to construct a very narrow "conduit" that would lead from the street to one individual work in the museum. I would select the work from the permanent collection of the museum. Access to this conduit would be free of charge, but it would only lead to this one work and then back to the street. There is no other egress, and no alternative but to look at this one work. The "conduit" would be constructed from pallets, cardboard, and other available materials, and it would not allow for any access to the museum, but for an understanding of the museum's architecture. I wanted the viewer to visit the museum for one work only, and I wanted to bring the work back into the street. The project was rejected for security reasons.

HUO:

Do you have utopian projects?

TH:

No, none of my projects are unrealizable.

HÖLLER, Carsten

Carsten Höller was born in 1961 in Brussels. He currently lives and works in Stockholm. Höller studied Agronomy at the University of Kiel in Germany and obtained a PhD in phytopathology with a thesis on olfactory communication between insects. While still advancing his academic career until 1993, Höller began to introduce scientific topics and methods into artistic contexts, and thus undermined the formal limitations of science. In his works that include interventions in the public sphere, installations, films, sculptures, and architectural projects, Höller has been investigating the conditions of ways to "look at the world," mainly by deliberately—but often playfully—inducing doubts and confusion. Deviating from his original scientific approach, he no longer collects data or works towards objective results and his works quite unscientifically emphasize the notion of individual and collective experience. The viewer/visitor/passerby, or "user", plays the role of onlooker, experimenter, and "guinea pig" in "subjective experiments." Höller has been working both independently and in collaboration with other artists for over ten years. His work has been exhibited internationally, most recently in the XXV Bienal Internacional de São Paulo (2002) and in "B.OPEN" (Baltic, Centre for Contemporary Art, Gateshead, 2002), and he has had one-person exhibitions at the Fondazione Prada, Milan (2000–2001), the Museum Boijmans van Beuningen, Rotterdam (2002), and the Institute of Contemporary Art, Boston (2003).

..................

This interview took place in Cologne in July 1999 and in Kitakyushu in July 2001.

[1]

Hans Ulrich Obrist:

You were talking about doubt.

Carsten Höller:

I was talking about what I call my *Laboratory of Doubt* (1999). I am not at all desperate, but completely perplexed, and I'm thinking about how one could translate this perplexity into a proper form without transposing it into imagery. I am quite grateful for this perplexity. I used to suppress it for a long time because it is associated with uneasiness, which is a wrong approach—one should rather try to disengage one from the other and come to appreciate perplexity for what it is. Doubt and its semantic cousin, perplexity, which are both equally important to me, are unsightly states of mind we'd rather keep under lock and key because we associate them with uneasiness, with a failure of values. But wouldn't it be more accurate to claim the opposite, that certainty in the sense of

brazen, untenable affirmation is much more pathetic? It is simply its association with notions of well-being that gives affirmation its current status. What needs to be done is to sever the connection between affirmation and well-being.

HUO:

This has actually been under discussion since the early '90s, when people again started doubting the object and the art world's strategy to posit conclusive stopping points to artistic processes. There was a growing sense of doubt about the idea of occupying exhibition spaces. Felix Gonzalez-Torres articulated this in an exemplary manner by showing, in his art and his texts, that the crucial thing is to open up territory and not to occupy it. His participatory and process-oriented art, which developed in response to the art world of the '80s, inspired an entire generation of artists. Nonetheless, we are currently experiencing a return to the doubt-free, conventional art object; there's even talk of an '80s revival.

CH:

Many people act as if they possessed some unassailable knowledge, as if they had something in hand that gives them the right to behave the way they do. Artists pretend that they're not perplexed, that they're visionaries, which is the opposite of perplexed people; but in fact none of this is true, at least not on a first level of meaning. Perplexity is much more symptomatic of the situation we're in.

HUO:

Your starting point is doubt about the exhibition as a medium. The question is how to make this doubt exemplary, how to carry doubt and perplexity beyond the context of art.

CH:

There is a general sense of perplexity: although our living conditions could be considered relatively good, they aren't necessarily, but they should be, because we're materially secure, our infrastructure works, and we haven't had a war here in a long time. There are many reasons why we should be feeling fine, but we aren't, nor are we really feeling better than before. Of course a lot of things could be improved. But beyond that, the saturation of needs produces a form of perplexity once you begin to question well-being as a maxim for living. At the same time, the impossibility of achieving well-being for all creates a kind of perplexity: you reach an impasse where social ideas and political structures you once believed in don't make sense anymore because it is impossible to achieve any real improvement—since "improvement" itself cannot heighten your sense of well-being.

HUO:

I'm still wondering how you can manage to find a form or forms for doubt and at the same time escape any formalization of the idea. Isn't it a paradox?

CH:

I try to avoid the formalization of doubt in the form of a project; perplexity engenders further perplexity. I'd like to give expression to perplexity, but it doesn't need to lead to anything. The idea is to seek situations where perplexity can be experienced, even if that means sitting on a bench and being perplexed. When you give a demonstration of it you're not really perplexed, since you've already found a form to overcome perplexity. So that creates a certain dilemma.

HUO:

Your Laboratory of Doubt *is mobile; you move it from city to city.*

CH:

You know these cars with loudspeakers on their roofs? I'll drive through the city to give expression to my perplexity. If only I knew what to say.

HUO:

The laboratory is in your white Mercedes, on which is inscribed "Laboratoire du Doute," "Labor des Zweifels," and so on, in several languages. But you will not put it in a museum as a readymade, but use it every day?

CH:

Yes, I'll be driving around in it and eventually drive it to the biennial in Istanbul, where I'll present my "diary of doubt." The diary will be entitled *Days of Doubt.* It deals with doubt about my own enterprises. Every day I will select a photograph and write a text about doubt. The whole bundle will then be translated into Turkish and published as a small book that will be distributed for free in Istanbul ("The Passion and the Wave," 6th Istanbul Biennial, 1999). And two years ago I showed there my "Flying Machine" (*Flugapparat*, 1996), a contraption that evokes a mixture of bliss and senselessness. *The Flying Machine's* directional indeterminacy— it can only go in a forward circle—already implies the whirling of doubt ("On Life, Beauty, Translations and Other Difficulties," 5th Istanbul Biennial, 1997).

HUO:

In our last conversation you mentioned one of Baldo Hauser's numerous texts on your work, where Hauser describes doubt as one of your themes.

CH:

Hauser wrote: "Since 1989 C.H. has dealt with major subjects such as security, the future, children, love, happiness, drugs, means of

transportation and houses... It is no less than logical that he is now focusing on doubt, especially since doubt is not in itself logical; it is irrational but not necessarily destructive."

HUO:

The Laboratory of Doubt *as a mobile laboratory in the urban environment also evokes your very first works of the early '90s, such as your* Children Demonstration for the Future *(1991) in front of the Reichstag in Berlin.*

CH:

If you see children as vehicles through time and space for all kind of information... In this case, the children were meant to perform the hopeless task of demonstrating for "the Future" (the project was a failure). Vehicles have been a recurrent theme in my work. I once was in Sète, in the South of France, and in the middle of town there were thousands of starlings perching in the trees and shitting all over the place. Under the trees there was this car with a loudspeaker on the roof, and the speaker kept transmitting birds' warning cries, making this shrill martial noise. It was a totally absurd situation. An old man with an extinct, filterless cigarette in his mouth was driving the car, all the time sounding these warning cries. The starlings completely ignored him and crapped on the car. The car with the loudspeaker was also used for advertising. There's something old-fashioned about it: the car as a multiplier to disseminate doubt.

HUO:

In the meantime you also had the idea to buy a bus from the Paris transit system and transform it into a knot. Why did you abandon this idea?

CH:

The knotted-up bus would have been perceived as a sculpture. The knot is a metaphor for coming to a standstill, a Gordian knot, which would have connected beautifully to the bus as a social vehicle. But I didn't like the idea of seeing it as a sculpture, like some huge heap of metal. I may as well tell these stories as I'm driving through Antwerp.

[2]

HUO:

Can you tell me about your lecture for the "Bridge the Gap?" symposium that I organized with Akiko Miyake. You gave your lecture the simplest title possible: "Doubt."

CH:

I wanted to talk at "Bridge the Gap?" with Heike Behrend, but she unfortunately could not come. Heike Behrend works at the Insti-

tute of African Studies in Cologne, and she has published a book about the Holy Spirit Movement (HSM) in Uganda (*Alice Lakwena and the Holy Spirits War in Northern Uganda, 1985–1997*, 2000).

HUO:

You told me about it and I read it. It's on this young woman who proclaimed herself under the orders of a Christian spirit, who raised an army and waged a war against perceived evil and came very close to her goal of overthrowing the government, but eventually she was defeated.

CH:

When I read the book I thought this is the most strange thing I have ever heard of, as strangeness is actively used as a "weapon" by the HSM troops under guidance of the spirits which take possession of Alice, the movement leader: the HSM soldiers (which had no guns) were performing behaviours so bizarre that the regular army troop soldiers didn't know what to do, and often ran away. Strangeness is something we try to exclude all the time—this exclusion is, somehow, in the core of European and North American culture—because it is so profoundly disturbing and incompatible with a concept of the world. I thought it would be a good addition to the conference to have somebody talking about the existing strange. First, because it is the natural opponent of the natural sciences, and second, as for the artists of all kinds who are traditionally dealing with the matter, whenever we do something which is strange, it becomes immediately neutralized by being art.

HUO:

How do you go from strangeness to doubt?

CH:

The strangeness I am referring to from a more personal perspective is the feeling that there's "something wrong here." Something unexplainably wrong. It seems that we have developed a whole variety of methods to keep these disturbing feelings down. We have methods to forget that there are things that don't fit into our concept. These doubts of how things appear to be are not—and this should be made clear—the same as skepticism or as doubting everything. It's not at all interesting to doubt everything. Most have had a phase as children when they thought that everything they perceive is somehow not the way it seems to be; that's something we luckily pass through, otherwise we wouldn't be sitting here, but would probably have ended up in some kind of hospital. However, there is something which remains, which is more difficult and vague, and which I would rather call an insecurity than a fundamental doubt or an ontological suspicion. If you feel that not

everything is the way it seems to be, then what do you do with the things that are the way things seem to be? The kind of doubt I would like to work with is difficult to talk about, because it's really not a matter of language. Spoken or written language seems to be "against" it, possibly because language is based on rules, order, and repetitions, on certainties so to say. However, there are a few aspects of what I'm interested in which can easily be said. One of these things is the exclusiveness of doing.

There is a main doubt, which is very simple: asking yourself if you're doing what you do in the right way, or if another way wouldn't be better. The exclusiveness of, in the end, what you're doing, and the necessity of not thinking of what you're not doing, is a method based on some kind of model, and this model (including all the inherent assumptions) is something that can constantly be doubted, not to the point where you doubt everything or become a skeptic—to say that again—and not to the point where I should stop making things because it doesn't make sense to do anything any more, but to the point where I try to include in what I do this moment of not knowing what really to do.

And this is something I feel is missing in our way of dealing with the situation, because we somehow put the disturbing question of "what really to do?" constantly aside. As a general strategy, there seems to be some way of judging the "best way." There is a belief that we do something great and have made a great discovery or we have made a great artwork, a beautiful film, have written a brilliant text or are raising a smart child or whatever, which I would like to call "calming the main doubt with pretentiousness." Obviously, this pretentiousness is mainly directed towards yourself, towards your doubts.

HUO:

It's like a defense mechanism?

CH:

Yes. The natural sciences have another potent method for justifying the exclusiveness of doing: the claim for truth, and its testing through falsification. You elegantly get rid of the doubts because unless someone can disprove what you are doing and saying, truth is the reason. The will to truth, however, is the most enigmatic of exclusions: truth is a problem, because it is the result of a combat, like [Michel] Foucault said in *The Order of Discourse* (*L'ordre du discours*, 1970).

HUO:

That's two distinct strategies...

CH:

But there are all kinds of strategies to forget. The most common strategy is "hysterical production," where you do so much to keep you busy enough in order not to let the doubts come up. This is a classical form of mass hysteria, and we live in the middle of it. To doubt production is also a motivation to produce, because what you do when you produce is to calm your doubts.

HUO:

This is obviously something that you've been resisting since you started as an artist. But, at the same time—you see I was just flipping through your Fondazione Prada catalogue (Register, 2000)—you have produced so many things in these fifteen years, it's what you call a "hysterical production."

CH:

For myself, by including some element of doubt in my own production, it does not necessarily make it less hysteric, but at least less exclusive in terms of what to do, and thus possibly hyper-hysteric by doing more than one thing at a time, being more confused, less clear, and hence less pretentious. However, I don't deny that to allow doubts is pretentious too, in another way, as it implies some kind of "greatness" resulting from the ability to afford doubts. It could be seen as a contemporary version of the potlatch ritual perhaps. Doubts are potentially destructive, and turn into display behavior if performed in public. The destructive potential of doubts is nevertheless widely instrumentalized to promote production: to model the production process, to falsify a hypothesis in the natural sciences, to predict, to prevent, and for potlatch purposes.

HUO:

What's the political side of doubt?

CH:

Doubt becomes political when it is used beyond its usefulness. To further uncertainty and to establish a condition of no decision is a political weapon. Doubt is politically effective precisely because it is not against something, or is proposing "another" way, but instead admits confusingly more.

HUO:

In our last conversation on doubt, we spoke about your Laboratory of Doubt. *I'd like to know how, retrospectively, you consider this project and how it functioned in the framework of the exhibition "Laboratorium" (various venues throughout Antwerp, 1999) that we all mounted together with Barbara {Vanderlinden}, and with the brainstorm group consisting of you, Bruno {Latour}, and Luc {Steels}.*

CH:

I should say that doubts appeared first in this exhibition, as the process of talking about the show with the others made me somehow incapable of coming up with some finite artwork—so I found myself in the position of not knowing what I should do. Instead of doing something, or not doing anything, I tried to include this moment of not knowing what to do in my contribution to "Laboratorium." And of course when you try to implement doubt in some kind of artwork, it immediately becomes nonexistent because you've implemented it. Doubt can only exist in a pre-implementory state. So first there was this little film with the car turning in circles on a place, with other cars going in all directions, filmed from above (*One Minute of Doubt*, 1999). But it was a more or less hopeless attempt to "metaphorize" a tiny bit of doubt by producing some kind of image for it, and keeping the methapor so little and cheap that it would not really work, and thus still allow for a moment of doubt, at least in terms of doubting its own metaphorical value. I don't know if this really works, because it is neither a failure nor a success. It's too small to be distinctive. It's somehow insignificant, but being insignificant was then the most adequate way I could find of dealing with the situation, of not being able to decide what to do.

In a second step, and being slightly more pragmatic, I thought a good way to deal with my doubts would be to find some mechanism, some vehicle to spread doubt, and so we bought this car and we placed big loudspeakers on the roof, to drive around and spread doubts. But I didn't know what to say in the microphone, and so I asked other people how one can spread doubts, but nobody knew how to do it. So we have been driving around, but the speakers weren't used, and after a while I took them off again because it didn't make sense anymore. I'm still driving the car, in case something will happen, in case some insight would pop up of how to spread doubts. So, it's not really about doubt, it's more in between this triangle of doubt, uncertainty, and perplexity. It's not about the "end of art," as there's so much of a crisis in the meaning of the object that it's becoming impossible to produce an object anymore, and so it's impossible to produce art anymore. I would say that it is impossible to end art, even if you try hard.

HUO:

And since you've continued producing objects, like your very slow-speed merry-go-rounds (**Carousel**, *1999–2000)...*

CH:

I'm still doing objects, even though the autonomous, precious and assertive art object has become quite meaningless to me. My objects are tools or devices with a specified use, which is to create a moment of slight confusion or to induce hallucinations in the widest sense. That is why I call them confusion machines. I've been doing works that act upon you, things that may even be aggressive or not very nice to be close to.

HUO:

Like your flashing hallucinating Light Wall *(2000)...*

CH:

Paradoxically, to embrace doubt adds to the clarity of one's thoughts, possibly as a result of being more honest in admitting the level of confusion that is part of production, instead of constantly oppressing and refuting it. In this context, I found it consistent to summarize all my previous, pre-doubt work and to look at it anew. In *Register,* which is, like you said, an extended curriculum vitae and comprises everything I ever showed as an artist, it's like a confession because it also comprises all the works that I'm not very proud of, including my first painting show. It includes errors and things that just don't go anywhere, together with things that might be more substantial; by mixing up these "bad" and "good" works and putting them all together, I was hoping to come to the point where it's not so much about what you see there anymore, or about what has been done, but more about this profound doubt as such, or its oppression that arises while producing these things.

HUO:

For Production *(2000), the book produced with Daniel Birnbaum for the Kiasma show ("Production/Tuotanto," Kiasma Museum of Contemporary Art, Helsinki, 2000), it was a completely different kind of operation than for the Prada survey, but it produced similar effects. It's interesting how artists like you or Philippe {Parreno} consider the catalogue as a way of extending the exhibition, not documenting them.*

CH:

Exactly in that case it was an attempt to extend the exhibition beyond the range of the objects shown: it is a printed dialogue, where we talk about what could be done, and about the production process in general. The decision of what actually to show can be retraced through the conversation. By doing so, we were hoping not only to make the production process more transparent, but foremost to act against the exclusiveness of the objects shown.

HUO:
What will be the next steps?

CH:

Forthcoming is the *Boudewijn/Baudouin Experiment*. It's going to take place in September 2001 in Brussels in the Atomium-building, the famous giant-molecule-like structure from the World's Fair of 1958. Boudewijn was the King of Belgium from the early '60s until the mid-'90s, with a short interruption. In 1990 he had been in the middle of a dilemma situation: as the King, he has the symbolic function of signing every new law that has been ratified by the parliament before it is passed, but he has no power in shaping that law. He knew that a new law was under way that would legalize abortion to a certain extent, and he was strongly Catholic, so he had a problem with it. He found a beautiful and very Belgian solution to the dilemma. For one day he was not King, and the law was signed by the prime minister. The next morning Boudewijn/Baudouin was king again. So the *Boudewijn/Baudouin Experiment* is to somehow follow the example of the late King of Belgium: to do nothing for 24 hours. One sphere of the Atomium will accomodate about 100 people for this time, who will stop doing what they usually do, whatever that is. How can I say... it's like a psychological group experiment situation, but with no clear outcome-intention. The event will not be documented by the media, or film, video or photo, to reinforce the collective memory of it. Because in contrast to Baudouin's lonely day off, this will be a very social thing to "do." The *Boudewijn/Baudouin Experiment* is an attempt to create a situation where not-doing-something can be practiced, and where this not-doing can be done together with others.

HUO:
"Collaboration is the answer but what is the question?"

CH:

Production is so much about exclusion: excluding all the other things that could be done or excluding the other ways how something can be done. So far, during "Bridge the Gap?", there has been a lot of talking about creativity as "something coming up." But you can as well see it the other way, in terms of putting down all the bad ideas, all the junk stuff; to "create" is a very selective process indeed. That putting down is at least as creative as the actual production in terms of "coming up" with something. The not-doing, in the Boudewijn/Baudouin way, is less exclusive, as it avoids the decision-making process of what to do. It creates space for diversified action and for undefined outcomes.

HOPPS, Walter

Walter Hopps was born in 1932 in Los Angeles. He currently lives and works in Houston. In 1950 Hopps studied medicine at Stanford University, Palo Alto, California, where he met Douglas MacAgy, then director of the California School of Fine Arts, and his wife Jermayne, who was a curator at of the San Francisco Museum of Art (now SFMOMA); they both a key influence in Hopps' formative years. In 1951, Hopps transferred to UCLA (University of California, Los Angeles) and he continued to take medical courses, while also taking as many art history and humanities courses as possible. In 1952, together with James Newman, he started an agency called Concert Hall Workshop, and began to arrange jazz bookings at colleges throughout the U.S., and that same year he opened a small art gallery, called the Syndell Studio. After organizing several group shows mixing jazz and artworks, he founded the Ferus Gallery in 1956, along with artist Edward Kienholz. Initially the gallery showcased the work of California artists, but in the early '60s the program expanded to include East Coast artists as well. Hopps showed work by the leading Abstract Expressionists, as well as by emerging Pop artists such as Andy Warhol and Roy Lichtenstein. In 1962, Hopps was hired as the Pasadena Art Museum's (now the Norton Simon Museum) first full-time curator, and a year later he became director of the museum. During his tenure, some of his milestone exhibitions included "The New Painting of Common Objects" (1962), which signaled the rise of American Pop Art; Frank Stella's first museum exhibition, and the first retrospective ever accorded to Marcel Duchamp, "By or of Marcel Duchamp or Rose Sélavy" (1963). From 1967 to 1972, Hopps was director of the Corcoran Gallery of Art, Washington, D.C.; he also served as the United States Commissioner of two Biennales: the VIII Bienal de São Paulo in 1965 and the XXXVI Biennale di Venezia in 1972. From 1972 to 1979 he was curator of twentieth-century American art at the National Collection of Fine Arts (N.C.F.A., now the National Museum of American Art), a branch of the Smithsonian Institution, in Washington, D.C. One of his most important exhibitions was the mid-career retrospective of Robert Rauschenberg, mounted in honor of the American bicentennial in 1976. Hopps joined the Menil Foundation in Houston in 1980 and became the founding director of the Menil Collection in 1987, resigning from the position two years later in 1989. Since then he has continued to organize large exhibitions for the Menil Collection, such as the exhibition "Robert Rauschenberg: The Early 1950s" (1991), and for other institutions, such as the Solomon R. Guggenheim Museum in New York (where he also holds the title of adjunct senior curator of twentieth-century art) or the Whitney Museum of American Art in New York. In 2001, the Menil Collection established the Walter Hopps Award for Curatorial Achievement, a $25,000 award bestowed biennially by an international jury of museum curators and directors to a curator for outstanding work on exhibitions and publications.

........................

This interview was recorded in Houston in April 1996.

Hans Ulrich Obrist:

You worked in the early '50s as a music impresario and organizer. How did the transition to organizing exhibitions take place?

Walter Hopps:

They both happened at the same time. When I was in high school
I formed a kind of photographic society, and we did projects and
exhibits at the high school. It was also at that time that I first met
Walter and Louise Arensberg. But some of my closest friends were
actually musicians, and the '40s were a great time of innovation in
jazz. It was a thrill to be able to see classic performers like Billie
Holiday around the clubs in Los Angeles, or the new people like
Charlie Parker, Miles Davis, and Dizzy Gillespie. The younger
musicians I knew began to try to get engagements and bookings,
but it was very hard in those days. Black jazz frightened parents; it
frightened the officials. It was worse in this way than rock and roll.
It had a subversive quality. I had the good luck to discover the
great baritone saxophone player Gerry Mulligan. Later, I had the
chance to go on a double date with his wonderful trumpet player,
Chet Baker. You know, those guys had a different sort of social life
than would normally be the case. Somehow I managed a jazz busi-
ness and the small gallery near UCLA, Syndell Studio, at the same
time I was in school.

HUO:

For contemporary artists there was an incredible lack of visibility.

WH:

Right. In Southern California there were only two occasions during
my youth when any of the New York School people were shown.
And the critics damned them. One was an incredible show of New
York School artists, "The Intrasubjectivists," that Sam Kootz and
others were involved with putting together. And there was a show
by Joseph Fulton, a predecessor of mine at the Pasadena Art Muse-
um. He brought in a beautiful show with Jackson Pollock and Enri-
co Donati—a mix of the new Americans and sort of more Surreal-
ist-oriented things. [Willem] de Kooning was in it, [Mark] Rothko,
and so on. The only critical writing we normally had access to was
Clement Greenberg's—who was so contentious and arrogant—and
the beautiful writing of Harold Rosenberg and Thomas Hess. Hess
constantly looked for every reason he could to champion de Koon-
ing, as you know. We had virtually no critics like that in Southern
California at the time. There was also Jules Langsner, who champi-
oned the abstract minimal kind of hard-edged painting—John
McLaughlin, etc. He just couldn't accept Pollock.

HUO:

How were these shows received?

WH:

What impressed me was that the audience was there—younger artists and people who were not officially part of the art world then were really intrigued. It had a real human audience.

HUO:

It seems like a paradox—there had been little to see, then suddenly around 1951 there was a climax in art on the West Coast. You've talked about a project of organizing a show of works all created in 1951.

WH:

I would see the crest of great Abstract Expressionist work as extending from 1946 through 1951. This is true for New York and also, on a smaller scale, for San Francisco. During this period, most of the important Abstract Expressionist painters in America were working in top form. I really wanted to do a show about 1951, with one hundred artists represented by a single major work apiece. It would have been fabulous. Lawrence Alloway, in London, understood what was going on in a way that many people in America did not. He had great insights about the new American art, I'll give him that.

HUO:

Previously you've mentioned {Alfred} Stieglitz's 291 Gallery in New York as a source of inspiration for your exhibitions.

WH:

Yes. I knew a little bit about what had gone on there at 291. Stieglitz was the first person to show both Picasso and Matisse in America. Even before the Armory Show, you know.

HUO:

So before Arensberg.

WH:

Yes. Arensberg's collection really began in 1913, at the time of the Armory Show. Several collections start then: Duncan and Marjorie Phillips' collection in Washington begins then; and the Arensberg's began. Katherine Dreier was crucial. She, with Duchamp and Man Ray, had the first modern museum in America. And it was actually called the Modern Museum, although it was mostly known as the Société Anonyme.

HUO:

The year 1913 leads us somehow back to the discussion we had during lunch, when you gave 1924 as a second very important date.

WH:

Oh, yes. Nothing really happened in museums until around 1924. It took that long. Then in New York and San Francisco, a little bit in Los Angeles, a little bit in Chicago—among certain collectors

within those museums—things began to happen. Soon after Arens-
berg moved to Southern California, he had the idea of founding a
Modern Art museum with his collection out there—combining
some other collections with his. But it was fated not to happen.
There were not enough collectors of Modern Art to support such a
project in Southern California.

HUO:

So 1924 is also the year he left New York?

WH:

Yes. To me, the Arensbergs coming to Southern California gave it
the cachet, the license to do anything, even though the public and
the officials were so contrary about contemporary art. Even during
my time, right after World War II—in the late '40s and early
'50s—the politics of the McCarthy era were very hard on art in the
institutions in Southern California. Picasso and even Magritte—
Magritte, who had no politics, who was, if anything, a kind of
patron of the royalists—had their work taken down as being sub-
versive and communistic in the one museum we had in Los Ange-
les. There was plenty of weak contemporary art in Southern Califor-
nia; the whole school of Rico Lebrun. There were all these Picasso-
like people and lots of insipid variations on Matisse; it just made
you sick. There was more authenticity and soul in some of the land-
scape painters. But things slowly began to creep in. In Southern
California, the hard-edge painters, like John McLaughlin, began to
be accepted in exhibitions. The public didn't like it, but they would
be hung by the museums, for example by James B. Byrnes, the first
curator of Modern Art at the Los Angeles County Museum of Art.
San Francisco was the other place in the United States where great
Abstract Expressionist art was beginning to be shown seriously, like
Clyfford Still and Mark Rothko, as presented by a brilliant and pio-
neering curator of Modern Art, Jermayne MacAgy.

HUO:

Was Richard Diebenkorn shown?

WH:

Diebenkorn was their student. He also began to be shown, as well
as David Park and others.

HUO:

*Could you talk about the emergence of the assemblage artists of your gener-
ation? What were their sources?*

WH:

Wallace Berman was fascinating—he had a great touch, and great
insights about Surrealist art, but he never became some thin carbon

copy of Surrealist form, which many artists did. He was crucial to the Beat sensibility. He was one of the serious people. He introduced me to the writings of William Burroughs. And he published his own little journal, *Semina*. One of the slightly older intellectuals that affected Beat culture so much on the West Coast was Kenneth Rexroth. He was a very intelligent man, and he was a great translator of some fascinating Chinese poetry. At the same time, he was something of a mentor to people like [Allen] Ginsberg and [Jack] Kerouac. So was Philip Whalen. But the cultures of San Francisco and Los Angeles were quite distant: the patronage, the infrastructure. The patrons who would spend money were mostly living in Southern California, and most, though not all, of the really interesting art was being created in the north. It was a difficult dialogue, and I felt it was crucial to unite the art from the north and the south.

HUO:

In Los Angeles and the West Coast in general, the artistic and intellectual circles seem to have been relatively open at the time, not dogmatic but inclusive.

WH:

Absolutely. You didn't have to make allegiances the way you would if you were in New York. Ed Kienholz could love Clyfford Still's work and that of his circle—Diebenkorn was fine; he liked Frank Lobdell even better, because he was dark and brooding. But he also liked de Kooning. He had no problem with that. In the world of the New York School it was very difficult: Greenberg became the champion of all the Color Field people; Rosenberg became the champion of de Kooning and Franz Kline. The artists took up their allegiances, also. But on the West Coast, someone like Kienholz could love both de Kooning and Still.

HUO:

And Kienholz was linked to Wallace Berman and then to the Beat generation as well?

WH:

Kienholz and Berman knew each other, but there was a schism between them. Kienholz was a private, tough realist. Berman was very spiritual, with a kind of cabalistic Judaism and regard for Christianity. Kienholz would not berate him, but he didn't want to have anything to do with him, either. They were very different. Both are represented near one another in the massive "Beat Culture" show curated by Lisa Phillips at the Whitney Museum in New York ("Beat Culture and the New America, 1950–1965,"

Whitney Museum of American Art, New York, 1995). Currently I'm working on a full-scale retrospective of the work of both Ed Kienholz and Nancy Reddin Kienholz, to be presented later this year at the Whitney. Ed's work was considered very controversial even into the '60s, when he had his first retrospective. Today, I suspect much less controversy, but you never know. With this exhibition I hope to reveal the continuity as well as the power of his art, and both its origins in an American sense of West Coast culture and its wide range of vital subject matter.

HUO:

To come back to the issue of curating: in an earlier interview you mentioned a small list of American curators and conductors you consider to be important predecessors.

WH:

Willem Mengelberg was a conductor of the New York Philharmonic who imported the grand Germanic tradition of running an orchestra and conducting. So I mention Mengelberg not so much for his style, but for his unrelenting rigor. No matter what, he'd make the orchestra perform. Fine curating of an artist's work—that is, presenting it in an exhibition—requires as broad and sensitive an understanding of an artist's work that a curator can possibly muster. This knowledge needs to go well beyond what is actually put in the exhibition. Likewise, as far as conducting goes, a thorough knowledge of the full body of Mozart's music underlies a fine conductor's approach to, say, the *Jupiter Symphony*. Mengelberg was the sort of conductor who had a broad knowledge of any composer he addressed. Of the curators, I admired Katherine Dreier enormously, with her exhibitions and activities, because she, more than any other collector or impresario I knew, felt she should facilitate what they actually wanted to do, to the greatest extent possible.

HUO:

So you could say she was the artist's accomplice.

WH:

Exactly. She didn't have other rich people on her board. She had Man Ray and Duchamp—having artists in this capacity is nothing but trouble, conventionally.

HUO:

You also mentioned Alfred Barr and James Johnson Sweeney.

WH:

Yes. Barr, who came from a Protestant Yankee family, might have become a Lutheran minister. Instead he became a great director and

curator with an institution that had all the resources the Rocke-fellers, and others, could provide at the time. There was a kind of moral imperative behind Barr. He preached that Modern Art was good for people, that the populace could somehow become incul-cated with the new Modernism and it would improve their lives. It's very close to a Bauhaus idea. Sweeney was more complicated and romantic. I don't think he would have argued that art per se was necessarily morally good for you, but I don't think he made a big case that it was not. But Sweeney was a genuine romantic who felt that the aesthetic experience was a whole other territory to explore. He was like an explorer. For him, Picasso was one of the great adventurers, you know. Sweeney was one of the first in his generation to admire Picasso. He worked briefly at the Museum of Modern Art, and then later the Guggenheim.

HUO:

And then in Houston?

WH:

Yes, he was at the Museum of Fine Arts, Houston, for a while at the very end of his career. He responded instinctively to the Abstract Expressionists. And because of his work in France during his youth—in literary journals and so on—he was responsive to the Tachistes as well, and was just beginning to have a certain empa-thy, a certain response, to the Nouveaux Réalistes, right before he died. I think if he had been younger and alive, for example he would have been the greatest champion of Yves Klein. Sweeney was also one of the most rigorous people in working out an instal-lation. When I was young, I had the chance to actually see him in the old Guggenheim townhouse before the Frank Lloyd Wright building was constructed. He was never happy with the Wright building. It was a clash of two giant egos. Sweeney wanted some-thing more neutral for his own stagecraft, where the art could hap-pen. However, one gorgeous show he did do in the Wright build-ing was the Calder show.

HUO:

In curating there is a need for flexible strategies. Every show is a unique situation, and ideally it gets as close as possible to the artist.

WH:

Yes. To me, a body of work by a given artist has an inherent kind of score that you try to relate to or understand. It puts you in a cer-tain psychological state. I always tried to get as peaceful and calm as possible. If there was a simple way of doing something, I would do it that way. When I did the Duchamp retrospective in 1963, he

and I walked through the old Pasadena Art Museum—the colors were white and off-white and brown; there was some wood paneling; some dark brown. Duchamp said: "It's just fine. Don't do anything that is too hard to do." In other words, he was always very practical. But he had a very subtle way of trying to orchestrate or bring out what was already there, to work with what was already given. Duchamp knew exactly how to work with what was there. But with other artists installations were very different. Barnett Newman was a very bright man, but he would get a preconceived notion of how a space should be. Wherever I showed him, we always had to do a lot of construction.

HUO:

You mean like in the São Paulo Biennial in 1965?

WH:

There, and then when I showed him in Washington. There was a huge wall that had distracting stuff way above, where the paintings were shown. It bothered Newman so much—but nobody else—that we had to build a false wall about ten-meters high, at great expense and difficulty.

HUO:

In terms of flexibility, in the '60s and, above all, the '70s, the European Kunsthalle was defined as something of a laboratory where things could be tested without the pressures of public success and thousands of square meters to be filled.

WH:

Yes. This is similar to the tradition behind Dominique de Menil, through her father's family, the Schlumbergers, in engineering. You could remove "Menil Collection" from the building's facade and call it "de Menil Research," and it would look like an engineering building.

HUO:

Was this the intention behind selecting Renzo Piano as the architect?

WH:

Absolutely. It's one reason we chose Piano, whose great love is engineering. I think his ancestors were shipbuilders, and there's nothing more beautiful than a ship. But its form is absolutely rational. Before Jean de Menil died in 1973, he wanted Louis Kahn to build the new museum. Philip Johnson's chapel already existed, so a kind of peaceful sanctuary had already been achieved. And Jean de Menil wanted the new museum, with these pavilions, on the same land in the park. Kahn died about a year later, so it was nev-

er possible to continue it. But I think Piano's engineered public space works well against the more contained sanctuary space of the Rothko Chapel (1971).

HUO:

You've also mentioned René d'Harnoncourt as an influence.

WH:

Yes, he was special. Nelson Rockefeller was fortunate to have met him. He was yet another person whose background was in the sciences, in chemistry. He could have become an engineer/businessman in one of the top firms in the chemical industry. But through his love of art—and ancient art, too—d'Harnoncourt became one of those who felt, instinctively, that there were archetypes of form in ancient art, relating any number of things that existed in the so-called tribal or primitive arts to what went on with the Modern. When he came to the Museum of Modern Art, he saw something deeper and broader going on with Pollock, deeper than Pollock simply being influenced by the French Surrealists—that Pollock, in his way, was going back to some of the ancient sources that the Surrealists themselves went to. D'Harnoncourt had a kind of stature as a diplomat who could keep all the departments, all the egos, more or less in balance. He was brought in to MoMA after Alfred Barr had a nervous breakdown, and his main job, as far as Nelson Rockefeller was concerned, was to help support Barr—which he did do; they got along well. I think the other one on this list is Jermayne MacAgy. She was the mistress, or the master, of beautiful theme shows. Her greatest work was in San Francisco at the Museum of Modern Art. She once did a show there around the theme of time. There's a work by [Marc] Chagall titled *Time Is a River without Banks* (*Le Temps n'a point de rives*, 1930–39). I think the phrase intrigued MacAgy—more so even than the work. Her exhibit was ahistorical, coming from any period, and cross-cultural. She included clocks and timepieces. She had a Dalí with the little clocks and so on, as well as all kinds of references and allusions to time—in old and new work. In another exhibition, the California Palace of the Legion of Honor in San Francisco wanted a show of arms and armor. She did a fantastic piece of drama as a set piece for it. She made a huge chessboard in the great atrium—and lined up the figures as two competing sides.

HUO:

In the '80s theme-exhibition boom, many shows started to look like stage designs, with artists being used as props or works being used as accessories.

How did MacAgy's theme shows avoid subordinating the work to the over-
all concept?

WH:

She had a very sure and spare touch, for the most part.

HUO:

You also mentioned her shows in terms of an almost empty design.

WH:

Yes. She managed to ignore design systems—or tried to work out-
side systems of taste for these shows. Early on, here in Houston,
when she did a Rothko show, she went out of her way to have beau-
tiful flowers in the entryway—living flowers, planting beds. It was
just a general reminder that you don't start trying to ask why flow-
ers are some color—you relax and enjoy their beauty. It was very
interesting reminders that viewers should not be upset with the
Rothkos if there's no image there, no subject. What is the image of
a flower? It's just a color, it's a flower.

HUO:

If one looks at the encyclopedic range of exhibitions you've organized, it's
striking that, besides the exhibitions that take place in and redefine muse-
um spaces, you've also done shows in other spaces and contexts where you
tend to change the rules of what an exhibition actually is. I'm interested in
these dialectics; the exhibitions that take place outside the museum create a
friction with what takes place inside the museum, and vice versa. By ques-
tioning these expectations, the museum becomes a more active space. When
you were a museum curator in Washington you organized the show called
"Thirty-Six Hours" at an alternative space (Museum of Temporary Art,
Washington, D.C., 1976).

WH:

Yes. "Thirty-Six Hours" was literally organized from the street.
There was practically no budget, no money.

HUO:

So you actually had just a small alternative space, the Museum of Tempo-
rary Art, at your disposal.

WH:

Right. It had a basement and four floors. It normally just showed
on two of those floors. So I said, "Let's clean up the basement and
these other floors so we can have it everywhere in the building."
And the people who ran the space said, "Why? We normally only
show on two floors." And I said, "You'll see. More people will come
than fit two floors." They said, "How do you know?" I said, "If you

say you're having a show where anyone who brings anything can be shown, people are going to come."

HUO:

How did you make it public?

WH:

We worked at letting people know for a couple of weeks. We put some posters up and got certain people to mention it on the radio. We had some musicians performing the opening night; one reason we had the musicians was that they knew the disc jockeys. I knew perfectly well that lots of working artists—you know, they're in their studios at night, and so forth, they listen to rock and roll, whatever's on the radio, and they're going to hear this. They'll call up and find out. And they will come.

HUO:

So not just artists—everybody.

WH:

Anybody—we made no distinction. But it's interesting how few people who were not really artists showed up. One drunk guy came in who had ripped out a lurid Hustler photo with this nude woman exposing herself. He crumpled up the paper and then flattened it out. He'd signed it, and he came in insisting it was his work. My role in this was to be there all 36 hours, meeting and greeting every single person who brought in a work. We'd walk to a space and they would help install it, right then and there. So here was this crisis. But I found a place that was reasonably dark—it wasn't spot lit—and I walked him over there and said, "This is the perfect place for it."

HUO:

So you actually did the hanging when people brought things.

WH:

Yeah. So we stapled this thing up, in a sort of shadowy corner. This guy was so out of it, and so surprised—this was just a dirty joke on his part, but I didn't treat it that way. We put it up there, and he went away, and that was fine.

HUO:

So the show was all-inclusive.

WH:

My only requirement was that it had to fit through the door.

HUO:

In the exhibitions you organized, there's something like a thread—from Duchamp or Joseph Cornell to Robert Rauschenberg—of artists whose work was encyclopedic.

WH:

Yes, that's true. They're all artists who would have a difficult time explaining to you what they would not put in their art. They're naturally inclusive.

HUO:

Many of your exhibition projects, like the "Thirty-Six Hours," or the unrealized project of the "1951 show" and, of course, the 100,000 images project (P.S.1 Contemporary Art Center, New York) have this same impetus.

WH:

Yes. Well, it's a very innocent response to natural phenomena. It's a perception of all the sorts of things one studies in the natural sciences, where you immediately get a vast realm of phenomena thrown out in front of you. I remember when I studied bacteriology, I had a good professor who went out of his way to talk about both bacteriophages and viruses so we might get a better sense of the whole category. Somehow, early on I got used to the idea that these people who were exploring any given subject were constantly pushing out beyond the boundaries, in order to understand what the boundaries were in the first place. You can tell from the museum here that I believe very much in sometimes isolating a single work with a very discrete situation—not having it cluttered or complicated. At the same time, I have a great feeling for really large numbers of works.

HUO:

This 100,000 images project was conceived as filling a single entire building?

WH:

That's right. I conceived of it as a really exciting project for P.S.1 in New York. I calculated that the whole building could hold 100,000 items, if you had some kind of discretion as to what the size would be. That may seem unimaginably large for an art show, but, on the other hand, if you counted the number of phases of music, or measures in an opera or a symphony, you'd get an unimaginably large number, too.

HUO:

Or a computer program.

WH:

That's right. I believe people could take in presentations of art that are almost as vast as nature. If a lot of things looked very repetitive, well, that's the way it is. If you're walking through the desert and looking at creosote bushes and some tamarack and some sage—

they're all different and discrete. But, on the other hand, they can appear very repetitive.

HUO:

And one could put together his or her own sequence.

WH:

Exactly. I think in the future some of the experience of finding one's way through vastly larger realms of information on the Web and in cyberspace will allow for what I'm talking about. But I've also tried to think of exhibits featuring only two or three works, or even one work, and some unusual comparisons. I've often thought that Vermeer's work would fit in this kind of show. The same is true of Rogier van der Weyden.

HUO:

The explosion of images and sources leads also to Rauschenberg.

WH:

Yes, in recent years I've had a lot of involvement with Rauschenberg, indeed. And to use your term, he's probably the most encyclopedic artist of our time.

HUO:

And you're working on a retrospective.

WH:

Yes, having done one at the National [National Museum of Art, Washington, D.C.] in 1976, the Guggenheim wants me to do one for what I guess will be 1997 or 1998—a little more than 20 years later.

HUO:

So it'll be the retrospective of retrospectives.

WH:

Yes. The difficulty will come in the work after 1976, where Rauschenberg begins to become prolific in larger-scale works—all the international touring he did.

HUO:

The global venues.

WH:

The overseas venues seemed, to most people, not very discriminating. There wasn't any sense of discrimination as to why this or that piece was chosen. I don't know whether, doing this show, I'll be beyond such a notion of discrimination. I'm concerned with whether one can get into that vast body of work—and truly represent the vastness of Rauschenberg's work, and yet have it seem discriminating.

HUO:

So it's a paradoxical enterprise to frame abundance without annihilating or reducing it.

WH:

Yeah. We're talking about using both spaces—both the uptown and the SoHo Guggenheim. That appeals to me.

HUO:

The last Rauschenberg retrospective you curated, in 1976—it must have been one of the first times a contemporary artist made the cover of Time Magazine.

WH:

Yes.

HUO:

This leads to what I call the double-leg theory: an exhibition that is highly regarded by specialists, but also makes the cover of Time—*in other words, having one leg in a popular field and one in a specialized field.*

WH:

Yes, I realized early on I couldn't live without both fields. It isn't made quite clear in Calvin Tompkins' article [in *The New Yorker,* July 29, 1991], but early on, when I was at UCLA, I kept this small gallery—Syndell Studio—which was like a very discreet laboratory. I didn't care if four or five people came, as long as there were two or three that were really engaged. I met any number of interesting people that way. We had only one or two reviews written in all the years it was there. It didn't matter. But, at the same time, I felt compelled to do this show of the new California expressionists in a very public place—in an amusement park on the Santa Monica Pier.

HUO:

Was this the "Action" exhibition?

WH:

"Action 1"—in a merry-go-round building (1953). It was near Muscle Beach. It attracted the most totally inclusive mix of people—Mom, Dad, and the kids, and Neal Cassady and other strange characters, and the patrons of a transvestite bar nearby. I got Ginsberg, Kerouac, and those people to attend. It's amazing they came. Critics I'd never met before showed up. It had a big attendance. So I wanted to work, as it turns out, both ways. You can see this clearly in the most extreme show I've done in recent years, "The Automobile and Culture" at MoCA, in downtown LA (Museum of Contemporary Art, Los Angeles, 1984), it later went to Detroit. Paul Schimmel and I came up with the absurd premise. I owe the title to Pontus Hulten. What I was talking about doing was looking at

the history of the automobile, from the late nineteenth century to the present—beautiful and interesting and important cars, no trucks, no motorcycles, just cars—as a kind of quotidian device and fetishistic emblem of cultural life in the twentieth century. The automobile had its own aesthetic and its own engineering imperatives. I wanted to see that in a fresh survey of twentieth-century art—in cases where the automobile becomes part of the subject matter and in other cases where I think the kind of mobility the car provides influences the art. So, as you can imagine, it was a crazy show. When you start looking for these references—arcane and goofy but perfectly wonderful things—other things turn up. There's an early Matisse in the show, a portrait of Madame Matisse sitting in the front seat of the car, looking through the windshield. He composed the whole painting as a horizontal structure, based on the kind of horizontal windshields cars had in the '20s. I had a wonderful picture of Alfred Stieglitz—a wonderful cityscape of old New York—where two things suggest the coming of Modernism. One is the steel frame of a skyscraper going up, and here, coming down the street, is a very early automobile—the first picture Stieglitz ever took that has an automobile in it. I was very serious and intrigued with that '84 show. But the local critics didn't care for it much—the local critic here in Los Angeles.

HUO:

Did it bring a non-specialized audience to the museum?

WH:

It was very, very popular. People who would never come down to look at Modern Art were there.

HUO:

Your first gallery, the Syndell Studio, was an almost private venue. "Action 1" and "Action 2" (Now Gallery, Los Angeles, 1956) on the other hand were very public venues. What about the Ferus Gallery? Was it a more in-between place for artists?

WH:

It was relatively more private, but less so than Syndell. Ferus was a complicated thing, in that when Kienholz and I ran it as partners from 1957 to 1958. We did it in our own clean but bohemian way. We did it just the way we wanted. We didn't care whether we sold work or not. I had enough money to pay the rent. But a number of the artists we represented started getting impatient; they wanted more material success. So the later history of Ferus, after 1958— when I hired Irving Blum to be director—well, I didn't compro-

mise the kind of art, but it was meant to be more conventionally economic. I had no idea what the gross sales would have been at the old Ferus Gallery for a year—maybe 5000 dollars, if that? In about eight months of the first year of the new Ferus, we'd sold 120,000 dollars worth of art. But it was a thoroughly commercial enterprise at that point.

HUO:

So at first the idea was to create a platform?

WH:

That's right. I mean, we could show this wonderful woman, Jay DeFeo, when there wasn't anyone to buy her work. Now she's at the Beat show at the Whitney. She's a heroine, and deservedly so. The style of the first Ferus was to resemble what an artist's working studio was like—or a salon that artists would run themselves, although they didn't. Kienholz could be ruthless with other artists; he was a taskmaster. I was never as blunt as he was. Sometimes he would cancel a show if he didn't think the work looked good enough. He would just say: "C'mon, get to work—let's see something better. We're not going to show junk. It's not good for you, it's not good for us." The first Ferus looked as though it didn't care whether it was successful or not. Somehow, clients could tell that. People came to it like it was a little Kunsthalle. The second one, with Blum, took exactly the opposite tack—it was to look very well-to-do, as if it were doing successful business—whether we were or not. And, I tell you, that approach works. [*Laughs*] It does work.

HUO:

So at the beginning it was almost like an artists' collective?

WH:

Right. The solidarity between the artists was very strong. That's the positive side. The negative side, by the way, is that the artists felt they had a ruthless say over who else would be part of the enterprise. Robert Irwin, for example, was an artist who wasn't with us in the beginning, and his work was kind of weak—very lyric, easygoing, a not very powerful version of Diebenkorn. He was a conventional abstract lyric painter; his paintings weren't bad, but they were of no particular distinction. He desperately wanted to be shown by Ferus, but there wasn't a single artist in the Ferus Gallery—around Los Angeles, anyway—who wanted him in there. I was president of the corporation. Being with him and looking at what he was up to—hearing what he was thinking about—I knew something was going to come of him. But a tyranny of the major-

ity would have prevented it. So there are times when you just have to risk losing everyone's good opinion and sort of ram it down their throats—that was one. So I just, by sheer will, forced an Irwin show in there. And he turned out to be quite an important artist, obviously. He knocked himself out with his first show trying to do the work. It owed a lot to Clyfford Still—it was a transition. And by his second show, things got different very quickly.

HUO:

At Ferus there was the idea that you did everything yourself. Harald Szeemann once defined the functions of the Ausstellungsmacher—*the one who puts on an exhibition*—*as "an administrator, amateur, author of introductions, librarian, manager and accountant, animator, conservator, financier, and diplomat." This list can be expanded by adding the functions of the guard, the transporter, the communicator, and the researcher.*

WH:

That's absolutely true. I'll tell you the worst thing I ever had to do. From time to time—maybe once a year—we would do a historical show. Nobody was showing Josef Albers in California, so we showed Albers. Prior to that we did a joint show of Kurt Schwitters' collages and Jasper Johns' sculpture. Anyway, one of the painters I loved—and I realized that a number of the artists, including Irwin, really loved—was Giorgio Morandi. No one was showing Morandi in the western United States. So I had been traveling, and I came back and discovered that Blum had not put an image by Morandi on the invitation. I was really furious. I said, "One in the thousand people who get our invitation will even know who Giorgio Morandi is. We've got to have one of his drawings on this invitation." Well, he hadn't had a photographer come in to take a picture. I said, "Clear this desk off, I'm going in the back and choosing a drawing." I picked out a Morandi drawing that was strong enough—it had glass over it—and I laid it down on the table. I took a piece of paper and laid it over the glass, took a soft pencil—and I'm not an artist; Blum would have been better, because he can draw—and I traced out that Morandi drawing, to life size, in my own crude version. Traced the son of a bitch out on a blank piece of paper, and I said, "There's the artwork." Blum said, "You can't do that. You've just made a fake Morandi." I said, "You watch me do it. You just watch me." And that went to the printer, so it's printed in red with its line cut very elegantly on a paper. We waited to see who would identify it as a fake. Never— no one, no one. Szeemann is right—there's no telling what you'll have to do.

HUO:

Certainly, in a small place like Ferus, you got used to doing everything yourself. Soon afterward, in 1962, you began curating and directing the museum in Pasadena. With only a few employees, you succeeded in doing an amazing number of exhibitions, 12 or 14 a year. You must have worked with enormous efficiency in such a small operation. You did big shows on Cornell, Duchamp, Jasper Johns, and so on—in a very short time.

WH:

Yeah. You have to be energetic and have good people. Sometimes the measures are extreme.

HUO:

And the museum was also a very small structure, wasn't it?

WH:

The building was small enough to manage. It was like a square, symmetrical doughnut. There were larger rooms, and a garden in the center. A curious building. The design was fake-Chinese, like Grauman's Chinese. But there were these rooms strung together. There were walkways through the gardens. All on one floor. The second floor didn't have galleries. But somehow these separate rooms, with the garden in the middle, were very pleasing to people—it worked very nicely.

HUO:

What about the staff?

WH:

We almost never had more than three or four people physically installing a show. The hours were terrible. Somehow we were able to get some very grand shows—with Kandinsky and Paul Klee and so on. And that would mean extra people working pretty long hours to get it all straight. You couldn't do it today. Nobody would allow artists to come in and help you handle Kandinskys. I've never had better workers. You know, with a little training, they care very much for the work.

HUO:

At this time, there was also your pre-Pop exhibition?

WH:

Oh, yes—"The New Painting of Common Objects."

HUO:

How did this show come about?

WH:

Just seeing the work—I had been seeing the work and was determined to do it. The word "Pop" was already in use in England, and was just beginning to be used in America. But I associated the

word with the English movement, so I wanted something very bland and dry. I didn't want to use the word. There were three East Coast artists—Andy Warhol, Roy Lichtenstein, and Jim Dine—and three West Coast artists—Ed Ruscha, Joe Goode, and Wayne Thiebaud. I asked Ruscha, who did design work, what to do for a poster. He said: "Well, let's do it right now. Here, let me sit down and use your phone. What are all our names? Write 'em out in alphabetical order. Here are the dates, and that's your title—fine. That's all I need to know." And he called up a poster place. I said, "What are you calling?" He said, "This place does prize-fighting posters." He went to a pop, mass-produced poster place. He got on the phone and said, "I need a poster"—and he knew the size—and he just read it off on the phone. The guy saw no layout or anything—he just read it off. And then I heard Ruscha say, "Make it loud. And we want this many." I gave him a number, they quoted a price. And he said, "Yeah, these folks are good for it," and he hung up. And I said, "Why the hell did you say, 'Make it loud'?" He said, "Well, after you give the guy the size, the copy, and how many you want, he wants to know the style." And I said, "That's all you said for style?" He said, "Those guys, that's all they want to hear—make it loud." It was perfect. The poster was done in yellow, red, and black, and very loud. It was the most important poster that museum had ever done, with one exception—the poster Duchamp designed for his show.

HUO:

In 1919, Duchamp was one of the first artists to use instructions. He sent his sister in Paris a telegram for his **Readymade Malheureux,** *to realize the piece on the balcony. Moholy-Nagy was the first artist to do a piece by transmitting instructions over the phone.*

WH:

Absolutely—just called it in. Sometimes the best solution is the easiest one to do—if you know what to do.

HUO:

If one looks at the museum situation now, creating small structures with flexible spaces seems to be of most importance.

WH:

Somewhere in the '70s in America—and in Europe, too—the idea of the smaller, more independent Kunsthalle rose up. In America, the so-called artists' space—that whole phenomenon.

HUO:

Which leads us back to the laboratory idea.

WH:

That's right. I hope the concept doesn't disappear. I hope a breed of entrepreneurs will come along who aren't worried about being chic or fashionable and will keep some of that alive. One damn way or another, some version of that idea has always been around. We don't have the salon now; we don't have the big competitive shows in smaller cities, you know? They don't mean much anymore. Most serious artists don't submit to those. In a sad way, the old salon is dead. I've been waiting for some breed of artist—some terrible little ancestor of Andy Warhol or whatever—to put out a mail-order catalogue of his or her work independently of the galleries. Whether it's printed matter or it ends up on the Web, people, without even using galleries, can find interested patrons. This was the thrust of what the East Village was all about. They had artist-entrepreneurs there. Never in SoHo. This market appeared, then died down again, but I think it could happen again. I really believe—and, obviously, hope for—radical, or arbitrary, presentations, where cross-cultural and cross-temporal considerations are extreme, out of all the artifacts we have. If you look at the Menil, with its range of interests—everything is quite manicured and segregated out. But there are some larger areas of juxtaposition as well. We have our African section, right up against a very small section of Egyptian art. But Egypt interposes—you can't get into the Central and Western European section, or to Greco-Roman culture, from Africa without going through Egypt. It makes a kind of sense. So just in terms of people's priorities, conventional hierarchies begin to shift some. But I mean beyond that—where special presentations can jump around in time and space, in ways we just don't do now. I really believe in these kinds of shows.

HORN, Roni

Roni Horn was born in 1955, in New York, where she continues to live and work. She received a B.F.A. from the Rhode Island School of Design in 1975 and an MFA from Yale University in 1978. Over the past twenty years, the work she has produced ranges from sculptural objects, to pigment drawings, sculptures embedded with text (some inspired by the poet Emily Dickinson), photographic installations and artist's books. She first visited Iceland in 1975, a country that has inspired many of her installations and books since then. Since her first solo show at the Kunstraum in Munich in 1980, she has exhibited widely throughout the U.S. and Europe: she has had solo exhibitions at the Museum of Contemporary Art, Los Angeles (1990); New Museum for Living Art, Reykjavik (1992); Baltimore Museum of Art (1994); Kunsthalle Basel (1995); Wexner Center for the Arts, Columbus, Ohio (1996); De Pont Foundation for Contemporary Art, Tilburg, The Netherlands (1998; 1994); Musée d'Art Moderne de la Ville de Paris (1999); Whitney Museum of American Art, New York (2000) and the Dia center for the arts, New York (2002). She has also exhibited in major international artistic events including the 47th International Exhibition of the Biennale di Venezia (1997); documenta IX (Kassel, 1992), and the 1991 Whitney Biennial (Whitney Museum of American Art, New York). Since 1989, Horn's Things That Happen Again *(1986) has been on long-term exhibition at the Chinati Foundation in Marfa, Texas. She is a participant in the Thames and Hudson Rivers Project, sponsored by Minetta Brook (New York) and the Public Art Development Trust (London).*

........................

This interview was recorded in Mexico City in November 2002.

Hans Ulrich Obrist:

Let's make a sound test. Do you like hearing your voice?

Roni Horn:

The first time I heard my voice was when my father brought home a used tape recorder from his pawnshop. It was a reel to reel. The whole family gathered round and we took turns talking into it. That was a Sunday, when I was about four or five years old. It was one of the momentous events of my life.

HUO:

I'd like to start this interview by discussing the topic of the dialogue between visual art and literature. This dialogue has played a crucial role in the twentieth-century avant-garde, but it has been interrupted somehow. However, in an exemplary way, you have always managed to retain this relationship between art and literature, on the one hand through your writings, and on the other, by bringing literature into your own artworks.

RH:

I'm not exactly sure how to address that, except by saying that literature and philosophy were the texts that I started reading when I was young. I associated them with invention, and visual art came much later for me, partly because you had to go to the museum to experience it. Really, I started out not thinking I would be a writer or anything like that, but just that the experience of the written word was kind of a focal point for my relationship to the world. And my identity seems to come through that as opposed to the visual realm. As far as following a tradition, though, I never saw it that way. Maybe it's a bit of a Jewish thing where language becomes so important. I think that the thing for me is that the experience of reading was really a metaphor for travel, even to the extent that this way of knowing the world is not as appealing to me; physically transporting myself to places is somehow less necessary because of the way I have occupied myself with literature and philosophy and these kinds of writing. I don't travel for touristy reasons at all. I make a point of never going anywhere just to see something—I go there just to be there, to draw it into my life, real time. I don't go to see monuments or to see how other people live. It's not that it doesn't interest me; it's more a matter of priorities. So I travel in my library. I've always thought of my library as the center of the world.

HUO:

What are the most cherished elements in this library that you'd like to talk about now?

RH:

Well that's a trick question, because on one day it would be one set of works and another day it would be a whole different group of writings. Basically, it changes from week to week, depending on what I'm focusing on at the time. For example, recently I've been reading a lot of interviews with directors, and today I'm reading interviews with Billy Wilder. I'm also very fond of Stefan Zweig's ability to grasp and to empathize with very different personalities, such as Marie-Antoinette or Casanova. And I'm drawn into that world. *A Letter from an Unknown Woman (Brief einer Unbekannten,* 1922) is, I think, an exquisite piece of writing. But I would hate to have to choose five books, that desert island thing; I don't know that I could do that as easily as someone else might be able to.

HUO:

Nonetheless, there are some threads such as Emily Dickinson.

RH:

You're right. Emily Dickinson is, for me, a writer whom you could read again as if you had never read her before; somehow, the work never becomes familiar. There is no structure that you can latch onto. Not that it's amorphous, but it is not something that you can identify or whose identity can be separated out from the experience—you have to go into it and it literally presents itself as if you are there with it. And in writing she is unique, and that experience is something that I'm very much seeking to offer in my own work. I think that's what I was doing with all the water. Ultimately, I saw that as being close to the intentions of Emily Dickinson: not that I want to make a direct comparison, but in the sense of there being an interest in never becoming familiar. Water has this quality as well. But then the idea of the book itself is very interesting to me because it's a nominal form, at best, until you enter it and it becomes what it is. But its visible aspect is diametrically opposed to its content and the nature of the content. I'm fascinated by that paradox.

HUO:

When you were asked to select an author for the monograph on your work published by Phaidon (2000), you chose an extract from Clarice Lispector's Apple in the Dark *(A maçã no escuro, 1961).*

RH:

Lispector is also someone who uses language in a way that I identify with very strongly. I feel at home in her way of relating herself to the world in her writings. I even think that my so-called Icelandic encyclopedia, "To Place" (1990–ongoing) is also based in this way of having an object that doesn't impart itself to you unless you actively go into it, you know. And also it's a model for real-time activity, which is something that I can develop over my lifetime, not over the next year or two or whatever the seasonal cycle is, because I'm not really at home with that, even though I am unable to not work. That seems to be the rule for me; it's easier for me to do something than to do nothing, but I feel very slow in terms of my ways of working— which I'm comfortable with, but the world pretty well pushes against that towards a much quicker pace. This encyclopedia for me is a way of maintaining my own sense of time.

HUO:

We have just begun to move from your readings to your own work with books. Before we cross that line completely, can you tell me at least a little more about how you feel close to Lispector or to other authors and how this may bounce back in your own work?

RH:

The way that Lispector puts together language and arrives at an image (it's a bit simplistic to call it an image), or a context for the viewer to rest in through her language, is a place that is always actually at least half-language, half-physical/metaphysical world. I think that continual acknowledgement of this at least dual realm... if you simplify it and talk about language and then everything else, I think that Lispector's language is very much about a process of consciousness and a process of being physically present and entwining those two sensibilities. So in this sense, I feel very close to her identity in the work. I loved Edgar Allen Poe, and I've read everything by him many times. I know there's a gothic element to it, but I think it was this obsessive quality and also, in his writings, extreme sensitivity to the physical presence of things. It is exquisite to the point of pure pain or horror. I guess I was drawn to that when I was younger. Somewhere in my work Poe is present, or at least I hope is present. Whenever you ask me to think of names, I always forget them.

HUO:

Let's focus on the ones that we already have then! Like Dickinson...

RH:

Yes... on another level, you could just take a short text by one person, and Dickinson will always be a good example, because you're not going to arrive in the same place every day with that one text, you know. Her writing in particular is very simple and very opaque. Which is a very odd paradox because she's using words very literally and very directly, and yet she somehow arrives at a level of, not obscurity exactly... but there's this enormous distance created because of how she sees meaning. Her idea of meaning is not a socialized one and it's not a verbal one either. It is based in written language, so in that sense she is quite unique. A lot of the classic authors also inspire me. I'm very fond of [Vladimir] Nabokov, Joseph Conrad for example, or Flannery O'Connor—I think she is an extraordinary writer—or Carson McCullers, *The Member of the Wedding* (1946). I'm drawn to simple writing that takes me places. It doesn't have to be really fancy, heavy stuff or really complex ideas. I'm also drawn to somebody like [Georges] Bataille—his ideas are extremely complex, but they're very sexual and direct.

HUO:

And what about some more contemporary literature?

RH:

I can't say I've been reading anything that I feel... I've been reading Chekhov a lot, and you have to read a lot of Chekhov to read

Chekhov at all, because the sensibility is so delicate in a way. [W.G.] Sebald I like very much, especially *The Rings of Saturn* (*Die Ringe des Saturn: Eine Englische Wallfahrt*, 1995). I like his relationship to memory and human consciousness in a broad sense, without individual identity entering into it in. In one of his books, maybe *Austerlitz* (2001), the main character suffered from a loss of identity and yet he had memory, and that paradox was fascinating. In general, his characters don't have so much of a personal identity, as a collective one—they are palimpsests. I'm drawn to paradoxes. I can't really see anything unless I see the opposite in it I guess, and then how those things co-exist is another realm.

HUO:

Let's cross the line now. How has the relation that you have to your own writing evolved? We have spoken in the past about making a book of your collected writings one day, and yet you have repeatedly said in interviews that you don't think of yourself as a writer. How do you view the status of writing in relation to your practice?

RH:

That's an interesting question, because I think that all the visual work comes through language. I believe I think with words. I can't verify that, but my understanding of how I put ideas together or how I put work together, forms together, is definitely involved with language in some way. But I definitely wouldn't say that I'm writing literature. As you indicated, I don't think of myself as a writer, but I do find myself writing, and I think that has a lot to do with the way that I draw. It's something that I feel I need to do to maintain my relationship to what I do, but I don't necessarily need to have an audience for it. This is very different from the installation works, where I feel the audience is really an integral part of the form of the work. That's a big difference. Recently I was doing a project where I was footnoting water extensively (*Another Water*, 1999); that was a text that included or sought out an audience, to create this triangular relationship between the image of the water, the viewer, and my voice. And that writing is really aural. It was written aurally, by which I mean speaking out loud and developing the cadence of the text. Originally I didn't think I was going to end up doing a monologue, but the piece took on so many different forms: there was the book [*Another Water* (*The River Thames, for example*), 2000] which was fifty or sixty images foot-noted continuously, there were 800 footnotes running through the images of water; and then you had *Still Water* (2000) which was the installa-

tion; and then finally it precipitated a monologue, *Saying Water* (2001), which excluded the visuals altogether. I'd like to work with the monologue in the future and develop that idea. But again, I don't feel comfortable putting myself in the realm of literature. But I don't feel comfortable thinking of myself as a visual artist either. The visual is something that I arrive at in the very last part of developing a work. It's usually the last thing to come together, so I don't know that I'm a natural visual artist either. I'd like to think that I don't have to be bound to a form to have an identity. I know that in terms of the packaging, people do that—they package you as a painter or a performance artist, this or that. I'm not comfortable with those identities; I'm not comfortable with gender identities or any of these things. I've kind of shied away from it. Maybe in part that's why I say I don't think of myself as a writer—I think it would be inappropriate.

HUO:

You just said, "I don't think of myself as a writer, but I do find myself writing, and I think that has a lot to do with the way that I draw." There's a very interesting text about your drawings by Louise Neri in the Phaidon monograph, about your daily practice of drawing that she compares to breathing. And it is something Gerhard Richter also refers to when he speaks about his daily practice of painting. Could you tell me about this intense drawing activity and the relationship between drawing and writing?

RH:

In a way, those two questions are the same. In a very literal sense, I think that my main activity in my studio and my work in general, is drawing. That certainly is true in terms of the photographic work that I do, the sculptural work that I do, and in a very extraordinary way, I think that the writing I do is so closely akin to the way that I draw. A lot of this has to do with the kind of time you have to see what you are doing and how that evolves, how that contact point evolves. It's a very similar process if you're working with a visual form, where I feel that the activity is really in composing relationships. That's what I do with drawings—I compose relationships: it is that abstract to me. It isn't a "putting lines down on a sheet of paper" sort of thing; it's more about a view and a viewer interacting. It is the same thing with the written texts and how they tend to evolve. Certainly, with *Another Water*, for quite an extended period of time, I found myself writing one or two footnotes a day. And that started to break down. And when I was traveling, I would wind up in Milan, take out my computer and discover there was a footnote

waiting for me, and that was happenstance. I'm not somebody who says, "Between eight and ten o'clock I will write and come up with something." That's not how I function. I come in to work and I don't know what's going to be on my plate. It's presented to me in the course of time and sometimes the options are so numerous that it thwarts me, but once I am able to focus, then I can go somewhere, go vertical with it. *Another Water* was, for me, like drawing. Those footnotes were like drawing. Because here too, it was a matter of making relationships.

HUO:

In the case of Gerhard Richter, it was clear that writing was quite a sporadic activity for him—he reacted to something when he was angered or suddenly felt inspired by something.

RH:

Exactly, it's the same thing for me. At the moment I'm doing a lot of writing to try to defend the ecology in Iceland, and I've been producing texts for the public, the Icelandic public, to be published in the daily newspaper there. And that's a very different kind of writing; there are a lot more descriptive, socio-political, didactic elements in it, and opinion. But normally what happens is I'll be somewhere and I'll make a connection to something and it'll enter into this low-level activity that's always going on. And when the mainstream hooks up with the tributary, I usually find something of interest to work on in writing. But it is definitely not a daily thing. It seems to happen more when I'm traveling. I tend to go towards writing because somehow it fulfills the same need I have to draw when I'm in the studio. I do write a lot in the studio as well. I feel that talking about writing in this way is too much, because it's such a small part of what I do. You might be thinking that there's a lot of writing, but there really isn't that much. There are just a few things.

HUO:

Are the texts published in the newspaper concerning environmental issues just columns, or are you also articulating images and texts in them?

RH:

Yes, I called them "visual editorials," but the editor was unhappy with that for obvious reasons, but that's really what they are. They were an attempt to promote self-tourism on the part of Icelanders. A point in fact is that over the years I have gotten to know Iceland better than most Icelanders because they don't tend to travel around in the countryside that much. So a lot of what I was trying to bring to

the public's eye was the incredible frailty of their own cultural history, their own architectural history, and also their environmental situation, which is reaching a climax whereby it will go industrial and the ecology will be destroyed, or they'll turn around and try to protect this young, small landscape that they have. So that was the intention, to talk about the value of being nowhere, the idea of nothing, a symbol like Timbuktu blowing away, and for me, when I was reading about Timbuktu and the fact that it was literally, physically blowing away, I had this adrenaline rush of fear in my system, because this symbol was so searing—the loss of nowhere is one of the most frightening things I could ever imagine. Iceland has a lot of these "nowheres" that are also being corrupted by overpopulation and over-consumption. So the intention was to try to create or talk about those kinds of issues, and by doing it every Saturday, introducing a very short text.

HUO:

Are you still involved in this kind of activism?

RH:

I was doing it weekly, though I have recently suspended that simply because I have been so busy with other things. It went on for about thirty weeks, and I just couldn't continue the practice and keep up with my other commitments. If you think about the use of language like in the *Key and Cues* (1994), I'm often asked what those pieces are about. I'm not sure what they're about, but I know that when you look at one of those, you've obviously got the physical object, but you've got this space that opens up as a consequence of the text, which is a whole other level of the view, and is not in any way related to the object. That's the kind of paradox that I seek. That an object can deliver you to a place that is opposite to what it physically is, for example.

HUO:

You seem to give very special attention to titles in your work—are they vehicles?

RH:

That's a very good question, because recently I've been working on a show and the curator asked me to give him a title. It's a collection of five installations. I guess it never really occurred to me to name the show, because the work already has titles. Titles are usually the focal point for when a concept finally comes together. Often the title is a starting point and sometimes it's the end point. Sometimes it comes after the fact. Like the title, *Her, Her, Her and*

Her came at the very end of the work. But a title like *Clowd and Cloun (Blue)* (2001) came at the very beginning, which also seemed to relate to this popular misunderstanding that was also mine, of the Stephen Sondheim song *Send in the Clowns*, which I always thought was *Send in the Clouds*.

HUO:

"You" pops up a lot in your titles.

RH:

Yes, "you" has an important presence, especially when you're thinking about an audience, whether I am the audience of the subject in the photograph (which often happens), or whether I'm thinking about that anonymous "you" standing in front of the finished work. And I think of myself as a "you" as well. *You are the Weather* (1994–1997). I have a title coming up for a piece that has not yet been developed, called *Rock the Hudson and Me (or You)*, and I know that will evolve into something, because it has so many levels of meaning and mutual necessity, reciprocity or whatever the right expression might be.

HUO:

And Dan Graham also pointed out the musical dimension of your titles. Music has played an important role for you, especially jazz.

RH:

The ones that we spoke about were taken from Thelonious Monk. His titles were some of the best I had ever heard, such as *Crépuscule with Nellie*; *Ruby, My Dear*; and *Well, You Needn't*. He's one of the first people that made me aware of titles. And titles are a really unique opportunity to bring the viewer into an epigrammatic form without pointing to the epigrammatic form, but rather just pointing towards an entrance. I think Richard Serra uses titles in an interesting way. My titles are not used the same way. I can't even remember my own titles. There must be some psychology to that.

HUO:

Lawrence Weiner once said, "Books furnish a room." It was a text piece from 1989. I was wondering what kind of roles books play for you; books seem to be more than merely catalogues for you.

RH:

I'm aware that in the arts there are a lot of catalogues being produced. I'm not so interested in that form. If a publication is being produced, I would like it to be a non-descriptive contribution to the world—something that actually offers an experience in its own right. That's how I've approached my publications. In the museum situations, I've tried to discourage catalogues and use those opportu-

nities to make books, or what I consider to be books. The books that I do have a very specific desire (that is exactly analogous to my installations), that revolves around some notion of the individual experience of the viewer in relation to an experience. Even though a book has a similar object form, it's a truly unique form in terms of the intimacy it offers, even the physical specificity of it in relation to the body. Then, of course, distribution is extremely important in terms of having thousands of copies as opposed to one, two, or three presented in highly elite settings. But this is something that has evolved in my practice.

HUO:

It started in the "To Place" series in 1990.

RH:

Yes, and at that point I was thinking that I wanted a format that could work like a series, something I keep coming back to over the years and add a chapter, a volume, or an entry or something like that—or updating them. And it was intended to be something that didn't necessarily have an end: it had a beginning and a passage. I'm not clear when the work ["To Place"] will end.

HUO:

So it's a kind of infinite series. How many volumes have been published so far?

RH:

Now there are eight completed volumes.

HUO:

So it's a partial encyclopedia?

RH:

Yes, someone pointed out that the addition of each new volume makes the entire work less complete. It's like any collection: the incompleteness defines the collection. It's a collection of my returns to Iceland. It's not documenting because it's not a literal process at all, but it's like when you come to something again and again, when you're in a different place and the place itself is in a different place, and so effectively, you're never coming to the same place, and that's what those books are doing. They're keeping things in the active form, rather than a definitive form. And then that too pulls you away from this idea of naming things and identifying in a way that I feel more comfortable with—that things don't have exclusive names and fixed identities. Identity is a river.

HUO:

You speak of intimate spaces rather than exhibition spaces.

RH:

And not only intimacy, but if it's any good at all, you'll come back to it again and again. It reiterates this sense of one's difference to oneself in time. And I've noticed that when I reread things or review picture books or whatever, I'm noticing different things. I often remember what I noticed the first time, and I'm shocked at the things that I'm noticing this time that I didn't notice the first time and vice versa. It's like walking through a landscape that you've walked through before and different elements become more prominent at different times. Most of the installations that I work with don't offer the chance to keep going back to look at, or to have a lived connection with. It isn't even really possible to offer that in a social setting, in a museum setting. So for me that's a difficulty.

HUO:

... with the accessibility of the work?

RH:

Yes. I have a difficulty with the inaccessibility of the large pieces, both to myself and to the kind of audiences I imagine.

HUO:

Could this be solved in a similar way to the Rothko Chapel *in Houston?*

RH:

Exactly. Though the unfortunate thing about the *Rothko Chapel* is that the quality of the work is physically deteriorating so quickly that is has become something different to that which he intended. When you go back to some place like Iceland, it is a physically different place. It changes from when you were there last, and I find that incredibly fascinating. People do tend to think of a place as a fixed identity—you think of the Caribbean or the Bahamas or the Virgin Islands and you have a fixed image. Of course, in Iceland, there are basic parameters like the volcanic thing, but you can go to the same valley over the period of ten years and it is completely reformed—the vegetation is different and the formation of the rock might be different. And of course, daily changes like the weather are always important to me.

HUO:

*From "To Place" to "No Place" is only one letter. "No place" is actually the definition Thomas More gave of Utopia. In "To Place"—*Book V: Verne's Journey *(1995) you made a reference to Jules Verne's* Journey to the Centre of the Earth *(Voyage au centre de la Terre, 1864), where Verne trained his imagination to inhabit a place that he had never visited. In terms of* To Place, *"No Place," and your relationship to Ice-*

land, is the notion of Utopia relevant? How do you feel about such a notion?

RH:

How would you define Utopia?

HUO:

I like the definition that Molly {Nesbit} introduced me to the best; it's by Ernst Bloch. In a conversation with {Theodor} Adorno, he said: "Something is missing."

RH:

"Something is missing" as a definition of Utopia? Well that's a beautiful definition of Utopia. Would you say that if something is missing then it is incomplete, or would you say that it is complete because there's something missing?

HUO:

I would say in both cases.

RH:

Yeah. I have an idea of wholeness whereby the element of perfection or completion is not intact. And that is what makes something a place. That is what takes it away from that discreet nameable thing that I find less engaging. With Iceland for example, there is always something not there. And I think that part of what is not there is the fact that I desire to seek something, and I desire to be in the act of seeking more than I desire to be in the act of knowing. So what is missing is not necessarily in the physical reality of the place, but in one's desires, how one sets up one's relation to the world. So you don't have your expectations falsely fulfilled. I like this "To Place" and "No Place" being one letter apart. That's very beautiful. I just wish it was a palindrome!

HUO:

Could you tell me about one of your unrealized projects, one of your unbuilt roads?

RH:

My future is my unrealized road. And there are always those footnotes I haven't gotten to—like dust collecting in the corner.

HUANG YONG PING

Huang Yong Ping was born in 1954 in Xiamen, Fujian Province, China. He has lived and worked in Paris since 1989. Huang graduated with a B.A. from Zhejiang Academy of Fine Arts, Hangzhou, in 1982, and in 1986 he co-founded the Xiamen Dada group. Staging radical Happenings and actions and taking part in the events surrounding the "China/Avant Garde" exhibition of 1989 at the National Art Gallery in Beijing, the group's activities have often been described as the triggering the student revolt and the "incidents" of Tiananmen Square in 1989. That same year, Huang was invited to participate in the exhibition "Les Magiciens de la Terre" ("Magicians of the Earth," Musée National d'Art Moderne, Centre Pompidou, Paris) and he decided to settle in Paris. From the outset, Huang's work was defined by the rifts and bridges between Eastern and Western thought. His early work, The History of Chinese Painting and the History of Modern Western Art Washed in the Washing Machine for Two Minutes *(1987–93), in which art history books are transformed to pulp under a ritualistic and electronic application of water, showed both a fascination with written sources and a belief in the power of the immaterial. Huang's strategy also often employs full-fledged exoticism to "interrupt a dominant (Western) discourse." Referring to ancient Chinese ideas, he extended his materials to include live animals and insects, substances usually unacceptable to art institutions as art media, in order to test the very limits of the cultural, legal, and moral systems in Western society. Huang Yong Ping is also very attentive to politics and current events, often using topical issues for subject matter, such as mad cow disease* (Péril de mouton, *1997) or Hong Kong's return to the mainland* (Da Xian, The Doomsday, *1997). Huang has had many solo exhibitions in institutions including: CCA Kitakyushu, Japan (1999); De Appel Foundation, Amsterdam (1997); Fondation Cartier pour l'Art Contemporain, Paris (1997); and the New Museum of Contemporary Art, New York (1994). In 1999 he represented France at La Biennale di Venezia (48th International Art Exhibition).*

..................

This interview was recorded in Paris in November 2002.

Hans Ulrich Obrist:

Can you tell me about your Chauve-souris *project (*The Bat, *2001–2002)? Your project was to build a replica of the American EP-3 spy plane which, following a collision with a Chinese plane, fell into the hands of the Chinese authorities in the spring of 2001 before being returned to the United States in pieces. Why did you choose to produce a work based on this incident and the diplomatic suspense to which, at the time, it gave rise?*

Huang Yong Ping:

I actually became aware of the incident itself almost by chance. It

was a French friend who first told me about the incident. I found the story very interesting and immediately thought of doing a project that would involve a reconstitution of the plane. That was in April 2001, but the idea didn't materialize right away. In May I learned of a project for an exhibition of contemporary Chinese sculpture in Shenzhen (He Xiangning Museum, Shenzhen); the French cultural attaché in China, as well as the French woman curating the exhibition, asked me if I would like to take part. As the show was scheduled to take place outside in the public sphere, I said to myself that this was the occasion to do the project. The real problem was that I didn't actually have much information about the incident itself. So I started researching it, assembling the different articles that had been written about the whole affair. Then, in Shenzhen, when I was looking around for a location to do the project, I came upon a Chinese aviation journal, where I found very thorough documentation regarding the American aircraft—its size and all its characteristics. Building and assembling the plane in Shenzhen was also interesting because the distance separating Shenzhen from the Island of Hainan—where the incident actually occurred—is not really very great. Finally, the exhibition's curators wanted something spectacular—they wanted the work to be a sort of *coup de théâtre* during the show.

HUO:

A monumental work of sorts, almost a commemorative monument.

HYP:

[*Laughs*] Let's say that insofar as the work was supposed to be shown for three years, its structure had to be particularly solid. At the outset, my project was to have been 35-meters long—a full-scale model of the plane from stem to stern. But to build the entire aircraft would have cost somewhere in the range of 70,000 dollars, which was obviously far too expensive. So, in the end I decided to produce three pieces of the plane—parts which showed the plane from its tail right up to its midsection. All told, the whole thing was twenty meters long. Ultimately, the fragmented aspect of the piece suited me just fine in the sense that one of the most interesting parts of the affair was the Chinese government's refusal to allow the Americans to repair their spy plane on location. They decided to carve the plane up into eight pieces, I believe, and then to send the various pieces back to the United States.

HUO:

What were the first reactions in China when you announced your project?

HYP:

Though the selection of the project for exhibition was decided upon by the French partners, the project's production and financial backing was the responsibility of the Chinese partners. Which means that they were very interested, even very excited by the project. They came up with a large portion of the budget for the exhibition, allowing me to carry it out. It was something to the order of 30,000 dollars, which is a tidy sum. And subsequently the project went ahead almost perfectly as planned, and was 90 percent finished...

HUO:

So then why was it censored? Why was the project ultimately withdrawn from the exhibition at the He Xiangning Museum in Shenzhen?

HYP:

It was actually only two weeks prior to the opening of the exhibition that I was told that the work "was a problem." They organized a conciliation meeting between me, the museum management, the exhibition curators, and the cultural attaché from the embassy. The alternative was clear: either I withdrew the piece or the exhibition as a whole would be cancelled. Why at that point? There are a whole series of reasons, in my opinion less artistic than diplomatic obviously.

HUO:

But the fact that the diplomatic can be condensed in the artistic fact is not uninteresting. The sculpture was no doubt feared because it would fix the event in time, conferring it a historical importance, which was completely different than that conferred by the media. The media's reaction produced the event, but allowed it to disappear very quickly as well. Your work often tackles these differences, these gaps and temporal constructions; in that respect, the problem was truly at the very core of the project of reconstituting the spy plane.

HYP:

As I said before, the project basically took shape by chance. In effect, some people have criticized me for having used a political event in the framework of a spectacular logic. Personally, however, I believe that, as you said, the gesture was not so much political as it was a reflection on the temporalities inherent in the political event and the artwork. Oftentimes when a political event is tragic, there is an attempt to forget it as quickly as possible. For me, dealing with something artistically is not so much about fighting against this mechanism of forgetting in order to prolong the event in history as it is about showing a work of time. Artworks do, of

course, have a timeless dimension, which is quite the opposite of politics. The case of the reconstitution of the spy plane had to do with a work entirely leaving the political context which had nurtured it. The work was censured because people refused to look at it objectively; people cannot prevent themselves cognitively from linking the work to the political context. Which is very interesting. It is for that reason that the French Consulate in Guangzhou reproached me with doing politics rather than art, and even told me that if I wanted to do politics it would be better to go to Beijing rather than Guangzhou. [*Laughs*]

HUO:

The work was censored for the second time in Guangzhou. And yet the two exhibitions were utterly different: the first was organizationally linked to French cultural institutional circles, whereas the second was a triennial of Chinese art ("Reinterpretation: A Decade of Experimental Chinese Art, 1990–2002," 1st Guangzhou Triennial, 2002). And moreover, it was almost a year later, long after the incident itself.

HYP:

There are both similarities and differences between the two cases. Here again, the censorship only took place late in the project, at the very end of the work's production phase—and it took place very suddenly. The principal difference was, as you say, that the exhibition was organized exclusively by the Chinese, which, one might have thought, should have simplified the diplomatic situation. For the Shenzhen exhibition it was France that decided on the censorship, allegedly at the request of, and bowing to pressure from, the American diplomatic authorities in China. But they didn't get involved directly; the United States operated like a specter, if the French are to be believed.

HUO:

A specter, like the spy plane itself...

HYP:

Exactly. The second time it took place far more directly. Americans came and took pictures of the work while it was being built. And that time, it was France that operated in specter-like fashion. Another difference is that the Shenzhen work was never revealed to the public, and never actually made it out of the factory. In Guangzhou, on the other hand, it had already been set up in the museum, which meant that the censorship was far more violent, and was carried out overtly, right in the public eye.

HUO:

Why did you entitle the work The Bat*?*

HYP:

That came quite simply from the fact that there was a picture of a bat on the spy plane itself. But personally, I like bats a lot because they are animals whose activity is nocturnal, and thus concealed, invisible. Perhaps the fate of the work itself was already sealed with the attribution of that name: a work which would remain invisible, accomplishing its work in invisibility.

HUO:

Is it conceivable that the work will be presented in a different context? Or is the Chinese context already part of the work?

HYP:

It's true that many of my works have been done site-specifically, and are therefore closely linked to the historical, geographical, institutional context of their initial presentation. As I said, I find it interesting to use the proximity between the site of the incident and Shenzhen to create the work. Subsequently, for Guangzhou, I responded to the express wishes of the triennial's organizers, who had commissioned that specific work. But inasmuch as Shenzhen took my work apart, I had to redo it. For this work, there are still other possibilities. The right wing of the plane still hasn't been built. I am waiting for Beijing to commission me to do a project, and I may well be able to finish the reconstitution. [*Laughs*] It's highly unlikely. In China, even in Beijing or Shanghai, it no longer strikes me as possible. It is conceivable that I gather together all the different pieces that already exist and show the project outside of China. But where?

HUO:

This was not the first time your work has been censored, either in China or elsewhere?

HYP:

No it wasn't! The first time was in 1987, and was in the Fujian province. With the Xiamen Dada group, we had trundled piles of garbage, sand, broken chairs and tables rather than paintings or sculptures into the Fujian Museum of Fine Arts, for an exhibition we were invited to take part in. The director considered our project to be aesthetically unacceptable and had the place shut down two hours after the opening. The second time was during the exhibition "Hors Limites" curated by Jean de Loisy at the Centre Pompidou (1994). The third time was with you (amongst others) during Manifesta 1 in Rotterdam (1996).

HUO:

Yes, in both cases, the problem had to do with the allegedly "cruel" use of animals. Brigitte Bardot and her association even demonstrated in Paris against you on the day of the opening of "Hors Limites"...

HYP:

In the case of "Hors Limites," the work was called *Le spectacle du monde* (*The spectacle of the world*, 1994), and I had built a giant turtle. It had a number of different drawers that could be opened, and in which I had placed a whole variety of animals, scorpions, spiders and so on. But it was actually the personnel of the Centre Pompidou who called in the animal protection associations in order to denounce me. The association then called in the police and I was summoned before the Centre Pompidou's director, who informed me that the museum was running the risk of a fine of 100,000 francs per day. I didn't want to cause them any trouble, so I decided to take out the animals. I subsequently learned that the association went ahead and brought court action against the museum. In Manifesta, I had entitled the work *Terminal* (1996). Because my piece was supposed to be presented in the Rotterdam Museum of Natural History, I had hoped to present a collection of living insects in the middle of the museum's collection of dead insects. The project didn't work out because the museum director wrote me a letter saying that my work violated the principles of humanism in force in the Netherlands [*laughs*]. So I decided to exhibit the director's letter and the letter that I sent back to him in response. That was my contribution to Manifesta.

HUO:

To come back to the Chinese censorship cases, you mentioned two: one that took place in 1987, the other much more recently. Between times, China has changed a great deal, both politically to a limited extent, and above all economically. The situation of contemporary art in China has also changed over the past 15 years; the world of Chinese contemporary art has opened up significantly to artistic experiments, and to everything that is taking place abroad. That said, as can be seen in what has just taken place, this whole process of opening up is far from over. How do you see these developments?

HYP:

I'll tell you an old Chinese tale. It is said that in ancient times there was a man by the name of Duke Ye who loved dragons. He loved them so much that he had decorated his entire house with dragon motifs—he had put them on all the walls, all the colonnades. But one fine day, when a very real dragon showed up in his house, Duke

Ye was so terrified that he fainted. As you know, contemporary art in China was for a very long time a clandestine activity. It is only over the past two years or so that public opinion and the government have begun to show a certain degree of tolerance for contemporary art and to accept it as such. But that is nevertheless based on a misunderstanding—in other words, that contemporary art is considered to be something fashionable, something akin to decorative art. Contemporary art is rather like Western fashion, like the luxury clothing one now finds in Shanghai. But they make no distinction between contemporary art and craft, between a decorative or a design approach. They do not perceive the critical dimension that underpins contemporary art. China just hasn't had the time to give thought to all these questions. In the current context of globalization, given that China is now heading straight into a globalized market economy, they can't refuse the globalization of culture. But they are not ready for it. Politically, the old Maoist refrain of autonomy and independence with regard to the United States is no longer in force; what with joining the WTO [World Trade Organization], taking part in APEC [Asia Pacific Economic Cooperation], showing support for the United States after September 11, there has been a convergence which would have been unthinkable just a few years ago. Nevertheless, we saw how even a single photograph taken by the Americans using a spy plane is liable to awaken feelings of mistrust.

HUO:

It was also perhaps this ambiguity that they sought to eliminate by preventing you from showing your work.

HYP:

True enough. I believe that the biggest change happened in the wake of Jiang Zemin's trip to the United States about one month ago. It was as if China acknowledged the United State's position of world leadership. China now has a far more pragmatic attitude. It remains to be seen what these sorts of pragmatic attitudes will lead to in the years to come.

HULTEN, Pontus

Pontus Hulten was born in 1924 in Sweden. He currently lives in Paris. Hulten spent his youth between Paris and Stockholm; in the '50s he made some short films and organized several exhibitions for Galerie Denise René in Paris and Agnes Widlund's Galerie Samlaren in Stockholm. Hulten was the first director of Stockholm's Moderna Museet—a position he held for 15 years (1958–1973), making the Moderna Museet one of the most dynamic contemporary art institutions in the '60s. During his tenure, the museum played a seminal role in bridging the gap between Europe and the U.S.; in 1964 Hulten organized one of the first European surveys of American Pop Art. In return, he was invited to curate an exhibition at New York's Museum of Modern Art in 1968: his first interdisciplinary show, "The Machine as Seen at the End of the Mechanical Age," which mingled sculpture and photography with engineering and industrial design. In 1973, Hulten left Stockholm and became the founding director of the Centre National d'Art et de Culture Georges Pompidou (Beaubourg), which opened in 1977 in Paris. There, Hulten organized large-scale shows that examined the making of art history between artistic capitals: "Paris–New York, 1908–1968–" (1977); "Paris–Berlin, rapports et contrastes, 1900–1933–" (1978); "Paris–Moscow, 1900–1930" (1979); and "Paris–Paris, Créations en France 1937 –1957" (1981). These shows included not only art objects that ranged from Constructivism to Pop, but also films, posters, documentation, and reconstructions of exhibition spaces such as Gertrude Stein's salon. At the urging of the artists Robert Irwin and Sam Francis, in 1980 Hulten left Paris to establish a museum in Los Angeles (Museum of Contemporary Art, LA MoCA), but after three years of infrequent exhibitions and too much fundraising he returned to Europe. In 1985 along with Serge Fauchereau, Daniel Buren, and Sarkis, he founded the Institut des Hautes Études en Arts Plastiques in Paris {Institute for Advanced Studies in The Visual Arts}. Since 1984 he has been, successively, in charge of Venice's Palazzo Grassi (1984–1990), the artistic director of the Kunst- und Ausstellungshalle in Bonn (1991 to 1995), and the head of the Museum Jean Tinguely in Basel since 1996.
........................
This interview took place in Paris in December 1996.

Hans Ulrich Obrist:

Jean Tinguely always said you should have been an artist. How did you end up running a museum?

Pontus Hulten:

In Paris, where I was writing my dissertation, I met Tinguely, Robert Breer, and some other artists who urged me to take up art making. I resisted this idea, but did make some films with Breer, who worked as an animator, and also some objects with Tinguely. To tell the truth, if I had had a chance to become a film director, I

wouldn't have hesitated. Though I managed to make some short films, I realized that the mid-'50s wasn't a very good time to try and make features. I made a twenty-minute film with a friend, but it was a great failure because the producer released it with the wrong feature film. It got some prizes, though, in Brussels and New York. I wrote a second screenplay, which I wasn't even able to finance. It was at that point that I was offered the job of creating a national museum of modern art in Sweden [Stockholm's Moderna Museet].

HUO:
Before you were put in charge of the Moderna Museet, you'd been organizing exhibitions for several years on your own.

PH:
Yes. In fact, in the early '50s, I started curating shows at a tiny gallery that consisted of two small spaces about 350-square feet each. Curiously enough, it was called The Collector [Samlaren, Stockholm]. The owner, Agnes Widlund, who was Hungarian, had invited me to do shows there, and she basically gave me carte blanche. I put together exhibitions with friends around themes that interested us. We did a big exhibition on Neo-Plasticism in 1951. Things were infinitely easier then. Paintings didn't have the value they do today. You could bring a Mondrian to the gallery in a taxicab.

HUO:
One of your shows, held in a bookstore in 1960, was of Marcel Duchamp's work.

PH:
I had done another one with pieces of his in 1956, but it wasn't a solo show. I'd been fascinated with Duchamp since I was a teenager. He marked me very deeply. At the bookstore, we did a small show— we didn't even have a *Box-in-a-Valise* (1935–1968), but managed to come up with replicas. Duchamp later signed everything. He loved the idea that an artwork could be repeated. He hated "original" artworks with prices to match. I had met Duchamp in Paris in 1954, I think it was. At that time he gave an interview in an art journal in which he discussed his notion of "retinal art"—of art made only for the eye and not for the mind. It had tremendous impact; people were really hurt. The painter Richard Mortensen, who was a friend of mine, was really shattered. He had misgivings about his own work that he couldn't express or wouldn't accept. Then Duchamp put this idea out on the table, just like that, and it was as if someone had rent the veil. I still have Mortensen's letter.

HUO:
Walter Hopps told me that in the United States, in the '50s, Duchamp was known mainly to artists, not to the general public. What about in Europe?

PH:

Duchamp was much appreciated by artists because they could steal from him without risk of discovery, since he was almost unknown. At that time, Duchamp's work had been forgotten, despite [André] Breton's praise of him in the heyday of Surrealism and again after the war. It was in many people's interest for Duchamp's work to remain unknown. For obvious reasons, this was especially the case for important gallerists. But he made a comeback—it was inevitable.

HUO:

It was at Denise René's Paris gallery that you organized an exhibition of Swedish art in 1953?

PH:

Yes. I used to go to the gallery a lot. It was one of the few places in Paris that was lively. We would gather there and talk about art every day.

HUO:

It sounds rather like the kind of forum created by the Surrealist magazine Littérature.

PH:

Unlike the Surrealists, we didn't expel anyone: but all the same, our discussions were infected by politics. There were great debates about how to deal with Stalinism and with capitalism. Some people seemed to think Trotskyism represented a viable alternative. There were people like Jean Dewasne (considered at the time to be a young Vasarely) who tended to take the communists' side. He was practically excluded from our circle. Eventually he left the gallery. We also engaged in numerous debates about abstraction, which were central to our discussions. Sometimes the great modernist figures would come around, like Alexander Calder when he was in Paris, or Auguste Herbin, Jean Arp, and Sonia Delaunay. It was very exciting to meet them.

HUO:

Were there other significant galleries?

PH:

There were two galleries then. Denise René was by then the most important one. She was wise enough to show not just the abstract "avant-garde," but also Picasso and Max Ernst. Then there was Galerie Arnaud, on the Rue du Four, which basically showed lyrical abstraction. Jean-Robert Arnaud had a journal called *Cimaise*: it was where I first encountered Tinguely's work. His art was shown in the gallery's bookshop. Gallery bookshops were a way of exhibiting the work of young artists without making a financial commitment. You have to understand how differently galleries operated then. Presti-

gious spaces usually showed artists with whom they had contracts.

HUO:

Didn't Alexandre Jolas also run a gallery?

PH:

Yes, a few years later. In his own way he was much wilder. I couldn't say whether or not he provided artists with stipends—Denise René's artists got serious money. With Alexandre, things changed a lot. There was a kind of looseness that mirrored life in the '60s.

HUO:

During your early years as a museum director in Stockholm, you created a number of "in-between" spaces where you combined various art forms—dance, theater, film, painting, and so on. Later this approach became central to your large-scale exhibitions, first in New York and then in Paris, Los Angeles, and Venice. How did you settle on this working method?

PH:

I discovered that artists like Duchamp and Max Ernst had made films, written a lot and done theater: and it seemed completely natural to me to mirror this interdisciplinary aspect of their work in museum shows of any number of artists, as I did several times, but particularly in "Art in Motion" in 1961 (Moderna Museet, Stockholm). One person who influenced me greatly was Peter Weiss, who was a close friend of mine and was known primarily for his plays such as *Marat-Sade* (1963) and his three-volume treatise *Aesthetic of Resistance* (*Die Ästhetik des Widerstands*, I-1975, II-1978, III-1981). Peter was a filmmaker in addition to being a writer; he also painted and made collages. All of that was perfectly natural; for him it was all the same thing. So, when Robert Bordaz—the first president of the Centre Pompidou in Paris—asked me to create shows that combined theater, dance, film, painting, and so on, I had no trouble doing so.

HUO:

Looking at your program in Stockholm in the '50s and '60s, you put on an impressive number of exhibitions despite very modest budgets. It reminds me of what Alexander Dorner—director of the Hannover Provinzial-Museum from 1923 to 1936, said that museums should be **Kraftwerke,** *dynamic powerhouses, capable of spontaneous change.*

PH:

That level of activity was quite natural, and corresponded to a need. People were capable of coming to the museum every evening; they were ready to absorb everything we could show them. There were times when there was something on every night. We had many friends who were working in music, dance, and theater, for whom

the museum represented the only available space, since opera houses and theaters were out of the question—their work was viewed as too "experimental." So interdisciplinarity came about all by itself. The museum became a meeting ground for an entire generation.

HUO:

The museum was a place to spend time in, a place that actually encouraged the public to participate?

PH:

A museum director's first task is to create a public—not just to do great shows, but to create an audience that trusts the institution. People don't come just because it's Robert Rauschenberg, but because what's in the museum is usually interesting. That's where the French Maisons de la Culture went wrong. They were really run like galleries, whereas an institution must create its public.

HUO:

When a museum lives through a great moment, it often becomes linked to a particular person. When people went to Stockholm, they talked of going to Hulten's; when they went to Amsterdam, of going to Sandberg's.

PH:

That's certainly true, and it leads me to another issue: the institution shouldn't be completely identified with its director; it's not good for the museum. Willem Sandberg knew this quite well. He asked me, as well as others, to do things at the Stedelijk [Stedelijk Museum, Amsterdam], and he would remain on the sidelines. For an institution to be identified with only one person isn't a good thing. When it breaks down, it breaks down completely. What counts is *trust*. You need trust if you want to present the work of artists who are not well known, as was the case when we first showed Rauschenberg's work (part of an exhibition of four young American artists) at the Moderna Museet. Though people didn't yet know who he was, they came anyway. But you can't fool around with quality. If you do things for the sake of convenience, or because you're forced to do something you don't agree with, you've got to make the public believe in you all over again. You can show something weak once in a while, but not often.

HUO:

What were the points of departure for the shows on artistic exchanges that you organized at the Pompidou: "Paris–New York," "Paris–Berlin," "Paris–Moscow," and "Paris–Paris"? Why do you think they were so successful?

PH:

I had proposed the "Paris–New York" show to the Guggenheim in

the '60s, but I hadn't received a response. When I started at the Centre Georges Pompidou, I had to establish a program for the next several years. "Paris–New York" brought together the people from the Musée National d'Art Moderne and those from various other departments—it was multidisciplinary. I should have taken out a patent on the formula that allowed me to unify so many different teams at Beaubourg; this approach later became very popular. The library also participated: in the "Paris–New York" show, their section was separate; in "Paris–Berlin" everything was part of one space. With these four shows I was also attempting to make a complex, thematic exhibition easy to follow—to be straightforward yet to raise many issues. "Paris–Moscow," for instance, reflected the beginnings of Glasnost before the West knew any such thing existed.

HUO:

Why did you choose to stress the relationship between East and West, rather than North and South?

PH:

Strangely enough, the East-West axis seemed less familiar at the time. I came up with the exhibition trilogy "Paris–New York," "Paris–Berlin," and "Paris–Moscow" to address the exchange between various cultural capitals in the West and those in the East. "Paris–New York" began with reconstructions of Gertrude Stein's famous salon, Mondrian's New York studio, and Peggy Guggenheim's gallery, Art of this Century, and ended with *Art Informel,* Fluxus, and Pop Art. "Paris–Berlin, 1900–1933" was confined to the period before national socialism, and provided a panoramic view of cultural life in the Weimar Republic—art, theater, literature, film, architecture, design, and music. For "Paris–Moscow, 1900–1930," thanks to a period of détente in French-Soviet relations, I was able to assemble works produced by numerous French artists showing in Moscow before the October Revolution, as well as Constructivist, Suprematist, and even some Social Realist artworks. The groundwork for the "Paris–New York" show and the shows that followed had been done before the Pompidou even opened. In the late '70s, it was considered odd to buy American art. Thanks to Dominique de Menil and her donations of works by Pollock and other American artists, American paintings became part of Beaubourg's collection. Before I mounted the first show in this series, I felt it was necessary to give the museum audience some historical background: in addition to major retrospectives of Max Ernst, André Masson, and Francis Picabia

at the Grand Palais, I organized a big Vladimir Mayakovsky show at CNAC [Centre National d'Art Contemporain], the space on Rue Berryer near place de l'Étoile. We redid Mayakovsky's show from 1930, which he had organized in hopes of providing a multifaceted portrait of himself; shortly after, he committed suicide. For that show, Roman Cieslewicz did the graphic design and he also did the covers for the catalogues for "Paris–Berlin," "Paris–Moscow," and "Paris–Paris." But for "Paris–New York," Larry Rivers did the cover. Those four big catalogues, which were sold out for a long time, were recently reissued in a smaller format. With that series we succeeded in establishing a good relationship with the public, because we also made conscious attempts to prepare our audience. The Centre Pompidou was embraced by the public because they felt it was for them, and not for the conservators. Conservator—what a terrible word!

HUO:

Who were the curators, for lack of a better term, with whom you spoke most frequently in the '50s and '60s?

PH:

Sandberg at the Stedelijk in Amsterdam, Knud Jensen at the Louisiana in Denmark, and Robert Giron in Brussels; once I even did a show with Jean Cassou on the paintings of August Strindberg at the Musée National d'Art Moderne. Sandberg and Alfred Barr—at MoMA [Museum of Modern Art, New York]—created the blueprint; they ran the best museums in the '50s. I got close to Sandberg. He came to see me in Sweden, and we got on very well. He kind of adopted me, but our friendship ended on a rather sour note. He wanted me to take over for him in Amsterdam, but my wife didn't want to move, so I decided not to.

HUO:

A few years later you got an offer to do an exhibition at MoMA in New York.

PH:

The Stedelijk adventure was over in 1962; the offer to work for MoMA came in 1967. MoMA and the Stedelijk were quite different. In New York, the structure was less open, more academic. It was more compartmentalized than at the Stedelijk, where Sandberg had succeeded in creating a fluid, lively structure. MoMA was relatively conservative because of the source of its financial support—wealthy donors. The Stedelijk had a different kind of freedom, because Sandberg was, essentially, a city employee; he could make policy as he saw fit. All he had to do was convince the mayor of Amsterdam. Catalogues, for instance, were absolutely his domain.

HUO:

You also put a lot of energy into your catalogues. Last year the university library in Bonn organized an impressive retrospective of about fifty of your publications ("The Printed Museum of Pontus Hulten: Art Exhibitions and Their Catalogues, 1953–1996", Universitäts und Landesbibliothek Bonn, 1996). Many of them seemed like extensions of your exhibitions. And some of them were really art objects in themselves: the Blandaren box from 1954–55 had lots of artists' multiples, or that fabulous catalogue in the form of a suitcase for the Tinguely show in Stockholm in 1972 ("Jean Tinguely," Moderna Museet, Stockholm, 1972). You also invented the encyclopedic catalogue: 500–1000-page volumes that have since become so common for the "Paris–New York," "Paris–Berlin," "Paris–Moscow," and "Paris–Paris" shows. So catalogues and books would seem to play a pre-eminent role for you as well.

PH:

Yes, but not as much as for Sandberg. It was from his idea of being part of the exhibition. He had his own style that he used for all his exhibitions. I am more in favor of diversification.

HUO:

Sandberg put together "Dylaby" ("Dylaby—a Dynamic Labyrinth") in Amsterdam's Stedelijk Museum in 1962, and in 1966 you organized the even more interactive project: "Hon" ("She—a Cathedral") in Stockholm, a monumental reclining Nana, 28-meters long, nine-meters wide and six-meters high. Could you say a bit about your collective adventure with Tinguely, Niki de St. Phalle, and Per Olof Ultvedt?

PH:

In 1961 and 1962 I had numerous discussions with Sandberg about doing an exhibition of site-specific installations created by several artists. He accepted, and "Dylaby" opened in Amsterdam in 1962. After that, I wanted to do something even more collaborative, with several artists working together on one large piece. Over the years, the project had several names: "Total Art," "Vive la Liberté," and "The Emperor's New Clothes." In the early spring of 1966 I finally managed to bring Jean Tinguely and Niki de St. Phalle to Stockholm to work with the Swedish artist Per Olof Ultvedt and myself. Martial Raysse withdrew at the last minute—he'd been selected for the French pavilion at the Venice Biennale. The idea was that there would be no preparation, nobody would have a particular project in mind. We spent the first day discussing how to put together a series of "stations," as in Stations of the Cross. The next day we started to build the station "Women Take Power." It didn't work. I was desperate. At lunch I suggested we build a woman lying on her back, inside of which would be several installations. You would enter

through her sex. Everyone was very enthusiastic. We managed to finish her in five weeks, inside and outside. She was 28-meters long and about 9-meters high. Inside there was: a milk-bar, in the right breast; a planetarium showing the Milky Way in the left breast; a mechanical man watching TV, in her heart; a movie-house showing a Greta Garbo film in her arm; and an art gallery with fake old masters in one leg. The day of the press preview we were exhausted; the next day there was nothing in the newspapers. Then *Time* wrote a favorable piece and everybody liked her. As Marshall McLuhan said, "Art is anything you can get away with." The piece seemed to correspond to something in the air, to the much-vaunted "sexual liberation" of that time.

HUO:

In 1968, you put together a big exhibition at MoMA, "The Machine as Seen at the End of the Mechanical Age." What was its premise?

PH:

MoMA had asked me to put together an exhibition on kinetic art. I told Alfred Barr that the subject was too vast, and instead proposed a more critical and thematic exhibit on the machine. The machine was central to much of the art of the '60s, and at the same time, it was obvious that the mechanical age was coming to an end, that the world was about to enter a new phase. My exhibition began with Leonardo da Vinci's sketches of flying machines and ended with pieces by Nam June Paik and Tinguely. It included over 200 sculptures, constructions, paintings, and collages. We also put together a film program. Tinguely was really in love with machines, with mechanisms of any kind. He had had his breakthrough on March 17, 1960, with *Hommage à New York*—a self-destroying artwork. Richard Huelsenbeck, Duchamp, and myself had written for the catalogue at the time, and Tinguely wanted to bring his friends Yves Klein and Raymond Hains with him to New York in 1960, but somehow it never happened.

HUO:

Your machine show could be thought of as a requiem to L'Homme-machine *(1748), the famous book by the eighteenth-century philosopher {Julien Offray de} La Mettrie, about the machine age.*

PH:

Yes—as its culmination. It was also the height of MoMA's golden age, a period when Alfred Barr was there and René d'Harnoncourt was director of the museum.

HUO:

Why was it so wonderful?

PH:

They were both great men. For one thing, no one ever mentioned the word "budget." Today it's the first word you hear. There were all kinds of possibilities. When, at the eleventh hour, we had to get one of Buckminster Fuller's Dymaxion cars from Texas, they said, "Boy, that costs a lot of money," but we got it. This was the last great exhibition of that period at MoMA. René d'Harnoncourt died in an accident shortly before the machine show opened, and Alfred Barr had retired the year before.

HUO:

Though there were numerous exchanges between Stockholm and the United States during your tenure at the Moderna Museet, you were the first to do big one-person shows in Europe with Claes Oldenburg and Andy Warhol. What about the Pop Art show at Moderna Museet in Stockholm ("Amerikansk POPKonst" {American Pop Art}, Moderna Museet, Stockholm, 1964)— wasn't it the first survey show of American Pop Art in Europe?

PH:

One of them. After my visit to New York in 1959, I curated two Pop Art exhibitions. The first was in '62 with Robert Rauschenberg, Jasper Johns, and others ("4 Americans," Moderna Museet, Stockholm, 1962). The second part was in 1964, with the second generation: Claes Oldenburg, Andy Warhol, Roy Lichtenstein, George Segal, James Rosenquist, Jim Dine, and Tom Wesselmann.

HUO:

One of your links to the United States was the electrical engineer Billy Klüver.

PH:

Billy was a research scientist at Bell Labs. In 1959 I came to New York and I started to give Billy a crash course in contemporary art; he generously accepted to act as a liaison between the Moderna Museet and American artists. Lots of artists needed technology. Billy started EAT (Experiments in Art and Technology) with Rauschenberg, Robert Whitman, and Fred Waldhauer, a collaborative effort that came to a bad end. Pepsi-Cola had commissioned them to do the youth pavilion at the World's Fair in Osaka ("Expo 70," Osaka), where they enclosed a dome-shaped pavilion in a cloud sculpture by Fujiko Nakaya. In a way it came from an idea of [John] Cage's—that a work of art could be like a musical instrument. When the pavilion was finished, Billy insisted on doing some live musical programming. After a month,

after three or four artists had performed, Pepsi-Cola took over the project—they wanted automated programming.

HUO:

What was the art scene like in Sweden in the '60s?

PH:

It was very open and generous. The great art star was Öyvind Fahlström, who died very young, in 1977. I did three shows of Swedish art later in my career: "Pentacle" at the Musée des Arts Decoratifs in Paris, 1968, a show of five contemporary artists; "Alternatives Suédoises" at the Musée d'Art Moderne de la Ville de Paris, in 1971, which focused on Swedish art and life in the early '70s; and a big show, "Sleeping Beauty," at New York's Guggenheim Museum in 1982 that included two retrospectives—one of Asger Jorn, the other of Fahlström—and occupied the entire museum.

HUO:

Many exhibitions you organized in the '60s didn't privilege the artwork as such. Documentation and participation in various forms became equally important. How come?

PH:

Documentation was something we found very exciting! It was in the spirit of Duchamp's different boxes. We began seriously buying books, like Tristan Tzara's library. There was also another dimension: the museum workshops became an important part of our artistic activities. We reconstructed [Vladimir] Tatlin's *Tower* in 1968, using the museum's own carpenters, not specialists brought in from the outside. This approach to installing exhibitions began to create a phenomenal collective spirit—we could put up a new show in five days. That energy helped protect us when hard times came at the end of the '60s. After 1968, things got rather murky; the cultural climate was a sad mixture of conservatism and fishy leftist ideologies. Museums were vulnerable, but we also withstood the tempest by doing more research-oriented projects.

HUO:

You also did political shows like "Poetry Must Be Made by All! Transform the World!" in 1969 (Moderna Museet, Stockholm), borrowing a sentence by Lautréamont, which was an attempt to link revolutionary parties to avant-garde artistic practices. It included almost no originals and a wall on which local organizations could affix documents stating their principles and goals. How was that show organized?

PH:

It was divided into five different sections: "Dada in Paris," "Ritual Celebrations of the Iatmul Tribe of New Guinea," "Russian Art,

1917–1925," "Surrealist Utopias," and "Parisian Graffiti, May '68."
It was about the changing world. It consisted principally of models
and photographic reproductions mounted on aluminum panels. We
used teams made up of people who served various functions at the
museum; they acted as animators or technicians. It was like a big
family: everyone helped each other out. Things were very different
then. At the time there were lots of volunteers, mostly artists who
helped install the work.

HUO:

*Another of your famous exhibitions was "Utopians and Visionaries"
("Utopians and Visionaries, 1871–1981," Moderna Museet, Stockholm,
1971) which began with the Paris Commune and concluded with contemporary Utopias.*

PH:

It was even more participatory than "Poetry Must Be Made by All!"
Held two years later, "Utopians and Visionaries" was the first open-
air exhibition of its kind. One of the sections was a 100th anniver-
sary celebration of the Paris Commune, in which the work was
grouped into five categories—work, money, school, the press, and
community life—that reflected its goals. There was a printing facil-
ity in the museum—people were invited to produce their own
posters and prints. Photos and paintings were installed in trees.
There was also a music school run by the great jazz musician Don
Cherry, the father of Neneh Cherry. We built one of Buckminster
Fuller's geodesic domes in our workshops and had a great time doing
it. A telex enabled visitors to pose questions to people in Bombay,
Tokyo, and New York. Each participant had to describe his vision of
the future, of what the world would be like in 1981.

HUO:

*"Poetry Must Be Made By All! Transform the World!" and "Utopians
and Visionaries" were forerunners of many exhibitions in the '90s that also
emphasize direct audience participation.*

PH:

In addition to the shows themselves, we organized a series of
evenings at the Moderna Museet that took things pretty far. During
"Poetry Must Be Made By All!" Vietnam draft-dodgers and soldiers
who had gone AWOL, as well as the Black Panthers, came to test
how open we really were. There was a support committee for the
Panthers that held meetings in a room set aside for public use. For
these activities, we were accused by parliament of using public mon-
ey to form a revolution.

HUO:

Talking about these shows reminds me of your famous plans for the Kulturhuset, Stockholm. It has been described as a cross between a laboratory, a studio, a workshop, a theater, and a museum—and in a certain sense as the seed out of which the Pompidou grew.

PH:

That's not far from the truth. In 1967 we worked on Kulturhuset for the city of Stockholm. The participation of the public was to be more direct, more intense, and more hands-on than ever before: that is, we wanted to develop workshops where the public could participate directly, could discuss, for example, how something new was dealt with by the press—these would be places for the criticism of everyday life. It was to be a more revolutionary Centre Pompidou, in a city much smaller than Paris. Beaubourg is also a product of '68—'68 as seen by Georges Pompidou.

HUO:

In your plans for the Kulturhuset, each floor was accorded one function. How could multi-disciplinarity and interactivity have been promoted in an institution structured that way?

PH:

It was designed so that as you went up a floor, what you encountered was more complex than what was on the previous floor. The ground floor was to be completely open, filled with raw information, news; we were planning on having news coming in from all the wire services on a telex. The other floors were to house temporary exhibitions and a restaurant; the latter is really important because people need somewhere to congregate. On the fifth floor we were going to show the collection. Unfortunately the Kulturhuset went awry of the politicians and parliament took over the building for itself. But the work I did conceiving that project proved to be a useful preparation for my work at the Pompidou.

HUO:

What about the On Kawara show you brought to the Pompidou in 1977, in collaboration with Kasper König?

PH:

I had met On Kawara in Stockholm; he was living in an apartment owned by the Moderna Museet, and he stayed for almost a year. We became friends. I have always thought On Kawara was one of the most important conceptual artists. The show included all the paintings he had done that year. There was absolutely no reaction on the part of the French press—not a single article!

HUO:

How do you see the Pompidou today?

PH:

I don't go there very often. I once made the mistake of going back as an adviser. I now no longer go back, on principle.

HUO:

How does a space like the Institute of Contemporary Arts in London, where they've always operated a bar, cinema, and exhibition spaces, compare with the Centre Pompidou and with the multifaceted, interdisciplinary role you envisioned for the Kulturhuset in Stockholm?

PH:

I think a collection is absolutely fundamental. The failure of André Malraux's Maisons de la culture can be traced to the fact that he was really aiming at theater. He wasn't thinking about how to build a museum, and that's why his cultural institution foundered. The collection is the backbone of an institution; it allows it to survive a difficult moment—like when the director is fired. When Valéry Giscard d'Estaing became president, there were some rather strong-willed people who asked why the Pompidou was exposing itself to all these problems with donors. Why not just leave the collection in the Palais de Tokyo and build a Kunsthalle without a collection? There was lots of pressure to go in that direction. I managed to convince Robert Bordaz that that would be dangerous, and we saved the collection and the project.

HUO:

So you are against the idea of separating collections from exhibitions?

PH:

Yes, otherwise the institution has no real foundation. Later, when I was director of the Kunst- und Ausstellungshalle in Bonn, I saw how fragile a space devoted to contemporary art could be. The day that someone decides that it's too expensive, it's all over. Everything is lost, almost without a trace. There'll be a few catalogues, and that's it. The vulnerability of it all is terrifying. But that's not the only reason I talk about collections with such passion. It's because I think the encounter between the collection and the temporary exhibition is an enriching experience. To see an On Kawara show and then to visit the collection produces an experience that is more than the sum of its parts. There's a curious sort of current that starts to flow—that's the real reason for a collection. A collection isn't a shelter into which to retreat, it's a source of energy for the curator as much as the visitor.

HUO:

You've always insisted on the importance of a serious scholarly monograph to accompany an exhibition. This seemed especially important in the '80s when you mounted an impressive series of retrospectives of artists who had meant a lot to you over the years.

PH:

Yes, it was wonderful to have the opportunity to do so. I loved Tinguely's retrospective in Venice at the Palazzo Grassi and Sam Francis's retrospective in Bonn. Those shows were both developed in close dialogue with the artists and marked great moments in the history of my friendship with them.

HUO:

What other exhibitions do you remember most fondly?

PH:

I did a show called "Futurismo & Futurismi" in 1986, which was the first show in Italy dedicated to the Futurists (Palazzo Grassi, Venice). It was divided into three parts: Futurism's precursors, Futurism itself, and its influence on artistic production until 1930. The exhibition is considered a classic, thanks in part to the catalogue, which reproduced all the works shown, and included over 200 pages of documentation. 270,000 copies were sold. The [Giuseppe] Arcimboldo show we did was dedicated to the memory of Alfred Barr, which really upset the Italian press, who called him a "cocktail director." In 1993, I installed the Duchamp show, at the Palazzo Grassi, grouping documents and works together in sections devoted to such topics as the readymade, the Large Glass (1915–1923), and the "portable museum."

HUO:

What about Claes Oldenburg's great happening, Il Corso del Coltello *{The Knife's Course}, at the Campo dell'Arsenale in Venice in 1985?*

PH:

Oldenburg does everything himself. The exhibition organizer becomes a kind of troubleshooter, but it was a great event. One of the main props of the performance, *Knife Ship* (1985) is now at LA MoCA. I had the role of a boxer, Primo Sportycuss. He buys an ancient costume that combines St. Theodore and a crocodile with which he confronts the chimera of San Marco. Frank Gehry played a barber from Venice; Coosje van Bruggen played an American artist who discovers Europe. The whole thing went on for three nights and there was a lot of improvisation. We had a good time.

HUO:

In 1980 you were asked to head the project to build a new contemporary art museum in Los Angeles, which became LA MoCA. How did that get started?

PH:

A group of artists, including Sam Francis and Robert Irwin, wanted to start a contemporaryart-museum. The artists asked me to come and work with them. I got along very well with them, less well with the patrons; there was very little financial support. The first exhibition, in 1983, was called "The First Show," which consisted of paintings and sculptures from 1940–80, drawn from eight different collections. It was an effort to examine what it meant to collect art. I did a second show called "The Automobile and Culture" (1984), a survey of the history of cars as objects and images that included thirty actual cars. I tried to raise money for four years. I finally had to leave because I was no longer practicing my profession. I had become a fundraiser instead of a museum director.

HUO:

After you were back in Paris you founded L'Institut des Hautes Études en Arts Plastiques, in 1985, a laboratory-school with Daniel Buren. Can you tell me a little about this project?

PH:

It was a kind of café, a place where people could meet every day, and where there was no real structure or authority figure. It grew out of a discussion I had with the mayor of Paris, Jacques Chirac. We nominated four professors: Buren, Sarkis, Serge Fauchereau, and myself. Including the time it took to put the "school" together, this project lasted ten years. Then the city of Paris suddenly decided to put an end to it. While it lasted, we invited artists, curators, architects, filmmakers, all of who came. There were only twenty students per year, and we were all together for a year. The "students" were all artists who had already finished art school; they were actually referred to as artists, not students. They each got a stipend. We did great things together—including going on an excursion to Leningrad where we did a site-specific show, and building a sculpture park in Taejon, South Korea. It was a great experience for me.

HUO:

Who were some of your students?

PH:

Absalon, Chen Zhen, Patrick Corillon, Jan Svenungsson, among others.

HUO:

What were your most significant exhibitions when you took the position at Bonn's Kunst-und Ausstellungshalle in 1991?

PH:

I opened with five shows, one of which was Niki de St. Phalle's retrospective (1992); the other, "Territorium Artis" (Territorium Artis: Key Works of the Art of the Twentieth Century, 1992), was a show of key works that marked decisive stages in the history of twentieth-century art. It ranged from Auguste Rodin and Michail Wrubel to Jeff Koons, Jenny Holzer, and Hans Haacke. I also did a Sam Francis retrospective: a show called "Moderna Museet Stockholm Comes to Bonn" ("The Great Collections IV: Moderna Museet Stockholm Comes to Bonn," 1996) in which we showcased the Moderna Museet's collection: and a similar one with MoMA's collection ("The Great Collections I: The Museum of Modern Art, New York. From Cézanne to Pollock," 1992).

HUO:

From your perspective, what does the '90s art world look like?

PH:

I see little coherence, something of a crisis. But also moments of great courage and, most importantly, an enormous general interest in art compared with when I started in the '50s.

HUO:

What are you working on at the moment?

PH:

The Museum Jean Tinguely in Basel, which has just opened. I'm also at work on a book about the beginnings of the Centre Pompidou, called *Beaubourg de justesse* [*Beaubourg*, just about]. And I'm writing my memoirs.

HUYGHE, Pierre

Pierre Huyghe was born in 1962 in Paris, where he currently lives and works. Huyghe graduated from the École Nationale Supérieure des Arts Décoratifs, Paris, in 1985. Since the beginning of his practice he has worked with a variety of formats and tools including events, billboards, film, architecture, and exhibitions. Huyghe gained international prominence in the '90s for his works that shift modes of production and reception. For instance, Huyghe has produced works that directly relate to films by Pier Paolo Pasolini, Andy Warhol, and Walt Disney, among others, using them as a potential for new scenarios and points of departure for experiments with translation, remaking or, as he puts it, "re-enacting." His meta-filmic interest has resulted in a series of large-scale productions that are admirable not only for their artistic rigor, but also for their innovative modes of presentation seen in works such as Remake *(1994),* Blanche-Neige Lucie *(Snow White Lucie, 1997), and* The Third Memory *(1999). Huyghe often works in a collaborative mode with his contemporaries, including artists Philippe Parreno, Dominique Gonzalez-Foerster, and Mélik Ohanian, architect François Roche, writer Douglas Coupland, and the musicians of Pan Sonic, among others. In his works and interventions, Huyghe attempts to bypass traditional formats of artistic projects and exhibitions and to decipher systems of social exchange by renegotiating structures of time—free time, working time, production time. Some of his collaborative projects include:* L'association des Temps Libérés *(Association for Freed Time, 1995);* Anna Sanders Magazine *(1997);* Mobil TV *(1995; 1998); and* No Ghost Just a Shell *aka "Annlee project" (2000–2003). His work has been presented in numerous important international group exhibitions including: Documenta 11 (Kassel, 2002); "Egofugal: Fugue from Ego for the Next Emergence," 7th International Istanbul Biennial (2001); "Premises," Solomon R. Guggenheim Museum, New York (1998). Recent one-person exhibitions were presented at institutions including: Solomon R. Guggenheim Museum, New York (2003); Kunsthaus Bregenz, Austria (2002); "Le Château de Turing," Pavillon Français, La Biennale di Venezia (49th International Art Exhibition, 2001); Stedelijk Van Abbemuseum, Eindhoven (2001); Centre National d'Art et de Culture Georges Pompidou/Musée National d'Art Moderne, Paris (2000); Renaissance Society, Chicago (2000); Secession, Vienna (1999); and ARC/Musée d'Art Moderne de la Ville de Paris (1998).*

......................

This interview was recorded in Paris in October 2002, with Luc Steels on the phone for a portion of the interview.

Hans Ulrich Obrist:

The group notion has come back, but in a different form, which isn't the static, close-knit group, but a proliferation of collaborations.

Pierre Huyghe:

In a group, the exchanges are always between the same people, whereas in collaborations, it's occasional: the associations are tem-

porary and more diverse, they disappear and reappear, taking on new forms elsewhere, producing singular situations. Discussion has become an important moment in the constitution of a project; you can enter or leave it at any moment, which also affects the modes of production and allows you to escape a rigid and monomaniacal way of thinking.

HUO:

You told me that in the early '80s you were part of a group. So how would you retrace this development towards another form of the group or the non-group, existing through dialogues and discussions that several people carry out on a regular basis? If we follow up this line, how has your relationship to the group transformed?

PH:

We all have a relationship to the group that varies in intensity. It starts with the groups that form at school, the little gangs, then you never cease moving from group to group, and you keep fine-tuning your relationships with each one; that way you are paradoxically independent and attached at the same time.

HUO:

If you take the example of a group like General Idea, which came out of the late '60s...

PH:

Or Group Material...

HUO:

Yes. Those are groups whose borders were open in a certain way, but at the same time they had a logo and many other attributes of direct identification.

PH:

Yes, in a certain way they were stable forms. Whereas here you have to reconstruct a temporary communal sense under which you can exchange things. So these collaborations have a blinking existence.

HUO:

When you began working in the '80s, was the group that you were part of still a prolongation of the groups of the '70s and before?

PH:

It didn't have so much to do with the ideological dimension as with the dynamics. There were six or seven of us doing interventions in public space. It was a very short experience, but enough to see the limits of a collective, whereas with collaborations, a renegotiation is always possible. It's a way to keep on learning. When

you ground yourself in one form of knowledge, you domesticate it, you polish it. But knowledge should remain rough. To remain that way it has to be fed by a continuous dialogue.

HUO:

It's almost cybernetic.

PH:

Let's say it goes through different forms of experience. That affects the work and its conditions of realization. It helps me to understand what's happening around an object, which means thinking in terms of a chain, of scenarios. The movement of an object through the chain is a question of trajectories...

HUO:

For me that brings to mind certain aspects of the science of strolling, the "promenadology" defined by Lucius Burckhardt in Kassel. The notion of trajectory was fundamental for him, even for understanding the very notion of landscape.

PH:

Of course, and it wasn't an accident that we talked about landscapes in the exhibition at the ARC ("Dominique Gonzalez-Foerster, Pierre Huyghe, Philippe Parreno," ARC/Musée d'Art Moderne de la Ville de Paris, 1998).

HUO:

The exhibition as landscape...

PH:

Not so much related to nature, but as something you cross, where you suspend your conclusions and resolutions, without losing the dynamic.

HUO:

It has become very fashionable in contemporary art exhibitions to use the metaphor of the city, and that's partially been done at the expense of the metaphor of landscape. But I think that the metaphor of landscape has not lost any of its pertinence, particularly in terms of dynamics. But of course, the very idea of dynamics has become so associated with the city...

PH:

Maybe we should avoid this play of metaphor, the generic metaphor of the city and the encounter, culture and the event; even the adventure takes place through this synthetic experience.

HUO:

In the second half of the '90s, you could see a diversification of the forms of collaboration proposed by artists. Although collaborations between artists

continued and are still going on, many artists now try to collaborate with other practitioners: architects, musicians, writers, etc. In your case, there is the work with Douglas Coupland, or with the musicians of Pan Sonic.

PH:

Yes, recently I thought of David Robbins because he had come up with a sentence like this: "The rules of the art restrict my imagination." But we should turn the camera on you right now, because for as long as I've known you, you've been telling me about the people you meet and your collaborations with architects, scientists, etc. We agree, the problem isn't framed in terms of a field, but of a shared thinking, an overlapping imaginary. That's why I work with François Roche or Douglas Coupland.

HUO:

So you wouldn't see this moment as something particularly new?

PH:

I don't know, art remains a free field; that's probably related to one's own particular relation to economy, but one that remains restricted by its own formats. It's less a problem to elude central questions by looking elsewhere than finding a way to produce forms of coexistence that inhabit the social field and test one's own capacity of resistance inside it. Operational scenarios are always fragile anyway. It's a way to explore other possibilities of exchange.

HUO:

What were the preliminaries of your meeting with Coupland and your collaboration?

PH:

First it was a meeting through the books *Generation X* (*Generation X: Tales for an Accelerated Culture*, 1991) and *Girlfriend in a Coma* (1995). I'm interested in the development of a group situation in the continual reconstruction that we just talked about. His novels are constructed through a series of details that sketch out a present; *Generation X* is the good example. It's a hyper-present that becomes a kind of pre-future. This feeling of the present is a something that really comes out of these collaborations. And you find that in Douglas Coupland's books, his thinking shifts through different forms and temporal slippages. We are now working together around the idea of a daily book, a book of one day.

HUO:

That's kind of intuitive and unpredictable: you have the feeling it's going to lead you to certain very concrete things, but you don't know yet precisely know what…

PH:

You simultaneously invent the object and the tool to grasp it. The magazine *Anna Sanders* was done that way. This is a chance to continue the experiment.

HUO:

Because Anna Sanders, *the magazine that you and Philippe {Parreno} did, has been more or less in limbo since the first issue.*

PH:

Yes, that's been the only issue so far. We were working on the scenario of a film, then we decided to publish at different phases of the production, in a nonlinear way.

HUO:

And where does the name "Anna Sanders" come from?

PH:

It's the name of a fictional character and it's also the name that we later gave to the production company that we created with Charles de Meaux: Anna Sanders Film. Each issue was supposed to present a new character who would give his or her name to the magazine. The whole series should constitute the scenario for a film. Doing this feature film at that point seemed too far away from our practice. In between times, there have been different collaborations: *Annlee* (2000–2003) and *Vicinato II* (with Liam Gillick, Douglas Gordon, Carsten Höller, and Rirkrit Tiravanija, 2000) among others, so today that doesn't seem very different from five people deciding to construct a village in Thailand or planning out an exhibition.

HUO:

I guess you're speaking about "The Land," Rirkrit's "massive-scale artist-run space" in Chiang Mai, Thailand. The slowness is also interesting in relation to the context of the exhibition, which is increasingly subject to an accelerator effect. In the early '90s, you had two years to do a biennial, now they call us five months before it opens. More and more you have to refuse that. Anna Sanders *or "The Land"—because there is no real beginning, there is no end—are a constant, like time itself—they are also ways of resisting that.*

PH:

It's another rhythm of production, but this slowness has nothing to do with the object produced, as is often the case for all the people who work only in opposition to speed...

HUO:

People like Theo Angelopoulos, the filmmaker who does very long shoots, who works in pure slowness and produces films that are just as slow.

PH:

I don't think it's a problem of slowness, but of distance. You have to produce a distance, that is, a path that must be walked in order to go from one point to another. And this path that must be walked, to get back to your theory of strolling, leads to a very different relationship with narration. It's the position of the narrator, who takes a different path to bring back something else. The problem isn't whether he brings it back slowly or quickly. *The Third Memory* is built around this distance; it concerns the memory of a man whose story was told by the press and later by Hollywood. It plays on the permutations between the person whose story is told, the one doing the telling, and the one to whom it is told.

HUO:

Have you heard about the books by Asger Jorn, which were republished a few months ago by Walther König in Cologne? They are books that Asger Jorn did during the late '60s, at the time when he began earning lots of money by selling his paintings. So he invented another activity for himself, and undertook intense research into medieval art in Greenland, which kept him busy for about five years. The book was just shelved for a long time before being republished. These kinds of things, the desire to write, to produce books, the time and slowness required for writing and publication, are what Philippe {Parreno} has been speaking to me about recently. So you also feel this desire?

PH:

It's another way of producing and defining one's own temporality in relation to a context.

HUO:

There we also touch indirectly on the projects that you have undertaken alone or in collaboration with others, in the attempt to go beyond the format of the group exhibition. I'm thinking of projects like Mobile TV, *or the one on the* Temporary School *(with Dominique Gonzalez-Foerster and Philippe Parreno, 1997).*

PH:

Through these different experiments, we tried to raise the question of the exhibition. Dominique, Philippe and I were invited individually to do different workshops and the *Temporary School* consists of reversing these requests and reprogramming them by bringing these workshops together in the same project. We had tried to think about transmission in the course of our different experiences, so that gave rise to a book, which served us as a guide for the production of scenarios. *Temporary School* is another form of the *Association des temps*

libérés (*The Association for Freed Time*, 1995), which brought together all the participants of an exhibition ("Moral Maze," Le Consortium, Dijon, 1995), giving them a social reality. It proposed to extend the time of these meetings outside the temporal frame, a departure point for a series of projects of an unspecified duration.

HUO:

So the idea was to change the rules...

PH:

Like when you did the book *Unbuilt Roads* (with Guy Tortosa, 1997): you found a scenario that changed the conditions of production and realization.

HUO:

Mobile TV *was another form of school for people like Mélik Ohanian, Marine Hugonnier, Olivier Bardin: most of the members of the young French scene were part of it.*

PH:

[*Laughs*] We should ask them. Opening a new television station was a way of asking questions on collective exhibiting, authorship, coexistence, programming, conditions of reception. Among certain production elements, the exhibition provided the participants with a TV platform and broadcasting equipment. It was a collaboration with Mélik Ohanian and many other people participated, Liam [Gillick], Dominique [Gonzalez-Foerster], Philippe [Parreno], Pierre Joseph, Chris Marker, and Douglas Gordon, among others. Most of the time the artists were sending proposals, which were then interpreted, or they came to make direct TV shows like Matthieu Laurette or Olivier Bardin did. The TV program was constructed around their proposals and process of concomitance. The exhibition was transmitted in the city. An exhibition as programming based on the time one has to oneself that can be opposed to leisure time or working time. A television, an exhibition, a book— it was a project through those three formats.

HUO:

Could we get back to the question of knowledge, of smooth and domestic knowledge, by contrast to what you call "rough knowledge?" I think it's worth exploring that issue further.

PH:

Knowledge is something that is often domesticated. Ways of thinking that don't get formatted, that manage to escape domestication are rare. Victor Segalen wrote a little book about exoticism where he tries to develop a theory of diversity (*Essai sur l'exotisme: une esthétique du divers*, posthumous, 1978). Wild is something for

which you can't make an image. Knowledge gets smoothed out because it has to be transmitted. It enters formats of transcription. Wild knowledge can't easily be categorized.

HUO:

And it's also true that in the academic context it's very difficult to publish and get recognition for forms of thinking and writing that would match your definition of rough knowledge.

PH:

Of course, but literature does it, and certain essays too. As soon as the knowledge goes through a format, it becomes domestic and looses its singularity. There's a sentence from the Situationists that goes something like this: "It's not so much a problem of arrangement, but of laws of these arrangements that should be explored."

HUO:

And does that hold for all the formats: the exhibition, the lecture, the biennial, the monographic or retrospective exhibition?

PH:

Exactly, if you evolve within those frames, you make arrangements. On the other hand, if you play with those formats, you play with the laws of arrangement.

HUO:

You could also say, like Deleuze, that the format is always a cliché.

PH:

For sure, a cliché is an image you know beforehand, before taking it. It's an image you verify.

HUO:

In that very nice conversation you had with Vincent Dieutre, you discuss Utopia with respect to Sleeptalking *(1998)...*

PH:

John Giorno is the sleeper in Andy Warhol's film *Sleep* (1963). In *Sleeptalking*, he talks about his dreams, very concrete dreams since they are the Utopias of the '60s. By talking about what he goes through, he becomes an actor and not just a sleepwalker. It's less about the failure of a Utopia than the way it transmutes and negotiates its relation to the everyday.

HUO:

Do you have projects you would call concrete Utopias?

PH:

What, for you, is the opposite of concrete Utopias?

HUO:

Let's say, totalizing or universalizing Utopias.

PH:

Heterogeneous Utopias.

HUO:

That's what Bloch said to Adorno, something is missing...

PH:

Self-satisfaction is this terrifying idea that brings the world to collapse in *Girlfriend in a Coma*. The only character that didn't lose her desire to change things announces that the world will collapse and in this post-apocalyptic world, this *"Day After,"* they start to reconsider their position. That's where we are now. Maybe Utopia should be embodied in something more concrete, something you construct, while eliminating the conclusion from the very outset. Keeping only the dynamics, the desire, the potential.

HUO:

In short, to use the vocabulary of urbanism, there is no master plan.

PH:

It's a problem of projection; that's what modernity did when it folded the present to validate the future it presupposed. There's no room for speculation. Liam [Gillick] did a very interesting essay on the relationship between the plan and the scenario as two different models of organization.

HUO:

Are you touching upon Utopia with Annlee*?*

PH:

Our intention was to have her disappear from the realm of representation...

HUO:

To pull the plug...

PH:

To work in such a way that this sign belongs only to itself. There is also definitely something utopian there because we are trying to find this legal void.

HUO:

An eternal life?

PH:

Outside the representation. We want to give back the rights that we have acquired when we first bought this character. Liberating the sign means making it autonomous. And that's not just leaving it in the public domain, because then it would belong to everyone.

HUO:

How did the Annlee *project begin?*

PH:

We contacted a Japanese agency specializing in the production of *manga* characters. Those characters are usually sold to film production and video game companies who need these characters to carry their stories. The prices depend on their narrative potential: the most elaborate ones have more powers and more sophisticated graphics. We deliberately chose a kind of secondary character and we deviated it from its chain of distribution, from its primary function, which is feeding the fiction market. Then this empty sign was filled with meaning by passing through the hands of different artists.

HUO:

In the beginning it was you and Philippe...

PH:

Chronologies don't matter—there's Dominique Gonzalez-Foerster, Liam Gillick, Pierre Joseph, and now Rirkrit Tiravanija and Joe Scanlan, who did that book project in the form of a do-it-yourself manual. It's a manual for constructing your own coffin using Ikea furniture (*DIY or How to Kill Yourself Anywhere in the World for Under $399*, 2002). *Annlee*, the empty shell, is used to carry out the demonstration. There's also Mélik Ohanian who will give the image of *Annlee* to be drawn by the pupils of an alternative school.

HUO:

And what about "Not Ghost Just A Shell," the exhibition gathering all the Annlee projects in the Kunsthaus Zurich?

PH:

You know, I would rather say the "*Annlee* exhibition," if you have to use such an expression, is always taking place; there is always one of us showing an episode somewhere. It's an exhibition in time and in space. To bring them all together is just a phase, not a final representation; this project is built up by appearing and disappearing, constructing its own form of exhibition.

HUO:

Seeing Annlee as a Utopia then seems even more pertinent, because it's a non-place; Annlee is from nowhere; that's the very definition of Utopia.

PH:

It's a set of details that are constantly organized and reorganized, rather than something that could be dominant or permanent.

HUO:

What are your unbuilt roads, your unrealized projects, waiting to be realized or too big to be realized—your "utopistic" projects, to use {Immanuel} Wallerstein's notion?

PH:

I'm working on this expedition project we talked about, a group of people on an offshore radio-boat, going to find this mountain without a name and they will perform a piece of music (for the penguins). It's another project for the *Association for Freed Time*. There's also a project from 1993 that I never did, *The Family Film Festival*, a social event. I had found in a little city an unoccupied movie theater with three projection rooms, and I thought about reopening it to bring together all the city's family films. The movie theater was transformed into a chain of production: from a place of reception and transformation to a room where the films would continuously be projected. Family films are all the same shared moments in weekends, holidays, resting times. Doing that in a small city, so that everybody would show up in each other's films, the neighbor in the background, a co-presence and a collective auto-portrait of a town. And so here again the idea was to...

[*Phone rings*]

HUO:

It's Luc {Steels}.

[...]

HUO:

Listen Luc, you caught me in the middle of an interview with Pierre Huyghe. Maybe we should continue it with you. Or maybe, Pierre, you can ask Luc a question.

PH:

Actually, I'd love to hear Luc speak about his own work, his experiments with robots and the learning of a language and the conception of time.

HUO:

Did you hear Pierre's question?

Luc Steels:

Yes. Well, here at the AI Lab {Artificial Intelligence Laboratory of the Free University of Brussels} we run experiments with robots that experience a series of events in time. One of these experiments is to have one person enter a room and another one go out. Robots do not comprehend notions of time differentiation (such as past, future, preterit), which are incredibly subtle notions that are implicit to our languages. So we try to make them formulate concepts of time differentiation and time description, to make them invent words that allow them to speak about time amongst themselves. The idea is to see whether, through these iterative language games, robots can begin to conceptualize time on a general level.

PH:

It seems that the conception of time that you're interested in is not that of measured time, which François Jullien says is characteristic of Western civilizations, but rather an Eastern conception, where time is determined by occasions, events, what occurs. There is the example of peasants, who had determined the proper time for cultivating by referring to seasons and observing seasonal shifts rather than going by the calendar or the clock.

LS:

We are utterly aware of the fact that the perception of time isn't identical in every culture; we know very well, for example, that in certain languages there are no visible differences between a story told in the past, a story told in the present, and a story told in the future. Some people also use space rather than time to identify actions: in some languages, instead of saying "it was yesterday," you would say "in a certain location." To be more precise, what we're trying to do here, in these experiments, is merely to work with possible pre-notions or preconceptions of time. It is obvious as well that in every attempt to represent things, and in particular when one makes a film or creates an image, a creation of time is involved.

PH:

Exactly. There is a temporality or a duration (which does not necessarily mean a measured time) that is inseparable from the coming into being of a form.

HUO:

Pierre was telling me about the Annlee *project and I think there is link with your research on nonlinearity, the symbolic and the post-symbolic. Can you tell us more about it?*

LS:

This much remains a mystery: the way we pass from a symbolic universe (a universe structured by language and signs) to a world that isn't organized that way, a continuum that must be mentally sorted out in order to be expressed through symbols. What interests me is this progression from an experience to its expression as representation, and how these representations in turn alter our experiences. And I am very interested in artists whose work revolves around these questions, who are doing research—in a manner completely different from mine, of course—on this oscillation between personal experience and its representation.

PH:

For me what is important is to make these signs or these modes of representation more fragile. It makes me think about what Carsten

[Höller] does, because Carsten delves far into this issue. Because for him the representation of an experience in the context of art becomes itself an experience, a different type of experience where the interactions between experience and representation are multiplied. For me, the crucial thing is that any experience is also that of the moment of reading this representation. The object and its representation are just transitory states. They need this fragility to be complex. And mistakes and forms of non-resolution also constitute an experience or an event.

LS:

You see, in generative linguistics, these considerations are entirely banned. In {Noam} Chomsky's linguistics, only errorless sentences are of interest. I am completely opposed to this idea, because you end up denying all the creative and living aspects of language. For Chomsky, this is how language can be turned into a formal system, like logic, which then becomes much easier to describe and to model in mathematical terms. What I am interested in, on the contrary, are the hesitations, the mistakes, the misinterpretations, and so on. In our experiments with the robots, we attempt precisely to reach the point where they are able to make mistakes, because that is, for us, a real form of learning. I think that the power of language, and in art the power of an image, proceeds from all the metaphors, analogies, or associations they can engender. You can't control what happens in someone else's head; that person will probably imagine things you haven't envisaged at all. That's power. If we don't go in that direction, we're like simple automata that can only exchange commands.

PH:

The combination is finite.

HUO:

Maybe we could speak about John Cage and the idea of chance?

LS:

Well, what I'm saying is that to communicate, one has to take risks, one has to go toward those dark areas (hesitations, mistakes, etc.), so there is indeed an element of randomness, but I don't think it's randomness in Cage's or {Iannis} Xenakis's sense.

PH:

Yes, because it's more in the sense of accident. This brings us back to the idea of occasion we brought up earlier. The idea of randomness for randomness' sake is in fact just another system; it's still an equation where accidents, risks, bring negotiations, discussions, language.

HUO:

Since you were an artist before becoming a scientist, Luc, and since your

working dynamic has been to collaborate with practitioners of various disciplines, I'd like you to explain your point of views on the transdisciplinary aspect of your respective approaches.

LS:

Let me say first that I find it extraordinary that the three of us manage to understand each other right away like this. And I think we really are understanding each other. This is just a small discussion, but I think we can go much further on these questions of experience, temporality, representation, and accident. I find it extraordinary, because after all, we're discussing topics that are extremely difficult to talk about. If we manage to do it, it's because we're working on similar subjects. Therefore, we're forced to develop an increasingly common vocabulary, and I'm surprised and delighted to see that the relationship between art and what I do, cognitive science, is becoming deeper and deeper.

PH:

Because it is, beyond a question of fields, of course above all a question of construction. It is at the outset that things are shared, as for example the relations of events in time and language; down the line, they insinuate themselves in different practices. But to elaborate this construction, you need to mobilize various disciplinary perspectives on the same issue or problem.

LS:

I completely agree. For me, artists and writers are especially gifted in the construction of representations and experiences, and those are precisely the processes that I'm focusing on in my research. After listening to such artists, ideas come to me and I'm able to go further. The difference is in the way we then choose to present our work to the world.

PH:

The question is less "what?" than "to whom?" It becomes a question of address.

LS:

I would love to continue, but I'm sorry I'll have to hang up. I have a class to teach and the students are probably already waiting for me. I leave you here.

HUO / PH:

Thanks a lot Luc. Have a nice day.

ISOZAKI, Arata

Arata Isozaki was born in Oita, Kyushu, Japan, in 1931. He studied architecture at the University of Tokyo and began collaborating with Kenzo Tange after graduating in 1954. In 1963 he established his own practice and began collaborating with members of the Japanese avant-garde on multidisciplinary exhibitions and projects such as Electric Labyrinths *(1968) for the legendary XIV Milan Triennale ("Large Numbers," La Triennale di Milano XIV, 1968) and The Festival Plaza for the World Expo of Osaka (Expo 70). As an architect, Isozaki honed a style that departed from the '50s Metabolists' skyscrapers, with projects cultivating heterogeneity and unexpectedness like the Kitakyushu City Museum of Art (1972–74) and the now-demolished interior of the Palladium discotheque on East 14th Street in New York. His first large public commission was the Oita branch of the Fukuoka Mutual Bank, completed in 1967. Other important public works followed in relatively rapid succession, and he quickly established his reputation with such buildings as the Gunma Prefectural Museum of Modern Art (1971–1974), Takasaki; the Kitakyushu City Museum of Art (1972–1974); the Kitakyushu Municipal Central Library (1972–1975); and the West Japan General Exhibition Center (1977), Kitakyushu.*

...............................

This interview took place in Venice in 2000.

Hans Ulrich Obrist:

It's interesting to notice that between the moment after you graduated from architecture school in 1954 and the moment you became a celebrated architect for commissioned buildings, you've played many very different roles, from exhibition curator to film contributor. I wondered how interdisciplinary the Japan art world was in the '60s?

Arata Isozaki:

I opened my office at the end of 1963. I had very small architectural projects at that time, and the first important projects were exhibition installations, for instance for an exhibition of the work of Taro Okamoto in 1964. Taro Okamoto was a hero of the Japanese avant-garde, a member in the '30s of the Surrealist Group under [André] Breton, and of Georges Bataille and Michel Leiris's "Collège de Sociologie." He was very young at the time, in his early-twenties; he came back to Japan before the war and was sent as a soldier to China. After the war he was one of the leaders of the Japanese avant-

garde movement, a special figure in the situation at the time. But maybe his influence was not so much on his own generation, but on the younger generation. He was very important in the Japanese scene in the middle of the '60s, where a lot of things happened. The most curious thing was that, when they did that exhibition at the Centre Pompidou in the middle of the '80s, called "The Japanese Avant-garde until 1970" ("Japon des avant-gardes, 1910–1970," Paris, 1986), Taro Okamoto's works were almost alienated. It was just a few years ago, after his death, that Okamoto has begun to be considered one of the most important Japanese artists.

HUO:

Soon you started to collaborate with composers and film directors...

AI:

Yes, other exhibitions followed in '64, '65 or '66. I did a first exhibition design for a show titled "Cloud and Movement" or something like that, in which composers Toshi Ichiyanagi and Toru Takemitsu were involved together with graphic and performance artists, graphic designers, and architects such as Hiroshi Hara and myself. It was designed as one environment.

HUO:

Was Yoko Ono involved? Because Ichiyanagi was the husband of Yoko Ono at the time, wasn't he?

AI:

Uh, no, already divorced. I don't remember Yoko Ono being part of that. In fact, she started as an artist in New York. At that time Yoko had already tried to cross to be with John [Lennon]. Three years after that I was asked by John to design a Japanese-type house for Yoko. Something like that. I designed a Japanese-style house. That was my first Japanese-style interior, crafted beforehand in Kyoto and disassembled and put into the air cargo and sent to London. But just at the time they left the United States, they couldn't go back to London because of drug problems. So I don't know what happened to all of my timber but Yoko asked me where it should be stored, because Japanese timber, is very sensitive to humidity and temperature and so on. Anyway, it was also at this time that I collaborated on Hiroshi Teshigahara's movie *The Face of Another* (*Tanin no kao*, 1965), a movie, which was very experimental. The whole film was made in this very '60s way. I appreciated Jean-Luc Godard a lot, I saw almost all his movies from the beginning—I remember watching *A Bout de Souffle* (*Breathless*, 1959) and *Le Mépris* (*Contempt*, 1963) in 1964—but also the films of Yoshida Yoshishige and Nagisa Oshima like *Cruel Story of Youth* (*Seishun*

zankoku monogatari, 1960), which somehow kicked the Japanese "New Wave." They were my generation. In more general terms, transdisciplinarity is something I've always tried to be involved with and to think about. My education in Modern or contemporary art was mostly about the Bauhaus and the Dada period, both of which were always about collaboration—collaborations between musicians, dancers, composers, painters... Léger, Picasso, Diaghilev... all these people were constantly collaborating, something which of course also influenced [László] Moholy-Nagy very much.

HUO:

And this philosophy was to find a timely stage with the upcoming World Expo of 1970, Expo 70?

AI:

Of course. In the five years before Expo 70, some preparations had already started. Around that time, like I told you I was working with many different artists, composers, and writers: Ichiyanagi, Takemitsu and artists like Katsuhiro Yamaguchi, Takehisa Kosugi and the many so-called Neo-Dadaists in Japan. With this kind of study group I organized a major part of the Expo 70, *The Festival Plaza*. I proposed this concept of a very large space with a moveable roof on top, 300-meters long, 100-meters wide, and 30-meters high. It was a very big box. And everything inside was moveable for the performance, a performance for maybe 20,000 people, but no more than that. At that time, our proposal was about sound and light and movement of the people, movement of the scenes. It was about water and fire and smoke and fog and that kind of thing. They were all moveable and controlled by computer—we thought of it as a kind of NASA space operation, using similar systems for the huge-scale performance for 20,000 people. And through this Expo 70 project, Toshi became more interested in not only the normal types of music performance, but more in the so-called environmental music. I believe that was at the very beginning of environmental music.

HUO:

Almost ambient music, the beginning of ambient, before Brian Eno coined the term and popularized the style.

AI:

Yes, exactly. That's right.

HUO:

So you were already working on Expo 70 when you were invited to participate in the 14th Triennale in Milan planned by Giancarlo De Carlo with Mar-

co Zanuso, Albe Steiner and Alberto Rosselli? How did this project start? How did you meet Giancarlo De Carlo? How did he know about your work?

AI:

I got an invitation letter from him. I don't know how he found me. It probably had some connection with Team X since he was a member at that time. I think some people from Japan, maybe Kenzo Tange or Fumihiko Maki, might have attended some meetings for Team X and the Triennale board. Perhaps De Carlo got some information about me through the Japanese. He told me Saul Bass and Archigram among others were included so I accepted the proposition even though we were already working on the project for "Expo '70." But the project for Osaka was a much larger-scale project— almost a national-scale project. The Triennale was a small work. It was a kind of little chamber music thing, actually. [*Laughs*]

HUO:

However, the story and the outcome of this exhibition of '60s critical avant-garde architecture in Milan made it of historical importance. Could you tell me the story from your point of view? I know that at the opening, during the press conference, several hundreds of artists, intellectuals, and architecture professors from the Milan University stormed the Triennale area and occupied it for the following ten days, and that by the end of the occupation, it was almost completely destroyed. They had turned your room as well as the rooms of Archigram, Saul Bass, Georges Candilis, Aldo Van Eyck, Gyorgy Kepes, George Nelson, Peter and Alison Smithson and Shad Woods to ruins. It never again opened to the public.

AI:

Like you said, I was invited in 1968 to the XIV Triennale in Milan, which was supposed to open at the end of May, but didn't see the opening. At the time, of course, similar movements against the establishment were also going on in Japan. Because I sympathized with these protests, I tried to reflect them in my Triennale exhibit. I was given some space to create an environment, so I asked several artist friends to work with me. One was a graphic artist who is my age—his name is Kohei Sugiura—and he's probably one of the best, most creative graphic artists we've had in Japan since the war. Another was a photographer my age, named Shomei Tomatsu. He recently had a retrospective in Tokyo at the Museum of Photography. He probably has one of the largest photographic collections of the last fifty years in Japan. And I invited Toshi Ichiyanagi, and asked him to create a kind of sound installation. My idea was to create 12, very large curved panels covered with an aluminum surface

on which numerous images were silk-screened. I chose from *ukiyo-e* prints about ghosts and terrible tragedies, and asked Tomatsu to find documentary stills about the atom bombs, rather than to use his own work. So he brought a film and some pictures of Hiroshima and Nagasaki. One famous one is of a kind of shadow made on a wall at the time the bomb exploded. These were the images I put on the panels, which also moved anytime anyone passed through an invisible infrared beam. They would turn and suddenly you would see a ghost or a dead body, which completely involved you in the movement of these strange images. They almost all had to do with the tragedy of the war or the crisis in society. At the same time, there were also large walls, ten meters long and five meters high, very large walls, on which I made a kind of collage about the ruins of Hiroshima and the mega-structure it would later become, which itself was in a state of ruin: a ruined structure on the ruins, which I titled *The City of the Future is the Ruins*. You know, I was very much obsessed by these ruins of the future. Anyway, this was on the wall and I projected many images of the future city onto it. At the time, we didn't have any kind of video system, just slide projectors with maybe five carrousels with 120 slides each, which meant a lot of images running through the projectors. We tried to show how the future city would itself constantly fall into ruin. This was on the moving panels, which, whenever they turned, would be accompanied by Toshi Ichiyanagi's strange sounds. It was an odd feeling to hear them. I called the installation *Electric Labyrinths*. This was my first exhibit of this kind outside of Japan, of course. Anyway, this is what I did for the Triennale, but then suddenly, the exhibition was completely occupied by protestors and didn't open. I didn't go back, but I heard two or three months later that they repaired it and it opened, though what happened afterwards I don't know. My sympathies were with the students and young artists who were protesting, so I signed a petition in support of their activities, which later caused big trouble with the organizers. They had invited me, paid for all my accommodations and travel expenses, as well as for the materials, but I had signed something opposing them. I did it, though, because I thought my work for the festival had precisely the same mentality, the same direction, as the student movements at the time.

HUO:

Later, you organized in Paris "Ma, espace-temps du Japon," an exhibition that again made history ("Ma, The Japanese Conception of Space and Time," Musée des Arts Décoratifs, Paris 1978). This was an exhibition in which different dimensions of ma were brought into experience. In the catalogue one can

find these different definitions of ma: "Ma *is the place in which a life is lived";* "Ma *organizes the process of movement from one place to another. The breathing and movement of people divide the space in which people live";* "Ma *is maintained by absolute darkness";* "Ma *is the sign of the ephemeral";* "Ma *is the alignment of signs.* Ma *is an empty place where all kinds of phenomena appear, pass and disappear…" And finally,* "Ma *is the way to sense the moment of movement."*

AI:

Yes. It was actually prepared in the early '70s, but not realized until later on in the decade. This was ten years after the Triennale and, again, I was asked to do something about Japanese art and music for the "Festival d'Automne" in Paris (1978). At that time, Michel Guy, who used to be the Minister of Culture, was directing the festival. Guy chose the composer Toru Takemitsu—who died unfortunately three or four years ago but who is probably the best known composer from Japan—and myself to be the artistic directors of the exhibitions. Takemitsu curated a series of performances of Japanese music, both classic and contemporary, and invited other Japanese avant-garde composers. I used all the available space at the Musée des Arts Décoratifs of Paris. Of course, I was asked to look at the Centre Georges Pompidou, which had already opened by that time, but I found it impossible to work in for the exhibition I was doing, because you can't touch the ceiling or change the order of the system of partitions they use. For these reasons, I preferred the Musée des Arts Décoratifs, because it's just a very large space in which you have to create the ceilings, walls, and floors entirely. We could do anything we wanted, which makes you very free for interdisciplinary shows. Both of us had a theme for the exhibitions and performance. Takemitsu's was based on the voice in Japanese music, which uses voice in a very special way, and he wanted to try to introduce this in his series. For example, if you attend a traditional Japanese musical performance, there is no score and no conductor, but there are drums, instruments, and singers.

HUO:

Does that mean that it is self-organized?

AI:

That's right. This is a very important point: all the participants have to listen to their colleagues' performances to decide when to come in. It's very similar to jazz, where people play without any conductor and things go along automatically. As for my part of the collaboration, I called it *Ma* and subtitled it "The Japanese Conception of Space and

Time." Traditionally, we didn't have a concept for space or for time in Japan, as Western philosophy or thought does. We only had *ma*. When the concepts arrived in Japan some 200 years ago, somebody had to translate the words, so chronos was added to *ma*. *Chronos* plus *ma* means time and emptiness, plus *ma* means space. This was how the words were interpreted. But the interesting thing is that the word *ma* already includes both time and space. So, when we think about time, we always think about space at the same time, and inversely, when we think about space, time is involved. And I found this way of thinking quite interesting, especially as it's also a notion found in every facet of art, including painting, theater, performance, music, sculpture, daily life, and architecture. For example, what you call planning, in the sense of a plan for a building, we call "taking the *ma* arrangement of the *ma*," since a room is also called *ma*. So, this simple word is found everywhere, and in every aspect of artistic expression, too. For example, the literal meaning of *ma* is "the in-between," or the space between object and object, as well as the silence between sound and sound. So, silence and interstices both are *ma*, which makes it quite significant, but for the Japanese, it's just a part of everyday life, something they would understand automatically, almost unconsciously. This is probably why I didn't bring this exhibition back to Japan, since the notion is such a commonplace, that everyone would understand it and so find nothing curious about it [*laughs*].

HUO:

But in terms of going beyond boundaries of disciplines, this exhibition was quite similar to the earlier one in Milan.

AI:

I broke it down along the lines of several sub-concepts of *ma*. For example, one of the rooms I called "Darkness," and in it, I made a performing platform very much the same size as a Noh theater one, and exhibited a sculpture cast by the artist Simon Yotsuya, who is still interesting and working. He created very strange dolls, one of which was a meditating Zen Buddhist who was completely naked; he also made a lot of multiples. And I asked Issey Miyake to make a costume for each of the dolls.

HUO:

Your exhibition introduced Issey Miyake to a Parisian audience for the first time.

AI:

He was not well known as an artist then, and this was one of the first times he was involved in an exhibition of this kind. I also invited the founder of the avant-garde dance/theater form "Butoh," Tatsumi

Hijikata, who choreographed the dancer Yoko Ashikawa. I also brought many musicians to Paris, like [Takehisa] Kosugi, the Fluxus member, who played on the stage in the dark, and the dancer Min Tanaka, who had never been abroad before. So, I was trying to introduce young artists to the world who were virtually unknown even in Japan, but who I found very intelligent, very original, and trying to do things in a special way. At the same time, I found a concept they all shared. I asked traditional Japanese carpenters, who are always thinking in terms of the concept of *ma*, as well as photographers, sculptors... Actually, there were no contemporary painters, but I brought many images of traditional painting. In the brush paintings of the Japanese tradition, there are lots of empty spaces, blank spaces, and this blankness we again call *ma*. So I showed examples of this, too.

HUO:

It must have been a very complex construction. Did you make the scenography, the overall design?

AI:

Yes, and I tried to organize each room around specific subjects. So, it was very much an interdisciplinary exhibition, I think. And at the same time, it was very important that I was able to find many talented people from different fields, most of whom were not well known at the time. Now, of course, they are almost all top masters of the Japanese scene. Actually, this exhibition was very well received in Paris. At first, it was supposed to last only two months, but the museum had so many visitors that it they decided to extend the exhibition, which was very unusual. Roland Barthes was so interested in it that he wrote little essays for it, and Michel Foucault also became interested in Japanese culture. He came to Japan afterwards and went to a Zen temple, where he tried to practice meditation, or something similar... Jacques Derrida also found that his key concept *espacement* was similar to *ma*. The exhibition then moved on to the Cooper-Hewitt Museum in New York, and afterwards traveled to Houston, Chicago, and so on. It also went to Northern Europe and the Scandinavian countries. Finally, it was supposed to go to Rome, but they found they had no money, so I decided to stop it because it was too much for us to bring anywhere else [*laughs*]. Traveling is okay, but if you do it constantly, it's very difficult to keep an exhibition up.

HUO:

So your work as a curator is not only about matching different kinds of producers, but also about bringing different audiences, coming from different realms, together?

AI:

Well, in this spirit of transdisciplinarity, I designed one discotheque in New York City in the mid-'80s: *The Palladium* (1983–1985). It was a renovation of an old 3000-seat theater. I converted the entire stage to a dance area, and turned maybe 24 television sets into one big screen with a giant robot hand, and had two big screens moving in the air for video art and so on. We also commissioned several artists, including Keith Haring and Francesco Clemente, all of whom were from the younger generation of artists at the time. Andy Warhol was also very interested in the process of design at about the same time, though it was nearly his last period. So, we thought, if it only lasts six months, it would be fine, since it was like an exhibition. But it's still there, even if the owner has sold it, though I don't know what's going on now. Anyway, it was three or four times larger in terms of numbers, so in one night, they might get 10,000 visitors. At the beginning they thought it would be enough to open three nights a week, but it wasn't long before they had to open every night. That's around 300 nights per year at 10,000 people per night, compared with Yankee Stadium, which holds 50,000 when it's full, and they only play sixty nights. And using completely new technologies, including video projections, computerized lights, and, of course, music. So, the success is in transdisciplinary techniques! But, you know, when I organized this first exhibition in 1965, that I was mentioning previously, with musicians, painters, artists, sculptors, and architects, which was also transdisciplinary, at that time, participation by the public was very important. So by the beginning of the '60s we already had ideas of this kind, and inter- or trans-disciplinarity was nothing very '60s. The problem probably began after 1968, when each of the art forms—painting, sculpture, architecture—tried to find its autonomy, its own autonomous form, in order to fashion some kind of formalistic idea about its own limited area. So, it went on like this for almost twenty years, during which one whole generation lost contact with the other fields.

HUO:

Speaking about this momentum in the '60s, could you tell me more about the external influences and the dialogues—as there seems to have been a lot of cross-fertilization of ideas— between you and Cedric Price, as well as with Archigram, Superstudio, and Archizoom?

AI:

Well, it really started in 1968, at the time of the Triennale, which was my first contact beyond Japan and when I found Peter Cook, Hans Hollein, and many other collaborators. Of course, we'd known

about each other through publications; I knew what Archigram, Hans Hollein, and Walter Pichler were doing, and they knew about our works. Then all of a sudden, we became very close. And it all happened in Milan. So, even if the Triennale show didn't open to the public, it triggered a lot.

HUO:

It triggered a real network? Did you also meet the Smithsons there?

AI:

Yes, I met them there, although I'd already attended one of Alison and Peter Smithson's lectures in Tokyo in 1960. They came to Tokyo for a design conference that I attended, so as a student, I knew what they were doing. This is how I found out about the interesting things that were going on. And what I found was a kind of radicalism that was trying to destroy traditional concepts of architecture and art, which is also what my generation started to do in the '60s. I wrote an essay called *Counter-architecture, or the Dismantling of Architecture* (1973) that was published in Japan in the mid-'70s. In a Japanese art magazine, I also got space to introduce the work of architects and groups like Hans Hollein, Archigram, Cedric Price, Robert Venturi, Superstudio... I didn't know many New York people at the time, so it was mostly Europeans. I tried to introduce Japanese readers to what was happening in the world, and at the same time, I was meeting these people in different places around the world. For example, I was briefly asked to teach at UCLA [University of California Los Angeles] at a time when both Peter Cook and Ron Herron were there, so we worked together. And also the director of The Cooper-Hewitt Museum in New York found Hollein's work at the Triennale very interesting, and so took him on as a kind of organizer or, as he called it, "conceptualizer," of the opening show of the new museum ("MAN transFORMS," 1976).

HUO:

Precisely my next question is about the museum. You've built many museums, beginning with the Kitakyushu City Museum of Art (1972–1974). How many actually?

AI:

Maybe ten altogether. Some are traditional and some are quite new in concept. I tried to change the concept each time, and finally I arrived at one based on a museum's activity. The traditional type of museum is fine, and then there are the so-called "Museums of Modern Art" that are based on a notion of art pieces that actually comes from the art market. Modern art is produced as a commodity by artists for the

art market; collectors collect from the market and museums get their collections from these collectors. Thus, the museum building has to be very flexible. When we design it, we don't know what kind of painting will be on the wall, what kind of sculpture on the floor, and so on. So we have to prepare very abstract, neutral elements—which is actually the concept on which museums of modern art are based. For a museum of contemporary art, like the one in Los Angeles (*Museum of Contemporary Art*, Los Angeles, 1981–1986) on the other hand, my understanding is that, starting in the '60s, artists were trying to escape from this notion of the traditional Modern Art museum, and to destroy the idea of the museum with counter-art, such as land art, site-specific art, and much more socially-focused art activities. All this started after 1960. At the time, we talked a lot about how to find a character different from that of the Centre Pompidou, whose character is extreme in Modern Art, and from that of the Museum of Modern Art in New York, which is much more conservative. My view on contemporary art was not just to prepare white walls and floors, but to prepare the space itself, which is more important. A specific space for art can be created in which the artist likes to hang his paintings or to create installations. Not just walls, but a kind of space in itself, including natural or artificial lighting, room proportions... everything that serves the staging of the environment for the art... an open space... I don't know how else I can explain it... So, I wanted to create a space that calls the artist's attention to developing work. For example, at the moment, Ilya Kabakov is having a very interesting show at the Art Tower, the museum I designed in Mito (*Mito Art Tower*, 1989–1990). Ilya visited the museum and was very impressed by the size and atmosphere of three of the rooms I prepared.

HUO:

You mentioned that the Mito Art Tower *was influenced by the Sir John Soane's Museum...*

AI:

Yes, [*laughs*] exactly. And another museum you probably know, the Nagi Museum of Contemporary Art (*Nagi MoCA*, 1992–1994). When I was asked to do it, I found that it didn't have an interesting collection, so I said it would be better to commission permanent installations from maybe three artists directly. So, I approached three artists and asked them to create their own environments or ideas and then collaborated with them, as the architect, by sheltering their spaces. One is a sort of drum by Shusaku Arakawa, which we call *Sun* (1994); one is a crescent-shaped building by Kazuo Okazaki, which we call *Moon* (1994); and the other is called *Earth*

(1994), which is a piece in a dark box by Aiko Miyawaki. So, there are only three permanent installations, and nothing else.

HUO:
Then there is this new museum of yours, which opened in Takasaki.

AI:
That is the contemporary art extension of the Gunma Museum of Modern Art.

HUO:
But you've also made the design of the original museum?

AI:
Yes, 25 years ago, it was 1971–1974. At the time, I was thinking in terms of "Modern Art," and now it's "contemporary," and one is very different from the other. This time, I concentrated more on creating the specific character of the space itself.

HUO:
We've already mentioned Sir John Soane's Museum in London. Besides the Soane's, what are your favorite museums?

AI:
I think the Kröller-Müller Museum in Otterlo. I like it very much. I don't quite know why... the scale, proportions...

HUO:
Could you tell me what your favorite unrealized project is?

AI:
I've had many unrealized projects [*laughs*]. I don't know which one was the most important, but there was our project for the Tokyo City Hall. Kenzo Tange designed it with terrible towers, though at the time of the competition, I tried to counter-propose a design with no towers. It was my view that all the space for the public, the citizens, should be inside the building, so I tried to create a kind of plaza with squares, but one that was inside rather than outside the building. But they didn't understand it at all. Of course, almost from the beginning, the commission expected Kenzo Tange to win, and though I knew this, I made my counter-proposal anyway. Still, I think this was one of my favorite projects. What else? Around the late '60s, I designed completely new machines using robots to create a responsible environment for the single-family home. It's so strange, looking back at my proposal now... It was still in the electric age, and technical devices were so limited. Today, it's an electronic age, and more elaborate technologies are available. I'm currently thinking about another new project, but I'm a little afraid of overrunning the limits of our age again.

KLÜVER, Billy

Billy Klüver was born in Monaco in 1927, and grew up in Sweden. He currently lives and works in Berkeley Heights, New Jersey. Klüver came to the United States in 1954. He received his Ph.d. in Electrical Engineering at the University of California, Berkeley, in 1957 and then served as Assistant Professor of Electrical Engineering. In 1958 he became a member of the technical staff at Bell Telephone Laboratories in Murray Hill, New Jersey, where he worked on small signal power conservation in electron beams, backward-wave magnetron amplifiers and infra-red lasers. In the early '60s, he collaborated with artists on works of art incorporating new technology, including Jean Tinguely, Jasper Johns, Yvonne Rainer, Robert Rauschenberg, John Cage and Andy Warhol. In 1966, he and Robert Rauschenberg organized "9 Evenings: Theatre and Engineering," a series of performance by 10 New York artists made in collaboration with more then 30 engineers from Bell Telephone Laboratories. The same year with Robert Rauschenberg, and Fred Waldhauer, he co-founded Experiments in Art and Technology (E.A.T.), a not-for-profit service organization for artists and engineers. E.A.T. established a technical services program to provide artists with technical information and assistance by matching them with engineers and scientists to collaborate with them. In 1968 E.A.T. organized the first international exhibition devoted to works of art incorporating technology and works created through the collaboration between artist and engineers ("Some More Beginnings," Brooklyn Museum of Art, New York). In 1970 E.A.T. initiated and administered a collaborative project to design and program the Pepsi Pavilion at Expo '70 in Osaka, Japan. In the '70s, E.A.T. instigate various interdisciplinary projects that extended the artist's activities into new areas of society. Projects realized at this time included: The Anand Project *(1969), which developed methods to produce instructional programming for India's educational television through a pilot project at Anand Dairy Cooperative in Baroda, India;* Telex: Q&A *(1971), which linked public spaces in New York, Ahmedabad, India, Tokyo, and Stockholm by telex, allowing people from different countries to question one another about the future; a pilot program in 1973 to devise methods for recording indigenous culture in El Salvador; and finally a large-screen outdoor television display system (1976–1977) for the Centre Pompidou in Paris (that was abandoned at its design stage because of the cost).*

........................

This interview was conducted in New York on August 1998.

Hans Ulrich Obrist:

Could you tell me about your first dialogues with artists, and how they lead to artistic projects involving technological skills? How did the process start?

Billy Klüver:

I will say it started by instinct. There was no dialogue. It's like "Lucy" three billion years ago. I don't think it had anything to do with dialogue between art and science. The artists were looking for new mate-

rials; they have always done that: the people who found marble in Italy; the guys who invented oil paint in Holland, stretching canvases, using silk-screens; and Rauschenberg's following it up as part of painting… or Duchamp choosing the snow shovel. In terms of artists expanding their means, I don't see much difference between that and including technology in the work. In the '60s, the new technology expanded at a phenomenal rate, and at Bell Labs, I was in the middle of it. At the same time there was an explosion in art in New York City. Abstract Expressionism had run its course, and what was needed was a new way of finding motifs and subject matter—and the American environment was the one that came closest at hand. The American environment was there: the pastry in the window, the stockings, the comic strips… They were close at hand; and the Americans didn't have this intellectual overlay of critics and others that decided in which direction artists should go. In the '60s in Paris, you had to belong to a movement or a specific direction in art. I had artist friends who were agonizing over whether they should sign a manifesto drawn up by what was essentially intellectuals who had nothing to do with art—people who found it a great, fun thing to behave like little dictators over an art movement—and so for my friends in Europe, the United States became the area of freedom, where you did not have to be concerned with any intellectual overlay.

HUO:

Is this at least part of the reason why you moved from Sweden to the U.S.?

BK:

That had nothing to do with my moving to this country. I moved to this country because I had seen so many movies and I wanted to see what it looked like. I had to wait until I was 26, otherwise I would have to do another two years of military service. So, I got here in 1954, in the middle of the atmosphere of fear and terror that Senator Joseph McCarthy's investigations of supposed Communist infiltration were generating in the technical community. So, I decided that I couldn't go and work for RCA or General Electric, which were prime targets for investigation. I found out that the best way to get around this problem was to get a PhD, which I did at Berkeley, and I continued on to Bell Laboratories in Murray Hill, in New Jersey in 1957, where I did research on electron beam motion in crossed electric and magnetic fields and plasmas and later lasers. At this time I began to work with artists in New York, and of course I had all the resources from Bell Laboratories behind me. I could use my assistants; I could use the guy who worked in the lab next door to ask a specific question. But, going back to your first question, it all began

in 1960 when Jean Tinguely asked me if I would help him to build a machine that would destroy itself, at the Museum of Modern Art. He had been given the garden to build a sculpture, but he didn't know what to do: He didn't know how big it should be or how to get parts. So I asked him, "What do you want?" and he said, "Bicycle wheels." Well, I walked down to the local bicycle shop and I asked, "Do you have old bicycle wheels?" and the guy said, "Yeah. I've got a lot of bicycle wheels," and he took me down to his basement and there were piles of old bicycles. I loaded them up in my Chevrolet convertible and carted them into the museum. Jean Tinguely got enormously excited, and after three weeks he had built this enormous construction. My colleagues and I at Bell Labs had devised timing and triggering devices, and various ways for it to break apart; smoke, smells, and fire would come out of it, and others things would happen to it during the time it took to self-destruct. On the 17th of March 1960, *Hommage à New York* destroyed itself in front of all the invited people from the Upper East Side. While we were working on the machine, other artists in New York came around and looked at us. I thought at that time that I could contribute to artists in the sense of giving them more possibilities through technology. But what happened was that Robert Rauschenberg saw the whole operation as a collaboration between the artist and the engineer. And that was a new starting point, because I immediately understood that if an artist and an engineer collaborate on a project on an equal basis, then something interesting and unexpected might really come out of it.

HUO:

What was the first project that you did with Rauschenberg?

BK:

In 1961 there was an exhibition at Moderna Museet in Stockholm entitled "Art in Motion," which was enormously important, and Pontus [Hulten] asked me to organize the American contribution. I went to every artist I could think of in New York and asked, "Do you have a work that moves?" Rauschenberg made a painting, *Black Market* (1961), in which visitors were asked to move objects in and out of the work. Meanwhile Bob had asked me if I wanted to collaborate with him on a project, and he had some ideas about an interactive environment where the temperature, sound, smell, lights, etc., would change as a person moved through it. Of course, we couldn't do it with the technology available in the early '60s. And four or five years later, after many discussions and a lot of work it ended up in *Oracle* (1965), the five-piece sound sculpture which is now on tour with the Rauschenberg retrospective. This piece took us

several years to build. It was quite complicated. It doesn't look complicated: the electronics and the ideas are not very complicated, but when it came down to actually realizing it, it was. This was because of two restrictions: Bob didn't want any wires connecting the five pieces, and he wanted all the controls in one of the pieces. So we had to build wireless transmitters from scratch and this produced interference and other problems. In those days I had to operate outside my normal work, outside my normal operating procedures, so it was basically a six o'clock to midnight job. I had the cooperation of the people in the laboratory, my assistants and the other people, and everybody helped. There was never any problem with all of this. They liked it, and everybody helped solve the problems.

HUO:

It leads to the "9 Evenings: Theater and Engineering" that you organized at The Armory in 1966, that were collaborations between artists and engineers from Bell Laboratories. What triggered these evenings, which are now a milestone of performance history?

BK:

Well, as I said, *Oracle* took several years to complete. It was first shown at Leo Castelli's gallery in 1965. Meanwhile I had worked with Merce Cunningham on a choreography for John Cage's music— the dancers triggered the music—and with Jasper Johns on two paintings with a neon letter, where he wanted the neon to be driven by batteries. My working with the dancers and composers on these projects finally led to a large-scale collaboration with Rauschenberg and other artists, and to something new in the history of art and technology. And like any history, a lot of parallel things happened at the same time, like the performances by Lucinda Childs, Yvonne Rainer, Steve Paxton, everybody... at Judson Church, which were going on full blast with the same two hundred people coming to see the performances there. By 1966 two things came together, which really had nothing to do with each other: the frustration of having such a small audience, and the huge interest in new technology, that ended up in the "9 Evenings: Theater and Engineering." The sequence of events was that Knut Wiggen from Fylkingen, the music society in Stockholm, asked me to help organize the American participation in an art and technology festival. I proposed the idea to Bob Rauschenberg. We invited a group of artists and I invited a group of colleagues from Bell Laboratories, and the artists and engineers began to meet together, and after listening to the artists' ideas, the engineers began to build equipment that the artists would use. During the summer, the

project with Sweden broke down, and we all decided to continue
working together and to hold the performances in New York City. It
was Simone Whitman who found the Armory on Lexington Avenue.
And so, in October 1966, we held a series of nine evenings of ten
artists' performances; each artist performed twice. This became a
huge operation, which 10,000 people attended. Now, to go from 200
people to 10,000 in a few months was an enormous undertaking.
More than thirty engineers from Bell Laboratories were working with
us on this, and a huge number of artists in New York participated as
performers or helpers in the ten pieces, and it made a historic change
in the whole business of art and technology. The films from "9
Evenings," which I've been storing in my basement, are now being
put together to document each artist's work as much as possible.
There are two films completed already, Öyvind Fahlström's *Kisses
Sweeter Than Wine* (1966) and Rauschenberg's *Open Score* (1966), and
the next one is John Cage's *Variations VII* (1966). We hope that in
about a year-and-a-half all ten of the films will be ready.

HUO:

*Soon after "9 Evenings," you began developing E.A.T.? Was E.A.T.
already an embryo at the time of "9 Evenings," or was it a consequence of the
enthusiasm demonstrated during the "9 Evenings"?*

BK:

During the "9 Evenings" there was an enormous amount of energy and
enthusiasm, right? And we had lots of meetings in the bar in the base-
ment of the Armory and around Rauschenberg's kitchen table and out
of these discussions Rauschenberg, Robert Whitman, Fred Waldhauer
and I decided that we needed a foundation to continue the kinds of
artist-engineer collaborations that "9 Evenings" had developed.
Because of the tax structure in the United States, we needed a not-for-
profit, tax-exempt foundation: thus Experiments in Art and Technol-
ogy was founded. The name was invented by our lawyer. None of us
liked the name because the word "experiments" doesn't denote some-
thing that is a finished work. Artists don't experiment. But there it
was. So, soon after "9 Evenings," we called a meeting at the Central
Plaza Hotel to see if artists in New York would be interested in some-
thing like E.A.T. Three hundred artists came to the meeting and we
collected eighty immediate requests for technical help.

HUO:

How exactly did Experiments in Art and Technology work as an organization?

BK:

The principal activity in E.A.T. was to match artists who had tech-
nical problems or projects with engineers or scientists who could

work with them. The basis of it is that you have one engineer and one artist, and you set up a situation where they can work together. Now, the engineer works inside a company, so he has access to all the information and equipment he wants. So you don't need a place, a building, a laboratory, or a space. From the very beginning, we were against that. You only needed a space for the engineers and the artists to meet, and you needed a matching system for one to contact the other. But otherwise there was nothing else to it.

HUO:

You needed a network of engineers also. Was it easy to find engineers and to convince them to participate?

BK:

We did all kinds of things to attract engineers. We held a competition where we put ads in the technical journals and in the *New York Times* for the best work of art from a collaboration, where the prize went to the engineers. We also went to engineering conventions, where we set up a booth with artists to talk to the engineers and sign them up. And then I gave talks at the engineering conventions; that way I got articles in technical journals like *"Eye-triple-E" (IEEE) Spectrum* [*Institute of Electrical and Electronics Engineers*]. Within a few years we had made contact with thousands of engineers, and we had two or three thousand engineer members who wanted to work with artists. Ultimately, it was not a problem. We established a system for finding an engineer to work with an artist with a specific technical problem: edge-notch cards and knitting needles. We had one person in charge of the matchings. Now, the idea of matching artists and engineers and establishing artist-engineer collaboration is obvious. But, in the early days of E.A.T., these ideas were completely new and different and you had to convince engineers to do it.

HUO:

Did Experiments in Art and Technology have a board of directors, or a team of artists and scientists acting as advisers?

BK:

Of course we had to have a board of directors. Rauschenberg was chairman of the board and I was president. And we assembled what we called a Council of Agents, individuals from industry, labor, politics, the technical community, and the art community, who would help us with our projects and activities.

HUO:

How did you concretely proceed in order to have these hybrid teams of artists and engineers collaborating on projects?

BK:

I mean, there is nothing mysterious about this whole process of matching artists and engineers. There are some things that we avoided with E.A.T. We never codified the artist-engineer collaboration in a building or in a separate laboratory environment. That might have helped the industry and engineers to understand what we were talking about; it could help to educate them. On the other hand, when you codify a process like this, you turn away artists and turn away creativity. We decided to concentrate on the collaboration between individuals. The artists would work with engineers who worked full-time in their profession, and the industry support would come from these collaborations. We did not focus exclusively on placing artists in industry. Of course, for E.A.T. the backing of the industry was very important. The engineers themselves chose to work on projects with artists that interested them, but also we needed recognition from the companies they worked for. And that recognition comes easier today. When we worked with Sennheiser to use their wireless microphones in the upgrade of *Oracle* this year, the company immediately wrote it up in their newsletter. As for matchings, we decided that E.A.T. would help everybody. But, of course, some projects are more serious than others. Nowadays when people call me, it's very easy to separate out the serious artists by a couple of questions. First I ask them, "How big is it?" and then they say, "Well, maybe it can be big or it can be small." So I say, "Is it inside or outside?" And they say, "Well, it can be inside or it can be outside," and then I say, "How many people are going to see it, two people or two hundred?" "Well, any number of people can see it..." Then I know that the person doesn't know what they're thinking about, and although I give them technical advice on what to do, I know the project will just slide.

HUO:

What was—and still is—particularly interesting in collaborations between an artist and a scientist is that the outcome is not predictable.

BK:

Of course, it's totally unpredictable. You never know.

HUO:

Everything can happen because nothing has to happen...

BK:

One thing that is predictable when you are doing something that is new or different is that you have to wait: wait for the artist to decide something, wait for a piece of equipment to be built, wait in line to buy a part. You have to be ready for this kind of waiting. Then something will happen.

HUO:

I have observed that there have been lots of discussion panels and conferences recently in Europe about art and science, and the outcome has never really been fruitful. And people don't really exchange: everybody just has his or her discourse. We organized this "Art and Brain" conference in 1994; everything was meticulously planned to not have a conference. The event consisted of coffee breaks.

BK:

At Bell laboratories everybody always said that the things happened by meeting somebody in the hallway or at ten o'clock at night somewhere. John Cage summed up the operating idea of E.A.T. when he said, "It's not about artists and engineers talking; it's about hands on, working together." The whole philosophy is hands-on. It is not about talking. I mean, everybody goes out afterwards to have a beer, but first you have to work. As far as the philosophy behind art and science, I've gone through it, but it never interested me deeply. If I had been really involved in the philosophy, I wouldn't have been able to understand that an engineer had to be an engineer and the artist had to be an artist. Just listening to Bob Rauschenberg talking about or responding to some of these philosophical ideas, I realized how stupid they were, how ridiculous. It did not have anything to do with what he was

HUO:

Now, there are also all the projects that you refer to as "Projects Outside Art" that started in the late '60s: several large-scale projects followed one another such as The Pepsi-Cola Pavilion project for Expo 70, in Osaka, Japan, a project with the Nehru Foundation in India, and E.A.T. also organized a work trip to India for a group of American artists including Yvonne Rainer, Terry Riley, La Monte Young, Marian Zazeela, Trisha Brown, and Jared Bark in 1970. How did these "outside art" projects start?

BK:

In the late '60s we got interested in multidisciplinary projects where the artists could work on a broader social level, outside of purely making art. In late 1968, Pepsi-Cola asked E.A.T. to design and program a pavilion for the World Expo in 1970, in Osaka, Japan. The four original artists who began the collaborative design of the pavilion were Robert Breer, Robert Whitman, Frosty Myers, and David Tudor. As the design of the pavilion developed, engineers and other artists were added to the project and given responsibility to develop specific elements. All in all, 63 engineers, artists and scientists in the United States and Japan contributed to the design of the pavilion. So for almost two years we were going back and forth to Japan and had to stop somewhere, so we ended up stopping in India.

But, way back in Sweden, before I came to the U.S., I was interested in instructional television, and actually made a film on the motion of electrons. The United States was putting an experimental satellite over India, ATS-6, which would be used for educational purposes, so that there could be instructional television programming broadcast direct to the thousands of villages in the countryside. And we met Vikram Sarabhai who was head of the Indian Atomic Energy Commission, which was responsible for the satellite project. He invited E.A.T. to organize a group of people to make a proposal on how to generate instructional programming for the satellite system, and that is how we ended up in Delhi and Bombay proposing what is now known as the *Anand Project* (1969–1971) or the "Television Site Project." Our group included educational specialists, engineers, and an artist, and the subject in this case was women who owned the milk-producing buffaloes at the Anand dairy cooperative in Baroda, in Gujarat state. The buffaloes died because they were underfed, or the lactation was wrong, or something else would go wrong. The women had to understand the basics so that the buffaloes would survive and provide the maximum amount of milk and wouldn't be slaughtered and sold to Bombay. We proposed to use half-inch video tape to record what the women actually did with the buffaloes, then take that material and go back to the studio, make a program and then take it back to the villages for testing. This sort of feedback and local involvement with the technology was possible with the new video technology. The people in Bombay and Delhi said, "You can't do that," because in those days they had two-inch tape and big air-conditioned studios in Bombay and Delhi and that's where everything was supposed to happen, and nobody learns anything. The professional television people in Delhi did not think that you could give a camera to a peasant. We knew it was essential in order to find out what they were actually doing with the buffaloes and what the visual clues were that can feed into educational programs. How can somebody who comes from Delhi, know about a village thousands of miles away? What we did was to introduce the notion of local aspects of production. We met the same attitudes in El Salvador where we were invited to devise ways of recording indigenous culture for the educational channels there in 1972. These half-inch Sony cameras had recently come on the market. They were heavy, but still you could go out into the field with them.

HUO:

How was this linked to artists?

BK:

It was the artists' idea to make full use of half-inch video technology to make what we called "visual research notes" and build educational programming up from local input in the process. Robert Whitman was part of the team. The whole idea was that artists can be active in projects outside art, in other areas of society.

HUO:

Art as an applicable model?

BK:

No. Artists as thinkers, as a brain. Whitman describes it perfectly: he said that the artist is the professional who carries with him the least cultural baggage or preconceptions. And this is the kind of openness and responsiveness you want if you end up in that small village in India. That's the whole point. It had nothing to do with any kind of artistic endeavor. In the non-art projects that E.A.T. undertook, at least one artist was part of the interdisciplinary team and we put a high value on the expertise the artist brought to the project.

HUO:

What about these American artists who had a grant to go to India.

BK:

E.A.T.'s project of sending artists to India was to expand their vision. We did that with a dozen or so artists, the ones that you mentioned before. We had a grant from the JDR [John D. Rockefeller] III Fund to ship them there, let them travel and do what they wanted, and then ship them back.

HUO:

What did the artists do there?

BK:

I have no idea. [*Laughs*] The idea wasn't to see what they did. Maybe they were sitting and drinking, I don't know. The point was not to create something. This was the inverse of the buffalo project.

HUO:

Another project that we haven't yet spoken about is the Automation House in New York

BK:

Automation House was a building on East 68th Street [in New York]. Theodore Keel, a labor mediator who was involved in the impact of automation on workers, was on the board of E.A.T. He invited us to have our office there. We held events and exhibitions there, but mainly we used it as office space.

HUO:

So it was more like a platform from which you organized the activities.

BK:

Yes.

HUO:

*Could one say that E.A.T. acted as a trigger? A catalyst? Because a cata-
lyst catalyzes something and then disappears, only to reappear to catalyze
something else.*

BK:

Bob Rauschenberg and I always said that if E.A.T. was successful it
would automatically disappear, because once everybody understands
the idea of artists and engineers working together there is no reason
for E.A.T. to exist. In the Automation House, we did, for instance, the
Telex: Q & A project together with Pontus Hulten in 1971. Pontus
had an exhibition at the Moderna Museet on the anniversary of the
Paris Commune of 1871, called "Utopians and Visionaries
1871–1981" and we had telex machines at the museum in Stockholm,
at Automation House, at the Design Institute in Ahmedabad, India,
and at a large public center in Tokyo organized by Fujiko Nakaya for
E.A.T.-Tokyo. People in all four places could telex questions to all the
other places about what the world would look like in 1981. We gath-
ered answers from both experts and the general public, to all the ques-
tions and telexed the answers back. Everyone in all four places around
the world answered the same questions, and anybody could ask a ques-
tion to anybody else. And we got the answers to everybody else. What
is sad is that this material has not been analyzed yet.

HUO:

What were the answers like?

BK:

All different. The Indians were very theoretical. The Japanese were
extremely positive.

HUO:

*Can you tell me about the early projects of "Artists and Television?"
(1971–72). In 1971, E.A.T. coordinated the cable broadcast of artists'
videos on the channels Sterling and TelePrompTer (New York)—artists like
Warhol, Michael Snow, Keith Sonnier, Les Levine, Joan Jonas, Larry
Rivers, Richard Serra. It seems almost incredible that in the history of tele-
vision there were so few projects accomplished where artists can use television,
don't you think?*

BK:

For me personally, I believed that artists could have an influence on
television, and that it was a medium which artists could use. Not
just as experimental television or video, but commercial television. I

wanted artists to be involved with broadcast television and with the realities of broadcast television. And when cable television came to New York in the early '70s, it seemed to make this a possibility. I even testified before the FCC [Federal Communications Commissions] on the importance of artists having access to cable channels. Then we did have a head-end at Automation House to originate programming for cable, and that was the most interesting part. You could actually feed programs onto the cable public access channels, and the idea of "Artists and Television" was for artists to generate programming and feed it into cable. We would have our own television network. At the beginning we showed video tapes that artists had already made—Les Levine, Lucas Samaras, Richard Serra.

HUO:

One of the things E.A.T. did was to ask artists to make proposals to produce video tapes for broadcast on cable.

BK:

Yes, we actually proposed producing artists' programs to the NEA [National Endowment for the Arts] directly, but they turned it down. The idea is that there were great possibilities, and I think the reason a lot of it didn't happen is that anything like that has to somehow get the interest of enough people to become self-sustaining. I really don't know. Maybe the interest from the artist wasn't enough to carry it. I tend to believe that an idea like that sounds terrific, but maybe the artists really don't want to get involved with television. Anyway, you try to open the door, and if they don't want to take advantage of the open door there is nothing you can do about it.

HUO:

Very early, in the late '60s, you had ideas about cheaper, more flexible ways of producing television programs. It was in the context of the United Nations when you proposed that Super 8 could be used for television. That seems like an incredibly interesting idea in today's context where this becomes a reality with digital cameras and very cheap TV can be produced. Can you tell me about this pioneering idea of "do-it-yourself" television?

BK:

It came from our experience in India and on the "buffalo" project. It was in El Salvador and it had to do with preserving the culture. In 1972, the Division of Culture of The Ministry of Education in El Salvador invited us to develop mobile broadcast television production equipment to travel around the country and record the culture and make programs for the educational channels. The idea is that

you use inexpensive recording devices to preserve the local and indigenous culture, which is disappearing all over the world. Cultural programming is a matter of recording, hearing stories or what have you. We also worked in Guatemala. We also proposed a project for the celebration of the bicentennial of the United States in 1976, called "U.S.A. Presents," combining Super 8 production with satellite broadcasting capabilities, in which we would provide Super 8 cameras to individuals and groups all over the United States who would make short 3-minute films of their lives and activities that would then be sent to satellite uplink centers and be broadcast to dedicated VHF, UHF, or cable channels on a 24-hour basis all year long. Dr. Wilbur Schramm was the great guy at Stanford University who pioneered instructional television in developing countries. We wanted to go one step further by using simple technical equipment together with artists to record and make programs about cultures that were being lost. For example, one project was to record the Bhai women, a group of woman in Benares, India, like Geishas, who were disappearing. We tried to get funding from the Rockefeller Foundation to go there and simply film them, preserve their music and singing, ideas like that. Then you get into very interesting questions, which have to do with editing and how you use television to teach people, which is what Wilbur Schramm was involved with at Stanford. How do you actually present the material so that people actually learn from it? Such questions.

HUO:

You've also been involved in projects for children, such as this program enabling children in different parts of New York City to converse using telephone, telex, and fax equipment. This sounds like a sketch for a connection system ages before the emergence of the Internet! It is another presentiment! What were you aiming at then?

BK:

This project was called *Children and Communication* (1971). We thought that children from one part of the city should know children from another part of the city without having to travel out of their own neighborhoods. Of course, this could happen with any two places between any two cultures, or the kids could be of the same culture with the same background. We collaborated with educational specialists from New York University to shape the project, and Robert Whitman built two environments—one at Automation House and one at 16th Street—that were connected with fax

machines, telephones, machines that you could write with a pen on, and telex machines. All these machines were there, and the kids could use them any way they wanted—type or write messages, send photographs, or just talk on the telephone—and make friends without ever meeting or seeing each other.

HUO:

Finally, I would like to ask about your relationship to museums in more general terms. Throughout the '60s you have been very strongly involved with the Moderna Museet in Stockholm and with Pontus Hulten. Hulten was a very progressive curator. Today it seems that museums are embracing the technological concepts in art more and more, but I can imagine that in the '60s or '70s there was some resistance to these concepts or forms.

BK:

There probably isn't a museum in any city that I have been in where I haven't been in the cellar or somewhere in the storage place crawling around on the floor. I find it very easy to work in museums; I never find any problem. You have to get the work done. The opening happens and when it happens you have to be ready, and everything has to be clean and the labels have to be on the wall. There are always people who are willing to help you if you need it. But it's true, there has always been some difficulty doing technical work in a non-technical environment like a museum. The works that incorporate technology often fall outside the expertise of many curators. I have heard this from many artists—that the curators would be up in arms against technological works because they can't handle them—it's too complicated, too difficult. A new generation of curators has to learn how to deal with these works, and that's going to be a challenge because curators can't really be engineers. At the Centre Pompidou in Paris, for instance, they have a very good technical guy, Alain Peron, who works freelance with the museum. The Menil Collection in Houston also has an excellent person. I have always thought that museums should have an engineer as a technical curator in charge of pieces with technology, on the level of the other curators. I don't see the museum as a producer of pieces. But they have a responsibility to show, maintain, and conserve work that incorporates new technology.

KOOLHAAS, Rem

Rem Koolhaas was born in 1944 in Rotterdam. After having lived in Indonesia between 1952 and 1956, Koolhaas worked as a journalist for the Haagse Post and as a film screenplay writer, before leaving for London to study architecture at the Architectural Association School. Two theoretical projects come from this period: The Berlin Wall as Architecture *(1970) and* Exodus, or the voluntary prisoners of archi-tecture *(1972). A scholarship obtained in 1972 allowed him to stay in the United States, where, fasci-nated by New York, he started to analyze the impact of metropolitan culture on architecture, which result-ed in* Delirious New York, a Retroactive Manifesto for Manhattan *(1978). At this stage, Koolhaas wanted to progress from theory to practical application and decided to return to Europe. In London in 1975, he created, with Elia and Zoe Zenghelis and Madelon Vriesendrop, the Office for Metropolitan Architec-ture (OMA), whose objectives were the definition of new types of relations—theoretical as well as practi-cal—between architecture and the contemporary cultural situation. Since 1978, several orders in Holland, such as the* Extension of the Netherlands Parliament, *led him to open an agency in Rotterdam which was henceforth centralize OMA's activities. At the same time, he created the Grosztstadt Foundation, an independent structure controlling the cultural activities of the agency, such as exhibitions and publications. Some of his realized projects include the* Netherlands Dance Theatre *in The Hague (1987),* Nexus Housing *in Fukuoka, Japan (1991), the* Kunsthal *in Rotterdam (1992), the master plan for Euralille and the Lille Grand Palais in Lille, France (1994), and the* Guggenheim Museum *in Las Vegas (2001). Several residential projects include the* Dutch House *in The Netherlands (1993) and the* Vil-la dall'Ava *in Paris (1991). More recently, OMA finished the* Educatorium, *a lecture hall for the Uni-versity of Utrecht (1995) and the* Maison *à Bordeaux (1998). Current projects include a commission for a master plan and two buildings for the Samsung Corporation Center for Social Studies and the Seoul National University Museum in Korea, a master plan for Universal Studios in Los Angeles, a master plan for the City Center in Almere, The Netherlands, the master plan for the Hanoi New Town in Vietnam, the* Netherlands *Embassy in Berlin, a master plan for the Song Do New Town for Inchon, Korea, and the new* McCormick Tribune Campus Center *for the Illinois Institute of Technology in Chicago. Cur-rently OMA is engaged in its largest project ever: the new headquarters for the Central Chinese Television (CCTV), a 550.000 m² headquarter and cultural centre in Beijing, to be completed in 2008 for the Olympic Games. In the 90's Rem Koolhaas and OMA created a new company, AMO exclusively dedicat-ed to the investigation and performance in the realm of media. AMO often works parallel to OMA for the same clients, providing extra services in the domains of organization and identity while, at same time, work on the design of a building is being conducted. Since* Delirious New York *Koolhaas has published* S, M, L, XL *(1995), and since 1995, he has been a professor at Harvard University, where he is leading a series of research projects for the "Harvard Design School Project on the City," a student-based research group studying different issues affecting the urban condition. Recent projects include the following studies: Five cities in the Pearl River Delta in China, "The Roman System, focusing on the ancient Roman city, "Shopping," an analysis of the role of retail consumption in the contemporary city, and "Lagos," a study of African cities, focusing specifically on Lagos, Nigeria.*

........................

This interview was recorded successively in Berlin, Seoul and London between 1998 and 2001.

[1]

Hans Ulrich Obrist:

In your book S,M,L,XL *(1995) there is a text on the "Berlin Wall as Architecture." Can you tell me about this very first project of yours on Berlin in the early '70s?*

Rem Koolhans:

I was a student at the end of the '60s, the end of a period of an innocent way of looking at architecture in general. There was especially an optimism that architecture could participate in the liberation of mankind. I was skeptical about this, and instead of going to Mediterranean villas or Greek fishing villages to "learn" (as most people did at that time), I decided to simply look at the Berlin Wall as architecture, to document and interpret it, to see what the real power of architecture was. It was one of the first times that I actually went out and did fieldwork. I really didn't know anything about Berlin and the Wall, and was totally amazed at many of the things I discovered. For example, I had hardly imagined how West Berlin was actually imprisoned by the Wall. I had never really thought about that condition, and the paradox that even though it was surrounded by a wall, West Berlin was called "free," and that the much larger area beyond the Wall was not considered free. My second surprise was that the Wall was not really a single object but a system that consisted partly of things that were destroyed on the site of the Wall, sections of buildings that were still standing and absorbed or incorporated into the Wall, and additional walls, some really massive and modern, others more ephemeral, all together contributing to an enormous zone. That was one of the most exciting things: it was one wall that always assumed a different condition.

HUO:

In permanent transformation.

RK:

In permanent transformation. It was also very contextual, because on each side it had a different character; it would adjust itself to different circumstances. It also represented a first naked confrontation with the horrible, powerful side of architecture. I've been accused ever since of taking an amoral or uncritical position, although personally I think that looking, interpreting is in itself a very important step toward a critical position.

HUO:

How do you feel about the disappearance of the Wall, the fact that it was completely erased?

RK:

In the early '80s we did a number of competitions for Berlin that anticipated the fall of the Wall—proposals for the "Afterlife of the Wall" that made a new beginning without removing all the traces...

HUO:

The IBA building?

RK:

Yes, but it's not the current building. In an early competition it was a much more interesting, more open situation, where walls were used to exclude the impact of the Wall... It was simply through a proliferation of walls that you could live next to the Wall. We thought that the zone of the Wall could eventually be a park, a kind of preserved condition in the entire city. I've been appalled ever since that the first thing that disappeared after the Wall fell was any trace of it. I think it is insane that such a critical part of memory has been erased, not by developers or commercial enterprises, but simply in the name of pure ideology—really tragic. The paradox is that it creates now a completely incomprehensible "Chinese situation."

HUO:

Can it be compared to the disappearance of the whole industrial architecture, which Hilla and Bernd Becher documented?

RK:

But at least it disappeared by accident. The Wall disappeared deliberately, and in the name of History.

HUO:

Could you tell me about your IBA building which was realized?

RK:

Actually, I was so offended by the whole notion of rebuilding the Friedrichstadt blocks that I didn't work on the IBA building. My partner, Elia Zenghelis, did it. He hadn't done the competition so he had a more objective relationship with the Checkpoint Charlie site. It was unbelievable for me to move from one kind of architectural proposal to a totally opposite proposal, so I couldn't do it.

HUO:

But you are very involved with the current Berlin projects...

RK:

Yes. It has been very exciting. That was the early '80s. In the ear-

ly '90s I participated in the Potsdamer Platz competition where I disagreed with the outcome. In fact, not even so much with the outcome, but with the whole content of the discussion, with the virulence of the discussion, with the arguments put forth.

HUO:

Do you agree with {Daniel} Libeskind, with his idea that there shouldn't be a master plan, that there shouldn't be an overall solution, that it should be much more heterogeneous, heteroclite, and fragmented?

RK:

There were many beautiful projects, not only the project by Libeskind, but also the project by [William] Alsop. The project by [Hans] Kollhoff was also really interesting. In other words, it's not that there weren't any interesting proposals, and the three of them, Alsop, Libeskind, and Kollhoff, were then in one camp of architects who could work with the destruction that was the essence of Berlin, and who were not out to repair, to (re)create a synthetic metropolis.

After the Potsdamer Platz competition, there was a serious discussion in the Berlin Parliament to deny me the right to enter the city... Recently it has been very exciting for me to be involved again in Berlin as the architect of the Dutch Embassy (*Netherlands Embassy*, Berlin, 2000–2002)—to rediscover Berlin and at the same time the Dutch, and also a certain spirit of adventure which is perhaps Dutch, in the sense that they chose a very courageous location, not near all the other embassies but in the former middle of Berlin, in the formerly communist part, according to a very logical reasoning that in this way they will be near to the other ministries. They are willing to engage in the East Berlin condition. What is fascinating there is also to discover that there is a whole army of formerly East German bureaucrats who are actually much more rational about the whole reconstruction of the city, who clearly feel offended that the "liberalism" of the East has led to the imposition of an inflexible urbanistic doctrine. So they have been extremely collaborative in terms of doing things differently. I think that simply because of the fact that we work with a formerly East German bureaucracy we have been able to experiment.

HUO:

One could say that since 1991 a conservative idea of architecture has been prevailing in Berlin. Philipp Oswalt explained this in his article published in ARCH+ *in 1994, "Der Mythos von der Berlinischen Architektur."*

There is this idea of conservative reformism which in Kollhoff's words follows the new only "if it proves to be more performative, more comfortable and beautiful than the old." But you told me yesterday that even if many forces in Berlin tried to reconstitute the center, it would, nevertheless, against all odds, become a "Chinese city." Could you explain to me what you meant exactly by that?

RK:

I think that Kollhoff as an architect is still very powerful and very interesting, and that the discourse is to be separated from what he does. I still sense that what he does is seriously felt. Disregarding the discourse, some of the work is strong. What's exhilarating about being involved in Berlin now is that there is a completely new situation. You can see the results of the "first wave." In a way I admire it. At least they were very serious. In spite of that, in spite of the most incredible effort to "control" the new substance, simply through the sheer quantity it has become a Chinese city. It shows that the Chinese city is seemingly inevitable anywhere that there is a lot of building substance.

HUO:

How would you define the Chinese city?

RK:

The Chinese city is for me a city that has built up a lot of volume in a very short time, which therefore doesn't have the slowness that is a condition for a traditional sedimentation of a city. Which is still for us the model of authenticity. Beyond a certain speed of construction, that kind of authenticity is inevitably sacrificed, even if you build everything out of stone and authentic materials—and that's a kind of irony. For instance, if you look at the color of the stone of the new Berlin, it's the color of all the worst plastics that were produced in East Germany in the '60s. It's kind of a weird color of pink, a weird color of light yellow—they're artificial. There is no escaping the artificial in the new architecture, and certainly not in large amounts of architecture being generated at the same time.

HUO:

There is this story that everyone tells in Shanghai, according to which the mayor of Berlin was boasting about the rate of construction in his city and the mayor of Shanghai responded by saying that in Shanghai it went probably 20 or 25 times faster. It appears that there seems to be very little knowledge in Germany about what's on going on elsewhere in terms of urban development and architecture.

RK:

That for me is the debatable thing about the Prussian style, because the Prussian is either a form of naïveté or just a strategic claim. There is a deep ignorance in Germany about conditions outside Germany, an incredible preoccupation with the self, and therefore those kinds of misreading occurs easily. At the same time, there is something irritating about the automatic assumption of modernity, of the "inevitability" of, or the application of, state modernism. For instance, their conversion of the Reichstag is at least as strange as the emphasis on Prussian building, because these are two forms of innocence or naïveté, and to think that in the Reichstag you can exorcise the spirits with a new sort of dome is a sort of very polite gesture and a very compromised esthetic. It is an equally weak intellectual stand.

HUO:

You think that Norman Forster's dome on the Reichtag has to do with "innocence"?

RK:

Innocent in terms of historical givings. For Foster, high-tech architecture was never dealt with in context, etc. To simply put a new head on a building that had an incredibly ambiguous history is innocent, or perverse, whatever you want to call it. Therefore, it's a very moving condition. Only now are all these civil servants realizing that they actually have to inhabit Nazi buildings as their new ministries, with the anxieties that emanate from that, that demand exorcism—but do glass and steel still drive out evil spirits?

HUO:

I remember this very strange event in 1991: there was the "Metropolis" exhibition at the Martin Gropius-Bau, followed by a party in the former Reichstag, which was abandoned at the time. It felt very scary.

RK:

That's the whole point: Berlin is very scary. And somehow everything that tries to cover it up, either by an ersatz past or by a kind of ersatz exorcism (which is what modernity is doing), is equally implausible. I also believe that the monumental production of monuments is not going to work either, because that's part of an "official exorcism."

HUO:

*Christian Boltanski's monument is very interesting (*The Missing House, *1990). On Grosshamburger Strasse, Berlin, at the site of an apartment house that was destroyed by aerial bombardment in 1945, he found that*

all the former residents were Jews, and he constructed a memorial space dedicated to "absence." He used signs to indicate the names of the residents at the approximate place where they lived in the building: their dates of birth and death, and occupations, which went across class lines. It's a sort of anti-monument.

RK:
Yes.

HUO:
And what about the East-West relationships and exchanges? In art, there is very little exchange between Berlin and Warsaw, Berlin and Prague... The lack of exchange is even more evident in Vienna, where Bratislava is half an hour away and there still is this wall in people's heads.

RK:
I think it is related to the whole misreading: the single misreading that has a number of sub-misreadings. The idea of the encounter between East and West is still based on difference. What they don't realize is that there is no difference. They consider themselves an advanced trading post. This was incomprehensible to me when I first came that West Berlin was sort of a satellite in the middle of East Germany, and that condition of being in the middle of another condition is something that they still do not completely assume. If you're working on this, and looking at it in an architectural context, there is one group of works that you should look at, which is an architectural operation by Oswald Mathias Ungers that he did when he was a professor at the TU [Technische Universität Berlin] in the '60s. He took Berlin as a laboratory and said "This is a unique situation of a city which is totally cut off and completely artificial, therefore presenting a new condition, so I'll turn it into a laboratory." He systematically investigated the conditions of Berlin in terms of a presence of historical particles, but also the presence of the contemporary, with a very utopian, futuristic dimension. As a professor, he organized a series of design seminars, which every time posed the question of how the historical and contemporary could coexist, and how the new numbers, new programs and the historical could coexist. For instance, he would have a year devoted to highways and plazas, or mass housing and the Brandenburg Gate. He made a very beautiful project for how to reconstruct Leipziger Platz in totally contemporary forms. That is a kind of hidden domain. People like [Jürgen] Sawade and Kollhoff, who are now

at the core of the "Prussian" architects, were very involved in that too. So there is an interesting ambiguity there.

There is kind of latent modernity there, which was evident in Kollhoff's Potsdamer Platz project. So the language of the architecture was retro, but the concept of the architecture, of the urbanism, was very contemporary.

HUO:

To go back to the article in S,M,L,XL, you write that Berlin is all about memory, loss, and emptiness. This is of course something Libeskind pointed out a lot, like when he kept the center in his building empty.

RK:

To see the Berlin Wall as architecture was for me the first spectacular revelation in architecture of how absence can be stronger than presence. For me, it is not necessarily connected to loss in a metaphysical sense, but more connected to an issue of efficiency, where I think that the great thing about Berlin is that it showed for me how (and this is my own campaign against architecture) entirely "missing" urban presences or entirely erased architectural entities nevertheless generate what can be called an urban condition. It's no coincidence, for example, that the center of Shenzhen is not a built substance but a conglomeration of golf courses and theme parks—basically unbuilt or empty conditions. And that was the beauty of Berlin even ten years ago, that it was the most contemporary and the most avant-garde European city because it had these major vast areas of nothingness.

HUO:

Landing in Berlin was very beautiful, with all these gaps and holes in the urban tissue.

RK:

Not only was it beautiful, but it also had a programmatic potential, and the potential to inhabit a city differently represented a rare and unique power. The irony of course is not only that the architecture being built is not the right architecture, but that it is built at all. It's a city that could have lived with its emptiness and have been the first European city to systematically cultivate the emptiness. Like Rotterdam, where there is a lot of emptiness inside. For Libeskind, emptiness is a loss that can be filled or replaced by architecture. For me, the important thing is not to replace it, but to cultivate it. This is a kind of post-architectural city, and now it's becoming an architectural city. For me that's a drama, not some kind of stylistic error.

HUO:

So it's not an issue of the quality of the architecture being built...

RK:

... nor aesthetics.

HUO:

What has happened in Berlin is that this city planning has happened without any involvement on the part of the different communities. I recently had a discussion with Itsuko Hasegawa, in Tokyo, who thinks that one should advance in a city in a participatory mode, so that the users of the buildings could almost say "This was my idea." Many contemporary artists today work with this issue of participation. This is a critique heard quite frequently in Berlin, that the city could have been built with the involvement of the people. What's your opinion?

RK:

That's a very tricky question, because if you ask around and do real surveys, I think the current reconstruction is very popular, because the current mythology of going back to a traditional notion of plazas and streets could be a very populist platform. The other conditions of inhabiting emptiness or living with scars and accepting the rampant and blatant oppositions of the East and West, and standing the distressed aesthetic, are much harder to grasp. The whole difficulty of participation in architecture is completely ambiguous. For instance, in the Bordeaux house (*Maison à Bordeaux*, 1996–1998), on the one hand you could say it's extreme architecture, but on the other hand it's extreme participation.

HUO:

Because it's a very strong dialogue.

RK:

Yes, and therefore participation is not necessarily for people to be able to say "this is my idea, this is your idea," but on the contrary, a situation where it becomes impossible to say whose idea it really is, either the architect or the user.

HUO:

So it's a kind of ping-pong?

RK:

Not necessarily, but rather to imagine a process in which the intelligence of others is mobilized. But it's not to establish a dogma according to assumed preferences, which I think is what's happening.

HUO:

Can you tell me how you came to the idea of building this house in Bordeaux for the Lemoine family with a mobile elevator-platform?

RK:

It was a house for somebody who in the middle of his life became handicapped, and who interestingly enough is very courageous and assumes that condition without any inhibitions. Therefore, it became interesting to think of a house not dealing with that issue, but almost inspired by that issue. So there are basically two attitudes toward the handicapped: the idea of helping them but reasoning within the possibilities which are still left; and building on the strength which exceeds by far the idea of compensation, or helping them in such a way that the entire building makes a step forward in general. So it's a building that is entirely based on his possibilities and not based on his impossibilities, and that has also allowed the entire family to live in that kind of logic.

[2]

HUO:

When was your first visit to Seoul?

RK:

My first visit to Seoul was maybe six years ago. We were working for Samsung, and it was a very interesting experience because, in the first phase of the work, we were working with a "chaebol" (a conglomerate of many companies) at its most megalomania—really insanely megalomaniac. I think at that point they were doing six hundred architectural projects, and this meant that there was an incredible traffic of international architects there who did not know of each other—that they were there, that they were working for the same client, what they were doing. So it was a typically unpleasant sort of architectural competition. And we were always surrounded by these kinds of phalanxes of some sort of executive assistants, etc. And the funniest thing is that we were doing a sort of museum, with Mario Botta, Jean Nouvel, and ourselves, which was a combination that had not been engineered by ourselves but engineered by someone near the chairman. So the chairman and his wife took a particular interest in it, and at some point I needed to explain the project to the chairman, and I was waiting in the Shilla Hotel, which is an incredible hotel—the level of smoothness in it is really unbelievable, it's as if you're in a dream in terms or preemptive service and preemptive comfort. But anyway, I was waiting, and then suddenly at four o'clock in the morning there was banging on my door, and it was the same Samsung executives, who said, "You

have to see the chairman now." And I said, "Why at this time?" It was the first meeting. And they said, "You have to see him now because he will be arrested at nine o'clock in the morning!" So I went, and I saw the chairman between six and eight. It was very quiet. He disclosed the whole thing; but that was also, of course, the first signal that things were going to change there. He was in a way the beginning of the crisis, when all of the endemic corruption was kind of dealt with, which showed the fragility of the whole economic structure and then it's unraveling.

So we made this project—it was actually a very interesting project. We had to connect the different architectures of Jean Nouvel and Mario Botta, who had started it. Our project is mostly underground. It is two volumes on a very beautiful hill, one of those parks full of villas. And because we did not want to add another building, we made a straight slice horizontally, part of which goes into the mountain and part of which emerges from the mountain, so that many of the facilities are underground. It was an interesting project. It's also a museum and a cultural institution. The only mark we've left so far in Seoul is a kind of enormous underground pit dug in granite. It is in a way the most beautiful building. And what I tried to convince them to do, and maybe I can still convince them, is to leave the pit, to do something with that incredibly bare... It's just the biggest negative space you've ever seen.

HUO:

Can you tell me what it is that you particularly like about Seoul?

RK:

What I think is really beautiful about Seoul is that it is a city that occurred on a site where there cannot really be a city. There isn't really room for a city there. So it's as if the metropolis has been established in the middle of the mountains, a city that has to coexist with mountains and beautiful forests, a kind of "Manhattan in the Alps." The middle class lives in the flat parts, those who can afford everything, and those who can afford nothing live on the hills. And throughout the city are scattered the remnants of this Metabolist project. And I simply like the speed with which it extends. I think Korean people are the most direct in Asia; they are very raw and direct, not prisoners of politeness, and very humorous.

HUO:

What about the screens? Do you like those big screens?

RK:

I think the screens are beautiful from a distance. From the hills, you see these flickering screens.

HUO:

You mentioned that when you visited Seoul for the first time after the eco-
nomic crisis, it was all of a sudden a completely different city. The city com-
pletely changed in a few days...

RK:

Yes, in a way, the future seems to be telescoping, and this exacer-
bates the inability I've always had to conceptualize the future as
future. The future is telescoping to the point that not only can you
no longer predict ten years away or five years away, but the accel-
eration of everything seems to make even next month completely
inscrutable and unpredictable. And one of the strongest signs of
this kind of acceleration is in the Asian crisis, and how the Asian
crisis has had an immediate impact on urban conditions—which
sometimes had only existed for three years, but in those three years
there were brand new sparkling products of the Asian economic
miracle. Soaring cities, exploding cities, then a sudden collapse.
Then, while everyone here was writing about the collapse, there
was already a kind of resurgence, and now an apparent gain in
strength. And this whole cycle was in a way a total mystery to peo-
ple in the West, because nobody here grasped the speed of it, nor
can anybody explain why it happened. My theory is that China
saved the capitalist world by not going bankrupt and by not
devaluing the currency, and that the communist system in the end,
in a very paradoxical way, came to the rescue of the capitalist sys-
tem. That is something that you never read about. And my most
perfect demonstration of it is that Seoul, a city known for its eter-
nal traffic, in the middle of the crisis all of a sudden became this
kind of eerie, silent city with no traffic: a city without pollution.
And maybe that was when I could finally see that Seoul was a kind
of Switzerland, really beautiful.

HUO:

In previous interviews and texts you have always said that you despised
futuristic city predictions; you said that you preferred to talk more about
present conditions.

RK:

I think anyone in their right mind should simply give it up. All
you can hope for today is some kind of intelligence about day-to-
day decisions. Another example, which is not as extreme as Asia, is
that we've been involved in Seattle for maybe a year, and that with-
in that year there have been major upheavals that happened in the
city that made it defenseless. From a kind of perfect city without
any trouble, it became a troubled, anxious city; there was also the

first major anticapitalist demonstrations since the New Deal, which traumatized the entire administration, and the fact that Microsoft, even nine months ago, was a completely vigorous, powerful, monopolistic entity that is now condemned and about to be divided, and Bill Gates, once a complete myth, is now no longer CEO, but chairman, etc. All those things are an incredible demonstration of how there is absolutely no certainty that you can count on. And the interesting thing is that the clients are trying to outwit this situation by accelerating more and more the whole pace of architecture. The buildings we once had to build in two years we now have to build in one year. In that sense, it was a good instinct to document in our Harvard research, in general, how fast architecture can be produced. But I could never have imagined at that time, when I discovered that some buildings in Shenzhen were produced in two afternoons on a home computer, that two or three years later we would be in the same position. But we are. And even so, we realize that we are not quick enough, or that architecture can never be quick enough.

HUO:

Does this affect the life span of buildings?

RK:

This is really interesting, actually. There is this planning project for La Defense Paris we did, where we considered everything more than twenty-five years old theoretically obsolete, ready to be taken down, so that you could build a new city on the site of the old. At the time it was considered totally visionary and an outrage. I recently had to give a presentation for the station in Rotterdam, where there will be a superfast TGV train, and I again launched the suggestion that after twenty-five years you could simply declare buildings redundant, because they are so mediocre, and this time there was a sort of barely suppressed nervous laughter. This limited life span of buildings is still an absolute area of blindness, and a real taboo in Europe.

HUO:

And in America?

RK:

In America you can only say in retrospect that this is in many cases true, but you can never make it the basis of architectural production in the beginning. And this is really unfortunate, because I think it could liberate an enormous amount of energy if you could be more independent vis-a-vis the lifetime of a building, and by

implication the context. Nevertheless, we are of course contradict-
ing ourselves when we do a public building, and we do not design
it as if it will disappear in twenty-five years. But the pressure
would be less if it were an automatic given that a building will
exist twenty-five years at the most.

HUO:

What is the part between slowness and speed?

RK:

It remains a very strong tension. In that sense, it is a very fascinat-
ing thing to see this medium-architecture that is now so popular
but has a sort of inherent resistance to completely following the cur-
rent tendency, which is toward acceleration. It may be that that is a
real conundrum for architecture, that it can accelerate but that it
also has some kind of intimate resistance, maybe more than televi-
sion, film, or music, and maybe that is why it is so interesting today.
But it also means that we have now discovered that architecture can
never reach certain speeds, and that discovery pushes us into anoth-
er domain, where the same kind of thinking now has to be applied
in a much more conceptual, theoretical, and disembodied way.

HUO:

*You mentioned OMA's {Office for Metropolitan Architecture} library proj-
ect for Seattle. I think there is a certain relationship between the notion of
the museum and the notion of the library, both often very defensive institu-
tions, and moralistic too. To energize these institutions evokes examples from
the '60s: for instance Cedric Price's* Fun Palace *(1960–1974), or the
way Willem Sandberg ran the Stedelijk Museum in Amsterdam. This is
part of your personal history as well?*

RK:

The moment I discovered art as an independent person, as a teenag-
er basically, coincided with the Sandberg regime. The exhibition
designs completely changed the museum each time. "Dylaby—A
Dynamic Labyrinth," (Stedelijk Museum, Amsterdam, 1962)
would now be a prophetic title again. All those shows were the
kind of shows that enabled me to be more modern than my par-
ents... so in a way I was kind of indoctrinated by it. And I think
all of that had a big influence on my museum projects. But of
course, at the same time, the museum, even in the '60s, was a very
demanding place, in the sense that it insisted on participation and
was presenting issues fairly aggressively. The big difference
between now and the '60s is not only that this kind of aggression
or those demands are missing in the presentations, but I think the

sheer numbers are drastically changing the entire equation, limiting the things you can say and do in a museum. One of the things no curator liked about our designs for the Tate or for MoMA (Museum of Modern Art, New York) was the notion of creating a fast-track tourist trajectory, a kind of shortcut that would also enable the return of slowness, or intensity. In the absence of a two-speed system, the museum experience is accelerated for everybody; you can see it with the new Tate installations, not based on accumulations but on "juxtaposition"—the grids of Gilbert & George next to Mondrian, a quick "Aha!" and on to the next "rhyme," all a form of fast-track, against complexity.

I think this is equally true for the library. Apart from all the kinds of ideologies that you could have—or launch or repeat or renew—the sheer fact of the numbers needs to be incorporated within the concept or course of each of these projects. You are often referring to the beautiful era of MoMA, "the laboratory years"—and it *was* a beautiful era, but I don't think that you can have a laboratory visited by two million people a year. And that is why, in both our libraries and our museums projects we are trying to organize the coexistence of urban noise experiences and experiences that enable focus and slowness. That is, for me, the most exciting way of thinking today, the incredible surrender to frivolity and how it could also be compatible with a seduction of focus and stillness. The issue of mass visitors and the core experience of stillness and being together with the work are what is at issue in [the Seattle] project.

HUO:

Richard Hamilton recently made a text piece in the form of a badge with the text "Give me hard copy." It's actually a fragment that he extracted from Ridley Scott's movie Blade Runner *(1982). Accordingly, the idea is that the museum gives the hard copy but the library does too. So I was wondering how you see the role of the museum and the library in terms of network conditions. How do you see the relation between the actual and the virtual? How do you avoid having hierarchies between different actual libraries and virtual libraries?*

RK:

I think this is very interesting, because in Seattle, there is a library system made up of 24 libraries, and this is the main library. So this is in itself already a sort of hierarchical position, which assumes that the main body of the government is in the main library. And so there is all the history and routine of centralism. But of course, it is entirely networked and about to be more networked. And what I find fascinating is that there is a lot of work going on these days by

people like Judith Donath at MIT [Massachusetts Institute of Technology], who are looking at the Internet but also at different kinds of databases as potential sources to fabricate new communities. And the irony is that, on the basis of network conditions, which are always assumed to be increasingly democratic, you can of course create new hierarchies. And what is currently the latent and almost threshold question is: "Does a network imply homogeneity?" or "Does a network imply democracy?" or "Does a network imply privacy?" The discourse on networks has always been a disturbance to universal distribution, but I don't see any ultimate reason why that should be the case, why its opposite potential should not be investigated. The moment at which the library will be able to connect, for instance, all the data that the readers generate—who reads which books—then that would be an incredible way of modernizing their function.

HUO:

At which point the library becomes an agent, to guide people on what to read...

RK:

Yes, but there is the question of privacy. And the same for the museum. And that is why I said yesterday that it's not only the end of the future but also the end of privacy. There's a whole thing, like a reservoir; you feel that the wall is cracking and that you'll simply go. And about the issue of flattening and hierarchy or value, the Internet does not only have to flatten value, it can also be used to create value, because you can disseminate eighty percent, and make the next ten percent really difficult, and the next five percent even more difficult, and then have a core two percent, which represents the equivalent of rare books: the rare information.

HUO:

What exactly do you set against flattening?

RK:

Instead of flattening, you can create value. And the defensiveness is not only in the wardens, it is also in the repulsive domain of public art, which so rarely is anything but the nostalgic reinforcement of, or compensation for, an abandoned domain, and therefore rarely able to convince anyone but itself. And if you ask about aging cities, the context of the city is no longer a physical context. And still, when we talk and think about context, we routinely think about mass.

HUO:

Reading will be one function among other functions?

RK:

Yes, even if it's not really an interference. We hope, since reading is only one of the advances in the library, that what we are doing is creating space where advances can take place. We've always done that. We've always noticed that, when the chips are down, there is nobody to run those kinds of programs, nobody to conceptualize that kind of activity, even though the buildings themselves would support it incredibly well. That is why we are very vehement that it's very important that somebody take care of that kind of thinking. But the tragedy is that there is still such an incredible war between words and images in libraries, even if in the outside world it's completely gone.

HUO:

I was wondering if you could tell me more about these different platforms. It's a very Deluezian idea, a "mille plateaux" idea, because they're really high-connectivity platforms.

RK:

Because the departments are very specific, we need to address their specificity in a precise way. But of course we also hope that more will happen than is defined in the program, so between platforms are the public spaces that, less contained, have room to evolve. In civil architecture, like in physics, the pressure between two dense plates in itself can create an enormous tension, and programming those plates can also trigger events in-between. We try to make the floor and the ceiling interactive, so that you could see clouds of color but also clouds of information. An aesthetic spectacle, so you could basically summon the people to come together at a certain point, or scatter them in different directions. So in that sense we are becoming more ambitious about recording those problems in the architecture also.

HUO:

Does this mean that the different sections will not become ghettos, but that there will be interdisciplinary exchange?

RK:

The whole thing was about breaking up this kind of division into departments, where one floor is this, another floor is that. We are reorganizing all that.

HUO:

But you still have four main sections?

RK:

Not really "main." It has become a continuous spiral of subjects, and there is a journey through it. It's not really a subdivision; in

my view, it's more what the French call a *mise en relation*, which does-n't exist in English, or perhaps you could translate it as "continuous exposure."

HUO:

This interview started with the city, then we came to Seattle—the library specifically: you talked about connectivity, hyper-connectivity within the building. In my last interview with Peter Smithson, I asked him about how he sees the present condition of the city. Here is what he answered: "I think that the critical thing to work through now is the space between. Most of the world out there is a nightmare. I worked in Montreal last winter, and the drive from the international airport to the city was one factory after another, one group of dwellings... it is unbelievable. And it has happened so fast: in twenty years, a generation has almost wiped out the notion of architecture... But there is no sense of the collective, the space between: all buildings are built as if they existed only in themselves." Do you share this view? Isn't it true also for Holland?

RK:

We see that there is an incredible dysfunctionality in terms of con-nections. We are really interested in working and thinking on the metastructural or infrastructural level on concepts to improve condi-tions. Fernando Romero took two and a half hours last night to get from Rotterdam to Amsterdam by public transportation, by train. He did all the socially right things: he walked to the station, took the train and the tram. So there is this kind of insanity in which, if you take public means of transportation in the way that you're intended to behave, it takes three times as long as going by car. That's why everyone takes their car, and that's why the car doesn't work either. It's a vicious circle. And we are incredibly interested in it and we're also good at conceptualizing interventions and solu-tions, but the difficulty is that that is the level of politics, and that is the level that is the hardest to ever enter. And even if you enter, you're going to be typecast very quickly as either a visionary, who has interesting but irrelevant visions, or a nuisance... or a megalo-maniac. I think there is something touching about Smithson and Team X; they were obsessed with conceptualizing new types and families of connections. And my feeling about their residue, their effect, is both more cynical and more optimistic, because I think, to a large extent, things connect in spite of the efforts of the archi-tect. There is an incredible infrastructure or architecture of con-nection, particularly in this century: all the ramps, all the highway crossings, all the pedestrian connections, etc.; and my instinctive

belief is that they all hinder exactly the kind of communication that they are supposed to generate. In Lagos, connections proliferate in spite of the infrastructure, or of the dead-end, the fiasco of infrastructure. That is typically one of the aspects of the profession that is fighting a rearguard action, because it denies all the connections that are in place already in supposedly lost or residual space. And the fact that those autonomous parts can exist now because there are remnants of invisible connections, I think is for me the interesting point, that somehow those invisible connections need an architecture, and that that kind of architecture probably benefits from a relationship with real architecture. And so that is why we are interested in that kind of virtual reality, because it enables you to conceptualize something without being literate about computer use or computer animation.

HUO:

Can you tell me about your interdisciplinary project at Harvard University?

RK:

Harvard is a school of architecture, a school of landscape, and a school of planning, where smart and more or less autonomous and independent people are both teachers and students. And the interesting thing is that these groups have the say-so to appoint new people, so on the whole, they're always appointed in conformity with what these fields represent. Architecture has lost certain abilities; landscape has taken them over. What could be very interesting would be to unite these residues, and what we have called it is this fourth thing. It is more a thing than a space, and to declare that this is the perfect domain to participate in a redefinition of...
—if within a school like Harvard you made a consultation of all the marginal people, you would obviously have some kind of government in exile, a kind of exiled Harvard, but also—and that would be more and more obvious—you would find that all those people have some intelligence that can no longer be completely fit into a given mold. So it's not really interdisciplinarity per se, but more about the power of marginalizing.

[3]

HUO:

When first approached by the Hayward Gallery to make a design for the installation of the exhibition "Cities on the Move," your proposal was to recycle other architects' recent exhibition designs for the gallery rather than producing a single, unified scheme.

RK:

I've always tried to be "economical" with our imagination. Schwitters' Merzbau (1923–1943) was an accumulation of (urban) debris that was reassembled a number of times. Here, Ole Scheeren and I have tried first to accumulate previous Hayward designs, then to reassemble them, almost as a form of urbanism. I thought it would be nice if the show revealed a number of things about the Hayward, especially since the existence of this very building is currently under question.

HUO:

You moved to London the year the Hayward opened, in 1968.

RK:

Yes, lured by people like Peter Cook and Cedric Price and the thought of the architectural scene in London as some kind of huge club.

HUO:

Do you remember the opening of the Hayward?

RK:

Yes, of course. I mean it was THE event, and now I've lived here through all its declines and falls and resurrections. I think it's an incredibly vital and generous space, mainly because it has never conformed to anyone's expectation or model of what an exhibition space should be. Although everyone always complains about it, I think the Hayward has had some of the best and most extreme exhibitions that I've ever seen.

HUO:

In the Louisiana Museum, where the exhibition was presented before coming to the Hayward, we organized the show into a number of different typologies of cities, following the many, many interconnected spaces of the building's architecture ("Cities on the Move," Louisiana Museum of Modern Art, Humlebaek, 1999). You decided not to do that at the Hayward.

RK:

I was worried about dispersal. The Hayward doesn't have sufficient different areas to divide the exhibition into many city typologies, and I wanted certain main points to be evident. I thought we should see whether we could compress the show into four or five cities, with a sense of introduction and some kind of compression chamber that tells you you're about to enter a continent in total upheaval and turmoil.

So, in the light of the recycling of previous Hayward exhibitions' architecture, what we have done is keep the basic structure from

the previous "Patrick Caulfield" exhibition (1999), and add many of the objects that Zaha Hadid designed for "Addressing the Century: 100 Years of Art & Fashion" (1999). We use the same circuit as for the "Caulfield," but we modify it, so that when you enter, there is a big arrow telling you which way to go, but there is also a smaller passage, which goes to the red light district. We'll do newness, like airport construction, but we'll also do decay, sex and drugs like in a real city.

HUO:

You think that at present the exhibition is not sexual enough?

RK:

Yes, very unsexual. I mean, given the fact that there is an enormous volume of sex tourism and that sex is one of the most important forms of transaction between people in cities, this show as it has been so far is almost oblivious to it. The problem is doing it without exoticism, and it's always difficult because of this reticence in Asia to talk about it. This I think is actually a really critical thing…

HUO:

And the architects?

RK:

It is a difficult issue for architects, how to deal with such an explosive phenomenon that seems to flourish beyond individual architects. How to connect to it? We'll put all the architecture together, into a sterile room of architecture…

HUO:

A torture chamber of architecture?

RK:

It's where my projects will go too…

HUO:

So there is no value judgement?

RK:

No, no value judgement, and I think this will let the works contaminate each other in an interesting way.

HUO:

Will there be other changes to the "Caulfield architecture" on the ground floor?

RK:

We'll make a kind of intimate streetscape with Zaha Hadid's plinths, turning them into video buildings and vitrines for icons so that one room becomes some kind of monumental alley. We'll tunnel through the corridor surrounding the ramp and put in some videos and plaster the walls with Armin Linke's installation photo-

graphs. Overhead will be Chen Zhen's bicycle/car dragon.

HUO:

Let's move to the top floor.

RK: It will be a "commercial area"—projectors in the staircase, and we'll use another of Zaha [Hadid]'s big vitrines to create a cinema. Then we'll have an area with things for sale, which will make us see the nearby cinema as commercial too. And then the space will end in political protest where eggs are thrown.

HUO:

You mentioned the idea of urban wallpaper.

RK:

The walls of the whole ground floor should be covered with wallpaper; wallpaper of urban images, of urban realities. There will be no words, with the exception of occasionally the front page of a newspaper. The wallpaper is a background, a grey presence everywhere, kind of overwhelming. That's the whole point of cities, a nightmare in a way. An overkill. Urban overkill inside the Hayward.

LEE BUL

Lee Bul was born in 1964 in Yongwol, South Korea. She currently lives and works in Seoul. The daughter of a longtime left-wing political dissident, Lee studied at the Hong Ik University, Seoul, graduating in 1987 with a Bachelor of Fine Arts in Sculpture. Since then, Lee has been tracing, exposing, and subverting the formation and circulation of ideologies, social, cultural, and aesthetic, that shape our present world. Her many performance pieces include Sorry for Suffering: You Think I'm a Puppy on a Picnic? *(1990), a twelve-day performance in which she wandered the streets of Tokyo donning monstrous soft-sculpture forms. In her installation series "Majestic Splendor" (1991–onwards), she has displayed fish adorned with sequins that slowly and noxiously putrefy. In 1997, Lee first presented her series of "Cyborgs," sculptures of female cyborgs with missing heads and limbs, inspired by Japanese anime and manga as well as current developments in bioengineering. For the Korean pavilion at the XLVIII Biennale di Venezia (1999) she created a standing karaoke booth, a project that she has since developed further, and through which she explores issues surrounding the vernacular language of pop culture and the authenticity of experience. Lee is one of the most prominent Asian artists on the international art scene. She has received wide recognition in Europe and America, and she won a prize at the Biennale di Venezia in 1999. She has had solo exhibitions of her sculpture, multi-media installations, and videos in major institutions including the Museum of Modern Art, New York (1997); the Kunsthalle Bern (1999); Le Consortium, Dijon (2002); the New Museum of Contemporary Art, New York (2002); and The Japan Foundation, Tokyo (2003).*

........................

This interview was recorded in Seoul in April 1998.

Hans Ulrich Obrist:

My first question is related to your Cyborg *sculpture made of silicon; you told me before that they were incarnations of male fantasies. Can you tell me how your work with cyborgs developed?*

Lee Bul:

There are two currents of thought in my work with the cyborgs. The first is that it references and elaborates on popular imagery borrowed from cyborgs in animation and films, but my cyborgs are all missing organs or limbs, so they are incomplete bodies in a sense, questioning the myth of technological perfection. The other idea is to invoke archetypal images of women, art-historical representations of femininity, particularly in Western art history— Michelangelo's *Pietà* (1499), Botticelli's *The Birth of Venus* (c.

1485), or Manet's *Olympia* (1863)—by rendering these cyborgs in those timeless, iconic, feminine poses. So the original conception for the cyborgs began with animation images, especially Japanese anime and *manga*, which are prevalent in Korea as well. Much more so than western images of robots and super-action heroes that are feminine, the Japanese and similar Korean cyborgs combine an ultra-violent, dystopian aspect with some mythical ideas about femininity. So you have cyborgs that have superhuman powers, but also with recognizably feminine physical features and the characteristics of girls. Interestingly, these cyborgs always have a master, usually a young man or boy who programs and controls them. In essence, there is superhuman power, the cult of technology, and girlish vulnerability working in ambiguous concert within this image of the cyborg, and that's what interests me. It seems in some ways to be a projection of the male desire to see the combination of superhuman strength, sexually identifiable feminine features, and vulnerability—all attributes that are very much associated with girls.

HUO:

Are you familiar with Donna Haraway's writings where she articulates an entire politics and epistemology of the cyborg, like in Simians, Cyborgs and Women: The Reinvention of Nature *(1991)?*

LB:

I'm familiar with some of her concepts for her famous essay *A Cyborg Manifesto* (A Cyborg Manifesto: Science, Technology, and Socialist-Feminism in the Late Twentieth Century, 1985). And what I do know of her work is very interesting and relevant to some of my own concerns: the notion of the cyborg as an entity that is both trans-human and trans-gender, how that operates as imagery in the popular imagination, and how it might serve to mediate issues of culture, politics and economy. But, as I said before, the impetus for me initially was the cyborg in animations, because it's so prevalent and popular here, especially among the young kids.

HUO:

There is a crossing of high and low references in your work, as when you describe applying it to art-historical references.

LB:

Aside from the crossing of high and low, which is inevitable in this case, I'm interested in how concepts and representations of femininity proliferate through various channels in the culture at large, whether it be high or low; and also the processes of their formation

and function, which seem to coexist and converge in high and low culture, as you see in art history and also in popular media images of women.

HUO:

In your earlier works, like in your performances that you did both outdoors and in museum or theater settings, you already used extensions of the bodies like artificial limbs. To what extent are the cyborg sculptures related to these early works?

LB:

In a way, it is an extension of my concerns from my earlier works, which explored the boundaries between the body, objects, and culture in a biological sense, so that the materiality of the world was seen as a sort of living organism; and I was trying to decipher its various manifestations and transformations. My concern with the body now deals with its extensions and substitutions, or its representations through technological means. And while notions of femininity may appear to be changing with the advent of new technologies and new ideas and theories arising from those technologies, I still find that certain representations simply reinforce and continue traditional discourses about what constitutes femininity and images of femininity.

HUO:

Do you see it as a critique of stereotypes?

LB:

Well, that's certainly a part of it, but it's not a one-dimensional critique of flat stereotypes. I'm trying to look at the processes, ideas, and ideologies involved in the formation of those so-called clichés and stereotypical images. In regards to technology (which heretofore has been considered, in some ways, neutral, but in fact operates within a context that is still very much complicit with the prevailing ideologies), I'm trying to question who has the power to use it and what sorts of images and products are created through that power and its attendant ideologies.

HUO:

There is also the question of how to disturb, to extend, or to change the existing framework of the computer or the camera.

LB:

Certainly what you mention is a part of my concern, specifically the notion of power and who controls these new technologies. My critical strategy in creating the cyborgs, with reference to images of women in high culture, low culture, art history, and popular media, is an intervention against a recursion of the kinds of ideologies that

are operative in such representations. One thing that I talked about before was that much of the so-called scientific technology, computer technology, advanced engineering, and so on, has always been seen as the domain of male privilege, and, in fact, this attitude is found in the popular notion that women don't know how to use computers or women don't build things that are highly technical.

HUO:

I recently had a discussion with Itsuko Hasegawa, an architect in Japan who made statements for horizontality as opposed to the vertical city.

LB:

Yes, the example you bring up is simple but it's good, because it's indicative of how certain images or products in culture that do come from a specifically masculine point of view, masculine attitude, have meanings pre-programmed into it. We accept these meanings, but they're not seen as specifically masculine; we accept them as a sign of advancement, a symbol of high technology, all sorts of ideas that exalt that achievement, but in fact it's very much implicated in time-honored traditions of masculine privilege and vision. So, I'm trying to explore ways to bring out those assumptions that operate beneath the shiny surfaces.

HUO:

Your early performances were about processes; your current work mainly consists of objects. Can you tell me how you have been oscillating between objects and processes in your practice?

LB:

When I began my career in the mid-to-late '80s, there was this idea circulating in the general art discourse that the artwork as an object is finished when the artist decides it's finished and it is presented in a gallery setting. The artwork as a finished, complete object was a notion that I never subscribed to; what I wanted to show in my work was how the object functions vis-à-vis the audience, within the context of audience response and interaction. Part of my early attraction to performance was that it was an indeterminate form; the results were never known ahead of time. There was always an improvisational element to it, and this notion of processes contingent on audience participation, reaction and interaction carries over into my other works now, which are in some ways physically more object-oriented, but always try to involve the audience—not simply viewer—in some sort of response that goes beyond a distanced viewing; and I feel that I have to do this because the object itself

has no power to exercise until it is encountered by the audience and what they bring to it.

HUO:

One very concrete example would be your work I Need You (Monument) *of 1996, which is a giant blow-up balloon representing a Korean woman who "needs" viewers to inflate her by means of foot pumps. It's almost an anti-monument: it's not imposed upon the viewer; the viewer actually decides upon its visibility.*

LB:

In the case of the balloon works—which are, as you say, anti-monument—I did not want simply to produce a parody of monuments. What I wanted to do was to criticize the processes actually enacted or reenacted in the form of a parody. So, there would be an object which borrows the imagery and structure of monuments—tall, phallic, public—but I also wanted the audience to actually participate. All monuments are, in short, collective efforts, whether we realize it or not. So the act of the audience pumping air collectively, to bring out this image (which is a very questionable representation of Asian femininity) on what eventually became this enormous, overwhelming object, was not only to critique [the] monument as an object, but also to enact the processes by which all monuments come into being. I'm trying to explore the mechanisms, the collective ideas and processes. So on the one hand it depends on how much the audience decides to push air into this monument to make it fully erect, but on the other hand, there is a tone of obvious humor in this act. They have to step up and down repeatedly on this foot pump, which is an absurd behavior in a gallery setting, but at the same time they are aware that this is not natural behavior, so they become more conscious of some of the forced collective action that is needed to bring this about. While they are aware that they are participating in this process, they are also self-conscious of its criticality.

HUO:

My next question is about the way you use nature in many of your works. In a discussion we had one year ago in Seoul, you told me about how you have been using real fish and real butterflies in your pieces such as your Majestic Splendor *displays or* (she was) as good as gold *(1995). The fish, for example, emanates a very strong smell, but at the same time includes elements like sequins and plastic material. For* Garden *(1994), your work in the exhibition "Technology, Environment & Information" at the Recycling Art Pavilion (Expo Science Park, Taejon, South Korea,*

1994), you used both given nature and manufactured nature, mixing arti-
ficial flowers, natural plants, metal beds, etc.
LB:
The garden work is more pertinent to your comment about the
crossing of existing nature and contrived or invented nature,
because the fish and the butterfly works have other issues that are
more central, i.e., what do natural objects signify about woman-
hood and femininity, particularly in Korean culture? The garden
piece was my response to the organizers of the exhibition, who
wanted a conventional artwork to place in a very unconventional
setting. The venue had an atrium-like roof, which was made of all
glass, and the exhibition was meant to last for one year. So, an art-
work, an object, had it been displayed in that setting, would have
eventually deteriorated from exposure to the extreme sunlight.
What I did was to put an ironic twist on the concept of the exhibi-
tion organizers, who wanted some sense of nature within this very
artificial setting. The subtitle of the artwork was *How far would this
contemporary art grow in a year?*, the idea being that what we take as
nature and natural—beyond human control, superhuman, or tran-
scendent—is in fact subject to all sorts of human forces, and we
simply idealize nature as something that exists apart from human
intervention, manipulation, and construction. So I used both artifi-
cial flowers and real plants, which either could die over the course
of the exhibition, or, depending upon how much human interven-
tion actually went into it, could grow into a garden.
HUO:
*What about the butterflies in this series of work where they are pinned onto
plastic hands with hairpins? You mentioned specific Korean connota-
tions...*
LB:
The butterfly pieces are part of a whole series of work entitled "Ali-
bi" (1994). The imagery and the references are from *Madame But-
terfly*, the Puccini opera, and its misguided fantasies and ideals
about what constitutes Asian femininity. The obvious reference
appears in the butterfly that is caught in a hand made of silicone.
In both Eastern and Western cultures there is this long tradition of
embodying enduring values through nature, because it seems to be
beyond human manipulation, intervention, and so on. But the but-
terfly in the work is a dried butterfly that appears alive but is in
fact preserved, so it refers to a certain amount of preservation of old
ideas that continue to exercise the force of immediacy. The materi-

al of the hand is silicone, which of course is often used in medical technology for enhancements of the body. Using both artificial material that is sometimes substituted for the body, and the idea of nature substituted for enduring "transcendent" beliefs, I was trying to undermine their conventional functions and meanings.

HUO:

The fish, and your "supplements" to the fish look extremely artificial, but it's not a representation. Even if it appears very artificial, it's real, because it starts to smell after a certain time (and Roland Barthes once said that photographed shit doesn't stink). Could you talk about this paradox and its exhibition history?—because I think that smell is a relatively unexplored sense in art exhibitions. How did it go when you presented these works inside the spaces of the MoMA ("Projects Bul Lee / Chie Matsui," Museum of Modern Art, New York, 1997)?

LB:

What I'm trying to examine is the idea of representation and its relationship to the privileging of vision as the dominant esthetic principle, and how this privileging of vision came about. If you trace the idea far back enough, the mastery that you acquire thorough vision was a distinctly masculine privilege, so all of the other senses were relegated to realms outside of high art. While the fish can be seen as a representation, it also evokes—because of this other element of smell, which doesn't fit in to the traditional categories of representational strategies—a sense of the real, of object immediacy, of something that is prior to, or beyond, representation. For instance, if you go to an exhibition where this fish work is shown, and if you have normal smelling capacities, what you will encounter first is the smell, the element that is outside representation, and through that context, you then come upon a visual representation. In a sense, I'm trying to reverse the traditional strategies of art, to disturb the supreme position of the image, or the privileging of image and visual experience in the traditional hierarchies of art apparatus. As for MoMA, I guess you could say that the white cube structure of the supreme modernist institution couldn't contain, in more ways than one, the disturbances set off by my work.

HUO:

Several of your earlier works, such as your performances on the street or your toilet installation, happened on the margins of institutional spaces or in unusual contexts. How do you see the oscillation of the exhibition between inner and outer institutional spaces?

LB:

The point you make about the oscillation between the inside and the outside pertains to, for instance, *Artoilet* (1989), a work I did using a photocopy collage on a public bathroom located on the grounds of an art museum (Total Art Museum and Sculpture Park, Jang Heung, South Korea). One of the things that I'm trying to disrupt is the compartmentalization of experience. For instance, when the audience approaches my actions, whether it be an object or a performance, the assumption is that because I am an artist the work is therefore art—that it is somehow separate from other aspects of experience and culture—and that it can only be experienced within certain physical settings, like an art museum, and cannot co-habit in other places or with other aspects of experience. One of the things I accomplished with *Artoilet* is that whenever people went to use the toilet, their experience of the work was inescapable; of necessity people have to go, and then there was this work there that they had to encounter. It also refers to inside and outside, what is private and what is public. There is an intermingling here, because they come face to face with art, but in a space that is supposed to be private and sort of divorced from the public setting of where art is viewed, or where one chooses to see art.

HUO:

What about the street?

LB:

The street performances and activities are different from my performances in a theater setting, which is a more conventional space in which you expect to encounter an artwork. In the theater, the audience is prepared for an aesthetic experience and they keep a certain amount of distance between what is happening on the stage and their viewing of it. There is ample room to aestheticize and intellectualize about the experience, whereas when I did pieces on the streets of Tokyo, the encounter was unexpected: the accidental audience is unprepared, they don't come with a set of assumptions about aesthetic experience [*Sorry for Suffering: You Think I'm a Puppy on a Picnic?*, 1990]. It's a spontaneous sort of mixing of life and art. In short, the audience comes to it disarmed, without any assumption about what constitutes an art experience, and they take away something that approaches the aesthetic but which is also very much implicated in daily life.

HUO:

My last question is about economic implications of your work. Throughout

this century, artists have been investigating different notions of the economy of art, from Marcel Duchamp to Marcel Broodthaers to the present. You discuss this in the catalogue of your Auction *work of 1994, which is a parody of an exhibition as an auction...*

LB:

The *Auction* work was specifically a response to the fact that there is no auction in the Korean art market. The prices, the evaluations, are essentially a collaboration, an invention between certain artists and certain galleries, so there is no free market logic operating here. But on the other hand, I was also speaking to the broader idea that there really is no free market logic operating in the economy of art. In this particular show, I considered the context in which the artwork was shown, a gallery (but not an upscale commercial gallery), so I knew that the people who would come there would be prepared to spend a certain amount of money for a certain type of work that could be collected. Also, the work itself had to have a certain degree of complexity, had to have some intellectual appeal, but not so complex that the potential collector would feel at a loss as to what it was about. So the artworks themselves constituted a representation, an index of the various desires of the collectors. They were all smaller works that could be displayed in private collections, and in a price range that these collectors could afford. There was a certain amount of labor that went into the making of the work, which corresponds to the notion that "good art" must manifest some individual "touch" of the artistic genius, and not simply a concept. By the act of bringing these desires to the surface through the selling of these works, I was suggesting that the economy of the art market operates through a certain amount of collaboration between the artist and the collector, and is in fact quite separate from a free market logic that we usually assume is a fair way to determine what things are worth.

MAHARAJ, Sarat and VARELA, Francisco

Francisco Varela was born in Santiago de Chile in 1946. Varela studied biology at the University of Chile in Santiago, with the neurobiologist Humberto R. Maturana. From 1968 to 1970, he pursued his graduate degree in biology at Harvard University. With his PhD in hand at the young age of 23, Varela declined a position as a researcher at Harvard, choosing instead to return to Chile to help build a scientific research community. It was during the years of 1970 to 1973 that Varela and Maturana, now colleagues at the University of Chile, formulated their famous theory of autopoiesis (Autopoiesis and Cognition: The Realization of the Living, 1973). According to this theory, living systems are autonomous systems (endogenously controlled and self-organizing), and the minimal form of autonomy necessary and sufficient for characterizing biological life is autopoiesis, i.e., self-production having the form of an operationally-closed, membrane-bounded, reaction network. A strong supporter of the Allende government, Varela was forced to flee Chile with his family after the General Augusto Pinochet overthrew the Allende government in September 1973. Varela undertook various academic positions in the U.S. and later back in Chile, and in Europe, before he moved to Paris in 1986, where he was based at the Institut des Neurosciences and at CREA (Centre de Recherche en Épistémologie Appliquée). In 1988, he was appointed as the Director of Research at the French CNRS (Centre Nationale de la Recherche Scientifique), a position he held until his death in 2001. During these years, Varela pursued two main complementary lines of work: experimental studies using multiple electrode recordings and mathematical analysis of large-scale neuronal integration during cognitive processes; and philosophical and empirical studies of the "neurophenomenology" of human consciousness. Varela published numerous technical, experimental and mathematical papers on the nonlinear dynamical analysis of brain activity, including groundbreaking studies on the prediction of seizures in epileptic patients prior to the onset of symptoms. Since the mid-'70s, Varela was a serious practitioner of Tibetan Buddhist meditation and a student of Buddhist psychology and philosophy. His conviction that this tradition and Western cognitive science have much to gain from each other provided another, ultimately spiritual and existential dimension, to his work. This dimension was the subject of his 1991 book (co-written with Evan Thompson and Eleanor Rosch), The Embodied Mind: Cognitive Science and Human Experience. Francisco Varela's death in 2001 is a tremendous loss felt across several fields of research and thought to which he contributed so creatively.

Sarat Maharaj was born in Durban, South Africa. He lives and works in London. Maharaj studied at the University of South Africa in Durban, one of the segregated universities of the Apartheid system, for non-whites of Indian origin, prior to emigrating to Great Britain under the United Nations Convention for Refugees. Maharaj was Professor of Art History and Theory at Goldsmiths College, University of London (1980–2003) where he is now Visiting Research Professor in Visual Arts. Maharaj was recently Professor of Visual Art and Knowledge Systems at Lund University, Sweden (2003). He will be Visual Research Fellow at the Institute for Advanced Research, Wissenschaftskolleg, Berlin (2005–2006). He was Research Fellow at the Jan Van Eyck Akademie, Maastricht (1999–2001) and the first Rudolf Arnheim Professor of Art History at Humboldt University, Berlin (2001–2002). A focus of his work has been on visual art as knowledge production—developed at Goldsmiths, Jan Van

Eyck Akademie and Malmö Art Academy. Through Lund University, he is planning to develop the subject in relation to cognition and epistemological studies, originally encouraged by discussions with Francisco Varela. He has published numerous texts and catalogue essays on cultural translation ("Perfidious Fidelity: The Untranslatability of the Other," 1993, and "Modernity and Difference," 2001), as well as on textile art, Marcel Duchamp, Richard Hamilton, James Joyce and on the sound-image theory projects "Monkeydoodle" and "Xenosonics" ("Mutations," ex. catalogue, Arc en Rêve Centre d'Architecture, Bordeaux, 2001). He co-curated, with Ecke Bonk, the exhibition "Retinal.Optical.Visual.Conceptual..." (Museum Boijmans Van Beuningen, Rotterdam, 2002) and he was one of the co-curators of Documenta 11 (Kassel, 2002).

........................

This interview took place near Hôpital Salpetriere in Paris in September 11, 2000.

Sarat Maharaj:

One of your striking contributions to neuroscience and consciousness studies is your focus on the "view from within"—on how the mind ticks from inside its own activity. You have referred to this as the "first-person" standpoint. Its "second- and third-person" counterparts, if we may speak with such brittle distinctions, tend to look at mental processes and experience "objectively." How does the "first-person" stance—the mind tackling its own streaming flux, its own procedures and operations—come about in your approach, what are its origins?

Francisco Varela:

The honest answer is that it was related to my interest in Buddhism picked up in 1974. I left Chile after the coup d'état in 1973, the Pinochet story. I went to the U.S. and that time—1974—was a bit of a crisis for me. My whole world was gone. I took a job at the University of Colorado, in Boulder, as a neuroscientist because I needed something. I ran into this very interesting person from Tibet called Chögyam Trungpa. He had come to the West as a young man, studied at Oxford and migrated to the States in the early '70s. He's a pioneer in bridging traditional Tibetan Buddhism and the West. He died in 1987. I met him early in 1974. He was so perceptive. I talked about my personal life—because like I said, I didn't know what to do—and he had tremendous advice. Most of all, he said, "Why don't you try and work a little bit with your own mind? Just think about who you are. You know, sit down for a while and look at it." I said, "Well, how do you do that?" He began to teach me basic Buddhist Siddhi or Shama meditation. I fell in love with it. That was really the beginning of understanding that the first-person emphasis is an attainable, doable strategy. It teaches you things you don't know and

you actually get to know who you are in clearer ways. That's really
the origin. For years, it was a separation of personal/professional life.
Then for seven or eight years, I was a complete meditation fanatic.

SM:
I was wondering if we could say that the experience of exile and
emigration—or the sense of trauma itself, of rupture and melt-
down, might have contributed to your sensing the creative poten-
tial of the "first-person" stance, and thus made you value its
force?

FV:
My feeling is that what trauma gave me was an open state of mind.
I grew up in a milieu in Chile where we had the idea of re-invent-
ing the southern continent, what we call "America." [*Laughs*] At
the time, the most obvious thing for a young person was to take a
"left" position, with a heavy dose of Marxism. I was fascinated by
science. My interests were in Western philosophy and I was "ratio-
nalist" through and through, a materialist-rationalist, as you would
expect from somebody with that background. With the coup d'é-
tat—I mean, for people who haven't been through an experience
like that, what it shatters takes us way beyond the rational mind.
To see a fascist regime all of a sudden crop up in the middle of the
street is as if society turned inside out, like all of the incredibly
dark, mysterious sides of the human mind made visible. The suf-
fering, violence, friends being killed and all the rest is just so shat-
tering that for the first time in my life I had the experience of say-
ing, "I don't understand a thing, I don't know anything. What is
this? I'm a complete nincompoop when it comes to understanding
what all of this is, what is human life, who am I?" That was the
road that I was on when I came to Boulder. Meditation seemed so
sane, because it didn't mean learning a new idea or reconstructing
any interpretation: it meant just being there and observing in a
fundamentally naked sense, who I was—something I realized I did-
n't know. Maybe if I had decided to stay on in the United States
after my PhD or if I had never been through that trauma in Chile,
I may never really have had that open-mindedness.

Hans Ulrich Obrist:
*But you didn't stay long in Chile, and soon you emigrated to Europe...
There have been successive exiles in your life: you went from Chile to the U.S.
for your Ph.D., then back to Chile resisting the security of a position at
Harvard to build up science in Chile, then to the U.S. again because of the
coup and back to Chile, and then you went to Europe where you settled on a*

more permanent basis. I'm wondering to what extent have these migrations
been "voluntary or involuntary exiles" to follow Jonas Mekas' distinction?
FV:
When I returned from the U.S., I tried to build my life in Chile
but I realized I couldn't. In 1985–86, I decided on Europe. That is
voluntary exile because nobody pushed me; there was no Pinochet
behind my ass to do that. It's true, it does make a difference, but I
think, in my case, the first exile is the one that counts. If it is invol-
untary, then it's a totally different flavor from when, for other rea-
sons, you decide to migrate: curiosity, love of diversity or whatev-
er. I have always felt I am an exile, because I was robbed of the pos-
sibility of actually making my life in my country as I wanted to. I
was forever robbed.

SM:
What you say suggests how displacement intersects not only with
shifts in thinking but also with the production of other modalities
of consciousness. To tie this to what Hans Ulrich is asking us, I
find my own journey out of the Apartheid State adds up to a series
of moves in and out of the registers of "voluntary/involuntary
exile." Because of our Indian background, we were subjected to
"internal exclusion" in South Africa, officially classified "alien" in
the context of the British Empire. Then, with the Apartheid
Republic, we were labeled "non-white of Indian origin" with sec-
ond-class citizenship in a racist state. Leaving South Africa in the
'70s, I became stateless, then given refugee status in Britain. These
moves seem to mix not only into perpetual uprooted-ness. They
also churned up mental turbulence, a heightened quest for other
modes of thinking-feeling-knowing. An anomaly that bugged me
was the feeling that it was not possible to voice my abiding inter-
est in Hindu-Buddhist philosophical systems of enlightenment
and liberation—especially the Nyaya-Vaisheshika—even if only as
some kind of half-felt counter position to Euro-epistemics. This
seemed at odds with historical materialist views on liberation. My
interest felt subterranean even in England. How to square rational-
ist-materialist models of social-political transformation—central to
liberation ideology—with philosophical elements that had been
de-legitimated as "non-rational," as "mystical-primitive" by Euro-
centric notions of consciousness.

FV:
Did you also suffer discrimination of Apartheid at the time, not as
a black person, but as someone of Indian descent? Was it as bad as
it was for the blacks?

SM:

Apartheid was bad news for everyone, but Africans suffered under every repressive law. They were subjected to violence from the time the first Dutch settlers set foot in the country through the era of colonial pacification to Apartheid. They were dispossessed of 87% of their land, forcibly removed, dumped on patches of land called Bantustans and plugged into a vicious circuit of migratory labor between black townships and white cities. Indians were mainly brought over during British colonial rule, impoverished workers for the sugar plantations and mines on an indentureship scheme introduced soon after the abolition of slavery—perhaps, a modern, wretched version of it. They stayed on after the indentureship period to eke out a living through market gardening. They were swindled again and again under the Group Areas Act, for no sooner had they built up an area of land it was then declared for occupation by whites only. Gandhi had come to South Africa as a smart English-trained lawyer to help a muslin trader. Soon enough, he was propelled into action with the poor indentured community. His 18-year stay amongst them forms the crucible of his practice of *satyagraha* or "truth-force"—the production of consciousness and self-understanding in the struggle against racial discrimination.

FV:

So when you decided to leave, it was because of the pressure of this very discriminatory life that was imposed at that time?

SM:

Apartheid was in full institutional spate by then: racial segregation in all aspects of everyday life according to ethnic boxes were devised by the Race Classification Board. There were separate live and work areas for the different race groups such as Zulu, Xhosa, Venda, Sotho, "people of mixed descent," etc. Through the segregated schools and universities, the regime hoped to train obedient staff for the Bantustans. I went to a university for non-whites of Indian origin. Voicing criticism through teaching, visual artwork, social activity, awakening consciousness through plays, performances, and satirical revues eventually made it impossible to continue.

FV:

I see. Did this engagement with the "political-rational" have to be kept apart from explorations in what was seen as "para-rational" forms of thinking?

SM:

I suppose the latter sprang from a hazy awareness of residues of traditional Indian culture that the indentured memory had somehow

stored. Apartheid had a stake in re-ethnicizing the various racial groups it had cooked up. Post 1960, Indian philosophy was offered for study at the segregated university for Indians at Durban alongside Western thought except taboo thinkers like Marx, Mao, and [Herbert] Marcuse amongst others. What passed as Indian thought was not exactly active engagement with "the technologies of introspection." More a parroting of a glorified, "essentialized" version of it meant to inculcate in us a sense of "Indian-ness." With this political drift, the engagement with it remained under a cloud, sidestepped and treated as compromised. Its potential to place under critique the political-rational hardly counted. Perhaps too late, it came to be seen as the gap in prevailing models of liberation as purely political-institutional transformation.

I wanted to connect this to the moving sessions of the Truth and Reconciliation Commission in South Africa today where we have had to learn to listen, often in-between painful, unspeakable lines, to ordinary people recounting their personal ordeal of the Apartheid years. The episodes showed that the search for "truth and reconciliation" has to go beyond legalistic frameworks. "Juridical understanding" has to be *supplemented* by—with the resonance [Jacques] Derrida gives the word—other dimensions, that is, explorations in personal consciousness, our ability to tussle with difference and heterogeneity, even with the "otherness" of the "enemy." It meant stepping into the scene you describe as "hetero-phenomenology." This seems like an urgent quest today—an ethics of difference.

FV:

What you say is very interesting because I was in Chile a few weeks ago and through my son-in-law, I met some younger people. I was astounded that a good part of their discourse was their rediscovery of what they call the "politics of intimacy," which I thought was a very beautiful term—the essential values including the life of the spirit. They even used the word "spirituality," which would have been totally unthinkable for where I was coming from in politics. These are not weirdoes. It seems to me to converge with what you are saying. We spent more than half of the time talking about what is "spiritual life," what does it mean, what actually are the pragmatics, what are the actual hands-on things you can do? I was very touched. My generation seems to have missed that completely. Now, at this point in my life, I thought it was just something individualistic. But they seem to be thinking very naturally of putting these two things together: the private-public. This is a conscious-

ness reborn out of very difficult times—very naturally after 25 years of dictatorship or after how many long years of Apartheid.

HUO:

What are the ways in which you see the ideas of working through first-person consciousness and elements of "new spirituality" making themselves felt in South Africa?

SM:

Within institutions and their limits, it is seen in the Dutch Reformed Church's "apology" to South Africa or in the work of Desmond Tutu's Anglican Church. These efforts are sacramental events—"lustrations"—public enactments of the desire for purification, forgiveness, for getting ready to reconcile couched in symbol, icon, ceremony, the regulated lingo of religion, also, in a wordless syntax. Beyond this, we have the reflections of Albie Sachs, head of the South African Constitutional Court today. He was a dogged opponent of Apartheid. The regime tried to kill him off with a bomb that left his body wrecked, his eyesight damaged. He notes the limits of the juridical using Gandhi's "Experiments with Truth" to expand modes of truth telling to *supplement* the institutional-juridical.

HUO:

These truth-telling modes seem to take in Gandhi's practices such as Ahimsa *(non-violent action),* satyagraha *passive resistance and civil disobedience.*

SM:

Some of his "Experiments with Truth" were a bit scandalous to over-delicate Victorian tastes, since they touched on sexual energy, body relationships, testing yourself in the face of difference, a kind of somatic plugging into otherness. There is perhaps a rough parallel with Francisco's more systematic notion of "embodied knowledge." (*The Tree of Knowledge*, with Humberto. R. Maturana, 1998) It is in this spirit that Sachs maps "existential-phenomenological-dialogic" modes of truth-telling to fill in what the rationalist-juridical model leaves out or rather tags on as "spirituality" in an instrumental way as officially sanctioned activity. Gandhi perhaps relates to what you develop as "embodied, enactive" rather than abstract knowledge and to your distinction between "know-what"—living by ready-made moral rules as opposed to know-how—uncertainties of ethical creativity.

FV:

Is that happening as a marginal thing or more in the mainstream of political renovation in South Africa?

SM:

The mainstream focus is on social-economic urgencies rather than trauma and therapy or their implications for processes of liberation. A managerial attitude prevails: first-person investigations are seen to be done and over with, vented in controlled, channeled fashion through due processes of the Truth and Reconciliation apparatus. Now people are expected to settle down, become regular citizens.

FV:

But it doesn't have to be about trauma. It could also be about taking it as an explicit part of reality. This is what I liked about the "kids" in Chile. It wasn't so much about going back to traumas that are still there as about the non-separability of the politics of intimacy and the pragmatics of the real.

SM:

Some do link pragmatics with experiments with truth and self. They're testing it in their own way, inventing their own lingo. It's not so much a single movement, but rather, a crop of impromptu intelligences, patched-together ways of coping. You see a group of women who were sewing machinists in a clothes factory. They lived a particular demeaning drill under Apartheid. Democracy might have arrived formally but they have to make sense of it beyond abstract government declarations. No less for formally-educated Albie Sachs. He too has to string together tools for self-understanding. It is not about simply mulling over trauma, but about mental-emotional devices for making sense of how it is that even though Apartheid is dismantled many of its features hang on? That we've gone through truth-telling, yet we find ourselves stuck with many troubling modes of thinking from the old dispensation.

FV:

That's very interesting to me to hear about South Africa, because it is coming out of a very dreadful, traumatic period in young countries. There are things in Chile we didn't have to deal with, fortunately, like the tremendous racial diversity and racial tensions. But the tensions are more of the right/left kind

HUO:

I think this conversation is progressing in a very nice way because there are some very interesting points in your biographies which kind of cross of course, there are also common elements between your respective works and approaches towards knowledge. I remember discussing with Sarat the contribution that you did, Francisco, for the exhibition I organized together with Barbara Vanderlinden ("Laboratorium," various venues throughout Antwerp, 1999). Maybe we should examine this now.

SM:

As with several of Hans Ulrich's projects, "Laboratorium" gave us models and propositions for seeing-thinking-knowing. I was delighted to come across your "portable, subjective laboratory": You seemed to situate, as I think you've called it, the "triple braid"—neuroscience, phenomenology, introspective technologies. The last term takes in Zen, Yoga, Transcendental Meditation and the vast *Abhidharma* corpus that over several centuries elaborated and documented techniques of first-person consciousness.

FV:

I'm engaged now in giving flesh to the neuro-phenomenology idea. It is not treated as abstract but through concrete examples of how we can go beyond the phenomenological-natural opposition, how to see the natural can be phenomenological and vice versa. In other words, that what we call personal experience is really not all that personal. There is always the public in the private or first-person is also third-person. The insight comes from traditional, more spiritual practices. But it doesn't have to carry "spiritualistic" connotations. On the other hand, when you work with the brain, in the end the images and the measures you get are very subjective. They belong to interpretation by a community that can only interpret them anyway because of their own experience. So there is a false dichotomy of first/third-person. Theoretically, the program is pretty much sketched out. How to implement it? One attempt is a simple perceptual task. You must have seen random-dot stereograms where if you cross your eyes a little you see the third dimension. It's striking. You actually do see 3-D although there is nothing there but random dots—a very strong phenomenological experience. If you subject somebody to a number of these random dots and ask a simple question, "Just tell me when the 3-D pops up by pressing on a button," then you have a perfectly standard psychology experiment. At the same time, we registered what was going on with the subject way before they would see the 3-D pop up. There was a long period where nothing seemed to be happening. Then the stimulus would be presented. Another innovation was to let the subject, after each time they see something, record a phenomenological account saying, "Well, in fact, when the stimulus came, I was really thinking about something else," or "I was half asleep," or "No, no, that was really good that was brilliant." You have repetitions, but also full, detailed accounts. Their first-person expression can actually be sorted out from third-person data. This is because you can say, "Well, let's take all the moments in which

the person was completely distracted, thinking about something else and separate them from ones where he says he was totally present, very prepared. All hangs on the time before the stimulus. We have what we call phenomenological clusters. The first-person actually constrains the way you treat the third-person. What you see when you look at third-person data on the brain are that they are two completely different things—when the subject reports being totally prepared and opposite ones. That's not surprising in itself had it not been for the fact that typically in the classical experiments this is not done at all. Everything mixes. We have in the brain means for sustained preparation that makes it possible to see it is a sophisticated personal-individual strategy, what you do to be prepared. You activate an approach to something that is endogenous, belonging to you before you see anything in the world.

We even worked with a long-time meditator, an extraordinary person called Mathieu Ricard. Does the name ring a bell? He trained as a scientist. But he left to become a personal assistant to one of the greatest Tibetan masters in this century, Dilgo Khyentse, for twenty years. Mathieu really knows that tradition and is a highly-developed meditator. We had Mathieu come and do exactly the same experiment.

HUO:

He came to the lab?

FV:

He did because we're friends. I said, "Mathieu, I need you." When you compare the ordinary Joe with Mathieu in the strategy, it's incredible. Mathieu has no distractions. He is so totally steady. You can see it in his electrical activity. The protocol is totally different for somebody like him where you can actually see the importance of the first-person development. There is no way to confuse the highly-trained first-person explorer from just a regular person. Those examples allow us to see that very clearly. You know, first-third, it's all mixed up. You cannot really separate what you see from the real data that comes from the first-person. But these distinctions are made on the analytical plane.

HUO:

The area that you are exploring now, Sarat—visual arts practice as a kind of "non-knowledge" does it overlap with the modes of knowing that Francisco is describing? Could you talk a little about it and how you've come to be investigating it?

SM:

I'm afraid my efforts are not as clearly testable as Francisco's. For "non-knowledge" I use the Sanskrit term *Avidya*. The word "*vidya*" means "to see-know." It gives us the Latin "video" ("to see") and the modern English "video" as in VCR. When we attach the prefix "A" to it, we normally mean to signal something like its opposite—"ignorance." But "A" can also neutralize rather than negate—as we find with in-between, indeterminate terms such as typical<*atypical*>untypical or moral<*amoral*>immoral. The middle term highlights the shortfalls of the binaries "knowledge/ignorance"—but it questions the assumption that by knowledge we only mean the full-blast variety such as the established disciplines. So, *avidya* or non-knowledge, contrary to appearance, is not anti-knowledge—unless we imagine it as exciting stuff like anti-matter. It is more a *détournement* of readymade knowledge systems, a flip-over and displacing of structured data and information, dissolving them as they try to settle and fix into institutional disciplines. Within knowledge systems, the learning-creating process centers on transfer and transmission of what's already known. It is about tracing-repeating-reproduction and representation of ready-made, canonical elements. *Avidya* is more about production, about generating new forms of think-feel-know, about first-person creativity, unknown circuits of consciousness. It treats visual art practice thinking today as an unscripted condition where anything might happen—verging on Francisco's challenge to absolutist first-third-person dividing walls.

FV:

For me this implies a widening process. The first-person stance doesn't so much invalidate science or classical objectivity. It is about a larger understanding of objectivity where it's not only your view from the outside, manipulating measures, that constitutes objective knowledge. These interact with first-person accounts to become inter-subjective, to become knowledge. In that sense they would be objective, although in principle, in their way of access, they are subjective. In fact, I don't like the word "subjective." It's just another mode of access to something like a base where we build objectivity—if by that we mean what can be made stable in inter-subjective dynamic.

SM:

I play on the paradox of visual arts practice as knowledge production that is at the same time non-knowledge. This back-to-front speak is partly to provoke us into probing precisely what knowledge systems leave out as "invalid" method, evidence, practice—

the "murky non-knowledge fog" around "clear-cut knowledge." In the knowledge systems league table, contemporary visual arts often ends up at the bottom, a "left-over" because it "fails" to cough up an all-encompassing, rigorous account of its foundations, axiomatics, methodologies. Today it's a strength that they are often not able to spell this out in advance. It's more likely that their principles and procedures get thrashed out in the making of each artwork or event. This links with Francisco's querying first-third-person boundaries not to undermine objectivity, but to rethink it—not least to ask how they originate and get fixed in the first place.

HUO:

Such thinking suggests non-linear kinds of flow and exploration, connections of a more neural network kind, inversions, detours from established pathways of knowing, perhaps rhizomatic moves?

FV:

How would you put more positively what is the knowledge that artists' produce in their work? Say of a painter we know it is not a kind of organized, rational belief but how would you describe it? Is it kind of a know-how? What would be, in other words, the content of *Avidya?*

SM:

That's the tough bit! Speaking of "know-how," [Gilles] Deleuze refers to [Henri] Bergson's celebrated swimming example to ask if we can ever learn to swim from a theoretical account? More likely, it seems being plunged into water forces us to come to grips with it. Otherwise, I suppose, we are truly sunk! We might possibly never get the hang of it through a theoretical exposition that tells us how swimming is like walking-in-liquid. The know-how springs from "just doing it"—hit or miss trying, tinkering, sticking things together to see if they work, a kind of non-sequential, assemblagist logic—what Hans Ulrich alludes to as non-linearity.

FV:

But shouldn't we wonder whether when an artist builds up his or her thinking in the painting process is it at all of the same nature as, say, swimming? The latter kind of know-how is very clear, it is bodily knowledge—it is so ancestral to learn how to cope with your body, of not having it as part of consciousness. Maybe the difference of art knowledge lies in the fact that it's less about coping with the world, more this imaginary activity, event?

SM:

To speak of artistic practice as "know-how" is simply a ruse to

kick-start an exploration of why it is not reducible to it. For it's also about conscious invention, creativity that is, paradoxically, destructive/de-constructive. It's like a dissolvent agent sprinkled on prevailing concept structures and conceptualizing—let alone the acidic, eat-away effect it has on the crust of convention, taste, fixed ways of doing and defining art.

FV:

Right. How come it is not possible to theorize it, even for a painter?

SM:

Is the drift of twentieth century visual arts less a know-how than a highly conceptual affair—even during periods of muscular anti-conceptual rhetoric? But what do we mean by "conceptual" in this context? I stop short of lumping artistic endeavor either with know-how or with regular concept-knowledge structures. What's the chink in-between? Non-knowledge? This is not easy to map in terms of broad principles because it resists hard-hat conceptualization.

FV:

Against know-how and against conceptual consciousness?

SM:

Against both. That's why, with non-knowledge one should think beyond the Renaissance painting model. Today, the contemporary setup is a spread of indeterminate practices. We face the prized possibility, to use Adorno, that "anything can count as art even if does not look like art." We can hardly figure what form the art event might take in advance of its making. But from installations, situations outside the museum-gallery circuits through to experimental events and improbable contraptions—we have a range of practices that style themselves as "conceptual." Strictly speaking, they are reducible neither to know-how or dexterity nor to concept-systems.

FV:

No, they cannot be reduced to know-how. But there's no concept category too?

SM:

That's why I prefer to see them as "indeterminate modes," as "non-knowledge." Should we speak here of the "conceptual against itself" or use something like Deleuze's phrase, the "non-conceptual conceptual."

FV:

Non-knowledge is a form of knowledge manifest in actions and inventions like the painter-practitioner's. That's why I feel to think it through as "non-knowledge" might somehow limit our grasp of

its particular quality. Is this not a kind of knowledge better grappled with as *prajna*?

HUO:

In this context, Francisco, can you tell us a little about how dialogues and encounters you might have had with artists or individuals in the field of art might have led you to look at what kind of knowledge or thinking art practice is?

FV:

For me these encounters are a little like Happenings. I run into people like you, then something happens. I don't have a systematic thing about it all. You know what happens when you put a chick into another pen than it has been in normally: there's this feeling of being lost. [*Laughs*] That's how I feel, like a hen out of my pen. I don't really have a story or a theory. What I do know is that artistic imagination somehow cannot be that different from the scientific or the philosophical. Perhaps, in this sense, it's not a form of non-knowledge because it manifests in production, right? Now what would it be? Let's go back to Sanskrit or to a Buddhist term *prajna,* because in Buddhism *avidya* is ignorance in a most basic metaphysical sense, right? *Prajna* is a form of intelligence but a non-conceptual one, it is intelligence without the negation I sense in *avidya.* We all have *prajna*: It's intelligence that happens when you let go of fixated ideas. Basically, that's how it manifests itself; it's the moment when you can just allow yourself to forget, suspend, put into parentheses. If you want, not unlike the idea of the phenomenological reduction. It's to put into suspense, and *poum!*: there is a little light that comes out which is a manifestation of *prajna.* I'm always fascinated by that quality. It is neither know-how, which is too low somehow, nor is it conceptual. There is no term for this in the West. Cognitive science too has none. At best, it's sometimes called "pre-conceptual or pre-linguistic or prenoetic." That's very flattening. It just signals what "comes before" but not what it is.

SM:

For this, I've used the term *"Aconceptual."* For me it mirrors the neutralizing prefix "A" in *Avidya.* It flags up non-knowledge as "non-negation," as switched into neutral gear. Essentially, I am using *Avidya* to signal something close to what you are referring to. This becomes a little clearer if we unpack *prajna.* The word comes from Sanskrit roots *para-gyana.* The prefix "para" is familiar to us in common words such as paraphrase, paranoid. To this is added *gyana* familiar to us in *gnosis,* which gives us the word *knowledge.*

"Para-gyana" means "above, beyond, around" knowledge—not concept-structure knowledge or scholarly learning but the flash of intuition-intelligence. What you speak of from the Buddhist route overlaps with *avidya* as developed in my, slightly wild etymology. But I think both of us are signaling not something anti-conceptual or sub-conceptual or pre-conceptual but rather a mode of consciousness that is "aconceptual."

FV:

Which would be *prajna*.

SM:

Prajna would be the ideal term. But the hint of negation, I retain by perversely using avidya to give it an edge. This has to do with applying it provocatively in the art/culture context. It's to say that if visual art is seen as a demoted, lesser form of knowledge, so O.K. we'll call it "non-knowledge." The provocation is nudged on a little by Duchamp's mind-boggling question, "How to make a work of art that is not a work of art".

FV:

How can you make a work of art that is not art? What a question!

SM:

Not so much a negation, but a non-negation. Perhaps more a *détournement* rather than sheer annulment.

HUO:

There's something I wanted to ask in this relation: This morning you were struck by this remark of the Dalai Lama, which you somehow linked to John Cage. I thought this an interesting moment to connect with this.

SM:

I think it sprang from the book you were glancing through: *Gentle Bridges: Conversations with the Dalai Lama on the Sciences of Mind* [Jeremy W. Hayward and J. Varela 1992]. The distinction crops up between Hindu thinking, Vedanta, and its structural-conceptual twin: Buddhist thinking or *Nyaya-Vaisheshika*. Like two-halves of the same thing. The former has a logocentric drift—it speaks of fullness, presence, self, metaphysical essences. The latter, in counter-terms of emptiness, no-self, non-presence, non-affirmation of ultimate reality. Real mirror images!

FV:

This is your classic Buddhist-Hindu debate, right? [*Laughs*]

SM:

Absolutely! Hans Ulrich triggered thoughts of it. On the one hand, Buddha's skeptical words about defining "ultimate reality": *neti, neti, neti*—"not this, not this, not this"—is by definition negation,

by deferral or by Derrida's *différance avant la lettre*. "Ultimate reality" is *nirvana*; burn out of consciousness, nothingness or *sunyata*. On the other hand, in Vedanta, ultimate reality is defined by affirmation "Tat vam asi," or "Thou art That." The self aspires to become one with *sat-cit-ananda* (absolute fullness of truth-consciousness-bliss). I was saying to Hans Ulrich that I was struck by John Cage's relationship with this mirror tradition. His writings show he was tuned in to these ideas through [L.C.] Beckett. Also through Daitzu Suzuki and Ananda Coomaraswamy. At any rate, Hindu-Buddhist traditions of self/no-self, empty-full consciousness provided him with a non-binary grist to the mill for his approaches to "music." This, at times, seems to be neither silence nor sound, neither noise nor music but indeterminate sonic construction—music/non-music, silence-sound, noise-non-noise?

FV:

It's a work of art but not a work of art! But this guy is something else! He knew all that?

SM:

In his own terms. Formally, through L.C. Beckett's writings, the Coomaraswamys, through Daitzu Suzuki's seminars at Harvard.

HUO:

That's incredibly interesting. As we discussed this morning, it would be great to trace these links between Cage, the Coomaraswamy, Suzuki, Duchamp?

SM:

The East Coast mob!

FV:

Did Duchamp ever point out what he felt was his most successful art that wasn't art? Did he have examples?

SM:

I must say I can't quite imagine him even suggesting one. Perhaps the project he secretly worked on *Étant donnés* (1946–1966) comes close. He was working on it when it was assumed he had stopped doing art. Does it look like he was doing something that wasn't? At the time *Étant donnés* was revealed, I suppose, it didn't quite look like art at all. A strange, strip show peephole through which we see, somewhat brusquely, a full-frontal nude in a landscape with a motorized, moving waterfall. It became a model for what is today taken for granted as installation—a genre that is neither the nude nor landscape, neither painting nor sculpture neither diorama nor film but takes in all elements. *Neti. Neti, Neti?* Maybe now it's very

much of "art"—exactly what he had sought to escape. He was try-
ing to maneuver between practices, between fixated ideas of
art/non-art, knowledge/non-knowledge—the space of *prajna?*

FV:

That's very close to my heart because that's basically your thread of
Ariadne into your own growth in the Buddhist context. The symp-
tom is you see this *prajna* growing or not. Then you can tell whe-
ther you're making any progress, if there is such a thing. Trungpa
always said we all have *prajna*, every human being. But most peo-
ple have "baby *prajna*"—a potential that has to develop. I feel when
somebody is acting from the basis of *prajna* you can see it. There is
a quality to it—intelligent spontaneity. But this can easily degrade
into, you know, "goofy golf," as they say in America.

HUO:

Can you expand a bit on the notion of this kind of spontaneity?

FV:

I feel "intelligent spontaneity" is what you see in the beginnings of
improvisation, the moment when everybody is suspended. You see
Keith Jarrett, all of a sudden, getting into his piano, a moment of
pure passion. But you have to be Keith Jarrett to display it on the
Indian drum. When an individual acts, in my experience, individ-
uals who have highly-developed minds, they often tend to be like
that. It's almost like *prajna*, I feel. It has a smell to it. It stops your
mind—the very first symptom is that it attempts to stop your
mind. It happens a lot in the Dalai Lama's company. He's a very
prajna guy. Brilliant *prajna* guy. When you enter in conversation,
oftentimes you find yourself listening with full intent, so your con-
ceptual mind just stops. His *prajna* has brought up your own *praj-
na*. A mutuality; it's like affection calling out affection that can just
sort of melt you down. You become affectionate. It's similar to
that.

HUO:

So it's a conversation in principle? I mean, that it happens in conversation?

FV:

In conversation, in encounter but it's usually a conversation. It's a
very interesting thing everybody notices with the Dalai Lama. I
took my wife to the meeting with him last March. She isn't par-
ticularly Buddhist though she totally respects it. After two days,
she said to me "I've never been with somebody like that. There is
something very unusual there." And she said exactly like I did,
"My mind stops." [*Laughs*]

HUO:

Could it be accounted for or explained by experiments such as those that you mentioned today? What exactly happens at the moment "the mind stops?" Could you not do an experiment while somebody speaks with the Dalai Lama?

FV:

With the Dalai Lama, it is too hard. That's why I bring people like Mathieu Ricard. But eventually I do want to do that. For it's the kind of person that can get himself in a position where there is no stream of conceptual thinking. Whatever he does is in terms of *prajna*,. This would be not unlike the 3-D perception experiments we spoke of, but maybe that's too flat, too simple, too poor a performance to relate to the experience of "the mind stops." Slowly, slowly we want to get there.

SM:

Are elements of consciousness always only knowable "at one remove"—through some mode of representation, sign-system or medium that has to relay them? Is a sense of immediacy and presence strictly impossible? Are we trapped in the prison-house of language and there is no direct, unmediated access to experience?

FV:

I don't really believe that we are always speaking through representation or living the moment through it. I think the first-person approach, the hands-on, actually doing, exploring mind and what you find through it, shows that the living present has a depth, which is just that. It's not representing anything. Within that living present, we can also have a discourse or a narrative: who you are, what you're doing, whatever. In that sense, of course, linguistically mediated, it has the quality of representation. But I think I have a genetic problem with "representation." The word almost means anything. The content of my experience is not a representation of anything. It's a *presentation*. You might say that language can represent something through its semantic links. That's very much the logician's view. There you have items in language, its about semantic correspondence. That might be fine for logic but human language is inseparably linked to emotions, to the body. Even psychoanalysis is about how language is so totally embedded in the constant going-on of the emergence of mind for us to speak of presentation rather than a representation. But to see all linguistic occurrence, a dialogue or a discussion, as representation, seems to me to be phenomenologically poor. If that is the problem, I really don't see it that way. It seems more true of the tradition of seeing language as a semantic object.

SM:

I'm tussling with the issue but I have no glimmer of an answer, not even a rough one. Leaving aside language as representation, what if we say that whatever emerges has to have a signifying system, a vehicle to articulate it. It sort of "stands in" for the experience and conveys it to the mind.

FV:

That's if it has to stand in for something. Why couldn't it just articulate what it articulates? Suppose you take language as something, with which we couple with the world. It follows there is no representation. It is what it is. We are moving in and with the world. The sign system is good for signifying objects. When it comes to language and interpersonal interactions, what you have is a *coupling* with another person, a dance of co-ordination of action. Language sits in there. Why does it have to stand for something else?

SM:

I suppose, because we normally say that a language has repeatable signs and signifiers of some sort, counters and units that "stand-in" for something—an external delivery system to put across experience. However, you are speaking of language as *coupling* with the world, an interactive system, which is engaging and rather suggestive.

FV:

The repetitiveness and syntaxicity of language should not imply that it has to stand for something else. The syntax I understand; it's the semantic argument I don't get. It does not seem to me to be necessary, unless one has a view of reality that needs knowledge to be some form of semantic mirroring. But what if knowledge is the shaping of your actions in the world? That sense comes from action not from representing anything. Let's put away the syntax. The semantics is a more a pragmatics: meaning is in what it does rather than what it stands for—as you know, a well-developed argument in pragmatic linguistics.

SM:

The level at which language as a system of signs comes in, is that at the level of narration, depiction and description?

FV:

At that level, I have in mind language in all of its glory and power. You can coordinate, you can describe, you can do injunctions, you can be performative. But in none of those do you need the idea that there is a standing in for something. Rather an effective, pragmatic capacity to change, coupling with the other and coordination like when I say, "Let's go."

HUO:

The question that comes to mind in relation to this is: where is the link to systems of coordination and control. I recently re-read Gordon Pask in terms of cybernetics. I mean, how far is this linked to cybernetic theory?

FV:

One link is what Gregory Bateson pleaded for: language as a performative look. His brilliant example is the *double-bind* of the schizophrenic mother and child in language. The mother says, "Don't do this." Yet the phrase can convey quite the opposite in another form of language, body language usually. The *"double-bind"* idea was already there in the early days of cybernetics. Gordon Pask is second generation. He introduced the fundamental notion of language as conversation—what ethno-methodologists like [Harold] Garfinkel and others, took up later. Their point was not to isolate language as a set of sentences you look at printed on the page—but to treat it as a mode of coupling. Therefore, the conversational dimension is essential—to study language is to look at conversations between people. Now Gordon's theory was incomprehensible! But his insight was absolutely right. Have you read his books on conversation theory?

HUO:

No. But I came to it actually via Richard Hamilton and Cedric Price, because there were connections there.

SM:

As Hans Ulrich says, Hamilton and others around the Independent Group in the '50s in Britain had glanced at Norbert Wiener's cybernetics. Two views of language and representation were at play. In Hamilton's Pop Art of the '50s, we see a version of the deconstructionist stance—decoding signs, symbols of contemporary style, fashion, ads, mass culture—the "mythologies of everyday life" as Roland Barthes put it. This is language as semiotic system—a "chain of substitutes" representing/signifying elements and experiences of the world. Alongside, was Wiener's model of systems of communication as transformative processes—language and representation as intrinsic to shaping activity in the world. Is something of this the drift of the "funhouse" that Hamilton, with John MacHale and John Voelcker, put together for the "This is Tomorrow" show (Whitechapel Art Gallery, 1956)? Their "crazy house" was a machine for the production of new feeling, thinking and action—not just a matter of unpacking representation. In this context, Derrida's view—his "origin of geometry" stance of the '50s—seems a drastic throwing into doubt of the notion of "self-

presence" by showing how signifying systems leave us and our experience always at "one remove" Quite a scuffle all round over language and representation.

FV:

I've always had a little puzzle about Derridian *différence* though I have read Derrida only partially and recently more than before. I'm always very impressed: he's so damned smart! I mean, it's unbearable how smart he is. It's embarrassing! [*Laughs*]

SM:

Is that supposedly a remark [Michel] Foucault made of him too?

FV:

They shouldn't let people as intelligent as him walk around like that. [*Laughs*] His stuff on *différence* has something reactive about it—to be a little critical of how he treats "immediacy." In his early, long commentary on the origin of geometry, how can you not agree? He drives the nail all the way through. But having done that, he seems, more recently, to take a more balanced position. Because it's not that immediacy is totally impossible. Rather it's always on the run, you cannot rest on it, it will always pull itself away. That seems to me very different from always falling into a linguistic interpretation. The life of language and meaning can indeed seem to constantly pull you along. You cannot nest in any particular present moment. It's not absolute that *différence* would be the only place where one could be. It's perhaps better to think of *différence* as dynamics of all present moments. That's my reading of Derrida. I'm not so sure he would disagree all that much today with that.

SM:

The tendency has been to whittle down his thinking to saying that he is speaking of either presence or absence when more likely his drift is the *undecidable*. It's becoming more apparent that we have to probe "immediacy and presence" on several fronts. From one position it appears, we can't be here and now, because we are always dispersed into there and then. The elusive sense of "self-presence" has always flitted on. But this way of speaking has pitfalls. It suggests some sort of readymade substance, some entity that is fugitive—uncatchable maybe but an entity no less. As you say, through *différence* perhaps we need to look at temporality. For me this would be duration, the continuous stream of becoming, each moment passing into and becoming its other, a ceaseless production of difference. What net of representation, concept-language, sign-system can ever hope to catch its flow and flux except at a brutally reductive price?

FV:

Therefore, I say the sense of "now" does have a depth to it, which is what gives it sight of "immediacy." This is exactly the where the preconceptual can come in or what you call the *aconceptual.*

SM:

Derrida himself remarks that his "concepts" are not strictly concepts, perhaps more image-ideas? Might he have even used "nonconceptual" to signal this? Generally, he seems to suggest that *aconceptual* devices come closer to capturing any sense of presence-absence. The issue remains that at some level we do feel powerfully an experience of "self-presence," of "being on the spot". But dissecting it through linguistics and logic, its something not easy to sustain in analytical terms.

FV:

There is another way that I'm trying to understand this through Derrida. These are just progress notes. Let's take the question of time. You have the Husserlian account of specious present, retention, protention. However, that stays in a single individual sphere: it's just the individual, the conscious individual at that. But there are the two spheres, which are not of the same nature. One is what I call the philogenetic or preconceptual, which is everything that comes with your entire bodily inheritance—emotional life, conscious and unconscious life that is going to shape that present and move it along, give it a dynamic. The other is inter-subjectiveness, the social, distributed nature of the self that language is going to pull in all senses that it normally does. Husserl's analysis is missing both of those. Somehow it is incomplete, all of the non-conceptual or aconceptual and preconceptual is missing. He only has the conceptual parameter. In that sense, I think Derrida is right. If you reduce things just to the point of measurable language, it's over-simplifying. I think the three levels have to be kept: the philogenetic, the ontogenetic—which is where you are in the "immediacy" and this Derridian de-centeredness of the subject. One day, maybe when I retire, I want to write on the phenomenology of time to put these three together. It's a bit daunting.

HUO:

So far an unrealized project?

FV:

Yes. You see, this is art that isn't art. This is my little box. [*Laughs*]

MANCOBA, Ernest

*Ernest Mancoba was born in Johannesburg, South Africa, in 1904. At the age of 24 Mancoba became the first artist in South Africa to depict the Virgin Mary as black and barefoot (*African Madonna *or* Bantu Madonna, 1929*). As it happened, black Africans thought Mancoba's sculpture fat and ugly, while white critics felt it was too European to be "authentic". Mancoba worked as a sculptor for a number of years, producing ecclesiastical and secular pieces in which he Africanized the prevailing Western norms of iconography and aesthetics. Because he saw no future for a black artist in the white-dominated South African art world of the time, he eventually left the country in 1938 to further his art studies at the École des Arts Décoratifs in Paris. There he befriended the Danish artists who later took part in the CoBrA group. In Europe, his focus gradually shifted from sculpture to painting, drawing, and print-making. In 1942, Mancoba married Sonja Ferlov; they both showed in Copenhagen in 1948 and 1949 and in several of the CoBrA group exhibitions until the demise of the group in 1951. Reflecting on Mancoba's contribution, Elza Miles wrote, "Throughout his career his integrity was impeccable, and he fully understood the responsibility of the artist who upheld the spiritual heritage of the past by expressing himself in the idiom and materials of his lifetime to ensure the survival of humanity." In 1994, after 56 years abroad, Mancoba returned to South Africa to attend the opening of "Sibambene/Hand in Hand," a retrospective exhibition of his art and that of his wife's, at the Johannesburg Art Gallery and the South African National Gallery in Cape Town. In 1997, Mancoba received a Pollock-Krasner Foundation grant. His work was featured in the exhibition "The Short Century: Independence and Liberation Movements in Africa, 1945–1994," which opened at the Museum Villa Stuck Munich in 2001, and traveled to Berlin, New York, and Chicago. He died in Paris in November 2002.*

..........................

This interview took place in Paris in March 2002.

Hans Ulrich Obrist:

Let's begin with the beginnings. How did you become an artist in South Africa in the early years of the twentieth century?

Ernest Mancoba:

I was born a black miner's son in 1904 in Turffontein, along the goldfields of the Reef near Johannesburg. My mother influenced very much what I later became, even though she was not an artist herself. But she went out at times with other women of her age group, as was the custom, to make (with clay, in a collective oven built with branches of wood) the earthenware pots which we used at home. I remember that she told me about the origins of my clan

among the Fingo people. They were originally Zulus who had emigrated, under persecution for opposing the military conquest of other tribes by King Shaka, in a way that they estimated contrary to the African tradition of democratic kingship. So they though it might have been justified to unite our nations against the colonial invasion. So they had taken refuge among the Xhosas—fingo means "wanderer." She taught me Ubuntu, the African "philosophy" of human brotherhood, and she was at the same time a fervent Christian. She also used to read us poetry aloud, African poetry from an old book wrapped in a piece of cloth, and she explained the importance of poetry, especially the notion of expressing the "unspeakable."

HUO:

What were your first works like?

EM:

I had never received any formal art training as such. During my school years, my vocation started at Grace-Dieu, the Anglican Teacher's Training College, near Pietersburg, where I learnt the technique of sculpting in wood from a nun, Sister Pauline. I made altar fronts and such pieces of church furniture. I became a teacher thereafter. But by then I already knew that I wanted to become, one day, a full-time artist. At that moment, what as I was doing was mainly woodcarving that was both inspired by and struggling with the European style, trying to make it my own. One of my religious carvings even got a fine reception, *Bantu Madonna* (1929), for which an African girl, one of my fellow-students, had posed. It didn't interrupt my studies though, and after Pietersburg I went to the University of Fort-Hare, at Alice, a little town in the Eastern Cape. Fort Hare had only just received university status; before that it had been known as the South African Native College. Religion and a certain form of humanism were at the heart of the institution; it was a tradition shared by the "black elite" (as they were expected to become) and by the white liberals, many of whom belonged to the clergy. Unlike the Bantu education later implemented in South Africa from the '50s, Fort Hare was not based on the assumption that black Africans require and deserve a different, inferior kind of education.

HUO:

The history of the African intelligentsia is inextricably linked to the University of Fort Hare...

EM:

Absolutely. It's in Fort Hare that political activists like Nelson
Mandela, my friends Govan Mbeki, Isaac [Bangani] Tabata and
Jane Gool, or poets like Dennis Brutus or, later on, Can Themba,
the *Drum* journalist, receive their higher education.

HUO:

Were there a lot of students training in art in Fort Hare?

EM:

In Fort Hare I did not study art—there was no such thing. My sub-
jects were English, history, mathematics, psychology and biology.
And like many black students then, I was also thinking about
becoming a journalist.

HUO:

*Did you have "dialogues" about art and the role of art in South Africa
there nevertheless?*

EM:

When I was in Pietersburg I became friendly with Gerard Sekoto,
who later became an important painter, and Thomas Masekela who,
though he was to dedicate his later life to an organization of hospi-
tals for our people, worked privately with sculpture; we had a con-
stant dialogue. And also, together with other African students and
young teachers like Nimrod Ndebele, another close friend, we
organized theatrical representations at the school and discussed the
future of the arts in South Africa. At Fort Hare, where I was head of
the debating society, we rarely spoke about art as such. When I
came to Cape Town (on a cargo ship from Port Elizabeth), the most
intense conversations that I had on the subject were probably the
ones with Lippy Lipschitz, whom I often visited in his studio, while
I had mine in "District Six," the ghetto for Colored people. Lippy
was a sculptor who had emigrated from Eastern Europe. He intro-
duced me to another South African sculptor, also of European ori-
gin, Elza Dziomba, whose studio in Johannesburg I entered by the
backdoor, pretending to be the service boy—as it was situated in an
area for "whites only." It was also Lipschitz who told me about the
growing interest in Europe for African art and about the influence
it had had at the beginning of the twentieth century. Paul Guil-
laume's book *Primitive Negro Sculpture* (*La sculpture nègre primitive*,
with Thomas Munro, 1929) was at the heart of those discussions. I
remember that on Lippy's advice I had gone to the National Library
in Cape Town to read that very book. People there could hardly

understand it, that a black man could have had anything to do in the place, and, even less, that he should have been asking for such a recently known trench author. But I argued and finally had the possibility to sit down and read the book, which they kindly brought me. While absorbing what I found in it, which astonished me very much, I began to think about how enriching it would be to have an exchange of ideas with such an open mind, who spoke with such deep respect about the expression of Africans—when I wasn't even considered as a full human being in my own country.

HUO:

So you decided to leave South Africa. It was 1938. How did you decide that it was time to leave? Did you see Paris as a place of freedom, both politically and artistically?

EM:

The first reason for my leaving South Africa was probably when I understood that I would not be able to become either a citizen or an artist in the land of my fathers, especially after a meeting I had with the Commissioner for Native Affairs in Pretoria, who, after seeing some of my works reproduced in a newspaper (*The Star*, I think it was), had decided that I should take part in the upcoming [British] "Empire Exhibition" (Johannesburg, 1936). The idea was, at first, to show visitors the production of folkloric art by natives, and, secondly, to develop a whole indigenous art trade by selling all sorts of pseudo-tribal figures for tourists. He offered me a good job with a fine salary, to gather young Africans to provide for this kind of traffic. I was shocked and, as politely as possible, refused the proposition. In my daily life I felt more and more humiliated at the conditions made to my people; and I had a growing difficulty in containing myself on certain occasions. Thus, I soon understood I would never be able to feel free enough, in my mind, to express myself as fully as I wished, but would always knock the head against the barriers which the colonial order had set up in my country, wherever I went.

HUO:

And at the time, Apartheid wasn't even instituted as a wholly legal coercive system?

EM:

It came only after the Second World War, but it had, indeed, existed ever since the European colonists decided, with full support of the metropolis, to exploit the black Africans in a system of near slavery for the purely economic reason of gold and diamonds. I felt

I had no time to lose with the petty vexations, the daily wrongs that the indigenous man had to put up with. Moreover, there was, basically, at the time, no public to receive what I had to express, in the colonial society where I was normally destined to spend the rest of my days. Several of my works have disappeared, probably because those who got them in hand at the time did not consider them worth preserving. Even some of my political friends told me that the artistic activity was not the most urgent thing to concentrate upon while our people were undergoing such a terrible plight. But I believed, on the contrary, that art was precisely also a means to favor a greater consciousness in Man, which, for me, is part of the struggle for any human liberation, and without which any practical achievement would probably, sooner or later, deviate and miss its point. Therefore, making art, I thought, was as urgent as working for the political evolution which, at the time, anyhow seemed still a faraway prospect. So I decided to engage upon a debate with European artists, by coming to Europe.

HUO:

But could you leave just like that?

EM:

As I had absolutely no means to travel, I had the good fortune to be helped by missionary institutions, and when I arrived in London I lived by Bishop Smythe, whom I had known as the head of my student hostel at Fort Hare. I naturally visited the British Museum, the National Gallery, and other institutions of art. But my goal was Paris, for all that this city represented as a center of artistic concern and responsibility: unique in the world, as I had been told by the artists who had emigrated from Europe. During these years you could come and, almost from one day to the next, enter into a universal debate about the political, cultural and spiritual destiny of mankind. Even if you did not join any group, and might at times feel isolated as an artist—indeed many have died there, in loneliness and poverty—you at least were given the minimum respect to breathe as an individual, and had the full freedom to create in a town that was open to the winds of the world.

In South Africa I had not been able to find anyone to discuss the work, apart from a traditional carver from the noble tribe, one or two schoolfellows, and the few immigrant artists I have mentioned, who themselves encouraged me to go to Europe. Moreover, certain words of my mother were ringing in my head. When I was a little

boy, I had wept because I, on certain occasions, missed having some-
one to play with, so I asked her for a brother, as she, at the time,
only had given me sisters. But she answered: "Do not weep, Ernest.
Your brothers—you'll find them in the greater world." So now I was
going away to try to find them in my fellow artists.

HUO:

And it happened when you arrived in Paris?

EM:

I took the ship from Cape Town. When I arrived in London I
remember that, out of solidarity, I had dressed up as a worker with
a cap, but when I crossed certain poor areas, children stared and
soon followed me through the streets, singing "Nigger, Nigger go
to hell. English, English ring the bell!" But already I had decided
not to stay, for Paris had always been the destination. Through
Bishop Smythe's connections in Paris, I got into the École des Arts
Décoratifs, rue d'Ulm. In fact, the students and the staff there had
been told that an Englishman from London would arrive the fol-
lowing day. So they were not a little astonished when they saw me!

HUO:

*Was it at the École des Arts Décoratifs that you met the group of Danish
artists with whom you worked closely afterwards?*

EM:

Yes, at the art school I met Christian Poulsen. He was studying
sculpture at the time, but later became a famous ceramist. He told
me he was in connection with a group of young Danish Surrealists.
He invited me to follow him to one of these, at the latter's studio.
Thus, I first met Ejler Bille, who was very interested in African art,
as were all the other members of the group. So he told me that I
would surely be glad to speak with one of his comrades. It was a
woman, who also had been a member of the "Linien" group,
together with Richard Mortensen and others. That is how I saw, for
the first time, Sonja Ferlov, who was to become my lifetime com-
rade and spouse. She came from a bourgeois family in Copenhagen.
And she happened to have been very familiar with African expres-
sion from early childhood, because her parents had a friend who was
the greatest collector and connoisseur of African art, Carl Kjers-
meier. So, as a little girl, instead of dolls, she had been sitting with
African masks and sculptures on her knees. This had developed in
her an intimacy with, and a feeling for African sculpture—but also
for Oceanic and Mexican expression as well—that was unique.
Thus, I know not which kind of destiny had brought me into the

presence of the ideal person, and the right group of artists, for a fruitful dialogue and collaboration. They were very interested to know more about the continent that had produced the objects they so admired. Only a few, though, wished to hear more about the actual conditions of the people in South Africa. But they appreciated my work, so I got more and more integrated to the group, and I could have many conversations with them, especially about the creations we had seen in the studios, the galleries, and the museums we visited regularly.

HUO:

You arrived in Paris only a few years after two other famous immigrants had arrived, one from Martinique, who was Aimé Césaire, the other from Dakar, Leopold Sédar Senghor. It was the beginning of "négritude." Did you meet them then?

EM:

In fact, strangely enough, I could well have met them, because the School of Decorative Arts was situated on the rue d'Ulm, in the same street as Césaire's school, l'École Normale Supérieure. But the occasion was not given to me of an encounter with these two great personalities. Césaire and Senghor both belonged to the French-speaking colonies or territories and were part of other circles than I was. Personally, it took me some time to learn the language, while the Danes spoke almost fluent English, which made it easier for me. I suppose I would have managed to understand Césaire and Senghor. But we might have had some disagreements also because the problem with their approach was that I never believed, for my part, that the racist ideology of the Occident is a problem of defective reason or insufficient comprehension. And I do not think, therefore, that it can be treated by forming new ideological concepts, like "*négritude*," any more than I would imagine that the humanity of the white man might rely upon any virtual concept of "*blanchitude*." For you will never prove or disprove the truth of our common humanity, any more than a child needs material evidence to instinctively know that his mother is his mother. No scientific or moral demonstration, no genetic test, nor any ethical imperative will ever add to this simple recognition, identification, and love. I made a sculpture on this fundamental relationship between mother and child (*Faith*, 1936).

HUO:

But "négritude" was part of an anti-colonial struggle strategy…

EM:

Indeed, but I do not believe that we Africans, any more than other people, should need (as it would not diminish racism a jot) to show the white man how good we are at speaking or writing his language, performing in his sports, learning his customs, manners and intellectual actions or developing ourselves along the lines of his so-called "universality," to be considered as human beings and his equals. Because the true universality is a common goal on the cultural, political, and spiritual horizon, that will be reached only when all ethnic groups achieve, through an authentic dialogue, the many-faceted diamond shape and the full blossom of the deepest and widest human integrity.

I hold Aimé Cesaire's oeuvre as vital, though, particularly in that he was the first in the West Indies to insist on the fact that black people, there or elsewhere, must reject the prejudice which the colonial masters have engrained into them about their African origins being something to be ashamed of. I, for my part, have only relied throughout my life on two ideas—one, from the deepest heart of Africa, which constitutes the basis of *ubuntu*: "Man is man by and because of other men," and the other, the precept of Christ: "Do unto others as you would have done unto you." I do not bother with anything else.

HUO:

Who were the artists that you met in Paris that you consider to have been influential?

EM:

So I met the Danish Surrealist group, that is, among others, Richard Mortensen, Egill Jacobsen, and particularly, also as I have said, Ejler Bille. At my studio on rue Daguerre, my neighbor was Henri Goetz, an American artist. Bille's neighbor was a German Expressionist painter, Erwin Grauman, who remained a good companion to us until his death, and by the intermediary of whom I met German anti-Nazi artists and, in particular, befriended Hans Hartung. In 1938 I also became friends with Alberto Giacometti. It was on his proposition (to help me live closer to Sonja, who had her studio next door on rue du Moulin Vert), that I even left my atelier in rue Daguerre for a little room on top of his atelier on the rue Hippolyte-Maindron. In fact, apart from his brother, Diego, I can say I remained for nine years (interrupted by my four-year internment during World War II) his nearest neighbor. We caught sight of each other practically every day, spoke from time to time,

and were always ready to give a hand for mutual support if need be. Sonja knew that she could always count on Alberto when we had a difficulty or were, as happened once or twice, economically in a fix. He also gave Sonja some good advice on working with plaster. But it was, above all, his unique personality that brought us one of the richest experiences in our life.

HUO:

Later you left for Denmark and took part in the CoBrA group. Could you tell me about your meetings with the other members of this group, such as Constant and Asger Jorn?

EM:

In Denmark we were members of the Höst group, and later the CoBrA group in the years 1948–1950, together with, among many others, Asger Jorn, Carl Henning Pedersen, Heerup, Erik Thommesen, Egili Jakobsen, and our Dutch comrades Karel Appel, Constant, and Corneille. But Sonja and I worked rather isolated in a little village, going to Copenhagen only for meetings with our Höst or CoBrA friends. As there came some misunderstandings in the group, we soon left the country. I felt a certain form of silent opposition to Sonja and me that hardly manifested itself openly, but, for instance, invitations to take part in exhibitions of the group inexplicably never reached us. I think that there was a certain irritation towards Sonja for repeatedly insisting on the movement, and also taking into account the plight of people still colonized by Europe. Though most of the founding members of CoBrA agreed with us—Jorn wrote a letter to us, just after the movement ended, expressing his solidarity with our attitude and his understanding for our reasons to go away—it seems that the time was not yet to come, in 1950, for the question to be clearly posed. The embarrassment that my presence caused—to the point of making me, in their eyes, some sort of "Invisible Man" or merely the consort of a European woman artist—was understandable, as before me there had never been, to my knowledge, any black man taking part in the visuals arts "avant-garde" of the Western world. Of course, Wifredo Lam showed his work along with the Surrealists in Paris, but he was a Creole, from an independent country, Cuba. Personally, coming from a colony where people were segregated by the law, but was still vital economically for Europe, my status was unclear. And probably it was also our very conception of mankind and of art that not only contributed to our isolation from some in the group, but that invalidated us in the appreciation of

the official art world, especially later, in the eyes and the evaluation of certain critics and art historians. Some critics totally obliterate my participation in the movement, as modest as it admittedly has been, on the reason that my work was suspected of not being European enough, and in his words, "betraying (my) African origins."

HUO:

I'm interested in knowing what kind of relationship you maintained with Africa in those years.

EM:

In those days, I also met regularly with my friend Gerard Sekoto, who had fled South Africa for Paris after the war. We discussed the news from home. And as he was at the time more in contact with other artists and intellectuals of the Parisian or English scene than myself, he kept me informed. I also had a few meetings at the library Présence Africaine with Alioune Diop. And from the '50s to the early '60s, I was a regular, or rather irregular, correspondent of the magazine *Le Musée Vivant*, which was at the time the only French publication genuinely interested, at least at the beginning, in giving the word from time to time to African intellectuals and artists. I had a rich dialogue for many years with Madeleine Rousseau, its editor, who, it must be said, with unbelievable courage—given the colonial context—faced the confrontation with the Other. She offered a possibility of expression and a platform for dialogue to people from the so-called "Third World" at a difficult time, until the political pressure became too intense because the struggles for independence had begun.

HUO:

Can you tell me about the oscillation between figuration and abstraction in your work?

EM:

In my painting, it is difficult to say whether the central form is figurative or abstract. But that does not bother me. What I am concerned with is whether the form can bring to life and transmit, with the strongest effect and by the lightest means possible, the being, which has been in me and aspires to expression—in the stuff or any material that is at hand. Our history has brought about, little by little, this dichotomy between abstraction and figuration, which provokes, more and more, a terrible atomization in the very essence of life. In no domain more than in the arts has this systematic dichotomy caused such destruction of the very foundation to the human identity, as both belonging to nature and sharing in the essence of an ideal being. Certain artists in Europe have too often been under

the dictatorship of philosophy, or what is known under that name—which denomination, by the way, has always been puzzling to me, because that area of learning has, for a long time, been used not so much to put in practice any love of wisdom, as its name would imply, but rather for trying to fit our conception of man into the social structures offered by history at any given time. Moreover, certain philosophers in Europe have had a more or less hidden aim to get rid of art altogether—for supposedly belonging to some outdated form of humanity—or to replace it by some purely intellectual ersatz that would help discipline and control the inspired freedom of poetry, a concern shared by the political authority: this, as far as I can understand, was the main motivation behind the foundation of the Academy. Hence we have lost the capacity to unite in our vision the outward aspect with the inner significance. Because our eye has been mis-educated, so to speak, by the superficiality of academicism, which can only estimate the worth of any representation of man according to the abidance by the purely esthetic rules it has established—as, for example, the one decreeing that the human head must come eight times (or seven, I have forgotten) into the full length of the body. So when they see an African sculpture with, for example, an enormous head and short legs, they will consider it ugly and judge it "worthless." But for the African artist it is not so much the abidance by certain rules (though he, too, generally works according to particular canons) that makes a thing beautiful, but its capacity to evoke the inner being by the strength of the outward aspect. To that effect, he uses all means, both figurative and abstract. When, in my younger days I made the *Bantu Madonna*, I worked along certain European or classical canons which some believers in the conception of "progress" in art will judge outdated. In the *Madonna* I followed a certain canon that was in contradiction with the newest Cubist or abstract ways and forms (which I, at the time, hardly knew) but without ever stopping my struggle with a style that was foreign to me. And the viewer, I hope, if I am lucky enough to have been understood and heard, can feel under the surface of the classical mould an African heart beat. In time, the inner spirit breaks through, first in the very innovation within the South African context, of taking a black woman to represent the Virgin Mary, and secondly in the warmth of the pulse that, though provisionally contained by the strictness of the style, speaks up under the skin or surface and threatens to burst free.

HUO:

In 1962 you wrote, "For the object of African art is not to please the eye or the senses but to use art as a means, as a language to express feelings and ideas in relation to the present, the future, and the past, to discover new concepts by which to regard the world for the salvation of man."

EM:

Yes, I remember when I wrote these lines. In fact, I would not change a word today. I think that this definition is still valid and could apply to the way I personally see my vocation as an artist even in the world to which I still belong, at this beginning of the twenty-first century. In my opinion, a certain evolution of art in the second part of the twentieth century has been influenced by the misunderstanding around Duchamp. Duchamp never pretended that exhibiting a manufactured product was, in itself, art. But the world, the so-called art world, has always made as if he had. In fact, as he himself insisted, his readymade—bought at the supermarket and put upon a pedestal—is only a challenge thrown at the face of the Academy and its spiritually empty canons. However, the misunderstanding became the accepted interpretation of this artist because it fitted into the aims of a certain established nihilism which, under the fastidious form of an objective aestheticism, in turn came to constitute a sort of new academism. Hence the development among many creators of a more or less imposed or self-imposed notion of non-art considered as art, which had the advantage of getting rid of the problem posed in a materialistic society by the invisible and by the enduring power of the universal mask, before or without ever facing the question: "What is art?"

I believe that one cannot answer this question as long as one has the false idea that humanity can be pigeonholed into different categories. That is why, for instance, I could never be considered as an artist in the South Africa of the early '30s, where the commissioner for the native affairs wished me to make what the colonial authority called "native art." There was a time when, also in Europe, even among apparently progressive people or certain modern artists, the notion existed that there was an art for the "savages," which was only fit for them and could never be appreciated seriously by modern humanity. Bertolt Brecht spoke of "children of science." One day, at the end of '50s, I met a well-known modern painter of the so-called Hard Edge group. When he saw me together with Sonja Ferlov, addressing both of us he said: "Ah, it is you who like the art of the negroes. They are too full of sensuality, always making sculp-

tures with a big sex, while we modern artists of Europe have left behind these primitive obsessions. Here it is all geometry, purity of lines, and clarity of the intellect." When I tried to tell him that there also was geometry in African art, he shook his head and went away. For me, art can only be founded on the single notion—of which it is both the confirmation and the proof—that Man is One. That is why an expression from a most foreign culture (let's say New Guinea, or the Mexico of the Aztecs)—and even without my having any knowledge of the particular customs and rites that gave birth to it—may touch me to the core, and sometimes infinitely more than some from my own cultural background and times. And this does not make me a Primitivist in any way. Only, the first condition for entering the world of the spiritual expression we call art is to be open to the Other, even to the ultimate Other, whoever he be, with the knowledge so well condensed by Arthur Rimbaud in his famous phrase: "Je est un autre" [I is somebody else]. It is still today shocking to many, that he, the "Gaul with blue eyes," as he called himself, should at times during his years of poetry have seen himself as "un nègre" ["a negroe"]. But it is upon this very awareness that he founded the meaning of any true modernity. Our present times, though, have completely misunderstood the notion, because when we hear Rimbaud's message: "Il faut être absolument moderne," ["one must be absolutely modern"] we think it is about driving the fastest car, surrounded with all the paraphernalia of the very latest technology, when what is meant thereby is much deeper and more radically subversive to all upon which we have based our society and our conceptions—even that of "modernity." That is why the fact of seeing creations from the farthest elsewhere may help us to break free from our prejudices and our formalistic or ethnic enclosures.

I remember how my friend Gerard Sekoto, in our younger days, was fascinated when I showed him reproductions of pictures by Van Gogh, and how touched he was—to the point of being inspired by it in his own work—when I told him the story of this Dutch painter's life, while we stood in the middle of the bush, near a distant country village in a tribal zone of the northern Transvaal.

HUO:

Like Asger Jorn you have been very interested in the Folk Art from Greenland.

EM:

Asger Jorn had participated, with other Surrealists, in the reappraisal and enthusiastic appreciation of ancient African art. When

the Second World War broke out, he could no longer travel but stayed in Denmark, where he could not see so many works from Africa and Oceania. So it dawned upon him that in the North, too, they possessed an original, primitive, pre-Christian art, which had previously been neglected or misrepresented: that of the Vikings, and also, in Greenland, that of the Eskimo people who had lived for so long out of reach of the influences of modern history. Together with Asger, all the members of CoBrA were touched by the strength, simplicity, and boldness of this expression. Sonja Ferlov was also fascinated by the reports of the great polar explorer Knud Rasmussen, who had lived for a long time among the Eskimos and had described abundantly their culture and customs. I was influenced by the art of the Eskimos, essentially in its economy of means and its capacity to treat just the essential in a harsh and difficult environment of nature.

HUO:

Can you think of any unrealized project of yours, a project that you have dreamt about but could not fulfill?

EM:

Yes, but I am not thinking about an artistic one. For me, what is still not realized is a common acceptance and understanding between whites and blacks (as the most contrasted opposition in terms of color, but between other races as well). The dialogue has not started yet. It reminds me of a passage in one of the books of the Danish writer Karen Blixen's where she says that if the encounter or the meeting between blacks and whites has happened historically; it has, in fact, not yet taken place.

MATTA, Roberto

Roberto Matta was born Roberto Matta Echaurren in Santiago, Chile, in 1911. Matta attended the French Sacré Coeur Jesuit College, Santiago, and was educated as an architect and interior designer at the Catholic University of Santiago, from 1929–31. In 1933, he became a merchant marine, which enabled him to leave Chile and travel to Europe. From 1933–34 he worked in Paris as a draftsman in Le Corbusier's office. Through his acquaintance with Federico García Lorca and Salvador Dalí, Matta met André Breton and became involved with the Surrealists, officially joining the movement in 1937, and exhibiting his drawings alongside the Surrealist paintings in the "Surrealist International Exhibition" held at the Galerie George Wildenstein in Paris in 1938. From 1936 to 1939 Matta worked successively with Walter Gropius and László Moholy-Nagy in London; with the architects of the Spanish Republican pavilion at the Paris International Exhibition (1937); in Russia on housing design projects; and he met Alvar Aalto and wrote on architecture in the Surrealist review Minotaure. The year 1938 marks the evolution of Matta's work from drawing to painting. Since his early "Psychological Morphologies"—which he later called "Inscapes" (internal landscapes)—Matta has demonstrated an outstanding inventiveness in his depictions of the origins of the cosmos and the confines of the universe with a surprising array of images that reference space—through the concept of an open cube that generates multiple perspectives. The outbreak of war in 1939 drove Matta into exile in New York, where he associated with other Surrealist émigrés including Max Ernst, Yves Tanguy, André Masson, and Breton. During the 40s, Matta's painting anticipated many innovations of the Abstract Expressionists and influenced artists such as Arshile Gorky and Robert Motherwell. He broke with the Surrealists in 1948 and returned to Europe. He lived in Paris and in Tarquinia, Italy where he died in 2002. Major retrospectives of his work have been presented at at the Museum of Modern Art, New York, in 1957; the Stedelijk Museum, Amsterdam, in 1964; the Nationalgalerie, Berlin, in 1970, and the Centre National d'Art et de Culture Georges Pompidou/Musée National d'Art Moderne, Paris, in 1985.

........................

This interview, which was recorded together with composer Ramuntcho Matta, took place in Matta's studio in Paris in March 2001.

Hans Ulrich Obrist:

To begin with, I would like you to talk about chance.

Roberto Matta:

That is an excellent idea because I am very interested in chance. For me, it is the best of things. It is a game between series. Chance rolls on and never stops. It's like the random button on a CD player. The numbers continually roll over and do not stop. It is as if they are caught in a sphere. They turn and turn and then stop by chance on

a track. We are like these numbers. We are rocked and bombarded from above and below, from right and left. We are a target, and bombarded from all sides. This is the administration of chance, a serial chance. Chance plays a very important role in my conception of architecture, for example.

HUO:

Is this something you discussed with Buckminster Fuller? How did you and Fuller meet? You met him in New York in the '40s, no?

RM:

In 1939. He was a very unusual person, rather delirious. I was very naïve and very young. Sometimes he came to talk to me at three o'clock in the morning about an idea he had just had. He was incredible and very funny.

HUO:

Buckminster Fuller and Alexander Dorner, the director of the Provinzial-museum in Hannover, met when Dorner emigrated, like you, to the U.S. in the late '30s. They had the project to construct a museum of the future. Did he tell you about it?

RM:

Fuller was interested in spaces like these [*draws*]. But I, on the contrary, was interested in entering into these spaces [*draws*]—spaces that had to do with forms drawn from non-Euclidean geometry. These structures do not rely on the sense of space as we know it. It is a space without limits and which transforms itself in time—a mutant space. It is the same thing with a representation of a fly's eye, or rather, the way in which a fly sees us. The fly has a very complex eye. What it sees certainly does not resemble what we see. We are transformed in the fly's vision. It is not a photo. And in the eye of the rhinoceros, in the eye of the serpent or in the eye of the squirrel, we are, no doubt, also different. We do not know this but it interests me to imagine it.

HUO:

How was it working for Le Corbusier at his office on rue de Sèvres?

RM:

I went mad in Corbu's studio. We didn't have any work to do! There were three of us: an Austrian, a Japanese, and me. The office was run by his cousin, [Pierre] Jeanneret, who was loaned by the Jesuit monastery. We had no work and we were not paid, obviously. Since there was nothing to do, I produced the mad architectural propositions that are represented in these drawings. [*Gestures*]

The others, they continued to do what they have always done. *[Laughs]* What was good in the long run is that all of this has remained more or less hidden. If I had become fashionable or fallen into the media, I would have continued working on these things forever. But since there was a silence about my work, I have never stopped working. I have worked a great deal. You cannot imagine it. As you see, there are rolls of unfinished things all over here. Sometimes, I find things, propositions about space, and I ask myself, "Ah, what was that?"

HUO:

What are the projects that you are currently working on?

RM:

You know, I do not really want to speak about them. They will come. And people will understand that a revolution in geometry has already happened, a hundred years ago or so. But nevertheless, artists continue to work always in the same manner, working on their small arrangement taken from Euclid.

HUO:

I know at least about your CD-ROM project.

RM:

Yes, this project is based on the question, "How do you make your own father?" Its goal is to create a base of inspiration that anyone can appropriate and transmit in turn, according to the principal of relay. I will give you an example: at the moment of the Pinochet affair, I made some drawings that I showed to a poet, Rafael Alberti, who in turn spent a whole night writing on the drawings. He managed to produce something of his own thanks to these drawings. He did not passively contemplate them and say, "Ah, that is beautiful." This is how art should be.

HUO:

It should trigger other works of art like in a chain reaction? So this is why the CD-ROM format is interesting; it's because it respects and authorizes the non-linear, the rhizomatic. This is something that appears also in your architectural drawings: they depict multi-dimensional and non-linear cities. I'm struck by how these drawings are a premonition of things that appeared in the fields of urbanism and city planning in the '50s and the '60s. Could you tell me more about the utopian architectural projects that you developed at the time?

RM:

I developed the project when I was a student at the catholic university with the Jesuits. At that time, in Geneva, there was the League of Nations, and I had this project which was a sort of

League of Religions. All the religions, all the theologies, all the interpretations of the question "Why is man on earth?" would be united in order to find out who was "more right than the other." I was 19 or 20 years old, and I had this idea to make the delegations of all of the world religions converge towards the same point. Of course, I did not know all of the religions, but I wanted to construct a common temple so that they would enter into discussion. There was a residence for each delegation. It was therefore an architectural project. I called them "aerodynamic architectures." You know, that at the time we had started to talk about aerodynamic cars. I drew models of cars after racing cars of the period. Later I said that everyone would have a car like that—aerodynamic. Everyone said, "But you are mad, that will never happen."

HUO:

Very often you refer to the trenches of World War I to describe our contemporary world. I was wondering whether you could develop this analogy a little. Do you envision modern cities as trench warfare?

RM:

Yes. First of all, because cities are constructed in the countryside. This is also more or less, what Le Corbusier thought. Only Corbu was unlucky and they transformed his housing units into barracks. And he had completely different ideas: he said, "We must give back the earth to pedestrians." Cars and the rest—he did not really know where to put them. His answer: "At any rate, not in the streets." As far as architecture is concerned, I think that it should rest on the ideas of Einstein and the new geometry. Man is constantly changing, and everyone should understand that others change as we change. So, there should be no edifices, no possessions—there should only be the ephemeral. It is like football.

HUO:

Like football? What do you mean?

RM:

What I mean is that when you play football, you win a match but that does not mean you have won for all of your life. Next time, you might lose. But we have difficulty understanding that. We tend to believe that once we have obtained something, it is ours forever.

HUO:

Have you put your architectural ideas into writing?

RM:

All that I havethought has been transmitted by oral means. And everyone interprets differently the things that I say. Nothing is

fixed on paper. It is better like that. To act as creator, to look for comparisons between things in order to capture them, is to invent. Otherwise it is recitation. You repeat what others have said. It is not what I have said that is important, it is the way that you heard it, that you understood it, and the way that you will, starting from that point, move forward with your own work. The problem in France is that there is a culture, a civilization almost, of recitation and repetition. There are many gleaners. Do you know what a gleaner is? They are very poor people who come after the market is over and who pick up rotten tomatoes, broken eggs and things that are left lying about, and afterwards do what they can with them. The artists of The School of New York were gleaners. They took what was left from the '20s and '30s—a little Man Ray, a little Max Ernst—and with that they made Warhol. The only ones who count are those who create something, those who propose non-Euclidean geometry: Einstein. It is these people who do things that are the important ones. But nobody does that. To do that would be to change things a little. But when you take a little Man Ray and then take a photo of Marilyn Monroe, you are nothing but a gleaner. It is the philosophy of "pick-up and go" that was commonly adopted after the '20s and '30s.

HUO:

"To resist" has always been your motto. How would you define "resistance"?

RM:

To "resist" is to be a poet and to live an uninterrupted metaphor. That means doing and saying something else all of the time. [*Laughs*] Resistance is in each of us. We resist by exercising our creativity. That is true poetry—when we seek new comparisons, other ways of looking and conceiving of things.

HUO:

You have been in constant dialogue with poets and philosophers. I'm thinking here, for instance, about your relationship with Édouard Glissant in the '50s—who often expressed how influential your paintings have been on the development of his theory of the "chaos world"—and of course Gilles Deleuze and Félix Guattari.

RM:

I only knew Deleuze a little. But I knew Félix very well. Since the beginning, I have spoken about psychological morphologies. For a long time I have stressed and worked around the idea that geometry is not in the psychology of everyone. They read, as it is possible for them to read, by projecting their own images. They read with

their own images and not with the ones that were imposing them-
selves on the mind of the author while he was writing. I have a nice
example: Slaves and the Church say that the woman is a flower. But
she is not a flower because each woman has an erotic dream. Even
the Virgin Mary had an erotic dream, which called the Holy Spir-
it and had finished by having his child. [*Laughs*] It is true. And
thus, every one has his or her own erotic dream. But what do we
know? We can only imagine what the dreams of others are by look-
ing at our own.

HUO:

*But somehow, I've always believed that Deleuze and Guattari, while writ-
ing Mille Plateaux (A* Thousand Plateaus. Capitalism and Schizo-
phrenia 2, *1980) were greatly inspired by your paintings, or by what they
thought your paintings might be if you'd rather put it this way. This is some-
thing that Eric Alliez also suggested when he chose one of your paintings for
the cover of his book on Deleuze (Gilles* Deleuze: une vie philosophique,
1998).

RM:

You think so? I've seen Félix a lot, but he never told me that, even
though we had a true dialogue together. I saw Deleuze very little;
he was always sick.

MEIRELES, Cildo

Cildo Meireles was born in 1948 in Rio de Janeiro, Brazil, where he currently lives and works. Meireles was raised in the capital city of Brasilia, and later studied at the Escola Nacional de Belas Artes and the Escola do Museu de Arte Moderna, Rio de Janeiro. Beginning with his first museum exhibition in 1967, Meireles aligned himself with the preceding generation of Brazilian Neo-Concre artists, Lygia Clark, Hélio Oiticica, and Lygia Pape, rejecting the passive nature of most art exhibited in museums in favor of creating participatory works and, in the process, forging a form of Conceptual Art that responded directly to the cultural conditions in Brazil. In a group of works made in 1970, Inserções em Circuitos Ideologicos *{Insertions into Ideological Circuits}, Meireles clandestinely intervened in the circulation of local currency and Coca-Cola bottles, placing subversive messages, such as "Yankee Go Home," in white transfer decals on the body of the bottles that subsequently passed through unknown numbers of hands. Responding to overt political pressure, including the cancellation of exhibitions, Meireles, like Oiticica, left Brazil and moved to New York City, where he lived from 1971 to 1973. Since his return to Brazil in 1973, Meireles has developed a vast and eclectic body of work including room-size installations, sculptures, and drawings. His conceptually-oriented, measured, tactile, sometimes labyrinthine installations, environments, and objects have been featured in numerous solo museum exhibitions, at institutions including the Museu de Art Moderna, Rio de Janeiro (1984), The Museum of Modern Art, New York (1990), IVAM (Institut Valencià d'Art Modern), Valencia (1995), the Institute of Contemporary Art, Boston (1997), Kiasma, Museum of Contemporary Art, Helsinki (1999), New Museum of Contemporary Art, New York (1999–2000), and the Musée d'Art Moderne et Contemporain, Strasbourg, France (2003).*

........................

This interview took place in Paris in June 2000.

Hans Ulrich Obrist:

Instructions have played a major role in your work since the '60s; what place do you give to these instructions, these "directions for use"?

Cildo Meireles:

Most often I construct my work from language. I try to distance myself from a pathological approach to the work of art (as something only the artist can produce). I prefer to imagine pieces that can be made by anyone at any time.

HUO:

Anywhere?

CM:

Yes, by anyone, at any time, anywhere. I've coined an expression to designate that type of work: "*fonomenos*." It's a play on words: *fenomeno* (phenomenon) and *fonema* (phoneme). In English, it could be written "*phonomenon*", with a "ph." The first *phonomenon* I made were the *Insertions into Ideological Circuits (Inserções em Circuitos Ideológicos*, 1970). This work takes up the question of place, the concept of circuit. But even earlier, the *Virtual Spaces: Corners (Espaço Virtuais: Cantos*, 1967–1968), one of my very first works, was perfectly doable from instructions. At the time, I also made three studies focusing respectively on space, time, and space and time. The first study consisted of choosing a location, closing one's eyes and listening, and perceiving a pure sound environment determined exclusively by the auditory system.

HUO:

A kind of subjective laboratory?

CM:

Absolutely. The second study, which had the beach as its setting, consisted of digging a hole in the sand and sitting inside it until the wind filled it. The third study required abstaining from drinking for 24 hours, then drinking the contents of a silver pitcher filled with cold water. I've only shown these studies once, as written instructions (typed on a sheet of paper) in Rio in 1969.

HUO:

A year before the "Information" exhibition at MoMA (Museum of Modern Art, New York, 1970)?

CM:

Yes. I even think that Kynaston McShine saw that piece. I didn't meet him at the time, but I know he came to Rio to prepare his exhibit.

HUO:

In the texts relating to the Virtual Spaces, *there's already the idea of a work emancipated from its author.*

CM:

This idea was at the center of all discussions at the time. The idea was to detach the work from its individual pathology. Only an artist with a truly extraordinary personal history can produce a personal, intimate work worthy of interest. Usually this is not the case and it is much more interesting to aspire to the illusion known as objectivity. I've been very interested in [Werner] Heisenberg's

"uncertainty principle," which in a way gives a scientific demonstration of the illusory nature of objectivity.

HUO:

Yet throughout the twentieth century the fiction of the objectivity of science has endured. Francisco Varela, a specialist of the brain wrote a text on that subject a few years ago. It consists of instructions for "a laboratory of subjectivity," "a portable laboratory."

CM:

Yes, quite right. I'm not a specialist, but I think that's precisely the subject of the great controversy that opposed Einstein and Heisenberg. The theory of relativity rested, actually, on the idea of objectivity. In the end it prevailed and became the thought of the majority. For Heisenberg, on the contrary, we are always observing the disorder we cause while we are in the act of observing and by the very fact of observing.

HUO:

Regarding your work you often mention a connection to the sciences.

CM:

Yes, it's an area that has always appealed to me, even if I never became involved in it, since in the end I turned to art. What interested me particularly was the poetry of mathematics and physics, more than the disciplines themselves. It's true this can be found in several of my works. There's a kind of tangency to science.

HUO:

Do you know any scientists?

CM:

Very few. I have an astronomer friend (he used to be the head astronomer of the National Observatory in Rio), but above all he likes poetry. He is a poet himself. His name is Ronaldo Mourão. He is very well known.

HUO:

To return to the Virtual Spaces, *you used the term virtual very early on. Today when it's used, people immediately think of virtual reality, whereas in your work, the idea is virtual as potential. How does this notion of instruction tie into your present large installations? Can the instructions be likened to musical scores? Do you conceive of the instructions as scores for your installations, devised so that, in a way, your works can be played again?*

CM:

Virtual/virtuality designates etymologically that which is potentially present. It is in that sense that I used the term. There is a similarity between the instructions and musical notation. One day

I'd like to make instructions so perfect that a piece could be accurately reproduced. *Através (Through,* 1983–1989) is a labyrinth made up of perfectly ordinary materials and objects found in shops and industrially manufactured. My friend Trudo Engels told me that in 15 years it would probably be difficult to find the same materials, and so what was originally a jumble of everyday objects would become a set of collector's items. It would be very expensive to follow the instructions then. Of course, this kind of work can be adapted. If you take the barrier for example, the idea in the work is to use it as a paradigmatic object—as a barrier, in fact. Obviously, if a Brazilian barrier is used in a piece that will be shown in Europe, it will not be perceived in the same way as it was in its original context. It is therefore indispensable to adapt the work to historical and geographical circumstances.

HUO:

You recently mentioned the importance of the circus... How is it linked to your work?

CM:

My work is centered on two main concepts: the first, of course, is the idea of *Pano de Roda,* linked to the decadence of the circus. The appearance of radio, film, and later television, virtually killed the circus, which had previously occupied an important place in Brazilian culture. When they could no longer honor their employees' contracts (jugglers, magicians, tightrope artists, etc.), circus owners would pay them by cutting out a piece of the big top. Gradually, as it was no longer possible to finance collective shows, each of the circus arts became individual again. Each artist traveled with a piece of canvas... This process of transformation of the circus is called *Pano de Roda.*

HUO:

Practical value became exchange value...

CM:

I'm very fond of this idea because it once again gives a certain independence to the work and a central place to the notion of individuality.

HUO:

There is no further question of objectivity then? What kind of economy is involved here?

CM:

The question isn't asked in theoretical terms. For economic rea-

sons—a new area of survival—of artistic survival, was created. The other idea that I tried to develop was the idea of the ambiguity between the concrete nature of the materials and their symbolic value. For *Ku Kka Ka Kka* (1992–1999), I used flowers and shit, two materials that have a strong symbolic content, as do bones or money.

HUO:

... yes the 600,000 coins, 800 hosts and 2,000 bones that you used for Missão/Missões (Como construir catedrais) *{How to build cathedrals}, 1987, that was presented in "Magiciens de la Terre" (Centre National d'Art et de Culture Georges Pompidou/Musée National d'Art Moderne, Paris, 1989.)*

CM:

Yes, and the same goes for match boxes. In Brazil, as everywhere, there's always a trademark that ends up being substituted, through metonymy, for the generic term. That's the case for the Olho: Fiat lux matches that I used for *The Sermon of the Mountain: Fiat Lux* (*O Sermão da Montanha: Fiat Lux*, 1973–1979).

HUO:

The Insertions into Ideological Circuits *are closely related to this set of problems, no?*

CM:

Initially the project began as a text on the notion of "Insertions." This text has a completely autonomous existence. Then, as samples from the text, I made the coin, the banknote, and the bottle of Coca-Cola. At the time I mostly showed the *Coca-Cola Project* (*Insertions into Ideological Circuits: Coca-Cola Project*, 1970). The *Coca-Cola Project* was about industry, capitalism; the *Cédula* [banknote] *Project* was about the state (*Insertions into Ideological Circuits: Cédula Project*, 1970). But at the time it was impossible to print a reproduction of a banknote; I would have had too many problems. Therefore I decided to use the Coca-Cola bottle as a metaphor for the banknote. This work has a lot of meaning for me. Of course, it expresses a definite political position.

HUO:

Of political infiltration?

CM:

Yes, and I still think that's the way to take action, like the "Insertions." It's a good method that consists in finding a flaw in an existing system and using it to spread counter-information.

HUO:

The "Insertions" are instructions... for making insertions?

CM:

Or rather for reproducing the same action. This work deals with a great many subjects, like the question of individuality, of authorship. It's also related to the "Theory of the Non-object," a fundamental text in Brazilian art, written by Ferreira Gullar in 1959. The "Insertions" also play on the notion of scale of action: a simple bottle of Coca-Cola can allow an isolated individual to attain the macrostructure. I loved that fiction—it looks like a fiction—of man landing on the moon in 1969. In fact, a documentary was recently aired, inspired from a book, that gives substance to the fiction theory. Do you know this story? The United States didn't really land on the moon in 1969: it was all made up. The film of man's first steps on the moon was made by Stanley Kubrick... In any case, fiction or not, I've always liked the story of the three astronauts: Armstrong (the captain), his teammate, whose name escapes me, and Collins. I've always thought that at that specific moment, the entire human race was in front of the television screen or listening to the radio. On earth, everyone was united; up there, on the surface of the moon, there were two men—who were therefore not alone. The only human being who was all alone at that moment was Collins, who stayed on board the spacecraft in orbit around the moon. I read somewhere that the reporters always interviewed Armstrong and his teammate, but never Collins, yet he was always there along with them. One day a reporter asked him, "What about you? How did you feel in this whole story?" And he answered—and this isn't fiction, "I felt like that guy who flew over the Atlantic before Lindbergh and whose name I've forgotten." I love that answer! [*Laughs*]

HUO:

{Hélio} Oiticica once said that heroes should be marginal. He had this message, "Seja marginal, seja herói" {Be marginal, be a hero}, on a banderole that he carried in demonstrations and to a concert by Caetano Veloso in 1968.

CM:

Yes, I think all this has a lot to do with an idea in a short story by Guimarães Rosa. He is a central figure in Brazilian literature. Unfortunately, he is untranslatable; he plays with words constantly. His writing is very complex, similar to Joyce's. The story is that of a man who decides to build a boat one day; he abandons his fam-

ily and past life, and boards the boat. When he reaches the middle of the river, he decides to spend the rest of his days without going ashore on either bank, but without turning back either. The title of the story is "The Third Bank." *Sal sem carne* (*Salt Without Meat*, 1975) is based on exactly the same idea: with the stereo, I tried to make people hear neither the sound of the speaker on the left, nor that of the speaker on the right, but a third sound located between the two, simultaneously immaterial and very present.

HUO:

Like limbo?

CM:

Yes, in a way, but "limbo" has a Christian connotation, which I find a bit sad. [*Laughs*]

HUO:

If you take Duchamp's readymades, on the one hand, you have the objects exhibited in a museum and thereby stationary; and on the other there are the instructions in which he says for example, "Take a dictionary and cross out all the words you dislike"—hence one can immediately go to a store and buy a dictionary and do it. This always makes me think of your work, and of the fact that this aspect of the readymade, though it hasn't been forgotten, has been somewhat marginalized. Your entire oeuvre, in a certain sense, is a continuation of that fluidity of the readymade.

CM:

Fine. We have two different things. The first comes at the beginning of the work on the "Insertions." The "Insertions" were concerned with what I would call a youthful pretension; even if they didn't exactly go in the opposite direction of the readymade—a concept I like very much—they nevertheless had the pretension of going in another direction. Not another meaning but another direction. The readymade consists of taking an industrial product and making it uncommon by way of subjectivity. The original idea behind the *Insertions* was the opposite: starting from a small, individual thing, one eventually reaches a very large scale by dint of bifurcations and ramifications (another very important notion in my work). It is exactly the opposite path than that of the readymade. This reminds me of a story: two years ago, an American artist [Rhonda Roland Shearer] set out to write an article on Marcel Duchamp. It's a wager: everyone has already written something on Duchamp. She was motivated by a particularly stimulating quote from the artist dating from 1948: "In fifty years people will understand the meaning of my work." She finally decided to work

on the readymade and began looking for the prototypes of the objects used by Marcel Duchamp.

HUO:

Oh yes! I've heard this story—highly contested—according to which the objects wouldn't exist...

CM:

Absolutely. She started with the Bazar de l'Hôtel de Ville catalogue, which Duchamp said he had used to buy his bottle rack, but she found nothing. The same goes for the bicycle wheel. Sometimes she found the factory; the trademark existed but not the specific model. Finally she discovered a suitcase containing a set of blueprints, apparently worked out by Marcel Duchamp—very detailed blueprints for each of his readymades. This story is a bit like that of the "Insertions," which are actually "handmade" rather than "readymade" to the extent that they originate in the private, individual sphere and later move toward a system that is on a larger scale. Whatever the case may be, that story of the suitcase and the rediscovered blueprints for the readymades is a true work of art.

HUO:

What's your view of the copyright question when it comes to practices that are no longer linked to objects?

CM:

I made a work that I never sold: the "Insertions." The work exists only if it is carried out (and not necessarily by the artist), and only during the time period when it is carried out. That's why I never sold it. Yet I'm not romantic to the point of thinking that I can protect my work from the market. What characterizes the art market is precisely the fact that it has always escaped state control. In fact, I don't think that too much regulation is a good thing in this area. This form of relative economic freedom is interesting it seems to me, even if it leaves the field open to dealers or institutions that sometimes abuse it. Above all, I think that the economy is an illusion that has gone much too far. I think that very soon we will be confronted with a series of questions that are much more crucial than the very abstract idea of the value of money. I think we are heading straight into a "Midas situation."

HUO:

"Midas?"

CM:

Yes, Midas, the man who changes everything he touches into gold

and who, one day, has nothing left to eat because, no matter how precious, gold can't be changed into food. We've gone too far in this race to value, and we've forgotten its true meaning. I, for one, think that very soon water will become much more precious than any kind of money, any kind of metal.

HUO:

And the other evening, you said you drink a lot of water...

CM:

Yes, ever since I was small. I grew up in Brasilia, Brazil's new capital. It's such a dry area that corduroy trousers dry in ten minutes in the shade. I can still remember the creaking of the floors when the nights became cooler in August and September. I've remained water-addicted since then.

MEKAS, Jonas

Jonas Mekas was born in 1922 in Semeniskiai, Lithuania. He currently lives and works in New York. In 1944, Jonas Mekas and his brother, Adolfas, were taken by the Nazis and imprisoned in a forced labor camp in Nazi Germany for eight months. After the War, he studied philosophy at the University of Mainz from 1946–48, and at the end of 1949 he emigrated with his brother to the U.S., settling in Williamsburg, Brooklyn, in New York. Two weeks after his arrival, he borrowed the money to buy his first Bolex 16-mm camera and began to record moments of his life. He discovered avant-garde film at venues such as Amos Vogel's pioneering Cinema 16, and he began screening his own films in 1953. He has been one of the leading figures of American avant-garde filmmaking, or the "New American Cinema" as he dubbed it in the late '50s, playing various roles: in 1954 he became editor-in-chief of Film Culture; in 1958 he began writing his "Movie Journal" column for the Village Voice; *in 1962 he co-founded the Film-Makers' Cooperative (FMC) and the Filmmakers' Cinémathèque in 1964, which eventually grew into Anthology Film Archives, one of the world's largest and most important repositories of avant-garde films. His own output—ranging from narrative films* (Guns of the Trees, 1961) *to documentaries* (The Brig, 1963) *to "diaries" such as* Walden (1969); Lost, Lost, Lost (1975); Reminiscences of a Voyage to Lithuania (1972); Zefiro Torna (1992), *and* As I was Moving Ahead, Occasionally I saw Brief Glimpses of Beauty (2001)—*have been screened extensively at film festivals and museums around the world.*

........................

This interview took place in New York in January 2001.

Hans Ulrich Obrist:

First, I want to ask about your thoughts and feelings concerning the presence of film inside museums of modern or contemporary art. It seems that somehow today the boundary between the museum context and the cinema context is about to disappear. What are the specific possibilities and opportunities that the museum context offers to filmmakers? And what are, on the other hand, the main constraints created by the museum context upon films and filmmakers?

Jonas Mekas:

I am a farmer. In my mentality, I always considered myself a farmer... So I'll try to look at the situation of museum and cinema from the practical, down to earth, farmer's angle. Somewhere around 1975, Brian O'Doherty, who was then in charge of the National Endowment of the Arts in Washington, passed the mes-

sage to the "field," saying, "Yes, I would like to get more money for the museums and art centers around the country, but there must be, first, a demand. If there is a demand, I can go and get more money." So this guy, Robert Haller from Pittsburgh, with assistance from Brian, began organizing media centers across the country, and created what became known as the National Alliance of Media Arts—bringing into existence literally hundreds of art centers who then attacked the National Endowment for the Arts with money demands, creating a "need." One of the side results of this was that cinema activists wanted some of that money to go to cinema, and they got all those media centers and museums to include cinema in their spaces and programs. The Trojan horse of cinema moved into the art spaces. Now, as time goes by, you know, across the country we still have about two hundred—maybe more—museums and art centers and galleries that show films. Since these places are not regular public movie houses, the special nature of these venues for film began determining what kinds of films are being shown in them. It's a really complex subject. And I am not even touching the universities—that is something else. Because at the same time, the filmmakers—actually, even earlier, already in the '50s Maya Deren was attacking universities and colleges. In 1963–64, as far as we knew, there were only some 15— that's maximum—universities and colleges with film courses or departments. Then the American Film Institute was created. In 1970 or 1971 they prepared a guide to film departments and courses in universities and colleges. They listed 1200 universities and colleges. In one decade, there was a jump from a dozen to 1200, one hundred times more! With about 22,000 different courses in cinema. Again, all those universities and colleges, at least major universities, have their own galleries and museums, and that's where the films are usually shown—they get budgets for it.

HUO:

One of the issues I was thinking about concerning the relationship between cinema and the museum context was that, for instance, the fact that every time the Whitney Biennial takes place—and it's not just the Whitney Biennial—there is a considerable number of filmmakers on the artists list. But most of the visitors—if such a show is visited by a few hundred thousand people—do not happen to be there on Thursday at 3:30 p.m. when the films are screened. This is for me one of the main problems of the presence of films within contemporary art group shows. And I think that this problem became all the more salient as video art projections increased throughout the

'90s... A Bill Viola installation, for instance, is shown Tuesday through Sunday from 10:00 a.m. to 6:00 p.m., whereas a film by a very important filmmaker is shown once a week from 3:00 p.m. to 3:30 p.m. only... Isn't it a problem for you or for filmmakers in general?

JM:

Of course, but it's a technical problem also; it's related to the projection equipment. A painting can hang there day and night on the wall, but whenever there is an electronic component or whatever, then of course there are some time restrictions. So that's understood. But how it's presented to the public, to the people, there is an obvious discrimination, gradation. Maybe avant-garde filmmakers should be happy about it, because if they were to become as successful or as recognized as the painters, and now installation artists, maybe that wouldn't be that good. Maybe it's that freedom that allows them to do some very good work. Some very good work is being done on Super 8 cameras, because nobody takes them seriously. Too much recognition is not always such a good thing. I still have many problems in this area. The Whitney Museum has a film/video program, which was inaugurated by John Hanhardt. Now Chrissie Isles is running it. When she came from London, we had a talk. I said, "There is an exhibition of works by an artist, a painter, not always the greatest, but they publish a catalogue for him or her, two hundred pages. And then we have a show by an important filmmaker, and there is nothing, usually two lines in a catalog. Why don't you insist on having catalogues for filmmakers too? Some of them deserve catalogues more than some of the painters or installation artists who are shown there." We discussed it and she thought it was the right thing to do. But nothing has happened. Museums don't think they should allocate money for something like that. So the film is still only a sideshow, in that respect. Exceptions are being made only for somebody like Bill Viola. I mean, you really have to build your name up to where they more or less become confused: "Is he an artist or is he just a film/video maker?" Now Viola is being presented as an "artist" at MoMA [Museum of Modern Art, New York], let's say. But those are really exceptions, rare exceptions. Film and video are still only footnotes in museums. Unless it's an installation. The attitudes to film and video have begun to change a little bit during the last five or so years. But mainly I think because of installation art, the reputation that installation art is getting. Video is part of the installations, and sometimes film too. So film and video are riding on the back of installation art. But filmmakers want to be recognized on their own. And that doesn't really exist yet.

HUO:

How would you envision a museum in which you would feel comfortable with the presence of avant-garde film?

JM:

It has to be a museum where cinema—and, of course that includes video—is treated with the same respect, love, and budgets as painting, sculpture, installation, and photography. Sometimes I get the impression that while painting and photography are taken as "real art," the avant-garde film is still being considered as an "experiment." Art is never an experiment. Museum curators, of course, *experiment* a lot these days with the ways works of art can be presented, or grouped together. That's where the "experiment" is, and it's O.K. I think that it's perfectly right to collect all those works and put them into new relationships or introduce some other contexts because, why not? But it's not an experiment that is being presented, but an idea. An idea is not an experiment.

HUO:

The question of curatorship leads to the question of film curating. This interview is taking place at Anthology Film Archives. When it opened on December 1, 1970, Anthology Film Archives issued a manifesto, which summarized its polemical position; it said:

> *"The cinematheques of the world generally collect and show the multiple manifestations of film: as document, history, industry, mass communication... Anthology Film Archives is the first film museum exclusively devoted to the film as an art. What are the essentials of the film experience? Which films embody the heights of the art of cinema? The creation of Anthology Film Archives has been an ambitious attempt to provide answers to these questions; the first of which is physical—to construct a theater in which films can be seen under the best conditions; and second critical—to define the art of film in terms of selected works which indicate its essences and parameters."*

Could you tell me about the beginnings of your practice as a film curator or programmer, which has always run parallel to your activity as a filmmaker?

JM:

Curating, preparing programs for Anthology has a long history. I began programming and organizing film screenings for the first time actually only two blocks from where we are sitting now, on Avenue A and First Street, at a little gallery which was called Gallery East. It was run by Joel Baxter and Louis Brigante, both

connected with the Tenth Street Group, [Willem] de Kooning, etc. That was in the spring of 1953. Now, if we jump from 1953 to, say, 1963, I could say, in 1963, or even 1965 that I had seen absolutely every avant-garde film made in San Francisco, New York, or anywhere else in the United States. There were some ten filmmakers in New York, another ten in San Francisco, and another few in other places. Today, and not only today—already in 1975—it would have been impossible to say that one could have seen everything that was done in avant-garde film in the United States, not talking about what was happening in other countries— there was already that much going. There are not only individual filmmakers: there are various national groups, there is the Black Cinema, and there is an Asian American cinema, Gay/Lesbian cinema, and so on and so on.

HUO:

And when did the Film-Makers' Cooperative come into existence?

JM:

That happened in January 1962. The Film-Makers' Cooperative included all the varieties of avant-garde/independent cinema. There weren't many of us. The first catalogue listed only some twenty or so. Today there are big catalogues representing each of the different groups that I just mentioned. And since it's impossible for any one person to see them all, at Anthology, what I do in my programming is I trust that in each of those areas of cinema there are people who know what's being done there. I do not know, for instance, what's happening in the Native American Cinema, or in Black Cinema, but some people who are involved in those cinemas, they know. So I engage them to prepare programs for Anthology, of their cinemas; I use many guest curators. And I give them complete freedom to include in their programs what they feel is important or good. This openness that I practice brings to Anthology a lot of variety and young people. And we do not program too far ahead in time, like what the MoMA or the Whitney Museum do; we program only two or three months ahead, and even within those two or three months we leave spaces for filmmakers who may be passing through town and would like to show their work on a short notice. So it's very very open. We are a living organism; there is very little that is permanent at Anthology. Of course, that makes our life more complex and problematic, but it also makes it more real, more exciting, and more useful to the film and video community.

Could you tell me about the very beginnings of Anthology, how it started?
JM:
It came into existence from necessity. Cinema is a living organism
with all kinds of different branches. We opened first to the public
in December 1970. As I already mentioned, the number of univer-
sities and colleges with film departments had jumped from a dozen
to 1200 in one decade. So around 1970, P. Adams Sitney and
myself found ourselves in a difficult position. If, say, a film class of
New York University wants to show some avant-garde films, they
have no problem: they are in a city where there is a lot of exposure
for the avant-garde. But if a university in, say, Nebraska wants to
have a few typical avant-garde film programs for their film stu-
dents, they have seen nothing. So they always called either P.
Adams Sitney to help them or me. And we did it. We did it ten
times, we did it twenty times, maybe thirty, then we had enough.
And we said, why don't we get together, and maybe we create a lit-
tle selection committee and we review the entire field and prepare
a list of what we think is the best, what is worth showing in uni-
versity film classes. Next time a university or college asks for our
help, we just send them the list and tell them that "every film on
that list is important, has contributed something to the art of cin-
ema, and you can show any of them." So we did that. We created a
committee of five: Stan Brakhage (later replaced by Peter Kubel-
ka), P. Adams Sitney, James Broughton, Ken Kelman, and myself.
We had many sessions: we looked at films, we argued, we fought,
and we selected some 330 titles, and we called it "Essential Cine-
ma Repertory." As we were doing this, Jerome Hill, a filmmaker
himself and a great supporter of the avant-garde, who had inherit-
ed a fortune from his railroad-building family, built us a very spe-
cial movie theater, designed by Peter Kubelka, at 425 Lafayette
Street in New York. That's where we introduced our "Essential
Cinema Repertory." And we thought that it would be our only
function, to screen this repertory of 330 films. This is our reperto-
ry and we are going to run it and run it. That is more or less what
we did for three years, nothing else. But then, it happened that our
sponsor, Jerome Hill, a visionary person without whom there
wouldn't have been Anthology Film Archives, died in 1973. We
had to move to SoHo, to 80 Wooster Street. We tried to continue
expanding the "Essential Cinema Repertory," but without financial

support we had to abandon the project. Our last meeting was held in 1974, and that's when the "Essential Cinema Repertory" collection froze. But cinema continued. I had no choice but to introduce other programs, besides the Essential Cinema programs, so that the new work could be also seen. So we expanded. We became more like—at the beginning I used to say that we were a museum.

HUO:

You mean a museum in the sense of a time storage facility?

JM:

Yes, Anthology on Wooster Street became a living museum where new works could constantly be seen. And it kept growing and changing until we reached the point where we are today.

HUO:

To break the linearity of the interview, since this Andy Warhol catalogue just arrived, could you tell me when and how you first met Warhol?

JM:

The problem here is that I usually say that I don't know when I met Andy Warhol. What happened was that the Film-Makers' Cooperative was created in my loft, at 414 Park Avenue South, between 28th and 29th Streets. My loft became the co-op office and headquarters. Every day and evening the place was full of filmmakers and strangers, and they were bringing films to show each other what they had filmed the day before, or the week before, or the same day. The place became very busy, so that the only place left for me to sleep was under my moviola, somewhere in the back corner. Andy used to come to see films; this was his film school, so to speak. And I discovered only six months or so later that he had been coming, many times sitting on the floor. There weren't enough chairs in my place. That was in mid-1962, before he made *Sleep* (1963).

HUO:

When did you see his films for the first time?

JM:

I was running a film showcase on East 27th street, at the Gramercy Arts Theater—that's where I presented *Sleep*. That was Andy's first film. We used to run his *Kisses* (1963) before our regular shows; he used to bring one new one every week. *Sleep* I presented in January 1964. It was made in the summer of 1963. I saw it for the first time at Andy's Factory.

HUO:

So Warhol's Sleep *came out of these visits?*

JM:

Yeah, that's where he met all the local filmmakers, and he got inspired, you know. I think that's where his inspiration came from. That's where he met Jack Smith, Barbara Rubin, Taylor Mead, Ron Rice, Jerry Joffen, and many, many others, some of his future stars.

HUO:

You spoke about the growing complexity of Anthology as an archive and a museum. Can you expand on this aspect of the Anthology's history?

JM:

This is a big subject. You see, at the beginning we thought that our function was to present the "Essential Cinema Repertory" and nothing else. But then we faced the problem of finding the best possible prints to show. But to get the best prints we had to find the original materials. With originals of some very well-known films, such as [Robert] Flaherty's *Man of Aran* (1934), nobody knew where the original negative was. It took us a year of detective work, we chased for it all over the world just to discover that it was right here in New York, a few streets from Anthology. When we went to the avant-garde, we discovered that in the case of deceased filmmakers, the estates did not know or did not care about the original materials, and even some living filmmakers didn't know where their materials were or in what condition. We discovered that many of them were fading, shrinking, disintegrating. The early film stocks held for only so long. Around 1970, they began fading. What I am saying is the real film preservation for the avant-garde film, and the entire cinema, began only around 1970, when the film stocks reached a point where they began disintegrating. So we had no choice but to start a film preservation program and try to save all of the original materials that still existed. Another immediate necessity was to start a reference materials and paper materials library, because when some university wanted to show some films by, say, Kenneth Anger, or Bruce Conner, they said, "Ah, yes, but we need some written materials, information on these guys." So we established probably the largest paper materials library on the avant-garde/independent film in the world. Then came the '80s and the '90s, when video came in and film labs began closing and going out of business because nobody was using film anymore. Film labs started dumping films, thousands of films, literally into the street dumpsters. So we dragged thousands of films from the dumpsters. Film labs already knew that we were crazy about saving films, so they used to call us, before they went into

bankruptcy, and say, "We have these films here, we are going to throw them out, do you want them? Come and get them." So we went and we got them. Last week, you saw it in the lobby—there are like one hundred big boxes, they just came. We don't have any space left, but it's O.K., we have to take them, we cannot allow them to be thrown into the street. So now this whole building, from top to bottom, is loaded with films.

HUO:

That's really curating in terms of its Latin sense of curare: *"taking care of."*

JM:

[*Laughs*] Yes, yes... So we take care of them... We don't even know what we have. I'll give you a tour later. Only a small fragment of what we have here is indexed.

HUO:

Since you mentioned video...

JM:

... We cannot keep up with that, we are so behind. In the '70s, Channel 13, the local public television station, had an experimental video program, with people like Nam June Paik, Bill Viola, Ed Emshwiller. They gave them access to all the available technology. A lot of material was produced. Then they discontinued the program and got stuck with all the video material, completed works and all the experimental, unfinished work. They called MoMA and asked if they wanted it. MoMA said, "No, we don't want it." So they called me, and I said "Yes, yes, yes, absolutely yes." And we got it all. It's not indexed, but we have it. We have a lot of other experimental video works from the early period, in outdated formats and systems of video. We have no money to transfer them to the new formats, current formats and systems. I hope those videos will last until we get money to transfer them to the new materials. And of course it's a very big job.

HUO:

In an earlier conversation you told me that you also see the archive as a school.

JM:

Because of the immensity of our collection—we now have somewhere around 30,000 titles here—and since we want to index all these materials, we work a lot with students and interns, volunteers. They come from various countries, from Japan, Scotland, Dublin, Paris. Some of them are studying film at New York University. By working at Anthology, looking at films, they get excit-

ed about filmmaking. A whole group of young filmmakers came out of our archives. We have become an unofficial school of cinema. Some call us a university of cinema... Many of these young filmmakers work with found footage, of which we have a lot of; They are all very young. The youngest is sixteen, Gregory Zucker, he has completed five little films. When he was twelve he had already read Brakhage's *Metaphors on Vision* (1963), which is very far-out aesthetically and a difficult book. Others are 19, 25... Filmmaking came into Anthology indirectly, some five or six years ago, and some very good work, especially on Super 8 film, has been produced. Some of them began as projectionists, some of them still work here as projectionists. It was an unpredictable development. And they all say that Anthology was their film school.

HUO:

In this sense it's also a trigger, it inspires people to do things.

JM:

Yes, and then, you know of course, in the basement we have a free music band... At the end of every two-month program season we have what we call "The Secret Life of Anthology" program when we all get together and we show our videos and films and play music.

HUO:

Do you use digital cameras as well?

JM:

The reason why I myself do not use digital video is because the editing equipment is very expensive. Sometimes I compare the regular Hi-8 video to digital video and it's like 16-mm filmmakers of the '60s and Hollywood. I use only Sony Hi-8, and the editing equipment costs only some $3,000, today maybe even less. And I like to have everything close to me, both filming and editing equipment. The digital equipment is too expensive for an average video-maker.

HUO:

Harmony Korine is using it.

JM:

Harmony Korine now has access to people who can help him with money. I don't have such access. I am still independent. I am still in Hi-8. I know very little about digital video, because it's beyond my financial means.

HUO:

To go back to the activity of film curating: what have you learned from this long and close history with films and film programming? How would you define your work as a film curator in general terms?

JM:

More like an orchestra conductor, maybe. I still have to make the main decisions, but it's more like decisions of an orchestra conductor. My curatorship is very very open, thematically, aesthetically, technically, morally, and in every other possible way. But still, we don't give our space, our theaters, or our time to any commercial venture. We send them to other places. But there are many non-commercial groups that have no other place to go but Anthology. We give preference to all the alternative forms of cinema and groups of cinema, and that includes all the non-Hollywood countries. This week, for instance, we are having our second annual Romanian cinema festival. There is no money in it nobody in his sane mind will show Romanian films in New York. But we do. We show Algerian, Mexican, Turkish, Greek, Lithuanian film surveys, films from many small national cinemas. We just had the first Cuban Film Festival in the United States, the first in thirty or more years. For strange political reasons nobody would show them. Not that these films are necessarily the greatest films ever made. No, not at all. Some of them are dreadful. But I think that people should see what kinds of films are being made in Cuba or Bulgaria. That is part of our openness.

HUO:

So it's a kind of a collecting of marginalities, bringing together of marginalities?

JM:

Yes, all of the marginalia. In my introduction to the Bulgarian Film Festival I said that cinema is a big tree, with many branches. And this tree doesn't grow only in one country, like, say, America. No, it grows everywhere. And sometimes the more difficult to reach it, the further, the more distant the places it grows, the more special the fruit. When somebody brings a festival of Bulgarian cinema, we are allowed to taste a very different fruit that we would have no other possibility of tasting. We may spit it out, but still, we should know what fruit grows on the Bulgarian cinema tree.

HUO:

I wanted to ask you, of course about your films, maybe not about your past films because you've spoken about them in many other interviews, but about what you are working on at the moment. What is the project that keeps you occupied right now?

JM:

I worked on my last film for the last two years. The first version was shown at the exhibition "La Beauté" in Avignon (2000). It was

shown on video. But I received the film print only last week. It's
called *As I Was Moving Ahead, Occasionally I Saw Brief Glimpses of
Beauty* (2001). Now, what the film is, is a diary of 25 years of my
life, my family, my friends, some travels—all personal footage of
the last 25 years. It's divided into 12 chapters; it's four hours and
45-minutes long, and it goes and goes and goes... I had much more
footage; those five hours came from thirty hours of material. I had
to be cruel with my footage; I kept only what was really acceptable
to me. And there is a lot of me talking, and I use sounds and music,
very often recorded at same time, or from the same period as the
images. They are never synchronized. I always carry with me in my
pocket a little tape recorder, and I just pick up some sounds or I
tape little bits from radio. When I was preparing the soundtrack—
I have thousands of reel-to-reel and cassette tapes—I pulled out
some of them and used it. What else can I say? I usually work on
my films very late at night, because during the day I work at
Anthology and have many other duties. So when I cannot do any-
thing else, late at night, usually at ten o'clock or so, I go into my
editing room and work on my films. That's how this film was com-
pleted. It's night work. My nightlife. I have a book, a manuscript
called "My Night Life," which consists of one year of my dreams,
my night, life...

HUO:
Is it to be published?

JM:
No. It was initiated around 1980 when I decided to follow my
dreams for a while. It's very interesting what happens when you
really begin to work on remembering your dreams. At first you
remember nothing, but the more you go into it, you work out ways
of how to remember. It was very interesting to keep a dream diary.
Anyway, that's how the film was completed. And I am very grate-
ful to "La Beauté," Jean de Loisy and all my French friends, because
it was an expensive project, the most expensive I have ever done.

HUO:
What was the budget for the film?

JM:
It cost me $53,000. I wouldn't have finished it without "La
Beauté." First, it's good to have a deadline... and then it's good
that somebody pays the basic laboratory expenses, basic materials.
That's where all those 53 thousands went.

HUO:

When we had lunch, you said that when people see this film they will make a difference, in contrast to the "Dogma" films.

JM:

I still have to see all the films that claim to be, whatever it is, Dogma. The basic principle is supposed to be the actual light, no interference with reality... But they bring actors into it and I consider that interference, and they bring plots and even scripts, minimal as they may be. Warhol did better than that. My film is real life, you see. O.K., even when I use musical sounds they have been recorded at the same time as the images. I do not claim to be my own Dogma filmmaker. In a sense, my film is a critique of Dogma cinema, filmmaking. They are just extensions, in a slightly changed style, of the usual, commercial cinema. And the first chance they get to make a "real" commercial film, they jump on it, and there goes Dogma. The so-called New York School of film of the '50s, or the Neorealists, were maybe more Dogma than those that proclaim themselves as Dogma filmmakers today. But it's O.K. At least there is something alive, some controversy, some enthusiasm. I think it's O.K. But it's not revolutionary, it's artificial. Of course, I have nothing against artificial cinema, or anything artificial, but they should not claim that they are the answer. They are only a new variety of artificiality. A new style, a new angle. Real reality is such a complex thing. I don't claim, for instance, that my film is not fiction. My films are fictions too. Television people go into real homes and follow real people, real lives: that is Dogma too. But these people that they film begin immediately to act... They become actors also... It's complex. The best Dogma film I've seen, and I like it very much, is Harmony Korine's *Gummo* (1997). But I've heard that Dogma people do not consider *Gummo* a Dogma film...

HUO:

My very last question is about your unrealized project or unrealized film. I remember you once sent me an answer about an unrealized project of yours for the book Unbuilt Roads *(1998).*

JM:

What I wrote about was that project that has just been completed now—my "La Beauté" film. At the time I wrote about it, I saw no chance at all, no idea how and when I could finish it. I had no money. But luck came my way. I will tell you what I really want to do next... I'll do it some day. I want to go to Paris with my two friends, Julius [Ziz], who edited the film *Et Le Cochon fut né* [And

the Pig was Born, 2000] that is shown in "Voilà" at the Musée d'Art Moderne de la Ville de Paris (2000), and Auguste [Varkalis], who makes all of our posters here, a great artist. We are all good friends and we like food and wine and, of course, women... I want to go to all the places that still exist where artists—painters, poets, musicians—of the '20s, '30s, '50s and '60s—and even going back to the *Incohérents*, to [Alfred] Jarry and his gang—and have their favorite drinks in their favorite bars and places. So the problem is to find out what their favorite drinks and foods were, and the places, and find out if they still exist. We want to drink what [Amedeo] Modigliani drank, what Apollinaire drank, and [Jean] Cocteau, and Jarry, and [Erik] Satie, and so on. And we are going to videotape it all. This will be our tribute to what Paris has given us, to the avant-gardes in all arts.

MERZ, Mario

Mario Merz was born in 1925 in Milan. He currently lives and works in Turin. Merz attended medical school for two years at the Università degli Studi di Torino. During World War II he joined the anti-Fascist group Giustizia e Libertà. He was arrested in 1945 and confined to prison. While imprisoned, Merz began making "continuous" drawings, without lifting the pencil from the paper. This idea of organic creation is central to Merz's works, as evident in his numerous neon pieces—hand-written numbers or words—where electricity circulates in a continuous flow of energy. By 1966, he began to pierce canvases and objects—such as bottles, umbrellas, and raincoats—with neon tubes, altering the materials by symbolically infusing them with energy. In 1967, together with several of his Italian contemporaries, including the artists Giovanni Anselmo, Alighiero Boetti, Luciano Fabro, Jannis Kounellis, Giulio Paolini, Giuseppe Penone, Michelangelo Pistoletto, and Gilberto Zorio he formed a group, becoming the central figure of a loosely-defined art movement labeled "Arte Povera" by critic and curator Germano Celant. In 1968, Merz produced Giap's Igloo, *the first of the dome-shaped temporary constructions that have become his signature works. Made of dried clay, the igloo bears neon letters on its crown with the famous statement of Vietcong General Vo Nguyen Giap: "If the enemy masses his forces he loses ground, if he scatters he loses strength." Merz's igloos express his preoccupation with the fundamentals of human existence: shelter, food, and man's relationship to nature. Each of these archetypal dwellings is built specifically for the exhibition in which it is shown; the materials used range from metal tubing to glass, sand bags, branches, stone, and newspapers. Many of Merz's works refer to the principles of the Fibonacci series, an exponential mathematical sequence that underlies the growth patterns of natural life. In 1971, Merz began a series of photographs applying the Fibonacci series to social groupings.* Fibonacci Naples *(1970), for instance, consists of ten photographs of factory workers on their lunch break, building from a solitary person to a group of 55. Merz has taken part in historic exhibitions including: "Arte povera + azioni povera" (Arsenali dell'Antica Repubblica, Amalfi, 1968); "Prospect '68" (Stadtische Kunsthalle, Düsseldorf, 1968); "When Attitudes Become Form: Live In Your Head" (Kunsthalle Bern, 1969); documenta 5 (Kassel, 1972); "Ambiente/Arte," La Biennale di Venezia (37th International Art Exhibition, 1976); "Zeitgeist" (Martin Gropius Bau, Berlin, 1982); documenta 7 (Kassel, 1982), and "Chambres d'amis" (Museum van Hedendaagse Kunst, Gent, 1986). Among his solo exhibitions, the most important were those in Zurich (Kunsthaus, 1985), New York (Solomon R. Guggenheim Museum, 1989), and Turin (Museo d'arte contemporanea Castello di Rivoli, 1990).*

........................

This interview was recorded in Paris in December 2001.

Hans Ulrich Obrist:

I'd like to open this conversation on something that we discussed just before, which is the consciousness of doing and the consciousness of doing nothing. Isn't the highest consciousness of doing the consciousness of doing nothing?

Mario Merz:

Well, that certainly happens when you're about to begin to speak. When you say something, you start from nothing; anything at all starts from nothing. The difficulty lies in observing something that's practically done... That's much harder.

HUO:

Could you tell me about the oscillation between working and not working or producing and not producing?

MM:

Doing something is always the worst thing, and doing nothing is definitely always the best. The problem of doing nothing is that you have to endure this nothing. So you acquire a capacity that immediately rises above the childlike qualities of man, which is the tendency to always do something: to survive, or at any rate to live with a purpose... In the choice to do nothing we are, so to speak, faced with an attempt at physical death, for purely intellectual survival. That's the problem of "nothing": it can only be that. And yet when you set yourself to do nothing you bring out those aspects of your physical being that are considered (or really are) the worst ones. So, for example, the inability to run very fast, violence against yourself, hunger, thirst, alcoholism, the urge to be stronger than you are... These are all related to nothingness. And in particular, the effort to be more, to be better... In short, the desire to be stronger than you really are is clearly an attempt to fill up the nothingness. What I see in everyone is, above all, the fact that they try to be more than what they are in reality, even in the way they present themselves, and the way they act... Even the social conveniences are often dictated by something similar, by this phenomenon, which is strangely the contrary of nothingness... I mean it's as if the objective was always the temptation to fill up the void. To fill up the nothingness! As if nothingness were *un grand trou*, a great void that needs to be filled up. We constantly have nothingness in front of us as a great void that we need to fill up. In short, nothingness is related to the void. Though it may seem a rash statement, I feel we can sum it up like that.

HUO:

Couldn't the resistance to the void be understood as a resistance to the idea of producing?

MM:

Producing would be equivalent to the specific nothingness. It would be the best thing, but instead everyone fills in this nothingness through production articulated in different ways and it

becomes something like a sort of... self-deception. In short, production is self-deception, and the fact that the self comes into play is equally interesting. It's interesting because it provides us with canons of honesty. When you realize that you're deceiving yourself, you also do more interesting work, ultimately. You realize something that is precisely this void, this nothingness. You're deceiving yourself, but you're aware that you're deceiving yourself. There's a problem of honesty in the work that—let me reflect—is specific... I can't explain it properly; it's specific to the person.

HUO:

Do you feel this form of self-deception is bound up with a form of resistance? In 1985 {Jean-François} Lyotard organized an exhibition on immateriality, investigating, for one thing, the flows of communication. ("Les Immatériaux," Centre National d'Art et de Culture Georges Pompidou, Paris). But in his view, doing an exhibition like "Les Immatériaux" implied that he would do a follow-up show on "resistance"—resistance in terms of physics. While you were speaking, I wondered whether this idea of nothingness wasn't perhaps bound up with some form of resisting, of resistance.

MM:

Yes, I think you could say that. And yes, true enough, we're speaking of resistance to the void. At a certain point—this is what I was thinking at that point—I realized that it was essential to start from the void: the void comes first! When you realize the existence of the void, perhaps you also realize that your material inserted there also becomes more honest, more humble in relation to the total void. Hence your material measures itself against a larger reality. Was that what you were asking? Was it in this sense that you were returning to the concept of resistance, measured against the void and nothingness, with doing nothingness?

HUO:

That's right, what you say expressed exactly the drift of the question I just asked just.

MM:

This is one of the tracks that an individual's velocity runs along. Because, in the ultimate analysis, the individual is above all a rapid being.

HUO:

Perhaps this idea of velocity and nothingness has been reinforced since September 11? Or is this an idea with an independent development?

MM:

No, no, it's something I've always noticed. To me, frankly, that event, in itself, means absolutely nothing at all. I find that all these self-accusations or generalized accusations are tedious. Yes, it's time to say clearly that the towers were... all towers have always been made to be knocked down ever since the world began. It's a catastrophe on the human level, but I don't feel that the business of the towers had any special significance. I don't know, take a shipwreck: sometimes you read about castaways, you find out the details, but compared with wars, this seems to me less, less... I mean not less random, but it becomes more... perhaps it becomes more elementary, that's it. [*Long pause*] You know, like a sandcastle you build... There's always something, someone, even the sea itself that sweeps the sandcastle away into the sand... and then recedes. This is what's interesting about architecture and so even the towers; the fact is they should always be there and they aren't there any longer. Perhaps that's how we should interpret things. The interesting thing about the towers is their lack of ever-presence. Of course the attack on the human presence is actually a big problem. This I can understand. Not that I understand it as a moral phenomenon: I understand it now thinking that usually men want to be very present in their buildings... and to make them last...

HUO:

That's true. In Europe, houses are considered permanent.

MM:

This is the... ancient urge, let's say. In Asia things aren't like that. Don't you feel that's so?

HUO:

Exactly. In Asia they speak of a ten-year life span. In Tokyo a house lasts about ten years.

MM:

I'm fascinated that the environmental phenomenon enables houses to endure. It's strange that it is precisely the environmental phenomenon that's the key to endurance. But the single detached house contains in itself a very strong temptation towards death. A double house or a triple, a "polyphemic" house ends up lasting longer. An example is Paris, or Venice; very few cities contain similar examples!

HUO:

The first exhibition of your work that I saw was the one organized by Harald Szeemann in Zurich ("Mario Merz," Kunsthaus Zurich, 1985). The exhibition centered on the theme of the house and the city and the progressive development of houses into cities.

MM:

That's right. If there's a single building you can get rid of it, destroy it. It's simple. When there are a lot of houses, it's much more difficult. Not because there are a lot of them, but because it becomes an environmental phenomenon, an urban phenomenon. I mean it becomes something else: instead of being like its own banner, alone, the house becomes involved in a significance that... I don't know, perhaps I shouldn't call it a collective, but in a certain sense it comes close. For instance, just yesterday, crossing the bridge, I realized that this river in Paris, despite everything, is harnessed by the bridge. It keeps on flowing under it. If you study it carefully, this river, despite everything, is forced to flow there. When you see a river in the countryside you never think it's forced to flow through a certain point that it necessarily has to go there, but in this case it's forced to pass there! So it is an absolutely extraordinary form of the constriction of nature.

HUO:

Can you tell me about the unreal city that was at the center of the exhibition mounted in Zurich? How did that exhibition get started?

MM:

Part of that idea that struck you about that exhibition actually emerged afterwards. In fact, it constantly happens that some things come to light, so to speak, only later. In that case, for instance, it's something that catches your eye, but it often happens that certain things only become clear after you've done them. Zurich was a case in point, with the structures you remember, these things became... they emerged. Man defines himself. In a certain sense, man identifies a certain rhythm, then the rhythm becomes more invasive. It's a bit like in the present: we're going towards the harmonization of the problem. In other words, we're moving towards an attempt to harmonize. It is the opposite of what happens with certain musicians that I favor. In short, in this case it's as if by increasing the number of players it seems logical for the music to become greater, but above all more convertible into an organization with its own emotive state. I'll give you an example: fruit is very beautiful when it's on a really big scale. You can see it at the market! You see some really wonderful markets just because... in a sense, the fruit in itself, which is what counts, loses its importance. Once the fruit is multiplied out of proportion the power of fruit itself is diminished, when instead its power lies precisely in this. So you understand how it's impossible to think of one of these Parisian buildings

transferred mentally into the middle of the countryside. It would become a metaphysical event and so it could be interesting for an analytical study. But at the same, it has no great social power in itself. Perhaps it has a power of analysis. Perhaps it holds a meaning for analysis, that's true...

HUO:

Utopia is a question of relationships...

MM:

Yes, Utopia is a question of relationships because you can't be utopian on your own. The utopian alone doesn't exist. I can't utopianize myself, my own thoughts alone, or an activity. But I can utopianize myself, one of my thoughts, or an activity that I engage in alone together with other people.

HUO:

What does this imply in terms of cities?

MM:

The city is a Utopia. A real Utopia. This idea of the unreal city that you brought up was in some ways—I think it's evident—the transition from the real to the utopian as if it were the same thing.

HUO:

So, if I've got it right, you feel that it's very important to understand the relationship existing in a rational Utopia like the one you've described, or the one that was presented in the Zurich exhibition. Because opposition to the totalitarian Utopias is strong and lies in the fact that the Utopia you're speaking about is never accomplished, is it? Let's say it draws its strength from being constantly only partial. In this lies all of its difference from totalitarian Utopias.

MM:

On the one hand, it's as you say. On the other, I confess I've never really understood what a totalitarian Utopia is. Those who've studied it maintain that it's a Utopia based on the coercion exerted over the men in order to give individuals a unified direction. While the Utopia of cities, which is what I'm talking about, is based on the conquest of space. But precisely for this reason it's more natural. I mean it's not the violent concentration of people in a single way—though deeper distinctions are really needed—it's never coercive, as happens in armies, for example. In short, it's not a question of a Utopia that involves the masses as with totalitarian Utopias. In that case, there's always an urge to concentrate men in a single way... to line them up with a germ inside, that's it: it's a disease.

HUO:

Do you think that in this respect the conflict that sprang up in the '50s between Le Corbusier and other architects about the new and possible urban forms of Utopia contributed something really revolutionary? The fact that they criticized Le Corbusier for creating spaces that weren't free? Is that something you've thought about?

MM:

Something rather curious and amusing occurs to me, though perhaps I'm wandering off the subject. I was astonished the other day passing in front of a shop window to see the reproduction of a painting by Le Corbusier, bizarre and a bit ironic. There was Le Corbusier's man and a ladder, in fact a stepladder of the sort used in the home. It was a painting and all at once,... I don't know, it was very odd because he seemed like one of those architects you call in to furnish the interior of the home.

HUO:

Like what? An expert of the "micro"?

MM:

That's right. A Le Corbusier not "macro," but "micro." I feel it's undeniable that Paris is a city that you can be happy to live in—I mean the center of Paris. Paris is an ancient city. In this sense it functions like Venice. If you had to go to Venice and say, "I'm going to stay in a new city on the lagoon," you wouldn't go for anything in the world! No one goes to a new city. The real Venetian wants to stay in Venice.

HUO:

In this respect I find the conception of the bridge that we talked about earlier interesting. Because in a later edition of Utopia *(1516) Thomas More describes an island that is connected to the mainland by a bridge. A bridge to Utopia. The thing that had always struck me about your ideal city is precisely all these bridges, they're like tentacles.*

MM:

That's true. In my utopian city the function of the bridge is actually a key function. I wanted to break with the separate block that has everything inside. Instead, I thought of a situation where if you wanted to have a kitchen, you could put it five or six houses further on. [*Laughs*] To get a cup of coffee perhaps it'd be better to reduce the distance to just two houses, unless you have a passion for running or you like jumping from roof to roof across the houses. [*Laughs*] The problem, in short, is space rebuilt by means

of houses. But a very, very livable space, let's say.

HUO:

I find this idea of having coffee in another house very interesting, as well as amusing. You can find similar thoughts or observation as the basis of lots of models of utopian cities designed in the '50s and '60s. There are Utopias of communication. And also in theories such as the one developed by Constant through his project of New Babylon *(1956–1974), there is the idea that houses don't belong to anyone but to everyone.*

MM:

But mind you, it's not that ours is a Utopia. Human experience shows that's the best life. I mean that it's not so much a question of having everything for yourself, everything ready, so much as being able to feel that nothing is ready, and yet... nearly ready but not quite ready.

HUO:

That's true. This idea of the "nearly ready" is a very important one. Can we compare this concept to what {Gilles} Deleuze calls becoming,"en devenir"?

MM:

I think so, yes. Nearly ready, yes. That's survival for man, his reason for living, otherwise he would cease to live almost immediately. Instead, he wants to see what happens, he waits and waits as long as possible, that's it. And it is precisely there that he discovers he has to cope with himself for some time, for a long time in fact. Yes, the problem is what to do when you've had coffee in a house somewhere else, what to do next! It's not what to do while I'm going to have a coffee, it's afterwards. I mean, the problem of before and after has to be coordinated, it's fundamental.

HUO:

A temporal problem rather than a spatial one?

MM:

The problem does actually become above all temporal. But if it changes from a spatial to a temporal one, it later becomes spatial again, but continues to incorporate all the time possible in itself.

HUO:

So, how should we approach the problem of time?

MM:

Well, I'm worried because these computers keep on eliminating time, eliminating as much as possible. I have good reason to be worried, because I say: if it takes three minutes to do something, and I decide to do it in ten minutes instead of three, I think this

thing becomes more interesting. Instead, the computer does exactly the opposite: it tells you can do something that usually takes you ten minutes in three minutes, meaning you do it in a time that seems more compact rather than shorter. No: I have my misgivings about this way of looking at time. The quality of time in our age is really alarming. I mean the time it takes to do something, hence to live a life. To me it's a serious question and I feel we're living in an age of constant menace.

HUO:

It's really interesting that you see things like this. Recently I happened to interview Toni Negri in Rome about his book Empire *(with Michael Hardt, 2000). In this book, Negri—and this strikes me as one of the most interesting things he deals with—denounces the danger inherent in the tendency of globalization to standardize our time. Perhaps we also need to invent different temporal scales.*

MM:

If there's a thing I find essential right from the start, it is the fact that mankind should have time available and that this time should be as long as possible. Just think for a moment how important music is in this respect. Because, you see, music creates personal time.

HUO:

What kind of music are you interested in, in particular?

MM:

Music that lasts, music that never gives me the feeling that it's declining towards a mono-system. I mean, music that criticizes itself is music that seeks to last, not music... that simply wants to end. I'm interested in music, but it's not really appropriate to speak of music as something that interests me... rather... I listen to it because it's something that authorizes me emotionally, as they would have said once, to while away the time. Music with its loud and soft sounds has this continuous capacity to embed me in time. The context of music is time! It's for this reason that it favors the self-awareness of time. Though at certain moments, it seems to make leaps, it's not easy... for music, I mean, it's not easy to make leaps. In fact a completely spatial music is still difficult.

HUO:

Now you're referring to contemporary music...

MM:

No not necessarily. Also ancient music. It's difficult to explain, but music in general—for example ancient music based on the religious sense of life—has a tendency to support the weight of time

without eliminating it. You might think that today's spatial music constitutes an elimination. I don't know, perhaps I'm naïve, but I feel that man's beloved computer plays incredible tricks on him! The computer is an extraordinary instrument. Given that, like everyone, I have a problem with memorizing things and this object memorizes well, it's a boon. But let me say this: strangely enough, it memorizes all the things that are of no use at all.

HUO:

You know that nearly all architects have told me that the practice of drawing disappears because of the use of the computer. This is a really big problem...

MM:

An enormous, colossal problem, because if the knowledge of how to do things disappears... the very gesture of doing something to bring something into existence. We try to do, rather than not to do. And so it seems that doing has a certain significance. Personally, I find it difficult for myself to think of a machine that does something in my place. It's boring!

HUO:

It reminds me of that wonderful work of yours that I saw some years back at Zerynthia in Paliano, where there was one person following another, and so on.

MM:

What was it, a drawing?

HUO:

A photo.

MM:

Ah, yes... one, then one, then two... yes. It was a bit ridiculous if I think back on it, but it's true.

HUO:

Was it a performance?

MM:

Something of the sort—without meaning to be a performance it was... let's say sort of, because it had to be enacted... [*Laughs*] Anyway, believe me, even a bridge is a performance, because crossing a bridge is a great credit to a person. Even yesterday I was in a taxi, and I said to myself, "Hey, there it is! Incredible, the taxi's crossing the bridge." Even in a taxi, meaning when someone else does the crossing for you, you become different than before. A bridge is a medium. It has a power... to accept nature, to feel it. Not to mention when you cross a bridge in Venice. When a Venet-

ian explains where something is he'll say, "Three bridges to the left then two to the right." [*Laughs*] You cross one bridge, then another... and it's beautiful, a really wonderful thing.

HUO:

Since we have spoken of Utopia, of concrete Utopias, the ideal city, I would like to know about your unrealized projects. Are there, for instance, projects that were censored? Projects that were too big or too small to be built? Could you talk to me about projects that haven't yet been realized?

MM:

Well, these unreal cities, these forms of craving, are unrealized projects. An unrealized project is something fixed: even if it has its dramas, it still has the security of the fact of existing, of being present. The idea of realizing projects is extremely important. Perhaps it's impossible to live any other way... In the end, I think even in the case of the most self-present artists such as Gilbert & George— these artists who always present themselves physically—there is an attempt at a project. Of course, you could object and say cynically that in their work there's only the effectiveness of being present... and yet this cynicism doesn't affect the project. The unrealized is like an illness that has to be cured. It's the illness of the void: it needs to be done. There are different elements. It's not just a taste for becoming, and yet in a sense there's also the taste *for* becoming. It's a bit like the skier who skis well and goes downhill. You see, this could be the taste for becoming, but designing is a taste for becoming that is even more ridiculous. Or, mind you, it may be even less ridiculous, depending on how you see it. Becoming, from a certain point of view may, strangely enough, be the side that asserts a physicality... an importance. Well, you won't believe me, but I'm always afraid of taking some form of transportation to go from one point to another. I'm always troubled by someone who says, "Hop in here and then I'll take you there." "O.K.," I say. It takes a lot of courage, if you think about it. Instead today it seems as if this is the best moment in life and it all boils down to that.

HUO:

*When you talk about becoming (*divenire*), is this verb the same as the French* devenir, *which Deleuze uses a lot?*

MM:

Certainly! Becoming, that's what seems to count. I don't know, do you think things can go on like this? *Devenir*... yes, it's the precise opposite of being, isn't it? Oh, on the subject of being: I saw the

Guimet Museum [in Paris]; it was absolutely stunning, all the people enclosed within these walls; absolutely stunning—that's the finest museum around.

HUO:

So it's your favorite museum?

MM:

No, no, it's only a museum that made a deep impression on me. I can't say it's my favorite. Favorite, no, because I practically prefer a different kind of art! I have to say that, despite everything, I don't love religious art as much as a more documentary kind. Not today's art, not in the least, but a more documentary kind of art interests me even more. So it's far from my favorite museum, but all the same it's extraordinary!

HUO:

What would your perfect museum be like?

MM:

I think it would be extraordinary if a museum could possess the capacity that its statues have to teach people passing by to be something, as if, ultimately, statues could suggest a similar capacity in the people passing by. A museum that was almost a sign of man's ability to pass from one era to another: that would be my favorite museum. But it's impossible to realize one because it would become a game that would be... false.

HUO:

There's one thing I just have to ask you about becoming. It seems to me this concept is really important to you. You find something similar when you read Deleuze. His becoming made me think of the use you make of the Fibonacci sequence, visualizing the systematic order in nature.

MM:

It's difficult to talk about this because in these mathematical and arithmetical series a thing is renewed through a scheme. I mean the scheme is almost more important than the thing. Naturally, the arithmetic scheme can be applied to a thing, in much the same way as a standard can be applied to an architectural experience. But in the technical, technocratic and substantively mathematical world we live in, I took this series that struck me as the most ambitious in its urge to flee, in its power to flee!

HUO:

How did you discover it?

MM:

Purely by chance. I found it so beautiful, this little system. I adopted it at once. But if you ask me how it occurred to me to use it,

adopting it so easily, I have to say it was a bit like slipping on a jacket. It may sound odd, but I can't go out without putting on my jacket. If I go out I put it on. And... well, you put on your jacket just the way you put on Fibonacci. That's pretty much how things went.

HUO:

Great!

MM:

What are you writing?

HUO:

Fragments.

MM:

As reminders?

HUO:

We've been talking almost an hour.

MM:

Time to quit.

HUO:

There are some things we haven't talked about yet. Perhaps I've overlooked some subjects you would have liked to speak about?

MM:

No, these are really important subjects. True, they're subjects that have lost their importance, they're longer likely to frighten anyone; they've been transferred to the plane of language.

HUO:

Frighten?

MM:

"*Épouvanter.*" It's like when someone calls you and says, "Are you afraid of death?" Then it's very simple: if the other person talks about it, in talking about it he doesn't answer the question... he simply starts talking about it. But if he doesn't want to answer and wants to stick to the question itself, well then the question is very difficult. It is rather like the artistic phenomenon itself. Basically there are always naturalistic answers given to colossal philosophical questions. Naturalistic answers... Like a river that flows from the mountains to the sea. Then it becomes nature... the mountain itself is a bit frightening because it's a peak.

MOFOKENG, Santu

Santu Mofokeng was born in 1956 in Johannesburg, where he currently lives and works. Mofokeng began his photographic career informally as a street photographer in Soweto. After a few years of working as quality-control tester in a pharmaceutical laboratory, Mofokeng was hired to work in a newspaper darkroom and established himself as a freelance photographer in 1985. One of the most respected photographers during the years of the struggle against apartheid in South Africa, when he was a member of the Afrapix Collective (1985–1992) and a photographer on the alternative newspaper New Nation *(1987–1988), Mofokeng recorded not only the harshness, but also the moments of happiness, the daily life of the inhabitants of the townships. From 1988 to 1998 he was a documentary photographer and researcher at the Institute for Advanced Social Research at the University of Witwatersrand in Johannesburg. His fieldwork and research have resulted in the creation of an archive of images of black working-class families in South Africa from 1890 to 1950 (*Black Photo Album/Look at Me, *1991–ongoing), offering a new perspective on urban black life, aspirations, and social history. With this archive project, Mofokeng has rescued early-twentieth-century family portraits from oblivion, taking his subjects and viewers back to the images that people wanted to give of themselves at that time. Mofokeng won the Ernest Cole Scholarship in 1991 and studied at the International Center for Photography in New York. He was the first Mother Jones winner for Africa in 1992. He has been nominated for many awards in Africa, the United States, and Germany, has received many fellowships, and has taken part in many exhibitions worldwide including: "In/Sight: African Photographers, 1940 to the Present" (Solomon R. Guggenheim Museum, New York, 1996); "blank___ Architecture, apartheid and after" (Nederlands Architectuurinstituut, NAI, Rotterdam, 1998); "Der Stand der Dinge" (Kunst-Werke, Berlin, 2000); Documenta 11 (Kassel, 2002) and "Survivre à l'apartheid" (Maison européenne de la photographie, Paris, 2002).*

........................

This interview was recorded in Paris in December 2002.

Hans Ulrich Obrist:

Let's begin with the beginnings. I was interested to know whether you started with photography or writing?

Santu Mofokeng:

The beginning was photography, the writing came later. When I was in primary school, I had a friend who was making photographs with a box camera. He was a close friend. I didn't have a camera at the time, and I was envious of the fact that he could chat to people about his camera and that people would come to him because he had one. And he always had some money in his pocket thanks to

the pictures he sold. This was in primary school. It wasn't until I was in high school in 1972 that my sister, who knew I had always wanted a camera, found out that a neighbor who lived one street away had a camera—it was in a dismal state of disrepair. But it was a Konica EE-MATIC. My sister promised to buy it from the man, and I don't know whether she paid him or not, but he came back to us a few months later and said that he wanted the camera back. I had taken the camera to be repaired. He took the receipt and left. And then a year later, I was working selling Collins encyclopedias and when eventually I managed to make a sale, I went back to where I had taken the camera for repair and I actually found it still lying on the shelf. I paid for it. And that was when I started as a street photographer, going around making portraits. People would ask me to go to birthday parties or a wedding, or the unveiling of tombstones and ceremonies like that. My social status was enhanced. Everywhere I went, strangers would approach me to have their photograph made or simply to talk, all because I was lugging a camera. Conversations revolved around the features of the camera. I hung on to the camera until 1975, but in 1976 my sister lent it to a neighbor. I can't remember where I was that day, but I was not at home. A neighbor borrowed the camera and it disappeared. I began to work in 1977 in the pharmaceutical industry—I was hoping to study pharmacology—and so I worked there for around four years before going back to photography. Working in research is different from working for a company; you have to work with specifications to make products, and I didn't find that interesting.

HUO:

In the '80s you took different positions as a photographer, first as a dark-room assistant for Citizen, *a newspaper from Johannesburg, then a few years later you become a freelance photographer and a member of the famous Afrapix Collective. What were the crucial meetings during this period?*

SM:

I met a guy who was working for the newspapers, basically in a dark-room way. This was in 1981. He gave me a roll of film, lent me a camera and told me to go and make pictures. Because he was working in a darkroom, he would process the film and make big prints. People were used to postcard size, but he would make bigger prints, 8-by-10s. When seeing them, he encouraged me to sell these pictures. I did that once or twice and then I told him that I really wanted to learn how to make pictures. Luckily, there was a vacancy, and so I worked in the darkroom for around four years. I learned how to

print, I learned the techniques, and practiced a lot. I would go and make photographs of sports and showbiz—the kind of thing you can sell to the papers. After three years, I worked as a photographer's assistant in an advertising studio. I did this for a year until they closed down. Then, like you said, I became freelance in 1985.

HUO:

So, 1985 was the first real moment of independence for you?

SM:

I would say that it is the moment that I came into my own. And also, I took some lessons from David Goldblatt, learning how to make pictures "talk."

HUO:

So Goldblatt was like a teacher, or a guide.

SM:

Yes, a teacher in a sense, though I knew how to make pictures before. I found his documentary work very exciting at that time. Then in 1986 I worked with Jürgen Schadeberg, who was responsible for *Drum* magazine. He was the photographer who earlier in the '50s had trained Peter Magubane and some of the big names in South African photography. He published some of the first *Drum* issues in the '50s. I had David Goldblatt as a kind of mentor, and then I began to work with Schadeberg, whose style is totally different from Goldblatt's: it's looser, more playful and jazzier. David's work is—how could I describe it—more sober. Schadeberg had just come back to South Africa; he had left some time in the '60s, and somebody said that he was looking for someone to publish books. So I worked with him. And looking at these two poles, these two styles of photography, I realized that there is not one way—it doesn't begin and end with Goldblatt's documentary style. And I thought that there was something I could do between the two styles: my style, my taste, my aesthetics. And that's when I began to work at it. In 1987 I wasn't making much money as a freelancer, so I took on more printing work. Later I was employed as a photographer for a newspaper.

HUO:

This is when you worked mostly for the **New Nation** *newspaper; again, it didn't last long...*

SM:

I worked with them for a while, sourcing images for them, choosing photographs and making pictures myself. It was an alternative newspaper. After a year, I wasn't happy there. The kind of work

they were asking for was overtly political. All they wanted for the front page was to show oppression. And in 1988 I moved away from the newspapers and began to work as a documentary photographer at Wits University [University of Witwatersrand, Johannesburg] on an oral history project. I went there and you can imagine how complicated it was. The oral history project was to record the voice of the voiceless!

HUO:

This time it was a more social project, aside from the realm of photojournalism.

SM:

... social history rather than a social project. I stayed with them off and on, and actually worked for them over a long period of time. When I finally left the university it was in 1998, so for almost ten years I had been working on small contracts. Of course, during that time the political landscape in South Africa had changed. When I look back at the projects I started to do in 1986, I see they were a form of "metaphorical biography"—like a large project that I divided into chapters, small chapters, looking at transport or shipping life, trying to plot what life was like in the townships. In 1996, in order to close this chapter, I went back to the project that I started with, which was looking at spirituality, something which is pervasive and not talked about.

HUO:

And that's your Chasing Shadows *series from 1997. I'd like to go back to the '80s: you left your job as a photojournalist because you were somehow disillusioned by the work you were doing and because what you wanted as a photographer was not only to record the harshness, but also the moments of happiness, and the unquenchable human spirit that kept people going through the time of apartheid in the townships. There is another interesting moment that you haven't mentioned that took place in 1989, when you put on a show at the Market Theatre—which is a place of historical significance in terms of cultural struggle—and you saw that your work was also misinterpreted there. Again, questions resurfaced concerning the efficacy of photography, making interventions, and mobilizing people around issues—though in the galleries and museums realm this time.*

SM:

For a while after this show, I didn't make images.

HUO:

It was a block?

SM:

Yes, I had a struggle. I had this show and the show was well received. The comments were very good, all apart from one, which came from a man, a black man, who wrote, "Making money with blacks." And in fact it didn't matter to me whether he understood what I was doing or what his education was, but what struck me was that what I was doing didn't make sense—it didn't resonate. I was making pictures, showing them in a museum or gallery in town, and most of the people who were looking at those pictures and who appreciated the pictures were not the people that I was photographing, who are township people. The work I was making wasn't making sense; it wasn't making sense to my sister; it wasn't making sense to my brother. Even now, if you ask them what Santu does, of course they know that I make pictures, but they don't *know* what I do.

HUO:

How would you define it?

SM:

What I'm trying to do is to get the people that I photograph to participate in my enterprise. One way is by looking at pictures that people keep in their own homes. When you come into a house what do you see on the wall? Portraits, maybe of someone's father or wedding portraits, *The Last Supper*, religious images, soccer images. Those are the pictures that I see. So then, I said to myself, "These are images that people keep for themselves, and they are not the images that we ever see celebrated in the papers." I wanted to do a project where I showed the work that I normally do, which is documentary with very large prints of these photographs in frames, and in the background I wanted to have these portraits and make them fill the walls, so that you have this confrontation between the private/personal on the one hand, and then the public/political on the other. The execution was not as I wanted, as I did not have funding for the work.

HUO:

In the wake of this post-exhibition blues, you decided to start asking black families if you might make photographic copies of their old family photographs, and that lead to your Black Photo Album/Look at Me *covering the period from 1890 to 1950.*

SM:

Yes, because going around the townships, looking at family photo albums, I realized that there were other images in those albums that did not talk to me—they had no place in my education and

my understanding of South African history. I was trying to think it through as to why that might be. One reason was my education, and if you look at South African history, apartheid was trying to frustrate the upward social mobility of black people. Later on, what did we do? In order to control apartheid, we looked to other histories as models, namely socialism and communism. Communism was used as a vehicle to show that the political condition in which we were living was not the only way, and that there are other ways. And we looked at American civil rights movements, and the idea of class struggle based on Marxism. You look at these portraits and then when you try to place them, it's almost like you're looking at this bourgeois society, at people who are bourgeois or elite, or who are aspiring to be bourgeois. That history of those people was at one time frustrated by the government, and later on by the exigencies of struggle—"We do not want to encourage a petit bourgeois." So I began to research these pictures. I began to look at them and try to give them context. That was how I began the *Black Photo Album*. Looking at these pictures was the beginning, and it was a moment in which I realized my ignorance. The intention was to publish a book and to try and reinsert these pictures in museums in South Africa. This is a history that you don't find in museums or galleries, basically. I was not getting enough funding and support for this work, so one strategy was to have a show and to inform people that such work was being done. So the intention of the show was to publicize my research, and from then on, to let it carry on by itself. But it could be looked at as a work of art.

HUO:

It's a blurring between art practice and research practice.

SM:

Yes, research. I have been disappointed sometimes. It was shown in Johannesburg and the first time it went abroad was when I took part in the exhibition "Fin de Siècle" in Nantes (1994). When it was shown in Johannesburg, the curators came and looked at the work and I talked with them about how it should be presented in Nantes. And then I came to Nantes and it was displayed as if the pictures had been put on a mantelpiece—there was no textual information, nothing. It was just pictures. It was intended to be appreciated as African portraiture.

HUO:

How foolish!

SM:

Yes, and that was kind of embarrassing for me, for while I copied those pictures, I did not make those pictures. My work is a process of bringing together the information and giving it context.

HUO:

Could you describe the methodology of your research?

SM:

When I began the work, it was a matter of amassing as many pictures as I could find, and they were mostly old pictures. Then you go about finding names and that leads to stories. Then I began to look at the image itself, as a document. Some of the pictures are enlarged, so I close them down to a point where I'm using the photographic process as a way to look at the date at which the photograph was made. How old is this photograph? It couldn't have been before a certain time. This makes the research slightly more scientific. But at the beginning it was a question of finding stories. Sometimes I find the person who was in the photograph, which is increasingly rare, as some of them are from the 1890s or early twentieth century. So those people are very old if I find them. When I do find them, they are often not very lucid, and have difficulty reading a photograph. It becomes more and more difficult. Then I stopped looking for photographs and tried to find the homes which were in the pictures that I already had.

HUO:

Do you accept the notion of testimony as a description of your practice?

SM:

My enterprise is more about reinsertion within a bigger understanding. To me it's a contradiction to disenfranchise people and then celebrate them in a museum. In museums in South Africa, you find pictures of loyal professionals or pictures of social life, but you don't find that in the townships. Then in the same museums you find a lot of ethnographic displays, and I'm trying to say that within those parameters, you can insert material, because these people actually existed. Museums tell you that around 1900, blacks were still walking semi-naked around the bush. But there were people who were traveling and studying in America and Canada: that information is not common knowledge. So I see what I'm doing with the *Black Photo Album* as a reinsertion. I hope that the government will take on this kind of work, but it's expensive. There are centers in South Africa that could contribute. They could collect or research information in different areas. What I'm still hoping to do is to put this in the form of a book

HUO:

Do you already have a title in mind?

SM:

I like the title *Look at Me.* I like that. It would be good if I can find space—and when I say space, I mean money—to aggressively pursue this message with the work I have already done. I have to juggle this with the work that I already have, my own work, and having to make money, and continuing to find stories. The last time I did this was in 2000. Sometimes I get lucky. I will find a photograph by accident, and it will be a relative, completely by chance. The people who show or give me pictures don't know who the people in the images are, but through conversation and coincidence, things are pieced together. One time I managed to trace some very old ancestors, whose children have all gone in different ways. One branch of the family still owns the family farm. One of the sisters from another part of the family had a relationship with a magistrate or something, and she had children and never got married, but because of apartheid laws they grew up as colored people. They just live thirty kilometers away from each other, but they didn't know that they come from the same family.

HUO:

So your work is about a dynamic form of memory in which things are brought together and connections are made.

SM:

Yes, it makes connections.

HUO:

This is very interesting because it shows memory not as something static, but as a process. The political dimension is a prominent aspect of your work, but at the same time, you stopped being a photojournalist because you were embroiled with propaganda. Could you tell me more about how you see your relationship with politics?

SM:

I'll give you an example. During the height of oppression, in 1985–1986, we were talking about police beating up black people; we were talking about people living in squalor. But family violence is something that was not spoken about—the breakdown of family life and structures. It wasn't talked about because if it was shown that black people fight against each others, or that some black men abuse women, people from overseas would have been confused. It is a struggle for humanism. Things were conceived as black and white—white people are bad and black people are good. It simpli-

fies pamphleteering. If you show that the reality is much more complex, people get confused and don't understand. People would like things to be easy, they don't like grey areas. I was reading about [Richard] Attenborough and the film *Cry Freedom* (1987). He made a film about Steve Biko, and in that movie all the policemen are white. Attenborough said, "If I'd shown that black policemen were also beating blacks, then people would be confused; they would not understand the message." Reality is much more complex. It's in this sense that my work is political. It is very hard not to be. If you suggest that black people are as human as white people in South Africa, it's already a political statement. On the one side, I do pictures of rallies, political funerals, political meetings, union work, but at the same time, my private project is to show life as I see it. That's not to say I believe and want to state that it is a definitive view of township life; it's more about things that I would ordinarily do that I care about. I would not go out and say, "I'm going to cover cricket because it's not something I grew up with." Like I say, I was not a very successful freelance photographer. Quotidian life is more like it. What do I do? I was making these images and there was no outlet or forum for them. I think it was only in 1988 that the world was tired of photographs of police beatings, and people were beginning to ask what ordinary life was like in the townships. I've been doing the project since about 1982. Suddenly there was a demand for ordinary life in the township, and I didn't have to go out and make those pictures because I already had them. It was a kind of confirmation.

HUO:

The political in the everyday. There is a nice passage in one of the texts of the Taxi book—"Communities of Interpretation" by Sam Raditlhalo (Taxi-004: Santu Mofokeng, 2001). He talks about the idea that you have expressed concerning the responsibility of photographers in the continuing struggle of the representation of history, and looking for the evanescent, hidden aspects of black life within the marginalized, denigrated, and forgotten.

SM:

As soon as you allow me to make a photograph of you, whether it's by agreement or commission, you are giving me a kind of license. There is a context to making pictures, and I use them outside of that context. This is something that people are not necessarily conscious of. Imagine if I take a picture of you and put it alongside a gallery of criminals, what then happens to the contract we had between us when I took the photograph? You should be afraid

every time you consent to have your picture taken because you don't know in what context it is going to be used.

HUO:

That leads us back to the notion of feedback; it had a central place in the practice of French documentary filmmaker Jean Rouch also. I was wondering what your unrealized projects are.

SM:

It's the book of the *Black Photo Album.* Every time I make pictures, I'm thinking about books. Books are a way of domesticating meaning. I've been making pictures about spirituality in South Africa. I had a show in Sweden where I showed prayer meetings in caves and on the streets, and I was showing the *Black Photo Album* at the same time. A Swedish lady who had been involved in supporting the anti-apartheid struggle in whatever capacity came and looked at the pictures. In relation to the *Black Photo Album,* she said she was not sure about showing black people in an unfavorable light. For her it was as if I was showing folkloric or ethnographic pictures, and I found her reading of my work very strange. I think that to tell the context, a book would be more efficient.

HUO:

In the Taxi book, there is a beautiful long autobiographical text entitled "Lampposts." It seems you've been writing for a long time and this is why my first question was whether writing or photography came first. What is the status of writing; is it part of your work?

SM:

Most of the time, when I've looked at catalogues or exhibition texts in which experts come in and talk about my work, I don't like it! I've always said that I'm going to write my own biography. I'm going to write the story so other people don't have to go out and look for it. This is also very much for my children. I was raised by a parent (my father died when I was four) who instilled in me a religious thing about always searching for meaning and purpose in everything we do. This informs my enterprise and the work that I do. And I'd like to write it—I'd like to be the interpreter of my work. Then maybe other people can have their own take. Sometimes I find art criticism dishonest—it's facile and just surface. Some of the issues that I try to raise in my photography are not comfortable. Writing does not come easily to me. It's not something that I do often. But I'm working on it.

ONO, Yoko

Yoko Ono is a multi-media artist who lives and works in New York City. She has been credited with being one of the originators of Conceptual Art. Her book* **Grapefruit**, *re-issued by Simon & Schuster in 2000, incorporates the conceptual ideas Yoko is universally recognized for. Forms and materials serve only as vehicles for Yoko ONO's art; her work resists categorization. An artwork might take the form of a film:* such as No. 4 ("Bottoms") 1966; or Rape 1969; or Fly 1970. *Or a sound recording such as* Two Virgins 1968; Fly 1971; Double Fantasy 1980; Season of Glass 1981; Blueprint For A Sunrise 2001. *Or a billboard:* War is Over! 1969/1970; In Celebration of Being Human 1994; Have You Seen the Horizon Lately? 1997; Imagine all the people living life in peace 2001/2002.

As an artist, Yoko has had numerous one woman exhibitions and has been included in many group shows in galleries and museums the world over. "Yes Yoko Ono," a 40-year retrospective of her work, organized by the Japan Society Gallery in NYC, and traveled to six North American cities, received the prestigious International Art Critics Award for Best Museum Show originating in New York City, 2001. "Mend Piece For The World" is Yoko's current global artwork. Set up at major museums around the world in the US, South America and Europe—it is a participation work encouraging viewers to "mend" broken pottery as a metaphor for healing themselves and the world.

The installation "Freight Train" has been exhibited in the Schlossplatz Berlin, at the Yokohama Tiennale Japan and currently at P.S.1 in Long Island City, NY. In 2002 Yoko had a special exhibition "From My Window" at the Viennale-Vienna Film Festival. Her latest work IMAGINE PEACE has been invited and will be exhibited at this year's Venice Biennale: "Utopia Station Show."

The recipient of two Grammy Awards, as a producer in 1981 for the John Lennon/Yoko Ono album Double Fantasy and in 2001 for the film Gimme Some Truth: the making of John Lennon's Imagine *album, YOKO has also produced over 10 albums as a singer/songwriter of her own compositions.*

In 2002 Yoko continued to be acknowledged for her ongoing contributions and was awarded the Skowhegan Medal for Assorted Mediums.

Musically, this is a banner year for ONO, with re-mixes by a variety of artists charting consistently in the Dance & Club charts. "Walking On Thin Ice" is the current release featuring re-mixes by Pet Shop Boys, Danny Tenaglia, Felix Da Housecat, Rui Da Silva, Peter Rauhofer, Orange Factory and FK/EK.

*(This text was kindly provided by Studio One, New York)

........................

This interview took place in New York in November 2001.

Hans Ulrich Obrist:
Could you tell me a little about the early beginnings?

Yoko Ono:

It started with music. I was trained as a musician since my preschool years. My mother put me in a very special school called Jiyu-Gakuen

in Japan, before I went to the elementary school. Jiyu-Gakuen, which translates as "Learning Garden of Freedom," gave early musical training to preschool children. We learned perfect pitch, harmony, playing the piano, and composing simple songs. Some very famous Japanese composers came out of this school. One of the most important things that I learned in that school, though I only knew how important it was in hindsight, was to listen to the sounds in one's own environment. We received homework in which you were supposed to listen to the sound of the day, and translate each sound into musical notes. This made me into a person who constantly translated the sounds around her into musical notes as a habit.

HUO:

The sounds of the city and the sounds of your life...

YO:

The sounds of the city and the sounds of your life of that particular day. Then you had to transform that into musical notation. Isn't that amazing?

HUO:

It is. When was that?

YO:

In the '30s. It was an incredible idea. It was homework... to transform the sounds into notations. So in my childhood, I was always doing that in my mind. When the clock went ding, ding, ding, I repeated it in my mind afterwards. I did not count when the clock chimed, but after the chime stopped. That was what came naturally to me. In hindsight, it was a remarkably interesting exercise. The whole concept of transforming noise into notation sounds like what was done by [John] Cage, later... but it was just homework in a kindergarten for early musical training. When I was living in my parents home in Westchester, N.Y., I was woken up in the morning by a grand chorus of birds outside my window. I found myself automatically making an attempt to translate the sounds of the symphony of birds into musical notes. Then I realized that since the singing of many, many birds was so complex, I could not possibly translate it into musical notations. I didn't have the ability to, is how I first thought. But I immediately realized that it was not a question of my ability, but what was wrong had to do with the way we scored music. Something got lost in the translation when you tried to notate the chorus of the birds. The score became a mere simplification of the natural sounds, without its original intricate beauty. Of

course, you could make a whole complex world of musical order, entirely separate from sounds of nature. But if you wished to bring in the beauty of natural sounds into music, suddenly you noticed that the traditional way we scored music in the West was not the way. So I decided to combine notes with instructions. Composers who created "Musique Concrète" must have gone through the same feelings I felt then. It was a natural step from there to creating events and instructions for paintings and sculptures. In music, you write the score and the performer interprets to perform it as closely as possible to the score. But the outcome is always merely an interpretation. When the score says pianissimo, how pianissimo are you supposed to express it? It depends on the interpretation of the musician. So there's always an argument to be made. It's fascinating that, in music, there was a separation of the score and the performance. Artists, whether they are composers or visual artists, always want their work to exist in eternity exactly how they have created it. But it is impossible for their work to maintain its original condition, and in the case of music, it has to be performed exactly in the way they intended.

HUO:

You've always been very prolific. Is it because of that that you came to think of the instructions work?

YO:

John Lennon once told a reporter, "Yoko got ideas like other people have diarrhea. It's like she's got diarrhea of the mind." It's true that ideas came to me like I was tuning into some radio from the sky. So I was always frustrated that I couldn't realize most of my ideas. But by instructionalizing my artwork I was, in effect, delegating the final outcome of it to others. It cleaned up my head, which was clogged with ideas. Until then—sometimes for financial reasons, sometimes for technical difficulties—I could never realize all the ideas, which were literally bombarding me. But now, I could just write instructions. It freed me. I became more and more daring. The instructions became more and more conceptual as well. In the conceptual world, you did not have to think about how an idea could be realized physically. I could be totally daring.

HUO:

And so the idea was that in making these projects there were no more limits at all?

YO:

Exactly. Because then I discovered that by instructionalizing art, you did not have to stick to the two-dimensional or three-dimen-

sional world. In your mind you can be in touch with a six-dimensional world if you wish. You can also mix an apple and a desk. It is physically impossible to mix an apple and a desk in the real world. But you can in a conceptual world. And in the process of mixing the two, you can mix them in the way you want. The other thing that derived from this was that the paintings or the sculptures did not have to be static. They could keep on moving and growing, like life. In those days, artists and musicians were slow in allowing others to touch their work. They did not like the fact that anyone else would touch their work. Even the public felt that that was not what an artist should do: to let others participate in their work. "You mean, you've let somebody else make this?" That was bad. The work had to be made solely by the artist and remain the way it was produced. But I was a war child. Life was transient, and often with sudden changes. I was always forced to move on. Static life seemed innately false to me. It was a fact that statues and paintings deteriorated in time, or were destroyed by political considerations. I knew that no matter how much you wanted it to, the work never stayed the same. So, as an artist, instead of trying to hold on to what was impossible to hold on to, I wanted to make "change" into a positive move: let the work grow by asking people to participate and add their efforts.

HUO:

So it is unlimited in duration also?

YO:

Exactly.

HUO:

And that is related to music, because in music there is the element of interpretation/participation.

YO:

Yes. But even in music there was an understanding that the score was for the performers to repeat the score as faithfully as possible. I wanted to give an unfinished work for others to add to, not to merely repeat. That's very, very different. In those days especially, most artists hated the idea of letting anybody touch or variate their works. It was a big step for me, too. I am a perfectionist. I also did not like the fact that somebody would touch my work. I did it in spite of myself, in a way. You can say that I did it for my growth, for me to let go of my artistic ego. I felt like I was representing the whole artistic community and releasing my ego on behalf of the elitist group of people. Sometimes there were still my instructions as the

measure to follow, but it was not the same as giving a finished score. There was a bit more leeway—a lot more, actually—for the performers to play with and express themselves in. Much later, in 1968, when my first record came out, I titled it *Unfinished Music No. 1*. In this one I did not give any instructions to follow. I just titled it "unfinished music." I thought that the hip ones would understand by then. It was, after all, a decade or so after I presented the idea to the world. But I don't think anybody was able to make heads or tails of it. At least, that was my impression.

HUO:

When did you meet John Cage?

YO:

I met John Cage towards the end of the '50s, through Stefan Wolpe. What Cage gave me was confidence that the direction I was going in was not crazy. It was accepted in the world called "the avant-garde." What I was doing was an acceptable form. That was an eye-opener for me. Pre-Cage composers such as Henry Cowell, Wolpe, and Edgar Varèse should be remembered for their brilliance and courage too. They were in pain already, because it seemed that they were rapidly forgotten once Cage came out. I still have warm feelings for them. As you know, Frank Zappa studied with Varèse, and he always spoke highly of Varèse. I met all of them: composers and artists. It was a great feeling to know that there was a whole school of artists and musicians who gathered in New York at the time, who were each in his/her own way revolutionary.

HUO:

So Grapefruit *(1964), your book of instructions to everyone to make art, is also an invitation for the unpredictable?*

YO:

Exactly. My Indica Gallery show in London in 1966 ("Unfinished Paintings and Objects") was the first time I actually incorporated the expression "unfinished paintings" in the title of the show, though my first show of "instruction paintings" was in New York City in 1961, at AG Gallery. But I didn't incorporate the word in the title of the show at the time, and therefore I had a lot of difficulty after that; several artists said things like, "Oh, that show of yours in AG was just a calligraphy show," or something like that to sweep it under the rug, so to speak. I only had one tiny mention in an obscure newspaper that showed that it was an instruction painting show. That situation changed in the middle of the '80s when

suddenly a whole roll of photo negatives of my show by George Maciunas came out. Thank you, thank you, George! For both of my shows—AG Gallery '61, and Sogetsu Art Center '62—I asked Toshi Ichiyanagi to print out the instructions instead of using my own handwriting, to make a point that they were instructions, not words drawn by the artist as visual images.

HUO:

In the '60s there was a very strong sense of bridging the gap between art and life. I wondered if this was the key element to your approach towards instructions.

YO:

Yes, that too. But I also wanted to add the time element. The time element was incorporated in the painting in the form of instructions, instead of leaving the work to naturally deteriorate in time.

HUO:

There are some very interesting connections between your work and that of {Olivier} Messiaen, who studied ornithology and transcribed many bird songs. He said that "Birds are the greatest musicians on the planet." Can you tell me about translation?

YO:

It struck me that one could not possibly make an exact translation of the birds singing, so that's where instructions came in. The instructional idea developed from realizing the limitations of our scoring, and suggesting an alternative to normal Western classical musical notations.

HUO:

It's a much more open notation in this sense. You mentioned the Cageian notion of the open partition even before you knew Cage.

YO:

It was that homework from Jiyu-Gakuen that did it! It's very interesting that it happened that way, isn't it?

HUO:

And what about Duchamp, whose ideas about this "partition" are also interesting?

YO:

You know what I thought? This may be construed as arrogance, but I felt I had gone a step further from his idea of "found objects." Duchamp is about the found objects. I was saying, "Here's something I'm presenting that you can add to. You can change the combination, make a new arrangement." I'll tell you a funny story. I had a painting called *Painting to be Stepped On* (1960)...

HUO:

Yes. "Leave a piece of canvas or a finished painting on the floor or in the street."

YO:

... yes, and on Chambers Street, I gave a series of concerts with La Monte Young, as you know. So then Cage brought all these incredible people to it: Peggy Guggenheim, Duchamp, and Max Ernst...

HUO:

When was this?

YO:

The first concert was held in December of 1960. It was a snowy day, and it was amazing that John Cage, David Tudor and all the "beautiful people" came from Stony Point, New York, in that weather. It took about two or three hours from Stony Point to Chambers Street on a good day. This concert series started to be a very famous and successful series, very fast, just by word of mouth. And so in one of these concerts, Duchamp and Max Ernst were there. I thought maybe Marcel might notice my *Painting To Be Stepped On.* I didn't think he did. He was looking around, and his eyes did go to the painting for a second, but I didn't think he focused on the idea. I was too shy and too proud to go to him and explain it or anything.

HUO:

And what about the do-it-yourself aspect, the fact that people could actually participate and also add or subtract? I saw your show at the Royal Festival Hall in London a few years ago, which was concerned a lot with adding. ("Yoko Ono and Fluxus," 1997). Could you tell me more about this adding/ subtracting device, which I think is very interesting in relation to the readymade.

YO:

That's exactly what it was: the instructions were for people to add or subtract, and to sometimes just imagine and do it only in your mind. In your mind you can do things that you can't do physically, which is very interesting, too. You can mix two paintings together in your mind—though physically that's impossible to do. It's also interesting that the way in which you mix the two paintings is your own way. You could mix two different things, of different dimensions, such as a painting and a sculpture. The idea of mixing a building and the wind... could you write that down for me? It might make a good instruction.

HUO:

Mix a building and the wind? That's beautiful.

YO:

Yes, in my mind I can just see the building becoming totally blurred because of the wind that's passing through it, through every cell of the body of the building. It'll be fantastic!

HUO:

You are always adding instructions to the list. Is it continually evolving?

YO:

Yes, of course. It's like a poet always thinking of different lines. I think of ideas all the time, so what am I supposed to do? The only thing I can do is write them down. You can't execute everything physically.

HUO:

And since Grapefruit *has come out, there have been a lot of different manifestations of these instructions. I wanted to ask you about these different appearances of the same instructions, because they exist as pieces in handwritten form that you put on walls, they exist in a very accessible published form—it's in English, Japanese, in several languages—and you have also put it out in the form of a web site.*

YO:

Yes. That particular web site project was almost like a book in itself. I was asked to do one hundred instructions, one instruction a day for one hundred days. They were not instructions from *Grapefruit*. They were all new instructions. So I called it "Acorns." (*Acorns, 100 Days with Yoko Ono*, web site, 1996)

HUO:

So these were new instructions for the Internet basically?

YO:

Yes. Once people started to get into it, they wondered every day what the instructions would be the next day. So that was interesting.

HUO:

Would you say that the Internet has changed the way you work? Does the Internet have a particular importance for you?

YO:

All the stuff we were discussing in the '60s in terms of the global village is actually happening now. What's happening is really important. It's happening on a conceptual level and it will become very physical one day—in fact, it's becoming physical already.

HUO:

So you tend to think that the Internet could be/have been a kind of partial realization of the Utopia of the '60s?

YO:

Of course. I think that it's almost like a logical conclusion. It was logical to think that way. Many artists, poets, and songwriters were giving us prophecy. I don't know what happens first: whether it's happening anyway and people feel it so they speak of it, or if it happens because the poets, songwriters, and artists willed it to happen by stating it in the form of prediction. But it's something beautiful and it's something that saves us from the horrible, destructive dream of the Doomsday. That's another thing. Many writers kept predicting Doomsday future. John and I kept predicting a very beautiful, open future. I say John and I because, off hand, I can't think of anybody else that was doing it so publicly. At the time, we were accused of being naive by other songwriters, artists, and underground political people. We felt we stood alone. I think it is very important to keep the dialogue going, and keep our future open, not closed.

HUO:

The instructions have been another thread throughout your whole concern with peace, which in the current condition is now again of an incredible relevance.

YO:

Amazing, isn't it? It's more likely that the human race will keep finding ways to survive. Some of us may even leave this planet for another... and we will survive.

HUO:

When we met for the first time, many years ago, you said something to me which I have never forgotten, and which I think is really essential. You said that the whole world was full of the war industry and that our task was to be the peace industry somehow.

YO:

The perfectionist in me is still there. The problem of a perfectionist is that you limit yourself with that image of perfection you have in your mind, so you don't really accept anything short of something you regard as perfect. Most of the time I go to a show and think to myself, "Oh, this artist is terrible, what a load of trash!" But my attitude is changing now. This world is separated into two industries: one being the war industry and the other being the peace industry. People who are in the war industry are totally unified by their ideas. They want to make war, kill, and make money. There is no argument there. They just get on with their objectives. Therefore, in that sense, they are a tremendously powerful force. But the people in the peace industry are like me: they are idealists and perfectionists. So they cannot agree with each other. They're always arguing in the

pursuit of the "perfect idea." They are asking themselves and each other, "What is the best way to get peace? Of course, it's *my* way. What's wrong with *your* way is that..." But instead of doing that, if we can only try to accept each other, forgive the differences and appreciate each other... because the fact is that all of us are in the peace industry. We should bless each other for that, and through that togetherness, somehow, we may be able to make the peace industry just as viable as the war industry, or more. Only then will we be able to stop the wars and bring peace to the world. The fact that the war industry is flourishing is because it's more profitable. It's more economically and financially profitable for some people to make war. It's as simple as that. Instead of arguing, we should embrace each other and come together.

HUO:

We should "do it".

YO:

Exactly, we should appreciate each other and just "do it." And for that you don't say, "Well, you're just a florist," you say, "It's beautiful that you're a florist. Thank you for taking care of the flowers," you know? Caring for each other and appreciating each other instead of using all our energy to try to change each other.

HUO:

This is interesting in terms of another topic I wanted to ask you about, which is Utopia. Utopia as a word has been very discredited in recent years because of its tendency to be totalitarian, to eliminate difference, but there are also many kinds of, and many moments of Utopia, and I think it is interesting to go back to the term not as a homogenizing, unifying, totalitarian system, but Utopia as a motor of change.

YO:

Yes. I don't know if you know this, but when John and I were about to be kicked out of this country [the United States] because of immigration problems and all that, we created a country called Nutopia, and we said that everybody, including us, was an ambassador of Nutopia. So we called a press conference and produced a white handkerchief from our pockets and said, "This is a flag to surrender to peace." Not *fight* for peace, but to *surrender* to peace was the important bit.

HUO:

Did you also make any statements or a manifesto?

YO:

Our statement for Nutopia is in the inside cover of the *Mind Games* record (1973). This year there is a group show of art by women

artists in Venice. They invited me and told me that I have to be representing a country. I thought about it, and I decided to represent Nutopia. I felt it was just right for this occasion to be representing Nutopia, a conceptual country. I make an effort to involve a wider section of the population in my artwork. For example, *Wish Tree*: when I have a *Wish Tree* in an exhibition, people line up to tie their wishes on the tree.

HUO:

When did you present a Wish Tree *for the first time?*

YO:

I don't remember exactly when. It was after 1981, after John, my husband's passing. When they did it in Finland they said one tree was not enough. They added so many trees it became like a mini-forest. You suddenly see very strong emotions of people coming out. It is fantastic. I'm keeping all the wishes from all the countries, although I never read any of them. I feel it's not right to read people's private wishes.

HUO:

It's a growing archive not be disclosed?

YO:

It's not an archive. I'll tell you what's going to happen: every piece of paper has a wish on it, I don't read it, and all of them will be put in one big tower of a sculpture, like a totem. It will be a very powerful sculpture... a tower that contains wishes of the people of the world of our time. All in one tower!

HUO:

What else can you say about Nutopia?

YO:

It *is* a conceptual country we all belong to. Did you notice that the back door of my apartment has a little plaque that says "Nutopian Embassy?" It was John's idea to put it there. I'll show it to you later.

HUO:

Did you make some logos and are there some other embassies?

YO:

We avoided politicizing and institutionalizing the concept. We are all embassies. We are all ambassadors.

HUO:

The moment when you did Nutopia was also the time that you were in contact with Jerry Rubin and Abbie Hoffman.

YO:

That's right.

HUO:

If I understood correctly, Abbie Hoffman and Jerry Rubin insisted that you and John give a concert, and somehow that ended up in the press, and then the government got suspicious and wanted to make problems for you with visas. It is ambiguous; you both agreed and disagreed with Abbie Hoffman.

YO:

We liked the theater that the Chicago 7 created in court. It had a great sense of humor. We saw it on TV when we were in London. So we immediately met Abbie and Jerry when we went to New York. But once we met, we discovered that there was quite a difference in our ideas. They believed in confrontation. That concert you mentioned, for instance, would have been a big confrontation with the government. We did not believe in confrontation. We wanted to bring about a change through our artworks and songs.

HUO:

So you agreed with Abbie Hoffman and Jerry Rubin about the necessity of change, but your means to achieve this goal were totally different.

YO:

Totally different. It was very important that John and I stuck to our way, which was the peaceful way. But the underground people thought we were naive, and the establishment thought we were, if anything, a nuisance, so we got it from both ends.

HUO:

One of the many mediums you used for peaceful possibilities was music, and another of the most effective mediums was the Bed-In. Could tell me a little about the "Bed-In" as a peaceful strategy of resistance?

YO:

Bed-In was theater. It was a statement on a very theatrical level and I think it was very effective. Basically, we were artists and did it our own way. I think what we did had an effect. For instance, the song *Give Peace A Chance* (1969)—that was big—opened possibilities to change the world through songs. Saying "I love you" with songs is good too. But this was about creating political awareness through songs.

HUO:

And did the Bed-In take place more than once?

YO:

We did it twice in 1969. Once in Amsterdam, and the second time was in Montreal. Never in New York. Although many people, for

some reason, think we did it here. We wanted to, but we couldn't.
So we thought if we did it in Canada, the message would go right
through to the States.

HUO:

But it became so global that it doesn't actually matter where it was.

YO:

That's right—nobody remembers where we did it! In a way, we did
it in the world.

HUO:

*In very general terms, you aimed at transcending geographical, cultural, sex-
ual, social, all kinds of possible differences.*

YO:

Allowing people to be different, that's very important. That's some-
thing we tried to convey. We felt that we were almost symbolic fig-
ures of that concept. John and I came from very different places. We
were man and woman, we were from the West and the East. Each of
us represented totally different social strata as well. We came from
extreme opposites. So in some ways, we were very different from each
other, but then in another way we were totally together. By the way,
we were very aware of that symbolism, and also how people hated us
for it. We were two people who transcended the positions they were
suppose to adhere to. We didn't get together just to do that, but we
felt that it was very magical that we fell in love with each other and
understood each other totally in spite of all the differences.

HUO:

*We are here in the "white room," so I was wondering if you could tell me a
bit about the space in which we are sitting.*

YO:

This is just a living room. We liked the fact that it had a white
motif. We didn't want too many colors to control and affect our
minds. We were both artists who wished to have our own vision. We
just wanted to breathe without being manipulated by the colors in
the room. As you know, each color has it's own special message,
energy and vibration.

HUO:

So it's not Utopia but Uchromia! *Non-color!*

YO:

[*Laughs*] Yes! Alright, Nuchromia then! Well, it made us breathe
better in our conceptual world without interference.

HUO:

At the same time it is a living room, but it is also a studio.

YO:

Look, for an artist everywhere is a studio.

HUO:

When we were talking about Utopia, I wanted to ask you about your personal Utopia and maybe also your unrealized projects—projects that have been too big or too small to be realized, projects which have been censored or forgotten.

YO:

My favorite unrealized project is the one that will come as an inspiration to me tomorrow. I don't wish to look back. When they were going to do a retrospective show of mine, I asked "Why? Isn't that what you do when the artist is dead or something?" I was kind of opposed to it. So they decided not to call it a retrospective. But the Japan Society show is, in reality, a retrospective show ("YES Yoko Ono." Japan Society, New York, 2000). If that is fun for people, then, Why not? is how I feel now... especially when a lot of my work was not known at the time in which it was made. Right now I'm looking forward to collecting all the wishes together and making them into one wish, a tower of wishes. That's something that I'm really looking forward to doing. And there is the *Freight Train* (1999) also. The *Train* was displayed in Berlin and in Yokohama already. But it's actually a working train. So I want to hook it up to a train that goes to different countries in Europe, and for it to visit every city in Europe that way. Each time it stops in a city or a town, I want people to see the train and write about their memories of what happened. I want the train to go around Europe like that. So that's one project I can still look forward to doing in Europe. I think Europe is the place to do it in, because the train connects all the different countries. It's nice. What else? Oh, I have so many ideas to do collages. And music, of course... I'm planning my next album now. That's about it, in terms of the immediate future. You've listened to *Blueprint for a Sunrise* (2001)? Well, the next album will be more about fun, I hope. [*Laughs*]

OROZCO, Gabriel

Gabriel Orozco was born in 1962 in Jalapa, Veracruz, Mexico. He currently lives and works in New York, Paris, and Mexico City. Orozco studied at the Escuela Nacional de Artes Plasticas, UNAM, in Mexico from 1981 to 1984, and at the Circulo de Bellas Artes in Madrid from 1986 to 1987. He started exhibiting his work in exhibitions held in Mexico in the late '80s. Through unexpected associations and conceptual links, Orozco addresses the relationship to common objects, creating a metaphor for the contemporary condition of transience through both time and place. Varied and everyday materials such as a rubber inner tube, balls of Plasticine, tins of cat food, or yogurt caps are subtly transformed in unexpected combinations that draw attention to and celebrate the discarded and mundane in contemporary life. Orozco's sculptures oscillate between the monumental and the modest, the majestic and the momentary. In 1993, he cut a vintage Citroen automobile lengthwise into three separate pieces, removed the middle portion, and fitted the remaining two perfectly together. Every piece—every screw, nut, and bolt—was split in two and reconstructed to make the original car exactly 62 centimeters thinner (La DS, 1993). Some other works are discreet to the point of invisibility: transitory interventions that last only as long as the time it takes to record them—the artist's breath gently fogging the surface of a polished piano in Breath on Piano *(1993), or the drawing created by riding his bicycle through puddles in* Extension of Reflection *(1992). Orozco's art, like the artist himself, is constantly on the move: from* Nature Recuperated *(1990), a nomadic sculpture that never settles in a permanent place in the gallery, to the photographic series* Until You Find Another Yellow Schwalbe *(1995), which details a series of encounters between his own and other identical mopeds in Berlin. Orozco has received wide international acclaim for his contributions to international group exhibitions such as the Venice Biennale in 1993, the 1995 Whitney Biennial in New York, the XXIV Bienal Internacional de São Paulo (1998), SITE Santa Fe, New Mexico (1999), documenta X (Kassel, 1997), and Documenta 11 (Kassel, 2002). He has had one-person exhibitions at the Museum of Modern Art, New York (1993), the Institute for Contemporary Arts in London (1996), the Stedelijk Museum, Amsterdam (1997), the Musée d'Art Moderne de la Ville de Paris (1998), and the Museum of Contemporary Art, Los Angeles (2000).*

There have been previous attempts to interview Gabriel Orozco, including my interrupted attempt in 1997–98 to film him speaking about his work while we were driving through Paris. That interview coincided with the moment Orozco was beginning to spend more time in Paris, a city that has since become one of the three cities—including Mexico City and New York City—in which he lives and works. The present interview was not interrupted, but it was a quite unusual way of conducting an interview since, at Orozco's request, it was not recorded on tape. In the over 200 interviews that I have conducted, this is the first that was not recorded by either video or audio tape and for which, instead, I had to manually and in real-time transcribe questions and answers. We decided to focus on relatively few questions and to spread it over two meetings. Each time, I wrote Orozco's answers down on blank paper borrowed from Paris' Café Beaubourg where the discussions took place. He had to speak slowly in order for me to take down what he was saying. It created a very interesting condition—a slowness—that went much slower than a conversation. Orozco took the time to think and formulate his responses quite precisely. Of course,

non-recorded interviews allow one to say things off the record, which, then, really are off the record. But more important, perhaps, is the fact that there is no authoritative, objective record to which one can turn, no magnetic tape that bears the "true" and "accurate" combination of words of Gabriel Orozco for any given moment in our conversation. The following is a transcription of what may come closest to "recording" this atypical interview.

.......................

This interview took place in Paris in February 2003.

[1]

Hans Ulrich Obrist:

I have heard a lot from artists (and most recently from Marine Hugonnier, who spent time with you and your group/workshop at the beach), that even if time spent with you seems a bit like a holiday, she had the impression that you and the whole workshop group worked all the time. She seems to describe an unusual and very playful way of working. I was curious about the notion of the workshop and the everyday. Could you speak about this and tell me how this works for you?

Gabriel Orozco:

It's like you and I over the years—conversations and everyday life are a working process. The best art comes from the natural development of the facts in life. I believe in the power of the individual as a unique phenomenon that grows in a community and makes a community grow. I have been a part of several communities that developed on a natural basis. I am part of a small community in Mexico, a small community in New York, and a small community in Paris. These are based on individual encounters so it is not an abstract thing. It is based on everyday life. At the beach, I always noticed that I work better when I am on a holiday—it is a more relaxed way of thinking. In fact, a lot of my work happens between work and non-work, between work and leisure, and between mobility and stasis.

HUO:

Is it a limbo space then?

GO:

I would say it is rather a limbo time.

HUO:

I was interested in knowing more about the Mexican workshop, this small community of artists in Mexico, which is not formally a group with strict boundaries or ideological premises and manifestos, yet nevertheless, clearly has a strong cohesion and has existed for more than ten years.

GO:

Indeed, it is a long story, one that started in 1987 when a group of five young artists came to see me. I was a bit older than they were

and they wanted to study with me. They started to come to my studio every Friday and I was a kind of teacher, even if I don't like the word teacher. I would say, rather, that I was a less-young artist. After five years of this practice some of them opened their own workshops with even younger people. It became like the branches of a tree and a kind of organic workshop with information and dialogue. Then we opened the gallery in Mexico in 2000, which was my idea because I thought it was time to open a different kind of gallery, not just because I needed one in Mexico, but also because there were all these artists without representation in Mexico. The energy was there after many years of work, learning and exchange. I decided to open the gallery with Jose Kuri and Monica Manzutto and we called the gallery Kurimanzutto. Since the energy was there and everyone had been preparing over the years, when the gallery opened in 2000, it was a boom. A real boom. The gallery is a workshop itself, but it is also a business. It is important that it works as a business in the marketplace.

HUO:

So it is not a non-commercial artist-run space even if it is artist-driven, thus unlike the tradition of those spaces one might think of in England—like Bank or City Racing—that sprung up in the '90s on the English scene?

GO:

There is a long tradition of artist-run spaces in Mexico, but they have never succeeded in inserting the work of their artists in the market. It was important to make it a real business but, at the same time, not a conventional gallery. There are some important aspects to it, like the fact that it does not have a permanent space and it does not have a white cube. The gallery started by showing the work of artists in places like a real fruit market, in rented commercial spaces, or touring in bars. What was important was that it was a gallery that started with strong ideas and a strong group of artists already active and with energy. For me, as the initiator of the project, I consider the beginning of the gallery an artwork. In a part of the gallery we keep doing other projects, workshop collaborations, etc., but at the same time the gallery is growing in multiple directions depending on the specifics of every single artist and the directions of Monica and Jose.

[*Break for lunch*]

GO:

Most the participants are also good friends. We travel together and when we are traveling we are always creating situations in which

we are talking in a very natural way. We can say many things to each other. We can be polemic, scream, and laugh. We laugh so much! We drink, we say stupid things. It's like an old-fashioned bohemian group before the market arrived, a bit like a Dada or Surrealist group, or even like Lawrence Weiner and Dan Graham in New York in the '60s. But New York is no longer like that.

HUO:

Is there a relationship, for you, between the art scene of New York in the '60s and Mexico in the '90s?

GO:

In Mexico in the '90s, the young artist was an outsider with no infrastructure so one had to create it. It took ten years. Actually, more than that, more like 15 years. We had no support from the government since there is no British Council or AFAA [Association française d'action artistique] in Mexico. Thus we didn't expect to have any support. Now we have some support from the government, but only because they are not blind: they help us now because they realize that now we have the power. We created it ourselves.

HUO:

You have evoked the artist-run space, the workshop, the energy of the artist, and, as an artist you are now curating a section in the Biennale di Venezia ("The Altered Quotidian," Venice Biennale, 2003). Can you speak about the power of the artist?

GO:

I believe that one artist can be the focus of an energy that can be very powerful. A lot of my energy was deposited in New York at the beginning of the '90s and it was not unnoticed. Then, starting in 1999, I focused on Mexico. When preparing my exhibition there I became aware that there was a latent energy with all the artists who continued to do things after the '87 workshop. I remember that some curators visited Mexico in the '90s and the young artists were not ready yet. They were young and now they are mature. And now they have the right platform to be launched. I remember talking to Jimmie Durham who was living in Mexico in the '90s. I remember talking to him at the time; there was nothing interesting going on in Mexico then. Now, I have invited him to join the project I am curating in Venice for the next Biennale. Durham was an outsider living in Mexico at a moment when there was little happening. The fact that he will be with us in the show in Venice will recover some of his relationship with Mexico that started a long time ago.

HUO:

Can you speak about the situation of Mexican artists who seem quite different compared to other countries in Latin America where artists have traditionally come from upper-class backgrounds? In Mexico it seems that artists come from all different kinds of backgrounds.

GO:

In the Venice exhibition, for example, the artists are from different backgrounds. Daniel Guzmán is from lower middle class; Abraham Cruzvillegas is the son of a university professor; Damián Ortega is from a middle-class intellectual family. My parents were artists. The art world in Mexico is like that, very mixed.

HUO:

I've heard that for the show in Venice, there will be no photography and no video, that these are the rules of the game.

GO:

I am behaving a little bit like a tyrant, but I like games, so I put rules on the game. There will be no walls, no video, no photography, no pedestals, and hopefully the artists will manage. I wanted to point the direction towards the practice of the analytical object and the real shit.

HUO:

Could you elaborate on the title of the show, "The Altered Quotidian," and the use of improvisation?

GO:

All the artists in this show have already been working with these issues. Improvisation is important since all the artists have used this practice as a way of speeding up and dislocating the frame of the institution in the moment of absorption. The show in Venice is the latest collaborative project between these participants. It is not the first show we have done together. I don't even consider myself a classic curator, in a stereotypical curatorial way. I am, rather, the head of a team, a coach, or a producer, an organizer, a representative, a cheerleader, a host of the party, a captain of the boat. A curator can be many things, including someone like Noah before the floods. In short, an activist, an activator, an incubator.

HUO:

For your retrospective at the Los Angeles Museum of Contemporary Art in 2000, you invited artists rather than critics to write on your work. Can you tell me why?

GO:

I invited Damián Ortega, Abraham Cruzvillegas, and Gabriel Kuri to write in my catalogue for the simple reason that they were

the only people in Mexico who truly knew about my work. The critics and curators were far behind in understanding my work. I wanted an important book for Mexico. Damian made a comic strip, Abraham wrote a historical text, and Gabriel wrote an analytical text. The important thing is that these artists keep doing their own work on a regular basis. To write about art, to talk about art, to drink about art, and to show art is one whole activity for the group in Mexico and one of the ways we grow in a common way.

HUO:

Can you speak about the group you had around you in New York?

GO:

We were a group by destiny, by chance really. We were all immigrants, including Americans from other cities who came to New York in those years between 1991–93. The real "nineties" were from 1992–1996/7 and then the '80s came back. We were all in different galleries but were doing things together and spent time together in the everyday. And then we started to travel outside, so we were all New Yorkers working around the world and not so much working in the local scene, except for Rirkrit Tiravanija and the project with Gavin Brown's Enterprise. I was more focused on the world. For me, it was time that New York ceased to be center of the art world. I wanted a New York more open *to* the world and working *for* the world, not like the situation in which the world was working *for* New York.

HUO:

Who was a part of this group?

GO:

I don't know exactly—Rirkrit Tiravanija, Elizabeth Peyton, Lincoln Tobier, Andrea Zittel, and others. It is strange and very funny, but I do not know if we actually were a group. Rirkrit and I developed a strong friendship, but I never became close friends with some of the others. I don't follow close relations framed in the institutions of the art world unless they become part of everyday life. The life outside of the art world is very important. Our Mexican group, for example, is beyond that. We are conscious that it can be threatened by art world alienation and that the art world can destroy everyday life. We are up for the challenge.

HUO:

Another subject that I'd like us to speak about is the prevalence of a situation that approached the '60s idea of post-studio practice, as Daniel Buren,

for instance, wrote. In the '90s, it seemed less a question of belonging to geography than being between geographies.

GO:

I feel closer to André Cadere than Daniel Buren. Because for Cadere, the scale of the work is in relation to the body in the landscape and the city, and thus more connected to reality. When you think of Cadere, you don't think of a powerful traveler who is locating his/her abstractions in exotic places. In the contrary, Cadere places himself as an exotic figure and exposes his body and persona to the abstract institutions—the white cubes of the world. Cadere put himself in a vulnerable position, almost to the point of being a martyr. This is more interesting to me than the idea of the untouchable traveler who is conquering the hearts of the people of the world—a position that approaches colonialism. It is a messianic role that is dangerous for the artist. I like traveling to expose myself, to generate spaces of exchange between an individual and the specifics of the world. I don't have a map of the world pointing to all the places I have been. I am not interested in filling every city of the world with works. When I travel, I am not an adventurer. In fact, I'm quite a city boy and traveling is not a romantic thing in my life.

HUO:

I want to ask you a question that was raised in the exhibition "Laboratorium" (various locations, Antwerp, 1999) about the studio and if maybe one cannot so easily trace the difference between the inside and outside of the studio or the laboratory anymore—a kind of Bruno Latourian drop? This may lead to a discussion of your longer trips to India or to Mali...

GO:

This touches the issue of the temporal studio and the abandoned studio. Working in a place very intensely, which you then leave for a time has the effect of stopping time in the studio. The post-studio practice in my case was to understand this studio on a temporal basis and not on a spatial basis. I took the word "studio" literally, not as a space of production but as time of knowledge. That time of knowledge can be generated in different places: outdoors or indoors. And the result of this, the product of temporal studio practice, is unpredictable, because I don't own the means of production: I don't own a factory, I don't have a school, I have no assistants. You have Warhol's factory, which is a travesty of the capitalist artist. You have Richard Serra, who has workshops around the world, creating a heroic vision of the worker. And you have Beuys, who contributed to the romantic notion of the social teacher

and is very related to the notion of schools. I can use all of these models. But my favorites are the street, kitchen, and table. And, most important of all, light. All of these supports, on a temporary basis, are important to my work, but where there is good light, there is my time to work.

HUO:

Can you speak about the three houses—in Paris, New York, and Mexico City—where you alternately spend time. In each house there are sedimentations of furniture, your works, and objects that you have found. How do the houses function and how are they distinct from the reality of the studio?

GO:

I got interested in the process of reconstruction and building up a house as a private, experimental place. It became a real pleasure to buy and make furniture, to construct spaces of thinking and living. I am interested in everyday life and the house is a natural consequence of that. These three houses are not properly studios, they are more like open houses and philosophical spaces in which books, carpets, and meals as much as music, light, and furniture are part of the thinking process to share with people. They are intimate places. They are not salons and I don't have parties or receptions there. I use them as spaces for thinking, for dialogues. The Paris house feels very philosophical, the house in Mexico City is more like a light box, and the apartment in New York is more like a cabinet.

[A week later]

HUO:

Continuing with the topic of the house, which is where we stopped in our last conversation, I am interested to know more about your unbuilt house. You submitted the unbuilt house project as your contribution to a book that I edited with Guy Tortosa titled Unbuilt Roads (1997). *That book started from the observation that architectural models are often submitted for competitions and while many of them are never built, they are often published, but that art projects that were not realized, for whatever reason, often remain unnoticed or little known. Changing this condition slightly was an idea explored in* Unbuilt Roads *through all kinds of unrealized projects. We had an important early discussion with Dan Graham who encouraged us not only to include unrealized utopian or visionary projects in the publication, but also to incorporate projects that, in a totally unromanticized way, are unfulfilled for technical and economic reasons. So* Unbuilt Roads *has been conceived in the spirit of a concrete Utopia, com-*

piled as a hybrid collection of materials full of contradictions, where possible and impossible concepts are presented in a field of tension been the unreal and the highly probable. So we could perhaps say that your house, Gabriel, is a concrete Utopia because it is a very feasible project.

GO:

Well, it's a nice coincidence that you have brought this up because I now have the occasion to build it. The house is based on the astronomical observatory in Delhi, Jantar Mantar. I like the idea of having a very simple structure of four spaces, four rooms surrounding a half sphere swimming pool. At last I have found a place to build it: in Mexico near the ocean. I have to say that for me, this project is not about building a house for someone else. It is a house for me. I would not be so sure of putting all my houses in the art-world context. This one is a work in progress. The others are platforms for thinking.

HUO:

Can you tell me more about the way that the house is experienced, how it is perceived?

GO:

In this house, when you leave a room, you don't see the house anymore. It is a house that disappears quite often. It is all concentrated in one point: the swimming pool. When you are in the swimming pool, the house disappears. The swimming pool is a semisphere in the roof. When you go out of your bedroom, you are immediately outside, and the house disappears.

HUO:

As with the Yogurt Caps *at Marian Goodman?*

GO:

With the four yogurt caps at Marian Goodman gallery you always miss one. You can see just three of them when you look at the whole room; it is as if they are not there. The yoghurt cups are very discreet and when you walk towards them, the room disappears.

HUO:

Could you tell me in general terms about your relationship to architecture. This is something we have discussed a lot, including your interest in the work of Dan Graham and also others in the architectural field.

GO:

At one point when I was at art academy in Mexico, I was also working with an architect, who was the father of a very good friend of mine and he invited me to work on some architectural competitions with him. From that I gained some knowledge of architecture. [Antonio] Gaudí was very important early on. I like Hans Scharoun

and Le Corbusier—the very basics in architecture. But I really fell in love with the work of Renzo Piano when I came to visit the Pompidou in 1982. I was twenty years old. I fell in love with the Beaubourg, the Centre Pompidou. It is a machine, a body, a building. It works. It is spectacular and practical.

HUO:

Can you tell me more about your interest in Gaudí?

GO:

I saw Gaudí's work for the first time when I was a kid. My father had books on Gaudí and they made my fantasies fly. I loved the organic shapes, the irrationality of them, and then to discover that there is rationality within them! I was impressed by the fantasy and the uniqueness of the work. He had a unique brain. When you see his architecture, you see someone thinking. Thinking is an organic process. It is not a technical process but an organic process. When an artist is thinking in technical terms, it is to do with efficiency and perfection, but when an artist is thinking organically, it is more related to his life, imperfections and creativity. It is a more unpredictable creativity. Gaudí invents structure and then he questions the structure to invent a new structure, which he questions again. It is an infinite questioning of the structure that makes the structure. I try in my work to be like this.

HUO:

I saw Gaudí's work for the first time in an exhibition curated by Harald Szeemann called "Der Hang zum Gesamtkunstwerk" in Zurich ("In Search of Total Artwork," Kunsthaus Zurich, 1983). I wanted to ask you if you could tell me about your ambiguous relationship to Utopia and the gesamtkunstwerk? On the one hand you have an interest in the ideas, and on the other, you've often demonstrated skepticism about the idea of imposing ways to live on other people.

GO:

I'm skeptical about architecture and Utopia. The experiments I do with architecture happen because I'm intrigued. They happen because I think it could be interesting to work on architecture. But, in the case of my houses, it's part of my private life. In other words, it's a private investigation. There are many people who have asked me to do a house for them. I don't think it is a good idea. But, of course, a lot of my work is quite related to architecture in part because of the way I use site-specificity. In the end, I think that architecture should function like a shoebox.

HUO:

Is this a reference to your Empty Shoebox that you showed at "Aperto '93" in Venice (Venice Biennale, 1993).

GO:

Yes. I think architecture should be a receiving space, a yielding space, not an imposing space. That's why I was interested in the idea of the "yielding stone." In the animal world, in the natural world, the stone is a platform where animals rest and sit, stand and view; it is a place where they have a better view of the landscape. I think architecture has to be a kind of yielding stone.

HUO:

I knew previously of your enthusiasm for Gaudí, but I didn't know that you were interested in Hans Scharoun. In the immediate postwar years Scharoun joined Bruno Taut's circle of Expressionist architects, the Gläserne Kette, and his lifelong commitment to socialist ideals dates from this time. Could you tell me more about your interest in him?

GO:

The Philharmonia in Berlin by Scharoun is one of my favorite buildings, both inside and out (*Berlin Philharmonic Hall and Chamber Music Hall*, 1956–1963). The outside is very intriguing. When you are inside you can feel the architect's thinking in every corner. The architect puts himself in the position of the inhabitant in every square meter of the building. When you go inside, every point in which you stand and at every moment you spend there, you sense that the architect had stood in that exact spot at some point, looking at the possible infinite. You never feel that he forgot about this corner or that. He considered every square inch of the building.

HUO:

In an interview with Benjamin Buchloh, he asked you to talk about non-space, and you said, "Let's talk about volume..."

GO:

The first approach was banal: the shoebox was a perfect white container. The top was on the bottom, leaving the box open, and very fragile. Monumentality is not related to size. I don't think monumentality has to do with size. That's why I'm not in a hurry to make bigger works. I thought that to put it into this white booth in the "Aperto '93," to occupy the whole space, and negate the whole space. As I said when we were talking about sculpture, I was interested in the container idea, the transportation thing, and just neutralizing or suspending the whole thing. It's the same with the yogurt cups, except with other expectations and another type of

space. So with an empty shoebox you see the whole nothing—it's a shoebox, it's not even a base or anything.

HUO:

What about {Carlo} Scarpa in relation to your new piece for the Venice Biennale, which you developed for the Italian Pavilion. Could you tell me more about this piece and your interest in Scarpa's work?

GO:

At this point the piece is not done. It is not easy to talk about a work that is not done. We can speculate. You can apply exactly what I say in the Benjamin Buchloh interview to this Scarpa work. The title of the piece I'm doing in Venice is *Shade Between Rings of Air*. And I'm reproducing the *Pensilina*, the pergola structure by Scarpa on the patio. I'm actually reproducing this in the adjacent space on a scale of 1:1. And maybe I'll make an ephemeral intervention in both of them, but I'm not sure about it yet. So you will have the distorted mirror image of the real patio reproduced as a kind of platonic ideal model, but it is the same size, so in a sense it is not a model, though it works as a real-size model. This pergola is a container. It is also a very light and fragile structure. It is a space within a space. The shoebox was a white cube within a white cube. This is a mirror in the space because they are together. With this space, I'm negating space, and it is still true in this case that this new object in the white cube is somehow independent of the white cube, which refers to reality, to the original structure and the real patio with the weather, sunlight, and vegetation. But then this is an object on its own, and because I take it out of the realms of the architectural and insert it in the realm of the art object it becomes a kind of sculpture. But it is also still a recipient, like the original building.

HUO:

It's not a readymade?

GO:

The shoebox was a recipient and this is also a recipient. The yogurt cups are also recipients. It still applies. Scarpa did this beautiful patio as a recipient for sculptural objects, but the problem is that it is so beautiful and strong that it became very difficult to use it for artists. My version of this patio is not a readymade. It works as usual. The shoebox is a shoebox.

HUO:

But this Scarpa pergola is a display feature with which to display sculpture. As Richard Hamilton told me a few years ago in a conversation, "Every relevant exhibition since 1851 has invented some new display feature."

GO:

Yes. It's a display feature and you can see that in the beginning it was used in the '50s and '60s by traditional modern sculptors like Jean Arp. Nowadays, this is obsolete. The problem with architecture is that if you make a museum, the architects most often try to do it and show it as a sculpture. In this case, I'm bringing an architectural piece inside the world of sculpture to see what happens. It's an experiment in the connections between art and architecture. Another aspect is that neither Scarpa's patio nor my *Shade Between Rings of Air* are monumental. That is an important difference. You could say that nowadays architecture is trying very hard to fulfill the apparent need of monuments that contemporary sculpture has refused to create anymore. This is a political aspect in which architecture is taking a role that contemporary art is not so interested in. It is a critique of architectural monumentality.

HUO:

The title of your piece is intriguing. What role do titles play for you, and where do you draw the line between the title and the work?

GO:

The titles are important in general. I try to use very descriptive straightforward titles but with some poetic potential. So when I say *Shade Between Rings of Air*, I'm not lying. It's quite accurate as a description of what this patio is doing, but I'm just naming it in a different way, and that's why it sounds poetic. Another example is *Extension of Reflection* (1992)—I'm not lying there either. You can see the water in the puddle and the reflection in it being extended by the wheels of the bicycle. It is an illusion, but it is somehow true.

HUO:

Speaking of inventions of new displays, your work very often invents new three-dimensional display features...

GO:

I'm interested in the fact that the three-dimensional work is freestanding and self-contained. I don't like walls. I don't like dark rooms and I don't like vitrines. I always try to generate the notion of landscape, maybe a forest, maybe a desert. I think the photographic piece is a kind of landscape with rocks, trees, and different objects. The "yogurt cups space" is a kind of desert with four rotating moons, and the "aquarium" in ARC is like a glass greenhouse. The show at ARC with *Color Travels through Flowers* (1998), enti-

tled "Clinton is Innocent," is a kind of promenade between air ventilators, toilet paper, music, visual vibrations and blackboards ("Clinton is Innocent," ARC / Musée d'Art Moderne de la Ville de Paris, 1998). There was a pond, a ping-pong table, and a doll's house. It was between a park and an urban configuration. The Philadelphia show, "Photogravity," was about display and time, between two-dimensionality and three-dimensionality, between reality and representation, between volume and light (Philadelphia Museum of Art, 1999). When you see the pieces from what we might call the front, there is the illusion of volume and sculpture. But, in fact, they are just flat photographs. When you look at the piece from what we might call the back, there is the illusion of a flat drawing with lines and dots, even if in reality it has volume and it is a sculpture with metal and wooden balls. There is a time factor in which you have to walk into the piece to travel from two-dimensionality to three-dimensionality.

HUO:

Of course it makes me think about Marcel Duchamp's remark that "the spectator does half of the work."

GO:

Yes, I was also playing with the memory of my own work—the Benjaminian reproducibility of my work through photography and arbitrary associations between my work and the pre-Hispanic collection of the museum. All of this in the context of a very grand and classical museum. I like the idea that this display looks a bit like an inexpensive museographic display in a regional museum.

HUO:

A question for you arrived by E-mail from Molly Nesbit. An interview always hides another interview, not unlike the Russian Matruschka dolls and similar to your own notion of space in which a space hides another space. So we have a shoebox question arriving via E-mail from New York City. Molly asks, "Do you put your horizons in a line and make a picture depend on it? (The photographs in the cemetery in Timbuktu are a great exception). But the horizon is, nonetheless always a factor, even if it has been moved somewhere else (beyond recognition?) in space. What would be the role of the horizon then and what is its use now?"

GO:

I'm actually not interested in the horizon very much. I believe in the possibility of several vanishing points or gravitational points. That's why I mix up sculptures and images, and I like the tension and possible translation between the vanishing point and the grav-

itational point. The yogurt cups are a good example: they are vanishing points at the limits of the space of the gallery, they open and close the space at the same time; and the gravitation point is the spectator, who moves and activates the vanishing points. They move at the same time that the gravitational points move.

HUO:

Could you tell me about your trip to Mali and your encounter with the cemetery at Timbuktu? This was shown last December (2002) in your exhibition at the Chantal Crousel Gallery, in which you brought together photography and sculpture once again. The Mali photographs were shown alongside tables with your pottery.

GO:

The roots of this are in my Documenta piece [*Cazuelas* (*The Bowls*, 2002) Documenta 11, Kassel, 2002]. I was interested in the pots because of my concerns about the recipient and in the systems of transportation (*La DS*, *The Elevator*, *The Schwalbes*, *The Shoebox*). When I did the *Cazuelas*, I was working with rotating recipients and at that point I became interested in Mali ceramics, and that's why I went there. In Mali, I discovered the cemetery of Timbuktu, which was an astonishing surprise because I'd never heard of it before. After that trip to Mali I continued my work with terracotta, thinking of recipients but also about other forms of containers and methods of transportation—thinking about bread, food, bottles and landscapes. That's why I put together the photographs with these works, because the photos are very documentary photographs. They are a reflection of the issues in my sculptural work. The connection between sculpture and photograph is sometimes indirect, while other times it is very direct—almost 1:1.

HUO:

You have said that one of the threads throughout the '90s was a constant questioning of the object, often resulting in the object as a by-product. What is the status of the object in your work?

GO:

There were two points of tension in the use of objects in the early '90s—one was the object as a by-product of an action in life; the other was an insertion of an everyday object and its function into the art context. This is still useful. It can still be used in its original capacity. I always try to put these two things together—*La DS*, for example, is a by-product of a very specific sculptural action. But it was also important for me that you can still get into the car and feel that you are traveling. It was the same with *The Elevator*. *The*

Shoebox is still a box that receives whatever might be in a shoebox after the shoes are gone. *The Yielding Stone* keeps transforming itself with the fingerprints of the spectators/activators. This brings us back to Duchamp's idea of the public doing half of the job. I hope that the new work, *Shades Between Rings of Air*, will still function as it was originally intended, as a kind of shaded corridor in a patio. Of course, in the realm of museums and conservation, there is a moment at which the museum won't allow these works to keep operating, like the chess piece—*Horses Running Endlessly* (1995), which is a game but is now protected in a vitrine in the Museum of Modern Art in New York. I am conscious that this will happen anyway, sooner or later, for the conservation of the object, but I hope it will still function in the minds of people, making the car, the elevator, and the ping-pong table work in their memories and imaginations. When I saw all the Fluxus objects in vitrines, I was terribly sad. They had become relics of past life. I would love my work to trespass out of the vitrine, and be clear enough to function in the imagination of people. Imagination is the first, the last, and the most important place for the art object.

HUO:

I'd like to ask you about the connection between the political and the act of placement, for example in the case of the oranges in your Home Run *project at New York's Museum of Modern Art (MoMA) (1993). The work involved you asking people to place oranges in cups, vases, and other containers in the windows of their apartments across the street from the museum. What are the possibilities of linking the exhibition space to private space, social space, and sacred space?*

GO:

The title *Home Run* is taken from baseball when the ball is hit out of the stadium and you run round all four bases at once. The piece speaks of public sculpture, private spaces, corporate spaces, everyday life, monumentality, perception, landscape, ephemeral installation, and sculptural practice. I tried to put all these things together and mix them up. I like to bring reality into the museum. I also like to kick art out of the museum and always to think in different ways to define the public, the spectator, the democratic space for art, and the economy of public monuments.

HUO:

Could you elaborate on the connection between the political and the act of placement?

GO:

In public sculpture, the political goes hand-in-hand with the eco-
nomical, and I don't trust any public sculpture that looks like a
political or an economical imposition. Corporate art is the new
political imposition.

HUO:

The MoMA installation in which you oscillate between the inside and the
outside leads of course to the question of how you deal, in more general terms,
with the museum.

GO:

I'm very sensitive to museums and I can recognize that they are
very different from each other. At this point in my life I know
many museums from the inside and the outside: the offices, the
washrooms, the guards (not to mention the trustees and the cura-
tors), and I can recognize the differences and the specificity of each
one. The atmosphere in the building and the people at ARC is very
different from Beaubourg, not to mention the atmosphere at
MoMA. I try to take the museum as a real thing so I try to be aware
of their accidents, their history, and their limitations, and I work
with museums as I work with a market in Cachoeira, Brazil, or the
cemetery in Timbuktu. I don't think the museum is a fictional
place. I think it is as real as a cemetery or as a market in which you
can have dead things, live things, rotten things.

HUO:

What is your relationship with archives and to the administrative aesthet-
ic—documents, files, and indexes—that conceptual art used to love? I
remember from a previous conversation that there was also a doubt that you
had concerning the cumulative nature of the archive.

GO:

The idea of the archive as a cataloguing or an accumulation of goods
or signs is boring to me. It is something I don't think so much
about. For example, unlike a Conceptual artist, I don't think about
using archive words, administrative aesthetics, and so forth—I pre-
fer to think that all the photos I've taken, I took today, and all the
works that I've made, I made today. If I don't feel that all my work
was done today, I would rather archive them in the trash, because
they are not useful any more. I prefer to think of a chance archive,
an archive without chronology and without hierarchies; divided or
"catalogued" with the accuracy of a trashcan in the street.

HUO:

I also wanted to ask you about your relation to science.

GO:

I am interested in mathematics, topology, geometry, physics, philosophy, and many other things. These have been important for my work. In most of my work there is something hidden and something evident. There is a reflection about philosophy, geometry, and physics. I like them to be a kind of secret behind the work. It is a secret meant to be discovered one day. I use science as a platform to launch the poetic. If the poetic happens, then you can have access to the scientific in my work. If it does not happen, my work just looks like nonsense, like a book full of diagrams that you don't understand. When someone thinks and tells me that they don't see the relationships between my different works or they cannot grasp the geometry behind it, that makes me happy because that is how I see reality—in its nonsense and its arbitrary nature. But we know that there are hidden rules, geometry and laws that are up to us to invent or discover. I think an artist has the responsibility of creating a universe that has the complexity and immensity of all human capacity, but this so often doesn't happen. We don't say, "I want to create in order to generate a universe," because it would be as absurd as to claim, "I want to do something poetic." That never works. Universes are created by chance, explosions, knowledge, intuitions, awareness, ignorance, and physical actions. There are possible scientific aspects of my work; I have an interest in the general laws of the universe and its fantasy to generate patterns of thought in my everyday life. But when artists try to be scientific, they make the same mistakes as when they try to be poetic or aesthetic. They end up making science for kids or poetry for teenagers. Art is for adults.

OTTO, Frei

Frei Otto was born in Siegmar, Germany, in 1925. He currently lives and works in Stuttgart. From 1931 to 1943 Otto attended Schadow School in Zehlendorf, Berlin, as a mason trainee. After serving as a fighter pilot in World War II, he trained at the Technical University of Berlin from 1948 to 1950. In 1952 he established a studio at Zehlendorf, and in 1957, he founded the Development Center for Lightweight Construction {Entwicklungsstätte für den Leichtbau} in Berlin. Seven years later he transferred the center's activities to the Institute for Lightweight Structures {Institut für leichte Flächentragwerke} at the Technical Academy in Stuttgart. Frei Otto is the seminal figure in the development of tensile architecture. He was the first to lead away from simple geometric solutions and toward organic free forms that could respond to complex planning and structural requirements. A lot of Otto's findings came from his study of the self-forming processes of soap bubbles, crystals, microscopic plants, animal life, and branching systems. He found that natural objects create forms that are very efficient, wasting nothing and using a minimum of material. Key structures and buildings designed by Frei Otto include: The Dance Pavilion and The Entrance Arch at the Federal Garden Exhibition in Cologne (1957); The Harbour of the Swiss National Exhibition (1964); the German Pavilion for Expo 67, Montreal World's Fair; the roof over the buildings of the Olympic Games in Munich (1972); and the Japanese Pavilion and the Venezuelan Pavilion at Expo 2000 in Hannover.

........................

This interview took place near Stuttgart in July 2000.

Hans Ulrich Obrist:

From the very beginning you have worked with ephemeral structures—light-weight tent-like structures. What stimulated your interest in this approach?

Frei Otto:

It is the doubt of architecture's durability. Already as a student I asked myself, "How long can the functions that make a building useful remain working? For how long does a one-family house fulfill its original purpose?" And then, one extraordinary event in post-war Germany was the blowing up of the Berlin bunkers. They were the most durable buildings ever built, with two-meter thick walls made of armed concrete. Durability is a very particular function of a building. But if you study the continuity of a building's functions, you realize that they change rather quickly. A family would have to rebuild their living quarters every five years, or would have to move and find new ones. But I also work on religious buildings, both for

the Protestant and the Catholic Church, and in 1970 I built a mosque in Mecca. I realized that even there, the necessities for a building constantly changed, regardless of how rigid the rules may be. After the war, the large churches were empty in Germany. So they built small community churches for congregations of 50 to 200 people. This was necessary for their self-support. The customs change as well, and with them the functions of a religious building. One catholic priest, who used an airplane for his missionary efforts, once commissioned a church tent that could be used simultaneously as an airplane hangar. That was an interesting challenge, for the tent was not supposed to weigh more than 900 kilos. I don't claim that light is good and heavy is bad. Rather, the right parts of buildings should be heavy or light. Lightweight buildings are easier to move and to recycle. I advocate for buildings to die in dignity.

HUO:

How do you explain that this idea has been very well accepted in Asia but rarely in Europe?

FO:

That is in part a question of building materials, I believe. If you build a stone house, it is more durable than a bamboo house. Bamboo houses have to be rebuilt constantly, and every generation builds a new house. There is a custom to burn the house after an owner has died. That has many reasons, hygienic ones among others. Adobe constructions, on the other hand, crumble and collapse if they are not inhabited. Adobe buildings are very durable, but require constant maintenance. The interesting aspect is that the different construction methods not only result in different houses, but also in different cities.

HUO:

Many of your works were developed for exhibitions. To what extent do you consider exhibitions to be laboratories for developing new designs and ideas? In 1955, for instance, you experimented with different tent designs for the "Bundensgartenschau" {"Federal Horticultural Exhibition"} in Kassel.

FO:

These tent constructions were developed by accident. I wrote my dissertation on "The Suspended Roof." The tent is one variety of a hanging roof. So I contacted the Firma Stromeyer, which was the leading manufacturer of tents at that time, and began experimenting together with Peter Stromeyer. We tested new tent shapes and designs. Among them were wave-shaped tents, umbrellas, and a so-called

four-point plane, which was suspended between two high and two low points. In January 1955, Hermann Mattern commissioned me to design pavilions for this Federal Horticultural Exhibition in Kassel's Fuldaaue park area. We used the four-point tent as a music pavilion: an umbrella pavilion, constructed of three double membranes suspended in rings, and for the sloping edge of the park we proposed a wave tent. At that time we also met Paul Bode and his brother Arnold, who organized the first Documenta in Kassel the same year.

HUO:

So the two events were really connected?

FO:

Of course. Experiments were not only part of the horticultural exhibition, but the really big experiment was the connection between the horticultural show and the new type of art exhibition that Bode organized: Documenta.

HUO:

In 1957 you participated in exhibitions in Cologne and in "Interbau '57" {"International Building Exhibition"} in Berlin, where you presented not only individual structures but also constellations of works...

FO:

For the "Federal Horticultural Exhibition" in 1957 in Cologne, my Berlin team—Siegfried Lohse, Dieter Frank, and Ewald Bubner— and I designed more experimental tent structures, which were all related to each other: the *Dance Pavilion*, the *Entrance Arch*, the *Riverside Shelter*, and several mobile fountains. Every building was constructed from simple cotton and was meant originally to last for just one summer. We thought the buildings would disappear after the exhibition, and the environment would not be harmed. This was part of a larger philosophical concept which allowed us to experiment unburdened. For the *Entrance Arch* we introduced a new fabric: glass silk, which is a kind of woven fiberglass. Today, stationary permanent tent structures all over the world are constructed from Teflon-coated fiberglass fabrics. One very special experience for us was the enormous popularity of the *Entrance Arch* and the *Dance Pavilion*, which, as a result, remained in Cologne for many years.

HUO:

You've always actively taken part in the construction itself, resisting the idea that the architect only provides the plans and that it's up to the client to execute the building?

FO:

I reject the idea. Architects, engineers, and contractors have to collaborate closely from the beginning and they have to finish the proj-

ect together. But prior to that, experiments and visions are necessary. We have investigated processes of autogenesis, natural constructions, the topic "Nature and Building," and even air—with pneumatic structures—as a construction material. We have conceived of buildings that only existed in our minds and have sketched plans that never were realized.

HUO:

Were those utopian projects?

FO:

They were utopian. I admire [Karl Friedrich] Schinkel's designs for the *Orianda Castle* (1838) in the Crimea. I am certain that it was best for these wonderful designs that the palace was never built. We cherished the possibility to design temporary structures for exhibitions, which often resonated more powerfully than permanent buildings could. [Ludwig] Mies van der Rohe brought this to my attention when I visited him in the U.S. as a student in 1950. When asked about his pavilion for the Barcelona International Exhibition in 1929, he just laughed and said, "It's gone. And that's good. Imagine it would still be there, but run down and decrepit in Barcelona. Everyone who remembered it clean and precise would be disappointed." This demonstrates that exhibition architecture can have an enormous impact, because the temporary statement can be more intense than the permanent one.

HUO:

Philip Johnson has a very similar position in this regard. He favors exhibition structures as the optimum possibility to make a powerful architectural statement.

FO:

I agree with Philip Johnson in this respect. Beyond that there are many differences, especially in regard to his position after 1972. We have known each other since 1960. Back then I taught at Yale University. A few years later we met in Berlin again. He presented a wonderful lecture about Schinkel, in which he analyzed the relation between Schinkel and Mies very precisely. In Berlin he was mainly attacked for his unwillingness to assume a determined position of thought. Obviously he searched for new models after the demise of Postmodernism, but he never found it in Deconstructivism. Now deconstructivism has passed as well, and the game is open again. I had high hopes that the Expo 2000 in Hannover would open a new direction. But although the fair received a better infrastructure and a few new buildings, it did not have the character of an international world exposition. Only very few

small nations really engaged the "green" topic.

HUO:

Could you explain the concept of your exhibition of architectural designs at the Museum of Modern Art in New York? ("The Work of Frei Otto," 1972).

FO:

Ludwig Glaeser organized the exhibition in the garden of the Museum of Modern Art. Photographs of my buildings and designs were presented on aluminum panels under a white tent structure, in a weatherproof outdoor installation. The exhibition successfully traveled to many other venues in the U.S., in Europe, Australia, and ultimately to Moscow.

HUO:

Peter Smithson explained to me that exhibitions provide a unique opportunity to test ideas. It seems to be true also in your case, if we look at the works you realized in the Federal Horticultural Exhibition in Kassel and even in Hannover.

FO:

For me this entails two aspects. On the one hand, exhibitions provided the opportunity to realize things I had only started to think about. I was able to advance my research and inventions through exhibitions, because I received official funding for my research only after 1968–69. And on the other hand, I realized that my work was not in opposition to society, that new things were accepted. Our success in the Expo 67 in Montreal with the German Pavilion made it clear. That was my way.

HUO:

I believe that way is exemplary for an approach to solve challenges experimentally and not routinely.

FO:

You cannot make exhibitions routinely. As soon as routine enters, exhibitions become boring. Experiments are necessary and will be rewarded.

HUO:

But today we can witness a disappearance of such a longing for experimental approaches. It's hard to imagine "Weissenhofsiedlung" taking place today, or to realize that Weissenhofsiedlung, this invitation made to the 17 leading architects of the time—Mies, Le Corbusier, Walter Gropius, etc.— to design and build housing structures, was only a component—of course a central one, but still—in a larger exhibition! ("Die Wohnung" {The Dwelling}, Stuttgart, 1927).

FO:

I knew some of the architects of the Weissenhofsiedlung personally. But I developed a direct relationship to the project only after I

began teaching in Stuttgart in 1964. Back then, students visited constantly to see the Mercedes Museum, the Porsche Museum, the Weissenhofsiedlung, and our institute. But if you studied the Weissenhofsiedlung more thoroughly, you realized that it was altered after World War II. Although only a few buildings were damaged during the war, their roofs were replaced with so-called "Stuttgart roofs" after the war and the buildings' original designs were no longer recognizable. Mia Seeger, Bodo Rasch and I founded an advocacy group—the "Friends of the Weissenhofsiedlung"—to raise funds for the reconstruction of the buildings by Mies van der Rohe, Le Corbusier, Hans Scharoun, and Peter Behrens. As a result, some of the buildings were restored to their original condition. But even though the city of Stuttgart is very proud of this unique architectural collaboration from the '20s, the urban quality of the original plan was never properly achieved again, which can be easily studied when compared to photographs from 1927. The Weissenhofsiedlung is a monument of cultural history. But the individual elements of social housing, simple construction, and experimentation are no longer visible to a desirable degree. I believe that the restoration of individual houses does not suffice, as many people think. Rather, I think we have to reconstruct the complete architectural design and its relation to the surrounding landscape.

HUO:

Do you think an exhibition project like the "Weissenhofsiedlung" is still possible today? It is, after all, the ideal of a group exhibition?

FO:

I tried to do this with my *Ökohaus* project in Berlin. (*Eco-Houses, 1985–1992*). We invited several architects to participate, and the Weissenhofsiedlung was of course the historical model. I only contributed to the concept of building inner-city one-family houses, and then I mediated between the parties involved. The current residents all seem very satisfied.

HUO:

In architecture exhibitions, models usually represent what has already been built, nice and steady models, whereas in your exhibitions, the models are an attempt at showing work in progress and the ideas that are really driving throughout the design and construction stages. I think here, for instance, of your exhibition at the Villa Stuck in Munich ("Frei Otto, Bodo Rasch: Finding Form," 1992).

FO:

We have to define the term "model." Models like those constructed

by professional model-builders don't interest me. My models are purely working models. They are not made to look perfect, but should fulfill the purpose of the experiment as well as possible. The experiment could be of constructive, formal, or functional nature, or it could concern the relationship between building and surroundings. I also tried to include processes of autogenesis into my experiments and study chance operations. Forms and structures of chance sometimes open entirely new trajectories. But you have to distinguish between processes of chance and of autogenesis.

HUO:

What has been the role of the computer for your designs? Because you've also pioneered the field of purely mathematical, computer-based procedures for determining shapes...

FO:

Since the Montreal World Expo in 1967 we have used the computer, but only as tool to calculate and draw. I develop the designs in my head. Architectural and sculptural objects are three-dimensional, and it is very difficult to visualize plans in three dimensions. The best tool for this is not the plan but the model. In the '80s and '90s, the model was out of style: people thought it could be replaced by the computer. But good architects always built models. When Norman Foster designed the Bank of Hong Kong (*Hong Kong and Shanghai Bank Tower*, Hong Kong, 1986), I saw about a hundred different skyscrapers on a table in his office, all of them attempts at the design of this bank. Models are indispensable for the design process, also to feed the right data to the computer and to control its results. A computer cannot tell you how the lightest building conceivable might look.

HUO:

How heavy would it be and what would it look like?

FO:

It would be about 30 kilograms and would have to be a pneumatic dome. But that is a technical solution and has nothing to do with fulfilling desires of habitation. As soon as such tasks for man and environment enter the equation, the possible solutions become infinite.

HUO:

The pneumatic structures are another variation of lightweight tension structure. Can you tell me about the beginnings of your work with them?

FO:

A British person invented pneumatic construction. I have studied the theoretical principles and have published a book about it (*Tensile*

Structures. Vol.1: Pneumatic Structures, 1973). I only built one pneumatic testing hall, which opened up many possibilities for new approaches however. Kenzo Tange and I developed the plan for a covered city in the Arctic. We were almost commissioned to build such a city in Northern Canada. Ultimately the project was abandoned as the oil prices dropped again. Today there are many pneumatically stressed membrane constructions. But I think they are rarely aesthetically pleasing. Only very few could be considered as nice architecture. I was more concerned to find out the physical minimum of materials necessary. As soon as you make demands that exceed the minimum, many possible solutions arise. I claim that you can construct an individually designed environment for every individual human being. Such infinite variety has biological reasons, which I studied in detail. It could be compared to soap foam: there are no two bubbles exactly alike.

HUO:

Do you hold patents for your inventions?

FO:

It is very difficult to realize patent protection in the field of architecture.

HUO:

Buckminster Fuller was another visionary engineer and architect. Were you in contact with him?

FO:

I met him in 1958 in St. Louis, when I was teaching there. We discussed necessary minimum buildings weights and their possible maximum span, and if he could actually build one of his geodesic domes around the entire surface of the earth. Only much later he agreed with me about the impossibility of such a project. He accepted my invitation to come to biologist [Johann-Gerhard] Helmcke's laboratories in Berlin to look at stereo-metric images of diatomeae and radiolaria. We showed him that his geodesic dome already existed in the micro-cosmos in form of radiolaria. Later he came often to my institute, where [Felix] Candela, [Ove] Arup, and the team of [Edmund "Ted"] Happold and [Peter] Rice met regularly as well.

HUO:

Can you tell me about the role that your Institute for Lightweight Structures played in your architectural work?

FO:

The first institute, the Development Center for Lightweight Construction, was founded in 1957 in Berlin. It was a private organiza-

tion, and was founded by Peter Stromeyer and myself. He used some of our patents and inventions. Together with my Berlin team I researched topics such as pre-stressed cable nets, minimum surfaces, bubble experiments, and lightweight construction. We developed methods and instruments to measure and test in advance the necessary mass of every object needed. Since 1964, since we transferred the center's activities to the Institute for Lightweight Structures in Stuttgart, we have measured many thousands of inanimate and technical objects, and thus we know fairly precisely how much things weight and how much energy they need. We researched the foundations of both natural and technical lightweight constructions and made the results accessible to specialists of all disciplines. Of course this also influenced my work as an architect.

HUO:

What is the significance of interdisciplinarity in your projects?

FO:

Obviously, the collaboration of specialists from different disciplines is indispensable for any architectural work. Already in Berlin I championed interdisciplinary collaboration, and in 1960 founded the research group "Biology and Construction" at the Technischen Universität [Technical University] in Berlin, together with the Helmcke. This group was incorporated in 1964 into my institute at the Technischen Hochschule [Technical Academy] in Stuttgart. We founded special research institutes on Wide Span Surface Structures and later on Natural Construction, where behavioral scientists, paleontologists, biologists, mathematicians, synergetic scientists, and philosophers jointly researched. In addition, I was always involved in interdisciplinary foundation research that was independent of projects and was intended to benefit natural science in general. My colleagues from biology particularly challenged me with inquiries on how to explain living organizations with the help of our knowledge. We searched for answers, but not to invent a new architecture or to imitate living objects.

HUO:

Among your unrealized projects, which one would you like to see realized?

FO:

The *Stuttgart Central Station* project (1998–ongoing). But you have to take into account that realized projects never are identical to the "beautiful dream" you had in mind...

HUO:

... as Schinkel said about his unrealized Orianda Castle.

PAPE, Lygia

Lygia Pape was born in Rio de Janeiro, Brazil, where she currently lives and works. Pape studied aesthetics and philosophy at the Universidade Federal do Rio de Janeiro. At the age of 25, she became involved, with Fayga Ostrower and Ivan Serpa, in the activities of the Grupo Frente, whose artistic philosophy embraced geometric abstraction, as opposed to figurative art, and they exhibited their works at the Galeria Ibeu Copacabana, Rio de Janeiro ("1° Grupo Frente," 1954), the Museu de Arte Moderna, Rio de Janeiro ("2° Grupo Frente," 1955), and at the 3° Bienal Internacional de São Paulo, (1955). In 1957 she participated in the Neo-Concrete movement's first exhibition alongside such Brazilian artists as Hélio Oiticica, Lygia Clark, and Ivan Serpa, and she was one of the signers of the Manifesto Neoconcreto *written by Brazilian critic Ferreira Gullar. Since the late '50s she has produced "Neo-Concrete Ballets" as well as numerous sculptures and drawings. She also developed a book trilogy (*Livro da Criação, Livro da Arquitetura, *and* Livro do Tempo*), worked with the filmmakers of Cinema Novo, and made several videos and experimental short films such as* La Nouvelle Création *in 1967. She worked on Projeto Hélio Oiticica in Rio de Janeiro, founded to preserve and to disseminate the work of Oiticica after his death in 1980. Internationally, Lygia Pape's work has been showcased in exhibitions including "Art in Latin America: The Modern Era 1820–1980" (Hayward Gallery, London, Moderna Museet, Stockholm and Palácio Velázquez, Madrid, 1989–1990), "Ultramodern: The Art of Contemporary Brazil" (National Museum of Women in the Arts, Washington, D.C., 1993) and "Brazil: Body and Soul" (Solomon R. Guggenheim Museum, New York, 2001).*

........................

This interview was conducted with Brazilian critic and curator Adriano Pedrosa, in Rio de Janeiro, in October 2001.

Hans Ulrich Obrist:

Let's begin with the beginnings, with the '50s, which marked a new, more abstract phase in Brazilian art, exemplified by the advent of the Concrete Art movement. I know that the openings of the Museu de Arte Moderna in São Paulo in 1947 and the Museu de Arte Moderna in Rio de Janeiro in 1948 played decisive roles in this phase for artists such as you or for Hélio Oiticica. Could we open the discussion on this moment?

Lygia Pape:

After the Museu de Arte Moderna [in Rio de Janeiro] was built, we began to frequent it. We met Ivan Serpa, Aluísio Carvão, and Abraham Palatnik, and we eventually formed a group, which became known as the Grupo Frente, a group that was interested in con-

structive process. No one wanted to draw figures or anything like that anymore, but we *were* interested in the constructive process.

Adriano Pedrosa:
What year was this?

LP:
This was more or less in 1953, until 1956. In 1956 we got together with a group from São Paulo and formed the Concrete group, and we put on two large exhibitions at the invitation of Max Bill (who had been awarded first prize for sculpture at the first São Paulo Bienal in 1951): the "Exposição Nacional de Arte Concreta" ("National Exhibition of Concrete Art," Museu de Arte Moderna, São Paulo, 1956, and Museu de Arte Moderna, Rio de Janeiro, 1957) and in Zurich the "Exposição Internacional de Arte Concreta" ("International Exhibition of Concrete Art," Helmaus Zurich, 1960).

HUO:
That's very interesting, actually, because I'm Swiss and I'd always heard in Switzerland that Max Bill had gone to Brazil and that it had been very important for you and for Oiticica.

LP:
At the first biennial, Max Bill won the grand prize for sculpture and we became friends. I visited Max Bill in Switzerland. I have one of his paintings... Later, there was a split, a disagreement, and the Grupo Neoconcreto [Neo-Concrete group] was formed: a group of visual artists I belonged to, along with Hélio Oiticica, Lygia Clark, Aluísio Carvão, Amilcar de Castro, and Franz Weissmann, which also attracted poets. Well, after that, like every good group, we drifted apart, around 1962.

AP:
What was the origin of the break-up? Was it, in fact, an aesthetic issue or a political matter?

LP:
An aesthetic problem, because the São Paulo poets had put together a project, a pilot plan for poetry, a ten-year work plan, and the people in Rio just couldn't accept that; they felt it was too rationalistic. The split came about, a separation, disagreements, and the Neo-Concrete group of Brazil was formed in Rio de Janeiro.

HUO:
What is your perspective today with regard to the group then and the way it functioned at that time? To what degree was the group more or less organized? Or was it more informal, and what was your role in it? How did you perceive your role within the group?

LP:

Well, the group was very serious and aspired to invent new languages. No one wanted to repeat what had already been done; everyone wanted to experiment. Sculpture, for instance, didn't need a base; it had to be free in space. We were breaking out of the frame, moving into three-dimensional space. Everyone was inventing something new in those days. Lygia Clark, for instance, invented the *Bichos* (*Animals*, 1960–1964). Hélio Oiticica began to make works which later became the *Parangolés* (1964–1979). And I made books, only they were books without words, just colors and shapes. They were objects, and in one of them, I told the story of the creation of the world: *Book of Creation* (*Livro da Criação*, 1959–1960). In yet another one, I narrated architectural styles: *Book of Architecture* (*Livro da Arquitetura*, 1959–1960). Then I worked for a whole year on the *Book of Time* (*Livro do Tempo*, 1960–1965). I made one unit every day so the book has 365 pieces. Immediately after that I did the *Livro Noite-Dia* (*Night–Day Book*, 1963–1976) where I "read" the light of these 365 days. After that came the *Livro dos Caminhos* (*Book of Paths*, 1963) and the *Livro dos Sentidos* (*Book of Senses*, 1963–1976), when I began my involvement with cities; the *Livro das Nuvens* (*Book of Clouds*, 1963–1976) and *Poemas-Luz* (*Light-Poems*, 1956–1957) where I treat poems like floating objects, among others. Each artist worked on his or her project and we would discuss all kinds of things; we were always getting together. It was a very serious and very productive project. We all went on working after the group split up. Everyone—who hasn't unfortunately died—continues to work intensively, to this day.

AP:

What was the group's time frame?

LP:

The period extends from 1957 to 1962 here in Rio—the Concrete group already existed in São Paulo. Our project was an original project which started in Brazil; the Neo-Concrete group had original ideas which had never been done anywhere else.

HUO:

Max Bill was an architect. He was also an artist, but he actually brought painting into an architectural context, and architecture into a context of painting. He created very synthetic situations, and I'd like to know about how such experiments of bridging disciplines were considered within the Neo-Concrete group.

AP:

Yes, and I should say, in this case, with the relationship to the world itself, to life. To me, it is a fundamental distinction and one which I feel is something in between Rio de Janeiro and São Paulo.

LP:

Of course, Max Bill was a sculptor, an engraver and a painter, and he also designed jewelry. He was an artist who made all these things. But that was a coincidence because there we were—before we ever met Max Bill—we were already moving in this direction because, besides the painters, there were sculptors and poets in our group, too.

AP:

That's true. I wanted to ask a question on the subject of rigidity, which, at the time, was attributed to the Paulistas (the natives of São Paulo state) or after the break up... There was a more rigid model, one which in my opinion was more invested in purity in the name of art, in an art unfastened from life, from the world, from the organic, from the body, which seems more present to me here {in Rio} within a tradition, one which begins here: a Carioca—from the city of Rio de Janeiro—tradition. Do you agree? How do you see this? I think, in a way, to this day this is reflected in the distinction made between some of the work that comes out of Rio and some of the work which comes out of São Paulo.

LP:

For example, when the group was all just one group, there was something not rigid, but rational. You used mathematics to structure a work; you used certain principles. When the group broke up, you no longer used mathematics, necessarily, to invent the structures, to organize space in a painting, for instance, or a sculpture. So this wound up influencing everything that was produced from that point on in Rio de Janeiro. In a sense, São Paulo also moved beyond that rigid early rationalism. For example, poets began to write poems which were more political, like [Augusto de Campos'] "Luxo/Lixo" ("Luxury/Garbage," 1966). So all these works, all of them, nobody went on as rigidly or as rationally as before. But the Rio group introduced poetry into Concrete experiments.

AP:

To me that's the fundamental part. But also very much in relationship with art and the body and art and life, art and everyday life, art and the street; these come from a Rio de Janeiro tradition, and this also relates, from my way of seeing, to a division between Rio de Janeiro and São Paulo that goes back to this division early on, which I think is still very present today... In the end, breaking out of the frame is a metaphor. I mean to say, it's break-

*ing the frame, from a plane space onto the wall, but it's a relationship to life,
to the world outside the frame, something which would be impossible in São
Paulo. You don't see this sort of attitude in São Paulo.*

LP:

That's true. For example, this experiment with the body also brings
about sensory things, so one begins sensory experiments, body
experiments. For example, I made an enormous cloth called *Divisor*
(*Divider*, 1968), which people enter and, all of a sudden, you have
a sea of heads.

AP:

It's a beautiful monochrome, a white monochrome.

LP:

This is something I experiment with every once in a while to this
day: a living work. I have another one called *Ovo* (*Egg*, 1968), which
is a cube you enter and break out of to experience your own birth.
I have it on video, too. Then there's the *Roda dos Prazeres* (*Wheel of
Delights*, 1968), where you taste things, put drops on your tongue,
your eye selects a color, then you get that color and drip it on your
tongue. So the palate might reject something the eye selected and
which gave the eye great pleasure. It creates relationships of oppo-
sition or support among the senses. So there were countless exper-
iments during that period. It's normal; even today people continue
to do things in a more relaxed way. People aren't worried about
being canonically Neo-Concrete.

AP:

*I wanted to go back to the subject of Rio de Janeiro. I work more with
artists from my generation, like Ernesto Neto, and we've just come from
Franklin Cassaro's studio, and it seems to me that they are artists who do
not programmatically recapture the sort of tradition you developed. But I
think they are also developing something with regard to geometry. Above
all, what seems interesting to me is the way they process formal questions—
the plane, geometry—which are also associated with the question of the
body. That seems interesting to me, and I do see it as very much a Carioca
tradition.*

LP:

I feel very comfortable with their work because I identify with it;
it's a way of inventing the world. Everybody has their own way, but
these are artists who are not restricted to formal matters.

AP:

*In this case, what I also find interesting is that—Fernanda Gomes, in a
certain sense, has this—these are pieces that deal with a strong sculptur-*

al tradition; they deal with sculpture. If you look at them as sculptures, all the formal questions are worked out there in a very complex way, but there is also a strong reference to science, there are strong references to life, and often to gestation or biology or even to the body. That is to say, it's another kind of tradition, which I think is typical of Rio de Janeiro and very unique even on an international scale. I keep thinking, maybe, that all this... because the Paulistanos never drift too far from plane geometry, they don't quite manage to let go of that autonomy and the purity of art, the contained object, contained sculpture. I think you can still see this today in contemporary art. Do you see this happening?

LP:

Look here, I am also very fond of Nuno Ramos's work. I think we can leave him out of this... I don't think Paulistas are all that rigorous or all that rational.

AP:

It's a complicated generalization to make. I think there's a tradition there...

LP:

Yes, I understand, but what I think we have here in Rio is great freedom. I don't know if it's because of the beach... the forest, so the body is always very present. You are never allowed to forget about your body, you can't stay locked inside the studio, thinking. You use the body constantly, so this also emerges in the works.

HUO:

There's a beautiful text by Guy Brett, who is in turn quoting Oiticica, in which Oiticica characterizes your work as experimental, as "a permanently open seed." Do you see a relationship between artistic practices, experimentalism, and the issue of the laboratory?

LP:

No. It's because, after you've been working for many years, you develop a work method, a vast laboratory experience, so it's not something you think about rationally. It's already part of your work. My concern is always invention. I always want to invent a new language that's different for me and for others, too. This is something I am extremely interested in. I don't like repeating things: "Oh, I'm going to do something just like it." I don't care for that at all. I want to discover new things. Because, to me, art is a way of knowing the world; it's the way I have to see how the world is... of getting to know the world.

HUO:

Could you tell us more about the relationships or comparisons between art

and the architecture of the '50s and '60s in Brazil, or art and poetry, a
topic on which we have already touched upon, although lightly.

LP:

This was very common. The poets were very close to us. I myself
used words too, as in poems. I made poems for the body as well. I
think that architecture... for instance, Niemeyer is a little baroque
for my taste. I don't think he's as close to us as the poets are—cer-
tain poets, not all poets. Like the São Paulo poets, the [Augusto and
Haroldo de] Campos brothers, Décio Pignatari—they're extremely
rigorous poets but they're also very good poets. [*Laughs*] Now, here
in Rio, you had Ferreira Gullar, you had Reynaldo Jardim, poets
who worked with us. For example, Reynaldo Jardim and I made
two ballets with geometric forms (*1º Ballet Neoconcreto*, 1958 and *2º
Ballet Neoconcreto*, 1959) in which the forms moved around the
stage. And what you saw wasn't the dancers—they were hidden
inside the forms—but you saw the motor of the body. It was the
movement of the body that was the expression of ballet.

HUO:

I'd like to know why you find Niemeyer to be so baroque.

LP:

It's a personal thing. For example, I think his museum in Niterói
(*Museu de Arte Contemporânea*, 1996) is very beautiful but it's very
hard to work in. It's a large sculpture, very beautiful, but working
inside it is complicated.

AP:

As a matter of fact, we've just come from the MAC and from the house
{Niemeyer's House *on Canoas Road in Rio de Janeiro (1953–1954)}—*
from a late work and from a very early work, one which I consider very
good and one which is, shall we say, not so good. And I think the house has
this whole geometric play, with the curve, with the grade, with the forest.

LP:

He's airier there. I don't know if it's because he designed it for him-
self—that's possible... For instance, I don't like the Ibirapuera
(*Conjunto Ibirapuera*, São Paulo, 1951). I find it heavy, not func-
tional. The ceiling is much too high, it's doesn't jibe with the
works, it makes it harder to deal with them. But Niemeyer's house
is perfect. It has a language, a body scale—that's what's good about
it. And the landscape is very beautiful; the environment is very sen-
sual, too, which is a great quality that his architecture has.

HUO:

What about your own work that almost takes the city... "Divider" is an
example of this—not so much a public or monumental scale, but a large-

scale work which deals with the city. How do you see this—what's your
interest in this type of scale?

LP:

It happens that I also worked with architecture. I taught at an
architectural school. I used to take my students to the Maré *favela*,
the Maré complex which stood on mud in those days—it wasn't
what you see today. And there was an invention of forms within the
favelas which was magnificent. So my classes were taught all over
the city. For instance, I would get on a train at the Brazil Central
[train] Station and go to Madureira with my students. It was an
experience for both body and mind. Conceptually, we situated our
bodies in real situations around the city.

HUO:

During what period was this?

LP:

From 1972 to 1985.

AP:

Where did you teach architecture?

LP:

At Santa Ursula University. Well, it was architecture, but I worked
more on plastic meaning, on spatial invention. It was part of the
course—the course was official—but I would go out into the city
with the students. So I identify deeply with the *favelas*. I visit them
often… less so nowadays, because of smuggling and drugs. But I'm
on very intimate terms with the entire city. For example, I used to
enjoy driving my car up and down the overpasses. It felt like I was
weaving space. That's the origin of *Tteias* (1978), a piece in which
I weave golden thread through an entire space, and it came from
this experience of the city.

HUO:

Is there any utopian project that you didn't have the chance to carry out for
some reason, because of its scale or dimension or production.

LP:

Personally, I don't like utopian work. I don't like dreams without
accomplishment. I think about something and then I do it. I can't
imagine sticking to a project if it isn't going to happen. No, I do it.
In whatever situation, I'm going to do things. It's part of my nature.

HUO:

You said you made poetry or you make poetry, you also did other types of
writing, on artists or texts—is there another type of production of texts in
this sense?

LP:

There is. I teach, although I'm not teaching now. But I write about art, too... And my poems aren't conventional poems. Sometimes they only have ten words. In my poems I use the spatialization of the page as form; to me this would be a link between literature and architecture and vice versa. Some of them, for example, are spatial. I work with forms in space. And I might use a word or two. I write texts, too, though I'm not interested in writing a book on art. For the time being I'm not interested.

AP:

Are these critical texts?

LP:

Of course.

AP:

Have they been published?

LP:

They have. I was one of the curators of the "Projeto Construtivo Brasileiro na Arte" (Museu de Arte Moderna, 1977), for which I wrote a text which I think is very interesting. Aracy Amaral wrote the informational section ("Projeto Construtivo Brasileiro na Arte") and I did the Rio de Janeiro part—a text in which I talk about the arrival of the French and their introduction of new concepts of sculpture and architecture which destroy the baroque, something I think is fundamental. So, all these subjects; I wrote a text about all that.

HUO:

I'd really like to know why also, for your generation, for you or Hélio Oiticica, the medium of the "book" has played such an important role.

AP:

Yes, in what way did this happen beyond, shall we say, the relationship with poetry—how did it actually happen in the work? And, also, do you think this has been somewhat lost in the contemporary?

LP:

It's a matter of identity. I, for example, used to call my works "Books"—in fact, there's a piece called *Books* in my current exhibition in the city center (Centro de Arte Hélio Oiticica, Rio de Janeiro, 2001). It's called that because I use words on forms. I made a *Book of Creation* and the *Book of Architecture*, and so I've always given ambiguous titles to visual art pieces which somehow also make them something linked to literature, though not in any conventional sense. Nor am I interested in writing to explain my visual art work. I may occasionally write, but not necessarily to explain that piece.

HUO:

This seems to be lost today. There no longer seems to be as strong a relationship with poets or with literature in the visual arts.

LP:

No, there isn't. For instance, not many people know Ezra Pound or James Joyce's *Finnegans Wake* (1939). Few people know Brazilian novelist Guimarães Rosa, whose work, I think, provides a blueprint for invention with sound and has an astonishing capacity for invention. The other day I was talking to an artist and I said, "You must read the poet João Cabral de Melo Neto." It was Fernanda Gomes. I think her work has a very strong affinity with Melo Neto's work. But she prefers that Portuguese poet, the most famous one that everybody quotes—[Fernando] Pessoa. Personally, I don't care for Pessoa, I think he's too saccharine. João Cabral de Melo Neto is a dry poet; he's precise, he's economical. That's what I like. Like my work—I only want what's strictly necessary. Not Fernando Pessoa. He's too sweet. I dislike him profoundly.

HUO:

What about cinema? In the '60s and '70s you made numerous video works, experimental short films and documentaries. You've been very involved in the film word, sitting in a number of film festival juries. Have there been relations or dialogues between you and Cinema Novo filmmakers Glauber Rocha, Nelson Pereira dos Santos, or Carlos Diegues?

LP:

I was always deeply in love with cinema because of the images. I have the privilege, for example, of having watched all of Cinema Novo in rushes, which means I saw those images while they were still clean and highly creative. I had the experience of absorbing those images before they were edited, transformed into "just movies." So much so that I've never seen some of those films again; I only saw the raw material. [Georges] Méliès, for example, is one of my passions—for his formal inventions. I also like [Yasujiro] Ozu and [Sergei] Eisenstein. I am familiar with all of international cinema. But I wasn't interested in making commercial films, either. I never wanted to make a feature, for example, because that would have made me dependent upon a producer, on an exhibition, and so on. I wanted to make something which would give me freedom. So I worked with something which was called experimental in the sense that it was free. I made lots of films. As matter of fact, I'm currently working on ten-, twenty-second videos. I like films in which I can say everything I need to say in the shortest possible length of time. For example, I won an award in Canada with a film

which was only fifty seconds long, about the creation of the world. It's called *La Nouvelle Création* (1967). And it was a very good film which only ran fifty seconds...

AP:

To switch subjects, I think there is a question, a topic that is very important and we haven't touched upon: do you think there is any connection between Brazilian art of the period—the late '50s and '60s—and Minimalism or Conceptual Art?

LP:

It wasn't known here at all. I think some of our things even preceded theirs. There was no contact with the Minimalists or the American Conceptualists. Later on we were able to see certain affinities, but our work was something absolutely independent.

AP:

There was never any reciprocal exchange?

LP:

None whatsoever.

HUO:

And since you mentioned meeting Max Bill, wasn't there, through Max Bill, a link with {Georges} Vantongerloo, {Alexander} Rodchenko, the early twentieth-century avant-garde movements and the Russian avant-garde? Were you (Oiticica, Lygia Clark and you) aware of this? Or was it also... was it really something which came out of your own... Wasn't it an influence?

LP:

[Kasimir] Malevich, [Piet] Mondrian, and Rodchenko are my passions. We knew their work, but it wasn't like we copied anything from books—that wasn't the case. It is most interesting that there were conceptual similarities to Mondrian, Rodchenko, Vantangerloo, and a host of others, all of whom belonged to a Constructivist lineage. But, later on with Neo-Concretism it all just drifted away. Later still, they all became just a memory.

AP:

Naturally, the critics of the day kept up with it all. I don't want to refer only to that period, but your work has some dialogue, some important reference with critics here in Rio who are always confabulating, following your work during your trajectory. Do you think this function is important?

LP:

My contact with critic Mário Pedrosa was very important. I frequented Mário Pedrosa's home and he was a brilliant, fascinating man, extremely intelligent. Nowadays I am in touch with critics

like Wilson Coutinho and Luiz Camilo Osório, but these are occasional contacts. When I hold an exhibition, they can write about it if they like. But there is no longer any dialogue or connection as strong as the one I had with Mário Pedrosa.

AP:

And that was very important at the time, wasn't it? Mário Pedrosa is the main figure of Brazilian art history and criticism. He was very influential during that period.

LP:

He was an important critic even by international standards. He was active in the Biennial, in international events, and he wrote a thesis called "On Creativity in Art," about Gestalt, in 1948. I even attended his dissertation presentation, and later on he submitted it in competition, but the person who won was someone who had written about a Dutch painter or some such thing. His topic was very original at that time. Meeting Mário Pedrosa was highly productive for the whole group. Later, it all came to an end. These days, I think the critic who most resembles Mário Pedrosa is Paulo Herkenhoff. He's tremendously erudite, he's interested in writing, he writes a lot, and he's very active. He did the big Biennial; I think Paulo Herkenhoff put on the best Biennial, in 1998 (XXIV Bienal Internacional de São Paulo, 1998).

PARENT, Claude

Claude Parent was born in 1923 in Neuilly-sur-Seine, France. He currently lives in Paris. Parent studied mathematics and engineering and later went to the École des Beaux-Arts de Paris, but he rebelled against the French architectural establishment by refusing to complete his formal training. For a short time, Parent worked for Le Corbusier, but the major influence on Parent came from French sculptor André Bloc, who was also editor of Architecture d'aujourd'hui *(AA) and an active promoter of the idea of "synthèse des arts" (synthesis of the arts). Bloc invited Parent and his partner Ionel Schein to join the Groupe Espace, a collective of artists and architects such as Fernand Léger, Jean Dewasne, Richard Neutra, Arne Jacobsen, Jean Prouvé, Robert Le Ricolais, Nicolas Schöffer, and Victor Vasarely. During the '50s and '60s, Parent worked for designs of houses and buildings with Schein, Bloc and Schöffer, and provided his technical skills to artists such as Jean Tinguely or Yves Klein on several projects. In 1963, Parent founded with critic Paul Virilio the Architecture Principe Group. Together they developed "bunker archaeology," an architectural theory based on the potential of the béton brut (raw concrete) used in the late works of Le Corbusier. It was discussed in a number of manifestos and formed the basis of the design for their Church of St. Bernadette-du-Banlay (Nevers, 1963–1966). They also developed the theory of the "fonction oblique" (oblique function), and the use of sloping surfaces, which was applied to the design of his* Maison Drusch *(Versailles, 1963–1965). Recent buildings designed by Parent include an activity center at Paris's Charles de Gaulle Airport (Roissy, 1995) and an office building for EDF {France Electricity} (Plaine St-Denis, 1998).*

........................

This interview was recorded in Paris in April 2002.

Hans Ulrich Obrist:

Perhaps you could start by telling me about the discussions you have had throughout your career with such artists as Nicolas Schöffer, Jean Tinguely and Yves Klein.

Claude Parent:

I have told the story many times. The people from whom I really learned the meaning of architecture were all artists. Very early on, I had a great deal of luck and opportunity. So, in 1945, when I got back to Paris after the war, I found myself, along with Ionel Schein (after an exchange of letters with André Bloc, and a meeting with that extraordinary character), in the company of the whole geometric-abstraction crowd. There was no need to even try to make contacts. It was just happy coincidence, as there often is in the life

of architects, which allows them to break out of anonymity. Anyway, it was a felicitous bit of luck, which allowed us to become immersed right away in art circles. We had no sooner met André Bloc—who, after founding his journal, *Architecture d'aujourd'hui*, had just founded *Art d'aujourd'hui*, a journal which, a few years later, was to become *Aujourd'hui*—then we met Pierre Guéguen and Léon Degand, who were both established art critics. Above all, we found ourselves in the midst of the creation of the Groupe Espace. The group was a movement of artists, who referred to themselves as visual artists (*plasticiens*), and who wanted to team up with architects in order to undertake what at the time was known as the synthesis or the integration of the arts. At the time, the Groupe Espace was a pretty diverse bunch: there was, for instance, Fernand Léger, with whom I had very lengthy discussions, and with whom I even worked on a city hall competition, for which he allowed us to use some drawings of his outdoor sculptures. There were also people like Sonia Delaunay, who were different in every respect; there were both young people, such as Jean Dewasne, [Edgard] Pillet, and even the last partisans of Neo-Plasticism: an old guy by the name of Félix Del Marle—in some respects the last representative of Neo-Plastic thought. Although in France that current of thought didn't really have a very illustrious career, so to speak, certain artists from the movement had nevertheless settled in Paris. I deliberately chose Neo-Plasticism. Instinctively it appealed to me; it was what I was after, in its highly geometric quest—its quest for movement. So you might say that I made a very personal choice very early on. If you look at the first house that I did with Ionel Schein, you notice that it is very Neo-Plastic. Moreover, very regularly Schein and I would go and visit Théo Van Doesburg's house (Meudon-Val-Fleury, 1929–1930), and when you look at our first house—the *Gosselin House* (1953), built in Ville-d'Avray, in a small residential suburb near Paris—you see that with its screen-wall, it is utterly Neo-Plastic. It is not, by the way, Corbusian, despite the fact that Schein and I, like all somewhat enlightened young people at the time, were very, very pro "Corbu." You have to bear in mind that at the École des Beaux-arts in Paris, Le Corbusier was never even mentioned. Worse still, in 1951 or 1952, when I ended up in a "studio," it was forbidden to talk about Le Corbusier or even to mention his name. As advanced—and thus Corbusian—as we were, this first house, the first house we did, was nevertheless in no way Corbusian. What is interesting about starting out that way is how

Neo-Plastic it is. We had made our choice instinctively. We sub-
sequently groped our way forward in a few other little houses we
did and gradually returned to more Corbusian things. But, for
myself at any rate, my choice—and what I really love—is high-
lighted in that very first house: movement was already included,
there was a also a screen-wall that broke up the overall unity...
There's a photograph where you can see our studio, located in an
old building dating back to 1918 or 1920, where we demolished
everything in order to set up our first agency, in very Mondrian-
like fashion.

HUO:

It's true that when you mention Van Doesburg, Mondrian also comes to
mind. Was your interest in interdisciplinary forms and elements something
that manifested itself very early on?

CP:

Yes, I would say that we accepted it automatically because we were
part of the Groupe Espace , a group that was founded on the idea of
fostering different forms of interdisciplinary practice between archi-
tects, painters, sculptors, landscapers, and so on. However, it was
not so much that as movement that interested me in Neo-Plasti-
cism. It's not easy to see in this particular photograph of the house,
but its layout is like two shifting bodies—what [Bernard] Tschumi
calls shifts—thanks to which we introduced a rupture in the work's
unity. However, the principal criticism directed at us—coming
from people who actually liked us a lot and whom we also held in
high esteem, such as [Georges-Henri] Pingusson (one of the best, if
not indeed the best modern architect)—stemmed from the fact that
our house seemed disarticulated, that it moved and wasn't in keep-
ing with the rule of unity. The choices we made—as I already men-
tioned—within the Groupe Espace, were precisely those choices: we
chose Mondrian, Théo Van Doesburg, forgotten in France, little
appreciated at the time, and whom I only discovered thanks to the
Groupe Espace, with Del Marle above all acting as go-between.

HUO:

Last week I met Jean Leering, the former director of the Van Abbemuseum
in Eindhoven, who is, as it turns out, Théo Van Doesburg's heir through
marriage.

CP:

Schein and I were very young at the time, and we didn't know any-
thing about Doesburg—nor about many other people for that mat-
ter. I had just graduated from high school; I had specialized in math-
ematics in order to become an engineer... And yet, when we found

ourselves projected into that universe, we made highly exacting and very concerted choices—myself in particular. Off we went with Schein and [Maximilien] Hertzelle, a painter who did mosaics and stained glass and with whom we worked a great deal, to see the Van Doesburg house and we discussed the appropriateness of the large square that concealed the staircase. Hertzelle said that it wasn't modern at all but archaic, and already raised the question as to whether French-style functionalism would come to dominate. French-style functionalism was the idea that everything has to be shown, that everything is function and has to be shown—or has to be made obvious. And thus, in keeping with strict functionalism, there can be no hiding staircases behind screens. Putting up a screen-wall is a purely aesthetic procedure, a purely formal procedure, where every element fits into or finds its place within the overall aesthetic organization. So you see, we had highly specialized discussions right from the outset, regarding things that for other people were often considered to be points of detail. Only recently, I sent Julien Gracq some notes on the necessity of critical geometry in architecture.

HUO:

Have you maintained an ongoing dialogue with Julien Gracq?

CP:

Yes, except that he doesn't particularly like to talk about architecture.

HUO:

Yet his writings on the city are amongst the most interesting that exist on the subject.

CP:

[*Laughs*] If you want to understand anything whatsoever about the city, there is obviously no point reading journalists or developers— the latter all deserve to be shot—or even architects, because they always see the city from their own narrow angle, and especially young architects, who tend to think in terms of urban decor (which is a veritable catastrophe). What you should do is read Julien Gracq's books. Gracq's knowledge of the city surpasses that which any architect could ever attain. It is just not possible for us, because the way architecture is taught tends to disembody us with regard to the city. That is one of the reasons for which, when architects are asked to create cities, the results are always so catastrophic. Architects have to re-embody themselves, learn how to read a city in the same way that Julien Gracq writes. They have to try and do their own reading, finding their way as they go along. And that's what I tried to do. One day I was invited by a group of civil engineers to

give a workshop, for which they had chosen speakers entirely out-
side of their ways of working and thinking. As reading and discus-
sion material, I assigned one of Julien Gracq's narratives, *La Route*
(*The Road*, 1963), which is an unfinished novel. Nevertheless, *La
Route* is a wonderful invention; it is an extraordinary text about the
transformation of a roadway, which dates back to I don't know
when, and which, as it gradually makes its way from one country to
the next, with time, takes on different aspects: it disappears, is
grown over by nature, or becomes a city. It is about the road in all
its purity of features and wounds. They read it, but they were so far
removed from such a way of seeing and analysis that they were
unable to understand how it could possibly help them...

HUO:

*Giancarlo De Carlo told me that he, himself, learned everything from Elio
Vittorini.*

CP:

I always tell Gracq, "You taught me everything that artists ought
to have taught me, if at some point they hadn't become a little too
arrogant with regard to architecture." And it is a fact—which I dis-
cuss in detail in the first autobiographical book I published with
Robert Laffont a long time ago now—that artists then insisted on
what they referred to as the weakness of architecture. And they
began doing so in the late '50s, and particularly in the '60s. Artists
postulated that architects were no longer capable of imagination,
that there was decadence, loss of meaning and lack of enthusiasm,
that formalism had dried up architectural creation. As a group,
architects were much disparaged and artists decided to rush in to
take advantage of the architectural vacuum. Why not, after all? It
is a normal reflex: they saw that architects were no longer up to the
task and they simply said, "Fine, then we'll do architecture our-
selves." That was a very painful experience for me, because when an
artist tries to do architecture alone, it just doesn't work out. It just
doesn't! So when [Emile] Gilioli tried to make houses, it was a
catastrophe, whereas he managed it nicely on the Glières Plateau,
with his monument to the martyrs (1973). He managed to make
the shift to monumental dimensions all by himself, and to produce
a form of architecture—though one that was uninhabited.

HUO:

*But what about the various dialogues that you have initiated with artists?
Are they ongoing?*

CP:

I was, as I said, part of the Groupe Espace. It's something I cannot insist upon enough: it was the starting point for everything. I went to the meetings, I listened to them, I went to see them in their studios. And in the end, it was Nicolas Schöffer with whom we first worked. He had an exhibition in the gallery which was next door to the School of Fine Arts, known as the Galerie "Mai" ("Schöffer: Oeuvres Spatiodynamiques," Paris, 1952). And when Schein and I saw the exhibition one day, as we were coming out of the school, it really caught our interest.

HUO:

What works were being shown? Was it the kinetic installations and the light games?

CP:

No, it was long before that. This was back in 1952, so it was primarily stuff that was along the lines of Russian Constructivist architecture. Schöffer did that sort of thing early on. I remember very clearly that the fine arts students sniggered when they saw his very delicate, very fine sculptures, made out of little steel and aluminum wires, a whole constructivist-like construction, so to speak, the like of which we had never even heard of. In France we knew nothing—and were taught nothing—about architecture from the '20s and '30s.

HUO:

It was already the object of a veritable amnesia...

CP:

A total amnesia regarding the '20s and '30s, the Russians, and Central Europe... But personally, I had the good fortune to get to know—thanks to the editorial board of *Architecture d'aujourd'hui*— such people as [André] Sive, [Édouard] Menkès, [Jean] Ginsberg— people like that, who came from Central Europe and who were part of the intellectual diaspora, forced to flee the Nazis. Many of them, unfortunately, including [Berthold] Lubetkin, went straight to England; or, like [Walter] Gropius and [Ludwig] Mies van der Rohe, went to the United States; but a few of them remained in France. Through them, we managed to find out something about these earlier projects. Nevertheless, I owe my initiation in this regard primarily to Nicolas Schöffer, with whom I subsequently worked for five years. It was with him that I was able to tackle those issues. To come back to our first meeting, we had asked Charles Gervais, who directed the gallery, if we could meet Schöffer. He replied, "He would be delighted to meet you because all

your buddies do—whether they be architects, painters or sculptors—is laugh when they see his works." And sure enough, I took a look at the visitor's book and it was chock-full of inanities like, "You call that sculpture, it's nothing but scaffolding." And this was in 1952! So it was Schöffer who first introduced us to spatiodynamism, which is why you still find movement in my work and in my curiosities: before all else, there is movement—always, always, always. If someone were to decrypt my work, it is its dynamic which would have to be examined, otherwise there is no point [in] my even beginning a discussion. And it was Nicolas Schöffer who welcomed us with great pleasure, and subsequently we exhibited Schöffer, Schein, and myself at the Salon des Réalités Nouvelles (Paris, 1953). We worked a great deal with him and, in some respects, that taught us that particular form of gymnastics inherent in working with artists. Afterwards, I became very friendly with Pillet, and people like that; we put together a project, but it never worked out. I was also in charge of all Bloc's exhibitions— all the exhibitions that Bloc referred to as a "synthesis of the arts."

HUO:

You were the curator?

CP:

Yes, I curated those exhibitions, I set everything up. I was both curator and warehouser.

HUO:

Where were those exhibitions shown?

CP:

In Dijon, in Rouen... there were seven or eight of them. Things always happened in more or less the same fashion: a curator interested in modernity would write to Bloc; Bloc would write back that he would send him an exhibition, and then he would say to me, "Parent, do the exhibition." I worked with Bloc like that for ten years, and saw him on an everyday basis. At one point Bloc decided that *Art d'aujourd'hui*—the little journal he edited—was too focused on the arts and so he turned *Art d'aujourd'hui* into *Aujourd'hui*, a journal in which there were different sections and particularly a "design" section, which I played a role in setting up. *Aujourd'hui* was all over the place. The '50s were the heady years of the synthesis of the arts, because everybody was working together. Personally, I worked with young decorators who were making furniture—such people as Alain Richard. There was Charlotte Perriand, who was also part of the group, and who had herself been

trained in the synthesis of the arts, because she had always worked with Corbu and [Pierre] Jeanneret. There was Léger, who had been part of the wall-art movement, and when I saw him he would tell me about his experiments in integrating the arts through his work with Le Corbusier. He'd talk about their discussions, books, wall art, which in itself is slightly different, because it primarily concerns frescoes, monumental-scale painting, but also had to do with truly collaborative endeavors. And he lived it in that way.

HUO:

Curator was but one of your hundred trades. Because you say, "I had a hundred trades..."

CP:

Yes, I worked as a curator, but I also worked with art critics, with real curators—for instance, with Simone Frigerio or Gérald Gassiot-Talabot, particularly in 1958 when, on the occasion of the big international fair in Brussels, I put up a huge synthesis-of-the-arts exhibition in Charleroi. Oftentimes I had to pack the works around myself... you can't imagine how many times I packed [Hans] Arp's gilded sculpture—I ended up hating that thing it was so heavy. [*Laughs*] We were all volunteers. We were driven by faith alone. When you find yourself like that, in the intimacy of things—like Gracq entering into the intimacy of his city—it is something that no one can teach you, whether through reading or through practice. It is something which you attain through good will alone, when you immerse yourself. Artists, just by the very fact of seeing me, start soliciting me. For years afterward I was—as I often say jokingly—the "operational agency" for those artists. And for some of the greats! When they had an idea, they would discuss it amongst themselves, and there was always one who would say: "Go see Parent, he'll do your show for you." It was I who did all of Bloc's monumental works for him in terms of drawing, and sometimes more than that, in their conception.

HUO:

Bloc died in 1966.

CP:

Yes, and it was a great loss. Artists didn't like him much because he was a sculptor, painter, architect, and publisher—he did everything... He did architecture with me, and we built three houses together. Because he earned a lot of money, he sometimes had dicey and tense situations with artists. And there was also something else about him that artists criticized a great deal but which I liked

enormously: he was extraordinarily curious. It is of course a quality, but it meant that as an artist, he was highly impressionable. One day, I remember, Bloc had asked me to redo a building in Nice. Bloc had done a sculpture and I was in the midst of setting it up in the hall when suddenly Klein and Armand showed up, and immediately starting criticizing André Bloc's sculpture, because they found it was excessively influenced by [Norbert] Kricke, which was true. But, as I saw it, these shifts in direction were a quality. There are so many artists who remain mono-functional their whole lives.

HUO:

In concrete terms, how did your operational artists' agency actually operate?

CP:

They came to see me with an idea and asked me to help them develop it. The role they asked me to play was to adapt the idea so that it could be shown or demonstrated. But, and I say this because it would be absurd at this point to fall into false modesty, if Bloc for instance kept asking me for years on end to work with him, it is because, on top of everything, there was also a personal contribution, an exchange... My work with the artists was also collaborative, based on close-knit associations. The artists, however powerful, when they came to work with me, never took me for what is known as a "ghost writer," and they always saw that they were up against someone whose sensibility was sufficiently developed for there to be a dialogue. And so, suddenly, things would evolve in the right creative direction. Because to get from an idea to its execution is what is most difficult.

HUO:

Could you come back to a few examples of collaborative projects?

CP:

Tinguely, for instance, came to see me one day because he wanted to make a "Lunatour" (Moon Tower). He had done a sketch—something very rudimentary—where he simply mentioned that he wanted to integrate the fairground attractions at Porte Maillot. Because at the time, Porte Maillot was the site of a fairground known as Lunapark—hence the name "Lunatour." Lunapark was scheduled to be demolished, Neuilly was in the midst of construction and the price of real estate had gone up considerably, so the city fathers wanted to get rid of the fairground. That's what cities are all about: their history is made up of rejections because of money, the price of land, hygiene, security, and what have you. There is no lack of reasons for cities to self-destruct and be rebuilt differently. The out-

come is not always better—to say the least—but that's how it is. So Tinguely wanted to rescue this super-popular attraction in a neighborhood that was at the edge of what was the most chic suburb of the time—that is, Neuilly. He wanted to recuperate the attractions and juxtapose them vertically. He did a drawing and was therefore looking for a form of architecture that would allow the project to be shown. In that project, he saw the possible realization of a gigantic Tinguely, some fifty- or one-hundred-meters high.

HUO:

Was that project ever actually carried out?

CP:

No, of course not. It's like with Klein's fountains at the Place de Varsovie; all the preliminary work was done, but the work never materialized. Through Bloc, we had access to the ministries, and pushed the project as far as we could, but France at that time was such an old and anguish-wracked country.

HUO:

But they truly were concrete Utopias?

CP:

Oh absolutely. For Tinguely, the idea itself had to do with recuperation, the same way his sculptures did. And what is more, it was in motion: we were recuperating something in motion; there was not even any need to set it into motion, because amusement parks are based on movement. So all that was required was to organize a structure—and that was my job—using a tubular network that was sufficiently robust to allow the different elements to be integrated. And there can be no doubt that it would have become a far more pleasant-looking urban spectacle than the skyscrapers. What is extraordinary about the project was that, in so doing, and without being aware of it, he recuperated Pop Art. And thus, in those instances, for two weeks or a month, I focused exclusively on that—I would draw, we'd talk it over, I would take whatever steps were required. I did everything because it was all part of my mindset, it was part of my way of staying alive and of breathing new life into my architecture by means of outside elements. The whole affair, as you must have noticed, is in the final analysis very close to the *Fun Palace*...

HUO:

Cedric Price's Fun Palace *(1961–1974)?*

CP:

Of course. Cedric Price was, to my eyes, one of the greats. I don't know what has become of him. I know that he made that wonderful aviary at the London zoo, back in 1961. When Bloc saw it, he

immediately started making aviaries for his own birds... [*Laughs*]
Price's aviary represents, to my mind at any rate, a milestone in
architecture. But if you ask young architects what they think about
him, I doubt they even know him.

HUO:

Yes, because there is a certain amnesia today with regard to those years, compa-
rable to the amnesia which, in the '50s, affected the architecture of the '20s...

CP:

Right. But you know, even the people who worked for me, who
actually saw the extent to which I was active, and not dozing off at
all, taking absolute risks in the name of modernity, people like
[Jean] Nouvel and that whole gang, who like me a lot, who still ask
to see me and who continue to talk to me—all those people had a
hand in bringing about this amnesia...

HUO:

Amnesia is not only the product of chance...

CP:

It's a whole tendency that becomes amnesic, a whole population...
After '68, the point was no longer to have any ancestors—there
were to be no more ancestors. When the left wing came to power,
with Mr. Jack Lang officiating as Minister of Culture, he actually
went so far as to say, in an official speech—which really depressed
me—that there were no architects in the country who were over
forty years old! What is that supposed to mean? It's like what hap-
pens in revolutions, where everybody has to be decapitated on the
grounds that there can be no exceptions. Take a guy like Danton,
who practically killed himself for freedom, and who got bumped
off, on the grounds that, "Hey, what do you want, if we start mak-
ing exceptions, the whole thing will cease to make sense!" That is
one of the things I find most exasperating, or that I even despise
the most: the decree that a community of thought, or of action, is
going to be stripped of its freedom of expression, or of life. In the
name of what? In the name of some new way of thinking? A new
way of life? What is that supposed to mean? Personally, I am not
nostalgic, I couldn't care less because I don't have much of a mem-
ory. However, very recently during a symposium, I said that my
big problem was to fight against my own memory in order to be
able to continue to create, and that it was no easy discipline. Nev-
ertheless, I am able to recognize my ancestors: [Frank Lloyd]
Wright, Le Corbusier—quite apart from the fact that I am against
him, and that I have written critically about some of the ideas he

defended, and though I feel I have clearly identified the limits of his work, because he was nonetheless a genius, and a precursor genius for me, in the absence of whom I would not be the person I am.

HUO:

Who else do you consider to be great precursors?

CP:

I like [Alvar] Aalto a great deal, and Wright as well as Bruno Zevi, even though he never built anything. I owe them a lot. There are others, too, such as [Erich] Mendelsohn, [James] Stirling, [Jørn] Utzon. There is a book that I will hold on to all my life, written by Anatole Kopp about the Russian Constructivists: *Ville et Révolution. Architecture et Urbanisme soviétiques des années vingt* (*Town and Revolution: Soviet Architecture and City Planning*, 1967). [Laszlo] Moholy-Nagy as well—who, as a matter of fact, was an ancestor of Schöffer.

HUO:

After having worked with Schöffer and Tinguely, you went on to work with Yves Klein.

CP:

Yes, it was in his late phase, just two or three years before his death. He was, for me, amongst the most dazzling artists of all. Klein was a dominator. You know, I think of myself as being someone with a very critical spirit, for different reasons, because of my scientific training, and in that way I am very French; I can't get away from this critical spirit. But with Klein I didn't argue. I didn't argue with his convictions, his ideas... I just swallowed them. He would show me things and I'd simply say, "Yes, that's right." He showed me colors that would combine to make pink or gold, at his home on rue Campagne-Première, and I would always just say, "Yes!" [*Laughs*] When I asked him what his leap into mid air (*Le saut dans le vide*, 1960) was all about, he said, "I jumped." I said, "But was anyone there to catch you?" And he said: "No. But I know what I'm doing. I am fourth dan." It's more than merely believing; it's not seeking not to believe. I could have sought to find out for myself, and it's now known that there were people and mattresses down below. But that is of no interest to me. The point was Klein in mid air, and from the moment he managed to get the idea across about this flying man. Well, the rest—and how he went about it—is of very, very little interest to me. On the contrary, I am happy still not to know.

HUO:

Did he ask you for very concrete, very specific things? Werner Ruhnau in Krefeld told me about a theater and a café that were never built. Did you know anything about those projects?

CP:

My collaboration with Klein came after the exhibition in Krefeld ["Yves Klein: Monochrome und Feuer" ("Yves Klein: Monochrome and Fire"), Museum Haus Lange, Krefeld, 1961], and that puts it pretty much at the very end of his life. I know there was a quarrel—which is actually still ongoing amongst his family—between Rotraut Uecker, his wife, and Ruhnau, that has to do with the allegation that the latter continues to exploit a small Klein capital with the sponges he managed to recuperate at Gelsenkirchen at the time. But, okay, it was nevertheless Ruhnau who did Gelsenkirchen and who gave Klein a sensational entrance into the realm of art. Klein may very well have been underestimated, he may have suffered on that occasion, I don't know. At any rate, he ended up as the orphan of an architect. He needed an architect, and that was when he came to see me. He showed me the drawings, which were just impossible for publication—it was horrible, a sort of unbelievable gouache... So we worked together on the meeting of water and fire, and the Place de Varsovie fountains (1961). The meeting of water and fire was his great obsession. I did the drawing, which was no mean feat, because the point was to materialize this instantaneous and ultimately immaterial meeting. So we just kept on doing one sketch after another until he was happy with what we had come up with. Guy Rottier sent me his book recently, and in the book are a certain number of the drawings. They can also be found in many books published in the United States. They disappeared for a while—and I didn't keep a single one of them. They were done for Klein, and so they were his. Two years ago, the guy who is in charge of the Klein archives, here in Paris, sent me a whole series of small drawings, asking me which of them were mine. And it's true that at the time I had a collaborator, who was, in fact, as I only noticed years later, much more of an artist than an architect, and who worked on developing several of my drawings. Thus, there were drawings done by me and others authenticated to have been done by Sargologo.

HUO:

Did Klein, who, I believe, always worked like mad at the last minute to get things done, put pressure on you for those drawings?

CP:

Always. Always. And that is precisely why I also asked my assistant to lend a hand. For the "Warsaw fountains," it was just like with Tinguely. He said to me, "We're going to pull it off because I have good connections with Gaz de France [French natural-gas utilities

company]. For the "Warsaw fountains" at Trocadero, you've got to whip up a sumptuous-looking drawing because I have an appointment with the city and gas authorities in order to change the fountain, we'll work on it together..." We talked it over at great length and then he showed up with all his gear and more or less set up camp in my agency over on Boulevard Suchet. And he didn't leave until the drawing was finished. It was just never what he wanted. We ended up having dinner there, right in the agency, the drawing was just about finished, there was water, and there was fire, everything was fine—except that he found that the whole thing still lacked atmosphere. And it was then that I had a "flash of genius," and I said to him, "In fact, what you really want are clouds of smoke, to underscore the significance of the meeting between water and fire; full columns of smoke making their way across the sky would give the whole thing real atmosphere." Jackpot! So, we added curls of smoke to the drawing. It was a fairly nice-looking drawing. And it was also at that point that I understood his dreamy side. Depicting the "golden age" in a drawing is no mean feat... It's a life-long endeavor. We, however, had very little time and nothing but the idea of nudity to work with. Nudity is what explained the freedom of the body, of living in freedom. What Klein also insisted upon was burying technology—which was something I understood. But what surprised me was that he was happy that I depict it with drawings whose graphic style showed affinities with a Jules Verne-like imagination, rather than by means of modern drawings. It was romanticism, in other words. In the same way, he only threw himself body and soul behind the "Warsaw fountains" once I had given a romantic dimension to what, at heart, was neo-classical architecture. Klein's taste, in that respect, was not some sort of joke, or snobbish posturing, but something that he truly believed in. I should have been able to figure that out right from the time of his wedding: the sword, the cocked hat, the arch of weapons on the way out of the church—that was all part of his life. For me, and contrary to what is sometimes alleged, there was no irony in any of that.

HUO:

Do you think that this urgency, which characterized both his life and his work, came from the fact that he knew he didn't have long to live?

CP:

There's no doubt about it. One day, he came to my place in his old jalopy, on the back of which he had attached a canvas. Not a very

snobbish thing to do, and something that was in stark contrast to his appearance, which was that of a dandy. In the recently published book on his work, the woman who wrote it tells with great apropos about how he rose to fame, his determination to achieve recognition and to make it to the top. And believe me, he didn't get any help. In judo he didn't get any help; artists didn't help him either; critics even less so, with the exception of [Pierre] Restany of course. For many people in my immediate circle—for someone like Gassiot-Talabot, for instance—Klein was nothing but phony, and so the only people who supported him were Restany, Iris Clert, Rotraut and me... [*Laughs*] Of course, he did have his friends as well, Tinguely, Arman, and so on.

Another collaborative initiative between Klein and myself had to do with producing the famous imprint on the architecture of air. He wanted me to sign it, which I refused to do. He called me over to his place one day to do an imprint; Rotraut was there along with a German strip-tease artist, whom he had discovered at Montmartre. He asked me to do all the attendant drawings. In order to create a general atmosphere of the air in positive and negative, he asked the girl to lie on her side, and drew the contours of her silhouette with a spray gun. It was utterly disembodied, and not the slightest bit erotic. Meanwhile, with scissors and paper, I was busy doing the decor. I drew the woman on her bed of air, cut out the palm trees to give a vision of a Caribbean environment—a hot environment, because the point was a world that existed in full nudity, protected from the rain, beneath a roof of air, in the midst of nature: that was his immaterial architecture program.

However, there was something very surprising about Klein, and that was the obsessive presence of the highway—which is something, by the way, that he never denied (which one also finds in Le Corbusier's work, and I would say, with the same naiveté as in Le Corbusier's work). The highway was supposed to symbolize exchange, and the flux of fluids—which is what the roof of air was all about. I believe that in that world of golden legend, there was a sort of seasonal migration: when one had had enough of some particular spot, off one went in search of another source of air roofs... Klein once said to me, for instance, "So, I'm going to Nice, I'm going to drive 1100 kilometers and everything that takes place in the course of the trip—the rain, the air, the wind—will impregnate and produce the canvas. The painting will be the journey from Paris to Nice, on such and such a day, at such and such a time." He

did a lot of those—I don't know if they had much success. Sometimes I would ask him why he did it. It was nevertheless strange because Klein was—contrary to what is sometimes supposed—a very demanding, very meticulous person, who couldn't bear to have his monochromes damaged or smudged, or that one might be able to see fingerprint traces, for example. He hated the randomness of matter. And there, on the other hand, he accepted an atmospheric smudging, whereby, in keeping with his principles, he didn't get involved at all, as he drove from Paris to Nice. Such a contradictory attitude is extremely curious. But Klein was also extremely charming, extremely warm, and extremely agreeable—he was a friend with whom you could have a laugh—and at the same time unsociable, driven by absolute truth and the need to convince.

HUO:

*In terms of absolute convictions, there is, particularly in your case, Utopia. In reading the book that Michel Ragon has written about you (*Monographie critique d'un architecte: Claude Parent, *1982), one sees that Utopia is the common thread that runs through your entire career. And yet you have never belonged to a group of utopian architects...*

CP:

The first time I ran up against the notion of Utopia—without actually knowing it—was with Nicolas Schöffer, and it had to do with spatio-dynamism: a detailed study of the spatio-dynamic city. That was the starting point for Schöffer's scale models, which I worked on with Schein—the never-ending cities. Schöffer said to us, "The right height for living in a building is sixteen meters above the ground." That is, on the fifth floor... Schöffer would regularly lead me into a building, take me up to the fifth floor, and say, "You see, Parent, how well positioned we are here. We're just above the trees." So in the cities which we came up with, there were only two levels which were actually for living on, and one had to rely on (preferably) helicopter transport of course... It's not the only project for a linear city; there was Constant's *New Babylon* (1956) as well, whose objectives were, I believe, somewhat the same. I still wonder if those two knew each other. I think they did; it seems to me that Schöffer knew Constant. But Schöffer never mentioned him to me. I only first heard about the Situationists from Virilio, and that was in 1964. Never before that—which is terrible. It has to be said that artists can sometimes have a sense of exclusion that can reach utterly unimaginable proportions. Personally, I can't even talk about my work with Klein without Ruhnau constantly coming to mind, and without having to

point out, as I mentioned earlier, that he was involved in the story long before I came along. A mystery surrounds Constant that I would very much like to clear up one day. Obviously, the whole idea of setting up sixteen-meter-high pillars—back in 1951–52!—was completely utopian. Obviously, everybody was laughing their heads off at me, except perhaps the young students who worked for me and thought that the whole thing was extraordinary. Later, Schöffer and I worked on a supermarket project, in Châtenay-Malabry, but it was refused; and after that there were two housing projects in Saint Cloud—but they too were abandoned and never built. We were in sheer Utopia, which is something my fellow architects never missed a chance to point out—except that they would refer to it as "utter irreality," since for them it was purely ridiculous. In 1950, for one whole year, we were in Utopia. But personally, I enjoyed that, in spite of my critical spirit: taking such utter freedom and asserting things that I believed in about the future of humanity. Subsequently in 1960, along with Lionel Mirabeau, I took another stab into the utopian register with the "cone cities"—the drawings are at the IFA (Institut Français d'Architecture), and the project was published in *L'Architecture d'aujourd'hui*. That was dated. When you talk about architectural Utopia, in order that the Americans—highly rigorous people in terms of archiving practices—classify you as a utopian, you have to have started prior to 1960. The people who in 1968 created Utopias—people such as Jean Paul Jungmann for instance—were, in the eyes of the Americans, already involved in a political current, a current of thought; they consider that in such cases architecture is not the trigger of Utopia. What is interesting in the Utopia that I advocated, both with Schöffer and with Mirabeau, is that it was *utopian architecture*. It is not the same thing as doing a type of architecture that will go with the utopian society of the future, as was the case after 1968. It's not the same thing at all. But that doesn't mean their drawings lack value and truth. I went back to Utopia once again, in 1964–65, with Paul Virilio. That was also our own Utopia, insofar as it was based on an architectural fact—that is, on the use of inclined planes for life. But in spite of all that, I feel it is important to point out that I have always been somewhat down to earth, and even though, on occasion, I made the odd foray into the clouds—and God knows I did—my work was to build projects. I was never satisfied with doing architecture on paper. That was never enough for me; it was too frustrating. After the '60s, there was a profusion of architecture on paper, especially surrounding the movements around 1968.

HUO:

But in the case of the oblique Utopia, in the case of the projects done in con-
junction with Virilio, what part of the work was actually feasible?

CP:

These projects are considered—probably quite rightly—to be
utopian inasmuch as we said: "You've been living on horizontal
planes for nine thousand years now, and you haven't given any
thought to living differently" (except in the case of those people
who either sail or mountain-climb, and as a matter of fact, when I
did my lectures in 1964, they were the only group of people who
understood, because they had already experienced the oblique in
their own fields). This Utopia found its way into the realm of the
sensitive all on its own, because the body, when placed permanent-
ly on an inclined plane, does not react as it does on the horizontal
plane. At the beginning, people would say to me, "But it's just not
possible!" And I would answer, "Just climb up on a ramp, walk two
meters, and you'll see that you no longer feel your body the way
you do on a horizontal plane." It's true, gravity pulls you toward a
vacuum, it is demonstrably tiring to climb up—in short, your
body is in unstable balance. Thus, in that instance, the sentient
realm shifts completely, except that in that case, we have managed
to embody it by changing and renewing the relationship. This
Utopia thus had a basic underpinning which was the relationship
to the body and to the way in which the body—and thus the
mind—behaved, if you were (or if you lived) on a slope. I therefore
brought together both the spirit of adventure, the imbalance and
thus the will for movement which has always been a constant with
me—and particularly in the last house that I did before meeting
Virilio, which had the shape of an up-ended cube, just on the verge
of tipping over... (*Maison Drusch,* Versailles, 1963–1965). I'd tell
clients that, in my eyes, it was a success if they were afraid the cube
was going to fall, which did nothing to reassure them... [*Laughs*]
But they're still living in it, and I believe they are very happy there.

HUO:

Those houses continue to fascinate people; Philippe Parreno, the artist, or
the architect François Roche, often allude to them in conversation.

CP:

Yes, the topological universe, which was invoked at the time, sub-
sequently caught a lot of people's imaginations, though it was not
understood at all at the outset. It has acquired a newfound topical-

ity because it echoes certain concerns of young people, whether with regard to what are known as hyper-surfaces, or through the work of people such as Stephen Perella, or Nox [Lars Spuybroek], who have also become interested in it.

HUO:

One can also imagine these oblique surfaces as performative spaces, or spaces of representation—which in that respect perhaps connect with your interest in the theater...

CP:

Sure... I rediscovered in the history of the oblique function, in which Virilio played a key role, the synthesis of everything that interested me or of everything that I was after. I am totally attached to the fact that, from then on, I could only think of architecture—even normal architecture—through that particular research.

HUO:

Amongst all your projects that remain unrealized or haven't yet been carried out, which one remains closest to your heart?

CP:

As I already said, I always have to fall back into reality; it's a necessity for me, it's crucially important. The project which I would most like to do would be to have three or four hundred inhabitants whom I could watch living, keeping an eye on their experimentations. I tried to get involved with the "medium-sized town" section, I was well noted, they promised I could do a student residence, but then the project got bogged down and never happened. Virilio and I did a house—the *"Mariotti" House* (1967)—and I would like to get that functioning, get it functioning in life, that is. And I would like to establish some relations as to how people react to, or live in, the space. As long as that has not been done, I will regret it. I cannot content myself by simply saying that young people now come to see me, or that Koolhaas himself now does slopes galore. Not to mention Zaha Hadid, because her work sometimes verges on decals. But that's all fine by me: architecture is made to inspire, and architects to be copied, and sometimes it's an improvement, an update, more sensitive, more incisive. I don't think that copying in architecture is a bad thing. On the condition that it is well copied. But personally, I prefer life. What people fail to understand is what life on a slope, on an inclined plane can mean. That's the deal: is it a grotesque assertion to say that all of a sudden you are going to feel better about yourself, more in sync with the modern world, more in sync with the future awaiting you, if you live on inclined planes rather than enclosed in

orthogonal spaces? Or is it, on the other hand, unbearable? Nobody knows yet. But what I know is that I am less and less able to put up with the partitioning of vertical walls—in other words, with what can be called the ghetto. My house is open—there are holes everywhere... I live in a little house in which I have managed to create a 14-meter sightline—and I could care less whether people can see me or whether they can't. I would like to experiment with the notion of dynamics and instability. I feel that man has reached a point of crisis, and that this crisis stems from the fact that he is enclosed behind orthogonal walls and that he has been fixed on horizontal planes. What I say is that within that framework, man is stable and comfortable, and that if man is to be able to do something in the third millennium, he is going to have to be destabilized, placed in a situation of discomfort. And the oblique is just the thing for that! So I believe that it is neither more nor less than the survival of the species that is at stake. There are two modes of survival: one consisting of relocating on other planets once everything has been used up on our own, and another which is based on the oblique, enabling man's mind and body to be far more apt for adventure than is the case for the time being. For the time being, I feel that our society is increasingly closing in on itself, increasingly—and voluntarily—closing itself off in micro-ghettos. And that's tragic—because it means the death of humanity. So, you see, the oblique is useful!

HUO:

Your project thus seems to be to test that hypothesis...

CP:

Of course... Unfortunately I'm 79 years old now, and my chances of ever seeing it happen are dwindling. The tragedy is to observe that young architects, who are now fifty years old, are just not concerned about it. But I am encouraged when I see people like François Roche, or like Nox, rereading the book and discussing it with me.

HUO:

You say in the book that you do "a hundred trades at the same time..."
In effect, you have been an architect, artist, urban planner, designer, you
have worked in advertising and done posters... I have the feeling that peo-
ple of my generation—and this is perhaps even more the case for those
younger than me, who are still students—also do hundreds of things at
once... This motto that "I do a hundred trades at once" has perhaps nev-
er been so true as it has become today.

CP:

I think that just as orthogonal architecture is a prison, a profession is a prison for professionals. When I hear that an architect is a "com-

petent professional," I say to myself that he's had it, he's finished...
[*Laughs*] Because if he reacts in keeping with his professionalism, he
has no chance. I prefer it when people say about me that I am not a
competent professional. Of course, I have to take the necessary steps
for that to make sense, because I do, after all, have responsibilities,
but I don't have any use for the title of "competent professional."
When I was young I had to seek out my path, but there has always
been a constant in my life: drawing. My good fortune is that I know
how to draw. I wanted to be an engineer, but I couldn't because I
wasn't good enough in mathematics. So my brother said to my par-
ents, "Turn him into an architect in that case." I never gave up
drawing. I cannot understand why young architects have given up
drawing in favor of the computer. What worries me about comput-
ers is the instantaneousness of the system. And it is liable to become
faster still. Soon, images will morph all by themselves on the screen,
and all they'll have to do is to freeze a frame, and pick out which
one they like. I think that in so doing, they miss out on the extraor-
dinary contribution provided by the time of the drawing. Drawing
is a manual—though of course also mental—process; manual in the
sense that it lasts, it is long and fastidious, and requires patience.
My imagination is at work the whole time it takes to do a drawing,
which can sometimes be up to two weeks. It is something highly
complex, because the drawing modifies itself, and is never what one
imagined it to be at the outset. Drawing is an adventure that both
fascinates me and keeps me going. Today, these young people are
going to have to find something in or with computers that will
enable them to discover this system, to rediscover time, something
for deforming. Of course, they manage to deform their drawing,
but it's just too fast in my opinion.

HUO:

In your opinion, a new slowness needs to be instilled into architectural practice...

CP:

Absolutely, and I even wrote an article on the subject some time ago.

HUO:

*Cedric Price told me an anecdote about you: apparently you showed up in
Folkestone, for the famous IDEA conference in April 1967, at the wheel of
a Rolls-Royce. Was that a performance?*

CP:

[*Laughs*] That is just a rumor. I had a Rolls-Royce subsequently,
but much later... At that time, I arrived just like everyone else, by
plane... The Folkestone conference was extremely important for

me because all the utopians from all around the world met there together. If I remember rightly, it was in 1967. What I do recall, however, is that Virilio and I got utterly panned by the Marxist-Leninist contingent, who accused us of being Nazis. They all started doing the Nazi salute in the lecture hall. And I can assure you that when, in the audience of some two hundred people, forty-odd students stood up to do the Hitlerian salute, while we were in the midst of speaking, it produced quite an effect on us.

HUO:
Who were they and what were their arguments?

CP:
They were, above all, people from the UP6 (École d'architecture de Paris–La Villette), who had crossed the Channel to do away with us. I believe that all the critical remarks leveled at me, whether in terms of ideas with regard to the oblique function, or my work as an architect in general, stem today from a political reflex. Not that I have ever been involved in politics, but because it was a form of thought that was not compatible with Marxist thinking. The university, however, like the architecture school, was dominated by Marxists, and UP6 was in this respect the most active cell of all. We knew that in Folkestone, [that] they were going to do something; we knew that they were set on perturbing our talk one way or another. So we went to see our translator and asked him to read the text as quickly as possible, in order to make it impossible for them to interfere with the talk. And it worked, because it was only once we started talking again that they intervened and had to leave. It was harsh... It was strange, too, because it never stopped them from being friends—even close friends—with all the people from Radical Italian Architecture—and they really were Marxists, doing agitprop, setting cars on fire, and were passionately involved in the anti-American movements around Vietnam—but there is something which, in France, made it impossible to envisage any active complicity between different forms of commitment under the common leadership of the progress of architecture. What is regrettable for France and for its university system is that so much time was squandered in knee-jerk quarrels, and in futile and unfounded battles, and wasted energies. Today, all that has changed.

PARRENO, Philippe

Philippe Parreno was born in 1964 in Oran, Algeria. He currently lives and works in Paris and Madrid. Parreno studied at the École des Beaux Arts in Grenoble in the '80s and he started exhibiting his work at the beginning of the '90s. Parreno's work revolves around the interrogation of the nature of an image as well as the modes of its exhibition. Most of his projects question the autonomy of individuals and groups within social systems and dwell on the interstice separating an image and its caption, the process and the product, the production and the consumption. Another characteristic of his practice is the exploration of the notion of the exhibition. Over the years, Parreno has tested different methods of exhibition practice, transforming the exhibition into a site for debate that should not only be conceived in terms of forms or object, but of forms of representation and interpreting the world. "Alien Seasons," his most recent one-person exhibition (Musée d'Art Moderne de la Ville de Paris, 2002), was organized around a series of programmed events that would appear and disappear at various intervals, with the elements of the show "edited according to time sequences." Parreno's artistic practice embodies the logic of conversation and dialogue. He has produced an oeuvre consisting of numerous projects that are often developed in collaboration with other artists and practitioners. Following his method in which discussion leads to the elaboration of a non-rigid, non-vectorial type of thought, Parreno, together with Pierre Huyghe, acquired the rights for a low-cost manga character named Annlee, from an agency in Japan specializing in off-the-shelf creations, and thus triggered a three-year project in which several artists were asked to adopt her and breathe life into the character. Through this project, notions of authorship, copyright, and representation were explored. A variety of models and designs of exhibitions of the complete Annlee *project have been tested resulting in an ever-changing "collective monographic" exhibition ("No Ghost Just a Shell") that has been presented at the Kunsthalle Zurich (2002), the Institute of Visual Culture, Cambridge (2002), and the Van Abbemuseum, Eindhoven, The Netherlands (2003). The project also included the production of a book* (No Ghost Just a Shell, *2003) and was featured on the cover of several magazines including* Artforum *(January 2003).*

..................

This interview took place in various locations over the course of 2001 and 2002.

Hans Ulrich Obrist:

There is, I think, a sentence that really sums up your relationship with your work today. You say: "Today, there are no longer images that are beautiful, there are chains." I think this phrase could also be a departure point for this conversation.

Philippe Parreno:

Yes, what I mean by chain is a dynamic structure that produces forms that are part of it: pre-production, production, post-

production. These narrative instances depend upon each other. In the course of the chaining of these sequences, a narrative unfolds. An image, a building, or a film comes from a more vast narrative structure, to which they belong and which they are elements of. In robotics, they use a very precise term, but I don't remember it anymore. But they talk of the threshold of tolerance or linear adjustment to describe this interior time interval in which a number of events will produce themselves. This semiotic chain that I am talking about appears in this space. It's like a book that we can read, but which was never written. Why aren't there any books written from films? Is the film the finality of cinema? Is a book or an object always the end of something? Does everything really always start with a scenario and end with an object? Should there always be a happy ending? Why wouldn't there be many endings?

HUO:

So you want to escape that fate?

PP:

The degree of resolution of your ideas depends on an economic choice, which either you make, or is imposed on you. For example, in architecture, you start with a project and then often arrive at a simplified, low resolution of the project. But I am more interested in procedures than in resolutions. Starting from an image, or from a moment considered as an image, you might read the whole work backwards finding all the connections, the chains, just like you can read a book starting from its end. That's a real experience of writing and reading. Some artworks are incredible scores. In the *Shining* (1980), by Stanley Kubrick, there's a scene in which the cook explains to the little boy—"You know Doc, when something happens it can leave traces of itself behind, it's like when you burn toast." It's not necessary to have "the shining" to see things. Liam Gillick's books aren't the scenarios for his plastic works, they are parallel to his practice; they are part of each other. Similarly, you cannot say that Carsten Höller's hermeneutics is his tool.

HUO:

Precisely, it seems to me that most collaborations between artists and architects are motivated by this research about the difference between conceiving and realizing a project, just like the work you're doing with François Roche. Where do you locate the beginning of this common interest of architects and artists for different modes of exhibiting and experimenting, and for ephemeral, undetermined forms?

PP:

These questions appear in a certain practice of art or architecture that we can maybe date to the '60s. Of course, the collaboration between Yves Klein and Claude Parent on immaterial architecture is the result. There are also Rauschenberg's *White Paintings* (1951): Merce Cunningham projected a film of the painting, [John] Cage with his silent score gave a reading for the duration of the painting, and this *statement* which was started, but of course never respected. A statement that paintings can be repeated, since the white light reflected will always be contemporary. The question of immanence and the contemporary are secular questions. Here are excellent chains of images. Since the opening of Kubrick's *Clockwork Orange* (1971), radical architecture groups disappeared after the Venice Biennale in '72. The history of architecture is a history of the object. In the same way, there are no longer any art books that retrace the history of the exhibition.

HUO:

Yes, the history of art is one of works, and never that of exhibitions. It is, I think, a fundamental problem. Exhibitions aren't collectible, and because of that, they aren't archived. As soon as time passes, they are forgotten. This amnesia that affects exhibition history has pernicious and very deep effects.

PP:

For example, this summer the Stedelijk Museum Amsterdam showed the work of Dennis Hopper. It's very symptomatic. Hopper is a horrible painter, but he really still takes part in the exhibition realm—the exhibition in all senses of the word. He's an amazing interpreter. Nevertheless, Rudi Fuchs presented him as an artist who is a painter. It's twisted, isn't it? Even still, it's paradoxical in the case of someone who has done everything but painting. Finally, he paints as he sees it being done around him. He interprets it; it's not really his best role. You imagine that, in 2002, the opposition between high culture and pop culture is always an issue. It's derived from fetishism.

HUO:

It's striking to see to what extent the questioning of the object by artists is a recurrent question that disappears and reappears. In this perspective, the '90s are a perfect illustration of this phenomenon because they make a very explicit return to forms of questioning the object, which would have otherwise disappeared at the end of the '80s. How do you envision the way in which you treat this question in relation to the ways artists did in the '60s–'70s?

PP:

From the '80s on, Sony and Thompson have been after the issue of resolution. The point is not to produce images, but to produce images with a good resolution. This idea was really like a virus. The issue was widely discussed in the '60s and '70s. Yves Klein, however, sold emptiness. In the '60s–'70s, the question of the object had been debated around very spectacular political and aesthetic questions. If today I wanted to approach these questions with Lawrence Weiner or Daniel Buren, I would quickly have the impression of being an illiterate brainless neoliberal.

Have you seen [Gary Ross's film] *Pleasantville* (1998)? It tells the story of two teenagers from the '90s who find themselves in a TV series of the '50s. Under their influence, the city's inhabitants slowly shift from black-and-white to color. It is interesting to notice that at the end of the movie, the town is just partially in Fujicolor, not completely. It's like [Don Siegel's film] the *Invasion of the Body Snatchers* (1956). It's the story of aliens devouring humans and replacing them, until they create a society of soulless replicants. In these films, this idea is terribly traumatic.

HUO:

Isn't there, all the same, a kind of dynamic that could explain why such issues appear again and again?

PP:

Yes, there is a kind of liberal dynamic. This kind of question is generally tackled with one's boss in the billiard room of the company, on Friday, wearing jeans, because Fridays you can dress as you like at work. When you take part in a workshop in a school of fine arts today, you can see that resolution is the biggest problem art apprentices have. They typically ask, "Your idea is fine, but is it resolved?" There is still the tendency to solve a problem within a form. Whereas to me, it's exciting when the content overflows beyond the form... What interests me is when it overflows in one way or another. It's the irresolution that is interesting. The dynamic of fluids is interesting because they question equilibrium.

HUO:

[Jean-François] Lyotard asked these questions in 1985, in the exhibition "Les Immatériaux" (Centre National d'Art et de Culture Georges Pompidou, Paris). Was that exhibition important for you and artists of your generation?

PP:

It was a super exhibition. It was at once an analysis and an experience, it responded also to all the questions on virtuality in the '80s.

The catalogue of "Les Immatériaux" was printed on slips of paper. It was made up of a series of exchanges between different people during a period of time. A sort of university web had been used to facilitate correspondence. That was the first time a kind of proto-Internet was used as a tool, not as an icon, but as a tool. The show in itself was surprising in the curatorial choices, in the manner in which objects and experiences were arranged. It was a superb reading experience. It's impossible to describe it if you weren't there, and I'll start inventing things. It's like the story of a tired guy who wants to rent a movie. He asks the manager, and he tells him, "I would like to rent a movie, but I forget the title and I don't know who directed it. It's a film in black-and-white, with parts in color, towards the end. There's Bruce Willis and Superman." You know? He ends up telling his dream.

HUO:

Was it a philosophical exhibition, like some complained at the time?

PP:

"Les Immatériaux" was an exhibition, a way to organize content within space and time. But that was very different than writing a book or developing a philosophical concept. And that's precisely what I loved in that exhibition, that it wasn't a conceptual exhibition. It was much more experimental, and in a certain sense "liquid." I learned later that Lyotard wanted to do another exhibition, "Resistance." "Resistance" isn't a good title. You immediately think of moral issues. But the first thing they teach you at school, when you study physics, is that friction force is not important, because it's too complicated to think about. I think that what he meant by "resistance" had to do with that. Finally, I imagine...

HUO:

Why not try to realize this second exhibition? That could really work against the widespread amnesia of the history of exhibitions.

PP:

Someone should try to find his notes. Posthumous books are published, why not a show?

HUO:

It would also be an occasion to reintroduce some slowness in the world of exhibitions, which, since the '90s, has been hectic as far as the number of exhibitions is concerned. It would be another form of resistance.

PP:

I think that this is a responsibility artists have. Maybe, one of the ways of resisting—or of putting into doubt, as Carsten Höller

would say—is to slow down rather than accelerate, to create another form of dependence; a dependence on inertia. I say that, but I like to move, in a sense, and to be distracted.

HUO:

When you talk with other artists about this kind of alternative, what kind of project do you imagine: are you thinking of exhibitions, works, and publications?

PP:

The book is a super format … maybe the experience of reading will become fundamental again. Reading is also a physical state; it demands a particular attention, a floating attention. The moments where you disconnect from the reading, when you start dreaming, are very pleasant. You are at once inside your head imagining things while you're being spoken to. I have lots of stupid ideas about books. I would love to make a book of images on the history of medical representation. From Leonardo da Vinci to virtual reality and synthetic images, all the techniques of representation have been invented by medicine. It would be fascinating to trace such a history. Modeling the liver happened in 3-D before making *Terminator 2*. Another book would be on the manner in which men have rationalized their relation to their waste. There are ethnologists today studying the manner in which the question of the greenhouse effect is managed by nations. They study how nations can negotiate between themselves. New extra-national bodies are created. In the same way that plumbing redesigned cities, the treatment of the greenhouse effect will modify our landscape. The palace of Versailles had been designed to evacuate odors… The Kyoto accords are a part of the history of the treatment of human secretions… That would make a beautiful book. A book of landscapes and of very spectacular spaces. I would also love to make a book on zoos, a geography book. Zoos are very accurate mirrors of the way we think about cities. All these are histories of books.

HUO:

Writing is a time of pause; it's also perhaps a more controlled kind of "mise en récit" (narrative) of your work and of the questions that are engaged in it, than the one offered by exhibitions.

PP:

I love to read magazines, but I often have the impression of being a part of history that is not written down while reading them. The *cut-up* of the magazine offers possibilities of very open readings, but without articulation.

HUO:

In terms of books, there is also this book project on the history of copyright and the author's rights that you're working on. One can imagine that this work might last ten years, which is rarely possible when making artworks... At the same time, one can also see the Annlee *project 2000–2003) as questioning the problem of copyright. Many issues begin to stack up.*

PP:

The history of the copyright is parallel to the history of individualism and of liberalism. It's a history starting with the statute of Anne in England. The history of the copyright is the history of a right that was detained by those in power, and which, by delegation, was given to the printer, then the printer gave it to the editor, the editor to the actor, the actor to the author. Today the authors nourish the capital. These Oscar-type parties begin to multiply. Even in art exhibitions we see longer and longer credits. The *Annlee* project is to give its right as an author to the sign itself, to have its own autonomy. It's the history of the copyright, "From the King to the Sign." But *Annlee* is also the follow-up of *Vicinato* (*Vicinato 1*, with Carsten Höller and Rirkrit Tiravanija, 1995; *Vicinato 2*, with Liam Gillick, Douglas Gordon, Carsten Höller, Pierre Huyghe and Rirkrit Tiravanija, 2000). How can several artists be in the same image and share it? *Annlee* is an image—a small *manga* character, a melancholic sign—in which many people will be able to live. You know the book *Painters and Villains* written by Maurice Pianzola (*Peintres et vilains, Les artistes de la Renaissance et la grande guerre des paysans de 1525*, 1993)? He describes the attempt of a pre-Marxist revolution at the beginning of the sixteenth century led by serfs and peasants. It was an insurrection that came from Germany. The book talks about the voyage of this peasant who travels throughout Europe looking for a painter who can invent what could be the flag of this revolution. *Annlee* is also the story of a community that finds itself in an image.

HUO:

What is the status of "No Ghost Just a Shell," the exhibition that gathers all the different films and projects done around the character of Annlee?

PP:

"No Ghost Just a Shell" is an exhibition that has become a work of art. The exhibition will be shown as a recent acquisition at the Van Abbemuseum of Eindhoven. Before that, it will travel to the San Francisco Museum of Modern Art and the Kunsthalle Zurich; all the films will be reunited. It's really a proposal for a group show, where the show is contained in the interior of each work, like a

motif. It's a monographic group exhibition. It is interesting to look for what is monographic in a group, or collective in a monograph.

HUO:

In terms of group exhibitions, apart from "Les Immatériaux," are there group exhibitions that particularly impress you?

PP:

Yeah, surely a lot. There was "No Man's Time" (Villa Arson, Nice, 1991), but mostly exhibitions organized by artists. There were also exhibitions that we made with Liam Gillick—"Le Procès de Pol Pot" ("The Trial of Pol Pot," Le Magasin, Grenoble, 1998) is the last to date. The whole exhibition space was treated like an object. The walls were white. On each wall there were fragments of texts, and questions were written in black Helvetica. It was a psychotic black-and-white environment that resembled the decor of "The Avengers." The show was easily reproducible. If you made a Xerox of a Xerox, you wouldn't lose much. A number of consultants whom we invited made proposals, and discussed this exhibition. Liam had invested a lot in the project. The exhibition wasn't a moment of clarity. At the time when we were treating the question of Pol Pot, the United States was starting to be involved in the story, and a trial had begun. What interested me was working on a show directly in relation to its reality. What was fascinating about the reality of the trial proceedings was that it took place in the jungle, and that there was an absence of images of the judgments.

HUO:

What's left of this exhibition?

PP:

We didn't make a catalogue. Publishing archives has its own para-scientific vocabulary. In the same way, at the real trial, not one judgment was made, and very few foreign observers were present. The exhibition ended that way also. It was a direct broadcast.

HUO:

And what about the Temporary School *project (with Dominique Gon-zalez-Foerster and Pierre Huyghe, 1997), which was also a form of alternative intervention in the art world, but this time more in relation to schools and institutions rather than to museum structures?*

PP:

The *Temporary School* is temporarily closed. Basically, we wanted to create a displaced school, to directly summon the real in the school. It was a parasitic school. But we made only one session.

HUO:

We have touched upon it lightly already, but I'd like to come back to these collaborations that you've set up with practitioners working in other fields.

PP:

The problem of working with others… finally the problem and the interest, of course, is that everything rests on the definition of the project. It is not a question of agreeing on everything, but for just a moment, on one specific project. It's already enormous. It's also a moment where you let yourself instrumentalized by someone else. Having common desires is a good way to have a sense of community. Later on, the museum can be a fantastic key to access other fields.

HUO:

Perhaps we could recall what are, or what were these different collaborations?

PP:

With people who aren't artists? I've worked with François Roche, and I worked with Dave Stewart, with Charles de Meaux, with Dagmar Berkoff, who is a TV journalist in Germany. With Dagmar we tried to treat the TV journal as a tale, and to recount information instead of just telling it (*While*, 1995). We wrote a text that was shown on public channels in Hamburg every day at the same time. There was a way of approaching information, not as an analysis or a presentation of facts, but the transformation of facts into a narrative. We taped this show at the Kunstverein in Hamburg… But she explained to me that she was bound by contract to tell the truth. It's funny; here is someone who doesn't have the right to lie.

HUO:

Can you tell me more about your collaboration with Charles de Meaux for the film Le Pont du trieur *(1999)?*

PP:

Charles de Meaux is a bit untypical as a cinema-lover. He's a real character from a novel. He is finishing his first feature film with Romain Duris, Caroline Ducet, and Melvil Poupaud. He is a very uncommon individual who before was a jockey. He was running a steeplechase and had an accident. He ended up blind, waiting for a cornea transplant. He later organized rock concerts. He organized the last tour of The Clash in France. Later, he met Alain Cavalier and he was the first assistant on his film *Thérèse* (1986). This is how he got started with cinema. So we made this documentary with Charles, *Le Pont du trieur*. It was very interesting to work with him because we had two completely different approaches. What got us together was again this need to present the information as a tale. We

made a documentary on a region of the world called Pamir, on the border of Afghanistan and Tadjikistan. Five years ago, nobody was talking about it, but it's a region that has always held a key place in history. We wanted to film this region at the end of its civil war. There was a real waiting period situation. If CNN didn't go there, it's because there were no images to make. We asked ourselves how to film a non-event. I wanted to make a film the way one makes an exhibition. I thought of the distribution like that... I wanted to make a radio broadcast, in the middle of which would be a film. The film would last thirty minutes and the radio broadcast would be one hour and thirty minutes, so when the film ends, the radio broadcast continues, the sound continues. So, to take back the figure of the channel that we were just talking about, the film belonged to a much more vast radio broadcast. The idea of the exhibition of the film, and of its distribution, was this: each time the film was shown, a local radio station played the radio broadcast, and the projection of the film was synchronized with the radio show. The film was always shown directly. One could have returned to the illuminated room, to read and wait, listening to the radio before the film started. Charles had another point of view, and we found a compromise.

HUO:

What was the compromise?

PP:

The compromise was to film a radio show, a fictitious radio show. In my twisted way, I always had the tendency to try to find a radio station in which to make a film.

HUO:

Did the collaboration continue?

PP:

Yes, we created a production company together for this film, Anna Sanders Films, also with Pierre [Huyghe], and Xavier Douroux, and we continue to use this partnership.

HUO:

Could you now talk about the project you are doing with François Roche...

PP:

With François Roche, because architectural processes are much longer, the collaboration is only now beginning to be concrete. We are building a bridge... It started with an invitation to participate in a rehabilitation project on the canals of Burgundy. For example, there is a long tunnel, three kilometers long, with no light except the lights from the boats which cross though it. In total darkness it makes one a bit afraid, like the ghost train of Prague where one

has the impression that the smallest spark could quickly light up the tons of accumulated dust since the cold war. It's not about plastic skeletons, it's about being enclosed. So with François we went to see it, and when we got there, just before the tunnel, we saw the pillars of a bridge for merchandise trains which was built by [Gustave] Eiffel at the time when the Burgundy canals actively participated in industrial development. We quickly told ourselves that it was interesting to conceive of a project around this... In fact, the financial backers needed a restaurant. We started to reflect on these bridge-restaurants that have been constructed over the freeways some decades ago. So, there was Eiffel and the industrial revolution, those Jacques Borel restaurants, and today there are boat tours. That's three generations. We worked on a bridge project and on a lighting system. It's a ghost-highway project. The Eiffel constructions were based on a triangular model. Here, to construct the bridge, we unfurled an iron wire... We also obtained a beam from another engineer. The building poses interesting architectural problems.

HUO:

Here, the artist is not associated with a project built by an architect, it's the opposite it's François who come to help you. Does it remain an art project, or has it become a problem of architecture?

PP:

What is the part of the architect and what is that of the artist? It's a question that interests François as well... in relation to a production strategy for architecture. Art could maybe be a way to foil, at a given moment, the mechanics of validation. It's a project that we did together, and we proposed to build this bridge for example, which isn't normal for architecture. The first studies will come out as books in winter 2003, and the construction will begin in 2004. The project is at once a bridge and robotic lighting in a tunnel.

HUO:

Could we speak about the catalogue for your exhibition at the Musée d'Art Moderne de la Ville de Paris ("Alien Seasons," 2002)? Your idea was to design the catalogue as a pop-up book?

PP:

The pop-up book is the first idea for the monographic exhibition, but I am still missing too many elements to speak about it... I'll try to articulate an idea about the book, because they're planning to make a monographic catalogue. I would like to start from this book to then prepare an exhibition. We will go to Rotterdam to meet Rem Koolhaas to see if he can play the role of the architect of this book. I'm

looking for someone who can help me go outside of the book, as in a pop-up book, a space in paper. The invitation card, the poster, the catalogue—everything will be in paper. You could burn it easily...

HUO:

It's something opposed to, or very different from, the "gallery gestures" that we often see today. In the previous discussion we had, you eliminated a large number of hypotheses, because you said that in reality everything leads to "gallery gestures."

PP:

A "gallery gesture" is easily reduced to its statement. But I don't know if I would follow through with this idea...

HUO:

In an interview with David Lynch about Mulholland Drive *(2001), he said that he didn't know what the end would be until he got there.*

PP:

Yes, he said that he knew that the film would start with the street sign "Mulholland Drive," lit up by a car's headlights, and that later there would be many stories that he wanted to connect. The sum of these little stories forms a narrative cloud at the end. The accumulation of these points produces a more or less apparent structure. So I have the idea of a book as a space for a monograph and it pops up as an exhibition space.

HUO:

Which is a little like a children's book...

PP:

Like Disney's *The Jungle Book*... Many tales for children start with an open book that we enter into. It's the structure of the tale.

HUO:

In terms of the casting of the architect, you wanted to see Claude Parent on Tuesday. What interests you about Parent? Is it the utopian dimension of his work?

PP:

François Roche advised me to see Parent. Parent is a myth for me, and the history of Parent/Klein is a mythic story as well... I rediscovered it looking at his texts and his theoretical projects. It is important for me to go meet him.

HUO:

*Another encounter that you would like to have happen is with Rauschenberg. You have been using his "White Paintings" series for your installation in Frankfurt. (*El sueño de una cosa, Portikus, 2002*).*

PP:

At Portikus, I showed a film called *El sueño de una cosa* (2001), which

I shot at the North Pole, and which lasts one minute. The film is a playground. The scenario is given by its exhibition. It's a quasi-object, like a football. It doesn't exist within itself. In Stockholm, I had shown it as an advertising campaign. It was shown for three weeks in all the cinemas of Sweden among other ads. The ads before and after were a bit like the ads that surround soccer fields, or playgrounds. The film was like a mental playground sponsored by ads. At Portikus, I showed it in an exhibition space, and so I had to find another scenario. I projected it on Rauschenberg's "White Paintings" series.

HUO:

A fake...

PP:

Yes, a fake. This painting was visible for four minutes and 33 seconds—the time that John Cage's "Silence" lasts (*4'33*, 1952)—this score that Cage composed for this Rauschenberg painting—and in my installation, at the end of four minutes and 33 seconds, like in a haunted house, the lights went off, the blinds fell and my film was projected. The exhibition is a haunted house. The title of the project, *El sueño de una cosa*, designs a film, which, like a recurring dream, is never the same each time it is seen!

HUO:

We return to this phrase from the beginning, "It's the chain that is beautiful."

PP:

Yes, similar to the way a score is played; it produces a direction, a different sound. In Stockholm, it produced one direction, and in Frankfurt a completely different one.

HUO:

But at the moment you left to shoot the film, how did you imagine its subsequent use, its placement in an exhibition space?

PP:

I didn't want to stop with only one choice. I started to think about this film while thinking about Rauschenberg's painting and other things. It's a film that is constantly in post-production.

HUO:

I had many different responses from people about the Portikus installation, and that confirms what you're saying because each person develops and tells his or her own story from the film.

PP:

It's great, isn't it? It's very complicated to make an open image, and the narratives can be numerous without resembling each other too much.

HUO:

Did Erased de Kooning *(1953) play a role in this story to use your vocabulary?*

PP:

Yes, of course.

HUO:

So this installation will be restaged in the exhibition in Paris. I'm wondering how it could "pop-up" from the book—if I follow you correctly, because for the moment, your book is still missing...

PP:

Yes. It would be designed by M/M—the idea is to diminish the text in relation to images, not to follow a chronological order, but a narrative one, to present each project as the head of a chapter, and to make it so the text doesn't appear because there's a lack of images. I also asked only artists to write texts.

HUO:

Finally to document and to also come back to the collaborative multiples that marked your work, and to make visible that this comes out of what Douglas Gordon calls a "promiscuity of collaborations."

PP:

Yes, a *Vicinato*, a neighborhood.

HUO:

Maybe the next thing we should talk about is Grenoble, and the question of Utopia and experimentation that you experienced living in Grenoble in the '70s, when the city was a "laboratory" of a new city. Maybe you can tell me about how Grenoble played the role of a toolbox during these years. Dominique {Gonzalez-Foerster} already told me a lot about her years in Grenoble. I'd like to hear about your experiences in Grenoble at the time.

PP:

You see, everything depended on the teachers who had a lot of courage and political conviction, and it all stopped when these same people left. It was a very specific moment. We benefited from both this enthusiasm and this bankruptcy.

HUO:

So there were many unconventional teachers in these schools?

PP:

Yes, some very convincing militants. Later on, at high school, there was Gilles Lipovetsky who taught French and philosophy, and also at high school there was a particularly wonderful drawing professor. There was also this cultural center where we went to see Carolyn Carlson or Pina Bausch with the school. You could really fall flat on your face from time to time, but it was all fraught with an educational dynamic.

HUO:

And when—and in particular, how—did this all end?

PP:

With the increase of Decaux billboards...

HUO:

You mean the outdoor advertising company?

PP:

Yes, Decaux billboards, postmodernism, the end of political engagement, the disappearance of lightning bugs and red poppies, the morals of baby boomers, the arrival of Michel Platini at the Juventus Turin.

HUO:

That's also what your film Crédits *(1999) deals with in some ways?*

PP:

For *Crédits* it was the fact that there weren't any images of the ZUP [Zones à Urbaniser en Priorité (priority urban development area)]. A text served as a model for *Crédits*, it's at the end of a [Pier Paolo] Pasolini's text derived from *Heretical Empiricism* (*Empirismo eretico*, 1972), where he speaks of the multiplicity of necessary viewpoints for observing an event. In fact it's the figure of the hologram... For Pasolini, only a harmonization of subjective points of view can offer a precise image of a given situation. To have an image of Kennedy's assassination, according to him, one must show all the films that were shot around the procession. While showing all these films, time would be lengthened and suspended like a hologram. I applied this idea, and I went to see kids that I grew up with, but also [Michel] Poniatowski who was the Minister of Interior under De Gaulle and many other key personalities of that period. I then went to see the people who had been directly involved with the ZUP and the ZAC [Zones d'Amenagement Concerté (comprehensive development area)] questions. The ZUP, contrary to the Grands Ensembles, were much less spectacular programs.

HUO:

[Jean-Luc] Godard also shot in the Villeneuve, Grenoble's experimental housing and social project... That's were he established his production and distribution company Sonimage.

PP:

Yes, and he participated with Anne-Marie Miéville on Villeneuve's cable channel. They also worked on the film *France, tour détour, deux enfants* (1977–1978) there, recording interviews with kids. So *Crédits* was a collection of intersecting viewpoints, designed to

form or reform an image. It's a bit like all these interviews you do. In your case, you are the point of intersection between people, whereas there, it was an absent image.

HUO:

Did you record or archive these conversations in one way or another?

PP:

No, I recorded nothing, I started to have an idea of an image while talking with everyone. The recording of these discussions is this scene with trees with plastic bags tied to the branches. Kids would hook the plastic bags in the trees that the mayor planted in the vacant lots in the city. They did this to recuperate their playground, which the mayor destroyed through green design. The ZUP were never completed.

HUO:

So in Crédits *the process of interviewing all these different protagonists is as important as the film itself that last six minutes or so. And this explains the title also, which makes clear the importance of the "chain" over the final object, the film. There's still another thing we haven't yet recorded, but we talked about it yesterday: your dust allergy and the way it has influenced your relationship to the object.*

PP:

I am allergic to dust, so I really can't accumulate things. When things accumulate, it gnaws at me, it's been like that for years, and it's getting worse and worse. I never keep books; I buy DVDs and then give them away. The biggest thing I have is this computer.

HUO:

It's very extreme, because for you, there's not only this will not to produce objects, but the impossibility to use or even keep objects. It's even more extreme than Le Corbusier's office, where he decided to keep nothing but a bookshelf, and so as soon as a book arrived, he had to sacrifice another. He never had more than one bookshelf...

PP:

I put everything in boxes and then I throw them away. It's unhealthy, so that simplifies everything.

HUO:

So a studio is impossible in your case.

PP:

Exactly. But many people work in their homes now. No, I can't have a studio. I can't even have an office. Mornings I tell myself that I must go to the office. No, I cannot manage my time like that. I

don't even have an office at my house. I work directly on the floor.

HUO:

This is related to your theory of bourgeois time and your reflections about {Francis } Picabia. Have you finally written something on that?

PP:

Yes, I tried to write about it. There was this book by Jean-Claude Milner, *Le salaire de l'idéal* (1998) in which he defines the concept of *"otium,"* time for oneself, defined as overtime, paid for by an over-salary. A historic time that belongs to the bourgeoisie... More and more, this time is replaced by leisure time, by entertainment. It's not the bourgeoisie that is interesting, but the idea of defining a social group according to its relationship with time.

HUO:

I believe that it's an investigation method that can be proven to be very rich and useful in understanding the biographies of certain artists. There's Picabia of course, and in particular, the subject of Picabia's relationship with Duchamp. Picabia was financially independent, and Duchamp wasn't. Picabia pushed Duchamp to marry a rich woman. And this marriage that Picabia arranged obviously turned out badly. Speaking about books, there is also Douglas Coupland, who comes up more and more often in the discussions that we have. What interests you the most about his novels?

PP:

It's a bit like Alighiero Boetti's lamp (*Lampada annuale*, 1966) that lights up once a year: for Coupland, there are scenes that stay in your head for a very long time, not really in *Generation X* (*Generation X: Tales for an Accelerated Culture*, 1991), but there are things that resonate for a long time, like with Felix Gonzalez-Torres's work.

HUO:

What is your favorite book?

PP:

Girlfriend in a Coma (1995). It's a fantastic book.

HUO:

What are the other writers that interest you? What about Neal Stephenson, who also fascinates Dominique {Gonzalez-Foerster}?

PP:

Neal Stephenson is a super sci-fi author, Greg Egan is as well... I consume a lot of sci-fi literature. Reading sci-fi is like seeing the most beautiful films.

HUO:

And Stanislaw Lem? It seems that many people are passionate about him at the moment...

PP:

His use of language is fascinating. It's also very molecular science fiction; it's pharmacology. *The Futurological Congress* (1983) brings you into parallel zones, one reality chasing another. Each reality is contained in a pill. Each reality is a chemical construction.

HUO:

Each has its own temporary definition, each lives his own Utopia.

PP:

To invoke Utopias today is a bit like using a Geiger counter to look for radioactive traces. It's very *The Day After*; you know this film [by Nicholas Meyer, 1983]?

HUO:

Yes. Apart from The Futurological Congress, *what other books by Lem interest you?*

PP:

The Mask (1976), *Solaris* (1961)...

HUO:

You know, when I mentioned {Andrei} Tarkovsky to Lem, it was one of the only times that I had to interrupt an interview before the end. Lem totally hates Tarkovsky's Solaris *(1972)...*

PP:

It's not surprising... in his books there are words that produce images. The ocean of *Solaris* brings out the desires of each person...
[...]

HUO:

One of the paradoxes of interviews is that the transcription ignores the silences of a discussion, which are often the most important elements.

PP:

You could insert blank pages in your interviews...
[...]

HUO:

I was just changing the tapes for the recorder and you started speaking about Serge Daney and the addiction to cinema. Could you go backwards?

PP:

... when I spoke of Daney, I wasn't talking about his theory of cinema. That's why I felt bad about Jacques Rancière... Like all adolescents who want to be cool, I always read the *Cahiers du Cinema*. It wasn't so much the moral code of the *Cahiers* that interested me.

It wasn't [Jacques] Rivette and his "le travelling est une affaire de morale" (the forward tracking shot is a matter of morality." It was Daney, who spoke to me about the signs that would constitute my present. I remember one of his articles in the newspaper *Liberation*, which traced a parallel between the Benetton campaign, [Luc] Besson's *Big Blue* (*Le grand Bleu*, 1988) and [Nanni] Moretti's *Palombella Rossa* (1989). When I speak about the differences between Daney and Rancière I am not making a critique. It's just that I don't like old people who moralize.

HUO:

But you should read his book La nuit des prolétaires (*The Night of Labor. The Workers' Dream in Nineteenth-Century France, 1981*)...

PP:

Perhaps, it's just that I don't know what to do with this kind of text... I knew what to do with Daney's texts for the most part. On the one hand, more and more signs are produced, and on the other hand, it's so hard to talk about them. Doug Aitken told me in an E-mail, "It's hard to edit your life without a time code." It's a typical generation X reflection. It's also something very profound. The relation to the present is very melancholic.

HUO:

The notion of melancholy is a notion that's never come up in our previous discussions. Today it seems to be at the heart of your reflection...

PP:

Yes, it's a dark sentiment, it's [Jean-Pierre] Melville... I love these stories. Melancholy can maybe offer a political alternative.

HUO:

Annlee *and* Vicinato *are two projects that pose the question of engagement; looking back, what do you think is the link between them and what distinguishes them?*

PP:

Vicinato was one of the first attempts to reunite a group around an image. We made two episodes and then it stopped. There wasn't any money left to continue.

HUO:

Unfortunately this kind of project doesn't come up except as a subsidiary activity; the principal activity is always individual. In the art world, in every way, collaborations are always considered subsidiary projects. And when it is a question of collaboration, such as with Carsten Höller and Rosemarie Trockel, these are the only pieces that can't be sold. Collaboration becomes something to be suspicious about.

PP:

The signature is what is validated in the art market, and basically I have no problem with that.

HUO:

Annlee *was a way of playing with the rules of the game...*

PP:

If *Annlee* worked better, it's because each project was signed by its author.

HUO:

Can you talk about the beginnings of Annlee...

PP:

In Japan in 1995, I learned about manga agencies that were selling some of their characters. When I told the story to Pierre [Huyghe], we wanted to do something with this information. We bought this character and started to work on the project.

HUO:

How much did it cost?

PP:

Not much at all. It was a character without quality. In the beginning, we didn't necessarily look for a character with a human appearance, we wanted to buy a sign. Annlee was melancholic, and that's what resounded with us. We wanted to tell the history of a sign.

HUO:

Today, how many Annlee *projects have seen the light of day? Seven? Eight?*

PP:

Twelve projects I think, and even more different authors have contributed to this history through various texts.

HUO:

Since then, you have the project to devote a book to Annlee...

PP:

Yes, to create an anthology of this sign. The last text of the book would be the legal contract that we will sign, a construction that gives its copyright to *Annlee.*

HUO:

You also told me that the chaining of different Annlee *projects could have become a summary.*

PP:

Yes, each project is an episode... It's a polyphony of voices

HUO:

Like Mikhail Bakhtin wrote...

PP:

Exactly, a carnival of authors.

HUO:

And you told me that the book was going to be printed in Russia, which is really nice when we think about science fiction, and of Stanislaw Lem, who was very much inspired by Russian science fiction.

PP:

We wanted to print the book in Kirghize, in Kirghizistan next to Baikonour, to make the book as if the project came from far away, or from temporarily far away. It was a graphic idea.

HUO:

It's connected with the projects that you're working on today: you have this project to make an expedition, and this really seems like a new step in your working process.

PP:

Yes, it's the *Mont Analogue* project: to adapt the book by René Daumal (*Le Mont Analogue*, posthumous, 1952), to share not a sign but a history. An expedition like a proposal for a group exhibition...

HUO:

I did an interview with Jean Rouch in which he talked a lot about a bond between expedition and exhibition in the '30s at the Museum of Ethnography in the Trocadero. You know that most of the African collections in the Musée de l'Homme arose from the Dakar–Djibouti mission? It lasted two years, from 1931–1933. There was in this expedition {Marcel} Griaule and {Michel} Leiris, who left to write; there was André Schaeffner, an ethnomusicologist who went with records and a gramophone so that people he met could listen to records; there was also a Russian prince... Basically everyone went, inspired by completely different motivations and desires. And they traveled together.

PP:

It's beautiful! I remember a Jean Rouch film where he was walking in the galleries of the Musée de l'Homme in Paris, camera on his shoulder, and in front of each object, he commented on their provenances and the conditions of their acquisition. These stories are really beautiful. What is important in the *Mont Analogue* adventure is to relate it to something you imagined before leaving. And it comes from this idea to take a month of traveling like a month of shared production. Six or seven people embarking on a boat, researching a place indicated on a map, unveiled by a novel.

HUO:

So again the book is a pretext, and the expedition is again another way to replace the object...

PP:

Or to produce a more complex object.

PISTOLETTO, Michelangelo

Michelangelo Pistoletto was born in 1933 in Biella, Italy, where he currently lives and works. Pistoletto began his career as a painter in the mid-'50s and became widely known as early as the 1960s for his "Mirror Paintings," in which life-size images of the human figure, usually shown in arrested action, were applied to a polished reflecting stainless steel background as if it were a canvas. Breaking down traditional notions of figurative art, these works reflected the surroundings and the spectator and so made them part of the work, linking art and life, the past and the present in an ever-changing spectacle directing towards the future. In January 1966, Pistoletto first showed his Oggetti in meno *(Minus Objects), which he defined as "Tangible, physical projections of images in space." As Pistoletto explained back then, the works "are not constructions or fabrications of new ideas, any more than they are objects which represent me, to be imposed on others or used to impose myself on others. Rather, they are objects through which I free myself from something—not constructions but liberations. I do not consider them more but less, not pluses but minuses, in that they bring with them a perceptual experience that has been definitively externalized." In the late '60s, Pistoletto was a key figure of the loosely-defined art movement labeled "Arte Povera" by critic and curator Germano Celant. Between 1968 and 1970 he established the "Gruppo Zoo," a workshop focused on creative collaboration, open to artists, filmmakers, intellectuals, poets, and the public. In 1975 Pistoletto started the first of twelve consecutive exhibitions called "Le Stanze" (The Rooms), and since then, he has developed several concepts designed as cycles that expand beyond the space-time dimension. They include:* Anno bianco *(White Year, 1989);* Tartaruga felice *(Happy Turtle, 1992); and* Progetto arte *(Art Project, 1994). Within this last cycle, the work of Pistoletto became the moving principle of the multifaceted activities that he called "Cittadellarte," which is home to the Pistoletto Foundation in Biella. Pistoletto has participated in a wide range of important international exhibitions including the Venice Biennale, Documenta, and the São Paulo Biennial, among others. His solo exhibitions have been held in distinguished institutions around the world, including: Walker Art Center in Minneapolis (1966), Palais des Beaux-Arts, Brussels (1967), Kestner Gesellschaft, Hannover (1973), Palazzo Grassi, Venice (1976), Neue National Galerie, Berlin (1978), the San Francisco Museum of Modern Art (1980), Galleria Nazionale d'Arte Moderna, Rome (1988), P.S.1 Contemporary Art Center, New York (1988), National Museum of Contemporary Art, Seoul (1994), Museu d'Art Contemporani, Barcelona (2000), and Musée d'Art Contemporain, Lyon (2002).*

........................

This interview was recorded in Biella in October 2002.

Hans Ulrich Obrist:

In our last meeting in San Gimignano we talked about Utopias. But there is a topic that we had just touched upon lightly back then—the topic of time—and so I think that we should begin with this now.

Michelangelo Pistoletto:

I think I may have already told you about my two-watch theory. As you can see, I feel the need to wear a watch on each wrist: the one on the right shows yesterday's time and the one on the left shows tomorrow's. We're in between. Time is something we somehow register as a concept of past and future. But in actuality, we find ourselves in a state that isn't quite as technical as we'd expect it to be. Maybe it would all be clearer if we were to tell ourselves that our lives are constantly shuttling between two times. After all, the present results from the balance between two juxtaposed instants. Let's push the image even further: you'll notice that the two watches that I'm wearing belong to different phases of socio-cultural reality. One of them is a gold watch: for ages, common belief had it that nothing was better than gold, thanks to the value lent to it by its stainlessness. The other one is a titanium watch. The value of things has changed, now that other stainless metals have been discovered. This watch is made of the same material used for interstellar voyages. There's another difference between these two watches as well, due to technological advances. Therefore there's more than just biological time—our life's time—but technological time as well.

HUO:

In San Gimignano you said that time is a recurring topic in your work and it goes back to your first mirror paintings of the early '60s.

MP:

You see, that's something I'm still convinced of. I think... well, I think that turning space into time is the primary feature of my first mirror painting. Because what you see inside a mirror painting is interior time. Space and time collide. The only work of this kind that I feel I can say contains this time phenomenon is Duchamp's glass. As a matter of fact, through the glass you can see reality as it changes and time as it goes by. The difference between my mirror paintings and Duchamp's glass is that the time I see in my mirror paintings isn't simply the time in front of me but the time behind me as well. This is because the mirror doesn't present us with just the perspective space that lies before us, like Renaissance perspective has handed down to us. Rather, it shows us what we have behind our eyes, i.e., behind our head, in the space behind us that is reflected in the mirror before us. So what is behind us is the past as well and probably the future. In any case, the mirror paintings project our space and time in two directions: backwards and forwards.

[Coffee is brought in]

HUO:

It was {Filippo Tommaso} Marinetti who said "I'm Europe's caffeine," wasn't it?

MP:

Sorry?

HUO:

The coffee just made me think of Marinetti. But we could speak about how Marinetti tried to encapsulate a reflection on time in a word.

MP:

Futurism, you mean?... Futurism was still projected towards a possible future time, in the sense of the perspective that exists in Duchamp's glass, Renaissance-like I mean. I'd say that it might have been the last instant of that time that used to be declared as progressive, the last moment of progress in the sense of the myth of modernity. There was this idea of moving forwards, of the future pushed to peak velocity: I mean Modernism, the cult of progress! In other words, a notion of time that was completely projected forward. Renaissance perspective marked the road to the future, the road seen in perspective, in front of the eye of the beholder. It's no surprise that scenes of Renaissance theater conceal everything behind the scenes. The mirror, on the other hand, shows everything that's behind the scenes—you're not a native speaker but you know what I mean when I say *le quinte* [scenes], don't you? I'm referring to the theater's *rideaux* [curtains], and in Renaissance theater what you see is what is in front of the spectator but not what's behind him, nor what's going on behind the scenes. But this is exactly what the mirror shows: what's behind, behind the audience and behind the scenes as well. That's the most obvious difference: the great reversal of perspective that allows perspective itself to open up again. In the twentieth century—the first half, to be more precise—Renaissance perspective and Duchamp's perspective as well reached an end. Very significant works in this sense were produced by artists such as Mondrian and Yves Klein, who completely zeroed in on the perspective view.

HUO:

{Lucio} Fontana's work comes to mind as well. I remember that in an interview with Germano Celant, you talked about the '50s deadlock and about how art had to be encouraged to move on.

MP:

I was asking myself: "Do artists still stand a chance of opening up a new perspective?" I mean, of opening up in the way that an artist such as Piero della Francesca did? I was wondering whether or not

artists nowadays could actually unveil a new perspective. This was my bet. True, Fontana made slits in the canvas, but all he did by puncturing it was to open a tiny fissure that always faced in the same direction: the direction of Renaissance perspective. Duchamp used to show what you could see through glass, but in fact the glass was a barrier, a transparent wall: it was where perspective ended! It was the conclusive moment, the final deliverance from perspective that, shifting beyond glass, made art give way to the triumph of the modern socio-economic and political system as it is today: readymades, *objets trouvés*. Mirror paintings break the Modernist design and open up a new concept of perspective. They make you leap forward by jumping backward. And they make you leap backward by jumping forward. There's a leap in both directions. This leap opens up the new perspective of art in life.

HUO:

Is it right to say that in this sense a mirror painting is circular, rather than being linear?

MP:

Yes, if by circular you mean that it becomes like a revolving door. But a revolving door that rotates vertically as well as horizontally. In other words, it becomes what I call a 360-degree view. Everything in front, wherever the reflecting work is placed, is behind as well and vice versa. What is above is below and vice versa. It actually includes what I call "time's double value."

HUO:

And so you believe that the consequences of this double value of time haven't been fully observed yet?

MP:

Let's put it this way: I think—I'm sure, actually—that the important elements of my mirror paintings have yet to be read and that one day this complex time that opens up in perspective will have to be recognized as the linking point, the turning point from Modernism to Postmodernism.

HUO:

Previously you said that postmodernism remains in a linear logic...

MP:

Absolutely. It would appear that the notion of the postmodern is a short-term, speculative one. We might say that it's a form of retro vision limited to the recovery of a very limited past. It's looking back to recent years, and yet Postmodernism is once again proof of how important it is to look back. It's a small step, but a step nevertheless.

HUO:

Can you tell me more about the issue of time in the artistic developments of the '50s and '60s?

MP:

To me, it's obvious that time in a canvas or an opaque object exists—from an objective point of view—in only one sense. However, time in this case may be psychological: a painting may carry psychological time, but from a phenomenological point of view it is marked by the time of its making and of its image, its "color," or its sign. On the other hand, when the time phenomenon is fully exposed this causes what could be called non-definition, in other words constant transformation. Granted, in Duchamp's work we can register movement through the glass and this gives us an undefined scene. This is, quite obviously, important, but what really counts for me isn't just the indetermination given by the transparency of the glass, but it's also the—let's call it inter-contemporary—implicit indetermination caused by specular reversal. You see, what makes me feel so close to mirror paintings is that they remove, actually they go beyond the problem of the final moment, of the dramatic existential moment that grew even more important after Duchamp's glass. In other words, they break away from the misleading device triggered by the glass through which you praise time and see movement, when in actuality the glass is nothing but a screen that projects the Renaissance perspective into a time that is shifting as it is now unfathomable. When Duchamp saw that his glass was broken, he was delighted because he almost had the illusion of being able to pass through the crack in the broken glass. But that's not true. Suffice it to say that in order to be portrayed, Duchamp had to go behind his glass and have his picture taken and then see himself in the picture. So there was a delay, a delay that just couldn't be avoided or made up for. The delay caused by the impossibility of experiencing simultaneity. Mirror paintings, on the other hand, provide an immediate self-portrait. You see yourself on the other side; you're on this side and on the other side at the same time, so transition poses no problem whatsoever. Mirror paintings dispel the problem that was in [Francis] Bacon and in all of the Action painters artists as well. They were all still focused on that end point, with no way out. The "screams" of Bacon are emblematic of that state of affairs and it should be noted that it came after Duchamp: it's clear that glass hadn't solved the problem. Bacon used a figure, Pollock used color, but in both there's a scream, a dramatic closing gesture. Just like in Fontana.

HUO:

It's exactly what you denounced, putting it differently, in the interviews where you spoke of a deadlock in the '50s.

MP:

That's precisely when I was struck by the fact that I had managed to include something different in my work. A mirror painting analyzes and solves many problematic phenomena; what I try to do is to open, in a constructive way, a road for each of these phenomena. A mirror painting is a fountain of answers. So, I'm not stating the existence of a problem but rather I'm providing a fountain of answers. It's funny that I used the word "fountain" to describe mirror paintings. Maybe you didn't even notice it, but at some point I used the expression "fountain of answers." It just came like that. Curiously enough, Duchamp himself used the word "fountain" to describe his "urinoir" (*Fountain*, 1917). But in that case it could be seen as a symbolic, emblematic fountain, whereas the mirror paintings are phenomenological fountains of answers. I'd say they provide the answer to all of our questions. All of a sudden the questions we used to ask ourselves in the past find an answer through the mirror paintings. You might even say that the mirror paintings find the answers to the questions that humankind is still asking itself, answers to fundamental questions.

HUO:

To all of them?

MP:

To all of them! There's nothing you can avoid. It's amazing! Infinite, quite, but not simply like an infinite phenomenon that overwhelms you and stuns you. No, it's a phenomenological infinity that always leads back to an understandable configuration.

HUO:

How do you interpret the appearance of collage in the course of the history of art? Some could describe collage in terms similar to the ones you used to describe your mirror paintings. The appearance of collage in art, much as in cinema—of course {Jean-Luc} Godard comes to mind—was in some way a period of massive shattering of perspective. Have you ever come across the wonderful pages of Manny Farber's book The Negative Space *(1971; 1998)?*

MP:

You see, if we consider a mirror painting in terms of a collage, we can't help admitting that it is, so to say, a quintessential collage. Quintessential or minimal. Mirror paintings do indeed include collage, or something like what you call collage. I'd say that two

moments are united in the form of a collage: one is memory, whereas the other one is the present. Progressive or regressive movement through time nurtures a feeling of nearness to what you describe in collage. So we might add that if it is indeed a collage, a mirror painting might be defined as figural, yes figural, but not spatial. Because what has been glued together isn't just an ensemble of highly imaginative, flat, fixed surfaces, but rather it's a collage of time lapses. Think about it for a minute: collage includes the attempt to create a passage, a spatial passage, by putting together different pieces. Notice how even Picasso's *Guernica*, as it is, represents an attempt at finding a passage. Even though it isn't a collage of pictures, *Guernica* is after all a collage of shapes, isn't it? They're many different shapes he put together and thus form a passage from one shape to another that might give the impression of abrupt movement and cause uneasiness. This in turn can kindle a feeling similar to the one we're talking of: a lack of security, a loss of steadiness. But when you're facing the fixed image of a figure stuck in a photograph and coexisting with the shifting and mirrored figures, well, that's another kind of collage: they're two figures made of time and not just space alone. There's a passage of something that's going backwards with something that's going forward. If you single out these two aspects you'll notice that basically one of them is pulling in one direction while the other one is pulling in the opposite direction. Through the photographic image that coexists with the mirrored image, all of the mirror's elements become moments that tend towards the past. They are drawn to the past by the photographic image, which is, quite inevitably, a thing of the past. Every photograph is a thing of the past, a memory, something that has already taken place. At the same time, the image of the past is dragged towards the future by the reflected images. This is because the image of the past still exists in the future, hence the duration I was referring to before. Therefore, it's a very significant moment—and part of collage—but becomes active. It's not a mere promise—it's fulfillment.

HUO:

Your "Stanze" of 1975–1976 were pushing forward the issues of the evolutionary temporal project to one year. Even the Zoo Group workshop project (1968–1970) was a sort of evolutionary project in terms of time. And of course there are your exhibitions at Galleria L'Attico in Rome (1968) and at the Galleria L'Ariete in Milan {"Tutte le donne..." ("All

Women...");, 1970} that clearly belong to this process as well. Can you tell me about how they developed in those two decades?

MP:

I'd say that the process developed bit by bit. I made my Plexiglas works back in 1964: they marked the first step towards the virtuality of the mirror within physical reality. But it took a few years after the first mirror paintings (1961–62) before a physical body was actually engaged. The first instance is represented by the *Oggetti in meno*, made between 1965 and 1966—definitely a crucial period. The *Oggetti in meno* works are based on, let's say, a "tired" form of time, something I might venture to call practical: not just image, but body as well, in the sense that what is embodied, solidified, is precisely every moment. This happens to every object because each so-called "minus" object is the pure result of a passage from imagination to reality. It's a physically blocked imagination. No longer is it a photographic, two-dimensional memory: it's a three-dimensional memory instead. It's no longer the photograph, but rather the object that incorporates memory. It's memory in the form of an accomplished and therefore unique fact. It can't become a style because the next work already belongs to another moment. Much as in the case of the mirror, what counts is that you can never find the same moment again. So what actually takes form is the phenomenon of time change.

HUO:

How did the Oggetti in meno *lead to the "Rooms"?*

MP:

In order to complete the *Oggetti in meno* works I had to pass through many different moments, which turned into places, and together they represented time passages. The spectator finds himself physically moving through past moments; however, since they are crossed by his presence, by his movement, these past moments enter the dynamics of present life, just like in the mirror paintings.

HUO:

A dynamic conception of memory is another red thread of your work...

MP:

Memory is one of art's motives. In my works, it becomes obvious how memory changes in time. In 1975 I prepared a photographic work that you might know—*Il contadino (The Peasant)*—which is indeed another work I dare say has its own rhythm in time. The peasant is represented by a man holding a spade to work the land with. This work gives voice to the crisis that struck painting when

photography was invented, as well as to the crisis that threatened the hand following the development of machines. Bit by bit, the hand was in fact replaced by machinery. I'm speaking of the crisis of manual skills in the same terms that I use to speak of the crisis of painting: the spade for working the earth is on the same level as the hand that holds the paintbrush. So what I did was to take a picture of the farmer holding the spade, then I stabbed a knife into the hand of the photographed farmer; at this point I reproduced the image and on the hand that I had stabbed with a knife, and which was also holding the spade, I did something else, which I in turn took a picture of in turn. I carried on like that until action after action of the figure of the farmer, which I repeatedly reproduced and photographed, dwindled and almost disappeared. The last action I performed on the hand was to burn it, which almost completely—physically—destroyed the photographic image, i.e., its memory.

HUO:

Memory is consumed...

MP:

Memory is consumed: that's what I want to point out. Memory tends to disappear—do you see what I mean? So change takes place also because of new realities that emerge in time. The image that has been reproduced is no longer the original image: I'm forced to reproduce the image because in actual fact I have to reproduce something I did to the image. On each reproduction, I register an action and this action becomes memory, which eats away previous memory!

HUO:

In exhibitions of your work, you always make sure that on the labels there are no detailed explanations on how your work should be interpreted...

MP:

No. I leave spectators free space among the objects. I don't want them to be guided by someone else's interpretation. Each time, the spectator relives the experience of differences, which do indeed come from the individual freedom given to each object. Moreover, the objects are never set out in a line and therefore the path from one object to another is never straight. Rather, each path is completely a matter of individual choices. You can go from one object to another by crossing the spaces among them in any way you want, and it's never the same experience. So in the end it's like living inside a mirror—walking inside a mirror—among moments.

You're walking among moments in a diluted, slowed-down present. This is a key factor of the *Oggetti in meno* works. Needless to say, there are other factors as well.

HUO:

Can you tell how you've worked on the specific time of the exhibition, the "duration" of the exhibition?

MP:

For me, the concept of "duration" is a very particular one and somehow came into being in a progressive way. Which exhibition are you referring to exactly?

HUO:

The 1968 one at the Attico.

MP:

Yes, I see. I do indeed think you might say that duration was an important factor in that exhibition and that it was seen in relation to a definite period of time as part of the work itself; in that case, the period of time I had chosen lasted a month. However, the month's duration was a lived duration and not a contemplative one. During that month, I worked with ten filmmakers and was thus able to complete ten works. I knew that at the end of that month we would screen the films that we managed to make during that period of time, starting from the shots made at the opening. I should point out that it was a collaborative project. And collaboration was becoming a very important thing because my work would pass from the concentration of aesthetic objects—to the objects themselves, to creation in the sense of collaboration among a number of individuals. The object was no longer the element that carried the aesthetic and moral message; rather, this message would emerge through the creative process involving individuals.

HUO:

Which one of your works marked the onset of this way of conceiving of the work's space?

MP:

The very first action was definitely made using movies. So how did it actually work? Well, I suggested an action, the filmmaker suggested a filmic action and the two things merged together. It was the first work I did that merged creativity even before the object existed. To put it better, the object was a sort of excuse for a meeting—a creative meeting. There was a direct exchange. This is very important because it associates the concept of object aesthetics with

sociality rather than with the physical object. Social aesthetics rather than object aesthetics: that's the key passage. Obviously, words also play an important role in this layout: the title *Oggetti in meno* was already enough to decrease the value of each object, even though they were used as an expression of maximum independence and a paradigm of plurality and difference. What's really important about the *Oggetti in meno* works is that a new phenomenon of cosmic reference—someone might call it holistic—appears once again, since each object is meant to be "The whole minus one." The uniqueness of each object is subtracted from the state of totality. The objects don't add up, they don't form a sum of homogeneous elements, they don't form a monument. Quite the opposite: they represent subtraction from a total, raw material. So what we have is totality minus one. Each object is subtracted from the shapeless total as a particle of exploded material. The same goes for the mirror: by resetting space, it explodes into every possible image and period of time.

HUO:

Can you tell me about the Gruppo Zoo, this workshop open to artists, filmmakers, intellectuals, poets, and the public, where each participant could become a mirror for the others. The Gruppo Zoo project is often described as a theater project. What was your role in the Zoo project—the one of a stage director?

MP:

"Theater" is a word you should always utter with the utmost care: what I wanted to do was to create areas where it was possible to meet and exchange creative ideas. Zoo was somehow the Cittadellarte of that period. It was where everyone would meet to exchange creative ideas, using not just plays but rather every possible form of expression: body music, sound, literature, and so on. Every form of expression you can imagine.

HUO:

Why was it called "Zoo"?

MP:

The name Zoo was chosen because there was this barrier we wanted to move beyond. Zoo symbolizes the barriers that place us on this side as well as on the other side of the bars, just like in a zoo. There's also the impression of going into and out of the period's institutional areas: take the barriers placed between the animals and the spectators: are the animals watching the people or are the people watching the animals? We wanted to turn separation into participation and sharing.

HUO:

Something that is central to your later initiatives such as Anno bianco or Cittadellarte, or the new campaign on the Mediterranean, is things that aren't dictated by the art world's temporality and spatiality or by structures, but rather are self-organized.

MP:

My first works in the mid-'50s were self-portraits: I thought I had to look into my own eyes. A mirror provides us with an eye on our eyes. No painter—no artist, for that matter—has ever managed to see his or her own eyes without a mirror. That's what a self-portrait is, the only difference being that a self-portrait done on canvas shows the artist's eyes only, whereas a self-portrait on a mirror shows the eyes of the whole wide world, all the eyes that exist— and the painter's as well. It becomes a self-portrait of the world, a self-portrait of everybody. Individual and collective problems become answers in front of a mirror. The answers come from an instrument that tells me what I am, tells you what you are and tells us what we are. Consequently, I carry on proposing systems that provide answers: not suggestions of my own, mind you, but answers. You see, I never determine anything; rather, I put nature in a condition to express itself, to give me answers, to show me its eyes, which in turn are mine. And since nature can see very far, I can see very far as well.

HUO:

Could you tell me about the manifesto that you wrote in 1968 for the Venice Biennale? And your work that revolved around this manifesto—the "Manifesto della Collaborazione Creativa."

MP:

When I was asked to bring my work to the 1968 Venice Biennale I made the "collaboration manifesto." It was a way of practically developing the previous creative collaboration. As you know, however, the whole thing was unfortunately wrecked by politics. There was violence and abuse throughout the city.

HUO:

Just like at the XIV Milan Triennale that same year, right?

MP:

Yes. Just think: I was invited to the Biennale and granted my own room, but in the end I didn't even go to Venice. Others—decidedly militant—went there to throw stones. I've never understood the point of going there to throw stones.

HUO:

But what about the manifesto itself? Was it a very "participatory" manifesto?

MP:

I made the manifesto in order to say in public that everyone was free to participate. Then it would have been possible to work together towards inhabiting the space I had been granted at the Biennale. The plan was quite simple: in the daytime we could remain silent— all of us—and just sleep in the exhibition hall. We would be, so to say, absent even though we were present. We could sleep on the floor and that way visitors would see us. The plan for the evenings was to go around Venice to create and leave small signs around the city that the local people would discover the following day.

HUO:

So the city was read, interpreted, and lived in as if it were a workshop.

MP:

Yes, that's quite right: the city as a workshop, a sensitive and constructive project. But in the end it wasn't feasible because the project was misunderstood and people started to suspect it was a political act. It turned out that the most idiotic form of political aggression got the upper hand and this contributed to make the creative participation I had envisaged impossible to implement.

HUO:

Well—you know I always ask this question—after all, this might be considered as your great unrealized project!

MP:

Absolutely! Looking back today, I'd definitely see it as an unrealized project. As far as I'm concerned, the project for the 1968 Biennale was never accomplished in practical terms; yet, at the same time it was fulfilled by going beyond itself.

HUO:

Like with the 1970 exhibition at the Galleria dell'Ariete in Milan?

MP:

Oh yes, Ariete, definitely! I had written a book called *L'uomo nero* [*L'uomo nero, il lato insopportabile* (*The Black Man, The Insupportable Side*), 1970]: it was another project, which, basically, was born in the same way, the ones we mentioned before were, featuring close connections to time. I had bought a notebook in which to write a book. It was a 365-page notebook: a page for each day of the year, in fact. My plan was to complete the book in a month, no more, no less. There were a series of numbers related to time: the year, the

month, etc., and in the end I did manage to finish my essay in a month. I instinctively followed the same method I used for the *Oggetti in meno* works: a method that doesn't take pondered connections into account. Each moment lives by itself thanks to the expression of written language instead of the physical expression of objects. I used to work in the contingency of the moments that make up a month. During the 1970 Ariete exhibition I even physically translated a passage from the book into a month of work in the gallery with Maria: the exhibition was called "Tutte le donne." Big white canvases painted during that month were repainted white.

HUO:

A few years later, you did the "Stanze."

MP:

I worked on the "Stanze" between September 1975 and September 1976. It was a very slow process, a meticulous study of time. Maybe we can talk about this some other time.

HUO:

I'd like that we talk about it now.

MP:

Sure! A fundamental element of the "Stanze" is the temporal dimension, namely the duration of the actual exhibition. It was a year-long exhibition, not the usual month-long one.

HUO:

You changed the rules...

MP:

Definitely: instead of staying there for just a month, I settled in for a year. But the concept of the monthly exhibition was still there because in a year, the space was renewed every month, twelve times in all. So there were twelve "Rooms," even though there were only three physically. There were three rooms where the exhibition took place but there were also twelve temporal rooms. Each temporal room was physically accomplished within the system. The twelve rooms were connected via the process of the passages required to move from one room to another. Thus, time was slowed down and the scene could be viewed in what technically might be called slow motion. This way, it was possible to single out each single movement required to reach the next step.

HUO:

It was a slow-motion exhibition, then!

MP:

Precisely. Slow in the sense that everything is dilatory, and motion in the sense that all of a sudden you manage to understand how the thought process between one object and another works. So I do an exhibition, then I start to think about it and ponder over the exhibition itself and the next exhibition as well. I write down what I think and then I make this process visible to the public. Having worked on writing as well as on objects, the trace of writing is just as important as the rest. The book I mentioned before entitled *L'uomo nero* is an example in this sense: this way, the written part joins the movement of time. I write as I pass through the "Stanze" and what I write I print and send out. I don't just send out invitations for the next exhibition: instead, I send an anticipatory text for each of the twelve exhibitions. This way I follow the traditional gallery customs but by inserting them into the creative process, because when I send out an invitation for an exhibition I'm actually sending out the description of what I imagine the next "Room" will be even before creating it. In the end I manage somehow to imagine and communicate what I believe will happen. I'm not saying that the exhibition will turn out exactly as I announced; still, the exhibition we're going to see will bear an evident relationship with the previous exhibition, the text and the current exhibition. Another thing that is demonstrated is that numbers are not just quantities; they also express very strong psychological entities and represent complex reasons because time determines not only quantity but deep symbolic qualities as well. The second exhibition cannot be the first, the fourth cannot be the third, nor can the third be the second. There is an inevitable movement among numbers, and this prevents us from jumping any of them and from shifting backwards without a good reason. Even while it is wearing away, the previous exhibition produces the next one. Hence the number sequence.

HUO:

Would you say this process is similar to the one of film editing?

MP:

If you want to, yes, but it's quite obvious that each number is first and foremost the historical consequence of the one before it. As I said, we're talking about its historical consequence here and not just its numerical one. There's a lapse of time between one and two that can be very diluted, you see—there's more than just the object and its density, but its vital, intermediate space as well.

HUO:

This is an approach, an attitude toward the exhibition as a medium and the object that has come back in the '90s... Can you tell me about your radical exhibition "Le cento mostre del mese di ottobre" ("The One Hundred Exhibitions of the Month of October," Giorgio Persano Gallery, Turin, 1976)?

MP:

The operation that took place in the "cento mostre" was exactly the opposite of the exhibition of the "Stanze." Everything clusters into speed: speed instead of slowness. During the month following the "Stanze" sequence—October 1976—I had one hundred exhibitions to my name: in a very brief lapse of time I thought up these one hundred exhibitions and I described them in writing again, but this time using it as an element of concentration, in order to condense them in space. The space I used was a small cube, a very small cube. A small book. What's interesting is that these one hundred exhibitions diluted again over time, since they turned into a sort of recipe book that I or other people might consult and perhaps decide to bring into being.

HUO:

You experimented with something similar back in 1966 with your Sfera di giornali *(Newspaper Sphere) work?*

MP:

I made the *Sfera di giornali* in 1965–66, during the "Oggetti in meno" exhibition [at Pistoletto's studio in Turin, 1966]. The leading notion was that a newspaper is an object that accumulates over time. Newspapers—dailies—the name itself says it all—have to do with the day. I was interested in this concept of the day, of the news of the day. There's the very fact that words and thoughts are drawn from the newspaper and consumed every day: words are absorbed by the mind and all that remains is the object, as the memory of the past rolling into the present. The past accumulates and so it turns into a large ball that takes up the whole room. A one-meter ball becomes a "walking sculpture" and rolls through the city. This ball creates dynamics that remove the work of art from institutional areas, where the big ball remains stuck.

HUO:

What do you think about the analogy between the recipe and the musical score?

MP:

A musical score? Why not? A score is like a recipe, a recipe that can be copied or reinterpreted. Recipes are always the same yet always different. There's a dash of interpretation each time, just as with

music: the person who plays the score is called the performer. There's always something different in the way the recipe is interpreted. Yes, I'd call it a recipe. The spheres that were made were compared to my newspaper-ball recipe: well, they're all different. Each of them was, so to say, reinterpreted. Funny, isn't it? Every recipe is so simple and yet everyone complicates them, follows them in a different way. It's all very interesting.

HUO:

Are there any other works, other than the "cento mostre," that might be explained using this comparison with a recipe?

MP:

One does come to mind. As you know, in 1969 we were living in Corniglia with the people who where there as part of the Zoo Group, and for a few months we carried out the operation called *La scoperta dell'Uomo nero* (*The Discovery of the Black Man*), in the town square. The *Uomo nero*, the Black Man was something of a peg: he was the project's director, and each one of us was director for a day and was free to create a situation involving everyone else. Then the group had to be directed so that everything worked out. We all took turns filling in the Black Man's duties as a director and the ensemble worked with the creative contribution of each one of us.

HUO:

So you changed directors every day?

MP:

Yes, every day! The Black Man was like a game, and as you know, in every game there's a winner and a loser, someone holding the ball, the candle, or the hot potato. The Black Man is the person who removes himself from the group and somehow becomes king or victim. The king is the victim as well.

HUO:

So in this case the comparison with a recipe comes from using the game's rules as the recipe?

MP:

Exactly, the game's rules. Each one of us had the responsibilities of being king of the situation and in charge for that day. He would choose tools and shapes. Sometimes the same tools were used but each one of us would do it in an entirely different way. This was a way of getting the villagers involved as well.

HUO:

And this brings us to another project: the **Anno uno** *(Year One, 1981). This was another very important project, a one-time representation on March 1981 at the Teatro Quirino in Rome.*

MP:

The *Anno uno*—it's apparent how in that case the piece referred to time somehow as well. It refers to the year, the year as the notion of the beginning of a social history. So why not give a preview of the year that was to come after 2000?

HUO:

In 1981!

MP:

Yes, in 1981. That's how I had conceived of the work called *Anno uno*: there were people from the village as themselves, i.e., the social group within the village, the town, the city, etc. A text I had written was played out, telling the history of time in an hour: history from Adam and Eve, I mean from Cain and Abel, to today, a brother killing his brother and conquering the throne. Even though we're not absolutely sure whether the city—and, consequently, the society we see represented by the townsfolk—was founded by Cain or Abel or Romulus or Remus. The dialogue between the people is quite apparent: it's the voice of society within the city, a voice that has been echoing since before the city was even founded. The work's starting point, when plans are being drawn up to found the city, is the memory of humankind that was there even before the city itself. The consideration's kingpin is the many people who have so often represented themselves and shaped the history of humankind from the past to today. The work featured the actual city and its actual, common folk. In later re-enactments the same society changed, obviously. For instance, I remember a baby who was born when the first representation was being held: his mother couldn't take part because she was giving birth. Fourteen years later, the baby had grown into a boy and was old enough to join the scene. He was tall enough to hold on his head the structures that made up the city's roofs, just like the others were doing.

HUO:

It was another representation of slowness.

MP:

Yes, it is a very slow evolution. Inside the dramatic structure you can see that society itself is physically evolving through time. If we were to re-enact the work today, there would be some very important transformations, since one of the former characters is dead and would have to be replaced. At some point there were a little girl and a little boy as well: they didn't want to leave their mothers and

they stayed there all cuddled up at their feet. So I decided to add a few lines for the children as well. The project itself feeds off this notion of evolving generations.

HUO:

Was Living Theater an important influence?

MP:

No, the project was developed in a completely independent way. With *Anno uno*, the important thing was the device itself. Within an hour the language the people used sometimes changed completely: in the beginning it was an epic language but then, as the represented time went by, it became more and more familiar, until it grew almost filmic, direct and daily. Language changes depending on whether we think in terms of temporal distance or temporal proximity.

HUO:

What about the Anno bianco?

MP:

The *Anno bianco* is an anticipatory year because since its beginning it was designed to absorb everything that would come to light during the year. So what is whiteness? It's nothing but a blank sheet of paper—*carte blanche*—and you can do what you want with it. I gave *carte blanche* to the events that were to take place throughout all of 1989. I trusted time and therefore I used the year the same way I'd use a mirror. A mirror reflects everything that passes in front of it. And everything that passes in front of the blank sheet during the year remains impressed.

HUO:

So the white—blank—sheet acts as a sponge.

MP:

Yes. In that year, I simply fixed a series of happenings. And the most remarkable things did happen, like the fall of the Berlin Wall: an event that rocked the world. That's something that marked a real "Year One." This happened towards the end of 1989, whereas the *Anno bianco* began in January, so it's also a way of unveiling a prophecy, how prophecies work, if you see what I mean.

HUO:

I saw four or five of the projects, but the Anno bianco *included twelve points, didn't it?*

MP:

Yes. I was planning on marking the year's rhythm with events that touched me personally. So I organized exhibitions that referred to my life in that period. In the meanwhile I kept making large plas-

ter of Paris casts. Yes, large white casts, large surfaces of white plaster, not sheets of paper but plaster of Paris I molded by hand. I was transmitting the urge to leave a mark.

HUO:

And you molded these casts into different locations, didn't you?

MP:

I also made some canvases, white canvases suspended in space. I worked on whiteness, whiteness as a point of contact and of possible absorption.

HUO:

Whiteness is a very concrete Utopia, a tangible Utopia.

MP:

Yes, but without a representation. Rather, it's like the act of laying, of solidifying and touching. Then came the year of the *Tartaruga felice.*

HUO:

What year was it?

MP:

1992.

HUO:

The year of documenta IX.

MP:

For me it was the year of the *Tartaruga felice.* I had been invited by Jan Hoet to visit my space at Documenta a year before the exhibition was slated to open. As soon as I set foot in the door, I said "I'd like to rig up thirty rooms in here," and I remember that Jan Hoet exclaimed "But you can't fit thirty rooms in here, there's not enough space!" So I replied, "But there's temporal space as well: we might not have enough room but we've got plenty of time: a year for thirty rooms." So I started moving from one country to another, from one place to another, bringing my home with me—just like a tortoise does. It was my home in Documenta. So my home in Documenta didn't actually stay there; instead, it followed me around.

HUO:

A traveling home.

MP:

A traveling home, just like a tortoise's. And I was a bit like a tortoise, going around with my home.

HUO:

The tortoise is a slow animal!

MP:

The tortoise is a slow animal but in a year it produces a home with thirty rooms. Once the journey was over I went back to Kassel and completed my work.

HUO:

But after all these years, after the Anno zero, the Anno bianco, the Tar-taruga project, what are you working on now? Is it true that you've given yourself ten years to complete a work on another temporality?

MP:

What I'm doing now is open in all directions, but I can tell you that I have given myself ten years' time for carrying out a test. In ten years' time I'm going to test what's been done and what has happened in terms of a "Responsible social transformation."

HUO:

From what you're saying, it sounds like a very matter-of-fact objective. No science fiction here, right?

MP:

Absolutely: it's all completely real, because I can see myself from very far away and this way I can live this passage minute by minute. It's a passage that draws me towards the physical fulfill-ment called being, called living. The notion of testing the future is simply part of time as it flows. But it's important to understand that being, living—from the moment it becomes real—is already memory. It's important to think that the mirror holds all existing things. Everything that exists is there in the mirror. It's already in the future, and coming from the future it becomes an object in front of the mirror. The object is reflected in the mirror, and this closes the circle. Usually, reality is thought to exist prior to the mirror. Instead, existence is inside the mirror and becomes reality once it comes out of the mirror and into the present. So reality reflects the mirror, making its content tangible, and then becomes memory. The mirror paintings contain both the past and the future. This happens because I'm positively certain that the mirror will show whatever the future may hold, including people that haven't been born yet. So they're already in there and they can't help being there and emerging bit by bit. So it's the universe's absolute nothing that comes true by revealing itself bit by bit, just like reflecting emptiness. Faced with this mirror painting, we look in awe as figuration is reset but at the same time the mirror reveals—yes, it does reveal it—all the figuration that's possible. In other words: it's the all-bearing zero. So you see how mirror paint-

ings contain the universal answer; things then carry on and are tested as matters develop in the next work.

HUO:

During our meeting in San Gimignano, you talked about globalization and about how we should resist all forms of standardization.

MP:

Standardization is the way to resist the phenomenon of diversification, which is the expression of reality itself. This is proven by the *Oggetti in meno*, the mirror and all the works involving the temporal dimension: there are no two same moments, nor are there two same people. Through reification every single thing takes on all sorts of appearances. Nature produces difference. Obviously, differences are governed by more or less slow or complex transformation systems; there are community systems as well. In other words, there are community structures consisting of individual bodies. This way, there is a social reproduction of natural systems, but these social structures are where difference is automatically produced. Resisting the reality of differences entails serious problems. On the other hand, diversity at its highest can generate irreparable conflict-ridden tension. It's wrong to speak of difference in absolute terms, as it is to speak of flat standardization. I have this slogan to suggest: "eliminate distance by keeping differences!"

HUO:

So now we're fully immersed in your project called Mediterraneo. *Could you tell me its principle? I understood that the most important thing for you now is to make it turn out as a movement rather than a project.*

MP:

Exactly. "Love Difference" is an artistic movement for an inter-Mediterranean policy. I hold high hopes for this project. We're talking about an artistic movement that just can't be compared to any of the ones that took place during the twentieth century. The only participants in these movements were almost always the artists who made them up for themselves. "Love Difference" is what I call an artistic movement for an inter-Mediterranean policy, and that's quite a different matter. It's an artistic movement open to everyone. And it's that way because it contains a clearly political element; the word "policy" itself makes everyone involved somehow and encourages society itself to be present. It's an artistic movement for a policy, so by using this artistic movement for a policy everyone can join the artistic movement. At the same time, the phenomenon of the artistic movement introduces artists to the world of politics. There's a sort of osmosis between the world of art

and the world of politics. We believe that artists can pump fresh blood into politics and that politics can show a new face thanks to the transfusion received from the world of art. Obviously, the movement is based on the experiences we've talked about so far, i.e., on the consideration of the cultural, economic, and political value of "diversity." By diversity I mean balance and integration between opposing poles, like the absolute and the relative, the back and the front, nothingness and everything.

HUO:

So what is it that attracts you the most in this project? What made you choose the Mediterranean?

MP:

Great civilizations were born in the Mediterranean and we're part of them. Western and Middle-Eastern civilizations influenced the whole world in the past, but now unfortunately what used to be a central point has become the extreme periphery. Today the Mediterranean is just like a dustbin: it's full of the most frightful things from all round the world. If we want to change this "global" society, if we want to work towards a "socially responsible transformation," then the Mediterranean is definitely the area to work on. We have to start off from the beginning and move towards a new principle.

HUO:

And how do you evaluate the project's utopian aspect? The idea of movements is indeed quite clearly reflected in Utopias.

MP:

A Utopia can be that white area, that white plaster, that yellow book or those empty rooms that slowly become fully accomplished works when you project them into time. A Utopia is a passage... A Utopia might be an empty mirror that contains everything. From emptiness comes fullness; things are physically reified and the process of existence is determined.

HUO:

You were also saying that this Utopia isn't a catalyst but rather...

MP:

"... a spring," like the one used to wind up clocks to trigger the mechanism inside and make it move through time.

HUO:

"Ce n'est pas un temps absolu." {It's not an absolute time.}

MP:

You're perfectly right! It's not at all absolute. It spurs movement... Action comes from an impulse. By expressing itself, or rather by

becoming an expression, a Utopia doesn't take the shape of a single time unit nor of infinity, but rather of the lapse of time relative to the drive it produces. So a Utopia moves beyond a state of inertia and becomes movement in turn. It triggers off processes that occupy space as they move through time. It's like the sexual attraction that leads to intercourse. Countless numbers of sperm flow inside and one of them might even manage to reach the egg. Similarly, a Utopia is attraction towards a non-place, which under certain conditions can give birth to a place. Utopias play on the "time" phenomenon, between maximum resistance and maximum drive. You can even imagine that time in a Utopia is like time in a migratory flight: you're no longer in one place and you still haven't reached the other place.

PRIGOGINE, Ilya

Ilya Prigogine was born in Moscow, Russia, in 1917. He currently lives and works in Brussels. In 1921 his family left Russia and settled in Belgium. In 1941 he received his PhD in chemistry from the Free University of Brussels, where he began teaching in 1945. In 1954, Prigogine published Introduction to Thermodynamics of Irreversible Processes, *in which he developed his theory of non-equilibrium thermodynamics and the concept of "dissipative structures" that has brought him a steady stream of honors, culminating in the Nobel Prize for Chemistry in 1977. At a later stage, Prigogine attached more and more philosophical implications to his scientific findings, writing books including:* Order Out of Chaos: Man's new dialogue with nature *(1979);* Entre le temps et l'éternité *(1988) and* La fin des certitudes *(The end of certainty. Time, chaos and the new laws of nature, 1997), all three in collaboration with the philosopher-physicist Isabelle Stengers. Prigogine's all-embracing vision brings together biology and physics, inevitability and chance, science and humanity. His thinking has had a powerful influence on the social sciences and cultural, political, economic, and technological thought, as well as on many artists who have found specific interest in Prigogine's idea of the importance of chaos as a creative, structuring principle and a renewed approach to synthesis.*

..........................

This interview took place in Brussels in June 1999.

Hans Ulrich Obrist:

Let's begin with the beginnings. When did your interest in science and the significance of time actually start, if such a thing is possible to localize more or less precisely?

Ilya Prigogine:

I have always considered my work to be a work of reconciliation. It is the result of a feeling of dissatisfaction. When I was young, I was interested in philosophy, and where philosophy is concerned, time is irreversible, the arrow of time and the inescapable condition of knowledge. Whereas for physicists, time appeared in determinist theories in which there are no events. There is no automatic distinction between past and future. In classical mechanics, quantum mechanics, and relativity there is a continuity of time. I have been conscious of this problem almost since I was an adolescent.

HUO:

Was this before you came to Belgium in 1929?

IP:

No, then I was only a child! It was in 1937. I wrote three articles that appeared in a student magazine in which I stated this question clearly. Obviously, there was no response. Force of circumstances led me to study the sciences, but this problem always stayed with me. My work comes from a feeling of dissatisfaction. As you know, Saint Augustine said that time "is something I believe I understand, but when I am asked what it is, I do not know." I am sure you know that for me time is of cardinal importance. For the philosophical sciences, the historical sciences obviously, and the social sciences too. But for physicists it did not have this importance. In fact, this is what guided my work, and I believe that anyone following this path would have achieved the same results. I do not feel particularly gifted or creative. Perhaps the only thing to my credit is that I identified this problem and devoted a great deal of time to it.

HUO:

So one could say that the question of time provided a starting point for the complex dynamic of your work?

IP:

That's right. That is to say that once I became interested in other problems, and problems of molecular physics in particular, I became interested in the question of time in thermodynamic terms, since thermodynamics is the first evolutionary physical science. However, classical thermodynamics states, in fact, that in an isolated system, entropy increases up to the point of thermal equilibrium. Thermodynamics gives time's arrow a very negative sense, as the only point the system can reach is equilibrium—but at least it talks about evolution. Whereas classical determinist dynamics or quantum determinist dynamics has no arrow of time. We associate time's arrow with our approximations, I have always found the idea that we should introduce time into a world that has no time bizarre. And yet there have been attempts to do so using all sorts of experiments, approximations, and cosmological considerations, according to which the entropy of the universe was very weak in the beginning and the universe was simply dissipating, hence entropy increases and this is time's arrow. But if it is a question of cosmology, if entropy is cosmological, how is it that not all phenomena are irreversible? There are reversible phenomena for which classical dynamics or quantum physics give excellent results. The

movement of the earth around the sun is a movement perfectly described by Newton's equations. Whereas any chemical reaction and all biology is associated with irreversible phenomena. Therefore, there is a duality, and this duality led me gradually to the idea that in certain cases it was necessary to modify the laws of fundamental physics. Obviously, for those who claimed that classical mechanics and quantum mechanics were definitive, this was quite unexpected, even a little heretical.

HUO:

Yesterday I was rereading {Henri} Bergson's work on the philosophy of duration. He said, and I quote, "Duration is the continued progress of the past which erodes the future and which expands as it advances. It is the movement that counts. Duration will reveal itself for what it is, continual creation, and the endless emergence of the new."

IP:

When Bergson wrote that, he was saying that physics does not speak about duration and that therefore metaphysics must. Whereas what I believe is that physics must be modified so that it does talk about duration. Physics, if you like, becomes a physics of probability, and innovation and creation have their place in a physics of this nature. Which brings us back to the idea that from a macroscopic point of view it is clear that reversibility creates new structures. Obviously, we are still a long way from a precise image of the creation of life, but nevertheless it is possible to believe that life came about as the result of a number of bifurcations. And so, if there are forms of life on other planets, they are probably different from life as we know it and from all its possible forms. Bergson is often criticized for being anti-intellectual. He had to be anti-intellectual to be able to talk about a creative evolution. I, of course, am speaking much later, roughly a hundred years later. Mathematics has made considerable progress in that time. The idea of introducing time into the fundamental laws is no longer viewed as impossible or indeed difficult. It is a problem we can address. I wanted to realize the ambition Bergson expressed so well, in the field of science. I am not a Bergsonist inasmuch as I do not wish to make a distinction between the philosopher's duration and the physicist's time. I want to complete the physicist's vision so that it includes duration.

HUO:

You said, "The creation of the universe is above all a creation of possibilities, some of which are realized." The whole idea of virtual reality or potentialities that you have defined as pre-realities, only a fraction of which we realize, is an everyday event on the Internet.

IP:

That's right, and generally speaking, creativity is characteristic of mankind. Since Neolithic times, man has created civilizations— the Egyptian, the pre-Columbian, etc.—and since that time civilizations have continued to evolve. This is apparent in the field of music, where roughly every fifty years new forms of music are created, and so it continues. Creativity is imminent to man, but it would be ridiculous to say that creativity is mankind's prerogative because there is evolution in the animal world and the plant world too. So there is also creativity in nature. We are not the only ones. We form part of a creative nature. These are the terms of creative evolution. So, either life and mankind are outside nature or it is a property of the universe in general. As far as we know, all objects in the universe have a directional time. The stars evolve in accordance with directional time, the universe evolves in accordance with directional time, but we know little of the detail. And we have extremely complex cosmological and astrophysical structures such as the rings of Jupiter, etc. So, in essence, it is difficult to deny time's arrow—its universal aspect. And if it has a universal aspect it must be basically governed by the laws of fundamental physics. And this is what I have tried to achieve in terms of classical mechanics and quantum mechanics. After many years of research I reached relatively simple results. Bergson separated metaphysical knowledge, which corresponded to the experience of the real, and physical knowledge, which was repetitive and determinist. What I have tried to do is to bring these two types of knowledge together. I have tried to bridge the gap that separated metaphysics and physics. I try to work out the transition between being and becoming—being is always a stage of becoming. Of course we have the laws of physics, but these laws express themselves differently in a universe in evolution. Now we have the mathematics of becoming.

HUO:

How does art come into this debate?

IP:

Because physics, by becoming a matter of probability and emphasizing the new and a certain indetermination in nature, produces a vision that emphasizes creativity. And creativity is the most important aspect of art. Art was never the same after Beethoven, or after Michelangelo or Mozart. The link with art comes from the fact that in a way the universe is coming closer to the work of art. Because the universe seems to us to have a history founded on creativity. If

we think about plants, flowers and trees, which are extremely complex mechanisms that could only have appeared as the result of a certain number of bifurcations, we find an analogy here with the work of art. The specific model of classical physics is the pendulum. Whereas the symbol of thought that I have tried to develop is the nature of a work of art. The question of whether the nature of a work of art is due to the immanence of the universe or to transcendency is one I cannot answer. Nature leads to wonder, this feeling of wonder, of transcendency.

HUO:

You find wonder in these sculptures that you collect—What importance do they have for your work? Are they a source of inspiration?

IP:

Yes, they are. Whether they come from Japan or elsewhere, these works are the very embodiment of creativity. At one time, in fact, my ideas seemed so heretical, so far from the direction taken by physics that I felt rather isolated. What is more, I wrote as much in the introductions to pre-Columbian exhibition catalogues.

HUO:

Have you shown your collection as a whole?

IP:

No, never as a whole, but some objects have been displayed as part of exhibitions.

HUO:

Going back to this bridge you have created between science, philosophy and art...

IP:

It's not so much a bridge—what I have tried to do is to remove the contradictions. I have not created a bridge inasmuch as I cannot offer advice to artists. That isn't my role, nor is it my domain. I have removed the contradiction between art/creation and nature/statics. It is a contradiction I have always found very arbitrary and even false. Nature is also creation, and as I had found creativity in systems far from equilibrium...

HUO:

Recently I visited a Rudolf Steiner exhibition. It included the remarkable drawings he made on black paper during his lectures. On one drawing there are the words "science, definition, I am cognition but what I am is not being; art, I am fantasy, but what I am is not truth." This could be a way of dissolving these contradictions.

IP:

Certainly. I will tell you a little about the mathematics of time. I began to talk about sets. Sets that had been considered as the result of our ignorance. In thermodynamics, sets play an important role and give new results. So I could not accept an explanation that claimed that creativity is due to our ignorance. On the contrary, creativity expresses itself through new possibilities, and a physics that denies time's arrow, denies what it does, i.e., to increase understanding. As far as the mathematics of time is concerned, you need to understand what a law of nature is. In the punctual transformations of classical mechanics there is a determinism, and one can show that as long as one is dealing with simple functions, which means that they belong to Hilbert space, which is a space in which functions play the same role as vectors in elementary calculus, the sets do not produce anything new. But once you go beyond Hilbert space—functions such as distributions and fractals—from that point forward punctual transformations are no longer equivalent to sets, and the sets have new properties. The physics of populations has, so to speak, more properties than the physics of individuals. Just as the sociology of a population is different from the sociology of a single individual, so the physics of populations gives different results from the physics of the individual, and the results of the physics of populations include the direction of time.

HUO:

One plus one makes three?

IP:

No, one plus one is two, but the very fact of talking in whole numbers is itself the result of non-equilibrium. Because, so to speak, in the beginning the world was a kind of soup in which it was difficult to distinguish one particle from another because all the particles were interacting. Now we are in a world which, although it may still be young, is very different from the primordial world. And in this world there are objects that are individualized. In this world we have a matchstick plus another matchstick. In a world of high synergisms the matchstick would not be stable; it would break up into particles and instead you would have a continuous medium. Whereas in our universe you have discontinuous objects, and that is the result of a cosmological evolution.

HUO:

How do you see the potential of individual creativity in terms of this notion of group?

IP:

Obviously, through the history of mankind, action has originated with groups. Groups act in a coherent manner, but also in a way in which individual interaction retains its value. Physics provides us with a vocabulary that we can use in a metaphorical sense or for systems of far greater complexity. Just as there are bifurcations in physics and chemistry, so there are bifurcations in history. There are events in history. For example, the transition from the Paleolithic to the Neolithic, 10,000 years before Christ in nearly every part of the world, which is already quite astonishing in itself since mankind had been around for ten million years. This transition to the cultivation of plants and the use of ores occurred in a different way in China than in Egypt, Babylonia or pre-Columbian America, and gave rise to an astonishing wealth of creativity. And this wealth also created other aspects such as differentiation among men. Men were needed who could build the pyramids as well as people who could give the order to build. So it also created the division of labor and slavery, which continued until roughly a century ago. So in some ways each bifurcation has its victims as well as those who benefit from it. And I can't pretend that this is a bad thing because it led to the creation of civilization and, of course, to our own way of life, in which people are at least more involved in their culture. But it also created inequalities, from which we still suffer today. It is possible to see history, especially western history, as the unexpected outcome of bifurcations. There was the Paleolithic bifurcation, another resulting from the production of coal, then from oil, electricity, and now a bifurcation produced by the computer revolution through which we are living. But each time there is also individual action on unstable ground. It would appear that society, and western society in particular, is an unstable society. And individual action is of considerable importance. For example, the Russian Revolution, which was the transition from the Czarist regime to a post-Czarist regime, could have taken any of a number of different forms, but the form that it took and the advent of Communism stemmed from the incompetence of the czar, the unpopularity of the czarina and the violence already taking place in the revolution. May '68, for all its faults and utopian ideals, was still an important event and one in which young people also played a part. We are in a very difficult situation too, as we can see from the situation in the Balkans and in Africa. Here again it is important that young people play a greater role. They must fight against resignation and the sense of powerlessness. It is precisely

these fluctuations and microscopic structures preceding an event that are so important. We talk about the globalization resulting from information technology, but globalization could mean the loss of the diversity of our cultures—and this would be a disaster.

HUO:

I read articles that claimed that it was becoming less and less clear that science was progressing—in fact that science is entering a state of uncertainty.

IP:

Yes, besides which today science is divided into increasingly separate branches. How can one compare an advance in biophysics with an advance in cosmology or astrophysics? Science has a movement that is one of both separation and reunion. It is rather like Europe, which is being built on the one hand, and the regionalist movement developing on the other. Belgium is a perfect example: Brussels is the headquarters of the European movement, but the country is profoundly regionalist with its federal government, the Flemish, Walloon, and Brussels governments, and that of the German region. There are movements in both directions.

HUO:

How do you see the future of science?

IP:

In general terms, it is important that scientists should become more aware of social problems. This is one of the problem areas of our period. Classical science was elitist. Today we tell ourselves that science is in close touch with society's problems. If you present a project to the European Commission it is much more likely to succeed if it is shown to have an effect on society. But, at the same time, the importance of pure science must also be acknowledged. This is a problem that is arising in our own time. I still say that today if Einstein had depended on the Commission he would never have been able to formulate his general theory of relativity, because they would have argued that he had spent ten years working on a theoretical problem and that it would be better to work on problems of a practical nature. Research has become more marginal. In advanced areas of research, such as elementary particles, problems exist. But, in essence, the world does not seem any simpler. It is very curious— we talk about complexity in biology and say that the human brain is the most complex thing we know, which is clearly true. But we know that complexity also exists in elementary particles. François Jacob said, "Cells dream of multiplying while a particle dreams of being stable," of not disintegrating into protons or something else.

HUO:

The end of certainty has become established discourse in relation to changes and fluctuations. Are we seeing the birth of a new rationality, a non-determinist rationality?

IP:

Classical rationality was determinist. But we are living in a different world. Rationality must incorporate time's arrow and creativity. This is not irrationality. Nature must be approached differently. Irrationality comes rather from postmodernism, developing the idea that we do not know how to attain the structure of nature, we can only talk about it. Measurement would come from man and would give information about nature, so we cannot attain nature. In my opinion this is a very pessimistic vision. According to the postmodernists, science is no more than a work of man. That is true. But man forms part of nature. The brain gives us a plan of nature. All life is to some extent an extrapolation of the future. But it is not simply an extrapolation—there are laws behind these extrapolations. The postmodernist sees man as being at the origin of science. But I do not believe this is so. Man produces chemical molecules, hundreds of thousands or perhaps millions every year. Many already exist in nature. But man also produces molecules that are not found in natural products. And man also produces mathematics. But it would be true to say that some aspects of mathematics have been invented by nature; that is how nature constructs trees, plants, etc. But all mathematics developed by man are not necessarily found in nature.

HUO:

With regard to the importance of the social aspect of science, you talked of a recent report in which you were involved, together with other thinkers. Could you tell me about this?

IP:

It is a collective work and I was only involved in one aspect of it. I limited myself to a single aspect: the model for the social sciences, a model that was often the Newtonian model. There are sociologists who say that the problem is finding Newtonian laws for society. According to Kant, determinism is the very condition of science. Hence sociology must be able to predict everything. As in classical physics, one predicts everything that might occur and one can also analyze the past. However, the science of the complex, the science of the irreversible, gives sociology other models, and in particular the model of bifurcation. That is to say that social events are not predictable, but perhaps one can try to isolate the points of bifurcation. Non-Newtonian science therefore gives sociology more plausible

metaphors. But it must be said that these are only metaphors; if not we would have to write nonlinear equations for society. But there are analogies, because a society is, on the whole, a nonlinear set. What you do influences what I do. But what you do is not altogether predictable. There is the average man and the non-average man. So, for example, someone living in the year zero could not have foreseen the influence of Christ. There are people who create fluctuations, events. There are microstructures of events. As I was saying before, in the Russian Revolution things could have happened in a number of ways. The world is based on probability, and the history of society is most definitely based on probability. The hope I would like to give young people is that probability lends importance to these fluctuations. History is not made, it is being made. In my writings I always stress the fact that history is still in its early stages—we only have 10,000 years of history. Man will change; man is only at his early stage. There are still so many people who have no involvement in their culture, who are still hungry. Is this necessary? Is it inevitable? I don't believe it is. Many people say that science is reaching its end, but if we look at nature we can only laugh at this attitude. We have not even discovered how plant life evolved. We don't know what lies behind the development of the brain. We don't know how the brain functions. So to say that science has reached an end seems an incredible claim. And the same is true on a microscopic level: there are complex phenomena and this complexity has not been unraveled. At the end of this century our major achievements are being challenged. These achievements were relativity and quantum mechanics. We cannot say that they are false. They apply to simple situations.

HUO:

There is another major topic you mentioned: the city.

IP:

The greater the density, the greater the importance of nonlinear phenomena is, because people have a mutual influence on each other. So the city is a melting pot for creativity and invention, but often a place of isolation too.

HUO:

Talking about the city, you spoke about a dream you often have. Could you tell me about it?

IP:

It's a dream that is rather like a story by [Isaac Bashevis] Singer. He imagines a writer who lands in South America and, contrary to expectations, finds nobody is there to meet him. He has come to

give a talk to a Hebrew organization. He gives the driver an address that leads to a hotel in the run-down, lower class quarter of town. He has no money, he doesn't know how to get into contact with the people who have invited him, and he becomes more and more concerned. After two days the people who invited him suddenly burst into his hotel. He had made a mistake about the hotel. So the anxiety here is resolved. Sometimes I dream I am in Chicago and that I have lost the address of my hotel. Perhaps this means that I am worried about following the wrong direction, that I should have done something else with my life. It's a dream I have often. I have always had a feeling of anxiety. It's a dream that shows that the path I chose to follow was in some ways a gamble, a risk. And it's true that in science as elsewhere, the great successes are connected with great risks. But great risks bring with them worry and anguish.

HUO:

One final question, in relation to your hopeful comments about the future— that history is not finished. Now, at the end of the century, it is interesting to think about what has been achieved, but also what has not yet been achieved, and what will perhaps be achieved during the coming century. What does the idea of the "road not taken," the project not achieved, mean to you? Is there some project you have not carried out but would like to?

IP:

The fact is that there are theories so monolithic that it is difficult to extend them and to include in them the element that perhaps should be included. The outstanding example is Einstein's general theory of relativity. It is a wonderful, monolithic construct, and yet to explain the evolution of the universe we have to apply Einstein's theory—it's inevitable. However, to talk about the age of the universe is already in a sense a non-Einsteinian concept because the age of the universe only has sense if the birth of the universe is an event, something irreversible, and that does not form part of Einstein's theory. We begin to see how the theory of irreversibility, time's arrow, comes into classical physics, quantum physics, and even into the physics of restricted relativity. But not into general relativity, I can't see that. One of the things I have not managed to do is to remain a good pianist. When I was young, I worked with the prospect of infinite time. When you are eighty, it is difficult to work with the same outlook.

RANCIÈRE, Jacques

Jacques Rancière was born in 1940 in Alger, Algeria. He currently lives and works in Paris. Rancière studied philosophy at the École Normale Supérieure in Paris with Louis Althusser, and he participated in the publication of Lire Le Capital *(Reading Capital, 1965), the collective intellectual effort presided over by Althusser and devoted to the theoretical analysis of Marx's* Capital. *With his first book,* La Leçon d'Althusser *published in 1974, Rancière distanced himself from his former "teacher" and started carrying out empirical historical research on the French working class movement during the nineteenth century; in 1981 he published* La Nuit des prolétaires *(The Night of Labor. The Workers' Dream in Nineteenth-Century France, 1981). In 1975 he co-founded the review* Les Révoltes Logiques, *which held the mission to explore forms of struggle and speech that were not sufficiently taken into account by "official" historians. With* Le Philosophe et ses pauvres *(The Philosopher and his Poor, 1983),* Aux bords du Politique *(On the Shores of the Political, 1990) and* La Mésentente *(Disagreement, 1994), Rancière reinvestigated the field of political philosophy but from a critical point of view, which drew upon the results of his previous historical research. He is currently Emeritus Professor at the University of Paris VIII (Dept. of Philosophy). In addition to publishing epistemological reflections upon the writing of history, such as* Courts Voyages au Pays du Peuple *(1990) and* Les Noms de l'Histoire. Essai de poétique du savoir *(The Names of History, 1992), Rancière recently started investigating new areas of research such as aesthetics and cinema. He recently published* Le Partage du sensible. Esthétique et politique *(2000),* L'Inconscient esthétique *(2001) and* La fable cinématographique *(2001), and he has contributed to magazines such as* Les Cahiers du Cinéma, *and* Vacarme, *as well as catalogues for contemporary art exhibitions including "Raymond Depardon, détours" (Maison européenne de la photographie, Paris, 2000) and "Sonic Process: A New Geography of Sounds" (Centre National d'Art et de Culture Georges Pompidou, 2002).*

........................

This interview was recorded in Paris in June 2001.

Hans Ulrich Obrist:

Let's begin, not with the beginnings maybe, but rather by speaking about your current work on aesthetics.

Jacques Rancière:

I'm working on the *idea* of aesthetics: for me, it is not philosophy, science, or the theory of art, but a regime of thinking specific to art. Therefore, I try to work at a distance from what some people call artistic modernity, because the term implies a kind of relation between history, politics, and art that doesn't satisfy me. A regime of art is a system of concordance between the ways artists do things,

the modes of perception, and the forms of conceivability of what they do. Art is also what you can see and what you can conceive as art; so I think about this overall coherency of a set of practices, with their forms of visibility and identification. Therefore, I oppose those who say that there is art, which is a practice on the one hand, and there is theory on the other, which is grafted onto practice. I also oppose lazy theories such as: art is what institutions decree to be art. It's not a matter of managerial decisions. Art is always at once a mode of perception, a mode of visibility, and an idea; and it's also on that level that I try to understand the relation between aesthetics and politics. For five or six years now I have been work-ing on two centuries of writing about art, from the great philo-sophical classics of aesthetics to the discourses that constitute or comment on a certain number of significant contemporary modes. Therefore, I try to understand both the evolution in visibility of that which is considered art and the manner in which that evolu-tion is conveyed through new and different arts. What happens when arts like photography or cinema appear? When painting changes in status, when it dissolves into a larger set called the visu-al arts? That is currently the object of my work, with a particular interest in cinema, a technically new art which, one can say, has been allegorical or almost emblematic. In certain theorizations of the '20s, it was emblematic of a new form of art, a sensible lan-guage, breaking with the tradition of representation. But cinema has a quite opposite meaning. It is the newest of the arts, but also the one that brought back an entire regime of art, modes of narrat-ing and typifying, which could seem outdated elsewhere, in litera-ture, for instance. There you have an example of work on the con-tradictions of a particular art.

HUO:

I recently read your text on Raymond Depardon published in the catalogue that accompanies the exhibition of his work at the Maison européenne de la photographie in Paris. Precisely, Depardon is particularly interesting in terms of the intersection between art and politics.

JR:

I'm not at all a specialist of photography, nor of Depardon. I did this text at his request, according to a double logic that character-izes my work. It follows its own course, extending over years. Then some people get interested and ask me to write about an exhibition, an artist's work, a particular circumstance, and for me, responding to these unexpected solicitations is a way of putting to the test the

work that I otherwise do on my own. Raymond Depardon asked me to do a text for his exhibition, which interested me for several reasons. First of all, his work questions the divide between kinds of photography. Originally he is a reporter; however, his works undermine the old, somewhat traditional division between art photographers and reportage photographers. I was interested in going beyond that opposition, in seeing how the reportage photographer could also embody an entire idea of the aesthetic regime of art, and how in the grasp of something which is given, which is not constructed by the artist's will, a specifically modern form of art could be defined. My other interest in Depardon, as I learned by looking at him closely, is that he works on the question of the frame. Traditionally, photography has mostly been conceived on the basis of the miraculous instant captured by the photographer. That was accentuated, of course, by Barthes' *Camera lucida* (*La Chambre claire*, 1980), with the category of the "punctum," a kind of affect specific to photography, which was conceived within the framework of an "indexical" theory of photography as a trace, something like an emanation of the body. So I was interested in taking a case that stood apart from all these discourses on photography, since Depardon doesn't capture a special moment; he always captures instants that you could call indifferent, and consequently the essential thing is not to seize that special moment, the moment of meaning—or of meaninglessness—but instead to adjust the relationship between the photographer and what is in front of him, particularly around this question I focused on in my text: the question of distance. The important thing is not the essential moment, but rather the right distance, where you can grasp the relationship between what's happening on the image and what leads the artist—the photographer—in front of the image. It was also a way to reformulate questions like: Do we have the right to make images? What is the political significance, or what is the ethical right, or non-right, of making this or that image? What interested me there was the fact that the question had shifted: it was no longer a matter of knowing if one had the right to photograph the genocide suspects locked in the Kigali prison, or not, but instead of knowing how it could be done. What finally interested me in Depardon's work was the relationship between speech, the fixed image, and the moving image, because I try to criticize a vision of artistic modernity, which would say that everybody is in their own place with their own medium and their own language. What seems important to me, on the contrary, is the relation between making photographs, making books

and making films, and what that implies in terms of community, but also maybe in terms of passage, of the transposition of one art to another. How, for example, in Depardon's work, the question of the frame and of the photograph's distance becomes the question of time in cinema, particularly through the time constraints that he puts on himself: ending a rotating movement of the camera, emptying a roll of film, whatever the "interest" of what the camera might encounter during that time. So he imposes on the image-taker a constraint that dispossesses him of his mastery. Those are general problems of the aesthetic regime of art that I was interested in testing on this particular body of work: the passages between the arts, the relation between the voluntary and the involuntary, between art and non-art.

HUO:

Another aspect is the passage of works from artistic contexts to non-artistic ones or the other way around. I'm thinking here, for instance, of the case of Albanian artist Anri Sala who did a film on the history of his mother and of communism in Albania (Intervista: Finding the words, *1998*)*. This film can be broadcast on television as a documentary and presented at the same time in museums or gallery settings as an artwork. In your text on Depardon you suggest that it's essential that the same work can appear in different forms and in different contexts, as a book and as an exhibition.*

JR:

Yes, absolutely. The film that you're speaking of, if I remember correctly, was part of the exhibition "Voilà" ("Voilà. Le Monde dans la tête," ARC/Musée d'Art Moderne de la Ville de Paris, 2000). It's in that context that I saw it, with that form of distracted attention that makes you go into a little projection room or not, that makes you stay or not stay. This is the kind of exhibition that questions a certain division of the roles between painting and cinema. Traditionally, painting is at once a work closed in on itself, but also a work that you pass by. Cinema, inversely, is a mobile image that flickers by, but at the same time implies that you settle down at a fixed point to look at the movement. Of course, this relation has been blurred in various ways, by films on television or by reproductions of paintings, for example. But what seems interesting to me is when the artistic device itself organizes this blurring, when phenomena like the infinite reproduction of pictorial works on books or zapping between films on TV are taken up in a specific art that re-orders all these forms of art, changing their mode of spatiality and of temporality. In that exhibition there were

also the films of Chantal Akerman, which were replayed in an installation of monitors that changed the meaning, since you saw *Jeanne Dielman* (*Jeanne Dielman, 23 Quai du Commerce, 1080 Bruxelles*, 1975), for instance, with the sound from another film; an installation that changed the perception of what you saw on the screen (*Self-Portrait/Autobiography: A Work in Progress*, 1998). I'm particularly sensitive to this shift. I think we've understood artistic modernity for much too long in [Gotthold Ephraim] Lessing's terms: each art having its own medium. What's been hooked onto that is a whole recurrent discourse on the purity of art: it criticizes words and particularly the words of philosophy, which are claimed to have a parasitic effect on the works, drawing them out of their proper regime of presence. Personally, I have tried to show that even in the history of painting, words have played a considerable role; they change the very visibility of what is painted. For example, I worked on the nineteenth century, on the way Rubens or Rembrandt or genre painting were looked at differently. The re-descriptions of painting that seize on the pictorial event instead of the figurative anecdote end up creating a new mode of visibility, which alone makes possible Impressionist painting, and everything that follows. So I'm sensitive to the way the mediums act on each other, and in particular the way words act on images and images on words. I don't think that a device that changes images or that changes words necessarily has a critical effect. We tend to think a little too quickly that this restaging device will make you see things differently, understand things differently. I'm thinking about certain exhibitions like "Au-delà du spectacle" that I saw in Paris ("Let's Entertain: Life's Guilty Pleasures," Musée Nationale d'Art Moderne, Centre Pompidou, Paris, 2000) where you start with the presupposition that an advertising clip reworked inside a small, separated space will necessarily bring about a critique of advertising. I'm not so sure, and in fact the curator often has to add a title card, to explain the critical nature of a device that is supposed to be critical all by itself. You have the same thing in all the areas.

HUO:

Would you describe your approach as an interdisciplinary or a multi-disciplinary one?

JR:

I've always tried to ignore the borders between disciplines. From a personal point of view, my work can be situated in different disci-

plines: certain works deal with philosophy, others with social history, others with aesthetics, and others with political philosophy and so on. I'm always tempted not to recognize these disciplinary divisions. Obviously, it's not the same thing when you want to find out what differentiates architecture and literature, as when you want to find out what's going to differentiate the philosopher from the historian. But I think that fundamentally, all the intellectual approaches obey rules, strategies, which are absolutely transversal with respect to what is claimed to be the essence of philosophy, of history, of political science or whatever. I think that the disciplinary borders in what are called the social sciences are simply borders of convenience, and that you can only think about something correctly if you're able to bring together materials and logics that come from various quarters. That doesn't mean that you have to put together a sociologist, historian, a philosopher, etc., as people usually do. It becomes a kind of social gathering. The same people have to turn themselves into sociologists, historians and philosophers all at once, and nothing comes out of it. Fundamentally, one follows modes of reasoning that entirely traverse the disciplines. The disciplinary divides are like convenient excuses to say that certain things don't depend on you, so you don't have to knock yourself out researching them. The kind of crazy side of my work is that I've never trusted the specialists of any discipline. When I worked on history I went to look in the archives. And when I worked on literature, I didn't do it as a philosopher talking about literature, but I totally immersed myself in this sort of historical revolution that makes literature become the new name for the art of writing in the nineteenth century. It's not a matter of a dialogue between different disciplines, it's a matter of denying the division of skills and trying, whenever you can, to go see by yourself.

HUO:

Originally trained as a philosopher, how did you gradually immerse yourself in other domains?

JR:

I had a university education as a philosopher, and after '68, with a new awareness of the gap between a certain discourse of Marxist philosophy in which I had shared and the reality surrounding me, I said to myself, "I am going to forget everything that has been said about philosophy, the proletariat and Marxist theory, and study the history of the constitution of working people's thought in the nineteenth century." I began looking at pamphlets, which referred me to other pamphlets and to other archives. So I built up my own corpus and I tried to study by abolishing the borders. A historian nor-

mally considers archives as a source of information. I tried to consider the archives as a text, and consequently to take the workers' texts that I was reading as literary and philosophical texts, to try to see what they said...

HUO:

Was this your book La Nuit des prolétaires.

JR:

Absolutely, that book was my thesis. In it I tried to break down the divide between the disciplines and between the high and low discourses, to bring literary texts and so-called historical texts directly into dialogue, texts considered to be social history and texts of philosophy, texts by workers on time and texts by Plato talking about working time. My approach was this: begin from a philosophical background and work as an autodidact, with this one difference: that often an autodidact doesn't even know where to look for things. Personally, I knew where to look for things but I've always tried to put aside the secondary literature, and I always read very few books "on" a historical period, "on" artists, "on" philosophers or writers. I try to look a little at the things themselves, insofar as the expression has any meaning; but also to considerably enlarge the field of words and events. Where the question of art and the aesthetic revolution is concerned, I have tried to work on all forms of transformation: for example, the transformation of typography, and all the forms of the distribution of painting, through the widest possible range of texts.

HUO:

Do you make history into a sort of traverse?

JR:

On one hand, I had the idea of going as much as possible to the primary material, but also the idea of getting rid of the categories, for example by bringing into contact literary texts and "politically involved" texts from a given period. I worked a lot on what could be called inconsequential literature, newspaper chronicles, little human interest items, the minor, the uninteresting, the anecdotal, the vignette, everything that defines regimes of perception of the ordinary, and gaps with respect to those regimes.

HUO:

Arlette Farge said about you: "Rancière refuses to oppose art and science, because this choice is political."

JR:

I don't situate myself in an overall vision of the relations between

art and science. I would simply say that in what I have tried to do—and there, obviously Arlette Farge is talking about my work as an historian—I have encountered the professional conception of history as a science. I've tried to revoke that division for myself, or in other words, to show that the science of history is itself the result of a literary revolution. While pursuing the work of literature in the nineteenth century, I tried to show how many of the paradigms of history, sociology, and the social sciences in general were first invented by literature, and how the idea of a "new history" was invented by writers, by Hugo or Balzac, who countered the history of events with a history of mores, a history of material life and of mentalities. You constantly come across exchanges or, at an even deeper level, zones of indiscernability between literary paradigms and scientific paradigms. And in my own writing, I absolutely had to revoke the divide between the scientific and the literary, because history is initially made up of a certain number of speech events, and of discourses that evaluate them, translate them, transcribe them. At that level, establishing a divide between scientific content and artistic form makes no sense whatsoever.

HUO:

Do you work alone?

JR:

Yes. That doesn't mean that I haven't sometimes done things in collaboration. For example, with other people I started a journal called *Les Révoltes Logiques*. It was named after Rimbaud, in *Illuminations* (1886): "We massacre the logical revolts." This journal, which existed for six years, stood on that line between history and philosophy. It was the time when I was working on the archives with a few other philosophers, and that work fed the journal.

HUO:

How many issues were published?

JR:

There were 15. I need to constitute my material myself, and therefore it would have taken my entire life. What's more, I was marginal with respect to the world of historians, and I found myself pushed back by them into the world of the philosophers. So I had to renounce my "tetralogy," to put a brake on my endless appetite for knowledge linked to the questions that concerned me. So you can chalk that up to the chapter of unfinished projects.

RICHTER, Gerhard

Gerhard Richter was born in Dresden in 1932. He currently lives and works in Cologne. Richter lived his first 13 years under National Socialism and after the war, he spent the following 16 years under East German Communism, before fleeing to West Germany in 1961, just a few months before the Berlin Wall was erected. Richter studied art at the Kunstakademie in Dresden (1952 and 1956) and at the Kunstakademie in Düsseldorf in the class of Ferdinand Macketanz and later with Karl Otto Götz. Soon after his first exhibition of paintings in 1962 (Galerie Junge Kunst, Fulda, Düsseldorf), Richter abandoned Art Informel and made his first photo-based paintings, using a projector. In 1963, Richter and Konrad Lueg (later Konrad Fischer) traveled to Paris where they saw Yves Klein's work at Galerie Iris Clert and introduced themselves (without success) to art dealer Ileana Sonnabend (and others) as "German Pop Artists." In 1963 Richter co-organized and exhibited his paintings in the satirical and provocative exhibition "Life with Pop: Demonstration for Capitalist Realism," at a furniture store in Düsseldorf ("Gerhard Richter/Konrad Lueg: Leben Mit Pop, eine Demonstration für den Kapitalistischen Realismus," Möbelhaus Berges, Düsseldorf). In 1966, he began work on the "Color Charts," (Farbtafeln series, ongoing) and exhibited his work with Sigmar Polke at Galerie h in Hanover. In 1968–1971, he began several series of works that he would develop over a number of years including: "Townscapes," (Stadtbilder series), "Gray Pictures," (Graue Bilder series), "Clouds," (Wolken sezries), "Landscapes," (Land schaften series) and "Shadow Paintings," among others. Considered a "conceptual painter," Richter himself says that he wanted to express through his art "the inadequacy in relation to what is expected of painting," the inadequacy of the making of images and the critical examination of it. In 1969 Richter reviewed the material that he had collected throughout the '60s and began to assemble pieces for Atlas, an ongoing compilation of photographs, clippings and sketches that he has exhibited several times since 1969 and recently at the Dia Center for the Arts (New York, 1995), documenta X (Kassel, 1997) and the Consorci del Museu d'Art Contemporani de Barcelona (MACBA) (1999). Since the late '60s, Richter has been one of the most widely-exhibited contemporary artists internationally, and numerous retrospectives of his work have been organized including recent exhibitions at the Moderna Museet, Stockholm (1994); Museo Nacional Centro de Arte Reina Sofia, Madrid (1994); The Israel Museum, Jerusalem (1995); Astrup Fearnley Museum of Modern Kunst, Oslo (1999); Centro per l'Arte Contemporanea Luigi Pecci, Prato (1999); Museum of Modern Art New York (2002); San Francisco Museum of Modern Art (2002). Richter has been a regular participant in Documenta in Kassel (documenta 5, 1972; documenta 7, 1982; documenta 8, 1987; documenta IX, 1992; and documenta X, 1997) and the Venice Biennale (La Biennale di Venezia – 35th International Art Exhibition, 1972 {German Pavilion}, 49th International Art Exhibition, 2001}.

........................

This interview was recorded in Cologne in May 1993.

Hans Ulrich Obrist:

You were uncertain about these "Notes from 1962," but you agreed to their reprint in the book nevertheless (The Daily Practice of Painting: Writings and Interviews 1962-1993, *1995).*

Gerhard Richter:

Yes, it all sounds rather sententious and stilted.

HUO:

It begins like this: "The first impulse towards painting... stems from the need to communicate."

GR:

That's certainly not wrong, but it's a bit of a truism.

HUO:

In the same text, you dissociate yourself firmly from the idea of "Art for Art's Sake." Against that, you emphasize the idea of content—not imposed content, but also not content infiltrated through the back door, of the kind you hear of nowadays.

GR:

That was an idea that was current in the East in the '50s, a kind of ritual abuse of decadent, bourgeois art. Somehow or other I had managed to internalize the idea that art can't be "Art for Art's Sake," but has to be about communication; I later said the same thing in a different way.

HUO:

The repetition from one text to another brings out certain basic structures in your thinking, such as your aversion to ideologies.

GR:

That's probably innate. By the age of 16 or 17 I was absolutely certain that there is no God—an alarming discovery to me, after my Christian upbringing. By that time, my fundamental aversion to all beliefs and ideologies was fully developed.

HUO:

This runs like a scarlet thread, as it were, through all the texts.

GR:

And on the other hand the knowledge that we need belief—which I sometimes refer to as a mania, an illusion that we need in order to survive or to do anything, a prime mover. And at the same time this vulgar materialist view that we do not essentially differ from the animals, that there is no such thing as freedom or free will— this doesn't directly come out in the texts, but those convictions were established very early on.

HUO:

That sounds fatalistic.

GR:

So it may, but the important thing for me is that this kind of fatal-

ism or negativism and pessimism is a useful strategy in life, there is a highly positive side to it because one has fewer illusions.

HUO:

Hopeless, or inescapable?

GR:

Either will do, to make us feel better, to make us create hope.

HUO:

So hope is another scarlet thread?

GR:

Hope is something I always have. And the less we deceive ourselves, the more pessimistically and fatalistically we see a thing, without kidding ourselves that we have free will, or that it is possible to move a pencil from left to right by our own autonomous decision, the more we shall succeed in not succumbing to false faiths.

HUO:

The press invitation to the exhibition "Life with Pop: Demonstration for Capitalist Realism" makes it clear that this was a unique event, a happening.

GR:

And not the inauguration of an art movement.

HUO:

More of a parody of all isms.

GR:

Perhaps.

HUO:

Why wasn't Polke there?

GR:

Purely by chance—maybe we'd temporarily fallen out at the time; but then, this demonstration was never meant to be all that important. We just wanted to do a little exhibition.

HUO:

In the course of your conversations and texts, the word "readymade" turns up again and again especially with Benjamin Buchloh, but also in more recent notes and interviews in which you speak of your "Abstract Pictures" ("Abstrakte Bilder" series, 1976–ongoing), as readymades—which is taking things as far as Duchamp's statement that the readymade concept expands to include the entire universe.

GR:

I do believe in the readymade in this overriding sense, because if you confine it to art alone it tends to turn glib and illustrative: [Piero Manzoni's] *Base of the World* (1961) was one example of that.

HUO:

Besides the "Demonstration for Capitalist Realism," were there other, similar projects that never came off?

GR:

Any amount of them. In Paris, on the roof of the Galeries Lafayette, we wanted to put up a photograph of the Alps, with a cutout of the skyline, so that Paris could have its own Alps. And there are some lovely views in the Neanderthal[?] area; we wanted to take people out there in buses and announce, "Here is our art." Others later did just that.

HUO:

On the one hand, there was this ubiquitous reference to Pop Art: existing and available images were taken out of context, appropriated and recombined. But on the other hand, the "Demonstration" also reveals a connection with Happenings and Actionism.

GR:

That's what fascinated me most, at that time. For instance, we were obsessed with the idea of holding an exhibition of [Roy] Lichtenstein paintings, all of which we would paint ourselves. But that turned out to be too much work.

HUO:

This skepticism about the ideas of authorship and genius has led to a number of attempts to deconstruct the Modernist claim to originality and authorship, by simply appropriating someone else's work without permission.

GR:

A terrible cop-out. Especially when a person builds his whole life on it. To do it once, as a demonstration, that I can understand.

HUO:

In your response to Pop Art at the time, were you already distancing yourself from it, or were you involved in adopting or appropriating it as a movement?

GR:

My distancing was mostly about Good and Bad, and the idea or the programs didn't interest me for long anyway. And nothing has changed, really. I always thought that some were bad and some not very good, and the best were Warhol, Lichtenstein and [Claes] Oldenburg. And that's the way it still is.

HUO:

The "Demonstration for Capitalist Realism" was an exercise in brinkmanship: it came close to a point where art dissolves into its social or political context, so that convergence must either take the form of disappearance or of a clash. And as to contextual convergence: the Happening took place in a

furniture store, and it left the existing display unchanged. Art converged with a pre-existing context, but it was never about art dissolving into the context of life.

GR:

Yes, we were rather playing with fire—to find out just how far we could go with the destruction of art. But in principle I never had the remotest desire to allow painting or art to dissolve into anything else. That kind of radicalism made no sense to me at all, though radicalism was generally regarded as the be-all and end-all at that time.

HUO:

As a criterion of quality?

GR:

No, art was the most important quality. That's why I then made fun of it all in the "Polke/Richter" text for Hannover ("Polke/Richter," Galerie h, Hannover, 1966), and said that I was conventional and loved Raphael and beautiful paintings.

HUO:

Were you conscious then of these distinct positions?

GR:

Yes, of course I was, and sometimes I had a guilty conscience about not being quite radical enough.

HUO:

Not even in the "Demonstration for Capitalist Realism"?

GR:

When you're doing something like that, you tend to get high on it and just do it. But then when you're making something of your own again, or thinking over how terrifically radical other people are—Pollock's drip paintings, or Carl Andre's metal plates, or Arman with his containers: now that was regarded as radical. And I've never seen myself that way, I've always painted.

HUO:

In spite of your constant dialogue and exchange of information with Polke and {Konrad} Fischer, the mechanisms of group bonding were never formalized, as they were for instance with Art and Language.

GR:

That was quite deliberate. There were rare and exceptional moments when we were doing something together and forming a kind of impromptu community; the rest of the time we were competing with each other.

HUO:

There's this text lifted from a newspaper, on a poster for Galerie Friedrich & Dahlem {Munich}.

GR:

Now that was a readymade, wasn't it?

HUO:

Your only textual readymade known to me, except for the Perry Rhodan composite in the Galerie h catalogue, and your non-statement in the book by Herzogenrath.

GR:

To me it was just the same as a found photograph. But I don't think anyone wigged out, because it was on the poster and just disappeared. Later I often tried out texts or text montages of the same kind.

HUO:

How did the Perry Rhodan text collage come about?

GR:

We'd read the stuff, and it fit into the utopian naivety of the '60s, with all those ideas about other planets. This inartistic, popular quality—it all went together with photographs, magazines, glossies, that was the Pop side of it. All completely unimaginable today.

HUO:

Another absurdist text is Polke's imaginary Richter/Thwaites interview from 1964. The term "Pop painter" turns up in it was it meant ironically, or did you all then define yourselves as the German representatives of Pop Art?

GR:

It was meant ironically; at that point we were trying to keep our distance from Pop. It was only at the very beginning that we were naïve enough to go off with Konrad Fischer and do the rounds of the galleries, Sonnabend and Iris Clert, and announce "We are the German Pop Artists."

HUO:

But the use of existing images and texts did come from the influence of Pop, which freed available, popular images from their contexts and saw them in a new way as pictures in new combinations.

GR:

Yes, of course, but maybe that can also be seen as the time-honored practice of taking something over, setting it in a new context, and so forth. Nothing new, really.

HUO:

In your texts and interviews, the word "Informel" turns up repeatedly. You

don't categorically reject it, but you draw a clear line of demarcation between "Art Informel" and realism. At the same time, your work is a kind of reaction against the then-dominant stylistic and mannerist games of the Informel and Tachist schools, which arose from automatism—and the term "Informel" stands for the exploitation of that potential. What does the word "Informel" mean to you today?

GR:

As I see it all of them—Tachistes, Action Painters, Informel artists and the rest—are only part of an Informel movement that covers a lot of other things as well. I think there's an Informel element in [Joseph] Beuys, as well; but it all began with Duchamp and chance, or with Mondrian, or with the Impressionists. Art Informel is the opposite of the constructional quality of classicism—the age of kings, of clearly formed hierarchies.

HUO:

So in that context you still see yourself as an Informel artist?

GR:

Yes, in principle. The age of the Informel has hardly begun yet.

HUO:

And this landscape here? {gestures}

GR:

This is Informel, in spite of all the structure, which has a rather nostalgic look to it.

HUO:

Although there's no leading idea, no leitmotiv, *there's no uncontrolled use of chance either. In your pictures, chance never takes the decisions; at most, chance asks the questions.*

GR:

It's the found object, which you then accept, alter or even destroy—but always control. The process of generating the chance event can be as planned and deliberate as you like.

HUO:

You talk about the photographs everyone takes and their function as cult objects. The banal source images reveal an unexpected, lasting, universal pictorial quality. When you said that, were you exploring the possible legitimization of illegitimate pictures—an "illegitimate art," as {Pierre} Bourdieu called it?

GR:

The legitimate pictures are the photographs—the devotional pictures that people hang or set up in their homes. We then sometimes use them for art, ⋅and that may well be illegitimate.

HUO:

In the same notes you also say that a photograph can be seen as a picture, outside the categories of High and Low, ritual photography and art. This is an important difference between you and Polke, isn't it, your refusal to go for darkroom manipulations?

GR:

That's more of a technical, formal point; it's not that significant. I just don't like being in darkrooms. But to go back to legitimization: perhaps it's also illegitimate to bring the snapshot form too close to the readymade. Photographs are only readymades because they're so easy to produce, in comparison with painstakingly hand-painted pictures; as with a readymade, you only have to select them. The whole distinction is a rather shaky one, because it may well turn out that there are no such things as readymades at all. There are only pictures, which have value to many people or to very few, which remain interesting for a very long time or only for a few seconds, and for which very little or a very great deal is paid.

HUO:

So the people who take the snaps are artists...

GR:

... Yes, and when I then paint another picture of Uncle Rudi (*Onkel Rudi*, 1965), the little officer, I'm actually watering down; the true work of art is achieved by those two or three private individuals who put Rudi behind glass and stood him on the sideboard or hung him on the wall. The only sense in which I'm not watering it down is that by painting the thing I am giving it rather more universality.

HUO:

The displacement makes it exemplary.

GR:

Yes, and blurring was the only way of getting this done quickly. The Photorealists later painted photographs in a finicky, detailed way. I haven't the patience for that; and then there are the distracting perceptual factors that find their way in. One is the outsize format, and the other is admiration of the labor involved: the fact that it takes a whole year, the response of marveling at the way it looks "just like a photo." I wanted to avoid all that by cheapening the production values. You can see that a photograph is meant, but it hasn't been laboriously copied and duplicated. This worked, and the pictures had the basic resemblance to photography without looking like copies of photographs.

HUO:

You also talk about photography as drawing—or as the camera obscura, *which Vermeer used—in the sense of being a preliminary stage in the production of a picture. This reverses the primacy of photography, which, is supposed to have given rise to Modernism by breaking down barriers. You simply use the photograph, in making the picture, as a matter of course.*

GR:

In the traditional practice of painting, that's the first step. In the past, painters went out into the open air and sketched. We take snapshots. It's also meant to counter the tendency to take photography too seriously, all that "second-hand world" stuff, which is wholly unimportant to me. Many critics thought that my art was a critique of contemporary life: criticizing it for being cut off from direct experience. But that was never what I meant.

HUO:

The camera crops an image. It doesn't give the one, absolute image. The selected, partial image pushes forward and simultaneously recedes.

GR:

It has often been said that my pictures look like details. That may be so, but I can't understand it, probably because I take it too much for granted already. But maybe it was meant to refer to a certain inconclusive, open-ended quality: pictures that are cropped on four sides but can never show anything but sections, details.

HUO:

And each time just one of many possibilities.

GR:

There are exceptions, of course, where it isn't one of many possibilities at all—as in the *Betty* portrait (1988) or the *Ema* nude [Ema (*Nude on a Staircase*); Ema (Akt auf einer Treppe), 1966]. Those works tend towards the masterpiece, and if they aren't masterpieces it's just because I know that that just won't do; it's only ever like a quotation of a masterpiece, perhaps. But in principle everything is a detail.

HUO:

In Betty *and* Ema *the masterpiece status just seems to creep in—I was also thinking of* Cathedral Corner *(Domecke, 1987).*

GR:

But it can also happen with a *Gray Picture* ("Graue Bilder" series, 1968–ongoing). On a museum wall there's something masterpiece-like about it: the way it's hung.

HUO:

And the other "Abstract Pictures"?

GR:

I might include pictures like *Janus* and *Juno*, for instance. But maybe only because they have, such beautiful titles. There are some.

HUO:

The masterpiece is the utter antithesis of the anecdote. And of the detail, and of the sequence. On the one hand, you talk about the impossibility of absolute painting, on the other, you bring back the concept of the masterpiece.

GR:

Perhaps that's what one is always striving for, the masterpiece; it's just that it never is one. The masterpiece seems so far outside time that one can't even strive to attain it.

HUO:

In the German dictionary of the Brothers Grimm, "masterpiece" is defined as "an excellent, artistically perfect picture." In his book Überwindung der Kunst *(The Way Beyond Art, 1947), Alexander Dorner tells of a survey conducted in department stores to find the criteria that defined the most popular pictures. The result is imaging. People buy color reproductions and posters based on the following criteria: (1) pictorial depth—a concept derived from centralized perspective; (2) narrative content.*

GR:

There's not much of either quality in van Gogh's *Sunflowers*. In that case, it's "The Vincent van Gogh Story" that seems to be most important. And the whole masterpiece debate is relativized by the fact that the pictures we now regard as masterpieces may well have been the perfectly ordinary consumer art of their own day.

HUO:

The Mona Lisa *had its aura, even in Leonardo's lifetime. That kind of premonition of the enduring quality of work is a well-known phenomenon.*

GR:

But at that time the word "master" itself had a different meaning, which had far more to do with craftsmanship.

HUO:

In London the Betty *portrait suddenly acheived enduring, universal, almost absolute quality; and curiously enough the same thing applied to the wider response that it got as a poster on the Underground. The masterpiece always implies this movement; you say it and then you take it back. It is one, and at the same time it isn't.*

GR:

It's slightly refracted by the historicist or nostalgic effect.

HUO:

The discussion of works and artists' positions, which are important to you, comes to a head in the Buchloh interview (in Gerhard Richter Paintings, 1988), *with a kind of reconstruction of your view of the history of art. In a much earlier interview you mentioned Barnett Newman as representative of a historical position and Gilbert & George as contemporaries.*

GR:

Barnett Newman was always important. He came to me straight after Mondrian and Pollock. Newman was an ideal, because he created these big, clear, sublime fields that I could never have managed. He was my complete opposite.

HUO:

Did your kinship with Gilbert & George lie in a shared interest and wish for normality at that time, the idea of disappearing into a completely banal life?

GR:

I liked them as outsiders, above all. At that time, Minimalism, Land Art and Conceptual Art were dominant. I valued all that, though I had very little to do with it. With Gilbert & George, too, I liked the very nostalgic side. They were the first people who liked my landscapes. I think what impressed me the most was the way they took their own independence as a matter of course.

HUO:

Not forcing pictures into the dogmatic Modernist straitjacket?

GR: -

The ideological straitjacket. Perhaps I have a kind of immunity to ideologies and fashions, because movements have always passed me by: the piety of my parent's house, the Nazi period, Socialism, Rock—and all the other fashions that made up the *Zeitgeist* in thought, attitudes, dress, haircuts and all the rest. To me it all seemed intimidating rather than attractive.

HUO:

It's a surprise that your never mention Magritte.

GR:

He's too popular, too pretty for me. Wonderful calendar art, village schoolmaster's art. *"This is not a pipe"* (*La Trahison des Images*, 1928): to me, that's just not a very important piece of information.

HUO:

What seems important to me is his recurrent doubt as to the names of things.

GR:

Perhaps it got excluded because I could already see that I was in danger of painting something a bit too popular. I notice that at exhibitions: I get a very good reaction. The doormen and cleaning ladies think it's all great, even the "Abstract Pictures." It's actually the ideal state of affairs, if you do something that everyone likes.

HUO:

The Modernist rejection of any "Art for All" sprang from a feeling of resentment, because painting had lost all of its representational functions to photography. The ease with which you use photography puts the boot on the other foot—though without reviving the old unity between observer and object, or reverting to direct experience of the object. The construction of the picture now appears in a shattered mirror.

GR:

The image of the artist as a misunderstood figure is abhorrent to me. I much prefer the high times, as in the Renaissance or in Ancient Egypt, where art was part of the social order and was needed in the present. The suffering, unappreciated van Gogh is not my ideal.

HUO:

And his pictures?

GR:

I like Courbet's better.

HUO:

How important was Beuys to you?

GR:

Mainly as a phenomenon and as a person. When I first saw the work, I wasn't all that interested; it was too eccentric for me. I'm increasingly in favor of the official, the classic, the universal.

HUO:

Along with Manet and Ingres, Beuys is the only other artist who hangs in your studio.

GR:

Because he still fascinates me as a person more than anyone else; that special aura of his is something I've never come across either before or since. The rest are far more ordinary. Lichtenstein and Warhol I can take in at a glance; they never had the dangerous quality that Beuys had.

HUO:

In connection with the abstract paintings of the '80s, you bring the idea of chance into play once again. John Cage made chance operations out of methods based on uncertainty. But I never see chance in your work in terms of

his interpretation of chance operations; you have less of the serial juggling with known elements, governed by the throw of a dice that was usual in Conceptual Art.

GR:

Except for the "Color Charts". Those were serial; I mixed the given colors and then placed them according to chance. I found it interesting to tie chance to a wholly rigid order.

HUO:

That means giving it a form.

GR:

An architect once asked me what was so good about the "Color Charts"; what was supposed to be the art in them. I tried to explain to him that it had cost me a great deal of work to develop the right proportions and give it the right look.

HUO:

To give it a form, in other words.

GR:

Yes, because there would have been other possible ways of realizing the idea. I could paint these biscuits here in different colors and throw them across the room, and then I would have 1024 colors in a chance form. Or in the "Gray Pictures": if I had painted those became I couldn't think of anything else and because it was all meaningless anyway, then I might just as well have spilled the paint out on the street, or done nothing at all.

HUO:

The later "Abstract Pictures" also evoke the idea of the picture as a "model." Is that meant in a Mondrian-like sense?

GR:

This was something that came up in an interview with Buchloh: the idea that Mondrian's paintings might be understood as social models of a non-hierarchical, egalitarian-world. Perhaps that was what prompted me to see my own "Abstract Pictures" as models, not of an egalitarian world but of a varied and constantly changing one. But fortunately Mondrian's paintings are not read as models of society. Their most important quality is a very different one. It would be terrible if [Mondrian's] *Broadway Boogie Woogie* painting (1942–1943) were a model of society; there would be the "Yellows, the Reds and the Blues," all moving ahead in straight lines.

HUO:

In 1973, Roland Barthes wrote, "To be modern is to know what is no longer possible."

GR:

What is no longer possible is everything that has already been said, and all the attendant stupidities of substance and form, pseudo-intelligent messages and dishonest intentions. If you try to avoid all that, it's hard at first, but eventually it works.

HUO:

This avoidance it something you once described as "escape"; and in your earlier pictures this referred mainly to the choice of motifs.

GR:

Like Beuys's hare. He was always on the run too, how shall I put it: escaping from falsehood is always a good starting-point.

HUO:

It seems to me that this idea of escape is always cropping up in the present-day world. It's an escape that faces the fact: neither a nostalgic escape into the past nor a utopian escape into the future.

GR:

I hope so. Although it does create more uncertainty; because the utopian or nostalgic escapees are always the ones who have the advantage of knowing where they're going.

HUO:

Uncertainty as the diametrical opposite of the controlled working plan?

GR:

Basically, yes; though the whole thing may seem fairly professional, it isn't, because it is not planned and controlled: it just happens.

HUO:

Whistler's "Art happens."

GR:

Or Buren's "It rains, it snows, it paints."

HUO:

In your ongoing collection of photographs Atlas *(c. 1962–ongoing) there are sketches and designs for rooms that reveal an effort to find a place to fit the pictures, to create a kind of site-specific quality.*

GR:

That sort of thing only works in sketches, because the execution would be unendurable, overblown and bombastic. But it was good to design sanctuaries of that kind, for pictures with an incredible total effect.

HUO:

Utopian spaces?

GR:

And megalomaniacal ones.

HUO:

The Two Sculptures For a Room by Palermo *(1971), now in the Lenbachhaus in Munich, create a slate of permanence without reference to the actual location.*

GR:

It's a very modest thing.

HUO:

What works of yours exist in public space? The Underground station in Duisburg, the Hypo-Bank in Düsseldorf?

GR:

And *Victoria (Victoria I, II,* 1986)*,* two large-format works in an insurance company's office. The two *Yellow Strokes* (dates) are in a school. That's all, almost. And at BMW, rather badly hung, there are three large canvases: *Red, Yellow, Blue,* each one three-meters high by six-meters wide—as an enlargement.

HUO:

Commissioned works...

GR:

Yes, sometimes I've enjoyed doing commissioned work, in order to discover something that I wouldn't have found of my own accord. And so, when Siemens commissioned my first *Townscape,* that led to all the "Townscapes" *(Stadtbilder* series, 1968–ongoing); that followed. It's also very nice when pictures have a known place to go to.

HUO:

You've always made it a point of principle not to control where your pictures go, not to decide where and how they are hung. No reliance on your own hall of fame or private museum: you've just let the pictures go.

GR:

Let them go unconditionally. They need no precautions. If they're any good, they'll always find the right place; if they're not, they'll end up in the basement, and rightly so.

HUO:

Hans Haacke, for instance, tries to get this total control. He has been trying to strengthen the artist's position.

GR:

Just imagine Giacometti making stipulations of that kind! I'm glad he didn't, so that his sculptures can be shown differently each time, now in Denmark; now in Stuttgart. Every time they look different, and yet they always stay the same. There are some frightful instances of artists who have created these imperishable monuments for themselves. A certain Herr Tiefenbach, for instance, on Capri. Embarrassing.

HUO:

There are some positive examples: the Segantini Museum, the Rothko Chapel, Walter de Maria's Earth Rooms *(1968; 1974; 1977).*

GR:

And his *Lightning Field* (1971–1977). And all those beautiful churches, of course—there it has worked wonderfully well.

HUO:

The works have lasted through time, thanks to their symbiotic relationship with the space.

GR:

We're a long way away from that at the moment. [Jannis] Kounellis, in that curious conversation he had with Beuys, [Anselm] Kiefer and [Enzo] Cucchi (*Ein Gespräch, Una discussione,* 1986), talked about building a cathedral. Simulated presence. It's sometimes done for reasons of art politics, when galleries and curators want to force something through and set up artificial monuments of that kind, full of pseudo-masterpieces.

HUO:

*In view of this combination of haste and cultural illiteracy, it seems to me more important than ever that there are some places where one can go and pay a visit to works—the way I visit your Baader-Meinhof work {*October 18, 1977 *(1988)}, in Frankfurt from time to time.*

GR:

Not that that's an ideal museum, exactly. But I know what you mean.

HUO:

When I saw your room in Kassel, ("A room of paintings," "Documenta IX", Kassel, 1992) I wondered at first whether the wood was chosen by you, whether it was taking up something that is implicit in the pavilion architecture. The wood might be part of a prefabricated kit, and it ironically forces the whole thing almost down to the level of a neat domestic interior. At the same time, it strongly emphasizes the break with the White Cube formula.

GR:

It was Paul Robbrecht who suggested the wood paneling. The obligatory white walls date back only sixty or eighty years.

HUO:

The only other place where I've seen that kind of floor-to-ceiling hanging in relation to your work is in your own studio.

GR:

It only works in small spaces, on the private side. Whenever I've

tried it on a temporary partition in a big exhibition it's never worked.

HUO:

What surprised me in Kassel was the flower piece {Flowers, (Blumen, 1992)?}. Was that painted after your visit to Japan?

GR:

Yes, perhaps that trip did have some influence: it affected those vertical scraped stripe paintings, too.

HUO:

The flower piece has remained unique in your work. But at the time it put me in mind of a cycle. It could be a starting point.

GR:

I have tried painting photographs of flowers since then, but there's nothing suitable. And when I tried to paint the flowers themselves, that didn't work either, unfortunately. I should have remembered that it hardly ever works for me to take a photograph in order to use it for a painting. You take a photograph for its own sake, and then later, if you're lucky, you discover it as the source of a picture. It seems to be more a matter of chance, taking a shot with the specific quality that's worth painting. The same happened with the Cathedral picture. I took the photograph in 1984. I was not in the best of moods at that time. And when I painted it, three years later, I went on to photograph some other "cathedral corners" of the same kind—but I didn't get one usable shot. The state of mind counts for a lot...

HUO:

... a state that is specific to a time...

GR:

... and makes you receptive to something. If I went to that cathedral now, I wouldn't know what to photograph. There's no reason why, and I can't force it. I even went all the way to Greenland, because Caspar David Friedrich painted that beautiful picture of *The Wreck of the Hope (1824)*. I took hundreds of photographs up there and barely one picture came out of it. It just didn't work.

HUO:

So the "quest for the motif" has very seldom led you to a picture?

GR:

The quest for the motif is strictly for the professionals. On the other hand, when I sit down somewhere out there, more or less aimlessly and not looking for the motif, then all of a sudden the thing

I've not been looking for may open up. That's good.

HUO:

The flower work? in particular raise the issue of the experiential reality of nature, which is no longer a direct experience of nature.

GR:

Because the flowers are cut and stuck into a vase...

HUO:

... or because it happens via the photograph.

GR:

I think that's less important, because directly painted flowers would be no less artificial. Everything is artificial. The bunch of flowers, the photograph—it's all artificial. There's nothing new about that.

HUO:

Or, to turn it round again: the Demiurge and Nietzsche's eternal recurrence of nature. The painter goes into nature and sees it as a picture created by him.

GR:

A nice idea, and one that's absolutely right, not only for painters, but for everyone. We make our own nature, because we always see it in the way that suits us culturally. When we look on mountains as beautiful, although they're nothing but stupid and obstructive rock piles; or see that silly weed out there as a beautiful shrub, gently waving in the breeze: these are just our own projections, which go far beyond any practical, utilitarian values.

HUO:

When did you first use mirrors?

GR:

In 1981, I think, for the Kunsthalle in Düsseldorf ("Georg Baselitz/Gerhard Richter," Kunsthalle Düsseldorf, 1981). Before that I designed a mirror room for Kasper König's "Westkunst" show, but it was never built ("Westkunst: Zeitgenössische Kunst seit 1939," Rheinhallen Köln, 1981). All that exists is the design, four mirrors for one room.

HUO:

Your **Kugel** *(Steel Balls, 1989) were also declared to be mirrors.*

GR:

It's strange about those *Steel Balls,* because I once said that a ball was the most ridiculous sculpture that I could imagine.

HUO:

If one makes it oneself.

GR:

Perhaps even as an object, because a sphere has this idiotic perfection. I don't know why I now like it.

HUO:

At the time when you made 4 Panes of Glass *in 1967, glass was being used a lot, both in art and in architecture.*

GR:

In art too?

HUO:

Glass was used in Minimal and Conceptual Art; Morris had mirror cubes, in which the exhibition space and the viewer became part of the work; and of course Dan Graham, in his "Corporate Arcadias" picture- essay done with Robin Hurst in 1987, shows the strong presence of glass in the architecture of that period. In buildings from the mid '60s, you watch the people on the lower floors working—it's transparent architecture.

GR:

That was a social preoccupation on Graham's part. What attracted me about my mirrors was the idea of having nothing manipulated in them. A piece of bought mirror, just hung there, without any addition, to operate immediately and directly. Even at the risk of being boring. Mere demonstration. The mirrors, and even more the *4 Panes of Glass*, were also certainly directed against Duchamp, against his *Large Glass*.

HUO:

Duchamp comes back all the time, like a boomerang. You take up a position opposed, to the complexity of the Large Glass, *and straightaway in comes the readymade idea as well.*

GR:

Maybe. But what interested me was going against all that pseudo-complexity. The mystery mongering, with dust and little lines and all sorts of other stuff on top, I don't like manufactured mystery.

HUO:

In the 4 Panes of Glass, the artistic act was reduced to the most minimal level.

GR:

Once again I had to take the trouble of finding the right proportion, getting the right framework. Thus it is not a readymade, any more than Duchamp's *Large Glass* is.

HUO:

Because so much work went into it.

GR:

That's right. At one point I nearly bought a readymade. It was a

motor-driven clown doll, about 1.5-meters tall, which stood up and then collapsed into itself. It cost over 600 Deutschmark at that time, and I couldn't afford it. Sometimes I regret not having bought that clown.

HUO:

You would have exhibited it just like that, as an unaltered readymade?

GR:

Just like that. There are just a few rare cases when one regrets not having done something, and that's one of them. Otherwise I would have forgotten it long ago

HUO:

In your studio there's a little mirror, hung in such a way that one is always seeing bits of recently finished paintings reflected in it.

GR:

In this case it's a good thing that it isn't eye-level, but a little higher, so that you see the mirror and not the usual mirror image, which is yourself.

HUO:

Over the last two years you've made the Gray and Colored Mirrors, which you showed in the "Mirrors" exhibition at Anthony d'Offay Gallery (London, 1991).

GR:

Those are panes of glass with a layer of paint on the back. This means that they are somewhere in-between, neither a real mirror nor a monochrome painting. That's what I like about them.

HUO:

I see the mirrors as a metaphor for your work as a whole. The word "reflect" has two planes of meaning, which bring the viewer into the picture, and thus the viewer is in two states at once. A reflective trick.

GR:

The pleasant thing is that it makes the pictorial space even more variable and more subject to chance than it is in photography.

HUO:

Even more open?

GR:

Yes, this is the only picture that always looks different. And perhaps there's an allusion somewhere to the fact that every picture is a mirror.

HUO:

Making fun of the Modernist attribute of flatness.

GR:

Or rather of the view that every picture has space and significance and is an appearance and an illusion, however radical it may be, right down to the Modernist goal of the flat surface, as in the "Gray Pictures": these surfaces, too, have once more become illusionistic.

HUO:

The Steel ball, by reflecting the pictorial space, is simultaneously both the receiver and the transmitter of appearance. Once the attribute of the Emperor's worldly power, it seems to have rolled out of the picture. Partly as a rejection of naïve forms of New Age holism. Lately, you've often added paint to paintings or scraped it off.

GR:

Just like playing boules. Shoot, create new situations.

ROSENFIELD, Israel

Israel Rosenfield was born in New York. He studied mathematics as an undergraduate and holds an M.D. from the New York University School of Medicine and a PhD from Princeton University. He currently teaches at the City University of New York and has been a guest lecturer in universities, museums, and other cultural institutions in North America, Europe, and Asia. Rosenfield's articles have appeared in The New York Review of Books *and other magazines and periodicals. His books, translated into a number of languages, include:* The Invention of Memory: A New Vision of Brain *(1988),* The Strange, Familiar, and Forgotten: An Anatomy of Consciousness *(1992), and* DNA for Beginners *(with Edward Ziff, 1984). In 2000, Rosenfield published a satirical novel,* Freud's "Megalomania", *which includes the first publication of Freud's final work and the story of why it was kept from the public for so long. Rosenfield's research and writings have recently been a focus of interest for contemporary artists such as Pierre Huyghe and Philippe Parreno, who asked him to contribute a text to their project entitled* No Ghost, Just A Shell *(2000–2003).*

........................

This interview took place in Paris, in April 1999.

Hans Ulrich Obrist:

Maybe we should start with the simplest definition of memory possible. What is memory?

Israel Rosenfield:

Memory in an obvious and perhaps trivial sense is our ability to recall people, events, and objects. But in a larger sense memory is about the past and our relation to that past at a given moment; and memory is about the present as well, since our way of making sense of the present depends on our past.

HUO:

To what extent is memory context dependent?

IR:

Very much so. There is no memory without a context. For example, if people are isolated, have no sensory input at all, they can't remember anything.

HUO:

Has it been tested, experimented? How do you do such experiments?

IS:

Yes. When you do extrasensory deprivation experiments, people hallucinate and they become totally incoherent. Recollection, as I have said, depends upon a context. Normally, context is just the fact that we are somewhere, sitting, standing, walking or whatever. We are constantly subject to sensations from around us, so we are always in a context. Without context, memory is not possible. Since we are often unaware of the context in which we are remembering, we think that our recollections are like those in a computer, that our brains are merely searching through stored information and that the context, the setting in which we find ourselves, is not important. But this is not true; without a context you don't have any specific memories, and I think people forget that. We can in fact recall very specific things, but that does not mean that these specific recollections are not in terms of some kind of context.

HUO:

At the recent "Envisioning Knowledge" conference of the Academy of the Third Millennium (Munich, 1999), Francisco Varela gave a lecture entitled "Reclaiming Cognition: Four Batons for the Future of Knowledge," where he spoke about a globalizing theory of the brain, resisting the idea of the localization of different zones such as memory within the neural tissue. Is it also your opinion?

IR:

I agree with what Varela said. Nobody has ever been able to find a specific memory in the brain. Indeed, one of the most spectacular claims, that there are specific localized memories, goes back to the '30s when the Canadian surgeon Wilder Penfield stimulated patients' brains with very weak electric currents and they had apparent specific recollections from their childhood. The recollections were fragmentary and disconnected. Penfield believed that sorts of "videotapes" were created within the brain containing memories beginning with early childhood. We are not aware of these "videotapes," or "recollections," Penfield believed, but we can be made aware of them when the brain is stimulated with weak electrical currents. And in the '50s he made a film of patients "recalling" moments from their past when their brains were stimulated with weak currents. It was widely believed that Penfield had proved that we actually have very specific memories *in* the brain. Nonetheless, there was something very odd about the "memories" Penfield elicited from his patients in the operating room. A patient would say, for example, "I see myself talking on the telephone when I was four

years old and I see my grandmother talking to me at the other end of the line." Obviously, memory is not seeing yourself on the telephone at four years old and seeing your grandmother at the other end of the telephone line—or perhaps it would be more accurate to say, if this is "remembering," it suggests that the original scene is being *reconstructed*, since, unless we are sitting in front of a mirror while talking to our grandmothers, we do not normally "see" ourselves. Subsequent studies showed that in fact Penfield's patients had overheard bits and pieces of conversations on their way to the operating room. The patients were unaware of the real source of what they were saying when Penfield stimulated their brains. They repeated these overheard conversations as if they were veridical recollections from their own childhood. Furthermore, it was noticed that only those patients whose limbic system (this is believed to be one of the emotional centers of the brain) had been stimulated by the electric current had, or thought they had, recollections. So memory and emotion are intimately linked. Generally, it is no longer believed that you can stimulate the brain and get out a specific memory. Indeed, if you took the brain out of the body and tried to stimulate it, nothing would come out of it. The brain functions within the body. Memory is dependent upon the body actively receiving sensations. Indeed, there are clinical disorders in which the brain-body relation is abnormal—for example, the patient might deny an arm or a leg is his—and so is the faculty of remembering. Hence, human and animal memory is very different from any kind of mechanical memory.

HUO:

Looking at the richness and complexity of life on earth in The Selfish Gene *(1976), {Richard} Dawkins acknowledged that an etiology of the gene alone was simply not robust enough to explain evolution. So he applied a Darwinian view of culture and argued for the concept of memes—ideas that are, to use the phrase of William Burroughs, "viruses of the mind." Memes are to cultural inheritance what genes are to biological heredity in a way. Human evolution, Dawkins postulates, is a function of a co-evolution between genes and memes. How do you see Dawkins' theory of memes and genes in relation to the importance of context for memory?*

IR:

Dawkins' memes are units of cultural transmission, ideas, tunes, fashion and so on. They are transmitted, as he puts it, through imitation, from brain to brain. Dawkins is suggesting that there is a kind of natural selection going on with ideas or "culture" in gener-

al. There might be something to this, but it has very little to do with memory. Culture and memory, in a human sense, depend on awareness. Dawkins is talking about information that can be passed on unconsciously. There might be information that we "acquire" or "absorb" subliminally in society—and much advertising certainly depends on this—but I suspect far more important is that tunes, ideas, and fashion spread for complex psychological and sociological reasons that depend on human awareness, as well as other factors. Consciousness is not an issue in Dawkins' ideas about "selfish genes" and "memes," and in that sense I find these ideas interesting, but not as deep as some claim. At the "Envisioning Knowledge" conference in Munich, I argued that selfish genes and the related applications of Game Theory to the Prisoner's Dilemma and to animal and human behavior in general—trying to explain why behavioral patterns can be competitive or cooperative—comes from John von Neumann, who was also interested in the nature of the bluff and deception. He tried to model bluffing in a simplified poker game. Of course, what is really interesting about bluff and deception is the suspense in not knowing for sure how things are going to turn out. Anticipation, suspense, the pleasure or disappointment of winning or losing—all are part of what we mean by self-awareness. Chess as a series of calculations is a game of absolutely no interest. We enjoy playing games, and if all we had to do was calculate from the first move and we'd know how the game would end—as a machine might eventually be able to do—we would not bother to play games. So it is interesting that Von Neumann in his lectures, which were published after he died (*The Brain and the Computer*, 1979), wrote that we don't really understand the nature of memory. It is very interesting that he says that, because some people—at least in the popular press—seem to believe that memory is nothing more than stored information. I think that is what dominated AI [Artificial Intelligence] in the '70s and to some extent in the '80s. I think what has happened since then is that we have become aware of the fact that memory is not information in a specific part of the brain. Memory is a kind of generalization, a categorization; I can recognize something because my memory is constantly taking account of the ways in which things are changing, as for example, the ways in which people I know act, talk, and appear different over even short periods of time and yet I still recognize them as the same friends and acquaintanc-

es. Memory is dynamic; it depends on context because it is dynamic. Even our motor capacities require an ability to generalize and not repeat an action exactly every time. Every time we move, we find ourselves in different circumstances—even if they are very similar—requiring different movements. A pianist never plays a sonata exactly the same way twice. Try to write ten identical letter "A"s. You can't. There is nothing we ever do that is identical. We have to be able to adapt to rapidly changing circumstances. People are constantly changing; it is as if we have many thousands of personalities. We have to be prepared for unpredictable circumstances. Information must be dynamic; otherwise, it would not be useful for us. Names, for example, represent a large number of possibilities. When I see the name Hans Ulrich: Hans Ulrich is not a fixed individual; he is a dynamic individual; Hans Ulrich can even surprise me; that's what being a person is. When I give you a name I am naming all possible Hans Ulrichs—including the Hans Ulrichs I may never know—that can be. So we have to adapt to changing circumstances all the time; that's why there is something mysterious about memory and consciousness. How does the brain do it?!

HUO:

For the exhibition "(La Ville), (le Jardin), la Mémoire," at the Villa Medici in Rome (1999), that I organized together with Laurence Bossé and Carolyn Christov-Bakargiev, artists, urbanists, and performers are invited to reflect on the notion of memory confronting the past and present of the site of the Villa Medici and its garden within the urban organization of Rome. Do we know, somehow, precisely how space and time interfere in the constructions of memories?

IR:

Consciousness is time. When we are watching a motion picture, we are watching a series of still images; we don't see the still images; we see motion. The brain is integrating two events, two stills, and it's creating from these two events something else, which is motion, movement. Memory is an integration of temporal events, in this sense, that is over time. It is relating events of one moment to the next, to previous moments and so on. Indeed, this is what the brain is constantly doing. It is the very nature of awareness. So I would say that memory is relationships: it is on the one hand temporal relationships, and on the other hand spatial. We are relating it in different spaces and in different temporal frames. Memory is these relationships; it is not a particular space nor a particular time, but rather a particular set of temporal and spatial relationships. In

the case of Rome and the Villa Medici, you have both time and space: if you take the city, you take something dynamic, which is constantly changing, and that you constantly see differently. A garden, too, is a dynamic entity; there is no such thing as a static garden. It changes from day to day and it changes from season to season. We have nostalgia for gardens and cities because there are no eternal moments in either. We can imagine them as fixed, but in fact everything in the garden and the city is always fleeting, changing, never the same. So we can always "miss" the "way things were" in a garden and a city. Gardens and cities are constantly reminding us of the temporality of things and temporality of space. The sense of nostalgia that one has in both is the sense that one will never capture any moment forever.

HUO:

In The Art of Memory *(1966), her study of how people learned to retain vast stores of knowledge before the invention of the printed page, Frances A. Yates traces the art of memory from its treatment by Greek orators, through its Gothic transformations in the Middle Ages, to the occult forms it took in the Renaissance, and finally to its use in the seventeenth century. Yates details different ideas and forms of spatializing the information evolving over time—different fictional internal memory-scapes that were used to catalogue the contents of a person's mind.*

IR:

These are basically techniques of memory. One does use them, and they show how contextual memory is… These are tricks or memory aides, such as imagining bits of information spread around an auditorium. All those tricks are dependent on different kinds of contexts—auditoriums, drawers, etc.—in order to recall and create a kind of coherent memory. There is a kind of mysticism that may be associated with these memory aides, but I suspect it arises because of the mystery of consciousness itself, without which, of course, there would be no recollection at all.

HUO:

How is memory vital?

IR:

Memory is relational. We consciously recall people, events, places, and so on, and all these recollections are, as I have already said, relations such as those of an individual to himself—the way he last appeared to us, or an emotion that upon seeing him is created in us, and so on—and his relation to his surroundings, his past, his place

of work, and so on. That is why there is—probably—no specific area in the brain where the memory of "him" is recorded as some kind of fixed image. But it is because memory is relational and dynamic that we can rapidly adapt to the changing circumstances that are the essence of our daily life. Otherwise, we would not be able to survive.

HUO:

Returning to Yates' study, the Renaissance saw the transformation of "artificial" memory space into physical space, taking the form of a Memory Theatre (1544). This was a construction of the architect Giulio Camillo that had become necessary because the growing amounts of data—and hence sites of memory—lead to confusion, asking for new structures. While mnemotechniques soon after were completely replaced by exterior storage media, the question of information structure encounters similar problems nowadays: in which ways could the accessibility of information be organized while taking the specific, interactive character of digital media into account? And on a more personal level, how does the use of computers affect human memory and our capacity to memorize?

IR:

I don't see where it should have any real direct effect on the nature of memory itself. One has always used filing cabinets; one has always used these kinds of systems in order to recall things. Computers are more complex filing systems. Whether or not the computer will help us absorb more information and think faster remains to be seen. I doubt it. What makes us interesting is the way we synthesize information, the ways in which we can transform information in ways that has meaning for us. I don't see where computers will synthesize new ideas, new ways of understanding ourselves and the world around us. But you never know!

HUO:

I recently interviewed Iannis Xenakis who told me about his unrealized urban sound installations and music pavilions; he said, "In music, what is not written down cannot be remembered." How do you see the archive as a storing system of things? Not of ephemeral life memories—feelings, ideas, psychological states—but of things, seemingly more permanent archives and memories?

IR:

Archives can also lose memory. Human memory is lost if it is not written down. Even if it is written down, it can be lost; even architectural masterpieces are lost. What would it mean to put a build-

ing in the archive? Maybe you can keep the plan, but even the plan can be lost. What does it mean to put the castles of Vaux-le-Vicomte or Versailles in the archive? The dynamic aspect of a building is lost. Even if you rebuilt every detail of Versailles, it would be a building without a history and consequently it would be different. There is a dynamic to old stones—as there is to all material and immaterial things—and it cannot be reproduced. So in any case there is no way that things can be redone or acts re-acted. It is always different.

ROUCH, Jean

Jean Rouch was born in 1917 in Paris. He currently lives and works in Paris. Rouch was trained as an engineer at the École des Ponts et Chaussées {School of Bridges and Roads} in Paris (1937–1941). Working on road planning in Niger in 1942, Rouch started doing ethnographic field research on animism in the Songhay-Zarma societies (Niger-Mali) and published his first articles in scientific publications as early as 1943. Among the generation of French ethnographers of the postwar period, Rouch distinguished himself by using film techniques extensively. In 1948 he started teaching at the Musée de l'Homme {Museum of Mankind} in Paris, where in 1952 he co-founded with Enrico Fulchignoni, Marcel Griaule, André Leroi-Gourhan, Henri Langlois, and Claude Lévi-Strauss, the Comité du film éthnographique (ethnographical film committee). Over the years, Rouch developed an entirely new kind of documentary film practice that blurred the boundaries between producer and subject, and fiction and reality. He has made more than one hundred films in West Africa and France, including Les Maitres Fous *(The Mad Masters, 1955),* Jaguar *(1955–1967),* Moi, un noir *(Me, a Blackman, 1958),* Chronique d'un été *(Chronicle of a Summer, with Edgar Morin, 1961),* La chasse au lion à l'arc *(The Lion Hunters, 1965), and* Cocorico, Monsieur Poulet *(1974). Rouch pioneered numerous film techniques and technologies, and in the process inspired generations of filmmakers, from New Wave directors who emulated his "cinéma-vérité" style, to today's documentary filmmakers.*

........................

This interview was recorded in Paris in December 2000.

Hans Ulrich Obrist:

In this tremendous book, published as the catalogue for the exhibition of your photographic work at the Musée de l'Homme ("Jean Rouch. Récits Photographiques," 2000), Raymond Depardon describes the different aspects of your work, in your capacity as an engineer, ethnographer, filmmaker, and photographer. Your work as a photographer has perhaps been the least well known or the least obvious aspect of your work. What role does photography play in your life and in your work, and how do you position it with regard to the other media you have worked with?

Jean Rouch:

First of all, seeing as you've asked me about Raymond Depardon, I should point out that for me Depardon is the very example, or very image of the photographer. I particularly liked what he said about me at the end: "Henceforth, in photography, between Pierre Verger

(a major photographer who went to spend the rest of his life in Brazil) and Cartier-Bresson (who worked in Paris) there is Jean Rouch." So, right away Depardon positioned me between these two individuals for whom we both have such admiration. That, for me, is the proof of an extraordinary friendship, because I only discovered he thought that in reading his text. It made me very happy. It proves that our profession is not just one of gangsters, and that friendship can exist. Whereas, in fact, you'd swear it couldn't exist anymore. It provides proof that photography, a modest exhibition, and the Musée de l'Homme can cleverly join forces to bring this about. And then in the catalogue itself we find Jean-André Fieschi—again, someone who has worked with me and was trained in our "school" so to speak. These are striking attestations of friendship—and I had no idea they were preparing any of it. It was a complete surprise to find myself suddenly in the midst of all this. I was overwhelmed with memories—memories of lost time. Of all the photos, my favorite is perhaps the one on page 31: a photo of Damouré Zika, taken in Prestea, Ghana. Damouré Zika was one of my old pals from Niger. And so I took this picture of him standing in front of a poster that we had happened upon—a poster against constipation. He stood in front of the poster, and suddenly the framing of the face was such that the overall impression was that he was speaking with the doctor who was shown on the poster saying, "Banish Constipation!" It was a unique creation based on a setting we happened upon in the street. It was what the Surrealists called *hasard objectif*—or "objective chance." Other examples of photographs that I find terribly moving are those of Jane, my wife, now deceased, and particularly the pictures she took of me as I was classifying my photos—pictures that I hadn't seen for years and years.

HUO:

When did you—in relation to cinema—start taking photographs?

JR:

Long before. In my family everyone took photographs. I got my first camera when I was fifteen. For us, photography and painting—because we painted at the same time—were primordial. That was what people did who were of my generation—that very unusual generation from the beginning of the century. We were curious people, artists...

HUO:

Were your parents artists?

JR:

Yes, all my family was, in their own way. In my family, everyone did painting, drawing, lithography, photography. My father was a naval officer, and was part of a famous polar expedition led by Commandant Charcot, on a ship called, *Le Pourquoi Pas.* There was a naturalist onboard who was studying emperor penguins—that was my mother's brother. In a certain way, I was born on that voyage. From the beginning, I was brought up by parents who were themselves artists—even if they didn't know it—and who took admirable amateur photos and painted very competently. As for myself, from a young age I painted in gouache. In fact, I still have these paintings.

HUO:

Did your view as to the status of the photograph change once you started making films?

JR:

No. It didn't change anything. I started making films just after the war, when I headed off down the Niger River with two of my classmates—both civil engineers like myself. I made my first films during that trip, having no idea about linking shots. I filmed bits and pieces that interested me—not worrying about the upcoming montage. But, for me, everything really started with the war. The war interrupted our engineering studies. We were asked to go and stop the Germans, and so we entered active life by blowing up bridges. We, who were meant to build bridges, began our engineering careers blowing them up! It served no purpose; of course, it didn't stop the Germans. We were in the Limousin region when the shame of the armistice was announced. I had just turned 23, and we had lost the war. We found ourselves in German-occupied Paris to finish our third and last year of engineering school at the École des Ponts et Chaussées. It was very strange working under those conditions. We're part of a lost generation. We were rebellious, and in my case, the rebellion took the form of my coming here, to the Musée de l'Homme, where the Cinémathèque Française was showing its first films.

HUO:

Was it a meeting place?

JR:

A meeting place and above all a place of resistance. It was there that the French Resistance against the Germans was born. Later, in the

very auditorium where the Resistance was born, I had the honor of showing a film made in the concentration camps to the association of former prisoners from the Musée de l'Homme. At the time, Resistance fighters met in the room just on the other side of the screen. That was where, in particular, they wrote up texts, which would then be put into the mailboxes of the surrounding houses by the students from the Lycée Janson de Sailly—located a bit further away. That was their downfall because one of the students at the high school felt guilty and went to confess—he was a Christian—to the high school chaplain. Nobody knew it, but the chaplain was a German army agent, and he had all the people involved arrested. There was a raid at the Musée de l'Homme—it's a terrible story... They were shot at Fort Mont Valérien after being forced to push the truck transporting them up the slope that was too steep for it. We lived through these things, and for me these stories are absolutely essential.

HUO:

The very personal history, which you have with the Musée de l'Homme, goes against the grain regarding the contemporary development of museographic institutions. Today, museums all over the world have all too often become dehumanized and depersonalized places. But this is not the case for the Musée de l'Homme, a place of real stories, meetings, confrontations...

JR:

It's a place of victims... It is horrible what happened there, and for me, for my generation, it remains an indelible stigma. The Musée de l'homme Resistance network was born right here... It was behind our film screen that the future was decided. And it was also here that Henri Langlois showed us films, at great risk, during the German occupation—films that were terrifying. For example, [Vladmir] Legotchine's *Au loin, une voile* (1937), a film about the first revolt of the Black Sea sailors. Filmed in a school in Odessa Bay, it was film about the Resistance at a period when the enemy was the Red Army. We were brought up in a state of permanent revolt. Not to mention the fact that I am of Catalan descent, so for me the Spanish Civil War already foreshadowed these events—and I might add that the role France played in that war was appalling. All told, we weren't able to stop the Germans. We lost a war and I have never gotten over it.

HUO:

All these various roles—I am thinking once again of the list made by Depardon—make your approach a multi-disciplinary one. You are an

ethnographer, engineer, filmmaker, photographer... Today these different disciplines, these different worlds, have become more and more specialized: the world of cinema has become hyper-specialized; the art world has also become hyper-specialized. And the very idea of general knowledge embodied by your life and artistic development strikes me as rare—and all the more worthy of emphasis.

JR:

That is no doubt due to the education I received at Ponts et Chaussées, given by a great engineer, Albert Caquot. Albert Caquot was the inventor of the theory of the resistance of materials, the resistance to alternating effort, as well as being somehow the man behind building the Golden Gate Bridge in San Francisco. He was also a painter and a musician. Albert Caquot would say to us: "First you draw the bridge, then you calculate it." A bridge is a work of art. That was one of the rules of my life. The same goes for ethnography: first ethnography is filmed, then it is theorized—and not the other way around.

HUO:

An inductive rather than a deductive method, so to speak.

JR:

Yes, there you're using a logician's language, but for us it was an emotive language. The point was to claim that the art of the engineer was this strange art that consists of drawing in one fell swoop a bridge that is beautiful, and therefore solid, and therefore a success. Aesthetics entered fully into these creations. I regret there were not more people who, after being educated as engineers, didn't go on to do ethnography. Today ethnography needs to be brought back into style; it has to be re-emphasized the extent to which it is important to take the time to study others. We ethnographers don't do "field work," we have *our own* field, we have an area we work on, and people we work with. And for these reasons I am proud to have gotten "feedback" through film. Feedback stems from being able to show the people you've filmed—and who are often illiterate—the film you've made about them. It really is something tremendous... These are people who can't read the ethnographical books written about them, and therefore can't critique them. But with a film it's totally different. And they are also paid royalties because we signed an agreement with the Sacem (association of authors, composers and music publishers), stipulating that the people we filmed be considered and paid as the film's co-authors. So, if the film does well, they get large sums of money that allows them to live better.

HUO:

So film really becomes a language?

JR:

It's not a language. It's an ethic; it's a moral, a ruthless moral, because if the film is a failure, the people reject it. If you give them an image of themselves that they don't care for, you've failed.

HUO:

You would show them the film once it was edited?

JR:

Even before it was finished.

HUO:

During the shooting?

JR:

Well no, not in the middle of the process, because back then we still had to develop it here, but I'd come back to the village a few weeks later with all the 16 mm equipment and the films. And we would screen them right in the village, so the people saw the film they were in.

HUO:

And after the screening were there discussions and negotiations?

JR:

There was no negotiation. They sometimes said that it was no good, and if it was no good, we started over. I'm proud I did it that way. Maybe I was lucky to have had the education I had, to have experienced dishonor. After everything I had lived through, I realized you couldn't just do things any which way... And, I felt that the people I filmed had lost a war too.

HUO:

What is your definition of what you've often referred to as "shared cine-anthropology"?

JR:

Well, it's exactly that: the fact of going to these villages, of getting into film, collecting royalties... Getting into something that anthropology couldn't come to terms with.

HUO:

So anthropology is a form of shared economy?

JR:

Not anthropology as such, because anthropology books don't make money. Rarely, in any case. Talking about the question of profit sharing to my anthropology colleagues, who don't make films, always led to a scandal. As they saw it, they alone are the authors. But morally, for me, it was absolutely natural to share.

HUO:

How did you get to know the other filmmakers who came to form the Nouvelle Vague?

JR:

It all started or unfolded in places like the Musée de l'Homme or the Cinémathèque Française. It was also there that the French Nouvelle Vague was born. We got to know one another when Langlois screened his films in a small cinema on the rue d'Ulm, close to the Pantheon, because we'd always sit in the first row. Why the first row? Because the only place we were at ease was in the first row. It was the only place without hats—women wore hats back then—which blocked the view of the film. And if it was a boring film, we could lie back and snooze and wait for the next one. The people I met there every night were the filmmakers of the Nouvelle Vague: [Jean-Luc] Godard, [François] Truffaut, and [Eric] Rohmer, among others. We got to know each other like that. We were the first-row folks. We were trained like that, without knowing each other beforehand, and we have remained very close. We were the students of Henri Langlois and the Cinémathèque. In fact, they only really discovered who I was when Langlois asked me to project my film *Moi, un noir* (1958). It was then, when they turned around from their first row seats and saw me in the projection room, that they said to themselves: "So that's Jean Rouch!" Before, we knew each other by sight, we'd go for coffee together, but they didn't know my name.

HUO:

In the special edition of CinémAction *on your work {"Jean Rouch, un Griot Gaulois,"* CinémAction, *1981}, there is an interview in which you bring up your Super 8 film adventure in Mozambique. I believe Godard was also asked to take part in the project. A friend of mine, Okwui Enwezor, told me that when you arrived in Mozambique, you set about to work right away, while Godard bided his time....*

JR:

That's true. [Richard] Leacock was also involved in the adventure. The difference between Godard and me was that he had already discovered video, and so he wanted to do something in video. Which was entirely justified given the material we had. But, it so happened that the people I was working with were film enthusiasts like myself, and we discovered, by using a Super 8 format, a way to make films that we could develop ourselves on location. So, we brought along some extraordinary equipment made by Kodak, with which it was very easy to develop a film negative yourself, in

an hour. So, we launched an entire film production operation which we called "direct cinema," with extraordinary equipment which, when it was perfected, made immediate development possible. The people that we were filming were involved in the film right from the start. It was a dream come true: filming in the morning, developing in the afternoon, and screening the pre-edited film in the village itself in the evening.

HUO:
So it prefigured what has become possible today with digital cameras?

JR:
Yes, in a certain way. And it was Godard himself who wanted to test out a video-montage system. But video montage bears no relationship to film montage. That was the whole issue. It was a time when film itself was looking for its bearings, when Godard and I were also trying to find our bearings. We were looking for the best way to make an ethnographic film. And we came up with an extraordinary solution. We had started in Porto, Portugal, with Jacques Arthuys, but the films were failures. And it was he who, once settled in Mozambique at the French Institute, encouraged us to come with an entire team from Nanterre University. The project made it possible for a lot of people to start making films, and they came to understand that cinematographic feedback was entirely possible. It had an enormous impact on Godard, who stopped making films with cameramen. He wanted to be his own cameraman. At first, I was my own cameraman. But that didn't stop me from working with cameramen on various occasions—and, on many occasions, I have learned a lot from them. My film adventure is complex and it's been a long road, but it is based on the fairly simple idea that film is an art that can be done with minimal means. We made films for two francs fifty...

HUO:
How do you see the development of documentary film today? In the interview you did in the '70s, you mentioned your experiments in Super 8, but what do you think about recent technical developments, such as digital equipment and its immediacy?

JR:
None of what I have been talking about exists today, so to speak. And to some extent, it's video that killed it. Take for instance what we're doing here right now: who's the director? Is it you? Is it me? Who is it? Is it the little machine there? [*Gestures to Obrist's digital camera*] Personally, I don't believe in that. Even if what is recorded

is true, even if there's no lying, something will constantly be missing. For example, if you turned now and if you went around me, you could see what is there behind me, the light shining on me from the window, and so on. But as it is, if your machine never moves, we miss all of that. Whereas with film, the setting and the decor were part of the director's decision.

HUO:

There's also a loss of light with digital cameras. I spoke about that recently with Aki Kaurismäki, who uses the camera that {Ingmar} Bergman used and then sold to him when he decided to stop making films. Kaurismäki told me that he would always use this same camera because he thinks that digital film has nothing to do with natural light.

JR:

My point of view is slightly different. Why work with something other than our old cameras when what they have to offer us is the best?

HUO:

Did you develop all the photographs yourself?

JR:

No. I've always had them developed and printed for me. Which brings up the long-running debate between those who used Rollei 66's and those who used Leicas. As I see it, the incontestable advantage of the Rollei is that by looking down, you change your viewing angle. And there, you see an image. With the Leica, you are looking straight on. The fact of having to bend down to see something was like having to lean toward a canvas to paint, or toward a paper to do a gouache or drawing.

HUO:

It means a change of perspective?

JR:

Yes, a change in viewing direction, in fact. The people with whom I began to do photography at the time were in stark opposition on the basis of these two completely different visions. I had both cameras, and used them both.

HUO:

Did you have an ongoing dialogue with artists, with painters?

JR:

No. Not at all. Those are very different activities, even if they are in the same domain. You have to know how to draw, that has always struck me as indispensable in my work as an engineer; and

you have to know how to paint. I regretted I wasn't a musician, because I'd have loved to play the piano. But you can't do everything.

HUO:

So that is one of your unfulfilled projects? Do you think you'll get to it one day?

JR:

No, because it's too difficult. My relationship to music is especially with jazz. I was intimately involved with early jazz. When I was in high school, in my graduating year, I went to the first Louis Armstrong concert in France. It was at the Salle Pleyel. At the time I had no money, so I was seated in the back row for the first half of the show, but I moved up to sit in the front row at intermission. I was sitting just in front of the stage and Louis Armstrong came on for the second half. He was accompanied by the founder of the Hot Club de France, Hugues Panassié, who was a jazz specialist. And Panassié, who spoke English very well, was joking with Armstrong. He asked him, "What would be the next song?" And Armstrong replied: "Oh, let's play, *On the Sunny Side of the Street!*" Panassié: "Please, I hate when you do your higher notes, please take it low." Armstrong: "Yeeaahh, I'll try to do it that way." And he started low, and it was absolutely fantastic. I was ten meters away from them. The day after, I bought every one of Armstrong's records, including *On the Sunny Side of the Street*— it's one of my favorite records. It's the history of jazz. Strangely, Paris was the capital of jazz thanks to the wonderful Hugues Panassié, who developed the theory of "swing"—a slightly out-of-step swaying.

HUO:

I really like the text entitled "La caméra et les hommes" (Men and the camera) that you wrote, which is also published in CinémAction *magazine. It strikes me as a text that could have been written today. In it, you talk about the different possible uses of the movie camera, and especially the technique whereby you use it not as a means to acquire an outside view, but rather as an instrument of penetration or immersion, which allows you to erase the borders between the author and what he is filming. Do you agree that they are still relevant?*

JR:

In fact, when Griaule and I started the film with the Dogons, film wasn't yet my field, and though Griaule had himself made films, they were only scientific films; he used the camera to record every-

day life. For him, cinema was a method of investigation—what you call the outside view. I was really making films, and as a matter of fact, Germaine Dieterlen reported that one day Griaule had a fit and said to her: "It's really too bad about Jean Rouch, because it's always film, nothing but film." But, in fact, my cinematographic adventure had begun long before that. The first time I ever held a 16mm camera in my hands was just after the war, when I went down the Niger River in a pirogue with two schoolmates from Ponts et Chaussées. Four thousand kilometers... pure insanity—it took us a whole year. We weren't in a hurry; we made a sort of portrait of the river. We sometimes filmed with a 16 mm camera. We found a clever way to subsidize this voyage by creating a fictional character, known as Jean Pierrejean (Jean Sauvy, Pierre Ponty, Jean Rouch), who had the ability to be omnipresent: he could be in three places all at once, which is rare for a foreign correspondent.... He was a character we had invented a few years earlier, during the Occupation, when in 1941 we had become engineers with the Ministry of Public Works for the Colonies: Ponty was in Dakar, Sauvy was in Guinea, and I was in Niamey... We had an excellent relationship with the French Press Agency, AFP. And when we left to go down the Niger, the AFP signed a contract with Jean Pierrejean. So it was the AFP that subsidized our trip down the Niger. We did photos, films and articles. We developed the photos ourselves with a battery-operated enlarger. We did the montage and we sent everything to the AFP during stopovers. The AFP would send us what they owed us at the next stopover. That's how we paid for our voyage: through the stories printed in the AFP newspapers.

HUO:

So it was a form of self-organization?

JR:

Yes. Along with the text—and I should mention that we wrote quite well, we had a good style, also thanks to our school training—there were photographs as well, and since we were very well prepared, subjects came up on their own. I'll give you an example: going down the river, we were bound to discover all the differences that could exist between pirogues. And in the Mopti region, we discovered that there was an art to the pirogue and in particular the magnificent pirogues known as sewn pirogues. The boards were sewn together. And so, we wrote an article about these beautiful sewn pirogues, entitled: "Pirogues haute couture." It struck a cord and so automatically the article was accepted, printed, distributed,

and so on. We trained ourselves in this sort of poetic play in every-day life and in our work, while at the same time taking enormous risks: running rapids, capsizing—but we were very good swim-mers, and in good shape. That 4200-kilometer expedition lasted eleven months. On the pirogue, we had the time to type the arti-cles ourselves. We dried the pictures at the top of the pirogue's mast, we worked our equipment with a little generator, in order to print the photos, and so on.

HUO:

It sounds fairly similar, in fact, to {Alexander} Medvedkin's "Cine-Train" project of 1932, where once the images were filmed, they were edit-ed in the train, and so on.

JR:

Yes, except that we did all that without any ideology. We had nothing to defend; our only goal was to reveal the wonderful adap-tation of the different tribes to their environment and to the river on whose banks they lived. The unity of our narrative was that 4000-kilometer river. The voyage had been motivated by the "explorers club" that had been set up at the Musée de l'Homme. The club inevitably attracted young guys like us who wanted to travel, to head off into the unknown. It was the end of the war, and we wanted to get away from four years of horror. The club's head-quarters were located in a small jazz club known as "Le Lorientais," in the basement of a building in the Saint Germain neighborhood, where *Rendez-vous de juillet* (1949) was filmed. The film sort of tells our story.

HUO:

Who was the director?

JR:

Jacques Becker. Becker was a real jazz lover. In fact we were all real jazz lovers—everything crossed over.

HUO:

In your book, you often mention Robert Flaherty and Dziga Vertov, and you say that you tried to achieve a synthesis between their respective styles...

JR:

Vertov was for us the very emblem of experimental film. He was a great, great cameraman, who thought that the camera should be the veritable fiancée of the people it filmed, that it should chroni-cle their lives. So, direct cinema, cinéma-vérité, Kino Pravda was our model. Vertov was someone who invented practically every-

thing. The film he made about Odessa is marvelous. Every time I
see it, I'm dazzled by its images and by the way it was made—it's
truly staggering. His films were made with one of the first portable
cameras, which was subsequently used by Joris Ivens. It was a small
wind-up camera, which had an autonomy of about twenty seconds.
So if you watch closely, no shot in Vertov's work lasts more than
twenty seconds. It was wonderful, because while you had, on the
one hand the birth of mainstream cinema, there was on the other
hand these do-it-yourselfers, who crafted their films themselves. In
that sense, going down the Niger was a Vertovian film. We did
everything like him. The difference was that his wife was a film
editor, and we didn't have a wife to edit the film... [*Laughs*] Not
that we considered ourselves part of the avant-garde; we didn't even
know what that meant. When we came back from Africa with our
films, it was Langlois who took over and showed them. I screened
the first film I made after traveling down the Niger at André Leroi-
Gourhan's, who was a professor here at the Musée de l'Homme. I
had just finished my degree in ethnology with him, and he imme-
diately considered my role in film to be self-evident. It was with
him that we subsequently set up the ethnographic film committee.
It all took place here because there was a genuine spirit for adven-
ture, because the Resistance was born here. All of these factors are
inseparable. How do things stand with regard to all of this in
today's world? I think it has become far more complicated, maybe
because of that little machine there [*gestures to the digital camera*],
because it introduces a form of voyeurism. We don't quite know
anymore what the images that it produces are worth—they may
well be worthless, and void of any interest... When I look at you,
your gaze is more important than that eye there.

HUO:

It's a doubling up of my eye, which is another form of omnipresence.

JR:

Perhaps, but if I say something stupid, you're the only one who
laughs, not that thing there. [*Laughs*]

HUO:

But it's not just the image that it is recorded; there is also the sound, the
conversation, the interview. What is the importance, to your mind, of this
form of recording, of archiving history through interviews?

JR:

For me, an interview is ethnography, and above all it is a quest for
information. It is what I've always done, and I have never had trou-

ble doing it, because the Africans knew me right from the beginning as a victim. I was like them, because I had been expulsed by a French governor from Niger during my first voyage to Africa in 1941–42, while working as an engineer with the Colonial Ministry of Public Works. I was responsible for the building of two roads, but I had started to get interested in ethnography, in carrying out an investigation. I had even sent a text to Griaule and to Théodore Monod, but my investigation was stopped short because I was denounced as an engineer straying into ethnography and as a dangerous Gaullist. The Africans thought of me as an odd adventurer, but they felt that I was part of their same age group. We were all in the war, and we didn't know where we were headed. For me, it was a period of great exploration, a quest for information. For others, it was other things too—for instance, in my wife's case. And while we're on the subject I'll tell you a story—a totally extraordinary story. I'll show you the photos. In my wife's archives I found this interview she did with Kwame Nkhrumah, who was the president of the newly independent Ghana. My wife spoke with him, and asked him, "Don't you think it would be important to go and cover a story on what's happening in the Congo?" And he replied, "But, what is so important in the Congo?" Jane: "Well, [Patrice] Lumumba." Him: "You think Lumumba's that important?" Her: "If you authorize me to go by plane to the Congo, I can continue my story on Lumumba..." And at that, he decided to send her there. And she met Lumumba immediately upon her arrival in the Congo; he welcomed her in an extraordinary manner. But, very quickly the Lumumba affair went awry, he was tracked down and then arrested. He was advised by a Belgian, who was his partner-in-crime, as the newspapers put it at the time. One day, when the situation was at its worse, she went into the bar where at the time all the journalists went, and she heard that the Belgian was about to be arrested. It just so happened that just then she saw him walk into the bar. And she immediately went up to him, told him to leave immediately and to jump out the window. The window was open, he jumped, and she went and ordered a drink at the bar as if nothing had happened. A few seconds later, the militia turned up with machine guns, but they were too late because the Belgian was long gone. For the Africans, she represented a sort of extraordinary angel because she had saved someone's life, and because she was there for Lumumba's last horrible hours. We met up with the Bel-

gian again at a film festival in Algiers. We were in a bar about to
have a drink with some people who worked in film in Algiers...
This guy enters, full of emotion at the sight of Jane, hugs her, and
says, "You see this elegant woman, she saved my life." Everybody
looked at Jane, and many began to cry. It was a very powerful, emo-
tional moment. For me that was a true lesson, because I was not
capable of doing that. She had understood right away—it was no
doubt thanks to her training as a journalist—that she was writing
the article of the future, meaning that she was writing about what
would happen three days later, three seconds later, or three years
later. For me that was an astonishing ability, because I would not
have been able to do any such thing. I was implicated in lots of
political intrigues, in Mozambique and elsewhere, but never was I
engaged in anything of that kind. If ever I had a revolution to car-
ry out, it was in Paris. And, well, we carried it out. I was active in
May '68, which in that case was self-evident.

HUO:

You made a short film, which I've never seen, called Les veuves de 15 ans
*(The 15-year old widows, 1964), in which you are alleged to have pre-
dicted May '68. It was about teenagers who begin to refuse authority.*

JR:

The project was a failure. It's one of my great regrets. I'm going to
make another film about May '68. I heard about the events of '68
while finishing a film on lion hunting, a film entitled *Un lion nom-
mé l'Américain* (*A Lion Named the American*, 1968). We were in the
middle of eating lion—because lion is an excellent meat to eat—
and a guy put on the radio and there I learned that the French
police had taken over the Sorbonne. I told my friends that under
these conditions I had to return to Paris. I packed my bags, loaded
up the equipment, got on a plane and flew to Paris. And, indeed, I
landed in a Paris in the throws of revolt. I had barely arrived when
I heard *The International* being sung on my street—I should point
out that at the time I lived on the rue de Grenelle, and hearing *The
International* on that street was not something that occurred fre-
quently. I opened the window, I looked down onto the street and I
saw a black flag passing by. So, long-time anarchist that I was, I
immediately went down to join the procession. They were heading
for the Odéon. I followed them. We occupied the Odéon, and they
put the black flag on the Odéon's façade, then the Sorbonne. At
that point I said to myself: "We've won, things are going great." I

followed the whole process but I quickly realized that things weren't really going so great at all, that everything was askew and very petit bourgeois. And toward the end of '68, we went to the last rally leaving—I don't know why—from the Gare de Lyon. They said to us, "Rendez-vous at five o'clock at the opera." We were with the people who were a bit worn out, but we were still all looking for new slogans, we still believed in it. And then we made a mistake along the way and we suddenly found ourselves in front of a military hospital. People asked, "What did you sing during the war?" Me: "During the last war?" And I started singing, "It's we Africans who've come back from afar, we've come from the colonies to liberate the land." It was a song of the African *tirailleurs*. And the people we were marching with all started singing this neo-colonial song. We went by the stock market, and someone said, "Comrades, remember Bakhunin taking Marx to task, saying that during the Commune, they didn't even burn down the stock market. Let's go burn down the stock market!" Along the square there was some poor newspaper vendor who was collecting up his newspapers. We bought a pile of newspapers from him, and in front of the stock market we lit the fire. We burned the stock market. We continued on, passed by the CGT (Confédération Générale du Travail), insulting the trade unionists, and we finally got to the Place de l'Opéra, completely worn out. And at that moment, one of the organizers, seeing the state the troops were in, called for an hour break and gave us a meeting point for an hour later. I left to go for a coffee, and when I came back I was all alone. There was just one guy left, who came up with the slogan: "To the Elysée, we're going to take De Gaulle." Well, that wasn't planned on the program. I told him to go have another coffee and to come back a half-hour later when there'd be more people. A half-hour later he wasn't there; I was all alone, and I went home to bed. And so I'd like to make a film about that—it's really easy to do—with the friends who were there, and around the idea of reaching total absurdity, with such funny elements along the way—like the singing of those colonial songs.

HUO:

Is that then one of your next projects?

JR:

Yes. I'll do it next spring... [*laughs*]

HUO:

I'd like to come back to your practice as a form of self-organization. You've often insisted, in describing your manner of filming, on your desire to work

with a very small crew and as little equipment possible. And you said that if it wasn't the theme of the film itself, or the objective, a priori, of the film from an ethnographic perspective, the film should be completely self-organized. It would decide how it was made, how it was directed. And that seems to me all the more interesting in the case of an ethnographic film, because you have also argued that one of the characteristics of ethnographic practice is that "the ethnographer tries to make the synthesis at the very moment of observation."

JR:

Yes, actually I believe that from the moment there is organization, there is no more poetry. It is therefore important not to organize. You have to be disorganized, and that's also my deep-seated anarchist belief. It is important not to create a state, but rather to destroy it. That's what we should have done in '68. We almost succeeded. But, there were the neo-bourgeois academics, who saw teaching posts and laboratories to be created in more or less unknown fields, in which they reserved places for themselves. My advantage over them was that people of my generation had experienced the war. We had ended up completely free of any hope... We had, in fact, won the war. So we had done our job. That's just the kind of people we were, and that I continue to be. It's also for that reason that it's very difficult to organize anything. It has to be done in this spirit of adventure that we had right at the beginning. In the case of the university it was symptomatic. In the end, what people were looking for in '68 was to create universities just to create jobs. Let me give you an example of the utter lack of organization in the university. I had Langlois named as professor at the new university of Nanterre. There was a sort of confusion at Nanterre: no one really knew who had a post and who didn't. The rumor started that Langlois was coming to Nanterre, and so a journalist called one of the directors of the university to find out if Langlois' arrival was confirmed. He, of course, had never heard anything about it. And then he asked the journalist: "Who told you that?" The journalist: "Jean Rouch." The other guy: "Well, if Jean Rouch told you, then it's true." There you go, that's how I got Langlois named, and that was how you had to do it. Never organize things too much if you want to succeed—that was what we constantly played on. But, very quickly, there was an entire bureaucracy that fell on the backs of anthropologists, and from that moment on I think everything was lost.

HUO:

Because the whole bureaucratic architecture is, above all, what causes parasiting and anxiety.

JR:

Exactly. But Langlois was a professor and so he had no problems from that point of view. His courses were incredible. They were all on Saturday mornings. The other teachers were very jealous, because the university allotted Langlois a large amphitheater, and all the other classrooms emptied out when Langlois' course began—everyone attended his courses. He was an incredible character; his courses were completely pieced together and so intelligent. But, unfortunately it didn't last because the other professors complained and then he didn't want to pay his taxes himself—he wanted his taxes to be paid for him—and so he left.

HUO:

Were his courses documented?

JR:

No, because they didn't last long enough. He started his courses up again somewhere else and he then, above all, devoted himself to the Cinémathèque. Nevertheless, in a very short while he managed to sow a fertile disorder.

HUO:

Could you tell me about an unrealized project? I'm thinking both of projects that you would like to do in the future, whether they are unproduceable or utopian, and of ones that you would have liked to have produced, but for various reasons were unable to, because of censorship or financial reasons.

JR:

There are tons of them. I have been lucky enough to have done a lot, like for instance *Paris vu par...* (*Six in Paris*, 1965) thanks to the greatest set of coincidences. I produced certain projects in incredible conditions. The things that I would have liked to produce, and which will perhaps be done now, are about the war. Right now, the project I have my heart most set on is to go back to the events that happened at Château-Thierry, during the absurd war that we lost. What was the purpose of blowing up those bridges? We blew up the impressive bridge at Château-Thierry, which had existed since the days of La Fontaine—the one where he wrote his fables and tales. We blew it up, but that didn't prevent the Germans from going across two hours later... And that is, I think, a very good argument. One of my schoolmates at Harvard— where I was visiting professor in the '80s—John Marshall, who made films about the Kalahari Pygmies, told me the story of his father. His father was a great electronics expert, one of the people who helped design the atomic bomb and who—because he was so

ashamed at having done that—decided to take his family and go
and live with the poorest population in the world, the Kalahari
Pygmies, for three years... to atone. And so John Marshall, one day
when he was in Paris, asked me how to get to Château-Thierry.
And then he told me his father, during World War I, had partici-
pated with the American Army in the great battle of Château-
Thierry in 1918. John went there, and he came back very shaken.
I suggested that we make a film together about Château-Thierry.
For him, in memory of his father; for me, in memory of the bridge,
for him, in memory of the war that his father had won at Château-
Thierry; and for me, in memory of the war that we then lost. And,
another fact that interested us both was that another documentary
film about the war had already been made at Château-Thierry. It
was called *Panzer* (1940), a film by Leni Riefenstahl, a filmmaker
who had been Hitler's mistress and who had filmed the arrival at
Château-Thierry of the entire armored division of German Panzers.
I had been in Germany and I found this film in the archives. At the
beginning, people told me that if I wanted to use the images from
this film, I would have to pay a significant amount in royalties.
But, in the end, they found my project so good, so interesting, that
they lifted the rights. So, this film is the beginning. I later hope to
tell about our absurd career of exploding bridges riding our bicy-
cles during the month of May 1940; from the Marne to the Seine,
from the Seine to the Loire, from the Loire to the Allier, and all the
way to Limoges, using in place of army maps, the regional maps on
postal calendars. All the way to Limoges, where we were told about
the disgraceful armistice and we received a note signed by Pétain
which said that the German Army agreed to authorize us to come
and reconstruct the bridges that we had blown up, but wearing the
German uniforms. That will be the end of the film, allowing us to
retrace all these events and what they represented for two genera-
tions, in the two halves of this century.

SALA, Anri

Anri Sala was born in Tirana, Albania, in 1974. He currently lives and works in Paris. Sala studied painting at the Académie National des Arts in Tirana before moving to France where he studied at the École Nationale Supérieure des Arts Décoratifs, Paris, and at the Studio National des Arts Contemporains at Le Fresnoy, Tourcoing. In 1998, Anri Sala released Intervista, Finding the words, *a 26' color film that brought him critical acclaim and international awards such as the Best Documentary at the 2000 Williamsburg Brooklyn Film Festival (New York).* Intervista *is based on the discovery of a twenty-year-old 16mm newsreel film, containing images of Sala's mother, once a leader of the Communist Youth Alliance, giving a speech and being interviewed during a congress of the Albanian Communist Party.* Intervista *captures the moment when Anri Sala shows his mother a video of the film, and confronts her younger self. "Twenty years later, my mother has to face her words pronounced at the time. What would she say today?" asks Sala. Since* Intervista, *Sala's subsequent short films, videos and installations have been featured in numerous exhibitions around the world. Recent solo shows include: "Anri Sala" (Kunsthalle Vienna, 2003); "Concentrations" (Dallas Museum of Art, 2002); "Missing Landscape and Promises" (TRANS>area, New York, 2002); "Anri Sala, Nocturnes" (Delphina project space, London, 2001); "Anri Sala" (De Appel Foundation, Amsterdam, 2000) and "Nocturnes" (MAMCO Geneva, 2000). Group exhibitions include the Biennale di Venezia (1999 and 2001); Manifesta 3 (Ljubljana, Slovenia 2000); "Voilà- Le Monde dans la Tête," (Musée d'Art Moderne de la Ville de Paris, 2000); "Uniform: Order and Disorder," (P.S.1 Contemporary Art Center, New York, 2001); the 2nd Berlin Biennial (2001); and the Yokohama Triennale 2001.*

........................

This interview with the artist began in Paris in November 2000 and was continued in March 2002 in Parisian Noura Restaurant, and on board a Frankfurt–Paris flight after the opening of Manifesta 4 in May 2002.

[1]

Hans Ulrich Obrist:

When I was in Tokyo, Japanese artist Tsuyoshi Ozawa asked me when I last cried in an exhibition. I could not give him an answer. He said it's interesting to notice that people cry a lot when watching movies—films like Lars von Trier's Breaking the Waves *(1996) for instance—but they can't remember having cried in an exhibition. I mentioned that to you some weeks ago when we decided to do this interview, but the recording didn't work so we had to stop...*

Anri Sala:

... and since that time I have been asking people the question. For example, in *Dancer in the Dark* (2000), people replied that either

they cried nonstop in front of the movie or they saw people crying in the cinema. Each time, I've been inquiring why they cry, what specifically made them cry. One of the answers I preferred—certainly because I find it most interesting—was: "It's the camera, the movements of the camera that made me cry; it's not the story." Someone told me that until the nineteenth century, people would cry in front of a painting. I haven't been able to verify this statement. Perhaps you know more. Do you think it's plausible?

HUO:

Yes, I think it's true; people cried in front of paintings before the moving image.

AS:

So what happened within 100 years—or even less—that people don't cry anymore? Why are they moved now by the moving image only? I can understand that people cry in movies, but I dislike it when they cry for the wrong reasons. I was speaking with a friend recently who saw *La Dolce Vita* (1960) a few days ago, and he cried. He said he was very happy not to have seen the film before. I think this is a case where someone's crying is unconditioned; it's the work that makes you cry, it's not because it's a film, and it's not because the producers, director, and actors tried everything possible to make you cry. In Zurich, I found this book, *No Drawing, No Cry* (2000).

HUO:

It was Martin Kippenberger's last book. He used to do all these drawings on hotel paper and published two books in 1992: Hotel – Hotel *and* Hotel – Hotel – Hotel. *And then he died; so* No Drawing, No Cry *is full of empty hotel paper from all over the world... Last night I saw for the first time your very first short film,* Déjeuner avec Maroubi *(1997). So to begin with the beginnings: What was the starting point of this film?*

AS:

This is the first thing I did when I came to Paris four years ago, and nearly the first time I was working with a computer program. That was in 1997. The image of the work was taken from a turn-of-the-century photograph taken by an Albanian photographer of Italian origin who established himself in the north of Albania, in a town called Shkodra. You can see from the photo that it was taken at the beginning of the century in some part of the Ottoman Empire, as Albania was part of this empire at the time. It was the first time a photographer's studio appeared in this town, and it's said people were so surprised when they saw themselves on photographic paper... On this photo you see three women—two Muslims and one Catholic—sewing with a sewing machine. I prepared a fabric

with a reproduction of Manet's *Déjeuner sur l'herbe* (1863)... It's just a joke about taboos, especially taboos in Albania in relation to this woman being naked and this foreign body... But it's also about the reactions to this painting when it was first shown in Paris. So in the film's animation, the women are sewing the painting in order to dress the naked women as themselves, in traditional north Albanian dress. It was a little bitter, not only about the gap but also about the differences in contexts.

HUO:

Have you always worked with photography and film? Did you ever paint?

AS:

I can show you photos of paintings I did from the time I was ten years old in Albania. I did mainly painting for a while, and then started making installations. Then I came to Paris. I didn't actually have an interest in cinema. I liked to watch movies though, but in Albania you could only see Albanian, Vietnamese, or Indian movies... When I came to Paris, I first did some animation because I was just amazed that I could work with a computer program and animate photographs. The next thing I did was *Intervista*. When I made *Intervista*, I didn't even know I was making a movie. It was just in the nature of the project to film what was happening with me and with the voice... It was afterwards when I had to edit the video that I began to realize it was becoming a movie.

HUO:

And that was the first moment you felt you should carry on as a filmmaker?

AS:

When the rushes were all done and the movie was already in the computer; more precisely, I guess the moment that I was completely sure about that was when I had to give the film a title, credits, and to thank all those who helped me...

HUO:

So it just happened?

AS:

Yes. I had become interested in researching this interview with my mother... I always become interested in things before I know how I'm going to handle them. In the case of *Intervista*, I learned how to use a camera while doing it.

HUO:

When you were a teenager in Tirana, did you have curiosity or even an obsession with foreign cinema and culture, as is often the case with teenagers

*who have been educated in countries under authoritarian regimes and who
later become artists?*

AS:

In Albania you couldn't see everything, but you could find things
"sous le manteau"—only in underground circuits. If you searched,
you could find books, circulating illegally, but only if you knew
certain people, and if they trusted you, because it was very danger-
ous—both for them and for you. You could find movies, but to see
a tape you needed a VHS player, and this was not part of our fur-
niture as it is today. So to see an illegal movie was practically
impossible. I remember the first movie I saw when I had access to
a VHS was *A Clockwork Orange* (1971). Some of the special things
we could see from the beginning were Chaplin's movies like *The
Great Dictator* (1940) or *Modern Times* (1936)—that I find fantastic,
especially *Modern Times*. I find it really amazing; I still have the
tape at home. There are thirty seconds in this movie where you
understand what happened with the art of the '70s in America, and
Pop Art. It is Chaplin dreaming: he's playing a guy in love with a
girl and they are starving, so they're dreaming. In the dream, the
man is leaving this nice, American-type house while the wife is say-
ing good-bye. She is very happy and she runs after him and kisses
him, dressed in a polka dot dress like a Roy Lichtenstein painting.
When she re-enters the house, it's just Pop, like the promised life.
It's incredible. Subjectively, personally, I find this to be the begin-
ning of Pop Art.

HUO:

Who are your other cinematic heroes? Films you saw over and over again.

AS:

I saw some [Jean] Epstein films several times.

HUO:

But of course not in Albania?

AS:

No, here. In Albania I saw very few movies. There is a place in Paris
called the Bifi (La Bibliothèque du Film) where for 100 francs a
year you can go and see all the films you wish. I used to go there a
lot during my first year in Paris. At the time, I wasn't thinking
about making films and I don't think I became interested in doing
films by watching them. I think it has more to do with the fact that
somehow I lost interest in painting, and because I realized that
video was a better way, a better medium to express what I was feel-
ing, my desires and what was important to me.

HUO:

Let's go back to the making of Intervista.

AS:

I left Albania in 1996. So I had been in Paris for one year when I went back to Albania for summer holidays to see my parents. It was 1997, and they had moved into a smaller house. So they asked me to sort out my stuff, to go through the boxes and throw away what I didn't need because there was not enough space. I came across this 16-mm thing in black plastic that I had never seen before. I later realized that it was my parents', but they had forgotten about it. They thought that anything related to image, painting, photography, etc., "would have to be Anri's because he's the artist in the family."

HUO:

So it was attributed to you!

AS:

I don't think that they even looked at it; they just saw a film and said "Anri." Tubes of color and said, "Anri"... That night I looked at some of the frames and saw that it was footage of my mother. Of course, looking at it like this was funny: I just saw it as photographs. I didn't see the movie, so I didn't know what it was about, what was happening; the roll was quite long. I got to see it only when I returned to Paris after holidays, when I got access to a 16-mm projector. I realized it was an interview with my mother, followed by her in a congress with Enver Hoxha, who was dictator at the time. That was a small surprise; I mean, historically I knew she had attended congresses so she might have met politicians of the time. But the incredible thing was to see how young she was! She was about thirty, and when I found it I was 24 and she was 53; so thirty was much nearer to my age than to hers. I found that this image of her belonged much more to me, to my age, to my moment, than to her somehow. It moved me and made me curious to find the sound reel. I had really hoped to find the sound and not just the words, but as the story turned out I couldn't find the sound; I went to a school for deaf-mutes for help. Even at that moment I wasn't thinking about turning it into a film. But I just said to myself, well, as I'm going back to Albania, I might as well take a camera and shoot all this. I wanted to remake this interview with my mother. So I had prepared five questions to ask her, but you only find the first one in the film, as the answer changes the

following questions... This was the only thing I knew I was going to ask; I had no such thing as a script. After doing this, I had learned a lot and became interested in continuing, not the same experience or same type of story, but continuing to learn about making film.

HUO:

What followed in terms of your filmography?

AS:

Nocturnes (1999) was next. It was different. I knew I didn't want to make a film in Albania because I wanted to try something more challenging; somehow, it's easier to choose a subject coming from your own country. And I had the possibility to make a 16-mm film, so why not try it? With *Intervista*, as I said, I didn't know I was making a movie, and I didn't know how to shoot; everything just happened like that. After completing the *Intervista* piece, I wanted to make something where I could control the image. As I came from painting, the frame, the composition of each scene was important to me, and I think it came back with *Nocturnes*. Once more it is a real story with two real characters, but I could decide much more how I wanted to film it; the image itself was much more important this time.

HUO:

Less improvisation, less chance, less randomness...

AS:

Improvisation remained. For example, with the young military man—one of the two protagonists of *Nocturnes*—because until the end I didn't know if he would even come or if he would let me film our meeting. And improvisation comes sometimes from constraints. For instance, the fact that I could only shoot his hands, his legs, or his back—but not his face—pushed me toward improvisation. The next film I did was a documentary on a French artist's exhibition in Tirana. The subject could be seen as much more ordinary. I found it very difficult to make something out of an exhibition. What was interesting for me was to have a French artist, Henri Foucault, going to Albania and presenting his work in another context: people there visiting the exhibition, people whom I know, who were my professors and in some cases who used to be my references. During the making of this film I found myself caught between these two things: him and them. It seemed much like an art history fairy-tale.

HUO:

With Intervista, *you reconstituted a missing voice so to speak, while in* Nocturnes, *you tried to outline an inability or resistance to communicate.*

AS:

In *Intervista* I am showing the story as it happened to me: what you see is what I saw. In *Nocturnes* it's completely different: what you see is what I show. *Intervista* is more personal and could be very dangerous politically, because it's dealing with the past and the idea of truth; but if you don't believe the story, at least you can believe the character, which in this case was my mother. It's less evident to believe the story of the young military guy in *Nocturnes*! You don't see him, I don't prepare the story, I don't show myself looking for him; he is there from the beginning. But he becomes increasingly credible.

HUO:

How did you meet him?

AS:

I arrived in Tourcoing, a small town in the north of France near where the Fresnoy Art School is—I was spending time there as one of the art school residents. I was trying to meet people because I knew nobody. I needed to meet people, to find stories, to understand a little bit where I was living. A friend of mine introduced me to two people. The guy who lives surrounded by fishes and aquariums—the other protagonist of *Nocturnes*—was one of them. The way he talks about his fishes is very subtle. He used to work in cinema designing sets, and was apparently quite successful at it. He stopped doing this only because he found he was becoming too professional. And so he decided to live with all these fishes.

HUO:

The film is about two forms of refusal to communicate. There is a desire for dialogue but at the same time a refusal to communicate.

AS:

When people see this film they say, "Oh my god this is interesting—those people are so crazy." But I don't think those people are crazy at all. You can see they like to speak, they would like to have a dialogue, but at the same time don't feel easy speaking with everyone, and don't fit well within the community where they live. In the rushes, the soldier said something interesting: when he came back from the war, it was impossible for him to wear jeans because he was used to military dress, so the first two months he still wore military clothes. Ordinary conversations, things like "Ça va ta

femme?" ("How is your wife?") seemed alien to him, as he was accustomed to talking only about war, snipers, and dead people. There were no wives or family relations in their discussions. But when people see the film, not everybody believes the story. I can tell you that no one would believe his story if you told it during a dinner. What helped me to make this film is that I believed in his story. We spent a lot of time together and I also told him stories I knew from Albania that were violent, maybe not that violent but where someone died in the end.

HUO:

How did you meet this man that we witness in Uomoduomo *(2000)— this man waiting and then sleeping on a seat inside Milan's Duomo, constantly falling and straightening up in his sleep?*

AS:

I was in Milan, where I actually went to work on another project that would take more time, and would go every day to the Duomo. I saw this man there twice, but I always had the camera with me, a small camera like yours. I had to be discreet. It was very difficult because in the cathedral there is a part where everyone can enter and sit, but you must be careful because people may be praying. Everybody is facing the front of the church, like the "Uomoduomo," so it's very difficult because I had to be facing the people to film him.

HUO:

Did he realize you were shooting him?

AS:

No.

HUO:

Was he there every day?

AS:

I saw him twice. It means two days during the five days that I was there.

HUO:

There are strange people who inhabit public spaces: since I live near Stalingrad, whenever I take a train or a plane I always pass by Gare du Nord, and there is this woman who is permanently standing at the corner there by the pharmacy, everyday from 6:30–7:00 a.m. to midnight, every day, even if it is snowing or raining. It's really scary.

AS:

And there is a woman in Les Halles, a black woman that you see whenever you walk in the main entrance where you buy tickets. She spends her entire day cleaning the glass there.

HUO:

She's not employed to do the work?

AS:

No, and it's a "public glass." It's not her property, but she has a strong relationship of belonging to it. She is like your character. I remember seeing her there four years ago when I came to Paris, and she is still there now.

HUO:

There is also a woman that used to be a well-known figure of the Cafe Carette at Trocadero. She is always waiting for an appointment that will never arrive. She would sit at the table all day long, occasionally walking out and asking if the appointment had arrived. The first time you didn't notice anything unusual, you would just think she is waiting for an appointment, and then you realize it's a loop kind of thing. That's why I thought Uomoduomo *was Beckett-like.*

AS:

You know, Samuel Beckett was one of the most fashionable and popular playwrights in Albania in the '90s. The first authors that you had the right to play after the Communist and Socialist's ones were Beckett and Ionesco.

HUO:

Once communism was gone...

AS:

Beckett came in. I think it has a lot to do with this "waiting for something."

HUO:

How have migrations and living in different cities influenced the way you work?

AS:

The most interesting thing for me is the sensation I get flying from one city to the other, from Paris to Tirana and back. I spend six or eight months in Paris, and just one month in Tirana, or one year in Paris and two weeks in Tirana—all of this traveling just to have this big sensation one day when the plane is landing, the day I arrive at home in Tirana and the first day I'm walking down the street... You have these eight months of Paris clashing with these three weeks of Tirana, but these three weeks in Tirana are not alone; it's really 24 years of Tirana coming back. What's interesting is to see what is in the minority now: is it Paris or is it Tirana?

HUO:

And in terms of language?

AS:

In terms of language it's also very interesting. Lots of things are still easier to say in Albanian, others are easier to write in English, and other things to say or to write in French. Very often, when I'm writing for myself, I begin in Albanian, continue in English, and end up in French. It depends on what I'm saying and which period of my living experience I'm dealing with. For example, if I write about something that happened fifteen years ago it's much easier in Albanian. If I write down an idea that concerns me now it's likely I will write it down in French; but there are no rules.

HUO:

I always have the feeling that when I'm in Paris, I must speak English, as to live in Paris and speak French entails a risk of assuming a new identity. So it's this idea of permanently escaping identity. Speaking English in Paris or French in London suits me better than speaking French in Paris.

AS:

This is a nice idea, although most of the time I have to speak French when I'm in Paris because it's difficult to speak English with people here. I'm also interested in the fact that I seldom leave Paris to go to the countryside. And although I know Albania better, lately when I go to Tirana I rarely go out to the villages. I go Tirana-plane-Paris, Paris-plane-Tirana, so I forget the relationship it has with the rural landscape, with the people living in villages. I accept to live through cities, but at the same time I think it's not right at all, and it doesn't help in understanding a city, because a lot of what helps to make a city comes from outside of the city. For instance, ten years ago Tirana had 300,000 inhabitants, and now it has about 800,000.

HUO:

That's similar to an Asian condition.

AS:

People came from the north and from the south of Albania to Tirana. This changed the city and the way people used the city: the preferences, which streets, which squares are used by which inhabitants, who is spending time in this square and who's spending it in the other one, dividing the city into different communities.

HUO:

Are you familiar with the films of Jonas Mekas and Johan Van der Keuken?

AS:

In the first film I saw by Mekas, he was filming snow in a park in New York, and I think it was later in the film he said he kept film-

ing and filming in New York and suddenly, looking at the rushes, he realized that the New York he was filming was similar to Lithuania. Without knowing it, he was trying to find a little bit of Lithuania in New York, and was filming something that no one could identify as New York. In Amsterdam I saw an Ulay exhibition, and there were these photographs in the market that made me think of *Amsterdam Global Village* (1996). I still have to think about why I haven't filmed in Paris yet... Until now in this Paris & me relationship there was no camera, so no image... no sound... no cry...

HUO:

"*No Paris, No Cry.*"

AS:

I think it's not "No Paris, No Cry," it's "Paris, No Cry."

[2]

HUO:

We haven't spoken for about 14 or 15 months, so this is the second chapter in a way; a lot of things have happened since then, so it would be good to catch up. You've been traveling a lot: Ljubljana, São Paolo, Turin, Tokyo, Tirana, and Paris...

AS:

Yes. I always love traveling. Sometimes you feel a bit tired, but I really love it. And Brazil was a very good experience for me. I lived there for two-and-a-half months.

HUO:

Was it in Brazil that you shot the images for Blindfold *(2002)?*

AS:

No, the images were shot in Albania, in two different cities in Albania. One is Tirana; the other town is Vlora, south of Tirana, where all the clandestine people catch the boat to go to Italy. In São Paulo, people said it looked like it was filmed in Brazil. When you see it, it could be in Brazil, as it could be elsewhere; there are things that could be anywhere, like the *favelas* or other urban similarities. The sun is behind the camera and hits the shimmering metallic structures of the empty billboards blinding the view and censoring the sight. Slowly the sun passes away and the light fades out, letting loose the image. The space increasingly appears behind the billboards. I liked to film the slowness of the sun. Cities in Albania are not like New York, Paris, or other big cities—they live slower. I liked shooting this slowness, the sun's walk.

HUO:

This idea of capturing slowness is something one can find in cinema. I was wondering whether you had been influenced by the films of {Theo} Angelopoulos or {Jean-Marie} Straub? Even if I think it's probably difficult or maybe strange to be influenced by both of them...

AS:

I know Straub & [Danièle] Huillet films. When I was studying in Le Fresnoy, Straub & Huillet came over. I like most of their films a lot. In their films there are these kinds of panoramic camera movements going to one direction and then coming back again to the first position. I like their films more than the theories behind them, like the one of undividable sound and image.

HUO:

You find it too much of a dogma?

AS:

Yes, but I like their results. For the soundtrack of *Blindfold,* I worked with musicians in São Paulo. There were two sound mixers, Joao and Eduard, and a musician, Wilson Sukorski.

HUO:

This has also come about since our last conversation—music has now arrived in your work. How did these sound and music aspects develop?

AS:

Sound has always been of importance for me. In *Intervista*, sound was important, even crucial. But not in terms of the physical sound, but rather sound as a language. In *Nocturnes*, sound is of a different matter, and then you have *Uomoduomo* where there is no sound at all. Then sound became an important part of my works. If it is not really useful, I don't use it. If I'm looking for a fragile image, the absence of the sound makes it even more fragile.

HUO:

No sound, no cry?

AS:

Let there be no sound! For *Blindfold,* I was more interested in creating a sound specifically for the video installation. I started to discuss with people who came from a cinematic background how we could create the sound of the sun passage. What happens in the image is very important, but it needs support from the sound. If there were no sounds, maybe visitors would leave before seeing the whole transformation of the light; perhaps the sound encourages one to stay longer. And it's all the more important as in *Blindfold,*

in which we bare witness to something, which the people passing by are not conscious of.

HUO:

Does the sound created for this installation echo the kind of music you're listening to?

AS:

I am very much interested in electronic music. I like DJ Krush. I like Tricky. And I buy CDs often by chance, and some are good.

HUO:

Are you going to push this practice of sound making further?

AS:

There is a new sound piece I'm working on at the moment, for a project curated by a friend of mine from Albania who is now working for Manifesta 4 (Frankfurt, 2002), Florian Agalliu. He decided he would do a small project in Frankfurt, a project concentrated "on research and trust, a process that often can push the limits of situations," and he invited several artists to participate. I don't know who they are, but there's an interesting idea behind the project. One part of the idea is that the only place he can show the works are places where they have no value, so whoever finds them can have them and take them home.

HUO:

What is the place that you've chosen?

AS:

A taxi. Florian asked me if he could show a video of mine, and I said no, I wanted to do something new. So, I came up with the idea of working with sound in a taxi. I hope it will work out. I'm working on it this weekend with another friend of mine. You know how cabs are in Germany—big Mercedes Benzes, very well isolated. So I asked the guy if he could find a taxi like that and he did. I wanted to make a CD that people can take with them for their cars. It's about creating a double-speed situation. As you're driving to or in the city you hear loud racing cars, super Dolby sounds followed now and then by stray dogs barking. I'm talking about dogs living in undeveloped urban areas or poor countries—geopolitically depressed dogs. So if you're in Frankfurt during Manifesta 4 you may get into this taxi, where the sound drives you into these cycles. It's only a small sound project, but I like that it will happen in Frankfurt, though it might have been even better in Monaco.

HUO:

Talking about disjunctions in speed, in Yokohama (Yokohama 2001,

International Triennale of Contemporary Art), with **Arena** *(2001), a film on Tirana's derelict zoo, you almost did the contrary as you instilled a moment of slowness in an otherwise much accelerated show. There was also a sense of emptiness coming from those images...*

AS:

The story about the Tirana Zoo is an important one to me. With this film, it was the first time that I wasn't working with people. Most of my works feature people. The tension between the city dogs and the zoo animals was interesting for me as a sign of urban dysfunction. There is a fight revealed through sound because there is a fence between them. Things had changed a lot in Albania in the '90s. Before we had only local animals such as wolves, foxes, and bears, and after the '90s we got tigers, lions, and lamas. It was part of the wish of integration (of the zoo institution) to the world. Like in other countries coming out of a dictatorship, there was a real hope that everything would change quickly and become more like what we saw on TV. The government was also supporting this feeling. We are entering Europe, but if we want to do that, we must do it in every possible way. So our zoo needed to look like Western zoos; Western zoos have African animals, then we also need African animals. So the government bought some. It was the first time that I had ever seen a real tiger in my country. Later on, in 1997, there was a financial bankruptcy and most of the animals were killed or kidnapped during the riots that followed. People felt insecure so they stopped going to work. The only animals to survive were the strongest. It's hard to steal a lion. One woman who continued working for the zoo told me that there was a small lion cub, which she took home for five months. They are not very reliable animals, so when he had grown a bit, she took him back to the zoo. Another thing throughout the '90s was that you literally couldn't see Tirana from the zoo, and now you can see the city, which mirrors what is happening everywhere. The capitals are getting bigger because people are moving to the cities to find work.

HUO:

The zoo is like a microcosm of the larger situation; it is a metonym.

AS:

That's right. For me it was the perfect place to make a film. The situation that you see in the film is a mirror of the changes that have taken place. It is like a scanning of that situation; that's why I wanted it to be slow.

HUO:

It's about urbanism also in a way.

AS:

I would say it's more a story through urbanism rather than through people.

HUO:

You say that you don't usually have the know-how about a project when you start...

AS:

Exactly. And I always pay the price for it. But I feel this gives the works a reason to exist; it's not as if a work has come out of another work. One of the reasons that I'm not always hundred percent sure about which project I'm working on next is that when I think of a new work, I don't start from what I know. When I think back about works, it's not that I recognize things but rather they help as milestones. We go through such different realities that the work itself is not the way, it only serves as a milestone on a highway you are following, but don't know where you have come from. You know that at a certain time in a certain place you were working on a project and this was the result. This is the testimony that comes from resistance. It is always at a crossroads.

HUO:

Could you give me an example of a still unrealized project that you have?

AS:

I'm getting more and more interested in projects which are not simple answers to a demand—film, video or whatever. It's not a real answer. Sometimes I feel I want to work on something which is larger, but not necessarily in terms of size: something which is more about society than art. Recently a friend, Edi Rama, Mayor of Tirana and who is an artist too, asked me to give him ideas on how to redesign a square. There is this square in Tirana that he wants to reconsider, to give a new identity. He is very interested in finding values in a country where people have lost their values. But I think it would be nicer to make a square without any values.

[3]

HUO:

We're on the Air France flight from Frankfurt to Paris, coming back from Manifesta 4's opening. The taxi project we were discussing in the previous interview has now been realized (No Formula One, No Cry, 2002). How did you finalize it?

AS:

I decided to take the sound of a Formula 1 race as well as the sounds of barking dogs. It's a work within a cycle, such as cars coming and going, passing by as if it is going in and out of your head. The dogs are related to this situation in urban areas in undeveloped countries. What I found interesting when I listened to it the first time as I was driving was the feeling of frustration. If you get in a car and have a taxi driver who's listening to these sounds, then you think he is mad and especially frustrated, maybe about not being able to go faster, maybe because the authorities ban it or he becomes frustrated because he can't afford a faster car, like a Ferrari.

HUO:

It's a circuit within a circuit. On the one hand you're in this taxi driving through the city, but you are also in this other circuit. It's quite schizophrenic.

AS:

Exactly, and there are also two speeds: the one of the car in which you are driving, but because the CD sound in the car is so loud, sometimes you might hear the sound of the city outside, but not the sound of your own car. What you hear goes faster than what you see. You're not synchronized.

HUO:

So you are experiencing different spatial and temporal understandings at the same time.

AS:

The speed of the car you are in, and the speed of the sound of the Formula 1 racing cars, and the third speed, which is the speed of the presumed geographical and political space introduced by the stray dogs.

HUO:

The dogs crop up within the noise of the Formula 1. It's another world, a more rural world.

AS:

On the contrary, it's another world but not a rural one; it is urban but not in the sense of a wealthy country, more in the sense of countries in the periphery.

HUO:

So it also echoes the Tirana zoo piece. It's like a microcosm of the city. And then there was also the notion of rumors. You didn't really announce it properly, so can you tell me about this? Hans Gunter was the taxi driver and he had a mobile phone, is that right? How did people know about the taxi?

AS:

We found Hans Gunter, a taxi driver in his forties, totally by chance. I asked him if I could put the CD in his player and the moment after he said, "Oh my god, I love this!" That's how it started. Then the rumors circulated after I spoke to you in Paris, but it wasn't a rumor—it was just between you, me, and the curator! And the taxi driver told me that so many people have been calling him up and he has been ferrying "Manifesta people" around all day, every day.

HUO:

What are you working on now, what's next?

AS:

Next is this project in Brussels for the "Forwart" exhibition you are co-curating (Mont des Arts, Brussels, 2002). I think I will show a work I have already made, but also a new one. I have a few ideas and images that I'm working with, but I'm not sure about everything yet. When I work on a new piece, it's like starting on something from the beginning. But the ideas that I have come often...

HUO:

I'm interested in your perception of Brussels as a city and of the Mont des Arts. It's a sort of Utopia that somehow failed. It's interesting in terms of the idea of **Gesamtkunstwerk** *in an urban context, of all the disciplines coming together. The notion of interdisciplinarity is interesting, and especially in relation to your work. You're now working more and more with music, and you've already bridged art and cinema a lot. I was wondering how you see this Wagnerian idea of the total work of art, which is obviously something that Matthew Barney continues today with opera meeting music, film, sculpture, and so on.*

AS:

I'm becoming more and more interested in music, though it will probably be something else in the future. When I look back at my artistic training, I think that it does have little to do with what I studied, but it's not really that. I think there was something that happened in the '90s, a kind of rupture in the society that makes us disbelieve in the things we've learned before and lose faith in the values we believed in before. Now, when I look back, I realize that most of the things that I learnt are not directly related to the art or my studies. What was good with these studies was that it kept my interest levels high; my curiosity for things that at the beginning was only visual became more social and political. Everyday you

wake up with this need for continuous change and exchange. At this moment, it comes from music. I don't know when it will happen, but I want to do a project—I don't know whether it will be a film—where most of the sound will be bass.

HUO:

Like drum and bass?

AS:

In the sense of air vibration: it will make the film breathe! And I think it will feel like a combination of bass units and vacuum cleaners.

HUO:

You'd like to invent a new type of filmmaking, a new camera mode to capture the world?

AS:

Not specifically, but I'm in the ideal position of becoming interested in more and more things. It's still far off, but it would be fantastic, a totally utopian idea, if every citizen could make his own camera and cinema with it. It's not about the stories, the rhythm of the montage, it's not about French cinema or American cinema, but it's about the question of What is cinema? Cinema came out of these inventions of new devices or cameras: the Zoopraxiscope (Muybridge), the Kinetograph and the Kinetoscope (Edison & Dickson), the Vitascope (Armat), the Cinematograph (Lumière), the Movietone, the Cinephone, etc. It's very interesting because everyone was building their own machines and responding to it in their own way, which is an image-reality thing. It would be great to work with a camera in the way that one works with a computer, adapting it to its own use. I don't know whether there are people who do that nowadays.

HUO:

So it's not just the idea of inventing new instruments, but modifying existing tools. Years ago, I had a discussion with Vilém Flusser, who told me that cameras only allow you to make pre-programmed images; only images that are programmed can happen. He said that one of the functions of art is to manipulate or change the directions for use—the rules of the game—of a camera.

AS:

There are people who worked with camera imperfections. There was a video camera that was produced around ten years ago, which had a problem with its focus facility. There was a guy who made a two-hour film with one of these cameras using this dysfunctionality. When I started to make videos and films I wasn't interested in

the manipulation of the image. You know, people like to do that a lot, but I am only interested in images coming from the source, from the camera. After that point I'm not interested in manipulating them. I'm mostly interested in things before they get into the camera or at the moment they enter the camera, but after that I'm only attracted in structuring and editing them.

HUO:

With the "Casa Zoo" series (2001), you also edited several photographs from Arena. *What is the role of photography in your work, in comparison to film and filming?*

AS:

I think it is the same thing that interests me in painting, especially in a painting by Manet, for example. It is one scene, but it's dense, it feels like it has a beginning and an end. That's what interests me about photography. It's the compression of a story and the compression of time in a photograph. That is different from video, because with video you have the possibility of developing stories, which is also very difficult. One doesn't frame the images the same way with video as with photography. It's interesting to look at how someone frames the same scene in video or photography or painting. Vuillard used to take photos of the interiors and people he would paint afterwards; it's interesting to see how he changed the frame of the scene in this process going from photography to painting.

HUO:

We're coming towards the end of this interview on a very bumpy flight between Frankfurt and Paris. Are you ever scared about flying?

AS:

No, never until now.

HUO:

We have three more minutes.

AS:

Imagine we crash and somebody finds the camera with the tape inside. Or maybe somebody finds it in the flea market in Clignancourt, and buys it and makes a film out of the tape! Have you seen that film by Chris Marker, *L'Ambassade* (*Embassy*, 1973)? It's a fantastic film. The story is set during what looks like the aftermath of a military putsch in a Latin American country, but the name of the country is never mentioned. Left activists are trying to get to the embassies in order to escape arrests and killing. They find shelter in an embassy a few days before leaving the country. At the end of the film, you see those people leaving the embassy in escorted cars

on their way to the airport. Last shot, you see the city out of the window and you perceive the silhouette of the Eiffel Tower. You realize that the story took place in Paris.

HUO:

Is Chris Marker important for you?

AS:

I discovered Chris Marker on my arrival in France and liked his films a lot.

HUO:

So the interview ends here as we arrive in Paris. In the first interview we were talking about landing, and now we are actually landing.

SEJIMA, Kazuyo

Kazuyo Sejima was born in Ibaraki Prefecture, Japan, in 1956. She currently lives and works in Tokyo. In 1981, Sejima obtained her architectural degree from the Japan Women's University. She joined Toyo Ito's office where she worked until 1987, when she established Kazuyo Sejima & Associates. Her first realizations were single-family houses in Japan and store designs. From 1995 she began collaborating with Ryue Nishizawa and they authored their projects under the name of SANAA (Sejima And Nishizawa And Associates). SANAA's architectural projects often act as open stages that attempt to facilitate freedom of movement while serving to mutually incorporate people, information, and media with the existing urban environments and landscapes. During the last decade, SANAA has consistently taken first place in competitions for large-scale projects such as the Edifici Mondo-Competition for the Recuperation of the Historical Center of Salerno, Italy; the Hirosaka Geijutsu Gai Design Proposal (21st Century Museum of Contemporary Art Kanazawa, Japan); a design competition for the Theater and CKV in Almere, the Netherlands; for the Instituto Valenciano de Arte Moderno (IVAM) in Valencia, Spain and the project of the design school Zollverein in Essen, Germany.
...................
This interview took place in Tokyo in July 2001.

Hans Ulrich Obrist:

We are in your architectural office in Tokyo, looking at the drawings of your projects: some show buildings that are already constructed now, others are just preliminary drawings for structures, and finally we have some drawings of projects that are unrealized. What is this one, for instance?

Kazuyo Sejima:

This is a project for Almere; it's a collaborative project between Nishizawa and me. It's a SANAA project. This shows the scheme at the end of the preliminary design phase. It is a theater and cultural center. As you can see, there are many routes connecting the various parts of the building, even though everything—including the circulation space—is a collection of different rectangular rooms, the different studios.

HUO:

Are these the different studios? It's not just a place for performing theater and music, but it's also a place for rehearsal and production?

KS:

Yes, but they're not meant to be used by professionals. It's a school of music, literature, painting, sculpture, computer engineering, etc.

For this reason, for this place we wanted the circulation between the spaces to be as free as possible—like in a park really. We tried to design the circulation space like different halls. Our intention is that these differently proportioned halls connect everything, but mainly that people feel like they are moving directly from one room to another when they flow through the building. Also, the space feels free of structure—it is designed with very thin sandwich panels. Every wall has the same thickness, and you can't tell the difference between structure and partition—there is no such hierarchy.

HUO:

Can you tell me about the public parts of the project that exist besides the labyrinth of rooms and studios?

KS:

This is a public theater. However, the performances in the theater and the things that happen in the rest of the building are not necessarily connected. The small theater will be used for half of each week by the theater people and for the rest of the week it will be used by the others. They share the performance space. [*Gestures*] This is an exhibition in Madrid, also a SANAA project (Arquería, Madrid, 2001). These were also thin panels... Instead of projecting images, we displayed an image and projected light onto it. And so, it was hard to take photographs of it! [*Laughs*] Actually, we mixed photos and drawings, lit by framed light, with video-projection. The luminosity was similar, resulting in an ambiguity between material image and projected image.

HUO:

And these are the models for the Kanazawa museum project (Twenty-first Century Museum of Contemporary Art Kanazawa, *1999–ongoing*). *They're organized like ornaments, like a cluster museum city. How did this amazing model for your project start?*

KS:

In the beginning, everyone participated in this project—the whole office. Everyone had one day to develop a scheme. Usually, when these kinds of models reach the end of their usefulness, they just get piled up and eventually thrown away. Luckily, the person in charge of this project somehow kept them. It was an exceptional case. The project is an art museum for the city of Kanazawa that Nishizawa and I are now designing.

HUO:

This is the museum Yuko Hasegawa is heading? She showed me some drawings. When is it due to open?

KS:

This is the final scheme. It will open in 2004, or perhaps at the end of 2003. Kanazawa is a historic city and the site on which the museum is being built is of particular historical importance. So we decided to put a particular focus on the landscape that the museum will slightly redefine. There you can find very old trees; each carries a very particular history. We wanted to show these "individualities" by distributing them over the site as solitary objects, rather than replanting them in groups.

HUO:

The city has a long tradition in pottery and craft. Yuko Hasegawa told me that besides the strong presence of contemporary art there will also be the inclusion of craftwork in context.

KS:

Hasegawa will bring in the traditional work in some way. However, she made a very strict selection of the traditional crafts, so that it will relate to the contemporary art. Things didn't get selected simply because they were old. Yuko Hasegawa, Nishizawa, and I are already collaborating very intensively. We're discussing the arrangement and the function of each room. Usually, the architect is allowed to design almost everything in a museum, even down to the arrangement and use of each room. It's only later that they assign the museum director, leaving them to use spaces that have already been designed and approved. So here, it's a completely different story.

HUO:

What did Yuko Hasegawa specifically ask for?

KS:

In the beginning, Hasegawa and we decided to make a large number of small spaces. In Japan, the client usually requires that the architect create big exhibition spaces that use movable walls. The idea is that you can change the space to suit the show. Hasegawa, however, hates movable walls. So we decided against making two or three big spaces, and designed 18 smaller fixed spaces instead. But the circulation is flexible, so that she can arrange the exhibition spaces in different ways, according to the needs of each show. The interior space will change with the exhibitions. This allows them to run separate, smaller shows simultaneously, or to use the whole museum. It's very different from the usual way of operating.

HUO:

How did you design the circular space then?

KS:

We are now thinking about how to create different senses of space in the corridors, because these are going to be a major element in the experience of the museum. There may be different ways of using the passage depending on the contents of each show. We are trying to inject a different sense of space, and also a different sense of time, into the experience of walking through the passages. Some passages have openings, but most don't. The corridors used by the public will change to suit each show. Normally, the peripheral areas are open, and people must pay to enter the central area. If there are two shows, however, the central corridor will be open to the public.

HUO:

And there will be no façade?

KS:

The circularity of the plan will make it accessible by pedestrians and vehicles alike from three sides. In order to encourage this multiplicity of approaches, both metaphorically and physically, we have intentionally resisted establishing a primary façade or entrance. So it has a disorienting sense of weightlessness, and of openness to unexpected experiences and perceptions.

HUO:

Another museum project of yours is the design competition for the Center for Contemporary Arts in Rome, a competition that was won by the Zaha Hadid Office.

KS:

In this design competition that we took part in, Nishizawa and I, there were some existing elements on the site that we thought were of little value, but we wanted to keep them anyway. There were lots of freestanding storage buildings, as well as some open spaces. We wanted to focus on this in-between space, so we proposed an in-between space that organized the warehouses. We inserted narrow, glazed spaces between the existing buildings. We eventually covered all the existing warehouses with glass as well. These glass boxes and glass walls surround the old warehouses, but people can see between them. People within the glazed spaces have the feeling that the storage spaces are somehow outside the museum, but people in the storage spaces feel that the glazed spaces are outside the museum.

HUO:

So you didn't take anything away? All the existing buildings remain?

KS:

We just removed the roofs. And what we thought about was to print

images of the existing buildings on the new faççdes. As the new façade has the same pattern as the old, it creates the illusion of a double layer. But as you move around, it distorts into different images. Of course, projects like the museum in Kanazawa are interesting, but in Europe we are very interested in using old spaces—castles or factories. In working in such spaces, we felt that we couldn't design new buildings—we wanted to have both old and new spaces, as well as the in-between space.

HUO:

So there would be a kind of seamlessness, a seamless transition between the old and the new?

KS:

Yes. Dealing with seams was the key issue of our project.

HUO:

What is your favorite unrealized project?

KS:

Yes, there was this project that I did with Nishizawa for a competition that was won by Rem Koolhaas: the Illinois Institute of Technology Campus Center in Chicago in 1998. We had great ambitions for the competition, and our proposal was a really utopian, ideal project. I wasn't so happy with it at the time, but as time passes, I like the project more and more. The scheme is very low, because of an elevated train line. We couldn't go above that height, so the interior has a very low ceiling. However, the building footprint is very large, and we tried to create a number of exterior spaces within it. We also tried to make a space without shadows.

HUO:

Do you plan to do an exhibition of your realized as well as unrealized work at one point?

KS:

I don't know whether or not it will be realized, but Luisa [Lambri] and one of the members of our staff are working on a photography project. Luisa has taken a huge number of photos of the work we've been doing, Nishizawa and me. They came up with a plan for a photography project, and asked lots of other photographers to take pictures of our work. We are not really involved, but their plan is to put together an exhibition or a book I think.

HUO:

Can you tell me about your collaboration with the Italian artist Luisa Lambri who ever since she discovered your and Nishizawa's work has pho-

tographed almost all of your buildings. She seems to play the role that Lucien Hervé was playing for Le Corbusier.

KS:

With Luisa's photos, even I can't tell which project each photo shows. *[Laughs]* They are so abstract: sometimes it's just a door or a window. This photograph here *[gestures]*—here I can tell you—is of our *M-House* (Tokyo, 1996–1997), a single-family house with a sheet metal façade that lets in light but, maintains privacy... And this, *[gestures]* I believe, is a view of our Gifu project (*Gifu Kitagata Apartment Buildings*, 1994–1998).

HUO:

In the last few years, there has been such an emphasis on the notion of shopping: architects, designers and artists are working more and more today on interior designs for stores. Future Systems are working on a sixty million spound Selfridges's department store in Birmingham; there are Rem {Koolhaas}'s three new Prada stores, and there's SANAA's Prada interior in Tokyo (Prada Beauty, 2000) and a future store for Dior. It seems to be a new phenomenon, even if, in your case it's true that you've been involved in such projects since the beginning of your career. How do you envision shopping and this phenomenon of working on store designs or retail architectural projects?

KS:

I don't have any preconceived ideas about commercial buildings—it depends on the client. If the client offers me something interesting, then I'll do the project, whatever it is. I started my career when the Japanese economy was booming. I was lucky to start at a time when everybody was open to commissioning young architects, because the established architects were busy doing big public buildings. And if I look back on this today, I would say that I was also lucky not to get more projects than I could handle.

HUO:

So there was a niche, or an opening for you?

KS:

Commercial activity created new possibilities for younger architects. This meant an opportunity, however I was not searching for a niche. I didn't really think of my position in a fixed way. I was and I am open to do anything really.

SOTTSASS, Ettore

Ettore Sottsass was born in Innsbruck, Austria, in 1917. He currently lives and works in Milan. Sottsass graduated with a degree in architecture from the Torino Polytechnico in 1939 and opened his own architectural and design studio in Milan in 1947. In 1958 he was hired by Olivetti as a design consultant, and in 1959 he designed, among other things, the first Italian electronic calculator and, later, various peripheral calculation systems and computers, as well as typewriter models such as Praxis *(1963),* Tekne *(1964),* Editor, *and* Valentine *(1969). A Valentine typewriter is now included in the permanent collection of New York's Museum of Modern Art. Over the years, Sottsass has created several hundreds of objects, electronic items and pieces of furniture, mostly one-offs, which have been widely exhibited in galleries and exhibitions. Following an exhibition of his work in Milan in 1966, a movement emerged in Italy during the late '60s that was called "Anti-design." The group rejected the formalist values of the neo-modern design movement in Italy and sought to renew the cultural and political role of design, believing that the original aims of Modernism had become nothing more than a marketing tool. In contrast to Modernism, the movement was founded on a belief in the importance of an object's social and cultural value as well as its aesthetic function. Employing all the design values rejected by Modernism, it embraced the ephemeral, irony, kitsch, strong colors, and distortions of scale to undermine the purely functional value of an object, and to question concepts of taste and "good design." Sottsass spearheaded the activities of several successive groups of designers that he founded, such as Archizoom, Global Tools, Alchimia Group, and Memphis Group. In 1980, he founded Sottsass Associati with Aldo Cibic, Matteo Thun, and Marco Zanini, whose activities range from architecture to interior design, graphics and exhibitions.*

........................

This interview was recorded in Milan in February 1999.

Hans Ulrich Obrist:

Let's begin with the beginnings. I'd like to start this interview by talking about the exhibitions that you participated in or organized in Milan just after the Second World War. I've heard that with Bruno Munari you curated the so-called "First International Exhibition of Abstract Art" held in Italy, which took place in Milan in 1946.

Ettore Sottsass:

I was living in desperate straits in Milan, penniless, and we were working on so-called abstract, or "concrete art" as it used to be called then, with immense enthusiasm. People just didn't want to know about it! I was living in the home of a Swiss architect—his name's sure to come back soon, it escapes me at the moment. He

married a Swiss lady who was seriously rich and he was interested in abstract art. With Munari we had worked on this exhibition, but actually I could be described as an outsider back then. I was a pupil of [Luigi] Spazzapan, perhaps you don't know him, a painter who worked with a very graphic style and did gestural painting. Just think, pre-gestural painting already back in '38–'39. Even my own abstract art was halfway between gesture and figurative representation. It wasn't unrecognizable as such, but underlying it there was a form of figuration.... The abstract art of Munari or Max Huber (another Swiss graphic artist who lived in Milan), or Max Bill, was by contrast a much more concrete form of abstraction, much more downright, more geometrical. It was almost by chance that I took part in the exhibition. There were very few of us in Milan doing these things, but at any rate I can hardly say I organized it. An exhibition I did organize, though, was the art show at Palazzo Reale a few years later. I think it was called "Abstract and Concrete Art." I wrote a text for the catalogue, a crazy text, and in the catalogue there were all the great European artists of those years. It was a rather serious affair, but the climate in Milan in those years, I mean 1948-1949, was different. In the culture of those years we were very isolated, it was a more political type of culture, we might even say a nationalistic culture.

HUO:

Reading these early catalogues it struck me that the boundaries between the disciplines were very fluid. And this was an important fact, something that then continued and became a constant feature of your work, which developed and so took in art, design, and architecture.

ES:

Yes, that's true enough.

HUO:

Can you tell me about this interdisciplinary approach and the importance of fluidity and circulating between these separate disciplines?

ES:

However you look at it, I feel the task of the designer or the architect is to design the artificial environment: from objects to architecture, spaces and so on. Each design corresponds directly or indirectly to an idea one has of life, of society, of the relations between the individual and society. It corresponds to the form of the *Weltanschauung* [worldview]; it remains the basic cultural background. And this happens no matter what you do. Whether I

design a vase or design architecture, there is always this background, this basic cultural background. The difference, then, is technical, only technical. It's clear that if I'm designing architecture I need to know things that are not that same as what I have to know to design a glass vase, and to design a glass vase you need to know things that are not the same as what you need to know in order to take a photograph. But apart from these technical differences—, which are certainly important, because they have an effect on what I can design and condition it—there still remains deep down what I think of life, why I do things, what I imagine happens when I design something. So I don't see the point of any clear-cut distinction between disciplines. Take the Renaissance. It was hardly an accident that the Renaissance was a period when many artists imagined above all a new kind of life. They imagined a new society, a new vision of the world, a new, say, interpretation of the potential of life. They didn't make a major distinction between Brunelleschi's dome and the design of, say, some other work of architecture, or a sculpture, a fresco. They tackled the technical differences that might, I repeat, influence the way they used these different vocabularies, but nothing more.

HUO:

You have always have spoken rather critically about this world of highly specialized architecture and have defined a much more transversal approach, and for this very reason you raised a lot of interest among young architects today.

ES:

They definitely feel this need. The important thing is to think—to think about what's happening. The fact is that if someone thinks hard he can then decide that a building ought to be made out of welded tubes or perhaps he'll decide to build it out of masonry. This means he has thought the question through. It means that behind it all there is some hard thinking, an inner tradition. For example, I come from the mountains. I was born in Innsbruck, I spent my childhood surrounded by woods, mountains, high crags. Inside me I have a sense of weight that's quite different from [Norman] Foster's, though I have no idea where he was born, but at any rate he has an idea of weight quite different from mine. Weight riles him, but it comforts me. If a thing is heavy, I feel laid back about it. If it's flying through the air, then I start to worry. So there are these different strands in our visions of the planet, of the cosmos, and the feeling we have, right from the start, about these things. But there's more to it

than that. Let's take another example. I'm an atheist, deep down. I don't know why, I don't know what path I took to reach this point, but I'm an atheist. When I say I'm an atheist, I don't mean I'm not a Catholic or not a Buddhist. I mean an atheist in the sense that I don't believe in the human mind's ability to conceive anything outside the measure that the brain itself is capable of, anything outside these limits. Once I was putting on my jacket and I saw a cat looking at me, and I thought: however hard the cat tries he can't understand why I'm putting on my jacket, he can't know the jacket is made of wool, he can't know why I get up in the morning and have to put on my jacket. We're in the same situation when it comes to these phenomena called extra ... I don't know quite what they're called, say religious or metaphysical. You see I'm here indoors, staying under a roof: we are and we live under a roof, we can't leap out from under this roof. So all our reasoning is related to this sensorial existence of ours that draws on and shapes itself in forms that are the forms of culture.

HUO:

Are you interested by the debates going on in the scientific field on the questions related to uncertainty?

ES:

About unreality.

HUO:

They talk about uncertainty and doubts...

ES:

It's a doubt that's developed in my own mind. But I think I'm not the only one to feel this. I believe it's valid for scientists, too. A few years ago, I began to have some sense of the scale of the cosmos. I tell myself our planet is in the solar system, which belongs to a galaxy, and in this galaxy there are hundreds of thousands, perhaps millions, of solar systems, and there are several billion galaxies. Well, at this point I say to myself, "I can't understand what all this means." Even the fact of seeing the earth from the moon or from the sky stuns me. It confirms the fact that this planet is a paltry orb spinning in a void. From one minute to the next it could blow up or collide with something, or just die slowly of cold, or whatever. Compared with this, all existential dimensions have a different scale. This is what I think, what I feel deep down, and at the same time I feel that while in olden times the whole effort consisted of trying to reach some point, to identify reality, today it's just the opposite. Today we can't get a grasp on anything. Existence is fragmentary, because we no longer accept the logic we hoped would tie

up everything. Even that great scientist strapped to a wheelchair, [Stephen] Hawking, said this: "If we could find a formula that holds together the universe I'd know what to think of God." The fact remains that this formula can't be found! It doesn't exist!

HUO:

Now a small part of the scientific community again thinks that they've found it...

ES:

Well, we'll see. At any rate the same problem exists in everyday life. When I read a newspaper, for example, I can't grasp the dimensions of what's happening between here and, say, the Middle East, between here and New York.

HUO:

I know that Oswald Wiener, a pioneer of cyberspace, worked in the '60s for Olivetti. You, too, since the late '50s have worked for Olivetti as a designer and design consultant, and I wondered if you had any dialogues with scientists there.

ES:

No, but for example, even when I worked at Olivetti on electronics, it was back in 1959 or 1960...

HUO:

When you were working on that first big computer?

ES:

Yes, a huge computer. It was in Pisa, I arrived by train. Then I had to get a horse-drawn carriage, because there were no taxis, and it took me to the outskirts of Pisa, where there was a nineteenth-century villa surrounded by a garden. Inside there were all these white-coated engineers walking about across miles and miles of cables snaking across the floor. Even electronics in those days was a bomb of uncertainty. It still worked with valves, valves of colossal dimensions. Now, not so many years later, we all have nice little packets of electronics in our pockets. But the odd thing was this place of total uncertainty, with the old-fashioned horse-drawn carriage, the villa, and the garden. It was all very odd.

HUO:

In your writings, you often use the terms planetary, or global. I would really like to explore that now, given the dimensions that these notions have achieved today.

ES:

I feel very deeply, even if one is an atheist, I mean even if he doesn't seek the truth—we are all compelled, conditioned, to act out a comedy. We're doing it here, too, at his moment. You ring me, you

arrive, we do these things. At this moment the comedy is reduced to these actors: you, me, and our photographer friend. You know there's this humdrum routine and there's also this humanity. Humanity exists. Humanity has a long history. What would be interesting, or at least I'd find it interesting, would be to understand, or try to understand, what the essence of this humanity is. Not its relationship with the cosmos, but its inner essence. Why we are men, what we are doing as men, what responsibilities we have as individuals with respect to society, and so forth. I find this is the most fascinating part of thinking at the current time. Heidegger already had this fixation with trying to understand the human essence. Why do we think? Why do we have these relationships? How far can we develop this line of argument, this comedy? How can we control this comedy or at least know something about it? If you did an exhibition in a kitchen, for example, that would be something that would interest me personally a great deal. To me it's like saying, O.K., we've got to eat, we talk about eating and we feel we're intellectuals in this place, a place where you eat.

HUO:

I know about your research into kitchens—I read an article of yours dating from 1992. When did you start working on this topic?

ES:

I can't really say. I think some time in the '60s.

HUO:

There are also a lot of photos of kitchens that you took.

ES:

Yes, there are a lot; partly because first I was married to a lady by the name of Fernanda Pivano, a writer well known in Italy for translating and writing about contemporary American literature, and she couldn't even make a cup of tea. For reasons I won't go into now, we split up and I met another young lady called Barbara Radice, and she has a lot to say about cooking, I mean how it's done. She talks a lot about it, not fervently, but almost as if it was a sacred ritual. For example, the other day she asked the chef at the Torre di Pisa how many minutes a certain kind of pasta had to cook. The chef, a woman, said, "Minutes? I just look at the pasta." Meaning she didn't need mathematics, or to measure time, but a visual, sensuous contact with the pasta to know if it was cooked or not. Years of experience.

HUO:

Do you know Cedric Price, the British architect?

ES:

Only by name, not personally.

HUO:

He's also interested in cooking, in terms of urban planning and architecture, and of course time.

ES:

Certainly time is very important. But here we're talking about another kind. Not continuous mathematical time. It's time reckoned as deformation, as change. Chinese fashion...

HUO:

What do you mean?

ES:

The ancient Chinese had no idea of continuous time, the mathematical idea of time as a continuum that can always be measured. They calculated time by kings, by dynasties, by the seasons, by sense data, and not cerebrally.

HUO:

On the subject of time, two weeks ago we did an exhibition in Bangkok, and there were different calendars: some say the exhibition was happening in 2000, and others that it was 2052.

ES:

That's one way of thinking. I don't mean we have to think that way, but it's certainly interesting to know people have thought like that or can think like that still.

HUO:

I have often wondered whether or not there was some affinity between Italo Calvino and you. If I think of Le Città Invisibili *(Invisible Cities, 1972) and some of your texts; I can see interesting crossing points in terms of making the invisible visible and vice versa. Was there any connection between you and Calvino?*

ES:

No, I knew him, but only causally. We never went beyond wishing each other good evening and we never worked together. But as for what you're saying, in '56 I went to America for the first time and I met George Nelson. We Europeans—I don't know if we can say "we Europeans," but we who belong to these cultures on this side of the Atlantic—we have death in our pockets. I mean we can never forget this destiny. When I used to talk with George about death, he said, "We Americans never talk about death, we never want to talk about death." And then there's an architect from San Diego, she's been working with me for years, Johanna Grawunder—whenever she sees something even indirectly connected with death she

says, "That's very strong. Why is this?" By contrast, in India, I found it very consoling. Whenever you look out the hotel window every half hour you see a corpse being carried off wrapped in a shroud and strewn with flowers. This ability to relate to this inexplicable phenomenon is consoling, it's very important.

HUO:

So you think the architect ought to make these things visible in his work? Or not make visible but work with this. In this same line of thought: are there other things that you find are overlooked?

ES:

It's no use asking me this because by now I think there's nothing to be done. There's nothing to be done because we now live in an industrial culture. We invented the machine a few centuries back and I feel the machine fulfils its own destiny. Just as bronze, say, meant a new way of waging war, of killing. The fact that a lot of products can be produced with machinery, mass-produced, resulting in masses of products, inevitably means that we have to sell these products, we have to give them to someone, and selling them inevitably entails all the possible forms of persuasion so people will buy them. The upshot is that we think less and less because we're increasingly conditioned. For all these reasons we can no longer say, "I wish the world was like this or like that." O.K., say it if you like, but it's pointless. The point, if there is one, is to find a way to navigate our way through this destiny.

HUO:

So you think it's not even possible to reverse or resist this process?

ES:

I don't know, I don't see a way. Anyway, I'm not someone who wants to change the world.

HUO:

And how do you see the evolutions that have taken place in cities and urbanization?

ES:

The city is jam-packed with cars. In Milan, anyway, you can hardly move, and we all keep saying, "Hell! It's full of cars, how can we keep going in a city like this?" But as long as Fiat or Mercedes keep on turning out 2000 automobiles a day, they've got to go somewhere! But if we tell Fiat to quit making cars there'll be thousands of people out of work! I feel this kind of impossibility, this thing I call destiny, something inevitable.

HUO:

It's also interesting to see what's happening in Asia. There are a lot of Westerners there, planners, who tell the politicians, "You've got to prevent the kind of problems we already have in the Western world from taking root here." The mayor of a Chinese city replied that first they wanted to have everything and create the same hash and then, perhaps...

ES:

That's inevitable. It would be like telling someone that lives by the sea not to go out in a boat, not to go fishing, or someone who falls in the water and can't swim not to drown. True, there's a life jacket, but that's not the solution. There's no solution on these levels; I just don't know what to say. That's why we increasingly talk about humdrum, everyday things, about private peace and quiet.

HUO:

Micro-Utopias.

ES:

Yes, I think so. Andrea Branzi sent me a text where he says, too, that we can only work on the micro-situations. That's why [*laughs*] I think the Dalai Lama enjoys a certain success. It's got nothing to do with it, really, but Buddhism, classical Buddhism, not the institutional kind, had this idea of working on our micro-existence, on micro-gestures, micro-events.

HUO:

Some years ago there was this community of thought that claimed: "We have to talk about the micro-world, about ourselves, see things in a dimension of micro-politics." But now we've reached a point where all that's left of this micro-politics is just sheer individualism.

ES:

No, I don't agree. The self exists politically, it doesn't exist nonpolitically. The self is determined by the fact that, for instance, I speak Italian, I feel Italian, and I had an Austrian mother. I'm myself because all around me there are a lot of people to whom I'm me. Someone invented the camera, so I'm myself because I take photos, and so on. I'm myself because someone invented tempera paints, and so on. The self doesn't exist as an abstract entity—it's politically determined. Then it depends on what you mean by politics. Anyway, I say it's socially determined, anthropologically determined. You work within these conditions, so the anarchist that talks about himself, the real anarchist that talks about himself, is someone that talks about himself with a great ethical conception in relation to the whole of his surroundings. And that's really very rare.

HUO:

What you say reminds me of a text that you wrote on houses where you describe places you visited and the impression you got of them. Your description, which is very precise, shows there's always someone who has essentially developed houses by adapting to the given conditions, rather as mushrooms adapt to a forest.

ES:

It's a situation that becomes clear if you travel a bit. For instance, you go to Myanmar and see houses that clearly correspond to a definite world. At the same time, the environment determines the house, the way the house is built. For instance, if there's a stream and the women have to fetch water, then the house is built near the stream; people wash themselves in the evenings by the stream, the way they do in India, for example. In mountain areas the houses are made of stone, in deserts of hangings. All of us carry around our own cultural symbols. There are peasant houses where they hang a sheaf of corn over the door for good luck. Then there are, say, bank buildings: they have massive doors that overwhelm you, so when you go and ask them for money they make you feel like: "Watch out! You're coming in here and we're going to make mincemeat out of you!" Of course there's this sum total that I call culture in general, the sum total of cultural residues that are sometimes very ancient.

HUO:

How do you see the issue of housing in the city?

ES:

As long as humanity goes on growing at the rate we're growing now, the distance between one person and another is going to grow bigger, like the distance between one place and another. Even bigger. So this idea that we can go from house to house on foot as in the Middle Ages, or the idea of the piazza—they just get lost. This formula where some houses, I mean the people living in a group of houses, all gather in a kind of outdoor salon, meaning the piazza—that's simply unattainable nowadays. In Milan I only ever visit one or two districts, that's all. All of us living in big cities just really live in one or two districts.

HUO:

But what about the subway system?

ES:

True, but if one of the young women that works in my office says she has to leave home at seven a.m. because she has to be here at

eight, I instinctively feel, poor thing! In New York it's even worse because you have a two-hour train ride every morning and two hours every evening to get home. You get home and your house stands in the middle of a garden but it's no use, because when you get home you have to hit the whiskey to get over the traveling, and that's no solution either. We all know about American and English garden cities, but you get home so shattered from hours of commuting that you no longer feel the house belongs to you. You ask me what I think about the problems of the city, but I don't know what to answer. I've often asked myself how I would conceive of a big city. We worked on a master plan in Korea, a project for the layout of an urban area around Seoul's big international airport, one of the biggest in Asia. There's a lot of competition in airports, between Japan, Korea, China...

HUO:

Because they'll soon be having the World Cup soccer.

ES:

Perhaps, but at present there's also competition for business. To build this airport they filled in the sea between two islands. For ten years they'd been unloading soil between one island and another and they asked us to put forward some ideas for a master plan. The project grew out of this. We asked ourselves, "What should we do in a place like this?" The only thing we could think of was to lay out some big express roads running through the center of the city and some other almost private minor roads, first semi-private and then private, that became increasingly convenient for people to use, easier for children, for women. We laid out big pedestrian precincts linked by express roads. This is not such an unusual concept; after all, it was one of Le Corbusier's ideas. We also thought—but I guess this was an ideological Utopia—we could create a city without ghettoes. To avoid having a working-class zone, a middle-class zone, and a zone for the rich. That these different zones should overlap. But I repeat, I don't know whether this can really be achieved. Anyway, we proposed a form of zoning to prevent what happened in Beverly Hills, where there are big chic areas with peaceful streets and then huge tenement blocks in the outer-city and so on. I repeat, I don't know if it's feasible, but I feel we have to think a bit more carefully about these situations.

HUO:

Could we talk a bit more about this project for Korea?

ES:

Here you can see it better [*gestures*]. That's the park and this is the business district. There's the university somewhere, here, if I'm not mistaken, close to the sports center. In short, planning is a makeshift science!

HUO:

That's a splendid definition! Is there a direct link with the documentary on kitchens?

ES:

Yes, I guess so.

HUO:

But speaking of this in terms of micro and macro, because it's a question I ask in every interview: Can you tell me also one of your favorite unrealized projects?

ES:

[*Laughs*] Nearly all of them are unrealized! To this question of my favorite, I always say there is no favorite. If you imagine life as a comedy of oddities, I could say someone once answered this question by saying: the next one. In much the same way, I'll reply, "The one I'm about to do!" By this I mean there's a continuous dynamic, a continuous urge, a permanent workshop in the way we live. There are periods when I feel better and periods when I feel worse. Because I often fall into a crisis, into a cultural crisis, let's call it. Times when I fall into the conventional, I get a kind of creative block and then I have to wait till some idea arrives. Afterwards there are times when I think I have discovered a makeshift solution, I keep going for a bit and then, crash! I collapse again. It's a continuous struggle to keep going.

HUO:

It's not straightforward.

ES:

No, it's not straightforward. And above all there are no definitive moments. There are crucial moments, but they are fleeting, because the crucial moments are fleeting. For instance, it's clear that my first visit to India back in 1960 was a crucial journey that confirmed some ideas and suggested others, but it was crucial mainly because it led me to a different place.

HUO:

I read that you produced some artworks based on your trip to India. In your book here you say they were a set of ceramics.

ES:

I went to India when I already had a kidney disease, though I didn't know it. My feet were swollen, but no doctor here in Milan told me I had this problem and I went to India, where I stayed a month, perhaps a bit longer. I wasn't well, I felt weak, but I didn't understand the reason, because I didn't know I was ill. When I got back I saw a doctor, who said, "Listen, you're dying." By the way, a *shadu* in Bombay had already said the same thing when I was coming out of the hotel. Outside the hotel there was one of these holy men, who offered to read my hand, something I have never done, but my wife was there and she said, "Go on, have your hand read"—I don't know why women are always interested in this business of magic. This guy, he looked at my hand, in fact he didn't even look at it. He looked me in the face and said to my wife, "Look, you have to take very great care of him, otherwise he's going to die." He had evidently seen I was ill, in my eyes, or my skin, perhaps. Back in Italy I began to have a lot of tests and at one point a doctor said, "You'd better make your will, because we have no idea what to do." In those days I was a close friend of Roberto Olivetti, who grasped the situation. He said, "Ettore, what are you going to do?" I said, "I want to go to Russia or America." At that time medical science was much more advanced in those countries than here in Italy and by chance there was an American doctor in Milan, a specialist in illnesses of this kind, who recommended a hospital in California. The upshot was I went to America, and after three months in the hospital I got over it. When I got back I did a series of ceramics that I called *Ceramiche delle Tenebre* (*Ceramics of Darkness*, 1963), and there's a great article, at least I think so, that I wrote about these ceramics, that brought out this problem of the darkness. I mean of looking death in the face, a problem that you feel very deeply in India. Among other things I felt a special rapport with this Indian way of thinking about death, perhaps because I was ill, but also because India is a place where this closeness becomes commonplace, it's their daily bread, so to speak. Then there was the experience of an American hospital, well organized, with voices booming out of loudspeakers in the corridors. All this was, so to say, a spectacle of death. Well, I worked on these ceramics, but it's not India so much as the experience of the closeness of death that was behind them.

HUO:

Another question about another text I read, the one where you describe an imaginary journey through your drawings and you speak of an archive. It also speaks of a cupboard as a mysterious, scented place...

ES:

Yes, once I wrote about this cupboard where I keep all the paints, the papers, my instruments for drawing, and whenever it's opened it gives off a wonderful perfume.

HUO:

What about the archive?

ES:

Some time ago I published a book of photos with the English publisher, Thames & Hudson, titled *The Curious Mr. Sottsass* (*The Curious Mr. Sottsass: Photographing, Design and Desire*, 1997). There's also an edition in French. For the occasion, about five years ago, I began to organize my photo archive better. I've almost finished.

HUO:

Your photos appear regularly in Terrazzo.

ES:

I love *Terrazzo*, a lot of my photos are published in it. There are my photos in every issue. You know, it's a very homemade magazine.

HUO:

Can you tell me about your addiction to travel?

ES:

Well, curiosity. There's an almost paranoid form of curiosity to see what's on the other side of the fence and also the urge to see if some things are confirmed or not confirmed by it. But actually I believe that you travel to confirm something, confirm your ideas, and whatever you can't confirm you discard as you travel. In practice you find yourself, in a certain sense you redesign yourself when you're traveling. But then there was a moment when I felt the need to get away from Italian provincialism, almost European provincialism even. The fact of getting away from Italian monotheism and finding myself all at once faced with this popular comic-book religion of India was a tremendous shock.

HUO:

And during these trips did you meet any artists, intellectuals?

ES:

Sometimes I did, sometimes not. I went to Japan a number of times and always met architects. On one of my trips to India I was staying with Francesco Clemente, I stayed at his place a month, and I learnt a lot there. For instance, this idea of accepting the corruption of things, the destruction of things as destiny. I learnt that in India, because the people there don't care in the least if things wear out.

They have a much more tenuous idea of life. Life wears out, you grow old and wear out, marble wears out, roads change, and this is a concept Western culture tries to avoid. We repaint the house, we keep things repaired, everything has to look new all the time, everything has to be under control. That kind of suppleness the Indians have, the fact that problems of this kind don't exist for them, strikes me as wonderful. All this is very obvious in Francesco, who is not just a painter but a thinker. At any rate he paints amid this permanent uncertainty, awaiting this destruction.

HUO:

Did you work with Clemente? Did you do anything together?

ES:

Yes, we did various things together, apart from the fact that I designed the furniture in his home at Amalfi.

HUO:

You designed Clemente's house in Amalfi?

ES:

Not the house, the furnishings, in a house belonging to Francesco's wife Alba, who's from Amalfi. Her parents had a very beautiful house and I designed the furniture for it. Anyway, when I was in India, Francesco produced a book this size [*gestures*], all covered in copper. And it was printed in India in color by a lady who had an old printing press; but she had colors you can't find anywhere, reds, oranges… She printed enormous reproductions of Clemente's drawings. This book was made from different colored papers, Indian papers, and I think it was divided into chapters, and between one chapter and another Francesco asked me to do the drawings. I didn't know what to do, because I didn't dare to draw with Francesco, but I remembered I'd once met some Bororo in Milan. You know who the Bororo are?

HUO:

Only, vaguely.

ES:

The Bororo are a tribe in the southern Sahara whose only religion is beauty. Just imagine, they keep holding beauty contests all the time. They're really beautiful, very tall, wear ornaments, men and women, fantastic, and one of the ornaments most important for their beauty are their teeth. In their beauty contests they continually show off their teeth. Well, these Bororo came to do a show at the Teatro Manzoni. They were coming from Paris on their way back to Africa. I went to see them almost by chance and, in short,

I was enraptured with these Bororo, they way they danced. They were so good-looking, tall, strange... So I went to meet them backstage, because I wanted to talk to them, hear what they said, but of course they didn't speak any language except their own. Luckily they had an agent I could speak to. The next day their bus was leaving at 7 a.m. and for once I got up at that hour to see them off. By the way, we went to drink some coffee together and when they saw me putting sugar in mine and I asked, "Do you take sugar?" he emptied the whole sugar bowl. Then they were fascinated by the window of a toyshop with popguns in it. You know, the ones that shoot a cork tied to a length of string. They really liked them. I had a Swiss book with me—I seem to have mislaid it now—with photos of the tribe. Well, I asked this guy to sign it for me—he was really good-looking—so he took the book and very, very slowly he covered all the pages with signs. And this very simple gesture was all I could think of doing in Francesco [Clemente]'s book, the only thing I felt I could do, avoiding any intellectualism. I've got a good relationship with Francesco. I study his watercolors very carefully because he has a very unusual technique. He plays a lot with uncertainty.

HUO:

You've used this watercolor technique yourself, haven't you?

ES:

Yes. You do a wash of paint and let it dry, then you wet it with water and put a drop of paint and this paint spreads in the water at random. If you look at one of Francesco's drawings, say of a leaf, it has a certain green color, then he wets the edge—these are secrets I shouldn't be revealing—with a darker color and what happens? That color spreads in the water and then, by molecular cohesion, it forms a sort of darker line. At one point it's blurred and at another there's a trace of definition.

HUO:

Can we go back to the question I asked you earlier, about your interest in other disciplines, the interdisciplinary approach so obvious in your work? One thing that comes out in your texts is the experience, or rather the attempt, to found Global Tools.

ES:

It's not that I founded it. I had founded the Archizoom Group with Andrea Branzi, plus some other people, especially some young Florentines. In Florence in the late '60s and early '70s there were some very aggressive groups that came from the political experiences of

'68, and we were all beginning to question our role. We asked ourselves about the professional position of designers in relation to industry. It was a period when I was hardly working any more. I no longer worked as a designer. I only worked for Olivetti because it was a rather special company. But it was there that I first refused to see myself as an industrial designer in the classic sense of the word.

HUO:

Meaning opposition.

ES:

Yes. In this context we founded Global Tools, which lasted a few months because the more extremist youngsters tried to destroy any intellectual operation. It was the period of the Cultural Revolution in China and they were dismissive of everything, they practically wanted to junk everything. This experience of ours didn't last long. The idea was to retrieve elements that had disappeared from design or never been part of it. For example, if it was a question of colors, we used to talk about natural colors. We tried to have a physical contact, more concentrated on the design, less remote, less abstract. The experience really meant a lot! Then there was all the Native American culture that reached us here from America. Then a whole series of feelings, of thoughts, of possibilities that concerned the redefinition of the word "designer" and the profession.

HUO:

Did you try to redesign some social aspect of the profession of designer?

ES:

In a sense, yes. We hoped to have a gallery we could use to hold exhibitions, to present our work together, without too many constraints. In the end we found a gallery but the gallery owner happened to be a big steelmaker, so those extremists objected, "We can't work in this gallery because we'll be conned by the steel-making capitalist." In short, all those problems that are partly true and partly false, though perhaps they were part of the debate going on then.

HUO:

In Global Tools there always appeared this sense of resistance, of priorities, of the exaggerated importance in our culture of the visual sense compared with the other senses.

ES:

More than the visual sense, the priority and the predominance of the intellect over the senses. The whole of Functionalism, as the word itself shows, was a hope that the intellect would succeed in

controlling design all the way through. Instead, and this was the novelty, we found confirmation for our ideas in India and many other places. What I think is that first of all we read the world sensuously, we catalogue it and, so to say, intellectualize it, but the source of everything remains the senses. To a Functionalist, the surface of this table is a geometrical square; to me it's a piece of plastic, warm or cold, or whatever.

HUO:

So Global Tools was also a revolt against Functionalism?

ES:

Not against it. We tried to go beyond it, let's say. We were never against anyone. I come from the Functionalist school, [Walter] Gropius, Le Corbusier. When I was young they were my myths and I've never forgotten them, I've never despised them. But I've always thought all this wasn't enough, that we could go much further. To those generations the word "functional" meant ergonomics more than anything else, the relation between the human body and physical space, a relationship based on measurement. But to me "functional" means, for example, that red is functional to the Communist party because it has a red flag, or the fact that, say, functionality often involves issues that can't be measured.

HUO:

Branzi says that modernity is not finished. The idea is to continue it.

ES:

Yes, definitely to continue because there are aspects of it that are still being developed. I believe in what a Catholic would call materialism. I mean this living in the body, eating, touching, and feeling, in the general spectacle; at any rate more in the spectacle than in thought. This is a form of contemporary destiny.

HUO:

Having begun with a question about your first exhibition, I'd like to finish with a question about exhibitions and museums. In the '80s and '90s there was a boom in museums. But museums are considerably less interdisciplinary than they used to be, say, in the '20s if we think of Alexander Dorner in Hannover, or in the '50s with Willem Sandberg's Stedelijk Museum in Amsterdam. Perhaps today a museum is nothing more than a sort of archive.

ES:

Yes, they're archives. I think, for instance, that a museum of design is out of the question. It just can't be done. An object has a value because we can touch it, use it. Even a museum of architecture is

almost out of the question in terms of my idea of architecture. Architecture is a space where you can walk, you pass through it, you touch it, you see the light, etc. I really believe a museum of applied design done like the few I've seen is pointless. They generally take a razor and put it on a pedestal, but a razor isn't a sculpture, it's a razor. Even a chair is a chair and you have to sit on it. So there's a big difficulty in doing a design museum. The same is true, for example, for a Happening in a contemporary art museum. Conceptual art comes out strangely in a museum. You go there and see a white room with a line and you say, "Heck, is that meant to be strange?" At times I think museums ought to be enormous, underground, gigantic archives, with the part the public visits just putting on temporary exhibitions, closely reflecting what is happening outside, historical changes, etc. At the same time each person would visit the museum a number of times because every exhibition would be different. I don't think there's much interest in museums conceived the way they are now, I mean as museums of institutional representation.

STEELS, Luc

Luc Steels was born in 1952. He currently lives in Paris and Brussels. Steels studied linguistics at the University of Antwerp (UFSIA and UIA) and computer science and electrical engineering at MIT (Massachusetts Institute of Technology). Since then, he has conducted research in several areas of Artificial Intelligence (AI). In 1983, he founded the Artificial Intelligence Laboratory of the Free University of Brussels (VUB), which is enjoying international acclaim in the field. The laboratory has been conducting research in reflection and meta-level architectures for knowledge representation and behavior-based approaches to AI through the experimental use of physical robots. More recently, in 1996, he became director of the Sony Computer Science Laboratory in Paris, where his focus is on the origins of language and the emergence of grammar in autonomous robotic agents. Recently, Steels has participated in a variety of contemporary art exhibitions and projects, developing experiments on the meaning of colors and collaborating with the artist Olafur Eliasson.

........................

This interview was recorded in Paris in April 2002.

Hans Ulrich Obrist:

You are a scientist, but I once saw you on the cover of a Belgian art magazine featuring your work in performance art. You looked very young in this picture. So already in your student years, you were a cultural protagonist and a science apprentice? Were you already interested in building bridges between the two disciplines?

Luc Steels:

My work has always focused on trying to understand the process of creating meaning. This is at the core of both language and art. It is also a central element of theater or performance, and these fields interested me enormously as a student. At that time, I was heavily involved in organizing exhibitions, doing performances and playing music, much more than in science. As a student, I studied languages and philosophy first, and only much later computer science and electrical engineering. It was only at the very end of my studies in language that I became interested in science, so maybe if that hadn't happened I would have become a curator or an organizer of art events or perhaps an artist.

HUO:

Was it a chance encounter that led you in the direction of science?

LS:

Yes, it was a completely chance encounter. A student in my dormitory told me about a course in computing and he invited me along. I said, "Yes, why not," although I did not have any clue what computers were. I came almost entirely from a humanistic background (philosophy, literature, psychology, art, theatre, etc.) although I was extremely interested in linguistics and logic already. The Chomskian revolution was taking place in Europe around that time, and the development of Montague grammar in logic. But then I suddenly encountered computing.

HUO:

What year was this?

LS:

1971.

HUO:

Early days!

LS:

Yes, there was only one computer at the university and we all had to take punched cards to a big machine that would run once a day. It was a very archaic situation compared to today. What I found attractive about computers is that they provide a way to test theories and to make very powerful models. For me, it is a lot like using clay to make a model for a sculpture, or the way that an architect makes a model of a house in order to visualize it and experiment with it. I was very surprised to discover (basically on my own) that you could use computers in that way for studying language. I had intuitions about certain aspects of language, for example about how we parse together sentences, but when I tried to make a computer model, it did not work. I realized that my intuitions had been completely wrong. So computer modeling is a way to advance in your thinking. Later, I used robots in the same way—to test ideas and make models of cognitive phenomena and behavior. This whole thing fascinated me so much that I became less and less involved in art, by necessity. Then I moved to the United States, to MIT, to study computer science and AI seriously. At MIT, there was an intense activity in science and engineering, but in terms of art, there was not much happening. This was the mid-'70s.

HUO:

The only area of this art activity that I know of is from this magazine arti-

cle with the mysterious cover in which you're wearing a contraption on your head. I was wondering if you could tell me more about the kind of perform-ance art that you were doing and your involvement in the Belgian art scene at the time.

LS:

That picture was actually taken at documenta V (1972) in Kassel, where we were doing unscheduled, unofficial performances on the side. We played in all sorts of arty venues with a changing group of young artists. Antwerp was a breeding ground of art—it always has been, so it was very natural to do these things. I also worked in a gallery at that time, as a student. There was the MTL – Art in Project Gallery in Antwerp.

HUO:

Wow! These were pioneer galleries in the '70s!

LS:

Yes, and so I had deep exposure to the conceptual artists of that time, such as the people from Art and Language, and Gilbert & George (they were just there at the door one day). But also Lawrence Weiner, Joseph Kosuth, and Sol LeWitt: they were all exhibiting in that gallery at the time. So I knew quite well what was going on. My own art practice was in performance, and we did a lot of perform-ances in those days. It was a combination of music, of "musique con-crète," and electronics, and various odd behaviors with theatrical props. Occasionally, the police would disrupt our performances or the public would get mad at us. In the early '70s, we didn't have any synthesizers or anything like that, so we built our own electronics. Various kinds of acts and performances would take place in the streets without any warning. They were often very bizarre events. I guess some of our inspiration came from earlier works in Happen-ings, such as those by Allan Kaprow or John Cage.

HUO:

"We" means that you were with a group of artists at the time?

LS:

Yes, actually I created a group called [*laughs*] "Dr Buttock's Players Pool," which was a mixed group of people. One of the great things about this time was that we didn't document anything—it was almost a part of the philosophy.

HUO:

So there were no traces....

LS:

Just a few pictures, and even those have since been destroyed. All of this was done in a totally pure spirit. There was no commercial or

institutional aspect to it. We did not take ourselves seriously for a single moment. And it was fantastic fun.

HUO:

But somehow a sense of radical experimentalism is common to your work, from these artistic experimentations to your later scientific work.

LS:

Yes, though in science you cannot always be so radical.

HUO:

Why less radical?

LS:

Because you must have discipline. In order to be accepted, in order for a paper to get published in a journal, you have to satisfy all sorts of requirements in terms of method and precision. This is, of course, also a good thing because it provides quality control. At the same time, one of the good things that happened when I went to MIT was that I met Marvin Minsky, who became my mentor. He was, and still is in some ways, a very controversial figure. He was also a playful experimentalist, and that's why I like him. Of course, he has upset many people with his provocative statements. In any case, I always want to go ahead and push further. As soon as something becomes too established, I try to break it down and go beyond it.

HUO:

What was your early work at MIT about? On what subjects did you start writing your first papers?

LS:

As I said, the thing that fascinates me is the making of meaning. I now see this as the thread through all of my work. It's really a fundamental question that I think is still unsolved: how do people create new meaning, and how do they create representations as part of the process of creating meaning. I emphasize that meaning is a process and not a fixed thing that you can grasp or put on a table or that is somewhere in your head. I believe that representations are a key to creating meaning. As part of this activity, we create representations. Of course, this is what artists do all the time, and this is why I am so interested in art. But language, which is the main topic of my scientific investigations, is the main medium that people use to create and communicate meaning. Scientific model making (like with robotic models and computer models) is also a way to make representations, and they also help us to create new meanings, communicate them to others, and explore them. My investigations into creating meaning started first with language, language and linguistics,

but I found the climate within linguistics very stifling. There was Chomsky at MIT and I was a student in his classes, but it was a very strict and dogmatic way of seeing things, and many of my fellow students seemed to follow him blindly as with a guru. So I decided that this was not creative enough or it wasn't going to be fruitful for me to remain within that little world where people invent and engage with formulas with no outside forces challenging them. It was like a sect playing with secret formalisms. So I got into AI, which is a fantastic field actually; it's a very creative and open field.

HUO:

So creativity is the reason why you turned to Minsky who, basically, pioneered the field of AI. You left the field of language and linguistics for AI— was it a critical moment or did it happen gradually?

LS:

First, I never left the subject of language. I just left the institution of linguistics. I think it came earlier, when I discovered the computer and then when I saw what some people were doing with it, like Terry Winograd who had built this computer program called *Shrdlu* at the MIT AI lab, which was a program for processing natural language by robots. You could give it commands like "pick up the red block" and it would execute the command. It was still in software simulation, but the goal was to do it on a real robot. When I saw this, it had a force that is comparable to artwork. It was not like a performance, but almost. It was a demonstration of something that was magic. Some of the earlier robots like *Shakey,* which were built at the beginning of the '70s at SRI [Stanford Research Institute] in California, were magic as well. These were the things that opened my mind from linguistics and philosophy into the field of computing and robots. I must say there was another major opening of my mind, which happened around 1984 or 1985, which was when I met [Ilya] Prigogine for the first time. This was at a dinner in Brussels (with Minsky as well). I didn't know Prigogine's work, so I thought I better read his books before I went to this dinner. And so I read *Order Out of Chaos* (*La Nouvelle Alliance. Metamorphose de la science*, 1979), which he wrote with Isabelle Stengers. In that book I found so many ideas that were completely new to me, and surely to linguistics and computer science, and it seemed to offer a window on all sorts of mechanisms and ways of looking at intelligence, coming from biology and physics. So I opened my mind further to all these fields and got into a very interdisciplinary context. That is still going on. One week I might give a talk at a

physics conference, and then the next week it might be at a psychology conference, the week after that at a biology workshop or a linguistics meeting. I read books coming from all these different fields and am absolutely fascinated by them all.

HUO:

You oscillate between these fields.

LS:

All the time. And those people invite me; it's not always necessarily that I seek them out. But other scientists can see the interdisciplinary possibilities of my work that are very exciting. The multi-disciplinary influence is also an important factor for me; I'm always seeking inspiration from other fields. For me, science is one big field. When some people in biology have interesting insights into living systems that they get from studying genetics, for example, why not use them? When a psychiatrist has ideas about the breakdown of mental representations of the self, why not incorporate that somehow? So it's about pooling knowledge and realizing that there are ways of making abstractions from the specifics of a certain field that carry over to another field. Of course, in chemistry, the field of Prigogine, they deal with molecular reactions, but that is not so important. What's important is the systemic aspects of complex non-linear chemical phenomena: the insight into the way such dynamic systems work. That is how I still get inspiration—by looking into other fields, and not just scientific fields.

HUO:

And with contemporary art, what is specifically driving you now?

LS:

What I find interesting about art, and not just contemporary art, but older art as well, even prehistoric art, is the idea of representation and how and why people do what they do. What is the process of making meaning, and what are the meanings that are behind it? How do representations get transformed in the process of interpreting them? All these kinds of things.

HUO:

When we met five or six years ago, you already had those two labs, the Sony Lab (Sony Computer Science Laboratory) in Paris and then the Artificial Science Laboratory at the Free University of Brussels. How did this come about?

LS:

For a while I worked at the MIT AI Lab, until 1980, with Minsky, and I was also very influenced by Seymour Papert. He's a key figure in education. He was a mathematician, but he worked with

[Jean] Piaget in Geneva and from there he went on to work at MIT with Minsky. Papert is obsessed with children and their learning of mathematics, and it was he who invented the LOGO language. I think he's causing a revolution in the teaching of mathematics, slowly. At the moment, I am also very much involved in discussions on the future of education. One of Papert's most recent books is *The Children's Machine*, by which he means the computer (*The Children's Machine: Rethinking School in the Age of the Computer*, 1993). Minsky was also very much influenced by cognitive development and Piaget, so what they were trying to do was to link a conceptual analysis of thought and on how the mind works and develops, with concrete computational and robotic experiments. And that is also what I am trying to do. I try to get very deep intuitions and then materialize them in terms of experimental models. That is another interesting connection to art, because this is also a field where people take very abstract ideas and materialize it somehow, so that it has an immediate impact on the viewer. With experiments too, you hope that they will have an immediate impact, so that somebody who sees it says, "Oh wow! You've changed my viewpoint!"

HUO:

So it's about catching people's attention?

LS:

Yes, catching people's attention and stimulating them enough to change their minds. And that is what an experiment is about—Bruno Latour also talks about this. Experiments, such as those by Pasteur, are not just about doing the science and writing the paper. It is also about convincing an audience, your colleagues and the public at large. Galileo did the same thing with his experiments—it's like trying to create an instant effect or shock in somebody else's mind.

HUO:

Were there other people at MIT who you interacted with a lot?

LS:

Yes, of course. One of them was Danny Hillis.

HUO:

... who built a supercomputer with 64,000 processors in 1985, and named it the "Connection Machine."

LS:

Yes, to me he is an absolute genius. I haven't spoken to him lately, but at that time it was amazing what he was doing. He would work for weeks on a lock on a box that you could open by a ball rolling around

in the box, if you did it right. This was a birthday present for Margaret Minsky! He conceived it and built it, and when you opened it there was nothing in the box: it was simply the act of opening it that was fun. He also built this big computer out of Tinker Toy sticks.

HUO:

It's a beautiful sculpture actually.

LS:

Yes. And at some points, the lab was full of these sticks. It was like a huge children's playground. All of this stuff was going on when I was there, and it was a very creative environment. This was before the MIT Media Laboratory started.

HUO:

The MIT Media Lab was founded by Nicholas Negroponte with {Jerome} Wiesner and opened its doors in the Wiesner Building, designed by I. M. Pei, in 1985. Was Negroponte already around at the time?

LS:

He was around, but in another department. I never met him. He was doing his Architecture Machine, and he had another project in Paris, at the Centre Mondial de l'Informatique [The World Center for Computers and Human Development]. In the '70s, the creative activity at MIT took place at the AI lab.

HUO:

Why did you leave MIT?

LS:

Well, I ran out of money and we were expecting a child, so I went to work for two or three years in an industrial research lab in Connecticut. This was also a very interesting experience because I learned how the industrial world works. We were involved there with geophysics, which was a completely different subject, and geology, trying to build systems that could take measurements. There, I learned a lot about the world of signal processing, making measurements of geological structures. This was another step to open my mind to other disciplines. Remember that geology was the original source of inspiration for Darwin as well. I thought that all this was quite interesting. Then in 1983, I came back to Europe and founded the AI lab in Brussels.

HUO:

Can you tell me about the very beginnings of this laboratory?

LS:

Well, I really started with nothing. I didn't even have a room. I took a lot of risks, also financially, and had to start building a group of graduate students from scratch. At the beginning, we did a lot of

work in knowledge engineering, in knowledge-based systems, and this led in all sorts of directions, looking at robotics and vision and complex systems, also at language. Any kind of topic would come up. At one point, this lab had thirty people working there—that was in the mid-'80s, working on all sorts of different subjects and coming from all sorts of disciplines, from physics and engineering to philosophy and linguistics.

HUO:

But you've always run it yourself, haven't you?

LS:

Yes. I have to find money for it and do all the management, which is a very tiring activity.

HUO:

The robots were there from the beginning?

LS:

No, the robots only really came in at the end of the '80s. This is when I met Rodney Brooks, so that was a very important shift in my thinking as well. Before that time, AI was focusing on disembodied intelligence. Symbolic AI emphasizes the idea that intelligence is essentially the processing of symbolic representations. I also followed this paradigm and worked a lot in symbolic AI. But then there was a paradigm shift. I organized a series of workshops that contributed a lot to this shift and launched the term "behavior-based AI" as an antidote to "knowledge-based AI." [William J.] Clancey was also in one of these workshops, as well as Chris Langton and Francisco Varela, and of course Brooks and his students like Maja Mataric and Cynthia Breazeal who later built *Kismet*.

HUO:

What was specific about post-symbolic AI?

LS:

It is like a pendulum. You can swing too far in the direction of purely symbolic cerebral thought processes, and then intelligence is like a monk sitting in a room saying, "I think therefore I am." There is no connection with the world. A chess player is a little bit like that in that she makes decisions completely in her mind. But in true human intelligence, you have a body and you have emotions and you have the real world. So what we tried to do with this paradigm shift is to get back to embodied intelligence. With purely symbolic AI, you cannot really explain where meanings come from, because the only things you have are formal symbols, which the system manip-

ulates. It's like a logical machine, and it doesn't have a connection with the world. But to get new meanings you have to interact with the world and with other people.

HUO:

So you need a body.

LS:

Yes, you need a body, you need sensors, actuators, a world; you need motivations and drive. Once this insight became clear I completely changed my direction and also the lab.

HUO:

That was a decisive moment?

LS:

Yes, I think it must have been 1988. You could say that one decisive moment was the discovery of self-organization stimulated by Prigogine around 1984 and the next one was the rediscovery of the body. It is interesting to make a parallel with art. The kind of Conceptual art that was made in the '70s was also a very disembodied kind of rationalistic art. So AI was part of the same zeitgeist. Performance art reacted to that by making the body very important again, as well as the real world experience. So you had these two opposing tendencies going on in the art world. In AI, you could call it a return to the body and the shift was profound. It turned out that many of the symbolic AI models just didn't work because they assumed that sensors would get all the information required by the model and the actuators would be like outputs to some motor or to some arm. It doesn't work like that at all. The real world is too unpredictable and dynamic and the information required by symbolic approaches to AI requires an intelligent observer.

HUO:

Was there also a distance from Minsky's position at that time, or is it more complicated than that?

LS:

It's more complicated than that: it's not really a matter of distance. Minsky is a very complex figure, who was also very involved with robotics earlier on. The big point is that if you're used to working with computers and getting them to do what you want, then it comes as a real shock that robots don't do what you want. Robots crash into the wall the batteries go up in smoke you make them turn 30 degrees and they turn 25 degrees for obscure reasons, etc. For a computer scientist who grows up in a neat, mathematical, predictable world, it is a very sharp dip into the real world.

HUO:

So one could say that your involvement with robots was a "return of the real" to quote Hal Foster.

LS:

Absolutely. A bit later in the early '90s, another influence on me was David McFarland, who is a famous ethologist from Oxford. He showed up in the lab one day and I built with him an experiment that started out as a reconstruction of the experiments of Grey Walter, the famous cybernetician. We built an arena with a certain number of robots, and a charging station. There's also a competition for the energy in the charging station in the form of boxes, and the robots had to push against these boxes to get enough energy in the charging station. McFarland uses this as a model of animals that have to work to get their food, so we built this environment in the lab with these small robots made from Legos. That's another element of playfulness actually, because when you walked into the lab it looked like a playground with all these Lego bricks, motors, etc., all around. Through this experiment, I learnt a lot from David McFarland about biology, about drive, motivation, and evolution. It was a very fruitful moment of interaction between biology and robotics.

HUO:

I am interested in finding out more about your relationship with cybernetics. Recently I interviewed Heinz von Foerster about the notion of the cybernetic legacy in relation to the current interest in self-organization. You know I'm interested in self-organization especially in terms of exhibitions. I wanted to ask you whether cybernetics is also of significance for your interest in self-organization.

LS:

All these people like Von Foerster, Grey Walter, Valentino Braitenberg; it was like a wave in the '50s of people who had been thinking about the body and about smooth interactive behavior in the environment through self-organization. They kind of got pushed into the background when AI came onto the scene in the late '50s, because AI was more about the symbolic reasoning, the chess playing, the theorem proving this kind of thing.

HUO:

And cybernetics was sidelined?

LS:

Yes, it was sidelined, but we shouldn't forget that Minsky grew up with these cybernetics people. There is a historical lineage. So we built this whole set up and did lots of experiments into self-sufficiency and autonomy. In a way it was a kind of revival of ideas from cybernetics, but of course now with the help of digital computers.

HUO:

Coming back to the robots, the first time we met was at a conference in Munich, when Carsten Höller and I had a fascination with your videos of flying robots.

LS:

Robots have a life of their own. Like this flying robot, a balloon-based robot that flies around. You couldn't just tell this robot to stop or to turn left; this robot has its own flow. This is a good example, because it is a culture shock compared to computer-based thinking. When you tell a computer to add one to one, it will always come up with two. But put a robot in a space, it will never behave in exactly the same way, and there is an enormous resistance from the thing itself. The fact that it will never do what you want it to is something that fascinated me. It was so difficult to get these things to do what you wanted them to, which makes it clear that there is a lot that we do not understand about these autonomous physical systems. When was the Munich conference?

HUO:

In 1995.

LS:

Well, that was the time when I was just returning to language.

HUO:

So it oscillated back, it's never a linear development for you?

LS:

No, all these ideas of evolution and self-organization and embodied intelligence were leading me back to language, to see how it could revitalize my investigations. This has been enormously fruitful. I am still keeping up the work with robots and self-organization. At the same time, I have come back to the idea of representation and creating meaning, which was my main subject in the very beginning. So my current work goes far beyond robot behavior.

HUO:

We are conducting this interview in your Sony Laboratory in Paris. You have mentioned pioneering this early European AI lab after returning from MIT to Brussels, so could you tell me about this laboratory in Paris, and how far it compliments your work in Brussels? The Sony Lab always seems more interdisciplinary than a university lab could ever be.

LS:

That's absolutely true. The basic problem in academia these days (at least in our field) is that it is very difficult to keep a fundamental research lab going. At one point, there were thirty people in my

Brussels lab and that was fantastic—things were happening and we were getting great results. But there has been no institutionalization of this lab, so almost every day I had to work out where the money would be coming from for the next day. This is not a good situation for really creative work, and so I decided that the lab in Brussels would be education-oriented. The average age there now is around 24 or 26, so they are young students. I give them lots of freedom and it's more like a workshop/studio where they can explore ideas. Of course, they need training and teaching, but I try to be unimposing. Whereas the Sony Lab is a much more professional environment. We are a group of independent professional scientists that have different topics, such as neuroscience, speech, but also music or cognitive robotics. The connection with Sony gives us the opportunity to be very close to the cutting edge of technology in general and robotics and computing in particular.

HUO:

Because of its corporate links with Sony research.

LS:

Yes. For example, there is a lab in Sony called the Digital Creatures Lab that has built the *AIBO*, dog-like robot, and is currently working on a humanoid robot. They are one of the top teams in the world in autonomous robotics.

HUO:

And have you been working with them?

LS:

Yes. We use their platforms and give them our ideas. In the '90s it was still possible to play around with amateurish robots built with Legos and all that and do interesting work, but now the level of engineering has gone way up.

HUO:

Your work in Brussels seemed to me to be close to the work of Panamarenko. There was a certain degree of "bricolage" involved.

LS:

Obviously!

HUO:

Was Panamarenko an inspiration?

LS:

Well. I knew him and thought his work was fun.

HUO:

But you think that the situation has changed since the '90s.

LS:

We're no longer in the '90s. It is true that these Lego robots look like "bricolage," and in fact they were, because we did not have the resources to build nice, completely engineered robots. You need a team of fifty very good people to build a humanoid robot.

HUO:

That no university can afford.

LS:

There is no research group anywhere in Europe who is doing this.

HUO:

And in America?

LS:

Well, Brooks at MIT, who pioneered the revival of humanoid robotics, has similar difficulties getting funding and keeping his lab afloat. He says, "I'm no longer doing humanoid robots," because it has become too difficult, especially in a university context where you always have new students coming in. Building a humanoid robot is like building a satellite system or something of similar complexity. You need a stable context and professional engineers.

HUO:

So you are in a very privileged position because on the one hand, you have an autonomous zone in terms of your research, but at the same time, you have the resources and support. It's an ideal situation.

LS:

Absolutely. I think that at the moment this is the only way to work in this field.

HUO:

How much freedom do you have to work on your own research topics?

LS:

A lot. The whole purpose is to come up with new things and new ideas. We need new ideas in computer science and AI—there is no question about that. But the scientific institutions in Europe have become very bureaucratic; the universities and the European funding institutions are a disaster because they stifle too much creativity. Just imagine an artist having to predict three years from now the major work that they will produce, stating what it will be, who will be interested, how much it will sell for and so on. Then you have to write a 200-page proposal with detailed budgets predicting when you are going to travel, etc. It's impossible to be creative if you have to do that kind of advanced planning. You are no longer in the business of creative work. Of course, I'm not saying that there shouldn't be any plan-

ning, budgeting, etc., but breakthroughs cannot be planned. At least that's my idea. There is a need to bring some freedom back into science, freedom that artists have been able to preserve.

HUO:

Are you now in a position to make useful mistakes?

LS:

Yes, you have to make mistakes. If you're not making mistakes, that means that whatever you're doing is not ambitious enough. A Formula 1 racer once said that if you can keep your car on the road, you're not going fast enough! For scientific work and innovation, if you're not making mistakes then you're not doing things right. You should be able to go down a path, discover that you're wrong, and be able to decide at that very moment to do something different, and not to say, "Oh, we have this project that we have signed up for with the European Commission, therefore we will continue to work on it for the next three years even though we know it is wrong."

HUO:

And then came the Talking Heads Experiment *around 1999. That was the first time we were able to come together on a project for the exhibition "Laboratorium" (co-curated with Barbara Vanderlinden, various venues throughout Antwerp, 1999). You proposed the* Talking Heads Experiment, *which was a radical form of experimentalism within the exhibition context.*

LS:

I look back upon this as a fantastic project. It was very complicated though. The goal was to create a situation where on the one hand we could test our ideas about the self-organization of language, but at the same time, the goal was to try and create a set-up that could convince people of new ideas about language and meaning.

HUO:

To convince non-scientists basically?

LS:

Yes, non-scientists. And this is very difficult because we were dealing with very abstract concepts and also a process in time. The self-organization of language takes time, obviously. So we did this set-up in Antwerp, but through the Internet there were also sites in Paris, Amsterdam, Tokyo and some other places. This was a totally different art experience, and a performance, if you can use these terms. It involved the Internet; so many more people looked at it from a distance than saw it in the Antwerp exhibition itself. Also we reached a

totally different group of people who had never had access to these kinds of things before. So there were many new factors entering into this experiment, which I believe to be a very good thing. I wouldn't say that we succeeded, although we got an enormous response to it. It was a stepping-stone, leading us to think deeper about communication of science and to conduct other experiments.

HUO:

In the last three years we have worked together on three distinct projects: firstly the Talking Heads Experiment *for "Laboratorium"; then "Bridge the Gap" that I co-organized with Akiko Miyake at Center for Contemporary Art, Kitakyushu, in 2001, a kind of coffee-break conference where you spoke about color. And then you engaged in a dialogue with Olafur Eliasson, and out of this grew a collaboration with Olafur for his show at the Musée d'Art Moderne de la Ville de Paris in 2002, that I co-curated with Laurence Bossé and Angéline Scherf ("Chaque matin je me sens différent—Chaque soir je me sens le même" {"Every morning I feel different—Every evening I feel the same"). It was Olafur Eliasson who connected to you and to Yona Friedman, which is interesting also, because I discovered that in the '70s Yona Friedman was at MIT: Negroponte had invited him to present his architectural ideas. Could you tell me about these projects and collaborations?*

LS:

What I found useful about the *Talking Heads Experiment* was the discussions we had with Bruno Latour about the notion of experiments and experimentation as performance. It was very useful to be in the exhibition context with this kind of work. Now, in terms of the "Bridge the Gap" conference, it was an opportunity to go deeper into the theoretical background. There are a couple of ideas that I believe in very strongly which are in direct opposition to Chomskian linguistics. One of these ideas is that language is always newly created and is not something that is fixed; it is also something that is very dependent on the culture and the community in which you are. Many people believe without hesitation that different languages have different color words (*"rouge"* in French versus *"red"* in English for example), but few people believe that different cultures actually categorize and even perceive color differently. So I started to explore this further, as an outcome of the *Talking Heads Experiment*, in Kitakyushu and later on in the installation with Olafur Eliasson in Paris. I want to show that colors are not objective or universal categories, but that color is very dependent on the individual and on their experiences. So in my talk in Kitakyushu, I tried to develop that. Then in the work with Olafur Eliasson, I

tried it again in a new installation. My question is always: How can you materialize these abstract ideas in a form that people can immediately grasp and understand? This was really what the collaboration with Olafur was about. And actually, I met him again in Venice recently and gave a talk in his studio at the School of Architecture. We are already thinking about other projects.

HUO:

Where will it be?

LS:

That has not yet been decided, but it's a project about after-image. The great thing about working with Olafur is that on the one hand, I think he has this artistic capability of immediately materializing all sorts of ideas in a way that touches many people, but he also has a lot of insight into perception and categorization. So I think there is room for further collaboration together.

HUO:

In which directions do you think the collaboration can evolve?

LS:

We can bring in lots of things from our robotic models of color vision and color experience, models of the brain and the language of color, and then he can project this out, integrate it and use it in exhibitions. So I think that out of all of the artists whose work I have been attracted to, this has been a very good match, which is due to you. I didn't know Olafur when you first proposed we have a discussion for Kitakyushu.

HUO:

That's the thing about coffee breaks—they trigger things. We did another conference called "Art and Brain" in Germany, where nothing was scheduled to happen because it's precisely at this moment that things start to happen. It's usually much more efficient to have a coffee break than to have a conference.

LS:

I agree, but that can be difficult with some sponsors sometimes! [*Laughs*] It's important to establish more common ground through talks and showing work, but that's the idea of getting a network of people to interact together on a regular basis, and in that way the common ground can be established. It cannot be done as a one-off: it has to be an ongoing dialogue. I have had further contact with Sarat [Maharaj], for example, who was also at Kitakyushu. And also with Stefano Boeri's colleagues, like John Palmesino.

HUO:

*Could you tell me about the more recent developments of your own work?
There is a new text, "Language Re-entrance and the Inner Voice" that you
have published in* The Journal of Consciousness Studies. *I was cross
reading your essay and the texts of Mikhail Bakhtin, on the use of polypho-
ny in Dostoyevsky's novels in* Problems of Dostoevsky's Poetics *{sic}
(1929) where he says that:*

> "... the plurality of voices and of independent consciousness
> constitute a fundamental trait of his work. What appears in his
> work is not the multitude of characters and destinies within a
> unique and objective world and elucidated by the only con-
> sciousness of the author, but the plurality of consciousness,
> which without fusing, combine in the unity of a given event.
> The principle heroes of Dostoyevsky are indeed in the conception,
> even of the artist, not only objects of discourse, but subjects of
> their own discourse which is somehow immediately signified."

*I was wondering whether it was just a coincidence or whether there is a link
between the polyphony of Dostoyevsky and your "re-entrance of the inner voice."*

LS:

Yes, this paper is quite important for me. The connection you are
making is totally amazing. The basic idea of the paper is the follow-
ing: People are all the time engaged in making external representa-
tions: language, drawing, pretend play, gesturing, etc., and this way
they bootstrap a lot of their knowledge and coordinate it with other
people. But the next logical step is that this external representation
making becomes internalized, that means that the brain starts to cre-
ate representations for its own sake, without making them public.
The inner voice, visual imagination, mental rehearsal of actions, etc.,
are all examples of this. It's almost like internal sheets of paper on
which one part of the brain is writing and the other part is looking
at it and interpreting it. I believe this internal representation mak-
ing is then the starting process for the construction of the self, mul-
tiple selves perhaps (like in the *Society of Mind idea* by Minsky), so
that gradually this polyphony talked about by Bakhtin emerges.

HUO:

So this notion of polyphony has some resonance for you?

LS:

Yes, it's a very interesting way to think about it, like you have
polyphony in medieval music, many voices going on at the same

time, which sometimes are coherent and sometimes independent. It is important to see how radical the idea is. Many people believe that you first make internal representations (for example in a language of thought) and then you learn to externalize them. For me it is the opposite. External representations come first, embedded in a social and cultural context, and only later, do we start to create internal representations through re-entrance and use them to build a model of ourselves. Disorders like schizophrenia show that this self-representation can become dysfunctional, for example, when self-attributions conflict with attributions made by the social environment. I am again trying to make very concrete models of all this and doing experiments. But at the same time I am interested in how the brain rewires itself for making representations and representation re-entrance.

HUO:

This is work in progress?

LS:

Yes, very much so. For example, it turns out that the areas of the brain that are involved in speaking aloud are the same as the areas engaged in the inner voice: the same structures are activated. I see many completely new developments possible in autonomous robots and AI based on these ideas.

HUO:

Could you tell me more about "the society of mind?" It's a wonderful expression.

LS:

Well, it's the title of a work by Minsky, where he develops the idea that the mind is made up of a large collection of agents. So he talks about how some agents are sensitive to other agents, how some are in competition with each other. So my intention in the paper was to make a link to Minsky and his notion of *The Society of Mind*. I think there are still an enormous number of things to be discovered about how we create representations, how we interpret them, and how they help to construct a model of ourselves. In fact, I think we know almost nothing about it, and I am pretty sure that this will be my next main line of work. I am keen to look more at drawings, especially children's drawings that are very creative. They easily invent new modes of expression and visual grammar, and therefore tell us something about pure, unconventional representation making at work. It would be, of course, also interesting to do this in the context of an exhibition. I mean, why do people draw? And not just drawing

from live subjects, but drawing as a means of communication, drawing to help construct representations of the world and yourself.

HUO:

Some heralded the death of drawing with the arrival of the computer: but if this is the case, why has it become so important in art again?

LS:

They said the same about photography—if you can make a photograph, why do you need to draw? But that completely misses the point of a drawing.

HUO:

And that's also part of the discussion between Gabriel Orozco and Ikegami Takashi on drawing.

LS:

Yes, but I think they look at it more in terms of externalizing certain formal, mathematical structures. But when I'm talking about drawing, I focus on meanings that are expressed through drawing. Drawings can be of models and still life and things like that, then there's mathematical drawing, where you can visualize very complicated mathematical structures, but I'm more interested in meaningful drawing, which is not realistic, but tries to express meaning. Here is a painting by another Belgian artist.

HUO:

James Ensor?

LS:

Yes. This is not a realistic drawing but there are all sorts of meanings in it.

HUO:

Hidden meanings?

LS:

Hidden in some sense. Some can no longer be understood. I can understand some, for example, this here is a judge, because this is how judges used to dress in Belgium. But if you don't know this, you would not recognize it. What interests me about drawings is: what knowledge do you need to interpret it, how are meanings selected for external representation, where does the common ground come from, how does it get communicated?

HUO:

The last question I want to ask you, which is the only question that is recurrent in all my interviews, is the question of your unbuilt roads. I was wondering whether you could tell me about some of your unrealized projects: projects that have been too big or expensive to be realized, projects that have been censored or self-censored, projects you left on the shelf...

LS:

Many, many, many. Usually when I start out on an experiment, it is always much more complicated when you actually build it. So, for example, for the *Talking Heads Experiment*, I wanted a body. We worked for a while on the body, but we couldn't get it to function because technologically it was too difficult. So I had to drop it. I am always involved in projects that cannot be done, and it is usually because the technology is not yet up to it or I cannot find the people who have the required technical competence. But I still hope that they can be done.

HUO:

So they are not unrealizable.

LS:

Not necessarily. The one that I would really like to do now, would involve at least two humanoid robots sitting at a table and engaging in a conversation with each other, pointing and picking things up and building a dialogue and creating meaning as they go along in the process. Maybe it will take another thirty years. That's the biggest project, but I think we will be able to achieve it at some point, because it can be done, just not today. And when it is done, it will be absolutely stunning.

HUO:

Is it possible to have a few more details on it?

LS:

Well, I imagine two robots sitting at a table, face-to-face, looking at each other, or moving around in a shared space. At the beginning, they have very few concepts. They must build up concepts and language by interacting with the world. Through the expression of these concepts, they build new concepts and progressively they build up their own mind. It's a bit like twins playing and inventing language. For me this is the ultimate experiment. This would be true Artificial Intelligence.

TIRAVANIJA, Rirkrit

Rirkrit Tiravanija was born in 1961 in Buenos Aires, Argentina. He currently lives and works in Bangkok, Berlin, and New York. Tiravanija was born to a Thai diplomat's family and studied art at the Ontario College of Art, Toronto, the Banff Center School of Fine Arts, Canada, the School of the Art Institute of Chicago, and the Whitney Independent Studies Program, New York. He gained critical attention in the early '90s with exhibitions in New York in which he set up portable stoves and fed Thai curry to gallery visitors, demonstrating an interest in art that evolves as visitors touch, eat, and converse with him and each other, thus creating the piece. Throughout the '90s, Tiravanija has taken part in numerous exhibitions, and for each one he has created a new space of interaction or set up situations so that they may unfold and take on a life of their own. Some of these exhibitions include: "Backstage" (Hamburger Kunstverein, 1993); "L'Hiver de l'amour" (ARC/Musée d'Art Moderne de la Ville de Paris, 1994); "Moral Maze" (Le Consortium, Dijon, 1995); "Truce: Echoes of Art in an Age of Endless Conclusions" (Site Santa Fe, 1997); and "More works about buildings and food" (Fundiçao de Oeiras, 2000). In 2000, Tiravanija, in partnership with Phatarawadee Phataranawik, established Namdee Publishing Station in Bangkok, which operates as a station for launching innovative ideas and activities in the form of artists' books, anthologies of texts, and a magazine (oVER magazine). In 1998, Tiravanija also initiated "The Land," a large-scale collaborative and transdisciplinary project taking place on a plot of land that has been purchased in Chiang Mai, Thailand. "The Land" is conceived of as a laboratory for self-sustainable development, but is also a site where a new model for art and a new model for living are being tested out.
.......................
The first part of this interview took place in Paris in December 1993 and the second part in Mexico City in July 2002.

[1] Paris, December 1993

Hans Ulrich Obrist:

You said, "Basically I started to make things so that people would have to use them, which means if you want to buy something then you have to use it… It's not meant to be put out with other sculpture or like another relic and looked at, but you have to use it. I found that was the best solution to my contradiction in terms of making things and not making things. Or trying to make less things, but more useful things or more useful relationships." In terms of your idea that "it is not what you see that is important but what takes place between people," when was the first time you set up a temporary kitchen and cooked curry in a museum or gallery setting?

Rirkrit Tiravanija:

It was called *Untitled 1989 (…)*. The first food piece was displayed

in a group exhibition at the Scott Hanson Gallery, which no longer exists ("Outside the Clock: Beyond Good & Elvis," Scott Hanson Gallery, New York, 1989). Four pedestals were blocking the passage between the entry way and the exhibition space. On these pedestals were displayed various processes of a curry being cooked, i.e., a pedestal for ingredients, a pedestal with curry cooking on a burner, a pedestal with waste products. The visitors could smell the cooking curry as they entered the space; the smell permeated through the gallery. A new pot of curry was cooked once a week. But the curry was not to be eaten.

HUO:

And when was the first time that you invited the "viewers" to share and taste the curry?

RT:

It was for *Untitled 1992 (Free)* in my one-person exhibition at 303 Gallery, New York. All of the contents of the gallery were emptied out into the main exhibition space, including the office. All doors (to office, storage rooms, cabinets, toilet, etc.) were removed from their frames to open and empty out hidden spaces. The office emptied out is then timed into a social/meeting space with two pots of curry (one red curry, one green) and a pot of rice to offer the visitor on their lunch. (The windows in an office play a significant role as external/internal can be viewed). On display in the office are the ingredients of the meal plus the remains from the cooking and eating process (which later becomes documentation of the situation at hand). The cooking and food for the first time (there were other projects previous to this, which occurred for only one evening or just for the opening of exhibition) is made continuously through the duration of the exhibition. The gallery office space became a central meeting point and rest stop for many regular visitors to SoHo. "(Free)" in this particular situation could signify the emptying of context/content. From exhibition to non-exhibit of place/non-place. "(Free)" could also be read as open—or as plain and simple as no charge for the situation (free food).

HUO:

Very quickly, you also developed more and more complex environments for these encounters. Could you tell me, for instance, about your tearoom at Exit Art in New York in 1993?

RT:

It was *Untitled 1993 (The Cure)* and it was in a group show called "Fever." In response to the context of "Fever," I built a tea tent using a material with the color of Thai Buddhist monks' robes: golden

orange. The dimensions of the tent were made to the specifications
of a Japanese tearoom—measuring ten-by-ten-by-ten-feet. The
measurement the Japanese got is derived from a Buddhist scrip-
ture—which is the measurement of a room in which the Lord Bud-
dha gave sermon to 40,000 monks (mind over matter). Tea plus
water plus kettle plus teapots with a table and chair were set into the
tent. The door of the tent faces a window—inside the space the exhi-
bition is blocked out of view. Tea, being a drink of medicinal quali-
ty (and for me with cultural significance) was to become an antidote
to the "Fever" and a space for rest, contemplation, etc.

HUO:

*Another type of environment like this one is the one that took place this summer
at the Biennale di Venezia ("Aperto 93," La Biennale di Venezia, 45th
International Art Exhibition, 1993).*

RT:

It was *Untitled 1993 (twelve seventy one)*. "Twelve seventy one"
because it was the year Marco Polo had set off to the Far East from
Venice. The centerpiece to this project is an aluminum canoe—the
canoe being an image of Native America—and inside the canoe are
two pots filled with water, which are being boiled—so there is
water also in the canoe itself. The image of boats with food being
cooked in them are drawn from Thailand. And accompanying the
canoe are local cafe tables—and fold out stools put out to be used
by the visitors to the Aperto. There are also Cup 'O Noodles in
boxes that were shipped in from the U.S. and that were made by a
Japanese company in California, and these cups of noodles were left
for the visitors to help themselves as they are instantly cooked. This
situation lasted as long as there were noodles for the viewers to con-
sume (this did not take too long). The remains were left as evidence
of the event. I had used Venice as a focus for the piece—which was
a collage of place, mythologies (Marco Polo and the pasta from the
Orient), hybrids of culture, tourism. And this also provided a pos-
sible place for rest and passage in the context of the exhibition.

[2] Mexico City, ten years later...

HUO:

*Your exhibition at the Secession (Vienna, 2002) is based on Rudolf
Schindler's house in Los Angeles, his house on Kings Road in Los Angeles,
built in 1921–1922; your idea was to install a reconstruction of the stu-
dio of the Schindler House in the main room of the Secession and use this as*

a stage for various activities, as a venue for a multimedia program includ-
ing film screenings, concerts, presentations and lectures. Your idea is to ani-
mate Schindler's world of ideas, his concept of inside and outside in rela-
tion to the conditions of private and public spaces, but not in a nostalgic
way in the sense that you are taking it as a frame for your own ideas on
relationships and communities, and your characteristic conception of art as
an investigation and implementation of "living well." Do you see it as a
station?

RT:

I see the idea of the station in the sense of a platform where people
have to come together at one point before going off to different
divergent positions again. The station is a place where, while you're
waiting, there could be an insertion of a program into the station
that the people passing through interact with.

HUO:

And it's a contemporary form of relay, like in old times when on a journey,
the horses got water and travelers got food.

RT:

Exactly. It is a place where you rest, but at the same time you pick
up more information. But of course, it's a different kind of absorp-
tion when you're resting and getting information than when you're
focusing just for the sake of getting information. But I think what's
interesting about this demonstration is a culmination of different
modes of presentation of both art and non-art.

HUO:

You spoke about another project of yours designed like a station in Japan.

RT:

The show is at the Asahi beer space [*Untitled, 2002 (demo station No.*
3), Sumida Riverside Hall Gallery—Asahi Beer Arts Foundation,
2002]. It's a space, which is programmed; there is a list of people
who come and use the space. It's the same as I did in Portikus when
we had a big unscheduled program that people knew about and
they came to [*Untitled, 2001 (Demo Station No 1)*, Portikus, Frank-
furt]. I think there are also possibilities for things to happen when
there is nothing happening, so that other people can come in and
actually take it over and use it.

HUO:

A bit like in your Whitney installation when there was nothing; you just
set up musical instruments, inviting museumgoers to make impromptu jam
sessions (1995 Biennial Exhibition, Whitney Museum of American Art,
New York).

RT:

Exactly, people who know that it's there can come and use it because they know that it is there. But I think that is a way to have both possibilities of presentation, so that it is static at the same time as being active.

HUO:

And an acceleration and a slowness, a new slowness.

RT:

"A new slowness," that's a good idea. There has always been a discussion about speed, but there's a speed at which you can think and a speed at which you cannot. I like the idea of always moving and thinking, not always just moving. It could just be in one place.

HUO:

I heard rumors that you're going to do a big summer academy in Frankfurt. Will this also be a station?

RT:

Well, it is definitely developing out of the station idea. It's more of an academy, but having been through that situation in Portikus, I think that it would be an amazing thing to do. You could make a station where all the young students could come to. It would be like a jamboree.

HUO:

A jamboree?

RT:

It's a term that they use for the scouts, when all the scouts come together from all around the world. But that was like the Utopia of the '70s. I always wanted to go to a jamboree.

HUO:

And you were a scout?

RT:

For a short time. I think as a young boy, the image of scouting was very important.

HUO:

You said that there is a sense of "no future" in New York, which is perhaps a global climate also. I think it is important that, for our Venice project ("Utopia Station," La Biennale di Venezia, 50th International Exhibition, 2003) we can provide a platform in a non-nostalgic and non-naive way, a platform of hope and of change. It is very important that there is a generosity and that we do not prescribe Utopia.

RT:

Absolutely not. I think it's impossible. What interested me in this funny discussion yesterday was that there was one paper, which was

presented which was about the idea of difference and otherness, and the person actually used a description of the idea as strangeness: "the others are strange," which was a way to make a low structure towards the sophistication of difference. I thought that was quite interesting, and my explanation of my anti-globalistic idea is that globalism doesn't really work because it's just a skin, a skin which gives you the excuse of not understanding the other even more. And through that conversation, it struck me that the idea of Utopia is really the idea of understanding difference. And the failures—I think these previously modeled utopian conditions have always been in a kind of conformity of ideas, which is to say that somehow everyone should become one cohesive structure, one cohesive consciousness, and that would bring with it a sense of freedom. But I think that this is impossible, and the reason why it will fail. I think that the possibility should be about understanding difference, which is something I think would be difficult for the western hegemony and the Eurocentric structures to open up to, even though they talk about globalization. I think it is very interesting in relation to the idea of hunger, because I think that is part of the economy that...

HUO:

Here is an article I read in this mornings' paper: "La lutte contre la faim dans le monde est en échec {the fight against hunger in the world is about to fail}. Starvation again threatens Austral-Africa. 800 million human beings are hungry everyday, and half of humans suffer from lack of food. In 1996, the rulers of the world made an engagement to reduce this figure by six million per year, the number of people who are undernourished. The agriculture of the southern countries is unable to nourish the population. The reasons for this are a lack of water, wars, and lack of organization of these countries' resources. The United Nations organization for alimentation and agriculture says that many of these countries devote less public funds to agriculture. It became more and more clear that if this situation continues, the world economic system which already witnesses a strong disequilibrium between the North and the South would have a big role for the destruction of the South. The disequilibrium comes from unequal exchange. The North asks the South to abolish the frontiers for industrial products, bank products, and agricultural products..."

RT:

... which is globalization.

HUO:

"... and at the same time it closes its doors to exports from the South, eroding its landscape by subventions which are higher and higher. So it basically makes a lobby of its own agriculture. This way, foods or cereals from

the south are prevented from entering this market but the beef from the
northern markets gets to African markets, doubling prices and leading to
the ruin of the local producers and hence destroying the local economy. The
recent decisions of President George W. Bush to augment $190 billion for
ten years would mean 80% of the subsidies sent from Washington to Amer-
ican agriculture are, in this context, catastrophic. Contrary to all the prom-
ises made by all the American authorities themselves on the occasion of the
OMC summit in Goa last year, it will reinforce even more than ever the
disequilibrium of the markets. But above all, it will break the small
amount of hope, of consciousness which could be borne out of the capital of
the North on the misdeeds of the global agricultural system. The message of
cold egoism which risks serving as a justification for other countries in the
North to reinforce even more their own agricultural aids. The U.S. is a bad
example. It could be in Europe, in France. Jacques Chirac blocks all kinds
of reform. Poverty and starvation forewarns them of this fake free exchange.
Fake free exchange is a bigger reason for poverty and starvation than the
decline in development aid. Now the drama is that the subsidies in the
North are not enough in order to avoid the situation where more and more
peasants abandon their wares in the United States as in Europe. So at the
end, the producers of the South and the North are ruined."

RT:

So it's like the subsidies are actually to keep farmers from farming.
The idea is to give money to people so that they don't do anything on
their farms because there's too much produce. I've read similar things
in which money is not given to the South but rather their products
are bought. But I think this is a funny humanistic idea of global econ-
omy, and it's always going one way and never the other. You can look
at the movements of people and you can see who is going where.

HUO:

A new kinetic elite—being able to travel.

RT:

People say to me, "Why don't you just get an American passport?"

HUO:

What is your passport?

RT:

Thai. And I would say it would be a lot easier for me to travel but
it would also mean that I would no longer recognize the fact that I
have to struggle to move around. I would rather struggle to move
around, to a point where I also don't feel I need to be anywhere. If
there is a wall there, obviously there will always be people behind
that wall who want me to go. But those people are going to have

to recognize the fact that there is a wall and they're going to have to deal with that.

HUO:

So you have a lot of trouble at customs?

RT:

Yes, generally. Every two years I have to get a new visa to be in Germany, which gives me some freedom around Europe. But I can't go to England today—I have to go and get a visa. I can't go to Tokyo instantly or to America. It's collapsing. Places that used to be free are now demanding more. It's like Scandinavia, which used to be a much more open and free place, but now you have to have a visa to go there...

HUO:

Obviously, there is a link between this "geo-political" situation and the way you are developing projects of stations. Where did this idea of the station come from?—because you haven't used the term until recently...

RT:

No, it is recent, and it came from the magazine (*oVER Magazine*). The idea of the magazine was that it was a publishing station (Namdee Publishing Station, Bangkok). I was very interested in the idea of publishing as an activity. I think publishing is a future activity, which can connect this kind of thinking to a bigger field and other structures. Publishing can be many things; it can be an object, a text, sound...

HUO:

... broadcasting, like you do through the "oVER Channel"...

RT:

Yes, so I wanted to move my idea of activity to publishing, and not just as an individual but as a collective.

HUO:

And where did the name Namdee come from?

RT:

I think there was a Surrealist or Dadaist magazine called *Spleen*, and Namdee is Thai for spleen. But it also plays on itself because it means "clean water." Clean water is a calming thing for Thai people, and of course, it is a place that gathers and then disperses.

HUO:

And the station still exists in Bangkok?

RT:

Yes, so the office is there for the station. Then I was trying to use that idea of the station to move it around in relation to the maga-

zine. The other side of that coin that I'm working on is the idea of demonstration. Even though there's this sense of "no future," there is a great deal of activism going on.

HUO:

Not in the art world.

RT:

Not in the art world, but elsewhere. And I think I'm trying to recognize that. I've been collecting images of lots of demonstrations.

HUO:

You have constituted an archive?

RT:

Yes, it's in Bangkok. Then a young artist is making drawings of them. It's like the way he survives—it's like a job for him. And that's also part of the Station, to connect people from outside to people there, to create an economic exchange structure. And it's particular interesting to do so in Thailand, because there are of course lots of people going into art school trying to become artists but there is absolutely no structure for artists.

HUO:

But there is the project of having a private museum there.

RT:

Well, I've been talking with this man literally for four years.

HUO:

He came to my office in Paris last week.

RT:

This man was hoping to work with Rem Koolhaas because he wants a building that will be famous. I said the most interesting thing would be to get an artist to design his museum for him. I suggested he talk with Jorge Pardo about it, but he wasn't sure about that. Then I asked Philippe [Parreno] and François [Roche] to come over to look at "The Land" because they were going to work together on this structure for "Utopia." So they came and had a look, and had some ideas. Then the night before they were leaving town we went to a party at a club. This man was there with some other friends. He came over and started talking to me about the museum some more. I suggested he speak to a couple of friends. It was a coincidence really. I had already thought it would be interesting for François to come to Thailand because I think his ideas are really interesting. Also, to understand this idea of the periphery— there are a lot more possibilities of doing things that you could never do in the center. It should be a lab. So this man talked to François and Philippe and went and checked out the web site of

François. The next morning they came and looked at "The Land," they talked more. And then François made a design and they were very happy about it.

HUO:

And now he wants to build it?

RT:

Yes, he would like to build it. I'm sure he would build it tomorrow if he could.

HUO:

When they came to my office, I asked when the museum would open. François said that it would perhaps be 2003 or 2004.

RT:

These things take time.

HUO:

Can you tell me about your large-scale collaborative and transdisciplinary project "The Land"?

RT:

First, I would say that it's not *my* land. It's just "The Land" itself.

HUO:

When was the project initiated and who owns "The Land"?

RT:

It was in 1998. "The Land" was the merging of ideas by different artists to cultivate a place of and for social engagement. It's been acquired in the name of artists who live in Chiang Mai. We purchased this plot of land, in the village of Sanpatong, near Chiang Mai, and we've been trying to find a way to turn it into a collective and to have the property owned by no one in particular. But really, that's one of the hardest things to do in Thailand. We cannot be a foundation. "The Land" is not a property.

HUO:

But to what extent would you define it as a project?

RT:

We don't want to have to deal with it as a presentation to the art structures, because I think it should be neutral; and, it's also one of the reasons why it's not about property. It was started without the concept of ownership and is cultivated using traditional Thai farming techniques. In the middle of "The Land" are two working rice fields, monitored by a group of students from the University of Chiang Mai and a local village. The harvest is shared by all of the participants involved and some local families suffering from the AIDS epidemic.

HUO:

Though initiated not solely as structures to be designed, built, and used by artists, most of the architectural projects on "The Land" to date are being developed by such, no?

RT:

A gardener house was build by Kamin [Lerdchaiprasert], and the collaborative Superflex developed a system for the production of biogas. There is no electricity or water, as it would be problematic in terms of land development in the area. Superflex have made experimentations to use natural renewable resources as alternative sources for electricity and gas.

HUO:

"Supergas."

RT:

Exactly. Superflex is using "The Land" as a lab for the development of a biogas system. The gas produced will be used for the stoves in the kitchen, as well as lamps for light.

HUO:

And what is your own architectural contribution to "The Land"?

RT:

I designed a house based on "the three spheres of needs": the lower floor is a communal space with a fireplace; it's the place of accommodation, gathering, and exchanges; the second floor is for reading and meditation and reflection on the exchanges; the top floor for sleep.

HUO:

"The Land" is something of a "massive-scale artist-run space" in which artists of all kinds are offered the chance to exceed the boundaries of their discipline, to construct works they may not have otherwise imagined, and to allow these works to be developed and experienced in an atypical way. Who are the other artists involved in the project?

RT:

Tobias [Rehberger], Alicia [Framis], and Karl [Holmqvist] have worked on housing structures, Philippe and François are making plans for a central activity hall that will function as a biotechnology-driven hyper-plug. Their *Plug in Station* uses nature to produce the interface: it will make use of a satellite downlink and a live elephant will generate the necessary power. And then [Peter] Fischli and [David] Weiss's project is a small office building for Chiang Mai, and Atelier van Lieshout developed a toilet system, Arthur Meyer

constructed a system for harnessing solar power, Prachya Phintong put in place a program for fish farming and a water library, Mit Jai In develops tree plants to be later turned into baskets.

HUO:

Are there people already coming to visit "The Land" for reasons other than because they have been invited to participate in the project?

RT:

A lot of people are visiting it and have been staying there even though it's not quite ready.

HUO:

So it's already functioning as a station...

RT:

Yes, as a self-sustaining station. All structures are for open use.

HUO:

What is the time span?

RT:

The thing I would say is that there is no time span, there is no beginning, there is no end. It's a constant, like time itself. And because we're not faced with problems of property or ownership, we don't ever have to feel obliged to finish or have any success in a way.

HUO:

*This is a logic that you've been trying to bring into the exhibition realm as well like with your installation at the Secession in Vienna, and already a few years before with the Cologne show, where you reproduced your New York apartment including the kitchen and bathroom at the Kunstverein in Cologne and required these rooms to be open 24-hours a day {*Untitled 1996 (tomorrow is another day)}.

RT:

For the one in Vienna now, we're basically going to build it through the "opening" so that there is no opening. There has never really been an opening for me. And I never feel the need to fix a moment where everything is complete.

HUO:

You've also been doing this project using models of {Ludwig} Mies van der Rohe's Seagram Building *(New York, 1954–1958) and his* Neue National Galerie *(Berlin, 1965–1968)...*

RT:

Actually I've been making this half-scale structure, a half-scale pavilion, but it's kind of like those Russian dolls, so there's the pavilion, and then inside that there's the *Neue National Galerie*, and then inside that there's the *Seagram tower*.

HUO:

So it's a building within a building within a building.

RT:

Yes, but the biggest building he made...

HUO:

... is the smallest.

RT:

And also I wanted to make a progression from private to corporate, which is what happened to Mies in a way; he went from a very ideological structure to a corporate American structure. I wanted to have a Barcelona chair inside which would act as Mies, so he's sitting in this pavilion, looking at all these things, and there's a radio on playing "The Life of Mies," which is a radio play.

HUO:

Read by whom?

RT:

Actors.

HUO:

And this is an existing radio play?

RT:

No, I'd make it up.

HUO:

And that's a whole show then?

RT:

Yes.

HUO:

And where will that be?

RT:

I haven't got a place for it, just an idea. I'm fascinated by Mies and I'm also fascinated by the contradictions of the movement.

HUO:

But for Vienna, you're focusing on Schindler?

RT:

Yes, it's something I'd been planning for a long time, even before the MoCA retrospective ("The Architecture of R.M. Schindler," Museum of Contemporary Arts, Los Angeles, 2001).

HUO:

And why are you interested in Schindler?

RT:

Because I think that he's an underground architect.

HUO:

More than {Richard} Neutra.

RT:

Much more than Neutra. He's the opposite. Neutra really worked with Schindler. Schindler was in LA and Neutra came and stayed with him and they were starting on a partnership and then they broke up. Then Neutra became successful because he was very ambitious too. Schindler for me is very interesting.

HUO:

About your Secession exhibition, you also made references to the market and to the dance floor, which are also kinds of stations.

RT:

Well, I was thinking about all the markets I have been to, such as in the Light Market in Thailand where people come and socialize. And the idea of the dance floor is a place of socialization through music and dancing. Then there's this market in Brazil where people arrive from the countryside and it's a huge open space where people from the countryside and can bring their food. I think that is an interesting way to think about the relationship between art and hunger. The people who work at the market have to get up at around two or three o'clock in the morning. People also go there at that time of the night to eat and somehow to participate in the entertainment that these people provide for themselves at the markets. There is a stall where people are sleeping after they have set up their meat. And then there are people who sit together and drink.

HUO:

Where is this market?

RT:

In Rio. But it's the same in many places. It's about the farmer's market really, about people coming in from the countryside. Some people have to drive all through the night to get there. The kiosks also make me think about the idea of the station. Before you go, you need to pick up some things. So, we're talking about some kind of space that is accommodating to the passage. At the Secession, it's more a semi-station in fact.

HUO:

A semi-station?

RT:

Yes, it's a semi-station in the sense that I would like to think of it more as a kind of park or a garden. That's something that I've been quite interested in, its interiority and exteriority, and ideas of nature and living, inside and outside. It's more like living outside, closer to camping, so really it's a kind of semi-station because it's

about the "outside space" rather than the "passage space" which is the station. I would say that semi-stations are more a place to rest than a lot of other spaces.

HUO:

And so for the moment it's a platform, and a platform of interaction that is also a platform on which a house will be built.

RT:

Yes, it's the foundation of a house, but the house itself is based on the idea of the "exterior." There is very little "interior" in a sense, presenting you with the interior so that you can experience it outside. And of course, in this case, one night of the week the space will be open all night so that people can come and spend the night there.

HUO:

For the show at the Secession, the idea is that it's the foundations for a house but at the same time there are the plants, the palms, which bring the outside inside and vice-versa.

RT:

Yes, of course. All things together in life! Which is interesting, and particularly interesting in relation to [Marcel] Broodthaers, although I'm not entirely sure why. And again, maybe it's the same sensibility that I also think about Schindler. There's an interesting relationship there. Schindler's garden plan is very symmetrical, and I don't remember thinking about it, but it struck me that I don't think Broodthaers would have made such a symmetrical plan.

HUO:

And how do you feel about Philippe Parreno's interests in evoking the collectivity? One of the ideas for the "Venice Station" is bringing in people, whether alive or dead. Here you are talking of bringing in Schindler and indirectly Broodthaers, but at the same time there are videos of people who are working now: so there is also this dimension to consider.

RT:

Yes. Well, I think that's interesting because of the idea of working with the vernacular.

HUO:

And because nothing is new anymore.

RT:

I think it's not so much a matter of nothing being new anymore, but that there are important ideas that have already been made. And rather than trying to represent it, to present the things that

already exist. So that's why I have been personally interested in collectivity; there are a lot of ideas already out there. We need to realize that it is part of our consciousness of reality. It's a presentation of the author, perhaps in a different kind of condition because times have often changed, but I think it's always important to look back at those ideas.

HUO:
In terms of collaboration and bilateral exchange rather than appropriation, Kurt Schwitters talked about the Merzbau (1923–1943) as a sort of shrine of friendship.

RT:
I think it's a good word and a good starting point. That's also something that was interesting in the interview that you did with [Peter] Smithson when you were talking about shows and how they're about collective friendships that come about and go away, oscillating.

HUO:
What would you say are the best group shows that you have been in?

RT:
I've been thinking about that and I think that they were all early on. "Backstage" was a formative group show for me ("Backstage," Hamburger Kunstverein, Hamburg, 1993). And as you say, it's the kind of situation where we all had the energy and we all had the sense. That was a show that we really enjoyed together. The group shows I enjoy are generally not so big. Firstly they weren't such big group shows, and then secondly there were always relations amongst the people who were in the exhibition. Always creating relations, people meeting people.

VARDA, Agnès

Agnès Varda was born in 1928. She currently lives and works in Paris. Varda first established herself as a photographer, and she worked for the Theatre Festival of Avignon and the Theatre National Populaire (T.N.P.). Varda pursued a career as a photojournalist, before she made her cinematic directorial debut in 1955 with La Pointe Courte, *which is considered a forerunner of the French "Nouvelle Vague." Varda rose to international prominence with her next feature* Cleo from 5 to 7 *(Cléo de 5 à 7, 1961), which unfolds in "real time" as she follows the life of a young woman awaiting the results of medical tests. In 1964, her film* Happiness *(Le Bonheur) received a Bear prize at the Berlin Film Festival. In Los Angeles, Agnès Varda directed two shorts and a hippie-Hollywood-style feature,* Lions Love *(1969). Back in France, Varda made documentaries including* Daguerreotypes *(1974), a film based on her neighbors on rue Daguerre in Paris. Varda's other features include* One Sings the Other Doesn't *(L'une chante, L'autre pas, 1976);* Vagabond *(Sans toit ni loi, 1985) which won the Grand Prize at the Venice International Film Festival;* Jane B. By Agnès V. *(1987), and* Kung-Fu Master *(1987). Varda married the celebrated filmmaker Jacques Demy (1931-1990) in 1962; in the '90s, and she made a film trilogy about her husband, which included a feature film based on Demy's childhood,* Jacquot De Nantes *(1990), and the two documentaries:* The World of Jacques Demy *and* The Young Girls Turned 25. *In 1999–2002 Varda met and followed various countryside and urban gleaners, which became an 82-minute documentary and a discreet self-portrait entitled* The Gleaners and I *(Les Glaneurs et la glaneuse), which received a number of international awards and wide acclaim all over the world in 2002.* Two Years Later *(Deux ans après, 2002) is a 64-minute follow-up to the* Gleaners. *Varda has also made 15 short films and she recently has begun to explore video installations.*

..........................

This interview was recorded in Paris in June 2002 and March 2003.

Hans Ulrich Obrist:

What are you working on right now?

Agnès Varda:

If you ask an apple tree about what he is doing, he'll tell you that before producing apples—good ones, bad ones, and the fallen rotten apples—it meditates in the winter, then... produces flowers. Flowers before fruits, isn't it wonderful? I know perfectly well that I'm not an apple tree, but could you accept the idea that in terms of creation, I'm about to bloom? In terms of action, I'm overburdened. I'm making "boni" (in Latin: bonus, boni). A "bonus" is

something that the people who buy a DVD want to find. They want notes, explanations on the director's ideas before shooting, or "making-of" pieces or other goodies related to the film that is the main course of the DVD. I'm working on boni for two documentaries of mine: *Daguerréotypes* (1974) and *Mur Murs* (1980). It's fun to see films that I have made again; I had forgotten the details. I'm trying to add something, not only comment. The DVD of *The Gleaners and I* already came out, with many boni. The bigger one is a kind of *Gleaners II*; it's 64-minutes long, and it's called *Two Years Later* (2002). I went back to see the people I had filmed in 2000, like that man whom I met in the street who eats from the leftovers and teaches French at night, or the psychoanalyst who had more to say about "psychoanalysis as gleaning." Inevitably, I met other people who pick up things, and also artists like Macha Makeieff, who gather objects and stack them up. Another one wrote me; he collects buttons. In short, I gave the opportunity to some poor people and to some eccentric ones to talk about the fact of gathering things that have fallen or been discarded. Most of them take a stand against over-consumption, and define a kind of ethics around this. But what comes out is the *link*, the fragile link existing between the finder and those who have thrown something away or lost it. And this is the link that I wish to establish between each spectator or DVD viewer and me, or better, between each real person in the film and each viewer through myself, through a simple documentary. I partially succeeded—I guess—since I receive so many letters, so many gifts from people who have seen my recent films.

HUO:

Watching The Gleaners and I, *I immediately thought of Robert Musil who used to say, "Art is always where you least expect it."*

AV:

The word "art" could take a full page in the dictionary—or it should be deleted from it: it is too complex to be defined. It's like the word "poetry"; it's very dangerous. When one says of someone that he "does poetry" or he "does art," there's already a problem, in the very association of the two words. The important word is he "does," he makes... or she... As an artist, as a filmmaker, well, very often I feel I'm a non-artist, not even a filmmaker; I gather and wander, my mind is nowhere, in a no-desire field. I work on other things and take care of the production company. Then it comes back; I have the desire to film; I must do it the way I know how to

do it. When it's not a fictional feature, you can throw yourself right away into the research and shooting: find the places, find the people, set up the possibilities of meetings, and shoot. When it comes to editing, I work with the images I've shot, and the sounds. Claire Simon, another French documentary filmmaker, said, "The Real— isn't it a better word than Reality?" She said, "The Real is a mystery and the filmmaker questions it." Yes, questioning it and learning from it. I'm almost fanatical when it comes to editing, looking at what has been shot and restructuring it. Not in order to manipulate it, to make it lie, but, in a way, to make it fluid enough so "the link" will also naturally appear. I have to forget what I had in mind or expected or wished. I love working in the editing room. The main thing, of course, is to find a collage that will be relevant to me at the time of doing it, but also relevant to other people, transmit a certain emotion. During the shooting of *The Gleaners and I*, I discovered, approached, and was impressed by those who eat by rummaging in the garbage bins and picking the dirty leftovers. You have to tell that to each person in the audience without making them feel guilty. We all have selfishness in ourselves but we are not guilty of the world's misery.

HUO:

Marcel Mauss used to say that you always learn more about a civilization by rummaging through its trash bins than through the treasures it exhibits. I was wondering—if such a thing is possible to put into words in the course of an interview—from following, speaking with and filming gleaners, in terms of this civilization issue that Mauss was raising, first of all, do you agree with that?

AV:

Well. I guess it's true. Did I learn something about our civilization or only about the reality I see around me or even about myself? Why did I enter into the film? Why did I film my hands? Discovering recently the little digital cameras, I was able to hold the camera in one hand while filming my other hand. Everybody came to tell me how they loved those shots, my old hands with rotten skin, rivers of veins and liver spots (by the way, Jacques' mother used to call them cemetery flowers). The same hands showing my age also play joyfully to virtually catch the enormous trucks on the road. The audience, while discovering the dignity of some poor gleaners, while approaching them, were approaching me, the aging me. But I'm aware that the main subject of *The Gleaners* is the waste in our society. Who eats the leftovers? I knew I had to give time and

patience and affection to the people I wanted to film. People who sleep in garden shacks, a woman who lives in a trailer, the only water she can get comes from a faucet somewhere among herbs. Having a shower is not even a desire for her. I took the time that was needed to look at everybody with attention and tenderness. Images and sound. I was often surprised that they say interesting things. Then I allowed myself to enter into the film as a discreet side subject—who knows why, it just happened like this. I felt I could do it and I did it. In a way, I was requesting from all those people to speak sincerely—and why not myself? It was fair. There is a nonstop movement that goes from images to words and from meaning to whatever comes across and from the desire to add music or not and/or special sounds to the need of silence. Constructing a film is complex and delightful. I got the same impression when I did my book (*Varda par Agnès*, 1994). It was fascinating to organize paragraphs of words and photographs, to decide on the connections between them.

HUO:

Indeed, it is a very original book, the way it switches back and forth between black-and-white and color as in your films. Did you decide on the design of the book on your own? Is it actually an artist's book?

AV:

Let's say that I got on extremely well with the layout artist and the graphic designer. I went there every day. I brought texts. I sometimes rewrote things right there to fit the space for images. There was a real collaboration. I wanted the book to be well executed and pleasing to read and convenient if you wanted to just grab it and read five pages or ten and go. I wanted it to be both serious and entertaining. I had to make it well, since it was the first book about my work. Let's make it clear: I was already 65 years old, had been a filmmaker for forty years, and there was no book about my work (in France). I'm not a famous filmmaker or the specialists were not interested in me. There were many articles in film magazines, but no book. I had to do it myself—plus there was this opportunity to have it on display at the time of a two-week retrospective of my work at the French Cinémathèque in 1994. The idea of the small dictionary at the beginning of the book came since I'd never done any writing and I felt I had so much to tell. Too much! And so I could insert a whole lot of little anecdotes or little encounters into the dictionary. B for Brassaï, S for Sarraute, but also M and R for my children Mathieu and Rosalie. To follow the alphabet as a rule

is exciting. It ended up as an original book. Sold out. Now we have to make a second publishing, but I have to write again to update it. I made four films since 1994. Will I be able to be inspired and do what I did at the time: writing every morning from 5:00 a.m. to 9:00 and then go to do other things? Writing for original projects suits me, and I must say I'm impressed by your projects: you make original books, you organize unusual meetings with an extension into writing, and also you are the director-editor of that thin strange magazine, *Point d'Ironie*, dedicated to one artist at a time. Each artist chooses what to do. I love that rare publication: huge as a folded poster, printed on a thin beige paper. I'm ready for it. The same way I'm ready for installations based on my filming—not the old ones, no. I'm thrilled to film for an installation: it's a way to enlarge the possibilities and to liberate impressions and feelings.

HUO:

"Liberate" seems to be a crucial notion for you. In The Gleaners and I, *there is this magnificent scene where you liberate a painting from a museum's storeroom. Picabia used to say that museums were like cemeteries.*

AV:

I don't agree with Monsieur Picabia. As for my film, I knew the Villefranche-sur-Saone Museum had a painting by Pierre Edmond Hédouin. I had seen a black and white photo. It looked beautiful. *Glaneuses fuyant l'orage* (*Gleaners fleeing before the storm*, 1852). I called the curator requesting to see and film the painting and she accepted. We filmed it in the museum storeroom. Then I asked to take it in the daylight because daylight is the best light for painting, blah, blah, blah. She accepted and we were lucky enough to see the stormy painting not only in the daylight but in the middle of a stormy wind. There's a sequel to this, namely that the curator, realizing the shame of that beautiful painting buried in the storeroom, had it restored and it's been on exhibit in the museum ever since. They invited me to the opening and so I re-filmed all that in the film bonus, *Two Years Later*. There's the time of the shooting, then there is a film, then there's also the life of the film. What happened to the viewers? About time: if you go to a museum, you will look at a painting for two seconds, ten seconds or ten minutes. If you like it, you will return. You're the one who determines how long you will look. In a film, it's the director-editor who decides whether you will look at something for 2 seconds, 10 or 25. In the

editing room, a part of the process for me is the mental exercise of thinking—deciding about the length of time the viewer will have to look at something. It's fascinating. You influence the impression of the viewer. It isn't a tyranny—well, it can be in some of [Jean-Luc] Godard's shots for example, or some of [Jean-Marie] Straub or [Chantal] Akerman, but they have decided the duration because they like it that long, it's their choice. How to decide if it may be too long and disconnect the viewer, or not long enough so that he's frustrated for not having seen it long enough. We can only follow what we feel in the editing room.

HUO:

You have used the DVD bonuses so that the film becomes less an object than a process, an ongoing story. Another shrewd device of the same kind is the one used by the group Daft Punk: they have found an original way of handling these connections to time and the time of the viewer by letting their record customers visit their web site regularly and download "bonuses" or "updates" of their creations free of charge. The chain never ends in that case also.

AV:

Well done. I will certainly do a web site like that later, but it takes too much energy to do it with pleasure. We started the site of the production and didn't find the time to do more than one film, precisely *The Gleaners!* (It's www.cine-tamaris.com). But let's come back to the rhythm of a film and this time issue. Maybe time doesn't fly. In the film I cheated time and made a visual joke with the wonderful plastic clock with no hands that I found by chance. It served my purpose. I strongly felt I had to pick up that piece of plastic that François had neglected when I was filming him gleaning in a street. Being a filmmaker obliges you to believe in your strong impressions as in the famous intimate conviction of the juries when they decide "guilty or not" without having strong evidence. For me I also have to trust opportunities, surprises, and chance.

HUO:

I wanted to ask you about the importance of chance encounters in your work...

AV:

See, I was filming the story of a disoriented woman feeling pain and not understanding what she had in mind. My camera was turned towards the beach in Venice (California), I saw and filmed a black woman, kneeling on the sand and digging into it like a dog. Further on the same beach, two men were kneeling on either side of a

lying woman with closed eyes. The three of them were dressed for cold weather. There was a Bible at the woman's feet. I filmed what I saw and it is perfectly meaningful in the film (*Documenteur* or *An Emotion Picture*, 1981). It adds visual confusion to the character that feels mental pain and confusion. But twenty years later, I still don't know what these people on the beach were doing. I just felt I was lucky it happened at the right time. Sometimes, situations of my private life, encounters and discoveries I make by chance, determine what I do. The documentary I made about the street where I am living in Paris, *Daguerréotypes*, was actually made because I had a demand from German television to do a film, a "carte blanche." I took the opportunity of a certain "Monsieur Mystag" proposing a magic show in the cafe next-door to decide to film my neighbor shopkeepers. But later on, I realized that I made that film totally very near our house. Is it because I felt I was stuck at home? I had just had a little baby, in fact rather late in life. Maybe I didn't want to be far from home and found no other inspiration than a "neighbor film." It's clear I have an almost organic connection— though organic isn't actually the right word—let's say a genuine connection between developments in my life, my private life, chance occurrences, the places where I happen to be, and that something which can be called inspiration. A kind of setting for inspiration. I never languish for an idea; I never sit down at my desk in front of a blank sheet of paper...

HUO:

You could describe it as a chain between life and inspiration.

AV:

When Jacques Demy was Oscar nominated for *Les Parapluies de Cherbourg* (*The Umbrellas of Cherbourg*, 1963), he went to Hollywood and was asked to direct a film there. He asked me if I wanted to join him. At first I said, "You know, it's not for me, America." I didn't really feel like going. But in the end I went and once I was there I fell in love with Los Angeles, and right away I made two shorts and a hip feature, *Lions Love*. I really had to do a film like this, to liberate me from French cultural references. This was in 1967–68. Is it a chain of things that are true or not true? I think you have to maintain threads between who you are, what you love, and what you do. I'm not in favor of autobiography as a focus, telling one's childhood or one's everyday life. That doesn't interest me. I have no desire to make autobiographical films. I want to make films in which I exist; I want to exist within the films I make,

whether they are fictional or not. The way of filming "other" people reveals you anyway, the way you film them. Commissioned films can even arrive at the right time. Constraints are interesting. I was asked to make a short film about the Paris caryatids. When you're commissioned you're obliged to respond to the demand in a way that you can accept as being yours. I had a spontaneous reaction because the period the Parisian caryatids were made corresponds to Baudelaire's last years. I could talk about Baudelaire and quote him. Nice opportunity.

HUO:

The last time we spoke was several months ago, between the two rounds of the French presidential elections, and for the first time in the history of the politics and government of the Fifth Republic there was an extreme right candidate at the second turn. You were devastated, and you were wondering very much about your role as a filmmaker, as an artist in society in light of these events.

AV:

Remember this blow on the head we all received. We were in a state of shock when we discovered a France that was 25 percent on the extreme right. This nation, these people, these workers, these unemployed, these people I've been devoting attention to, want to be helped. And what did they do? They voted for the extreme right. Why? A country's real situation is very hard to grasp. We fell into our own trap. The socialists first and foremost, for they didn't understand what had to be done. We didn't expect that there were many people in the working classes, including immigrants who have been naturalized French, who thought that the extreme right could solve their problems. Were they only badly informed? It is difficult to understand.

HUO:

Yet some intellectuals, Etienne Balibar for instance, had analyzed this phenomenon a long time ago.

AV:

Yes, some people were relatively clear-sighted. The socialist left wasn't. The socialist left did a great deal for the workers, for the people, for artists, for the provinces, and thanks to the socialist left there was a real opening of the individual to personal qualities, to self-expression; but the leading party didn't understand what was really going on in people's minds and bodies. I was in a state of shock as a person, a citizen and an artist, and it's still incredibly difficult to accept that we had to vote right to push the extreme right out of the

way. Now France is leaded by a moderate right wing. Well...

HUO:

So now what do you think about the engagement of the artists?

AV:

At some point we can go in the street, we can speak to our neighbors and relatives, but as an artist I see two very different ways of reaction: one way of working for the understanding of our world, the other one to sublimate reality and make it a daydream. Let's speak about the first way. A voice can be given to those that are never listened to. Remember that man in *Two Years Later?* I met him near a market in Nantes, that man with very beautiful white hair and beard, a kind of out of season Santa Claus with an extraordinary look. He was on the ground, picking up an artichoke and peeling it. I went up to him and asked him if I could film him. I did the best I could because there was noise, cars going by, men cleaning the street. It doesn't matter. He said, "One shouldn't lose one's touch, one should keep picking up. With the changes in government, who is going to look after the poor?" It was terrific, that expression: "One shouldn't lose one's touch." That isn't well filmed. But once the editing was done, this man exists, he is beautiful, and the way he speaks moves us all. "Waste is disrespect towards the people who did something or grew it." I liked that man instantly; I might never see him again. I felt my work was as when you say to friends, "There's this great guy coming to my house for dinner tonight, come over, I'd like you to know him." I made everybody in the audience meet this man with an artichoke. If you knew the number of letters I received for my two recent documentaries... Maybe three hundred or four hundred letters. People feel affection for the filmed persons and they are grateful to me since I'm the one who introduced them. My second, totally different way of reacting to the difficult world in which we live is to daydream, filming moments of life out of life, filming objects, vegetal stuff and/or textures that give me the strong feeling of what beauty is. You may call it Utopia since you, Hans, are so interested in this notion.

HUO:

Is there a utopian dimension to your work?

AV:

I'm not very utopian. I've read a lot of ideas on Utopias, etc., but the dimension of impossible achievement of Utopia doesn't please me. I'm therefore incapable of big utopian mental and active con-

structions. I believe that *rêverie* (daydreaming) is very useful in life, and so is making people share it. But total Utopia, no, that isn't my thing.

HUO:

How do you feel about exhibits of your work? You used to be a photographer, a practice that you later gave up to make films. In the book, however, you mention a slide projection show with synchronized sound done in 1982—in other words twenty years ago. What significance does this work have? Has it been shown since?

AV:

No, not since that experience in the big antique theater in Arles. There were columns of cypress trees surrounding a huge screen, plus moonlight, and the photos went by one after the other, with my voice commenting, with music and film excerpts related to photography. It was very magic on that nice July night. What can be done to revive that slide show? Maybe I should make it like a film or turn it into an installation. More than ever I am a "has been" photographer, because the photos were from the '50s, my images of [Jean] Vilar and [Gérard] Philippe in the Avignon Theater Festival, and my work in China, in Portugal, and other places. I've been asked if I'd like to have a large exhibition at the Maison Européenne de la Photographie in Paris and make a book. I'm flattered: Shall I do it?

HUO:

A solo show only of your old photographic work? It would be nice also because one could see with your portraits all the trajectories that kind of crossed in different points in those years: you met Brassaï, Calder, Warhol... Which encounters or conversations with artists have been the more important to you?

AV:

I feel I didn't meet enough artists and I didn't spend enough time with them. Now, at the end of my life, I regret, perhaps, that I worked in such a solitary fashion. I could have met [Nicolas] De Staël in Ménerbes or Antibes. [Pierre] Soulages was almost my neighbor in Sète. I admired [Maurice] Pialat as soon as he started. We knew Godard, we were close friends in the '60s, but then we went to California and he took a switch. When we came back, we didn't meet again. In LA I met [David] Hockney, just hello. We met John Cassavetes, but only once. I wish I had seen him again, but it didn't happen. There are some artists I wish I'd known better. We met Luis Buñuel in Acapulco, and the meeting made quite an impression. He even knew my films and said he loved them. Why didn't I try to establish meetings with him? I love his films so

much and the man was a delight. Why didn't I try to approach Rauschenberg? I met Warhol and we got along. His work impressed me—as a painter for his daring suggestions, and mostly for his films, sometimes boring to watch but definitely important in filmmaking history. He broke all the habits of filming well; he established a daring time relationship between the filmmaker and the viewer. He was a genius and a passionate-cool artist. I certainly didn't meet him enough. Too bad for me! We have always been, Jacques and I, staying aside, both shy in a way, and lonely. People would drop by, neighbors, workers, foreigners who come to say hello. I've certainly had many more conversations with workers and ordinary people than with artists. Now I regret very much that I was not involved in a group of artists who meet, discuss, eat and drink. Artist communities sometimes take on an elitist tone very, very quickly; maybe we were afraid of it. Now I feel I have nobody of my generation to speak with.

HUO:

There is a danger of artistic salons. John Cage used to say that salons should be in the kitchen.

AV:

Gosh, you have quotes for all situations! Yes, as you've noticed, I spend more time in the kitchen than anywhere else. I work here a lot. Susan Sontag, whom I met in New York, also used to write at her kitchen table. Many feminist women have said to other women (and it was a good way to speak) "Get out of your kitchen and do things for yourself," but we all know the kitchen is still a very female realm. I'm not saying that we're all cooks or cleaning women, but we, women, feel comfortable in the kitchen. It's also the place of the food. The family soup. The oven. The cakes and the cookies. As for the children, the small ones spend a great deal of time there and they do their homework on the kitchen table. So do the older children when they come back at Mom's—look at Mathieu who is a grown up—he drops by and sits in the kitchen. That's where he wants to speak with me. Or read the paper. So does Rosalie. The kitchen is a great place, even in our mental life.

HUO:

The kitchen as laboratory then?

AV:

No, forget experimentation. The kitchen is a center, as the heart. It deals with childhood memory. It's comfortable but it also deals with mixed feelings. There are big mysteries about ideas, places

and people that have built us but also that relate to separation and nostalgia or deep pain. Why that place? Why that family? Why those pains? Is it fate or chance? Buñuel came up with a terrific sentence—he said, "Somewhere between chance and mystery, imagination slips in and it is man's total freedom." We are faced with things which we don't understand. We don't understand ourselves so well! It is the work of artists to deal with the lack of understanding and the recurrent mysteries. And to believe in the good effects of mystery and the possibility of communication. Artistic work is eminently solitary work. Even when you have a good cameraman, or a good editor, or excellent actors, when you're making a film you're on your own. I've had marvelous actors—Sandrine Bonnaire in *Vagabond* was magnificent—but the film, its structure, and the editing, were completely my own decision. It's not "me, me, me." It's simply that sharing with the viewer can only go through one person. Art or film is a person-to-person story.

WEINER, Lawrence

Lawrence Weiner was born in 1942 in the Bronx, New York. He currently lives and works in New York and Amsterdam. Weiner attended the Stuyvesant High School in Manhattan and studied philosophy and literature at the Hunter College in New York City. Having decided to follow an artistic career, he went to California where he experimented with painting and performing open-air projects; e.g., a series of explosions in the ground in Mill Valley (1960). After his return to New York, he had his first one-person show at Seth Siegelaub's gallery in 1964. Already in 1969, Weiner had laid down the principles for his work in an often-cited declaration, which he has stood by ever since: "1) The artist may construct the work; 2) The work may be fabricated; 3) The work need not be built; Each being equal and consistent with the intent of the artist, the decision as to condition rests with the receiver upon the occasion of receivership." In a radical restructuring of the traditional artist/viewer relationship, Weiner shifted the responsibility of the work's realization to its audience, while also expanding upon systems of artistic distribution. A work can be physically realized or merely spelled out on a museum wall, but it can also be read in a book or heard if uttered aloud. Weiner's art can literally be disseminated by word of mouth. Since the late '60s, for his installations, Weiner has worked exclusively with language, and with the generalities of material rather than with its specifics, spreading nondescript lettering painted on gallery and museums walls. Although this body of work focuses on the potential for language to serve as an art form, the subjects of his epigrammatic statements are often materials, or a physical action or process, as exemplified by works such as ONE QUART GREEN EXTERIOR INDUSTRIAL ENAMEL THROWN ON A BRICK WALL *(1968) or* EARTH TO EARTH ASHES TO ASHES DUST TO DUST *(1970). At other times, the subject involves* A TRANSLATION FROM ONE LANGUAGE TO ANOTHER *(1968) or an encounter with a national boundary, as in* THE JOINING OF FRANCE GERMANY AND SWITZERLAND BY ROPE *(1969). In the succeeding decades, Weiner explored the interaction of grammar, punctuation, shapes, and color to serve as inflections of meaning for his texts. In 1997, he created* Homeport, *an interactive environment for the contemporary art web site äda'web, in which visitors can explore a space defined by linguistic rather than geographic features. Weiner has also published numerous books, and produced various films and videos since the early '70s that reposition the relations of the actors to one another and to the viewer. Recent one-person museum exhibitions include "Until It Is" (Wexner Center for the Arts, Columbus, Ohio, 2002); "As Far As the Eye Can See" (Kölnischer Kunstverein, 2000); "Nach Alles/After All" (Deutsche Guggenheim, Berlin, 2000); and "In One Place and Another" (Dvir Gallery, Tel Aviv, Israel, 1999).*

........................

This interview was recorded in New York in January 2003.

Hans Ulrich Obrist:

What do you think of the "Utopia Station" project that we're developing with Rirkrit {Tiravanija} and Molly {Nesbit} for Venice (La Biennale di Venezia, 50th International Art Exhibition, 2003)?

Lawrence Weiner:

I'm very interested in the "Utopia Station" working, but I'm in a bit of a dilemma about what to do in Venice, because I've never been there as an artist.

HUO:

You mean this will be the first time that you show something in Venice?

LW:

I went to Venice in 1972, and John Baldessari reminded me that I slept in Gary Shum's truck, as they didn't consider us worth anything. But we showed our video there in the Biennale in 1972, as we had been invited. Then I went there in the role of theater director, and I went also as one of Die Damen, so I went as a female Austrian performer! The only time I've been to Venice when my being an artist had some meaning was for a talk at Benetton during the winter. I had four days to draw and it was fabulous. So now, I'm looking forward to it, but I have a real problem with the work. Wherever I put the work in Venice, it will look like it belongs there because it doesn't have any precedent; it doesn't have any needs.

HUO:

Perhaps you could make it mobile.

LW:

I don't know yet, we'll have to discuss it. It's a collaboration show, and I hope that all of our colleagues understand that collaboration doesn't mean being somebody else. It does mean putting your work into a context that is collaborative. For me to go into Venice with an idea at this point... we still have quite a few months. We will have other conversations along the way—maybe not in a group, but we'll be talking to each other. Let me determine how we do it.

HUO:

We'll keep it open.

LW:

I'd appreciate that.

HUO:

There are so many possible avenues to begin this interview with...

LW:

You start and we'll go along with the flow. I won't extrapolate!

HUO:

Well, let's start with collaboration since it has already come up. You have been influential in this area, not only through your collaborations with musicians, but in so many other areas. Could you tell me about the history of collaboration in your practice?

LW:

Okay, but I have to personalize it. My own praxis is based on my relationship to materials. It's a studio practice. The studio might be the North Sea, but it's still a studio praxis. There's no difference between a landscape painter carrying their easel out into the land- scape or staying inside and looking at a photo—it's the same for me. It's very good for contemporary artists when you are trying to have a conversation with the world as it is—not as it was—to work with other people. You can't make music, you can't make film— you can't even make a book without working with other people who have skills that are on the same level as yours. And I like that. It takes you out of the ivory tower. I'm also in the position where I have a reasonably good life but I don't have a lot of extra money, so if somebody is working with me on a project, they're not going to be making a lot of money. I have to entice them. I have to make it worthwhile for them to take their skill and put it with my con- tent, or else they're not going to do it. By the time you walk away, you walk away with a book. When you open it up, all the credits are there. When you see a DVD you know who handled the com- puter, and every one of those things determines how that project is done. It's no longer a matter of the artist being the Hollywood auteur. It doesn't work. You have to accept that there is a division of labor. One of the things that you do in that division of labor is accede to another person's concept of context, because if your work cannot exist within their context, then it cannot exist as a univer- sal that you claim it can when it goes into another world. I see con- text and content as inherently different. I used to believe that aes- thetics were ethics, but the more I've worked, the more I've real- ized that this is the reason for a lot of the political malaise that we have. In fact, aesthetics are not ethics; aesthetics are aesthetics. Ethics seem to be something that can cross aesthetic lines, and I'd like to have an aesthetic that can cross ethical lines.

HUO:

That is something that has been present in your work since the very beginning.

LW:

That was the reason for making it, and my reason for becoming an artist. You've seen my biography, so you know that I was educated in the New York City public school system, but through my own devices and through the generosity of a lot of other people, I am reasonably well educated. But I had a choice as to my real involve- ment at a certain time, which was an attempt to set up situations that were more amenable than civil rights and labor organizations,

and the making of art. I made the decision that art was what I was going to do: it was not a vocation from heaven; it was an intellectual decision. Of course, Benjamin [Buchloh] had the same problem, he just didn't understand that the systems he believed in as a youth did not fail him—they got worn out, and that's no failure. It's a funny thing; you can't personalize that. You can't say, "I wasted my time thinking that." All those people that were caught up in the Structuralist rage, they didn't waste any time, but if they spend any more time trying to defend a theory that didn't work, then I think it's fair to say that they've wasted time. But having gone through a legitimate, sincere analysis of the society that they lived in—that is not a waste of time. And I don't think that any of my endeavors are designed to succeed or to fail. I don't really know. I don't like being responsible for other people. The work is useful. If somebody can use it, that's the whole point of the work. And that's true for anybody's work, and not just mine. A Mondrian is fantastic because it does increase our understanding of material reality. Pollock is fantastic because you understand the idea of attempting to find your own place within the cosmos and mark it. That's fine. But, hurray, where do we go from there? In terms of the collaborative element, I really believe that I've had a lot of luck in working with lots of musicians, and as far as the praxis of art goes, I was able to use that. From the beginning, working with musicians made me realize that with group exhibitions ... and you'll have noticed when we were talking about "Utopia Station," I didn't ask you who was going to be there or who I would be sitting next to or whose context I would be in—because as long as the work is dignified (and I took it for granted that you, Molly and Rirkrit were not going to invite people who are not dignified), then it can't harm you, it can only do good. If everybody is genuinely awful and they really fuck up, and you do your job well and not with the intention that everyone will look at you, but rather look at your work, then you will do fine. If it fails, it doesn't rub off on you. And if everyone is superfabulous, then you look even better! And every musician in the world would explain that to you. The trick of it is that in the midst of it, you have to do your job as best you can.

HUO:

So that's what you learnt from the music context.

LW:

Yes, that's what I learnt from the music context. My involvement with music began in New York City. At one point, practically

everyone there could play or read and write music. There were set-
tlement houses and places you could learn to do it. It was consid-
ered the normal thing to learn. So it started when I was a kid. Then
I lost interest in playing the saxophone. I was much more interest-
ed in the results of the music and in leaving the playing to other
people. But I found myself getting along very well with musicians.
The first feature I made wouldn't have been possible without the
support of Richard Landry. He wrote a score for the movie, but he
was also a grip—he helped set things up.

HUO:

And that was in 1972?

LW:

We shot it in 1972. He was a consummate musician. Then we
made a record together for Munich [*Having Been Built On Sand.
With Another Base (Basis) in Fact*, 1978]. I've always worked around
musicians. I worked with Peter Gordon on movie scores and we did
the opera in Berlin (*The Society Architect Ponders the Golden Gate
Bridge*, 2000). That was an experience!

HUO:

Where was that?

LW:

At the Hamburger Bahnhof. That was three years ago. I'm very bad
on time—I have no concept of when I did things. There's a book
that Walther König published that has the whole libretto. It has
all the music that Peter wrote, and it has the stage directions and
everything else. It was an idea to take a simple, almost chamber
opera, and deal with the court case that I had in 1980 when I was
in a car crash. In the state of California, they spent a week proving
that what I made was of no value, and therefore —and as the judge
agreed—even as a person with a history in California and as a basi-
cally decent person, I had no value. I could not be inconvenienced
by a car crash because I didn't do anything of any value—just a lot
of words and a lot of noise. At the time, that was a disaster, but
legally, I was a person of no value—,which is the aspiration of every
artist in the entire world! [*Laughs*] So that's the music thing. It
doesn't go any deeper.

HUO:

*Another issue I'd like to discuss with you is the fact that you describe your-
self as a studio artist.*

LW:

I have always been a studio artist. I am a materialist, and I am not
a Conceptual artist. The people whose work has continued to have

value and use within our structure are all materialists, from Robert Ryman to Daniel Buren—he is involved in the material of history. But his reference is always to history. I like to have a practice that doesn't have to refer to history. That's the difference.

HUO:

What about context and site-specificity?

LW:

No, I don't see it. Site-specificity. I don't understand it. If someone says to me "Lawrence, we have a city and we'd like you to deal with it," then that's a context. So I'll say, "Look, this is what I am working-ing on at the moment; this is what I can do best right now, because it's the thing that is closest at hand, so I'll place it within your context. Let's go for it." And I try to do the best job that I can. I try to find out all I can about drainage, city planning and things like that, for that site, and I'll put the work in, but I'm not going to change the work for them. There's no reason why I should, and I don't think people expect it, although they like to think it's special for them. No, it's special after it's made. Then it becomes something else. But it's not site-specific: it comes out of a studio practice.

HUO:

You have studios in different places, in New York and in Amsterdam. Is one a mobile studio and the other a static studio?

LW:

No, they're both static. And they're both different. Basically I go to Amsterdam to draw because the light is good. And I literally adore the concept of Dutch culture; there is something about it that I find extremely dignified. But I didn't find the Dutch art world particularly exciting. By luck, my politics at the time, in the '70s, when I first moved to Amsterdam, didn't even allow me to think in terms of taking a subsidy. So I have no relationship to that structure whatsoever, other than as an artist who sometimes gets invited to make a show. And that's a nice sense of freedom. And I have the exact same freedom there as I do in New York. When you go to Paris for a show, you're a guest worker. You have other obligations.

The studio is a place where I can work. I'm not that brilliant. I really require, every once in a while, a little bit of protected space and enclosure. I'm one of those people, by luck, that only likes to work where they sleep and sleep where they work. The studio is a studio,

and we made a lot of movies in it. I'm just lucky that's the way it is. I know artists who can't sleep where they work. I can't separate it.

HUO:

In an interview with Buchloh, you rejected the studio as a metaphor for the outside world.

LW:

Nor is the academy a metaphor for anything—it's the academy. That's why my relationship to when people are teaching becomes a rather heated situation. I don't see the museum and the gallery as a metaphor. I see it as a reality, and as a reality it will have facets that are viable and facets that are false, as a metaphor it can have nothing except your hatred. Your hatred is worth shit; my hatred is worth shit. The only thing is—because of the privileges that artists and intellectuals have of being able to talk to larger groups of people than the average person in the supermarket—is that that anger can inform you. But it cannot be a reason for existence. It's not enough; you really better be able to say, "The emperor has no clothes on." You can't say that if you are part of the academy because you're part of the emperor.

HUO:

This is something you often repeated in public talks and conferences.

LW:

You know in conferences, when somebody asks you a question and you don't know the answer? You don't say, "I don't know the answer"—you say: "Wittgenstein!" You know what I'm talking about don't you! The ones that say "John Cage!" "Duchamp!" I have no fucking idea what kind of an answer that's supposed to be. Say there's a hole where you're asking me to put my foot: "Wittgenstein!" [*Laughs*]

HUO:

[Laughs]

LW:

I'm sorry if I'm sounding silly, but it's the truth! I'm so fed up with this; they've taken these people who were dignified people and turned them into idiots! I must say that most of the people I know who teach sure as hell earn their money. I'm not saying this is a rip-off, I'm saying that nobody has questioned the academy to such an extent without using silly words like "free" and "open." I don't think that it's a scam. I just don't see it as a functioning entity. I don't want to join the establishment. I feel very much like Groucho Marx. "What would I think of a club that would have me as a

member?" It's a joke, but it's not much of a joke. I think the same thing. My job is really to be a pain in the ass.

HUO:

It's about resisting?

LW:

No, it's about keeping true to what I still see as my job description.

HUO:

Another remark of yours in this interview that I found very interesting, and that I'd like you to develop, was that you thought that {Robert} Rauschenberg was underrated.

LW:

I think Rauschenberg is fabulous. In many ways and in my eyes, he is an example of what a functioning artist should be. He was constantly taking risks. Sometimes he succeeded and sometimes he failed. And as he was lucky enough to have acquired social standing and financial security, his sense of generosity towards other artists grew enormously. As a human being, he was always very agreeable and decent. But as an artist, I think he is underrated because instead of making what he knew how to make, each time he would try to make something he didn't know how to do. And of course, it failed. And that's why [John] Chamberlain is such a good artist too.

HUO:

So in your eyes the most important thing for an artist to do is to take risks and make mistakes?

LW:

You just have to make it and not worry so much about how it will fit in the catalogue raisonné of your life. That's not what an artist is about. An artist is not building a catalogue raisonné. An artist is a participating member of society, who at that moment is the person on the wire—they take on that responsibility. They expect, as we should, to be compensated for it and treated a little bit differently. The person who has to walk the high wire has different social needs than others. That doesn't give you an excuse to do things to other people that you're not supposed to, but it does give you certain kinds of leeway. The artist is different from the person who goes everyday into a standard structure and does their job and functions as a useful member of society. There are different functions in our society. The people that dig the tunnels underneath are not expected to function in other social ways. They are expected to have

certain checks and balances, certain projects, and that's all it is. So Rauschenberg is somebody who tried. As he aged, he adapted to living the equivalent of the high wire.

HUO:

Would you describe it as radical experimentalism?

LW:

I would say that it was just a commitment to doing your job. It wasn't a radical experiment; it was a commitment. If someone hires you to do a job, then you do it. And if there's something not quite right, then you do something about it. Most people will do something to try to make the situation better. Most people will do something to try to make themselves look like they've saved the situation. A legitimate artist just takes what's there from that staging area—like your "Utopia Station"—and builds something that deals with the same question. Sometimes it doesn't look the way it's supposed to and sometimes it doesn't work. Along with Robert Rauschenberg, I could name twenty or thirty other artists who for all of their lives have attempted to take what they've learned and move on with it, and publicly.

HUO:

Could you name some of them?

LW:

Chamberlain. I really respect his work. There's a dignity to the endeavor that I find really rewarding to watch. It has to do with his work. I think artists are either dull or colorful people—they are good or they are bad, and it makes no difference whatsoever. It makes a difference to the person, but it doesn't make a difference to the work. Penicillin that is made correctly by a bad person will still solve the infection.

HUO:

Chamberlain worked with Billy Klüver for his television projects also.

LW:

Exactly, he did all this stuff with Billy Klüver and Merce Cunningham. He worked with David Tudor and was supportive of performers. He saw himself as an integral part of a living, vibrant culture. The problems with living, vibrant cultures are the same problems as for rock 'n' roll groups. They get old. And people lose interest. But the fact that the person still believes in themselves enough to be able to deal with it and still believe in society enough to think it is worth doing, even though they could sit back on their haunches and produce two or three paintings a year and put them out and

play that whole game. I'm afraid to say that this has happened to so many people from the '90s. This is a pity. If you're too old for doing it, however, then quit. Stop all this nonsense about *the meister*, that *the meister* just keeps on *meistering* along. They don't *meister* along. They either function or they should quit. When a surgeon feels that his or her hands are not stable enough, they stop cutting into people's brains and teach instead. Maybe that's what the whole thing is—nobody wants to admit that, "hey, I did that real good but I can't throw the ball that far any more." You don't have to leave the thing that you know and you don't have to stop doing it, but maybe you can't perform any more. Artists are not special people. We're supposed to do good each time but if you fall on your face enough times then there is a legitimate reason for people to say, "no thank you!" It's not because they hate art. And everybody gets so confused about this whole thing. They think that if someone rejects what you do then they must hate art and hate you, but maybe they just don't like it. There is no God-given rule that says that everybody in the world has to accept your premises, and that doesn't make them a philistine. Chamberlain takes risks; Chamberlain succeeds. He will go on for years then all of a sudden something occurs to him. He is always in conversation with other artists. He produces things such as the film pieces out of nowhere. And the paintings that he did. This is not in terms of a career; this is in terms of somebody taking risks when he is interested by things. A lot of the things that he took a risk with were inevitable and they didn't work. But you don't save all the little things that don't work—you throw them away.

HUO:

So it's a matter of editing?

LW:

It's editing, yes. And it's out of respect for your public, not for your career. Editing was the seventy paintings that I didn't think worked so I destroyed them. Editing is the work that you never see. Even in the catalogue raisonné from France, as I was walking along I realized that there were mistakes in some of them, so I changed them and I showed people in the book how it changed from what to what. Does that make me less of an artist? No, it doesn't do anything: it's just the truth. If you cook for somebody on Tuesday and you forget to put the salt in, on Wednesday you remember to put the salt in.

HUO:

So once the decision is made to stop being an artist, is it then reversible?

LW:

Yes, some people believe that the decision is reversible. But artists don't write prescriptions for medicine and they don't fly airplanes with 400 people in the back. You fuck up and you look foolish. I think you can survive looking foolish—it's worth the risk. You must have been having trouble getting people for your "Utopia Station," afraid that they're going to find themselves in a context that they're not going to look alright in.

HUO:

At the beginning of the project, there was a sort of perplexity and questioning, and then all of a sudden there has been more and more involvement.

LW:

And presumably there were a lot of people that others didn't know and as they began to see that there was an energy coming out, then they could see it was the place to participate—even if you disagree, it is the place to disagree. All it requires is a certain amount of courtesy in order to disagree with colleagues. But you don't have to bend. So I find that extremely exciting. It's great that you're pulling it together. And there is such a diverse group of people around the table, with everyone taking it quite seriously. Everybody decided to be who they were. That's why I really liked Rirkrit's response that he refused to give up the position of Peter Pan that he has taken on.

HUO:

Would you say that the fact that we proposed that everyone do a poster has acted like a trigger?

LW:

It was an attempt to take what I thought was my skill and do something with the grace of a *Lawrence Weiner* but that didn't look like a *Lawrence Weiner*, that's not a work. I wanted to make posters that anybody could fly their flag under, and it seems to have worked. I like it. I like what happened. I was a little nervous about sending it off, but it's true: What is Utopia? This is Utopia, one, two, three. Right now. Utopia now.

HUO:

Here and now.

LW:

Here and now. Not in the future. I'm so oppressed with what I don't believe in. I don't believe in footnotes and I don't believe in stealing. And I don't believe in building your whole case on somebody else's quote.

HUO:

And you're against appropriation?

LW:

I don't approve. To this day, I'm really sorry, I don't believe in appropriation. I think appropriation is theft. If it's good enough to be appropriated then it's good enough to be used as it is. A copy of a Walker Evans is just telling me that it's a reproduction of a Walker Evans. I'll give credit if the person does a good reproduction, but I can't say it's their work. But at the same time, if the Walker Evans is still inherent in your work, it's because you can't think of anything else to do. Making a replica of something else doesn't work. In fact, if people knew a little bit more about this art history that they adore so much, but that they know shit about, all of these fantastic artists have been abused and misused by people making copies of them. That's appropriation. The artist has a right to the profit and maybe they have the right to not having their work recreated. Reproduction is something very different. I've said it too many times, and it sounds silly, but if you work on the factory floor and you steal, you go to jail. If you run the factory and you steal, you go to jail. If you steal someone's ideas, you're a thief. But if you're the bourgeois managerial class and you steal, they reward you because if they don't they're afraid that you'll do something even worse. Only an asshole steals when it would be just as easy to use. Coming back to Rauschenberg, I think it was a gesture but it wasn't a necessary gesture. He took a de Kooning drawing that he said he was going to erase. This was not something that he did as a vicious act, and that is not appropriation.

HUO:

It was a subtraction.

LW:

It was something else, and he got his permission.

HUO:

One of the things that you have done which inspires many young artists is that you constantly work without hierarchy.

LW:

I can't accept the hierarchies. I don't believe in them. Money is the only reason for the hierarchies. I'd like to figure out a way to have the financial rewards without having to go against my usefulness in what I am representing. A poster is a poster, a book is a book, and a piece of sculpture is a piece of sculpture. Where is the hierarchy?

The market has given these things a financial hierarchy, but they are all necessary. You were turned on by Lautrec posters before you were turned on by Lautrec's paintings. If he hadn't paid attention to those posters, he wouldn't have been able to communicate with you what he was trying to communicate. I mean, what is the big deal? I really don't get it. If you make a cigarette lighter, suppose you're an artist—it has to be well designed. If you can't design it, then *say* you can't do it. If somebody else's was just as good, why would I want to go and make something that was like somebody else's when I would much rather pay the five dollars and buy theirs? I really mean it. And that's what I meant when I said that there is no need for appropriation when there is a dignified relationship between human beings.

HUO:

The idea of appropriation was prominent in the '80s and then in the '90s there was much more talk about infiltration, which is something you have pioneered a lot.

LW:

Yes, but I don't think it is a good word. If you're infiltrating, what you're doing is taking the trouble to place something within contexts. But then again, we're talking about financial things that might not really repay the effort, but once it goes in, if it really functions, it will be accepted and adapted by people because most people are not particularly prejudiced against things that artists make. Often they have no idea that it is the work of an artist. When I say I'm doing social service, I'm doing a show for a small Kunstverein, say, where I have to put in three months' work, I design and do everything—there are no financial rewards, but I think the cultural situation could use it. That's social service. When I make a poster or do a show for The Wrong Gallery [in New York], that's not social service. That's not a structure; that's just placing something out for people to be able to see or to use. Again, I prefer to make shows in commercial galleries rather than in museum structures most of the time, because people can come in, look at it, laugh and go home. In a museum, they think they missed something. I don't want people to feel that they missed anything. If they didn't get it, they didn't get it and it has no use for them. Coming back to the "Utopia Station," I'd like to see what happens with my colleagues. We're going to be in Venice, within a context, and that context has to prove itself not as exotic, but as a context that is not mistaken for the biennale context, but at the same time, doesn't say

it's not art. I don't know if we can do it. It's very complex and it's a real challenge. But if it weren't complex, why would everybody get so much work? You have the same problem as most artists—you have to have three or four jobs just to pay for your passions!

HUO:

Can you tell me a little about your use of postcards?

LW:

Artists have made postcards for years. And they've sent them around for years. Everyone gets to see it, even the postman, and you've spread your message. You can't spend your life going to the same bar and telling the same people the same story. If you've got a good story, put it out. It's about function. It's what the content is. That's why for me, I have a rule that when I sell work to someone, if they don't want it in an exhibition that's fine, but they can't keep it out of the catalogue, and they agree to that. So it can always be put in, in some way. My work does have an advantage—nobody can tell somebody that they have it and won't let them see it without telling them what it is. It's not a problem. The only problem I have is that I never realized that my work would end up at Sotheby's or Christie's. And the work doesn't function there. It never occurred to me to write it into its structure. Isn't that odd? It crops up from time to time, but it's not made for it. People have to stand there and read it.

HUO:

I interviewed Seth Siegelaub a few years ago and he mentioned the "Artist's Contract" {The Artist's Reserved Rights Transfer and Sale Agreement} from 1971, which was meant to protect the artist within the existing system.

LW:

I hate the fucking contract. From the beginning it has made no sense, none whatsoever. If the art world wasn't so corrupt and if everybody didn't think they were special, you put something up for sale for ten dollars, somebody walks in and pays the ten dollars—that's what you ask and that's what they paid. Ten years later they need money to send their kid to college or to buy new art—they get tired of using it, like you get tired of clothes—so they sell it and low and behold, they get $150,000 for what they paid ten dollars for. If they have a certain sense of regard for you, they go and buy something that you've made now, and they use the rest of the money to send their kid to college, or they go and buy a younger artist. They pay the ten dollars to somebody else. If they use the money to send the kids to college or buy a car or whatever, I don't

care. They earned that money—it's not my money. They paid the price I asked. Doesn't it end there as long as I retain the right that the work is not misrepresented? Those are universal rights. It doesn't need anything. Maybe not in the States, but in civilized places it's the law.

The contract says that artists are special people. Why did the subsidy system in Holland collapse and not really produce terribly much? It should have been like the unemployment system—if you're making shoes and they want to have shoe stores in their society, and the shoe store person isn't making enough money, they can get food stamps if they want to continue making shoes, and they can manage. Why don't they do exactly the same with artists and give them the same unemployment insurance that they give to someone else until they can make a living? That's fine, but why give them more? What makes artists so special?

HUO:

So you think that the contract is elitist?

LW:

Yes, it takes into consideration a hierarchy of production by artists above the production of other human beings.

HUO:

Gerhard Richter also once told me that he is against the contract because when a work leaves the studio it is like a grown up kid, and it is as if you want to control the life of a grown up kid.

LW:

It's a very good one—I like that a lot. I have always been intrigued by Ad Reinhardt: how can you tell somebody to stand five feet away from the canvas when they have their own eyes? It makes no sense. When you tell somebody that they have to stand here when we know that nobody's eyes are the same, it is as if you are saying there is a correct way to see, and there is no correct way to see. Other people's ways are not as good as yours: that's disgusting.

HUO:

What do you think of the instructions of John Cage, which referred to the "open partition"?

LW:

Cage was in a different situation. With the *mise-en-scène*, the camera can go outside of the *mise-en-scène*. Cage was involved much more in a moral sense—very much like Charles Ives—of how to get through life and notice what's going on whilst still getting to

where you're going. That's interesting. I discovered whilst working
on the book for Tel Aviv—it was in Arabic, English and Hebrew—
that in Arabic it's almost impossible to talk about something that
didn't previously exist. In Hebrew it's difficult, but possible. We
have surmounted many of those problems to try to present ways of
dealing with objects that didn't previously exist in a place. We
used drawings with the text, which were presented in such a way
that you can always see the other language upside down. This all
comes out of one of the cartoons, which asserts that the world
takes it for granted that all people understand the significance of
certain things, whereas in fact, the great majority in the world
does not understand straight lines. Many people grow up not
knowing any straight lines. And we think that straight lines are
the idea of Modernism. That's why I asked the question that the
psychiatrists didn't quite get. The whole point is that those build-
ings stink. Okay, color, but why not a nice, clean, gray building?
They could have made them just as well as if they were dirty to
begin with. They should have cleaned them first. I didn't care. I like
color. But it wasn't that, it was about making a hierarchy. Immedi-
ately color makes people's lives brighter. Take Mies Van der
Rohe—he was a person with a lust for life. When he made those
libraries in France, that was all gray concrete but they were cheer-
ful. It wouldn't have been cheerful if they had looked like those
Dutch day schools that are red, green and blue. It was cheerful.

HUO:

So there is no a priori for colors for you?

LW:

There isn't supposed to be.

HUO:

Could you tell me about how you work with translators?

LW:

If they have an idea of what the sculpture looks like, that's good
enough for me. I'm careful, but as long as it gives the general idea,
that's fine. Objects do have a destiny and you can change it. Ura-
nium has a destiny. Everything has a use and you change the use,
and form cannot follow function because that's saying that you
know all the functions of every object that is put before you. Look
at this lighter. There's a piece of stone in there. Twenty years ago,
the thought was fantasy. You can't get blood from a stone? Maybe
you can if you can get electricity from a stone. Artists are supposed

to look at the material world with wonder each day. That's what they get paid for. That's what scientists get paid for. If they don't look at it with wonder, then they're not doing their job. What happened to [Lucio] Fontana and all these other people? They're not looking at the canvas with wonderment everyday, but someone like Robert Ryman transcends that because every day he looks at the canvas with wonder. Truly, that's what I said about having respect for Rirkrit at the conference when he refused to give up his wonderment. Fuck them, why should he? So he can look like he should be a professor? If you want to be a professor, make your own school.

HUO:

Would you agree to say that your work completely changed the rules of the game by introducing language as a sculptural material?

LW:

I'm not sure it was so radical—it's common sense, and an acceptance of material reality. I'm not trying to be modest, but if it was helpful for people to better understand the placement of things within a society, then great. As far as taking credit goes, I used my insight as a sculptor, and that was a big deal for me, though I don't see it as radical. It came right out of the praxis of the work that I was making. It grew out of making paintings and things that I hadn't seen before, and finding that although I could do them and that they functioned in the world, they would not satisfy the needs that I had. My use of the material was for my own personal needs and was not a revolution. I don't think it revolutionized anything but it added to what was already there.

HUO:

Usually, at the end of the interview, I ask about unrealized projects, but some time ago, you didn't feel like talking about unrealized projects.

LW:

An unrealized project is something that you should be trying to get realized. I try not to have unrealized projects, and I'm willing to bring them about at the right time, but often nobody's interested in them. It's interesting when you do something and five years later everybody wants to do it, and it's already been done, for better or for worse.

HUO:

My last question is about beginnings. You often refer to the importance of the City Light bookshop in San Francisco as a decisive encounter.

LW:

And the Discovery bookshop as well. I went to San Francisco to get

away from stuff and I found that the people there were open to me as a human being, and these people clustered around a little block in North Beach where there was a bar called Vesuvius. There was a bookshop there called City Lights that had been publishing things that I had seen, and there was another bookshop called the Discovery bookshop. Amongst that group of people, I met enough people to realize that I might be a young person with a lot of mixed up ideas, but at the same time I was a person and my choice of making art had some relevance to the people that I respected. The personal friendships didn't even really count—what mattered was that I found myself functioning as what I wanted to be. And if you function as what you want to be for long enough, you are it. Eventually you will probably get it right.

HUO:

So this was, in a sense, the beginning?

LW:

Oh yes, totally the beginning. I've been very lucky. That's why I don't see the art world as malevolent. I have been rather lucky in the people that I have encountered along the way. They listened. They might have disagreed, but they listened. All an artist craves is to be heard—at least once.

WEST, Franz

Franz West was born in 1947 in Vienna, Austria, where he currently lives and works. West attended the Akademie der Bildenden Kunst Vienna (Academy of Fine Arts), where he had Bruno Gironcoli for a teacher. His first works, dating from the early '70s were small-format collage pictures for which West employed such elements as newspaper clippings, photo fragments, and crumpled paper. In the mid-'70s, he produced his first Paßstücke (Fitting Pieces or Adaptives), a sculptural series he has continuously advanced up to the present day. These amorphous, three-dimensional forms made from plaster and papier-mâché are intended to be worn or used by the viewer, who thus enters into a discourse with the oddly-shaped objects. Many such actions were documented by West in videos and photographs. In the '90s, West won wide international acclaim with his environments of furniture sculptures. He has created resting places and furniture sculptures for sites such as the rooftop of the Dia Center for the Arts in New York (1994), an open-air cinema at documenta IX (Kassel, 1992), and the conference hall of documenta X (Kassel, 1997). These furniture sculptures are a way for West to address the ambivalent position of his works between autonomous works of art and objects of utility. West's work, ranging from video, drawing, collage, poster design, sculpture and furniture to installation and environments, has been shown in many international exhibitions of contemporary art as well as in numerous solo-exhibitions including: "2topia" (Wexner Center for the Arts, Columbus, Ohio, 2001); "Gnadenlos" (Museum für Angewandte Kunst, Vienna, 2001); "In & Out" (Zentrum für Kunst- und Medientechnologie, Karlsruhe, 2000); "Franz West" (Rooseum Center for Contemporary Art, Malmö, Sweden, 1999); and "Franz West. Gelegentliches" (Städtisches Museum Abteiberg, Mönchengladbach, 1996).

........................

This conversation took place in Vienna in March 2001.

Hans Ulrich Obrist:

To begin with the beginning: How was your time at the Academy of Fine Arts in Vienna?

Franz West:

I had a very nice time at the academy and I thought I would like to have that my entire life. That would be a reason for going there again; but on the other hand, I have something like situation anxiety. I never volunteered for something like that again.

HUO:

Bruno Gironcoli was a teacher there at the time, no?

FW:

Yes, I saw him once or twice a month. We said hello or exchanged gestures. He invited me to come to him in case of a question or a

concern. For questions regarding materials, I could turn to the assistants. In hindsight, I think he just controlled and observed the atmosphere or mood—or however you want to call it—in that building. Maybe sometimes at night he looked at what the students produced—because he lived there, you know. In any case, you really had the chance to develop. For instance, we could attend lectures on nude drawing. I once tried to talk about this with Gironcoli, but that was difficult—maybe because I was always a little afraid of authority figures.

HUO:

Is that true?

FW:

I came to Gironcoli via a friend, the poet Hermann Schürrer. Once, when he came over, I told him about my sculptures, which I stored in the attic. I told him that the attic was leaking and it was raining in, and everything I had made was sagged, drowned, and sunken into pulp. My entire work of the last years had become pulp. I bitterly complained. Now I wanted to work in a different material, with polyester, but I did not know how to do it. Schürrer said, "Call Bruno Gironcoli." And I asked, "Are you sure?" I told him that I was afraid. Out of fear for such institutions. I had the worst grades in school... On the other hand, I recognized that this was an asylum, that one was kept alone. Elsewhere people scrutinized you with questions like: "That is not art." "What do you want to do there, what will you become?" "Then you have to work forever; there you can live for free, there you can get a tea." But I wanted wine and tobacco. So I went to Gironcoli, and he said: "I can tell you how to do that," and he asked his assistants to help me. I could work at the academy; at home the fumes and the smell would have been unbearable. I went there every day, [it was] boring but still, and after a while he said he had to register me officially. I was amazed that that was possible. And so I stayed at the academy, but I had very little contact with Gironcoli, because he did not give lectures either. Jacques Müller, for instance, was different, he addressed the students personally, he lectured, and in the evenings he organized circles where you sat together to get to know each other. With Gironcoli, however, you had almost no contact. But one had the certainty to be able to ask. He provided me with an externally secured guidance and with social support. The academy was a space where one was not disturbed. I was able to materialize my thoughts, correct the product, and then recalibrate my thoughts

again. You envisioned something and then you did it—and the result usually did not correspond to the initial idea at all. This discrepancy between concept and result was very interesting.

HUO:

You said there was no teaching and no real course work. Gironcoli did not organize but just created an atmosphere...

FW:

Yes. He regulated that, and thereby avoided that one would turn into his student or his follower. I studied with him, but he gave total freedom to his students. No one imitated his works. Many teachers at the academy wanted to form the students and destroyed them with their maybe twenty-year-old ideas. Gironcoli, on the other hand, gave them space for their own development. This freedom was very important for me. It was great luck for me. Gironcoli did not educate you; you had to educate yourself.

HUO:

Have you reproduced the same kind of relationship with artists younger than you?

FW:

Now I have several assistants. I create ideal conditions for them. They can work in the studio when there is nothing to do. But I have so much to do that they don't get to do their own projects. It does not work at all. I heard about a certain George Pullman who built railway cars, and had a travel company: he built a house for all of his workers, and gave them a car, which they could pay off over time. He was exemplary. But despite all that, in the end everyone was angry with him. I think social actions don't turn out so well.

HUO:

Can you tell me about your own experiences as a teacher? I know that you are now teaching at the École des Beaux Arts in Paris. Is that the first time that you have taught for an extended time in one place, or did you have professorships before?

FW:

I was at Städelschule Frankfurt for one-and-a-half years. But that was so exhausting for me that I was glad when it was over.

HUO:

That was during Kasper König's tenure?

FW:

Yes. It was very difficult for me to adjust to the mentality of the Frankfurters. They are a little tougher, and I had difficulties communicating with them. The students always spoke so loudly. It was too difficult for me to adjust to that noise level, and their humor

was lost on me. But all in all, it was quite good what we did. But I believe that it does not make much sense to force the students. One should allow for their own development.

HUO:

What about your studio? Do you see the studio as a kind of laboratory?

FW:

For me, the studio is ultimately just an extension of the spaces I had at the academy. You could use these spaces autonomously. The studios were sheltered from everything. I enjoyed that for a while, but at some point you realize how introverted you become. Of course, there is a constant flow of assistants, but you don't meet artists there.

HUO:

Nevertheless, you often work together with other artists, or include other artists' works in your exhibitions.

FW:

Encounters are good, forging ties is not. Encounters are absolutely necessary. The more you develop your own position, the more difficult it becomes. Encounters with assistants are good, because they have not developed an explicit position on their own. They can still vary. With other artists... some are friends of mine. But that friendship should not become obtrusive. Apparently, it is the fate of the artist to live in isolation. [Joseph] Beuys, my former idol, resisted against this isolation, but he was not able to make his program influence real life.

HUO:

Today, you only see Beuys' drawings and sculptures in exhibitions. The social and political aspect of his work is cast aside...

FW:

But all that can be excused. Within the studio, the socio-political part works. One supports each other. But in direct democracy, the voters would have to be mature. They would have to understand what it is about. Take the assistants, for instance. It often happens that one has ideas that are actually really good. And I just take them and incorporate them and they just look dumbstruck [*laughs*].

HUO:

There are several models in this context. On the one hand, there is the formation of groups—you were never really involved in such groups, you never founded a group or were part of one—on the other hand, there are long-term collaborations, like the one between Dieter Roth and Richard Hamilton, who created hundreds of works together over a period of twenty, thirty

years. I always thought what makes you so interesting is that loose, almost organically developing network with, for instance, Gilbert Brettenbauer, Heimo Zobernig, Bernhard Riff, Rudolf Polansky, or Marcus Geiger.

FW:

Yes. When it works, I am afraid it could end. That happens sometimes, you know. Then you find yourself in total isolation and you don't know where to turn. But from somewhere, new themes arrive, and it continues. Maybe it would be better without these deliberate comradeships, ties, and obligations. One has to see how it works for oneself. I prefer not to go to bars with people to talk, even if I might really need it.

HUO:

What is special about your form of collaboration is not only that the ties are often rather loose, but also that they are trans-generational. You work with very young artists as well as with artists that are decades older than you, like Carla Accardi or Raymond Hains.

FW:

That is basically the scope. There is almost no one from my generation in Vienna. That is what my generation—give or take five to ten years—is like. Some were absorbed by Actionism and those that followed are already part of the next generation. Lately, I have been to Rome more often and meet with Arte Povera artists like Prinio Jannis [*sic*] and Kuno Emilis [*sic*] for dinner.

HUO:

Yes, I know Prinio too. It is interesting how he refuses to stop the process.

FW:

The question arises if the life of an artist has a value as art. I think oeuvre and life should be separated. Emilis, on the other hand, does not make this distinction so clearly, I think. His art is lived art. The decisive aspect of my work has to do with the haptic perception and the fact that art should not be something respectable, something too considered. It is important that it is being lived.

HUO:

In your series of Paßstücke *(Fitting Pieces) that you started in 1976 or so, visitors are invited to manipulate the objects—they can wind them around their bodies, adapting their forms to the works. In an interview, you said that the* Paßstücke *had a lot to do with your half brother Otto Kobalek and his theatrical gestures. Can you tell me about this?*

FW:

The explanation is rather mundane. When my brother visited me for lunch, he always got up and mimed or imitated someone or made fun of someone. You felt more like you were at the theater,

rather than at lunch. He always gestured very vividly. I really enjoyed this fiddling around, it was so lively. I never found a reason to do so, for I am a rather calm person who always just sits around and listens or talks. So if you take the *Paßstücke*, one has to grab them and then "gesticologies" arise. That is the reason: To gesture in art. "Gesticology" is not unimportant in the Viennese tradition. [Egon] Schiele, for instance, worked on gestures. I am not particularly fond of him, but my mother liked his works. She had Schiele posters in the waiting room of her dentist's office. She liked those contortions.

HUO:

I met Otto Kobalek a few times, at your house for dinner. He was a poet.

FW:

Yes. Even though he did not write many poems. But he had manuscript pages by the pound. That was very interesting...

HUO:

Four poems. That is his entire oeuvre. Has it been published yet?

FW:

Yes. In my catalogue *Otium* (1996). He was an actor and he drank a lot. That was irreconcilable. He was in contact with the Wiener Gruppe [Vienna Group] around the Actionists. They proposed a different kind of life. He immersed himself in a kind of *vie bohème*; that still existed back then. Later, I slipped into similar areas myself. But that was a bit more nihilistic, with interest in pop and Schlager music. Otto still belonged to a generation that identified with that sort of life, in close connection to art. There was also a strong relation to the humorous, to the comedic, like the Cabaret Voltaire or the Dadaist circles. Dieter Roth belonged to this tradition as well. I once read an interview with Raoul Hausmann in which he railed heavily at Dieter Roth. He complained that Roth was incompetent and merely self-aggrandizing. Now, today, I almost became a sort of "artist on commission," but I loosened the ties to the permanent commissions again. I had no free space anymore—and no more anxieties. Freedom always creates anxieties and worries. If you become pragmatic about it, you become fat and lazy and life becomes terribly boring.

HUO:

Is that why you are in a state of change again at the moment?

FW:

Certain anxieties come over time; you don't know what change will bring. People often assume I would tend toward the baroque. I disagree. I always thought that the *Paßstücke* were on the one hand

influenced by my brother, and on the other hand by an uncle who dealt in African art. His apartment was filled with it. I looked at the masks and staffs and thought that one should wear them and move around in them. African art, so they say, was very influential for European art in the first half of the twentieth century. So Picasso again. But these elements were also influential for Modigliani. Giacometti was more influenced by the Etruscans. African art is a direct art. Africans placed their objects in their homes and used them; masks were worn for particular occasions; the furniture, like the figures, has a value beyond pure use.

HUO:

Can you tell me more about your relation to the baroque?

FW:

"Baroque" could be understood in the sense of painting, of the two-dimensional. While in my case, one would try to live with it, if one only had the furniture. A room in which you have sculptures in it is already a different room. That's why I believe that it is alright to copy sculptures, even though the thought of what happens to them is unreal. Mostly they end up in storage, in displays, i.e., museums, or with collectors... but the thought that you could have it or make it for yourself is quite appealing. That's really why I became an artist. I also wanted to live in rooms full of art. So I began to make art myself—for my surroundings. But you get frustrated quickly if all you have around is your own stuff. So I began to swap and to collaborate with other artists. I like to have stuff around me and on my walls. I think that for that I succeeded. [*Laughs*]

HUO:

Like Sol LeWitt. I recently went to his studio: he has an entire hangar full of exchanged art.

FW:

Yes. That's what I did. I have a Sol LeWitt too.

HUO:

Let's come back to the context of the Paßstücke. *One constantly recurring question is that the work is less about the permanency of the object and more about its instruction, the partition. In case the object would break, it could be rebuilt. But I know that at the beginning, in the galleries, contrary to your intention, the* Paßstücke *were not allowed to be touched or handled.*

FW:

At Hummel's for instance [Kunsthandlung Julius Hummel, Vienna], they attached the works to the pedestals so that no one could pick them up. It was very much against the logic of the market that

the works would become shabby after a while. And in a way I think that there is a catch also with instructions. I like the *Paßstücke* very much, for one simple reason: the concept that you can go to the museum and pick up the object. So, the object must not be behind glass, but should be presented such that one can do something with it. Most people don't even know what to do with it. That is the experience I made. The videos show what others have done with it. But you can do something entirely different with it. When you go to the museum with students, one always picks up the gesturing relatively successfully, but we could do it ourselves as well... I am not a fan of Nietzsche. As much as I dislike Schiele, I dislike Nietzsche. But one of his sentences is important: "If an illusion helps you in life, then it is a reality." Illusions become means. It is interesting to transfer this onto art which is commonly referred to as illusionistic. In my case, this also has repercussions for the illusion of the *Paßstücke*. For a while, when I showed with Hummel and nowhere else, it was interesting to me that he had rather fine things by the Actionists in his exhibitions—and my works were right next to them. So I could compare: do my works look bad now? Do they not deserve to be placed next to it? Warhol and Man Ray, some minor works, were exhibited next to mine. I was able to train myself on what doesn't go well together and what does.

HUO:

How has your relationship to the art market evolved over the years?

FW:

In the beginning I sold my works myself. If something was finished, I went to some people and asked if they wanted to buy it— for very cheap, to make sure I would sell it even though I had no academic diploma or the approval of a gallery. For a work on paper I charged 50 to 100 Schillings [five to ten dollars] and for an outdoor sculpture I charged 1000 to 2000 Schillings [100 to 200 dollars]. That's what I was able to make. Later, Hummel insisted I offer him everything first. But that was already later. After a while, the gallerist said that if I would produce what he likes, I could stay with him. That made me so mad. But when I was broke, I went back to him. That had an impact on my style. I became a little more "baroque," I think, or maybe like "Art Nouveau," or... somehow it has influenced my style. On the other hand, it also meant that I had to overcome this barrier, which in some ways was what sociology called the "art of impression management." If someone has art at home, it has heraldic functions. Sociologically speaking,

these forms have distinct styles that can be named, like "that is Art Nouveau" or "this is baroque." At the same time, it also implies that one "identifies with this period, and its philosophical world view." Or it might mean that "I can afford to purchase something from this period," or maybe it is there for reasons of tradition, it was an heirloom or so on. For me it's all the same. The "Paßstücke", which ended up being formalistic, at the same time went beyond this formalism. Maybe that's why they are so hermetic for the observer. I wanted to counteract this heraldry of the untouchable, the untouchable world.

HUO:

What came after the Paßstücke*?*

FW:

I made three different kinds of sculpture. The *Paßstücke* were my route to so-called art. When I made the *Paßstücke* I thought that the handling of the works basically resembled the movements and gestures of the sculptor. The production contains gestures. Maybe for me the production of the *Paßstücke* was a simulation of an artist's existence: being a sculptor. Whether a sculptor could still properly be called an artist, or whether he should be called just a decorator is a different matter, which one could discuss or contemplate. The crucial element of the *Paßstücke* is the handling, I suppose, because it is part of the production process. The *Paßstücke* is thus no longer an artwork only to be looked at, but an artwork to be handled and fiddled with. And that is the situation of the artist. The object no longer stands between the artist and the viewer, it induces a change of roles. The experience does not emerge from the contemplation of a fabricated object, but from the movements of its fabrication. And these movements usually take place in a studio. Here it comes full circle again. So, that is my first group of works. The second group are the sculptures; very small ones in the beginning. Exhibiting the *Paßstücke* by attaching them or presenting them behind glass was completely counterproductive. Their visual presentation was only supposed to be an incentive to play with them. I thought it was silly to just look at a *Paßstücke*. Then I might as well make sculptures. So I made sculptures that were just to look at.

HUO:

The important thing was the introduction of color in your work?

FW:

The *Paßstücke* are white to make the contours recede. To color a sculpture was very difficult for me in the beginning. I did not know how to use color and the longer you study color, the more

difficult it gets. One day you think "this does not fit," and just when you thought you finally made a successful composition, you look at it the next day and think "for heaven's sake!" There is a certain satisfaction I did not know before. You get "high." I always refer to Michelangelo in this context, who complained in a letter that he had not had a "sphera superiora" in weeks. I guess having a "superior sphere" is like being "high." If you succeed, suddenly you acquire such a particular sphere, such a superior state. Maybe it is naive to think that by handling a *Paßstücke* you could reach a "sphera superiora" too.

HUO:

How would you describe this state of ecstasy?

FW:

When I work on these sculptures for two, three hours, I am in a very special mood. When I leave the house in this mood I feel like a kid on bromine. Special states do exist.

HUO:

Let's define the second category precisely. It consists of the painted sculptures and...

FW:

... often they are not painted; rather, I mix pigment into the papier-mâché. I almost never use a brush. That is too complicated a technique. To color isn't simple at all. I guess I have learned it now—after twenty years.

HUO:

The common thread is the material: papier-mâché. Do you always use telephone books?

FW:

No, sometimes I use newspapers and all the stories that are printed in them.

HUO:

So when you look at a sculpture, there are many stories of daily Vienna life in them...

FW:

... or telephone numbers...

HUO:

Every resident.

FW:

Three sculptures actually contain every resident. The last category consists of the outdoor sculptures. In a very subtle and light way, I think I would have liked to make these already in my student years... or even earlier. But that was a complete taboo until

Richard Serra was accepted. He was the solution. In recent years, art has been in a constant state of apocalypse. That is the reason for its dynamism, I believe. That's nothing new. I read about a fifth century Greek painter who asked all his colleagues to abandon painting, because he had created the ideal painting.

HUO:

The idea of the last painting...

FW:

... of course, like [Kasimir] Malevich. Apparently, that already existed in the fifth century, and it wasn't the last time. Anyway, these assumptions of being the last ones: take Actionism, for instance, or its opposite, Richard Serra's Minimalism. You could not be more Minimal. In the '80s, the separations opened or dissolved and you had a certain anonymity. And you could produce outdoor sculptures. In a world where all my early work had turned into pulp, I wanted to make outdoor sculptures. But back then, that was unthinkable.

HUO:

What was your first public sculpture?

FW:

My first outdoor sculptures were the *Lemurenköpfe (Lemur Heads)* for the Vienna bridge. I was told I had to cast the sculptures in aluminum. The production costs were so high, I could have lived from it for two years.

HUO:

When was that, the early '90s?

FW:

No, that was still in the late '80s. Outdoors, I thought, I could bring the inside to the outside. I was often invited to make outdoor works. There was a big exhibition in Antwerp, two years ago ("Franz West," Middelheim Open Air Museum, Antwerp, 1998). I made a few sofas for outside. What can you do in such a short time?

HUO:

These are the three categories. Are they connected?

FW:

Yes. The connection is the process of shaping, what I call their "styling." But on another note: if you can't produce plastically, spatially anymore, you would have to turn toward the two-dimensional, or toward the immaterial.

HUO:

Your early collages are the basis for the collage principle, which is the com-

*mon thread of your entire oeuvre. The sculptures made from telephone books
also employ a sort of transformative collage. In one interview you mentioned
Richard Hamilton's collages that founded Pop Art. Can you tell me about
the collage principle in your work?*

FW:

I did not have a unified concept of collage. I could be honest and
say that I cannot draw. You might be able to learn how to draw,
but I think you should not learn it. It should not become some-
thing trained. Collage can be handled differently. I think it is more
spontaneous, and it has no correct scale. And I have to admit that
you can either like it or not, almost like a piece of music. In collage
you have to account for all kinds of subtleties. You can mix up
everything and reassemble it in the strangest of relations. As for
Pop: you are right, I discovered it in English Pop Art, and in Max
Ernst's collages, even though they were so old fashioned.

HUO:

But graphically relevant?

FW:

Yes, pretty much. While Hamilton's skewed proportions seemed
like a proper dream world.

HUO:

*This reference to Hamilton and English Pop Art is very interesting. How
did you come across Pop Art?*

FW:

About ten, fifteen years ago, I saw an exhibition of Pop Art in
Vienna, including collages and wooden boxes filled with little
things. I added the key to a friend's apartment to one of the boxes.
It is still there. Pop was stimulating the same way contemporary
art was directing me. Those were life forms. I thought the forces
behind the presented works were certain conducts of life, which
generated the art that was presented. There is no world like the one
on view; it's a good measure of distance to one's surrounding world.

HUO:

Do you work on several collages simultaneously?

FW:

I always produce ten, twelve works at a time. That is the maxi-
mum. And then I think I can never do it again. You always have
the same problems. When I was forty years old, I thought I could
never create a sculpture again, this is the last time, or I would not
be able to produce collages anymore. It happens so often to me. But
then you had to make new ones. And suddenly, it continued.

HUO:

The different bodies of work you referred to have all been produced or are in
the process of production. Can you talk about your unrealized projects? My
question is not only directed at unrealized projects like entries for public
sculpture competitions that were not selected, it also includes forgotten proj-
ects, or projects you self-censored or that were censored from the outside.

FW:

There are plenty. I just often cannot remember anymore. Take the
Lemurenköpfe, for example. They were commissioned for a bridge.
But my designs were not accepted. Later, they were realized for
documenta IX, where they were shown for completely different
reasons, and in the end they ended up in an office building in
Houston, Texas, where they fit quite nicely.

HUO:

The bridge was not realized according to your designs?

FW:

It turned into something different. It often happened to me that
my designs turned into something else, but it almost never hap-
pened that they were completely forgotten. Currently I am work-
ing on a robot-table. That is a table that walks by itself, and has a
laptop with my autobiography on top. I came up with it at the
Yokohama triennial: *Self-portrait as Johnny Walker* ("Mega-Wave.
Towards a New Synthesis", Yokohama 2001: International Trien-
nale of Contemporary Art). The table walks, and when it walks, it's
a Walker. Thus a "Self-portrait as Walker." I thought of it when
someone told me that the Japanese industry is trying to produce
robots for domestic applications.

HUO:

Yes. These robots become increasingly anthropoid.

FW:

These ideas are unrealizable in the real world. But in art, you can
realize these stupid ideas. Fortunately, there are artists.

HUO:

What is your favorite museum, or in case it doesn't exist, what would your
ideal museum be like?

FW:

I am disappointed by the museums in New York. I think that they
are too large; maybe they were more interesting in the '60s. Amer-
ican museums aren't that thrilling. But there are a few small muse-
ums in Japan that I really like. I saw a private collection in Tokyo

that only exhibited some old things and a garden. You have to be very alert to notice the precision of the tree positions and heights. And somewhere lays one stone. Inside this museum are a few Buddha heads without any facial expressions. So in a way there is nothing to look at, the Buddha heads just stand around. Their faces are so flaccid; smiling... I did the same. I closed my eyelids halfway and tried to become indifferent. When you make this expression, it mirrors to the inside. That was my problem with the "Paßstücke": how does the external expressive movement affect the inside? In music, there is the rule that the singer should never identify with the lyrics. He should always maintain a distance to himself in order to keep his emotions from influencing his expression. That's what is going on in these sculptures. That is their meaning. The singer may never identify with the role he is interpreting. Is that the same feeling you have when acting out these gestures? Those were my concerns with the "Paßstücke". That goes back to Raymond Roussel, who I read back then. You know, *Locus solus* (1914), where they make the most important actions of their lives—in their fish tanks. At first, the "Paßstücke" thus acquired a rational component, which by now is the only other component I can remember. I always wanted to experience that, via mimic and mimesis: "oh, this person now feels the way he looks." And does he really? The "Paßstücke" make you strike very odd poses. But do you feel the way you look on the outside? That's what is so interesting about these Buddha heads, which don't mean anything to us Europeans. Their facial expression is anonymous, and when you look, you don't see anything. You feel undisturbed, unobserved, you acquire a very unique expression. You experience these mini-oases. You are relieved of everything, and you don't care about anything. And that is very good.

WYN EVANS, Cerith

Cerith Wyn Evans was born in Llanelli, Wales in 1958. He currently lives and works in London. Wyn Evans started out making short experimental films after studying at St Martin's School of Art in London and graduating from London's Royal College of Art in 1984, with a Master of Arts degree in film and video. During this time, he worked as an assistant to the film director Derek Jarman and he taught at the Architectural Association for six years. His medium changed tracks in the '90s as he moved towards sculpture and installation, film, photography, neon, and fireworks. Although a division is apparent between his earlier work as a filmmaker and the more recent sculpture and installation work, Wyn Evans has referred to his first films as "sculptures," documenting "places that are conceived for particular forms of action." His installation for his inaugural exhibition at the White Cube gallery in London (1996) was a concave mirror, **Inverse Reverse Perverse** *(1996), revealing a bizarrely distorted close-up reflection but turning more distant surroundings upside-down, creating a simultaneous atmosphere of innocent wonder and underlying unease. In 2001, Wyn Evans showed* **Cleave 00** *to accompany Tate Britain's exhibition, "William Blake" (2001). For this piece, bits of Blake's texts were randomly selected by a computer, translated into Morse code and then refracted off a large mirror ball to create a disorientating, swirling pattern of light shifting over people, plants and walls.*

...................
This interview took place in Brussels on February 23, 2002.

Hans Ulrich Obrist:

You once told me that you were very interested in notions of weakness and uncertainty, ambiguity and disorientation. American anthropologist James Clifford speaks about "lucid uncertainty" as a working methodology, while Carsten Höller frequently refers to his "laboratory of doubt"; these ideas seem crucial today. Could you specify the interest that you have in these notions, and how you proceed to open up areas of questioning by making viewers doubt what it is that they're seeing?

Cerith Wyn Evans:

Uncertainty in the sense of not defining these terms is probably the best example of what I'm trying to define! It seems to me to be something between an ethics of weakness and a politics of doubt that is hinted at or sought after. And by that, I mean it seems— and here I agree with Carsten Höller on this matter—that a process of hesitation is something worth remembering; it's somehow more

interesting to seek out weak connections than to reinforce strong connections. This is all rather complicated to talk about; perhaps it will emerge through our conversation. It's difficult to come to such a topic cold and to try to map out some post-ideological territory.

HUO:

Yes, you're right, and I'm sure we will come back to these questions later on, or they will pop up in the middle of the conversation. Today we were together at the Palais des Beaux-Arts in Brussels talking about Marcel Broodthaers. Maybe it can be another starting point then: the moment of encounter with Broodthaers' work at the Institute of Contemporary Arts (ICA) in London in the '70s...

CWE:

That is much easier to talk about! I remember being very impressed with one of the first exhibitions that I'd probably ever seen. I was 17, coming from Wales and visiting London in 1975; it was a show by Marcel Broodthaers at the ICA ("Décor: A Conquest," 1975). It was one of his decor pieces, and I was enormously impressed with it. I'd seen various works by modern and contemporary artists in museums, at the Tate Gallery and the Hayward Gallery, but this was the first exhibition that made a real impression on me in terms of contemporary art practice: the idea that this work might have been finished just a few weeks before the show, and that I was somehow a part of that. I'm sure it's not fair to use such an approximate and general category to describe Marcel Broodthaers as an installation artist, but this piece was very much an installation. It was surprising. The floor was covered, there were things around the walls, there was garden furniture inside, guns and canons, and various tropes, plays and puns on the location of the ICA. Through the window, you could see Big Ben and the Houses of Parliament, something that clearly wouldn't have gone unrecognized by Broodthaers. I felt I had discovered something very exhilarating, and part of that exhilaration came from thinking that this work was somehow forbidden, unsanctioned, not allowed. It was one of those feelings, partly shock in a sense, because it seemed very stimulating that the pieces didn't add up, that there was room to move, or if there were connections, they were weak connections. I didn't feel as if I was losing out on the experience of the piece by not being able to source all of the references; it was a kind of liberation, a newfound sense of freedom. The decor felt like a set, a stage setting, as if you had walked in by accident through the wrong door onto someone else's stage, or perhaps

the right door, but the wrong door feels more appropriate—through the wrong door you find an encounter with something that you don't actually expect, and so consequently you are somehow refigured or remodeled against the backdrop of another; somehow you find yourself in a scenario that isn't of your own writing. It wasn't sculpture, because it was too much like window-dressing, but it wasn't window-dressing either, nor theater. It felt more like a decor, a setting.

HUO:

In Broodthaers' work, what is fascinating is what is at stake or what happens between the objects that compose the pieces.

CWE:

This idea of decor was the revelation. By making choices and making relationships between objects, it was possible to construct meanings and to change the ways in which we perceive of these things as singular objects. William Burroughs and Brion Gysin wrote a text called *The Third Mind* (1978), and they said that whenever there are two minds together they create a third—the third mind represents the dialogue between the first two, and both are changed and somehow compromised by it. In this kind of "third space"—the dialogue between one and two (and it's very rarely binary in my experience of looking at Broodthaers)—there are conversations that happen. It's not much like this conversation where I speak, then I feel that I've said as much as I want to say, then there's a pause, you catch up with what that is, you speak and then I respond to that; it's not this kind of ping-pong conversation. It may be possible that I'm speaking in Flemish, you're speaking in Japanese, you're speaking about the history of the organization of certain structures of classification within Japanese historical porcelain, and I'm talking about my top 12 recipes of what to do with *foie gras*, for instance. But somehow, the dialogues appear to take the form of a conversation in that they're happening at the same time, somehow they're eliding or slipping over each other, such that you could go in on many different levels. One of the things that impressed me was that Broodthaers was capable of making this happen in the room; what normally happens in your mind would happen in the room. Mark Cousins wrote a text that I have been fond of for many years, and actually it was a text that I asked him to write about an installation I had made—I'm sorry, it sounds arrogant to describe it as one of my favorite texts because it's written about my own work!—but I was very pleased with what he wrote because it picked up on things and put things into language

that I was unable to put into language myself and that I was try-ing to put into the space. If I were able to translate what I was doing into words, this would be one of the voices that I would be pleased to hear. And so there is a certain sense of satisfaction that there is someone out there who gets what you're trying to do, or is thinking about it in the same kind of way. He talks about image and object swinging on a hinge; an idea that I still find very attrac-tive. Another one that I was pleased with, which some people might think of as an insult, but for me was the exact opposite, was talking about the experience of walking into this installation and seeing the piece I'd made: Mark said that it felt a bit like being a deaf man staring at a radio. There is something preposterous in that—obviously, there is something amusing about it but when you break it down and look at the subtle things that undercut a statement like that, there's a perversity at the core of it. That kind of aggression, that classic clinical subversive tactic is something that is very nourishing because it goes against a liberal, humanist, progressivist notion of creativity: of creativity being generally for the human good in some sense; that creativity is nourishing; that it is some kind of energy that is tantamount to biological growth; that it is in some sense natural. For as long as I remember, I have been very antagonistic towards this idea of creativity being a thwarted version of childbirth or procreation—that it's a natural outlet.

HUO:

The early films that you made were influenced by your encounter with the work of Broodthaers; they were always arrangements of objects, trajectories, histories, meanings and associations. But I was wondering how the inter-est that you've showed for films and cinema developed.

CWE:

Welsh is my first language, and learning English was something that just happened; I don't think I had lessons—it was on television and all around me in Llanelli where I grew up. I went to a Welsh primary school where it was forbidden to speak English, but outside school hours it was familiar. I think the idea of translation started early for me, of thinking that you can have the same word in two languages, but the shapes and appearance of the words are very dif-ferent although they have the same kind of meaning or idea, and this became a space for ideas for me. In [Jean-Luc] Godard's *Two or Three Things I Know About Her* (*Deux ou trois choses que je sais d'elle*, 1966), there is a marvelous moment at the beginning of the film where Marina Vlady, the extraordinary actress who plays Juliette

Jeanson, is looking out of a balcony whilst a voice-over says, "Now we are seeing the actress Marina Vlady, she is of Russian origin, she's looking to the left, she's..." The shot continues to be exactly the same shot and then the voice says "Now we are seeing Juliette Jeanson," so there is kind of transition, which for me is a profoundly moving paradigm: a wonderful thing happens in the transition from proper noun to proper noun, from proper noun Cerith Wyn Evans, to proper noun the character he is playing. And it may be that I'm playing a character that just happens to have the same proper noun as my name—the same as the actor, if you see what I mean: these kinds of slippages, the slippage between two different languages, different identifications. As a child, watching television somehow opened up this wonderful space to the exotic, it represented escape, a way in which I could free myself from the confines of who I was in that kind of situation. To a certain extent, it was a kind of delusional fantasy space that saw, for instance, the possibility of another language as something that could carry all kinds of powers of fantasy: watching a foreign film with subtitles in English was a great revelation, a great pleasure.

HUO:
So in a sense you started to be interested in this idea of the "third space" very early on and because of foreign cinema. From a retrospective point of view, it's really fascinating!

CWE:
Exactly, early on I became more interested in the space that was opened up by the idea of the foreign film. Perhaps at that time, the kind of film that would probably have been screened late at night on BBC2 or on an arts channel, like a series of films by [Federico] Fellini, [Pier Paolo] Pasolini, [Claude] Chabrol or Godard—mainstream continental cinema from the '60s. Being aware of these films as a child, probably from the age of around 12, I became fascinated by the gap that happened between the text and the picture, and specifically with what that gap was in relation to the kind of space that it allowed me to occupy, the space in that gap. You learnt certain words because you recognized certain things in translations, such as a proper noun and where it happened in a sentence: if someone were to call someone else's name, that would also appear in the subtitles as a link. I became interested in links between the gaps, what these gaps were, what the elision was between image and object, between image and text, and the kind of friction that happens between the pictorial text and the literary text or the writ-

ten text. What kind of static occupies that kind of gap, the fact that the gap fluctuates all the time, the fact that the gap is constantly reforming itself around this difference? The European avant-garde tradition, as well as Americans like Kenneth Anger or Maya Deren, became very important to me. Cinema was important, early on it was much more important—I hardly see films any more—but for a time it really was a kind of obsession, and a lot of those effects are still very present in the work I'm doing. Other forms of image technology have now superseded cinema, and as a result, some of the fetishizations of the cinema will cease to exist. Cinema somehow replicated the experience of the stage, those kinds of notions of threshold, boundary, distance, what is in the frame, what is out of frame; what those dimensions are, how monocular and binocular perspective work, hierarchies and technologies of the visual, in and around what it is phenomenologically to experience and "unpack" an idea. To me it sounds like an art school academic, probably a visiting American professor, coming over and talking about "unpacking ideas," of deconstruction—a pulling apart to see what the construction is made of—that's what I understood it to mean.

HUO:

When you were a student at St Martin's and the Royal College of Art in London, you had John Stezaker and Peter Gidal for tutors. How have they influenced you, respectively?

CWE:

John Stezaker was as influential, if not more influential, in thinking about my practice as an artist, than even Peter Gidal.

HUO:

Stezaker worked with cut-up photographs?

CWE:

Yes, using a scalpel. John was a critical precursor to what Richard Prince became the father of, although you can't say father because Richard Prince is partly about the death of the father, the murder of the father—at least a dirtying of the word. This was something that was also very important for someone like John, who was using found images as raw material; there was a given, a readymade property to the image, which belonged to a communality, a family of images—stereotypical Hollywood images from the '40s and '50s. It was the kind of *film noir* that created a scar, a wound for John that he felt he had to re-wound or remake in a sense. This literal cutting into an image, into the surface, on a horrifically violent symbolic level, was a deformation of the image, a castration of the

image. It was very much about cutting into that space and the condition of the edge—what happened when one image ruptured the space of another? What kind of violence was represented by the friction of these thresholds, the point at which one image abutted another? Anything that upsets the proper place of things was something that became an attractive area to work in. What was necessary to do in order for that to happen, or to happen effectively, was that there had to be an a priori knowledge of what the complete picture might have been in the first place in order for the thing to register as a site of trauma. It was quite a Foucauldian position that reaffirmed the frame of the original by rupturing it, tearing it apart or clashing it, "icono-clashing" it into another space. So what was left out was the ghost of an image that had been taken away. Where is the mental screen, where is the internalized phenomenological screen that we each play our images out on? And to what extent do representation and the tropes of representation mirror the internal screen, the mental screen, the mind screen that we're able to play images out on? We have to go in both directions: what we know about pictures influences the way in which we construct them in our head, and vice versa, in that the technologies of picture making are based on ways that visualization is formed. I perceive a kind of flow in this trafficking of images. So John was very important in introducing me to a critique of representation, a critique of the image especially within an intellectual neo-Marxist kind of way—the prominent position in art schools in the mid-to-late '70s. Coming into contact with Peter Gidal who had a very different view from John—it was really much more brutal than John, if it was possible to think of someone taking a knife to cut off the head of a woman in a picture as one of the most brutal things you can do to a picture. Peter took it through that brutality into a space that denied that the woman ought to have existed in the picture in the first place. I hope Peter forgives me if he ever gets wind of this, for getting it wrong, because Peter is a far more subtle and accurate a thinker than I ever was about this—he was very clear about what he felt was worth doing and what was wrong, this kind of negativity was very strong. It also takes us back to the notion of doubt we spoke about before, or weakness: always desist, always say no. Even the titling of works became problematic for Peter. It was very much about the materiality of the image generating the image-making process. When I first met Peter, in my first few weeks as a

student at the Royal College of Art, he was on his way out. There had been a bunch of organizers brought in—moneymen—to kick out the lesbians and the junkies who had become students in the film department. There was a clearing up, new people were appointed; and this new agenda was a disastrous move, a criminal move on behalf of the school. It was actively discouraged to be interested in avant-garde film at the time.

HUO:

Similar things happened in the late '70s across the board in many art schools where the radical had become a little played out.

CWE:

From the mid-to-late '70s, there was a terrible, violent disruption, a kind of expulsion of people who were interesting. Peter was one of these people. He was too clever, too subversive, too radical for those who wanted to rein people in a bit. His films radically divided people between those who took the time to look and those to whom this level of attenuation within "cinema" was tantamount to assault! He was so hardcore that he was out there on a limb, and he still sort of is to an extent. To cut a long story short, I remember asking Peter very gingerly—I was a little bit wary of him, a little shy—I asked him whether I could be one of his students and whether he would give me a tutorial. And he said "Tutorial? Well I'm not sure I want to be your tutor" and so on. This slight but very humorous and gentle hostility was there at the beginning. He was taken aback, but agreed. He then said, "Okay, but now I have some conditions to make. I don't mind seeing you for a one-hour tutorial every week as long as we don't have to discuss your work," at which point I knew I was in the right hands. There was something so comically outrageous about that—what else do you do in tutorials apart from ask your mentor to look at your work? And at that point, there was a kind of paradigm shift that happened through Peter's good humor and absolute seriousness, as I knew I was going to get more out of these conversations than I had with people before and for years after. It was a crucial moment that opened up a wealth of possibilities. We did finally meet every Thursday afternoon for two years until he left, and I always looked forward to it. He said, "Okay, read this by next Thursday," and he handed me a photocopy of an English translation of [Samuel] Beckett's essay on [Marcel] Proust, which was perhaps the most wonderful way to start our conversation. I went away and read that, which was a revelation in itself, and then I went back and he asked me what I

thought. We spoke about temporality, proportion, all these things that were incredibly relevant to what we each might have been doing and thinking about as practitioners, the methods that we took to make and construct our work. I never had to sit Peter in front of an editing machine—it would have been futile to do so, and we spoke in far greater detail though on a more general level. And to this day I wish I could see more of his work, and that he would make more work, but he works at the pace he needs, so that's fine. I'm sure he has certain regrets about some things, but then again, I think he's worked it all out pretty well.

HUO:

It is often said that you started out in the film context and then came into the art world, but in reality it seems to be far more complex.

CWE:

Yes, in a way. And perhaps what's been happening in the last ten years in art will go some way towards dissolving that. Someone wrote a review of my work a couple of years ago that described me as dishonest, as someone who has jumped ship because he's really a filmmaker, but now he's making art because art makes more money and because Brit Art is now trendy. This was bizarre and insulting in a way because that wasn't the way it was. It isn't true. I must have made the distinction between my practice as an artist making films and my practice as an artist doing other things. The way that it worked was that I used to paint, draw, and make sculpture, and when I left home, going to art school was a great liberation. I know this is really a cliché, but that was somewhere that I always really wanted to be. It represented some kind of ridiculous cartoon, but that was fine by me, not in the sense of smelly long hair, but in the sense of protest, experimentation, drugs, and radicalism. It's embarrassing to admit now, but this was very much something that I felt I wanted to be part of, and it was the cool thing to do. There wasn't this idea of having to think whether you were on the sculpture course, the painting course, the ceramics course or whatever. I used to go to the Sculpture A course at St Martin's, which was the multimedia course: you could choose to do a performance, make photo-based work or make slide-text pieces, which were very popular at the time. Gilbert & George had been on the same course many years earlier, and so had Richard Long, a whole generation who had come to prominence throughout the '60s and early '70s. This was the climate I felt comfortable in, although I had quite a tough time there and wasn't very interested in making work. After all, this was 1976 and 1977, and of course it was cool to be at art

school, but somehow not very cool to be casting bits of lead and bronze when you were on the Charing Cross Road and punk was happening on your doorstep. It was much cooler to listen to music, go to concerts, and take part in this whole cultural revolution for young people at the time in London. It was an amazing moment of energy, of people coming together. I didn't make work for my first two years at St Martin's; I'd sit and read with John, or he'd teach me about William Blake or Jacob Bohme. So coming back to what you were saying about whether I was a filmmaker, sculptor, or visual artist—those boundaries have always seemed like limits to me, and limits that aren't particularly constructive in thinking about making work, in thinking about changing the structure of things that it seems necessary to do in the world: in order to get across more, in order to enjoy more, to get closer to your own desires or those of other people, to get thicker into the stuff of life. It didn't seem interesting to me to take a formal position in relation to where something starts and where something stops. Certainly, formality on all sorts of different levels is essential because it becomes the proportions of what is happening psychically, socially or literally within the text within the work.

[*Piano music in the background*] Now we find ourselves in a situation in this bar with this guy playing the piano next door, which is hilarious and at the same time absolutely god-sent, because this could now be transcribed not as an interview with an artist, but as a kind of musical piece that could be performed in twenty years on a stage somewhere. I'm sure it's possible not only to transcribe what I'm saying word by word, but also to write down the notes that this guy is playing in the background: the idea of there being a soundtrack to what is happening, a parallel activity. If you're open to it, you realize that there is elision, that there are parallels, there's always a soundtrack to the film that's going on.

HUO:

When did you start making films?

CWE:

At St Martin's, I was about to be kicked off the course because I refused to make any work, and I thought, "Well, I've been here for three years and I've had the most wonderful time of my life." I felt that I could stick with my principles—that weren't even my own principles—of not producing anything. They were principles that were enforced on me by the tutors who felt that these were princi-

ples that I had; in fact they were much weaker than that; I just did-
n't feel that producing work was the way that I visualized my worth
as a student in that situation. The reason I turned to making films
in the end was that I set up a series of temporary propositions. I
remember looking at early photographic records of the Viennese
Actionists—the work of Kurt Kren and specifically the work of
Rudolf Schwarzkogler. It's not an exaggeration to say they just
inspired me, and not by the actions and images in and of themselves
(which were also kind of startling), but by the realization that many
of these pictures had been set up without an audience there, with-
out them being relics from another performance. They were actual-
ly set up for the camera and the documentation was the only form
in which the performances could stay alive. This sort of radical
tableau vivant became something that I was very interested in:
somehow posing for the camera. It's no accident that my father was
a photographer and there were thousands of photos of me taken as a
child; and posing for the camera was something that was very natu-
ral to me. Of course, there's a great difference between the subject
matter of a Rudolf Schwarzkogler performance and what would end
up being a very good example of an amateur photographer experi-
menting with his willing subject (or sometimes not so willing sub-
ject). But I think that's digressing somewhat, because the point that
I wanted to make was that the first films that I started making were
a way of recording in time these objects that I'd put together. They
were films of sculptures actually: Super 8 films with soundtracks
put onto them. One of the fun things to do was to change the
soundtrack every time you'd show the film. Nothing was really
married: no sound or image was ever married for long, there was a
weak connection (again). I've made the same piece of work for thir-
ty years; it's just that it takes different forms. It's this slippage, this
kind of elision of two different texts, a different soundtrack to a dif-
ferent text, by seeing it from a slightly different angle.

HUO:

So how did your work develop then?

CWE:

It happened in stages, I'd say. I don't want to forget the quote from
Alain Robbe-Grillet's *La Jalousie* (1957) which is still pertinent to
answer this current question. In the book, there is a kind of foot-
note that interrupts the text in italics, and says, "Same scene shot
from a different angle." In a sense, it is the same scene shot from a
different angle. I became a little more confident, I suppose, if you

can say this, in a very conventional sense in operating a camera. In one of the first films I made, one of these sculpture films, there was a large double mirror hanging in the middle of the room, roughly the same proportion as the frame of the film itself. (I'm working with these double-sided mirror pieces again, making new pieces.) And the mirror revolved, it spun, so that front on, you had this image of the camera reflecting itself, but then from the side you just get a line; from another angle the mirror would start to refract. I was interested in the relationship between the projector and the camera, the eye and the screen, these kinds of "Metzian" moments where the cinema became the subject. Rather than the sculpture being somehow in the round, the film became its own subject, and the machinations of film projection became the sculpture that I was then interested in filming. It was about a tautological relationship to the materiality of cinema and the materiality of the visual and the visible. The move away from setting up a situation that would fall under the rubric of a sculptural situation or a performance-sculpture hybrid was about the self-consciousness of the film as a medium in and of itself, somehow recording itself. I tried to introduce a kind of lucidity within the iconography of film as a producer of itself—a certain kind of looping, a Mobius looping. That led me into perhaps a more conventional perspective because the camera was pulled back a little more; the camera was involved in filming its own condition, but not in the sense as with people such as John Hilliard or Michael Snow from a generation or two earlier. I wanted to introduce a certain kind of queering of that space, a re-theatricalization of that space. A staging of space. A staging of the stage. The prop became important: the prop as a property of the scenario, literally, but a prop also as a kind of crutch. I play a lot on crutches because the whole eroticism of cinema became something fascinating for me: the eroticism of framing various forms of desire, desires that I felt were not represented by the imagery that I was surrounded by. In a sense, there were several shifts that all sort of happened on different levels at different times, but within those years, I moved towards a more "proper" form of filmmaking.

HUO:

Were there some influential dialogues with artists or filmmakers that marked these shifts?

CWE:

By the time I had left St Martin's and the Royal College I'd befriended the filmmaker Derek Jarman, a very kind man. I never

saw eye-to-eye with Derek about the kinds of films that he made, or what we were thinking about in terms of making films or art in a sense. Of course he was of another generation, he was older... It was a different dialogue, a dialogue about a cultural history in a sense. And coming from that generation, he was closer to identifying an importance with that cultural history; and what became important for me later on was the notion of the gay father or grandfather: looking to predecessors, looking at the spaces where desire had been spoken with a certain degree of confidence and courage in situations of great prejudice. Derek's books and records were much more of a resource than his films or thoughts about making film. I had a fondness for the things very much before my time and before my friendship with Derek: the films that he made in the '60s and early '70s, these experimental Super 8 films. Derek thought of himself very much as a "fine artist," in fact, as a painter whilst at the Slade School of Art, and then living in this kind of squat space very close to where Tate Modern is now (at the time it was an abandoned warehouse space and had this sort of arty, hippy, gay life in the late '60s and early '70s, which was certainly attractive from the point of view of a certain form of nostalgia). But with the making of films such as *Jubilee* (1977), I actually found them, at best, embarrassing because I felt they were out of touch with my experience of what that was; I think *Sebastiane* (1976) is a different film—it's rarely seen and there is still something about it that fascinates me, in that there's a certain level of perversity in making a porn film in Latin. But I mustn't be ungenerous to him because he was exactly the opposite of me, and he in fact organized the first screening of my films at the ICA, which was a season of films ("A Certain Sensibility..." 1981). This seems absurd to think about today because there were only enough films to make two programs!

HUO:

At the time of this first screening, were you already interested in the exhibitions context?

CWE:

It was there completely from the beginning. The cinema for me was never a neutral space, it was never a white cube or a black box. A film screening always had... it was conventional—interval music within the cinema, although it wasn't conventional to have interval music within an art house context. There would always be incense, fruit to eat, a table with books or music to play if you didn't want

to watch the film, and the seating would be rearranged. It was much more about creating a kind of ambience, which either compliment-ed, or perhaps more often, contrasted with the emotional, intellec-tual temperature of the films, the subject of the film. As things became more formalized, which happened a few years later, you would shoot something on film and it would end up being a video-tape, sent off by the Arts Council or whoever to some festival and be shown in a kind of a neutral context. In the early days at least, there was a crossover between cinema screening and performance. There was certainly a sense of people being encouraged to behave in dif-ferent ways to those that they might have done in the anonymous darkness of a commercial cinema or theater space.

HUO:

The differences between spaces also produce differences in temporalities.

CWE:

The temporal and the spatial are, specifically within the practice of filmmaking, inextricably entwined. Godard famously talks about reality being 24 frames per second, thereby exposing the artifice of what a given is when we forget how to examine it, and how neces-sary it is for the dominant ideological narrative to hide the forms of its own construction. Norman Bryson says that for an image to be believable by a community, its technologies of production must remain hidden as an independent form. Temporally, we're dealing with a kind of shift of axis, and it's quite telling what kinds of dis-tinctions are made, the articulation of spatial practices and the articulation of temporal ones, given that they are so intertwined, but at the same time so usefully separable in order to bias the dis-tinctions and various forms with which we can think. For example, there are interesting things such as scale, experimental notions of scale within the spatial and temporal; for me there's an interesting paradoxical axis of registration that happens between these two registers intersecting in a sense. It's certainly possible to underline or highlight one possibly at the expense of the attention of the oth-er. The intuition of space is over determined by the intuition of time. I think that's a truism that we can agree to, or set up and begin to explore. What we know or experience of space is largely colored by our temporality in relation to our perception of that space. No one mines this territory better than a writer like [Mau-rice] Merleau-Ponty. To go back to a sequence from a book that was the voice-over text from the first film I made: *The Visible and*

the Invisible by Merleau-Ponty (*Le visible et l'invisible*, 1964). He writes, "How are we to name, how are we to describe such as I see it from my place that lived by another which is not nothing for me since I believe in the other, and that which furthermore concerns me myself because it is there as another's view upon me." There's this extraordinarily lyrical flow from subject to subject.

HUO:

What were these first films that you showed in the ICA?

CWE:

They haven't been seen since actually. There was a film called *Still Life with Phrenology Head* (1979), which is a sculpture film with books on a table; and it now seems extraordinarily pretentious that at the age of 18, I was using Hegel's *Phenomenology of Mind* as a prop. The other films were called *The Attitude Assumed* (1980), and another named after a book on Godard was called *Have you seen Orphée recently?* (1980). This title refers to an homage, or maybe even pastiche, that appears in *Alphaville* (1965) in relation to Jean Cocteau. This kind of avuncular relation, the idea of looking back at others, is now slipping into another territory, something that has been commented on in my more recent work: homage. And I wonder why I'm so resistant to this notion of homage? It's because it's misplaced; I think it's slightly different from homage.

HUO:

An appropriation rather?

CWE:

It's certainly an appropriation on a certain level, but it's probably worth going into exactly for what reasons. For instance, we're talking today about the possibility of using an element in a borrowed sculpture as part of this exhibition at the Palais des Beaux-Arts in Brussels, a necessary inclusion of a monstrosity if you like. It's not quite as simple as saying that I'm paying homage. What's important here is the discourse—as I alluded to earlier—a conversation in which the two people don't understand at all what they're saying. There isn't necessarily a reply, or that there might be a correspondence happening that we're completely missing—missing the reply or that we're being floated past the object into a space which is behind.

HUO:

So it doesn't matter whether someone understands the references you use; what's more important is to be seduced by the materiality of the work and being uncertain in front of it? Now we are really coming back to this notion of weakness that you were mentioning earlier.

CWE:

It has to do with a weak connection, yes, and what's at stake there psychoanalytically; it's some kind of fear of commitment, I'm sure, to the idea of being understood or simple communication, or direct communication. I think this willful indirectness is something that Liam Gillick talks about: the simplicity of playing into the hands of the powerful elite is something close to direct communication; a kind of will to short-circuit or fuck-up the meaning or distort it. This is very different from what Guy Debord thought when he said, "In harmony, how often will this scene be repeated and in how many states hitherto unseen in languages as yet unborn." It's almost like a melancholic imaginary, but somehow this melancholic projection of acting-out again at some point in the future in ways that we cannot be certain of, of a similar scenario—the scene happens again and again. And it somehow alludes to the way that I think of the same scene being shot from a different angle.

HUO:

We are now speaking of "Cerith Wyn Evans, Artist" rather than "Cerith Wyn Evans, Filmmaker," like you often ironically say. Obviously, the relationships between your films and your installations are very legible, but in order to be more explicit about these latter works, perhaps we cans speak now of what you intend to do here in the Palais des Beaux-Arts in Brussels. Again, you're thinking about using different referential elements: a Morse code translation of an extract of Georges Bataille's The Accursed Share (La Part Maudite, 1949), *a palm tree in reference to Marcel Broodthaers' use of a palm from the Belgian Congo that he took from the Palais des Beaux-Arts; and a chandelier in order to reflect on the cultural history of the space. It all started from {Ossip} Zadkine, correct?*

CWE:

Jacob Epstein was alive to the idea of autobiography and pompous titles, and how people seem to want make their own history grand, but the title of Epstein's biography was *Let There Be Sculpture*. So, this kind of ridiculousness made me think it would be a good component rather than thinking seriously about Zadkine. What I really wanted to evoke in all of this is that idea of "the wounded returning to the battlefield"—a homeopathic response to the history of the space by bringing something back, of keeping the wound fresh, opening up possible transport routes to different situations; or at least making the illusion of that possible. The other thing that I have thought about is heading in a different direction, moving

away from Morse code, in that the palm would have a Morse code voice. I don't know if you've seen Max Ophül's *Lola Montez* (1955)? It's a masterpiece cliché film, and one of the things I like about it is when the curtain or screen is introduced. I've always loved this idea of how the screen becomes alive in a cinema, and how it works in different ways in different places. One of the places I remember is the National Film Theater, or NFT1, the biggest screen there. They have this great abstract '50s sculptural door that has mismatched teeth that open to reveal the screen. The other thing I have always adored is the way that the projector is switched on before the curtains have opened, so you get the numbers counting down, the blip on three and then the film starts properly. *Lola Montez* has a spectacular opening; it's a black-and-white film but it opens with what you can only imagine to be red velvet curtains. It announces itself twice as it is about "staging the stage." When the curtains open and the camera comes up from the orchestra pit, I assume, onto the stage, there is this rush. It's an old trick but it is always literally spectacular, what's it called?... a parasympathetic response, where the body is tricked by the illusion, like those IMAX cinemas that work like a camera attached to the front of a roller coaster. You're sitting in your seat and are well aware that you are in the cinema, but you are somehow still tricked by the camera. As the camera moves in, the walls and the set on the stage itself separate and move out mechanically, so there is a heightened sense of zooming in. But one of the things that happens at this moment is these huge, monstrous chandeliers—that are on stage in the set for whatever opera or play is on at the time—rise. There's an extraordinary moment of zooming in, the set spreading out, but seeing these enormous chandeliers elevate was something I can remember being very excited about. A possibility might be to hang a large chandelier from the ceiling of the space, arranging a conversation between a chandelier and a palm. Initially the idea was to have the sculpture and the palm and because the sculpture was of the sculptor, sculpting himself in some kind of narcissistic, solipsistic, tautological way, and then have the palm that stands in for so many different things in that space, having a conversation between them. Now maybe it should become more of a monologue. So let's think more in terms of the performer on these steps. Say the palm is somehow all of the above, it's kind of Broodthaers, it's kind of show business, it's colonialism, it's an organic McGuffin versus the chandelier, which is another form of institutional camouflage.

I don't see the point. Well I do, but I think it becomes a bit deca-
dent from the point of view from which I had envisaged it. I don't
much see the point of a talking spotlight onto a chandelier. It needs
to have its own agency. Maybe the plant can somehow have a
monologue, but the chandelier is somehow just mute in the space.
Maybe it's enough just to have it there.

HUO:

*Can you tell me also about the "Dreamachine" that you made together with
Brion Gysin in 1984, and that you recently decided to rebuild in 1998
using a revolving cylinder producing a flickering light, said to induce a
state of lucid dreaming in the viewer? Was Gysin's involvement about
inviting chance?*

CWE:

It's about forcing the hand of chance, making chance work for you;
somehow manipulating chance in a more radical notion or even a
more archaic notion than Cage's Zen-like notion. This is really
much more willful and much more in the realm of tuning in to the
possibility of being able to control what happens—a much more
pro-active position. As concerns Gysin and the "Dreamachine,"
again this goes back to links with a whole bunch of people I had
met in London, some of whom were also collaborators with Derek
Jarman. One of my great heroes was the musician and artist Gene-
sis P. Orridge. At the Royal College, you could ask people to come
in from the outside to give a tutorial, and I asked for Genesis. He
came in and we ended up collaborating, with me supplying his
band Psychic TV with visuals and them supplying a soundtrack for
a film I made. Again, here is a story of a group of people who start-
ed off within a British Fluxus tradition and moved into the terri-
tory of being musicians and filmmakers, an interdisciplinary loose
group. And through Genesis P. Orridge I was introduced to
William Burroughs and Brion Gysin. There was a series of per-
formances at a gay nightclub in London called Heaven. Burroughs
had come from New York, and Gysin came from Paris; John
Giorno came for a reading at the Wag Club, which was originally
called The Whiskey A-Go-Go in the '60s. And I projected films on
the walls while he read. I'd never met the man before, although I'd
read some of his poetry and had seen Andy Warhol's *Sleep* (1963).
I remember meeting this group of people at the time and going to
an exhibition opening with Gysin, sharing a taxi with him. The
following day, I was asked to show films at a festival in Turin, and
we got to talking and Gysin said, "What are you doing this
evening?" and I said "Oh I'd better have an early night because I've

got to catch a plane in the morning to go to Turin." He then replied, "Maybe I should come with you," and the idea of going on an adventure with Brion Gysin to Turin was very thrilling at the time, because I looked up to him so very much. We spoke about the "Dreamachine," and made some together, as well as a film called *The Dream Machine* with Michael Kostiff, John Maybury, and Derek Jarman (1982). About 15 years later, I decided to remake or "reissue" the work. I was aware of the "dreamachine" and the claims made for it, and I was very interested in constructing what Gysin describes as how each person who experiences it can have access to their own autonomous movies. And this was very interesting to me, because of the way in which it purportedly changes. He also says that it's "the only work of art ever made to be looked at with your eyes closed," which I'm not sure is a true claim because of various works and experiments that have been made. The point he's making is that it is in some sense explicitly retinal, and so I think there is a relationship to Duchamp and particularly the Rotoreliefs—these kinds of machines. I've not read much work, which goes into these kinds of comparisons or conjectures, but this playing of the conjecture between the authorship and the lineage, the parentage of these machines and their ways of working, is, I think, a stimulating one. I then went on to design a more formal or specific version made in lacquered, laser-cut steel with various electronics. Originally, "Dreamachines" were made with cutout cardboard cylinders and recycled old record players, which would play at 78 rpm; you would then take a light bulb flex from the ceiling and hang it down the middle of the cylinder at a certain height. I felt it would be interesting to produce this—other people have too; there are many different versions of the "Dreamachine" that exist.

HUO:

Does the notion of Utopia inspire you?

CWE:

Why is Utopia always tainted with the notion of failure, or even worse, thought of as a naive state of wish fulfillment, which is close to the unrealistic dreams of children? Utopia is always kind of bound to a sort of cynicism that invades the present. It's dogged with notions of naivety or childishness, which is never really achievable, and if it were it would certainly be something we couldn't speak about or contain within language. Language is already a language that forbids it from happening because it has a history, so what is a Utopia without history?

HUO:
How is it linked to the future anterior?

CWE:
I think it has to do with what I think of as the gap between what was an aspiration... so to look back on the anterior or to think of it as a speech act, that's how I think of it. It's suffused with a certain kind of melancholia, and it's the melancholia of the great alcoholic cynics; this is the melancholy of Guy Debord especially; think of him in relation to the great utopian project of Dada, the great utopian project of the Lettristes, the great way to let us somehow be rid of our parents, be rid of our genetic code, be rid of anything that ties us to mortality, to realness; let's demand the impossible, let's be free of anything that could contain us. When you have the profound loss, which for me is at the core of the melancholia of the radical voice of Guy Debord, of course it's the voice of the master, the grave grand voice that is very problematic in itself. When he says, "We have lost Paris," I think Utopia is around these ideas of loss. Utopia is a project that is bound up in mourning. You can think of Utopias as little islands for a short period of time, or as little villages, as Christiania in Copenhagen or in terms of communities. I've always had an appetite for cults that are about to be collected by the spacecraft and then at the last minute they all take poison and die. That's a great Utopia, to be bound up in this belief in something that is absolutely thoroughly and ethically impractical. Dystopia and Utopia are almost interchangeable as terms. Successful Utopias are purely imaginary, within literature or ones that are so bound up with a moral sense of the proper place. Rather, "... Each body distributes in its own special way, without model or norm, the non-finite and changing totality of its desires. Come, enter the arena of contradictions where pleasure and reality embrace..."

ZEILINGER, Anton

Anton Zeilinger was born in Ried im Innkreis, Austria, in 1945. He currently lives and works in Vienna. After studying physics and mathematics, Zeilinger obtained his doctorate at the University of Vienna in 1971, with a thesis project entitled "Neutron Depolarization in Dysprosium Single Crystals." Zeilinger became interested in fundamental quantum-mechanical aspects of neutron interferometry and continued research in this area at the Atom Institute in Vienna. Zeilinger later joined the Neutron Diffraction Laboratory at the Massachusetts Institute of Technology (MIT), becoming associate professor there in 1981. In 1983 he accepted an associate professor position at the Technische Universität in Vienna and spent significant amounts of time throughout the '80s as a visiting professor at various international institutions, including the University of Melbourne in Australia, Hampshire College in Massachusetts, the Technische Universität in Munich, and the Institute Laue-Langevin in Grenoble, France. Zeilinger became professor of Experimental Physics at the Universität Innsbruck, Austria, in 1990, and Chair for Experimental Physics at the University of Vienna in 1999. In 1997, Zeilinger and his group confirmed the possibility of teleportation, an aspect of quantum theory first predicted and later rejected by Albert Einstein. Using entangled photons, Zeilinger showed the teleportation of their quantum state over a distance of several kilometers, making headlines in journals including the cover of Scientific American. While this work has serious interpretational and philosophical implications, it also may provide the basis for future technological applications like interaction-free measurements, quantum computation, and quantum cryptography.

........................

This interview was recorded in Davos, Switzerland, in January 2001.

Hans Ulrich Obrist:

If, of course, the dream of teleportation as the ability to travel by simply reappearing at some distant location has exerted an enduring fascination on many people over the years, how do you explain the fact that your research on teleportation found its way and such an echo into the world of art?

Anton Zeilinger:

That is something I really can't explain. My paper on teleportation was published in the last couple of months of 1997, and by the end of that year it was causing a great surge of media interest. In 2000 it suddenly all started again.

HUO:

Can you tell me about the beginnings of teleportation?

AZ:

The beginnings go back to when I was a student. At that time, the University of Vienna didn't have a fixed syllabus. I had never studied quantum mechanics systematically, but I consciously chose the subject for the exams. It grabbed me and hasn't let go since. In the '90s I finally had the resources and the opportunity to set up a laboratory. Then, in 1993, an international group of six people put the subject of teleportation forward. At the time I thought it was impossible—an idea only theorists could have.

HUO:

And yet you still wanted to tackle the problem: to see if the impossible might just be possible.

AZ:

After roughly two years it was obvious that we had gotten it. Then it was only a problem of planning. How do you pursue the idea? What is the best strategy? What methods are best?

HUO:

A few weeks ago, I met up with Gregory Chaitin in Paris. He talked a lot about risk and about the idea that the difference between art and science is not as great as people always think. When scientific breakthroughs are achieved, they often have to do with the risk involved in doing something that might possibly prove impossible.

AZ:

All the same, enjoying the element of risk is no reason for doing our sort of work. The important thing is to do something you yourself find fascinating. During our basic research phase, which started years ago, quite a few of my colleagues told me I was wasting my time. They said there was nothing left to discover in quantum mechanics. All that was left to discuss was the aspect of technical applications. They said that fundamental experiments were uninteresting.

HUO:

In the field of art, people talk about obsession. Could we call this a case of scientific obsession?

AZ:

It depends on what obsession is. It gets a hold on you; you really want to do it whatever happens. You have the feeling that you have reached a point where things are getting interesting. The difference between our work and art is that ultimately what we do is tested by experiments carried out on nature. It must be seen to work. That is the difference between art and science: at least between art and the

natural sciences. The knowledge involved in the humanities is something different again.

HUO:

My next question is one that I am sure you are often asked; it's the connection between teleportation and science fiction literature. Has it been of any importance to you as a research scientist that science fiction authors wrote about teleportation before its existence could be scientifically proved? Is there any connection?

AZ:

No, there isn't. Although I do find science fiction entertaining, but not at the same level. Science fiction is literature, it's fiction and poetry. It may, of course, have some influence without me being aware of it. Our motives for doing things are normally not clear to us. The stories we tell each other afterwards are generally invented to suit our own purposes. That is the famous problem with oral history.

HUO:

In your writings, you have claimed that teleportation will even be possible with molecules in the long term. Then we would be dealing with actual beaming.

AZ:

That is right. So far, only protons, particles of light, have been teleported. They are the smallest elements we can deal with in a laboratory. We proved that for the first time in 1997.

HUO:

And now you are working on the tele-transportation of molecules?

AZ:

We are working on teleportation, as we call it. Tele-transportation would be too concrete for me, too similar to transport; that would be crazy [*laughs*]. Our next goal is to manage distances of a few hundred meters, perhaps a few kilometers with light particles. Molecular technology is way behind light technology, which has been around for more than a hundred years: just think of optics. At the moment we are working on the famous "football molecules." I don't know if you are familiar with them. They are very pretty and really look like footballs. But we still have a long way to go before we achieve the teleportation of molecules. We are talking about at least a decade or more.

HUO:

Do you assume that the original will be destroyed during the process?

AZ:

We aren't teleporting the object, only the information. We are transferring all the information from the original to a new original. The recipient will be made of matter, which must already be at the reception end, that is true, but it will carry all the information and will be no different from the original. And that raises the very old philosophical question: What does identity mean? When are two objects identical? For me, as a physicist, there can only be one conceivable criterion: If something carries all the characteristics of the original, then it is the original. The information is transferred in the sense that it is really drawn out of the original.

HUO:

Does this lead to the breakdown of the original?

AZ:

The original doesn't have the specific information any more. That is really funny. We are now talking about quantum states in which a system no longer possesses any characteristics. From a philosophical point of view, these processes are incredibly fascinating and have never even been touched on. I would almost go as far as to say that the vast majority of physicists consider these philosophical questions frivolous. Despite the fact that a great deal of the most significant progress ever made has been the work of people who gave a lot of thought to philosophical questions; you can see that if you look at the history of science.

HUO:

Have you studied philosophy at all?

AZ:

Yes, I have. The fundamental questions of life interest me. Unfortunately, there are not nearly enough philosophers you can talk to who are willing to think radically about the possibility that our views on the world might be incorrect. Philosophers, and some physicists as well, often spend too much time thinking about what other great philosophers said at some time in the past. In that way I am revolutionary. You have to throw some things overboard if you want to make any progress.

HUO:

How do you define coincidence?

AZ:

For me there are two different forms of coincidence, which are intrinsically different from each other. I call one type objective coincidences and the other subjective coincidences. Subjective coinci-

dences are those where I don't know why a specific thing happens (for example, if I meet you by chance in the street), but afterwards I can reconstruct the situation and understand why things took place the way they did; or when I throw a six, which happens because I turned my hand a certain way, because of the nature of the table and so on. I can give a reason for what happened, or at the very least, a reason is conceivable. Objective coincidences have to do with a chance event for which there is no cause, not even a hidden one. In quantum mechanics we are familiar with these objective coincidences. Here we are dealing with something that arises and cannot be traced back to a cause in the past; it is completely new. It has been termed an elementary act of creation. It arises from nothing. Incidentally, that is the main reason why Einstein criticized quantum mechanics. Because it gives chance a completely new function. He wasn't able and didn't want to understand that. But he was one of the very few who realized to what extent quantum mechanics would lead to a new way of looking at the world. That is an incredible intellectual achievement. The fact that he turned out to be wrong is of secondary importance. It is often more important to raise a question than to answer it correctly. The discovery of pure coincidence is certainly one of the most important intellectual discoveries of the twentieth century.

HUO:

What about the concept of risk in this context then?

AZ:

That is a good question, in a general sense as well. What is the meaning of what you do as a physicist? What does it mean for you as a person, for your life? It has consequences. When people have accepted this concept of pure coincidence, their way of looking at life becomes much more open. We are at the mercy of the unforeseeable anyway. Uncertainty is the centerpiece of human identity. A great many poets have said that again and again. But I do find it funny that science comes to the same conclusion.

HUO:

What risks do you take?

AZ:

You have to be guided by what you find interesting, and you have to assess risks: Is something impossible or is it only very, very difficult? People's existence is at stake as well. You have students working there and they want to get a job, too, later on. And of course every decision carries with it the risk that it might be wrong. That makes life romantic and interesting. Without that risk, life would

be as dull as dishwater. If the view of the world we get in classical physics were right, and everything worked like clockwork, that would really be extremely distressing. On the other hand, we are, of course, at the mercy of risk.

HUO:

Can you speak about teleportation and the cross-linking phenomenon? For instance, when a dice is thrown in Budapest and the result is a six, and another dice is thrown in Vienna or in some other town and the result is also a six...

AZ:

... that is the famous phenomenon of cross-linking, which comes into its own in teleportation. You have two quantum systems, and before they were observed, neither had any characteristics. I observe one and by pure chance, the objective coincidence again, it takes on a characteristic. In the case of the dice, you throw a specific number, and at that moment the other dice, which is a long way away, will show exactly the same number. That means we've got two cases of objective coincidence, which are connected. You could say that one causes the other. But that is not the case. There are identical coincidences a long distance apart. But there is nothing causing what has happened.

HUO:

And no connection at all?

AZ:

There isn't. They come from the same source. But at the moment when they are thrown, there is no connection. This phenomenon is the basis of teleportation.

HUO:

To change subjects completely: How do you, as a scientist, experience museums?

AZ:

I like going to all sorts of museums, for instance, the museum of art history in Vienna. Not long ago there was a beautiful exhibition of Persian art there. I go and look at modern art as well, and technical and scientific exhibitions. There's positive curiosity about everything there with no holds barred. It would be exciting to draw the different fields closer together. But ultimately, what counts in a museum is not what is on show but the ideas behind the exhibits. When a new idea strikes you it doesn't matter in the least where it comes from.

Acconci. The first part of this interview was originally published on the website of the museum in progress, Vienna (www.mip.at) in 1993. The second part of this interview was originally published in: *The Discursive Museum*; Peter Noever (ed.), MAK Vienna, Hatje Cantz Publishers, Ostfildern Ruit, 2001 (pp. 142-156).

Ballard. This interview was originally published in: *Beck's Futures 2003* (exh. cat.), Institute for Contemporary Arts, London, 2003 (Separate booklet; pp. 1-18).

Barney. The first part of this interview was originally published in: *Tate Magazine* (London) 2, Nov-Dec 2002 (pp. 58-60). The second part of this interview was originally published on the website of the museum in progress, Vienna (www.mip.at) in 2000.

Birnbaum. This is a revised edition of an interview that was originally published on the website of the museum in progress, Vienna (www.mip.at) in 1995.

Boeri. Some portions of this text first appeared in: *Flash Art International* (Milan) 222, January-February 2002 (pp. 49-51).

Cattelan. This is a revised edition of an interview that was originally published on the website of UnDo.Net-Network per l'Arte Contemporeanea, Milan (www.undo.net) in 2001.

Cladders. This interview was originally published in: *Trans>* (New York) 9-10, 2001 (pp. 60-70).

Eliasson. This is an extended version of an interview that was originally published in: *Olafur Eliasson. Chaque matin je me sens différent—Chaque soir je me sens le même* (exh. cat.), Laurence Bossé and Angéline Scherf (eds.), ARC/Musée d'Art Moderne de la Ville de Paris, Editions Paris Musées, Paris, 2002 (unpaginated).

Esquivel! This is a revised edition of an interview that was originally published in: *Com & Com: We Love You. Selected works and essays (1997-2003)*, Georg Rutishauser (ed.), Niggli Publishers, Zurich, 2003 (pp. 162-166).

Friedman. Some portions of this text first appeared in: *Atlantica* (Las Palmas) 28, [MIR, trans.] 2000 (pp. 30-48).

Gadamer. This is a revised edition of an interview that was originally published in: *Highway 101 / The Journal* (Brussels) 5, [Martine Bom, trans.] February 2001 (pp. 7-24).

Glissant. This interview was first published in French and in Japanese translation in: Я *[a: r]* (Kanazawa) 1, 2002 (pp. 28-39).

Gonzalez-Foerster. Some portions of this text first appeared in: *Tema Celeste* (Milan) 92, 2002 (pp. 48-51). Translated from French for this edition.

Gonzalez-Torres. This is a revised edition of an interview that was originally published on the website of the museum in progress, Vienna (www.mip.at) in 1994.

Gordon. This interview was originally published as a folder by the museum in progress,

Vienna, in 1996 (unpaginated).

Grigely. This interview was originally published in: *Janus* (Antwerp) 11; 2002 (pp. 52-56).

Hadid. This is a revised edition of an interview that was originally published on the website of UnDo.Net-Network per l'Arte Contemporeanea, Milan (www.undo.net) in 2001.

Hopps. Hopps. © *Artforum*, February 1996, "Walter Hopps Hopps Hopps: Hans-Ulrich Obrist Talks with Walter Hopps," by Hans-Ulrich Obrist. *Artforum* (New York) 34 (6), 1996 (pp. 60-63; 98; 101; 104; 106).

Hulten. © *Artforum*, April 1997, "The Hang of It: Hans-Ulrich Obrist Talks with Pontus Hulten," by Hans-Ulrich Obrist. *Artforum* (New York) 35 (8), 1997 (pp. 74-79; 113-114).

Huyghe. Some portions of this text first appeared in: *Flash Art International* (Milan) 225, [Brian Holmes, trans.] July-September 2002 (pp. 76-81), and in: *Parkett* (Zurich) 66 [Anthony Allen, trans.]; January 2003 (pp. 149-155).

Isozaki. This is a revised edition of an interview that was originally published in: *Trans>* (New York) 9-10, 2001 (pp. 8-19).

Klüver. Some portions of this text first appeared in: *Janus* (Antwerp) 2, 1999 (pp. 12-16).

Koolhaas. Some portions of this text first appeared in: *BB1, Berlin Biennale 1* (exh. cat.), Klaus Biesenbach, Hans Ulrich Obrist and Nancy Spector (eds.), Cantz Verlag, Ostfildern, 1998 (pp. 55-60); and in *Media_City Seoul 2000* (exh. cat.), A.B. Onfante-Warren (ed.), Inter

media_city Seoul 2000, Seoul, 2000 (pp. 169-177).

Lee Bul. This is a revised edition of an interview that was first published in *Lee Bul* (exh. cat.) Kim Sun-jung (ed.), Artsonje, Seoul, 1998 (unpaginated).

Matta. This is a revised edition of an interview that was originally published in: *Tate Magazine* (London) 4, March-April 2003 [Sara Cochran, trans.] (pp. 46-48).

Ono. This interview was originally commissioned by e-flux (New York) for the online project, "DO-IT at e-flux" (www.e-flux.com/do_it/index.html).

Parent. Some portions of this text first appeared in: *Hunch* (Rotterdam) 6/7, June 2003. Translated from French for this edition.

Parreno. Some portions of this text first appeared in: *Boiler* (Milan) 1, January-March 2003 (pp. 16-23). Translated from French for this edition.

Pistoletto. Some portions of this interview first appeared in Italian in: *JOURNAL-Progetto Arte* (Biella) 7, June 2003.

Prigogine. This interview was originally published in: *Janus* (Antwerp) 5, [Gregory Ball, trans.] 2000 (pp. 24-27).

Rancière. This text was previously published in the catalogue of the Prize "Community-Art-Collaboration" organized by the Evens Foundation; *Community Art Collaboration 2002*, Hou Hanru and Germana Jaulin (eds.), [Brian Holmes, trans.], Evens Foundation; Antwerp,

2002 (pp. 15-17). The interview was originally published in French in *Traversées* (exh. cat.), Laurence Bossé, Hans Ulrich Obrist and Aurélie Voltz (eds.), ARC/Musée d'Art Moderne de la Ville de Paris, Editions Paris Musées, Paris 2001 (unpaginated).

Richter. This text was previously published in: *Gerhard Richter: The Daily Practice of Painting. Writings 1962-1993*, Hans-Ulrich Obrist (ed.), [David Britt, trans.] Thames and Hudson / Anthony d'Offay Gallery, London, 1995 (pp. 251-273). The interview was originally published in German in *Gerhard Richter. Texte: Schriften und Interviews*, Hans Ulrich Obrist (ed.), Insel Verlag, Frankfurt (pp. 140-160).

Rosenfield. This is a revised edition of an interview that was originally published in the catalogue of the exhibition *La Ville, Le Jardin, La Mémoire* (exh. cat.), Laurence Bossé, Carolyn Christov-Bakargiev and Hans Ulrich Obrist (eds.), Villa Medici, Rome, Editions Paris Musées, Paris, 1999 (pp. 81-86).

Rouch. Some portions of this text first appeared in a German translation in: *Schnitt* (Cologne) 27; 2002 (pp. 20-23).

Sejima. This interview was originally published in: *Make* (London) 22, 2002 (pp. 34-36).

West. This interview was originally published in German in: *Franz West*, Dörte Zbikowski (ed.), Silke Schreiben, Munich, 2002 (pp. 7-33).

Zeilinger. This interview was originally published in *Risk &*

Chance, glamour engineering™ (eds.), Allianz Risk Transfer, Zurich, 2000 (pp. 32-36.)

To find out more about Charta,
and to learn about our most recent
publications, visit

www.chartaartbooks.it

Printed in May 2003
by Tipografia Rumor, Vicenza
for Edizioni Charta